CONTEMPORARY AMERICAN WOMEN SCULPTORS

CONTEMPORARY AMERICAN WOMEN SCULPTORS

Virginia Watson-Jones

ORYX PRESS
1986

The rare Arabian Oryx is believed to have inspired the myth of the unicorn. This desert antelope became virtually extinct in the early 1960s. At that time several groups of international conservationists arranged to have 9 animals sent to the Phoenix Zoo to be the nucleus of a captive breeding herd. Today the Oryx population is over 400, and herds have been returned to reserves in Israel, Jordan, and Oman.

Published by The Oryx Press
2214 North Central Avenue
Phoenix, AZ 85004

Published simultaneously in Canada

Every effort has been made to ensure that the information in this book is accurate. However, the author and publisher take no responsibility for any harm which may be caused by the use or misuse of any materials or processes mentioned herein.

Printed and Bound in the United States of America

∞ The paper used in this publication meets the minimum requirements of American National Standard for Information Science—Permanence of Paper for Printed Library Materials, ANSI Z39.48, 1984.

Library of Congress Cataloging-in-Publication Data

Watson-Jones, Virginia.
 Contemporary American women sculptors.

 Includes indexes.
 1. Women sculptors—United States—Biography.
2. Sculpture, Modern—20th century—United States.
I. Title.
NB212.W37 1986 730'.92'2 [B] 84-42713
ISBN 0-89774-139-0

For Dorothy and Ben

Table of Contents

Introduction

Design of Study

This book is a study of living American women sculptors and provides a visual and written record of their achievements. It serves both art and history by identifying established and emerging artists and their works and by offering previously unpublished information for those who wish to gain insight into the careers of women who pursue art through sculpture.

Since more complete documentation can be acquired during an artist's lifetime for the enrichment of future generations, contemporary women sculptors were chosen for inclusion in this study. The selected documentation reflects the artists' public recognition and their contributions to sculpture on regional, national and international levels during the past fifty years. (A few of the artists began exhibiting as early as the 1930s.)

The word "American" in the context of this study refers to individuals who were born in the United States or who are American by citizenship or reputation. The term "sculptor" refers to artists who describe themselves as professional sculptors or their work as sculpture. Traditional categories of sculpture have been supplemented in recent years and the word "sculpture" as used in this study refers to multiple styles of work usually, but not always, in the round.

To begin this study, artists' names were compiled from questionnaires sent to art historians, museums, galleries, associations of sculptors, professional art societies, critics, art librarians, college and university art departments, and state arts organizations across the nation. Responses to the questionnaires provided names of living women sculptors whose work was represented in local, state and national exhibitions and public and private collections. Names also were provided by respondents to inquiries placed in art newsletters, as well as by some women sculptors themselves. The resulting preliminary lists contained the names of nine hundred sculptors who were requested to submit photographs of work and biographical information. Names were continually added as the study progressed.

Of some fifteen hundred artists eventually contacted, over one thousand responded. Portfolios—resumes, photographs, slides, and biographical materials—were reviewed on an individual basis. Artists were selected from all fifty states. In addition, a small number of American artists were added from abroad. The number of artists chosen was in proportion to the number of known women sculptors who reside in each state. The greatest number of artists are concentrated in the major metropolitan centers of California and New York.

The artists responding included individuals who have established distinguished records of production and exhibition as well as many who are relatively unknown. The overall presentation was designed to survey artists of varying ages and backgrounds, of different professional training and experience, of diverse sculptural attitudes and media, and from different geographical regions. Inclusion, finally, was on the basis of the quality of the works of art themselves, without promoting any one style or school of contemporary sculpture.

The information provided by the responding artists was varied and sometimes fragmentary. In the process of creative activity, many artists do not preserve sufficient documentation of their careers. Extended correspondence and intensive study of published material often supplied information not initially furnished.

Exhibition titles of the artists' work in this volume are as accurate as possible. Brochures, catalogs and other records frequently listed several titles to the same exhibit and omitted the dates. Published catalogs were not always listed in standard bibliographical sources. For the purposes of this book, exhibition titles and their corresponding dates have been made consistent. Titles of exhibitions outside the United States are given first in the language of the country of exhibition.

As can often be noted within a single artist's entry, the names of museums, galleries and universities have sometimes changed during the years. Here, the name of each gallery, museum or university is given as it was at the time of the exhibition. Many museums and galleries are affiliated with universities, although this affiliation may or may not be acknowledged in the name; for example, "Henry Art Gallery, University of Washington, Seattle, Washington" is shortened by the Gallery to "Henry Art Gallery." Titles of foreign galleries and museums are given in the language of the country.

Arrangement of Text

The entries are arranged alphabetically by last names. The biographical information (based on material provided by the artist) is outlined as follows:

Artist's Name is her professional name.
Née is the artist's maiden or family name if different from her professional name. The first and middle name may also be found here.
Husband's Name may or may not appear.
Born includes month, day, and year of birth (when provided); city, state, and country of birth; and citizenship (when other than American).
Education and Training describes the artist's general educational background and in certain instances specific training, apprenticeships and instructors in sculpture.

Selected Individual and Group Exhibitions includes regional, national and international exhibitions arranged chronologically. Exhibition sequence within a given year may or may not be chronological because the months and days of exhibitions generally are not recorded. Whenever the list is large, the individual and group exhibitions are selective rather than comprehensive, and are in proportion to the exhibition record of the artist. The selections represent on-site installations as well as conventional gallery presentations. In order to include a comprehensive listing within the limitations of space, individual and group exhibitions of different years but at the same location are listed together. Also, the numerical designations which are sometimes part of the titles of those group exhibitions are all omitted.

Individual exhibitions are listed separately without titles. Catalogs accompanying exhibitions and retrospective exhibitions have been cited wherever possible.
Selected Public Collections includes a listing of commissioned and purchased work and permanent, on-site installations for regional, national and international collections, colleges and universities, corporations, museums and galleries, and libraries and art centers.
Selected Private Collections lists up to five collectors of the artist's work.
Selected Awards is a listing of up to three significant prizes and honors.
Preferred Sculpture Media gives the artist's preferred media in up to three categories.
Additional Art Field(s) gives the artist's other studio interests.
Related Profession(s) includes professional interests other than sculpture.
Teaching Position lists the artist's present teaching position as stated by the artist. All positions are in art unless otherwise designated.
Selected Bibliography lists up to five items of additional information available about the artist. References include only commentary published in books, periodicals and selected newspapers. The arrangement is alphabetical by author or, if the author is not identified, by title. Most regional published sources are excluded because they are largely inaccessible to a national audience. Artist's papers are noted when included in archival collections. Films or taped interviews are not included. Articles or books by the artist are listed only when they mention the artist's sculpture.

Additional references about the artist may be available in catalogs or in standard reference guides such as *Art Index*. The artist's gallery often will provide resumes upon request. Local libraries sometimes can provide files on area artists. In general, the amount of bibliographical material about the artists varies widely. Extensive material is available on only a few artists, while most receive slight attention.

Gallery Affiliation lists galleries, representatives, and agents.

Mailing Address lists the address where the artist receives professional mail and also indicates the artist's geographical area.

Artist's Statement is a brief explanation of intent or philosophy of work written by the artist for this book. The artist's signature is shown beneath her statement. A few artists declined to give either a statement or signature.

Indices provide the geographical distribution of the artists and a list of their media. The book has no general bibliography, since the artists' bibliographies in themselves provide abundant sources of information.

Each photograph illustrates a major direction in the artist's work. Each is accompanied by the title and a description which includes the date, materials, and dimensions. Dimensions are given in feet and inches in order of height, width, and depth. The circumstances of exhibition or location are described wherever possible. All photographs are by courtesy of the artists when not otherwise credited.

Notes on Research

The biographical and bibliographical details chart the growth of the artists' careers: the oldest artist listed is eighty-nine years old; the youngest, twenty-seven. The intimate connection between the events of the artists' development and the evolution of their ideas over the years is manifested in their sculpture. The written statements by the artists reveal their intentions or their perceptions of their work, and often show how personal experiences have had an influence on their imagery.

Many artists also have achieved excellence in painting, printmaking, drawing, video and film making. A biographical profile, a bibliography, and a single illustration of sculpture is a selective record of their professional attainments. Continued documentation not solely of the artists in this study but also of many others who are not represented can provide a broad base of information which might otherwise be lost.

A comparison of the profiles and photographs of work reveal the artists' initiative, determination, commitment and creativity, often without public acknowledgement or financial gain. More than a few artists are barely known outside their regions and have not received visibility or recognition in publications or collections. Most are making a special effort to exhibit their work on a broader geographical basis.

Of the artists whose work is represented in national and international collections and museums, many have played decisive roles in the development of contemporary art. Most artists, however, must struggle to obtain alternative exhibition opportunities, either by self-promotion or through a network of supportive patrons.

By serving as a reference guide and a survey of the artists' accomplishments, this book offers an opportunity to introduce one artist to another and to introduce the public to artists whose work may not be familiar. The photographs can give only an insufficient idea of the sculpture which, of course, should be viewed directly.

This book is about artists whose work is strong, vital, and often innovative. In addition to my gratitude to the artists, I extend my warmest thanks to the many individuals, librarians, museums, galleries and personal friends who have given me assistance and information during the preparation of this book. In particular, I would like to mention Elizabeth Snapp, Director of Libraries of the Texas Woman's University, for her generous encouragement of my efforts.

Individual Artists' Entries

Kim Abeles

née Kim Victoria Wright
Born August 28, 1952 Richmond Heights, Missouri

Education and Training
1969 American Field Service, Utsunomiya, Japan; study in Japanese arts
1974 B.F.A., Painting, Ohio University, Athens, Ohio
1974 Kindergarten, Elementary and Secondary Certification, Art, Ohio University, Athens, Ohio
1980 M.F.A., Studio Art, University of California, Irvine, Irvine, California

Selected Individual Exhibitions
1981 Los Angeles Municipal Art Gallery, Los Angeles, California
1982 Los Angeles City Hall, Los Angeles, California
1983, Karl Bornstein Gallery, Santa Monica,
85 California
1983 Phyllis Kind Gallery, Chicago, Illinois
1985 University Art Gallery, Pepperdine University, Malibu, California

Selected Group Exhibitions
1979, "New Work," Libra Gallery, Claremont
80 College, Claremont, California
1980 "University of California, Irvine; California College of Arts and Crafts and Claremont College Exhibition," Los Angeles Contemporary Exhibitions, Los Angeles, California
1981 "Southern California Artists," Los Angeles Institute of Contemporary Art, Los Angeles, California
1981 "Kim Abeles and Jan Taylor," Stage One Gallery, Orange, California
1981 "Los Angeles Street Scene Festival Bridge Gallery Exhibition," Los Angeles City Hall, Los Angeles, California
1981 "Kim Abeles and Jean Edelstein," Mirage Gallery, Santa Monica, California
1982 "Fabric," Fine Arts Gallery, Golden West College, Huntington Beach, California
1982, "Summer Exhibition," Karl
83, Bornstein Gallery, Santa Monica,
84 California
1983 "X-Change," Linda Farris Gallery, Seattle, Washington
1983 "Breaking and Entering," Josef Gallery, New York, New York
1983 "Gallery Artists," Phyllis Kind Gallery, Chicago, Illinois and Phyllis Kind Gallery, New York, New York

1983, "Artist's Toys," Vanderwoude
84 Tananbaum Gallery, New York, New York
1984 "Critics Choice: Downtown Artists," Transamerica Center, Los Angeles, California, catalog
1984 "A Broad Spectrum: Contemporary Los Angeles Painters and Sculptors '84," Design Center, Los Angeles, California, catalog
1984 "Altar Ego," de Saisset Museum, Santa Clara, California
1984 "Non-Traditional Sculpture," Stage One Gallery, Alhambra, California
1984 "Masks, Masquerades, Megillot," Skirball Museum, Hebrew Union College—Jewish Institute of Religion, Los Angeles, California
1984 "Kim Abeles and Barbara A. Thomason," Glendale Community College, Glendale, California
1984 "Art Gear," Hunsaker/Schlesinger Gallery, Los Angeles, California
1984 "Equal Time," Angels Gate Cultural Center, San Pedro, California
1984 "Artists Call," Thinking Eye Artwork, Los Angeles, California
1985 "Kim Abeles and Carole Caroompas: New Work," Karl Bornstein Gallery, Santa Monica, California
1985 "Transformed Objects," Edge Gallery, Fullerton, California
1985 "Eight Artists," Mount San Antonio College Art Gallery, Walnut, California
1985 "The Missing Project #2: Fifteen Artists Respond in a Mixed Media Exhibition," SPARC Gallery, Venice, California
1985 "Kim Abeles and Tom Stanton," University of California, Irvine, Irvine, California
1985 "Deborah Small and Kim Abeles, Paintings & Sculpture," Southwestern College, Chula Vista, California
1985 "Kim Abeles, Scott Reeds and Peter Plagens," Orange County Center for Contemporary Art, Costa Mesa, California
1985 "Monuments To: ," University Art Museum, California State University Long Beach, Long Beach, California
1985 "Have a Heart," Akron Art Museum, Akron, Ohio
1986 "The Magic of California Assemblage," California State University Dominguez Hills, Carson, California

Selected Public Collections
Chittendon Corporation, Curacao
Fashion Institute of Design and Merchandising, Los Angeles, California
Steve Chase and Associates, Rancho Mirage, California

Selected Awards
1977 United States Steel Award, "Associated Artists of Pittsburgh Annual Exhibition," Museum of Art, Carnegie Institute, Pittsburgh, Pennsylvania, catalog

1979 Honoraria Program Recipient, Recognition of Outstanding Student Research and Creative Achievement, University of California, Irvine, Irvine, California
1984 Fellowship, Hand Hollow Foundation, East Chatham, New York

Preferred Sculpture Media
Varied Media

Additional Art Fields
Painting and Photography

Related Professions
Art Instructor and Author

Selected Bibliography
Bedient, Calvin. "Los Angeles: Kim Abeles at Pepperdine University and Karl Bornstein." Art in America vol. 73 no. 5 (May 1985) pp. 178, 181, illus.
Clarke, Orville O., Jr. "Exhibitions: Reliquaries for the Lost." Artweek vol. 14 no. 37 (November 5, 1983) p. 4, illus.
Hammond, Pamela. "Reviews of Exhibitions, Performances: Kim Abeles and Jean Edelstein at Mirage, Santa Monica." Images & Issues vol. 2 no. 4 (Spring 1982) pp. 79-80, illus.
Rubin, Edward. "New York Reviews: Breaking and Entering." Art News vol. 82 no. 6 (Summer 1983) p. 196.
Wortz, Melinda. "Artists the Critics Are Watching, Report from Los Angeles: Kim Abeles, Kimonos Floating in Space." Art News vol. 80 no. 5 (May 1981) pp. 88-89, illus.

Gallery Affiliations
Karl Bornstein Gallery
1662 12 Street
Santa Monica, California 90404

Phyllis Kind Gallery
313 West Superior Street
Chicago, Illinois 60610

Phyllis Kind Gallery
136 Greene Street
New York, New York 10012

Mailing Address
240 South Broadway
Los Angeles, California 90012

Artist's Statement

"I view my work as an opportunity to transform philosophical issues into visual dialogue: the rituals of daily life which are self-created or inherited through culture and the relationship of the individual to the social environment. Much of my early sculpture has been influenced through a residence in Japan where I learned the domestic art of kimono construction and developed a profound respect for the philosophy reflected in Shingon Buddhism. My work incorporates the suggestion of the person as well as symbols and contemporary objects that allude to and comment on the nature of human existence.

"Crucial to this mode of narrative is a time element which Gertrude Stein has called the 'continuous present.' This time reference extends beyond the sculptural structure to the continual personal narratives which the form evokes in viewers. These private histories give the impressions of confessions because of the shrine-like qualities of the sculpture."

Kim Victoria Abels

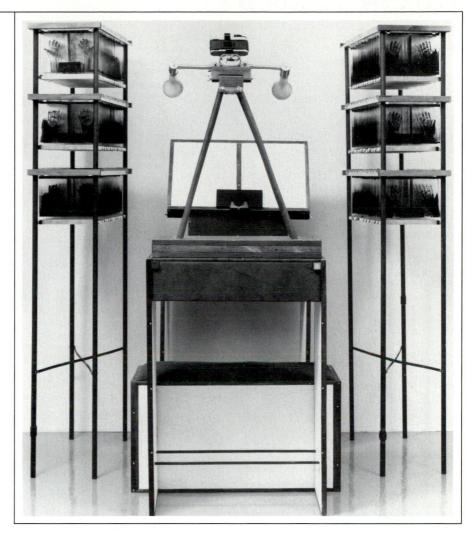

Experiment to Identify Change. 1982-1983. Wood, metal, stucco, canvas, camera, plaster mold to align hands for photographing each day and transparencies, 73"h x 63"w x 52"d. Courtesy Karl Bornstein Gallery, Los Angeles, California. Photograph by Daniel Martinez.

3

Cecile Abish

(Husband Walter Abish)
Born New York, New York

Education and Training
1953 B.F.A., Sculpture, Brooklyn College, Brooklyn, New York

Selected Individual Exhibitions
1969 Newark College of Engineering, Newark, New Jersey
1971 Bykert Gallery, New York, New York
1971 112 Greene Street Gallery, New York, New York
1973 Ramapo College of New Jersey, Mahwah, New Jersey
1974 Institute of Contemporary Art, Boston, Massachusetts
1975 Rutgers University, Douglass College, New Brunswick, New Jersey
1975 University of Maryland at Baltimore, Baltimore, Maryland
1977 Alessandra Gallery, New York, New York
1978 Fine Arts Gallery, Wright State University, Dayton, Ohio
1981 Anderson Gallery, Virginia Commonwealth University, Richmond, Virginia
1982 Fine Arts Center, State University of New York at Stony Brook, Stony Brook, New York, retrospective and catalog

Selected Group Exhibitions
1969 "Other Ideas," Detroit Institute of Arts, Detroit, Michigan, catalog
1970 "Sculpture Exhibition," Traveling Exhibition, Mead Library of Ideas, New York, New York
1971 "Contemporary Arts Program," New York University, New York, New York
1971 "Twenty-Six Contemporary Women Artists," Aldrich Museum of Contemporary Art, Ridgefield, Connecticut, catalog
1972 "GEDOK American Woman Artist Show," Kunsthaus, Hamburg, Germany, Federal Republic, catalog
1972 "American Women: 20th Century," Lakeview Center for the Arts and Sciences, Peoria, Illinois, catalog
1972 "Ideas Wanted," Museum of Contemporary Crafts, New York, New York

1972 "Five Sculptors—7,000 Sq. Feet: Cecile Abish, Bill Bollinger, Peter Gourfain, Robert Grosvenor, Jene Highstein," 10 Bleeker Street, New York, New York, catalog
1973 "Women Choose Women," New York Cultural Center, New York, New York, catalog
1973 "NETwork of Ideas," Power Gallery of Contemporary Art, Sydney, Australia
1974 "Sculpture in the Park, An Exhibition of American Sculpture," Van Saun Park, Paramus, New Jersey (Sponsored by Bergen County Parks Commission, Paramus, New Jersey), catalog
1974 "Group Exhibition," Bykert Gallery, New York, New York
1975 "Thirty Artists in America Part I: Thirteen Women Artists," Michael Walls Gallery, New York, New York
1976 "Style and Process," Fine Arts Building, New York, New York, catalog
1977 "For the Mind and the Eye: Artwork by Nine Americans," New Jersey State Museum, Trenton, New Jersey
1978 "Abish, Kazuko and Okumura," Nobé Gallery, New York, New York
1979-80 "Supershow!," Traveling Exhibition, Hudson River Museum, Yonkers, New York, catalog
1980 "Arts Festival of Atlanta," Piedmont Park, Atlanta, Georgia
1981 "Retrospective," Rutgers University, Douglass College, New Brunswick, New Jersey, catalog
1981 "Natur-Skulptur, Nature-Sculpture," Württembergischer Kunstverein, Stuttgart, Germany, Federal Republic, catalog
1983 "Comment," Long Beach Museum of Art, Long Beach, California, catalog
1984 "Land Marks," Edith C. Blum Art Institute, Bard College Center, Annandale-on-Hudson, New York, catalog
1985 "The Maximal Implications of the Minimal Line," Edith C. Blum Art Institute, Bard College Center, Annandale-on-Hudson, New York

Selected Awards
1974 Creative Artists Public Service Grant, New York State Council on the Arts
1977, 80 Individual Artist's Fellowship, National Endowment for the Arts

Preferred Sculpture Media
Varied Media

Additional Art Field
Photography

Related Professions
Visiting Artist and Lecturer

Selected Bibliography
Alloway, Lawrence. "Cecile Abish: Recent Sculpture." *Arts Magazine* vol. 51 no. 6 (February 1977) pp. 140-141, illus.
Baker, Kenneth. "Review of Exhibitions: New York, Cecile Abish at Alessandra." *Art in America* vol. 65 no. 3 (May 1977) pp. 110-111, illus.
Keeffe, Jeffrey. "Cecile Abish: Building from the Ground Up." *Artforum* vol. 17 no. 2 (October 1978) pp. 35-39, illus.
Kingsley, April. "Six Women at Work in the Landscape." *Arts Magazine* vol. 52 no. 8 (April 1978) pp. 108-112, illus.
Kuspit, Donald B. "Cecile Abish's Museum of the Absurd." *Art in America* vol. 70 no. 1 (January 1982) pp. 111-115, illus.

Mailing Address
Post Office Box 485
Cooper Station
New York, New York 10276

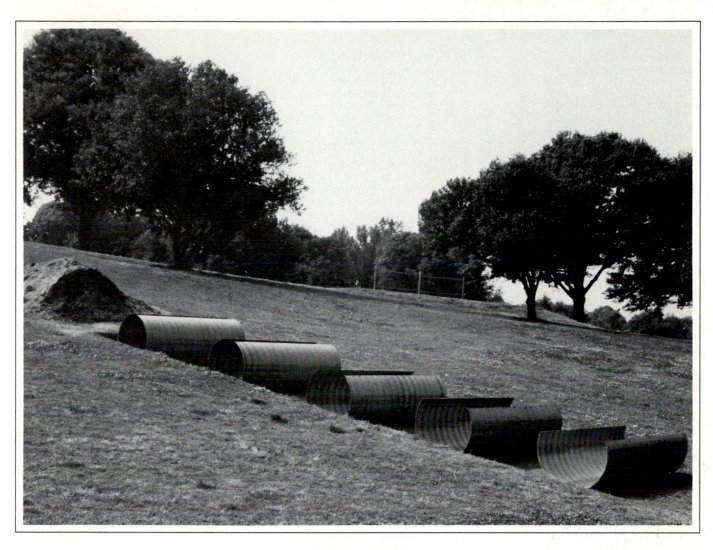

Renaissance Fix/Piedmont Project. 1980.
Fiberboard and earth, excavation cut, 35'4"l x 7'w
x 16"d; earth heap, 4'6"h x12'l x 12'w; cylinders,
36"h x 7'w. Installation view 1980. "Arts Festival of
Atlanta," Piedmont Park, Atlanta, Georgia.

Artist's Statement

"Site related works such as I build leave an
imprint, a personal imprint on the landscape.
The imprint, hopefully, is an act of
imagination which activates the surrounding
area. In a sense, to view a work is to be
within its field of influence. *Renaissance
Fix/Piedmont Project*, the outdoor sculpture
installed in Piedmont Park, Atlanta, was
inspired by my impression of the vast
railroad networks and embankments in that
city. Atlanta had at one stage of its history
been the terminus for the southern railroad.

"The sculpture is not intended to evoke
the railroads—merely the idea of cutting, of
leveling, of distance, of gradients and of
considering each fresh cut as the new
surface, something the builders of the
railroads had to take into consideration as
well. The railroad engineers changed the
landscape without looking at the changes;
they exposed new surfaces only in order to
traverse them. The surface that enters
Renaissance Fix in Piedmont Park is also the
surface which connects it to the surrounding
terrain."

5

Alice Adams

née Alice Patricia
(Husband William D. Gordy)
Born November 16, 1930 New York, New
York

Education and Training
1953 B.F.A., Painting, Columbia University,
New York, New York
1953- École Nationale d'Art Decoratif,
54 Aubusson, France

Selected Individual Exhibitions
1971, 55 Mercer, New York, New York
73,
74,
75
1977 Wilson College, Chambersburg,
Pennsylvania
1979, Hal Bromm Gallery, New York
81 New York
1980 Artemesia Gallery, Chicago, Illinois
1980 City Hall Park, New York, New York
1980 Princeton University, Princeton, New
Jersey
1982 City of Dayton, Belmont Park, Dayton,
Ohio
1983- Hammarskjöld Plaza Sculpture
84 Garden, New York, New York

Selected Group Exhibitions
1966 "Eccentric Abstraction," Fischbach
Gallery, New York, New York
1966, "American Abstract Artists' Annual
69, Exhibition," Riverside Museum, New
70 York, New York
1971 "1971 Annual Exhibition:
Contemporary American Sculpture,"
Whitney Museum of American Art,
New York, New York, catalog
1971 "Group Exhibition," Penthouse Gallery,
Museum of Modern Art, New York,
New York
1971 "Artists at Work," Finch College
Museum of Art, New York, New York
1972 "GEDOK American Woman Artist
Show," Kunsthaus, Hamburg,
Germany, Federal Republic, catalog
1972 "13 Women," 117 Prince Street
Gallery, New York, New York
1973 "1973 Biennial Exhibition:
Contemporary American Art," Whitney
Museum of American Art, New York,
New York, catalog
1974 "New York Eleven," C. W. Post Center
of Long Island University, Greenvale,
New York, catalog
1974 "Painting and Sculpture Today 1974,"
Indianapolis Museum of Art,
Indianapolis, Indiana, catalog

1975 "Spare," East Hall Gallery, Port
Washington, New York, catalog
1976 "Four Sculptors," Williams College
Museum of Art, Williamstown,
Massachusetts, catalog
1977 "Wood," Nassau County Museum of
Fine Arts, Roslyn, New York, catalog
1978 "Outdoor Sculpture and Works Inside,"
City University of New York
Queensborough Community College,
Bayside, New York, catalog
1978 "Sculpture," P.S. 1, Institute for Art
and Urban Resources, Long Island
City, New York
1978 "Sculpture," Hal Bromm Gallery, New
York, New York
1978 "Artpark: The Program in Visual Arts,"
Artpark, Lewiston, New York, catalog
1978 "Architectural Analogues," Whitney
Museum of American Art, Downtown
Branch, New York, New York, catalog
1978- "Dwellings," Institute of Contemporary
79 Art of The University of Pennsylvania,
Philadelphia, Pennsylvania; Neuberger
Museum, Purchase, New York, catalog
1979 "The Artists' View," Wave Hill, Bronx,
New York, catalog
1979 "New Editions: Adams, Chamberlain,
Hall, Highstein," Hal Bromm Gallery,
New York, New York
1980 "Special Project Installation," P.S. 1,
Institute for Art and Urban Resources,
Long Island City, New York
1980 "New York: 1980," Galleria Banco,
Brescia, Italy
1980 "Sitesights," Pratt Institute Gallery,
Brooklyn, New York
1980 "Architectural Sculpture," Los Angeles
Institute of Contemporary Art, Los
Angeles, California, catalog
1982 "The Image of the House in
Contemporary Art," University of
Houston Lawndale Annex, Houston,
Texas, catalog
1983 "The House that Art Built," California
State University Fullerton, Fullerton,
California, catalog
1983 "Fragments," Tangeman Fine Arts
Gallery, University of Cincinnati,
Cincinnati, Ohio, catalog
1984 "The Varieties of Sculptural Ideas,"
Max Hutchinson Gallery, New York,
New York
1984 "Exhibition of Work by Newly Elected
Members and Recipients of Honors
and Awards," American Academy and
Institute of Arts and Letters, New
York, New York, catalog
1984 "An International Survey of Recent
Painting and Sculpture," Museum of
Modern Art, New York, New York,
catalog
1984 "Citywide Contemporary Sculpture
Exhibition," Crosby Gardens, Toledo,
Ohio (Sponsored by Arts Commission
of Greater Toledo, Ohio; Toledo
Museum of Art, Toledo, Ohio and
Crosby Gardens, Toledo, Ohio),
catalog

1985 "Installation: Builtwork," Sarah
Lawrence College Gallery, Bronxville,
New York

Selected Public Collections
Chase Manhattan Bank, New York, New York
City of Dayton, Belmont Park, Dayton, Ohio
Crosby Gardens, Toledo, Ohio
Weatherspoon Art Gallery, Greensboro, North
Carolina
Wilson College, Chambersburg, Pennsylvania

Selected Private Collections
Martin Melzer, Great Neck, New York
Gerald Rosen, New York, New York
Isiah and Enid Rubin, New York, New York
Robert and Merrill Wagner Ryman, New
York, New York
Christina Zecca, New York, New York

Selected Awards
1978 Individual Artist's Fellowship, National
Endowment for the Arts
1981 John Simon Guggenheim Memorial
Foundation Fellowship
1984 Recipient of an Award in Art,
American Academy and Institute of
Arts and Letters, New York, New York

Preferred Sculpture Media
Stone, Varied Media and Wood

Additional Art Fields
Drawing and Printmaking

Teaching Position
Sculpture Instructor, School of Visual Arts,
New York, New York

Selected Bibliography
Kramer, Hilton. "Art: Less Is More, Two
Cases in Point." *The New York Times*
(Friday, January 26, 1979) p. C15.
Linker, Kate. "Princeton: Alice Adams."
Artforum vol. 20 no. 5 (January 1982) pp.
84-85, illus.
Lippard, Lucy R. "The Abstract Realism of
Alice Adams." *Art in America* vol. 67 no. 5
(September 1979) pp. 72-76, illus.
Malen, Lenore. "Alice Adams." *Arts Magazine*
vol. 53 no. 9 (May 1979) p. 13, illus.
Nadelman, Cynthia. "New York Reviews:
Alice Adams (Hal Bromm)." *Art News* vol.
80 no. 9 (November 1981) p. 202, illus.

Mailing Address
55 Walker Street
New York, New York 10013

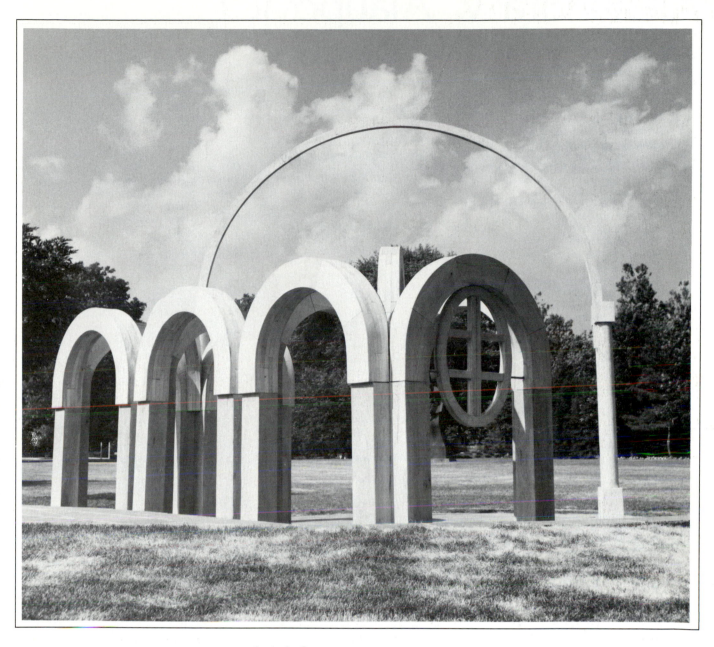

Small Park with Arches. 1984. Wood, stone and concrete, 18'h x 20'w x 22'd. Installation view 1984. "Citywide Contemporary Sculpture Exhibition," Crosby Gardens, Toledo, Ohio (Sponsored by Arts Commission of Greater Toledo, Ohio; Toledo Museum of Art, Toledo, Ohio and Crosby Gardens, Toledo, Ohio), catalog. Collection Crosby Gardens, Toledo, Ohio. Photograph by William D. Gordy.

Artist's Statement

"I have always used the vocabulary of architecture in my sculpture as a way of drawing people in and compelling them, unconsciously at first, to explore and focus on the interaction of the spaces I define with the structures that I build. Within this context my own life and how I remember places and things has come into play. My interest in public participation in my work has led naturally to out-of-door site work and most recently to commissions in public places. Taking clues from the site and my response to the terrain and the surroundings, I begin at ground level and go on building from there."

Alice Adams

Alexandra V. Alaupović

née Alexandra Vrbanić
(Husband Petar Alaupović)
Born December 21, 1921 Podravska Slatina,
Yugoslavia

Education and Training
1944- Akademija Likovnih Umjetnosti,
48 Zagreb, Yugoslavia; study in sculpture
with Professor Frano Kršinić
1949 Akademie Výtvarných Uměni, Prague,
Czechoslovakia; study in sculpture
with Professor Karel Pokorny
1949- Majstorska Radionica, Zagreb,
54 Yugoslavia; additional study with
Professor Frano Kršinić
1966 M.F.A., Sculpture, University of
Oklahoma, Norman, Oklahoma; study
with Joseph Taylor

Selected Individual Exhibitions
1969, Rental and Sales Gallery, Oklahoma
73, Art Center, Oklahoma City, Oklahoma
78
1975 Museum of Art, University of
Oklahoma, Norman, Oklahoma
1976 Extraordinary Unusuals Gallery,
Aspen, Colorado
1984 La Mandragore Internationale Galerie
d'Art, Paris, France

Selected Group Exhibitions
1956 "Exposition de l'Association des
Peintres, Graveurs et Sculpteurs de
Croatie," Institut d'Histoire de
l'Academie Yougoslave, Villa
Sorkočević, Dubrovnik, Yugoslavia,
catalog
1965 "Thirty-Fifth Annual Exhibition,"
Springfield Art Museum, Springfield,
Missouri, catalog
1966, "Annual Eight State Exhibition of
71 Painting and Sculpture," Oklahoma Art
Center, Oklahoma City, Oklahoma,
catalog
1967, "Oklahoma Artists Annual Exhibition,"
71, Philbrook Art Center, Tulsa,
72 Oklahoma, catalog
1968 "On Music," Museum of Art, University
of Oklahoma, Norman, Oklahoma,
catalog
1969 "Oklahoma Biennial," Oklahoma Art
Center, Oklahoma City, Oklahoma
1976 "Saenger National Jewelry & Small
Sculpture Exhibit," Saenger Center,
Hattiesburg, Mississippi, catalog
1979 "Oklahoma Sculpture Today,"
Oklahoma Museum of Art, Oklahoma
City, Oklahoma; Charles B. Goddard
Center, Ardmore, Oklahoma, catalog
1982 "Art Annual III," Oklahoma Art Center,
Oklahoma City, Oklahoma, catalog
1983 "Le Salon des Nations a Paris," Centre
International d'Art Contemporain,
Paris, France, catalog
1983 "Dimensions: Art U.S.A.," Gallery II
R.S.V.P., Charlottesville, Virginia

Selected Public Collections
First Unitarian Church, Oklahoma City,
Oklahoma
Gradski Muzej, Hvar, Yugoslavia
Mercy Health Center, Oklahoma City,
Oklahoma
Museum of Art, University of Oklahoma,
Norman, Oklahoma
Oklahoma Art Center, Oklahoma City,
Oklahoma
Oklahoma, Aviation and Space Hall of Fame
and Museum, Oklahoma City, Oklahoma
Oklahoma State Art Collection, Oklahoma
City, Oklahoma
One Benham Place, Oklahoma City,
Oklahoma
University of Oklahoma Health Sciences
Center, College of Dentistry, Oklahoma
City, Oklahoma
University of Oklahoma Sam Viersen
Gymnastics Center, Norman, Oklahoma
University of Oklahoma, Stovall Museum of
Science and History, Norman, Oklahoma

Selected Private Collections
Edgar Eisner, New York, New York
Stephen M. Eisner, Oklahoma City,
Oklahoma
Mrs. Erich P. Frank, Oklahoma City,
Oklahoma
Dr. and Mrs. Jean-Charles Fruchart, Lille,
France
Dr. Robert H. Furman, Indianapolis, Indiana

Selected Awards
1964 Oscar Jacobson Award, "Annual
Student Exhibition," Museum of Art,
University of Oklahoma, Norman,
Oklahoma
1969 First and Second Prize, "Seventh
Annual Temple Emanuel Brotherhood
Art Festival," Temple Emanuel, Dallas,
Texas
1970 Sculpture Award, "Thirtieth Oklahoma
Artists Annual Exhibition," Philbrook
Art Center, Tulsa, Oklahoma, catalog

Preferred Sculpture Media
Clay and Metal (cast)

Additional Art Field
Drawing

Mailing Address
11908 North Bryant
Route 1 Box 167A
Oklahoma City, Oklahoma 73111

Artist's Statement

"The expression of dynamic forces represents an artist's intuitive drive to communicate the organized complexity in nature. I attempt to express feelings for order and harmony using traditional and contemporary elements of art in an intricate and everchanging life."

Alexandra V. Alaupovic

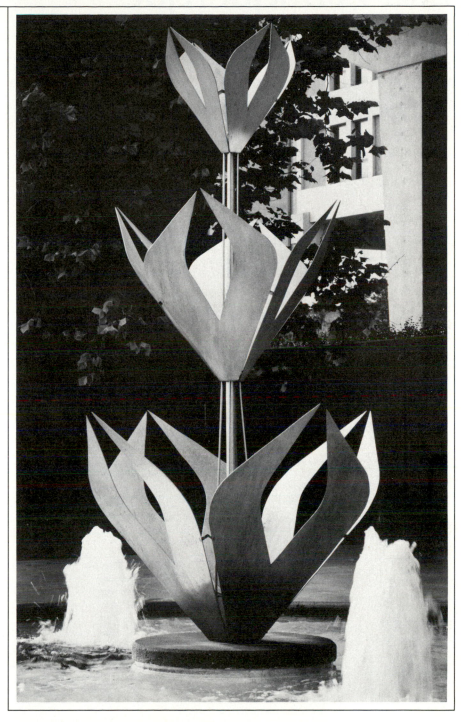

The Tree. 1974. Stainless steel, 156"h x 72"w x 72"d. Collection Mercy Health Center, Oklahoma City, Oklahoma. Photograph by David G. Fitzgerald.

Lita Albuquerque

Born January 3, 1946 Santa Monica, California

Education and Training
1968 B.A., Art History, University of California, Los Angeles, Los Angeles, California
1971- Otis Art Institute, Los Angeles,
72 California; study in painting and sculpture

Selected Individual Exhibitions
1978 University Art Museum, Santa Barbara, Santa Barbara, California
1978 San Francisco Art Institute, San Francisco, California
1979, Janus Gallery, Los Angeles,
81 California
1980 Diane Brown Gallery, Washington, D.C.
1980 El Mirage Dry Lake, El Mirage, California
1980, Marianne Deson Gallery, Chicago,
84 Illinois
1984 Laband Art Gallery, Loyola Marymount University, Los Angeles, California

Selected Group Exhibitions
1980 "Contemporaries: 17 Artists," Security Pacific National Bank, Los Angeles, California, catalog
1980 "Eleventh International Sculpture Conference," Area Galleries and Institutions, Washington, D.C. (Sponsored by International Sculpture Center, Washington, D.C.)
1981 "California Landscape," Newport Harbor Art Museum, Newport Beach, California, catalog
1981 "Directions 1981," Hirshhorn Museum and Sculpture Garden, Smithsonian Institution, Washington, D.C.; Sarah Campbell Blaffer Gallery, Houston, Texas, book-catalog
1982 "L. A. Times: 8 Contemporary Artists from Los Angeles," Art Gallery, San Diego State University, San Diego, California

1982 "Twenty American Artists: Sculpture 1982," San Francisco Museum of Modern Art, San Francisco, California, catalog
1982 "Michael Todd, David Bottini, Lita Albuquerque," Gallery Paule Anglim, San Francisco, California
1982 "Twelfth International Sculpture Conference," Area Galleries and Institutions, Oakland, California and San Francisco, California (Sponsored by International Sculpture Center, Washington, D.C.)
1982 "Exchange Between Artists—An Experience for Museums," Traveling Exhibition, Musée d'Art Moderne de la Ville de Paris, Paris, France
1983 "Urban Sculpture: Architectural Concerns," Security Pacific National Bank, Los Angeles, California
1983 "Six Sculptors," University of South Dakota, Vermillion, South Dakota
1983 "A Collaboration: Abhasa—Image Bearing Light," University of Southern California, Los Angeles, California, catalog
1983 "The First Show," Museum of Contemporary Art, Los Angeles, California, catalog
1984 "Natural Elements Sculpture Park Proposals," Santa Monica City Hall, Santa Monica, California, catalog
1984 "Lita Albuquerque, Jud Fine, Dwain Valentine and Michael Todd," Prudential Insurance Company of America, Airport Towers, El Segundo, California, catalog

Selected Public Collection
Orange Coast College, Costa Mesa, California

Selected Private Collections
Duke Comegys, Los Angeles, California
Aviva Covitz, Los Angeles, California
Marcia Weisman, Los Angeles, California

Selected Awards
1983 Art in Public Places Grant, Orange Coast College, Costa Mesa, California and National Endowment for the Arts
1983 Art in Public Places Grant, University of South Dakota, Vermillion, South Dakota and National Endowment for the Arts

Preferred Sculpture Media
Stone and Varied Media

Additional Art Fields
Painting and Photography

Teaching Position
Professor, Otis Art Institute of Parsons School of Design, Los Angeles, California

Selected Bibliography
Hughes, Robert. "Art: Quirks, Clamors and Variety." *Time* (March 2, 1981) pp. 84-85, 87, illus.
McEvilley, Thomas. "Reviews San Francisco: Twelfth International Sculpture Conference." *Artforum* vol. 21 no. 3 (November 1982) pp. 80-81.
Schipper, Merle S. "Lita Albuquerque." *Arts Magazine* vol. 52 no. 5 (January 1978) p. 6, illus.
Wilson, William. "Art Review: Sculpture Dwarfed by Setting." *Los Angeles Times* (Tuesday, November 8, 1983) calendar section, pp. 1, 3, illus.
Wong, Herman. "Orange County Arts Notebook: Prestigious Sculptor to Work at OCC." *Los Angeles Times*, (Thursday, October 13, 1983) calendar section, pp. 1, 5, illus.

Gallery Affiliation
Janus Gallery
8000 Melrose Boulevard
Los Angeles, California 90046

Mailing Address
305 Boyd Street
Los Angeles, California 90013

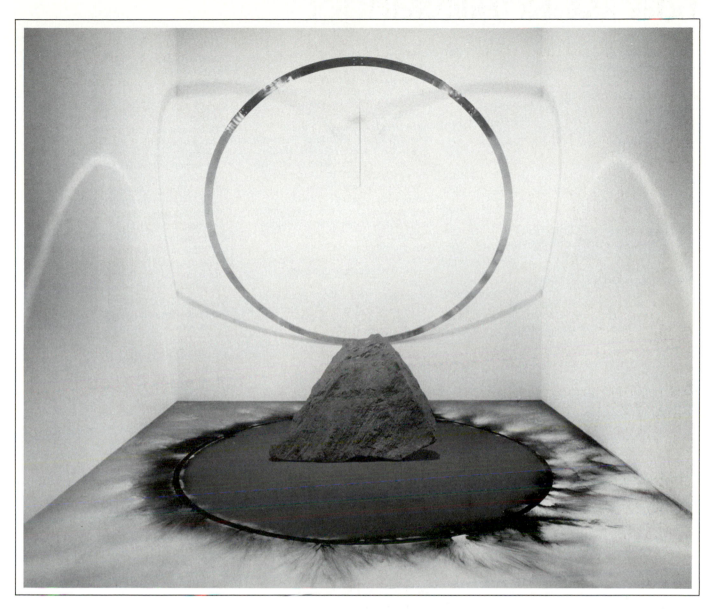

The Horizon Is The Place That Maintains The Memory. 1981. Solid copper ring, granite boulder and powdered pigment, 12′h x 12′w x 12′d. Installation view 1981. "Directions 1981," Hirshhorn Museum and Sculpture Garden, Smithsonian Institution, Washington, D.C.

Artist's Statement

"My work is a visualization of my interests in metaphysics, time, memory and dream states. It is my explication of where I feel we are in terms of evolution as a human community within the context of the universe and the forever evolving consciousness. Hence, such titles as: *The Horizon Is The Place That Maintains The Memory, Pyramids are Chunks of Stars Fallen from the Sky. . . and Beneath the Black Polished Granite are a Series of Subterranean Islands Each One floating on a Copper Plate.* . . . I think I am part of the new awareness that has arisen since thanks to the space program, we have been able to play the role of the observer on the very nature of our planet. Most of my pieces are symbolic of notions of placement and location as seen from various perspectives of time and space.

"*The Horizon Is The Place That Maintains The Memory* is such a piece. It stems from my interpretation of the planet as a reflective surface. The copper ring attached to the wall is meant to be a diagram of the earth cut in half. The granite boulder covered in red pigment is a symbol for the primal memory emerging from the energy source of the earth itself. The myth the ancients maintained is that the memory of a certain knowledge is within the horizon line and it is up to us to find it again."

Marsia R. Alexander

née Marsia Rose
Born June 30, 1939 Valparaiso, Chile

Education and Training
1962 B.A., Painting, Park College, Parkville, Missouri
1965- Private classes with Ethel
68 Schwabacher, New York, New York; study in painting
1974 M.F.A., Painting and Sculpture, Claremont Graduate School and University Center, Claremont, California

Selected Individual Exhibitions
1974 Brand Library Art Center, Glendale, California
1976 Vanguard Gallery, Fullerton, California
1977, Vanguard Gallery, Los Angeles,
79 California
1977 Moreau Gallery Three, Saint Mary's College, Notre Dame, Indiana
1981 Works Gallery, San Jose, California
1985 Fine Arts Gallery, Long Beach City College, Long Beach, California
1985 Junior Arts Center, Los Angeles, California

Selected Group Exhibitions
1974 "First Annual California Sculpture Exhibition," Fine Arts Gallery, California State University Northridge, Northridge, California
1974 "On Exhibit: Exhibition II Marsia Alexander, Recent Works; Bill Mitchell, Sculpture; Neda Al-Hilali, Paper Works," Riverside Art Center and Museum, Riverside, California
1974 "Paper Works," Art Gallery, California State University San Bernardino, San Bernardino, California
1974 "Alexander, Gordon, Rothstein," Pasadena Artist's Concern, Pasadena, California
1974 "Young Sculptors," Lang Art Gallery, Scripps College, Claremont, California

1975 "Sensibilities," Wilshire West Plaza, Los Angeles, California
1976 "Contemporary Masters Exhibit," Libra Gallery, Claremont Graduate School and University Center, Claremont, California, catalog
1977 "Alexander and Cantley," Pasadena Artist's Concern, Pasadena, California
1977 "Paper Art," Lang Art Gallery, Scripps College, Claremont, California, catalog
1977 "Marsia Alexander, Tom Holste, Bob Walker," El Camino College Art Gallery, Los Angeles, California
1978 "Marsia Alexander and Michael Vance Kelly," Guggenheim Gallery, Chapman College, Orange, California
1979 "Abstractions/Sources/Transformations," Los Angeles Municipal Art Gallery, Los Angeles, California, catalog
1979 "Structures," Hera Gallery, Wakefield, Rhode Island, catalog
1980 "In/Sites," Woman's Building, Los Angeles, California
1980 "Marsia Alexander, Michael Davis, Jud Fine and Bruce Nauman: Architectural Sculpture," Baxter Art Gallery, California Institute of Technology, Pasadena, California, catalog
1980 "Architectural Sculpture," Los Angeles Institute of Contemporary Art, Los Angeles, California, catalog
1981 "Gatewood, Page, Alexander—Paper Constructions," Pierce College Art Gallery, Woodland Hills, California
1983 "Boxed Art," Laguna Beach Museum of Art, Laguna Beach, California
1983 "An Affair of the Heart," Baxter Art Gallery, California Institute of Technology, Pasadena, California
1984 "Masks, Masquerades, Megillots," Skirball Museum, Hebrew Union College—Jewish Institute of Religion, Los Angeles, California
1984 "You Gotta Have Art," Laguna Beach Museum of Art, Laguna Beach, California

Selected Public Collection
International Paper Company, New York, New York

Selected Private Collections
Joni Gordon, Los Angeles, California
Robert Hagel, Northridge, California
Dennis Hudson, Irvine, California
Laura Newhouse, Long Beach, California
Roland Reiss, Venice, California

Preferred Sculpture Media
Paper and Wood

Additional Art Field
Performance

Teaching Position
Instructor, Los Angeles Southwest College, Los Angeles, California

Selected Bibliography
Bijvoet, Marga. "Art Experiments in the California Deserts—In Search of Self Through Nature." Arts + Architecture vol. 2 no. 3 (Fall 1983) pp. 40-43, illus.
Muchnic, Suzanne. "Marsia Alexander's Sculptural Wrappings." Artweek vol. 8 no. 24 (July 2, 1977) p. 6, illus.
Thompson, Lea. "Dimensional Paintings, Pyramidal Sculptures." Artweek vol. 9 no. 32 (September 30, 1978) p. 4, illus.
Wilson, William. "Calendar Art: Abstract Art More Historic Than Modern." Los Angeles Times (Sunday, March 18, 1979) calendar section, p. 96, illus.
Wortz, Melinda. "Exhibitions: Measurements of Time and Structures for Experience." Artweek vol. 11 no. 36 (November 1, 1980) p. 5, illus.

Mailing Address
384 North Oakland
Pasadena, California 91101

Artist's Statement

"Approaching the holistic function of art, my sculptures become participants in the natural environment. These 'Nomadic' sculptures act as structures from an ancient culture which are presented in a gallery installation as found anthropological forms. A poetic play on the notion of documentation occurs when their active state in the landscape is photographed and the forms are then folded and presented in a dormant state, evoking outer and inner states of mind."

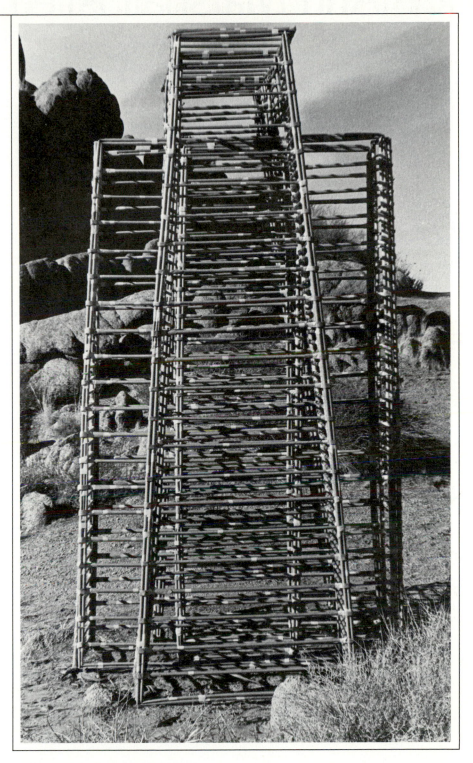

Nomadic Sculpture, Set III: The Desert Piece, Gateway. 1978. Paper, tape and rhoplex, 94"h x 50"w x 88"d.

Joe Ann Marshall Allen

(Husband Jere Hardy Allen)
Born November 1, 1946 Atlanta, Georgia

Education and Training
1965 Ringling School of Art, Sarasota, Florida
1981 B.F.A., Sculpture, University of Mississippi, University, Mississippi; study with Ron Dale
1984 Vulcan Foundry, Taylor, Mississippi; study in bronze casting with Bill Beckwith

Selected Individual Exhibitions
1982 University Gallery, University of Mississippi, University, Mississippi
1983 Fine Arts Gallery, Itawamba Junior College, Fulton, Mississippi
1983 Sarah Isom Center for Women's Studies, University of Mississippi, University, Mississippi

Selected Group Exhibitions
1978 "Grand Opening 1978," Mississippi Museum of Art, Jackson, Mississippi
1979 "Fifth Annual Bi-State Art Exhibit," Meridian Museum of Art, Meridian, Mississippi
1980 "Mississippi Collegiate Exhibition," Mississippi Museum of Art, Jackson, Mississippi
1983 "Southeast Ceramics Invitational," University Gallery, University of Mississippi, University, Mississippi
1983 "Annual Outdoor Gumtree Arts Festival," City of Tupelo, Mississippi
1984 "Ceramics Invitational," Fine Arts Gallery, Itawamba Junior College, Fulton, Mississippi
1984 "Images '84, Louisiana World Exposition," Mississippi Pavilion, World's Fair, New Orleans, Louisiana

Selected Public Collection
Tupelo Medical Complex, Tupelo, Mississippi

Selected Private Collections
Dr. and Mrs. Uri Lliong, Singapore, Singapore
Dr. and Mrs. Velon Minshew, Granbury, Texas
Gigliola Nocera, Siracusa, Italy
Mr. and Mrs. Paul Rice, Washington, D.C.

Selected Awards
1983 Exhibition Grant, National Endowment for the Arts
1983 Exhibition Grant, Mississippi Arts Commission
1983 Special Grant, Sarah Isom Center for Women's Studies, University of Mississippi, University, Mississippi

Preferred Sculpture Media
Clay and Varied Media

Additional Art Field
Painting

Gallery Affiliation
One Main Street Gallery
1 Main Street
Taylor, Mississippi 38673

Mailing Address
1103 South 14 Street
Oxford, Mississippi 38655

Artist's Statement

"I find myself more comfortable with the label "maker" than any other. My sculptural medium are three-dimensional assemblages of clay or cast metal and found objects. I am attracted to clay and use it as my major material. Human and animal forms are my predominate images. The concepts for these works are inspired and developed out of ordinary life occurrences and fleeting impressions.

"In size, the sculptures range from small to large. While the titles are not accidental, neither are they precise meanings. Usually a found object will trigger an idea and be the basis of an entire piece. Combining improbable materials, the work is assembled much like a puzzle."

Joe Ann Marshall Allen

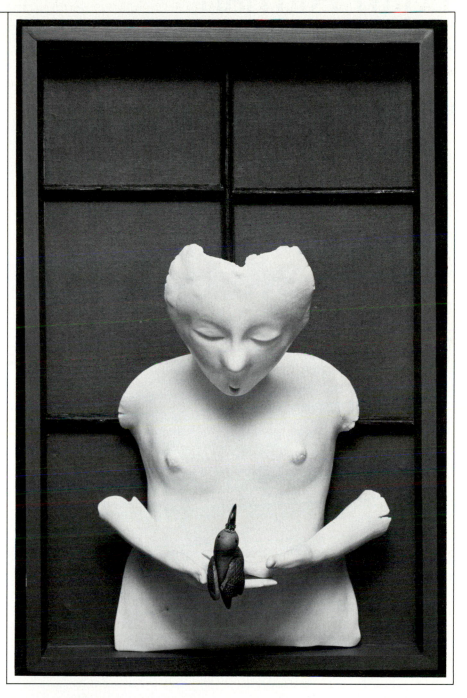

Young Woman Singing to a Bird. 1984. Porcelain and earthenware clay, 34"h x 22"w x 12"d. Photograph by William Martin.

Edith Altman

née Edith Hittman
(Husband Murray Altman)
Born May 23, 1931 Altenburg, Germany,
Democratic Republic

Education and Training
1950- Wayne State University, Detroit,
52, Michigan
55
1956- Marygrove College, Detroit, Michigan
57

Selected Individual Exhibitions
1971 Richard Fiegan Gallery, Chicago,
Illinois
1975 Theodore Lyman Wright Art Center,
Beloit College, Beloit, Wisconsin,
catalog
1976, Marianne Deson Gallery, Chicago,
79, Illinois
83
1977 Bertha Urdang Gallery, New York,
New York
1982 Goethe Institute, Chicago, Illinois
1983 Art Gallery, University of Nebraska at
Omaha, Omaha, Nebraska, catalog
1984 Galerie Baecker, Cologne, Germany,
Federal Republic

Selected Group Exhibitions
1973 "Preview '73," Studio San Guisippi,
College of Mount St. Joseph, Mount
St. Joseph, Ohio, catalog
1973 "Mass '73, Monumental Works of
Sculpture by International Artists,"
One Illinois Center, Chicago, Illinois
(Sponsored by Michael Wyman
Gallery, Chicago, Illinois)
1973, "Exhibition by Artists of Chicago and
77, Vicinity," Art Institute of Chicago,
81 Chicago, Illinois, catalog
1975 "Group Exhibition," Bertha Urdang
Gallery, New York, New York
1975 "The Plastic Earth and Extraordinary
Vehicles," John Michael Kohler Arts
Center, Sheboygan, Wisconsin
1976 "Group Exhibition," Henri Gallery,
Washington, D.C.
1976 "Abstract Art in Chicago," Museum of
Contemporary Art, Chicago, Illinois,
catalog
1976 "Illinois Artists Traveling Bicentennial
Exhibition," Center for the Visual Arts
Gallery, Illinois State University,
Normal, Illinois, catalog
1976 "Women Artists: Here and Now,"
O'Shaughnessy Gallery, University of
Notre Dame, Notre Dame, Indiana,
catalog

1976- "The Chicago Connection," Traveling
77 Exhibition, E. B. Crocker Art Gallery,
Sacramento, California, catalog
1977 "American Women Artists," Galleria del
Cavallino, Venice, Italy, catalog
1978 "Arte Fiera 78," Mostra Mercato
Internazionale d'Arte Contemporaneo,
Bologna, Italy (Represented by
Marianne Deson Gallery, Chicago,
Illinois), catalog
1978 "Chicago: Self-Portraits," Nancy Lurie
Gallery, Chicago, Illinois, catalog
1978 "Chicago in Dallas," Delahunty Gallery,
Dallas, Texas
1978 "Chicago Abstractionists:
Romanticized Structures," Traveling
Exhibition, University of
Missouri-Kansas City Art Gallery,
Kansas City, Missouri, catalog
1979 "The Unpainted Portrait: Contemporary
Portraiture in a Non-Traditional Media,"
John Michael Kohler Arts Center,
Sheboygan, Wisconsin, catalog
1979 "A Day in the Life of a Creative
Woman," ARC Gallery, Chicago,
Illinois, catalog
1979 "American Portraits of the Sixties and
Seventies," Aspen Center for the
Visual Arts, Aspen, Colorado, catalog
1979- "Chicago Karlsruhe," Galerie Schloss
80 Ettlingen, Karlsruhe, Germany, Federal
Republic; Kunstverein, Munich,
Germany, Federal Republic, catalog
1980 "American Women Artists 1980,"
Museu de Arte Contemporânea da
Universidade de São Paulo, São
Paulo, Brazil, catalog
1980 "New Dimensions: Time," Museum of
Contemporary Art, Chicago, Illinois
1981 "Chicago Artists," Mitchell Museum,
Mount Vernon, Illinois, catalog
1981 "New Art from Chicago," German-
American Institute, Frieburg, Germany,
Federal Republic; Heidelberg,
Germany, Federal Republic;
Kunstverein, Cologne, Germany,
Federal Republic; Amerika Haus,
Stuttgart, Germany, Federal Republic;
Tubingen, Germany, Federal Republic;
Frankfurt, Germany, Federal Republic
(Represented by Marianne Deson
Gallery, Chicago, Illinois), catalog
1982 "Chicago: N.A.M.E. Gallery at Hewlett
Gallery," Carnegie-Mellon University,
Pittsburgh, Pennsylvania
1982 "Signs and Symbols in North American
Indian and European Art," Museum of
the American Indian, New York, New
York, catalog
1982 "Jewish Themes: Contemporary
American Artists," Jewish Museum,
New York, New York, catalog
1984 "Tenth Anniversary Exhibition,"
N.A.M.E. Gallery, Chicago, Illinois

Selected Public Collections
A.B. Dick Company, Chicago, Illinois
Ball State University Art Gallery, Muncie,
Indiana

International Business Machines Corporation,
Chicago, Illinois
Joslyn Art Museum, Omaha, Nebraska
Museum of Contemporary Art, Chicago,
Illinois
Standard Oil Company, Chicago, Illinois

Selected Private Collections
Roger Barrett, Winnetka, Illinois
Dr. Mario Bigazzi, Milan, Italy
Henry Hacker, New York, New York
Maurice A. Lipschultz, Forest Park, Illinois
Mr. and Mrs. Robert Samuels, Chicago,
Illinois

Selected Awards
1979 Project Completion Grant, Illinois Arts
Council
1984 Individual Artist's Fellowship, Illinois
Arts Council

Preferred Sculpture Media
Varied Media

Additional Art Field
Conceptual Art

Related Profession
Art Instructor

Selected Bibliography
Dresner, Hannah. "Reviews Chicago: Edith
Altman, Charles Wilson, Marianne Deson
Gallery." *New Art Examiner* vol. 10 no. 10
(Summer 1983) p. 17.
Frueh, Joanna. "Reviews Chicago: Edith
Altman, Marianne Deson Gallery," *Artforum*
vol. 18 no. 4 (December 1979) pp. 77-78,
illus.
Morrison, C. L. "Reviews Chicago: Deborah
Butterfield, Zolla/Lieberman Gallery; Edith
Altman, Marianne Deson Gallery." *Artforum*
vol. 15 no. 4 (December 1976) pp. 76-77,
illus.
Taylor, Sue. "Edith Altman at the Goethe
Institute, Der Kunstler Detektiv: Altman's
inquiry into victimization." *New Art
Examiner* vol. 10 no. 4 (January 1983) pp.
11-12, illus.
Turner, Norman. "Arts Reviews: Edith Altman,
Bertha Urdang." *Arts Magazine* vol. 51 no.
7 (March 1977) pp. 33-35, illus.

Gallery Affiliation
Marianne Deson Gallery
340 West Superior Street
Chicago, Illinois 60610

Mailing Address
811 West 16 Street
Chicago, Illinois 60608

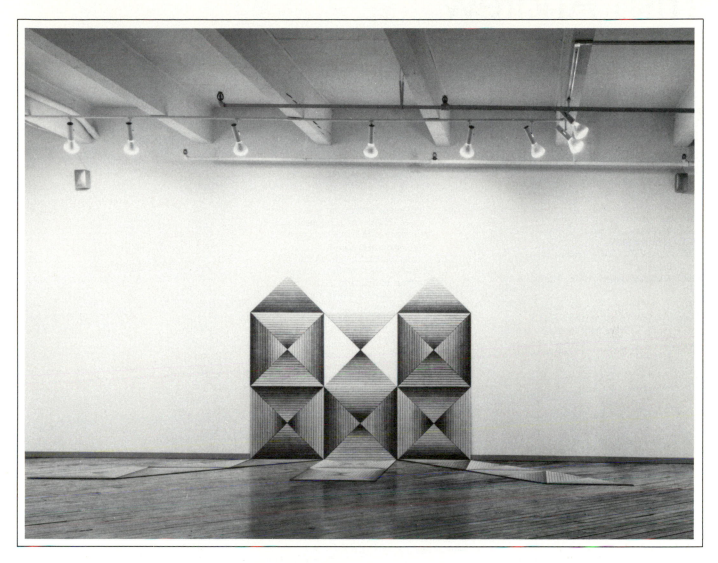

Time/Space, The Hidden Dimension In a 24 Hour Drawing: The Measurement of the Labyrinth of 3 Houses and 3 Paths. 1983. Conte on acrylic on masonite with photo/text and audio tape, wall 90"h x 105"w; floor 204"w x 105"d. Installation view 1983. Art Gallery, University of Nebraska at Omaha, Omaha, Nebraska, catalog.

Artist's Statement

"Whatever the formats I choose to work with—sculpture, drawing, photography, texts and sound, or installations involving all these elements—they are based upon some elusive aspects of time. A recording of time relationships as a process in nature reaffirms a connection between my personal experience and the prehistoric and ancient past. The underlying characteristics of my rituals and environments recall sacred number and form in geometry, architecture, psychology and mythology. I hope to reawaken within ourselves the forgotten symbols that heal and reunite us with a collective universal language of form which transcends the experience of time."

Edith Altman

17

Trish Andrew

née Patricia Lynn
Born January 29, 1948 Turlock, California

Education and Training
1983 B.A., Sculpture and Literature, University of Nevada Reno, Reno, Nevada

Selected Individual Exhibitions
1980 Getchell Library Gallery, University of Nevada Reno, Reno, Nevada
1984 Weinstocks Gallery Window, Reno, Nevada
1984 Exhibition Space Gallery, Western Nevada Community College, Carson City, Nevada
1985 Macy's Fine Arts Gallery, Reno, Nevada
1986 Manville Gallery, Reno, Nevada

Selected Group Exhibitions
1979 "Sharon Thatcher and Patricia Andrew," Sheppard Fine Art Gallery, University of Nevada Reno, Reno, Nevada

1979 "Masks," Norfolk Gallery, Reno, Nevada
1980 "Voices and Silences: Nevada Women in Art," Getchell Library Gallery, University of Nevada Reno, Reno, Nevada
1981 "Walter McNamara Takes Shots at Other Artists," Sheppard Fine Art Gallery, University of Nevada Reno, Reno, Nevada; University of Nevada Las Vegas, Las Vegas, Nevada
1981, 82 "Annual Open Competition," Northern California Arts, Sacramento, California
1982 "Bob Brown, Photography and Trish Andrew, Sculpture," Sheppard Fine Art Gallery, University of Nevada Reno, Reno, Nevada
1982 "House Works, Environmental Sculpture: Trish Andrew, Sharon Thatcher and Charle Varble," Word O'Mouth Gallery, Reno, Nevada
1984 "Cast Sculpture," Jones Visitor Center, University of Nevada Reno, Reno, Nevada
1984 "New Work on Exhibit," Nevada Gallery, Gannet Publishing Building, Reno, Nevada
1984 "Trish Andrew and Sharon Thatcher," Winnemucca Fine Art Gallery, Carson City, Nevada
1984-85 "Nevada Sites Pit Exhibition: 39° 30'N, 118° 65'W," University of Nevada Reno, Reno, Nevada; University of Nevada Las Vegas, Las Vegas, Nevada
1985 "The Woman as Artist," University of Nevada Reno, Reno, Nevada

Selected Public Collections
Nevada State Council on the Arts, Reno, Nevada
Sheppard Fine Art Gallery, University of Nevada Reno, Reno, Nevada

Selected Private Collections
William and Cynthia Andrew, Delhi, California
David Lash, Reno, Nevada
Robert Morrison, Reno, Nevada
Mr. and Mrs. Michael Sheldon, Sacramento, California
Sharon Thatcher, Carson City, Nevada

Selected Awards
1979 First Place, "Annual Show of Art," University of Nevada Reno, Reno, Nevada
1980 Craig Sheppard Scholarship, University of Nevada Reno, Reno, Nevada
1982 First Place, "Women's Art Show," Student Union, University of Nevada Reno, Reno, Nevada

Preferred Sculpture Media
Metal (cast) and Varied Media

Additional Art Fields
Painting and Photography

Related Professions
Artist in Residence and Curator

Mailing Address
Post Office Box 50261
Reno, Nevada 89513

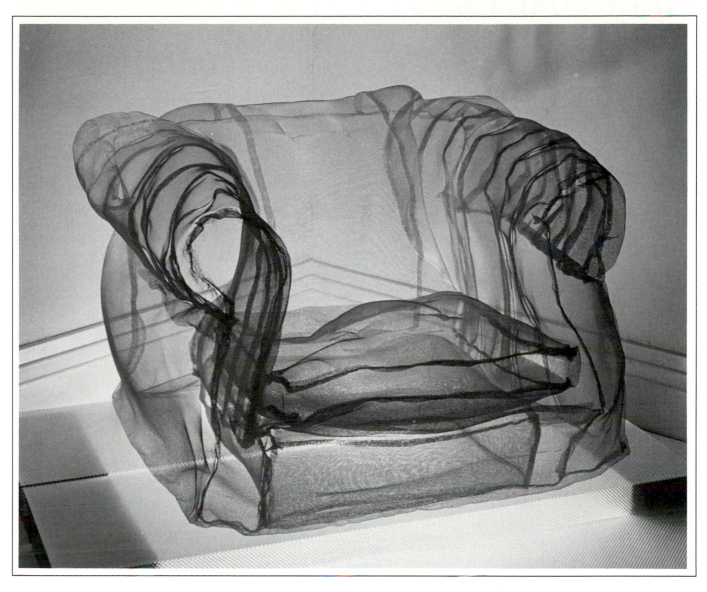

Easy Chair. 1982-1984. Wire mesh, 26"h x 36"w x 26"d.

Artist's Statement

"Reno is not exactly the contemporary artist's dream; galleries open and fold like butterfly wings. Yet the quest for the avant garde in Nevada is equaled if not surpassed by the work and concern for the survival and growth of contemporary art. In this art-bleak atmosphere, existing on the edge of the Nevada landscape of sand and sage with downtown deserts of neon and social security gamblers, I have found the center of my creative energy.

"It is here that I started working almost exclusively with wire mesh. It can be hand molded like clay, ripped and sewn like fabric and welded as a metal. Wire mesh is delicate looking but very strong. It responds to light as a solid wall, yet it is transparent, catching shadows and reflecting light beams. The historic concept of sculpture as a solid surrounded by space is retained, while at the same time, reversed. Not only are all sides visible from any one viewpoint but the interior details and volume are apparent. The sculpture exists yet does not block the sight and the flow of any landscape or architecture beyond it. The sculptures, like the desert, claim existence but suggest denial."

Anneli Arms

née Anna Elizabeth Muschenheim
(Husband John Milton Arms)
Born May 23, 1935 New York, New York

Education and Training
1956- Art Students League, New York, New
58 York; study in painting
1957 B.A., Painting and Sculpture,
 University of Michigan, Ann Arbor,
 Michigan; study in sculpture with
 Thomas McClure

Selected Individual Exhibitions
1968, The Floating Gallery at 113 Greene
83, Street, New York, New York
84,
85
1971, Elaine Benson Gallery,
85 Bridgehampton, New York
1978, Phoenix Gallery, New York, New York
81,
83,
84,
85
1978 Westtown Art Center, Westtown,
 Pennsylvania
1981 Fairleigh Dickinson University Edward
 Williams College, Hackensack, New
 Jersey
1982 Friends of Guild Hall, Bridgehampton,
 New York

Selected Group Exhibitions
1968 "Group Exhibition," Forsyth Gallery,
 Ann Arbor, Michigan
1974, "Gallery Exhibition," Elaine Benson
77 Gallery, Bridgehampton, New York
1975 "Group Exhibition," Jean Paul Slusser
 Gallery, University of Michigan, Ann
 Arbor, Michigan
1975 "Artists of Suffolk," Heckscher
 Museum, Huntington, New York,
 catalog
1977 "10th Street Days," Landmark Gallery,
 New York, New York, catalog
1977 "Anneli Arms, Rela Banks and Nancy
 Brown," Phoenix Gallery, New York,
 New York
1977- "Annual Members' Exhibition," Guild
85 Hall Museum, East Hampton, New
 York
1978 "O.I.A. Constructs Exhibition," 10
 Bleeker Street, New York, New York
1978, "Gallery Artists," Ingber Gallery,
79 New York, New York
1978 "Art as Furniture, Furniture as Art,"
 Ingber Gallery, New York, New York
1981 "The Chair Show," Thorpe Intermedia
 Gallery, Sparkill, New York
1981, "Sculpturesites: Outdoor Sculpture,"
82, Abraham's Path, Amagansett, New
83 York, catalog
1982, "Group Exhibition Series: Creatures,"
83, Elaine Benson Gallery,
85 Bridgehampton, New York
1984 "Springs Improvement Society Annual
 Exhibition," Ashawagh Hall, Springs,
 New York
1984, "Multi-Media Sculpture Invitational
85 Exhibition," 14 Sculptors Gallery, New
 York, New York

Selected Private Collections
Michael Rader, New York, New York
Richard and Odile Stern, New York, New
 York

Selected Award
1984 Nora Mirmont Hambuechen Award for
 Sculpture, "Twenty-Ninth Annual
 Exhibition of Long Island Artists,"
 Heckscher Museum, Huntington, New
 York

Preferred Sculpture Media
Plastic and Varied Media

Additional Art Fields
Painting and Printmaking

Selected Bibliography
Buonagurio, Edgar. "Arts Reviews: Anneli
 Arms/Rela Banks/Nancy Brown." *Arts
 Magazine* vol. 52 no. 2 (October 1977) pp.
 26-27, illus.
Caldwell, John. "Chairs and More 'Chairs'."
 The New York Times (Sunday, December
 13, 1981) p. WC26.
Ness, Wilhelmina Van. "Anneli Arms." *Arts
 Magazine* vol. 55 no. 6 (February 1981) p.
 12, illus.
Schiro, Anne-Marie. "Furniture as Art: To See
 and to Sit On." *The New York Times*
 (Thursday, December 21, 1978) p. C6,
 illus.
Vaughan, Mary. "Anneli Arms." *Arts Magazine*
 vol. 52 no. 6 (February 1978) p. 18, illus.

Mailing Address
113 Greene Street
New York, New York 10012

Artist's Statement

"My present work, sculptured heads and insects, is part of an ongoing, aesthetic and intellectual development which began primarily in 1965. I developed the use of freely poured liquid polyurethane and have altered my methods of sanding, modeling, and painting only in terms of subject matter.

"Basic questions of opposition are fused in a series of themes concerning self and nonself, weight and weightlessness, fragility and monumentality, playfulness and seriousness. Specific and archetypic motifs are intertwined with naturalism, aspects of nature and references to Eastern and Western art history. The essential mysteries and ironies of existence are part of this body of work, also intended simply to be objects."

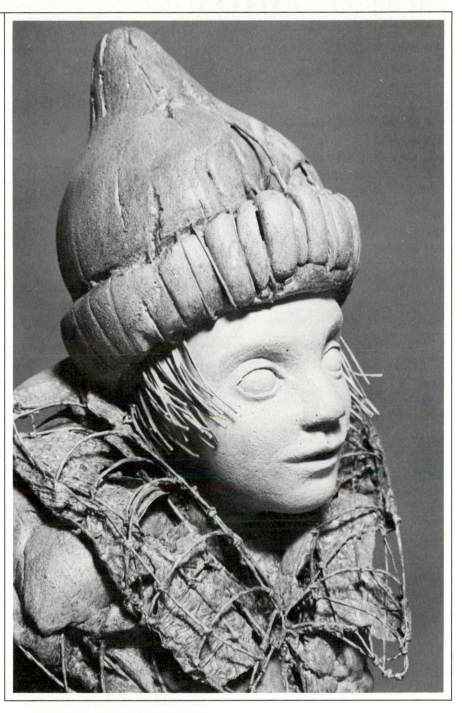

Boy with Nipple Cap. 1977. Polyurethane, wire and acrylic, 21"h x 15"w x 13"d. Photograph by John M. Arms.

Jane B. Armstrong

née Jane Botsford
(Husband Robert Thexton Armstrong)
Born February 17, 1921 Buffalo, New York

Education and Training
1939- Middlebury College, Middlebury,
40 Vermont
1940- Pratt Institute, Brooklyn, New York
41
1964 Art Students League, New York, New
 York; study with José de Creeft and
 John Hovannes

Selected Individual Exhibitions
1969, Bennington Museum, Bennington,
70 Vermont
1971 Bristol Art Museum, Bristol, Rhode
 Island
1971, Frank Rehn Gallery, New York, New
73, York, catalog
75,
77
1972 New Britain Museum of American Art,
 New Britain, Connecticut
1972 Columbus Gallery of Art, Columbus,
 Ohio, catalog
1973 Johnson Gallery, Middlebury College,
 Middlebury, Vermont
1974 North Carolina Museum of Art,
 Raleigh, North Carolina
1974 J. B. Speed Art Museum, Louisville,
 Kentucky
1975 Arts and Science Center, Nashua,
 New Hampshire
1975 State University of New York at
 Buffalo, Buffalo, New York
1975 Columbia Museums of Art & Science,
 Columbia, South Carolina
1976 Marjorie Parr Gallery, London, Great
 Britain, catalog
1977 Columbus Museum of Arts and
 Sciences, Columbus, Georgia
1977 Arkansas Arts Center, Little Rock,
 Arkansas
1978 Dallas Museum of Fine Arts, Dallas,
 Texas
1978, Wichita Art Museum, Wichita Kansas,
82 catalog
1979 Wadsworth Atheneum, Hartford,
 Connecticut
1980 Southeastern Center for
 Contemporary Art, Winston-Salem,
 North Carolina
1981 Sculpture Center, New York, New
 York, catalog
1983 Sid Deutsch Gallery, New York, New
 York
1983 Foster Harmon Galleries of American
 Art, Sarasota, Florida
1985 Burchfield Art Center, Buffalo, New
 York

Selected Group Exhibitions
1968- "Annual Exhibition," National Arts Club,
84 New York, New York
1969- "Allied Artists of America Annual
85 Exhibition," National Arts Club, New
 York, New York
1970- "Audubon Artists Annual Exhibition,"
85 National Academy of Design, New
 York, New York, catalog
1971- "Painters and Sculptors Society of
85 New Jersey Annual Exhibition," Jersey
 City Museum, Jersey City, New Jersey
1972- "Knickerbocker Artists Annual
85 Exhibition," National Arts Club, New
 York, New York
1972 "Critics' Choice," Sculpture Center,
 New York, New York, catalog
1972 "Twenty-Three Sculptors," Philadelphia
 Museum of Art, Philadelphia,
 Pennsylvania
1972- "National Association of Women
85 Artists Annual Exhibition," National
 Academy of Design, New York, New
 York, catalog
1973 "Annual Exhibition," National Academy
 of Design, New York, New York,
 catalog
1973- "Annual Exhibition," National Sculpture
85 Society, New York, New York, catalog
1975- "Sculptors Guild Annual Exhibition,"
85 Lever House, New York, New York,
 catalog
1976- "Reflections: Images of America,"
77 Traveling Exhibition (Eastern and
 Western Europe), United States
 Information Agency, Washington, D.C.
1979 "Major Florida Artists," Harmon Gallery,
 Naples, Florida
1981- "Catharine Lorillard Wolfe Art Club
85 National Annual Exhibition," National
 Arts Club, New York, New York,
 catalog
1981 "Sculpture in the Garden 1981,"
 Sculptors Guild at the Enid A. Haupt
 Conservatory, New York Botanical
 Garden, Bronx, New York, catalog
1981- "Artists of America Annual Exhibition,"
85 Colorado Heritage Center, Denver,
 Colorado, catalog

Selected Public Collections
Burchfield Art Center Buffalo, New York
Columbus Museum of Art, Columbus, Ohio
David and Eula Wintermann Library, Eagle
 Lake, Texas
Flint Institute of Arts, Flint, Michigan
Fontbonne College, St. Louis, Missouri
Indiana University of Pennsylvania, Indiana,
 Pennsylvania
Massachusetts Institute of Technology,
 Boston, Massachusetts
New Britain Museum of American Art, New
 Britain, Connecticut
New York Zoological Society, Bronx Zoo
 World of Birds Building, Bronx, New York
Northern Telecom, Research Triangle Park,
 North Carolina
Norton Simon, Incorporated, New York, New
 York

Rollins College, Cornell Fine Arts Center,
 Winter Park, Florida
Southern Life Insurance, Greensboro, North
 Carolina
Texas Gulf Chemicals, Raleigh, North
 Carolina
Wichita Art Museum, Wichita, Kansas
Worcester Polytechnic Institute, Worcester,
 Massachusetts

Selected Private Collections
J. J. and Ziuta Akston, New York, New York
 and Palm Beach, Florida
Dr. Paul Henkind, New Rochelle, New York
Steven C. Rockefeller, Middlebury, Vermont
Mr. and Mrs. William P. Rogers, Bethesda,
 Maryland and New York, New York
David and Eula Wintermann, Eagle Lake,
 Texas

Selected Awards
1976 Bronze Medal, "Annual Exhibtion,"
 National Sculpture Society, New York,
 New York, catalog
1976 Gold Medal of Honor, "Allied Artists of
 America Annual Exhibition," National
 Academy of Design, New York, New
 York, catalog
1981 Maurice B. Hexter Prize, "Forty-Eighth
 Annual Exhibition," National Sculpture
 Society, New York, New York, catalog

Preferred Sculpture Media
Stone

Selected Bibliography
Armstrong, Jane B. *Discovery in Stone*. New
 York: East Woods Press, 1974.
Armstrong, Jane B. "From the Mountains of
 Vermont." *National Sculpture Review* vol.
 23 no. 2 (Summer 1974) pp. 23-25, illus.
Garwood, Keith. "Palpation: The Forbidden
 Art of Appreciation." *Queen's Quarterly* vol.
 88 no. 2 (Summer 1981) pp. 226-232.
Loercher, Diane. "Jane Armstrong—Late-
 Blooming Sculptor." *The Christian Science
 Monitor* (Monday, December 19, 1977) p.
 15, illus.

Gallery Affiliations
Sculpture Center
167 East 69 Street
New York, New York 10021

Sculptors Guild
110 Greene Street
New York, New York 10010

Foster Harmon Galleries of American Art
1415 Main Street
Sarasota, Florida 33577

Mailing Address
2909 South Ocean Boulevard-3D
Highland Beach, Florida 33431

Nocturne. 1982. Vermont marble, 30"h x 36"w x 5"d. Collection Northern Telecom, Research Triangle Park, North Carolina. Photograph by Robert T. Armstrong.

Artist's Statement

"In childhood, the illustrated books by Ernest Thompson Seton inspired my love of animal art and, like many children, I also collected interestingly shaped pebbles and rocks. Much later this emerged in a struggle to capture the ballet and comedy of animals and birds in a material as enduring as stone. My goal is to harmonize subject and stone, line and mass without losing that special movement or animal essence which first captured my attention. In my abstract sculpture I let various richly-veined marbles impose their own rhythms on the final form.

Not a path-seeker by nature, I take comfort in Frost's line 'The fact is the sweetest dream that labor knows.'

"Mindful of an artist's quest for new forms of expression, I remain a person who finds beauty in the ordinary. As the poet evokes with words, I want to capture the transitory in a material as strong, honest and solid as stone."

Jane B Armstrong

23

Anne Arnold

née Mary Anne
Born May 2, 1925 Melrose, Massachusetts

Education and Training
1946 B.A., Art, University of New
 Hampshire, Durham, New Hampshire
1947 M.A., Art, Ohio State University,
 Columbus, Ohio
1949 Universidad de Guadalajara,
 Guadalajara, Jalisco, México
1949- Art Students League, New York, New
53 York; study in wood and stone
 sculpture with John Hovannes
1951- Art Students League, New York, New
53 York; study in clay and plaster
 sculpture with William Zorach

Selected Individual Exhibitions
1960 Tanager Gallery, New York, New York
1964, Fischbach Gallery, New York, New
67, York
69,
71,
72,
74,
76,
79
1970 Bard College, Annandale-on-Hudson,
 New York
1971 Moore College of Art, Philadelphia,
 Pennsylvania, retrospective and
 catalog
1972 Galerie Brusberg, Hannover, Germany,
 Federal Republic
1981 American Kennel Club, New York,
 New York, catalog
1981 Belfast Free Library, Belfast, Maine
1983 University Art Galleries, Paul Creative
 Arts Center, University of New
 Hampshire, Durham, New Hampshire,
 retrospective

Selected Group Exhibitions
1958, "New Sculpture Group Annual
59, Exhibition," Riverside Museum,
60, New York, New York
61
1962 "Twelve New York Sculptors,"
 Riverside Museum, New York, New
 York, catalog
1964 "Sixty-Seventh Annual Exhibition of
 American Paintings and Sculpture,"
 Art Institute of Chicago, Chicago,
 Illinois, catalog
1964, "Group Exhibition," Maine Coast
69, Artists Gallery, Rockport, Maine
81
1965 "Pop Art and the American Tradition,"
 Milwaukee Art Center, Milwaukee,
 Wisconsin, catalog

1966 "Current Trends in American Art,"
 Westmoreland County Museum of Art,
 Greensburg, Pennsylvania
1966 "Art in Embassies," Museum of
 Modern Art, New York, New York
1967 "Thirtieth Sculptors Guild Annual
 Exhibition," Lever House, New York,
 New York, catalog
1969 "The Partial Figure in Modern
 Sculpture from Rodin to 1969,"
 Baltimore Museum of Art, Baltimore,
 Maryland
1971 "Gallery Exhibition," Galerie Darthea
 Speyer, Paris, France
1972 "Painting and Sculpture," Storm King
 Art Center, Mountainville, New York
1972 "Unmanly Art," Suffolk Museum, Stony
 Brook, New York, catalog
1972 "Critics' Choice," Sculpture Center,
 New York, New York
1973- "Waves'," Cranbrook Academy of Art
74 Museum, Bloomfield Hills, Michigan;
 Grand Rapids Art Museum, Grand
 Rapids, Michigan
1973 "Women Choose Women," New York
 Cultural Center, New York, New York,
 catalog
1973 "Collector's Choice," Philbrook Art
 Center, Tulsa, Oklahoma
1974 "Painting and Sculpture Today 1974,"
 Indianapolis Museum of Art,
 Indianapolis, Indiana, catalog
1974 "Woman's Work: American Art 1974,"
 Museum of the Philadelphia Civic
 Center, Philadelphia, Pennsylvania,
 catalog
1976 "American Artists '76: A Celebration,"
 Marion Koogler McNay Art Institute,
 San Antonio, Texas, catalog
1976 "The Cow as Art," Queens Museum,
 Flushing, New York
1977 "Magic Circle," Bronx Museum of The
 Arts, Bronx, New York
1977 "The Object as Poet," Renwick Gallery
 of the National Collection of Fine Arts,
 Smithsonian Institution, Washington,
 D.C., catalog
1977 "American Sculpture Folk and
 Modern," Queens Museum, Flushing,
 New York, catalog
1978 "Animal Kingdom," Everson Museum
 of Art, Syracuse, New York, catalog
1980 "Perceiving Modern Sculpture:
 Selections for the Sighted and
 Non-Sighted," Grey Art Gallery and
 Study Center, New York University,
 New York, New York
1981 "The Animal in American Art: 19th and
 20th Centuries," Nassau County
 Museum of Fine Arts, Roslyn, New
 York, catalog
1981 "The Animal Image: Contemporary
 Objects and the Beast," Renwick
 Gallery of the National Museum of
 American Art, Smithsonian Institution,
 Washington, D.C., catalog
1981 "Tracking the Marvelous," Grey Art
 Gallery and Study Center, New York
 University, New York, New York,
 catalog

1981 "A New Bestiary: Animal Image in
 Contemporary Art," Institute of
 Contemporary Art of the Virginia
 Museum of Fine Arts, Richmond,
 Virginia, catalog
1981 "Elaine de Kooning Collection," Elaine
 Benson Gallery, Bridgehampton, New
 York
1982 "Women's Art: Miles Apart," Aaron
 Berman Gallery, New York, New York;
 East Campus Gallery, Valencia
 Community College, Orlando, Florida,
 catalog
1983 "Affects-Effects," Philadelphia College
 of Art, Philadelphia, Pennsylvania
1983 "One Hundred and Fifty-Eighth Annual
 Exhibition," National Academy of
 Design, New York, New York, catalog
1983 "Carved Wood Sculpture," Thorpe
 Intermedia Gallery, Sparkill, New York
1983 "Selected Recent Acquisitions from
 the Metropolitan Museum," Queens
 Museum, Flushing, New York
1984 "Animals!: Tradition and Fantasy in
 Animal Sculpture," Washington Square
 Partnership and Public Art Trust,
 Washington, D.C., catalog

Selected Public Collections
Albright-Knox Art Gallery, Buffalo, New York
Chrysler Museum, Norfolk, Virginia
Ciba-Geigy Corporation, Ardsley, New York
Citibank Corporation, New York, New York
Housatonic Community College, Bridgeport,
 Connecticut
Metropolitan Museum of Art, New York, New
 York
Weatherspoon Art Gallery, Greensboro, North
 Carolina

Selected Private Collections
Mr. and Mrs. Dieter Brusberg, Hannover,
 Germany, Federal Republic
Mr. and Mrs. Sydney Lewis, Richmond,
 Virginia
Mr. and Mrs. Rodrigo Moynahan, Paris,
 France
Mr. and Mrs. John W. Payson, Hobe Sound,
 Florida
Darthea Speyer, Paris, France

Selected Award
1983 Recognition in Creative Arts, Ingram
 Merrill Grant, New York, New York

Preferred Sculpture Media
Clay and Wood

Additional Art Fields
Drawing and Painting

Teaching Position
Associate Professor, City University of New
 York Brooklyn College, Brooklyn, New York

Selected Bibliography

Campbell, Lawrence. "The Animal Kingdom of Anne Arnold." *Art News* vol. 63 no. 8 (December 1964) pp. 32-33, 64-65, illus.

Kramer, Hilton. "Art: Anne Arnold's Peaceable Kingdom." *The New York Times* (Sunday, April 18, 1971) p. D23, illus.

Myers, John Bernard. "The Other." *Artforum* vol. 21 no. 7 (March 1983) pp. 44-49, illus.

Ratcliff, Carter. "Anne Arnold." *Craft Horizons* vol. 31 no. 3 (June 1971) pp. 18-21, 69-70, illus.

Schwartz, Sanford. *The Art Presence*. New York: Horizon Press, 1982.

Gallery Affiliation

Fischbach Gallery
24 West 57 Street
New York, New York 10019

Mailing Address

50 West 29 Street
New York, New York 10001

Artist's Statement

"Much of my earlier work was constructed and carved wood figures. At that time, I could obtain wood free on beaches, in woods and on the streets of New York; however, working in a studio two flights up without elevators, life-size elephants and cows became unmanageable. I then attempted lightweight mixed media structures of plywood combined with fabric and polyester resin. When prolonged exposure to epoxy became a health hazard, I turned to clay as a safe substitute.

"As a sculptor, I had used clay directly for firing small studies or as a step toward casting in other materials. Clay, a natural product of the earth, has proved to be the most versatile in structure, texture and color although extremely difficult technically.

"My preferred themes are animal and human forms. Animals and humans have always been subject matter for art and always will be—whatever the current fashion may be. Most of my animal sculptures are portraits which explains the titles."

Anne Arnold

Drummond. 1978. Stoneware, 16½"h x 18"w x 31"d.
Courtesy Fischbach Gallery, New York, New York.
Photograph by Robert Brooks.

Maria Artemis

née Maria Artemis Papageorge
(Husband Henry C. Sawyer)
Born April 21, 1945 Greensboro, North
 Carolina

Education and Training
1969 B.A., Psychology, Agnes Scott
 College, Decatur, Georgia
1975 Penland School of Crafts, Penland,
 North Carolina; study in ceramics with
 Eric Gronborg
1977 M.F.A., Ceramic Sculpture, University
 of Georgia, Athens, Georgia; study
 with Jerry Chappelle, Ron Meyers and
 Andy Nasisse
1976 Penland School of Crafts, Penland,
 North Carolina; study in photography

Selected Individual Exhibitions
1978 Atlanta Art Workers Coalition Gallery,
 Atlanta, Georgia
1979 University of Wisconsin-Superior,
 Superior, Wisconsin
1980 Nexus Gallery, Atlanta, Georgia
1981 Kipnis: Works of Art, Atlanta, Georgia
1983 Studio/1200 Foster Street, Atlanta,
 Georgia
1984 Art Gallery, Fine Arts Center,
 University of Tennessee at
 Chattanooga, Chattanooga,
 Tennessee
1984 Upstairs Gallery, Tryon, North Carolina

Selected Group Exhibitions
1977 "Forty-Fifth Southeastern Painting and
 Sculpture Competition," Southeastern
 Center for Contemporary Art,
 Winston-Salem, North Carolina
1978 "Thirty-Six Women Artists," Peachtree
 Center Gallery, Atlanta, Georgia
1978 "Small Works," Raw Gallery, Hartford,
 Connecticut
1978 "Thirty-Fourth Annual Scripps
 Invitational Ceramic Exhibition," Lang
 Art Gallery, Scripps College,
 Claremont, California
1979 "Converge/Converse: Marcia R. Cohen
 and Maria Artemis," Atlanta Art
 Workers Coalition Gallery, Atlanta,
 Georgia, catalog
1979 "The Avant-Garde: 12 in Atlanta," High
 Museum of Art, Atlanta, Georgia,
 catalog
1980 "Atlanta Women's Art Collective,"
 A.I.R. Gallery, New York, New York
1980 "Earth Art: Sand and Clay,"
 Southeastern Center for
 Contemporary Art, Winston-Salem,
 North Carolina
1982 "Ceramic Southeast," University of
 Georgia, Athens, Georgia
1982 "Southeastern Invitational," Columbia
 Museums of Art & Science, Columbia,
 South Carolina, catalog
1984 "First Atlanta Biennial," Nexus Gallery,
 Atlanta, Georgia
1985 "Arts Festival of Atlanta," Piedmont
 Park, Atlanta, Georgia, catalog

Selected Public Collections
The Lannan Foundation, West Palm Beach,
 Florida
North Carolina National Bank, Charlotte,
 North Carolina
University of Georgia Student Union, Athens,
 Georgia
Wilson, Hull & Neal, Atlanta, Georgia

Selected Private Collection
Anne Emanuel, Atlanta, Georgia

Selected Awards
1977 Graduate Study, Ford Foundation
 Grant
1980 Exhibition Grant, Nexus Gallery,
 Atlanta, Georgia and National
 Endowment for the Arts

Preferred Sculpture Media
Varied Media

Teaching Position
Lecturer, Atlanta College of Art, Atlanta,
 Georgia

Selected Bibliography
Kipnis, Jeff. "Profiles: Atlanta Profiles, Maria
 Artemis (Atlanta)." *Art Voices* vol. 4 no. 3
 (May-June 1981) p. 41, illus.
"Maria Artemis Sawyer." *Ceramics Monthly*
 vol. 26 no. 8 (October 1978) p. 47, illus.
Nasisse, Andy. "Media Mix: Maria Artemis
 Sawyer." *Craft Horizons* vol. 38 no. 3
 (August 1978) p. 86.
Nasisse, Andy. "Reviews: Maria Artemis." *Art
 Papers* vol. 5 no. 1 (January-February
 1981) pp. 17-18, illus.

Mailing Address
2854 North Hills Drive NE
Atlanta, Georgia 30305

Artist's Statement

"Every aspect of our experience reveals layers of information. If we are open we can learn a great deal. Consequently, all materials, situations, technologies are within my field of consideration. My choice at any point is based on my own intuitive awareness. We each have a working 'map' of reality, consisting of theories about 'the way things are.' At its best this 'map' is open to constant revision. My work is a language, half-invented, half-discovered, used to explore and articulate new territory for my 'map in process.'"

Parallax. 1979. Mixed media, 10′h x 9′w x 12′d. Installation view 1979. "The Avant-Garde: 12 in Atlanta," High Musem of Art, Atlanta, Georgia, catalog. Courtesy High Museum of Art, Atlanta, Georgia. Photograph by Jerome Drown.

Alice Aycock

née Alice Frances
Born November 20, 1946 Harrisburg,
Pennsylvania

Education and Training
1968 B.A., Studio Art and Art History,
Rutgers University, Douglass College,
New Brunswick, New Jersey
1971 M.A., Sculpture, City University of
New York Hunter College, New York,
New York; study with Robert Morris

Selected Individual Exhibitions
1971, Fry Farm, Silver Springs, Pennsylvania
76
1972, Gibney Farm, New Kingston,
73, Pennsylvania
74
1974, 112 Greene Street Gallery, New York,
77 New York
1974 Williams College Museum of Art,
Williamstown, Massachusetts
1977 Project Room, Museum of Modern Art,
New York, New York
1978 Portland Center for Visual Arts,
Portland, Oregon
1978, John Weber Gallery, New York,
79, New York
81,
82,
84
1978 University of Rhode Island, Kingston,
Rhode Island
1978 Muhlenberg College Center for the
Arts, Allentown, Pennsylvania, catalog
1978 Philadelphia College of Art,
Philadelphia, Pennsylvania, catalog
1979 Contemporary Arts Center, Cincinnati,
Ohio
1979 San Francisco Art Institute, San
Francisco, California
1979, Protech-McIntosh Gallery,
80 Washington, D.C.
1980 P.S. 1, Institute for Art and Urban
Resources, Long Island City, New
York
1980 Battery Park Landfill, Battery Park
City, New York
1981 State University of New York College
at Plattsburgh, Plattsburgh, New York
1981 University of South Florida, Tampa,
Florida, catalog
1982 Lawrence Oliver Gallery, Philadelphia,
Pennsylvania
1982 Rutgers University, Douglass College,
New Brunswick, New Jersey
1983 Klein Gallery, Chicago, Illinois
1983 Museum of Contemporary Art,
Chicago, Illinois
1983- Württembergischer Kunstverein,
84 Traveling Exhibition, Stuttgart,
Germany, Federal Republic,
retrospective and catalog
1983 Roanoke College, Salem, Virginia

Selected Group Exhibitions
1971 "Twenty-Six Contemporary Women
Artists," Aldrich Museum of
Contemporary Art, Ridgefield,
Connecticut, catalog
1975 "Projects in Nature," Merriewold West,
Far Hills, New Jersey, catalog
1976 "Sculpture Sited," Nassau County
Museum of Fine Arts, Roslyn, New
York, catalog
1977 "Documenta 6," Neue Gallerie, Kassel,
Germany, Federal Republic, catalog
1977 "Artpark: The Program in Visual Arts,"
Artpark, Lewiston, New York, catalog
1977 "Metaphor and Illusion," City of
Dayton, Ohio, Wright State University,
Dayton, Ohio and First National Bank
Building, Dayton, Ohio
1978 "Fading Bounds in Sculpture,"
Stedelijk Museum, Amsterdam,
Netherlands, catalog
1978- "Dwellings," Institute of Contemporary
79 Art of The University of Pennsylvania,
Philadelphia, Pennsylvania; Neuberger
Museum, Purchase, New York, catalog
1978 "Quintessence: Alternative Spaces
Residency Program," City Beautiful
Council, Dayton, Ohio and Wright
State University, Department of Art,
Dayton, Ohio, catalog
1978, "Venice Biennale," Venice, Italy,
82 catalog
1979 "The Decade in Review: Selections
from the 1970s," Whitney Museum of
American Art, New York, New York,
catalog
1979 "Contemporary Sculpture: Selections
from the Collection of the Museum of
Modern Art," Museum of Modern Art,
New York, New York, catalog
1980 "Projects: Architectural Sculpture,"
University of California, Irvine, Irvine,
California, catalog
1981 "Machineworks: Vito Acconci, Alice
Aycock, Dennis Oppenheim," Institute
of Contemporary Art of The University
of Pennsylvania, Philadelphia,
Pennsylvania, catalog
1981 "Myth and Ritual," Kunsthaus, Zürich,
Switzerland, catalog
1982 "Metaphor, New Projects by
Contemporary Sculptors," Hirshhorn
Museum and Sculpture Garden,
Smithsonian Institution, Washington,
D.C., catalog
1983 "Het Idee Van de Stad, Idea of the
City," Kunst Actualiteiten Arnhem,
Arnhem, Netherlands, catalog
1983 "Biennale 17," Middelheim Open-Air
Museum for Sculpture, Antwerp,
Belgium, catalog
1983 "Forum Skulptur 1983," Abdijcomplex,
Stichting Forum, Middelburg,
Netherlands
1984 "Bayou Show," Houston Festival,
Houston, Texas
1984 "Environment and Sculpture,"
International Contemporary Sculpture
Symposuim, Lake Biwa, Japan,
catalog

1984- "Content: A Contemporary Focus
85 1974-1984," Hirshhorn Museum and
Sculpture Garden, Smithsonian
Institution, Washington, D.C.,
book-catalog
1984 "Projects: World's Fairs, Waterfronts,
Parks and Plazas," Rhona Hoffman
Gallery, Chicago, Illinois
1984 "Citywide Contemporary Sculpture
Exhibition," Toledo Museum of Art,
Toledo, Ohio (Sponsored by Arts
Commission of Greater Toledo, Ohio;
Toledo Museum of Art, Toledo, Ohio
and Crosby Gardens, Toledo, Ohio),
catalog
1984 "Time: The Fourth Dimension in Art,"
Traveling Exhibition, Palais des
Beaux-Arts, Brussels, Belgium, catalog
1985 "A New Beginning 1968-1978," Hudson
River Museum, Yonkers, New York,
catalog

Selected Public Collections
Australian National Gallery, Canberra,
Australia
City of Antwerp, Belgium
Fattoria de Celle, Pistoria, Italy
Laumeier International Sculpture Park And
Gallery, St. Louis. Missouri
Museum of Contemporary Art, Chicago,
Illinois
Museum of Modern Art, New York, New York
Roanoke College, Salem, Virginia
Rutgers University, Douglass College, New
Brunswick, New Jersey
Salisbury State College, Salisbury, Maryland
Skulpturenmuseum, Marl, Germany, Federal
Republic
State University of New York College at
Plattsburgh, Plattsburgh, New York
University of Nebraska-Lincoln, Lincoln,
Nebraska
University of South Florida, Tampa, Florida
Village of Miyazaki-Mura, Japan
Whitney Museum of American Art, New York,
New York

Selected Awards
1976 Creative Artists Public Service Grant,
New York State Council on the Arts
1980 Individual Artist's Fellowship, National
Endowment for the Arts
1983 Faculty Research Grant, City
University of New York Hunter
College, New York, New York

Preferred Sculpture Media
Metal (welded), Varied Media and Wood

Additional Art Field
Drawing

Teaching Position
Assistant Professor, City University of New
York Hunter College, New York, New York

Selected Bibliography

Fry, Edward. "The Poetic Machines of Alice Aycock." *Portfolio* vol. 3 no. 6 (November-December 1981) pp. 60-65, illus.

Kuspit, Donald B. "Aycock's Dream Houses." *Art in America* vol. 68 no. 7 (September 1980) pp. 84-87, illus.

Lippard, Lucy R. *Overlay: Contemporary Art and The Art of Prehistory*. New York: Pantheon Books, 1983.

Price, Aimée Brown. "Artist's Dialogue: A Conversation with Alice Aycock." *Architectural Digest* (April 1983) pp. 54, 58, 60, illus.

Tsai, Eugenia. "A Tale of (at least) Two Cities: Alice Aycock's Large Scale Dis/Integration of Microelectric Memories (A Newly Revised Shantytown)." *Arts Magazine* vol. 56 no. 10 (June 1982) pp. 134-141, illus.

Gallery Affiliation

John Weber Gallery
142 Greene Street
New York, New York 10012

Mailing Address

62 Greene Street
New York, New York 10012

Artist's Statement

"During the past several years, I have been involved in a series of sculptures entitled *Times/Creation Machines*. The sculptures of this series make use of a general image I have arrived at through incorporating information and experiences related to plows, fans, windmills, food processors, turbines, tool-making and crescent shapes of the moon as it moves through its phases. Just as my earlier work incorporated mazes and pitched rooted structures as a generic image to architecture, this new image of the *Time/Creation Machines* is a generic image to technology.

"More recently, some of my work is a further symbolic and metaphorical merging of these generic images of architecture and technology. The configurations of the spinning 'blades' are derived from theoretical and schematic diagrams by the 16th century hermetic philosopher, Robert Fludd, in his attempt to explain the order of the universe. . . . These sculptures wed images of the 'Fertile Crescent,' the land of paradise where it is thought man first settled, with images of the invention of the plow which gave man access to feeding himself, and with architecture which gave man a means of shelter and protection from the environment—both acts of creation and preservation."

The Miraculating Machine In The Garden (Tower of The Winds). 1982. Steel, galvanized sheet metal, neon light, cable, bells, aluminum, copper and glass, 26'h x 20'w x 20'd. Collection Rutgers University, Douglass College, New Brunswick, New Jersey. Photograph by Wenda Habenicht.

Barbara Baer

née Barbara Ann Beisner
(Husband William Allen Baer)
Born June 2, 1949 Baton Rouge, Louisiana

Education and Training
1971 B.F.A., Sculpture, Tulane University, New Orleans, Louisiana; study with Arthur Kern
1978 M.F.A., Sculpture, University of Colorado at Boulder, Boulder, Colorado; study with John Wilson

Selected Individual Exhibitions
1978 Henderson Museum, University of Colorado at Boulder, Boulder, Colorado
1979 St. Charles on Wazee Gallery, Denver, Colorado
1979 Colorado Women's College, Denver, Colorado
1979 Fine Arts Gallery, University Memorial Center, University of Colorado at Boulder, Boulder, Colorado
1980 Gallery 234, Laramie, Wyoming
1981 Montalvo Center for the Arts, Saratoga, California
1981 Boulder Center for the Visual Arts, Boulder, Colorado
1982 Contemporary Arts Center, New Orleans, Louisiana
1985 Colorado Springs Fine Arts Center, Colorado Springs, Colorado

Selected Group Exhibitions
1975 "Rocky Mountain Women in the Arts," 323 Gallery, Casper, Wyoming
1979 "Colorado Women in the Arts," Arvada Center for the Arts and Humanities, Denver, Colorado, catalog
1980 "Sixth Colorado Annual," Denver Art Museum, Denver, Colorado, catalog
1980 "Women from Colorado," Washington Women's Arts Center, Washington, D.C.
1981 "Front Range: Women in the Visual Arts," ARC Gallery, Chicago, Illinois; Boulder Center for the Visual Arts, Boulder, Colorado; Plains Art Museum, Moorhead, Minnesota; Community Gallery of Art, Arapahoe Community College, Denver, Colorado, catalog
1981 "Clothworks," Sangre de Cristo Arts and Conference Center, Pueblo, Colorado
1981 "Women as Artists," Mariani Gallery, University of Northern Colorado, Greeley, Colorado
1983 "Non-Two-Dimensional," Emmanuel Gallery, Denver, Colorado
1983 "Merge/Emerge: A Collaborative Environment by Barbara Baer and Sally Elliott," Spark Gallery, Denver, Colorado
1984 "A Decade of Women's Art," Boulder Center for the Visual Arts, Boulder, Colorado
1984 "Art '84: Colorado Women Who Create," Foothills Art Center, Golden, Colorado, catalog

Selected Public Collections
Arvada Center for the Arts and Humanities, Denver, Colorado
Auraria Higher Education Center, Denver, Colorado
Hockinson School District, Hockinson Heights School, Brush Prairie, Washington
International Athletic Club, Kansas City, Missouri
Wickliff and Company, Denver, Colorado

Selected Private Collection
Nancy Spanier Dance Theatre, Boulder, Colorado

Selected Awards
1981, Finalist, Art in Public Places, Colorado
82 Council on the Arts and Humanities
1982 Award for Excellence, Women in Design International, Ross, California

Preferred Sculpture Media
Fiber and Varied Media

Additional Art Field
Drawing

Related Profession
Visiting Artist

Teaching Position
Adjunct Faculty, University of Colorado at Denver, Denver, Colorado

Selected Bibliography
Chafee, Katharine Smith. "Charles Parson and Barbara Baer: Recent Environmental Projects." Artspace vol. 4 no. 2 (Winter 1980) pp. 18-20, illus.
Julian, June. "Reviews: All Colorado Women Artists Juried Exhibit." Artspace vol. 3 no. 4 (Summer 1979) pp. 63-66, illus.
Singletary, Suzanne M. "Barbara Baer and Sally Elliott at Spark Gallery." Artspace vol. 7 no. 2 (Spring 1983) pp. 85-86, illus.
Weil, Carol S. "Non-Two-Dimensional at Emmanuel Gallery, Denver." Artspace vol. 8 no. 2 (Spring 1984) p. 25, illus.

Gallery Affiliation
Carson-Sapiro Art Consultants
2601 Blake Street
Denver, Colorado 80205

Mailing Address
1027 Steele Street
Denver, Colorado 80206

Artist's Statement

"My fabric sculptures release a buoyant sense of place, a lively interaction of art and architecture. The soft grace of fabric contrasts with the ordered structures which shape and support the installations. The shifting forms of the cloth constructions suggest sails, kites, clouds, airships or streamers.

"Fabric sculpture designed for specific architectural spaces give an imposing scale and durability with less expense and weight than conventional sculptural materials. The familiar nature of fabric communicates a warmth and appeal of structural rhythm, interplaying light and shadow and spatial discovery."

Barbara Baer

Light Waves. 1984. Painted satin and aluminum, 30'h x 8'w x 60'd. Collection Wickliff and Company, Denver, Colorado. Photograph by Javan Bayer.

Frances Stevens Bagley

Born April 7, 1946 Fayetteville, Tennessee

Education and Training
1969 B.F.A., Painting, Arizona State University, Tempe, Arizona
1971 M.A., Art Education, Arizona State University, Tempe, Arizona
1971- Apprenticeship to Michael Leach,
72 Yelland Manor Pottery, Devon, Great Britain; assistant in the technical creation of production pottery
1973 Independent study and travel in Great Britain
1980 M.F.A., Sculpture, North Texas State University, Denton, Texas

Selected Individual Exhibitions
1976 Del Mar College, Corpus Christi, Texas
1976 Texas Woman's University, Denton, Texas
1979 500 Exposition Gallery, Dallas, Texas
1981, DW Gallery, Dallas, Texas
84

Selected Group Exhibitions
1975 "National Acquisition Exhibition," University of Texas at Arlington, Arlington, Texas
1975 "Artists Make Toys," Art Museum of South Texas, Corpus Christi, Texas
1975 "Miniature Works Exhibit," The Museum, Texas Tech University, Lubbock, Texas
1975 "New Clay Relics International," University of Texas at Arlington, Arlington, Texas, catalog
1976 "Frances Bagley and Sandra Taylor," Farmers & Merchants Gallery, Pilot Point, Texas
1976 "Miniature Show Invitational," D. W. Co-Op, Dallas, Texas
1978 "Tree Show," D. W. Co-Op, Dallas, Texas

1979- "Woman-in-Sight: New Art in Texas,"
81 Traveling Exhibition, Dougherty Cultural Arts Center, Austin, Texas, catalog
1980 "American Women Artists 1980," Museu de Arte Contemporânea da Universidade de São Paulo, São Paulo, Brazil, catalog
1980- "Sculpture Park at Creedmoor,"
81 Creedmoor Psychiatric Center, Queens Village, New York, catalog
1981 "Dallas Exhibition," Bath House Cultural Center, Dallas, Texas
1981 "First Annual Connemara Sculpture Exhibition," Connemara Conservancy, Allen, Texas
1982 "Group Exhibition," 500 Exposition Gallery, Dallas, Texas
1982 "Group Invitational," 500 Exposition Gallery, Dallas, Texas
1982 "Sculpture Invitational," North Texas State University, Denton, Texas
1983 "Fourth Texas Sculpture Symposium," Area Galleries and Institutions, Austin, Texas (Sponsored by College of Fine Arts and Humanities, University of Texas at Austin, Austin, Texas)
1983 "Showdown," Alternative Museum, New York, New York; Diverse Works, Houston, Texas, catalog
1984 "Presenting Nine, Gihon Foundation Awards Exhibition," D'Art Visual Art Center, Dallas, Texas
1984 "Personal Scale, Sculpture Invitational," Richland College, Dallas, Texas
1984 "High Tech Invitational," University of Texas at Dallas, Richardson, Texas
1984 "Dallas Public Library Sculpture Exhibition," Dallas Public Library, Dallas, Texas
1984 "Susie Phillips and Frances Bagley," DW Gallery, Dallas, Texas
1985 "Fifth Texas Sculpture Symposium," Sited throughout Central Business District, Dallas, Texas and Connemara Conservancy, Allen, Texas (Sponsored by Texas Sculpture Symposium, Dallas, Texas), catalog

Selected Public Collections
Arkansas Arts Center, Little Rock, Arkansas
Cranford and Associates, Little Rock, Arkansas
Southwestern Bell Telephone Company, Dallas, Texas
University of Texas at Arlington, Arlington, Texas

Selected Awards
1975 Individual Exhibition Award, "Ninth Annual National Drawing and Small Sculpture Show," Del Mar College, Corpus Christi, Texas
1976 Best of Show, "Women in the Arts Festival," University of Texas at Arlington, Arlington, Texas

Preferred Sculpture Media
Varied Media and Wood

Additional Art Fields
Drawing and Painting

Related Profession
Art Instructor

Selected Bibliography
Glueck, Grace. "Guide to What's New in Outdoor Sculpture." *The New York Times* (Friday, September 12, 1980) pp. C1, C20.
Kutner, Janet. "The Southwest Texas Ranges: Dallas, Acquisitions Are Only Part of the Action." *Art News* vol. 81 no. 10 (December 1982) pp. 86-88.
McFadden, Sarah. "Going Places, Part II: The Outside Story, Creedmoor Psychiatric Center." *Art in America* vol. 68 no. 6 (Summer 1980) pp. 51-55, 57-59, 61.
Taylor, Elmer. "An Apprenticeship in England." *Ceramics Monthly* vol. 21 no. 1 (January 1973) pp. 28-29, illus.

Gallery Affiliation
DW Gallery
3200 Main Street
Dallas, Texas 75226

Mailing Address
Post Office Box 26342
Dallas, Texas 75226

Moon of the Red Grass. 1984. Cedar and lacquer, 72"h x 102"w x 84"d. Photograph by James Flannery.

Artist's Statement
"My major concern in sculpture is with movement in space and its relationship to human scale physically and psychologically. An additional interest is the translation of sound (as it has form, tone and movement in time and space) into primarily line in space. I feel I am actually sculpting the negative space with the line defining the absent form."

Francis Bagley

Rela Banks

née Rela Heuberg
(Husband Staley F. Banks)
Born October 8, 1932 Jaroslaw, Poland

Education and Training
1961- Studio of Lawrence Umbreit, Summit,
72　New Jersey; study in stone sculpture
1962- Art Students League, New York,
63　New York; study in painting
1964 Museum of Modern Art, New York,
New York; study in tempera and
watercolor
1964- Art Students League, Woodstock,
66　New York; study in watercolor
1965- Studio of Herbert Kallem, West
70　Orange, New Jersey; study in
sculpture
1966- Studio of Raymond Roklin, West
67　Orange, New Jersey; study in
sculpture

Selected Individual Exhibitions
1973 Robbins Art Gallery, South Orange,
New Jersey
1974 Montclair State College, Upper
Montclair, New Jersey
1974, Caldwell College, Caldwell,
82　New Jersey
1976 Summit Art Center, Summit, New
Jersey
1976 Newark Academy, Livingston, New
Jersey
1978 Rutgers University, Douglass College,
New Brunswick, New Jersey
1979, Phoenix Gallery, New York, New York,
81,　catalog
83
1979 First Women's Bank, New York, New
York
1982 Ann Leonard Gallery, Woodstock, New
York
1982 Morris Museum of Arts and Sciences,
Morristown, New Jersey
1985 New England Center for
Contemporary Art, Brooklyn,
Connecticut; Schiller-Wapner Galleries,
New York, New York

Selected Group Exhibitions
1972 "Juried Exhibition," Art Center of the
Oranges, East Orange, New Jersey
1972 "New Jersey Invitational," Gallery 9,
Chatham, New Jersey
1972 "Juried Exhibition," Fairlawn Art
Center, Fairlawn, New Jersey
1972 "Juried Exhibition," Summit Art Center,
Summit, New Jersey
1972 "Juried Exhibition," Hunterdon Art
Center, Clinton, New Jersey
1973, "Summit Art Center Exhibition," Lever
75,　House, New York, New York
79

1974 "Painters and Sculptors Society of
New Jersey," Jersey City Museum,
Jersey City, New Jersey
1975, "Members Exhibition," Woodstock
79,　Artists Association, Woodstock,
81　New York
1975 "Rela Banks and I-Chao Chu," Gallery
9, Chatham, New Jersey
1975, "Audubon Artists Annual Exhibition,"
76　National Academy of Design, New
York, New York, catalog
1977 "Rela Banks and Linda Handler,"
Sculptors 5 Gallery, Chatham, New
Jersey
1977 "Anneli Arms, Rela Banks and Nancy
Brown," Phoenix Gallery, New York,
New York
1977 "Rela Banks, Robert Selkowitz and
Alexander Viola," Woodstock Artists
Association, Woodstock, New York
1978, "Spectrum," Fairleigh Dickinson
82　University, Florham-Madison Campus,
Madison, New Jersey
1978 "Process as Art," Phoenix Gallery, New
York, New York; Wing Gallery, Merrick
Library, Merrick, New York
1979 "New Jersey Invitational," Morris
Museum of Arts and Sciences,
Morristown, New Jersey
1979, "Stone Sculpture Society of New
81　York," Lever House, New York, New
York
1980 "Stone Sculpture Society of New
York," Searles Castle, Great
Barrington, Massachusetts
1980, "Stone Sculpture Society of New
81　York," American Standard Gallery,
New York, New York
1981 "Summit Art Center at Nabisco,"
Nabisco Gallery, East Hanover, New
Jersey
1981 "People, Figures and Faces," First
Women's Bank, New York, New York
1981 "A Selection of Contemporary
Sculpture," Nabisco Gallery, East
Hanover, New Jersey
1982, "Linear Show," Phoenix Gallery, New
83　York, New York
1982 "Androgyny in Art," Emily Lowe
Gallery, Hempstead, New York,
catalog
1983, "Stone Sculpture Society of New
84　York," Warner Communications
Gallery, New York, New York
1984 "The State of the Arts in New Jersey
1984," Morris Museum of Arts and
Sciences, Morristown, New Jersey,
catalog
1984 "Invitational Sculpture Garden Show,"
Woodstock Artists Association,
Woodstock, New York
1984 "Rela Banks and Robert Waterman,"
American Telephone and Telegraph
Gallery, Basking Ridge, New Jersey

Selected Public Collections
Clements Associates, New York, New York
Emily Lowe Gallery, Hempstead, New York
Everson Museum of Art, Syracuse, New York
Frost King Industries, Paterson, New Jersey

Larsta Industries, Kearny, New Jersey
Millburn Free Public Library, Millburn, New
Jersey
Morris Museum of Arts and Sciences,
Morristown, New Jersey
Tucson Museum of Art, Tucson, Arizona
Woodstock Historical Society, Woodstock,
New York
Woodstock Playhouse, Woodstock, New York

Selected Private Collections
Mr. and Mrs. Stephen Dietz, New York, New
York
H. O. Gerngross, New York, New York
Mr. and Mrs. David Gernstein, Short Hills,
New Jersey
Ann Leonard, Woodstock, New York
George Sponseller, Detroit, Michigan

Selected Awards
1974 Best in Show, "Garden State Art
Center Exhibition," Art Center of
Oranges, East Orange, New Jersey
1974 First Prize, "New Jersey State Annual
Exhibition," Outdoor Sculpture
Exhibition, Irvington, New Jersey

Preferred Sculpture Media
Metal (soldered), Stone and Wood

Selected Bibliography
Amaya, Mario. "Primordial Grace: New
Sculpture by Rela Banks." *Studio
International* vol. 198 no. 1009 (1985) p.
22, illus.
Buonagurio, Edgar. "Arts Reviews: Anneli
Arms/ Rela Banks/Nancy Brown." *Arts
Magazine* vol. 52 no. 2 (October 1977) pp.
26-27, illus.
Gallati, Barbara. "Rela Banks." *Arts Magazine*
vol. 58 no. 3 (November 1983) p. 20, illus.
Raynor, Vivien. "Art: 16 State Sculptors
Come Into Their Own." *The New York
Times* (Sunday, June 24, 1979) p. N.J.2.

Gallery Affiliations
Phoenix Gallery
30 West 57 Street
New York, New York 10019

Ann Leonard Gallery
63 Tinker Street
Woodstock, New York 12498

Mailing Address
15 Deer Path
Short Hills, New Jersey 07078

Artist's Statement

"I began carving when I was a child living in Russia: wooden toys, dolls, birds and sailboats. As a young girl, I continued to carve and experiment with paint, drawing and collages. My formal study in art began in oil painting but I changed to sculpture, first in metal, then stone in subtle, contrasting color tones. Stone is my favorite material because it is versatile and ageless.

"My work explores the concept of life as eternal, the birth and development of all forms of life endlessly evolving. The circle and egg are both recurrent symbols of wholeness and perfection. By dividing and rearranging the circle and incorporating other geometric shapes, they represent the different aspects of progression and development that take place in life. This is my statement of hope over the destructive forces of man's nature."

Rela Banks

The Evolving Series: Pericarp. 1978. African wonderstone, 17"h x 12"w x 7"d. Collection Emily Lowe Gallery, Hempstead, New York. Photograph by Richard West.

35

Loretta S. Wonacott Barnett

née Loretta Sue Wonacott
(Husband David A. Barnett)
Born June 22, 1951 Boise, Idaho

Education and Training
1974 B.F.A., Sculpture, Boise State University, Boise, Idaho; study with Alfred J. Kober
1976 M.F.A., Sculpture, Ohio State University, Columbus, Ohio; study with Stephen Lawson

Selected Group Exhibitions
1972 "Thirty-Sixth Annual Artists of Idaho," Boise Gallery of Art, Boise, Idaho
1973 "The Art Works," Art Works Gallery, Boise, Idaho
1973 "Mainstreams '73, Eighth Annual Marietta College International Competitive Exhibition for Painting and Sculpture," Grover M. Hermann Fine Arts Center, Marietta College, Marietta, Ohio, catalog
1975 "Ohio Arts Festival," State Towers Gallery, Columbus, Ohio
1978 "Spirits and Savages," Marian Graves Mugar Gallery, Colby-Sawyer College, New London, New Hampshire
1978 "New Hampshire Arts Biennial," Manchester Institute of Arts and Sciences, Manchester, New Hampshire, catalog

1978- "Annual Faculty Exhibition," Marian
85 Graves Mugar Gallery, Colby-Sawyer College, New London, New Hampshire
1979 "Art Works Five," Phenix Hall Gallery, Concord, New Hampshire
1980 "Fourteenth Annual National Painting and Sculpture Exhibition," Edison Community College Gallery, Fort Myers, Florida, catalog
1980 "Fifth Annual Regional Juried Exhibition," Sharon Arts Center, Peterborough, New Hampshire
1982 "Barnett, Barnett, Bott and Hicklin," Library Arts Center, Newport, New Hampshire
1982 "Regional Selections 1982," Jaffe-Friede Gallery, Hood Museum of Art, Hanover, New Hampshire, catalog
1982 "New Works by Art Professors of New Hampshire," Rivier College, Nashua, New Hampshire
1983 "10" x 10" Imagination and Images," AVA Gallery, Hanover, New Hampshire
1983 "Seventeenth Annual National Drawing and Small Sculpture Show," Joseph A. Cain Memorial Art Gallery, Del Mar College, Corpus Christi, Texas, catalog
1983 "10 on 8: Inside and Outside—A Dual Presentation," City Gallery, New York, New York
1983 "Fifth Annual 100 Artists Show," Ten Windows on Eighth Avenue Fine Art Space, New York, New York
1984 "Art Faculty and BFA Seniors of Colby-Sawyer College," Channel Associates of Boston, Boston, Massachusetts

Selected Private Collections
Howard Huff, Boise, Idaho
Alfred J. Kober, Boise, Idaho
Mrs. Robert J. Schile, Boise, Idaho
Arnold Skov, Boise, Idaho
Patrick Whitelaw, St. Louis, Missouri

Selected Awards
1974 Judges Special Mention, "Thirty-Eighth Annual Artists of Idaho," Boise Gallery of Art, Boise, Idaho
1981 Alexandra K. Schmeckebier Memorial Award, "Ninth Annual Regional Art Exhibition," Hopkins Center, Hood Museum of Art, Hanover, New Hampshire
1984 Individual Artist's Fellowship, New Hampshire Commission on the Arts and National Endowment for the Arts

Preferred Sculpture Media
Metal (welded) and Wood

Additional Art Fields
Drawing and Painting

Teaching Position
Assistant Professor of Sculpture, Colby-Sawyer College, New London, New Hampshire

Gallery Affiliation
Condeso/Lawler Gallery
76 Greene Street
New York, New York 10012

Mailing Address
Post Office Box 1361
New London, New Hampshire 03257

Artist's Statement

"My sculpture symbolizes a psychological portrait of a particular movement or the transition between perception and full awareness. Flowing lines and forms versus angular or truncated ones—the juxtaposition of contrasts, the visual transition between active and more spartan surfaces—all become part of the total spatial structure.

"Many of my sculptures are statements about being a woman and the people, places and things with which I am most intimately connected. The work is intended to echo the elements of calm, excitement, tension and evolution present in our lives."

Anonymous Portraits, D and L. 1981. Left: Wood, polychromed, 78"h x 11"w x 12"d. Right: Wood, plastic and sticks, polychromed, 73"h x 16"w x 26"d.

Dina Barzel

née Eva Dina Rosenfeld
(Husband Yoram Barzel)
Born November 23, 1931 Iara, Romania

Education and Training
1957 B.A., Mathematics, Hebrew University, Jerusalem, Israel
1969 Factory of Visual Art, Seattle, Washington
1970-71 Camden Institute, London, Great Britain; study in art

Selected Individual Exhibitions
1973 Henry Art Gallery, Seattle, Washington
1976 Contemporary Crafts Gallery, Portland, Oregon
1977 University Gallery, Boise State University, Boise, Idaho

Selected Group Exhibitions
1972, 74 "Crafts," Tacoma Art Museum, Tacoma, Washington, catalog
1973 "Northwest Craftsmen Exhibition," Henry Art Gallery, Seattle, Washington, catalog
1973 "The Shape of Things," Jaid Gallery, Richland, Washington
1973 "Bodycraft," Portland Art Museum, Portland, Oregon
1973 "Five Award Winners of the Northwest Craftsmen Exhibition," Henry Art Gallery, Seattle, Washington
1973 "Crafts '73," Cheney Cowles Memorial Museum, Spokane, Washington
1974 "Invitational Textile Exhibition," Panaca Gallery, Bellevue, Washington
1975 "Fiber Arts in the Bay Area," Palo Alto Cultural Center, Palo Alto, California
1976 "Fiber Structures," Linda Ferris Gallery, Seattle, Washington
1976 "Northwest Designer Craftsmen," Bellevue Art Museum, Bellevue, Washington
1977 "Northwest '77," Seattle Art Museum, Seattle, Washington, catalog
1978 "Salute to Joan Mondale," Seattle Art Museum, Seattle, Washington
1978 "Northwest Designer Craftsmen," Contemporary Crafts Gallery, Portland, Oregon
1980 "Felting," American Craft Museum, New York, New York, catalog
1980 "Natural Fibers," Bellevue Art Museum, Bellevue, Washington
1981 "Felt and Burnish," Contemporary Artisans, San Francisco, California
1982-84 "New Directions: Clay and Fiber-1982," Traveling Exhibition, East Carolina University Museum of Art/Gray Art Gallery, Greenville, North Carolina, catalog
1982 "Washington Craft Forms: An Historical Perspective 1950-1980," Washington State Capitol Museum, Olympia, Washington, catalog
1982 "Three-Dimensional Textile Structures," Northwest Craft Center Gallery, Seattle, Washington
1983 "National Fiber Exhibition," Traver Sutton Gallery, Seattle, Washington
1983 "Regional Crafts: An Historical View," Bellevue Art Museum, Bellevue, Washington
1983-84 "Regional Crafts: A Contemporary Perspective," Bellevue Art Museum, Bellevue, Washington
1984 "Vessels," Cerulean Blue Gallery, Seattle, Washington, catalog
1984 "Northwest Designer Craftsmen," Northwest Craft Center Gallery, Seattle, Washington
1984 "Crafts '84," Bellevue Art Museum, Bellevue, Washington

Selected Public Collections
Seattle Center Playhouse, Seattle, Washington
Temple Beth-Am, Seattle, Washington

Selected Private Collections
Miriam Farkas, Bné Brak, Israel
Leslie Grace, Seattle, Washington
Marcy Johnson, Seattle, Washington
Anita Mayer, Anacortes, Washington
Shirley Shapley, Seattle, Washington

Selected Awards
1976 Best Sculpture Award, "Convergence '76," Heinz Gallery of the Museum of Art, Carnegie Institute, Pittsburgh, Pennsylvania, catalog
1979 Special Commendation, Honors Program for Visual Artists, Washington State Arts Commission and National Endowment for the Arts
1983 Award of Honor, Excellence in Religious Art Program, "Annual Liturgical Art In Architecture Exhibit," Marriott Crystal Gateway Hotel, Arlington, Virginia (Sponsored by Interfaith Forum on Religion, Art and Architecture, Washington, D.C.), catalog

Preferred Sculpture Media
Fiber

Selected Bibliography
"Ecclesiastical Fiber." *Fiberarts* vol. 4 no. 6 (November 1977) pp. 34-46, illus.
Glowen, Ron. "Exhibitions: Metaphoric Vessels." *Artweek* vol. 15 no. 14 (April 14, 1984) p. 4.
Kuo, Susanna Campbell. "Exhibitions Media Mix: Dina Barzel—John Takehara—Donald Douglas." *Craft Horizons* vol. 36 no. 2 (April 1976) p. 63, illus.
Lutz, Winifred. "Felting." *American Craft* vol. 40 no. 4 (August-September 1980) pp. 2-9, illus.
Vierthaler, Bonnie. "Structures in Fiber." *Artweek* vol. 7 no. 19 (May 8, 1976) p. 5.

Gallery Affiliation
Traver Sutton Gallery
2219 Fourth Avenue
Seattle, Washington 98121

Mailing Address
750 96 Avenue SE
Bellevue, Washington 98004

Artist's Statement

"I grew up in a strict orthodox Jewish family in eastern Europe. It never occurred to me then to become an artist. Am I an artist now? The objects I am compelled to make have come to me much later, as a grown woman. I have taken art classes, whenever I could, but have learned most of my skills myself.

"I work in fiber: fleece, thread, cloth, sticks, pieces of bone, worn pieces of wood. The work grows stitch by stitch. I love the slowness, the intimacy of every inch.

"I do not believe statements about visual art can add to it. Quite the contrary, they divert attention from the work by focusing it on the artist. I would like the viewer to see my work for itself, to contribute his own response the way I do mine."

Dina Barzel

Guard. 1973. Fiber, 8'h x 14'w x 4"d. Installation view 1973. "Five Award Winners of the Northwest Craftsmen Exhibition," Henry Art Gallery, Seattle, Washington. Photograph by Steven S. N. Cheung.

Mary P. Bates

née Mary Patricia Beal
(Husband Douglas George Bates)
Born January 30, 1951 Billings, Montana

Education and Training
1969- University of Colorado at Boulder,
70 Boulder, Colorado
1973 B.F.A., Sculpture, Colorado State
 University, Fort Collins, Colorado
1981 M.F.A., Sculpture, Indiana University
 Bloomington, Bloomington, Indiana

Selected Individual Exhibitions
1977 Fort Hays State University, Hays,
 Kansas
1981 Johnson Atelier Technical Institute of
 Sculpture, Princeton, New Jersey
1985 A R T Beasley Gallery, San Diego,
 California

Selected Group Exhibitions
1974 "Colorado Country Invitational
 Exhibition," Don McMillen Building,
 Loveland, Colorado, catalog
1975 "Juried Membership Exhibition,"
 Foothills Art Center, Golden, Colorado
1976 "Spree '76, Festival of the Arts,"
 Denver Museum of Natural History,
 Denver, Colorado
1979 "Women's Work, An Exhibition of Five
 Sculptors," Arbutus Gallery, Indiana
 University Bloomington, Bloomington,
 Indiana
1980 "Women's Work II, An Exhibition of Six
 Artists' Work," Arbutus Gallery,
 Indiana University Bloomington,
 Bloomington, Indiana, catalog
1982 "Bronze, A Group Exhibition of
 Sculpture," Ben Shahn Gallery, William
 Paterson College of New Jersey,
 Wayne, New Jersey, catalog
1982, "Annual National Exhibition," Galerie
83 Triangle, Washington, D.C., catalog
1982 "New Jersey Great Ideas—A Festival
 of Sculpture," Pavilion Galleries, Mount
 Holly, New Jersey
1982 "The Figure, The Landscape, The Still
 Life," Brookdale Community College,
 Lincroft, New Jersey
1982 "Sculpture Exhibition," Traveling
 Exhibition, Shippensburg State
 College, Shippensburg, Pennsylvania
1982 "Group Exhibition of Sculpture,"
 Johnson Atelier Technical Institute of
 Sculpture, Princeton, New Jersey

1982 "Ellarslie Open National Exhibition,"
 Trenton City Museum, Trenton, New
 Jersey
1983 "Pacific Regional '83," Old Cabrillo
 Beach Museum, Los Angeles,
 California
1983 "Marin Society of Artists Sculpture
 Show," Marin Society of Artists
 Gallery, Ross, California
1983 "Annual Juried Membership Exhibition,
 Northern California Chapter, Women's
 Caucus for Art," San Mateo Arts
 Council Gallery, San Mateo, California
1983 "Faculty Exhibition," Art Gallery,
 Sonoma State University, Rohnert
 Park, California
1983- "Landscape and the Architectonic,"
84 Santa Rosa City Council Chambers,
 Santa Rosa, California
1983- "New Jersey State Council on the Arts
84 Fellowship Exhibition," Hunterdon Art
 Center, Clinton, New Jersey, catalog
1984 "Second Annual Competition," Design
 International, Ross, California, catalog
1984- "Small Sculpture National," Traveling
85 Exhibition, Central Michigan University
 Art Gallery, Mount Pleasant, Michigan
1984 "California Women Artists, 1984,"
 Corporate Center Gallery,
 Sacramento, California
1984 "Women's Caucus for Art National
 Juried Exhibition," Ralph L. Wilson
 Gallery, Alumni Memorial Building,
 Lehigh University, Bethlehem,
 Pennsylvania, catalog
1984 "Sculpture by Mary Bates and Painting
 by John d'Arcy," San Francisco
 Women Artists Gallery, San Francisco,
 California
1984 "All California '84," Laguna Beach
 Museum of Art, Laguna Beach,
 California
1984 "Big Sister is Watching You!," Gallery
 Space, Market Cultural Center, San
 Francisco, California, catalog
1985 "Of Earth and Essence: Sculpture by
 Mary Bates and James Russell,"
 A R T Beasley Gallery, San Diego,
 California
1985 "O.K.—U.S.A., National Sculpture
 Exhibition," University Gallery,
 Cameron University, Lawton,
 Oklahoma, catalog

Selected Public Collections
Fort Hays State University, Department of
 Art, Hays, Kansas
Kievskij Ordena Lenina Politehniceskij
 Institut, Kiev, Union of Soviet Socialist
 Republics
South Seattle Community College, Seattle,
 Washington

Selected Private Collections
Dr. and Mrs. James Barnard, Garden City,
 Kansas
Mrs. Guy P. Berner, Angola, New York
Ira Gelder, Longmont, Colorado

Mr. and Mrs. George Harvey, Hopewell, New
 Jersey
James Siefkin, Fort Collins, Colorado

Selected Awards
1978 Ford Fellowship in the Visual Arts,
 Indiana University Bloomington,
 Bloomington, Indiana
1982 Individual Artist's Fellowship, New
 Jersey State Council on the Arts
1984 Exceptional Merit Service Award,
 Sonoma State University, Rohnert
 Park, California

Preferred Sculpture Media
Metal (cast) and Metal (welded)

Additional Art Field
Drawing

Related Profession
Chamber Musician

Teaching Position
Assistant Professor, Sonoma State
 University, Rohnert Park, California

Selected Bibliography
"Exhibitions." *Artweek* vol. 15 no. 14 (April 14,
 1984) p. 10, illus.

Mailing Address
243 Arlen Drive
Rohnert Park, California 94928

Artist's Statement

"My work involves the use of landscape elements. In many of my sculptures these represent interior states: emotions, moods, vestiges of memory, images collected on long journeys. There is an influence of earlier years spent on the Great Plains.

"The prairies, plains and mountains of the Midwest and the West seem to me to be endowed with a starkness and clarity, an open, unconcealed lucidity. Initially barren in appearance, this kind of landscape can be rich in anthropomorphic qualities. I wish to push identification with this selected geography to the point that a land/flesh transformation takes place and there is a dissolution of the boundaries between exterior and interior landscape.

"Some of my sculptures are wall pieces, some float above ground plane and others are freestanding. Although the materials are metals—bronze, steel and aluminum—and I fabricate and assemble the cast and cut components, I do not generally have a constructivist outlook. Rather, I approach sculpture as I do drawing, using linear and graphic elements which move through three-dimensional space. I want my work to have the feeling of subject matter which is personal and can be intensely felt."

Mary P. Bate

Curtain. 1983. Bronze, 26"h x 22"w x 2½"d.
Collection South Seattle Community College,
Seattle, Washington. Photograph by Victor Krispin.

Lilian A. Bell

née Lilian Ann Nichols
(Husband Anthony Edward Bell)
Born November 5, 1943 London, Great
Britain

Education and Training
1956- William Morris Technical School,
60 London, Great Britain; study in art and
general education
1969- Linfield College, McMinnville, Oregon;
70 study in sculpture with Peter Teneau

Selected Individual Exhibitions
1976, Contemporary Crafts Gallery, Portland,
79 Oregon
1977 Lane Community College, Eugene,
Oregon
1979 Willamette University, Salem, Oregon

Selected Group Exhibitions
1971 "Objectmakers," Utah Museum of Fine
Arts, Salt Lake City, Utah, catalog
1972 "Artists of Oregon," Portland Art
Museum, Portland, Oregon, catalog
1972 "Lilian A. Bell and Judith Johnson
Teneau," Linfield College, McMinnville,
Oregon
1972 "Lilian A. Bell and Judith Johnson
Teneau," Contemporary Crafts Gallery,
Portland, Oregon
1972 "Mayor's Invitational," Salem Civic
Center, Salem, Oregon, catalog
1972 "The Paper Show," Portland Art
Museum, Portland, Oregon, catalog
1973 "Tenth Annual Southern Tier Arts &
Crafts Exhibition," Corning Glass
Center, Corning, New York
1974 "Under 35 Invitational," Portland Art
Museum, Portland, Oregon, catalog
1975 "Twenty-Seventh Annual Exhibition,"
Cheney Cowles Memorial Museum,
Spokane, Washington, catalog
1975- "Contemporary Crafts of the
77 Americas," Traveling Exhibition,
Colorado State University, Fort Collins,
Colorado, book
1976 "Mixed Media 7 Artists," Portland Art
Museum, Portland, Oregon, catalog
1976 "Northwest Eccentric Art," Traveling
Exhibition, Cheney Cowles Memorial
Museum, Spokane, Washington,
catalog
1976 "Northwest Projects," And/Or Gallery,
Seattle, Washington, catalog
1976 "Paperwork 2," Portland Art Museum,
Portland, Oregon, catalog

1977 "Flags, Banners & Kites Invitational,"
Seattle Center, Seattle, Washington,
catalog
1977 "National Small Sculpture
Competition," Sculpture Gallery, San
Diego, California, catalog
1978 "Paper Invitational," Peters Valley
Center, Layton, New Jersey
1978 "Lilian Bell and Valerie Willson," Keller
Gallery, Salem, Oregon
1978 "Innovations in Paper," Birmingham
Bloomfield Art Association,
Birmingham, Michigan, catalog
1978- "Western States Arts Foundation
79 Fellowship Awards Exhibition,"
Colorado Springs Fine Arts Center,
Colorado Springs, Colorado; Montana
State University, Bozeman, Montana,
catalog
1979 "The Book Crafts of the Pacific
Northwest," Suzzallo Library,
University of Washington, Seattle,
Washington
1980 "Bell, Austin, Glowacki, Lyman and
Pintor," Synopsis Gallery, Winnetka,
Illinois
1980 "Bell, Sahlstrand and Ferris," Factory
of Visual Art, Seattle, Washington
1980 "Bell, Ely and Kuroiwa," Erica
Williams/Anne Johnson Gallery,
Seattle, Washington
1980 "Contemporary Crafts from Oregon,"
Renwick Gallery of the National
Collection of Fine Arts, Smithsonian
Institution, Washington, D.C.
1980 "Biennial of the Pacific," Metropolitan
Museum of Manila, Manila, Philippines
1980 "Invitational Exhibition," Boston
University, Boston, Massachusetts
1980 "Pulp," Traveling Exhibition, Wellington
City Art Gallery, Wellington, New
Zealand, catalog
1981 "Paperworks: Bell, Cole and
Sahlstrand," Traveling Exhibition,
Portland State University, Portland,
Oregon, catalog
1981 "Paper Week III," Visual Art Centre,
Beer Sheva, Israel
1981 "Gallery Artists," Elements Gallery,
New York, New York
1981 "Textures," Elaine Potter Gallery, San
Francisco, California
1982 "Works: Paper," Ohio University,
Athens, Ohio, catalog
1982 "Through the Mill: Works from the
Collection of the Leslie Paper Mill,
Visual Art Centre, Beer Sheva, Israel,"
American Cultural Center, Tel Aviv,
Israel, catalog
1982 "Workshop Exhibition," Museu de Arte
Moderna de São Paulo, São Paulo,
Brazil
1983 "Breaking the Bindings: American
Book Art Now," Elvehjem Museum of
Art, Madison, Wisconsin, catalog
1983 "Handmade Paper National
Invitational," Liberty National Bank,
Louisville, Kentucky, catalog
1984 "Paper Exhibition," Brighton
Polytechnic Faculty of Art, Brighton,
Great Britain

1984 "National Handmade Paperworks
Invitational," Cheney Cowles Memorial
Museum, Spokane, Washington,
catalog
1984 "Books! Books?" Oregon School of
Arts and Crafts, Portland, Oregon
1984 "Papermaking Invitational," Gibbes Art
Gallery, Charleston, South Carolina,
catalog
1985 "Works of Substance: An Exhibition of
Mixed Media & Paperworks," Sun
Valley Center, Ketchum, Idaho
1985 "Blackfish Gallery Sixth Anniversary
Exhibition," San Jose Institute of
Contemporary Art, San Jose,
California

Selected Public Collections
Museum of Art, University of Oregon,
Eugene, Oregon
Portland Art Museum, Portland, Oregon
Seattle City Light Portable Works Collection,
Seattle, Washington
Visual Art Centre, Beer Sheva, Israel

Selected Award
1977 Visual Arts Fellowship, Western States
Arts Foundation, Denver, Colorado

Preferred Sculpture Media
Paper (handmade) and Wood

Related Professions
Lecturer, Visiting Artist and Writer

Selected Bibliography
Getty, Nilda C. Fernández and Robert J.
Forsyth. Contemporary Crafts of the
Americas. Chicago: Henry Regnery, 1975.
Meilach, Dona Z. and Elvie Ten Hoor.
Collage and Assemblage; Trends and
Techniques. New York: Crown, 1973.
Rowley, Kathleen. "Words in Fiber." Fiberarts
vol. 11 no. 2 (March-April 1984) pp. 66-69,
illus.
Toale, Bernard. The Art of Papermaking.
Worcester, Massachusetts: Davis, 1983.
Walsh, Mike E. "Symbolic Images from Four
Artists." Artweek vol. 9 no. 17 (April 29,
1978) pp. 12-13.

Gallery Affiliation
Blackfish Gallery
325 NW Sixth Avenue
Portland, Oregon 97209

Mailing Address
1970 South Davis Street
McMinnville, Oregon 97128

Artist's Statement

"I work with handmade paper because of its plasticity, immediacy and ease as a sculptural medium. The three-dimensional potentialities of paper facilitate my assemblage/collage approach and allow for a playful freedom within the aesthetic encounter. I process my own papers directly from materials like mulberry, gampi and milkweed fibers.

"The abstract and representational formats examine the relief aspects of paper used in sculptural wall reliefs and sculptural book forms. Wood and Plexiglas structures, such as shadow box constructions, are both prop and counterpoint for the paper forms which are cast from sheer and opaque layered pulps incorporating 'trapped' images. Concepts develop from personal issues and narratives as well as drawings from found objects. These are integrated into formal arrangements which speak of a fusion of both graphic and sculptural mediums."

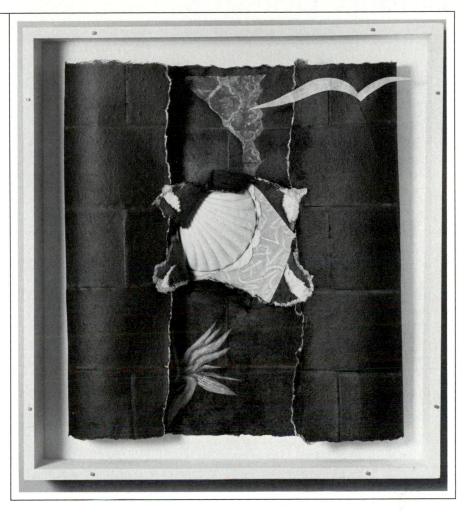

La Zona Rosa. 1983. Cast paper and wood construction, 19"h x 17½"w x 3½"d. Collection Seattle City Light Portable Works Collection, Seattle, Washington. Photograph by Bill Bachhuber.

Lynda Benglis

Born October 25, 1941 Lake Charles, Louisiana

Education and Training
1960-61 McNeese State College, Lake Charles, Louisiana
1963 Summer School of Art and Music, Yale University, New Haven, Connecticut
1964 B.F.A., Painting, Newcomb College, New Orleans, Louisiana
1965 School of the Brooklyn Museum, Brooklyn, New York

Selected Individual Exhibitions
1969 University of Rhode Island, Kingston, Rhode Island
1970, 74, 76, 80, 84 Paula Cooper Gallery, New York, New York
1970 Janie C. Lee Gallery, Dallas, Texas
1970 Galerie Hans Müller, Cologne, Germany, Federal Republic
1971 Hayden Gallery, Massachusetts Institute of Technology, Cambridge, Massachusetts
1972, 74, 77 Hansen Fuller Gallery, San Francisco, California
1973, 80 Portland Center for the Visual Arts, Portland, Oregon
1974, 79, 81 Texas Gallery, Houston, Texas
1977, 80, 85 Margo Leavin Gallery, Los Angeles, California
1979 Hansen Fuller Goldeen Gallery, San Francisco, California
1979, 80, 81 Galerie Albert Baronian, Brussels, Belgium
1980 University of South Florida, Tampa, Florida and Miami-Dade Community College, Miami, Florida, catalog
1980 Lowe Art Museum, Coral Gables, Florida
1980 Heath Gallery, Atlanta, Georgia
1980, 83 Suzanne Hilberry Gallery, Birmingham, Michigan
1981 University of Arizona Museum of Art, Tucson, Arizona
1981 Jacksonville Art Museum, Jacksonville, Florida
1982 Fuller Goldeen Gallery, San Francisco, California

Selected Group Exhibitions
1969 "Other Ideas," Detroit Institute of Arts, Detroit, Michigan
1969 "Invitational Exhibition," Carmen Lamanna Gallery, Toronto, Ontario, Canada
1970 "Lynda Benglis, George Kuehn and Richard Van Buren," Paula Cooper Gallery, New York, New York

1971 "Works for New Spaces," Walker Art Center, Minneapolis, Minnesota
1971 "Directions 3: Eight Artists," Milwaukee Art Center, Milwaukee, Wisconsin
1972 "GEDOK American Woman Artist Show," Kunsthaus, Hamburg, Germany, Federal Republic, catalog
1972 "American Women: 20th Century," Lakeview Center for the Arts and Sciences, Peoria, Illinois, catalog
1973, 81 "Biennial Exhibition: Contempory American Art," Whitney Museum of American Art, New York, New York, catalog
1974 "Opening Exhibition," Galerie John Doyle, Paris, France
1975 "Fourteen Artists," Baltimore Museum of Art, Baltimore, Maryland
1976 "Nine Sculptors," Nassau County Museum of Fine Arts, Roslyn, New York
1976 "American Artists '76: A Celebration," Marion Koogler McNay Art Institute, San Antonio, Texas, catalog
1976 "Sydney Biennale," Art Gallery of New South Wales, North Sydney, Australia, catalog
1976-77 "Women Artists, 1550-1950," Traveling Exhibition, Los Angeles County Museum of Art, Los Angeles County Museum of Art, Los Angeles, California, catalog
1977 "Five from Louisiana," New Orleans Museum of Art, New Orleans, Louisiana, catalog
1977 "Recent Acquisitions," Solomon R. Guggenheim Museum, New York, New York
1977 "Ten Years: A View of a Decade," Museum of Contemporary Art, Chicago, Illinois, catalog
1978 "Fading Bounds in Sculpture," Stedelijk Museum, Amsterdam, Netherlands, catalog
1979 "Contemporary Sculpture: Selections from the Collection of the Museum of Modern Art," Museum of Modern Art, New York, New York, catalog
1980 "Extensions: Jennifer Bartlett, Lynda Benglis, Robert Longo and Judy Pfaff," Contemporary Arts Museum, Houston, Texas, catalog
1980 "Jack Brogan: Projects," Baxter Art Gallery, California Institute of Technology, Pasadena, California, catalog
1981 "Developments in Recent Sculpture," Whitney Museum of American Art, New York, New York, catalog
1982 "U.S. Art Now," Nordiska Kompaniet, Stockholm, Sweden
1982 "Early Work: Lynda Benglis, Joan Brown, Luis Jimenez, Gary Stephan and Lawrence Weiner," New Museum, New York, New York, catalog
1982 "Currents: A New Mannerism," Jacksonville Art Museum, Jacksonville, Florida; University of South Florida Art Galleries, Tampa, Florida
1982 "New York Now," Traveling Exhibition, Kestner-Gesellschäft, Hannover, Germany, Federal Republic, catalog

1983 "Directions 1983," Hirshhorn Museum and Sculpture Garden, Smithsonian Institution, Washington, D.C., book-catalog
1983 "Minimalism to Expressionism: Painting and Sculpture Since 1965 From the Permanent Collection," Whitney Museum of American Art, New York, New York
1983 "The Sixth Day: A Survey of Recent Developments in Figurative Sculpture," Renaissance Society, University of Chicago, Chicago, Illinois
1984 "Citywide Contemporary Sculpture Exhibition," Toledo Museum of Art, Toledo, Ohio (Sponsored by Arts Commission of Greater Toledo, Ohio; Toledo Museum of Art, Toledo, Ohio and Crosby Gardens, Toledo, Ohio), catalog
1984 "Content: A Contemporary Focus 1974-1984," Hirshhorn Museum and Sculpture Garden, Smithsonian Institution, Washington, D.C., book-catalog
1984-87 "Works in Bronze, A Modern Survey," Traveling Exhibition, University Art Gallery, Sonoma State University, Rohnert Park, California, catalog
1984 "American Bronze Sculpture: 1850 to the Present," Newark Museum, Newark, New Jersey, catalog
1985 "Lynda Benglis and Ida Kohlmeyer," Pensacola Museum of Art, Pensacola, Florida

Selected Public Collections
Albright-Knox Art Gallery, Buffalo, New York
Allen Memorial Art Museum, Oberlin, Ohio
Baltimore Museum of Art, Baltimore, Maryland
Chase Manhattan Bank, New York, New York
Detroit Institute of Arts, Detroit, Michigan
Fort Worth Art Museum, Forth Worth, Texas
Hokkaido Museum of Modern Art, Sapporo, Japan
The Lannan Foundation, West Palm Beach, Florida
Miami-Dade Community College, Miami, Florida
Museum of Fine Arts, Houston, Houston, Texas
Museum of Modern Art, New York, New York
National Gallery of Australia, Canberra, Australia
National Gallery of Victoria, Melbourne, Australia
National Museum of American Art, Smithsonian Institution, Washington, D.C.
New Orleans Museum of Art, New Orleans, Louisiana
New York University, New York, New York
Philadelphia Museum of Art, Philadelphia, Pennsylvania
Prudential Insurance Company of America, Newark, New Jersey
Seattle Art Museum, Seattle, Washington

Storm King Art Center, Mountainville, New
York
University of Rhode Island, Kingston, Rhode
Island
Walker Art Center, Minneapolis, Minnesota
Whitney Museum of American Art, New York,
New York

Selected Private Collections
Ian and Frederika Hunter Glinnie, Houston,
Texas
Mr. and Mrs. Edward Hudson, Fort Worth,
Texas
Albert A. List Family Collection, Greenwich,
Connecticut
S. I. Newhouse, Jr., New York, New York

Selected Awards
1975 John Simon Guggenheim Memorial
Foundation Fellowship
1976 Individual Artist's Fellowship,
Australian Art Council
1979 Individual Artist's Fellowship, National
Endowment for the Arts

Preferred Sculpture Media
Varied Media

Additional Art Field
Drawing

Related Profession
Visiting Artist

Teaching Position
Adjunct Faculty, School of Visual Arts, New
York, New York

Selected Bibliography
Davis, Douglas. *Artculture: Essays on the
Post-Modern.* New York: Harper & Row,
1977.
Kuspit, Donald B. "Cosmetic
Transcendentalism: Surface-Light in John
Torreano, Rodney Ripps and Lynda
Benglis." *Artforum* vol. 18 no. 2 (October
1979) pp. 38-40, illus.
Pincus-Witten, Robert A. "Lynda Benglis: The
Frozen Gesture." *Artforum* vol. 13 no. 3
(November 1974) pp. 54-59, illus.
Welch, Douglas. "Arts Reviews: Lynda
Benglis." *Arts Magazine* vol. 55 no. 3
(November 1980) p. 35.
Wortz, Melinda. "The Nation Los Angeles:
Lynda Benglis." *Art News* vol. 84 no. 6
(Summer 1985) p. 101, illus.

Gallery Affiliation
Paula Cooper Gallery
155 Wooster Street
New York, New York 10012

Mailing Address
222 Bowery
New York, New York 10012

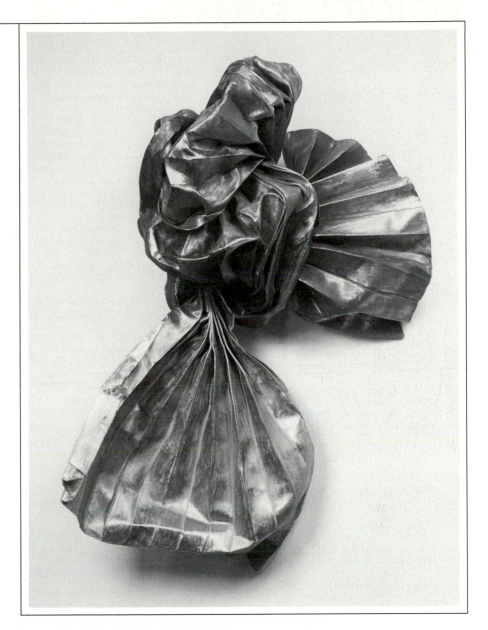

Hyades. 1982. Bronze wire, zinc, copper, aluminum
and lacquer coating, 41"h x 33½"w x 17"d.
Photograph by eeva-inkeri.

Artist's Statement
"My work is suggestive of the physical
expansion and contraction of forms known,
but not specifically defined, in motifs which
combine painting and sculpture. I have
always been interested in how to define form
and surface using tactile materials in a
nonlogical contained activity. My interests in
human scale and body reference, in layering,
surface texture and color are symbolic of the
repose and tension inherent in form and
frozen in a fixed gesture."

Dorothy Berge

née Dorothy Alphena
Born May 8, 1923 Ottawa, Illinois

Education and Training

1944 Cranbrook Academy of Art, Bloomfield Hills, Michigan; study in ceramics with Maija Grotell
1945 B.A., Art, St. Olaf College, Northfield, Minnesota
1945-46 School of the Art Institute of Chicago, Chicago, Illinois
1950 B.F.A., Sculpture, Minneapolis School of Art, Minneapolis, Minnesota
1958-59 Syracuse University, Syracuse, New York; study in sculpture with Ivan Meštrović
1976 M.V.A., Sculpture, Georgia State University, Atlanta, Georgia

Selected Individual Exhibitions

1960 Walker Art Center, Minneapolis, Minnesota, catalog
1964 Kilbride-Bradley Gallery, Minneapolis, Minnesota
1965 Alexander Gallery, Atlanta, Georgia
1968 High Museum of Art, Atlanta, Georgia, catalog
1970 St. Olaf College, Northfield, Minnesota
1971 Unitarian Church, Atlanta, Georgia
1972 Image South Gallery, Atlanta, Georgia
1978, 79 Heath Gallery, Atlanta, Georgia

Selected Group Exhibitions

1956, 58 "Biennial of Paintings, Prints and Sculpture," Walker Art Center, Minneapolis, Minnesota, catalog
1956 "Southdale Artists," Walker Art Center, Minneapolis, Minnesota, catalog
1959 "Artists Equity Exhibition," Rochester Art Center, Rochester, Minnesota
1959 "Recent Sculpture U.S.A.," Traveling Exhibition, Museum of Modern Art, New York, New York, catalog
1960 "Sixteen Younger Minnesota Artists," Walker Art Center, Minneapolis, Minnesota, catalog
1967 "Twenty-Second Southeastern Annual Exhibition," High Museum of Art, Atlanta, Georgia
1971, 72 "Georgia Artists Exhibition," High Museum of Art, Atlanta, Georgia, catalog
1976 "Invitational Sculpture Exhibition," Anges Scott College, Decatur, Georgia
1978 "Artists in Georgia," High Museum of Art, Atlanta, Georgia, catalog
1980 "Continuum II," Dulin Gallery, Knoxville, Tennessee, catalog

Selected Public Collections

Atlanta Botanical Garden, Atlanta, Georgia
Atlanta-Fulton Public Library, Sandy Springs Branch, Atlanta, Georgia
Colony Square, Atlanta, Georgia
Georgia State University, Atlanta, Georgia
High Museum of Art, Atlanta, Georgia
Inverness Center, Birmingham, Alabama
Lovett School, Atlanta, Georgia
Mead Packaging Corporation, Atlanta, Georgia
Minneapolis Institute of Arts, Minneapolis, Minnesota
Purdue University, West Lafayette, Indiana
Southdale Shopping Center, Minneapolis, Minnesota
St. Olaf College, Northfield, Minnesota
University Gallery, University of Minnesota Twin Cities Campus, Minneapolis, Minnesota
Walker Art Center, Minneapolis, Minnesota

Selected Private Collections

Dr. and Mrs. Morton P. Galina, Atlanta, Georgia
David Harris, Atlanta, Georgia
Dr. and Mrs. Malcolm McCannel, Minneapolis, Minnesota
Mr. and Mrs. Philip Sanguinetti, Anniston, Alabama
Mr. and Mrs. Gudmund Vigtel, Atlanta, Georgia

Selected Awards

1955 First Award, "Local Artists Exhibition," Minneapolis Institute of Arts, Minneapolis, Minnesota
1957 First Award, "Invitational Exhibition," Walker Art Center, Minneapolis, Minnesota
1961 Ford Foundation Grant, Program for the Humanities and Arts

Preferred Sculpture Media

Metal (cast) and Metal (welded)

Selected Bibliography

Baur, John I. H. "New Talent in the U.S." *Art in America* vol. 45 no. 1 (March 1957) pp. 10-11.
O'Connor, William Van. *A History of the Arts in Minnesota: Music and Theater by John K. Sherman, Books and Authors by Grace Lee Nute, Art and Architecture by Donald R. Torbert.* Minneapolis: University of Minnesota Press, 1958.
Rood, John. *Sculpture with a Torch.* Minneapolis: University of Minnesota Press, 1963.
Torbert, Donald R. *A Century of Art and Architecture in Minnesota.* Minneapolis: University of Minnesota Press, 1958.
"Two Level Shopping Centers." *Architectural Forum* vol. 105 no. 6 (December 1956) pp. 114-126, illus.

Mailing Address

4586 Roswell Road NW-Z3
Atlanta, Georgia 30342

Artist's Statement

"I have worked as a professional sculptor since 1953, mainly in welded and cast metals. I believe I was one of the few women in the country working directly in metal by welding as early as 1953. My sculpture has been almost totally abstract and mainly produced in CorTen steel, aluminum, copper, brass and cast bronze. Over the past fifteen years my work has become more geometric, a reduction or simplification directed toward a more pure statement of form and idea.

"The elimination of extraneousness, the breakdown of superfluous complexity is fundamental to the essential attitude of the sculpture. My search for this essence is not entirely the similar direction taken by the minimalists in their somewhat cheerless renunciation of extraneousness. Rather it is a search for sculptural expression conveying attitudes of positiveness and movement within the use of geometric forms and slight variations of those forms. Simplification and reduction confront the viewer, speaking to his or her own intellectual and emotional experience. The sculpture must have a quiet assertiveness, a clean reality, a meaningful statement."

Dorothy Berge

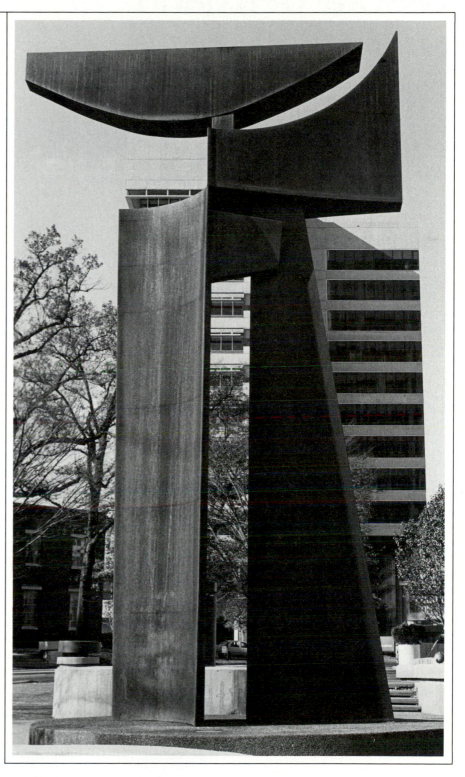

Untitled. 1969. CorTen steel, 30'h. Collection Colony Square, Atlanta, Georgia. Photograph by N. Scott Mitchell.

Lenora Bermann

Born September 2, 1942 Forest Hills, New York

Education and Training
1960-63 School of Fine and Applied Arts, Boston University, Boston, Massachusetts

Selected Individual Exhibitions
1976 Garage Gallery, Birmingham, Alabama
1981 Chelsea Gallery, A. K. Hinds University Center, Western Carolina University, Cullowhee, North Carolina, catalog

Selected Group Exhibitions
1974, 76, 79 "Alabama Art League Annual Juried Exhibition," Montgomery Museum of Fine Arts, Montgomery, Alabama, catalog
1974 "Lenora Bermann and Ted Metz," Columbus Museum of Arts and Sciences, Columbus, Georgia
1976 "International Women's Year Exhibition," Montgomery Museum of Fine Arts, Montgomery, Alabama; Birmingham Museum of Art, Birmingham, Alabama; Fine Arts Museum of the South at Mobile, Mobile, Alabama
1977, 78, 79 "Annual Invitational Exhibition," Birmingham Art Association, Birmingham, Alabama
1977 "Lenora Bermann and Ted Metz," Gallery of Art, University of Alabama in Huntsville, Huntsville, Alabama
1978 "Jerry Uelsmann, Frank Fleming and Lenora Bermann," Leigh Gallery, Birmingham, Alabama
1978 "Sculpture Invitational," Birmingham Museum of Art, Birmingham, Alabama

1979 "Moving Parts, National Sculpture Exhibition," Nexus Gallery, Atlanta, Georgia
1979 "Southeast Sculpture Exhibition," Lyndon House Gallery, University of Georgia, Athens, Georgia
1979-80 "Southern Realism," Traveling Exhibition, Mississippi Museum of Art, Jackson, Mississippi, catalog
1979 "Sculpture Commission Models Exhibit," Mississippi Museum of Art, Jackson, Mississippi
1979 "After the Dinner Party," Kennedy Art Center, Birmingham-Southern College, Birmingham, Alabama
1979 "Toys Designed by Artists," Arkansas Arts Center, Little Rock, Arkansas
1980 "Southern Exposure," Hanson Gallery, New Orleans, Louisiana, catalog
1980 "Alabama Sculpture Invitational," Eastern Shore Art Association, Fairhope, Alabama
1980 "Recent Work: Carol Sokol, Lenora Bermann and Sara Armstrong," University of Montevallo Art Gallery, Montevallo, Alabama
1980 "Images 1980: An Exhibition of Alabama Women Artists," University of Montevallo Art Gallery, Montevallo, Alabama, catalog
1980 "National Sculpture 1980," Traveling Exhibition, McKissick Museum of Art, University of South Carolina, Columbia, South Carolina, catalog
1981 "Lenora Bermann/Elizabeth Shannon: NEA Artist Spaces Exhibition," Nexus Gallery, Atlanta, Georgia
1982 "Gallery Invitational," Southeastern Center for Contemporary Art, Winston-Salem, North Carolina
1982 "7 Natures," Anniston Museum of Natural History, Anniston, Alabama
1983 "Special Spring Exhibition," Maralyn Wilson Gallery, Birmingham, Alabama

Selected Public Collection
Mississippi Museum of Art, Jackson, Mississippi

Selected Private Collections
Frank Fleming, Birmingham, Alabama
Hughes Kennedy, Birmingham, Alabama
Phillip Morris, Birmingham, Alabama
Dr. Wolf Rafflenbeul, Hannover, Germany, Federal Republic
Dr. Emanuel Yellin, Haifa, Israel

Selected Awards
1981 Individual Artist's Fellowship, Alabama State Council on the Arts and Humanities
1981 Foy Gilmore Goodwyn Memorial Award, "Alabama Art League Annual Juried Exhibition," Montgomery Museum of Fine Arts, Birmingham, Alabama, catalog
1983 Pre-Finalist, First International Water Sculpture Competition, "Louisiana World Exposition," New Orleans, Louisiana

Preferred Sculpture Media
Varied Media and Wood

Additional Art Fields
Collage and Drawing

Related Professions
Designer, Juror and Visiting Artist

Selected Bibliography
Kipnis, Jeff. "Reviews: Lenora Bermann/Elizabeth Shannon." *Art Papers* vol. 5 no. 4 (July-August 1981) p. 23.
McPherson, Heather. "7 Natures: Anniston Museum of Natural History, Anniston, Alabama," *Art Papers* vol. 7 no. 1 (January-February 1983) pp. 24-25.

Mailing Address
67-23 Exeter Street
Forest Hills, New York 11375

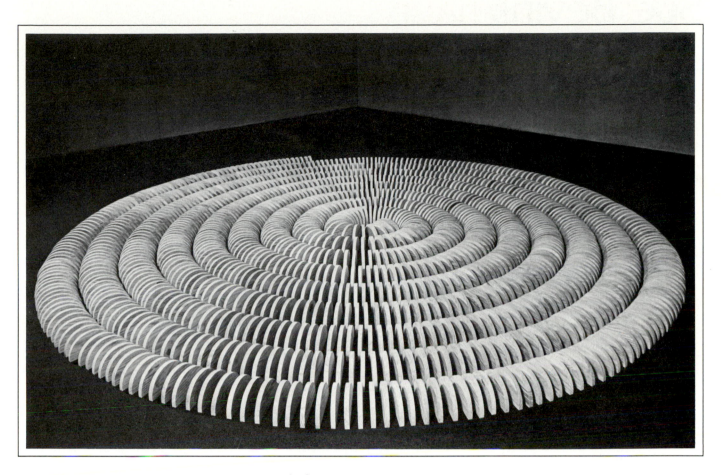

Domino Spiral. 1979. Pine, 14′w x 14′⅜″d.
Photograph by Ted Tucker.

Artist's Statement

"My works are of an exploratory nature, which I hope may be viewed on various levels; not only the visual, but the emotional and intellectual as well. Over the years the themes that recur deal with intimacy, sensuality, vulnerability, humor, irony and color. I like to discover the variations and paradoxes evoked by these themes: the simple and the complex; the intimate and the expansive; the spontaneous and the ordered."

Lenora Bermann

Sue Bevins

née Susie Qimmiqsak Smith
Born September 7, 1941 Beechey Point,
Alaska

Education and Training
1968- Atlanta School of Art, Atlanta,
69 Georgia
1970- Anchorage Community College,
71 Anchorage, Alaska; study in sculpture
 with Keith Appel
1975 Cook Inlet Historical Society,
 Anchorage, Alaska; study in stone
 carving with Jim Schoppert
1981 Visual Arts Center of Alaska,
 Anchorage, Alaska; workshop in clay
 and plaster with John Toki
1981 Visual Arts Center of Alaska,
 Anchorage, Alaska; workshop in wood
 carving and tool making with Wayne
 Price
1982 Visual Arts Center of Alaska,
 Anchorage, Alaska; workshop in found
 object art with Greg Card
1982 Visual Arts Center of Alaska,
 Anchorage, Alaska; workshop in
 metals with Robert Pfitzenmeier
1982 Visual Arts Center of Alaska,
 Anchorage, Alaska; workshop in metal
 casting with J. Fred Woell
1983 Visual Arts Center of Alaska,
 Anchorage, Alaska; workshop in wood
 joinery with David Felker

Selected Individual Exhibitions
1983 Alaska Native Arts & Crafts,
 Anchorage, Alaska
1984 Arco Gallery, Visual Arts Center of
 Alaska, Anchorage, Alaska, catalog
1984 Alaska Gallery, New York, New York

Selected Group Exhibitions
1973, "Earth, Fire and Fiber," Traveling
76, Exhibition, Anchorage Historical and
81 Fine Arts Museum, Anchorage,
 Alaska, catalog
1980 "Thirty-Fourth Annual Fur Rendezvous
 Art Exhibit," International Market
 Place, Anchorage, Alaska
1980 "Susie Bevins and Larry Ahvakana,"
 Artique Limited, Anchorage, Alaska
1981 "Alaska Native Artists, Alaska
 Federation of Natives Convention,"
 Anchorage Westward Hilton,
 Anchorage, Alaska
1981 "The Last Show," Visual Arts Center of
 Alaska, Anchorage, Alaska
1981 "Seventeenth Annual All Alaska Juried
 Art Exhibit," Anchorage Historical and
 Fine Arts Museum, Anchorage,
 Alaska, catalog
1982 "Inside/Outside 1982 Sculpture
 Invitational," Visual Arts Center of
 Alaska, Anchorage, Alaska, catalog
1982 "New Stuff," Visual Arts Center of
 Alaska, Anchorage, Alaska
1982 "Inuit Art Show, Inuit Circumpolar
 Conference," Watergate Hotel,
 Washington, D.C.
1983 "Visual Arts Resources," Traveling
 Exhibition, Museum of Art, University
 of Oregon, Eugene, Oregon, catalog
1983 "A Sense of Humor," Visual Arts
 Center of Alaska, Anchorage, Alaska
1983 "Native Alaskan Group Exhibition,"
 Alaska Gallery, New York, New York
1983 "Four Artists," The Gathering,
 Ketchikan, Alaska
1984 "April in Paris Art Exhibit," Hotel
 Captain Cook, Anchorage, Alaska
1984 "Bridges from the Past," Stonington
 Gallery, Anchorage, Alaska

Selected Public Collections
Alaska National Bank of the North,
 Anchorage, Alaska
Anchorage Historical and Fine Arts Museum,
 Anchorage, Alaska
Aniak School District, Aniak, Alaska
Surreal Studio, Anchorage, Alaska
Wayne's Keepsake Jewelry, Anchorage,
 Alaska

Selected Private Collections
Saradell Ard, Anchorage, Alaska
Leonard M. Fertman, Los Angeles, California
Michael J. Keenan, Anchorage, Alaska
Steven E. Nathanson, Anchorage, Alaska
Sandra K. Saville, Anchorage, Alaska

Preferred Sculpture Media
Stone and Varied Media

Related Profession
Artist in Residence, Visual Arts Center of
 Alaska, Anchorage, Alaska

Gallery Affiliation
Stonington Gallery
550 West Seventh Avenue
Anchorage, Alaska 99501

Mailing Address
6618 Lakeway Drive
Anchorage, Alaska 99502

Artist's Statement

"My work represents my own impressions and experiences from a cross-cultural point of view. Most of my sculpture has been based on everyday themes important in the Eskimo culture: hunters, fishermen and dancers in traditional dress performing traditional activities. Although my concepts were determined within this culture, I felt it was necessary to explore and expand my work beyond traditional representation. As I experimented with new techniques and materials, I began to feel freer to use them in nontraditional ways, combining different stones with metals and wood. The present imagery tends to exemplify my Inupiat heritage in a contemporary style of abstract shapes and mixed media without the stylistic limitations of the culture."

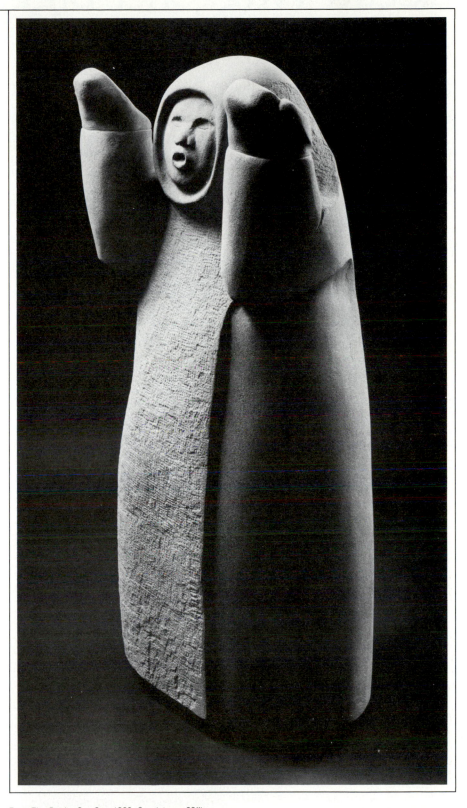

Even The Rocks Cry Out. 1983. Sandstone, 38"h x 14"w x 12"d. Collection Anchorage Historical and Fine Arts Museum, Anchorage, Alaska. Photograph by Dennis Hellawell.

Electra Waggoner Biggs

née Electra Waggoner
Born November 8, 1916 Fort Worth, Texas

Education and Training
1934 Columbia University, New York, New York
1935 Fonderie Valzuani, Paris, France; independent study in bronze casting and marble cutting techniques
1936 Wellesley College, Wellesley, Massachusetts

Selected Individual Exhibitions
1935 Seligmann Gallery, New York, New York
1937 Corcoran Gallery of Art, Washington, D.C.
1940 Junior League of Houston, Houston, Texas

Selected Public Collections
Amarillo Art Center, Amarillo, Texas
American Express Company, New York, New York
Amon Carter Museum, Fort Worth, Texas
Buffalo Bill Historical Center, Cody, Wyoming
Cattle Ranchers Association, Fort Worth, Texas
City of Fort Worth, Will Rogers Memorial Coliseum, Fort Worth, Texas
City of Los Angeles, Griffith Park, Los Angeles, California
Clint W. Murchison Memorial Library, Athens, Texas
Eisenhower Birthplace State Historic Site, Denison, Texas
First National Bank, Fort Worth, Texas
Harry S. Truman Library and Museum, Independence, Missouri
Hockaday School, Dallas, Texas
InterFirst Bank, Fort Worth, Texas and Wichita Falls, Texas
Mobil Corporation, New York, New York
National Cowboy Hall of Fame and Western Heritage Center, Oklahoma City, Oklahoma
Red River Valley Museum, Vernon, Texas
Republic Bank of Dallas, Dallas, Texas
Shelburne Museum, Shelburne, Vermont
State Capitol, Austin, Texas
Texas A & M University, Robert Justus Kleberg, Jr. Animal and Food Science Center, College Station, Texas
Texas Christian University, Fort Worth, Texas
Texas Tech University, Lubbock, Texas
Texas Wesleyan College, Fort Worth, Texas
Topeka, Kansas Railway Station, Topeka, Kansas
University of Notre Dame, Notre Dame, Indiana
Vernon Regional Junior College, Vernon, Texas
Waggoner National Bank, Vernon, Texas
Weatherford College, Weatherford, Texas
Wichita Falls Museum and Art Center, Wichita Falls, Texas
Will Rogers Memorial, Claremore, Oklahoma
Woolaroc Museum, Bartlesville, Oklahoma

Selected Private Collections
The Honorable and Mrs. Dolph Briscoe, Uvalde, Texas
Amon G. Carter Foundation, Fort Worth, Texas
The Honorable and Mrs. William P. Clements, Jr., Dallas, Texas
Mary Martin, Rancho Mirage, California
President and Mrs. Ronald Wilson Reagan, Santa Barbara, California

Preferred Sculpture Media
Metal (cast) and Stone

Additional Art Field
Portrait Medallions in Gold

Selected Bibliography
Broder, Patricia Janis. Bronzes of the American West. New York: Harry N. Abrams, 1974.
Holmes, Nancy. "The Rancher Is a Lady." Town & Country no. 4625 (November 1974) pp. 189-191, 211-213, 240, illus.
Lasher, Patricia J. "Gracious Texas Spreads." Ultra vol. 1 no. 2 (July 1982) pp. 36-39, 74, illus.
Porter, Roze McCoy. Thistle Hill: The Cattle Baron's Legacy. Fort Worth, Texas: Branch-Smith, 1980.
"Will Rogers Remembered." Southern Living vol. 19 no. 10 (October 1984) p. 37, illus.

Mailing Address
Santa Rosa Ranch
Vernon, Texas 76384

Artist's Statement

"I inherited certain artistic inclinations from my family: my mother sang, an aunt painted and an uncle sculpted. As a child, my mother subjected me to every kind of lesson, however, nothing lasted. My career in art began when I was grown and living in New York and a friend suggested a sculpture class.

"I discovered I liked portrait sculpture and was successful in capturing a likeness. The process of sculpture is difficult and physically demanding but working with my hands has given me great satisfaction and pride in my accomplishments."

Electra Waggoner Biggs

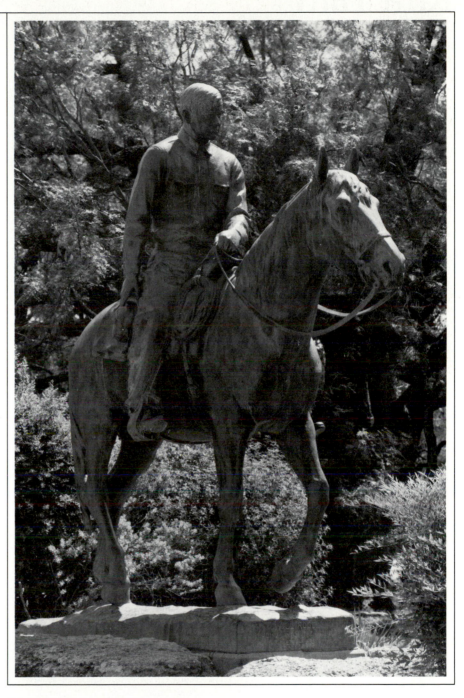

Riding Into the Sunset. 1947. Bronze, life-size, 10'1"h, including base. Collection City of Fort Worth, Will Rogers Memorial Coliseum, Fort Worth, Texas. Photograph by Arthur L. MacDonald.

Rita Blitt

née Rita Lea Copaken
(Husband Irwin J. Blitt)
Born September 7, 1931 Kansas City,
Missouri

Education and Training
1948- University of Illinois at Urbana-
50 Champaign, Urbana, Illinois
1952 B.A., Art, University of Kansas City,
Kansas City, Missouri
1951- Kansas City Art Institute, Kansas
58 City, Missouri; study in painting

Selected Individual Exhibitions
1969 Spectrum Gallery, New York, New
York
1974 Angerer Gallery, Kansas City, Missouri
1974, Johnson County Community College,
79 Overland Park, Kansas
1977 Martin Schweig Gallery, St. Louis,
Missouri
1977 Harkness House Gallery, New York,
New York
1978 Gargoyle Gallery, Aspen, Colorado
1978 Tumbling Waters Museum of Flags,
Montgomery, Alabama
1980 Saint Louis University, St. Louis,
Missouri
1984 Jewish Community Center, Omaha,
Nebraska

Selected Group Exhibitions
1966 "Holiday Exhibition," John and Mabel
Ringling Museum of Art, Sarasota,
Florida
1967 "Thirty-Seventh Annual Exhibition,"
Springfield Art Museum, Springfield,
Missouri, catalog
1970 "Thirty Miles of Art," Junior League
Headquarters, Kansas City, Missouri
1972 "Twelfth Biennial Exhibition," Joslyn Art
Museum, Omaha, Nebraska, catalog
1975 "Blitt, Boruta, Banners and
Hundertwasser," Art Center of Battle
Creek, Battle Creek, Michigan
1975 "Group Exhibition," Doug Drake
Gallery, Kansas City, Missouri
1977 "Paintings and Collages by Natalie
Melbardis-Ronai, Sculptures and
Drawings by Rita Blitt," Cyvia Gallery,
New Haven, Connecticut
1978 "Twenty-First Annual Delta Art
Exhibition," Arkansas Arts Center,
Little Rock, Arkansas, catalog
1978 "Holiday Group Exhibition," Gargoyle
Gallery, Aspen, Colorado
1980 "Holiday Open House," Tallgrass Fine
Arts Gallery, Overland Park, Kansas
1980 "Black and White," Elaine Benson
Gallery, Bridgehampton, New York
1980- "Northeast Kansas Art Exhibit,"
81 Governor's Mansion, Cedar Crest,
Topeka, Kansas
1982 "December Exhibition," Art and Design
Gallery, New York, New York

Selected Public Collections
Bannister Mall, Kansas City, Missouri
City Hall, Kansas City, Kansas
Eastland Shopping Center, Bloomington,
Illinois
Embassy Suite, Overland Park, Kansas
Golden Ring Mall, Baltimore, Maryland
Hickory Point Mall, Decatur, Illinois
Indian Springs Shopping Center, Kansas
City, Kansas
Jefferson Square, Joliet, Illinois
John F. Kennedy Library, Boston,
Massachusetts
Loehmann's Plaza, Miami, Florida and
Orlando, Florida
Oak Park Mall, Overland Park, Kansas
The Renaissance, Overland Park, Kansas
Rockaway Office Park, Rockaway, New
Jersey
Rockaway Town Square, Rockaway, New
Jersey
Town East Mall, Wichita, Kansas
Tumbling Waters Museum of Flags,
Montgomery, Alabama

Selected Private Collections
Mr. and Mrs. Richard Baxter, Vancouver,
British Columbia, Canada
Bill Blass, New York, New York
Rollo May, San Francisco, California
Ambassador and Mrs. Charles Price, London,
Great Britain
Berta Walker, New York, New York

Preferred Sculpture Media
Metal (welded), Plastic and Wood

Additional Art Fields
Drawing and Painting

Selected Bibliography
Barnes, Valerie. "Sculpture: A Listing For
Morris County." *The New York Times*
(Sunday, December 10, 1978) pp. N.J.
26-27.
Bostick, Virginia L. *The History of the Public
Monuments & Sculpture of Morris County,
New Jersey.* New Jersey: New Jersey
State Council on the Arts, 1978.
Wooster, Ann-Sargent. "New York Reviews:
Rita Blitt (Harkness House)." *Art News* vol.
77 no. 2 (February 1978) pp. 146-147.

Gallery Affiliations
Morgan Gallery
1616 Westport Road
Kansas City, Missouri 64111

Joanne Lyon Gallery
525 East Cooper Avenue
Aspen, Colorado 81611

Mailing Address
8900 State Line
Leawood, Kansas 66206

Artist's Statement
"Flower drawings with grandpa
Trees drawn as I was growing up
Quick figure sketches in college
My love of dance
All led to that moment:
When drawings began to flow from me
 First with one hand
 Then both at once.
I felt like I was dancing on paper.
From that time on
Everything
Sculpture taller than trees
Began with a spontaneous outburst
A line from my heart."

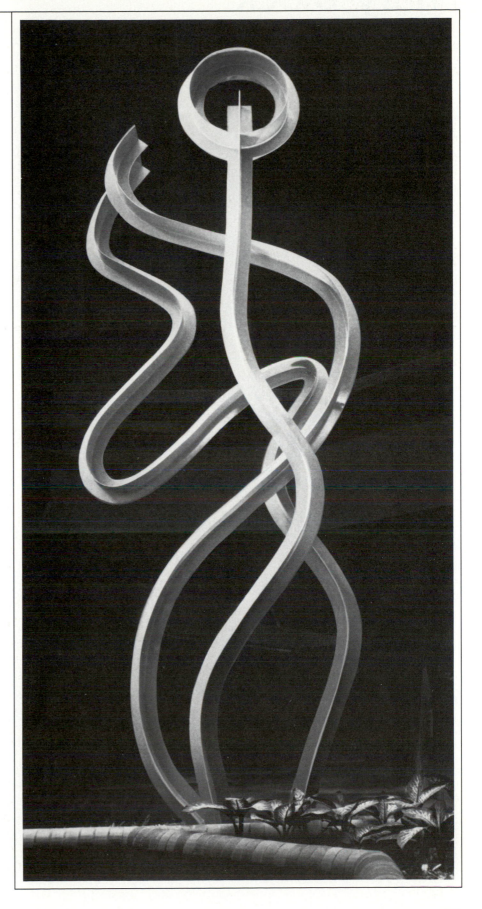

Dancing. 1980. Steel, 26'h x 10'w x 5'd. Collection Bannister Mall, Kansas City, Missouri. Photograph by E. G. Schempf.

Mary Block

Born November 11, 1951 St. Louis, Missouri

Education and Training
1969 Chicago Academy of Fine Arts, Chicago, Illinois
1973 B.F.A., Sculpture, University of Illinois at Urbana-Champaign, Urbana, Illinois; study with Roger Blakley and Peter Fagen
1973 Skowhegan School of Painting and Sculpture, Skowhegan, Maine; study in sculpture
1974 University of Iowa, Iowa City, Iowa; study in sculpture with Julius Schmidt
1976 School of Engineering, University of Illinois at Urbana-Champaign, Urbana, Illinois; independent research in cast stainless steel with James Leach

Selected Group Exhibitions
1979 "Concepts I," Triton College, Rivergrove, Illinois
1980 "Painting and Sculpture," Lake County Museum, Wauconda, Illinois
1980, "American Society of Interior Design,"
82 Show Case Home, Chicago, Illinois, catalog
1982 "Humor in American Art," ARC Gallery, Chicago, Illinois, catalog
1982 "Figurative Art," Charles A. Wustum Museum of Fine Arts, Racine Art Association, Racine, Wisconsin; Montgomery Ward Gallery, University of Illinois at Chicago, Chicago, Illinois, catalog
1984 "Six Sculptors: Billingsley, Block, Emmons, Sebastian, Toman and White," Milwaukee Institute of Art and Design, Milwaukee, Wisconsin, catalog

Selected Public Collections
City of Highland Park, Illinois
Mayfair Shopping Mall, Milwaukee, Wisconsin

Selected Private Collections
Mr. and Mrs. Sy Baskin, Chicago, Illinois
Mr. and Mrs. David Kaufman, Palm Springs, Florida
Shelly Lind, Chicago, Illinois
Lloyd Marks, Chicago, Illinois
Mr. and Mrs. Jeff Newman, Chicago, Illinois

Preferred Sculpture Media
Clay and Metal (cast)

Gallery Affiliation
Roz Mallin
1253 Merchandise Mart
Chicago, Illinois 60654

Mailing Address
1907 Second Street
Highland Park, Illinois 60035

Artist's Statement

"The sculpture I am involved with is figurative, somewhat narrative and often humorous. I pose my models informally, giving them a synopsis of the intent of the sculpture. Their personal interpretation of how to sit or stand, whether clumsy or graceful, helps create a uncontrived piece.

"These sculptures (often commissions by private individuals and architects) are primarily life-size and designed for a specific site. This allows me to present a psychological and physical drama within a designated area, rather than to treat space anonymously. Sculpture is communication and this is the form I have found to best express interactions and interacting with people."

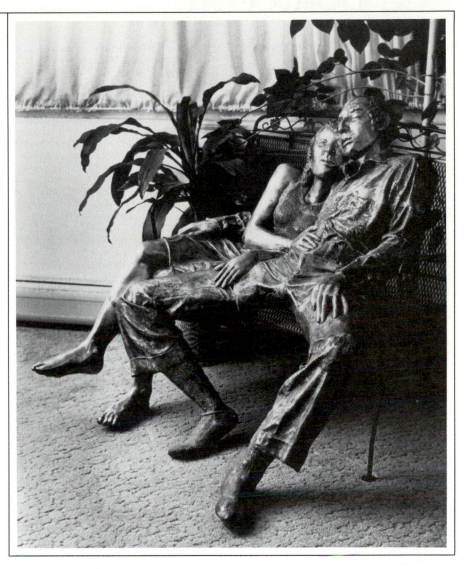

Marc and Laraine. 1980. Bronze, 48"h x 50"w x 36"d. Photograph by Mike Block Studio.

Lee Bontecou

Born January 15, 1931 Providence, Rhode Island

Education and Training
1952 Bradford Junior College, Bradford, Massachusetts
1952-55 Art Students League, New York, New York; study in sculpture with John Hovannes and William Zorach
1956 Showhegan School of Painting and Sculpture, Skowhegan, Maine

Selected Individual Exhibitions
1959 Gallery G, New York, New York
1960, 62, 66 Leo Castelli Gallery, New York, New York
1965 Galerie Ileana Sonnabend, Paris, France
1968 Städtisches Museum Schloss Morsbroich, Leverkussen, Germany, Federal Republic, catalog
1968 Museum Boymans-Van Beuningen, Rotterdam, Netherlands, catalog
1968 Kunstverein, Berlin, Germany, Democratic Republic
1972 Museum of Contemporary Art, Chicago, Illinois, retrospective and catalog
1976 Halper Gallery, Palm Beach, Florida
1977 Hathorne Gallery, Skidmore College, Saratoga Springs, New York, retrospective

Selected Group Exhibitions
1958 "Festival of Two Worlds," Spoleto, Italy
1960 "New Media-New Forms I and II, Painting and Sculpture," Martha Jackson Gallery, New York, New York
1961, 70 "Pittsburgh International Exhibition of Painting and Sculpture," Museum of Art, Carnegie Institute, Pittsburgh, Pennsylvania, catalog
1961-62 "The Art of Assemblage," Museum of Modern Art, New York, New York; Dallas Museum for Contemporary Arts, Dallas, Texas; San Francisco Museum of Art, San Francisco, California, book
1961 "Six Sculptors," Dwane Gallery, Los Angeles, California
1961 "Le Nouveau Realism," Galerie Rive-Drôite, Paris, France

1961 "VI São Paulo Bienal," Museu de Arte Moderna de São Paulo, São Paulo, Brazil
1961 "New New York Scene," New London Gallery, London, Great Britain
1962, 63 "Annual Exhibition of American Paintings and Sculpture," Art Institute of Chicago, Chicago, Illinois, catalog
1962 "Continuity and Change," Wadsworth Atheneum, Hartford, Connecticut
1963, 64 "Annual Exhibition: Sculpture and Prints," Whitney Museum of American Art, New York, New York, catalog
1963 "Twenty-Eighth Biennial Exhibition," Corcoran Gallery of Art, Washington, D.C., catalog
1963 "Americans," Museum of Modern Art, New York, New York
1963 "Salon International de Galeries Pilotes," Musée Cantonal des Beaux-Arts, Lausanne, Switzerland
1963 "Mixed Media and Pop Art," Albright-Knox Art Gallery, Buffalo, New York
1964 "New York State Theater Exhibition," Lincoln Center for the Performing Arts, New York, New York
1964 "New American Sculpture," Pasadena Art Museum, Pasadena, California, catalog
1964 "Painting and Sculpture of a Decade," Gulbenkian Foundation, Tate Gallery, London, Great Britain
1964 "International Prize," Instituto Torcuato di Tella, Buenos Aires, Argentina
1964 "Recent American Sculpture," Jewish Museum, New York, New York, catalog
1964 "The New School of New York," Morris International Gallery, Toronto, Ontario, Canada
1966 "Harry N. Abrams Family Collection," Jewish Museum, New York, New York
1966 "Flint Invitational," Flint Institute of Arts, Flint, Michigan
1966, 68 "Annual Exhibition: Contemporary American Sculpture," Whitney Museum of American Art, New York, New York, catalog
1967 "Ten Years," Leo Castelli Gallery, New York, New York
1967 "Sculpture—A Generation of Innovation," Art Institute of Chicago, Chicago, Illinois
1967 "The 1960s: Painting and Sculpture from the Museum Collection," Museum of Modern Art, New York, New York
1969 "Ars '69 Helsinki," Ateneumin Taidemuseo, Helsinki, Finland
1969 "An American Report on the Sixties," Denver Art Museum, Denver, Colorado
1970 "L'Art Vivant Americain," Fondation Maeght, Nice, France
1972 "American Women: 20th Century," Lakeview Center for the Arts and Sciences, Peoria, Illinois, catalog
1972 "Unmanly Art," Suffolk Museum, Stony Brook, New York, catalog
1974 "In Three Dimensions," Leo Castelli Gallery, New York, New York

1975 "Thirty Artists in America Part I: Thirteen Women Artists," Michael Walls Gallery, New York, New York
1976 "American Artists '76: A Celebration," Marion Koogler McNay Art Institute, San Antonio, Texas, catalog
1976 "A Selection of American Art: The Skowhegan School 1946-1976," Institute of Contemporary Art, Boston, Massachusetts; Colby College Museum of Art, Waterville, Maine
1977 "The Liberation: 14 American Artists," Traveling Exhibition, Corcoran Gallery of Art, Washington, D.C.
1977 "Brooklyn College Art Department: Past and Present, 1942-1977," Davis & Long Company, New York, New York; Robert Schoelkopf Gallery, New York, New York, catalog
1978 "Collection: American Sculpture," Solomon R. Guggenheim Museum, New York, New York
1980 "New York Collection Portfolio," Tyler Museum of Art, Tyler, Texas
1980 "Reliefs," Kunsthaus, Zürich, Switzerland
1982-83 "Castelli and His Artists: Twenty-Five Years," Traveling Exhibition, La Jolla Museum of Contemporary Art, La Jolla, California
1984 "Socialites and Satellites," Ron Feldman Gallery, New York, New York

Selected Public Collections
Akron Art Museum, Akron, Ohio
Albright-Knox Art Gallery, Buffalo, New York
Arkansas Arts Center, Little Rock, Arkansas
Cleveland Museum of Art, Cleveland, Ohio
Corcoran Gallery of Art, Washington, D.C.
Dallas Museum of Art, Dallas, Texas
Elvehjem Museum of Art, Madison, Wisconsin
Herbert F. Johnson Museum of Art, Ithaca, New York
Hirshhorn Museum and Sculpture Garden, Smithsonian Institution, Washington, D.C.
Moderna Museet, Stockholm, Sweden
Museum of Art, Carnegie Institute, Pittsburgh, Pennsylvania
Museum of Fine Arts, Houston, Houston, Texas
Museum of Modern Art, New York, New York
New York State Theater, Lincoln Center for the Performing Arts, New York, New York

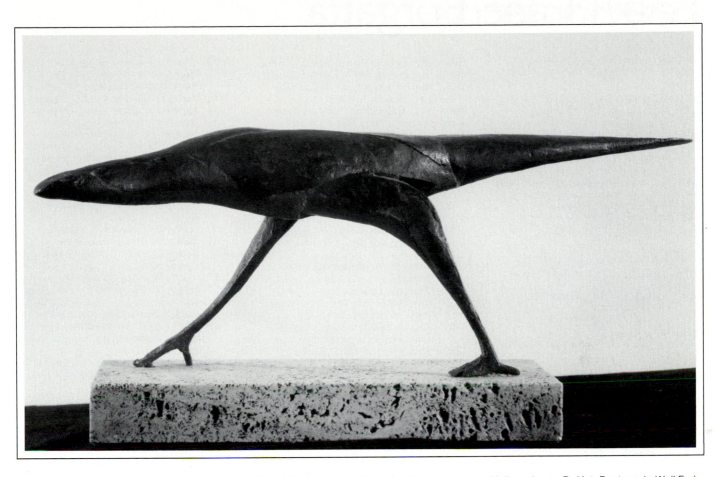

Untitled. 1965-1966. Bronze, 4¼"h x 10¼"w x 2¼"d.
Courtesy Leo Castelli Gallery, New York, New York.
Photogaph by Eric Pollitzer.

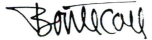

Offentliche Kunstsammlung, Basel,
 Switzerland
Smith College Museum of Art, Northampton,
 Massachusetts
Solomon R. Guggenheim Museum, New
 York, New York
Stedelijk Museum, Amsterdam, Netherlands
Virginia Museum of Fine Arts, Richmond,
 Virginia
Walker Art Center, Minneapolis, Minnesota
Whitney Museum of American Art, New York,
 New York
Yale University Art Gallery, New Haven,
 Connecticut

Selected Awards
1957 Fulbright Fellowship (Italy)
1959 Louis Comfort Tiffany Foundation
 Grant
1963 Sculpture Award, "Twenty-Eight
 Biennial Exhibition," Corcoran Gallery
 of Art, Washington, D.C., catalog

Preferred Sculpture Media
Metal (welded) and Varied Media

Additional Art Field
Drawing

Selected Bibliography
Judd, Donald. "Lee Bontecou." *Arts Magazine*
 vol. 39 no. 7 (April 1965) pp. 16-21, illus.

Mellow, James R. "Art: Bontecou's Well-Fed
 Fish and Malevolent Flowers." *The New
 York Times* (Sunday, June 6, 1971) p. D19,
 illus.
Munro, Eleanor C. *Originals: American
 Women Artists.* New York: Simon and
 Schuster, 1979.
Rubinstein, Charlotte Streifer. *American
 Women Artists: From Early Indian Times to
 the Present.* Boston: G. K. Hall, 1982.
Seitz, William Chapin. *The Art of
 Assemblage.* New York: Museum of
 Modern Art, 1961.

Gallery Affiliation
Leo Castelli Gallery
420 West Broadway
New York, New York 10012

Mailing Address
2704 Huntingdon Pike
Huntingdon Valley, Pennsylvania 19006

Isabel Case Borgatta

née Isabel Marie Case
Born November 21, 1922 Madison, Wisconsin

Education and Training
1938- Smith College, Northampton,
40 Massachusetts
1944 B.F.A., Sculpture, Yale University, New Haven, Connecticut; study with Robert G. Eberhard and Everett Meeks
1944- New School for Social Research, New
46 York, New York; study in drawing
1944- Studio of José de Creeft, New York,
46 New York; study in stone and wood sculpture

Selected Individual Exhibitions
1947, Village Art Center, New York, New
51 York
1955 Tyringham Gallery, Tyringham, Massachusetts
1957 Galerie St. Etienne, New York, New York, catalog
1960 Hudson River Museum, Yonkers, New York
1961 Gallery 10, New York, New York
1963 Ann Ross Gallery, White Plains, New York
1964 Exhibits Unlimited, Ardsley, New York
1968, Frank Rehn Gallery, New York,
71, New York
74,
77
1971 Briarcliff College, Briarcliff, New York, retrospective and catalog
1972 Overseas Press Club, New York, New York
1974 Seton College, Yonkers, New York
1975 Bridge Gallery, White Plains, New York
1975 Museum in the Mall, Bridgeport, Connecticut
1976 Fair Lawn Public Library, Fairlawn, New Jersey
1977 Gallimaufry Gallery, Croton-on-Hudson, New York
1977 General Electric Gallery, Fairfield, Connecticut
1978, Elaine Benson Gallery,
83 Bridgehampton, New York
1978 Cathedral Museum, St. John the Divine, New York, New York
1978 Galerie Coach, Paris, France
1979 Nardin Galleries, New York, New York, catalog
1984, Sid Deutsch Gallery, New York, New
85 York, catalog

Selected Group Exhibitions
1947- "Audubon Artists Annual Exhibition,"
75 National Academy of Design, New York, New York, catalog
1949, "Annual Exhibition," National Academy
58 of Design, New York, New York, catalog
1950, "Annual Exhibition of Painting and
51 Sculpture," Pennsylvania Academy of the Fine Arts, Philadelphia, Pennsylvania, catalog
1950, "20th Century Sculpture," Hudson
60 River Museum, Yonkers, New York
1950, "Annual Exhibition: Contemporary
51 American Art," Whitney Museum of American Art, New York, New York, catalog
1954 "Isabel Case Borgatta and Josef Scharl," Galerie St. Etienne, New York, New York, catalog
1955 "New York Artists," Riverside Museum, New York, New York
1960 "20th Century Sculpture," Hudson River Museum, Yonkers, New York
1961 "Women Artists 1961," Stamford Museum and Nature Center, Stamford, Connecticut
1965 "Sculpture Benefit Exhibition for Memorial Hospital," M. Knoedler & Co., New York, New York
1972 "12 Women," Hechtlinger Gallery, Great Neck, New York
1973 "Women Choose Women," New York Cultural Center, New York, New York, catalog
1973- "Sculptors Guild Annual Exhibition,"
85 Lever House, New York, New York, catalog
1975 "Women's Work," Traveling Exhibition, Brooklyn Museum, Brooklyn, New York
1975 "Sculptors League Exhibition," Union College, Cranford, New Jersey
1975 "Smith College Centennial Exhibition," Smith College Museum of Art, Northampton, Massachusetts
1975 "Works on Paper: Women Artists," Brooklyn Museum, Brooklyn, New York, catalog
1976 "Sculpture in Stone," Rockefeller Center, New York, New York
1976 "Invited Alumni Sculptors," Yale University, New Haven, Connecticut
1977, "Sculptors League Members
78, Exhibition," Lever House, New York,
79 New York
1978 "Women Artists '78: Metropolitan Area, New York, New Jersey, Connecticut," Graduate Center, City University of New York, City College, New York, New York, catalog
1978- "Visual Artists Coalition," Fordham
79 University at Lincoln Center, New York, New York; Avery Fisher Hall, Lincoln Center, New York, New York; Adelphi University, Garden City, New York; Connecticut College, New London, Connecticut
1978 "Sculptors Guild Invitational," Sculpture Center, New York, New York

1978 "The Many Talents of the Sculptors Guild," General Electric Gallery, Fairfield, Connecticut
1979 "Inaugural Exhibition of the College Museum," College of New Rochelle, New Rochelle, New York
1979 "Women Painters and Sculptors," Cummings Arts Center, Connecticut College, New London, Connecticut, catalog
1980 "Sculpture Survey," Columbia University Club, New York, New York
1980 "First International Festival of Women Artists," Ny Carlsberg Glyptotek, Copenhagen, Denmark, catalog
1981 "Sculpture by Members of the Sculptors Guild," Canton Art Institute, Canton, Ohio
1981 "Sculpture in the Garden 1981," Sculptors Guild at the Enid A. Haupt Conservatory, New York Botanical Garden, Bronx, New York, catalog
1983 "More Figuratively Speaking," Elaine Benson Gallery, Bridgehampton, New York
1985 "Self-Portraits by Women, Inaugural Exhibition," Ceres Gallery, New York, New York
1985 "Sculptors Guild," 112 Greene Street Gallery, New York, New York
1985 "Selection from the Sculptors Guild," Imprimatur Gallery, Minneapolis, Minnesota

Selected Public Collections
Book of the Month Club, New York, New York
Brand Hyatt Hotel, New York, New York
Chrysler Museum, Norfolk, Virginia
College of New Rochelle, New Rochelle, New York
H. I. Feldman Corporation, New York, New York
Hudson River Museum, Yonkers, New York
Krannert Art Museum, Champaign, Illinois
Smith College Museum of Art, Northampton, Massachusetts
Sy Miller Associates, New York, New York
William Benton Museum of Art, Storrs, Connecticut
Yeshiva College, New York, New York
Zolfital SPA, Rome, Italy

Selected Private Collections
Harry Belafonte, New York, New York
Jennings Lang, Beverly Hills, California
Jean Leuchtenburg, Centerbrook, Connecticut
Donald Trump, New York, New York
Rudolph Wunderlich, Briarcliff, New York

Selected Awards

1968 Artist in Residence, MacDowell Colony, Peterborough, New Hampshire
1973 Artist in Residence, Corporation of Yaddo, Saratoga Springs, New York
1975 Woman of the Year, County of Westchester, White Plains, New York

Preferred Sculpture Media
Paper (cast) and Stone

Additional Art Fields
Drawing and Etching

Selected Bibliography

Brown, Gordon. "Arts Reviews: Isabel Case Borgatta." *Arts Magazine* vol. 51 no. 10 (June 1977) pp. 39-40.

Olson, Roberta J. M. "Arts Reviews: Isabel Case Borgatta." *Arts Magazine* vol. 48 no. 8 (May 1974) pp. 65-66, illus.

Papers included in the Archives of American Art, Smithsonian Institution, New York, New York.

Roller, Marion. "The Challenge of Space." *National Sculpture Review* vol. 31 no. 1 (Spring 1982) pp. 8-13, illus.

"Sculpture: A Maternal Art." *Life* vol. 37 no. 23 (December 6, 1954) pp. 101-102, illus.

Gallery Affiliation
Sid Deutsch Gallery
20 West 57 Street
New York, New York 10024

Mailing Address
617 West End Avenue
New York, New York 10024

Artist's Statement
"My sculpture relates more to the earth and to the seasons than to the world of technology. Woman as earth mother, nurturer, source of strength or serenity and woman in her relationship with others (with special emphasis on her subjective responses to herself and the world around her) are themes to which I have returned throughout my career. The materials which I find most expressive for these motifs are wood and stone.

"The secondary direction of my exploration is the quality of tension where land meets water which I express both in drawings and in abstract bas-reliefs of cast paper. They relate to my stone carvings in their rhythms, their use of strong textural contrasts and their general sensibility. They also share qualities of timelessness and endurance which are important to me."

Isabel Case Borgatta

Affirmation. 1978. Marble, 36"h x 25"w x 20"d.
Photograph by Otto E. Nelson.

Louise Bourgeois

Born December 25, 1911 Paris, France

Education and Training

1932- Université Paris-Sorbonne, Paris,
35 France
1936- École du Louvre, Paris, France
37
1936- Atelier Bissière, Paris, France
37
1936- École des Beaux Arts, Paris, France
38
1937- Académie de la Grande Chaumière,
38 Paris, France
1938 Académie Julien, Paris, France
1938 Atelier Fernand Léger, Paris, France
1939- Art Students League, New York, New
40 York

Selected Individual Exhibitions

1949, Peridot Gallery, New York, New York
50,
53
1959 Andrew D. White Art Museum, Cornell
 University, Ithaca, New York
1964 Stable Gallery, New York, New York
1964 Rose Fried Gallery, New York, New
 York
1974 112 Greene Street Gallery, New York,
 New York
1978 Hamilton Gallery of Contemporary Art,
 New York, New York
1978 University Art Museum, Berkeley,
 California
1978 Xavier Fourcade Gallery, New York,
79, New York
80
1980 Max Hutchinson Gallery, New York,
 New York, catalog
1981 Renaissance Society, University of
 Chicago, Chicago, Illinois, catalog
1982, Robert Miller Gallery, New York, New
84 York
1982- Museum of Modern Art, New York,
83 New York, Traveling Exhibition,
 retrospective and book
1984 Daniel Weinberg Gallery, Los Angeles,
 California; Daniel Weinberg Gallery,
 San Francisco, California
1985 Serpentine Gallery, London, Great
 Britain, catalog
1985 Galerie Maeght Lelong, Zürich, Swit-
 zerland; Galerie Maeght Lelong, Paris,
 France, retrospective and catalog

Selected Group Exhibitions

1947 "Fact and Fantasy," Bertha Schaefer
 Gallery, New York, New York
1950 "The Year's Work," Peridot Gallery,
 New York, New York
1951, "Recent Acquisitions," Museum of
62 Modern Art, New York, New York
1953, "Annual Exhibition of Paintings and
54, Sculpture," Stable Gallery, New York,
56 New York
1953, "Annual Exhibition: Contemporary
54, American Sculpture, Watercolors and
55, Drawings," Whitney Museum of
56 American Art, New York, New York,
 catalog

1955 "Contemporary Painting and
 Sculpture," Krannert Art Museum,
 Champaign, Illinois
1958 "Nature in Abstraction," Whitney
 Museum of American Art, New York,
 New York
1960, "Sculptors Guild Annual Exhibition,"
64, Lever House, New York, New York,
65, catalog
67
1962 "Women Artists in America Today,"
 Mount Holyoke College, South Hadley,
 Massachusetts, catalog
1964 "Constant Companions: An Exhibition
 of Mythological Animals, Demons and
 Monsters, Phantasmal Creatures and
 Various Anatomical Assemblages,"
 University of St. Thomas, Houston,
 Texas, catalog
1965 "Les Etats-Unis: Sculpture du XX
 Siècle," Musée National Auguste
 Rodin, Paris, France
1968, "Annual Exhibition: Contemporary
70 American Sculpture," Whitney
 Museum of American Art, New York,
 New York, catalog
1969 "The Partial Figure in Modern
 Sculpture," Baltimore Museum of Art,
 Baltimore, Maryland, catalog
1970 "L'Art Vivant aux Etats-Unis,"
 Fondation Maeght, St. Paul de Vence,
 France, catalog
1970 "American Sculpture," University of
 Nebraska Art Galleries, Sheldon
 Memorial Sculpture Garden, Lincoln,
 Nebraska, catalog
1972 "American Women: 20th Century,"
 Lakeview Center for the Arts and
 Sciences, Peoria, Illinois, catalog
1972 "Unmanly Art," Suffolk Museum, Stony
 Brook, New York, catalog
1973, "Biennial Exhibition: Contemporary
83 American Art," Whitney Museum of
 American Art, New York, New York,
 catalog
1973- "Sculpture in the Fields," Storm King
76 Art Center, Mountainville, New York
1975 "Sculpture: American Directions,"
 National Collection of Fine Arts,
 Smithsonian Institution, Washington,
 D.C.
1975 "American Art Since 1945 From the
 Collection of The Museum of Modern
 Art," Traveling Exhibition, Museum of
 Modern Art, New York, New York,
 catalog
1976 "200 Years of American Sculpture,"
 Whitney Museum of American Art,
 New York, New York, book
1979 "In Small Scale, Phase II," Marian
 Locks Gallery, Philadelphia,
 Pennsylvania
1980 "Pioneering Women Artists 1900 to
 1940," La Boetie Gallery, New York,
 New York
1980 "10 Abstract Sculptures: American
 and European 1940-1980," Max
 Hutchinson Gallery, New York, New
 York, catalog
1981 "Permanent Collection Installation,"
 Grey Art Gallery and Study Center,

New York University, New York, New
York
1981 "Decade of Transition: 1940-1950,"
 Whitney Museum of American Art,
 New York, New York
1981 "Edinburgh International Festival 1981:
 American Abstract Expressionists,"
 Fruitmarket Gallery, Edinburgh,
 Scotland
1981 "The New Spiritualism: Transcendent
 Images in Painting and Sculpture,"
 Traveling Exhibition, Oscarsson-Hood
 Gallery, New York, New York, catalog
1982 "Nature as Image and Metaphor:
 Works by Contemporary Women
 Artists," Greene Space Gallery, New
 York, New York, catalog
1982 "Casting: A Survey of Cast Metal
 Sculpture in the 80s," Fuller Goldeen
 Gallery, San Francisco, California,
 catalog
1982 "Twenty American Artists: Sculpture
 1982," San Francisco Museum of
 Modern Art, San Francisco, California
1982 "The Human Figure," Contemporary
 Arts Center, New Orleans, Louisiana
1983 "Artists in the Historical Archives of
 the Women's Interart Center of New
 York City," Philadelphia College of Art,
 Philadelphia, Pennsylvania
1983 "Twentieth Century Sculpture: Process
 and Presence," Whitney Museum of
 American Art at Philip Morris Incorpo-
 rated, New York, New York, catalog
1983 "Bronze Sculpture in the Landscape,"
 Wave Hill, Bronx, New York, catalog
1983 "Exhibition of Work by Newly Elected
 Members and Recipients of Honors
 and Awards," American Academy and
 Institute of Arts and Letters, New
 York, New York, catalog
1984 "American Women Artists Part I: 20th
 Century Pioneers," Sidney Janis
 Gallery, New York, New York, catalog
1984 "Exacting Clouds, Dismantling
 Silence," Fayerweather Gallery,
 University of Virginia, Charlottesville,
 Virginia
1984- "Content: A Contemporary Focus
85 1974-1984," Hirshhorn Museum and
 Sculpture Garden, Smithsonian
 Institution, Washington, D.C.,
 book-catalog
1984- "The Third Dimension: Sculpture of the
85 New York School," Traveling Exhibi-
 tion, Whitney Museum of American
 Art, New York, New York, catalog
1984- "Primitivism in 20th Century Art:
85 Affinity of the Tribal and the Modern,"
 Museum of Modern Art, New York,
 New York, catalog
1984- "Works in Bronze, A Modern Survey,"
87 Traveling Exhibition, University Art
 Gallery, Sonoma State University,
 Rohnert Park, California, catalog
1985 "Forms in Wood: American Sculpture
 of the 1950s," Philadelphia Art
 Alliance, Philadelphia, Pennsylvania,
 catalog

Selected Public Collections

Australian National Gallery, Canberra, Australia
Detroit Institute of Arts, Detroit, Michigan
Grey Art Gallery and Study Center, New York University, New York, New York
Metropolitan Museum of Art, New York, New York
Musée d'Art Moderne de la Ville de Paris, France
Museum of Modern Art, New York, New York
New Orleans Museum of Art, New Orleans, Louisiana
Portland Museum of Art, Portland, Maine
Rhode Island School of Design, Providence, Rhode Island
Storm King Art Center, Mountainville, New York
Whitney Museum of American Art, New York, New York

Selected Awards

1981 Honorary Doctorate of Fine Arts, Bard College, Annandale-on-Hudson, New York
1984 Honorary Doctorate of Fine Arts, Rutgers University, Douglass College, New Brunswick, New Jersey
1984 Honorary Doctorate of Fine Arts, Maryland Institute College of Art, Baltimore, Maryland

Preferred Sculpture Media

Stone, Varied Media and Wood

Additional Art Field

Drawing

Selected Bibliography

For a comprehensive chronological biography, exhibitions, and bibliography from 1911 to 1982, refer to Deborah Wye's *Louise Bourgeois*, New York: Museum of Modern Art, 1982.
Gallati, Barbara E. "Arts Reviews: Louise Bourgeois, Robert Miller." *Arts Magazine* vol. 57 no. 7 (March 1983) pp. 33-34.
Rose, Barbara E. "Two American Sculptors: Louise Bourgeois and Nancy Graves." *Vogue* (January 1983) pp. 222-223, illus.
Rubinstein, Charlotte Streifer. *American Women Artists: From Early Indian Times to the Present*. Boston: G. K. Hall, 1982.
Storr, Robert. "Louise Bourgeois: Gender & Possession." *Art in America* vol. 71 no. 4 (April 1983) pp. 128-137, illus.

Gallery Affiliation

Robert Miller Gallery
724 Fifth Avenue
New York, New York 10019

Mailing Address

347 West 20 Street
New York, New York 10011

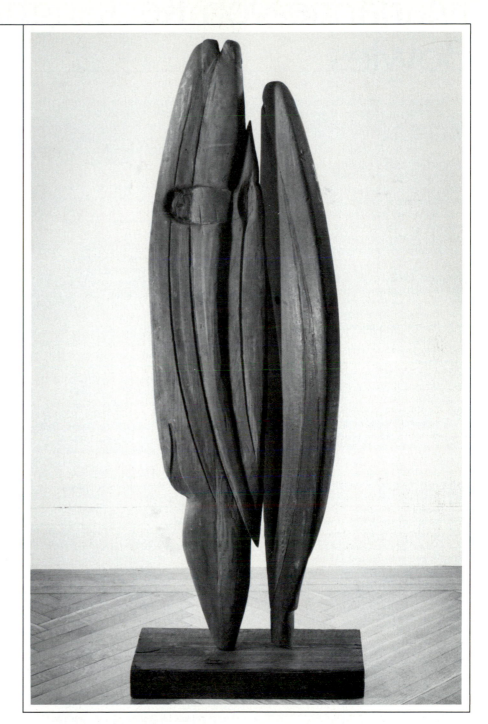

Brother and Sister. 1945-1946. Carved wood, 69"h. Courtesy Robert Miller Gallery, New York, New York. Photograph by Bruce C. Jones.

Artist's Statement

"My first experience in art was to draw on canvas for Aubusson tapestries. Later I studied geometry at the Sorbonne and was able to see in mathematics references that symbolized the complicated and difficult relationships that I had with members of my family. The three-dimensional pyramids, rectangles and shapes of geometry became personal symbols for order, stability and rationality.

"All my work has to do with the relationships of men and women, whether in abstract or figurative approaches and in any material. I am completely free from allegiance to material but I am faithful to my subject. I use symbols through sculptural forms to express a private vocabulary. If you have the privilege of a private language, you cannot be certain anyone will understand it."

Louise Bourgeois

Marianne von Recklinghausen Bowles

née Marianne Eva von Recklinghausen
(Husband Edmund Addison Bowles)
Born January 24, 1929 Munich, Germany,
Federal Republic

Education and Training
My formal schooling ended in tenth grade
due to war, subsequent immigration to
America, and economic necessity. My art
education was acquired gradually as I
absorbed visual aesthetics and requisite
skills by observation, experimentation, and
a natural inclination toward learning.

Selected Individual Exhibitions
1966 Alonzo Gallery, New York, New York
1967, Silvermine Guild of Artists, New
80 Canaan, Connecticut
1968 Summit Art Center, Summit, New
 Jersey
1980- Bridge Gallery, White Plains, New
81 York
1982 Katonah Gallery, Katonah, New York
1982 Westbeth Gallery, New York, New
 York
1983 Goethe Institute, Boston,
 Massachusetts; Catholic University of
 America, Washington, D.C.
1984 Hudson River Museum, Yonkers, New
 York

Selected Group Exhibitions
1965 "All-American Artists," Stern Brothers
 Gallery, New York, New York
1966- "Annual New England Exhibition,"
83 Silvermine Guild Center For The Arts,
 New Canaan, Connecticut, catalog
1968 "Fourteenth Annual Drawing and Small
 Sculpture Show," Ball State University,
 Muncie, Indiana, catalog

1973 "Washington Artists New Work," Henri
 Gallery, Washington, D.C.
1974 "Where Has All The Color Gone?"
 Henri Gallery, Washington, D.C.
1974 "Nineteenth Area Exhibition," Corcoran
 Gallery of Art, Washington, D.C.,
 catalog
1975 "An Exhibit on Women," George
 Washington University, Washington,
 D.C.
1975 "Women on Women," Art Barn,
 Washington, D.C.
1975 "New Washington Women," Anderson
 Gallery, Virginia Commonwealth
 University, Richmond, Virginia
1976 "Bicentennial Americana," Henri
 Gallery, Washington, D.C.
1976 "Year of the Woman: Reprise," Bronx
 Museum of The Arts, Bronx, New
 York, catalog
1976 "The Eye of Davenport," Washington
 Women's Art Center, Washington,
 D.C.
1977 "Artists Company: Nine from
 Washington, D.C.; Mint Museum of
 Art, Charlotte, North Carolina; Art
 Associates, Lake Charles, Louisiana;
 The Art Center, Waco, Texas, catalog
1979, "Artists of the Gallery," Katonah
81, Katonah Gallery, Katonah, New York
84
1980 "Black and White," Silvermine Guild
 Center of Artists, New Canaan,
 Connecticut
1980 "Boxes," Gallery 10, Washington, D.C.,
 catalog
1981 "The Animal Image: Contemporary
 Objects and the Beast," Renwick
 Gallery of the National Museum of
 American Art, Smithsonian Institution,
 Washington, D.C., catalog
1981- "Collage & Assemblage," Traveling
84 Exhibition, Mississippi Museum of Art,
 Jackson, Mississippi, catalog
1983 "Beyond the Wall," Aaron Berman
 Gallery, New York, New York
1983 "Art of the Northwest USA," Silvermine
 Guild Center For The Arts, New
 Canaan, Connecticut, catalog

Selected Private Collections
Dr. and Mrs. Lawrence Albert, Scarsdale,
 New York
Mrs. Charles Bowen, Greenwich, Connecticut
Mr. and Mrs. Robert Durfee, Annandale,
 Virginia
Mr. and Mrs. Gilbert H. Kinney, Washington,
 D.C.
Mr. and Mrs. Lloyd Sherwood, Scarsdale,
 New York

Selected Awards
1965 First in Show, "Westchester Art
 Society Annual Juried Competition,"
 Westchester Art Society, White Plains,
 New York

1966 Charles of the Ritz Foundation Award,
 "Sixteenth Annual New England
 Exhibition," Silvermine Guild of Artists,
 New Canaan, Connecticut, catalog
1983 William Henry Lowman Memorial,
 "Thirty-Fourth Annual New England
 Exhibition," Silvermine Guild Center
 For The Arts, New Canaan,
 Connecticut, catalog

Preferred Sculpture Media
Varied Media

Additional Art Fields
Drawing and Painting

Selected Bibliography
Burton, Scott. "Reviews and Previews:
 Marianne Bowles." *Art News* vol. 65 no. 6
 (October 1966) pp. 10-11.
Lewis, Jo Ann. "Art Galleries: Expressly
 German, Bowles' Constructions at CU."
 The Washington Post (Thursday, November
 3, 1983) p. D7.
Raynor, Vivien. "Portrait of Artists As Their
 Models." *The New York Times* (Sunday,
 December 14, 1980) p. WC24, illus.
Russell, John. "A Guide to Treasure Hunting
 In Nearby Country Museums." *The New
 York Times* (Friday, August 24, 1979) pp.
 C1, C24, illus.

Mailing Address
5 Sage Court
White Plains, New York 10605

Artist's Statement

"I am a dealer in myths, a teller of stories, recounting legends from life: psychic history is retold as it was, as it might haven been, as it should have been. I consider myself a psychic realist concerned particularly with the myths of humanity and the realities of perception hidden in them. The multilayered concept of that most enduring myth 'Paradise' provides the motif for these 'secular altarpieces,' each a chapter in a book of life. The sequential triptych form of the constructions permits the simultaneous existence of several physical and perceptual levels, shifting or reversing the thrust of each tale as the wings are opened and then closed again."

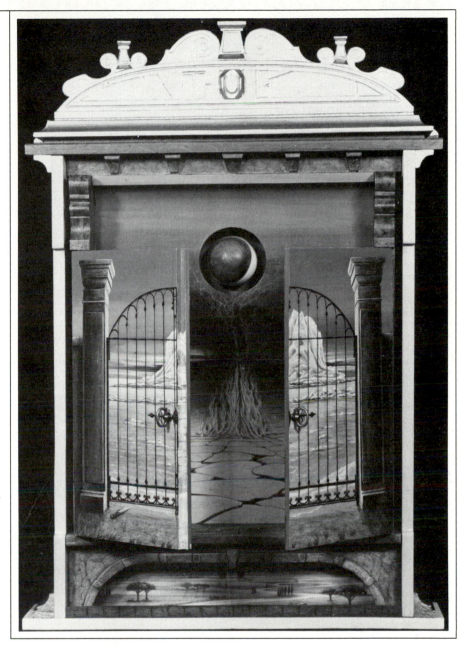

Landscape of Ancient Myths: Paradise Series. 1977.
Acrylic on wood, 23¼"h x 16¼"w x 4"d. Photograph by David Bowles.

Mary E. Bradley

née Mary Elizabeth Hartz
Born June 4, 1942 Detroit, Michigan

Education and Training

1963 B.A., Education, University of Michigan, Ann Arbor, Michigan
1965 M.A., Special Education, University of Michigan, Ann Arbor, Michigan
1973-75 Apprenticeship to Conrad Stack, Woodshed Furniture, Detroit, Michigan; study in woodworking techniques
1975 Center for Creative Studies-College of Art and Design, Detroit, Michigan; study in drawing
1976-78 Studio of Aidron Duckworth, Meriden, New Hampshire; study in drawing and sculpture
1977-79 Studio of David Perkins, North Newport, New Hampshire; study in welded sculpture
1978 Oxygen Welding Supply, White River, Vermont; independent study in welding techniques
1983 Studio of Winslow Eaves, Wilmont, New Hampshire; study in wax modeling techniques

Selected Group Exhibitions

1978 "New Hampshire Arts Biennial," Manchester Institute of Arts and Sciences, Manchester, New Hampshire, catalog
1979, 80 "Area Art Show," Library Arts Center, Newport, New Hampshire
1980 "Women in Art," Marian Graves Mugar Gallery, Colby-Sawyer College, New London, New Hampshire
1981 "Sculpture/New Hampshire," Area Galleries and Institutions, State of New Hampshire (Organized by New Hampshire Visual Arts Coalition)
1981, 83 "Area Art Exhibit," Claremont Art Association, Claremont, New Hampshire
1982, 83 "Regional Art Exhibition," Hopkins Center, Hood Museum of Art, Hanover, New Hampshire
1983 "Interim I: An Exhibition of Contemporary Outdoor Sculpture," Chesterwood, Stockbridge, Massachusetts
1983 "The Berkshires Lifeyard Project," Outdoor Sites, Pittsfield, Massachusetts
1984 "Friends of Plymouth Invitational," Plymouth State College of the University System of New Hampshire, Plymouth, New Hampshire
1984 "The Last Rouse of Summer," Kimball-Jenkins Estate, Concord, New Hampshire
1985 "Summer Invitational," Manchester Institute of Arts and Sciences, Manchester, New Hampshire

Preferred Sculpture Media

Metal (welded)

Selected Bibliography

"Artist Profiles: Mary Bradley." *Options* (Spring 1983) pp. 6-7, illus.
Zucker, Barbara M. "Museum News: Sculpture/New Hampshire." *Art Journal* vol. 42 no. 1 (Spring 1982) pp. 64-65, illus.

Gallery Affiliation

Artist Express Depot
38 Depot Street
Ashland, New Hampshire 03217

Mailing Address

Box 14
Grantham, New Hampshire 03753

Artist's Statement

"The truth that may be projected through a work of art is the same truth found in nature. In each the meaning exists as a potential and must be sought through a connection which transcends rational thought.

"The creative process is a pathway between inner and outer consciousness. It is a journey beyond time to a space where pure energy dances. Within this space paradox dissolves into unity and pain and ecstasy become one. I have found working as an artist celebrates the magic and mystery of life."

Mary E Bradley

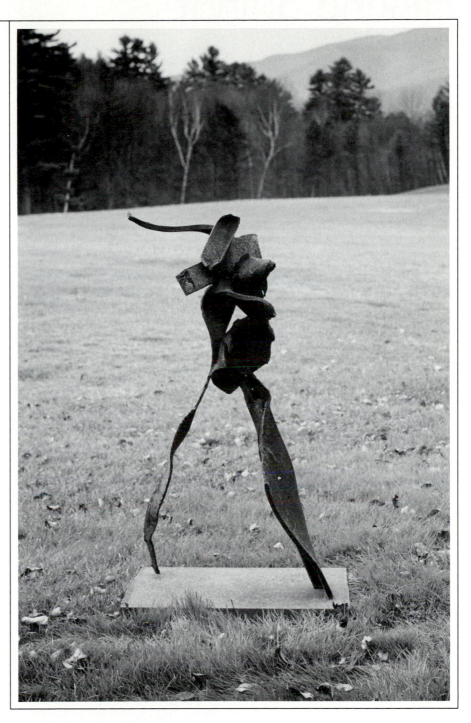

Raven. 1983. Steel, 40"h x 22"w x 14"d.
Photograph by Julia Russell.

Helene Brandt

née Helene Blain
(Husband Philip Williams Brandt)
Born September 17, 1936 Philadelphia,
Pennsylvania

Education and Training
1970 B.A., Sculpture, City University of New York, City College, New York, New York
1975 M.F.A., Sculpture, Columbia University, New York, New York; study with Ronald Bladen, George Sugarman and Sahl Swarz
1976 Certificate of Advanced Studies, Saint Martin's School of Art, London, Great Britain; study in sculpture with Anthony Caro, Philip King, Timothy Scott and William Tucker

Selected Individual Exhibitions
1973 Hudson River Museum, Yonkers, New York, catalog
1980 Women's Interart Center, New York, New York
1982 Sculpture Center, New York, New York, catalog
1982 M.O.A. Gallery, New York, New York
1983 Queens Museum, Flushing, New York
1983 Staten Island Children's Museum, Staten Island, New York
1984 Bronx Museum of The Arts, Bronx, New York
1984 Discovery Room, Nassau County Museum of Fine Arts, Roslyn, New York

Selected Group Exhibitions
1976 "Sculptors from Saint Martin's School of Art," Harlow Gallery, Harlow, Great Britain
1976 "New Contemporaries," International Art Centre, London, Great Britain
1978 "Art Arte Kunst," Bronx Museum of The Arts, Bronx, New York
1978 "Hands Off/On," Gallery at Hastings-on- Hudson, Hastings, New York
1979 "Inaugural Exhibition," Manhattan Laboratory Museum, New York, New York
1980 "Discovery-Rediscovery," Sculpture Center, New York, New York
1981, "O.I.A. Sculpture Garden," Manhattan
82 Psychiatric Center, Ward's Island, New York
1981 "Toys by Artists," Sculpture Center, New York, New York
1982 "Mixed Bag," Alternative Museum, New York, New York, catalog
1982 "Celebration," Bronx Museum of The Arts, Bronx, New York
1982 "Discovery Room," Nassau County Museum of Fine Arts, Roslyn, New York, catalog
1983 "Bridges," Pratt Institute, Brooklyn, New York, catalog
1983 "Spare Parts: A Material for the Arts Show," City Gallery, New York, New York, catalog
1983- "Sculpture Garden Two," South Beach
84 Psychiatric Center, Staten Island, New York
1983 "Ornaments as Sculpture," Sculpture Center, New York, New York
1984 "Sculpture to Touch," Allentown Art Museum, Allentown, Pennsylvania
1984 "Architecture/Sculpture, Sculpture/ Architecture," Thorpe Intermedia Gallery, Sparkill, New York
1985 "Small Works 1985," 80 Washington Square East Gallery, New York, New York

Selected Public Collections
American Telephone and Telegraph Company, Bedminster, New Jersey
Columbia University, New York, New York
Grenoble Holdings Limited, New York, New York
Hudson River Museum, Yonkers, New York
Israel Museum, Jerusalem, Israel
Thorpe Village, Sparkill, New York

Selected Awards
1980 Artist in Residence, Northern State College, Aberdeen, South Dakota and National Endowment for the Arts
1982 Career Development Grant for Women Sculptors, Betty Brazil Memorial Fund, Tarrytown, New York
1985 John Simon Guggenheim Memorial Foundation Fellowship

Preferred Sculpture Media
Metal (welded)

Additional Art Field
Drawing

Selected Bibliography
Brenson, Michael. "Sculpture of Summer Is in Full Bloom: 'Bridges.'" The New York Times (Friday, July 8, 1983) pp. C1, C18, illus.
Brenson, Michael. "Art: Welded Sculptures By Helene Brandt." The New York Times (Friday, April 6, 1984) p. C29, illus.
Olejarz, Harold. "Bridges." Arts Magazine vol. 58 no. 1 (September 1983) p. 17.
Roustayi, Mina. "Helene Brandt." Arts Magazine vol. 59 no. 2 (October 1984) p. 13, illus.
Shepard, Richard F. "Going Out Guide: Pickup Art." The New York Times (Monday, June 13, 1983) p. C16.

Mailing Address
43 Great Jones Street
New York, New York 10012

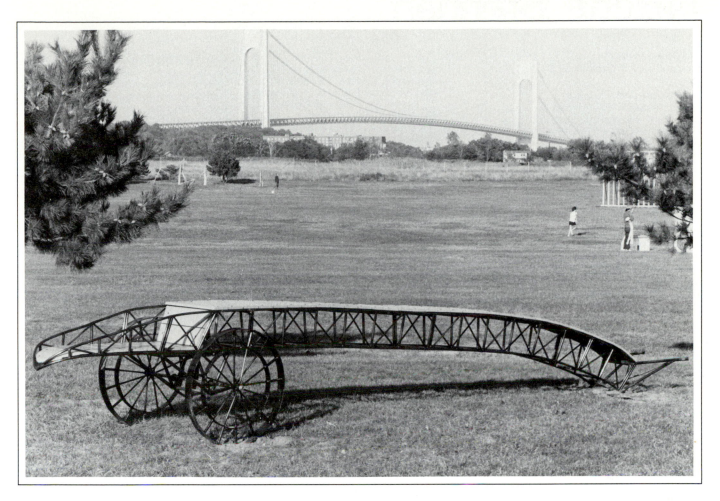

Portable Bridge. 1983. Steel and wood, 3'h x 4'w x 22'd. Installation view 1983-1984. "Sculpture Garden Two," South Beach Psychiatric Center, Staten Island, New York. Photograph by Robin Brown.

Artist's Statement

"My sculptures are vehicle or chair-like structures with wheels which can be entered by the viewer and propelled by another person. Earlier sculptures were conceived with the duality of the dangers of confinement within a rigid structure, either voluntary or involuntary, and the longing for womb-like security. While the enclosures restricted the range of experience of the voyager, the newer sculpture permits the viewer to escape self-limitations. They express a desire for freedom and have become fantasy vehicles."

Helene Brandt

Nizette Brennan

née Denise Michelle
Born July 6, 1950 Washington, D.C.

Education and Training
1969- University of Maryland at College
71 Park, College Park, Maryland
1973 Athens Center for the Creative Arts, Athens, Greece

Selected Individual Exhibitions
1974 United States Cultural Center, Thessaloniki, Greece
1975 Hellenic-American Union, Athens, Greece
1977 Villa Edelstein, Genève, Switzerland
1979 Cramer Gallery, Washington, D.C.
1981 Osuna Gallery, Washington, D.C.
1984 Wallace Wentworth Gallery, Washington, D.C., catalog
1985 Southeastern Center for Contemporary Art, Winston-Salem, North Carolina

Selected Group Exhibitions
1978 "First Annual International Sculptors Exhibition," Centro Citta, La Cappella, Italy
1978 "Sculptori e Artigiani en un Centro Storico, Sculptors and Artisans in a Historical Center," Centro Citta, Pietrasanta, Italy
1980 "Sculpture Summer '80," Cramer Gallery, Washington, D.C.
1980 "D.C. Scapes," Cramer Gallery, Washington, D.C.
1980 "Twenty Washington Sculptors," Washington Project for the Arts, Washington, D.C.
1980 "Sculpture 1980," Maryland Institute College of Art, Baltimore, Maryland, catalog
1980 "Maquettes for Large Sculpture," Arlington Arts Center, Arlington, Virginia
1980, "Annual WPA Auction," Washington
81, Project for the Arts, Washington, D.C.
83
1981 "A Slice of Washington Art," Office of the Mayor, Washington, D.C.
1981 "Essentially Sensuous," Gallery 10, Washington, D.C.
1981 "Glen Echo Instructors' Show," Glen Echo Gallery, Glen Echo, Maryland
1982 "Exhibition of Work by Newly Elected Members and Recipients of Honors and Awards," American Academy and Institute of Arts and Letters, New York, New York, catalog

1982 "Twelfth International Sculpture Conference," Area Galleries and Institutions, Oakland, California and San Francisco, California (Sponsored by International Sculpture Center, Washington, D.C.)
1983 "Divergencies," Maryland Art Place, Baltimore, Maryland
1984 "Washington Sculpture: Prospects & Perspective," Georgetown Court Artists' Space, Washington, D.C.
1984 "Artist Fellowship Exhibition," Montgomery County Arts Council, Bethesda, Maryland
1984 "Sited Towards the Future: Proposals for Public Sculpture in Arlington County," Arlington Arts Center, Arlington, Virginia; Georgetown Court Artists' Space, Washington, D.C., catalog
1984 "The Garden: Concepts and Realities," Fendrick Gallery, Washington, D.C.
1985 "Art in Transit," King Street Metro, Alexandria, Virginia
1985 "The Washington Show," Corcoran Gallery of Art, Washington, D.C., catalog
1985 "The Garden Environment: Sculptural Setting, Setting for Sculpture," Audubon Naturalist Society, Chevy Chase, Maryland
1985 "The Southeast Seven VIII," Southeastern Center for Contemporary Art, Winston-Salem, North Carolina

Selected Public Collections
Noxell Corporation, Cockeysville, Maryland
Rouse Company, Columbia, Maryland and Philadelphia, Pennsylvania
Sigal Construction Corporation, Washington, D.C.
Spaulding & Slye, North Bethesda, Maryland
United States Mission to International Organizations, Genève, Switzerland

Selected Private Collections
Mr. and Mrs. James Fitzpatrick, Washington, D.C.
Anita Reiner, Bethesda, Maryland
Gloria Gaston Shapiro, Washington, D.C.
Phillip M. Smith, Washington, D.C.
Thea Westreich, Washington, D.C.

Selected Awards
1982 Recipient of an Award in Art, American Academy and Institute of Arts and Letters, New York, New York
1983 Individual Artist's Fellowship, Montgomery County Arts Council, Bethesda, Maryland
1984 Grant in Aid, D.C. Commission on the Arts and Humanities

Preferred Sculpture Media
Stone

Selected Bibliography
Forgey, Benjamin. "The Uptown-Downtown Insider-Outsider World of Washington Art." Art News vol. 78 no. 7 (September 1979) pp. 50-54, illus.
Forgey, Benjamin. "Park for Art's Sake: Arlington's New Shapes: 'Sited Toward the Future.'" The Washington Post (Saturday, July 7, 1984) pp. D1, D7.
Richard, Paul. "The Equinox of Art: City Scenes of Ruin and Renewal." The Washington Post (Saturday, April 5, 1980) pp. E1, E3.
Swift, Mary. "Profiles: Nizette Brennan (Washington, D.C.)" Art Voices/South vol. 3 no. 3 (May-June 1980) p. 69, illus.
Wittenberg, Clarissa K. "Washington Sculptors in San Francisco." Washington Review vol. 8 no. 3 (October-November 1982) pp. 11-12, illus.

Gallery Affiliation
Wallace Wentworth Gallery
2006 R Street NW
Washington, D.C. 20008

Mailing Address
805 Channing Place NE
Washington, D.C. 20018

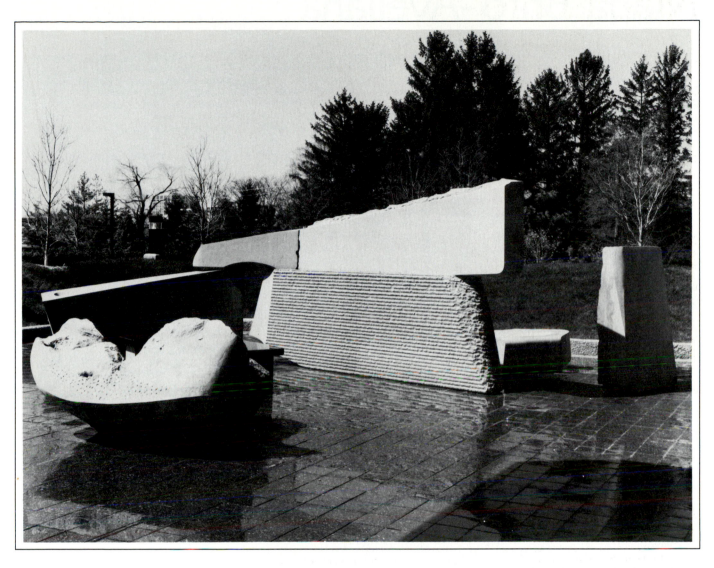

Zen Zag. 1982. Limestone, slate and water, 7'h x 30'w x 35'd. Collection Noxell Corporation, Cockeysville, Maryland. Photograph by Frank Herrara.

Artist's Statement

"Sculpture, the study of form in space, has led me to explore the landscape and the urbanscape, the figure and the architectonic, the organic and the geometric. My explorations of scale in three dimensions were advanced considerably during the three years I spent in Pietrasanta; I began combining pebbles with river rocks and architectural slab stone with mosaics to create individual compositions. These studies have been the basis for my work on a larger scale and for my understanding of the proportional relationships between sculptural form and particular spaces, environments or sites. The large-scale sculpture *Zen Zag* reflects my growing interest in relief and texture. I am currently involved in designing a corporate garden using stone indigenous to the area for functional as well as sculptural purposes."

71

María Brito-Avellana

née María Brito
(Husband Luis H. Avellana)
Born October 10, 1947 Havana, Cuba

Education and Training

1967 A.A., Miami-Dade Community College, North Campus, Miami, Florida; study in sculpture with Duane Hanson
1969 B.Ed., Education, University of Miami, Coral Gables, Florida
1976 M.Ed., Art, Florida International University, Miami, Florida
1977 B.F.A., Ceramic Sculpture, Florida International University, Miami, Florida; study with William Burke
1979 M.F.A., Ceramic Sculpture, University of Miami, Coral Gables, Florida; study with Christine Federighi and David Vertacnik

Selected Individual Exhibitions

1980, Gallery at 24, Miami, Florida
82
1982 Art Gallery at Sequoyah Lake, Highlands, North Carolina
1985 Gallery at 24, Bay Harbor Islands, Florida

Selected Group Exhibitions

1978 "Annual Hortt Memorial Exhibition," Museum of Art, Fort Lauderdale, Florida, catalog
1978 "Re-encuentro Cubano '78," Cuban Museum of Arts and Culture, Miami, Florida
1978 "Woman Artist of the Seventies," Long Gallery, Fort Lauderdale, Florida
1978 "Cuban Sculptors Invitational," Kromex Gallery, New York, New York
1979 "De Armas Gallery Invitational," Virginia Gardens, Miami, Florida
1979 "Twenty-Ninth Annual Ceramic League of Miami," Metropolitan Museum and Art Center, Coral Gables, Florida
1979 "Miami Arte Nuevo," Museum of the American Foundation of the Arts, Miami, Florida
1980 "10865 Re-encuentro Cubano '80," Main Library, Miami-Dade Public Library, Miami, Florida
1980 "Arts Council of Florida Grant Recipients Invitational Show," Lemoyne Art Foundation, Tallahassee, Florida, catalog
1981 "Thirty-First Annual Florida Craftsmen Exhibition," Boca Raton Center for the Arts, Boca Raton, Florida
1981 "Southeast '81 Craft Competition," Lemoyne Art Foundation, Tallahassee, Florida
1981 "Latin-American Art: A Woman's View," Frances Wolfson Art Gallery, Miami-Dade Community College, New World Center Campus, Miami, Florida, catalog

1981 "The Faculty Speaks," Danielson Gallery, Metropolitan Museum and Art Center, Coral Gables, Florida
1982 "Women's Art: Miles Apart," Aaron Berman Gallery, New York, New York; East Campus Gallery, Valencia Community College, Orlando, Florida, catalog
1982 "The Four Arts Regionals: María Brito-Avellana and Mary Lou Stewart," Four Arts Center, Florida State University/Institute for Contemporary Art, Tallahassee, Florida
1982 "María Brito-Avellana and Judith Greavu," Gallery at 24, Miami, Florida
1982 "Hispanics U.S.A. 1982: Twenty-Seventh Annual Contemporary American Art Exhibition," Ralph L. Wilson Gallery, Alumni Memorial Building, Lehigh University, Bethlehem, Pennsylvania, catalog
1982 "Sixteenth Annual National Drawing and Small Sculpture Show," Joseph A. Cain Memorial Art Gallery, Del Mar College, Corpus Christi, Texas, catalog
1982 "American Art Annual," Middletown Fine Arts Center, Middletown, Ohio
1982 "Six Downtown: Brito-Avellana, Falero, Garcia, Lezcano, Trasobares, Vadia: The Generation of the '70s," Main Library, Miami-Dade Public Library, Miami, Florida
1982 "Florida Artists See Themselves," Frances Wolfson Art Gallery, Miami-Dade Community College, New World Center Campus, Miami, Florida, catalog
1983 "The Miami Generation," Cuban Museum of Arts and Culture, Miami, Florida; Meridian House International, Washington, D.C., catalog
1983 "Artists of Florida," Miami-Dade Community College, New World Center Campus, Miami, Florida, catalog
1984 "Aquí: Twenty-Seven Latin-American Artists Living and Working in the United States," Fisher Gallery, University of Southern California, Los Angeles, California; Mary Porter Sesnon Gallery, University of California, Santa Cruz, Santa Cruz, California, catalog
1984 "Young Collectors of Latin-American Art," Metropolitan Museum and Art Center, Coral Gables, Florida, catalog
1985 "National Endowment for the Arts: Fellowship Artists, Florida 1984," Fine Arts Gallery, School of Visual Arts, Florida State University, Tallahassee, Florida, catalog
1985 "María Brito-Avellana, George Dombek and Mary Rhoads," Florida Center for Contemporary Art, Tampa, Florida

Selected Public Collections

Archer M. Huntington Art Gallery, Austin, Texas

Cintas Foundation, Institute of International Education, New York, New York
Miami-Dade Community College, South Campus, Miami, Florida
Miami-Dade Public Library, Main Library, Miami, Florida
University of Florida, Gainesville,, Florida

Selected Private Collections

Giulio Blanc, New York, New York
Richard Haft, Miami, Florida
Dr. Adolfo Maldonado, Miami, Florida
George Miller, Tallahassee; Florida
Dr. Jorge Presser, Miami, Florida

Selected Awards

1981, Cintas Fellowship, Cintas
85 Foundation, Institute of International Education, New York, New York
1984 Individual Artist's Fellowship, National Endowment for the Arts

Preferred Sculpture Media

Clay and Varied Media

Teaching Position

Art Instructor, Miami-Dade Community College, New World Center Campus, Miami, Florida

Selected Bibliography

Edwards, Ellen. "South Florida: No Longer a Last Resort for Art." *Art News* vol. 78 no. 10 (December 1979) pp. 78-81, 84.
Forgey, Benjamin. "Arts Galleries: The Cuban Evolution." *The Washington Post* (Thursday, June 14, 1984) p. B7.
Kohen, Helen L. "Open Season in Miami." *Art News* vol. 81 no. 2 (February 1982) pp. 114-116.
Muchnic, Suzanne. "Art Review: Latino Work Escapes Ethnicity." *Los Angeles Times* (Monday, November 12, 1984) calendar section, pp. 1, 6, illus.
"News & Retrospect: Ceramic League of Miami." *Ceramics Monthly* vol. 27 no. 8 (October 1979) pp. 81, 83, illus.

Gallery Affiliation

Gallery at 24
1052 Kane Concourse
Bay Harbor Islands, Florida 33154

Mailing Address

8995 SW 75 Street
Miami, Florida 33173

Artist's Statement

"My work expresses abstract elements of feelings, emotions and sensations discovered through a constant search into my own life. Ideas thus emerge intuitively and initially materialize in an informal sketch. Rarely does the final outcome resemble the first drawing. It is a state of mind in which insight and intellect strive together for the most direct realization of an idea.

"The pieces are assembled from found and constructed objects. As space allows, I keep potentially useful materials visible in my studio. A found object or material assumes an entirely different presence when placed within the context of a particular work. It is a uniquely satisfying experience to witness the transformation."

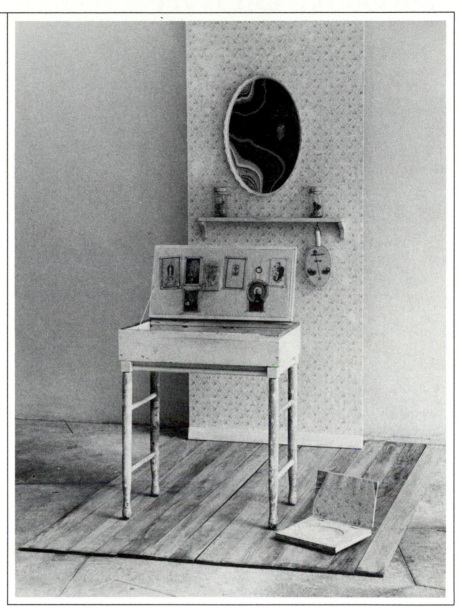

Woman Before a Mirror. 1983. Mixed media, 78"h x 51"w x 70"d.

Carol K. Brown

née Carol Kapelow
(Husband Peter Brown)
Born September 29, 1945 Memphis,
Tennessee

Education and Training
1965 Tulane University, New Orleans,
Louisiana
1967 New School for Social Research, New
York, New York
1978 B.F.A., Sculpture, University of Miami,
Miami, Florida; study with Richard
Gillespie
1981 M.F.A., Sculpture, University of
Colorado at Boulder, Boulder,
Colorado

Selected Individual Exhibitions
1977 South Campus Art Gallery,
Miami-Dade Community College,
Miami, Florida
1979 Access Gallery, Contemporary Arts
Center, New Orleans, Louisiana
1980 Fine Arts Gallery, University Memorial
Center, University of Colorado at
Boulder, Boulder, Colorado
1981 University of Colorado Art Galleries,
Sibell-Wolle Fine Arts Building,
Boulder, Colorado
1982 Boulder Public Library, Boulder,
Colorado
1982 Sebastian-Moore Gallery, Denver,
Colorado
1983 Gloria Luria Gallery, Bay Harbor
Islands, Florida

Selected Group Exhibitions
1976 "Sculptors of Florida," Metropolitan
Museum and Art Center, Coral
Gables, Florida
1976 "Annual Hortt Memorial Exhibition,"
Museum of Art, Fort Lauderdale,
Florida, catalog
1977 "Selected Florida Sculptors," Art and
Culture Center of Hollywood,
Hollywood, Florida
1977 "American Portraits," Art and Culture
Center of Hollywood, Hollywood,
Florida, catalog

1979 "Four New Faces," St. Charles on
Wazee Gallery, Denver, Colorado
1980, "Colorado Annual," Denver Art
81 Museum, Denver, Colorado
1980 "Vail Outdoor Sculpture Exhibition,"
Area Locations, Vail, Colorado
1981- "Front Range: Women in the Visual
82 Arts," ARC Gallery, Chicago, Illinois;
Boulder Center for the Visual Arts,
Boulder, Colorado; Plains Art Museum,
Moorhead, Minnesota; Community
Gallery of Art, Arapahoe Community
College, Denver, Colorado, catalog
1981 "Women as Artists," Mariani Gallery,
University of Northern Colorado,
Greely, Colorado
1981 "A Woman's Place," John Michael
Kohler Arts Center, Sheboygan,
Wisconsin, catalog
1981 "Great Plains Sculpture Exhibition,"
University of Nebraska Art Galleries,
Sheldon Memorial Art Gallery, Lincoln,
Nebraska
1982 "Carol Kapelow Brown, Luis Eades
and Fran Metzger," Fine Arts Gallery,
Colorado Mountain College,
Breckenridge, Colorado
1982 "Front Range: Small Works,"
Northwest Community College, Powell,
Wyoming
1982 "Arts '82," Boulder Center for the
Visual Arts, Boulder, Colorado
1983 "Woman's Caucus for Art
Competition," North Miami Museum
and Art Center, Miami, Florida
1984 "A Decade of Women's Art," Boulder
Center for the Visual Arts, Boulder,
Colorado
1984 "Texas Fine Arts Association National
Exhibition," Laguna Gloria Art
Museum, Austin, Texas
1984 "Florida Fellows," East Campus
Gallery, Valencia Community College,
Orlando, Florida, catalog
1985 "National Endowment for the Arts:
Fellowship Artists, Florida 1984," Fine
Arts Gallery, School of Visual Arts,
Florida State University, Tallahassee,
Florida, catalog

Selected Public Collections
Atlantic Richfield Company, Denver,
Colorado
Denver Art Museum, Denver, Colorado
Lowe Art Museum, Miami, Florida
University of Colorado at Boulder, Boulder,
Colorado

Selected Awards
1983 Individual Artist's Fellowship, Arts
Council of Florida
1984 Individual Artist's Fellowship, National
Endowment for the Arts

Preferred Sculpture Media
Metal (welded)

Additional Art Field
Drawing

Selected Bibliography
Lyman, Lindy. "Reviews: Exhibition Notes,
Denver." *Artspace* vol. 4 no. 1 (Fall 1979)
pp. 53-54, illus.

Gallery Affiliation
Gloria Luria Gallery
1033 Kane Concourse
Bay Harbor Islands, Florida 33154

Mailing Address
101 West Dilido Drive
Miami Beach, Florida 33139

Artist's Statement

"My interest in sculpture evolved from a love of building when I was a child. My serious interest in sculpture as a profession began when I was a student. At that time I learned bronze and aluminum casting techniques but I was dissatisfied that I did not always have complete control over the process. I found fabricating directly, primarily in steel, gave me greater freedom to build exactly what I wanted.

"For the last decade I have explored the very fine line between what is whimsical and what is unsettling or malevolent. I am fascinated with the single object which makes one person smile and another feel threatened. A single steel 'figure' with anthropomorphic or zoomorphic qualities can take on an entirely different character when placed in a larger environment of similar figures."

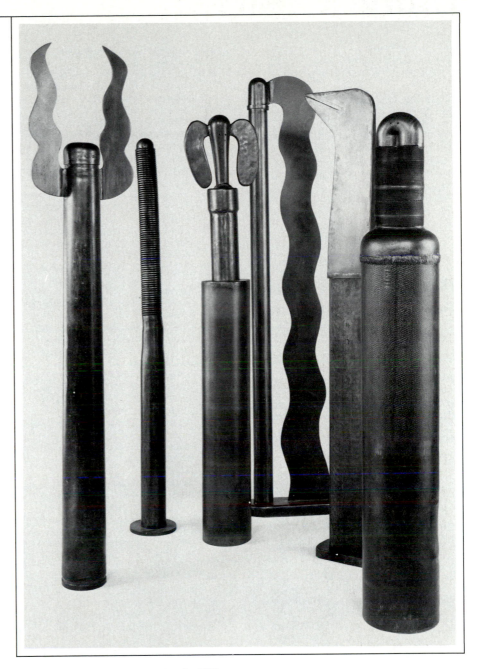

Untitled. 1980. Steel and cast iron, six units, 5'9"h.
Courtesy Denver Art Museum, Denver, Colorado.

Bruria

née Bruria Shimshon
(Husband David Bruce Finkel)
Born August 2, 1932 Jerusalem, Israel

Education and Training
1953 B.H., Art Education, Seminar Hakibutzim, Tel Aviv, Israel
1955 Alfred University, Alfred, New York

Selected Individual Exhibitions
1972, Jacqueline Anhalt Gallery, Los
74, Angeles, California
76,
77,
82
1975 Roberts Gallery, Santa Monica, California
1978 Woman's Building, Los Angeles, California
1978 Corner Gallery, Design Center, Los Angeles, California
1978 Anhalt-Barnes Gallery, Los Angeles, California
1980 de Saisset Museum, Santa Clara, California
1980 Palm Springs Desert Museum, Palm Springs, California
1981 Tom Luttrell Gallery, San Francisco, California
1981 Malibu Art & Design, Malibu, California
1982 Meredith Niles Gallery, Santa Barbara, California
1982 University of California, Irvine, Irvine, California, catalog
1984 Artworks, Los Angeles, California
1985 Skirball Museum, Hebrew Union College—Jewish Institute of Religion, Los Angeles, California, catalog

Selected Group Exhibitions
1967 "Ceramics," Los Angeles County Museum of Art, Los Angeles, California
1972 "The Cup Show," David Stuart Gallery, Los Angeles, California
1973 "Inaugural Invitational," Womanspace, Los Angeles, California
1973 "Fire and Clay," California Museum of Science and Industry, Los Angeles, California
1974 "Female Imagery Female Identity," Womanspace, Los Angeles, California
1975 "National Invitational," Rebecca Cooper Gallery, Washington, D.C.
1976 "The Magical Mystery Tour," Los Angeles Municipal Art Gallery, Los Angeles, California

1977 "4 Artists," Woman's Building, Los Angeles, California
1977 "Overglaze Imagery, Cone 019-016," Visual Arts Center, California State University Fullerton, Fullerton, California, catalog
1978 "Metamagic," California State University Dominguez Hills, Carson, California
1979 "Artist as Critic," Los Angeles Municipal Art Gallery, Los Angeles, California, catalog
1979 "West Coast Clay Spectrum," Security Pacific Bank, Los Angeles, California, catalog
1979 "Le Ambiguità dell'io, The Ambiguous Self," Galleria Il Traghetto, Venice, Italy, catalog
1980 "The Mask as Metaphor," Craft and Folk Art Museum, Los Angeles, California
1980- "American Porcelain: New Expressions
85 in an Ancient Art," Traveling Exhibition, Renwick Gallery of the National Museum of American Art, Smithsonian Institution, Washington, D.C., catalog
1981 "Three L.A. Artists," Meredith Niles Gallery, Santa Barbara, California
1981 "Small Images," Downtown Gallery, Los Angeles, California
1982 "Tradition in Transition: Bruria, Gilah Yelin Hirsch, Beth Ames Swartz and Michele Zackheim," University of California, Irvine, Irvine, California, catalog
1983 "Icons and Images for Children of All Ages, Dedicated to the Memory of Nancy Hanks," Clark Humanities Museum, Scripps College, Claremont, California
1983 "At Home Exhibition," Long Beach Museum of Art, Long Beach, California, catalog
1984 "Book Art," Otis Art Institute of Parsons School of Design, Los Angeles, California
1984 "Olympiad 1984 Invitational," Koplin Gallery, Los Angeles, California

Selected Public Collections
Leo Baeck Temple, Bel Air, California
National Museum of American Art, Smithsonian Institution, Washington, D.C.
Sussman/Prejza Company, Santa Monica, California

Selected Private Collections
Ganz Collection, Beverly Hills, California
Mr. and Mrs. Eric Lidow, Bel Air, California
The Muchmore Collection, Atherton, California
Jonas Rosenfield, Los Angeles, California
Edward and Melinda Wortz Collection, Pasadena, California

Selected Award
1976- Artist in the Schools Program,
78 California Arts Council

Preferred Sculpture Media
Clay, Metal (cast) and Paper (handmade)

Additional Art Field
Art Books

Related Profession
Art Commissioner, City of Santa Monica, California

Selected Bibliography
Donhauser, Paul S. *History of American Ceramics: The Studio Potter.* Dubuque, Iowa: Kendall/Hunt, 1978.
McCloud, Mac. "Bruria." *American Ceramics* vol. 1 no. 4 (Fall 1982) pp. 48-49, illus.
Tiberman, Marcy. "Reviews: Bruria at Meredith Niles, Santa Barbara." *Images & Issues* vol. 3 no. 5 (March-April 1983) p. 66, illus.
Weisberg, Ruth. "Exhibitions: Metamorphoses of Material and Form." *Artweek* vol. 11 no. 44 (December 27, 1980) p. 6, illus.
Wortz, Melinda. "Tradition in Transition: Bruria, Gilah Yelin Hirsch, Beth Ames Swartz and Michele Zackheim." *Journal: A Contemporary Art Magazine* number 31 vol. 4 no. 11 (Winter 1981) catalog insert, pp. 5-12, illus.

Gallery Affiliation
Jacqueline Anhalt Gallery
748½ North La Cienega Boulevard
Los Angeles, California 90069

Mailing Address
1225 Hill Street
Santa Monica, California 90405

Artist's Statement

"The continuous issue of my work is to alter and expand the traditional norms of art. The rich source of my imagery is the mystical learning and symbolism of the Kabbalah which challenges tradition and dogma and integrates art into the daily fabric of life. The context of my sculpture (in porcelain, bronze and handmade paper) is the relationship between the spiritual and the human, man's own image. Sculpture is particularly appropriate to these perceptions because it suggests transitions beyond the form."

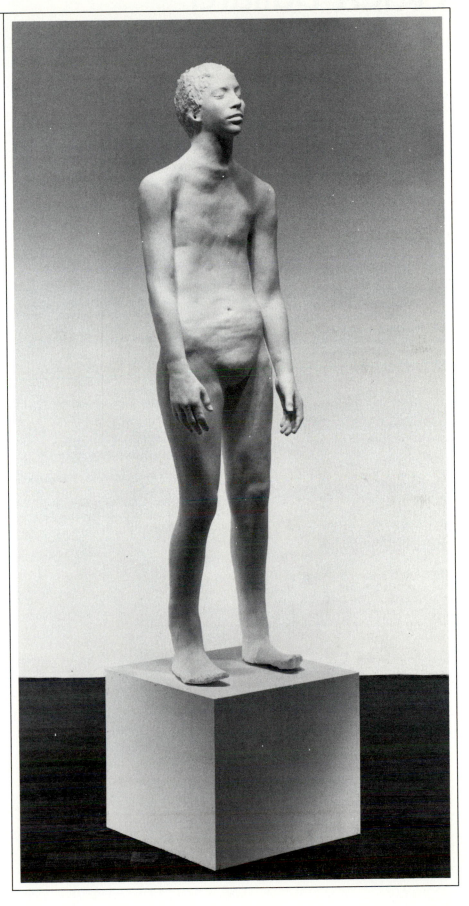

Edge of Change. 1982. Porcelain, 5'h. Photograph by Douglas M. Parker.

Helen Bullard

Born August 15, 1902 Elgin, Illinois

Education and Training
1921-25 University of Chicago, Chicago, Illinois
1958-60 Atelier 9, Washington, D.C.; study in wood sculpture with Alicia Neathery

Selected Individual Exhibitions
1955 Oak Ridge Library, Oak Ridge, Tennessee
1957 Young Women's Christian Association, Washington, D.C.
1961 Hammond Gardens, Birmingham, Alabama
1963 The Club, Birmingham, Alabama
1963 L. H. Ayres, Indianapolis, Indiana
1965 Oak Ridge Art Center, Oak Ridge, Tennessee
1966 Children's Museum, Nashville, Tennessee
1967-68 Frank H. McClung Museum, Knoxville, Tennessee
1968 Cumberland Playhouse Gallery, Crossville, Tennessee
1970 Children's Museum, Detroit, Michigan
1972 Tennessee State Museum, Nashville, Tennessee, catalog
1980 "National Institute of American Doll Artists Annual Convention," Sheraton Washington Hotel, Washington, D.C., retrospective
1981 The Toy Shoppe, Richmond, Virginia

Selected Group Exhibitions
1951-81 "Southern Highland Handicraft Guild Annual Exhibition," City Auditorium, Asheville, North Carolina; City Auditorium, Gatlinburg, Tennessee
1951-84 "National Institute of American Doll Artists Annual Convention," Major cities and hotels throughout the United States
1958-73 "Annual Dogwood Arts Festival," Frank H. McClung Museum, Knoxville, Tennessee
1963-73 "Annual Plum Nelly Clothesline Art Show," Town of Plum Nelly, Georgia
1964-76 "McClung Annual Exhibition," Frank H. McClung Museum, Knoxville, Tennessee

Selected Public Collections
Cumberland County Medical Center, Crossville, Tennessee
Tennessee State Museum, Nashville, Tennessee

Selected Private Collections
Dewees Cochran Doll Museum, Orwell, Vermont
Magge Head Kane, Nashville, Tennessee
Bernard Kaufmann, New York, New York
Herbert Simon, Little Rock, Arkansas
Alma Jones Waterhouse, West Hartford, Connecticut

Preferred Sculpture Media
Wood

Additional Art Field
Handcarved Dolls

Related Profession
Writer

Selected Bibliography
Bullard, Helen. *My People in Wood.* Cumberland, Maryland: Hobby House Press, 1984.

Mailing Address
Route 7 Pleasant Hill
Sparta, Tennessee 38583

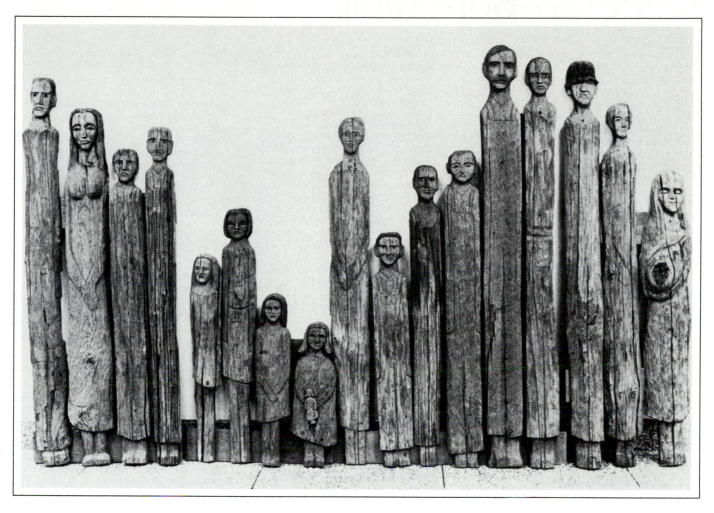

Old Mountain Family. 1970-1972. Chestnut slabs, 3'-6½'h x 18'w x 6"-9"d. Collection Tennessee State Museum, Nashville, Tennessee. Photograph by Terry Tomlin.

Artist's Statement

"My strong feeling for wood comes from having spent many years in the forested hills of the Cumberland Plateau. My taste for modern and abstract art and the simple planes of Egyptian and early Chinese sculpture has developed steadily since my first exposure to these forms in undergraduate work at the University of Chicago.

"I work primarily with old chestnut logs and slabs taken from the woods near my home. The dead trees have stood some sixty years since the blight killed them. The rain-scarred slabs are worn grey and full of striae and form a material full of special character for the portrayal of old mountain people. My objective is to bring this wood to life with a minimum of chisel and gouge cuts, dispensing with every unessential detail in the development of character."

Helen Bullard

Deborah Butterfield

(Husband John E. Buck)
Born May 7, 1949 San Diego, California

Education and Training

1972 B.A., Ceramics Emphasis, University of California, Davis, Davis, California

1972 Skowhegan School of Painting and Sculpture, Skowhegan, Maine

1973 M.F.A., Sculpture Emphasis, University of California, Davis, Davis, California; study with Robert Arneson, Roy De Forest and William T. Wiley

Selected Individual Exhibitions

1976 Madison Art Center, Madison, Wisconsin

1976, Zolla/Lieberman Gallery, Chicago,
79, Illinois
83

1978, O.K. Harris Works of Art, New York,
79, New York
82,
84

1978 Hanson Fuller Gallery, San Francisco, California

1981 Israel Museum, Jerusalem, Israel, catalog

1981 Museum of Art, Rhode Island School of Design, Providence, Rhode Island

1981 Galerie Rudolf Zwirner, Cologne, Germany, Federal Republic

1981- ARCO Center for the Visual Arts, Los
82 Angeles, California; Oklahoma State University, Stillwater, Oklahoma; University of Oklahoma, Norman, Oklahoma; Saint Louis Art Museum, St. Louis, Missouri; University of Colorado at Colorado Springs, Colorado Springs, Colorado; Walker Art Center, Minneapolis, Minnesota; Seattle Art Museum, Seattle, Washington; Boise Gallery of Art, Boise, Idaho; Utah Museum of Fine Arts, Salt Lake City, Utah, catalog

1982 Dallas Museum of Fine Arts, Dallas, Texas

1983 Southeastern Center for Contemporary Art, Winston-Salem, North Carolina

1983 San Antonio Art Institute, San Antonio, Texas

1983 Oakland Museum, Oakland, California

1983 Aspen Center for the Visual Arts, Aspen, Colorado

1983 Chicago Cultural Center, Chicago, Illinois

Selected Group Exhibitions

1973 "Statements," Oakland Museum, Oakland, California, catalog

1974 "Two Sculptors: Deborah Butterfield and Rudy Serra," University Art Museum, Berkeley, California

1976 "Midwest Painters and Sculptors," Krannert Art Museum, Champaign, Illinois, catalog

1977 "Seventy-Sixth Exhibition by Artists of Chicago and Vicinity," Art Institute of Chicago, Chicago, Illinois, catalog

1978 "The Presence of Nature," Whitney Museum of American Art, Downtown Branch, New York, New York

1979 "1979 Biennial Exhibition: Contemporary American Art," Whitney Museum of American Art, New York, New York, catalog

1979 "The Decade in Review: Selections from the 1970s," Whitney Museum of American Art, New York, New York

1979 "Eight Sculptors," Albright-Knox Art Gallery, Buffalo, New York, catalog

1980 "Clay Attitudes: Recent Works by 15 Americans," Queens Museum, Flushing, New York

1980 "Woodworks 1: New American Sculpture," Dayton Art Institute, Dayton, Ohio

1981 "Painting and Sculpture Today 1980," Indianapolis Museum of Art, Indianapolis, Indiana, catalog

1981 "The Animal Image: Contemporary Objects and the Beast," Renwick Gallery of the National Museum of American Art, Smithsonian Institution, Washington, D.C., catalog

1981 "A New Bestiary: Animal Imagery in Contemporary Art," Institute of Contemporary Art of the Virginia Museum of Fine Arts, Richmond, Virginia

1982 "The West as Art," Palm Springs Desert Museum, Palm Springs, California, catalog

1982 "First Wild West Sculpture Show," Alberta College of Art Gallery, Calgary, Alberta, Canada

1982 "100 Years of California Sculpture," Oakland Museum, Oakland, California, catalog

1982 "S/300 Sculpture/Tricentennial/1982," Philadelphia Art Alliance and Rittenhouse Square, Philadelphia, Pennsylvania, catalog

1982- "Forgotten Dimension. . . A Survey of
84 Small Sculpture in California Now," Traveling Exhibition, Fresno Arts Center, Fresno, California, catalog

1983- "Living with Art, Two: The Collection
84 of Walter and Dawn Clark Netsch," Miami University Art Museum, Oxford, Ohio; Snite Museum of Art, University of Notre Dame, Notre Dame, Indiana, catalog

1984 "A Celebration of American Women Artists Part II: The Recent Generation," Sidney Janis Gallery, New York, New York, catalog

1985 "Body and Soul: Aspects of Recent Figurative Sculpture," Traveling Exhibtion, Contemporary Arts Center, Cincinnati, Ohio, catalog

Selected Public Collections

Atlantic Richfield Company, Los Angeles, California

Dallas Museum of Art, Dallas, Texas

Walker Art Center, Minneapolis, Minnesota

Whitney Museum of American Art, New York, New York

Selected Private Collections

Mr. and Mrs. Edward A. Bergman, Chicago, Illinois

Mr. and Mrs. Ivan Karp, New York, New York

Mr. and Mrs. Sydney Lewis, Richmond, Virginia

Albert A. List Family Collection, Greenwich, Connecticut

Walter and Dawn Clark Netsch, Chicago, Illinois

Selected Awards

1977, Individual Artist's Fellowship,
80 National Endowment for the Arts

1980 John Simon Guggenheim Memorial Foundation Fellowship

Preferred Sculpture Media

Metal (welded) and Varied Media

Teaching Position

Adjunct Assistant Professor, Montana State University, Bozeman, Montana

Selected Bibliography

Clothier, Peter. "Review of Exhibitions Los Angeles: Deborah Butterfield at ARCO Center." *Art in America* vol. 70 no. 3 (March 1982) p. 155, illus.

Crowe, Ann Glenn. "Deborah Butterfield." *Artspace* (Fall 1982) vol. 6 no. 4 cover, pp. 13-15, illus.

Guenther, Bruce. *50 Northwest Artists: A Critical Selection of Painters and Sculptors Working in the Pacific Northwest.* San Francisco: Chronicle Books, 1983.

Lucie-Smith, Edward. *Art In The Seventies.* Ithaca, New York: Cornell University Press, 1980.

Morrison, C. L. "Reviews Chicago: Deborah Butterfield, Zolla/Lieberman Gallery." *Artforum* vol. 18 no. 2 (October 1979) p. 68, illus.

Gallery Affiliations

O.K. Harris Works of Art
383 West Broadway
New York, New York 10012

Fuller-Goldeen Gallery
228 Grant Avenue
San Francisco, California 94108

Zolla/Lieberman Gallery
365 West Huron Street
Chicago, Illinois 60610

Mailing Address

11229 Cottonwood Road
Bozeman, Montana 59715

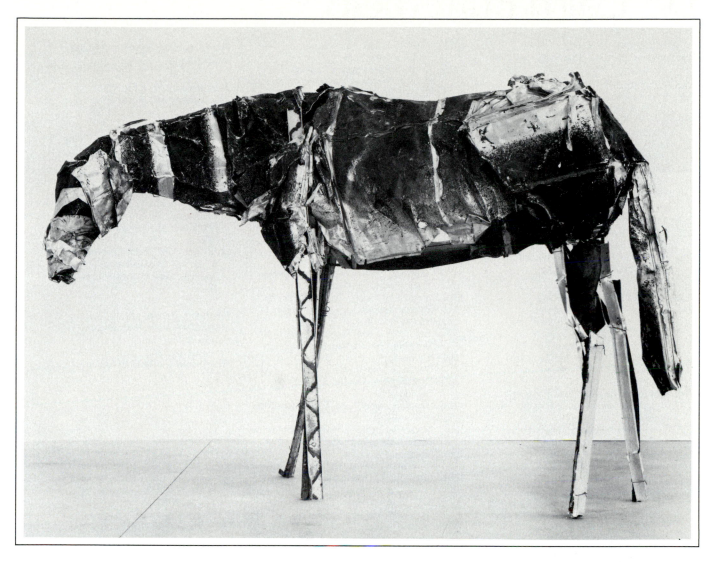

Horse No.6-82. 1982. Steel, aluminum and tar, 76"h
x 108"w x 41"d. Collection Dallas Museum of Art,
Dallas, Texas. Photograph by Jayme Schlepp.

Artist's Statement

"The horse has always been a vital influence
and actual presence in my life. I began using
the horse image in my art in 1973. The first
horses were romantic and naturalistic as a
way of suggesting the way horses look.
Gradually the work began to reveal more the
'inner' horse so that while the work *looked*
less horselike, it *felt* more horselike. The
confrontational and expressionistic nature of
the found materials represent the mental
imagery and temperament of each horse;
however, the horse as a metaphor for more
human concerns is intended to transcend
the materials."

Deborah Butterfield

W. Calman

née Wendy Lynn
Born February 23, 1947 New York, New York

Education and Training
1968 Studies Abroad Program, Tyler School of Art, Temple University, Rome, Italy
1969 B.A., Art History, University of Pittsburgh, Pittsburgh, Pennsylvania
1970 M.Ed., Art, Tyler School of Art, Temple University, Philadelphia, Pennsylvania
1972 M.F.A., Printmaking, Tyler School of Art, Temple University, Philadelphia, Pennsylvania

Selected Individual Exhibitions
1983 Northern Kentucky University, Highland Heights, Kentucky
1985 Art Center Association, The Water Tower, Louisville, Kentucky

Selected Group Exhibitions
1973 "Images: Dimensional, Movable, Transferable," Akron Art Institute, Akron, Ohio, catalog
1974 "University of Tennessee Faculty Exhibition," Frank H. McClung Museum, Knoxville, Tennessee, catalog
1974 "Photography Unlimited," Fogg Art Museum, Cambridge, Massachusetts, catalog
1974 "Calman and Reising," Frank H. McClung Museum, Knoxville, Tennessee
1974 "Seventeenth National Art Round-Up," Las Vegas Art Museum, Las Vegas, Nevada
1974 "Women's Show Photography '74," Cheltenham Art Centre, Cheltenham, Pennsylvania
1975 "New Photographics/75," Central Washington State College, Ellensburg, Washington

1975 "Flight," Hudson River Museum, Yonkers, New York
1975 "What is Photography?" Henry Art Gallery, Seattle, Washington
1976- "The Photographers' Choice,"
78 Traveling Exhibition," Addison House, Danbury, New Hampshire
1976 "Photo/Synthesis," Herbert F. Johnson Museum of Art, Ithaca, New York, catalog
1976 "Photographers' Choice," Witkin Gallery, New York, New York
1978 "Nine Artists," Fine Arts Museum, Wake Forest University, Winston-Salem, North Carolina
1979, "Faculty Exhibition," Indiana University
84 Art Museum, Bloomington, Indiana
1979 "Twenty-Second National Print and Drawing Exhibition," University Art Galleries, University of North Dakota, Grand Forks, North Dakota
1979 "Indiana University Fine Arts Faculty," Sheldon Swope Art Gallery, Terra Haute, Indiana
1980 "Sixteenth Joslyn Biennial," Joslyn Art Museum, Omaha, Nebraska, catalog
1980 "Potsdam Prints '80," Brainerd Art Gallery, Potsdam, New York
1981 "Indiana Five," Dayton Art Institute, Dayton, Ohio
1981 "Photo/National," Erie Art Center, Erie, Pennsylvania
1981 "Photo-Printmaking," Catskill Center for Photography, Woodstock, New York
1981 "Paper in Particular," Columbia College, Columbia, Missouri
1981 "Photofusion," Manhattan Center Gallery, Pratt Institute, New York, New York; Pratt Institute, Brooklyn, New York, catalog
1981 "Indiana Five + 1," Indianapolis Art League, Indianapolis, Indiana
1982 "Sights Unseen," A.I.R. Gallery, New York, New York; Bard College, Annandale-on-Hudson, New York
1984 "Off the Press: 16 Contemporary Photo- Printmakers," State University of New York College at New Paltz, New Paltz, New York, catalog
1984 "Invitational Print Exhibition," Kathryn Nash Gallery, University of Minnesota Twin Cities Campus, Minneapolis, Minnesota
1985 "National Invitational Print Exhibition," University of Tennessee Knoxville, Knoxville, Tennessee

Selected Awards
1979 Ford Foundation Grant, School of Fine Arts, Indiana University Bloomington, Bloomington, Indiana
1980 Summer Faculty Research Fellowship, Indiana University Bloomington, Bloomington, Indiana
1982 Creative Research Grant, Indiana University Bloomington, Bloomington, Indiana

Preferred Sculpture Media
Varied Media

Additional Art Fields
Photography and Printmaking

Teaching Position
Associate Professor, School of Fine Arts, Indiana University Bloomington, Bloomington, Indiana

Selected Bibliography
Newman, Thelma R. *Innovative Printmaking: The Making of Two-and-Three-Dimensional Prints and Multiples.* New York: Crown, 1977.
Wise, Kelly, ed. *The Photographers' Choice: A Book of Portfolios and Critical Opinion.* Danbury, New Hampshire: Addison House, 1975.

Mailing Address
Indiana University Bloomington
School of Fine Arts
Fine Arts Building
Bloomington, Indiana 47405

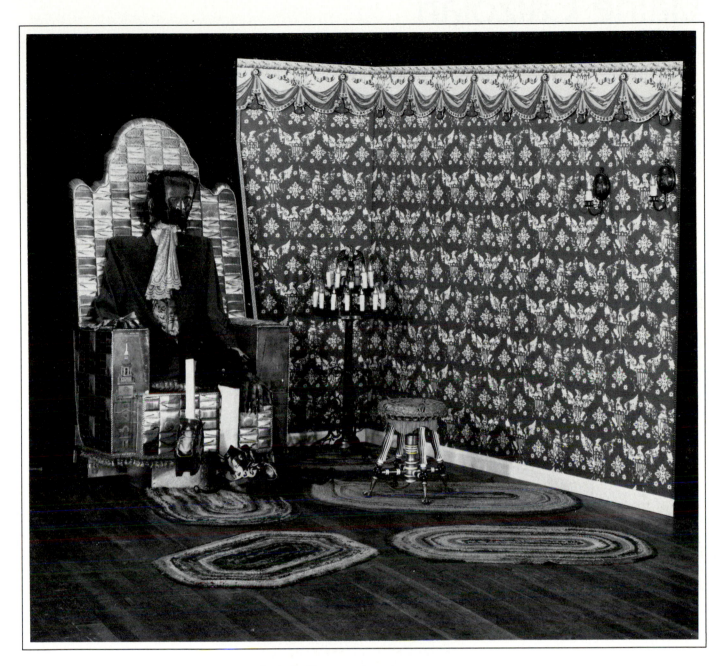

Franklinstein. 1981. Photo-mechanical construction
with movement and sound, 8'h x 23'w x 14'd.

Artist's Statement

"My work is pluralistic, deriving from different
traditions, containing diverse and sometimes
incongruous materials. An involvement with
photo-printmaking techniques for creating
the illusion of space on two-dimensional
surfaces led to my three-dimensional
constructions. Incorporating mechanics,
sound and other sensory stimuli, the viewer
is the missing element in the sculptural work
I create and the piece is always incomplete
without her or his active participation. Humor
is also a basic component, discerning the
spectator, inviting a direct, uninhibited
response."

W. Calman

Elaine Calzolari

Born December 30, 1950 Albertson, New York

Education and Training
1972 Sculpture in the Quarries, Sarah Lawrence College, Lacoste, France; study in stone sculpture with Diska
1972 Study in sculpture with Louise Kramer, New York, New York
1973 B.A., Sculpture, Hofstra University, Hempstead, New York; study with David Jacobs
1973 Additional study in sculpture with Diska, Lacoste, France
1976 Further study in sculpture with Diska, Lacoste, France

Selected Individual Exhibitions
1979 St. Charles on Wazee, Denver, Colorado
1985 Sebastian-Moore Gallery, Denver, Colorado

Selected Group Exhibitions
1977 "Superior Small Sculpture Competition," Sculpture Gallery, San Diego, California
1977 "Drawing and Sculpture Competition," Kutztown State College, Kutztown, Pennsylvania
1978 "Selections from the Santa Fe Festival of the Arts, Western States Arts Foundation," United Bank of Denver, Denver, Colorado

1978 "Sculpture Exhibit," Arvada Center for the Arts and Humanities, Denver, Colorado
1979 "Fifth Annual Outdoor Sculpture Exhibition," Shidoni Gallery, Tesuque, New Mexico
1979 "Colorado Women in the Arts," Arvada Center for the Arts and Humanities, Denver, Colorado, catalog
1979 "Summer Group Exhibition," Edward Thorp Gallery, New York, New York
1979 "Invitational Group Drawing & Sculpture Exhibit," Lyle True Gallery, Colorado Women's College, Denver, Colorado
1980 "Sixth Colorado Annual," Denver Art Museum, Denver, Colorado, catalog
1980 "Sculpture in the Park," Boulder Center for the Visual Arts, Boulder, Colorado
1981, "Annual Outdoor Sculpture Exhibition,"
82 Shidoni Gallery, Tesuque, New Mexico, catalog
1982 "Colorado: State of the Arts, Outdoor Sculpture," Denver Art Museum, Denver, Colorado
1983 "The Four State Survey, Santa Fe Festival of the Arts," Sweeney Convention Center, Santa Fe, New Mexico, catalog
1984 "Collaboration at the Station: Art and Architecture for the MBTA," Massachusetts Transportation Building, Boston, Massachusetts, catalog
1985 "Station Modernization Program at the MBTA, Arts On The Line," Federal Reserve Bank Gallery, Boston, Massachusetts

Selected Public Collections
Denver Art Museum, Denver, Colorado
Massachusetts Bay Transportation Authority, Quincy-Adams Station, Boston, Massachusetts
Museum of Transportation, Boston, Massachusetts
Piper, Jaffray and Hopwood, Minneapolis, Minnesota
Rocky Mountain Energy Company, Broomfield, Colorado
University of Colorado Medical School, Denver, Colorado

Selected Private Collections
George A. Anderman, Denver, Colorado
Dr. Patricia DeCoursey, Columbia, South Carolina
Frederick R. Mayer, Denver, Colorado
Jesus Bautista Moroles, Rockport, Texas
James Wright, Dallas, Texas

Selected Award
1974 Individual Artist's Fellowship, Eagle Valley Arts Council, Vail, Colorado

Preferred Sculpture Media
Stone and Varied Media

Mailing Address
1282 South Pearl Street
Denver, Colorado 80210

Artist's Statement

"I love to chop rocks. I love to work so hard that all my muscles ache and my knuckles bleed and I feel so drained I know I have done enough. And in that drained state I feel completely full. An object exists apart from me with its own time, weight, space and mass and has become its own thing. This enormous effort is so stabilizing, a release from all the ego baggage one carries about."

Elaine Calzolari

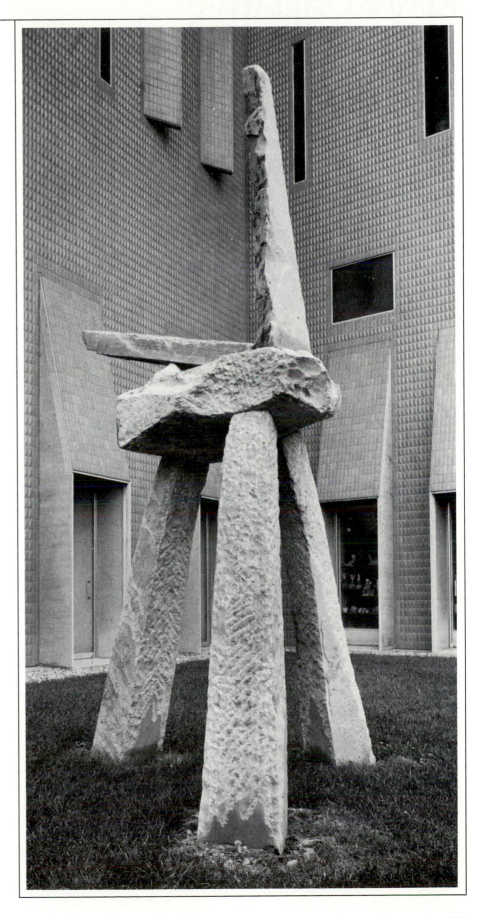

Tundra Walker IV. 1982. Stone, 13'h x 7'w x 7'd. Installation view 1982. "Colorado: State of the Arts, Outdoor Sculpture," Denver Art Museum, Denver, Colorado. Courtesy Denver Art Museum, Denver, Colorado.

Rhys Caparn

(Husband Herbert Johannes Steel)
Born July 28, 1909 Onteora Park, New York

Education and Training
1927- Bryn Mawr College, Bryn Mawr,
29 Pennsylvania
1929- École Artistique des Animaux, Paris,
30 France; study with Édouard Navellier
1931- Alexander Archipenko Art School,
33 New York, New York

Selected Individual Exhibitions
1933, Delphic Studios, New York, New York,
35 catalog
1944, Wildenstein & Company, New York,
47 New York
1955 Dartmouth College, Hanover, New
Hampshire
1956 Munson-Williams-Procter Institute,
Utica, New York
1956, Meltzer Gallery, New York, New York
59,
60
1961 Riverside Museum, New York, New
York, retrospective and catalog
1970 La Boetie Gallery, New York, New
York, catalog
1973 Bertha Schaefer Gallery, New York,
New York
1977 Bethel Gallery, Bethel, Connecticut,
retrospective
1977 Washington Art Gallery, Washington
Depot, Connecticut
1980 Phyllis Weil & Company, New York,
New York, retrospective
1984 Gallery Felicie, New York, New York,
retrospective

Selected Group Exhibitions
1940, "Sculpture Exhibition," Fairmount Park
49 Art Association, Philadelphia,
Pennsylvania
1941 "Fifteen Sculptors," Traveling
Exhibition, Museum of Modern Art,
New York, New York
1941, "Annual Exhibition: Contemporary
53, American Sculpture," Whitney
54, Museum of American Art, New
56, York, New York, catalog
60
1950 "New York Six," Musée du Petit Palais,
Paris, France
1951- "American Sculpture," Metropolitan
52 Museum of Art, New York, New York,
catalog
1952- "Annual Exhibition of Painting and
64 Sculpture," Pennsylvania Academy of
the Fine Arts, Philadelphia,
Pennsylvania, catalog

1956 "The Figure in Sculpture,"
Munson-Williams-Proctor Institute,
Utica, New York
1956 "Sculpture of the Twentieth Century,"
Silvermine Guild of Artists, New
Canaan, Connecticut
1956 "Contemporary Sculpture," Joe & Emily
Lowe Art Gallery, Syracuse, New York
1958 "American Sculpture Today," Virginia
Museum of Fine Arts, Richmond,
Virginia
1958 "Animals in Sculpture by Three
Americans," American Museum of
Natural History, New York, New York
1959 "Friends of the Whitney Museum,"
Whitney Museum of American Art,
New York, New York
1960 "Aspects de la Sculpture Américaine,"
Galerie Claude Bernard, Paris, France
1960 "New Sculpture Group: Guests and
Members Fifth Exhibition," Stable
Gallery, New York, New York, catalog
1965 "Women Artists of America
1707-1964," Newark Museum, Newark,
New Jersey, catalog
1968 "An Exhibition of Contemporary
Painting and Sculpture," National
Institute of Arts and Letters, New
York, New York, catalog
1972 "Women: A Historical Survey of Works
by Women Artists," Salem Fine Arts
Center, Winston-Salem, North
Carolina; North Carolina Museum of
Art, Raleigh, North Carolina, catalog
1974 "Woman's Work: American Art 1974,"
Museum of the Philadelphia Civic
Center, Philadelphia, Pennsylvania,
catalog
1976 "Exhibition of Works by Candidates for
Art Awards," American Academy of
Arts and Letters and the National
Institute of Arts and Letters, New
York, New York, catalog
1980 "Federation of Modern Painters and
Sculptors," Contemporary Arts Gallery,
New York, New York
1981 "Three Connecticut Abstractionists:
Rhys Caparn, Louis Schanker and
Seymour Fogel," Stamford Museum
and Nature Center, Stamford,
Connecticut
1983 "Forty-Third Anniversary Exhibition
Federation of Modern Painters and
Sculptors," City Gallery, New York,
New York, catalog

Selected Public Collections
Barnard College, New York, New York
Brooklyn Botanic Garden, Brooklyn, New
York
Chrysler Museum, Norfolk, Virginia
Colorado Springs Fine Arts Center, Colorado
Springs, Colorado
Connecticut College, New London,
Connecticut
Corcoran Gallery of Art, Washington, D.C.
Dartmouth College, Hanover, New Hampshire
Detroit Institute of Arts, Detroit, Michigan
Elvehjem Museum of Art, Madison,
Wisconsin

Museum of The City of New York, New York
North Carolina State Museum, Raleigh, North
Carolina
Rose Art Museum, Brandeis University,
Waltham, Massachusetts
Saint Louis Art Museum, St. Louis, Missouri
Texas Woman's University, Mary Evelyn
Blagg Huey Library, Denton, Texas
University of Washington, Seattle,
Washington
Whitney Museum of American Art, New York,
New York
Yale University Art Gallery, New Haven,
Connecticut

Selected Private Collections
Mr. and Mrs. Louis Beck, New York, New
York
Dr. and Mrs. Richmond C. Hubbard, Bethel,
Connecticut
Mrs. R. Sturgis Ingersoll, Philadelphia,
Pennsylvania
Morton D. May, St. Louis, Missouri
Mr. and Mrs. Benjamin Wintringham, London,
Great Britain

Selected Awards
1943 Anonymous Prize for Sculpture,
"National Association of Women
Artists Annual Exhibition," New York,
New York, catalog
1960, National Medal of Honor for Sculpture,
61 "National Association of Women
Artists Annual Exhibition," National
Academy of Design, New York, New
York, catalog

Preferred Sculpture Media
Metal (cast) and Stone

Additional Art Field
Drawing

Selected Bibliography
Brummé, C. Ludwig. Contemporary American
Sculpture. New York: Crown, 1948.
Hale, Robert Beverly. Rhys Caparn. Danbury,
Connecticut: Retrospective Press, 1972.
Longman, Robin. "Rhys Caparn: The
Eloquence of Form." American Artist vol.
45 no. 469 (August 1981) pp. 60-65, 86-88,
92-93, illus.
Papers included in the Archives of American
Art, Smithsonian Institution, New York,
New York.

Mailing Address
Taunton Hill Road Route 1
Newtown, Connecticut 06470

Artist's Statement

"Watching my father work in his garden as a small girl, I became aware of the basic dignity of natural life and natural forms. The idea of becoming a practising artist occurred to me while still at college. In my training as a sculptor, I learned respect for the material of which a form is composed and the importance of exploiting the qualities inherent to the material.

"In the early years, I explored the basic forms and characteristics of the animal, the shape of the bovine or the bird in flight, as a constant search for the connecting link between the animal and the natural landscape. The later works slowly transcended into landscape works of the earth itself—the relationship of the immovable forms of nature to the finite forms of architecture and the infinite forms of space."

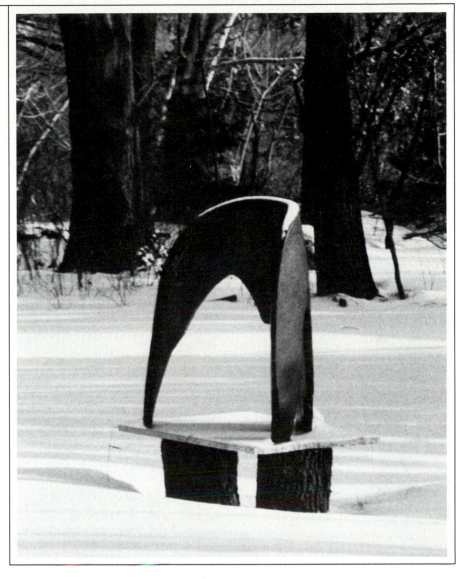

Bird from Without. 1977. Bronze, 3'6"h x 3'w x 3'd.

Elaine Carhartt

née Linda Elaine
(Husband John Alan Reveley)
Born November 5, 1951 Grand Junction,
 Colorado

Education and Training
1975 B.F.A., Sculpture, Colorado State
 University, Fort Collins, Colorado;
 study with John Berland

Selected Individual Exhibitions
1977, Aarnum Gallery, Pasadena, California
 79
1981 Gallery Six, Los Angeles County
 Museum of Art, Los Angeles,
 California
1982, Asher/Faure Gallery, Los Angeles,
 84 California

Selected Group Exhibitions
1980 "The Magical Mystery Tour," Los
 Angeles Municipal Art Gallery, Los
 Angeles, California
1980 "Elaine Carhartt, Kathryn Halbower
 and Dale Haven Loy," Asher/Faure
 Gallery, Los Angeles, California
1982 "Pacific Currents/Ceramics 1982," San
 Jose Museum of Art, San Jose,
 California, catalog

1982 "Painted Sculpture," Los Angeles
 Municipal Art Gallery, Los Angeles,
 California
1983 "Young Talent Awards," Los Angeles
 County Museum of Art, Los Angeles,
 California
1983 "Ceramic Echoes: Historical
 References in Contemporary
 Ceramics," Nelson-Atkins Museum of
 Art, Kansas City, Missouri, catalog

Selected Public Collection
Los Angeles County Museum of Art, Los
 Angeles, California

Selected Private Collections
Betty Asher, Los Angeles, California
Gene and Betty Burton, Los Angeles,
 California
Monte and Betty Factor, Los Angeles,
 California

Selected Award
1980 New Talent Award, Los Angeles
 County Museum of Art, Los Angeles,
 California

Preferred Sculpture Media
Clay and Varied Media

Selected Bibliography
"Elaine Carhartt." *Ceramics Monthly* vol. 26
 no. 6 (June 1978) p. 119, illus.
McCloud, Mac. "Elaine Carhartt." *American
 Ceramics* vol. 2 no. 1 (Winter 1983) pp.
 50-51, illus.
"Portfolio: Elaine Carhartt." *American Craft*
 vol. 41 no. 3 (June-July 1981) p. 41, illus.
Wortz, Melinda. "The Nation: Los Angeles,
 White Writing and Pink Horses." *Art News*
 vol. 79 no. 9 (November 1980) p. 163, illus.

Gallery Affiliation
Asher/Faure Gallery
612 North Almont Drive
Los Angeles, California 90069

Mailing Address
1641 Fiske Avenue
Pasadena, California 91104

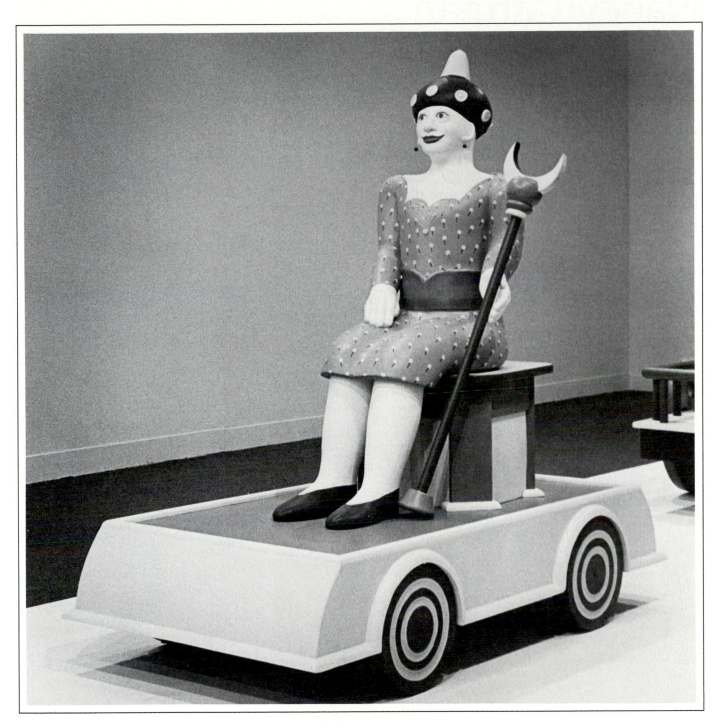

Queen (detail of *Parade*). 1980. Ceramic and wood painted with acrylic, 53″h. Installation view 1981. Gallery Six, Los Angeles County Museum of Art, Los Angeles, California. Collection Los Angeles County Museum of Art, Los Angeles, California. Courtesy Asher/Faure Gallery, Los Angeles, California.

Artist's Statement

"I strive in my work for the middle ground between imagination and intellect. If I depend entirely upon intangible thoughts without sustaining my imagination with concrete images, I find my work becomes a mechanical repetition. On the other hand, strict intellectual interpretation of an idea produces stiff, derivative work. I have experienced both extremes with unhappy results.

"I do find being interested in many things helps immensely in the development of ideas. There are periods when I can be completely absorbed studying pre-Columbian and Summerian art or reading biblical and Latin American folklore until my work suffers from lack of concentration.

"I handbuild my pieces without supports or armatures, using engobes and paint for the final finish. I am beginning to see cycles of the same themes recurring in my work. It is a very interesting way to spend one's life."

Elaine Carhartt

Nancy Carman

née Nancy Jean
Born November 7, 1950 Tucson, Arizona

Education and Training
1968- American River College, Carmichael,
69 California
1972 B.A., Art, University of California,
Davis, Davis, California
1972- San Francisco Art Institute,
74 San Francisco, California
1976 M.F.A., Ceramic Sculpture, University
of Washington, Seattle, Washington;
study with Ed Blackburn, Howard
Kottler and Patti Warashina

Selected Individual Exhibitions
1981, Helen Drutt Gallery, Philadelphia,
83, Pennsylvania
85

Selected Group Exhibitions
1976 "Thirty-Second Annual Ceramics
Exhibition," Lang Art Gallery Scripps
College, Claremont, California
1976 "Northwest Eccentric Art," Cheney
Cowles Memorial Museum, Spokane,
Washington, catalog
1977 "Clay and Glass '77," Eutectic Gallery,
Emeryville, California
1977 "Fifty-Second Crocker-Kingsley Annual
Open Exhibition," E. B. Crocker Art
Gallery, Sacramento, California,
catalog
1977 "Ceramic Sculpture Purchase Award
Show," Boehm Gallery, Palomar
College, San Marcos, California
1977 "Richmond Designer Craftsmen
Exhibition," Richmond Art Center,
Richmond, California, catalog
1977 "Overglaze Imagery, Cone 019-016,"
Visual Arts Center, California State
University Fullerton, Fullerton,
California, catalog
1977 "Nancy Carman, John Toki and Janet
Lowe," Dominican College of San
Rafael, San Rafael, California

1978 "Ceramic Potpourri," Anna Gardner
Gallery, Stinson Beach, California
1978 "Thirty-Second Annual San Francisco
Art Festival," Civic Center Plaza, San
Francisco, California
1978 "Clay Bricks," Crossman Gallery,
University of Wisconsin-Whitewater,
Whitewater, Wisconsin
1978 "Young Americans: Clay/Glass,"
Traveling Exhibition, Museum of
Contemporary Crafts, New York, New
York, catalog
1980 "Westwood Clay National 1980," Otis
Art Institute, Los Angeles, California,
catalog
1980 "Viewpoint '80," The Museum, Texas
Tech University, Lubbock, Texas,
catalog
1980 "Contemporary Ceramics: A Response
to Wedgwood," Traveling Exhibition,
Museum of the Philadelphia Civic
Center, Philadelphia, Pennsylvania
1980 "Robert L. Pfannebecker Collection: A
Selection of Contemporary American
Crafts," Moore College of Art,
Philadelphia, Pennsylvania, catalog
1981 "16 Bay Area Ceramicists," Anna
Gardner Gallery, Stinson Beach,
California
1981 "Faculty Exhibition," University Gallery,
California State University Hayward,
Hayward, California
1982 "Animal Imagery," Meyer Breier Weiss
Gallery, San Francisco, California
1982 "Imbued Clay Figures," Antonio Prieto
Memorial Gallery, Mills College,
Oakland, California
1983 "An Exhibition in Honor of Lenore
Tawney, Honor Award Recipient,
Women's Caucus for Art," Helen Drutt
Gallery, Philadelphia, Pennsylvania
1983 "American Clay Artists: Philadelphia
'83," Clay Studio, Philadelphia,
Pennsylvania, catalog
1983 "Self Images," Sharpe Gallery, New
York, New York
1983 "SOUP SOUP Beautiful SOUP!"
Campbell Museum, Camden, New
Jersey, catalog
1984 "American Ceramics," Galerie Ferrer,
Berlin, Germany, Federal Republic
1984 "1984 Ceramic Visions," Detroit Gallery
of Contemporary Crafts, Detroit,
Michigan
1984 "A Passionate Vision: Contemporary
Ceramics from the Daniel Jacobs
Collection," DeCordova and Dana
Museum and Park, Lincoln,
Massachusetts

Selected Public Collection
Henry Art Gallery Seattle, Washington

Selected Private Collections
Jay Cooper, Phoenix, Arizona
Daniel Jacobs Collection, New York, New
York
Robert L. Pfannebecker Collection,
Lancaster, Pennsylvania

Selected Award
1979 Individual Craftsman's Fellowship,
National Endowment for the Arts

Preferred Sculpture Media
Clay

Additional Art Field
Drawing

Related Professions
Visiting Artist and Lecturer

Selected Bibliography
Harrington, LaMar. *Ceramics in the Pacific
Northwest: A History.* Seattle: University of
Washington Press, 1979.
Kester, Bernard. "Exhibitions: Los Angeles."
Craft Horizons vol. 38 no. 2 (April 1978)
pp. 66-68.
Levin, Elaine. "China Painting—Past and
Present." *Artweek* vol. 8 no. 42 (December
10, 1977) p. 5.
"Nancy Carman." *Ceramics Monthly* vol. 29
no. 9 (November 1981) pp. 56-57, illus.
Wechsler, Susan. *Low-Fire Ceramics: A New
Direction in American Clay.* New York:
Watson-Guptill, 1981.

Gallery Affiliation
Helen Drutt Gallery
1721 Spruce Street
Philadelphia, Pennsylvania 19103

Mailing Address
2325 3 Street-300
San Francisco, California 94107

Artist's Statement

"I tend to devote my energies to each piece individually, sometimes working on completely different types of forms from one piece to the next: from small narrative and landscape scenes to large, close-up figurative busts. Although in a different context, some themes persist: recurring images of water, repeated use of certain angles and curves, stances and gestures.

"I work from preliminary sketches and continue resketching until I have a definite idea of the image. In some way, I feel that the images are fortuitous, inspired perhaps by unconscious archetypal forms whose symbols and configurations signify aspects of energy and growth."

Nancy Carman

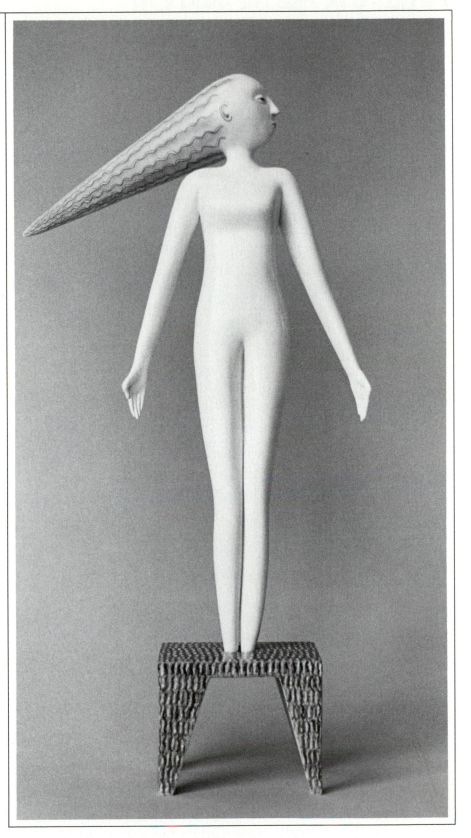

The Feminine. 1982. Low fire clay, glazes and china paint, 21½"h x 12"w x 4"d.

Maryrose Carroll

née Maryrose Finnegan Groth
(Husband Paul Carroll)
Born June 12, 1944 Chicago, Illinois

Education and Training
1968 B.F.A., Ceramic Sculpture, University
of Illinois at Urbana-Champaign,
Urbana, Illinois; study with Tony
Packard, Don Pilcher and Art
Sinsabaugh
1974 M.A., Sculpture, Illinois State
University, Normal, Illinois; study with
Keith Knoblock and Barry Tinsley

Selected Individual Exhibitions
1974 Gallery III, Center for the Visual Arts
Gallery, Illinois State University,
Normal, Illinois
1976 Clark Arts Center Gallery, Rockford
College, Rockford, Illinois
1977 Marianne Deson Gallery, Chicago,
Illinois
1978- Northwestern University, Chicago
80 Campus, Chicago, Illinois
1979 N.A.M.E. Gallery, Chicago, Illinois
1982 Hewlett Gallery, Carnegie-Mellon
University, Pittsburgh, Pennsylvania
1983, Klein Gallery, Chicago, Illinois
84

Selected Group Exhibitions
1969- "Young Americans," Traveling
72 Exhibition, Museum of Contemporary
Crafts, New York, New York
1975, "Illinois Invitational," Illinois State
82 Museum, Springfield, Illinois, catalog
1975 "'75 Sculpture Show," Union League
Club, Chicago, Illinois

1976 "Women Artists: Here and Now,"
O'Shaughnessy Gallery, University of
Notre Dame, Notre Dame, Indiana,
catalog
1976 "Painting and Sculpture Today 1976,"
Indianapolis Museum of Art,
Indianapolis, Indiana, catalog
1976- "The Chicago Connection," Traveling
77 Exhibition, E. B. Crocker Art Gallery,
Sacramento, California, catalog
1977 "The Challenge of New Ideas:
Contemporary Chicago Sculpture,"
Kalamazoo Institute of Arts,
Kalamazoo, Michigan, catalog
1977 "Edinburgh Arts '77 Exhibition," Fruit
Market Gallery, Edinburgh, Scotland
1978 "Chicago Abstractionists:
Romanticized Structures," Traveling
Exhibition, University of
Missouri-Kansas City Art Gallery,
Kansas City, Missouri, catalog
1978 "9' x 9' Invitational Group Show,"
N.A.M.E. Gallery, Chicago, Illinois
1978 "Outdoor Sculpture," Ewing Castle,
Illinois State University, Normal, Illinois
1978- "Sculpture II," Traveling Exhibition,
79 Illinois Arts Council, Chicago, Illinois
1979 "Illinois % for Art Dedication Exhibition,
State of Illinois Capitol Development
Board," Department of Transportation
Grounds, Springfield, Illinois, catalog
1981 "City Sculpture," Chicago Cultural
Center, Chicago, Illinois
1981 "Chicago International Art Exposition
1981," Navy Pier, Chicago, Illinois
(Represented by Young-Hoffman
Gallery, Chicago, Illinois), catalog
1982 "Selections from the Dennis Adrian
Collection," Museum of Contemporary
Art, Chicago, Illinois, catalog
1983 "Chicago Sculpture International/Mile
2," Navy Pier, Chicago, Illinois
(Represented by Young-Hoffman
Gallery, Chicago, Illinois), catalog
1983- "Living with Art, Two: The Collection
84 of Walter and Dawn Clark Netsch,"
Miami University Art Museum, Oxford,
Ohio; Snite Museum of Art, University
of Notre Dame, Notre Dame, Indiana,
catalog
1983- "Chicago: Some Other Traditions,"
86 Traveling Exhibition, Madison Art
Center, Madison, Wisconsin, catalog
1984 "Artists Call," Rhona Hoffman Gallery,
Chicago, Illinois
1985 "Sculpture Exhibition," Hyde Park Art
Center, Chicago, Illinois

Selected Public Collections
Chicago Union League, Chicago, Illinois
Dayton Art Institute, Dayton, Ohio
Governors State University, Park Forest
South, Illinois
Illinois State Museum, Springfield, Illinois
Museum of Contemporary Art, Chicago,
Illinois
The State Journal-Register, Springfield, Illinois
Triton College, River Grove, Illinois

Selected Private Collections
Dennis Adrian Collection, Chicago, Illinois
Samuel and Blanche Koffler, Chicago, Illinois
Walter and Dawn Clark Netsch, Chicago,
Illinois
David C. Ruttenberg, Chicago, Illinois

Selected Award
1980 Individual Artist's Fellowship, Illinois
Arts Council

Preferred Sculpture Media
Metal (welded) and Varied Media

Teaching Position
Sculptor in Residence, Northwestern
University, Evanston, Illinois

Selected Bibliography
Bach, Ira J. and Mary Lackritz Gray. *A Guide
to Chicago's Public Sculpture.* Chicago:
University of Chicago Press, 1983.

Gallery Affiliation
Klein Gallery
356 West Huron Street
Chicago, Illinois 60610

Mailing Address
1682 North Ada Street
Chicago, Illinois 60622

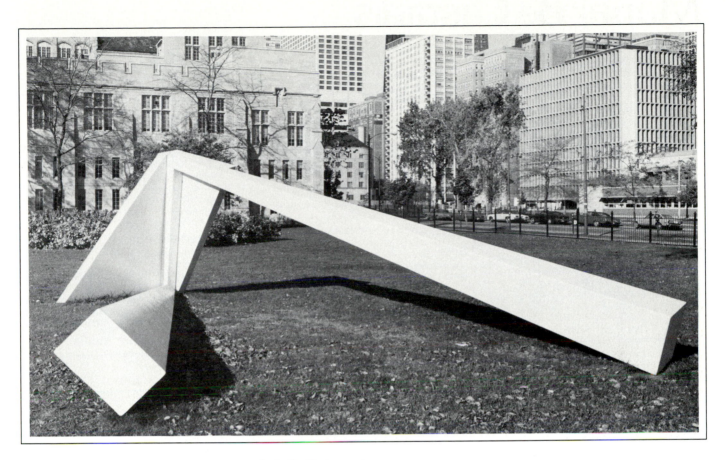

Pioneer. 1978. CorTen, 8'h x 20'w x 25'd. Installation view 1978-1980. Northwestern University, Chicago Campus, Chicago, Illinois. Collection Triton College, River Grove, Illinois.

Artist's Statement

"The intent of my angular, diminishing and expanding forms is to immediately engage the viewer in their dynamic displacement in space; the painted metal beam-like shapes serve as metaphors and visualizations of compacted energy. I prefer to design for a specific architectural site integrating my work with the character of the natural environment and geographical or historical referents.

"While my work began with abstract concerns, I have been steadily including box-like objects, doors and windows to suggest a different awareness. Cutting metal, welding, climbing a scaffold, planning and dreaming about my work are all enjoyable. The only necessity I demand is that my work continue to grow and change."

Maryon Carroll

Muriel B. Castanis

née Muriel Julia Brunner
(Husband George Castanis)
Born September 27, 1926 New York, New York

Selected Individual Exhibitions
1968 Ruth White Gallery, New York, New York
1972 Caravan House, New York, New York
1974 James Yu Gallery, New York, New York
1978 Rutgers University, Douglass College, New Brunswick, New Jersey
1980, O. K. Harris Works of Art, New York, New York
83,
85
1981 O. K. Harris West, Scottsdale, Arizona
1982 Maurice M. Pine Free Public Library, Fairlawn, New Jersey
1984 Michael Berger Gallery, Pittsburgh, Pennsylvania
1984- Graduate Center, City University of
85 New York, City College, New York, New York
1985 Tweed Gallery, New York, New York

Selected Group Exhibitions
1968, "Exhibition of Provincetown Art
69 Association," Provincetown Art Association and Museum, Provincetown, Massachusetts
1971 "Bathroom Environment," Hundred Acres Gallery, New York, New York
1972 "First Annual Sculpture Exhibition," Hundred Acres Gallery, New York, New York
1972 "Feminine Perceptions," Upton Hall Gallery, State University of New York at Buffalo, Buffalo, New York
1972 "Eats: An Exhibition of Food in Art," Emily Lowe Gallery, Hempstead, New York
1972 "Summer Invitational," O. K. Harris Works of Art, New York, New York
1972 "Unmanly Art," Suffolk Museum, Stony Brook, New York, catalog
1972 "Inaugural Exhibition," Women's Interart Center, New York, New York
1972 "Women in the Arts," Hillwood Art Gallery, C. W. Post Center of Long Island University, Greenvale, New York
1973 "Women Choose Women," New York Cultural Center, New York, New York, catalog
1973 "Feminist Symposium and Art Exhibition," Sarah Lawrence College, Bronxville, New York
1973 "Artvance," Loeb Student Center, Contemporary Arts Gallery, New York University, New York, New York
1974 "Contemporary Reflections 1973-1974," Aldrich Museum of Contemporary Art, Ridgefield, Connecticut, catalog

1974 "Point of View," Portland Museum of Art, Portland, Maine, catalog
1975 "Plastics," Brainerd Art Gallery, Potsdam, New York
1975 "Report from SoHo," Grey Art Gallery and Study Center, New York University, New York, New York
1976 "New York Artists," Fine Arts Gallery, Milwaukee, Wisconsin
1976 "Ten Artists," Landmark Gallery, New York, New York
1977 "Maquettes for Large Sculpture," Monique Knowlton Gallery, New York, New York
1977 "Sculpture," Northeastern University, Boston, Massachusetts
1977 "Gallery Artists," Monique Knowlton Gallery, New York, New York
1978 "Sacred Image: East and West," Cathedral Church of St. John the Divine, New York, New York
1979 "Odisea de Icaro, Icarus Odyssey," Centro de Arte Moderno, Guadalajara, Jalisco, México
1979 "Women and Autobiography," Rutgers University, Douglass College, New Brunswick, New Jersey
1980 "Duane Hansen and Muriel Castanis," O. K. Harris Works of Art, New York, New York
1981 "Wave Hill 1981: Tableaux," Wave Hill, Bronx, New York, catalog
1981 "Human Forms," Moravian College, Bethlehem, Pennsylvania
1982 "Gallery Exhibition," Myers Fine Arts Gallery, State University of New York College at Plattsburgh, Plattsburgh, New York
1983 "The Great Illusionists," Ben Shahn Gallery, William Paterson College of New Jersey, Wayne, New Jersey
1983 "Material, Illusion/Unlikely Material," Taft Museum, Cincinnati, Ohio, catalog
1983 "O. K. Harris Artists," Royal Palm Gallery, Palm Beach, Florida
1984 "Discover Linen," BFM Gallery, New York, New York; Parsons School of Design, New York, New York
1984 "The David Bermant Collection: Color, Light, Motion," Wadsworth Atheneum, Hartford, Connecticut, catalog
1984 "Games of Deception: When Nothing Is As It Appears," Shirley Goodman Resource Center, Fashion Institute of Technology, New York, New York
1984- "Bill Traylor and Muriel Castanis,"
85 Acme Art, San Francisco, California
1985 "Artists of O. K. Harris," Helander-Rubinstein Gallery, Palm Beach, Florida
1985 "The Classic Tradition in Recent Painting and Sculpture," Aldrich Museum of Contemporary Art, Ridgefield, Connecticut, catalog

Selected Public Collections
Gerald D. Hines Interests, 580 California Street, San Francisco, California

New School for Social Research, New York, New York

Selected Private Collections
The FORBES Magazine Collection, New York, New York
Gordon Hanes, Winston-Salem, North Carolina
Mr. and Mrs. Sydney Lewis, Richmond, Virginia
Martin Z. Margulies, Miami, Florida
Mr. and Mrs. Sidney Shapiro, New York, New York and Westport, Connecticut

Selected Awards
1977 Louis Comfort Tiffany Foundation Grant
1979 Award of Distinction, "Twenty-Seventh Biennial Exhibition," Virginia Museum of Fine Arts, Richmond, Virginia, catalog

Preferred Sculpture Media
Fiber

Selected Bibliography
Brown, Gordon. "In the Galleries." *Arts Magazine* vol. 42 no. 8 (June/Summer 1968) p. 61.
Dreiss, Joseph. "Arts Reviews: Muriel Castanis." *Arts Magazine* vol. 49 no. 6 (February 1975) pp. 16-17, illus.
Glueck, Grace. "An Outdoor-Sculpture Safari Around New York." *The New York Times* (Friday, August 7, 1981) pp. C1, C20, illus.
Glueck, Grace. "Art Views: When Today's Artists Raid the Past." *The New York Times* (Sunday, July 21, 1985) section two, pp. H29, H31, illus.
Marter, Joan M. "Muriel Castanis." *Arts Magazine* vol. 52 no. 8 (April 1978) p. 23, illus.

Gallery Affiliation
O. K. Harris Works of Art
383 West Broadway
New York, New York 10012

Mailing Address
O. K. Harris Works of Art
383 West Broadway
New York, New York 10012

Artist's Statement

"Consider how we accept cloth only in relation to firmer structures—draped over a chair, a table, a grouping of boxes or even the human form. Freezing the cloth into rigidity with liquid resins enables me to remove these distractions. Here time and motion stop. Space and light reveal the cloth directed by illusion without alibi. In this state, the subject becomes historic; movement is released from purpose. Cloth itself becomes both reference and subject and finally subject and form."

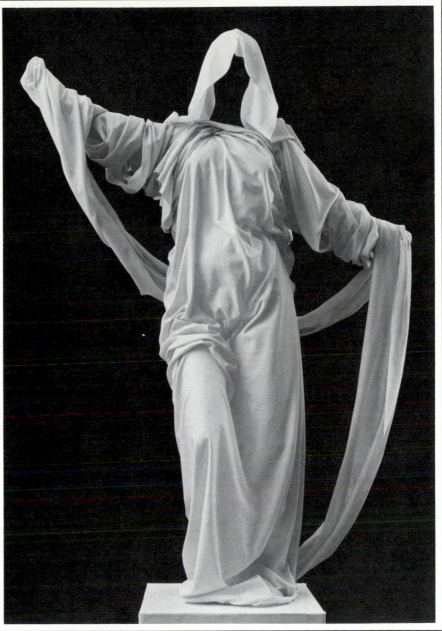

Maquette for 12' Permanent Installation. 1983. Cloth and epoxy, 6' h x 4'w x 2'd. Collection Gerald D. Hines Interests, 580 California Street, San Francisco, California. Photograph by D. James Dee.

Elizabeth Catlett

(Husband Francisco Mora)
Born April 15, 1919 Washington, D.C.
(Mexican citizenship)

Education and Training
1937 B.S., Art, Howard University, Washington, D.C.
1940 M.F.A., Sculpture, University of Iowa, Iowa City, Iowa
1941 School of the Art Institute of Chicago, Chicago, Illinois; study in ceramic sculpture
1943 Studio of Ossip Zadkine, New York, New York; study in sculpture
1948 La Esmeralda, Escuela de Pintura y Escultura, México, D.F., México; study in wood carving with José L. Ruiz

Selected Individual Exhibitions
1947- Barnett-Aden Gallery, Washington,
48 D.C., catalog
1962 Escuela Nacional de Artes Plásticas, Universidad Nacional Autónoma de México, México, D.F., catalog
1970 Museo de Arte Moderno, México, D.F., México, catalog
1971 Brockman Gallery, Los Angeles, California
1971 Studio Museum in Harlem, New York, New York, catalog
1972 Howard University, Washington, D.C., catalog
1973 Carl Van Vechten Gallery of Fine Arts, Fisk University, Nashville, Tennessee
1973 Jackson State University, Jackson, Mississippi, catalog
1974 Southern University and Agricultural and Mechanical College, Baton Rouge, Louisana
1975 Scripps College, Claremont, California
1978 Traveling Exhibition, Alabama Agricultural and Mechanical University, Normal, Alabama
1978 Nexus Gallery, New Orleans, Louisiana, catalog
1979 Pyramid Gallery, Detroit, Michigan; Your Heritage House, Detroit, Michigan, retrospective and catalog
1980 Chi-Wara Gallery, Atlanta, Georgia, catalog
1981 Malcolm Brown Gallery, Shaker Heights, Ohio
1982 The Gallery Tanner, Los Angeles, California
1983 New Orleans Museum of Art, New Orleans, Louisiana
1984- Southeast Arkansas Arts and
85 Science Center, Pine Bluff, Arkansas; Kilcawley Center Art Gallery, Youngstown, Ohio; Arkansas Arts Center, Little Rock, Arkansas; African American Museum, Dallas, Texas; Howard University, Washington, D.C.; University of Mississippi, University, Mississippi; Masur Museum of Art, Monroe, Louisiana

Selected Group Exhibitions
1946- With the Salón de la Plástica
85 Mexicana, México, D.F. México, United States and other countries
1951 "Tenth Anniversary of Exhibitions of Paintings, Sculpture and Prints by Negro Artists," Atlanta University, Atlanta Georgia, catalog
1962 "Primera Bienal Nacional de Escultura," Instituto Nacional de Bellas Artes, México, D.F., México, catalog
1964 "Segundo Bienal Nacional de Escultura," Museo de Arte Moderno, México, D.F., México, catalog
1968 "Cultural Program of the XIX Olympics," Museo de Arte Moderno, México, D.F., México; Villa Olympica, México, D.F., México; Palacio de Bellas Artes, México, D.F., México
1970 "Dimensions of Black," La Jolla Museum of Art, La Jolla, California, catalog
1971 "Pensamiento Mágico," Instituto de Arte de México, México, D.F., México, catalog
1971 "La Mujer en la Plástica," Museo Nacional de Antropologia, México, D.F., México, catalog
1972 "Black Expo '72," Bay Area Locations, San Francisco, California
1973 "Francisco Mora and Elizabeth Catlett," Altes Schloss der Prinzen von Sachsen, Dresden, Germany, Democratic Republic
1974 "Directions in Afro-American Art," Herbert F. Johnson Museum of Art, Ithaca, New York, catalog
1974 "Barnett Aden Collection," Anacostia Neighborhood Museum, Smithsonian Institution, Washington, D.C.
1975- "Amistad II: Afro-American Exhibition,"
77 Traveling Exhibition, Studio Museum in Harlem, New York, New York
1976 "Elizabeth Catlett and Francisco Mora," The Gallery, Los Angeles, California
1976- "Two Centuries of Black American
77 Art," Traveling Exhibition, Los Angeles County Museum of Art, Los Angeles, California, book-catalog
1976 "20th Century Black Artists," San Jose Museum of Art, San Jose, California, catalog
1979 "Black Artists/South," Huntsville Museum of Art, Huntsville, Alabama
1980 "Pensamiento y Obra de la Plástica Feminina," Salón de la Plástica Mexicana, México, D.F., México, catalog
1980 "Color Space Images," Washington Women's Arts Center, Washington, D.C.
1980 "Voices Beyond the Veil," University of Maryland Baltimore County, Catonsville, Maryland, catalog
1980 "Plástica Mexicana," Galeria Metropolitana, Universidad Autónoma Metropolitana, México, D.F., México, catalog

1981- "Forever Free: Art by African-American
82 Women 1862-1980," Traveling Exhibition, Center for the Visual Arts Gallery, Illinois State University, Normal, Illinois, book-catalog
1981 "Muestra Banamex de Escultura," Seguros America Banamex, México, D.F., México, catalog
1984 "A la Sazon de los 80," Casa del Lago, Universidad Nacional Autónoma de México, Bosque de Chapultepec, México, D.F., México

Selected Public Collections
Atlanta University, Atlanta, Georgia
City of New Orleans, Louisiana
Fisk University, Nashville, Tennessee
Howard University, Washington, D.C.
Instituto Nacional de Bellas Artes, México, D.F., México
Instituto Politecnico Nacional, México, D.F., México
Museo de Arte Moderno, México, D.F., México
Narodni Galerie, Praque, Czechoslovakia
New Orleans Museum of Art, New Orleans, Louisiana
Secretaría de Educación Pública, México, D.F., México
Schomburg Center for Research in Black Culture, New York, New York
Studio Museum in Harlem, New York, New York
University of Iowa, Iowa City, Iowa

Selected Private Collections
Mr. and Mrs. William Cosby, Santa Monica, California
Congressman George W. Crockett, Jr., Washington, D.C.
Dr. Samella S. Lewis, Claremont, California
Ida Lieber, New York, New York
F. Peggy Strauss, New York, New York

Selected Awards
1971 Alumni Award, Howard University, Washington, D.C.
1981 Honor Award for Outstanding Achievement in the Visual Arts, National Women's Caucus for Art Conference, San Francisco, California
1983 James Van Der Zee Award, Brandywine Workshop, Philadelphia Museum of Art, Philadelphia, Pennsylvania

Preferred Sculpture Media
Metal (welded), Stone and Wood

Additional Art Field
Printmaking

Selected Bibliography

Dover, Cedric. *American Negro Art*. London: Studio Books, 1960.

Fax, Elton C. *Seventeen Black Artists*. New York: Dodd, Mead, 1971.

Lewis, Samella S. *The Art of Elizabeth Catlett*. Claremont, California: Hancraft Studios, 1984.

Lewis, Samella S. and Ruth Waddy, eds. *Black Artists on Art*. Los Angeles: Contemporary Crafts, 1976.

"Richmond Barthé and Elizabeth Catlett, An Exchange." *The International Review of African American Art* vol. 6 no. 1 (Spring 1984) pp. 14-25, illus.

Mailing Address

Apartado Postal 694
Cuernavaca, Morelos, México

Artist's Statement

"I believe that sculpture tells us about the culture of people—past and present. My purpose is twofold: one, to present black people in their beauty and dignity for our race and others to understand; two, to exhibit publicly where black people can visit and find art to which they can relate. This experience can lead them to other museums and galleries and the art of other peoples."

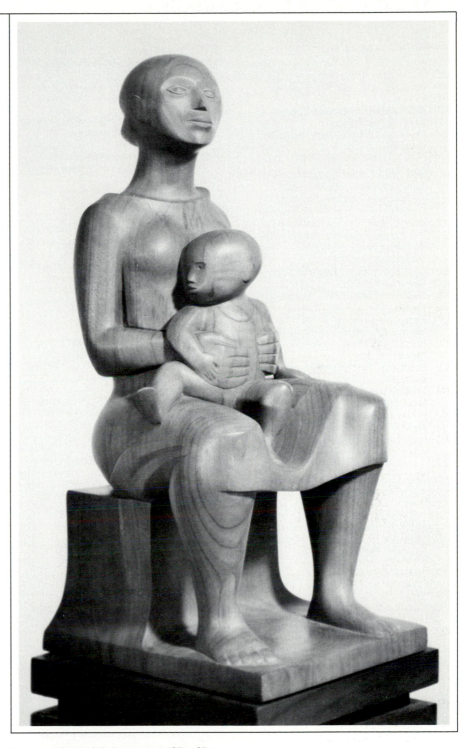

Mother and Child. 1972. Pecan wood, 13"h x 9"w x 11"d. Courtesy Dr. Samella S. Lewis, Claremont, California. Photograph by Armando Solis.

Silvana Cenci

Born August 4, 1926 Florence, Italy

Education and Training
1946- Accademia di Belle Arti, Florence, Italy
49
1949- Académie de la Grande Chaumière,
50 Paris, France
1951- Lewis and Clark College, Portland,
52 Oregon

Selected Individual Exhibitions
1957 Galleria Numero, Florence, Italy
1957 Galleria San Carlo, Naples, Italy
1958 Galleria d'Arte Totti, Milan, Italy
1958 Galeria Beno, Zürich, Switzerland
1960 Nova Gallery, Boston, Massachusetts
1964 Weeden Gallery, Boston,
 Massachusetts
1966 Capricorn Gallery, New York, New
 York
1974 Roach-Hoffman Gallery, Naples,
 Florida
1976 Bristol Art Museum, Bristol, Rhode
 Island, retrospective
1978 Frank Tanzer Gallery, Boston,
 Massachusetts
1978 Symphony Hall, Boston,
 Massachusetts
1978 Musica Viva, Cambridge,
 Massachusetts
1979 Los Llanos Gallery, Santa Fe, New
 Mexico
1985 Northern Arizona University, Flagstaff,
 Arizona

Selected Group Exhibitions
1952 "Oregon Artists," Lincoln County Art
 Center, Lincoln, Oregon
1955 "Exhibition of Painting and Sculpture,"
 Henry Art Gallery, Seattle, Washington
1956 "West Coast Sculptors," Portland Art
 Museum, Portland, Oregon

1957 "Mostra Nazionale del Bianco e Nero,"
 Museo Civico Castello Urasino,
 Catania, Italy
1962 "New England Art Today,"
 Northwestern University, Boston,
 Massachusetts
1964 "New England Sculptors Association,"
 Boston City Hall, Boston,
 Massachusetts
1965 "Silvana Cenci and Calvin Libby,"
 Bristol Art Museum, Bristol, Rhode
 Island
1971 "Adele Seronde and Silvana Cenci,"
 Weeden Gallery, Boston,
 Massachusetts
1975 "Contemporary Italian Art-Italian
 Heritage," Boston City Hall, Boston,
 Massachusetts, catalog
1985 "Explosion of Form, Color, Imagination:
 Works by Silvana Cenci, Adele
 Seronde, Theodosia Anderson," Art
 Gallery, Northern Arizona University,
 Flagstaff, Arizona

Selected Public Collections
Collezione Fiamma Vigo, Rome, Italy
Colonnade Hotel, Boston, Massachusetts
Community School, Dorchester,
 Massachusetts
First Baptist Church, Keene, New Hampshire
Galleria d'Arte Moderna, Florence, Italy
Graham Junior College, Boston,
 Massachusetts
Massachusetts Bay Transportation Authority,
 South Station, Boston, Massachusetts
Merchants Bank, Manchester, Massachusetts
Millhouse-Bundy Performing and Fine Arts
 Center, Waitsfield, Vermont
Western Front Restaurant, Cambridge,
 Massachusetts

Selected Private Collections
Mr. and Mrs. Joshua Levy, Boston,
 Massachusetts
Mr. and Mrs. Jean Montagu, Brookline,
 Massachusetts
Mr. and Mrs. Edward Shapiro, Brookline,
 Massachusetts
Dr. and Mrs. James Skinner, Bow,
 Massachusetts
Frederic Rothchild, Portland, Oregon

Selected Awards
1971 First Honorable Mention, "Design in
 Transit," Massachusetts Bay
 Transportation Authority Competition,
 Institute of Contemporary Art, Boston,
 Massachusetts
1974 Research in Creative Art Grant,
 Blanche E. Colman Foundation,
 Boston, Massachusetts
1983 Statue of Victory, World Culture Prize
 for Letters, Arts and Sciences, Centro
 Studi e Ricerche delle Nazioni,
 Salsomaggiore Terme, Italy

Preferred Sculpture Media
Metal (exploded)

Additional Art Field
Drawing

Related Professions
Artist in Residence and Lecturer

Selected Bibliography
Brolin, Brent C. and Jean Richards.
 *Sourcebook of Architectural Ornament:
 Designers, Craftsmen, Manufacturers and
 Distributors of Custom and Ready-Made
 Exterior Ornament.* New York: Van
 Nostrand Reinhold, 1982.
Cooper, Ed. "Cenci Sculptures at Nova." *The
 Christian Science Monitor* (Tuesday,
 November 21, 1961) p. 7, illus.
Hughes, John A. "Explosion in Northwood."
 New Hampshire Profiles vol. 13 no. 6
 (June 1964) pp. 38-39, 56, illus.

Gallery Affiliation
Southwest Symphony Gallery
Post Office Box 1356
Sedona, Arizona 86336

Mailing Address
Northwood Narrows, New Hampshire 03261

Artist's Statement

"Trained in monumental sculpture in Florence and Paris, the first part of my career I worked mainly in plaster, reinforced concrete and cast bronze. In 1963 I began experimenting with explosives and developed a technique for shaping mild steel, architectural bronze and stainless steel. This method considerably reduces the process traditionally associated with sheet metal forming and allows me greater freedom. The planning of a piece of work may take months, but the actual execution, only a split second. Even though I do not use a torch and hammer, I feel a direct involvement with the material. The explosion is fast, immediate and yet controlled and exact.

"Although my work is created by controlled explosion rather than the more conventional means, the work maintains a classical-modern vision. I have a great admiration for the incredible world of man with its pace of life and discovery, the period I am living in and for this moment—intellectually, I am a contemporary of my time. But this world's chaotic disorder, its frustration and injustice, stands in contradiction to the stillness, the serenity and unchanging order of the world of nature. I live and strive in the conflict between worlds and in my work, I find an equilibrium."

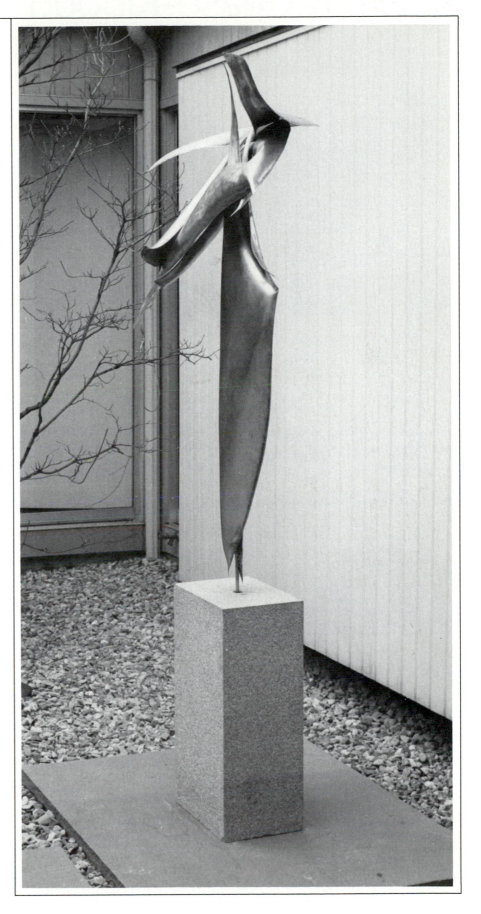

Forma Lunare. 1966. Stainless steel explosively formed, 5'h. Photograph by Bela Kalman.

Barbara Chase-Riboud

née Barbara Dewayne Chase
Born June 26, 1939 Philadelphia,
Pennsylvania

Education and Training
1957 B.F.A., Sculpture, Tyler School of Art,
Temple University, Philadelphia,
Pennsylvania
1960 M.F.A., Design and Architecture,
School of Art and Architecture, Yale
University, New Haven, Connecticut

Selected Individual Exhibitions
1966 Galerie Cadran Solaire, Paris, France
1970 Bertha Schaefer Gallery, New York,
New York
1970 Massachusetts Institute of
Technology, Cambridge,
Massachusetts
1972 Betty Parsons Gallery, New York, New
York
1973 Leslie Rankrow Gallery, New York,
New York
1973 University Art Museum, Berkeley,
California, catalog
1973 Detroit Institute of Arts, Detroit,
Michigan
1973 Indianapolis Museum of Art,
Indianapolis, Indiana
1974 Galerie Merian, Krefeld, Germany,
Federal Republic
1974 Musée d'Art Moderne de la Ville de
Paris, Paris, France, catalog
1974 Kunsthalle, Baden-Baden, Germany,
Federal Republic
1974 Kunstmuseum, Düsseldorf, Germany,
Federal Republic
1975 United States Information Service,
Washington, D.C., Traveling Exhibition,
United States Cultural Center, Tunis,
Tunisia; United States Cultural Center,
Dakar, Senegal; United States Cultural
Center, Teheran, Iran
1976 Kunstmuseum, Friedberg, Germany,
Federal Republic, catalog
1976 Musée Rèattu, Arles, France
1980 P.S. 80, New York, New York
1981 Stampatori Gallery, New York, New
York

Selected Group Exhibitions
1958 "Pittsburgh International Exhibition of
Painting and Sculpture," Museum of
Art, Carnegie Institute, Pittsburgh,
Pennsylvania, catalog
1970 "Afro-American Artists," Museum of
Fine Arts, Boston, Massachusetts
1971 "Annual Exhibition: Contemporary
American Sculpture," Whitney
Museum of American Art, New York,
New York, catalog
1971 "Two Generations," Newark Museum,
Newark, New Jersey

1971 "Contemporary Black Artists in
America," Whitney Museum of
American Art, New York, New York,
catalog
1971, "Salon de Mai," Musée d'Art Moderne
72 de la Ville de Paris, Paris, France
1971, "Salon des Nouvelles Realites," Musée
72 d'Art Moderne de la Ville de Paris,
Paris, France
1973 "Gold," Metropolitan Museum of Art,
New York, New York
1973 "Sculpture as Jewelry as Sculpture,"
Institute of Contemporary Art, Boston,
Massachusetts
1973 "Internationalar Markt für Aktuelle
Kunst," Düsseldorf, Germany, Federal
Republic
1974 "Women's Art: American Art '74,"
Museum of the Philadelphia Civic
Center, Philadelphia, Pennsylvania
1974 "Masterworks of the 70s, Jewelers and
Weavers," Albright-Knox Art Gallery,
Buffalo, New York
1975 "Art Today," United States Cultural
Center, Teheran, Iran
1977 "The Object as Poet," Renwick Gallery
of the National Collection of Fine Arts,
Smithsonian Institution, Washington,
D.C., catalog
1980 "Three Artists: Barbara Chase-Riboud,
Richard Hunt and Mel Edwards,"
Bronx Museum of The Arts, Bronx,
New York
1981- "Forever Free: Art by African-American
82 Women 1862-1980," Center for the
Visual Arts Gallery, Illinois State
University, Normal, Illinois; Joslyn Art
Museum, Omaha, Nebraska;
Montgomery Museum of Fine Arts,
Montgomery, Alabama; Indianapolis
Museum of Art, Indianapolis, Indiana,
book-catalog
1983 "Noeuds et Ligatures," Centre National
des Arts Plastiques, Paris, France
1984 "East/West: Contemporary American
Art," Museum of African American Art,
Los Angeles, California, catalog

Selected Public Collections
Centre National des Arts Contemporains,
Paris, France
Ciba-Geigy Foundation, New York, New York
Harlem State Office Building, New York, New
York
Metropolitan Museum of Art, New York, New
York
Musée National d'Art Moderne, Paris, France
Museum of Modern Art, New York, New York
Newark Museum, Newark, New Jersey
New York State Council on the Arts, New
York, New York
Philadelphia Art Alliance, Philadelphia,
Pennsylvania
Schomburg Center for Research in Black
Culture, New York, New York
St. John's University, Jamaica, New York
University Art Museum, Berkeley, California

Selected Private Collections
Marquis d'Ashnash, Milan, Italy
Pierre Cardin, Paris, France
The Honorable Ambassador F. A. Cook,
Alexandria, Egypt
Jacques Kaplan, New York, New York
Mr. and Mrs. Antoine Riboud, Grasse, France

Selected Awards
1973 Individual Artist's Fellowship, National
Endowment for the Arts
1981 Honorary Doctorate of Humanities,
Temple University, Philadelphia,
Pennsylvania

Preferred Sculpture Media
Fiber, Metal (cast) and Stone

Additional Art Field
Drawing

Related Profession
Writer

Selected Bibliography
Bevlin, Marjorie Elliott. *Design through
Discovery*. New York: Holt, Rinehart and
Winston, 1984.
Fine, Elsa Honig. *The Afro-American Artist*;
Search for Identity. New York: Holt,
Rinehart and Winston, 1973.
Munro, Eleanor C. *Originals: American
Women Artists*. New York: Simon and
Schuster, 1979.
Rubinstein, Charlotte Streifer. *American
Women Artists: From Early Indian Times to
the Present*. Boston: G. K. Hall, 1982.
Waller, Irene. *Textile Sculptures*. London:
Studio Vista, 1977.

Gallery Affiliations
Hessmayling Corporation
Fine Arts Division
32 Quai Aux Briques
Brussels, Belgium 7000

Cara Panticalli Art Gallery
5 East 75 Street
New York, New York 10021

Galleria l'Isola
5 Via Gregoricena
Rome, Italy

Mirror d'Encre
7 Place A. Lemans
Brussels, Belguim 1050

Mailing Address
3 Rue Auguste Comte
75006 Paris, France

Artist's Statement

"What interests me consistently in my work is the combination of opposites: the burnished and the mat, the hard and the soft, the forceful and the tender, what resists and what submits. The poetic power of the sculpture is the interaction among the materials and the need to join opposing forces: male/female, positive/negative and black/white. My principal aim is to reinterpret in post-modernist terms the magical and poetic qualities of a primary vision of the world."

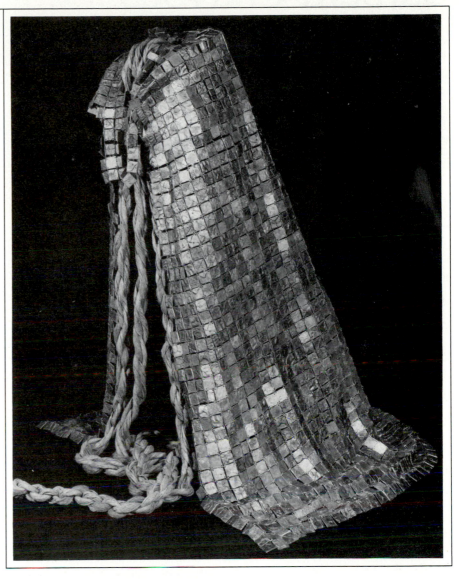

The Cape. 1973. Multicolored bronze, hemp and copper, 8'1½"h x 4'10½"w x 4'10½"d. Photograph by Picto.

Barbara Chavous

née Barbara Elizabeth
Born January 7, 1936 Columbus, Ohio

Education and Training
1960 B.S., Elementary Education, Central State University, Wilberforce, Ohio
1968-69 Art Students League, New York, New York
1971-72 Glassboro State College, Glassboro, New Jersey; study in sculpture
1971-72 Camden County Vocational School, Washington, New Jersey, study in welding

Selected Individual Exhibitions
1977 Ohio University, Athens, Ohio
1978 Franklin University, Columbus, Ohio
1979 Columbus Cultural Arts Center, Columbus, Ohio
1979 Columbus Technical Institute, Columbus, Ohio
1980 Artreach Gallery, Columbus, Ohio
1980 Karamu House, Cleveland, Ohio
1981 Collector's Gallery, Columbus Museum of Art, Columbus, Ohio
1981 Worthington Arts Council, Worthington, Ohio
1982 Spaces Gallery, Cleveland, Ohio
1982 Anderson College, Anderson, Indiana
1982 District of Columbia Foundation for Creative Space, Washington, D.C.
1984 Gallery 200, Columbus, Ohio

Selected Group Exhibitions
1976 "Ten Ohio Black Artists," Ohio University, Athens, Ohio
1979 "10 from Ohio," Lake Erie College, Painesville, Ohio
1979 "Black Expressions," Artreach Gallery, Columbus, Ohio
1980 "Columbus Artists Exchange Exhibition," City Hall, Honolulu, Hawaii; Nationwide Gallery, Columbus, Ohio, catalog
1981 "Sign, Symbol and Spirit," Mansfield Art Center, Mansfield, Ohio
1981 "5 Views 5 Sculptors, Proposed Monuments for the City of Columbus," Franklin University, Columbus, Ohio
1981 "One Hand Clapping," Southern Ohio Museum and Cultural Center, Portsmouth, Ohio

1981 "Sculpture '81, Upper Arlington Cultural Arts Commission," Upper Arlington Municipal Services Center, Columbus, Ohio, catalog
1981, 83 "Annual Atlanta Life National Art Competition and Exhibition," Atlanta Life Insurance, Atlanta, Georgia, catalog
1981 "Five from Ohio," Purdue University, West Lafayette, Indiana
1981 "Three from Columbus," Arts Consortium Gallery, Cincinnati, Ohio
1981-84 "Collage & Assemblage," Traveling Exhibition, Mississippi Museum of Art, Jackson, Mississippi, catalog
1982 "Contemporary Sculpture/ Contemporary Landscapes 1982," Holden Arboretum, Kirtland, Ohio
1982 "Echoes for Earthy Poets," 200 Gallery, Columbus, Ohio
1983 "Summer '83," University of Cincinnati, Cincinnati, Ohio
1983 "Off the Walls," Huntington Galleries, Huntington, West Virginia
1983 "Franklin County Sculptors 1983," Greater Columbus Arts Council, Columbus, Ohio, catalog
1983 "In Search of the Desert Witch," Franklin University, Columbus, Ohio
1983 "Five Sculptors," Youngstown State University, Youngstown, Ohio
1983 "Black Women in the Arts," Montgomery County Historical Society, Dayton, Ohio
1983 "Artworks—Women of Central Ohio," Columbus Cultural Arts Center, Columbus, Ohio
1983 "The Ohio Selections," New Gallery of Contemporary Art, Cleveland, Ohio
1984 "Five Sculptors," Columbus Cultural Arts Center, Columbus, Ohio
1985 "Arts Festival of Atlanta," Piedmont Park, Atlanta, Georgia, catalog

Selected Public Collections
Coke Harpham, Incorporated, Columbus, Ohio
Columbus Museum of Art, Columbus, Ohio
Greater Columbus Arts Council, Columbus, Ohio
Ohio Arts Council, Columbus, Ohio
Wendt Bristol Pharmaceutical Company, Columbus, Ohio

Selected Private Collections
Mr. and Mrs. Budd Harris Bishop, Columbus, Ohio
Bonnie Kelm, Columbus, Ohio
Mr. and Mrs. John Kobacker, Columbus, Ohio
Wayne Lawson, Columbus, Ohio
George and Lee Rinker, Columbus, Ohio

Selected Awards
1980, 84 Individual Artist's Fellowship, Ohio Arts Council
1983 Sculpture Award, "Columbus Art League Annual Exhibition," Columbus Art League, Columbus, Ohio

Preferred Sculpture Media
Varied Media and Wood

Additional Art Field
Drawing

Related Profession
Lecturer

Selected Bibliography
Bremner, Ann. "Reviews Midwest Ohio: Barbara Chavous, Gallery 200." New Art Examiner vol. 12 no. 3 (December 1984) p. 67, illus.
Kelm, Bonnie. "Commentary Barbara Chavous: Mysticism & Totems." Dialogue (January-February 1980) pp. 36-37, illus.
Kelm, Bonnie. "Commentary: The Sounds of Transcendence." Dialogue vol. 4 no. 4 (March-April 1982) pp. 12-13, illus.
Kiefer, Geraldine Wojno. "Commentary Cleveland: A Demonstration Garden and Earthly Delights." Dialogue vol. 5 no. 1 (September-October 1982) pp. 12-13.

Mailing Address
776 Franklin Avenue
Columbus, Ohio 43205

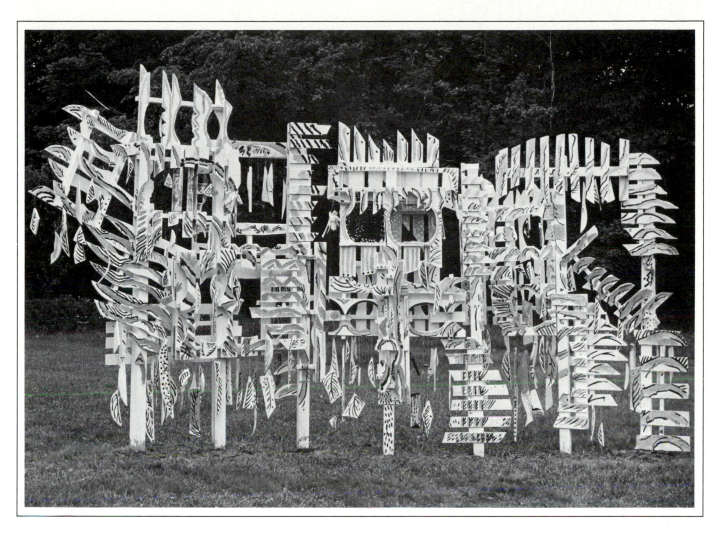

Sky Woman. 1982. Painted wood, 14'h x 14'w x 8'd. Installation view 1982. "Contemporary Sculpture/Contemporary Landscapes 1982," Holden Arboretum, Kirtland, Ohio. Photograph by Ellen Eisenman.

Artist's Statement

"I first created a totem while living in New Jersey. Our yard with large oak trees was like a temple with light filtering through a roof of branches and leaves and a source of inspiration for making totems, icons and talismans. I collected wooden forms from the railroad scrapyards and learned how to weld and use wood-working machines.

"Had it not been for my years in New York studying the collection in the American Museum of Natural History, I probably would not have become an artist. This experience revealed the spirituality and magic of African, Indian and Oceanic image-forms. My work, however, is direct and spontaneous, influenced by American abstract expressionism, and relates hand-crafting of sculptural found elements with plastic-painted surfaces. Within the color, textures and forms, I am expressing my own experience and knowledge. Art is the state of becoming and is never simply the object produced."

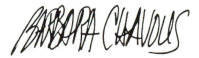

103

Betty Collings

née Betty Hebden
(Husband Edward William Collings)
Born January 15, 1934 Wanganui, New
Zealand (New Zealand citizenship)

Education and Training
1956 Professional Diploma, Wellington
Teachers College, Wellington, New
Zealand
1965 Haystack Mountain School of Crafts,
Deer Isle, Maine; study in ceramics
1970 B.F.A., Ceramic Art, Ohio State
University, Columbus, Ohio
1974 M.F.A., Ceramic Art, Ohio State
University, Columbus, Ohio
1980 Museums Management Institute,
Berkeley, California

Selected Individual Exhibitions
1974 Purdue University, West Lafayette,
Indiana
1974 Community Art Center, Springfield,
Ohio
1975 Denison University, Granville, Ohio
1976 New Gallery of Contemporary Art,
Cleveland, Ohio
1977 Lynn Mayhew Gallery, Ohio Wesleyan
University, Delaware, Ohio
1978 Akron Art Institute, Akron, Ohio
1979 Bertha Urdang Gallery, New York,
New York, catalog
1980, Bertha Urdang Gallery, New York,
83 New York
1982 Antioch College, Yellow Springs, Ohio
1983 Graduate Center, City University of
New York, City College, New York,
New York
1984 Christine Price Gallery, Castleton
State College, Castleton, Vermont

Selected Group Exhibitions
1971 "Women '71," Northern Illinois
University, DeKalb, Illinois
1972 "Beaux Arts Designer Craftsmen,"
Traveling Exhibition, Columbus Gallery
of Art, Columbus, Ohio
1977 "Betty Collings and Ginna Brand,"
University Gallery, Kent State
University, Kent, Ohio
1977 "10 From the File," Columbus Gallery
of Art, Columbus, Ohio, catalog
1977 "Drawing as Process," Akron Art
Institute, Akron, Ohio
1979 "Generative Issues: A Common
Ground," Wright State University,
Dayton, Ohio

1980 "Columbus Art League Invitational,"
Nationwide Gallery, Columbus, Ohio,
catalog
1981 "Sculpture Documentation," San
Francisco State University, San
Francisco, California
1981 "Columbus Art League Annual
Exhibition," Columbus Museum of Art,
Columbus, Ohio
1981 "Black and White," Bertha Urdang
Gallery, New York, New York
1981 "Ohio State Fair Fine Arts Exhibition,"
Cox Fine Arts Building, Columbus,
Ohio
1982 "Tribute to Bertha Urdang," Israel
Museum, Jerusalem, Israel, catalog
1983 "Triple Helix: Betty Collings, Jean
Grosser, Ralph Williams," Gallery for
the Visual Arts, Ohio
University-Lancaster Campus,
Lancaster, Ohio, catalog
1983 "Franklin County Sculptors 1983,"
Greater Columbus Arts Council,
Columbus, Ohio, catalog
1984 "Preparation & Proposition," Islip Art
Museum, East Islip, New York
1984 "Give Peace a Dance," Nuclear
Weapons Freeze Campaign, Lausche
Building, Columbus, Ohio

Selected Public Collection
Israel Museum, Jerusalem, Israel

Selected Private Collections
Agnes Denes, New York, New York
Robert A. Pincus-Witten, New York, New
York
Lloyd H. Siegel, Chicago, Illinois
Bertha Urdang, New York, New York
Hans von Bemmelen, Buenos Aires,
Argentina

Selected Awards
1980 Distinguished Service Award for
Contributions to the Visual Arts,
Columbus Art League, Columbus,
Ohio
1981 Individual Artist's Fellowship, Ohio
Arts Council
1981 Sculpture Award, "Sculpture '81,
Upper Arlington Cultural Arts
Commission," Upper Arlington
Municipal Services Center, Columbus,
Ohio, catalog

Preferred Sculpture Media
Clay, Metal (cast) and Plastic (vinyl)

Additional Art Field
Drawing

Related Professions
Critic and Museum Professional

Selected Bibliography
Burnside, Madeleine. "Betty Collings." *Arts
Magazine* vol. 54 no. 1 (September 1979)
p. 19, illus.

Kalister, Fred. "Triple Helix: Betty Collings,
Jean Grosser, Ralph Williams." *Dialogue*
vol. 6 no. 1 (September-October 1983) p.
24, illus.
Kuspit, Donald B. "Midwest Art: A Special
Report, Columbus." *Art in America* vol. 67
no. 4 (July-August 1979) pp. 65-68.
Leach, David. "Generative Issues: A Common
Ground." *Dialogue* (November-December
1979) pp. 47-49.
Olander, William. "Selected 81-82 O.A.C.
Fellowship Exhibitions: Mark Soppeland/
Cal Kowal/Betty Collings," *Dialogue* vol. 5
no. 1 (September-October 1982) pp. 25-27,
illus.

Gallery Affiliation
Bertha Urdang Gallery
23 East 74 Street
New York, New York 10021

Mailing Address
1991 Hillside Drive
Columbus, Ohio 43221

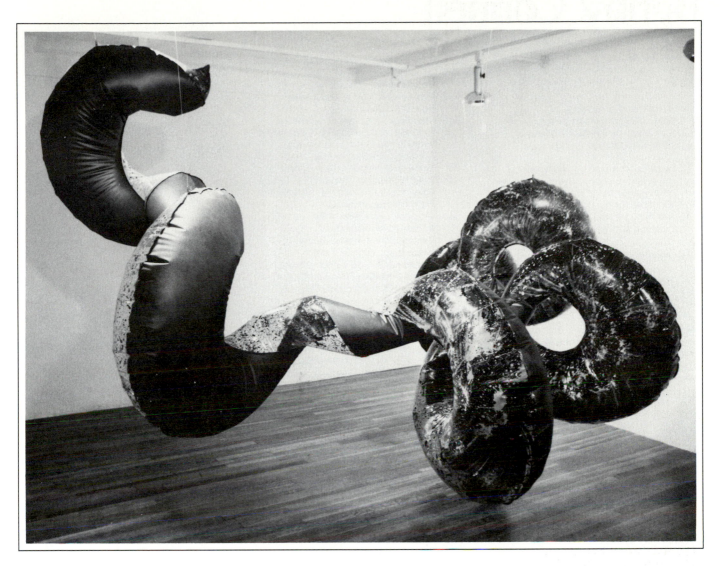

Gold Plume. 1982. Acrylic on vinyl, 7'h x 7'w x 7'd. Installation view 1983. Bertha Urdang Gallery, New York, New York.

Artist's Statement

"Before 1964, I had trained and worked as a teacher and then as an administrator. I had lived in two foreign countries. At age thirty, I was startled and compelled by the discovery that it was possible for a single comprehensive activity to bring together intuitively derived concepts and then to develop them via a synthesis of both physical and mental action. Since that time, I have created functional ceramics, cast figurative images in bronze and clay, constructed environments in which individual participants could explore both the physical and psychological aspects of form, devised a sculptural geometry, and through observing the progressive development of this geometry, began to form an independent hypothesis on the nature of cognition.

Through curating and criticism, I am examining the way in which art interacts with culture. I now see the satisfying and compelling sense of integration which was uncovered in 1964 has, in an unpremeditated yet subconsiously ordered way, led me into, through, and out of art, and thus back into culture."

Betty Collings.

105

Bunny Connell

née Irene Watts Smyth
(Husband Jay Robert Connell)
Born September 4, 1925 St. Louis, Missouri

Education and Training
1948 A.B., Geography and Geology, University of Colorado at Boulder, Boulder, Colorado
1960- Sheridan College, Sheridan, Wyoming
72 (extension courses by University of Wyoming, Laramie, Wyoming); study in oil painting
1970- Sheridan College, Sheridan, Wyoming;
84 intermittent study in life-drawing, oil painting and watercolor

Selected Individual Exhibitions
1980 New Directions in Art Gallery, St. Louis, Missouri, catalog
1981 Billings Art Center, Billings, Montana
1981, Sheridan Inn Gallery, Sheridan,
83 Wyoming
1984 Living Desert Reserve Gallery, Palm Springs, California, catalog
1984 James Barker Hunt Galleries, Palm Beach, Florida, catalog

Selected Group Exhibitions
1975, "Biennial Exhibition of Game
77, Conservation International,"
79, San Antonio Convention Center,
81 San Antonio, Texas
1981 "American Academy of Equine Art Annual Juried Exhibition," Morven Park International Equestrian Institute, Leesburg, Virginia, catalog
1981- "Society of Animal Artists Annual
82 Juried Exhibition," Academy of Natural Sciences of Philadelphia, Philadelphia, Pennsylvania, catalog
1982 "American Academy of Equine Art Annual Juried Exhibition," Commissioned Works Gallery, Middleburg, Virginia, catalog
1982 "Society of Animal Artists Annual Juried Exhibition," Denver Museum of Natural History, Denver, Colorado, catalog
1983 "Society of Animal Artists Annual Juried Exhibition," Cincinnati Zoo, Cincinnati, Ohio, catalog
1983 "Society of Animal Artists Annual Juried Exhibition," A. M. Adler Fine Arts, New York, New York, catalog
1983 "Society of Animal Artists Annual Juried Exhibition," Mulvane Art Center, Topeka, Kansas, catalog
1983 "American Academy of Equine Art Annual Juried Exhibition," Fine Arts Center of Kershaw County, Camden, South Carolina, catalog
1984 "American Academy of Equine Art Annual Juried Exhibition," Mitschke Gallery, Del Mar, California, catalog
1984 "Society of Animal Artists Exhibition," Cleveland Museum of Natural History, Cleveland, Ohio, catalog

Selected Private Collections
Dr. and Mrs. Donald L. Bricker, Lubbock, Texas
M. Paul von Gontard, Jackson, Wyoming
Mr. and Mrs. Paul Hoff, Jr., Denver, Colorado
Mrs. S. Watts Smyth, Big Horn, Wyoming
Mr. and Mrs. Peter A. B. Widener, Palm Beach, Florida

Preferred Sculpture Media
Metal (cast)

Selected Bibliography
Mead, Jean. *Wyoming in Profile*. Boulder, Colorado: Pruett, 1982.

Gallery Affiliation
Arthur Ackerman & Sons
50 East 57 Street
New York, New York 10022

Mailing Address
Post Office Box 4009
Sheridan, Wyoming 82801

Artist's Statement

"With a degree in geology, I began painting after my children were in school. Having grown up on a horse ranch near one of the earliest polo fields in the United States, I portrayed equine polo figures in different painting media and drawings. In 1972 I attended a course in the approach to bronze sculpture and found the ideal media to represent the intense action of the horse. After extended study in welded steel sculpture, I turned to bronze and learned all the foundry techniques. Because bronze is permanent and strong, it lends itself to extremes of motion and attitude.

"Living on a ranch in the Big Horn Mountain region of Wyoming offers a continual supply of material for animal life imagery; deer, elk, moose, a number of lions, an occasional bear and the family's herd of yellow Labradors as well as horses and cattle. In addition to endless hours of observing animals in their natural habitats, I watch movies taken on a family visit to Uganda and Kenya to understand the rippling muscle effect of large jungle cats and video tapes of polo games to articulate the individual forms of equine sculpture."

Bunny Cornell

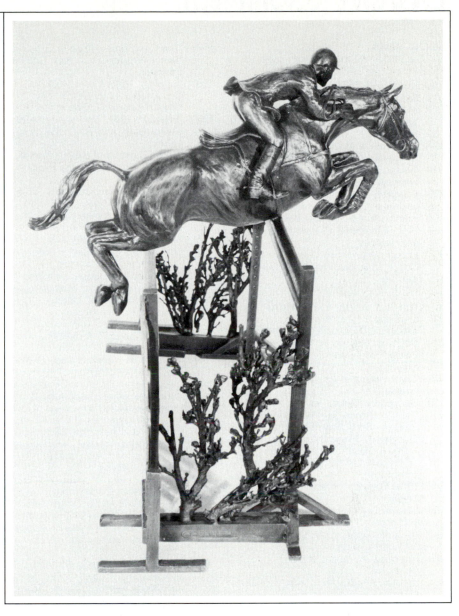

Royal Oxer. 1982. Bronze, 17"h x 14"w x 18"d.

Clyde Connell

née Clyde Dixon
Born September 19, 1901 Belcher, Louisiana

Education and Training
1918- Brenau College, Gainesville, Georgia;
19 study in painting
1919- Vanderbilt University, Nashville,
20 Tennessee
1924- St. Vincent's Academy, Shreveport,
25 Louisiana; study in oil painting
1924- George Doke Studio, Shreveport,
25 Louisiana; study in oil painting
1950- Louisiana State Museum, Shreveport,
55 Louisiana; study in figure drawing
1954- Independent study, New York, New
84 York; semi-annual visits to museums
and galleries
1958 Travigno Workshops, Allison Art
Colony, Way, Mississippi; study in
painting

Selected Individual Exhibitions
1973 Louisiana State University at
Alexandria, Alexandria, Louisiana
1979 Meadows Museum of Art of Centenary
College, Shreveport, Louisiana,
catalog
1979 Tyler Museum of Art, Tyler, Texas,
catalog
1980 DW Gallery, Dallas, Texas
1981 The Clocktower, New York, New York
1981 Louisiana State University in
Shreveport, Shreveport, Louisiana
1981 Barnwell Garden and Art Center,
Shreveport, Louisiana, retrospective
and catalog
1982 Texas Christian University, Fort Worth,
Texas
1982 Mississippi Museum of Art, Jackson,
Mississippi
1982 Alexandria Museum, Visual Art Center,
Alexandria, Louisana, catalog
1983 Firehouse Art Center, Norman,
Oklahoma
1984 Delahunty Gallery, New York, New
York

Selected Group Exhibitions
1972 "Clyde Connell and David Middleton,"
Barnwell Garden and Art Center,
Shreveport, Louisiana
1974 "Four Sculptors," Meadows Museum of
Art of Centenary College, Shreveport,
Louisiana
1976, "Shreveport Art Guild National Juried
77, Exhibition," Meadows Museum of Art
78, of Centenary College, Shreveport,
81 Louisiana
1977 "Twentieth Annual Delta Art
Exhibition," Arkansas Arts Center,
Little Rock, Arkansas, catalog
1978 "Clay, Canvas, Earth Sculpture, Fibre,"
Longview Museum and Arts Center,
Longview, Texas

1979 "The Great Gator Group of Louisiana,"
Galerie Simonne Stern, New Orleans,
Louisiana
1980 "Louisiana Major Works, 1980,"
Contemporary Arts Center, New
Orleans, Louisiana, catalog
1980 "Sculpture 1980," Maryland Institute
College of Art, Baltimore, Maryland,
catalog
1980 "Clyde Connell and George Krause,"
Louisiana Tech University, Ruston,
Louisiana
1981, "Group Exhibition," Delahunty Gallery,
83 New York, New York
1981 "Visions," Contemporary Arts Center,
New Orleans, Louisiana, catalog
1981 "Louisiana Sculpture Biennial,"
Contemporary Arts Center, New
Orleans, Louisiana, catalog
1981- "Collage & Assemblage," Traveling
84 Exhibition, Mississippi Museum of Art,
Jackson, Mississippi, catalog
1982 "The Image of the House in
Contemporary Art," University of
Houston Lawndale Annex, Houston,
Texas, catalog
1982 "Four Artists," Tibor de Nagy Gallery,
New York, New York
1983 "Fourth Texas Sculpture Symposium,"
Area Galleries and Institutions, Austin,
Texas (Sponsored by College of Fine
Arts and Humanities, University of
Texas at Austin, Austin, Texas)
1983 "New Orleans Triennal," New Orleans
Museum of Art, New Orleans,
Louisiana, catalog
1983 "A Partial Look," Art Museum of South
Texas, Corpus Christi, Texas
1983- "Louisiana Women in Contemporary
84 Art," Traveling Exhibition, University
Museum, Southern Illinois University at
Carbondale, Carbondale, Illinois,
catalog
1983 "Collaborations: Spring Art Festival,"
Brown-Lupton Student Center Gallery
and Moudy Exhibition Space, Texas
Christian University, Fort Worth, Texas
1984 "Works by Women: From the
Collection of the Gihon Foundation,"
Traveling Exhibition, Gihon
Foundation, Dallas, Texas
1985 "Inaugural Exhibition," Barry Whistler
Gallery, Dallas, Texas

Selected Public Collections
Alexandria Museum, Visual Art Center,
Alexandria, Louisana
Atlantic Richfield Company, Dallas, Texas
First National Bank, Shreveport, Louisiana
Gihon Foundation, Dallas, Texas
Jay R. Broussard Memorial Gallery
Permanent Collection, Old State Capitol,
Baton Rouge, Louisiana
Laguna Gloria Museum of Art, Austin, Texas
Louisiana State Division of Art, Baton Rouge,
Louisiana
Louisiana State University Library,
Alexandria, Louisiana
Memel, Jacobs, Pierns and Yersh, Los
Angeles, California

Prudential Insurance Company of America,
Newark, New Jersey
Worthen Bank, Little Rock, Arkansas

Selected Private Collections
Margaret Ann Bolinger, Dallas, Texas
Laura L. Carpenter, Dallas, Texas
Dr. Warner Hall, Charlotte, North Carolina
Linda Surls, Chico, California
Vasa, Los Angeles, California

Selected Awards
1982 Creative Visual Artists Award, Adolph
and Esther Gottlieb Foundation, New
York, New York
1984 Honor Award for Outstanding
Achievement in the Visual Arts,
National Women's Caucus for Art
Conference, Toronto, Ontario, Canada

Preferred Sculpture Media
Varied Media and Wood

Additional Art Field
Drawing

Selected Bibliography
Butera, Virginia Fabbri. "Arts Reviews: Group
Show." Arts Magazine vol. 56 no. 8 (April
1982) p. 17, illus.
Kutner, Janet. "The Nation: Dallas, Seaworthy
Sculpture." Art News vol. 79 no. 6
(Summer 1980) pp. 207-208, 210.
Lewis, Jo Ann. "Suddenly This Summer:
Baltimore's Art Renaissance." The
Washington Post (Sunday, June 8, 1980)
pp. L1, L11.
Moser, Charlotte. "Review of Exhibitions:
Houston, Clyde Connell at Lawndale
Annex, University of Houston." Art in
America vol. 68 no. 2 (February 1980) pp.
136-137, illus.
Raynor, Vivien. "Art: Seven Sculptors at Penn
Plaza; Clyde Connell (Delahunty)." The
New York Times (Friday, June 15, 1984) p.
C23.

Gallery Affiliations
Barry Whistler Gallery
2708 Commerce Street
Dallas, Texas 75226

Hiram Butler Gallery
2318 Portsmouth
Houston, Texas 77098

Mailing Address
Lake Bistineau
Route 1 Box 686
Elm Grove, Louisiana 71051

Communication Piece. 1982. Left: Mixed media, 79"h x 72"w x 49"d. *Stone Place*. 1980. Center: Mixed media, 52"h x 44"w x 39"d. *Dark Side of the Moon*. 1982. Right: Mixed media, 90"h x 48"w. Installation view 1983. Delahunty Gallery, Dallas, Texas. Courtesy Delahunty Gallery, Dallas, Texas. Photograph by Stephen D. Dennie.

Artist's Statement

"I was born in a plantation community. Each child grew up in a world of two cultures. Early in life, I began to think of people and communication. These ideas triggered my work when I began as a painter. The marks, shapes and colors in my collage/drawings are interpretations of nature and the movement and sounds of the bayou: trees, wind, water, birds, animals and insects.

"When I felt there was something in my experience I had not begun to present, I began using discarded metal and gates and posts from the plantation molded with grey papier-mâché that resembles steel. This plaster-like material is a mixture of paper and glue which has a quality related to dirt dobber, wasp and moth nests. From these media—metal, wood and paper pulp—I began to produce a series of work which refer to places of contemplation and shelter. The continuing effort of all the years to understand and produce 'good art' has been very exciting. I am still on the search."

Clyde Connell

Stephanie Cooper

née Stephanie Louise
(Husband Charles Emmett Reder)
Born April 21, 1951 Arlington, Virginia

Education and Training
1973 B.F.A., Sculpture, Virginia
 Commonwealth University, Richmond,
 Virginia; study with Lester Van Winkle
1980 M.F.A., Sculpture, University of
 Cincinnati, Cincinnati, Ohio; study with
 Robert Beaven

Selected Individual Exhibitions
1979 Carnegie Art Center, Covington,
 Kentucky
1981 Fendrick Gallery, Washington, D.C.
1982 Rike Center Gallery, University of
 Dayton, Dayton, Ohio
1983, Toni Birckhead Gallery, Cincinnati,
85 Ohio
1983 Gallery One, Columbus Museum of
 Art, Columbus, Ohio, catalog
1983 Ells Gallery, Blossom Music Center,
 Kent, Ohio
1985 Colburn Gallery, Kenyon College,
 Gambier, Ohio

Selected Group Exhibitions
1979 "Small Sculpture Exhibition," Scott
 McGinnis Gallery, Richmond, Virginia
1979 "C.A.G.E. Exhibition," Contemporary
 Arts Center, Cincinnati, Ohio
1979 "Surrealism Now," Spaces Gallery,
 Cleveland, Ohio
1980 "Cincinnati Stories," Spaces Gallery,
 Cleveland, Ohio; C.A.G.E. Gallery,
 Cincinnati, Ohio

1980 "Small Sculpture Invitational," Art
 Academy of Cincinnati, Cincinnati,
 Ohio
1980- "Stephanie Cooper and Lisa
81 Jameson," Contemporary Arts Center,
 Cincinnati, Ohio
1981 "1981 Cincinnati Invitational
 Exhibition," Cincinnati Art Museum,
 Cincinnati, Ohio
1981 "18 Ohio Sculptors," Alma Gallery,
 Lima Art Association, Lima, Ohio,
 catalog
1982 "Ohio Arts Council Fellowship
 Recipients," Spaces Gallery,
 Cleveland, Ohio
1982 "Stephanie Cooper, Sculpture and F.
 Clark Stewart, Paintings," Giles
 Gallery, Jane F. Campbell Building,
 Eastern Kentucky University,
 Richmond, Kentucky
1983 "Fire 1," Art Center Association, The
 Water Tower, Louisville, Kentucky
1983- "In The Round," Southern Ohio
84 Museum and Cultural Center,
 Portsmouth, Ohio
1984 "Cincinnati Selections," Cincinnati Art
 Museum, Cincinnati, Ohio, catalog
1984 "Figuratively Speaking," Art Gallery,
 Cleveland State University, Cleveland,
 Ohio, catalog
1984 "MFA Alumni Exhibition," Tangeman
 Fine Arts Gallery, University of
 Cincinnati, Cincinnati, Ohio
1985 "Ohio Artists," Sculpture Center, New
 York, New York; Spaces Gallery,
 Cleveland, Ohio, catalog
1985 "Body and Soul: Aspects of Recent
 Figurative Sculpture," Traveling
 Exhibition, Contemporary Arts Center,
 Cincinnati, Ohio, catalog

Selected Private Collections
Toni Birckhead, Cincinnati, Ohio
Ron and Judy Isaacs, Richmond, Kentucky
Michael Lowe, Cincinnati, Ohio
Mrs. Arthur Motch, Cincinnati, Ohio
Anthony M. Walsh, Cincinnati, Ohio

Selected Award
1981, Individual Artist's Fellowship,
83 Ohio Arts Council

Preferred Sculpture Media
Varied Media and Wood

Additional Art Field
Drawing

Selected Bibliography
Bless, Nancy. "Reviews Midwest Ohio:
 Stephanie Cooper, Toni Birckhead Gallery."
 New Art Examiner vol. 10 no. 10 (Summer
 1983) p. 21.
Zurcher, Susan. "Roots, Rituals & Dreams—
 Stephanie Cooper: Sculpture/University of
 Dayton/September 1-30." *Dialogue* vol. 5
 no. 2 (November-December 1982) pp.
 15-16, illus.

Gallery Affiliation
Toni Birckhead Gallery
342 West Fourth Street
Cincinnati, Ohio 45202

Mailing Address
924 Morris Street
Cincinnati, Ohio 45206

Artist's Statement

"My art is about magic in small worlds where figures and animals act out events. I make them mainly for myself because I believe they exist and I want to see them as if they were alive. The movement of their arms and legs, the piercing quality of their eyes and the performance of the rituals add to their reality.

"The images, constructed from weathered wood, old bits of cloth and metal, are both male and female such as gypsies, fairies and witches. Cats, lizards, fish, snakes, wild boars and horned animals also interact with the figures in open-spaced environments or Renaissance rooms with arched windows. Images that appear in the environments are my personal symbols. Some of these are round spheres (usually the moon), candles, scarfs, tables, chairs, tiled floors, mirrors, herbs, baskets, boxes and other containers.

"I used to believe in fairies and loved haunted houses with spider webs, fantasy and surreal images. I believe in spirits which are an interface between the spiritual plane and the human. I think of my work as magical earth and air, joining the benign and the malign."

Stephanie Cooper

The Sister of Esmarelda. 1983. Wood, cloth, paint and hair, 33′h x 8″w x 22″d. Photograph by Tony Walsh.

Sara D'Alessandro

née Sara Hankinson
Born August 20, 1944 Port Jefferson, New
 York

Education and Training
1968 B.F.A., Art Education, Pratt Institute,
 Brooklyn, New York
1978 Studio of Richard McDermott Miller,
 New York, New York; assistant in
 sculpture for enlargement
1981 Studio of Robert Berks, Orient, New
 York; assistant in the technical
 preparation of sculpture molds

Selected Individual Exhibitions
1978 Landmark Gallery, New York, New
 York
1978 East End Arts and Humanities
 Council, Riverhead, New York
1981 Nina Pratt Gallery, Amherst,
 Massachusetts
1984 Art Complex-East, Riverhead, New
 York

Selected Group Exhibitions
1971 "Visual Witticisms," Erotic Art Gallery,
 New York, New York
1971 "Erotic Art by 20 Artists," Erotic Art
 Gallery, New York, New York
1972 "New Mexico Fine Arts Biennial,"
 Museum of Fine Arts, Museum of New
 Mexico, Santa Fe, New Mexico,
 catalog
1973 "Nine New Mexico Artists," Pyramid
 Gallery, Washington, D.C., catalog
1974 "Interpretations of Sexuality,"
 Albin-Zeglen Gallery, New York, New
 York
1976, "Brooklyn Artists," Brooklyn Museum,
78 Brooklyn, New York
1976 "Artists' Choice: Figurative Art in New
 York," SoHo Center for Visual Arts,
 New York, New York
1980 "Younger Artists: A Benefit Exhibition,"
 A. M. Sachs Gallery, New York, New
 York

1980- "Sculpture in the 70s: The Figure,"
82 Pratt Manhattan Gallery, New York,
 New York; Pratt Institute Gallery,
 Brooklyn, New York; Arkansas Arts
 Center, Little Rock, Arkansas;
 University of Oklahoma, Norman,
 Oklahoma; Arizona State University,
 Tempe, Arizona; Hood Museum of Art,
 Hanover, New Hampshire, catalog
1981, "Annual Mather Memorial Hospital
83, Sculpture Show, Sculpture Garden
84 Exhibit," Mather Memorial Hospital,
 Port Jefferson, New York
1982 "Twenty-Eighth Annual Juried
 Exhibition of Art," Parrish Art Museum,
 Southampton, New York
1983 "Bodies & Souls," Midtown Gallery,
 New York, New York
1983 "Instructors Exhibition," Young
 Woman's Christian Association
 Gallery, New York, New York
1984 "SoHo South and Archie Wolfe
 Associates Presents," Archie Wolfe
 and Associates, Memphis, Tennessee
1984 "The Associate Artists Invitational," Art
 Complex-East, Riverhead, New York
1984 "Portraits: Form and Concept," First
 Women's Bank, New York, New York
1984 "Artists' Choice Museum: The First
 Eight Years," Artists' Choice Museum,
 New York, New York

Selected Public Collections
Brooklyn Model Works, Brooklyn, New York
Pamlico Technical College, Grantsboro, North
 Carolina

Selected Private Collections
Sue Fuller, Southampton, New York
Charles Hinman, New York, New York
Joel and Helen Lefkowitz, Setauket, New
 York
Reinfeld Collection, New York, New York
Richard and Phyllis Weiss, Huntington
 Station, New York

Selected Awards
1978 Visiting Artist Program, North Carolina
 Arts Council
1981 Finalist, "By The River's Edge," County
 Center, Riverhead, New York;
 Traveling Exhibition of Award Winners
 during 1982 to schools, libraries and
 other public places on the East End
 of Long Island, New York
1981 Artist in Residence, East End Arts
 and Humanities Council, Riverhead,
 New York and New York State
 Council on the Arts

Preferred Sculpture Media
Clay and Metal (cast)

Related Profession
Model Maker for Sculpture

Selected Bibliography
Bass, Ruth. "New York Reviews: Alive and
 Well in the '70s." Art News vol. 80 no. 2
 (February 1981) p. 214.
Glueck, Grace. "Art: Sculptured Figures Of
 70's at Pratt Gallery." The New York Times
 (Friday November 7, 1980) p. C19.
Stolbach, Michael Hunt. "Arts Reviews:
 Artists' Choice." Arts Magazine vol. 55 no.
 3 (November 1980) pp. 23-24.

Mailing Address
108 Woodhull Avenue
Riverhead, New York 11901

Brocade Chair. 1973. Terra cotta unique, 16"h x 21"w x 14"d. Photograph by Elaine Taylor.

Artist's Statement

"My sculpture of polychromed terra cotta is figurative and representational but not rooted in classicism. Rather, I pursue dilemmas of existence in a highly personal iconography of nonidealized form. Sometimes I work from observation but my favorite pieces arise from the imagination and contain surreal juxtaposition or cropping. The additive process in shaping clay supplies a mortal quality; polychroming develops mood beyond form."

Sara D'Alessandro

Bernadette D'Amore

née Bernadette Ann
Born December 15, 1942 Washington, D.C.

Education and Training
1962-63 Università degli Studi di Roma, Rome, Italy
1964 B.A., Sociology, Boston University, Boston, Massachusetts
1971 Massachusetts College of Art, Boston, Massachusetts; study in sculpture with George Greenamyer
1980-81 Studio Nicoli, Carrara, Italy; independent study in sculpture
1982-83 Accademia di Belle Arti, Carrara, Italy; study in bronze casting with Giorgio Antonazzi and marble cutting with Rino Giannini

Selected Individual Exhibitions
1977 Mills Gallery, Boston Center for the Arts, Boston, Massachusetts
1978 Boston Psychoanalytic Institute, Boston, Massachusetts
1982 Lobby Gallery, Prudential Center Tower Building, Boston, Massachusetts
1983 Art Center Gallery, Cambridge School of Weston, Weston, Massachusetts
1984 J. Todd Galleries, Wellesley, Massachusetts
1984 Trustman Art Gallery, Simmons College, Boston, Massachusetts
1984 By Design Gallery, Cambridge, Massachusetts

Selected Group Exhibitions
1977 "Invitational Exhibition," Brockton Art Center/Fuller Memorial, Brockton, Massachusetts
1979 "Stone Studies," Lincoln Arts Center, Santa Rosa, California
1981 "Boston Visual Artists Union at the Prudential," Lobby Gallery, Prudential Center Tower Building, Boston, Massachusetts

1981 "Constructions," Campus Center Art Gallery, Fitchburg State College, Fitchburg, Massachusetts
1981 "Annual Members Show," Boston Visual Artists Union, Boston, Massachusetts
1982 "Artists for Survival," Advent Gallery, Boston, Massachusetts; Gallery 345, New York, New York
1982 "Young Artists," Provincetown Art Association and Museum, Provincetown, Massachusetts
1982 "New England Sculptors Annual Exhibition," Lobby Gallery, Prudential Center Tower Building, Boston, Massachusetts
1982 "Artists in the Round," Upper Rotunda, Faneuil Hall, Boston, Massachusetts
1982 "Twelfth International Sculpture Conference," Area Galleries and Institutions, Oakland, California and San Francisco, California (Sponsored by International Sculpture Center, Washington, D.C.)
1982 "Gallery Artists," J. Todd Galleries, Wellesley, Massachusetts
1983 "Scultura en Versilia, Sculpture in Versilia," Chiostro di Agostino, Pietrasanta, Italy
1983 "New England Sculptors Annual Exhibition," Cambridge Art Association Gallery, Cambridge, Massachusetts
1984 "Local Abstractions," Project Center Art Gallery, Cambridge, Massachusetts
1984 "10 Sculptors 10," Concourse Gallery, Hotel Meridien, Boston, Massachusetts
1984 "The Full Circle: Images of Maternity and Birth," Newton Arts Center, Newton, Massachusetts
1984 "Boston Stone," Mills Gallery, Boston Center for the Arts, Boston, Massachusetts
1984 "Faculty Exhibition," School of the Museum of Fine Arts, Boston, Massachusetts
1984 "A Touching Experience," Museum of Science, Boston, Massachusetts
1984 "Aspects of the Human Form," Fitchburg Art Museum, Fitchburg, Massachusetts

Selected Public Collections
Hotel Meridien, Boston, Massachusetts
Massachusetts Medical Society, Waltham, Massachusetts

Selected Private Collections
Stephen and Randy Goldberger, Wayland, Massachusetts
Michael and Sandra Kamen, Stamford, Connecticut
Phyllis Kraus-Braun, Chicago, Illinois
Henry and Audrey Parker III, Princeton, New Jersey
Matthew and Donna Pitchon, Seminole, Florida

Selected Awards
1978 First Prize, "Crafts and Fine Sculpture," Marin Society of Artists, Kentfield, California
1981 First Prize, "New England Sculptors Annual Exhibition," Federal Reserve Bank Gallery, Boston, Massachusetts
1982 Fulbright-Hays Fellowship (Italy)

Preferred Sculpture Media
Metal (cast), Metal (welded) and Stone

Teaching Positions
Sculpture Instructor, Cambridge School of Weston, Weston, Massachusetts
Sculpture Instructor, School of the Museum of Fine Arts, Boston, Massachusetts

Gallery Affiliation
J. Todd Galleries
570A Washington Street
Wellesley, Massachusetts 02181

Mailing Address
480 Pleasant Street
Winthrop, Massachusetts 02152

Artist's Statement

"Sculpture is my way of life. When I first began carving wood, I remember realizing 'This is the center of my life. How am I going to make it real?' This desire has been an uphill struggle with tremendous financial and family pressures. I am a sculptor because I cannot choose to be anything else. I am primarily self-taught, although I have learned specific skills from the Italian artisans in Carrara.

"Most of the sculptures combine the energies of marble, steel and bronze. I use a combination of hand and pneumatic tools on the stone and an arc welder on the steel. The steel is garnered from scrapyards—the detritus of the modern age—and then welded and forged. The marble, quarried from the depths of the earth, is the ultimate skeletal structure carrying us back to ancient time. The sculptures represent a spritual journey in which I seek to integrate some of the diverse elements of our world. They also allow for play and change, inviting viewers to touch and turn the movable pieces."

Bernadette A. D'Amore

Crescent. 1981. Carrara marble and steel, steel circle revolves, 22½1"h x 14¾"w x 12"d.

Joan Danziger

née Joan Schwartz
(Husband Martin Danziger)
Born June 17, 1934 New York, New York

Education and Training
1954 B.F.A., Painting, Cornell University, Ithaca, New York
1954- Art Students League, New York, New
55 York and Woodstock, New York
1958 Certificate, Accademia di Belle Arti, Rome, Italy

Selected Individual Exhibitions
1970 Abby Aldrich Rockefeller Folk Art Center, Williamsburg, Virginia
1973 Galerie Simonne Stern, New Orleans, Louisiana
1973 Henri Gallery, Washington, D.C.
1975 Corcoran Gallery of Art, Washington, D.C.
1977 Museum of Art, Science and Industry, Los Angeles, California
1978 Fendrick Gallery, Washington, D.C.
1979 Jacksonville Museum of Arts & Sciences, Jacksonville, Florida
1980 Terry Dintenfass Gallery, New York, New York
1982 Joy Horwitch Gallery, Chicago, Illinois
1982 New Jersey State Museum, Trenton, New Jersey, catalog
1983 Rutgers University, Douglass College, New Brunswick, New Jersey, catalog
1984 Benjamin Mangel Gallery, Philadelphia, Pennsylvania
1985 Textile Museum, Washington, D.C.

Selected Group Exhibitions
1970 "New Sculpture: Baltimore, Washington, Richmond," Corcoran Gallery of Art, Washington, D.C., catalog
1972 "Second Annual Exhibition of Washington Artists," Phillips Collection, Washington, D.C., catalog
1973 "Washington Sculptors," Philadelphia Art Alliance, Philadelphia, Pennsylvania; Glassboro State College, Glassboro, New Jersey
1973 "Suspended Sculptures," New Orleans Museum of Art, New Orleans, Louisiana
1973 "11 From Washington," 55 Mercer, New York, New York
1974 "Gems of Imagination," Art Museum of South Texas, Corpus Christi, Texas, catalog

1974- "Figure & Fantasy," Renwick Gallery of
75 the National Collection of Fine Arts, Smithsonian Institution, Washington, D.C.
1976 "One Hundred Artists Commemorate Two Hundred Years," Xerox Square Exhibition Center, Rochester, New York, catalog
1980 "Images of the 70s: 9 Washington Artists," Corcoran Gallery of Art, Washington, D.C., catalog
1981 "Taft Museum Menagerie," Taft Museum, Cincinnati, Ohio, catalog
1981 "The Animal Image: Contemporary Objects and the Beast," Renwick Gallery of the National Museum of American Art, Smithsonian Institution, Washington, D.C., catalog
1981 "A New Bestiary: Animal Imagery in Contemporary Art," Institute of Contemporary Art of the Virginia Museum of Fine Arts, Richmond, Virginia, catalog
1982 "Masks," Morris Museum of Arts and Sciences, Morristown, New Jersey
1983 "Alexandria Sculpture Festival," The Athenaeum, Northern Virginia Fine Arts Association, Alexandria, Virginia, catalog
1984 "Artworks '84, Louisiana World Exposition," World's Fair, New Orleans, Louisiana

Selected Public Collections
Capital Children's Museum, Washington, D.C.
Frostburg State College Student Center, Frostburg, Maryland
George Meany Center for Labor Studies, Silver Spring, Maryland
Jacksonville Museum of Arts & Sciences, Jacksonville, Florida
National Museum of American Art, Smithsonian Institution, Washington, D.C.
National Museum of Women in the Arts, Washington, D.C.
New Jersey State Museum, Trenton, New Jersey
New Orleans Museum of Art, New Orleans, Louisiana
Plaza of the Americas Hotel, Dallas, Texas

Selected Private Collections
Sophie Engelhard, Washington, D.C.
Gary Goodwin, Chicago, Illinois
Preston Greene, Washington, D.C. and Yorktown, Virginia
Gilbert Kinney, Washington, D.C.
Sam Rosenfeld, New York, New York

Preferred Sculpture Media
Varied Media

Additional Art Fields
Drawing and Painting

Selected Bibliography
Conroy, Sarah Booth. "Design: Houses Fitted to Artistry, Spaces for Arts, Crafts and All

Manners of Creativity." *The Washington Post* (Sunday, April 2, 1978) *The Washington Post Magazine*, pp. 37-45, illus.
Nadelman, Cynthia. "New York Reviews: Joan Danziger." *Art News* vol. 79 no. 10 (December 1980) p. 193.
Pailla, Maryse. "A Portfolio of Regional Artists: Joan Danziger (Washington, D.C.)." *Art Voices* vol. 4 no. 4 (July-August 1981) p. 51, illus.
Raymer, Patricia. "Visual Arts: Artists in Fantasyland." *The Washingtonian* vol. 10 no. 2 (November 1974) pp. 69-70, 72, illus.
Shaw-Eagle, Joanna. "Keep Your Eye on American Women in Sculpture." *Harper's Bazaar* (August 1981) pp. 162-163, 190.

Gallery Affiliations
Fendrick Gallery
3059 M Street NW
Washington, D.C. 20007

Joy Horwich Gallery
226 East Ontario Street
Chicago, Illinois 60611

Benjamin Mangel Gallery
1604 Locust Street
Philadelphia, Pennsylvania

Mailing Address
2909 Brandywine Street NW
Washington, D.C. 20008

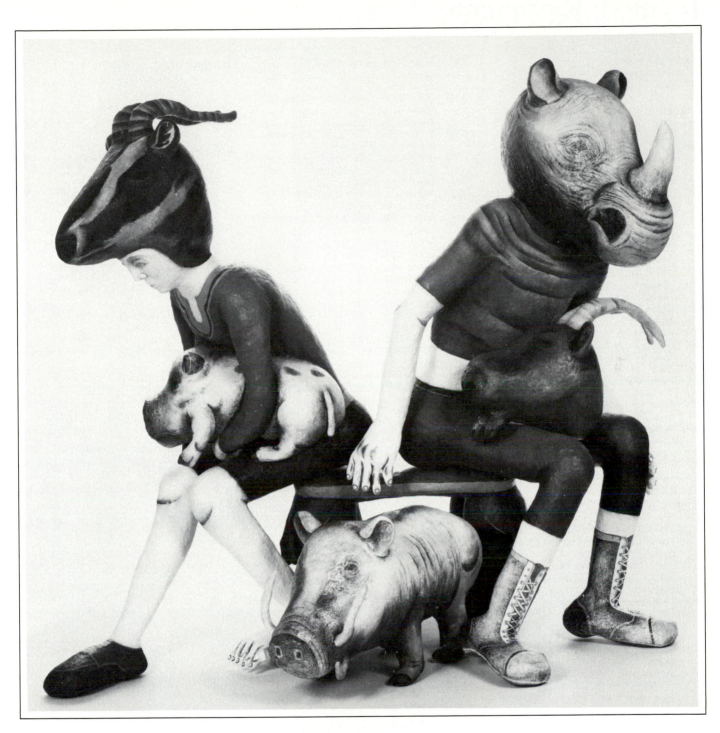

Waiting Room. 1980. Resin-reinforced fabric over wood and wire armature, celluclay, acrylic paint and pencil, 72"h x 83"w x 49"d. Photograph by Joel Breger.

Artist's Statement

"My sculptures represent my personal mythology. They combine an interplay of the animal strength and beauty with the human spirit. The works focus on my ideas about people, their relationship with each other and to the world around them. They are involved with the irrational versus the rational and are drawn from inconsistent fragments of my life.

"I have always been fascinated with dream imagery and the concept of metamorphosis. The sculptures are from my subconscious and deal with questions of isolation, confrontation and psychologically hidden people. They unmask our secret identities."

Joan Danziger

117

Carol Kreeger Davidson

née Carol Kreeger
(Husband Donald Davidson)
Born May 17, 1931 Chicago, Illinois

Education and Training
1953 B.A., Literature, Northwestern University, Evanston, Illinois
1967 B.F.A., Sculpture, Hartford Art School, University of Hartford, West Hartford, Connecticut
1973 M.F.A., Sculpture, Rhode Island School of Design, Providence, Rhode Island

Selected Individual Exhibitions
1974 New Britain Museum of American Art, New Britain, Connecticut, catalog
1976 Institute of Contemporary Art, Boston, Massachusetts
1977 Bonino Gallery, New York, New York
1978 Gloria Cortella Gallery, New York, New York
1978 Austin Arts Center, Trinity College, Hartford, Connecticut
1979 Stewart Neill Gallery, New York, New York
1980 Hudson River Museum, Yonkers, New York, catalog
1982 Terry Dintenfass Gallery, New York, New York
1982 Addison-Ripley Gallery, Washington, D.C.
1984 Joseloff Gallery, Hartford Art School, University of Hartford, West Hartford, Connecticut, retrospective and catalog
1985 LoHo Gallery, Louisville, Kentucky

Selected Group Exhibitions
1973 "New Talent," Terry Dintinfass Gallery, New York, New York
1975 "Contemporary Reflections 1974-1975," Aldrich Museum of Contemporary Art, Ridgefield, Connecticut, catalog
1975 "New Sculpture," Storm King Art Center, Mountainville, New York
1975 "Two for Thirty-Two," Parsons-Truman Gallery, New York, New York
1976 "Three Artists," Max Hutchinson Gallery, New York, New York and Sculpture Now, New York, New York
1976 "Invitational Exhibition," John Weber Gallery, New York, New York, catalog
1977 "Exhibition as Process," Wadsworth Atheneum, Hartford, Connecticut, catalog
1977 "Invitational Paper Exhibition," Gloria Cortella Gallery, New York, New York

1978 "Carol Kreeger Davidson/Leah Rhodes/Ann Sperry," Galerie Denise René, New York, New York
1978 "Four New England Artists," Rose Art Museum, Brandeis University, Waltham, Massachusetts
1978 "Paper Show," VanDoran Gallery, San Francisco, California
1978 "New Art for New Year," Penthouse Gallery, Museum of Modern Art, New York, New York
1978 "Painting and Sculpture Today 1978," Indianapolis Museum of Art, Indianapolis, Indiana, catalog
1978 "Connecticut Drawing, Painting and Sculpture 1978," Carlson Art Gallery, University of Bridgeport, Bridgeport, Connecticut; New Britain Museum of American Art, New Britain, Connecticut; Cummings Arts Center, Connecticut College, New London, Connecticut, catalog
1980 "Form and Figure," Mary and Leigh Block Gallery, Northwestern University, Evanston, Illinois
1980 "Spatially," Westport-Weston Arts Council, Weston, Connecticut
1985 "Group Invitational," Kouros Gallery Estate, Ridgefield, Connecticut

Selected Public Collections
Aldrich Museum of Contemporary Art, Ridgefield, Connecticut
Coopers and Lybrand, Hartford, Connecticut
Gulton Industries, Princeton, New Jersey
New Britain Museum of American Art, New Britain, Connecticut
New Jersey State Museum, Trenton, New Jersey
Slater Memorial Museum, Norwich, Connecticut
University of Hartford Library, West Hartford, Connecticut

Selected Private Collections
Nina Cullinum Collection, Houston, Texas
Dr. and Mrs. Charles Gibbs Collection, Attleboro, Massachusetts
Mr. and Mrs. Robert Lazarus, Jr., Columbus, Ohio
Mr. and Mrs. Robert Spitzer, New York, New York
Suzanne Weil Collection, Washington, D.C.

Selected Awards
1981 Distinguished Alumna of the Year, University of Hartford, West Hartford, Connecticut
1983 Individual Artist's Fellowship, National Endowment for the Arts
1983 Individual Artist's Fellowship, New York State Council on the Arts

Preferred Sculpture Media
Metal (joined) and Varied Media

Additional Art Field
Drawing

Related Professions
Video Artist and Visiting Artist

Selected Bibliography
Alloway, Lawrence. "Art." *The Nation* vol. 224 no. 15 (April 16, 1977) p. 476.
Madoff, Steven Henry. "Review of Exhibitions: Carol Kreeger Davidson at Terry Dintenfass." *Art in America* vol. 71 no. 3 (March 1983) p. 161, illus.
Mann, Virginia. "Carol Kreeger Davidson: The Guardians." *Arts Magazine* vol. 54 no. 2 (October 1979) pp. 118-119, illus.
McHugh, Caril Dreyfuss. "Carol Kreeger Davidson." *Arts Magazine* vol. 57 no. 2 (October 1982) p. 15, illus.
Rohrer, Judith C. "Carol Kreeger Davidson." *Arts Magazine* vol. 51 no. 10 (June 1977) p. 15, illus.

Gallery Affiliations
Addison-Ripley Gallery
9 Hillyer Court NW
Washington, D.C. 20008

LoHo Gallery
414 Baxter Avenue
Louisville, Kentucky 40204

Mailing Address
21 Glenwood Road
West Hartford, Connecticut 06107

Artist's Statement

"I am interested in the fusion of opposites.
I shall not blend or harmonize, but
give distinctness and clarity to
opposing elements.
Opposition creates tension and tension
demands resolution.
The fusion takes place within the viewer.

I search for a visual sign which gives
shape to thought.
It is a Meta-Physical unity
I seek."

Carol Kreeger Davidson

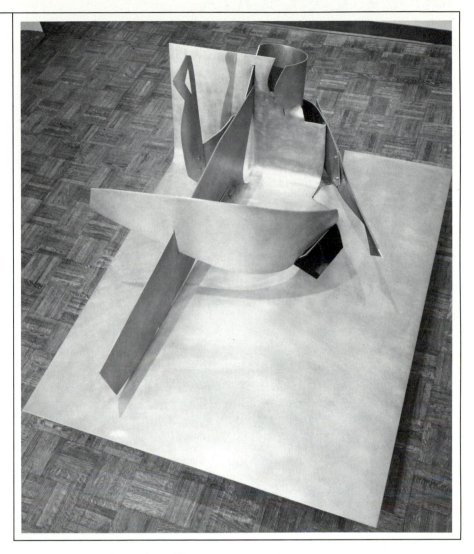

Demeter. 1982. Bronze, 36"h x 48"w x 60"d.
Photograph by Jerry L. Thompson.

Janet deCoux

Born October 5, 1904 Niles, Michigan

Education and Training
1925-27 Carnegie Institute of Technology, Pittsburgh, Pennsylvania
1927-28 New York School of Industrial Design, New York, New York
1927-28 Apprenticeship to Carl Paul Jennewein, New York, New York
1928-29 Rhode Island School of Design, Providence, Rhode Island
1928-29 Apprenticeship to Aristide B. Cianfarani, Providence, Rhode Island
1929 Apprenticeship to Gozo Kawamuro, New York, New York
1930-31 School of the Art Institute of Chicago, Chicago, Illinois
1930-31 Apprenticeship to Alvin Meyer, Chicago, Illinois
1932-35 Apprenticeship to James Earle Fraser, Westport, Connecticut

Selected Individual Exhibitions
1946 Museum of Art, Carnegie Institute, Pittsburgh, Pennsylvania, catalog
1951 Arts and Crafts Center, Pittsburgh, Pennsylvania, catalog
1953 University of Pittsburgh, Pittsburgh, Pennsylvania, catalog
1967 William Penn Memorial Museum, Harrisburg, Pennsylvania, catalog

Selected Group Exhibitions
1938 "American Sculptors," Museum of Art, Carnegie Institute, Pittsburgh, Pennsylvania, catalog
1942 "Religious Sculpture," Art Institute of Chicago, Chicago, Illinois, catalog
1946 "Exhibition of Works by Candidates for Art Awards," American Academy of Arts and Letters, New York, New York, catalog
1948 "Liturgical Arts," Liturgical Art Society, New York, New York
1955 "Invitational Exhibition," National Academy of Design, New York, New York
1960 "Religious Art," Hebrew Museum, New York, New York, catalog
1964 "Religious Art," Saint Louis Art Museum, St. Louis, Missouri

Selected Public Collections
Brookgreen Gardens, Murrells Inlet, South Carolina
Brookline Methodist Church, Pittsburgh, Pennsylvania
College of New Rochelle Library, New Rochelle, New York
St. Ann Chapel, Stanford University, Palo Alto, California
St. Barnabas Mother House Chapel, Gibsonia, Pennsylvania
St. Germaine Roman Catholic Church, Bethel Park, Pennsylvania
St. James Episcopal Church, Penn Hills, Pennsylvania
St. Margaret Memorial Hospital Chapel, Pittsburgh, Pennsylvania
St. Mary's Church, Manhasset, New York
St. Paul Episcopal Church, Southington, Connecticut
St. Scholastica Roman Catholic Church, Aspinwall, Pennsylvania
St. Stephen and The Incarnation Episcopal Church, Washington, D.C.
St. Stephen Episcopal Church, Sewickley, Pennsylvania
St. Thomas Church In-The-Fields, Gibsonia, Pennsylvania
St. Vincent Archabbey, Latrobe, Pennsylvania
William Penn Memorial Museum, Harrisburg, Pennsylvania

Selected Private Collections
Convent of St. Helena Chapel, Vail's Gate, New York
Reverend Virgil Funk, Washington, D.C.
Anne Morrow Lindbergh, Darien, Connecticut
Eliza Miller, Gibsonia, Pennsylvania
Mary Bates Swiss, Gibsonia, Pennsylvania

Selected Awards
1939-41 John Simon Guggenheim Memorial Foundation Fellowship
1942 Widener Gold Medal, "One Hundred and Thirty-Seventh Annual Exhibition of Painting and Sculpture," Pennsylvania Academy of the Fine Arts, Philadelphia, Pennsylvania, catalog
1954 Distinguished Daughter of Pennsylvania

Preferred Sculpture Media
Stone and Wood

Additional Art Fields
Architectural Design and Drawing

Selected Bibliography
deCoux, Janet. "Sculptor at Home." *Carnegie Magazine* vol. 64 no. 8 (October 1970) pp. 326-330, illus.
Ellis, Joseph Bailey. "A Saturday Sculptor's Saga: The Story of Janet deCoux." *Carnegie Magazine* vol. 14 no. 4 (September 1940) pp. 109, 112, illus.
Evert, Marilyn and Vernon Gay. *Discovering Pittsburgh's Sculpture*. Pittsburgh: University of Pittsburgh Press, 1983.
Henze, Anton and Theodor Filthaut. *Contemporary Church Art*. New York: Sheed & Ward, 1956.
Proske, Beatrice Gilman. "American Women Sculptors, Part II." *National Sculpture Review* vol. 24 no. 4 (Winter 1975-1976) pp. 8-17, 28, illus.

Mailing Address
3930 Dickey Road
Gibsonia, Pennsylvania 15044

Artist's Statement

"All persons are concerned with communication of the issues of their inner being. From the endless movement of the spiritual and intellectual, they seek to choose and immobilize some fragment of innate or discovered self-truth to render it visible to others. Only thus do they feel the bond of immortality with God and others which perpetuates the spirit and reiterates the great rhythms of truth. Art is this fragmentary vision of truth, made articulate through labor and guidance of hand and eye. Taking root outside ourselves, it grows and blossoms in the new soil of another's understanding. Thus is established this miraculous language, which speaks to person from person, renewing their contact with God, clarifying their concepts and giving voice to their own nostalgic souls."

Janet de Cruz

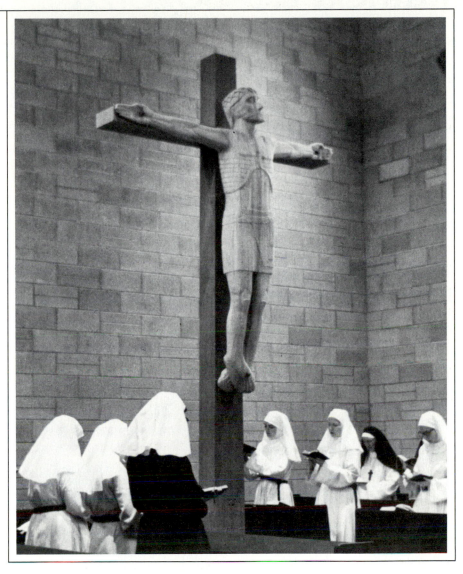

Crucifix. 1960. Wood, 7'h. Collection Convent of St. Helena Chapel, Vail's Gate, New York.

Patricia de Gogorza

(Husband James Gahagan)
Born March 17, 1936 Detroit, Michigan

Education and Training
1956- Atelier 17, Paris, France; study in
59 engraving and etching printmaking
 techniques
1958 B.A., Art, Smith College, Northampton,
 Massachusetts
1975 M.A., Sculpture, Goddard College,
 Plainfield, Vermont

Selected Individual Exhibitions
1973 Sculpin Gallery, Edgartown,
 Massachusetts
1978 First Branch Gallery, Chelsea,
 Vermont
1981 Wood Art Gallery, Montpelier, Vermont
1982 Millhouse-Bundy Performing and Fine
 Arts Center, Waitsfield, Vermont
1984 Garage Gallery, Montpelier, Vermont
1984 Dibden Gallery, Johnson State
 College, Johnson, Vermont

Selected Group Exhibitions
1967 "Manhattan Counterpoints," Lever
 House, New York, New York
1967 "Florence Benefit Exhibition,"
 Capricorn Gallery, New York, New
 York
1967, "All Vermont Juried Show," Millhouse-
76, Bundy Performing and Fine Arts
78 Center, Waitsfield, Vermont
1969, "Group One," MUSEUM at Broadway
70 and Waverly Place, New York, New
 York
1971 "Gallery Exhibition," Stratton Mountain
 Arts Center, Stratton Mountain,
 Vermont
1973 "Group Exhibition," Sculpin Gallery,
 Edgartown, Massachusetts
1974- "Annual Faculty Exhibition," Goddard
80 College, Plainfield, Vermont

1975- "Annual Exhibition," Art Resource
85 Association, Montpelier, Vermont
1978 "White Mountain Arts Festival,"
 Outdoor Sculpture Exhibition,
 Jefferson, New Hampshire
1978, "Norwich Art Annual Juried Exhibition,"
79, Norwich University, Northfield,
80 Vermont
1979 "Cabin Fever: Women Artists from
 Maine, New Hampshire and Vermont,"
 Hera Gallery, Wakefield, Rhode Island,
 catalog
1980 "New Members Exhibition,"
 Provincetown Art Association and
 Museum, Provincetown,
 Massachusetts
1980, "Summer Show," Notch Gallery Fine
81, Arts Co-Op, Stowe, Vermont
82,
83,
84
1981 "Recent Acquisitions," Provincetown
 Art Association and Museum,
 Provincetown, Massachusetts
1983 "Inauguration Exhibition," Federal
 Courthouse, Barre, Vermont
1983 "Group Exhibition," AVA Gallery,
 Hanover, New Hampshire
1984, "Gallery Exhibition," Colorism Gallery,
85 New York, New York
1985 "Contemporary Vermont Artists,"
 College Hall, Vermont College of
 Norwich University, Montpelier,
 Vermont

Selected Public Collection
Provincetown Art Association and Museum,
 Provincetown, Massachusetts

Selected Private Collections
Mr. and Mrs. William Cathey, Montpelier,
 Vermont
Mr. and Mrs. Richard Leary, Washington,
 D.C.
Anita Morreale, Plattsburgh, New York
Jean C. Sousa, Worcester, Vermont
Peggy Spidel, Simi, California

Selected Awards
1975 Individual Artist's Fellowship, Vermont
 Council on the Arts
1982 First Prize, "First Annual Vermont
 All-Media Juried Show,"
 Millhouse-Bundy Performing and Fine
 Arts Center, Waitsfield, Vermont
1983 First Prize, "Norwich Art Annual Juried
 Exhibition," Norwich University,
 Northfield, Vermont

Preferred Sculpture Media
Metal (cast) and Wood

Additional Art Field
Printmaking

Teaching Position
Field Faculty, Vermont College of Norwich
 University, Montpelier, Vermont

Selected Bibliography
Grabon, Marie La Pre. "Regional Reviews
 Vermont: Millhouse-Bundy Performing and
 Fine Arts Center/Waitsfield: Vermont
 All-Media Show." *Art New England* vol. 4
 no. 1 (December 1982) p. 9, illus.

Gallery Affiliation
Notch Gallery Fine Arts Co-Op
Stowe, Vermont 05672

Mailing Address
RFD Box 116
East Calais, Vermont 05650

Artist's Statement

"I believe my work is more a process of questioning than a statement which I can articulate in words. My early attempts at carving were encouraged by my artist-parents. My first important studies were as a printmaker at Atelier 17 in Paris. The techniques of woodcut relief and copper engraving permit a direct manipulation of the image.

"My first carvings in wood and stone were done in Portugal. The design elements in sculpture from New Guinea, New Hebrides and several African traditions were sources of inspiration for this early work. Cutting the wood from my own land and incorporating color and natural surfaces, the unifying approach in my work of the past ten years has been the pursuit of a personal mythology. The development of the images, the combination of animal and female forms and the persistent androgyny of the pieces could possibly stem subconsciously from much older societies. This retrieval of submerged self-images may be but a preamble to a basic expressive vocabulary. The mind and eye will reveal a sequence that is inherently meaningful but which cannot be rushed."

Patricia de Gogorza

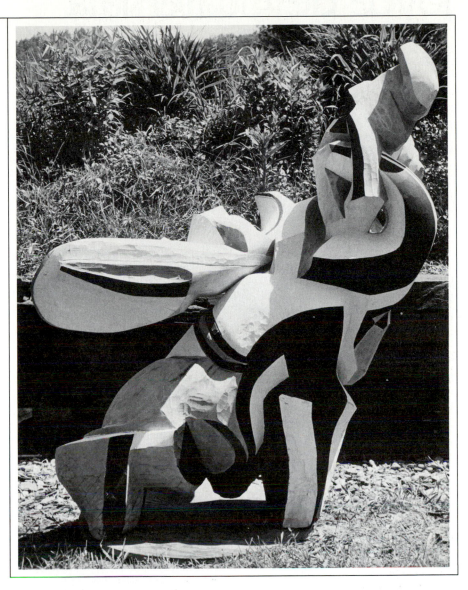

Dutch Bull. 1976. Basswood and paint, 57″h x 53″w.

Joyce de Guatemala

née Joyce Bush Prado
(Husband Jason Leander Vourvoulias)
Born February 25, 1938 México, D.F., México
(Guatemalan citizenship)

Education and Training
1958 Universidad Nacional Autónoma de México, México, D.F., México
1959 University of Wisconsin-Madison, Madison, Wisconsin
1960- Silpakorn University, Bangkok, 62 Thailand
1969 Physics Certificate, Universidad de San Carlos de Guatemala, Guatemala, Guatemala
1973- Cromados Industriales, Guatemala, 75 Guatemala; machinist/welder to learn technical skills applied to sculpture

Selected Individual Exhibitions
1970 Salon Enrique Acuña, Escuela de Bellas Artes, Guatemala, Guatemala, catalog
1973 Galería Macondo, Guatemala, Guatemala
1974 Galería Feokarril, Guatemala, Guatemala, retrospective
1976 Escuela Nacional de Bellas Artes, Guatemala, Guatemala, catalog
1977 Museum of Modern Art of Latin America, Organization of American States, Washington, D.C.
1979, Marian Locks Gallery, Philadelphia, 85 Pennsylvania
1980 Student Center Gallery, University of Delaware, Newark, Delaware
1981 Cedar Crest College, Allentown, Pennsylvania
1982 Barbara Gillman Gallery, Miami, Florida
1982 Northwood Institute, West Palm Beach, Florida
1983 Ralph L. Wilson Gallery, Alumni Memorial Building, Lehigh University, Bethlehem, Pennsylvania
1985 Marian Locks Gallery East, Philadelphia, Pennsylvania

Selected Group Exhibitions
1972 "Artistas Guatemalteca Contemporánea, Contemporary Guatemalan Artists," Galería El Túnel, Guatemala, Guatemala
1973 "Cien Obras de la Colección de John Gody, One Hundred Art Works from the Collection of John Gody," Biblioteca Nacional de Guatemala, Guatemala, Guatemala

1974 "De Cien Años de Soledad a Cien Años de Realidad, From One Hundred Years of Solitude to One Hundred Years of Reality," Galería Macondo, Guatemala, Guatemala
1974 "Four Artists," Trend House Gallery, Tampa, Florida
1975 "Juannio: Exhibicíon y Subasta Nacional de Arte, Juannio: National Art Exhibition and Auction," Biblioteca Nacional de Guatemala, Guatemala, Guatemala, catalog
1975 "La Mujer en Arte Guatemalteca Contemporánea, The Women in Contemporary Guatemalan Art," Escuela de Bellas Artes, Guatemala, Guatemala
1975 "Young Artists '75: Fourth International Art Exhibition," Union Carbide Exhibition Hall, New York, New York
1976 "Latin American Horizons: 1976," John and Mabel Ringling Museum of Art, Sarasota, Florida; Metropolitan Museum and Art Center, Coral Gables, Florida; Pensacola Museum of Art, Pensacola, Florida; Museum of Art, Fort Lauderdale, Florida, catalog
1978 "Inaugural Group Exhibition, Contemporary Latin American Artists," Noble/Polans Gallery, New York, New York
1978 "Philadelphia Women Artists Salute Women in Transition," Marian Locks Gallery, Philadelphia, Pennsylvania
1979, "Sculpture Outdoors," Temple 80 University Music Festival, Ambler Campus, Ambler Pennsylvania (Co-Sponsored by Cheltenham Art Centre, Cheltenham, Pennsylvania), catalog
1979 "Philadelphia Art '79: The Commonwealth of Ideas and Man," Federal Courthouse, Philadelphia, Pennsylvania
1980 "Selected Works from Sculpture Outdoors '80," Cedar Crest College, Allentown, Pennsylvania
1981 "Sculpture '81," Beaver College, Glenside, Pennsylvania (Co-Sponsored by Cheltenham Art Centre, Cheltenham, Pennsylvania)
1981 "Sculpture '81/13 Sculptors," Temple University, Philadelphia, Pennsylvania
1981 "Regional Trends in Sculpture," Stockton State College, Pomona, New Jersey
1982 "Five Hispanic Artists of Pennsylvania," Alfred O. Deshong Museum, Widener University, Chester, Pennsylvania, catalog
1982 "Expressions of Excellence," William Penn Memorial Museum, Harrisburg, Pennsylvania
1982 "Six Latin American Artists," Forum International Gallery, Atlanta, Georgia
1983 "Sculpture/Penn's Landing," Port of History Museum, Philadelphia, Pennsylvania (Co-Sponsored by Cheltenham Art Centre, Cheltenham, Pennsylvania)

1983 "Naomi Savage, Joyce de Guatemala and Works on Paper Exhibition in Honor of Charles Demuth," Noyes Museum, Oceanville, New Jersey, catalog
1983 "Four Latin American Sculptors," Museum of Modern Art of Latin America, Organization of American States, Washington, D.C., catalog
1983 "XVII Bienal Internacional de São Paulo," Museu de Arte Moderna de São Paulo, São Paulo, Brazil, catalog
1985 "Outdoor Sculpture Exhibition," Seton Hill College, Greensburg, Pennsylvania (In celebration of the Seventy-Fifth Anniversary Associated Artists of Pittsburgh, Pennsylvania)

Selected Public Collections
Cámara de Industria, Guatemala City, Guatemala
Cedar Crest College, Allentown, Pennsylvania
Elkins Park Free Library, Elkins Park, Pennsylvania
Escuela de Bellas Artes, Guatemala, Guatemala
Exmibal Corporation, El Estor, Guatemala
Hemisphere Services, Philadelphia, Pennsylvania
Hershey Foods Corporation Technical Center, Hershey, Pennsylvania
John and Mabel Ringling Museum of Art, Sarasota, Florida
Kensington Townhouse Project, Philadelphia, Pennsylvania
Lehigh University, Bethlehem, Pennsylvania
Museo de Arte Moderno, México, D.F., México
Museo Nacional de Historia y Bellas Artes, Guatemala, Guatemala
Museum of Modern Art of Latin America, Organization of American States, Washington, D.C.
Noyes Museum, Oceanville, New Jersey
Pan American Bank, Miami, Florida
Wolf D. Barth Corporation, Philadelphia, Pennsylvania

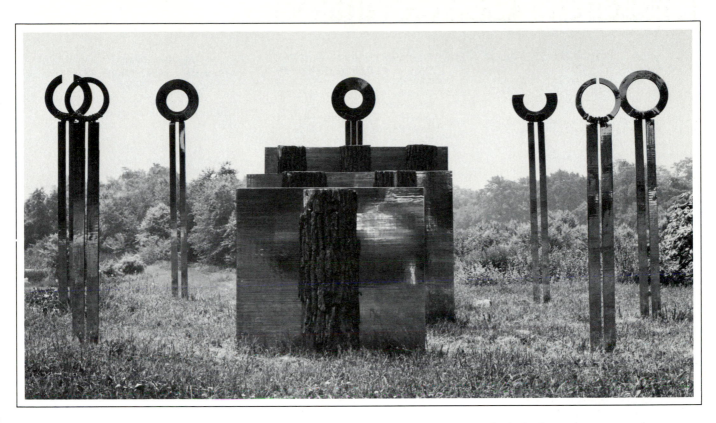

Tribute to the Moon: The Temple and the Guardians. 1983. Stainless steel and wood, 4'-10'h x 30'w x 30'd. Installation view 1983. "XVII Bienal Internacional de São Paulo," Museu de Arte Moderna de São Paulo, São Paulo, Brazil, catalog. Photograph by Albert L. Vourvoulias.

Selected Private Collections

Mr. and Mrs. Philip Berman, Allentown, Pennsylvania

John Gody, New York, New York; Guatemala, Guatemala and Paris, France

Marian Locks, Philadelphia, Pennsylvania

Mr. and Mrs. Mario Mory, Beverly Hills, California

Mr. and Mrs. Richard Ravenscroft, Bryn Mawr, Pennsylvania

Selected Awards

1975 Grand Prize for Latin American Francisco Matarazzo Sobrinho, "XIII Bienal Internacional de São Paulo," Museu de Arte Moderna de São Paulo, São Paulo, Brazil, catalog

1975 Highest Art Award, Order of Garcia Granados, Government of Guatemala

1985 Creative Sculpture Grant, Djerrassi Foundation, Woodside, California

Preferred Sculpture Media

Metal (welded)

Gallery Affiliation

Marian Locks Gallery
1524 Walnut Street
Philadelphia, Pennsylvania 19102

Mailing Address

Fairview Road
RD 2 Box 506A
Glenmoore, Pennsylvania 19343

Artist's Statement

"My sculptures are drawn from the collective, universal memory that allows different cultures to share symbolic structures for the representation of inexplicable or natural phenomena. They allude to magical sites, quiet and isolated places which provoke meditation and ritual. Sites where tradition or the structured past becomes tangible and yet, where one can feel the eminence of change, the future's imperious pull.

"I build my sculptures of stainless steel which I work to a highly reflective finish. The mirrored quality of the steel is based on the ancient and transcultural idea that reflective surfaces serve as doorways to a different, hidden and even supernatural world. It also absorbs the immediate journalism of the present. The added natural element of wooden trunks is the catalyst in the creation of a complex structure. Universal and personal, material and conceptual, mythological and real, the sculptures bear witness to our era."

Joyce de Guatemala

Deborah de Moulpied

Born November 22, 1933 Manchester, New Hampshire

Education and Training
1956 Diploma, Sculpture, School of the Museum of Fine Arts, Boston, Massachusetts; study with Ernest Morenon
1960 B.F.A., Sculpture, School of Art and Architecture, Yale University, New Haven, Connecticut; study with Robert Engman and Erwin Hauer
1962 M.F.A., Sculpture, School of Art and Architecture, Yale University, New Haven, Connecticut; additional study in sculpture with Robert Engman and Erwin Hauer

Selected Group Exhibitions
1961, "Structured Sculpture," Galerie 68 Chalette, New York, New York, catalog
1961 "Recent Acquisitions," Museum of Modern Art, New York, New York, catalog
1961 "Plastics U.S.A.," Traveling Exhibition (Russia), United States Information Agency, Washington, D.C.
1961- "Recent Sculpture and Painting in 62 America," Traveling Exhibition (Europe and South America), Museum of Modern Art, New York, New York, catalog
1962 "Geometric Abstraction in America," Whitney Museum of American Art, New York, New York, catalog
1962 "Five Connecticut Collectors," Wadsworth Atheneum, Hartford, Connecticut
1962 "Structured Sculpture," Katonah Gallery, Katonah, New York
1962 "Group Exhibition," Contemporary Arts Museum, Houston, Texas
1967 "Group Exhibition," Galerie Simonne Stern, New Orleans, Louisiana
1968 "Eleven Sculptors," Yale University, New Haven, Connecticut
1968 "Exhibition of Works by Contemporary American Artists," National Institute of Arts and Letters, New York, New York, catalog
1969 "Annual Exhibition: Contemporary American Sculpture," Whitney Museum of Modern Art, New York, New York, catalog

1970 "MacDowell Colony Artists 1970," Keene State College, Keene, New Hampshire
1970 "Acquisitions for the Museum of Modern Art 1959-1969," Aldrich Museum of Contemporary Art, Ridgefield, Connecticut, catalog
1974 "Selected Paintings and Sculpture from the Hirshhorn Museum and Sculpture Garden," Hirshhorn Museum and Sculpture Garden, Smithsonian Institution, Washington, D.C., catalog
1980 "International Sculpture Competition," Robeson Center Gallery, Rutgers University, University College-Newark, Newark, New Jersey
1981 "Ten Maine Sculptors," Carnegie Hall, University of Maine at Orono, Orono, Maine
1981 "Maine Women Artists," Maine Coast Artists, Rockport, Maine
1983 "Aspects of Abstraction: Sculpture by Deborah de Moulpied, Gerald di Guisto and Lawrence Fane," Colby College Museum of Art, Waterville, Maine
1983, "New England Invitational Sculpture 84 Show, Ogunquit Art Association," Barn Gallery, Ogunquit, Maine
1983, "Sculptors Guild Annual Exhibition," 85 Lever House, New York, New York, catalog
1984 "Sculpture Exhibition 1984," Great Space of St. Paul's Depot, Imprimatur Gallery, St. Paul, Minnesota
1985 "Inaugural Exhibition," Naples Gallery, Naples, Florida

Selected Public Collections
Bangor Area State Office Center, Bangor, Maine
Chase Manhattan Bank, New York, New York
Colby College Museum of Art, Waterville, Maine
Hirshhorn Museum and Sculpture Garden, Smithsonian Institution, Washington, D.C.
Museum of Modern Art, New York, New York

Selected Private Collections
Dr. Lawrence Abt, Larchmont, New York
Olga Hirshhorn, Washington, D.C.
Gertrude A. Mellon, New York, New York
Dr. Herbert Robbins, New York, New York
Dr. Jerome Sterling, New Haven, Connecticut

Selected Awards
1962 Clarissa Bartlett Traveling Fellowship (Europe), School of the Museum of Fine Arts, Boston, Massachusetts
1969 Artist in Residence, MacDowell Colony, Peterborough, New Hampshire
1974 Research Associate Grant, School of Art and Architecture, Yale University, New Haven, Connecticut

Preferred Sculpture Media
Metal (cast), Plastic (thermal formed) and Varied Media

Teaching Position
Associate Professor, University of Maine at Orono, Orono, Maine

Selected Bibliography
Burnham, Jack. Beyond Modern Sculpture: The Effects of Science and Technology on the Sculpture of this Century. New York: George Braziller, 1968.
Ebitz, David. "Regional Reviews Maine: Carnegie Hall/University of Maine/Orono, Ten Maine Sculptors." Art New England vol. 2 no. 5 (April 1981) p. 6, illus.
Jacobs, Jay. "New York Gallery Notes: The Eclectic Circus." Art in America vol. 56 no. 6 (November 1968) pp. 106-110, illus.
Newman, Thelma R. Plastics as an Art Form. Philadelphia: Chilton, 1964.
Rickey, George. Constructivism: Origins and Evolution. New York: George Braziller, 1967.

Gallery Affiliations
Arlene McDaniels and Associates
Ellsworth Gallery and Wiley Gallery
10 Phelps Lane
Simsbury, Connecticut 06070

Imprimatur Gallery
415 First Avenue North
Minneapolis, Minnesota 55401

Naples Gallery
275 Broad Avenue South
Naples, Florida 33940

Mailing Address
Box 7
Hancock, Maine 04640

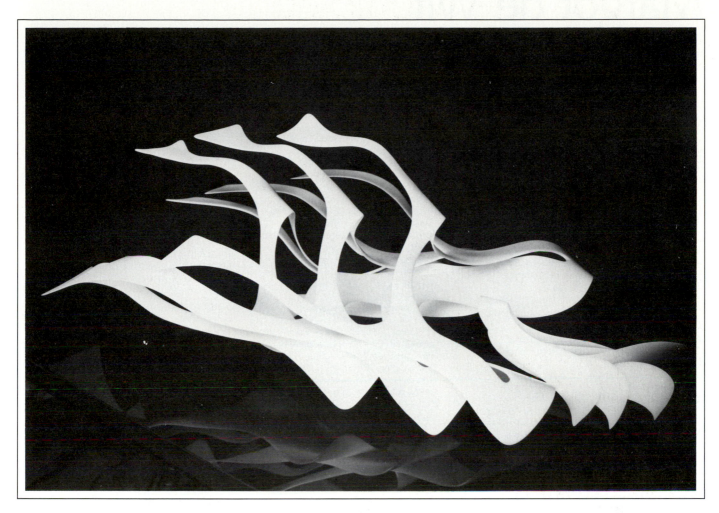

Endo-Exo. 1981. Lucite, 36"h x 48"w x 18"d.

Artist's Statement

"Most of my artistic career, from traditional training to experimental work, was devoted more to the process of creating than to what I was creating. I was originally attracted to working in sheet plastic because it was the only material which would allow me to transform a two-dimensional plane into a progression of thin curved forms. The first series of shell forms were stationary forms; the next series explored the relationship of form to space and were suspended, hanging, mobile. The following wall relief series revealed the unobtrusive power trapped in the changing form. The *Endo-Exo* series (internal vs external) appeared to capture a sense of the potential of the power, growth and movement of skeletal structures.

"In a new series, I am exploring an organic form image which appears to communicate both the time and space aspects of potential growth and change without encasing itself in the amber of identifiable object. Like many other modern sculptors, I am energized by the exploration of dimensions which have not been articulated."

Deborah del Monfried

Margot de Wit

née Margaretha Augusta Louise Maria
(Husband Veeraswamy Samy Naiken)
Born June 29, 1936 Zeist, Netherlands
(Dutch citizenship)

Education and Training
1963 L.O., RijksNormaalschool-Opleiding
Tekenleraren, Amsterdam,
Netherlands
1967 M.A., Art Education, Atelier 63,
Haarlem, Netherlands; study in
sculpture with Friso ten Holt
1970 M.F.A. Equivalency, Sculpture, Tyler
School of Art, Temple University,
Philadelphia, Pennsylvania; study with
Italo Scanga
1972 Tyler School of Art, Temple University,
Philadelphia, Pennsylvania; additional
study in sculpture with Italo Scanga
1983 Universiteit van Amsterdam,
Amsterdam, Netherlands; study in art
history

Selected Individual Exhibitions
1967, Galerie 96, Amsterdam, Netherlands
68
1975 Gloucester County College, Sewell,
New Jersey
1977 Westby Gallery, Glassboro State
College, Glassboro, New Jersey
1978 Mitchel Hall, West Chester State
College, West Chester, Pennsylvania
1978 Philadelphia Art Alliance, Philadelphia,
Pennsylvania
1978, J. Walter Thompson Gallery,
79 Amsterdam, Netherlands
1979 A. J. Wood Galleries, Philadelphia,
Pennsylvania
1980, Centrum de Vaart, Hilversum,
81 Netherlands
1982 Galerie de Bleeker, Heemstede,
Netherlands, catalog
1984 Orange County Center for
Contemporary Art, Laguna Beach,
California
1984 Kunstenaars Centrum Bergen, Bergen,
Netherlands
1985 Chauncey Conference Center Gallery,
Educational Testing Services,
Princeton, New Jersey

Selected Group Exhibitions
1971 "Annual Exhibition," Woodmere Art
Gallery, Philadelphia, Pennsylvania
1974 "Sculpture '74," Tyler School of Art,
Temple University, Philadelphia,
Pennsylvania
1976, "Annual Exhibition," National Academy
77 of Design, New York, New York,
catalog
1976, "Annual Regional Sculpture Show,"
77 Museum of the Philadelphia Civic
Center, Philadelphia, Pennsylvania
1978 "Artists Equity Annual Exhibition,"
Museum of the Philadelphia Civic
Center, Philadelphia, Pennsylvania
1979, "Sculpture Outdoors," Temple
80 University Music Festival, Ambler
Campus, Ambler, Pennsylvania
(Co-Sponsored by Cheltenham Art
Centre, Cheltenham, Pennsylvania),
catalog
1979 "Art in Boxes," Philadelphia Art
Alliance, Philadelphia, Pennsylvania
1979 "Twenty-Five Pennsylvania Women
Artists," Southern Alleghenies Museum
of Art, Loretto, Pennsylvania
1979 "Philadelphia Art '79: The
Commonwealth of Ideas and Man,"
Federal Courthouse, Philadelphia,
Pennsylvania
1980 "Big Things for Big Spaces:
Architecture/ Sculpture," Woodmere
Art Gallery, Philadelphia, Pennsylvania
1981- "Sculpture '81," Temple University,
82 Main Campus, Philadelphia,
Pennsylvania (Co-Sponsored by
Cheltenham Art Centre, Cheltenham,
Pennsylvania), catalog
1981 "Sculpture '81," Franklin Plaza and
International Garden Franklin Town,
Philadelphia, Pennsylvania
(Co-Sponsored by Cheltenham Art
Centre, Cheltenham, Pennsylvania)
1982 "First Thoughts," Muse Gallery,
Philadelphia, Pennsylvania
1982 "S/300 Sculpture/Tricentennial/1982,"
Philadelphia Art Alliance and
Rittenhouse Square, Philadelphia,
Pennsylvania, catalog
1982 "Dutch Artists Living in New York,"
Lever House, New York, New York;
Kling Gallery, Philadelphia,
Pennsylvania
1983 "Carved Wood Sculpture," Thorpe
Intermedia Gallery, Sparkhill, New
York
1983 "Sculpture/Penn's Landing," Port of
History Museum, Philadelphia,
Pennsylvania (Co-Sponsored by
Cheltenham Art Centre, Cheltenham,
Pennsylvania)
1984 "'84 Sculptors," Roger La Pelle
Galleries, Philadelphia, Pennsylvania
1985 "CON=STRUCT=URES=1985,"
Reading Public Museum and Art
Gallery, Reading, Pennsylvania,
catalog

Selected Public Collections
City of Beverwijk, Netherlands
Telegraphics, Philadelphia, Pennsylvania

Selected Private Collections
Ellen Reese, Philadelphia, Pennsylvania
Gary Stein, Philadelphia, Pennsylvania

Selected Award
1978- Artist in Residence, Glassboro
85 State College, Glassboro,
Pennsylvania

Preferred Sculpture Media
Varied Media and Wood

Additional Art Fields
Printmaking and Photography

Related Professions
Consultant, Curator and Exhibition
Coordinator

Teaching Position
Artist in Residence, Glassboro State College,
Glassboro, Pennsylvania

Selected Bibliography
Butera, Anne Fabbri. "Three Sculptors." *Arts
Magazine* vol. 54 no. 5 (January 1980) p.
24.
Meilach, Dona Z. *Woodworking, The New
Wave: Today's Design Trends in Objects,
Furniture, and Sculpture, with Artist
Interviews.* New York: Crown, 1981.

Gallery Affiliations
Dolan-Maxwell Gallery
1701 Walnut Street
Philadelphia, Pennsylvania 19103

Galerie de Bleeker
Bleekervaartweg 18
Heemstede, Netherlands

Mailing Address
4418 Spruce Street
Philadelphia, Pennsylvania 19104

Artist's Statement

"When I first arrived in the United States in 1967, I was struck by the visual contrast between my native country Holland and America. The landscape in Holland is flat with wide vistas and everchanging skies. Any form or structure creates a link between sky and land. Structures or architectural forms are mere connections between two large bodies, one static and horizontal, the other changing and continually moving.

"America's landscape seems totally different. Large-size architecture creates a more definite form, seeming to reach into the immense and distant sky. The sky appears a static grey-blue background sharply outlining the natural or architectural environment in the landscape.

"My reaction to the scale and quality of American life was an important challenge to my artistic comment. My constructions and prints combine these new experiences with the intimacy and cultural values from the old world."

Margot de Wit

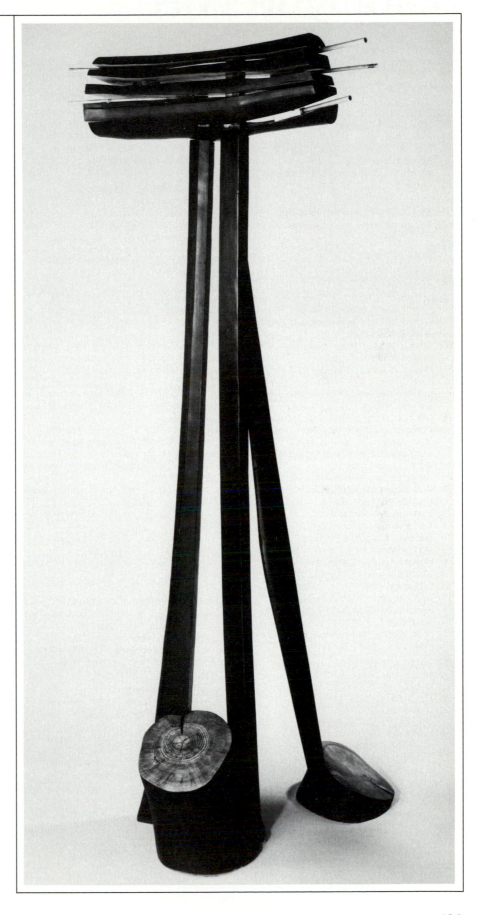

Architectural Form No. 1. 1979. Wood, 7½'h x 2'w x 1½'d. Photograph by Bill Dobos.

Dorothy Dehner

née Dorothy Florence
Born December 23, 1901 Cleveland, Ohio

Education and Training
1921- University of California, Los Angeles,
22 Los Angeles, California
1926- Art Students League, New York,
30 New York
1952 B.S., Art, Skidmore College, Saratoga
Springs, New York
1952- Atelier 17, New York, New York
56

Selected Individual Exhibitions
1957, Willard Gallery, New York, New York
59,
60,
63,
66,
70,
73
1959 Gres Gallery, Washington, D.C.
1964 Albany Institute of History and Art,
Albany, New York
1965 Jewish Museum, New York, New York,
retrospective and catalog
1967 Hyde Collection, Glens Falls, New
York
1969 Cummer Gallery of Art, Jacksonville,
Florida, catalog
1970 City University of New York Bernard
M. Baruch College, New York, New
York
1971 Time-Life Building, New York, New
York
1973 Weiss Gallery, Cleveland, Ohio
1974 Fort Wayne Museum of Art, Fort
Wayne, Indiana, catalog
1976, Elaine Benson Gallery,
78 Bridgehampton, New York
1977 Marian Locks Gallery, Philadelphia,
Pennsylvania
1978 Storm King Art Center, Mountainville,
New York
1980 Barbara Fiedler Gallery, Washington,
D.C.
1980 Parsons-Dreyfuss Gallery, New York,
New York
1981, A. M. Sachs Gallery, New York, New
82, York
84

Selected Group Exhibitions
1957- Major museums and galleries in the
85 United States, Canada, South America
and Europe
1984 "Dorothy Dehner/David Smith: Their
Decades of Search and Fulfillment,"
Jane Voorhees Zimmerli Art Museum,
Rutgers University, University
College-New Brunswick, New
Brunswick, New Jersey, catalog

Selected Public Collections
American Telephone and Telegraph
Headquarters, Basking Ridge, New Jersey
Cleveland Museum of Art, Cleveland, Ohio
Columbus Museum of Art, Columbus, Ohio
Cummer Gallery of Art, Jacksonville, Florida
Great Southwest Industrial Park, Atlanta,
Georgia
Hirshhorn Museum and Sculpture Garden,
Smithsonian Institution, Washington, D.C.
Hyde Collection, Glens Falls, New York
Metropolitan Museum of Art, New York, New
York
Museum of Modern Art, New York, New York
Neuberger Museum, Purchase, New York
New York Medical College, Valhalla, New
York
Newark Museum, Newark, New Jersey
Philadelphia Museum of Art, Philadelphia,
Pennsylvania
Phoenix Art Museum, Phoenix, Arizona
Rockefeller Center, New York, New York
Saint Louis Art Museum, St. Louis, Missouri
Solomon R. Guggenheim Museum, New
York, New York
Storm King Art Center, Mountainville, New
York
Time-Life Building, Tower Suite, New York,
New York
Union Camp Corporation, Wayne, New
Jersey
Whitney Museum of American Art, New York,
New York

Selected Private Collections
Edward Broide, Los Angeles, California
Ralph Colin, New York, New York
Olga Hirshhorn, Washington, D.C.
Gertrude A. Mellon, New York, New York
Walter Thayer, New York, New York

Selected Awards
1982 Honorary Doctorate of Fine Arts,
Skidmore College, Saratoga Springs,
New York
1983 Honor Award for Outstanding
Achievement in the Visual Arts,
National Women's Caucus for Art
Conference, Philadelphia,
Pennsylvania

Preferred Sculpture Media
Metal (cast) and Wood

Additional Art Field
Drawing

Selected Bibliography
Ashton, Dore. "Fifty-Seventh Street in
Review: Dorothy Dehner." Art Digest vol.
26 no. 16 (May 15, 1952) p. 19, illus.
Marter, Joan M. "Dorothy Dehner." Arts
Magazine vol. 53 no. 7 (March 1979) p. 4,
illus.
Marter, Joan M. "Dorothy Dehner." Woman's
Art Journal vol. 1 no. 2 (Fall 1980-Winter
1981) pp. 47-50, illus.
Munro, Eleanor C. Originals: American
Women Artists. New York: Simon and
Schuster, 1979.
Papers included in the Archives of American
Art, Smithsonian Institution, New York,
New York.

Gallery Affiliation
A. M. Sachs Gallery
29 West 57 Street
New York, New York 10019

Mailing Address
33 Fifth Avenue
New York, New York 10003

Artist's Statement

"From the earliest days in childhood we were encouraged to draw. Mother believed we should make our toys with drawing paper, crayons and chalks. We made collages (although they were not called that then) and Christmas ornaments and paper hats and decorations for parties. My two aunts and cousins were painters who were quite persistent and serious. The family was all very musical. Later I acted in plays and literature opened a tremendous world to me. When I first traveled to Europe and saw the architecture, the museums and the medieval quality, I wanted to be a sculptor. I began painting and exhibiting in New York, but I did not exhibit sculpture until 1957.

"In my work there are many feelings but I never put them into words; I express them in forms. I have a kind of image in my head but it gets changed in working. Sometimes I make a small sketch and it will start me on a whole series of ideas. The satisfaction of creative activity has helped me live. It has been a great catharsis and an affirmation of existence."

Dorothy Dehner

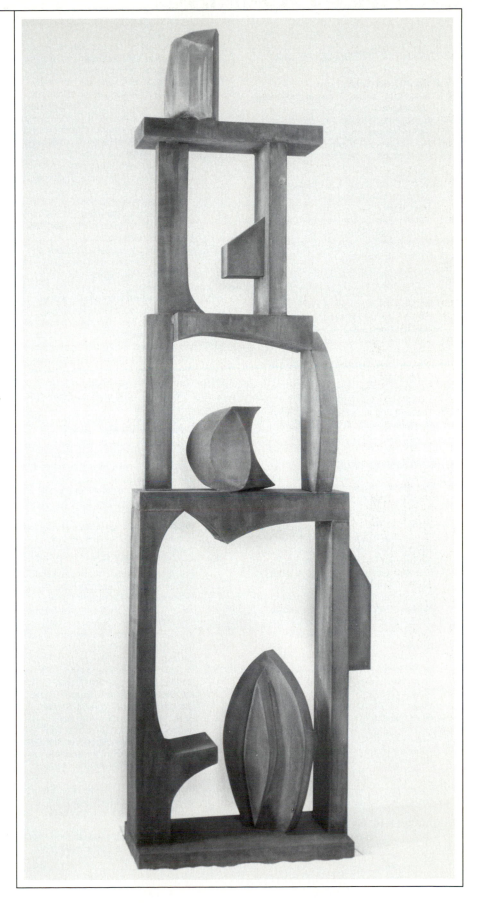

Scaffold. 1983. CorTen steel, 8½'h. Courtesy A. M. Sachs Gallery, New York, New York.

Donna Dennis

née Donna Frances
Born October 16, 1942 Springfield, Ohio

Education and Training
1964 B.A., Art, Carleton College, Northfield, Minnesota
1964- College Art Studies Abroad Program,
65 Paris, France; study in painting
1965- Art Students League, New York, New
66 York; study in painting

Selected Individual Exhibitions
1973 West Broadway Gallery, New York, New York
1974 Wilcox Gallery, Swarthmore College, Swarthmore, Pennsylvania
1976, Holly Solomon Gallery, New York, New
78, York
80,
83,
85
1977 Musical Theater Lab, John F. Kennedy Center for the Performing Arts, Washington, D.C.
1978, Abe Adler Gallery, Los Angeles,
83 California
1979 Contemporary Arts Center, Cincinnati, Ohio, catalog
1980 Sullivant Gallery, Ohio State University, Columbus, Ohio
1981 Galleria Locus Solus, Genoa, Italy
1985 Philippe Bonnafont Gallery, San Francisco, California

Selected Group Exhibitions
1974 "Eccentrics and Fantastics," University Art Gallery, State University of New York at Albany, Albany, New York; Brainerd Art Gallery, Potsdam, New York, catalog
1974 "Contemporary Reflections 1973-1974," Aldrich Museum of Contemporary Art, Ridgefield, Connecticut, catalog
1974 "19 Women Artists," Portland Museum of Art, Portland, Maine
1977 "Sculpture: Potsdam '77," Brainerd Art Gallery, Potsdam, New York, catalog
1977 "Scale and Environment," Walker Art Center, Minneapolis, Minnesota, catalog
1977 "Ten Years of Ten Downtown," P.S. 1, Institute for Art and Urban Resources, Long Island City, New York
1977 "Small Objects," Whitney Museum of American Art, Downtown Branch, New York, New York

1978 "Three Alumni: Donna Dennis, Alan Larkin and Diane Williams," Carleton College, Northfield, Minnesota
1978 "Architectural Analogues," Whitney Museum of American Art, Downtown Branch, New York, New York, catalog
1978- "Dwellings," Institute of Contemporary
79 Art of The University of Pennsylvania, Philadelphia, Pennsylvania; Neuberger Museum, Purchase, New York, catalog
1978 "New York," San Francisco Art Institute, San Francisco, California, catalog
1979 "1979 Biennial Exhibition: Contemporary American Art," Whitney Museum of American Art, New York, New York, catalog
1979 "Directions," Hirshhorn Museum and Sculpture Garden, Smithsonian Institution, Washington, D.C., book-catalog
1980 "Les Nouveaux Fauves-Die Neuen Wilden," Neue Galerie Sammlung Ludwig, Aachen, Germany, Federal Republic, catalog
1980 "Architectural Sculpture," Los Angeles Institute of Contemporary Art, Los Angeles, California, catalog
1980 "Tableau: An American Selection," Middendorf/Lane Gallery, Washington, D.C., catalog
1980 "Painting and Sculpture Today 1980," Indianapolis Museum of Art, Indianapolis, Indiana, catalog
1981 "Inner/Urban," First Street Forum Gallery, St. Louis, Missouri, catalog
1981 "Developments in Recent Sculpture," Whitney Museum of American Art, New York, New York, catalog
1981 "Aspects of Post-Modernism: Decorative and Narrative Art," Squibb Gallery, Princeton, New Jersey, catalog
1981 "Home Work: The Domestic Environment Reflected in the Work of Contemporary Women Artists," National Women's Hall of Fame, Seneca Falls, New York; Joe & Emily Lowe Art Gallery, Syracuse, New York; Henry Street Settlement Urban Life Center, New York, New York, catalog
1982 "4 Sculptors: Maureen Conner, Donna Dennis, Irene Krugman, Eileen Spikol," Art Gallery, Fine Arts Center, State University of New York at Stony Brook, Stony Brook, New York, catalog
1982 "The Image of the House in Contemporary Art," University of Houston Lawndale Annex, Houston, Texas, catalog
1982 "Aspects of Post-Modernism," Fay Gold Gallery, Atlanta, Georgia
1982, "Venice Biennale," Venice, Italy,
84 catalog
1982 "Contemporary Realism at One Penn Plaza," One Penn Plaza, New York, New York, catalog

1982 "New York Now," Traveling Exhibition, Kestner-Gesellschäft, Hannover, Germany, Federal Republic, catalog
1983 "Connections: Bridges/Ladders/Ramps/ Staircases/Tunnels," Institute of Contemporary Art of The University of Pennsylvania, Philadelphia, Pennsylvania, catalog
1983 "Artists' Architecture," Institute of Contemporary Arts, London, Great Britain, catalog
1983 "Paintings and Sculpture by Candidates for Art Awards," American Academy and Institute of Arts and Letters, New York, New York, catalog
1983 "Ornamentalism: The New Decorativeness in Architecture and Design," Hudson River Museum, Yonkers, New York; Archer M. Huntington Art Gallery, Austin, Texas

Selected Public Collections
Levi Strauss Company, San Francisco, California
Musée d'Art et d'Histoire, Genève, Switzerland
Neue Galerie Sammlung Ludwig, Aachen, Germany, Federal Republic
Walker Art Center, Minneapolis, Minnesota

Selected Private Collections
Abe Adler, Los Angeles, California
Marlyse Black, New York, New York
Olga Hirshhorn, Washington, D.C.
Martin Z. Margulies, Miami, Florida
Horace and Holly Solomon, New York, New York

Selected Awards
1977 Individual Artist's Fellowship, National Endowment for the Arts
1979 John Simon Guggenheim Memorial Foundation Fellowship
1981 Creative Artists Public Service Grant, New York State Council on the Arts

Preferred Sculpture Media
Varied Media

Additional Art Fields
Drawing and Printmaking

Teaching Position
Instructor, School of Visual Arts, New York, New York

Selected Bibliography

Armstrong, Richard. "Reviews New York: Donna Dennis, Holly Solomon Gallery; Joel Shapiro, Paula Cooper Gallery." *Artforum* vol. 22 no. 2 (October 1983) pp. 76-77, illus.

Blau, Douglas. "Review of Exhibitions: Donna Dennis at Holly Solomon." *Art in America* vol. 71 no. 8 (September 1983) p. 171, illus.

"C. S." "New Editions: Donna Dennis." *Art News* vol. 82 no. 4 (April 1983) pp. 87-88, illus.

Jensen, Robert and Patricia Conway. *Ornamentalism: The New Decorativeness in Architecture and Design.* New York: Clarkson N. Potter, 1982.

Munro, Eleanor C. *Originals: American Women Artists.* New York: Simon and Schuster, 1979.

Gallery Affiliation

Holly Solomon Gallery
724 Fifth Avenue
New York, New York 10019

Mailing Address

131 Duane Street
New York, New York 10013

Artist's Statement

"A building is like a person: a basic structure which is altered and enriched over the years. I like buildings which show the passage of time, that look like they have lived, that connect me with the past. My interest is in reassembling known images and isolating, combining and inventing architectural details and elements to create a new imaginary place.

"In the early 1970s, I began to notice certain small 19th and early 20th century buildings in New York and found that for me these humble structures had strong emotional connections. My work makes direct reference to these familiar urban—as well as rural—architectural forms: hotels, subway stations and resort cabins scaled down to human height. Discovering these evocative structures, generally considered unimportant as architecture, is like focusing on overlooked areas of history."

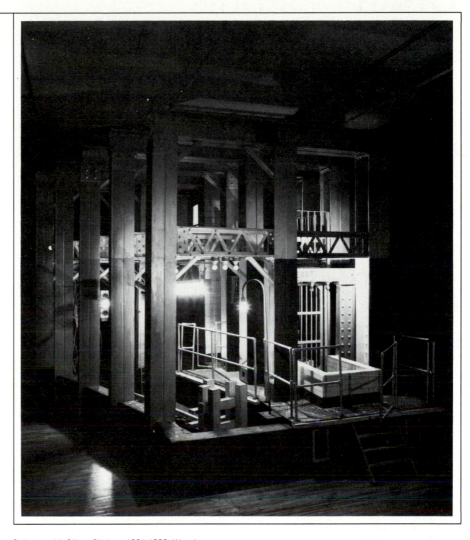

Subway with Silver Girders. 1981-1982. Wood, masonite, acrylic, enamel, cellulose compound, glass, electrical fixtures and metal, 12′2½″h x 12′2½″w x 14′3½″d. Courtesy Holly Solomon Gallery, New York, New York. Photograph by Peter Aaron, Esto Photographics.

Diska

née Pat
Born May 27, 1924 New York, New York

Education and Training
1944 B.A., Economics, Vassar College, Poughkeepsie, New York
1947 Académie Julien, Paris, France

Selected Individual Exhibitions
1961 Galerie Colette Allendy, Paris, France, catalog
1961 American Cultural Center, Paris, France, catalog
1961 Galleria XXII Marzo, Venice, Italy, catalog
1965 Galerie Les Contards, Lacoste, France, catalog
1965 Southern Methodist University, Dallas, Texas
1966 Galerie Jacques Casanova, Paris, France
1969 Ruth White Gallery, New York, New York

Selected Group Exhibitions
1961 "International Sculpture Symposium," Portorož, Yugoslavia
1961, "Exposition Internationale de
65 Sculpture," Musée National Auguste Rodin, Paris, France
1962 "Exposition de la Sculpture Contemporaine," Musée Maison de la Culture, Le Havre, France
1962 "Exposition Internationale de Petit Bronze," Musée d'Art Moderne de la Ville de Paris, Paris, France
1962 "International Sculpture Symposium," Mitzpeh Ramon, Negev Desert, Israel
1964 "Internazionale Bildhauerzeichnungen," Museum des XX Jahrhunderts, Vienna, Austria
1966 "École de Paris," Musée des Beaux Arts, Istanbul, Turkey
1966 "Exposition de Sculpture Américaine," Musée des Augustins, Toulouse, France
1966 "International Sculpture Symposium," St. Margarethen, Austria

1966 "Sculpture Contemporaine de Quatre Nations," Galerie Les Contards, Lacoste, France
1970 "International Sculpture Symposium," Port Barcarès, France
1974- "Sculptors Guild Annual Exhibition,"
85 Lever House, New York, New York, catalog
1974 "Bijoux de Sculpteurs Contemporains," Musée des Augustins, Toulouse, France
1980- "Bijoux Cailloux Fous," Maison de la
81 Culture, Amiens, France
1981 "Sculpture in the Garden," Sculptors Guild at the Enid A. Haupt Conservatory, New York Botanical Garden, Bronx, New York, catalog
1984 "La Part des Femmes dans l'Art Contemporain," Galerie Municipale, Vitry-sur-Seine, France, catalog
1984 "Expo Sculptures Contemporaines," Centre Urbain, Ville de Vitrolles, France

Selected Public Collections
Centre Cultural et Sportif, Lançon-de-Provence, France
Centre Social, Avignon, France
Collège d'Enseignement Secondaire, Crest, France
Collège d'Enseignement Secondaire Camille Reymond, Château-Arnoux, France
Collège d'Enseignement Secondaire Gaston Bachelard, Valence, France
Collège d'Enseignement Secondaire Henri Bosco, Ville Nouvelle de Vitrolles, France
Collège d'Enseignement Secondaire Rocher-du-Dragon, Aix-en-Provence, France
Collège d'Enseignement Secondaire St. Exúpery, Rosny-sous-Bois, France
École Maternelle des Cordeliers, Apt, France
École Maternelle des Ramières, Sorgues, France
École Maternelle du Pavillon, Salon-de-Provence, France
École Maternelle les Condamines, Cavaillon, France
Groupe Scolaire Pous-du-Plan, Carpentras, France
Groupe Scolaire Prairial, Ville Nouvelle de Vitrolles, France
Groupe Scolaire St. Chamand, Avignon, France
Jardins Publiques, Ville de Vitry-sur-Seine, France
Kindergarten Henri-Wallon, Aix-en-Provence, France
Ministère de la Culture, Paris, France
Musée d'Art et d'Industrie, Saint-Etienne, France
Musée en Plein Air de la Ville de Paris, Paris, France
Palm Springs Desert Museum, Palm Springs, California
Place de la Fountaine (Melum-Sénart), Ville Nouvelle de Moissy-Cramayel, France

Place des Medecis, Salon-de-Provence, France
Place du 4 Mai, Portes-les-Valence, Paris, France

Preferred Sculpture Media
Metal (cast), Stone and Wood

Selected Bibliography
Hichisson, Marjorie. "Pat Diska: Sculptress." *Architectural Association Journal* vol. 80 no. 892 (May 1965) pp. 336-337, illus.
Meilach, Dona Z. *Contemporary Stone Sculpture: Aesthetics, Methods, Appreciation.* New York: Crown, 1970.
Padovano, Anthony. *The Process of Sculpture.* New York: Doubleday, 1981.

Gallery Affiliation
Diska
305 West 28 Street
New York, New York 10001

Mailing Address
84710 Lacoste
Vaucluse, France

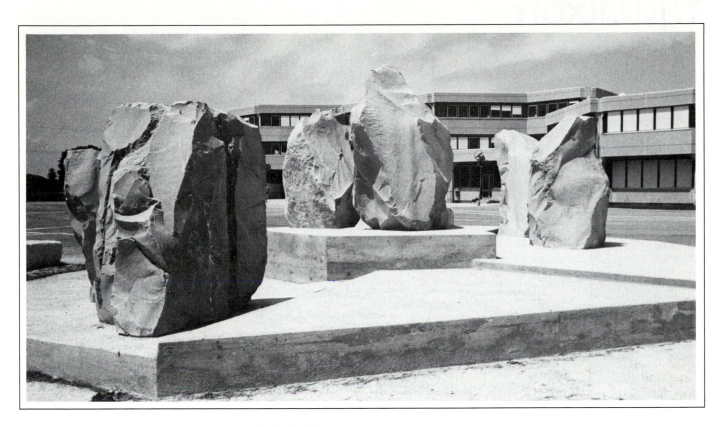

Chess Game: The Black Pieces. 1979. Stone on concrete bases, 10'h x 30'w x 30'd. Collection Collège d'Enseignement Secondaire, Crest, France.

Artist's Statement

"I prepared to become a sculptor by majoring in Economics at Vassar. This diploma enabled me to come to Paris immediately after the war as a research assistant in a relief organization, but soon I was spending my lunch hours sketching along the Seine. I worked in the studio of a sculptor who taught me to cut stone—and stone became my great love. The hardness of the material seems to impose a vigor and a discipline which is useful in the creation of a monumental work. My primary interest has been in site-specific works, which explains the dearth of personal exhibitions since 1965.

"The most crucial problem for any artist, and especially for a sculptor who must have a ground-floor workshop with ample space, is finding a studio. Then there are materials, maintenance, taxes and the incredible expenses in casting and transport. Because it is my practice to work directly on the site, whether architectural or natural with a local stone, I side-step the ever-present transport headache. I have learned much from switching from time to time to completely different materials and have become increasingly interested in cast iron, a material that permits greater freedom and spontaneity."

T. J. Dixon

née Trine Jane Dixon
(Husband Peter Eichner-Dixon)
Born June 14, 1951 Roswell, New Mexico

Education and Training
1972- Friedrich-Alexander-Universität
73 Erlangen-Nürnberg, Erlangen,
Germany, Federal Republic
1973 B.A., Literature and Language,
University of Colorado at Boulder,
Boulder, Colorado
1977- College of Fine Arts, Sunderland,
80 Great Britain; study in ceramic
sculpture with Ron Mottram and Brian
Sefton

Selected Individual Exhibitions
1980 Collingwood College Gallery,
University of Durham, Durham, Great
Britain
1980 Galerie Bayerischer Wald, Zandt,
Germany, Federal Republic
1980 Galerie im Fernsehstudio, Bad
Homburg Germany, Federal Republic
1982 Austria Galerie, Erlangen, Germany,
Federal Republic

1982 Galerie Fuchs, Vienna, Austria
1982 Altstadtgalerie Wiesbaden,
Wiesbaden, Germany, Federal
Republic
1982 Galerie im Rentmeisterstock,
Burghausen, Germany, Federal
Republic
1983 Kurdian Gallery, Wichita Art Museum,
Wichita, Kansas
1984 Galerie Bollhagen, Worpswede,
Germany, Federal Republic
1984 Galerie Worpswede, Bonn, Germany,
Federal Republic

Selected Group Exhibitions
1981 "Audubon Artists Annual Exhibition,"
National Arts Club, New York, New
York, catalog
1982 "North American Sculpture Exhibition,"
Foothills Art Center, Golden, Colorado,
catalog
1982 "American Artists Professional League
Grand National Exhibition,"
Salmagundi Club, New York, New
York, catalog
1983 "Artists of America," Denver Heritage
Center, Denver, Colorado, catalog
1984 "Sigurd Beyer, Bilder; T. J. Dixon,
Sculpturen; Anna Christina Bernstorff,
Bilder," Galerie Bolhagen, Worpswede,
Germany, Federal Republic

Selected Public Collection
Wichita Art Museum, Wichita, Kansas

Selected Awards
1981 Colorado Sculpture Award, "North
American Sculpture Exhibition,"
Foothills Art Center, Golden, Colorado,
catalog
1982 Best of Show, "Art Annual III,"
Oklahoma Art Center, Oklahoma City,
Oklahoma
1983 Visual Arts Studio Residency,
Worpswede Fellowship, Worpswede,
Germany, Federal Republic

Preferred Sculpture Media
Clay

Selected Bibliography
Eichner-Dixon, Peter. "T. J. Dixon." *American
Artist* vol. 48 no. 507 (October 1984) pp.
60-65, 92-93, illus.

Gallery Affiliation
North American Sculpture
2175 Cowper Street
Palo Alto, California 94301

Mailing Address
1116 13 Street
Boulder, Colorado 80302

Artist's Statement

"My main inspiration comes from watching people. The single, typical gesture of an individual tells me so much about a person's being, physical appearance and personality. It is this gesture which I isolate and use to capture not only that person, but hopefully something more general about the way human beings communicate.

"To me clay is the ultimate medium in both its working features and final appearance after the piece has been fired. The exquisite color, the rich textural surface and the preservation of accurate and sharply modeled detail, usually lost in the transfer process from clay to bronze, are rich rewards for the sometimes emotionally trying and technically complicated processes in the creation of large-scale clay sculpture."

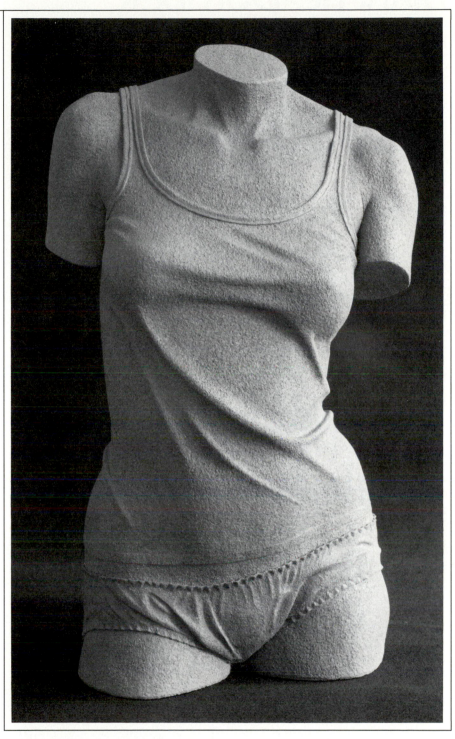

Torso. 1982. Clay, 26"h x 17"w x 12"d. Photograph by Ken Sanville.

Blanche Dombek

Born June 30, 1908 New York, New York

Education and Training
1938 Study in sculpture with Alexandre Zeitlin, New York, New York
1943 Study in sculpture with Leo Amino, New York, New York

Selected Individual Exhibitions
1945 Pinacotheca Gallery, New York, New York
1954 Galerie Colette Allendy, Paris, France
1954 Peridot Gallery, New York, New York
1960 Pasadena Art Museum, Pasadena, California
1965 Draco Fine Arts Gallery, Lone Pine, California
1969 Thorne-Sagendorph Art Gallery, Keene, New Hampshire
1974 Franklin Pierce College, Rindge, New Hampshire
1975 Jaffrey Civic Center, Jaffrey, New Hampshire
1975 Sharon Arts Center, Sharon, New Hampshire
1977 The Art Center in Hargate, St. Paul's School, Concord, New Hampshire
1978 United Church of Christ, Keene, New Hampshire
1979 Art Center, Paul Klapper Library, Queens College, Flushing, New York
1981 Manchester Institute of Arts and Sciences, Manchester, New Hampshire

Selected Group Exhibitions
1945 "Group Exhibition," Clay Club Sculpture Center, New York, New York
1947 "Forty-Seven American Sculptors," American British Art Centre, New York, New York
1947 "Sculpture Group Exhibition," Brooklyn Museum, Brooklyn, New York
1947, "Annual Exhibition: Contemporary
48, Art," Whitney Museum of American
50, American Art, New York, New York,
52, catalog
55
1947 "Annual Exhibition of Painting and Sculpture," Pennsylvania Academy of the Fine Arts, Philadelphia, Pennsylvania, catalog
1949 "Third International Sculpture Exhibition," Philadelphia Museum of Art, Philadelphia, Pennsylvania
1951 "International Group Exhibition," Worcester Art Museum, Worcester, Massachusetts

1952 "Société de L'École Française Federation de Groupes d'Expósants," Palais des Beaux Arts, Paris, France
1954- "Sculptors Guild Annual Exhibition,"
85 Lever House, New York, New York, catalog
1956 "Twentieth American Abstract Artists Annual Exhibition with Painters Eleven of Canada," Riverside Museum, New York, New York
1957 "Twenty-First American Abstract Artists Annual Exhibition," The Contemporaries Gallery, New York, New York
1965 "Marin Museum Association," Frank Lloyd Wright Civic Center, San Rafael, California
1967 "Group Exhibition," Ankrum Gallery, Los Angeles, California
1974 "Sculpture Exhibition," Phenix Hall Gallery, Concord, New Hampshire
1974 "The Monadnock Group," Jaffrey Civic Center, Jaffrey, New Hampshire
1975 "Sculpture Exhibition," National City Bank, New York, New York
1978 "Artistic Resources in the Community," Thorne-Sagendorph Art Gallery, Keene, New Hampshire
1981 "Sculpture/New Hampshire," Area Galleries and Institutions, State of New Hampshire (Organized by New Hampshire Visual Arts Coalition)
1981 "Sculpture in the Garden 1981," Sculptors Guild at the Enid A. Haupt Conservatory, New York Botanical Garden, Bronx, New York, catalog
1981 "Sculpture by Members of the Sculptors Guild," Canton Art Institute, Canton, Ohio
1984 "Sculpture Exhibition 1984," Great Space of St. Paul's Depot, Imprimatur Gallery, St. Paul, Minnesota
1985 "Helen Homer, Paintings and Blanche Dombek, Sculpture, Drawings and Paintings," Virginia Lynch Gallery, Tiverton, Rhode Island

Selected Public Collections
Brooklyn Museum, Brooklyn, New York
Cheshire Hospital Collection, Keene, New Hampshire
Currier Gallery of Art, Manchester, New Hampshire
Kunstverein, Freiburg, Germany, Federal Republic
MacDowell Colony, Peterborough, New Hampshire
Randolph-Macon Woman's College, Lynchburg, Virginia
Thorne-Sagendorph Art Gallery, Keene, New Hampshire

Selected Private Collections
Larry Calcagno, Taos, New Mexico
Mr. and Mrs. James Ewing, Keene, New Hampshire
Mr. and Mrs. Josef Papp, New York, New York
Mr. and Mrs. David Putnam, Keene, New Hampshire

Mr. and Mrs. Thomas Putnam, Keene, New Hampshire

Selected Awards
1958 Artist in Residence, Huntington Hartford Foundation, Pacific Palisades, California
1977 Artist in Residence, MacDowell Colony, Peterborough, New Hampshire
1984 Artist in Residence, Virginia Center for the Creative Arts, Sweet Briar, Virginia

Preferred Sculpture Media
Clay and Wood

Additional Art Fields
Drawing and Painting

Selected Bibliography
Brummé, C. Ludwig. *Contemporary American Sculpture.* New York: Crown, 1948.
O'Hara, Frank. "Reviews and Previews: Blanche Dombek." *Art News* vol. 53 no. 6 (October 1954) p. 52, illus.
Rood, John. *Sculpture in Wood.* Minneapolis: University of Minnesota Press, 1950.
Seuphor, Michel. *The Sculpture of This Century.* New York: George Braziller, 1960.
Seuphor, Michel. *The World of Abstract Art.* New York: George Wittenborn, 1957.

Mailing Address
RFD 1 Box 751
Hancock, New Hampshire 03449

Artist's Statement

"I exhibited my sculpture for the first time in New York in 1945. I spent my entire life in New York, working and exhibiting until 1958. Between the years 1951-1954 I lived in Paris. My studio was opposite that of Constantin Brancusi. It was a great privilege to visit him often and become a friend.

"As wood has always fascinated me, I have used this material for forty years, carving in snakewood, African ebony and Brazilian redwood, among others. In France I carved old oak columns from churches destroyed in World War I. Because of my admiration for the cathedral at Vézelay, my sculpture became architectonic but related to the human form. From the beginning in the 1940s I have carved simplified form abstracted from human proportions.

"Carving demands physical strength, time and absolute concentration to sustain the original idea and emotional feeling. I also have found great joy in the modeling of wax for bronzes and welding metal, modeling porcelain sculpture and drawing and painting."

Blanche Dombek

Au Zoo. 1952-1953. Foreground: Old French oak, 5'6"h without base. *Marine Sculpture.* 1957. Middleground: Yew, 37"h x 30"w. *Buddha.* 1955. Background: Brazilian rosewood, 5'6"h. Collection Cheshire Hospital, Keene, New Hampshire. *Indian Spirit.* 1970. Wall: Charcoal drawing, 63"h x 45"w. Installation view (partial) 1977. The Art Center in Hargate, St. Paul's School, Concord, New Hampshire. Photograph by Bernice B. Perry.

Clarice A. Dreyer

née Clarice Annette Johnson
(Husband Frank Dreyer)
Born September 10, 1946 Missoula, Montana

Education and Training
1979 B.A., Sculpture, Montana State University, Bozeman, Montana; study with John E. Buck
1979 M.A., Sculpture, University of California, Berkeley, Berkeley, California
1981 M.F.A., Sculpture, University of California, Berkeley, Berkeley, California; study with Peter Voulkos

Selected Individual Exhibitions
1980 White Room, University of California, Berkeley, Berkeley, California
1981, Eaton/Shoen Gallery,
 83 San Francisco, California,
1982 Yellowstone Art Center, Billings, Montana
1983 Paris Gibson Square, Great Falls, Montana
1983 University of Montana, Missoula, Montana
1983 Touchstone Visual Arts Center, Spokane, Washington
1984 Traver Sutton Gallery, Seattle, Washington

Selected Group Exhibitions
1978, "Annual Juried Exhibition," Montana
 79 State University, Bozeman, Montana
1980 "Clarice Dreyer, Susan Hazlewood and Joanne Signer," Worth Ryder Gallery, University of California, Berkeley, Berkeley, California
1980, "Prize Winners' Exhibition," Worth
 81 Ryder Gallery, University of California, Berkeley, Berkeley, California

1980 "Eleventh International Sculpture Conference," Area Galleries and Institutions, Washington, D.C. (Sponsored by International Sculpture Center, Washington, D.C.)
1981 "Fourth Season Opening," Rental Gallery, San Francisco Museum of Modern Art, San Francisco, California
1981 "Selections from Eaton/Shoen's First Year," Eaton/Shoen Gallery, San Francisco, California
1981- "Selections from Eaton/Shoen Gallery,"
 82 Frank Lloyd Wright's H.C. Price "Grandmother" House, Scottsdale, Arizona
1982 "Artists' Furniture," San Francisco International Airport, San Francisco, California
1982 "Women and Environment," Missoula Museum of the Arts, Missoula, Montana
1983 "1984—A Preview," Ronald Feldman Gallery, New York, New York
1983 "Fiftieth Annual Montana Artists," Yellowstone Art Center, Billings, Montana
1983 "Construction," San Francisco International Airport, San Francisco, California
1983 "Contemporary Montana Sculpture Exhibit," Custer County Art Center, Miles City, Montana
1983 "Sweet Pea '83 Juried Art Exhibition," Montana State University, Bozeman, Montana
1983 "Food for the Soup Kitchens," Fashion Moda, New York, New York
1983 "Northwest Juried Art '83," Cheney Cowles Memorial Museum, Spokane, Washington, catalog

Selected Public Collections
Sheridan Elementary School, Spokane, Washington
State Capitol Law and Justice Building, Helena, Montana
Washington State Arts Commission, Olympia, Washington

Selected Awards
1983, Individual Artist's Fellowship,
 84 National Endowment for the Arts
1983 Individual Artist's Fellowship, Montana Arts Council

Preferred Sculpture Media
Metal (cast)

Additional Art Field
Painting

Selected Bibliography
Burstein, Joanne. "Mystery and Malevolence." *Artweek* vol. 12 no. 38 (November 14, 1981) p. 6, illus.
Burstein, Joanne. "Lyrical Metaphors." *Artweek* vol. 14 no. 15 (April 16, 1983) p. 5, illus.

Carpenter, Arthur Espenet. "The Rise of Artiture: Woodworking Comes of Age," *Fine Woodworking* no. 38 (January-February 1983) pp. 101-102.
Jay, Bill. "Reviews Eaton/Shoen Installation at Frank Lloyd Wright's H. C. Price 'Grandmother' House, Scottsdale, Arizona: Confessions of a Gallery Hater." *Artspace* vol. 6 no. 2 (Spring 1982) pp. 68-70, illus.
Stofflet, Mary. "Reviews: Clarice Dreyer at Eaton/Shoen." *Images & Issues* vol. 2 no. 4 (Spring 1982) p. 87, illus.

Gallery Affiliation
Eaton/Shoen Gallery
500 Paul Avenue
San Francisco, California 94124

Mailing Address
4750 Jordan Spur Road
Bozeman, Montana 59715

Rainbows for Dad. 1983. Cast aluminum and paint,
4'10"h x 10'w x 5'd.

Artist's Statement

"I see in nature what I feel in
myself—mystery, complexity, simplicity,
strength, weakness, beauty, joy and pain.
These are the elements that give life to my
art. General contrasts of life, such as
strength and fragility, are mirrored in our
surroundings. Birds, snakes, butterflies,
stones and plants help define daily
experiences for us all. Life and nature are
additive and complex—as is art. My work is
a search for images of simple and direct
visual power. I consider art and life one."

Clarice Dreyer

Ruth Duckworth

née Ruth Windmüller
Born April 10, 1919 Hamburg, Germany,
Federal Republic (British citizenship)

Education and Training
1936- Liverpool School of Art, Liverpool,
40 Great Britain; study in drawing,
painting and sculpture
1955 Hammersmith School of Art, London,
Great Britain; study in ceramics
1956- Central School of Arts and Crafts,
58 London, Great Britain

Selected Individual Exhibitions
1953 Appolinaire Gallery, London, Great
Britain
1960, Primavera Gallery, London, Great
62, Britain
67
1972 Jacques Baruch Gallery, Chicago,
Illinois
1973 Kunstkammer Ludger Köster,
Mönchengladbach, Germany, Federal
Republic
1973 Calgary School of Art, Calgary,
Alberta, Canada
1974 Exhibit A, Evanston, Illinois
77,
80,
82
1976 Museum für Kunst und Gewerbe,
Hamburg, Germany, Federal Republic
1979 Museum Boymans-Van Beuningen,
Rotterdam, Netherlands

Selected Group Exhibitions
1965 "14 Artists," Illinois State Museum,
Springfield, Illinois
1969- "Objects: USA," Traveling Exhibition,
71 Renwick Gallery of the National
Collection of Fine Arts, Smithsonian
Institution, Washington, D.C., book
1969 "Three Artists," Art Institute of
Chicago, Chicago, Illinois
1972, "British Potters," Primavera Gallery,
73, Cambridge, Great Britain
75
1972 "International Ceramics 1972," Victoria
and Albert Museum, London, Great
Britain, catalog
1973 "Ceramic Art of the World 1973,"
University of Calgary, Calgary,
Alberta, Canada

1974 "World Crafts Council Exhibition,"
Alberta College of Art, Calgary,
Alberta, Canada
1974 "Towards Ceramic Sculpture," Oxford
Gallery, Oxford, Great Britain
1976 "Europaische Keramik der Gegenwart,"
Keramikmuseum, Frechen, Germany,
Federal Republic
1976 "American Crafts '76: An Aesthetic
View," Museum of Contemporary Art,
Chicago, Illinois
1977 "Contemporary Ceramics: The Artist's
Viewpoint," Kalamazoo Institute of
Arts, Kalamazoo, Michigan, catalog
1979- "A Century of Ceramics in the United
80 States 1878-1978," Everson Museum
of Art, Syracuse, New York; Renwick
Gallery of the National Collection of
Fine Arts, Smithsonian Institution,
Washington, D.C., book
1979 "Ruth Duckworth and Claire Zeisler,"
Moore College of Art, Philadelphia,
Pennsylvania, retrospective and
catalog
1980- "American Porcelain: New Expressions
85 in an Ancient Art," Traveling
Exhibition, Renwick Gallery of the
National Museum of American Art,
Smithsonian Institution, Washington,
D.C., catalog
1983 "Prime Evidence," Exhibit A, Chicago,
Illinois
1985 "Ceramic Art of the 70s: A Review of
a Decade," Exhibit A, Chicago, Illinois

Selected Public Collections
Beth Israel Synagogue, Hammond, Indiana
Continental Bank, New York, New York
Dresdner Bank, Chicago Board of Trade
Building, Chicago, Illinois
Hodag Chemical Company, Skokie, Illinois
Main Bank of Chicago, Chicago, Illinois
Mills College, Oakland, California
Museo, Biblioteca e Archivio, Bassano del
Grappa, Italy
Museum Boymans-Van Beuningen,
Rotterdam, Netherlands
Museum für Moderne Keramik, Deidesheim,
Germany, Federal Republic
National Museum of Modern Art, Kyoto,
Japan
Perkins and Will, Chicago, Illinois
Philadelphia Museum of Art, Philadelphia,
Pennsylvania
Purdue University, West Lafayette, Indiana
St. Joseph's Church, New Malden, Great
Britain
Solel Synagogue, Highland Park, Illinois
Stedelijk Museum, Amsterdam, Netherlands
University of Chicago, Hinds Laboratory for
the Geophysical Sciences, Chicago, Illinois
Utah Museum of Fine Arts, Salt Lake City,
Utah
Windsor Castle, New Windsor, Great Britain

Selected Award
1982 Honorary Doctorate of Fine Arts,
DePaul University, Chicago, Illinois

Preferred Sculpture Media
Clay

Selected Bibliography
Clark, Garth. *A Century of Ceramics in the
United States 1878-1978: A Study of its
Development*. New York: E. P. Dutton,
1979.
Hall, Julie. *Tradition and Change: The New
American Craftsman*. New York: E. P.
Dutton, 1977.
"Ruth Duckworth Exhibition." *Ceramics
Monthly* vol. 28 no. 2 (February 1980) pp.
48-51, illus.
Westphal, Alice. "The Ceramics of Ruth
Duckworth." *Craft Horizons* vol. 37 no. 4
(August 1977) pp. 48-51, illus.

Gallery Affiliation
Exhibit A
361 West Superior Street
Chicago, Illinois 60610

Mailing Address
3845 North Ravenswood
Chicago, Illinois 60613

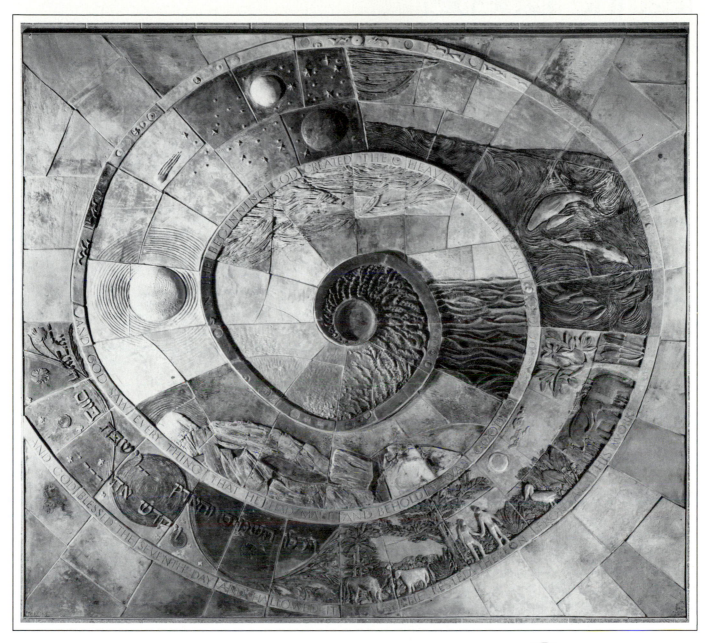

The Creation. 1982. Stoneware mural, 17'h x 15'w.
Collection Beth Israel Synagogue, Hammond,
Indiana. Photograph by Melville McLean.

Jeanne Dueber

Born July 14, 1937 St. Louis, Missouri

Education and Training
1961 B.A., Drawing and Sculpture, Webster College, St. Louis, Missouri; study in sculpture with Rudolph Torini
1969 M.A., Sculpture, University of Iowa, Iowa City, Iowa; study with Olivier Strebelle
1972 Fulbright-Hays Fellowship (Italy); independent study in art history
1973 Independent research in architecture in France, Germany, Spain and Switzerland

Selected Individual Exhibitions
1971 Gallery of Loretto-Hilton Center, St. Louis, Missouri
1974 Rockhurst College, Kansas City, Missouri
1975 May Bonfils Library, Denver, Colorado
1976 Stairways Gallery, Louisville, Kentucky
1979 Actors Theatre, Louisville, Kentucky
1979 Mundelein College, Chicago, Illinois
1981 Regional Arts Center, Centre College of Kentucky, Danville, Kentucky
1981 Swearingen Gallery, Louisville, Kentucky
1982 Spalding College Gallery, Louisville, Kentucky
1982 Welsley on the Square, Louisville, Kentucky

Selected Group Exhibitions
1971 "Woman Show," Northern Illinois University, DeKalb, Illinois, catalog
1973 "Expatriates of Kansas City Art Institute," Art Center, Kansas City, Missouri
1975 "Thirty Miles of Art," Nelson Gallery of Art, Atkins Museum of Fine Arts, Kansas City, Missouri
1976 "Architectural Sculpture," Fifth Street Gallery, Wilmington, Delaware
1979 "Exhibition 280," Huntington Galleries, Huntington, West Virginia, catalog
1981 "Earth 1," Art Center Association, The Water Tower, Louisville, Kentucky
1981 "Jeanne Dueber and David L. Mahoney," Swearingen Gallery, Louisville, Kentucky
1983 "Art Alumni Invitational Exhibition, Webster University," Gallery of Loretto-Hilton Center, St. Louis, Missouri, catalog
1985 "Gallery Invitational," Katzman Werthan Gallery, Nashville, Tennessee

Selected Public Collections
Bellarmine College, Louisville, Kentucky
Brown-Forman Distillers, Louisville, Kentucky
Mary Hartman and Associates, Minneapolis, Minnesota
Hallmark Center, Kansas City, Missouri
Loretto Academy, Kansas City, Missouri
Ruskin High School, Kansas City, Missouri
Ryken House, Louisville, Kentucky
St. Aloysius Church, Kansas City, Missouri
St. Andrew's Episcopal Church, Kansas City, Missouri
St. Catherine of Siena Church, Kansas City, Missouri
Universal Press Syndicate, Mission, Kansas
Welcome Enterprises, New York, New York

Selected Private Collections
James Andrews Family, Overland Park, Kansas
R. Bruce Farrer, Prospect, Kentucky
Lee Hildebrand, Louisville, Kentucky
Stephen Murphy, Kansas City, Missouri
Vernon Robertson, Louisville, Kentucky

Selected Awards
1976 Merit Award, Sculpture Competition, "Ninth International Sculpture Conference," Area Galleries and Institutions, New Orleans, Louisiana (Sponsored by International Sculpture Center, Washington, D.C.)
1978, Merit Award, "Kentucky Small
80 Sculpture Competition," Georgetown College, Georgetown, Kentucky

Preferred Sculpture Media
Varied Media and Wood

Additional Art Field
Drawing

Related Profession
Artist in Residence, Rhodes Hall Gallery, Loretto Motherhouse, Nerinx, Kentucky

Gallery Affiliation
Swearingen Gallery
4806 Brownsboro Center
Louisville, Kentucky 40207

Mailing Address
Rhodes Hall
Nerinx, Kentucky 40049

Artist's Statement
"I work principally in wood and have been influenced by those artists who have an organic feel whether ancient or contemporary. I approach sculpture by arranging masses at angles and counterbalancing an external appearance of forms jutting into space. I want to express in sculpture the constant energies and strivings of human beings, their vitality, strength and tensions, and the pull of everyday life."

Figure Thrust No. 5. 1970. Fiberglass and wood, 13'h x 15'w x 10'd. Installation view 1971. Gallery of Loretto-Hilton Center, St. Louis, Missouri.

Edris Eckhardt

Born January 28, 1910 Cleveland, Ohio

Education and Training
1932 B.F.A., Sculpture, Cleveland Institute of Art, Cleveland, Ohio; study with Alexander Blazys
1932 Studio of Alexander Blazys, Cleveland, Ohio; study in wood carving
1932- Studio of Alexander Archipenko,
33 Woodstock, New York; study in ceramic sculpture
1961- Cleveland Institute of Art, Cleveland,
63 Ohio; study in bronze casting with John Clague
1962 University of California, Berkeley, Berkeley, California; study in bronze sculpture with Julius Schmidt

Selected Individual Exhibitions
1946 Manning Galleries, Cleveland, Ohio
1952 Art Colony Galleries, Cleveland, Ohio
1958 Howard Wise Gallery, Cleveland, Ohio
1960, Women's City Club, Cleveland, Ohio
62,
65,
67
1962 Little Gallery, Museum of Contemporary Crafts, New York, New York, catalog
1962 University of California, Berkeley, Berkeley, California
1962 Miami University, Oxford, Ohio
1963, Winton Place Gallery, Lakewood, Ohio
67,
68
1964, Cleveland Playhouse Gallery,
66, Cleveland, Ohio
70
1964 Circle Gallery, Cleveland, Ohio
1964 America House, New York, New York
1968 Corning Glass Center, Corning Museum of Glass, Corning, New York, retrospective and catalog
1978 Women's City Club, Cleveland, Ohio, retrospective
1980 Wichita Art Association, Wichita, Kansas
1982 Beachwood Museum, Beachwood, Ohio, retrospective and catalog
1983 Everson Museum of Art, Syracuse, New York, retrospective and catalog

Selected Group Exhibitions
1933- "Annual Ceramic National Exhibition,"
52 Syracuse Museum of Fine Arts, Syracuse, New York, catalog
1933- "Annual May Show," Cleveland
67 Museum of Art, Cleveland, Ohio, catalog
1933 "American Federation of Art Exhibition," Museum of Contemporary Crafts, New York, New York
1936 "World's Fair," American Pavilion, Paris, France
1937 "First American Ceramic Exhibition," Traveling Exhibition (Denmark, Sweden, Finland and England), Syracuse Museum of Fine Arts, Syracuse, New York, catalog
1939 "World's Fair," New York, New York

1939 "Golden Gate International Exposition," San Francisco Museum of Art, San Francisco, California, catalog
1941 "First Exhibition of Contemporary Ceramics of the Western Hemisphere," Traveling Exhibition (Canada, South America and United States), Syracuse Museum of Fine Arts, Syracuse, New York, catalog
1945- "Annual Ohio Ceramic and Sculpture
66 Show," Butler Institute of American Art, Youngstown, Ohio
1955, "International Ceramic Exhibition,"
56, National Collection of Fine Arts,
57, Smithsonian Institution, Washington,
63 D.C.
1956- "Exhibition of Contemporary Ceramics
58 of the Western Hemisphere," Traveling Exhibition, Syracuse Museum of Fine Arts, Syracuse, New York
1956, "Annual Decorative Arts and Ceramic
57, Exhibition," Wichita Art Association,
58, Wichita, Kansas, catalog
70
1957- "Annual National Exhibition," Traveling
58 Exhibition, University of Miami, Coral Gables, Florida
1958 "The Grail Show," Brooklyn Museum, Brooklyn, New York
1958 "American Handicrafts," Museum of Fine Arts, Boston, Massachusetts
1958, "Ohio Designer Craftsmen," Columbus
64 Gallery of Art, Columbus, Ohio
1958 "The Patron Church," Museum of Contemporary Crafts, New York, New York
1958 "2000 Years of Western Religious Art," Dallas Museum of Fine Arts, Dallas, Texas
1958 "World's Fair," American Pavilion, Brussels, Belgium
1959 "International Glass '59," Corning Museum of Glass, Corning, New York, catalog
1959 "International Ceramic Exhibition," Metropolitan Museum of Art, New York, New York
1961 "Fine Arts in Living," Lee Nordness Gallery, New York, New York
1963 "Craft Invitational Exhibition," Nelson Gallery of Art, Atkins Museum of Fine Arts, Kansas City, Missouri
1964 "Glass Sculpture Invitational Exhibition," Dallas Museum of Fine Arts, Dallas, Texas
1965 "Invitational Exhibition," Ohio State University, Columbus, Ohio
1966 "National Glass Invitational," Toledo Museum of Art, Toledo, Ohio
1966 "National Glass Invitational," San Jose State University, San Jose, California
1966 "Edris Eckhardt and Anthony Vaiksnoras," Circle Gallery, Cleveland, Ohio
1967 "Western Art Invitational," Traveling Exhibition, Museum of Modern Art, New York, New York
1967 "Edris Eckhardt and Anthony Vaiksnoras," Naples Gallery of Art, Naples, Florida

1970 "Contemporary Off-Hand Glass Invitational," Sheridan College, Ottawa, Ontario, Canada
1970 "Contemporary Craft National Invitational," Galleries III, Charlottesville, Virginia
1976 "National Exhibition of Glass," Bergstrom-Mahler Museum, Neenah, Wisconsin
1979- "A Century of Ceramics in the United
80 States 1878-1978," Everson Museum of Art, Syracuse, New York, New York; Renwick Gallery of the National Collection of Fine Arts, Smithsonian Institution, Washington, D.C., book
1984- "The Diversions of Keramos: American
85 Clay Sculpture from 1925-50," Traveling Exhibition, Everson Museum of Art, Syracuse, New York, catalog
1984 "Early Studio Glassmakers: Edris Eckhardt, Maurice Heaton, Frances and Michael Higgins," Glass Gallery, Bethesda, Maryland
1985 "Spring Art Exhibition," One Bratenahl Place, Cleveland, Ohio
1985 "Invitational Art Exhibition," Cleveland Institute of Art, Cleveland, Ohio, catalog
1985 "Edris Eckhardt, Glass and Bronze; Mary Wawrytko, Bronze," Touchstone Gallery, Cleveland, Ohio

Selected Public Collections
American Craft Museum, New York, New York
Bethlehem Lutheran Church, Cleveland, Ohio
Butler Institute of American Art, Youngstown, Ohio
Cleveland Museum of Art, Cleveland, Ohio
Corning Museum of Glass, Corning, New York
Everson Museum of Art, Syracuse, New York
Massillon Museum, Massillon, Ohio
Philadelphia Museum of Art, Philadelphia, Pennsylvania
Renwick Gallery of the National Museum of American Art, Smithsonian Institution, Washington, D.C.
Temple on the Heights, Cleveland, Ohio
United States Embassy, Paris, France
Wichita Art Association, Wichita, Kansas
Wichita Art Museum, Wichita, Kansas

Selected Private Collections
A. J. Austin, Massillon, Ohio
Elizabeth II, Queen of England, London, Great Britain
Ray Grover, Naples, Florida
Dr. Paul Nelson, Cleveland Heights, Ohio
Jacqueline Kennedy Onassis, New York, New York

Selected Awards
1956, John Simon Guggenheim Memorial
59 Foundation Fellowship
1959 Louis Comfort Tiffany Foundation Grant

Preferred Sculpture Media
Clay, Metal (cast) and Glass

Related Professions
Art Instructor, Juror, Lecturer and Writer

Selected Bibliography
Beard, Geoffrey W. *International Modern Glass*. New York: Charles Scribner's Sons, 1976.

Clark, Garth. *A Century of Ceramics in the United States 1878-1978: A Study of its Development*. New York: E. P. Dutton, 1979.

Grover, Ray and Lee. *Contemporary Art Glass*. New York: Crown, 1975.

Papers included in the Archives of American Art, Smithsonian Institution, New York, New York.

Rothenberg, Polly. *The Complete Book of Creative Glass Art*. New York: Crown, 1974

Gallery Affiliation
Winton Place Gallery
12700 Lake Avenue
Lakewood, Ohio 44107

Mailing Address
3788 Monticello Boulevard
Cleveland Heights, Ohio 44121

Artist's Statement
"Believing in growth and change, my career is divided into three overlapping parts: ceramic sculpture (1933-1953) in which I developed special glazes and lusters; glass sculpture (1953 to the present) in which I discovered antique glass formula and investment materials, particularly gold and silver; and bronze casting (1961 to the present) in which I have studied bronze casting and metal compositions, fusing glass and bronze to produce jewel-like sculpture of symbolic themes.

"Every artist must occasionally take stock of himself, his time and his relation to it. He must constantly change, enlarge, diversify or be left stranded on an island of his own making while the stream of life flows by. Quite accidentally I saw Byzantine gold glass at the Metropolitan Museum of Art in 1953 and realized that this medium offered wide fields to explore unhampered and uncontrolled by fashions of the day. I used all my knowledge of glaze chemistry to good advantage but revised to suit the demands of the serious, grave illusive beauty of glass. I have felt great excitement and moments of prayerful pride in this lonely but enchanting path I have followed."

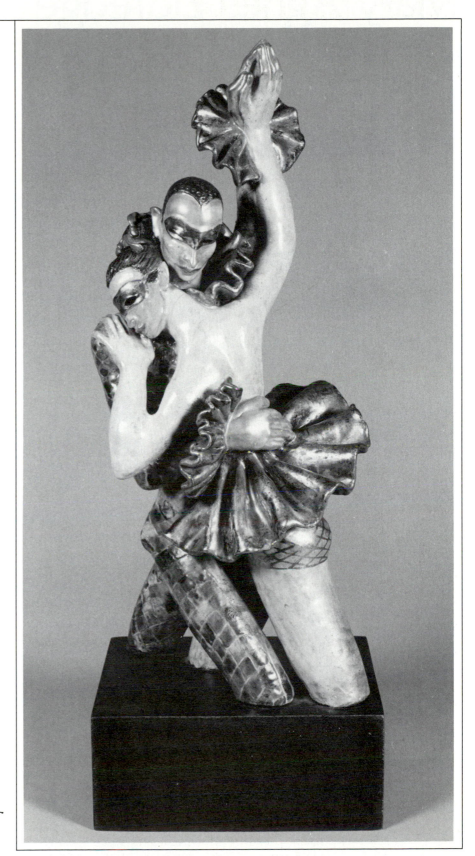

Harlequin Dance. 1950. Ceramic with luster glazes, 14"h x 7"w x 8"d. Collection Everson Museum of Art, Syracuse, New York. Photograph by Mark C. Schwartz.

Mary Agnes Eldredge

Born January 21, 1942 Hartford, Connecticut

Education and Training
1963 B.A., Art History, Vassar College, Poughkeepsie, New York; study in sculpture with Juan Nickford and Concetta Scaravaglione
1965 M.F.A., Sculpture, Pius XII Institute, Florence, Italy; study with Josef Gudics

Selected Individual Exhibitions
1965 Dartmouth College, Hanover, New Hampshire
1966 Southern Vermont Art Center, Manchester, Vermont, catalog
1967 Contemporary Christian Art, New York, New York, catalog

Selected Group Exhibitions
1957- "Annual Exhibition," Southern Vermont
85 Art Center, Manchester, Vermont
1965 "Mostra del Arte Religiosa per Pasqua," Palazzo Strozzi, Florence, Italy
1968 "Modern Art and the Religious Experience," Fifth Avenue Presbyterian Church, New York, New York, catalog
1969 "Sixth Biennial National Religious Art Exhibition," Cranbrook Academy of Art, Bloomfield Hills, Michigan, catalog
1973 "Eldredge Family Exhibition," Brattleboro Museum and Art Center, Brattleboro, Vermont
1981 "Forty-Second Annual Liturgical Art in Architecture Exhibit," Radisson Hotel, Chicago, Illinois (Sponsored by Interfaith Forum on Religion, Art and Architecture, Washington, D.C.), catalog

Selected Public Collections
Calvary Hospital Chapel, Bronx, New York
Cathedral of the Immaculate Conception, Burlington, Vermont
Catholic Chapel 1, Andrews Air Force Base, Maryland
Church of Saint Andrew and Holy Communion, South Orange, New Jersey
Church of SS. Joachim and Ann, Mt. Loretta, Staten Island, New York
Church of St. Mary Our Mother, Horseheads, New York
Church of the Good Shepherd, Lake Wales, Florida
Corpus Christi Church, New York, New York
Green Mountain College Library, Poultney, Vermont
Holy Family Church, New York, New York
Hood Museum of Art, Hanover, New Hampshire
Mercy Hospital Chapel, Springfield, Massachusetts
Newman Chapel, University of Wisconsin-Stevens Point, Stevens Point, Wisconsin
Our Lady of Mt. Carmel Church, Staten Island, New York
St. Anne's Church, Middletown Springs, Vermont
St. Anselm's Abbey, Washington, D.C.
St. Francis de Sales Church, Bennington, Vermont
St. Gabriel Episcopal Church, Milton-Oak Ridge, New Jersey
St. Joseph's Church, Roseburg, Oregon
St. Mary's Abbey, Morristown, New Jersey
St. Mary's Church, Springfield, Vermont
St. Paul's Church, Nassau, Bahamas
St. Vincent Ferrer Church, New York, New York
Shrine of the Most Blessed Sacrament, Washington, D.C.
Trinity Church, New York, New York

Selected Private Collections
Dr. A. H. Behrenberg Collection, Princeton, New Jersey
Archbishop Robert Dwyre Collection, San Francisco, California
Mrs. Christian Rockefeller DuBois, Stockbridge, Massachusetts
Mrs. D. J. Keating, Philadelphia, Pennsylvania
Pope Paul VI Collection, Vatican City, Rome, Italy

Selected Awards
1966 Therese Richard Memorial Prize for Religious Sculpture, "Exhibition of Religious Art," National Arts Club, New York, New York, catalog
1967 Sculpture Award, "Eighteenth Annual National Exhibition of Realistic Art," Museum of Fine Arts, Springfield, Massachusetts, catalog
1977 Craftsmanship Award, "Sixteenth Annual Building Awards Program," Staten Island Chamber of Commerce, Staten Island, New York

Preferred Sculpture Media
Metal (brazed) and Wood

Selected Bibliography
Wilson, Patricia Boyd. "The Home Forum: Mary Eldredge." *The Christian Science Monitor* (Thursday, September 8, 1966) p. 8, illus.

Gallery Affiliation
Contemporary Christian Art
217 East 66 Street
New York, New York 10021

Mailing Address
520 Parker Hill Road
Springfield, Vermont 05156

Artist's Statement

"I am not a compulsive sculptor but one by choice. I enjoy working with three-dimensional forms: simplifying and abstracting human and animal forms, exploring shape and gesture to create a mood or feeling. Although the finished work is abstract, the forms are clearly representational, still firmly connected with reality.

"The final sculpture suggests the lightness or heaviness of the material. Stone, wood and copper have very different and special characteristics. Stone is compact, solid, heavy; wood is dense but not as heavy and solid in its forms. Copper lends itself to more open and airy forms, even to winged angels.

"Since my sculptures are usually intended for religious environments, I seek beauty in form, design and materials. It is through beauty that one most readily senses the holy. Qualities of simplicity and dignity enable the viewer to see beyond the sculpture itself to the unseen reality which it represents or suggests."

Mary Eldredge

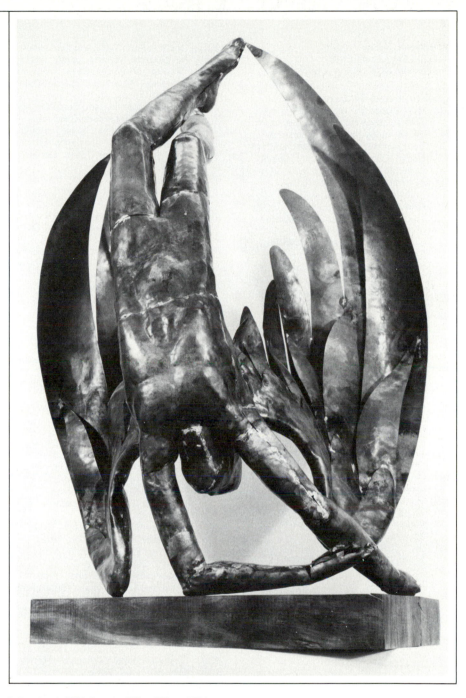

Fallen Angel. 1965. Copper, 40"h x 22"w x 18"d. Collection Hood Museum of Art, Hanover, New Hampshire. Courtesy Hood Museum of Art, Hanover, New Hampshire.

Rowena C. Elkin

née Rowena Jossey Caldwell
(Husband Price Bush Elkin)
Born January 8, 1917 Fort Worth, Texas

Education and Training
1938 B.S., Visual Art and Drama, Texas State College for Women, Denton, Texas; study in three-dimensional design with Marjorie Baltzel, Edith M. Brisac, Carlotta M. Corpron, Marie Delleney, Mattie Lee Lacy, Dorothy Antoinette LaSelle and Thetis Lemmon
1940- Community Players, Houston, Texas;
42 study in stage design with Margo Jones
1956- Studio of Arnold Leondar, Midland,
57 Texas; study in water color
1965 Dallas Museum of Fine Arts, Dallas, Texas; study in sculpture with Octavio Medellin
1968- International Sculpture Conferences in
85 Canada and the United States
1977- Intermittent travel and study in Egypt
85 and Europe

Selected Group Exhibitions
1947 "Los Alamos Artists and Craftsmen Exhibition," Los Alamos High School Auditorium, Los Alamos, New Mexico (Sponsored by Mesa Club, Los Alamos, New Mexico)
1948 "Los Alamos Artists and Craftsmen Exhibition," Community Center, Los Alamos, New Mexico
1949- "Exhibition of Gallery Artists," Canyon
50 Gallery, Santa Fe, New Mexico
1950, "New Mexico Alliance for the Arts
51 Exhibition," Museum of Fine Arts, Museum of New Mexico, Santa Fe, New Mexico
1951 "Los Alamos Artists Invitational Exhibition," Museum of Fine Arts, Museum of New Mexico, Santa Fe, New Mexico
1965 "Texas Fine Arts Association Regional Winners Exhibition," Laguna Gloria Art Museum, Austin, Texas, catalog

1967, "Midland Arts Association Exhibition,"
68 Fairgrounds, Midland, Texas, catalog
1968 "Museum of the Southwest Invitational Exhibition," Museum of the Southwest, Midland, Texas
1971 "Regional Painting and Sculpture Exhibition," Richardson Civic Art Society, Richardson, Texas, catalog
1975 "Texas Fine Arts Association Region II Exhibition," Medical Center, Dallas, Texas, catalog
1976 "Saenger National Jewelry & Small Sculpture Exhibit," Saenger Center, Hattiesburg, Mississippi, catalog
1977 "First Texas Sculpture Symposium," Southern Methodist University, Dallas, Texas
1978 "Texas Fine Arts Association Regional Winners Exhibition," Laguna Gloria Art Museum, Austin, Texas
1979 "Rowena Elkin, Sculpture; Linda Finnell, Photographs and Susan Shiels, Color Etchings," James K. Wilson Gallery, Dallas, Texas
1979- "Women-in-Sight: New Art in Texas,"
81 Traveling Exhibition, Dougherty Cultural Arts Center, Austin, Texas, catalog
1979- "Big Name Invitational," 500 Exposition
80 Gallery, Dallas, Texas
1980- "Art III," Dallas City Hall, Dallas,
81 Texas, catalog
1981 "Third Texas Sculpture Symposium," Southwest Texas State University, San Marcos, Texas
1981 "American Association of University Women Centennial Art Exhibition," School of Visual Arts, Boston University, Boston, Massachusetts, catalog
1981 "1981 Invitational Exhibition," 500 Exposition Gallery, Dallas, Texas
1981 "Opening Exhibition," Ruth Wiseman Gallery, Dallas, Texas
1982- "Specific Sites Invitational," Area
83 Locations, Dallas, Texas (Sponsored by 500 Exposition Gallery, Dallas, Texas)
1982 "Susan Brown, Paper Pieces and Rowena Elkin, Sculpture," Ruth Wiseman Gallery, Dallas, Texas
1983 "Zoo Invitational Exhibition," Clifford Gallery, Dallas, Texas
1985 "Fifth Texas Sculpture Symposium," Sited throughout Central Business District, Dallas, Texas and Connemara Conservancy, Allen, Texas (Sponsored by Texas Sculpture Symposium, Dallas, Texas), catalog
1985 "Sculpture Exhibition," Ruth Wiseman Gallery, Dallas, Texas

Selected Awards
1965 Second Place, "Texas Fine Arts Association Region II Exhibition," Highland Park Town Hall, Dallas, Texas, catalog
1978 First Place, "Texas Fine Arts Association Region II Exhibition," First National Bank, Dallas, Texas, catalog

Preferred Sculpture Media
Metal (cast), Varied Media and Wood

Additional Art Fields
Blockprinting, Drawing, Furniture Design and Construction, House Design, Metalwork and Painting

Gallery Affiliation
Sculpture Resources, Incorporated
6032 Deloache
Dallas, Texas 75225

Mailing Address
6623 Orchid Lane
Dallas, Texas 75230

Artist's Statement

"My visual imagery began at age one: first Christmas piano and doll. Mother's opera records and father's nature and fairy stories developed my imagination. Add: my family's love, lessons in violin and drama, musical concerts, children's Shakespeare, awareness of shapes, textures and colors in museums, zoos and wilderness regions.

"All know the horrors of war and sadness. Only through great spiritual and aesthetic experiences and humor can the world survive. As a person and through art I hope to lift spirits."

Rowena C. Elkin

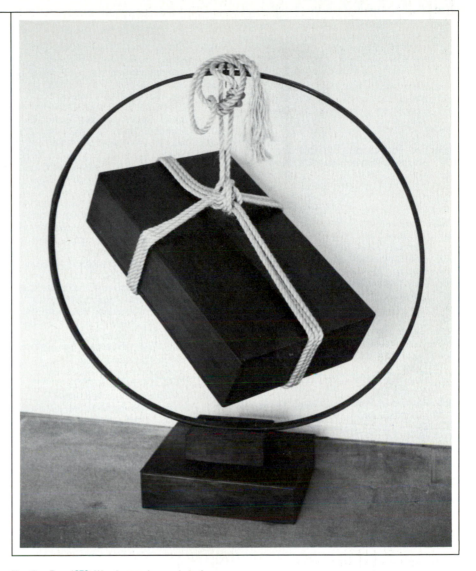

Hanging Box. 1978. Wood, rope, iron and steel, 61"h x 52"w x 37"d.

Lin Emery

(Husband Shirley Braselman)
Born New York, New York

Education and Training
1950 Atelier Ossip Zadkine, Paris, France
1952 Sculpture Center, New York, New York

Selected Individual Exhibitions
1957, Sculpture Center, New York, New
58, York
59,
60,
61,
62
1962 Tennessee Fine Arts Center, Nashville, Tennessee
1962, Isaac Delgado Museum of Art, New
64 Orleans, Louisiana, catalog
1962, New Orleans Gallery, New Orleans,
64, Louisiana
67,
68
1963 Marble Arch Gallery, Miami, Florida
1963 Valley House Gallery, Dallas, Texas
1964 Royal Athena Gallery, New York, New York
1965 Gallery of Modern Art, Scottsdale, Arizona
1966 Museum of Fine Arts, Museum of New Mexico, Santa Fe, New Mexico
1967 Centennial Art Museum, Corpus Christi, Texas, catalog
1975 Bodley Gallery, New York, New York
1977 Lauren Rogers Library and Museum of Art, Laurel, Mississippi
1978 Contemporary Arts Center, New Orleans, Louisiana
1982 Max Hutchinson Gallery, New York, New York, catalog
1985 Heath Gallery, Atlanta, Georgia

Selected Group Exhibitions
1960 "Five American Sculptors Interpret Freedom," Traveling Exhibition, American Federation of Arts, New York, New York
1960, "Annual Exhibition of Painting and
64 Sculpture," Pennsylvania Academy of the Fine Arts, Philadelphia, Pennsylvania, catalog
1962 "New Directions," Traveling Exhibition, American Federation of Arts, New York, New York
1964 "Contemporary Sculpture," American-Israel Pavilion, World's Fair, New York, New York
1965 "Fountains in Contemporary Architecture," Traveling Exhibition, American Federation of Arts, New York, New York, catalog
1965 "Sculpture: 1900-1965," Dewaters Art Center, Flint Institute of Arts, Flint, Michigan

1965 "New Art, New Orleans," John and Mabel Ringling Museum of Art, Sarasota, Florida
1966 "Flint Invitational," Flint Institute of Arts, Flint, Michigan, catalog
1973 "Eight State Exhibition," Oklahoma Art Center, Oklahoma City, Oklahoma
1976, "Sculptors Guild Annual Exhibition,"
78, Lever House, New York, New York,
80 catalog
1976 "Fine Arts in New Federal Buildings," New Orleans Museum of Art, New Orleans, Louisiana
1977 "Exhibition of Work by Newly Elected Members and Recipients of Honors and Awards," American Academy and Institute of Arts and Letters, New York, New York, catalog
1980 "Nine Louisiana Sculptors," Museum of Fine Arts, Houston, Houston, Texas
1980 "Art in Architecture: General Services Administration Projects," National Museum of American Art, Smithsonian Institution, Washington, D.C., catalog
1980 "Eleventh International Sculpture Conference," Area Galleries and Institutions, Washington, D.C. (Sponsored by International Sculpture Center, Washington, D.C.)
1983- "Lin Emery and James Drew, A
85 Collaborative Audio-Kinetic Installation, 'Becket: The Final Moments'," Contemporary Arts Center, New Orleans, Louisiana; Max Hutchinson Gallery, New York; Museo del Arte Moderno, México, D.F., México
1984 "Artworks '84, Louisiana World Exposition," World's Fair, New Orleans, Louisiana
1984- "Sculptors Guild Member Artists
85 Outdoor Exhibition, Schulman Sculpture in the Park," White Plains Office Park, White Plains, New York

Selected Public Collections
Chrysler Museum, Norfolk, Virginia
City of Lawrence, Civic Center, Lawrence, Kansas
City of New Orleans, Louisiana
City of Tulsa, Helmerich Park, Tulsa, Oklahoma
Columbia Museums of Art & Science, Columbia, South Carolina
Ellender Federal Building, Houma, Louisiana
Emanuel Baptist Church, Alexandria, Louisiana
Embottelladora Guajardo, Monterrey, N.L., México
Fidelity Bank, Oklahoma City, Oklahoma
Flint Institute of Arts, Flint, Michigan
Helmerich & Payne, Tulsa, Oklahoma
Historic New Orleans Collection, New Orleans, Louisiana
Hotel InterContinental, New Orleans, Louisiana
Hunter Museum of Art, Chattanooga, Tennessee
Huntington Galleries, Huntington, West Virginia

Jewish Community Center, New Orleans, Louisiana
K & B Plaza, New Orleans, Louisiana
Linclay Executive Plaza, Cincinnati, Ohio
Longue Vue House and Gardens, New Orleans, Louisiana
Louisiana State Library, Baton Rouge, Louisiana
National Museum of American Art, Smithsonian Institution, Washington, D.C.
New Orleans Museum of Art, New Orleans, Louisiana
Norton Gallery and School of Art, West Palm Beach, Florida
Pan American Life Insurance Building, New Orleans, Louisiana
Pensacola Art Center, Pensacola, Florida
South Central Bell Telephone Building, Birmingham, Alabama
Sweet Briar College, Sweet Brair, Virginia
University of South Carolina, Humanities Complex, Columbia, South Carolina

Selected Award
1980 Mayor's Award for Achievement in the Arts, New Orleans, Louisiana

Preferred Sculpture Media
Metal (welded) and Varied Media

Selected Bibliography
Feldman, Edmund Burke. *Art as Image and Idea*. Englewood Cliffs, New Jersey: Prentice-Hall, 1967.
Green, Roger. "The Kinetic Sculpture of Lin Emery." *Arts Magazine* vol. 54 no. 4 (December 1979) pp. 106-107, illus.
Redstone, Louis G. and Ruth R. Redstone. *Public Art: New Directions*. New York: McGraw-Hill, 1981.
Rubinstein, Charlotte Streifer. *American Women Artists: From Early Indian Times to the Present*. Boston: G. K. Hall, 1982.
Thalacker, Donald W. *The Place of Art in the World of Architecture*. New York: Chelsea House, 1980.

Gallery Affiliation
Max Hutchinson Gallery
138 Greene Street
New York, New York 10012

Mailing Address
7520 Dominican Street
New Orleans, Louisiana 70118

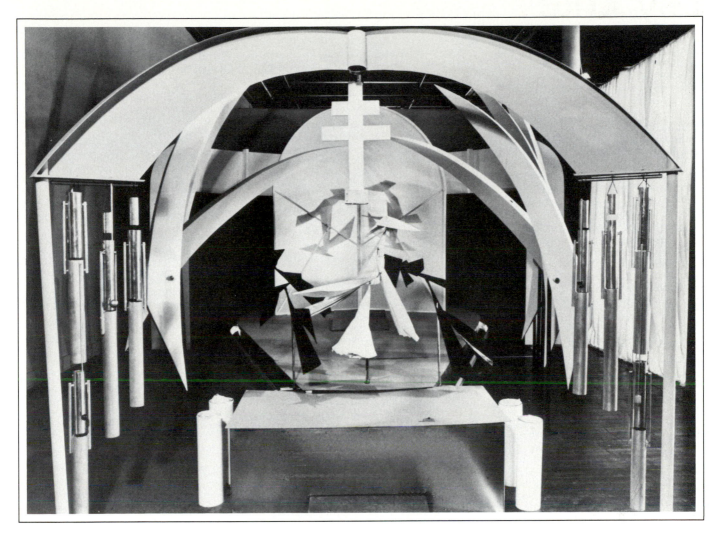

Becket: The Final Moments (in collaboration with composer James Drew). 1983. Mixed media, automated drama, 12'h x 13'w x 25'd; dimensions variable to installation. Installation view 1983. Contemporary Arts Center, New Orleans, Louisiana. Photograph by S. Ray Kutos.

Artist's Statement

"My current work has developed from collaborations with a composer, a physicist, an architect, an environmental artist, another sculptor. This experimentation and invention increases the amplitude and velocity of the creative process. Accustomed to the sculptor's idiom, I find it fascinating to be led into other vocabularies. In each new approach, I have attempted to express the movement of sculptural forms in space, responsive to gesture and pantomine and the changes and vagaries of natural forces."

Lily Ente

née Lena Deitchman
Born April 3, 1905 Dunayevtsy, Ukraine,
 Union of Soviet Socialist Republics
Died November 18, 1984 New York, New
 York

Education and Training
I attended school in pre-revolutionary Russia.
Later I studied in France. When I came to
the United States in 1925, I learned stone
cutting from the monument carvers of the
Washington Cemetery in Brooklyn, New
York.

Selected Individual Exhibitions
1955, Loeb Student Center, Contemporary
59 Arts Gallery, New York University,
 New York, New York
1965 East Hampton Gallery, New York, New
 York, catalog
1966 Fordham University at Rosedale,
 Rosedale, New York
1967 Fordham University at Lincoln Center,
 New York, New York

Selected Group Exhibitions
1954 "New Jersey Artists Annual Exhibition,"
 Riverside Museum, New York, New
 York
1956 "New Sculpture Group Annual
 Exhibition," Riverside Museum, New
 York, New York
1956 "New Sculpture Group," Hansa
 Gallery, New York, New York
1956 "Anna Walinska, Ahron Ben-Shmuel
 and Lily Ente," Bodley Gallery, New
 York, New York

1957 "Contemporary American Painting and
 Sculpture," University of Illinois at
 Urbana-Champaign, Urbana, Illinois,
 catalog
1958 "Group Exhibition," James Gallery,
 New York, New York
1960 "New Sculpture Group: Guests and
 Members Fifth Exhibition," Stable
 Gallery, New York, New York, catalog
1960 "Aspects de la Sculpture Américaine,"
 Galerie Claude Bernard, Paris, France
1963 "Contemporaries," Riverside Museum,
 New York, New York
1963 "First Sculpture Exhibition," Millhouse-
 Bundy Performing and Fine Arts
 Center, Waitsfield, Vermont, catalog
1967 "Sculpture: New York Scene,"
 Riverside Museum, New York, New
 York, catalog
1973 "Louise Nevelson, Sari Dienes and Lily
 Ente," Buecker and Harpsicord
 Gallery, New York, New York
1976- "Thirty-Fifth Anniversary Exhibition
78 Federation of Modern Painters and
 Sculptors," Traveling Exhibition,
 Gallery Association of New York
 State, New York, New York, catalog
1977 "Space/Matter '77," Women's Interart
 Center, New York, New York, catalog
1982 "Eight Artists," Buecker and
 Harpsichord Gallery, New York, New
 York

Selected Public Collections
Chrysler Museum, Norfolk, Virginia
Edwin A. Ulrich Museum of Art, Wichita
 State University, Wichita, Kansas
Hirshhorn Museum and Sculpture Garden,
 Smithsonian Institution, Washington, D.C.
Phoenix Art Museum, Phoenix, Arizona
Rose Art Museum, Brandeis University,
 Waltham, Massachusetts
Safad Municipal Museum, Safad, Israel

Selected Awards
1954 Honorable Mention, "Biennial
 Exhibition," Brooklyn Museum,
 Brooklyn, New York
1956 Bronze Medal of Honor, "Painters and
 Sculptors Society of New Jersey,"
 Newark Museum, Newark, New Jersey
1966 Amelia Peabody Award for Sculpture,
 "National Association of Women
 Artists Annual Exhibition," National
 Academy of Design, New York, New
 York, catalog

Preferred Sculpture Media
Stone and Wood

Additional Art Fields
Drawing and Graphics

Selected Bibliography
"D. A." (Dore Ashton.) "About Art and Artists."
 The New York Times (Thursday, November
 15, 1956) p. 32.
"E. S. P." "Reviews and Previews: Lily Ente."
 Art News vol. 58 no. 2 (April 1959) p. 60.
"M. S." (Martica Savin.) "Fortnight in Review:
 Lily Ente." *Arts Digest* vol. 29 no. 14 (April
 15, 1955) p. 25.
Schwartz, Sanford. "New York Letter." *Art
 International* vol. 17 no. 2 (February 1973)
 pp. 60-61.
Tillim, Sidney. "New York Exhibitions: In the
 Galleries, Contemporaries." *Arts Magazine*
 vol. 37 no. 5 (February 1963) p. 55.

Mailing Address
Paulette Esrig
330 West 28 Street
New York, New York 10001

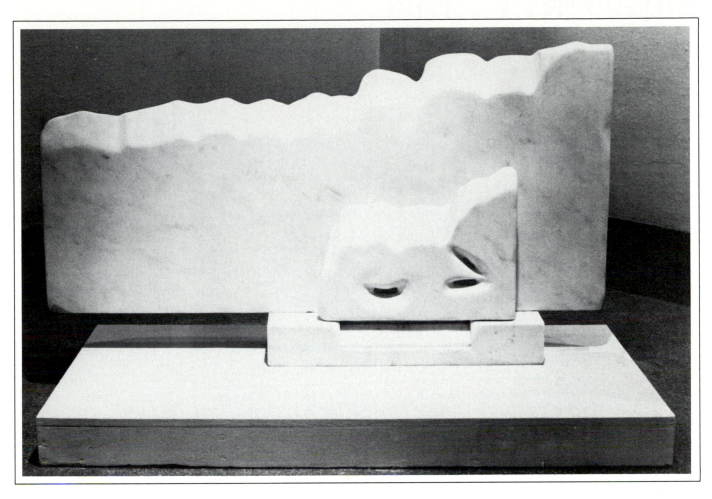

Noon. 1964. Marble, 3'h x 5'w x 2'd. Photograph by Otto E. Nelson.

Artist's Statement

"As a child during the First World War, my life and that of those around me was infected by poverty and ugliness. My response to these experiences was a desire to combat this deprivation with beauty. My choice of marble as a medium was made in part because it challenged me more than clay and I found great joy in the beauty of the natural forms and surfaces I could achieve. In recent years I have worked almost exclusively in either black or white marble. My search has been for a unique form which would best express my concepts of sculptural form—space, balance, the interplay of volumes, beauty of material and the sensitivity of the hand and mind to these values.

"Printmaking, instead of drawing, has become an arena for further exploration of sculptural ideas on a two-dimensional surface. The tactile nature of ink replaces the texture of stone. Concepts of balance can be explored in the reaction between block forms, organic and architectonic, and the surface of the paper. This dynamic impact creates space which is the primary concern of the sculptor."

Lily Ente

Elizabeth C. Falk

née Elizabeth Chabot
(Husband Daniel A. Falk)
Born June 26, 1941 New York, New York

Education and Training
1959 Silvermine Guild of Artists, New Canaan, Connecticut
1962-63 New York University, New York, New York
1970 B.F.A., Sculpture, Ohio State University, Columbus, Ohio

Selected Individual Exhibitions
1981, 82 Mitzi Landau Gallery, Los Angeles, California
1982, 83 Middendorf Gallery, Washington, D.C.

Selected Group Exhibitions
1970 "Annual Juried Exhibition," Columbus Gallery of Art, Columbus, Ohio
1971 "Annual Drawing and Small Sculpture Show," Ball State University, Muncie, Indiana
1976 "Vermont '76," Millhouse-Bundy Performing and Fine Arts Center, Waitsfield, Vermont
1976 "Saenger National Jewelry & Small Sculpture Exhibit," Saenger Center, Hattiesburg, Mississippi, catalog
1976 "Fourth Annual Regional Art Exhibit," Dartmouth College, Hanover, New Hampshire
1977 "Juried Show," Provincetown Art Association and Museum, Provincetown, Massachusetts
1978 "Twenty-First Area Exhibition: Sculpture," Corcoran Gallery of Art, Washington, D.C., catalog
1979 "Five Sculptors," Grace Gallery, Reston, Virginia
1979 "City Art," Studio Gallery, Washington, D.C.
1980 "Twenty Washington Sculptors," Washington Project for the Arts, Washington, D.C.
1980 "Sculpture 1980," Maryland Institute College of Art, Baltimore, Maryland, catalog
1980 "Tableau: An American Selection," Middendorf/Lane Gallery, Washington, D.C., catalog
1981 "The Human Form: Interpretations," Maryland Institute College of Art, Baltimore, Maryland
1981 "The Figure in Bronze: Small Scale," Middendorf/Lane Gallery, Washington, D.C.
1984 "Recent Sculpture—Johnson Atelier: Workshop and Studio," New Jersey State Museum, Trenton, New Jersey, catalog
1984 "Washington Sculpture: Prospects & Perspective," Georgetown Court Artists' Space, Washington, D.C.
1984 "Sculpture 84," Washington Square Partnership and Public Art Trust," Washington, D.C.

Selected Public Collection
The Washington Post, Washington, D.C.

Selected Private Collections
Mr. and Mrs. Harlow Carpenter, Wakefield, Vermont
Mr. and Mrs. Edward Kienholz, Hope, Idaho

Selected Awards
1975 First Prize, "Twelfth Exhibit of Vermont Artists," Norwich University, Northfield, Vermont
1975 Individual Artist's Fellowship, Vermont Council on the Arts

Preferred Sculpture Media
Metal (cast)

Selected Bibliography
Fleming, Lee. "Some Notes on the Psychological Figure, Circa 1982, in D.C.: Elizabeth Falk, Middendorf-Lane Gallery." *Washington Review* vol. 8 no. 1 (June-July 1982) p. 4, illus.
Lewis, Jo Ann. "Galleries: Beauty Out of The Blue, Sculptor Elizabeth Falk." *The Washington Post* (Saturday, May 22, 1982) p. C3.
Lewis, Jo Ann. "Galleries: Studies In Isolation," *The Washington Post* (Saturday, January 14, 1984) p. C3, illus.
Richard, Paul. "Galleries: Timeless Figures in Bronze." *The Washington Post* (Saturday, October 24, 1981) p. B3, illus.

Gallery Affiliation
Middendorf Gallery
2009 Columbia Road NW
Washington, D.C. 20009

Mailing Address
1330 New Hampshire Avenue NW-914
Washington, D.C. 20036

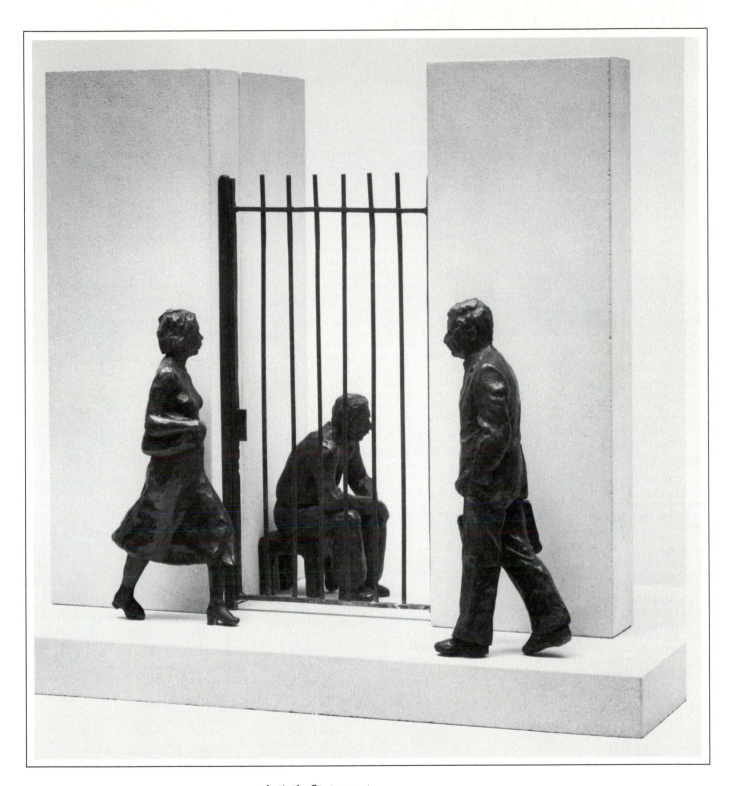

The Gate. 1980-1981. Bronze and limestone, 16½"h x 20"w x 13"d. Photograph by Joel Breger.

Artist's Statement
"My work is my statement."

Elizabeth Falk

Claire Falkenstein

née Claire Lindley
Born July 22, 1908 North Bend, Oregon

Education and Training
1930 A.B., Art, University of California, Berkeley, Berkeley, California
1934 Mills College, Oakland, California; study with Alexander Archipenko
1944 Atelier 17, New York, New York
1950-63 Independent research and study in Europe

Selected Individual Exhibitions
1940, 58 San Francisco Museum of Art, San Francisco, California
1947 M. H. de Young Memorial Museum, San Francisco, California
1948 Santa Barbara Museum of Art, Santa Barbara, California
1953 Institute of Contemporary Arts, London, Great Britain, catalog
1955, 58, 60, 62, 72 Galerie Stadler, Paris, France
1958 Galleria Il Segno, Rome, Italy
1960 Galerie Parnass, Wuppertal, Germany, Federal Republic
1961 Galleria Il Canale, Venice, Italy
1962 Pavilion Marsan, Musée du Louvre, Paris, France
1963 Esther Robles Gallery, Los Angeles, California, catalog
1963, 73 Galleria Il Traghetto, Venice, Italy, catalog
1965 Martha Jackson Gallery, New York, New York, catalog
1966 Galleria Il Cerchio, Venice, Italy, catalog
1967 Phoenix Art Museum, Phoenix, Arizona, retrospective and catalog
1968 Long Beach Museum of Art, Long Beach, California, retrospective and catalog
1969 Fresno Art Center, Fresno, California, catalog
1970 California Federal Savings, Los Angeles, California, catalog
1977 Grossmont College Art Gallery, El Cajon, California, catalog
1977 Senior Eye Gallery, Long Beach, California
1978, 81 Stewart Neill Gallery, New York, New York
1980 Palm Springs Desert Museum, Palm Springs, California, retrospective and catalog
1980 Stewart Neill Gallery, New York, New York, retrospective and catalog
1981 Smith Andersen Gallery, Palo Alto, California, retrospective
1981 Tortue Gallery, Santa Monica, California

1984 Riverside Art Center and Museum, Riverside, California, retrospective and catalog

Selected Group Exhibitions
1947-48 "Fifty-Eighth Annual Exhibition of American Paintings and Sculpture: Abstract and Surrealist American Art," Art Institute of Chicago, Chicago, Illinois, catalog
1948 "Mobiles and Articulated Sculpture," California Palace of the Legion of Honor, San Francisco, California, catalog
1953 "Annuel Salon de la Jeune Sculpture Contemporaine," Le Jardin du Musée National Auguste Rodin, Paris, France
1959 "Arte nel Vitalità," Palazzo Grassi, Venice, Italy, catalog
1960, 64 "Annual Exhibition: Contemporary American Sculpture," Whitney Museum of American Art, New York, New York, catalog
1962 "Artiste Objets," Musée des Arts Décoratifs, Paris, France, catalog
1964 "Pittsburgh International Exhibition of Painting and Sculpture," Museum of Art, Carnegie Institute, Pittsburgh, Pennsylvania, catalog
1965 "Les Etats-Unis: Sculpture du XX Siècle," Musée National Auguste Rodin, Paris, France, catalog
1974 "Public Sculpture/Urban Environment," Oakland Museum, Oakland, California, catalog
1974 "Topological Image Transducer," Museum of Art, Science and Industry, Los Angeles, California, catalog
1975 "Measurable Only In Probabilities," Arts Council Cultural Center, Thousand Oaks, California, catalog
1976 "Painting and Sculpture in California: The Modern Era," San Francisco Museum of Modern Art, San Francisco, California; National Collection of Fine Arts, Smithsonian Institution, Washington, D.C., catalog
1978 "90 by 30: A Festival of Small Sculpture," Martha Jackson Gallery, New York, New York, catalog
1979 "Selections from the Permanent Collection," Seattle Art Museum, Seattle, Washington
1979 "Vanguard American Sculpture 1913-1939," Traveling Exhibition, Rutgers University, Rutgers College, New Brunswick, New Jersey, catalog
1979 "Americans in Paris: The 50s," California State University Northridge, Northridge, California, catalog
1980 "Portraits and Palettes," Los Angeles County Museum of Art, Los Angeles, California, catalog
1982 "100 Years of California Sculpture: The Oakland Museum," Oakland Museum, Oakland, California, catalog
1984 "A Broad Spectrum: Contemporary Los Angeles Painters and Sculptors '84," Design Center, Los Angeles, California, catalog

Selected Public Collections
Long Beach Museum of Art, Long Beach, California
Los Angeles County Museum of Art, Los Angeles, California
Museum of Art, Carnegie Institute, Pittsburgh, Pennsylvania
National Museum of American Art, Smithsonian Institution, Washington, D.C.
Oakland Museum, Oakland, California
Palm Springs Desert Museum, Palm Springs, California
Phoenix Art Museum, Phoenix, Arizona
Saint Basil Church, Los Angeles, California
San Diego Fine Arts Gallery, San Diego, California
San Francisco Museum of Modern Art, San Francisco, California
Seattle Art Museum, Seattle, Washington
Solomon R. Guggenheim Museum, New York, New York and Venice, Italy
Tate Gallery, London, Great Britain
University of Southern California, Los Angeles, California
Wadsworth Atheneum, Hartford, Connecticut

Selected Private Collections
Conto Paolo Marzotto, Venice, Italy
Dr. and Mrs. Richard Newquist, Santa Ana, California
Mr. and Mrs. Donald Olsen, Berkeley, California
Baronne Alex de Rothschild, Pont l'Eveque, France
Mr. and Mrs. Sam Rubenstein, Palm Springs, California

Selected Awards
1965 Sculpture Award, International Sculpture Symposium, California State University Long Beach, Long Beach, California
1978 John Simon Guggenheim Memorial Foundation Fellowship
1981 Honor Award for Outstanding Achievement in the Visual Arts, National Women's Caucus for Art Conference, San Francisco, California

Preferred Sculpture Media
Glass, Metal (welded) and Wood

Additional Art Fields
Graphics and Painting

Selected Bibliography
Brommer, Gerald F. and Joseph A. Gatto. *Careers in Art: An Illustrated Guide.* Worcester, Massachusetts: Davis, 1984.
Bullis, Douglas, ed. Selected by Henry Hopkins. *50 West Coast Artists: A Critical Selection of Painters and Sculptors Working in California.* San Francisco: Chronicle Books, 1981.

Lerman, Ora. "Arts Reviews: Claire Falkenstein Invites Us to 'Complete the Circle.'" *Arts Magazine* vol. 56 no. 5 (January 1982) pp. 64-67, illus.

Rubin, David S. "Americans in Paris: The 50s." *Arts Magazine* vol. 54 no. 5 (January 1980) p. 19, illus.

Tapié, Michel. *Claire Falkenstein*. Rome: De Luca Art Monographs, 1958.

Gallery Affiliations

Smith Andersen Gallery
200 Homer Avenue
Palo Alto, California 94301

Tortue Gallery
2917 Santa Monica Boulevard
Santa Monica, California 90404

Galerie Stadler
51 Rue de Seine
75006 Paris, France

Mailing Address

719 Ocean Front Walk
Venice, California 90291

Artist's Statement

"Although I had intensively researched Renaissance perspective and had been immersed in Einstein's theory of relativity from university days, I was impelled to discover my own method of forming structure in space and the tension of natural growth.

"One early and continuing theme in my work is the interaction of lines to form the boundaries of space which in turn shape the paths of air flow in the structures. This culminates in a woven wire-mesh structure with connecting rods and wires to create the 'Never-Ending Screen.' The space drawing in metal leads the eye of the observer through a spatial experience limitless from every side. The interlocking shapes are a means of creating an interior openness which acts as a spatial continuity; the exterior is created matter.

"My position changed from confronting nature to becoming integrated with nature. These ideas have formed many areas of my sculpture and painting: line, plane, mass and the rhythmic flow of movement through time."

Claire Falkenstein

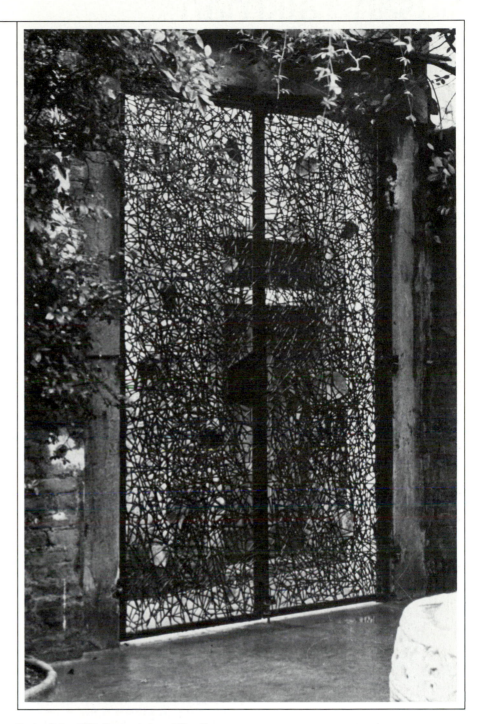

Garden Gates. 1961. Steel and glass, 12'h x 8'w x 10"d. Collection Solomon R. Guggenheim Museum, Venice, Italy. Photograph by Ferruzzi.

Susan Falkman

née Susan Fries
Born March 9, 1945 Davenport, Iowa

Education and Training
1967 B.S., Education and Psychology, University of Illinois at Urbana-Champaign, Urbana, Illinois
1968- Peace Corps, Liberia, West Africa
70
1972 Apprenticeship in sculpture to Annie Basse, Naxos, Greece
1973- Independent study in marble carving, Naxos, Greece
76
1977 University of Wisconsin-Milwaukee, Milwaukee, Wisconsin; independent study in sculpture with Narendra M. Patel
1978- Studio Nicoli, Carrara, Italy; independent study in marble carving
80

Selected Individual Exhibitions
1975 Aegean Hotel, Naxos, Greece
1976 Diogenes Gallery, Athens, Greece
1978 Marine National Bank, Milwaukee, Wisconsin
1979 Teatro Verdi, Carrara, Italy
1980 Gallery 700, Milwaukee, Wisconsin
1982 Carroll College, Waukesha, Wisconsin
1982 Joy Horwich Gallery, Chicago, Illinois
1984 La Chiesetta, Fosdinovo, Italy
1984 David Barnett Gallery, Milwaukee, Wisconsin
1985 Winmar Corporation, Milwaukee, Wisconsin

Selected Group Exhibitions
1976 "Gallery Artists," Kreonidis Gallery, Athens, Greece
1976 "Gallery Exhibition," Diogenes Gallery, Athens, Greece
1977 "Group Exhibition," Irving Gallery, Milwaukee, Wisconsin
1977 "Group Exhibition," Gilman Gallery, Chicago, Illinois
1978 "Midwest Sculpture," University of Wisconsin-Milwaukee, Milwaukee, Wisconsin
1979, "Simposio Internazionale di Scultura,"
80 Internazionale Marmi Macchine, Carrara, Italy, catalog
1979 "Mostra Commune," Palazzo Municipale, Sarzana, Italy
1980 "Scolpire all'Aperto, Studio in the Open," Piazza Alberica, Carrara, Italy
1981 "XVII Mostra Internazionale di Scultura," Fondazione Pagani, Milan, Italy
1981 "XI Mostra Artigiani del Marmo," Piazza Lisa, Carrara, Italy
1981 "Gallery Artists," Joy Horwich Gallery, Chicago, Illinois
1981 "Gallery Exhibition," Hokin Gallery, Palm Beach, Florida
1982 "Artists' Open Studios," Lincoln Center for the Arts, Milwaukee, Wisconsin
1982 "Bastille Day City Celebration," Area Locations, Milwaukee, Wisconsin
1983 "Wisconsin Impressions," Cudahy Gallery of Wisconsin Art, Milwaukee Art Museum, Milwaukee, Wisconsin
1984 "Corporate Art," David Barnett Gallery, Milwaukee, Wisconsin
1984 "Member Artists Exhibition," Perihelion Gallery, Lincoln Center for the Arts, Milwaukee, Wisconsin
1984 "The Art of Tria Gallery," Tria Gallery, Ellison Bay, Wisconsin
1984 "What's New," Byer Museum of the Arts, Evanston, Illinois
1984 "Arte Estate," Piazza Centrale, Marina di Carrara, Italy

Selected Public Collections
Byer Museum of the Arts, Evanston, Illinois
Casa di Risparmo, Carrara, Italy
City of Carrara, Italy
City of Digne, France
First Bank of Wisconsin, Milwaukee, Wisconsin
Universal Food Corporation, Milwaukee, Wisconsin
Winmar Corporation, Milwaukee, Wisconsin

Selected Awards
1980 First Prize, "Scolpire all'Aperto, Studio in the Open," Piazza Alberica, Carrara, Italy
1983 Second Prize, "V Symposium International de Sculpture," Plaza Centrale, Digne, France
1984 First Prize, "VI Simposio Internazionale di Scultura," Piazza Alberica, Carrara, Italy, catalog

Preferred Sculpture Media
Stone

Related Profession
Artist in Residence, Lincoln Center for the Arts, Milwaukee, Wisconsin

Selected Bibliography
Newman, Cathy. "Carrara Marble: Touchstone of Eternity." *National Geographic* vol. 162 no. 1 (July 1982) pp. 42-59.
Vance, Alexander. "History, Ideology, and Art: Sculpture Transformed." *Wisconsin Academy Review* vol. 31 no. 2 (March 1985) pp. 14-22, illus.

Gallery Affiliation
David Barnett Gallery
2101 West Wisconsin Avenue
Milwaukee, Wisconsin 53233

Mailing Address
1108 West River Park Lane
Glendale, Wisconsin 53209

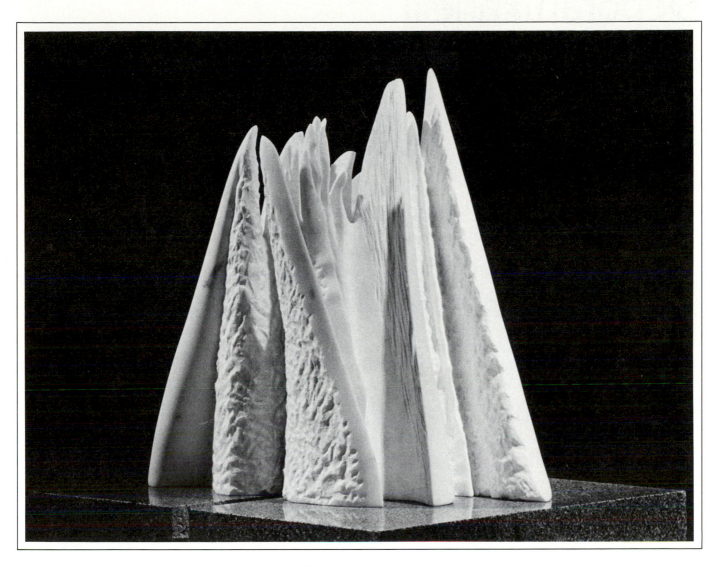

Path of Dreams. 1984. Marble, 26"h x 22"w x 27"d.
Photograph by Dean E. Johnson.

Artist's Statement

"My work is inspired by all of nature, the
mountains and particularly the sea. The
delicate and vulnerable forms I create reflect
the instability of the human condition in the
modern world. I attempt to convey a sense
of terrain with the hint of a living form. I want
my work to reawaken our spiritual linkage
with nature and interconnectedness with our
lives. As I explore the surface and interior of
the marble, I am also delving into my
subconscious and recording what is
occurring in my life.

"Through carving marble I am involved in
the process of recreating and transforming
the beauty of the stone into a new form
which still maintains its relationship to other
organic objects. And, like objects in nature,
my work evokes a feeling of dynamic
movement, similar to the plants in the sea,
patterns in dance or rhythms in music."

Deborah Fanelli

née Deborah Ann
Born June 5, 1957 New London, Connecticut

Education and Training
1977 Apprenticeship to George Weltner, Old Church Pottery, Haddam, Connecticut
1978 Haystack Mountain School of Crafts, Deer Isle, Maine; study in architectural constructions
1981 B.F.A., Ceramics, Sculpture and Glass, Cleveland Institute of Art, Cleveland, Ohio; study in ceramic sculpture with Judith Solomon
1983 M.F.A., Sculpture, Rhode Island School of Design, Providence, Rhode Island; study with Michael Beresford

Selected Group Exhibitions
1980, "Summer Show," Cleveland Institute of
81 Art, Cleveland, Ohio
1982 "Installation," Gallery 401, Rhode Island School of Design, Providence, Rhode Island
1982 "Glass Department Exhibition," Woods-Gerry Gallery, Rhode Island School of Design, Providence, Rhode Island
1982 "On the Farm," Tillinghast Estate, Barrington, Rhode Island
1983, "Faculty Exhibition," Scales Fine Arts
85 Center, Wake Forest University, Winston-Salem, North Carolina
1984 "North Carolina Artists Exhibition," North Carolina Museum of Art, Raleigh, North Carolina
1985 "Here and Now Series," Greenville County Museum of Art, Greenville, South Carolina
1985 "Installation Exhibition," Greenville County Museum of Art, Greenville, South Carolina

Selected Awards
1981 Mary C. Page Award, Cleveland Institute of Art, Cleveland, Ohio
1984 Individual Artist's Fellowship, National Endowment for the Arts
1985 Faculty Research Grant, Wake Forest University, Winston-Salem, North Carolina

Preferred Sculpture Media
Metal (welded) and Wood

Additional Art Field
Glass

Teaching Position
Art Instructor, Wake Forest University, Winston-Salem, North Carolina

Mailing Address
Box 7232
Reynolda Station
Winston-Salem, North Carolina 27109

La Mort Vivante. 1983. Wood, 8′5″h x 25′w x 15′d.
Installation view 1983. "Faculty Exhibition," Scales
Fine Arts Center, Wake Forest University,
Winston-Salem, North Carolina.

Artist's Statement

"I strive to present in image form the
enrichment of the end of life's cycle that has
filled my heart with such pain. To reveal this
concept, the wooden forms I construct have
an animated quality. These forms, which
contain a central slot or opening, symbolize
housing for the soul. The rising or walking
quality they appear to have represents
regeneration.

"Recently I have become intrigued with
utilizing scrap salvage wood. I have found
that life and beauty still exist within this
material. It can live and breathe again when
it is sliced open to reveal the inner
untouched core."

163

Christine Federighi

née Christine Marie
Born June 22, 1949 San Mateo, California

Education and Training
1972 B.F.A., Ceramics, Cleveland Institute of Art, Cleveland, Ohio
1974 M.F.A., Ceramics, Alfred University, Alfred, New York

Selected Individual Exhibitions
1979 Florida Atlantic University, Boca Raton, Florida
1980, Gallery at 24, Miami, Florida
82,
83
1980 Stetson University, Deland, Florida
1984 By Design Gallery, Minneapolis, Minnesota

Selected Group Exhibitions
1973 "Ceramic Art of the World 1973," University of Calgary, Calgary, Alberta, Canada
1975, "Earth, Fibers and Fantastic Forms,"
77 Grove House, Coconut Grove, Florida
1976 "Professional Women Artists of Florida," Lowe Art Museum, Coral Gables, Florida
1976 "Sculptors of Florida," Metropolitan Museum and Art Center, Coral Gables, Florida
1977, "Annual Hortt Memorial Exhibition,"
78 Museum of Art, Fort Lauderdale, Florida, catalog
1978 "Young Americans II," Tucson Museum of Art, Tucson, Arizona
1979 "Ceramic Invitational," Birmingham Museum of Art, Atlanta, Georgia
1979 "Dog and Pony Show," Sebastian-Moore Gallery, Denver, Colorado
1980 "Arts Council of Florida Grant Recipients Invitational Show," Lemoyne Art Foundation, Tallahassee, Florida, catalog
1981 "Viewpoint: Ceramics, 1981," Grossmont College Gallery, El Cajon, California, catalog
1981 "Ceramics Southeast," University of Georgia, Athens, Georgia

1981 "The Animal Image: Contemporary Objects and the Beast," Renwick Gallery of the National Museum of American Art, Smithsonian Institution, Washington, D.C., catalog
1981 "Paint on Clay: A Survey of the Use of Nonfired Surfaces on Ceramic Forms by Contemporary American Artists," John Michael Kohler Arts Center, Sheboygan, Wisconsin, catalog
1981 "Southeastern Center for Contemporary Art Ceramic Invitational," University Museum, University of Mississippi, University, Mississippi
1982 "The Southeast Seven V," Southeastern Center for Contemporary Art, Winston-Salem, North Carolina; Greenville County Museum of Art, Greenville, South Carolina, catalog
1982 "The Animal Kingdom," Marcia Rodell Gallery, Los Angeles, California
1982 "14 Florida Sculptors," University of Miami, Miami, Florida
1983 "Christine Federighi and Ron Fondaw," Form and Function Gallery, Atlanta, Georgia
1983 "Ceramic Echoes: Historical References in Contemporary Ceramics," Nelson-Atkins Museum of Art, Kansas City, Missouri, catalog
1983- "Southern Sculpture on the Go,"
84 Traveling Exhibition, Loch Haven Art Center, Orlando, Florida
1984 "Group Ceramics Exhibit," Dorothy Weiss Gallery, San Francisco, California
1984 "Christine Federighi, Graham Marks and David Middlebrook," Ohio State University, Columbus, Ohio
1984 "Fantasy Forms and Images," Polk Public Museum, Lakeland, Florida
1984 "Private Domains," Elements Gallery, New York, New York
1985 "Southern Exposure: Not a Regional Exhibition, Part 1," Alternative Museum, New York, New York, catalog

Selected Public Collections
City of Calgary, Alberta, Canada
Miami-Dade Community College, Miami, Florida
Museum of Arts and Sciences, Daytona Beach, Florida
R. J. Reynolds Industries World Headquarters, Winston-Salem, North Carolina
Stetson University, DeLand, Florida
University of South Florida, Tampa, Florida

Selected Private Collections
Daniel Jacobs Collection, New York, New York
John Michael Kohler, Jr. Collection, Sheboygan, Wisconsin
Joan Mannheimer Collection, Des Moines, Iowa

Martin Z. Margulies, Miami, Florida
Dr. Edward and Barbara Okun, St. Louis, Missouri

Selected Awards
1979, Individual Artist's Fellowship, Arts
83 Council of Florida
1981 Individual Artist's Fellowship, National Endowment for the Arts and Southeastern Center for Contemporary Art, Winston-Salem, North Carolina

Preferred Sculpture Media
Clay

Teaching Position
Professor, University of Miami, Coral Gables, Florida

Selected Bibliography
Kash, Joanne. "Profiles: A Portfolio of Regional Artists, Christine Federighi (Miami, Florida)." Art Voices vol. 4 no. 3 (May-June 1981) p. 71, illus.
Kohen, Helen L. "Forecast: Bright Days for Art in South Florida." Art News vol. 79 no. 10 (December 1980) pp. 96-99, illus.
Nigrosh, Leon I. Low Fire: Other Ways to Work in Clay. Worcester, Massachusetts: Davis, 1980.
"Portfolio: Christine Federighi." American Craft vol. 42 no. 1 (February-March 1982) p. 36, illus.
Wechsler, Susan. "Interview: Views on the Figure." American Ceramics vol. 3 no. 1 (Spring 1984) pp. 16-25, illus.

Gallery Affiliation
Gallery at 24
1052 Kane Concourse
Bay Harbor Islands, Florida 33154

Mailing Address
4351 SW 12 Street
Miami, Florida 33134

Artist's Statement

"I enjoy the visual vitality of folk art, ethnographic art and religious art of various cultures. I am intrigued by the narratives to these particular types of art forms. My past sources have been American Indian art, folk artists, visionaries and story tellers but my interests are broad and ideas come from many areas.

"For the most part I like a piece to 'happen.' An image evolves from the physical or psychological encounter with an environment, a group of people or a person. I become the story teller. Sometimes the work is directly narrative and other times it is merely a relationship of whimsical parts. Above all I want the delivery to be fresh and honest. I do the work for my own entertainment and hope it can become that for viewers."

Christine Federighi

Horse and Rider. 1980. Talc clay body, terra sigillata and paint, 36"h x 12"w x 21"d. Photograph by Susan Kurtz.

165

Bella Tabak Feldman

née Bella Rose Tabak
Born March 1, 1940 New York, New York

Education and Training
1961 B.A., Education and Anthropology, City University of New York Queens College, Flushing, New York
1972 M.A., Sculpture, San Jose State University, San Jose, California

Selected Individual Exhibitions
1967 Arleigh Gallery, San Francisco, California
1968 Philadelphia Art Alliance, Philadelphia, Pennsylvania
1970 Nommo Gallery, Kampala, Uganda
1972 Bolles Gallery, San Francisco, California
1973 San Jose State University, San Jose, California
1973 Berkeley Art Center, Berkeley, California
1975 University of California, Santa Barbara, Santa Barbara, California
1975 Athol McBean Gallery, San Francisco Art Institute, San Francisco, California
1975 Galerie Bernard Letu, Genève, Switzerland, catalog
1976 Grapestake Gallery, San Francisco, California
1976 Mills College, Oakland, California
1976 Gallery West, California State University Hayward, Hayward, California
1980 Memorial Union Art Gallery, University of California, Davis, Davis, California
1982 San Jose Museum of Art, San Jose, California
1983 University of Denver, Denver, Colorado
1984 Fiberworks Gallery, Berkeley, California
1984 Monterey Peninsula Museum of Art Association, Monterey, California
1984 University of Iowa, Iowa City, Iowa
1984 Miller/Brown Gallery, San Francisco, California

Selected Group Exhibitions
1964 "Bay Area Artists," San Francisco Museum of Art, San Francisco, California
1972 "Bay Area Sculpture," College of Marin, Kentfield, California
1974 "Taboo Show," Womanspace, Los Angeles, California
1976 "The Multiple Image," M. H. de Young Memorial Museum, San Francisco, California

1976- "The Handmade Paper Object,"
82 Traveling Exhibition, Santa Barbara Museum of Art, Santa Barbara, California, catalog
1977 "Three Sculptors," College of Marin, Kentfield, California
1977 "Three Attitudes: Paper," Fiberworks Gallery, Berkeley, California
1978 "Death Show," Space Gallery, Los Angeles, California
1978- "Paper as Medium," Traveling
80 Exhibition, Renwick Gallery of the National Collection of Fine Arts, Smithsonian Institution, Washington, D.C.
1982 "Inside/Outside 1982 Sculpture Invitational," Visual Arts Center of Alaska, Anchorage, Alaska, catalog
1982 "Between the Lines: Lightweight Sculpture," Civic Arts Gallery, Walnut Creek, California
1982 "Atlantic Coast/Pacific Coast," California College of Arts and Crafts, Oakland, California, catalog
1982 "Art and/or Craft: USA and Japan," Traveling Exhibition, MRO Hall, Hokuriku Broadcasting Company, Kanazawa, Japan, catalog
1983, "Fibre/Espace: Biennale Internationale
85 de la Tapisserie," Musée Cantonal des Beaux Arts, Lausanne, Switzerland, catalog
1984 "Fiber Cross-Currents," John Michael Kohler Arts Center, Milwaukee, Wisconsin
1984 "Art in Craft Media," Twining Gallery, New York, New York
1984 "The Presence of Light," Meadows Museum and Sculpture Court, Dallas, Texas, catalog
1985 "Fibers East/Fibers West," Fiberworks Gallery, Berkeley, California
1985 "Menagerie: Contemporary Animal Images," San Francisco International Airport, San Francisco, California
1985 "Six Artists of the Biennale," Galerie Focus, Lausanne, Switzerland

Selected Public Collections
City Hall, Mountain View, California
Crystal Elementary School, Suisun City, California
Hydronautics, Incorporated, Washington, D.C.
International Business Machines Corporation, San Jose, California
Marina Vista Plaza, Vallejo, California
Martin Luther King, Jr. High School, Science and Industrial Arts Building, Berkeley, California
Medical Building, Redding, California
Newport Shopping Center, Newport, California
Oakland Museum, Oakland, California
Potrero Project, Richmond, California
Temple Rodef Sholom, San Rafael, California
University of California, Berkeley, Berkeley, California

Selected Awards
1975 First Prize, "San Francisco Women Artists," San Francisco Art Institute, San Francisco, California
1975 East African Arts Research Grant, E. L. Cabot Trust Fund, Harvard University, Cambridge, Massachusetts

Preferred Sculpture Media
Varied Media

Teaching Position
Professor of Sculpture, California College of Arts and Crafts, Oakland, California

Selected Bibliography
Boettger, Suzaan. "Exhibitions: Potent Allusions." Artweek vol. 13 no. 32 (October 2, 1982) p. 4, illus.
Feldman, Bella Tabak. "A View of Evolution Expressed in Sculpture: A Reflection of Nuclear Angst." Leonardo vol. 16 no. 4 (Autumn 1983) pp. 259-264, illus.
Frym, Gloria. Second Stories: Conversations with Women Whose Artistic Careers Began After Thirty-Five." San Francisco: Chronicle Books, 1979.
Scarborough, Jessica. "The Visual Language of Bella Feldman." Fiberarts vol. 11 no. 4 (July-August, 1984) pp. 30-33, illus.
Workman, Andree M. "Sculpture in Search of Space." Artweek vol. 11 no. 28 (August 30, 1980) pp.5-6, illus

Gallery Affiliation
Miller/Brown Gallery
355 Hayes Street
San Francisco, California 94102

Mailing Address
12 Summit Lane
Berkeley, California 94708

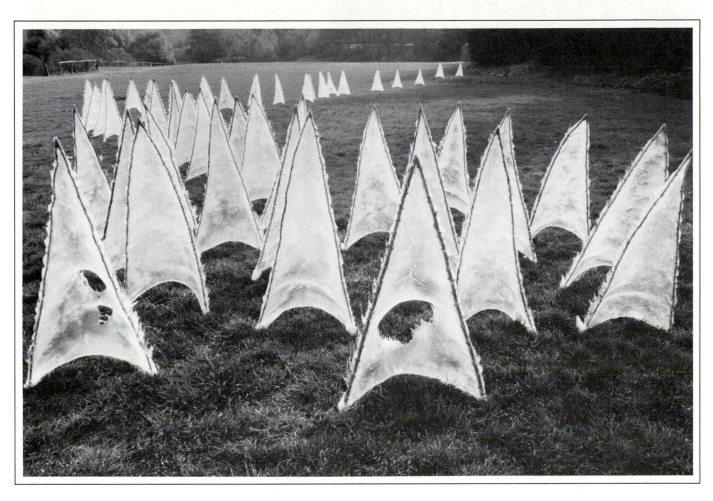

Cadmus Cadre. 1982. Fiberglass resin and rose cane, forty-five units each approximately 36"h x 16"w x 10"d. Installation view 1982. San Jose Museum of Art, San Jose, California.

Artist's Statement

"My work is often regarded as feminine. It appears fragile yet it is quite tough and resilient. In recent years I have been influenced by an interest in biological or organic forms. The particular forms I have developed since 1977 refer to the simple but elegant primary shapes in nature. This interest derives naturally from the many childhood hours spent at the Bronx Zoo. Home, only a city block or two away, was three barely-furnished dreary rooms in a working class tenement building surrounded as far as one could see or walk with others much like it. The zoo was a visual feast of animals and plants.

"In the studio, I work intuitively. I am almost in the same position as the viewer in interpreting the finished structures. Marcel Duchamp once said, 'Let the viewer complete the work.'"

BELLA T. FELDMAN

Catherine Ferguson

née Catherine Watson
(Husband Terrence Ferguson)
Born January 11, 1943 Sioux City, Iowa

Education and Training
1961- Rosary College, River Forest, Illinois
63
1965 B.A., English Literature, Creighton
University, Omaha, Nebraska

Selected Individual Exhibitions
1978 Joslyn Art Museum, Omaha, Nebraska
1979 University Art Galleries, Vermillion,
South Dakota
1980 Gallery 72, Omaha, Nebraska
1980 Sioux City Art Center, Sioux City,
Iowa, catalog
1981 Joslyn Art Museum, Omaha,
Nebraska, catalog
1982 South Dakota Memorial Art Center,
Brookings, South Dakota

Selected Group Exhibitions
1970 "Catherine Ferguson and Eleanor
Thompson," Sioux City Art Center,
Sioux City, Iowa
1976 "Catherine Ferguson and Mary
Kester," Artists' Cooperative Gallery,
Omaha, Nebraska
1977 "Northwestern Crafts II," South Dakota
Memorial Art Center, Brookings, South
Dakota
1977 "Women in Art," Sioux City Art Center,
Sioux City, Iowa
1978 "Women Artists Today," Traveling
Exhibition, University Art Galleries,
Vermillion, South Dakota, catalog
1979 "Sofa Size Art Invitational," Joslyn Art
Museum, Omaha, Nebraska
1979 "Beds, Sweet Dreams and Other
Things," Brunnier Gallery, Iowa State
Center, Iowa State University, Ames,
Iowa, catalog

1979 "Objects '79," Western Colorado
Center For The Arts, Grand Junction,
Colorado
1981 "The Nebraska Triangle, Wellsprings of
America: A Festival of Women's Art
Through the Humanities," Peter Kiewit
Conference Center, Omaha,
Nebraska, catalog
1981 "Eight Nebraska Sculptors," University
of Nebraska Art Galleries, Sheldon
Memorial Art Gallery, Lincoln,
Nebraska, catalog
1982 "Art and Artists in Nebraska,"
University of Nebraska Art Galleries,
Sheldon Memorial Art Gallery, Lincoln,
Nebraska, catalog
1982 "Eppley Competitive Art Exhibition,"
University of Nebraska Art Galleries,
Sheldon Memorial Art Gallery, Lincoln,
Nebraska, catalog
1983 "Summer Outdoor Exhibition,"
Randolph Street Gallery, Chicago,
Illinois
1984 "The Sioux City Connection," Sioux
City Art Center, Sioux City, Iowa,
catalog

Selected Public Collections
Brenton Banks, Des Moines, Iowa
Creighton University, Ahmanson Law Center,
Omaha, Nebraska
Graceland College Union, Lamoni, Iowa
Richard Young Memorial Hospital, Omaha,
Nebraska
University of South Dakota, Vermillion, South
Dakota
Valentino's Restaurant, Omaha, Nebraska

Selected Private Collections
Holliday T. Day, Chicago, Illinois
Michael and Anne Fenner, Omaha, Nebraska
John Himmelfarb, Chicago, Illinois
Robert and Roberta Rogers, Omaha,
Nebraska

Selected Awards
1979 Juror's Award for Excellence,
"Nebraska Crafts Exhibition,"
University of Nebraska Art Galleries,
Sheldon Memorial Art Gallery, Lincoln,
Nebraska, catalog
1981 Sculpture Award, "Great Plains
Outdoor Sculpture Exhibition,"
University of Nebraska Art Galleries,
Sheldon Memorial Art Gallery, Lincoln,
Nebraska
1983 Arts Woman of the Year, Nebraska
Women's Political Caucus

Preferred Sculpture Media
Varied Media

Related Profession
Visiting Artist

Selected Bibliography
Bissell, Jane. "Hangups: Beds, Sweet
Dreams, And Other Things." *Fiberarts* vol.
6 no. 4 (July-August 1979) pp. 70-71, illus.

Gustin, Chris. "National Profiles: Catherine
Ferguson, Omaha, Nebraska." *Art Voices*
vol. 4 no. 1 (January-February 1981) p. 74,
illus.
Norwood, Tom. *Contemporary Nebraska Art
& Artists*. Omaha: University of Nebraska
at Omaha, Omaha, Nebraska, 1978.
White, Patrick E. "Reviews Midwest Iowa,
The Sioux City Connection: An Alumni
Show." *New Art Examiner* vol. 11 no. 7
(April 1984) p. 21.

Mailing Address
2602 Leavenworth Street
Omaha, Nebraska 68105

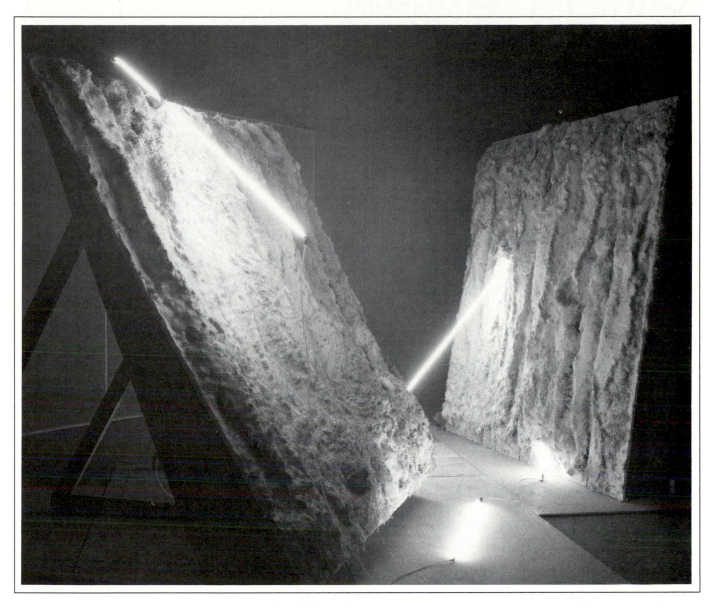

South Dakota Garden Wall. 1982. Plaster, gauze screen, wood, neon and sound, 8'h x 25'w x 30'd. Installation view (detail) 1982. South Dakota Memorial Art Center, Brookings, South Dakota.

Artist's Statement

"The Midwest is horizon-dominated. It is a simple, straightforward, unembellished landscape, mostly earth and sky. Historically, there has not been time for frills or pretensions. I find these aspects of Nebraska influencing my work.

"I discovered the physical reality of forms were more interesting than two-dimensional design. My work has progressed from fabric design, photography and serial geometric forms to neon outdoor and indoor earth installations and indoor garden architecture without plants. The search for materials leads me to many nonesthetic worlds of industrial fabrication facilities and equipment.

"I am most engaged by the disparity between the initial abstract idea and the final work. The confrontation with the materials produces a synthesis of old and new ideas, skills and materials which I find pleasing and stimulating."

Catherine Ferguson

169

Kathleen Ferguson

née Kathleen Elizabeth Wurtz
Born January 31, 1945 Chicago, Illinois

Education and Training
1963- Stephens College, Columbia, Missouri
64
1969 B.F.A., Sculpture, Layton School of Art, Milwaukee, Wisconsin
1971 M.F.A., Sculpture, Rhode Island School of Design, Providence, Rhode Island

Selected Individual Exhibitions
1972 Hall of Medical Sciences, National Museum of American History, Smithsonian Institution, Washington, D.C.
1975 Connecticut College, New London, Connecticut
1975 University of Rhode Island, Kingston, Rhode Island
1977, Nobé Gallery, New York, New York
79
1979, Jan Cicero Gallery, Chicago, Illinois
84
1980 R.H. Oosterom Gallery, New York, New York
1980 Center for Contemporary Art, University of Kentucky, Lexington, Kentucky
1982 C.A.G.E. Gallery, Cincinnati, Ohio
1982 University of Cincinnati, Cincinnati, Ohio
1984, Graham Modern, New York, New York
85
1985 Morlan Gallery, Mitchell Fine Arts Center, Transylvania University, Lexington, Kentucky

Selected Group Exhibitions
1971 "First Annual Sculpture Exhibition," Hundred Acres Gallery, New York, New York
1973 "Virginia Artists," Virginia Museum of Fine Arts, Richmond, Virginia, catalog
1975 "Sculpture Exhibition," Artists Space, New York, New York
1975 "1975 Biennial Exhibition: Contemporary American Art," Whitney Museum of American Art, New York, New York, catalog

1976 "Gallery Exhibition," Penthouse Gallery, Museum of Modern Art, New York, New York
1976 "Group Exhibition," Ginza Nissan Gallery, Tokyo, Japan
1978 "Contemporary Selections '78," Hillwood Art Gallery, C. W. Post Center of Long Island University, Greenvale, New York, catalog
1978 "Constructs," Organization of Independent Artists, New York, New York
1978 "Private Myths," Queens Museum, Flushing, New York, catalog
1978 "Small Works," 55 Mercer, New York, New York
1979 "Women Artists," Marymount Manhattan College, New York, New York
1979 "Small Works," 80 Washington Square East Gallery, New York, New York
1979 "American Abstract Artists," Betty Parsons Gallery, New York, New York
1979 "Group Show," R. H. Oosterom Gallery, New York, New York
1979 "Women Painters and Sculptors," Cummings Arts Center, Connecticut College, New London, Connecticut, catalog
1980 "Painting and Sculpture Today 1980," Indianapolis Museum of Art, Indianapolis, Indiana, catalog
1981 "Group Show," Art Galaxy, New York, New York
1981 "Primitive Sources—Contemporary Visions," Jan Cicero Gallery, Chicago, Illinois
1981 "Young Collectors Show, Renaissance Society," University of Chicago, Chicago, Illinois
1983 "New Decorative Works from the Collection of Norma and William Roth," Jacksonville Art Museum, Jacksonville, Florida, catalog
1983 "Fire I," Art Center Association, The Water Tower, Louisville, Kentucky
1983 "Kentucky Art 1983," University of Kentucky Art Museum, Lexington, Kentucky, catalog

Selected Public Collection
Richard B. Russell Courthouse, Atlanta, Georgia

Selected Private Collections
R. H. Oosterom, New York, New York
William and Norma Roth, Winter Haven, Florida
Randal Rupert, New York, New York
Jack Tilton, New York, New York
Berta Walker, New York, New York

Selected Award
1985 Artist in Residence, Helene Wurlitzer Foundation, Taos, New Mexico

Preferred Sculpture Media
Metal (cast) and Varied Media

Additional Art Field
Painting

Related Profession
Visiting Artist

Selected Bibliography
Friedman, Jon R. "Kathleen Ferguson." *Arts Magazine* vol. 54 no. 7 (March 1980) p. 15, illus.
Graham, William. "Reviews Chicago: Primitive Sources—Contemporary Visions, Jan Cicero Gallery." *New Art Examiner* vol. 8 no. 4 (January 1981) p. 20.
Phillips, Deborah C. "New York Reviews: Group Show (Art Galaxy)." *Art News* vol. 80 no. 7 (September 1981) p. 236.
Staniszewski, Mary Anne. "New York Reviews: Kathleen Ferguson (R. H. Oosterom)." *Art News* vol. 80 no. 3 (March 1981) p. 232.
Yau, John. "Review of Exhibitions: Kathleen Ferguson at Nobé." *Art in America* vol. 67 no. 3 (May-June 1979) pp. 141-142, illus.

Gallery Affiliations
Graham Modern
1014 Madison Avenue at 78 Street
New York, New York 10021

Jan Cicero Gallery
437 North Clark Street
Chicago, Illinois 60610

Mailing Address
Post Office Box 54865
Lexington, Kentucky 40555

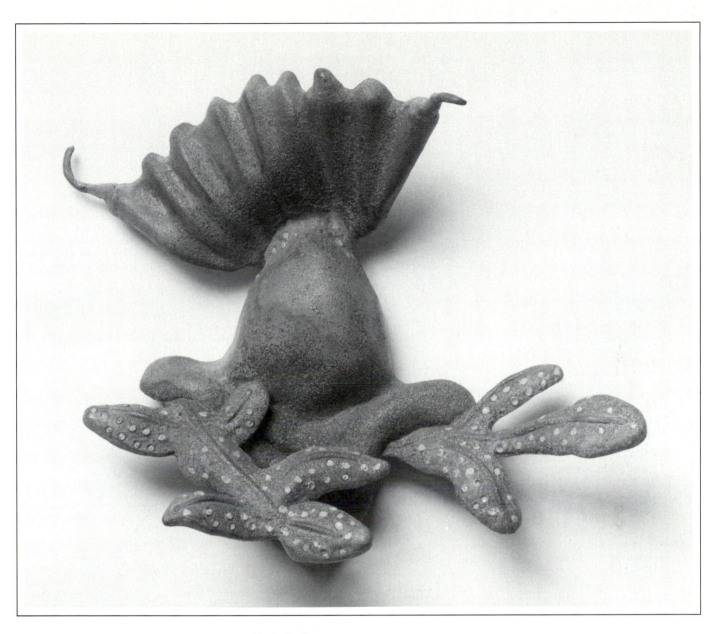

Series Z: A-HS⁸. 1984. Bronze, 5½"h x 7¾"w x 2¾"d.
Courtesy Graham Modern, New York, New York.
Photograph by D. James Dee.

Artist's Statement

"My creative life has included many techniques and materials: fiberglass, wood, ceramics, latex rubber, cast paper, mixed media and recently bronze because it is a permanent and intrinsically valuable material. Nature and its wonderment have been studies since early childhood. The paradoxes found in plants and animals can be beautiful and repelling, such as fish fins, animal claws and predatory plants.

"Each piece involves mental and emotional vigor. The creative breakthrough is the undefined instant which transcends normal thinking when the conscious mind is pliable. It is my hope that the ongoing energy reflected in the finished work can be felt and a metaphysical exchange take place between the viewer and the object."

Kathleen Ferguson

Jackie Ferrara

née Jacqueline Hirschhorn
Born Detroit, Michigan

Selected Individual Exhibitions
1973, A. M. Sachs Gallery,
74 New York, New York
1975 Daniel Weinberg Gallery, San Francisco, California
1975- Annual Exhibition, Max Protetch
85 Gallery, New York, New York
1977 Ohio State University, Columbus, Ohio
1978 Minneapolis College of Art and Design, Minneapolis, Minnesota
1979 University of Rhode Island, Kingston, Rhode Island
1979 Glen Hanson Gallery, Minneapolis, Minnesota
1980 Okun-Thomas Gallery, St. Louis, Missouri
1980 University Gallery, University of Massachusetts at Amherst, Amherst, Massachusetts; Emanuel Walter Gallery, San Francisco Art Institute, San Francisco, California; University of Southern California, Los Angeles, California, catalog
1981 Laumeier International Sculpture Park And Gallery, St. Louis, Missouri
1981 Marianne Deson Gallery, Chicago, Illinois
1982 Lowe Art Museum, Coral Gables, Florida, catalog
1983 University of North Carolina at Chapel Hill, Chapel Hill, North Carolina
1983 Galleriet, Lund, Sweden
1983 Janus Gallery, Los Angeles, California
1984 Susan Montezinos Gallery, Philadelphia, Pennsylvania

Selected Group Exhibitions
1970 "1970 Annual Exhibition: Contemporary American Sculpture," Whitney Museum of American Art, New York, New York, catalog
1972 "GEDOK American Woman Artist Show," Kunsthaus, Hamburg, Germany, Federal Republic, catalog
1973 "Jackie Ferrara and Louise Kramer," University of Rhode Island, Kingston, Rhode Island
1973, "Biennial Exhibition: Contemporary
79 American Art," Whitney Museum of American Art, New York, New York, catalog
1974 "Seven Sculptors: New Involvement with Materials," Institute of Contemporary Art, Boston, Massachusetts
1974 "Painting and Sculpture Today 1974," Indianapolis Museum of Art, Indianapolis, Indiana, catalog

1976 "New York—Downtown Manhattan: SoHo, Berlin Festival," Akademie der Kunst, Berlin, Germany, Federal Republic
1976 "Four Sculptors," Williams College Museum of Art, Williamstown, Massachusetts, catalog
1977 "Ferrara, Lichtenstein, Nevelson, Ryman," Sarah Lawrence College, Bronxville, New York, catalog
1978 "Architectural Analogues," Whitney Museum of American Art, Downtown Branch, New York, New York, catalog
1979 "Art and Architecture, Space and Structure," Protetch-McIntosh Gallery, Washington, D.C.
1979 "Quintessence: Alternative Spaces Residency Program," City Beautiful Council, Dayton, Ohio and Wright State University, Department of Art, Dayton, Ohio, catalog
1979 "Castle Clinton: Interpretations '79," Castle Clinton National Monument, Battery Park City, New York, catalog
1980 "Intricate Structure/Repeated Image," Tyler School of Art, Temple University, Philadelphia, Pennsylvania
1980 "Wave Hill 1980: Temporal Structures," Wave Hill, Bronx, New York, catalog
1980 "Twelfth International Sculpture Conference," Area Galleries and Institutions, Washington, D.C. (Sponsored by International Sculpture Center, Washington, D.C.)
1980- "Across the Nation: Fine Art for
81 Federal Buildings 1972-1979," National Collection of Fine Arts, Smithsonian Institution, Washington, D.C.; Hunter Museum of Art, Chattanooga, Tennessee
1980 "Architectural Sculpture," Los Angeles Institute of Contemporary Art, Los Angeles, California, catalog
1980 "Woodworks I: New American Sculpture," Dayton Art Institute, Dayton, Ohio
1981 "Architecture by Artists," Rosa Esman Gallery, New York, New York
1981 "Thirty Years of Public Sculpture in Illinois," Lakeview Museum of Art and Sciences, Peoria, Illinois
1981 "Currents, Trends for the 80s," Jacksonville Art Museum, Jacksonville, Florida
1983 "Connections: Bridges/Ladders/Ramps/ Staircases/Tunnels," Institute of Contemporary Art of The University of Pennsylvania, Philadelphia, Pennsylvania, catalog
1983 "Objects, Structure, Artifice: American Sculpture 1970-1982," University of South Florida, Tampa, Florida; Bucknell University, Lewisburg, Pennsylvania
1983 "Recent Acquisitions," Museum of Modern Art, New York, New York
1984 "A Celebration of American Women Artists Part II: The Recent Generation," Sidney Janis Gallery, New York, New York, catalog

1984 "Projects: World's Fairs, Waterfronts, Parks and Plazas," Rhona Hoffman Gallery, Chicago, Illinois

Selected Public Collections
Aldrich Museum of Contemporary Art, Ridgefield, Connecticut
American Medical Association Headquarters, Washington, D.C.
Baltimore Museum of Art, Baltimore, Maryland
Burroughs Wellcome Fund, Research Triangle Park, North Carolina
Chase Manhattan Bank, New York, New York
Cornell University, Ithaca, New York
Des Moines Art Center, Des Moines, Iowa
Gelco Corporation, Eden Prairie, Minnesota
General Mills Corporation, Minneapolis, Minnesota
General Services Administration Building, Carbondale, Illinois
Indianapolis Museum of Art, Indianapolis, Indiana
Laumeier International Sculpture Park And Gallery, St. Louis, Missouri
Louisiana Museum of Modern Art, Copenhagen, Denmark
Lowe Art Museum, Coral Gables, Florida
Metropolitan Museum of Art, New York, New York
Minneapolis College of Art and Design, Minneapolis, Minnesota
Mobil Oil Corporation, Fairfax, Virginia
Museum of Modern Art, New York, New York
National Museum of American Art, Smithsonian Institution, Washington, D.C.
Saint Louis Art Museum, St. Louis, Missouri
Technimetrics, New York, New York
University of North Carolina at Greensboro, Greensboro, North Carolina
Wadsworth Atheneum, Hartford, Connecticut

Selected Awards
1975 Creative Artists Public Service Grant, New York State Council on the Arts
1976 John Simon Guggenheim Memorial Foundation Fellowship
1977 Individual Artist's Fellowship, National Endowment for the Arts

Preferred Sculpture Media
Wood

A198 Tower & Bridge for Castle Clinton. 1979. Cedar, 12'6"h x 23'6"w x 13'10½"d. Installation view 1979. "Castle Clinton: Interpretations '79," Castle Clinton National Monument, Battery Park City, New York, catalog. Photograph by Doug Hollis.

Additional Art Field
Drawing

Selected Bibliography

Bourdon, David. "Jackie Ferrara: On the Cutting Edge of a New Sensibility." *Arts Magazine* vol. 50 no. 5 (January 1976) pp. 90-91, illus.

Heartney, Eleanor. "Jackie Ferrara." *Arts Magazine* vol. 57 no. 7 (March 1983) p. 9, illus.

Linker, Kate. "Jackie Ferrara's IL-Lusions." *Artforum* vol. 18 no. 3 (November 1979) pp. 57-61, illus.

Patton, Phil. "Sculpture The Mind Can Use." *Art News* vol. 81 no. 3 (March 1982) pp. 108-112, illus.

Wallis, Brian. "Jackie Ferrara." *Arts Magazine* vol. 54 no. 4 (December 1979) p. 6, illus.

Gallery Affiliation
Max Protetch Gallery
37 West 57 Street
New York, New York 10019

Mailing Address
Max Protetch Gallery
37 West 57 Street
New York, New York 10019

Jackie Ferrara

Carole Jeane Feuerman

née Carole Jeane Ackerman
Born September 21, 1945 Hartford,
Connecticut

Education and Training
1963 Hofstra University, Hempstead, New
York
1964 Tyler School of Art, Temple University,
Philadelphia, Pennsylvania
1967 B.F.A., Painting, School of Visual Arts,
New York, New York

Selected Individual Exhibitions
1976, MJS International Gallery, Fort Worth,
78, Texas
81
1980 Hansen Galleries, New York, New
York
1981 Elaine Horwitch Galleries, Santa Fe,
New Mexico
1982 Galerie Ninety-Nine, Bay Harbor
Islands, Florida; Sindin Galleries, New
York, New York, catalog
1984 Galerie Ninety-Nine, Bay Harbor
Islands, Florida
1985 Gallery Henoch, New York, New York

Selected Group Exhibitions
1972 "Group Exhibition," Union Carbide
Gallery, New York, New York
1979 "New Talent," Allan Stone Gallery, New
York, New York, catalog
1979 "Basel Art Fair," Basel, Switzerland
(Represented by MJS International
Gallery, Fort Worth, Texas)
1980 "Annual Exhibition," Parrish Art
Museum, Southampton, New York
1981 "Gala Art Exhibit and Sale," Fordham
University at Lincoln Center, New
York, New York, catalog
1981 "Four II: A Shifting Focus/Carole Jeane
Feuerman, Elwood Howell, Nancy
Metz and Roy Nicholson," Heckscher
Museum, Huntington, New York,
catalog
1982 "National Association of Women
Artists Annual Exhibition," Bergen
Community Museum, Paramus, New
Jersey, catalog

1982 "Group Exhibition," Gallery Odin, Port
Washington, New York
1982 "Carole Jeane Feuerman, Sculpture
and Aris Koutroulis, Paintings," O. K.
Harris West, Scottsdale, Arizona
1982 "Group Exhibition," Gallery Yves
Arman, New York, New York
1983 "Smallworks '83: Exhibition of Fine
Art," University of Massachusetts at
Amherst, Amherst, Massachusetts,
catalog
1983 "Time Out: Sport and Leisure in
America Today," Tampa Museum,
Tampa, Florida, catalog
1984 "International Art Competition
Exhibition," Traveling Exhibition, Long
Beach Museum of Art, Long Beach,
California
1984 "Group Exhibition," Gallery Henoch,
New York New York
1984 "Games of Deception: When Nothing
Is As It Appears," Shirley Goodman
Resource Center, Fashion Institute of
Technology, New York, New York
1984 "New Realism," Robert L. Kidd
Associates, Birmingham, Michigan
1984 "Three Realists: Carole Jeane
Feuerman, Larry Gerber and Frederick
Nichols, Jr.," Leslie Levy Gallery,
Scottsdale, Arizona
1985 "On the Figure: Opie, Feuerman,
Crum, Hausey and Calas," Galerie
Simonne Stern, New Orleans,
Louisiana
1985 "The Real Thing," North Miami
Museum and Art Center, North Miami,
Florida, catalog

Selected Public Collections
The FORBES Magazine Collection, New
York, New York
K & B Plaza, New Orleans, Louisiana
Lever Brothers, New York, New York
National Bank of Florida, Miami, Florida
Southeast Banking Corporation, Miami,
Florida

Selected Private Collections
Mr. and Mrs. George Karpay, Tampa, Florida
Mr. and Mrs. William Mack, New York, New
York
Mr. and Mrs. Lawrence Singer, Coconut
Grove, Florida and Blowing Rock, North
Carolina
Mr. and Mrs. Howard Stringer, New York,
New York and Murfreesboro, Tennessee
Frederick Weisman, Los Angeles, California

Selected Awards
1979 Betty Parsons Sculpture Award,
"Group Exhibition," WomanArt, New
York, New York
1982 Amelia Peabody Award for Sculpture,
"National Association of Women
Artists Annual Exhibition," Jacob K.
Javits Federal Building, New York,
New York, catalog
1984 First Prize, "United States National
Fine Arts Competition and
International Exhibition," State Capitol,

Tallahassee, Florida; American Center
of Fine Arts, Paris, France;
Internationale Burckhardt Akademie,
Rome, Italy; Akademie der Bildenden
Künste, Munich, Germany, Federal
Republic

Preferred Sculpture Media
Plastic (polyester resin)

Additional Art Fields
Drawing and Painting

Related Profession
Visiting Artist

Gallery Affiliations
Galerie Ninety-Nine
1088 Kane Concourse
Bay Harbor Islands, Florida 33154

Gallery Henoch
80 Wooster Street
New York, New York 10012

Galerie Simonne Stern
518 Julia Street
New Orleans, Louisiana 70130

Mailing Address
371 Sagamore Avenue
Mineola, New York 11501

Artist's Statement

"For the past seventeen years I have been committed to the expansion and development of fragmented form in sculpture. My goal is to achieve the perfect fusion of abstraction and reality with the focus on emotion and humanism.

"I have always tried to look past the obvious and eliminate the extraneous. When I pose a model, I look for the essence of the process that precedes the actual sculpting, adding and subtracting until the sum total is perfect for me. This is how the fragmentation of my sculpture is conceived. Fragmentation invites the viewer to intellectualize the sculpture as a totality. Involving the viewer emotionally and intellectually is the prime force.

"In my exploration of the subject I strive to observe and communicate the feeling involved, as well as the related objects and conditions affecting those feelings. Objects and clothing are made of resin and oil painted to look real. I have explored the myriad ways water might be portrayed by manipulating the various patterns and shapes as an integral part of the artistic concept. I want to continue to examine the added dimension of time, time suspended, along with the dimension of illusion and reality. A painter takes three dimensions and converts to two. I take three dimensions and convert to four."

Catalina. 1981. Oil painted resin, 22"h x 15"w x 7"d. Photograph by Ken Spencer.

Betty W. Feves

née Betty Jean Whiteman
(Husband Louis J. Feves)
Born March 11, 1918 Lacrosse, Washington

Education and Training
1937 University of Washington, Seattle Washington; study in ceramic sculpture with Alexander Archipenko
1939 B.F.A., Painting and Sculpture, Washington State College, Pullman, Washington
1940 Studio of Alexander Archipenko, Woodstock, New York; additional study in ceramic sculpture
1940 Saint Paul School of Art, St. Paul, Minnesota
1941 M.A., Art Education, Columbia University, New York, New York
1943 Art Students League, New York, New York; study in ceramic sculpture with Ossip Zadkine

Selected Individual Exhibitions
1953 Oregon Ceramic Studio, Portland, Oregon
1959 Portland Art Museum, Portland, Oregon
1965 University of Puget Sound, Tacoma, Washington
1970, Contemporary Crafts Gallery, Portland,
74 Oregon
1973 Museum of Art, Washington State University, Pullman, Washington
1974 University of Idaho, Moscow, Idaho
1975 Carnegie Art Center, Walla Walla, Washington
1976 Museum of Art, University of Oregon, Eugene, Oregon
1976 Art Barn, Yakima, Washington
1977- Statewide Art Services, Traveling
78 Exhibition, Museum of Art, University of Oregon, Eugene, Oregon
1978 Salishan Lodge Art Gallery, Gleneden Beach, Oregon
1979, Fountain Gallery of Art, Portland,
82 Oregon
1983 Empire Gallery, Pendleton, Oregon

Selected Group Exhibitions
1952, "Northwest Ceramic Exhibition,"
53, Oregon Ceramic Studio, Portland,
54, Oregon
59,
62,
64
1952, "Annual Ceramic National Exhibition,"
54, Syracuse Museum of Fine Arts,
56 Syracuse, New York, catalog
1954 "National Design Exhibition," Texas Western College, El Paso, Texas
1955 "Fifth Annual International Exhibition of Ceramic Arts," National Collection of Fine Arts, Smithsonian Institution, Washington, D.C., catalog

1955 "Western Sculpture and National Print Exhibition," Oakland Art Museum, Oakland, California
1955, "Northwest Craftsmen Exhibition,"
57, Henry Art Gallery, Seattle, Washington
59
1957, "Annual Decorative Arts and Ceramic
58 Exhibition," Wichita Art Association, Wichita, Kansas, catalog
1957 "Designer Craftsmen of the West," M. H. de Young Memorial Museum, San Francisco, California
1958 "World's Fair," American Pavilion, Brussels, Belgium
1959 "Recent Sculpture U.S.A.," Traveling Exhibition, Museum of Modern Art, New York, New York, catalog
1960 "Forty-Sixth Annual Exhibition of Northwest Artists," Seattle Art Museum, Seattle, Washington
1960 "International Cultural Exchange Exhibition," Traveling Exhibition, Palais de Ariana, Genève, Switzerland, catalog
1961 "Contemporary Craftsmen of the Far West," Museum of Contemporary Crafts, New York, New York
1964 "Thirty Northwest Craftsmen," Museum of Art, University of Oregon, Eugene, Oregon
1964 "International Exhibition of Contemporary Ceramic Art," Traveling Exhibition (Japan), Tokyo National Museum, Tokyo, Japan, catalog
1965 "Artists of Oregon," Portland Art Museum, Portland, Oregon, catalog
1977 "Regional Exhibition of Sculpture & Painting," Carnegie Art Center, Walla Walla, Washington
1979 "Shirley Gittelsohn, Paintings; Betty Feves, Ceramic Sculpture," Fountain Gallery of Art, Portland, Oregon, catalog
1980- "Ceramic Traditions," Traveling
83 Exhibition, Oregon State University, Corvallis, Oregon, catalog
1984 "Eugene Visual Art Symposium, Oregon Invitational," Hult Center for the Performing Arts, Eugene, Oregon
1984 "Art about Agriculture 1984," Oregon State University, Corvallis, Oregon

Selected Public Collections
Byers Avenue Clinic, Pendleton, Oregon
Central Oregon Community College, Bend, Oregon
City of Pendleton, Vert Auditorium, Pendleton, Oregon
Contemporary Crafts Gallery Permanent Collection, Portland, Oregon
Eastern Oregon State College, La Grande, Oregon
Empire Machinery Company, Mesa, Arizona
Everson Museum of Art, Syracuse, New York
Keingeldt, Incorporated, Seattle, Washington
Lloyd Corporation, Portland, Oregon
Nerco Company, Portland, Oregon
Oakland Museum, Oakland, California
Pendleton Public School, Westhills Elementary, Pendleton, Oregon

Portland Art Museum, Portland, Oregon
Regan, Roberts and O'Scaunlain, Portland, Oregon
Salem Public Schools Collection, Salem, Oregon
San Francisco Public Schools Collection, San Francisco, California
State Capitol, Salem, Oregon
U.S. Data Corporation, Portland, Oregon
Western Heritage Savings and Loan, Pendleton, Oregon

Selected Private Collections
Dr. and Mrs. Wallace Baldinger, Eugene, Oregon
Mr. and Mrs. Dunbar Carpenter, Medford, Oregon
Tom Hardy, Portland, Oregon
Mrs. James Haseltine, Portland, Oregon
Mr. and Mrs. David S. Touff, Denver, Colorado

Selected Awards
1952 Hanovia Chemical and Manufacturing Company Award for Ceramic Sculpture, "Annual Ceramic National Exhibition," Syracuse Museum of Fine Arts, Syracuse, New York, catalog
1964 Harris Clay Company Award for Ceramic Sculpture, "Annual Ceramic National Exhibition," Everson Museum of Art, Syracuse, New York, catalog
1977 Governor's Award for Contribution to the Arts, Governor of Oregon, Salem, Oregon

Preferred Sculpture Media
Clay

Additional Art Field
Pottery

Selected Bibliography
Nichols, Ellen. *Images of Oregon Women.* Salem, Oregon: Madison Press, 1983.
Riegger, Hal. "The Slab Sculpture of Betty Feves." *Ceramics Monthly* vol. 11 no. 1 (January 1963) pp. 22-25, 32, illus.

Gallery Affiliation
Fountain Gallery of Art
117 NW 21 Avenue
Portland, Oregon 97209

Mailing Address
304 NW Furnish Avenue
Pendleton, Oregon 97801

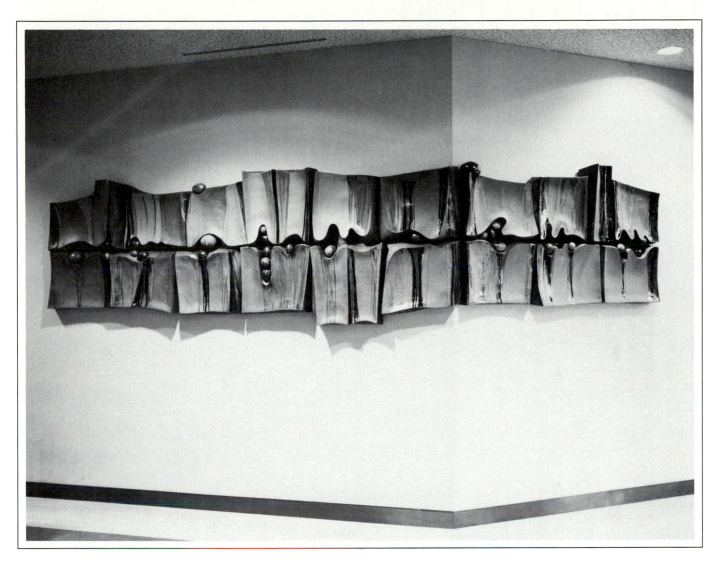

Clift Patterns. 1982. Ceramic, 4'h x 20'w x 8"d.
Collection Lloyd Corporation, Portland, Oregon.

Artist's Statement

"I am influenced by people, the surrounding countryside and the materials with which I work. Even when figurative, my sculpture is closely related to the visual forms of wheat fields and basalt cliffs of the Eastern Oregon landscape. Process is important to me, from digging and preparing local materials, to working with the clay, to applying the glaze, to firing the kiln. The individual steps may be simple enough but coordinating them into a successfully completed work of art is the challenge.

"The properties and limitations of the clay have much to do with the form and structure of the final piece. Clay can be handled in many different ways, but to fire relatively large pieces to 2300° F., they must be built to stand up to the heat and shrinkage that takes place in the kiln. I consider a piece successful if it develops, during this process, a presence. So many elements of one's experience go into a given work, most of it subconscious, that verbalizing about the meaning usually misses the point. A visual art work must be experienced directly for its meaning to be felt. The direct encounter is all important to understanding."

Kathryn E. Field

née Kathryn Elizabeth
(Husband Philip Edward Simmons)
Born October 13, 1954 Berkeley, California

Education and Training
1976 B.F.A., Metalsmithing, Tyler School of Art, Temple University, Philadelphia, Pennsylvania

1979 M.F.A., Sculpture, University of Wisconsin-Madison, Madison, Wisconsin

Selected Individual Exhibitions
1980 Humanities Gallery, University of Wisconsin-Madison, Madison, Wisconsin

1981 Monroe Art Gallery, Monroe, Wisconsin

Selected Group Exhibitions
1977 "Drinking Companions," John Michael Kohler Arts Center, Sheboygan, Wisconsin

1978 "Works and Smiths," Susan B. Anthony Gallery, University of Wisconsin-Madison, Madison, Wisconsin

1979 "Loosely Proportionate and Semi-Structural," Center Gallery, Madison, Wisconsin

1979 "20 Artists in 14 Days," Center Gallery, Madison, Wisconsin

1981 "6/6 Show," ARC Gallery, Chicago, Illinois

1982 "Around Here: Outdoor Installations," Randolph Street Gallery, Chicago, Illinois

1983 "Faculty Exhibition," Hopkins Gallery of Fine Art, Ohio State University, Columbus, Ohio

1983 "As You See It," Noyes Gallery of Art, Antioch College, Yellow Springs, Ohio

1983 "Ingress," Bixby Gallery, Washington University, St. Louis, Missouri

1983 "Sculpture St. Louis," Hunt Gallery, Webster College, St. Louis, Missouri

1983, 84, 85 "Annual Faculty Exhibition," Steinberg Gallery, Washington University, St. Louis, Missouri

1984 "Art Walk," West End Neighborhood Art Council, St. Louis, Missouri

1985 "Opening Exhibition," Locus Gallery, St. Louis, Missouri

1985 "International Outdoor Sculpture Exhibition," Central West End Locations, St. Louis, Missouri (Sponsored by St. Louis Council on the Arts, St. Louis, Missouri)

Selected Awards
1984 Faculty Research Grant, Washington University, St. Louis, Missouri

1984, 85 Artist in Residence, Johnson Atelier Technical Institute of Sculpture, Princeton, New Jersey

Preferred Sculpture Media
Metal (cast), Varied Media and Wood

Additional Art Field
Drawing and Papermaking

Teaching Position
Assistant Professor, Washington University, St. Louis, Missouri

Gallery Affiliation
Locust Gallery
710 North Tucker
St. Louis, Missouri 63101

Mailing Address
Washington University
School of Fine Arts
Box 1031
St. Louis, Missouri 63130

Artist's Statement

"Over a period of time, my work has developed from an emphasis on created objects to installations and environments. I first began by exploring the need of individuals for personal space, both emotional and physical. I used wood constructions, sheets of lead, aluminum castings and found or discarded objects to create sculptures that triggered forgotten memories (or archetypes) of personal history.

"My present work focuses more specifically on communication and the creation of an analytical framework for portraying individual and group responses to our contemporary environment. These installations are concerned with the problem of remembrance. We confront any experience for only a moment, then it fragments, and forever after we must reconstruct it from pieces, always forming different patterns, different interpretations. A line from *Light in August* by Faulkner captures in words the mood I hope to create visually: 'Memory believes before Knowing remembers.'"

Kathryn P. Field

Gesturing. 1984. Bronze, aluminum, wood and paint, 9′h x 9′w x 4′4″d; figures, life-size. Photograph by Frank Sipos.

Susan Fiene

née Susan Selene
Born April 17, 1946 Bristol, Virginia

Education and Training
1968 B.F.A., Sculpture and Printmaking,
Virginia Commonwealth University,
Richmond, Virginia
1972 M.F.A., Ceramic Sculpture and
Printmaking, University of Michigan,
Ann Arbor, Michigan
1981 Certificate, Minneapolis Technical
Institute, Minneapolis, Minnesota;
study in gas welding and braising

Selected Individual Exhibition
1973 University of Minnesota Twin Cities
Campus, Minneapolis, Minnesota

Selected Group Exhibitions
1973 "Seventh Biennial Beaux Arts Designer
Craftsmen," Columbus Gallery of Art,
Columbus, Ohio
1974 "Women's Work/11 Women Artists,"
College of St. Catherine, St. Paul,
Minnesota
1975 "Women in Clay," Woman's Building,
Los Angeles, California

1976 "Artists' Choose," Minneapolis Institute
of Arts, Minneapolis, Minnesota,
catalog
1977 "Space Real/Spaces Implied," Carleton
College, Northfield, Minnesota
1978 "Susan Fiene and Carole Fisher,"
WARM, Women's Art Registry of
Minnesota, Minneapolis, Minnesota
1978 "Clay from Molds: Multiples, Altered
Castings, Combinations," John
Michael Kohler Arts Center,
Sheboygan, Wisconsin, catalog
1979 "Two Installations," Walker Art Center,
Minneapolis, Minnesota
1979 "In Situ," St. Paul Art Collective at
Landmark Center, St. Paul, Minnesota,
catalog
1979 "Selections from the Permanent
Collection," Walker Art Center,
Minneapolis, Minnesota
1980 "15 Minnesota Artists," Kiehle Gallery,
St. Cloud State University, St. Cloud,
Minnesota
1980 "Environmental Art and Sculpture
Exhibition," Minneapolis Central
Riverfront and Seward Neighborhood,
Minneapolis, Minnesota, catalog
1981 "American Art: The Challenge of the
Land," Pillsbury Center, Minneapolis,
Minnesota, catalog
1981 "Minneapolis College of Art and
Design Faculty Exhibition," University
of Minnesota Twin Cities Campus,
Minneapolis, Minnesota
1982 "Environmental Sculpture," St. Cloud
State University, St. Cloud, Minnesota
1982 "Invitational Exhibition," Macalester
College, St. Paul, Minnesota
1983 "Projects and Proposals," Minneapolis
Institute of Arts, Minneapolis,
Minnesota
1985 "Selected Work: Fiene, Schwartz and
Lazorick," Kathryn Nash Gallery,
University of Minnesota Twin Cities
Campus, Minneapolis, Minnesota

Selected Public Collections
Northwestern National Bank, Minneapolis,
Minnesota
Walker Art Center, Minneapolis, Minnesota

Selected Awards
1978 Bush Foundation Fellowship for
Artists, St. Paul, Minnesota
1979 Project Grant, Minnesota State Arts
Board
1979 Installation Project Grant, Minneapolis-
St. Paul (Minnesota) Metropolitan
Council, Jerome Foundation and
Dayton Hudson Foundation,
Minneapolis, Minnesota

Preferred Sculpture Media
Varied Media

Additional Art Field
Printmaking

Teaching Position
Assistant Professor, University of Minnesota
Twin Cities Campus, Minneapolis,
Minnesota

Selected Bibliography
McFadden, Sarah. "Midwest Art: A Special
Report, Detroit, Minneapolis, Kansas City,
St. Louis." Art in America vol. 67 no. 4
(July-August 1979) pp. 56-65, illus.

Mailing Address
3617 10 Avenue South
Minneapolis, Minnesota 55407

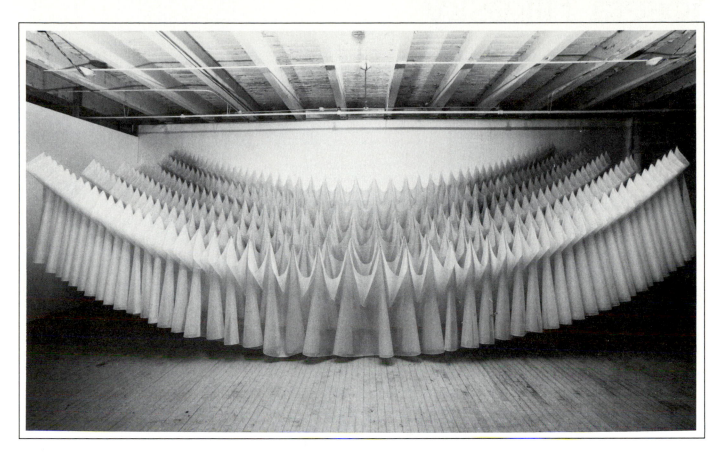

Interior Landscape for Walker Art Center. 1979.
Nylon line, scrim fabric and paper fasteners, 23'h x
10'w x 10'd. Studio view. Collection Walker Art
Center, Minneapolis, Minnesota.

Artist's Statement
"My work is concerned with problems of
landscape representation. My intention is to
make the landscape experience portable—to
bring it indoors for consideration. I allow
concepts to suggest the appropriate
materials for the work. If, for example, I am
dealing with ideas related to the earth
quality of the natural landscape, I may use
clay. In this particular piece, I choose
translucent scrim fabric to reflect the
atmospheric properties of the landscape."

Susan Fiene

Josefa Filkosky

Born June 15, 1933 Westmoreland City, Pennsylvania

Education and Training
1955 B.A., Fine Arts, Seton Hill College, Greensburg, Pennsylvania
1963 B.F.A., Sculpture and Metalsmithing, Carnegie-Mellon University, Pittsburgh, Pennsylvania; study in sculpture with Clark Winter
1968 M.F.A., Metalsmithing, Cranbrook Academy of Art, Bloomfield Hills, Michigan; study in sculpture with Julius Schmidt
1968 School of the Art Institute of Chicago, Chicago, Illinois; study in metal sculpture with Richard Hunt and Steve Urry

Selected Individual Exhibitions
1970 The Art Image in All Media Gallery, New York, New York
1971, Pittsburgh Plan for Art, Pittsburgh, 73 Pennsylvania
1972 Indiana University, Indiana, Pennsylvania
1973 Bertha Schaefer Gallery, New York, New York
1974 RM Gallery, Toronto, Ontario, Canada 75

Selected Group Exhibitions
1964- "Annual Invitational Regional Painting 78 and Sculpture Exhibition," Westmoreland County Museum of Art, Greensburg, Pennsylvania
1968- "Annual Three Rivers Arts Festival," 73 Gateway Center, Pittsburgh, Pennsylvania, catalog
1970 "Discoveries '70," The Art Image in All Media Gallery, New York, New York
1971 "Contemporary Sculptors," Vassar College, Poughkeepsie, New York
1971- "Associated Artists of Pittsburgh 76, Annual Exhibition," Museum of Art, 83, Carnegie Institute, Pittsburgh, 84 Pennsylvania, catalog
1973- "Sculpture in the Fields," Storm King 75 Art Center, Mountainville, New York
1974 "Woman's Work: American Art 1974," Museum of the Philadelphia Civic Center, Philadelphia, Pennsylvania, catalog
1974 "Sculpture in the Park, An Exhibition of American Sculpture," Van Saun Park, Paramus, New Jersey (Sponsored by Bergen County Parks Commission, Paramus, New Jersey), catalog

1978 "90 x 30 Small Sculpture Exhibition," Martha Jackson Gallery, New York, New York
1979 "Twenty-Five Pennsylvania Women Artists," Southern Alleghenies Museum of Art, Loretto, Pennsylvania
1979- "A.R.E.A. Sculpture on Shoreline 80 Sites," Roosevelt Island, New York, catalog
1980 "Eleventh International Sculpture Conference," Area Galleries and Institutions, Washington, D.C. (Sponsored by International Sculpture Center, Washington, D.C.)
1980 "Seeing the Unseen," Courthouse Gallery, Pittsburgh, Pennsylvania
1980 "Monumental Sculpture," Gallery 401, Magnolia, New Jersey
1981- "Sculpture '81," Temple University, 82 Main Campus, Philadelphia, Pennsylvania (Co-Sponsored by Cheltenham Art Centre, Cheltenham, Pennsylvania), catalog
1982 "Sculpture—Area Artists," Zenith Gallery, Pittsburgh, Pennsylvania
1983, "Sculptors Guild Annual Exhibition," 84 Lever House, New York, New York, catalog
1983 "Four Pennsylvania Artists: Brodsky, Filkosky, Mulcahy and Osby," Kennedy Gallery, Saint Vincent College, Latrobe, Pennsylvania
1985 "Outdoor Sculpture Exhibition," Seton Hill College, Greensburg, Pennsylvania (In celebration of the Seventy-Fifth Anniversary Associated Artists of Pittsburgh, Pittsburgh, Pennsylvania)

Selected Public Collections
Briarwood Shopping Center, Ann Arbor, Michigan
Craig Street Association, Pittsburgh, Pennsylvania
Everson Museum of Art, Syracuse, New York
Gateway Center, Pittsburgh, Pennsylvania
Greater Pittsburgh Merchandise Mart and Expo Center, Pittsburgh, Pennsylvania
Harlan Corporation, Southfield, Michigan
Hudson River Museum, Yonkers, New York
J & L Steel Corporation, Pittsburgh, Pennsylvania
Merwin Research Center, Pittsburgh, Pennsylvania
Paulsen Recreation Center, Pittsburgh, Pennsylvania
PPG Industries, Pittsburgh, Pennsylvania
St. Lawrence University, Canton, New York
Seton Hill College, Greensburg, Pennsylvania

Selected Private Collections
Richard and Rhoda Neft, Pittsburgh, Pennsylvania
Dr. John Pignetti, Greensburg, Pennsylvania
John Sabry, Toronto, Ontario, Canada
Vern and Renata Sawyer, Pittsburgh, Pennsylvania
Alvin Silverman, Roslyn, New York

Selected Awards
1976 Winner, St. Lawrence National Sculpture Competition, St. Lawrence University, Canton, New York
1976 Sculpture Award, "Associated Artists of Pittsburgh Annual Exhibition," Museum of Art, Carnegie Institute, Pittsburgh, Pennsylvania, catalog
1978 Finalist, "National Sculpture Competition," Traveling Exhibition, South Dakota Memorial Art Center, Brookings, South Dakota

Preferred Sculpture Media
Metal (welded)

Additional Art Field
Sculptured Jewelry in Gold and Silver

Teaching Position
Professor of Art, Seton Hill College, Greensburg, Pennsylvania

Selected Bibliography
Benton, Suzanne. *The Art of Welded Sculpture*. New York: Van Nostrand Reinhold, 1975.
Evert, Marilyn and Vernon Gay. *Discovering Pittsburgh's Sculpture*. Pittsburgh: University of Pittsburgh Press, 1983.
Glueck, Grace. "New Sculpture Under the Sun, From Staten I. To the Bronx," *The New York Times* (Friday, August 3, 1979) pp. C1, C15, illus.
Miller, Donald. "Sister Josefa's Pipe Dreams." *Art International* vol. 25 no. 10 (December 20, 1971) pp. 50-51, illus.
Robinette, Margaret A. *Outdoor Sculpture: Object and Environment*. New York: Whitney Library of Design, 1976.

Mailing Address
Seton Hill College
Greensburg, Pennsylvania 15601

Artist's Statement

"Making large-scale sculptures became a dream of mine in 1967 when I walked around Tony Smith's works exhibited in front of the Detroit Institute of Arts. My association with a local power piping company since 1970 has made it possible for me to have large works in 10″ or 12″ diameter in steel or aluminum tube fabricated under my supervision.

"During the fabrication and finishing processes each sculpture receives the greatest possible care to protect and preserve its existence as an exciting object. The transitions from the cast elbows welded to the straight sections must be blended to obtain the effect of continuous flowing movement. All the welds must be structurally sound. Many hours of grinding and surface finishing are required before the sculpture is ready for painting. Only the best products in automotive fillers and paints are used to insure durability. When the work is finally primed and painted it takes on its identity, its form and shape many times more exciting than I visualized. A great deal of work precedes this intense moment of fulfillment."

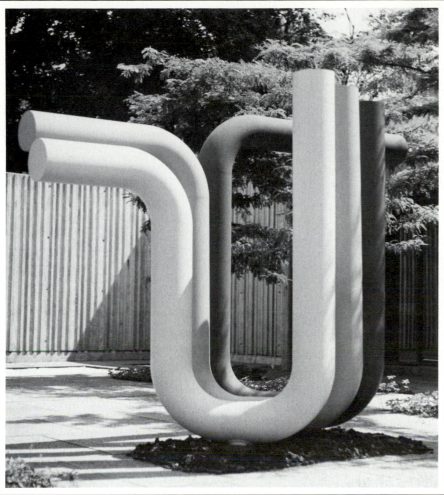

Pipe Dream V. 1972. Aluminum tube, 10″ diameter, 8′h x 12′w x 5′d. Collection Hudson River Museum, Yonkers, New York.

Joan Fine

née Joan Greene
(Husband Daniel H. Fine)
Born March 5, 1942 New York, New York

Education and Training

1963 B.A., Early Childhood Education, City University of New York Queens College, Flushing, New York

1965- School of Fine Arts, University of
67 Pittsburgh, Pittsburgh, Pennsylvania; study in design and drawing

1972- Columbia University, New York, New
77 York; study in sculpture with Robert Blackburn, Minoru Niizuma and Anthony Padovano

1979- Saint Martin's School of Art, London,
80 Great Britain; study in sculpture with David Annesley, Anthony Caro and Philip King

1980 Camberwell School of Arts, London, Great Britain; study in bronze foundry techniques

1983 M.F.A., Sculpture, Columbia University, New York, New York; study with Luise Kaish and Reeva Potoff

Selected Individual Exhibitions

1978 Fifth Street Gallery, New York, New York

1979, 14 Sculptors Gallery, New York, New
83, York
85

1979 Mari Galleries, Mamaroneck, New York

1979 National Art Center, New York, New York

1980 Leonia Public Library, Leonia, New Jersey

1982 Bergen Community Museum, Paramus, New Jersey

Selected Group Exhibitions

1978 "Audubon Artists Annual Exhibition," National Academy of Design, New York, New York, catalog

1978 "14 Sculptors at Nexus," Nexus Gallery, Philadelphia, Pennsylvania

1979 "SoHo-Greenwich," Hurlbutt Gallery, Greenwich Library, Greenwich, Connecticut

1979, "Sculptors Guild Annual Exhibition,"
81 Lever House, New York, New York, catalog

1979 "The Great Atlanta-New York Sculpture Exchange," Nexus Gallery, Atlanta, Georgia

1980 "Stone Sculpture Society of New York," American Standard Gallery, New York, New York

1980 "Stone Sculpture Society of New York," Elaine Benson Gallery, Bridgehampton, New York

1980 "Sculptors Guild Exhibition," Sculpture Center, New York, New York

1981 "Centennial Sculpture Exhibition," New Jersey Institute of Technology, Newark, New Jersey

1981 "Sculpture by Members of the Sculptors Guild," Canton Art Institute, Canton, Ohio

1981- "National Association of Women
82 Artists: U.S.A.," Traveling Exhibition (Egypt and Israel), American Cultural Center, New York, New York, catalog

1981 "Sculpture in the Garden 1981," Sculptors Guild at the Enid A. Haupt Conservatory, New York Botanical Garden, Bronx, New York, catalog

1982 "Members Group Exhibition," 14 Sculptors Gallery, New York, New York

1983 "Columbia at Greene Street," 112 Greene Street Gallery, New York, New York

1984- "14 Sculptors Gallery at the College
85 Gallery," Kean College of New Jersey, Union, New Jersey

1985 "Old Friends/New Sculpture," 14 Sculptors Gallery, New York, New York

Selected Public Collection

Leonia Public Library, Leonia, New Jersey

Selected Award

1984 Individual Artist's Fellowship, New Jersey State Council on the Arts

Preferred Sculpture Media

Stone and Varied Media

Selected Bibliography

Ehrlich, Robbie. "Arts Reviews: Joan Fine." *Arts Magazine* vol. 53 no. 9 (May 1979) p. 40.

Fine, Joan. *I Carve Stone*. New York: Thomas Y. Crowell, 1979.

Mailing Address

41 Brook Terrace
Leonia, New Jersey 07605

Artist's Statement

"As a young child, I was happiest when making things—creating little objects, dolls and toys. Later I was fascinated by the primitive sculptures I saw at the American Museum of Natural History in New York. I also was profoundly affected by natural objects—rocks, trees, shells, plants and animals and by their myriad shapes and colors. In my teen years I was guided by my aunt Rose Fried who showed radical new non-objective art in her 68 Street Gallery. I attended Music and Art High School where I spent four years talking with other students about modern art and studying its multitudinous manifestations.

"Sculpture, and particularly marble, slowly became my medium. In London at Saint Martin's School of Art, I expanded my love of carving into an interest in constructed sculpture. I began to use color in conjunction with sculpture during my master's studies at Columbia University. All my work is and has been on a human scale. My early sculpture reflected a strong interest in the sensual possibilities of stone and wood; the most recent sculptures represent a departure into a realm of fantasy, at once primitive and surreal, using both organic material and man-made found objects."

Joan Fine

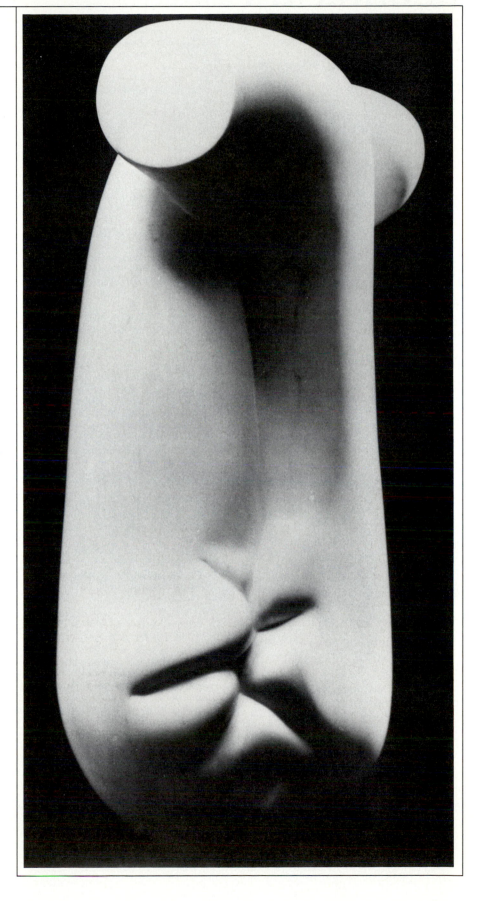

Pushing Out. 1978. Marble, 24"h x 12"w x 12"d. Photograph by Louis Waldeck.

Leonda F. Finke

née Leonda Froelich
(Husband Arnold I. Finke)
Born January 23, 1922 Brooklyn, New York

Education and Training
1939-42 Art Students League, New York, New York; study in drawing
1941-44 Educational Alliance, New York, New York; study in sculpture with Chaim Gross
1946 Brooklyn Museum School, Brooklyn, New York

Selected Individual Exhibitions
1967, 84 Port Washington Public Library Gallery, Port Washington, New York
1969 Firehouse Gallery, Nassau Community College, Garden City, New York
1972, 75, 80 Harbor Gallery, Cold Spring Harbor, New York
1973 Nassau Museum Gallery, Nassau County Historical Museum, East Meadow, New York
1974 Roslyn Public Library, Roslyn, New York
1976 Plandome Unitarian Church, Plandome, New York
1979 Benbow Gallery, Newport, Rhode Island

Selected Group Exhibitions
1960 "Brooklyn and Long Island Artists Exhibition," Brooklyn Museum, Brooklyn, New York
1965, 67, 68, 71, 72, 74 "National Association of Women Artists Annual Exhibition," National Academy of Design, New York, New York, catalog
1966 "Annual Exhibition of Painting and Sculpture," Pennsylvania Academy of the Fine Arts, Philadelphia, Pennsylvania, catalog
1968 "Annual Exhibition," Heckscher Museum, Huntington, New York
1970, 74 "Annual Exhibition," National Sculpture Society, New York, New York, catalog
1970-85 "Annual Exhibition," New York Society of Women Artists, New York, New York
1973, 74, 75 "Audubon Artists Annual Exhibition," National Academy of Design, New York, New York, catalog
1974 "Contemporary Long Island Artists," Suffolk Museum, Stony Brook, New York
1976 "Jack Culiner, Leonda Finke and Phillip Noteriani," Sculpture Center, New York, New York
1976-77 "Reflections: Images of America," Traveling Exhibition (Eastern and Western Europe), United States Information Agency, Washington, D.C.
1977, 84 "Annual Exhibition," National Academy of Design, New York, New York, catalog
1980-85 "Sculptors Guild Annual Exhibition," Lever House, New York, New York, catalog
1981 "Sculpture in the Garden 1981," Sculptors Guild at the Enid A. Haupt Conservatory, New York Botanical Garden, Bronx, New York, catalog
1981 "National Association of Women Artists: U.S.A.," Traveling Exhibition (Egypt and Israel), American Cultural Center, New York, New York, catalog
1983 "More Figuratively Speaking," Elaine Benson Gallery, Bridgehampton, New York
1983-84 "American Medallic Sculpture Association Exhibition," American Numismatic Society, New York, New York; American Numismatic Association, Colorado Springs, Colorado; San Francisco Old Mint, San Francisco, California, catalog
1984 "Music Mountain Sculpture Exhibit," Music Mountain, Falls Village, Connecticut, catalog

Selected Public Collections
Chrysler Museum, Norfolk, Virginia
City of Sunrise Convention Center, Sunrise, Florida
Nassau Community College, Garden City, New York
National Portrait Gallery, Smithsonian Institution, Washington, D.C.
Plainview-Old Bethpage Public Library, Plainview, New York
Port Washington Public Library, Port Washington, New York

Selected Private Collections
McDonald Beckett, Santa Monica, California
Arthur and Dr. Adrienne Block, New York, New York
Maurice and Helen Brooks, Great Neck, New York
Irving Mitchell Felt, Los Angeles, California
Austin and Mildred Perlow, Hempstead, New York

Selected Awards
1974 Bronze Medal, "Annual Exhibition," National Sculpture Society, New York, New York, catalog
1982 Chaim Gross Foundation Award, "Audubon Artists Annual Exhibition," National Academy of Design, New York, New York, catalog
1984 Sculpture Prize, "North American Sculpture Exhibition," Foothills Art Center, Golden, Colorado, catalog

Preferred Sculpture Media
Clay and Metal (cast)

Additional Art Field
Drawing

Related Profession
Juror

Teaching Position
Professor, Nassau Community College, Garden City, New York

Selected Bibliography
Cleary, Fritz. "Reality Reflected." *National Sculpture Review* vol. 26 no. 1 (Spring 1977) pp. 8-17, 25, illus.
Meilach, Dona Z. and Dennis Kowal. *Sculpture Casting; Mold Techniques and Materials, Metal, Plastics, Concrete.* New York: Crown, 1972.
Proske, Beatrice Gilman. "American Women Sculptors, Part II," *National Sculpture Review* vol. 24 no. 4 (Winter 1975-1976) pp. 8-17, 28, illus.
Russell, Stella Pandell. *Art in the World.* New York: Holt, Rinehart and Winston, 1984.
Shirey, David L. "Art: Epic Sculpture." *The New York Times* (Sunday, May 25, 1980) p. L.I.19.

Gallery Affiliations
Fisher Galleries
1509-11 Connecticut Avenue NW
Washington, D.C. 20036

Sculpture Center
167 East 69 Street
New York, New York 10021

Mailing Address
10 The Locusts
Roslyn, New York 11576

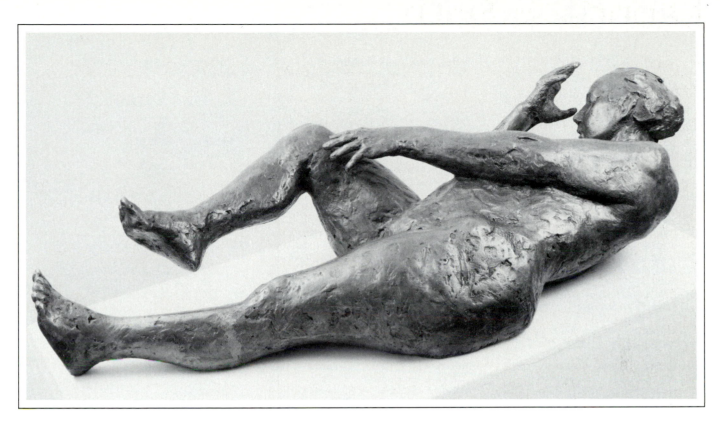

Survivor. 1980. Bronze, 9"h x 35"w x 15"d.
Photograph by Eric Pollitzer.

Artist's Statement

"As my work develops I have less to say *about* it but more and more pieces clamoring in my head to be done! My sculpture is, first, a response to the rich variety of strange and moving forms in the human figure. I find the largest vocabulary of forms with figures of women. Added to this is my need to be involved with human feelings—to communicate. The forms have become increasingly active; there is more movement in space. The figures are less contained and quiet—the feelings I am concerned with are open, more intense.

"I work in direct plaster which is both resistant and responsive and so it is close to the cast bronze. I love bronze—the flow—the textures—its ability to hold the fresh imprint of my fingers and tools."

Leonda F. Finke

Joan FitzGerald

Born February 18, 1930 Chicago, Illinois

Education and Training
1948- School of the Art Institute of Chicago,
54 Chicago, Illinois;
1955- École des Beaux Arts, Paris, France;
57 study in sculpture with Louis League
1957- Scuola delle Belle Arti, Florence,
58 Italy; study in sculpture with Guilio
 Porcinai

Selected Individual Exhibitions
1957 Galerie de la Maison des Beaux Arts,
 Paris, France
1958 Galleria Tornabuoni, Florence, Italy
1961 Galleria XXII Marzo, Venice, Italy
1962 Bevilacqua La Masa, Venice, Italy
1963 Chicago Public Library, Chicago,
 Illinois
1964 United Staes Information Service,
 Milan, Italy; Mickelson Gallery,
 Washington, D.C.
1966, Galleria d'Arte Il Traghetto, Venice,
69, Italy
77
1968 Mickelson Gallery, Washington, D.C.
1980 Ateneo Veneto, Venice, Italy
1982 Galleria Fenice, Venice, Italy
1985 Gallerie d'Arte Il Traghetto, Venice,
 Italy, catalog

Selected Group Exhibitions
1958 "Ans d'Exposition des Beaux Arts,
 Grande Semaine de l'Université:
 César, Lattier, FitzGerald," Université
 Paris-Sorbonne, Paris, France, catalog
1965, "Biennale des Bronzetti," Sala della
67, Ragione, Padova, Italy
73,
83
1972 "Artistas di Venezia," Bevilacque La
 Masa, Venice, Italy
1975 "Artists in Space," National Gallery of
 Art, Washington, D.C.

Selected Public Collections
American Wholesalers, Landover, Maryland
Art Museum, Princeton University, Princeton,
 New Jersey
Chiesa di San Moisè, Venice, Italy
City of Lignano Sabbiadoro, Italy
City of Venice, Italy
City of Wellfleet, Massachusetts
Fitzwilliam Museum, Cambridge, Great
 Britain
Kunsthistorisches Museum, Vienna, Austria
National Air and Space Museum,
 Smithsonian Institution, Washington, D.C.
National Portrait Gallery, Smithsonian
 Institution, Washington, D.C.
Peterson Collection, San Diego, California

Selected Private Collections
Walter Bareiss, Greenwich, Connecticut and
 Munich, Germany, Federal Republic
Mr. and Mrs. Jean Delmas, New York, New
 York and Venice, Italy
The Right Honorable Viscount David Eccles,
 London, Great Britain
T. S. Matthews, Gavandish, Great Britain
Robert Peterson, San Diego, California

Preferred Sculpture Media
Metal (cast)

Additional Art Field
Drawing

Mailing Address
2539 San Marco
30124 Venice, Italy

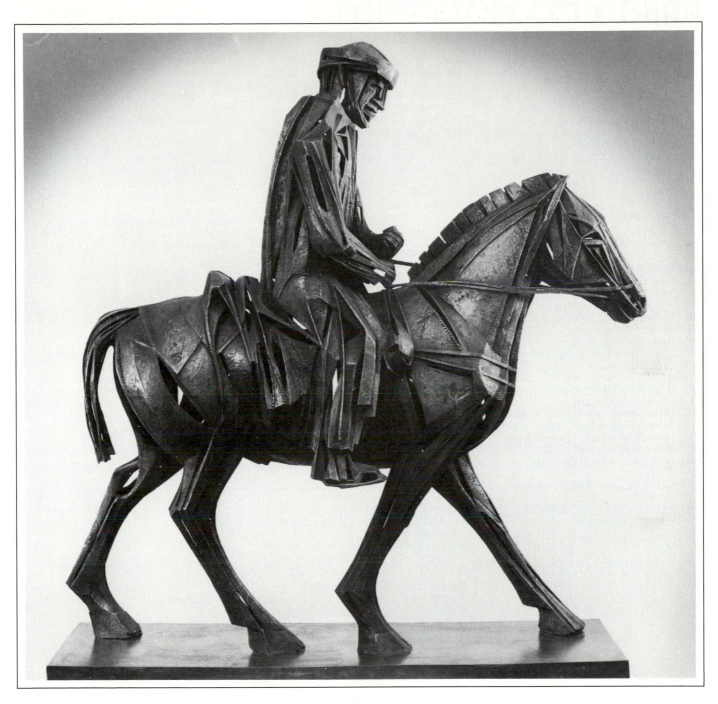

Marco Polo. 1982. Bronze, 4½′h x 4⅓′w x 1′8″d.
Photograph by Edmondo Tich.

Artist's Statement

"What motivates one's life? Values. One's choice of work? Natural gifts. All creative work demands dedication and need to realize one's self. Sculpture chose me—not I it—when I was four or five years old. I was born with a sense of design. I never enjoyed anything else as much or did anything else as well. The technical stages in my growth as a sculptor have been practice—practice—practice. Drawing and modeling are skills one practices continually to improve. With time and patience, the results are always a bit better.

"The culture brought me to Europe: in France, the Gothic sculpture; in Greece, the classic; in Italy, the Renaissance. In Venice, tradition is a continuation: the peace, the movement of the water, the sense of civilization continually in motion. Our time has no standards so we must work blindly, in relationship to work of the past and our own last piece. Art really has no function in our time. As Ezra Pound said in 1930: 'Art is no longer made to live with or endure but to sell and sell quickly.' Sculpture is a language to read as any other. The visual is what the sighted viewer sees; the philosophy is what my own reflection reveals."

189

Lillian H. Florsheim

née Lillian Hyman
Born May 17, 1896 New Orleans, Louisiana

Education and Training
1916 B.A., Philosophy, Smith College, Northampton, Massachusetts
1920 University of Chicago, Chicago, Illinois
1946-47 Studio of Henry Hensche, Provincetown, Massachusetts; study in painting
1948-50 Studio of Rudolph Weisenborn, Chicago, Illinois; study in painting
1948-54 Studio of George Buehr, Chicago, Illinois; study in painting
1951 Institute of Design, Chicago, Illinois; study in sculpture with Hugo Weber

Selected Individual Exhibitions
1966, 70, 72 Main Street Gallery, Chicago, Illinois
1966 Northern Illinois University, DeKalb, Illinois
1967 Galerie Krugier, Genève, Switzerland
1968 Galerie Denise René, Paris, France
1969 Galerie Denise René-Hans Meyer, Krefeld, Germany, Federal Republic
1970 Museum of Contemporary Art, Chicago, Illinois, catalog
1972 Circle Gallery, New Orleans, Louisiana
1973 Pyramid Gallery, Washington, D.C.
1980, 83 Fairweather Hardin Gallery, Chicago, Illinois
1980, 84 Patricia Moore Gallery, Aspen, Colorado
1981 Galerie Simonne Stern, New Orleans, Louisiana
1985 Loyola University of Chicago, Chicago, Illinois, retrospective

Selected Group Exhibitions
1964, 67 "Mouvement," Galerie Denise René, Paris, France
1965 "Art et Mouvement," Helena Rubinstein Pavilion, Tel Aviv Museum, Tel Aviv, Israel
1967 "A Selection of Abstract Art 1917-1965: Lillian H. Florsheim Foundation for the Fine Arts," Steinberg Hall, Washington University, St. Louis, Missouri; Isaac Delgado Museum of Art, New Orleans, Louisiana; Krannert Art Museum, Champaign, Illinois, catalog
1967 "Chicago Area Artists," Des Moines Art Center, Des Moines, Iowa, catalog
1967 "Art of the 20th Century," Museum des XX Jahrhunderts, Vienna, Austria
1967 "Art et Mouvement," Musée d'Art Contemporain, Montreal, Quebec, Canada
1981 "The Geometric Impulse: Selected Works from the Lillian H. Florsheim Foundation for the Fine Arts," Swen Parson Gallery, Northern Illinois University, DeKalb, Illinois, catalog
1984 "Annual Exhibition by the Artist Members, Paperworks + Sculpture," Arts Club of Chicago, Chicago, Illinois, catalog
1984 "Carte Blanche Denise René," Traveling Exhibition, Galerie Denise René, Paris, France

Selected Public Collections
Art Institute of Chicago, Chicago, Illinois
National Museum of American Art, Smithsonian Institution, Washington, D.C.
New Orleans Museum of Art, New Orleans, Louisiana
Smith College Museum of Art, Northampton, Massachusetts

Selected Private Collections
Umberto Agnelli, Rome, Italy
Mr. and Mrs. Edwin A. Bergman, Chicago, Illinois
Mr. and Mrs. Leigh Block, Chicago, Illinois
Olga Hirshhorn, Washington, D.C.
Mrs. Edgar B. Stern, New Orleans, Louisiana

Selected Award
1965 Old Orchard Award, "Annual Exhibition of Area Artists," North Shore Art League, Evanston, Illinois

Preferred Sculpture Media
Plastic

Selected Bibliography
Bunch, Clarence. *Acrylic for Sculpture and Design*. New York: Van Nostrand Reinhold, 1972.
Krantz, Claire Wolf. "Reviews Chicago: Lillian Florsheim, Fairweather Hardin Gallery." *New Art Examiner* vol. 10 no. 6 (March 1983) p. 16, illus.
Krantz, Claire Wolf. "Lillian Florsheim: A Conversation with An Independent Abstractionist." *New Art Examiner* vol. 10 no. 8 (May 1983) pp. 12, 33, illus.
Meilach, Dona Z. *Creative Carving: Materials, Techniques, Appreciation*. Chicago: Reilly & Lee, 1969.

Gallery Affiliation
Fairweather Hardin Gallery
101 East Ontario Street
Chicago, Illinois 60611

Mailing Address
1328 North State Street
Chicago, Illinois 60610

Artist's Statement

"I began studying painting and drawing but I felt that I had a better sense of form than of color. My work is very simple: abstract geometrical freestanding and relief constructions. I concentrate on forms even though it may appear I am more concerned with light and its reflection. That portion is the exciting bonus achieved after I have found the shapes which I think are most conceptual and correct for each work.

"I start with the material of Plexiglas and begin my design with a concept based on geometry. One piece is no sooner finished than I am propelled into the next—how to make it better, simpler perhaps, more complicated, perhaps. How far can one go with a square and a circle? Apparently, ad infinitum."

Lillian Florsheim

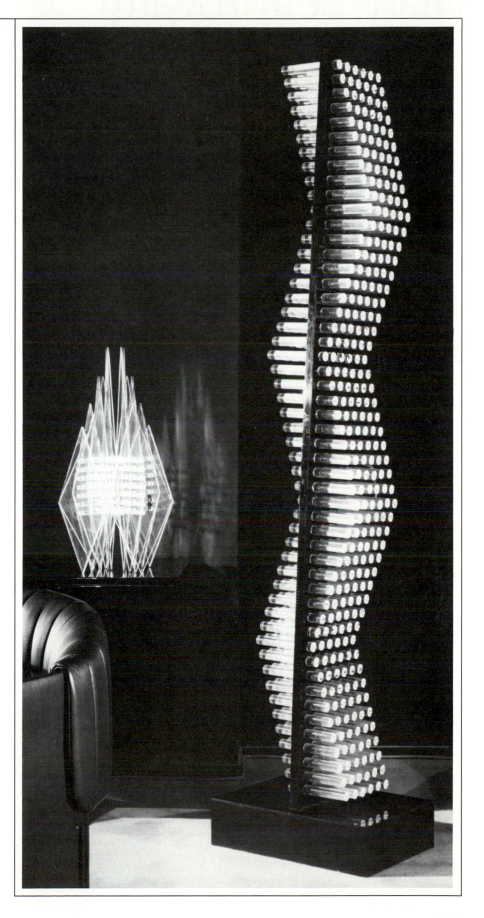

Untitled. 1978. Left: Acrylic, 27"h x 11"w x 11"d.
Untitled. 1977. Right: Acrylic, 6'h x 1'w x 1'd.

Mary Beth Fogarty

née Mary Elizabeth Schmidt
(Husband Edward Frances Fogarty)
Born February 19, 1940 Omaha, Nebraska

Education and Training
1960-61 Los Angeles Art Center, Los Angeles, California
1962 A.A., Painting, Stephens College, Columbia, Missouri
1964 B.A., Painting, San Jose State University, San Jose, California
1974 University of Nebraska at Omaha, Omaha, Nebraska; study in painting
1975 Creighton University, Omaha, Nebraska; study in sculpture with Lee Lubbers
1975 University of Nebraska at Omaha, Omaha, Nebraska; study in sculpture with Sidney Buchanan
1983-85 University of Nebraska-Lincoln, Lincoln, Nebraska; study in printmaking and study in sculpture with Doug Ross

Selected Individual Exhibition
1981 Sheldon Memorial Art Gallery, University of Nebraska-Lincoln, Lincoln, Nebraska

Selected Group Exhibitions
1977 "Sculpture Exhibition," Creighton University, Omaha, Nebraska
1978 "Jesuit Seminar Art Exhibition," Creighton University, Omaha, Nebraska
1979 "Sculpture Exhibition," Gallery 72, Omaha, Nebraska
1980 "Mary Beth Fogarty and Dale Graham," Creighton University, Omaha, Nebraska
1981 "Designer Show House Exhibition," Designer Show House Gallery, Omaha, Nebraska
1981 "The Nebraska Triangle, Wellsprings of America: A Festival of Women's Art Through the Humanities," Peter Kiewit Conference Center, University of Nebraska at Omaha, Omaha, Nebraska, catalog
1982 "Art and Artists in Nebraska," Sheldon Memorial Art Gallery, University of Nebraska-Lincoln, Lincoln, Nebraska, catalog
1982 "Mary Beth Fogarty and Jim Butkus," Rental and Sales Gallery, Joslyn Art Museum, Omaha, Nebraska
1982 "Eppley Competition," College of Fine Arts, University of Nebraska at Omaha, Omaha, Nebraska
1983 "The Governor's Arts Awards—An Exhibition," Governor's Mansion, Lincoln, Nebraska
1985 "A Celebration of Women Artists," State Office Building, Lincoln, Nebraska, catalog

Selected Public Collections
Creighton University, Omaha, Nebraska
Emmy Gifford Children's Theater, Omaha, Nebraska
Nebraska Art Collection, Kearney, Nebraska
Nebraska Arts Council, Omaha, Nebraska
North Platte Museum Film Theater, North Platte, Nebraska
Security National Bank, Omaha, Nebraska
Sheldon Memorial Art Gallery Film Theater, University of Nebraska-Lincoln, Lincoln, Nebraska

Selected Private Collections
Dr. and Mrs. Ben Copple, Omaha, Nebraska
Emmy Gifford, Omaha, Nebraska
Myriel Hiner, Omaha, Nebraska
Mr. and Mrs. James Keene, Omaha, Nebraska
Mr. and Mrs. John Taylor, Omaha, Nebraska

Selected Award
1983 Governor's Art Award, "Fifth Annual Governor's Arts Awards," Nebraska Arts Council, Omaha, Nebraska

Preferred Sculpture Media
Metal (rolled) and Paper

Additional Art Fields
Painting and Printmaking

Gallery Affiliations
Franz-Pagel Contemporary Art
1840 Twin Ridge Road
Lincoln, Nebraska 68506

Rental and Sales Gallery
Joslyn Art Museum
2200 Dodge Street
Omaha, Nebraska 68102

Mailing Address
508 North 38 Street
Omaha, Nebraska 68131

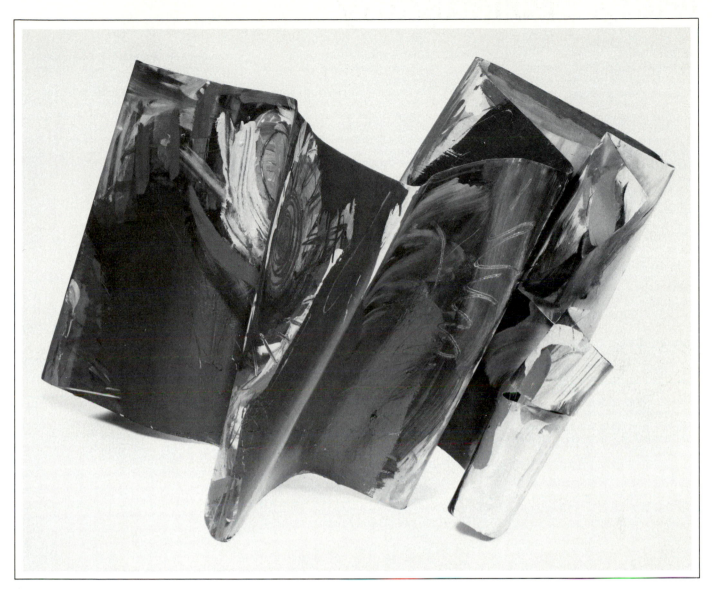

River Bottom Annie. 1985. Rolled steel with acrylic bronzing powders, 3'h x 4'w x 2'd. Photograph by Larry S. Ferguson.

Artist's Statement

"I have wanted to be an artist all my life. My severe German grandmother insisted that the family rise each day at dawn to work. But she instilled in me more than the work ethic. She taught me how to eliminate, to see the world as it is. Through the years, I learned to escape farm chores by stealing away to the Platte River and the surrounding woods. I could only guess about the culture that lay beyond the plowed fields to the distant lights of the city of Omaha.

"The texture, mood and patterns imprinted on our land have been central to my art and the contrast between the chaos of the city and the order of the country. I have made images of biomorphic, map-like formations stained with iridescent touches of paint . . . a patch of gold . . . metropolitan glitter . . . and layers of rugged, massive rock, mother earth. My work encompasses differences in materials and aesthetics, beauty and ugliness; busy energetic lines and quiet areas of space; color contrasts, black overlaying brash hues. I am compelled to polarize many viewpoints, then synthesize. Through working with cast-off materials such as paper, cement and metals, I attempt to resolve the conflict I see between nature and society."

Mary Bethe Fogarty

Jean F. Follett

née Jean Frances
Born June 5, 1917 St. Paul, Minnesota

Education and Training
1940 A.A., Psychology, Political Science and Literature, University of Minnesota Twin Cities Campus, Minneapolis, Minnesota
1936- Saint Paul School of Art, St. Paul,
40 Minnesota; study in oil painting
1946- Hans Hofmann School, New York,
50 New York; study in drawing
1950- Atelier Fernand Léger, Paris,
51 France; study in drawing
1950- Atelier Ossip Zadkine, Paris, France;
51 study in ceramic sculpture

Selected Individual Exhibitions
1953, Hansa Gallery, New York, New York
54,
56,
57

Selected Group Exhibitions
1951- "Members' Annual Exhibition," Hansa
57 Gallery, New York, New York
1954 "Painting and Sculpture Exhibition," Tanager Gallery, New York, New York
1956 "Group Exhibition," Camino Gallery, New York, New York
1957 "Younger Generation, New York School," Jewish Museum, New York, New York

1957 "Sixth New York Artists' Annual Exhibition," Stable Gallery, New York, New York
1958 "Members' Invitation Annual," James Gallery, New York, New York
1958 "Pittsburgh International Exhibition of Painting and Sculpture," Museum of Art, Carnegie Institute, Pittsburgh, Pennsylvania, catalog
1959 "Recent Sculpture U.S.A.," Traveling Exhibition, Museum of Modern Art, New York, New York, catalog
1960 "New Media-New Forms I and II, Painting and Sculpture," Martha Jackson Gallery, New York, New York
1960 "New Sculpture Group: Guests and Members' Fifth Exhibition," Stable Gallery, New York, New York
1960 "Aspects de la Sculpture Américaine," Galerie Claude Bernard, Paris, France
1961- "The Art of Assemblage," Museum of
62 Modern Art, New York, New York; Dallas Museum for Contemporary Arts, Dallas, Texas; San Francisco Museum of Art, San Francisco, California, book
1961 "Recent Acquisitions," Museum of Modern Art, New York, New York, catalog
1961 "Recent Acquisitions," Whitney Museum of American Art, New York, New York
1962 "Member Artists' Exhibition," Leo Castelli Gallery, New York, New York
1977- "Now, 10th Street Show," Noho
78 Gallery, New York, New York; Landmark Gallery, New York, New York, catalog
1977- "The 10th Street Days, The Coop of
78 the '50s," Pleiades Gallery, New York, New York
1979 "Group Exhibition," Martha Jackson Gallery, New York, New York

Selected Public Collections
Massachusetts Institute of Technology, Cambridge, Massachusetts
Museum of Modern Art, New York, New York
University Art Museum, Berkeley, California
Whitney Museum of American Art, New York, New York

Selected Award
1966 Individual Artist's Fellowship, National Endowment for the Arts and Humanities

Preferred Sculpture Media
Metal (cast), Varied Media and Wood

Additional Art Fields
Drawing and Painting

Selected Bibliography
Hess, Thomas B. and Elizabeth C. Baker, eds. Art and Sexual Politics; Women's Liberation, Women Artists, and Art History. New York: Macmillan, 1973.

Kaprow, Allan. Assemblage, Environments & Happenings. New York: Harry N. Abrams, 1966.
Rubinstein, Charlotte Streifer. American Women Artists: From Early Indian Times to the Present. Boston: G. K. Hall, 1982.
Sandler, Irving. The New York School: The Painters and Sculptors of the Fifties. New York: Harper & Row, 1978.

Gallery Affiliation
Richard Bellamy Gallery
157 Chambers Street
New York, New York 10007

Mailing Address
1510 English Street
St. Paul, Minnesota 55106

Many Headed Creature. 1958. Wood and found objects, 24"h x 24"w x 3¼"d. Collection Museum of Modern Art, New York, New York. Photograph by Frank J. Darmstaedter.

Artist's Statement

"I have always drawn and painted, from the time I was old enough to look over a table top, four years or so, continuing on through mud pies and colored sand and years of private art school. My father was a cement and rock builder of bird baths, garden benches and walls and my mother painted in oils. My parents always encouraged me throughout all my years of study. I am convinced that I inherited my ability, taking this for granted throughout my life.

"My work is psychologically and spiritually necessary for me. I am in the business of probing the subconscious and the mysterious secrets of the human soul. I worked in charcoal drawings, still life and life painting in oil before concentrating exclusively in abstract conceptions with psychological input."

Jean F. Follett

Betty Davenport Ford

née Betty Blocker Davenport
(Husband Harold Ford)
Born April 26, 1924 Upland, California

Education and Training
1946 B.A., Ceramic Sculpture, Scripps
College, Claremont, California; study
with Albert Stewart
1950 M.F.A., Ceramic Sculpture,
Metalsmithing and Weaving,
Cranbrook Academy of Art, Bloomfield
Hills, Michigan; study in ceramic
sculpture with Maija Grotell and
small-scale metal sculpture with
Richard Thomas
1969- Mount San Antonio College, Walnut,
71 California; study in welding

Selected Individual Exhibitions
1948, Dalzell Hatfield Galleries, Los Angeles,
51, California, catalog
56
1958 Laguna Beach Art Association Gallery,
Laguna Beach, California
1960 Ontario Art Association, Ontario,
California
1962 San Bernardino Valley College Gallery,
San Bernardino, California
1963 Museum of Art, Science and Industry,
Bridgeport, Connecticut, catalog
1975 Downey Museum of Art, Downey,
California, retrospective and catalog
1976 Citrus College Art Gallery, Azusa,
California
1977 Gallery 8, Claremont, California
1977 Griswold's Art Gallery, Claremont,
California
1978 Edward-Dean Museum of Decorative
Arts, Cherry Valley, California
1984 Hillcrest Congregational Church, La
Habra Heights, California
1984 Chaffey Community Art Association
Museum of History and Art, Ontario,
California

Selected Group Exhibitions
1940- "Annual Art Exhibition, Los Angeles
65 County Fair," Los Angeles County
Fairgrounds, Pomona, California
1948, "Annual Ceramic National Exhibition,"
49, Traveling Exhibition, Syracuse
50, Museum of Fine Arts, Syracuse,
52, New York, catalog
54
1948, "Annual Decorative Arts and
50, Ceramic Exhibition," Wichita Art
52 Association, Wichita, Kansas, catalog
1948- "National Orange Annual Exhibition,"
65 San Bernardino County Fairgrounds,
San Bernadino, California, catalog
1949, "Michigan Artists," Detroit Institute of
50, Arts, Detroit, Michigan, catalog
59

1951, "Artists of Southern California,"
52, Pasadena Art Museum, Pasadena,
53, California, catalog
57
1952 "Cranbrook Alumnae," Cranbrook
Academy of Art Museum, Bloomfield
Hills, Michigan, catalog
1952, "Annual Exhibition," National Academy
53, of Design, New York, New York,
54, catalog
56
1952, "All California Art Exhibition, California
53, State Fair and Exposition," State
54, Fairgrounds, Sacramento, California,
56, catalog
58,
64
1953 "Audubon Artists National Exhibition,"
National Arts Club, New York, New
York, catalog
1953 "National Invitational Exhibition,"
Denver Art Museum, Denver,
Colorado, catalog
1954- "Annual Invitational Exhibition," Desert
84 Sun School, Idyllwild, California
1955, "Los Angeles and Vicinty Artists,"
56 Los Angeles County Museum of Art,
Los Angeles, California, catalog
1958- "Annual Laguna Beach Festival of Art,"
61, Laguna Beach, California, catalog
62,
64
1959 "Selections From The American
Collection," Arizona State University,
Tempe, Arizona, catalog
1962 "California Artists," Otis Art Institute,
Los Angeles, California, catalog
1964 "Exhibition of Work by Scripps College
Distinguished Art Alumnae," Lang Art
Gallery, Scripps College, Claremont,
California, catalog
1978 "The Family in Art," Downey Museum
of Art, Downey, California
1979 "Animal Kingdom," Fine Arts Gallery,
Cypress College, Cypress, California
1980 "Betty Davenport Ford, Sculptor and
Milford Zornes, Painter," Charles B.
Goddard Center, Ardmore, Oklahoma,
catalog
1981 "Women's Work," Chaffey Community
Art Association Museum of History
and Art, Ontario, California, catalog
1981 "Artists From Our Collection," Wichita
Art Association, Wichita, Kansas,
catalog
1982 "The California Spirit Exhibition," Fine
Arts Building, Los Angeles County
Fairgrounds, Pomona, California
1983 "Artists of Note, Fourth Invitational
Exhibition," San Bernardino County
Museum, San Bernardino, California
1984 "Animals We Have Known," Riverside
Art Center and Museum, Riverside,
California, catalog
1984 "The Imaginative Approach,"
Edward-Dean Museum of Decorative
Arts, Cherry Valley, California
1985 "Second Annual Artists Exhibition,
American Society of Interior
Designers," Goodman Associates
Gallery, Claremont, California

Selected Public Collections
Ahmandson Bank Building, Beverly Hills,
California
Arcadia Federal Savings and Loan, Arcadia,
California
Arizona State University Collection of
American Art, Tempe, Arizona
California Federal Savings, Los Angeles,
California
Chaffey High School, Gardiner W. Spring
Auditorium, Ontario, California
Corona-Norco Unified School District, Adams
Elementary School, Corona, California
City of Claremont, Wheeler Park, Claremont,
California
City of Scottsdale Collection, Scottsdale,
Arizona
Cranbrook Academy of Art Museum,
Bloomfield Hills, Michigan
Everson Museum of Art, Syracuse, New York
Federal Savings and Loan, Dallas, Texas
Hillhaven Rest Home, Palm Springs,
California
Jordan Tile Company, Corona, California
Kemper Tool Company, Chino, California
Kingman Chapel, Claremont, California
Laguna Beach Museum of Art, Laguna
Beach, California
Millard Sheets and Associates, Claremont,
California
Pilgrim Congregational Church, Pomona,
California
Pilgrim Place, Porter Hall, Claremont,
California
Pomona Mall, Pomona, California
St. Anthony's Catholic Church, Upland,
California
St. Mark's Episcopal Church, Upland,
California
San Antonio Gardens, Claremont, California
Scripps College, Claremont, California
South Coast Plaza Hotel, Costa Mesa,
California
Western Savings and Loan, Phoenix, Arizona

Selected Private Collections
Mr. and Mrs. George Charlebois, Claremont,
California
Walter Cronkite, New York, New York
Mr. and Mrs. Ray Kroc, La Jolla, California
Mr. and Mrs. Richard Novack, Ontario,
California
Mr. and Mrs. Ray Swanson, Pomona,
California

Selected Awards
1954 Richard Halliburton Award, "Los
Angeles and Vicinity Artists," Los
Angeles County Museum of Art, Los
Angeles, California, catalog
1960 First Prize, "Sixth Annual Exhibition,"
Laguna Beach Museum of Art,
Laguna Beach, California
1985 First Prize, Religious Category,
"Twenty- Fifth Annual Hillcrest Festival
of Fine Arts," Hillcrest Congregational
Church, La Habra Heights, California,
catalog

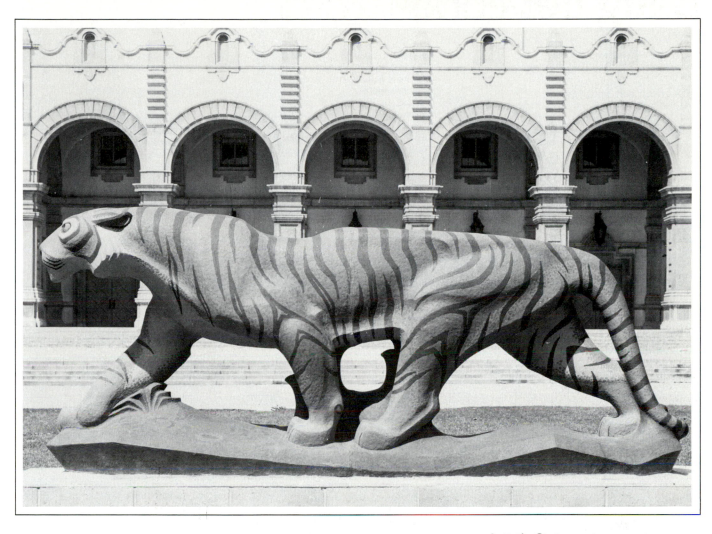

Tiger. 1960. Stoneware and cement filled, 4½'h x 10'w x 2½'d. Collection Chaffey High School, Gardiner W. Spring Auditorium, Ontario, California.

Preferred Sculpture Media
Clay, Metal (cast) and Metal (welded)

Additional Art Fields
Drawing and Photography

Related Profession
Sculpture Instructor

Selected Bibliography
"Betty Davenport Ford." *American Artist* vol. 14 no. 7 issue 137 (September 1950) pp. 50-51, 78, illus.
Ford, Betty Davenport. *Ceramic Sculpture.* New York: Reinhold, 1964.
Lovoos, Janice Penney. "Sculptor Perfects Her Art." *The Christian Science Monitor* (Monday, August 9, 1954) p. 4, illus.
Lovoos, Janice Penney. "Betty Davenport Ford, Ceramic Sculpture." *American Artist* vol. 22 no. 9 issue 219 (November 1958) pp. 34-39, 62-63, illus.

Gallery Affiliations
Jones Gallery
1264 Prospect Street
La Jolla, California 92037

O'Brien's Art Emporium Gallery
7122 Stetson Drive
Scottsdale, Arizona 85251

Stary-Sheets Gallery
Box 343
Gualala, California 95445

Mailing Address
4123 Via Padova
Claremont, California 91711

Artist's Statement
"My approach to my work begins and ends with this—I love the living things upon this planet. I am thrilled by the beauty of living forms and by their strangeness and even their ugliness. I am intrigued by their adaptations and diverse characteristics. I am an artist because I must express my feeling for these things in tangible form. I wish to share my delight with other human beings and enrich their understanding of the world I see. Yet, I would be compelled to give dimension to my ideas were there none to see, for in the developing of the concept and in the work itself I find the greatest satisfaction. Then comes the process of simplifying the knowledge, reducing it to the terms of a design that will suit the material I have chosen. I use a measure of the abstraction of our modern idiom to give greater clarity to the idea, so that others may see what I have done and understand life more completely and simply."

Betty Davenport Ford

Margaret Ford

née Margaret Josephine Herrick
Born October 30, 1941 Oakland, California

Education and Training
1963 B.A., History, Occidental College, Los Angeles, California
1972 B.F.A., Ceramic Sculpture, University of Washington, Seattle, Washington; study with Howard Kottler and Patti Warashina
1974 M.F.A., Ceramic Sculpture, University of Washington, Seattle, Washington; study with Howard Kottler and Patti Warashina

Selected Individual Exhibitions
1976, Foster/White Gallery, Seattle,
79, Washington
81,
84
1979 Contemporary Crafts Gallery, Portland, Oregon
1981 Mandell Gallery, Los Angeles, California
1981 Elements Gallery, New York, New York
1984 Spokane Falls Community College, Spokane, Washington

Selected Group Exhibitions
1971 "Objects: 1971," Western Colorado Center for the Arts, Grand Junction, Colorado
1972 "Ceramics 1972," American Crafts Council, New Paltz, New York
1972, "Northwest Craftsmen Exhibition,"
73, Seattle Art Museum, Seattle,
74 Washington, catalog
1973 "Ceramic Art of the World," University of Calgary, Calgary, Alberta, Canada
1975 "Twenty Women," Foster/White Gallery, Seattle, Washington
1975 "Marietta College Crafts National '75," Traveling Exhibition, Grover M. Hermann Fine Arts Center, Marietta College, Marietta, Ohio, catalog
1976 "One Hundred Artists Commemorate Two Hundred Years," Xerox Square Exhibition Center, Rochester, New York, catalog
1976 "Celebration 20," Museum of Contemporary Crafts, New York, New York
1976- "Northwest Eccentric Art," Traveling
80 Exhibtion, Cheney Cowles Memorial Museum, Spokane, Washington, catalog
1977 "Ceramic Conjunction 1977," Long Beach Museum of Art, Long Beach, California, catalog

1977 "Overglaze Imagery, Cone 019-016," Visual Arts Center, California State University Fullerton, Fullerton, California, catalog
1978 "Landscape: New Views," Herbert J. Johnson Museum of Art, Ithaca, New York, catalog
1978- "Women Artists: Clay, Fiber, Metal,"
79 Traveling Exhibition, Bronx Museum of The Arts, Bronx, New York
1979 "West Coast Clay Spectrum," Security Pacific National Bank, Los Angeles, California, catalog
1979 "The Fire Arts," Bellevue Art Museum, Bellevue, Washington
1979 "Another Side to Art: Ceramic Sculpture of the Northwest 1959-1979," Modern Art Pavilion, Seattle Art Museum, Seattle, Washington, catalog
1980 "Westwood Clay National 1980," Otis Art Institute, Los Angeles, California, catalog
1981 "Portopia '81," Washington State Exhibition, International Trade Fair, Kobe, Japan
1982 "Pacific Currents/Ceramics 1982," San Jose Museum of Art, San Jose, California, catalog
1982- "New Directions: Clay and Fiber-1982,"
84 Traveling Exhibition, East Carolina University Museum of Art/Gray Art Gallery, Greenville, North Carolina, catalog
1982 "Art and/or Craft; USA & Japan," Traveling Exhibition, MRO Hall, Hokuriku Broadcasting Company, Kanazawa, Japan, catalog
1983 "The Pacific Northwest Today," Brentwood Gallery, St. Louis, Missouri
1984 "Clay: 1984, A National Survey Exhibition," Traver Sutton Gallery, Seattle, Washington
1984 "The American Ceramic National Exhibition," Downey Museum of Art, Downey, California, catalog
1984 "Selections from the Seattle City Light Portable Works Collection," Seattle Art Museum Pavilion, Seattle Center, Seattle, Washington, catalog
1985 "Clay National," Erie Art Museum, Erie, Pennsylvania, catalog
1985 "Northwest Sculpture Invitational," Blackfish Gallery, Portland, Oregon

Selected Public Collections
City of Seattle, Washington
Henry Art Gallery, Seattle, Washington
Herbert F. Johnson Museum of Art, Ithaca, New York
The Lannan Foundation, West Palm Beach, Florida
Pacific Northwest Bell, Seattle, Washington
Safeco Insurance, Seattle, Washington
Westwood Ceramic Supply, City of Industry, California

Selected Private Collections
Allan Chasanoff, Jericho, New York
Suzanne Karlen, Kilchberg, Switzerland

Howard Kottler, Seattle, Washington
Joan Mannheimer Collection, Des Moines, Iowa
Marvin Sharpe, Seattle, Washington

Selected Awards
1975 Individual Craftsman's Fellowship, National Endowment for the Arts
1975 First Prize, "Contemporary Crafts of the Americas," Colorado State University, Fort Collins, Colorado, book-catalog
1985 Artist in Residence, Ohio State University, Columbus, Ohio

Prefered Sculpture Media
Clay and Varied Media

Additional Art Field
Textiles

Related Professions
Visiting Artist and Lecturer

Selected Bibliography
Harrington, LaMar. Ceramics in the Pacific Northwest: A History. Seattle: University of Washington Press, 1979.
"News & Retrospect: Margaret Ford." Ceramics Monthly vol. 27 no. 8 (October 1979) cover, pp. 87, 89, 91, illus.
"News & Retrospect: Margaret Ford." Ceramics Monthly vol. 29 no. 9 (November 1981) p. 77, illus.
"Portfolio: Margaret Ford." American Craft vol. 41 no. 6 (December 1981-January 1982) p. 41, illus.
Wechsler, Susan. Low-Fire Ceramics: A New Direction in American Clay. New York: Watson-Guptil, 1981.

Gallery Affiliations
Foster/White Gallery
311½ Occidental Avenue South
Seattle, Washington 98104

Elements Gallery
90 Hudson Street
New York, New York 10013

Mailing Address
3632 Interlake Avenue North
Seattle, Washington 98103

Artist's Statement

"The robe sculptures are inspired by the experiences and impressions of a five-month visit to Asia in 1973. Asian culture and mythology can be experienced on a variety of levels, including subject matter, surface decoration and use of space. I chose the robe as a metaphor for human form and movement and because the image provides the pleasure of pattern, color and texture. I am more concerned with content than impressing with technical virtuosity. This allows a quieter voice and more room for the viewer."

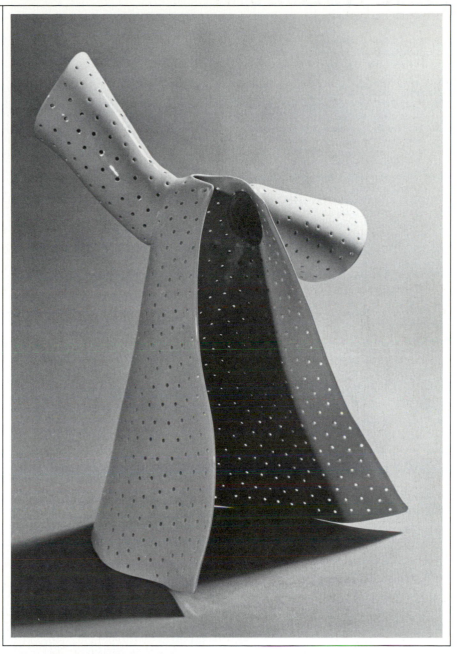

Plane Wrapper. 1980. Ceramic, 17½"h x 12"w x 10"d. Photograph by Colleen Chartier.

Jane Frank

née Jane Babette Schenthal
(Husband Herman Benjamin Frank)
Born July 25, 1918 Baltimore, Maryland

Education and Training
1935 Diploma, Commercial Art and Fashion
Illustration, Maryland Institute School
of Fine and Practical Arts, Baltimore,
Maryland
1938- New York School of Fine and Applied
40 Art, New York, New York
1960 Hans Hofmann School, Provincetown,
Massachusetts
1962 Rinehart Fellowship, Rinehart School
of Sculpture, Maryland Institute
College of Art, Baltimore, Maryland;
study with Norman Carlburg

Selected Individual Exhibitions
1975 Philadelphia Art Alliance, Philadelphia,
Pennsylvania, catalog
1975 Towson State University, Baltimore,
Maryland, retrospective

Selected Group Exhibitions
1971- "Invitational Sculpture Exhibition,"
75 Inner Harbor Sculpture Garden,
Baltimore, Maryland
1974 "A Decade of Sculpture," Philadelphia
Art Alliance, Philadelphia,
Pennsylvania
1975 "Bicentennial Azalea Garden Sculpture
Exhibition," Philadelphia Museum of
Art, Philadelphia, Pennsylvania
1977, "Sculpture Outdoors," Temple
78, University Music Festival, Ambler
79, Campus, Ambler, Pennsylvania
80 (Co-Sponsored by Cheltenham Art
Centre, Cheltenham, Pennsylvania),
catalog
1979 "Sculpture Exhibition," Zenith Gallery,
Washington, D.C.
1981 "Sculpture '81," Franklin Plaza and
International Garden Franklin Town,
Philadelphia, Pennsylvania
(Co-Sponsored by Cheltenham Art
Centre, Cheltenham, Pennsylvania)
1982 "Artists Equity Invitational Sculpture
Exhibition," George Meany Center for
Labor Studies, Silver Spring, Maryland
1983 "Sculpture Spaces Baltimore," Charles
Center, Baltimore, Maryland and
Hopkins Plaza, Baltimore, Maryland

Selected Public Collections
Federal Reserve Bank of Richmond,
Richmond, Virginia
Frank, Bernstein, Conaway & Goldman,
Baltimore, Maryland
Goucher College, Towson, Maryland
Jewish Family and Children's Service,
Baltimore, Maryland
Murphy Fine Arts Center, Morgan State
University, Baltimore, Maryland
Porcelain Enamel Institute, Washington, D.C.
Samuel B. Morse Elementary School,
Baltimore, Maryland
Towson State University, Baltimore, Maryland
University of Maryland at College Park,
College Park, Maryland

Selected Private Collections
Mr. and Mrs. J. Prentiss Browne, Baltimore,
Maryland
Mr. and Mrs. Leonard Greif, Jr., Baltimore,
Maryland
Mr. and Mrs. William Hahn, La Jolla,
California
Mr. and Mrs. David Halle, Stevenson,
Maryland
George Hirshman, Baltimore, Maryland

Selected Award
1983 Sculpture Prize, "1983 Maryland
Artists Exhibition," Dundalk
Community College, Baltimore,
Maryland, catalog

Preferred Sculpture Media
Metal (welded), Plastic and Varied Media

Additional Art Fields
Painting and Tapestry

Selected Bibliography
American Artists of Renown. Gilmer, Texas:
Wilson, 1981.
Busch, Julia M. *A Decade of Sculpture: The
1960s.* Philadelphia: Art Alliance Press,
1974.
Stanton, Phoebe B. *The Sculptural
Landscape of Jane Frank.* Cranbury, New
Jersey: A. S. Barnes, 1968.

Mailing Address
1300 Woods Hole Road
Towson, Maryland 21204

Artist's Statement

"My earliest work in the 1940s was extracted from my environment and how I saw and felt about it; sometimes that still pertains. Invariably, I was interested in texture and space. Sculpture and tapestry evolved from my painting when I attempted to make a three-dimensional statement on the two-dimensional surface. Actual apertures on the multilayered canvases were a step away from three-dimensional tapestries, freestanding sculptures, as well as stone and wood reliefs.

"As the work has progressed over the years, one procedure has led to another almost spontaneously, although often it has been frustrating, always hard work. In a rather strange way, there are many stages during the creative process that simply 'happen,' decisions unmade until they appear, learning from oneself, often including 'good mistakes.' I suspect artists must let their records speak for themselves, while I hope that the audience will read between the lines."

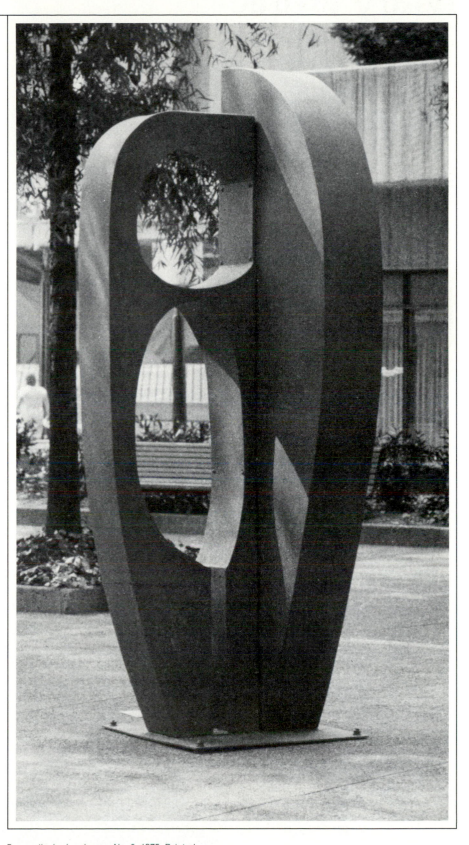

Perpendicular Landscape No. 3. 1975. Painted aluminum, 72"h x 40"w x 24"d. Installation view 1983. "Sculpture Spaces Baltimore," Hopkins Plaza, Baltimore, Maryland. Photograph by Mettee Photography.

Mary Frank

née Mary Lockspeiser
Born February 4, 1933 London, Great Britain

Education and Training
1949 Studio of Martha Graham, New York, New York
1951 Hans Hofmann School, New York, New York

Selected Individual Exhibitions
1958 Poindexter Gallery, New York, New York
1961, Stephen Radich Gallery, New York,
63 New York
1965, Boris Mirski Art Gallery, Boston,
67 Massachusetts
1968, Zabriskie Gallery, New York, New
70, York, catalog
71,
73,
75,
77,
78,
79,
81,
83,
85
1974 Proctor Art Center, Bard College, Annandale-on-Hudson, New York
1975 University of Connecticut, Storrs, Connecticut
1976 Harcus Krakow Gallery, Boston, Massachusetts
1976 Cummings Arts Center, Connecticut College, New London, Connecticut
1976 Arts Club of Chicago, Chicago, Illinois
1976 University of Bridgeport, Bridgeport, Connecticut
1978 Neuberger Museum, Purchase, New York, retrospective and catalog
1982 Makler Gallery, Philadelphia, Pennsylvania
1984 Quay Gallery, San Francisco, California

Selected Group Exhibitions
1960 "New Sculpture Group: Guests and Members Fifth Exhibition," Stable Gallery, New York, New York
1960 "Aspects de la Sculpture Américaine," Galerie Claude Bernard, Paris, France
1965 "Women Artists of America 1707-1964," Newark Museum, Newark, New Jersey, catalog
1972 "10 Independents," Solomon R. Guggenheim Museum, New York, New York
1972 "GEDOK American Woman Artist Show," Kunsthaus, Hamburg, Germany, Federal Republic, catalog
1972 "Unmanly Art," Suffolk Museum, Stony Brook, New York, catalog
1972, "Annual Exhibition: Contemporary
79 American Sculpture," Whitney Museum of American Art, New York, New York, catalog

1973, "Biennial Exhibition: Contemporary
79 American Art," Whitney Museum of American Art, New York, New York, catalog
1973 "Women Choose Women," New York Cultural Center, New York, New York, catalog
1975 "Masterworks in Wood," Portland Art Museum, Portland, Oregon
1975 "Three Centuries of the American Nude," New York Cultural Center, New York, New York; Minneapolis Institute of Arts, Minneapolis, Minnesota; Fine Art Center, University of Houston Central Campus, Houston, Texas, catalog
1976 "American Artists '76: A Celebration," Marion Koogler McNay Art Institute, San Antonio, Texas, catalog
1976 "Seventy-Second Annual Exhibition of American Paintings and Sculpture," Art Institute of Chicago, Chicago, Illinois, catalog
1977 "Contemporary Women: Consciousness and Content," School of the Brooklyn Museum, Brooklyn, New York
1977 "Small Objects," Whitney Museum of American Art, New York, New York
1978 "Figure in the Landscape," Wave Hill, Bronx, New York, catalog
1978 "Eight Artists," Philadelphia Museum of Art, Philadelphia, Pennsylvania
1978 "Perspective '78: Works by Women," Albright College, Reading, Pennsylvania
1979- "A Century of Ceramics in the United
80 States, 1878-1978," Everson Museum of Art, Syracuse, New York, book
1979 "By The Sea: Twentieth-Century Americans at the Shore," Queens Museum, Queens, New York
1980 "The Figurative Tradition," Whitney Museum of American Art, New York, New York, book
1980- "Sculpture in the 70s: The Figure,"
82 Pratt Manhattan Gallery, New York, New York; Pratt Institute Gallery, Brooklyn, New York; Arizona State University, Tempe, Arizona; Hood Museum of Art, Hanover, New Hampshire, catalog
1981 "Tracking the Marvelous," Grey Art Gallery and Study Center, New York University, New York, New York, catalog
1981 "The Human Form: Interpretations," Maryland Institute College of Art, Baltimore, Maryland
1981 "The Clay Figure," American Craft Museum, New York, New York
1983 "Bronze Sculpture in the Landscape," Wave Hill, Bronx, New York, catalog
1983 "Fragmentation," New Britain Museum of American Art, New Britain, Connecticut
1983 "Contemporary Sculpture 1983," State University of New York College at New Paltz, New Paltz, New York
1983 "Forming," Parrish Art Museum, Southampton, New York

1984 "American Women Artists Part I: 20th Century Pioneers," Sidney Janis Gallery, New York, New York, catalog
1984 "Figurative Sculpture: Ten Artists/Two Decades," California State University, Long Beach, University Art Museum, Long Beach, California, catalog
1984- "Works in Bronze, A Modern Survey,"
87 Traveling Exhibition, University Art Gallery, Sonoma State University, Rohnert Park, California, catalog

Selected Public Collections
Akron Art Museum, Akron, Ohio
Arnot Art Museum, Elmira, New York
Art Institute of Chicago, Chicago, Illinois
Brown University, Providence, Rhode Island
Connecticut College, New London, Connecticut
Des Moines Art Center, Des Moines, Iowa
Everson Museum of Art, Syracuse, New York
Hirshhorn Museum and Sculpture Garden, Smithsonian Institution, Washington, D.C.
Kalamazoo Institute of Arts, Kalamazoo, Michigan
Michael C. Rockefeller Arts Center Gallery, Fredonia, New York
Metropolitan Museum of Art, New York, New York
Museum of Modern Art, New York, New York
Neuberger Museum, Purchase, New York
Storm King Art Center, Mountainville, New York
University of Bridgeport, Bridgeport, Connecticut
University of New Mexico, Albuquerque, New Mexico
Whitney Museum of American Art, New York, New York
Worcester Art Museum, Worcester, Massachusetts
Yale University, New Haven, Connecticut

Selected Awards
1973, John Simon Guggenheim Memorial
83 Foundation Fellowship
1984 Fellowship, American Academy and Institute of Arts and Letters, New York, New York

Preferred Sculpture Media
Clay and Metal (cast)

Additional Art Fields
Drawing and Printmaking

Selected Bibliography

Clark, Garth. *A Century of Ceramics in the United States, 1878-1978: A Study of its Development.* New York: E. P. Dutton, 1979.

Hughes, Robert. "Art: Images of Metamorphosis." *Time* (July 10, 1978) p. 76, illus.

Kingsley, April. "Mary Frank: A Sense of Timelessness." *Art News* vol. 72 no. 6 (Summer 1973) pp. 65-67, illus.

Munro, Eleanor C. *Originals: American Women Artists.* New York: Simon and Schuster, 1979.

Raynor, Vivien. "Sculptural Marvels of Mary Frank." *The New York Times* (Friday, June 16, 1978) pp. C1, C23, illus.

Gallery Affiliation

Zabriskie Gallery
724 Fifth Avenue
New York, New York 10019

Mailing Address

139 West 19 Street
New York, New York 10011

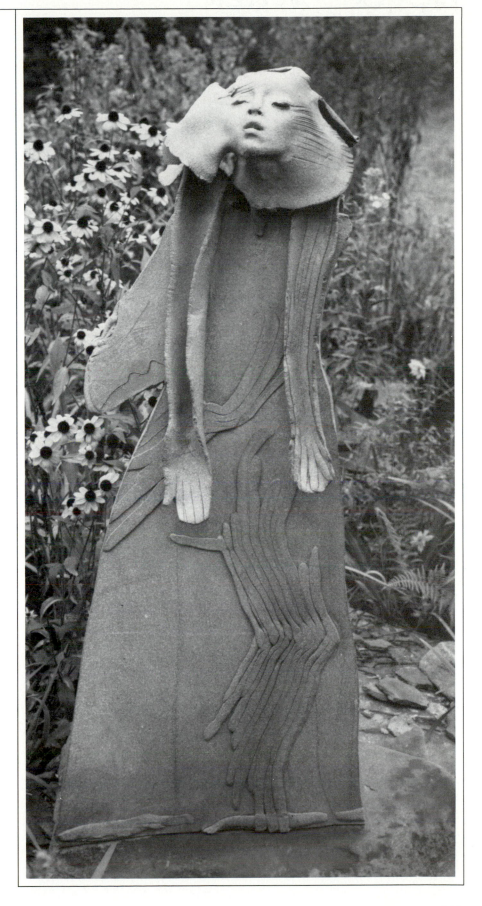

Standing Figure. 1980. Ceramic, 37"h x 12"w x 15¼"d. Courtesy Zabriskie Gallery, New York, New York. Photograph by Jerry L. Thompson.

Beverly Frazier

née Beverly Glaze
Born June 28, 1928 Oxford, Kansas

Education and Training
1945- Philbrook Art Center, Tulsa,
47 Oklahoma; study in sculpture with
Bernard Frazier
1947- Kansas City Art Institute, Kansas City,
48 Missouri; study in sculpture with
Wallace Rosenbauer
1949- School of the Art Institute of Chicago,
50 Chicago, Illinois; study in drawing
1951- Assistant to Bernard Frazier, Tulsa,
56 Oklahoma; co-sculptor in the creation
of sculpture
1957- Assistant to Bernard Frazier,
75 Lawrence, Oklahoma; co-sculptor in
the creation of sculpture
1960- National and International Sculpture
82 Conferences and Workshops in the
United States
1970 B.A., Art Education, University of
Kansas, Lawrence, Kansas; additional
study in sculpture with Bernard
Frazier and Elden C. Tefft
1978 Co-Sculptor with Malcoln Frazier,
Lawrence, Kansas

Selected Individual Exhibitions
1985 Pratt Community College, Pratt,
Kansas
1985 Oxbow Gallery, Lawrence, Kansas

Selected Group Exhibitions
1983 "Kansas Three: Painting, Drawing,
Printmaking and Sculpture Exhibition,"
Mulvane Art Center, Topeka, Kansas
1985 "Kansas Five: Painting, Drawing,
Printmaking and Sculpture Exhibition,"
Mulvane Art Center, Topeka, Kansas

Selected Public Collections
Fidelity National Bank, Oklahoma City,
Oklahoma
First Methodist Church, Wichita, Kansas
Governor's Mansion, Cedar Crest, Topeka,
Kansas
Kansas State Historical Society Museum,
Topeka, Kansas
Liberal Historical Society and Coronado
Museum, Liberal, Kansas
Lutheran Church, Kansas City, Missouri
Oklahoma Publishing Company, Oklahoma
City, Oklahoma
Plymouth Congregational Church, Lawrence,
Kansas
Thomas H. Bowlus Fine Arts Center, Iola,
Kansas
University of Tulsa, Sharpes Memorial
Chapel, Tulsa, Oklahoma

Selected Private Collections
Anna Bing Arnold, Beverly Hills, California
Ronald Frankum, McLean, Virginia
Gordon Glasco, Santa Fe, New Mexico
Zula Bennington Greene, Topeka, Kansas
Michael Stolzberg, Los Angeles, California

Selected Awards
1981 Second Award, National Sculpture
Competition, Kansas State Historical
Society, Topeka, Kansas
1985 Sculptor in Residence, Pratt
Community College, Pratt, Kansas

Preferred Sculpture Media
Metal (cast), Plastic and Varied Media

Additional Art Fields
Architectural Design and Portraiture

Related Professions
Art Administrator and Writer

Selected Bibliography
Canaday, John. "Art: Kansas On My Mind."
The New York Times (Sunday, June 23,
1968) p. D27.

Mailing Address
Box 1414
Lawrence, Kansas 66044

Artist's Statement

"My life came into focus through my first sculpture class at 17. My search for meaningful expression taught me that form is the language I speak fluently. My goal is to understand the system of harmonic proportion which is the essence of individual form. Form in this way can be replicated, as in portraiture, or varied and altered for expression in other work. Designing is a process which reduces, in my mind, large-scale works to correct proportions while at-scale studio pieces seem very large, whatever their physical sizes.

"Womankind, I believe, has an atavistic faith only deepened by challenge. I hope my work reflects a positive loving response to the world and compassion for the human condition."

Beverly Frazier

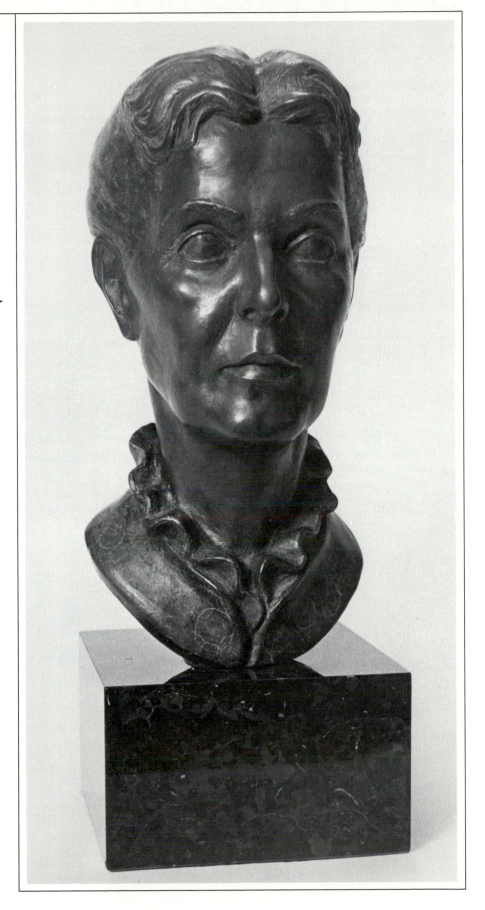

Hildreth Spencer Frankum. 1984. Bronze, 13½"h x 7"w x 9"d, base 4½"h x 6¾"w x 6"d. Photograph by Will Hess.

Lena Beth Frazier

née Lena Elizabeth Murphy
Born November 11, 1944 Ardmore, Oklahoma

Education and Training
1968 B.F.A., Sculpture, University of Oklahoma, Norman, Oklahoma; study with Joseph Taylor
1968- University of Oklahoma, Norman, Oklahoma; additional study in sculpture with Joseph Taylor
69

Selected Individual Exhibitions
1978 Governor's Gallery, State Capitol, Oklahoma City, Oklahoma
1979 Firehouse Art Center, Norman, Oklahoma
1980 Mabee-Gerrer Museum, St. Gregory's College, Shawnee, Oklahoma
1980 Charles B. Goddard Center, Ardmore, Oklahoma
1982 Oklahoma Art Center, Downtown Extension, Oklahoma City, Oklahoma

Selected Group Exhibitions
1979 "Oklahoma Sculpture Today," Oklahoma Museum of Art, Oklahoma City, Oklahoma; Charles B. Goddard Center, Ardmore, Oklahoma, catalog
1981 "Oklahoma Sculpture Society Annual Exhibition," Kirkpatrick Center—Oklahoma Center for Science and Arts, Oklahoma City, Oklahoma
1981 "Living Women—Living Art Exhibition," Governor's Gallery, State Capitol, Oklahoma City, Oklahoma

1982 "National Governor's Conference Art Exhibition Invitational," Shangrila, Afton, Oklahoma
1982 "Oklahoma Diamond Jubilee Exhibition," Governor's Gallery, State Capitol, Oklahoma City, Oklahoma
1983 "Oklahoma Sculpture Society Annual Exhibition," Oklahoma Museum of Art, Oklahoma City, Oklahoma
1983 "National Sculpture Juried Exhibition," Pen and Brush, New York, New York
1983 "Governor's Inaugural Art Gala," State Capitol, Oklahoma City, Oklahoma
1985 "Lena Beth Frazier and Beth McAnich," Kirkpatrick Center—Oklahoma Center for Science and Arts, Oklahoma City, Oklahoma

Selected Public Collections
Charles B. Goddard Center, Ardmore, Oklahoma
Commerce Bank, Oklahoma City, Oklahoma
Fourth National Bank, Tulsa, Oklahoma
Governor's Gallery Permanent Collection, State Capitol, Oklahoma City, Oklahoma
Hardy Murphy Coliseum, Ardmore, Oklahoma
Kirkpatrick Center—Oklahoma Center for Science and Arts, Oklahoma City, Oklahoma
Lakeshore Bank, Oklahoma City, Oklahoma
Mabee-Gerrer Museum, St. Gregory's College, Shawnee, Oklahoma
One Benham Place, Oklahoma City, Oklahoma
Oscar Rose Junior College, Midwest City, Oklahoma
Seminole Junior College, Seminole, Oklahoma
University of Oklahoma, Bizzell Memorial Library, Norman, Oklahoma

Selected Private Collections
Sylvan N. Goldman, Oklahoma City, Oklahoma
John E. Kirkpatrick, Oklahoma City, Oklahoma
Dr. A. Edward Maumenee, Baltimore, Maryland
Mr. and Mrs. Sam Noble, Ardmore, Oklahoma
Dr. and Mrs. Bradley R. Straatsma, Los Angeles, California

Selected Awards
1978 Artist in Residence, State Arts Council of Oklahoma
1978 Juror's Award, "Oklahoma Sculpture Society Annual Exhibition," Kirkpatrick Center—Oklahoma Center for Science and Arts, Oklahoma City, Oklahoma
1978 Sculpture Award, "Seventeenth Annual Artists Salon," Oklahoma Museum of Art, Oklahoma City, Oklahoma

Preferred Sculpture Media
Clay and Metal (cast)

Selected Bibliography
Ridgway, Peg. "Profiles: Portfolio of Regional Artists, Lena Beth Frazier (Norman, Oklahoma)." *Art Voices* vol. 4 no. 6 (November-December 1981) p. 43, illus.

Gallery Affiliation
Oklahoma Design Center
6478 Avondale Drive
Oklahoma City, Oklahoma 73116

Mailing Address
Post Office Box 2269
Norman, Oklahoma 73070

Artist's Statement

"At the age of nine, I made a conscious decision to be an artist. While studying art, it became clear to me that my greatest passion was sculpture. I love the challenge of expressing reflections of life three-dimensionally. Formal study of dance, music and psychology influence my art. I am motivated to demonstrate human emotion through vital movement of the figure. I am a full-time sculptor involved in a continuing process of discovery."

Lena Seth Frazier

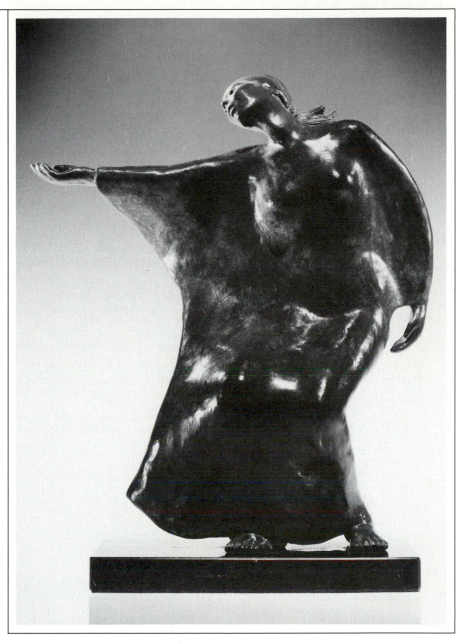

Invitation. 1982. Bronze, 12"h x 10"w x 4"d.
Photograph by Cris Lafferty.

Viola Frey

Born August 15, 1933 Lodi, California

Education and Training
1952- Stockton Delta College, Stockton,
53 California
1956 B.F.A., Painting, California College of Arts and Crafts, Oakland, California
1958 M.F.A., Ceramics, Tulane University, New Orleans, Louisiana

Selected Individual Exhibitions
1974 Wenger Gallery, San Francisco, California
1975 Hank Baum Gallery, San Francisco, California and Hank Baum Gallery, Century City, California
1975, Wenger Gallery, La Jolla,
77 California
1980 Quay Gallery, San Francisco, California
1981- Crocker Art Museum, Sacramento,
84 California, Traveling Exhibition to museums throughout the United States and Canada, retrospective and catalog
1982 California State University Fullerton, Fullerton, California
1983, Quay Gallery, San Francisco,
85 California, catalog
1984 Asher/Faure Gallery, Los Angeles, California
1984 Greenberg Gallery, St. Louis, Missouri
1984 Whitney Museum of American Art, New York, New York; Moore College of Art, Philadelphia, Pennsylvania; Pittsburgh Center for the Arts, Pittsburgh, Pennsylvania; Erie Art Museum, Erie, Pennsylvania, catalog

Selected Group Exhibitions
1969 "Annual Ceramic National Exhibition," Traveling Exhibition, Everson Museum of Art, Syracuse, New York, catalog
1974 "Baroque," Museum of Contemporary Crafts, New York, New York
1977 "Viewpoint: Ceramics, 1977," Grossmont College Gallery, El Cajon, California, catalog
1977 "Overglaze Imagery, Cone 019-016," Visual Arts Center, California State University Fullerton, Fullerton, California, catalog
1979- "A Century of Ceramics in the United
80 States 1878-1978," Everson Museum of Art, Syracuse, New York; Renwick Gallery of the National Collection of Fine Arts, Smithsonian Institution, Washington, D.C., book
1979 "Large Scale Ceramic Sculpture," Richard L. Nelson Gallery, University of California, Davis, Davis, California, catalog
1979 "The Uainted Portrait: Contemporary Portraiture in a Non-Traditional Media," John Michael Kohler Arts Center, Sheboygan, Wisconsin, catalog

1979 "West Coast Clay Spectrum," Security Pacific Bank, Los Angeles, California, catalog
1981 "The Clay Figure," American Craft Museum, New York, New York
1981 "Sculpture and Clay," Walter Phillips Gallery, Banff Centre, School of Fine Arts, Banff, Alberta, Canada
1982 "Clay Bodies: Autio, De Staebler and Frey," Maryland Institute College of Art, Baltimore, Maryland, catalog
1982 "Pacific Currents/Ceramics 1982," San Jose Museum of Art, San Jose, California, catalog
1982 "Figurative Clay Sculpture," Quay Gallery, San Francisco, California, catalog
1982 "100 Years of California Sculpture," Oakland Museum, Oakland, California, catalog
1982 "Art and/or Craft; USA & Japan," Traveling Exhibition, MRO Hall, Hokuriku Broadcasting Company, Kanazawa, Japan, catalog
1982 "Three Dimensions: Clay, Glass, Fiber," Katonah Gallery, Katonah, New York
1983 "Contemporary Clay Sculpture: Selections from the Daniel Jacobs Collection," Heckscher Museum, Huntington, New York
1983 "A Personal View: Selections from the Joan Mannheimer Ceramic Collection," University of Missouri, Lawrence, Missouri
1983 "Ceramic Echoes: Historical References in Contemporary Ceramics," Nelson-Atkins Museum of Art, Kansas City, Missouri, catalog
1983 "California Clay Works," San Francisco Museum of Modern Art, San Francisco, California
1983 "Nuclear Age: Tradition and Transition," Phoenix Art Museum, Phoenix, Arizona
1983 "The Raw Edge: Ceramics of the 80s," Hillwood Art Gallery, C. W. Post Center of Long Island University, Greenvale, New York, catalog
1984 "Figurative Sculpture: Ten Artists/Two Decades," California State University, Long Beach, University Art Museum, Long Beach, California, catalog
1984 "Directions in Contemporary American Ceramics," Museum of Fine Arts, Boston, Massachusetts
1984 "A Passionate Vision: Contemporary Ceramics from the Daniel Jacobs Collection," DeCordova and Dana Museum and Park, Lincoln, Massachusetts, catalog
1984 "Art of the States: Works from a Santa Barbara Collection," Santa Barbara Museum of Art, Santa Barbara, California
1984 "American Sculpture: Three Decades," Seattle Art Museum, Seattle, Washington
1985 "Art in the San Francisco Bay Area, 1945-1980," Oakland Museum, Oakland, California, book-catalog

Selected Public Collections
Minneapolis Institute of Arts, Minneapolis, Minnesota
Nelson-Atkins Museum of Art, Kansas City, Missouri
Oakland Museum, Oakland, California
Saint Louis Art Museum, St. Louis, Missouri
San Francisco Museum of Modern Art, San Francisco, California

Selected Private Collections
Rena Bransten, San Francisco, California
Mr. and Mrs. Frank Kolodny, Princeton, New Jersey
Mr. and Mrs. William Kurtz, New York, New York
Manual Neri, Benicia, California
Mr. and Mrs. Rene di Rosa, Napa, California

Selected Award
1978 Individual Artist's Fellowship, National Endowment for the Arts

Preferred Sculpture Media
Clay and Metal (cast)

Additional Art Fields
Drawing and Painting

Selected Bibliography
Clark, Garth. *A Century of Ceramics in the United States 1878-1978: A Study of its Development.* New York: E. P. Dutton, 1979.
Clark, Garth, ed. *Ceramic Art: Comment and Review, 1882-1977: An Anthology of Writings on Modern Ceramic Art.* New York: E. P. Dutton, 1978.
Dunham, Judith L. "Ceramic Bricolage: The Protean Art of Viola Frey." *American Craft* vol. 41 no. 4 (August-September 1981) pp. 29-33, illus.
Kelly, Jeff. "Viola Frey." *American Ceramics* vol. 3 no. 1 (Spring 1984) cover, pp. 26-33, illus.
Wechsler, Susan. *Low-Fire Ceramics: A New Direction in American Clay.* New York: Watson-Guptill, 1981.

Gallery Affiliation
Quay Gallery
254 Sutter Street
San Francisco, California 94108

Mailing Address
663 Oakland Avenue
Oakland, California 94611

Artist's Statement

"Working with my selected materials, fragments and odd movements, people and things, I realized that without light there was no color or form. The monochrome colors of clay surfaces tended to force three-dimensional figures and objects towards profile and silhouette. They became almost two-dimensional and took on quasi-religious, quasi-primitive qualities. An uncertain mysticism I neither intended nor wanted.

"I first started color study under Rothko at Tulane. I well remember him saying '. . . red is not a color but is the sensation of a red apple on a red table cloth . . . the crack in the sidewalk . . . the unobserved, unremarked area which is between.'

"Later I conducted a color workshop for the painting department at the California College of Arts and Crafts from 1967 to 1969. That technical training added to my clay experience and made it reasonable that I turn to color to clarify and intensify the effects I was trying to achieve. Hence I was able to bring to ceramic sculpture all the resources available to painting, drawing and sculpture."

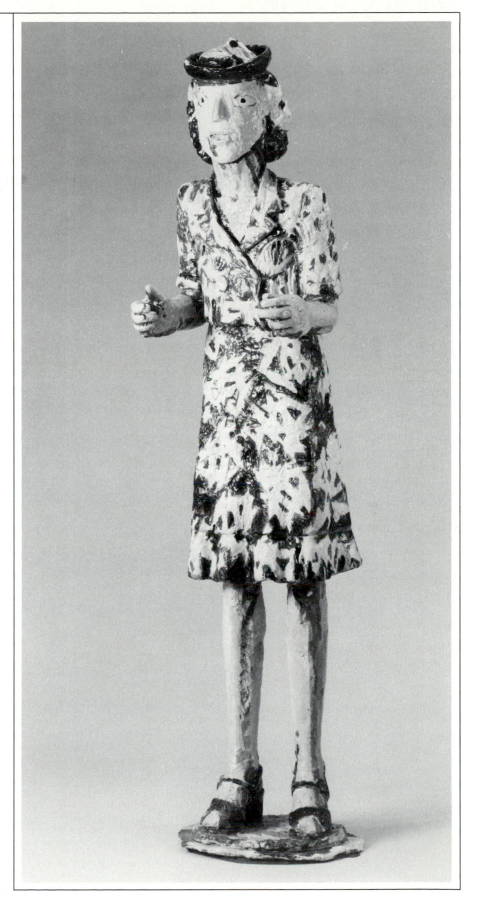

Grandmother, Black and White Dress. 1982. Ceramic, 7'h. Quay Gallery Permanent Collection, San Francisco, California. Photograph by M. Lee Fatherree.

Mary Fuller

née Mary Ellen
(Husband Robert Pearson McChesney)
Born October 20, 1922 Wichita, Kansas

Education and Training
1943 A.A., University of California, Berkeley, Berkeley, California
1945- California Faience Company, Berkeley, 47 California; apprenticeship in ceramics to William Bragdon

Selected Individual Exhibitions
1947 Artists' Guild Gallery, San Francisco, California
1950 Lucien Labaudt Gallery, San Francisco, California
1961 Bolles Gallery, San Francisco, California
1971 Sonoma State University, Rohnert Park, California
1974 Santa Rosa City Center, Santa Rosa, California
1980 Olive Hyde Art Gallery, Fremont, California
1981 Petaluma Historical Museum, Petaluma, California
1981 Rohnert Park—Cotati Public Library, Rohnert Park, California
1982 Forge Patio Art Gallery, Lafayette, California

Selected Group Exhibitions
1948, "Painting and Sculpture Annual
 60, Exhibition," San Francisco Museum
 64 of Art, San Francisco, California
1950 "San Francisco Women Artists Exhibition," San Francisco Museum of Art, San Francisco, California
1960 "Northern California Sculptors Annual Exhibition," Oakland Art Museum, Oakland, California
1968- "Annual San Francisco Art Festival,"
 79 Civic Center Plaza, San Francisco, California
1971 "Sala de Arte," Universidad Regional del Sureste, Oaxaca, México
1974 "Mary Fuller and Robert McChesney," City Hall Council Chambers, Santa Rosa, California
1975 "Gallery Exhibition," James Willis Gallery, San Francisco, California
1976 "The Printed Work," San Jose State University, San Jose, California
1976 "Garden of Delights," University of St. Thomas, Houston, Texas
1978 "Spring Festival," Sonoma State University, Rohnert Park, California
1978 "Christmas Art," University of California, Davis, Davis, California
1978 "International Self Portrait Invitational," Arizona State University, Tempe, Arizona
1980 "Negative-Positive," City Hall Council Chambers, Santa Rosa, California

Selected Public Collections
Andrew Hill High School, San Jose, California
City of Squaw Valley, California
Department of Motor Vehicles Building, Yuba City, California
Petaluma Library, Petaluma, California
Portsmouth Square Totlot, San Francisco, California
Salinas Community Center, Children's Sculpture Garden, Salinas, California
San Francisco Art Commission, San Francisco, California
San Francisco General Hospital, San Francisco, California
Southwest Treatment Water Plant, West Side Pump Station, San Francisco, California

Selected Private Collections
Anshen-Mays Collection, Sausalito, California
Henrik Bull, San Francisco, California
Alec Cushing, Squaw Valley, California
Eleanor Kneibler, Healdsburg, California
Allan Temko, Berkeley, California

Selected Awards
1947, First Prize Ceramic Sculpture,
 49 "Annual Pacific Coast Ceramic Exhibition," Rotunda Gallery, San Francisco, California
1971 Merit Award, "Fifty-Second Annual San Francisco Art Festival," Civic Center Plaza, San Francisco, California

Preferred Sculpture Media
Concrete

Related Profession
Novelist and Writer

Gallery Affiliation
Forge Patio Art Gallery
3420 Mountain Diablo Boulevard
Lafayette, California 94549

Mailing Address
2955 Sonoma Mountain Road
Petaluma, California 94952

Artist's Statement

"I have always felt alienated from Western European culture as a source for my art and my sculpture has been profoundly influenced by pre-Columbian and African work. If my sculpture comes close to achieving the vitality, the strength, humor and humanity of the work of the unknown artists from those cultures, I shall be very proud because they are my esthetic and artistic guides."

Mary Fuller McChesney

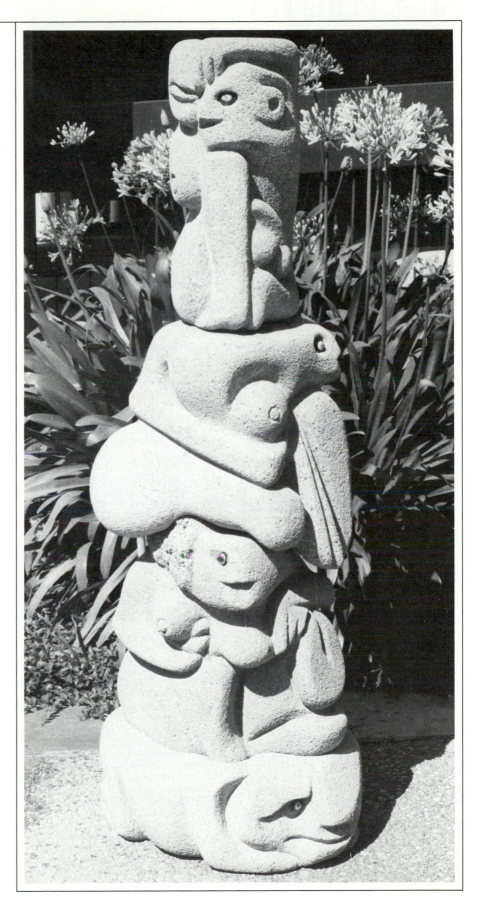

Blue-Eyed Devil Totem No. 2. 1974. Directly carved concrete, 5'h x 3'w x 3'd.

Sue Fuller

née Caroline Susan
Born August 11, 1914 Pittsburgh,
Pennsylvania

Education and Training
1934 Ernest Thurn School of Art,
Gloucester, Massachusetts
1936 B.A., Painting and Design, Carnegie
Institute of Technology, Pittsburgh,
Pennsylvania
1939 M.A., Art Education, Teachers
College, Columbia University, New
York, New York
1943- New School for Social Research, New
45 York, New York
1944 Camera Club, New York, New York

Selected Individual Exhibitions
1951 Corcoran Gallery of Art, Washington,
D.C.
1952, Bertha Schaefer Gallery, New York,
56, New York
61,
65,
67,
69
1957 Mint Museum of Art, Charlotte, North
Carolina
1957 Hunter Museum of Art, Chattanooga,
Tennessee
1960 Grinnell College, Grinnell, Iowa
1965 Southern Illinois University at
Carbondale, Carbondale, Illinois
1966 Storm King Art Center, Mountainville,
New York
1967 Norfolk Museum of Arts and Sciences,
Norfolk, Virginia
1967 Marion Koogler McNay Art Institute,
San Antonio, Texas
1975 Chalette International, New York, New
York
1978 Port Washington Public Library, Port
Washington, New York
1978 Elaine Benson Gallery,
Bridgehampton, New York
1978 Plum Gallery, Kensington, Maryland

Selected Group Exhibitions
1951 "Abstract Art in America," Museum of
Modern Art, New York, New York,
catalog
1952 "Spring Annual," Whitney Museum of
American Art, New York, New York
1955- "The New Decade, Thirty-Five
56 American Painters and Sculptors,"
Traveling Exhibition, Whitney Museum
of American Art, New York, New York
1956 "Five Women Artists," Marion Koogler
McNay Art Institute, San Antonio,
Texas; Fort Worth Art Center, Fort
Worth, Texas
1956 "Albers, Callery and Fuller," Currier
Gallery of Art, Manchester, New
Hampshire

1957 "Sixty-Second Exhibition of American
Paintings and Sculpture," Art Institute
of Chicago, Chicago, Illinois, catalog
1962 "Geometric Abstraction in America,"
Traveling Exhibition, Whitney Museum
of American Art, New York, New York,
catalog
1965 "The Responsive Eye," Museum of
Modern Art, New York, New York,
catalog
1965 "Women Artists of America
1707-1964," Newark Museum, Newark,
New Jersey, catalog
1965 "Boxes and Wall Sculpture," Rhode
Island School of Design Museum,
Providence, Rhode Island
1966 "Collectors Choice," Joslyn Art
Museum, Omaha, Nebraska
1967 "Contemporary Paintings and
Sculpture," Newark Museum, Newark,
New Jersey
1968 "Highlights of the 1966-1967 Art
Season," Aldrich Museum of
Contemporary Art, Ridgefield,
Connecticut, catalog
1968 "Contemporary Arts Exhibition,"
Indianapolis Museum of Art,
Indianapolis, Indiana
1968 "Made of Plastic," Flint Institute of
Arts, Flint, Michigan, catalog
1969 "American Report: The 1960s," Denver
Art Museum, Denver, Colorado
1970 "String and Rope," Sidney Janis
Gallery, New York, New York
1970 "National Women Artists," Skidmore
College, Saratoga Springs, New York
1970 "American Sculpture," University of
Nebraska Art Galleries, Sheldon
Memorial Sculpture Garden, Lincoln,
Nebraska, catalog
1971 "Women Artists from the Permanent
Collection," Whitney Museum of
American Art, New York, New York
1971 "Artists at Work," Finch College
Museum of Art, New York, New York
1972 "Women: A Historical Survey of Works
by Women Artists," Salem College,
Winston-Salem, North Carolina; North
Carolina Museum of Art, Raleigh,
North Carolina, catalog
1972 "Women in Art," Brainerd Art Gallery,
Potsdam, New York, catalog
1972 "American Women: 20th Century,"
Lakeview Center for the Arts and
Sciences, Peoria, Illinois, catalog
1973 "Bertrand Russell Centennial
Exhibition," Tate Gallery, London,
Great Britain
1976 "American Artists '76: A Celebration,"
Marion Koogler McNay Art Institute,
San Antonio, Texas, catalog
1976 "Recent Acquisitions," Solomon R.
Guggenheim Museum, New York, New
York
1978 "American Sculpture," Solomon R.
Guggenheim Museum, New York, New
York
1979 "Fiftieth Anniversary Celebration for
Artists in the Permanent Collection,"
Whitney Museum of American Art,
New York, New York

1980, "Sculptors Guild Annual Exhibition,"
83, Lever House New York, New York,
84, catalog
85
1985 "Seventy-Five Years of Pittsburgh Art,"
Pittsburgh Plan for Art, Pittsburgh,
Pennsylvania, catalog

Selected Public Collections
All Souls Unitarian Church, New York, New
York
Art Institute of Chicago, Chicago, Illinois
Des Moines Art Center, Des Moines, Iowa
Marion Koogler McNay Art Institute, San
Antonio, Texas
Metropolitan Museum of Art, New York, New
York
Museum of Modern Art, New York, New York
Saint Louis Art Museum, St. Louis, Missouri
Solomon R. Guggenheim Museum, New
York, New York
Tate Gallery, London, Great Britain
Whitney Museum of American Art, New York,
New York

Selected Award
1974 Alumni Merit Award, Carnegie-Mellon
University, Pittsburgh, Pennsylvania

Preferred Sculpture Media
Fiber and Plastic

Additional Art Fields
Printmaking and Watercolor

Selected Bibliography
Broadd, Harry A. "The String Constructions
of Sue Fuller." *Arts & Activities* vol. 91 no.
3 (April 1982) pp. 32-36, illus.
Browne, Rosalind. "Sue Fuller: Threading
Transparency." *Art International* vol. 16 no.
1 (January 20, 1972) pp. 37-40, illus.
Hedges, Elaine and Ingrid Wendt, comps. *In
Her Own Image: Women Working in the
Arts*. New York: Feminist Press and
McGraw-Hill, 1980.
Shirey, David L. "Art: Esthetic Magic Of
Geometry." *The New York Times* (Sunday,
April 23, 1978) p. L.I.18, illus.
"String Patterns: Artist Works with Colorful
Twine." *Life Magazine* vol. 27 no. 18
(October 31, 1949) p. 77, illus.

Gallery Affiliation
Chalette International
9 East 88 Street
New York, New York 11928

Mailing Address
Post Office Box 1580
Southampton, New York 11968

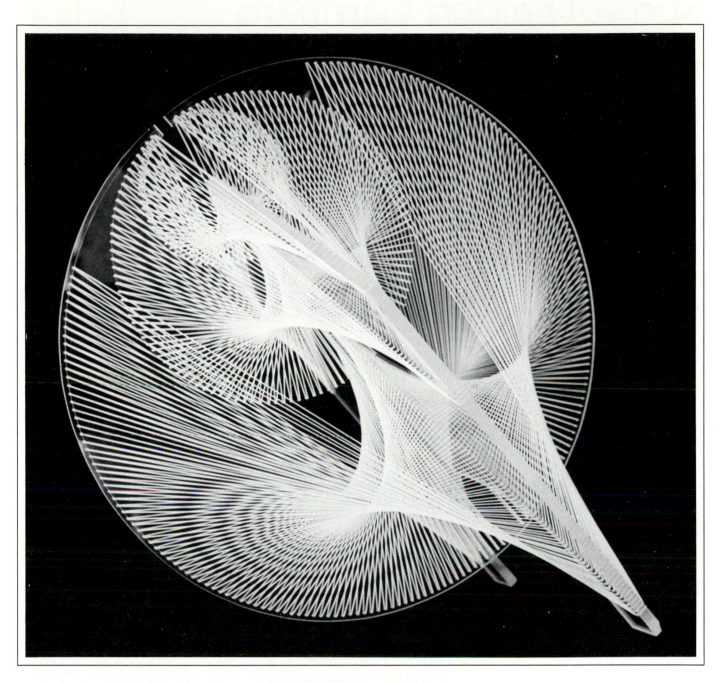

String Construction No.731. 1981. Lucite and Teflon, 22"h x 19"w x 27"d. Collection Marion Koogler McNay Art Institute, San Antonio, Texas. Photograph by Jay Hoops.

Artist's Statement
"To know the past, to live the present, to be the future, encompassing our dear planet and the universe in its myriad forms of life requires an aesthetic of reality beyond mere appearance. For me the order of harmonious being is best expressed in geometric progression—the unseen law of growth and form for ages past and beyond the space age."

Sue Fuller

Retha Walden Gambaro

née Retha Walden
(Husband Stephen A. Gambaro)
Born December 9, 1917 Lenna, Oklahoma

Education and Training
1969 Corcoran School of Art, Washington,
D.C.; study in sculpture with Berthold
Schmutzhart
1970- Schmutzhart Studio, Washington,
71 D.C.; additional study with Berthold
Schmutzhart

Selected Individual Exhibitions
1970 Art League of Northern Virginia,
Alexandria, Virginia
1973 Art Patch, Springfield, Virginia
1983 Somerstown Studios & Gallery,
Somers, New York
1984 Ya-Ta-Hey Gallery, New London,
Connecticut
1985 Gallery Lounge, Armour J. Blackburn
University Center, Howard University,
Washington, D.C.

Selected Group Exhibitions
1974 "The Artist and the Animal," FAR
Gallery, New York, New York, catalog
1976 "The Indian, the Land, and the
Animal," Folger Shakespeare Library,
Washington, D.C.
1977 "Indian Artists, 1977: American Indian
Society of Washington, D.C.," Via
Gambaro Gallery, Washington, D.C.,
catalog
1980 "Eleventh International Sculpture
Conference," Area Galleries and
Institutions, Washington, D.C.
(Sponsored by International Sculpture
Center, Washington, D.C.)
1980 "National American Indian Women's
Art Show," Via Gambaro Gallery,
Washington, D.C., catalog
1981 "A Slice of Washington Art," Office of
the Mayor, Washington, D.C.
1982 "Night of the First Americans," John F.
Kennedy Center for the Performing
Arts, Washington, D.C.

1982 "Contemporary North American Indian
Art," National Museum of Natural
History, Smithsonian Institution,
Washington, D.C., catalog
1984 "Shadows Caught: Images of Native
Americans by Stephen Gambaro,"
Thomas Gilcrease Institute of
American History and Art, Tulsa,
Oklahoma
1984 "Contemporary Art Exhibition,"
Washington Cathedral, Washington,
D.C.
1984 "New York Expo," New York, New
York (Represented by Tallix Foundry,
Peekskill, New York)
1984 "Native American Art," The Gallery,
York, Pennsylvania
1984 "Interact '84: Arts of the American
West Benefit Exhibition," Fox Chase
Cancer Center, Philadelphia,
Pennsylvania, catalog
1984 "The American Indian Exhibition,"
Slater Memorial Museum, Norwich,
Connecticut
1985 "She Holds Her Own: Transitions &
Traditions of Native American
Women," GCCA Catskill Gallery,
Catskill, New York

Selected Public Collections
Bedford Public Library, Bedford, Virginia
B'nai B'rith Klutznick Museum, Washington,
D.C.
Cascade Christian Church, Grand Rapids,
Michigan
Church of the Reformation, Washington, D.C.
City of Washington, D.C., Convention Center,
Washington, D.C.
Daybreak Art Center, Seattle, Washington
Fox Chase Cancer Center, Philadelphia,
Pennsylvania
Gallaudet College, Washington, D.C.
Howard University, Washington, D.C.
Inspirational Art Foundation, Washington,
D.C.
National Arboretum, Washington, D.C.
Rossier, White and Company, Atlanta,
Georgia
Rossmoor Interfaith Chapel, Rockville,
Maryland
St. Thomas Episcopal Church, Upper
Marlboro, Maryland
United States Department of Parks,
Arlington, Virginia
Wesley Theological Seminary, Washington,
D.C.

Selected Private Collections
Dr. Joseph Allen, Houston, Texas
Senator Mark Hatfield, Washington, D.C.
Marjorie Holmes, Lake Jackson, Virginia
Hugh S. Hunt, Potomac, Maryland
James Nicholson, Englewood, New Jersey

Selected Awards
1970 Best in Show, "Annual Members
Exhibition," Art League of Northern
Virginia, Alexandria, Virginia
1980 Distinguished Service Award,
American Indian Society of
Washington, D.C.

Preferred Sculpture Media
Metal (cast) and Stone

Selected Bibliography
American Artists of Renown. Gilmer, Texas:
Wilson, 1981.
Isberg, Emily. "The Arts: A Gallery of Modern
Indian Art." *The Washington Post*
(Thursday, June 22, 1978) p. D.C.5, illus.
*Ohoyo One Thousand: A Resource Guide of
American Indian/Alaska Native Women.*
Wichita Falls, Texas: The Center, 1982.
Swift, Mary. "Profiles Portfolio of Regional
Artists: Retha Walden Gambaro
(Washington, D.C.)." *Art Voices/South* vol.
3 no. 3 (May-June 1980) p. 46, illus.

Gallery Affiliation
Via Gambaro Gallery
416 11 Street SE
Washington, D.C. 20003

Mailing Address
414 11 Street SE
Washington, D.C. 20003

Artist's Statement

"I am most influenced by artists whose works speak of some spiritual experience—works which show the inspiration from which they come. The sculptural material I use is dictated by the subject and its intricacies. Therefore, I find the use of many mediums very rewarding. Accomplishing a special communication among sculptor, sculpture and viewer is my aim and my reward."

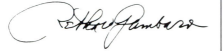

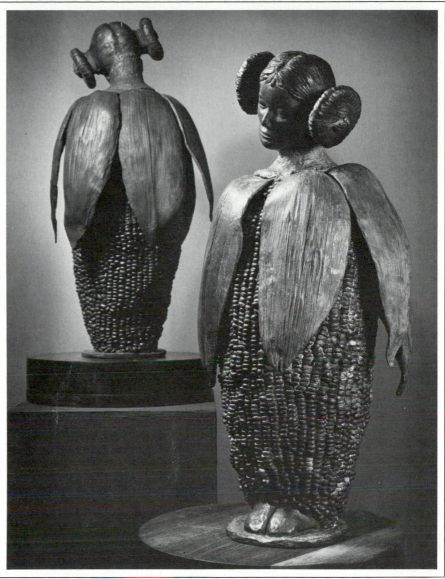

Corn Woman. 1983. Bronze, 20″h. Photograph by Stephen A. Gambaro.

Moira Marti Geoffrion

née Moira Magdalena Marti
(Husband Charles Albert Geoffrion)
Born November 7, 1944 Olney, Maryland

Education and Training
1965 B.F.A., Painting, Boston University, Boston, Massachusetts
1967- Indiana University Bloomington,
69 Bloomington, Indiana; study in figure sculpture and investment casting of aluminum and bronze with Jean Paul Darriau
1974 M.F.A., Sculpture and Fiber, Southern Illinois University at Edwardsville, Edwardsville, Illinois; study with James Sampson and Arturo Sandoval
1980 Towson State University, Baltimore, Maryland; study in ceramic shell casting with Dana Stewart and Ron Young (Pre-Conference Program, "Eleventh International Sculpture Conference," International Sculpture Center, Washington, D.C.)

Selected Individual Exhibitions
1976 Rasdall Gallery, Lexington, Kentucky
1976 Wabash College, Crawfordsville, Indiana
1976 Northland College, Ashland, Wisconsin
1977 Corvallis Art Center, Corvallis, Oregon
1977 Andrews University, Berrien Springs, Michigan
1978 O'Shaughnessy Gallery, University of Notre Dame, Notre Dame, Indiana, catalog
1978 North River Community Gallery, Chicago, Illinois
1978 Ball State Art Gallery, Ball State University, Muncie, Indiana
1979 Western Illinois University, Macomb, Illinois
1979 Miami University, Oxford, Ohio
1979, Zaks Gallery, Chicago, Illinois
80,
81,
85
1980 Maude I. Kerns Art Center, Eugene, Oregon
1980 University of Dallas, Irving, Texas
1981 Goshen College, Goshen, Indiana
1982 Slippery Rock State College, Slippery Rock, Pennsylvania
1983 Kit Basquin Gallery, Milwaukee, Wisconsin

Selected Group Exhibitions
1976 "Indianapolis 500 Show," Indianapolis Museum of Art, Indianapolis, Indiana
1976 "Women Artists: Here and Now," O'Shaughnessy Gallery, University of Notre Dame, Notre Dame, Indiana, catalog

1976- "Annual Faculty Exhibition,"
85 O'Shaughnessy Gallery, University of Notre Dame, Notre Dame, Indiana
1976 "Indiana Artists: Then and Now," Ball State University, Muncie, Indiana, catalog
1977 "Women's Symposium," Turman Gallery, Indiana State University, Terre Haute, Indiana
1978 "Group Invitational," Fort Wayne Museum of Art, Fort Wayne, Indiana
1979 "Small Works," 80 Washington Square East Gallery, New York, New York
1979 "Nineteenth National Art Round-Up," Las Vegas Art Museum, Las Vegas, Nevada
1979 "National Sculpture 1979," Traveling Exhibition, Gallery 303, Georgia Southern University, Statesboro, Georgia, catalog
1979, "Annual Regional Juried Exhibition,"
80 Midwest Museum of American Art, Elkhart, Indiana
1980, "Michiana Regional Art Exhibition,"
81 Art Center, South Bend, Indiana
1980 "Outside Indianapolis," Herron Gallery, Indianapolis, Indiana
1981 "Constructions: Hard and Soft," Indianapolis Art League, Indianapolis, Indiana
1981 "Selections: Sixty-Eighth Indiana Artists Show," Indianapolis Museum of Art, Indianapolis, Indiana, catalog
1981 "Men and Women in the Arts," West Bend Gallery of Fine Arts, West Bend, Wisconsin
1981 "Regional Exhibition," Indianapolis Art League, Indianapolis, Indiana
1982 "Sculpture—Sculptural," Marycrest College, Daveort, Iowa
1982 "Women Artists: Indiana—New York Connection," Traveling Exhibition, Snite Museum of Art, University of Notre Dame, Notre Dame, Indiana, catalog
1982 "Twelfth International Sculpture Conference," Area Galleries and Institutions, Oakland, California and San Francisco, California (Sponsored by International Sculpture Center, Washington, D.C.)
1982 "The Essence of Line," Lafayette Art Center, Lafayette, Indiana
1982 "Paper Invitational," Gallery Sanchez, San Francisco, California
1982, Chicago International Art Exposition,"
83, Navy Pier, Chicago, Illinois
84 (Represented by Zaks Gallery, Chicago, Illinois), catalog
1983 "New Works Invitational," Boston City Hall, Boston, Massachusetts
1985 "The Sculpted Line," Art Center, South Bend, Indiana, catalog

Selected Public Collections
Aero Club of Indianapolis, Wier Cook Airport, Indianapolis
Ball State University, Muncie, Indiana
Crowe Chizek, Incorporated, South Bend, Indiana

Goddard College, Plainfield, Vermont
Indianapolis Museum of Art, Indianapolis, Indiana
Midwest Museum of American Art, Elkhart, Indiana
NIBCO, Incorporated, Elkhart, Indiana
Wabash College, Crawfordsville, Indiana

Selected Private Collections
Kit Basquin, Milwaukee, Wisconsin
Dr. Stefan and Dr. Judith Baumrin, New York, New York
Mr. and Mrs. Peter Lowes, Zomba, Malawi
Ron Shintaku, Chicago, Illinois
Thomas Smith, Chicago, Illinois

Selected Awards
1982 Independent Research (India), Indiana Consortium for International Programs and Fulbright Foundation
1983, Faculty Research Grant, Institute for
84 Advancement of Research and Scholarship, University of Notre Dame, Notre Dame, Indiana and Mellon Foundation

Preferred Sculpture Media
Metal (cast), Paper (handmade) and Wood

Additional Art Field
Drawing

Teaching Position
Associate Professor of Sculpture, University of Notre Dame, Notre Dame, Indiana

Gallery Affiliation
Zaks Gallery
620 North Michigan Avenue
Chicago, Illinois 60611

Mailing Address
814 Ashland Avenue
South Bend, Indiana 46616

Artist's Statement

"My recent sculpture consists of structures combined with fragments of handmade paper or cast bronze forms which are predominantly linear gestures in space. This stems from a concern for the interplay of light creating illusion and shadow as it falls on and between constructed space, thus defining alternative forms of existence.

"I draw and paint on each of my works bringing to the surface a painterly quality and textural substance. The use of color varies from delicate and warm muted tones to bold and aggressive shades which echo living in village Africa and more recent travels in India. In these countries, the juxtaposition of the stark and the brilliant are set in harmony in ways not experienced in western culture."

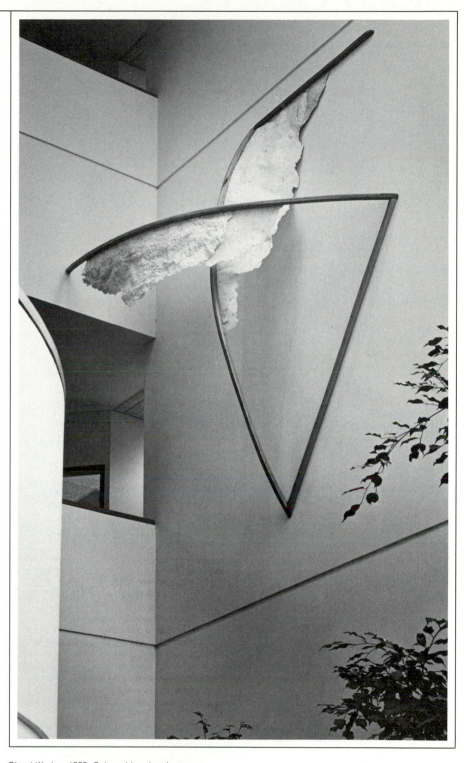

Cloud Wedge. 1980. Oak and handmade paper, 14'h x 14'w x 3'd. Collection Crowe Chizek, Incorporated, South Bend, Indiana. Photograph by Stephen R. Moriarty.

217

Helen Gilbert

née Helen Odell
Born April 6, 1922 Mare Island, California

Education and Training
1943 B.A., Art, Mills College, Oakland, California
1968 M.F.A., Multimedia, University of Hawaii at Manoa, Honolulu, Hawaii
1969- Polaroid Corporation, Cambridge,
70 Massachusetts; independent research in light as an art media with special emphasis on light polarization
1979- Pratt Graphics Center, New York,
80 New York

Selected Individual Exhibitions
1970 Esther Robles Gallery, Los Angeles, California
1971, Honolulu Academy of Arts, Honolulu,
77 Hawaii
1972, Gima's Gallery, Honolulu, Hawaii
75
1975 Janus Gallery, Los Angeles, California
1978 Wailea Art Gallery, Wailea, Hawaii
1981 Wallnuts Gallery, Philadelphia, Pennsylvania
1982 Arras Gallery, New York, New York
1983 Contemporary Arts Center, Honolulu, Hawaii
1984 Galerie Edward Meissner, Hamburg, Germany, Federal Republic, catalog
1984 Galerie Maghi Bettini, Amsterdam, Netherlands
1984 Seasons Gallery, The Hague, Netherlands

Selected Group Exhibitions
1968- "Artists of Hawaii Annual Exhibition,"
77, Honolulu Academy of Arts, Honolulu,
81 Hawaii
1970 "New Sculpture," Esther Baer Gallery, Santa Barbara, California
1970 "California/Hawaii Exhibition," San Diego Museum of Art, San Diego, California
1971 "Gallery Artists," Esther Robles Gallery, Los Angeles, California
1977 "Group Exhibition," Ruth Shaffner Gallery, Los Angeles, California
1979 "The Language of Abstraction," Betty Parsons Gallery, New York, New York, catalog
1980, "Basel Art Fair," Basel, Switzerland
81, (Represented by Galerie Edward
82, Meissner, Hamburg, Germany, Federal
84 Republic), catalog
1981 "Helen Gilbert and Ken Bushnell," Sande Webster Gallery, Philadelphia, Pennsylvania
1981, "New York Art Expo," New York, New
82 York (Represented by Galerie Edward Meissner, Hamburg, Germany, Federal Republic)
1982 "Düsseldorf Art Fair," Düsseldorf, Germany, Federal Republic (Represented by Galerie Edward Meissner, Hamburg, Germany, Federal Republic)
1984 "Connections: Science into Art," Summit Art Center, Summit, New Jersey
1984 "Lichteffecten in Schilderkunst en Sculpture," Technische Hogeschool Delft, Delft, Netherlands, catalog

Selected Public Collections
Berkeley Art Center, Berkeley, California
Castle & Cooke, Honolulu, Hawaii
Contemporary Arts Center, Honolulu, Hawaii
Hawaii State Foundation on Culture and the Arts, Honolulu, Hawaii
Honolulu Academy of Arts, Honolulu, Hawaii
San Diego Museum of Art, San Diego, California

Selected Private Collections
Jakki Milici, Honolulu, Hawaii
Alfred Ostheimer, Honolulu, Hawaii
Dura Tufting, Kassel, Germany, Federal Republic

Selected Awards
1969, Individual Research Grant, University
70 of Hawaii at Manoa, Honolulu, Hawaii
1978 Special Project Grant, Ford Foundation

Preferred Sculpture Media
Varied Media

Additional Art Fields
Painting and Printmaking

Teaching Position
Professor of Art, University of Hawaii at Manoa, Honolulu, Hawaii

Gallery Affiliations
Galerie Edward Meissner
Lemsahler Dorfstrasse 51
2000 Hamburg 65
Hamburg, Germany, Federal Republic

Arras Gallery
Fifth Avenue at 57 Street
New York, New York 10019

Mailing Address
2081 Keeaumoku Place
Honolulu, Hawaii 96822

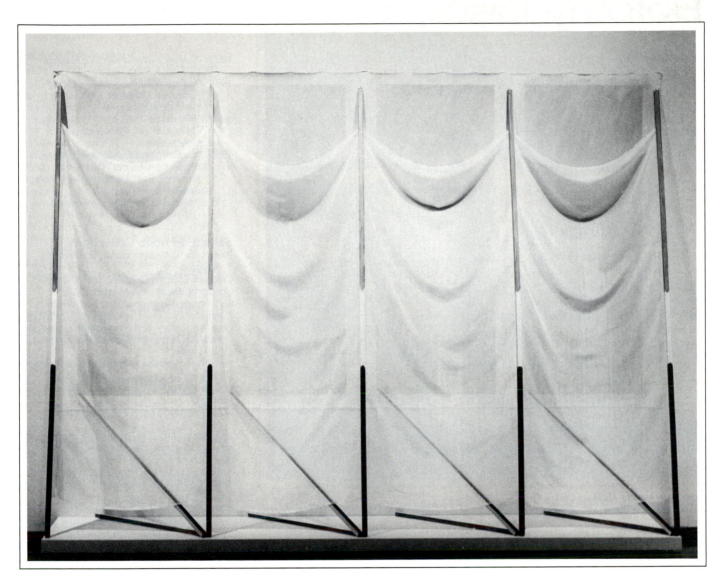

Veronica. 1983. Wood, canvas, gauze and light, 6′h x 8′w x 18″d. Photograph by Gil Gilbert.

Artist's Statement

"I have always been interested in the emotive breadth of music and dance, experienced in time. I am attempting to capture the essence of this experience in my light sculptures.

"The experiments with light polarization began in 1968 when I decided to adapt filters which had been made for use in scientific research to my work as an artist. I found that simple, geometric lines and forms have the capacity to suggest an endless variety of forms, space and light. They seem to have the borderless sensation of music or dance.

"Nature is also a source of imagery. Underlying geometric orders in crystal and plant structures, the color produced by light diffraction, reflection and transmission, provide a skeletal matrix for shape systems which move in harmonic progressions and contribute to the illusion of changing spatial depth."

Linnea Glatt

née Linnea Elizabeth
(Husband James B. Cinquemani, Jr.)
Born September 8, 1949 Bismarck, North
Dakota

Education and Training
1971 B.S., Art Education, Moorhead State
University, Moorhead, Minnesota
1972 M.A., Printmaking, University of Dallas,
Irving, Texas

Selected Individual Exhibition
1976 D.W. Co-Op, Dallas, Texas

Selected Group Exhibitions
1973 "Faculty Exhibition," Dallas Art
Institute, Dallas, Texas
1974 "Faculty Exhibition," Dallas County
Community College, Dallas, Texas
1974 "Faculty Exhibition," Richland College,
Dallas, Texas
1975 "Tarrant County Annual Exhibition,"
Fort Worth Art Museum, Fort Worth,
Texas
1976 "Valentine's Invitational," Frogmore
Gallery, Dallas, Texas
1976 "Women in the Arts Festival,"
University of Texas at Arlington,
Arlington, Texas
1977 "Linnea Glatt and Ann Stautberg,
D.W. Co-Op, Dallas, Texas
1978, "Dallas Art," Dallas City Hall,
80 Dallas, Texas

1978 "Invitational Exhibition," Cedar Valley
College, Lancaster, Texas
1979 "Linnea Glatt and Gilda Pervin,"
Brookhaven College, Farmers Branch,
Texas
1979 "Gift Wrap," DW Gallery, Dallas, Texas
1979 "Linnea Glatt and Marvin Coats," DW
Gallery, Dallas, Texas
1979 "Fire: One Hundred Texas Artists,"
Contemporary Arts Museum, Houston,
Texas, catalog
1979 "12: Artists Working in North Texas,"
Dallas Museum of Fine Arts, Dallas,
Texas
1980 "Group Invitational," DW Gallery,
Dallas, Texas
1981 "Invitational '81," Longview Museum
and Arts Center, Longview, Texas
1982 "Linnea Glatt and Gene Bavinger," 500
Exposition Gallery, Dallas, Texas
1983 "Showdown," Alternative Museum,
New York, New York; Diverse Works,
Houston, Texas, catalog
1983 "Third Annual Connemara Sculpture
Exhibition," Connemara Conservancy,
Allen, Texas
1983 "Construction/Site," DW Gallery,
Dallas, Texas
1984 "Rooted in North Dakota," North
Dakota Museum of Art, Grand Forks,
North Dakota
1984 "Sculpture Invitational," The Art
Center, Waco, Texas
1984 "Presenting Nine, Gihon Foundation
Awards Exhibition," D-Art Visual Art
Center, Dallas, Texas
1984 "A Place to Perform," Bath House
Cultural Center, Dallas, Texas
1985 "Fifth Texas Sculpture Symposium,"
Sited throughout Central Business
District, Dallas, Texas and Connemara
Conservancy, Allen, Texas (Sponsored
by Texas Sculpture Symposium,
Dallas, Texas), catalog

Selected Public Collections
Bath House Cultural Center, Dallas, Texas
Richland College, Dallas, Texas

Selected Private Collection
Laura Carpenter, Dallas, Texas

Selected Awards
1981 First Place, Design Art Competition,
Lawton Arts and Humanities Council,
Lawton, Oklahoma
1982 Anne Giles Kimbrough Fund Grant,
Dallas Museum of Fine Arts, Dallas,
Texas
1984 Artist in Residence, Bath House
Cultural Center, Dallas, Texas; City of
Dallas, Texas; Texas Commission on
the Arts and National Endowment for
the Arts

Preferred Sculpture Media
Varied Media

Teaching Position
Adjunct Assistant Professor of Sculpture,
Southern Methodist University, Dallas,
Texas

Selected Bibliography
Freudenheim, Susan. "Art: Linnea Glatt's
Sculpted Sanctuaries." *Texas Homes* vol. 8
no. 6 (June 1984) pp. 22-23, 25, illus.
Hickey, Dave. "Linnea Glatt and Patricia
Tillman: Post-Modern Options." *Artspace*
vol. 9 no. 3 (Summer 1985) pp. 28-31, illus.
Lippard, Lucy R. "Report from Houston:
Texas Red Hots." *Art in America* vol. 67
no. 4 (July-August 1979) pp. 30-31.
Raczka, Robert. "Linnea Glatt." *Artspace* vol.
5 no. 3 (Summer 1981) pp. 21-23, illus.
Rifkin, Ned. "'Fire' or Flood?" *Artweek* vol. 10
no. 10 (March 10, 1979) pp. 1, 16.
Rifkin, Ned. "An Uneven Dozen." *Artweek* vol.
10 no. 34 (October 20, 1979) p. 3.

Gallery Affiliation
DW Gallery
3200 Main Street
Dallas, Texas 75226

Mailing Address
2412 Hardwick Street
Dallas, Texas 75208

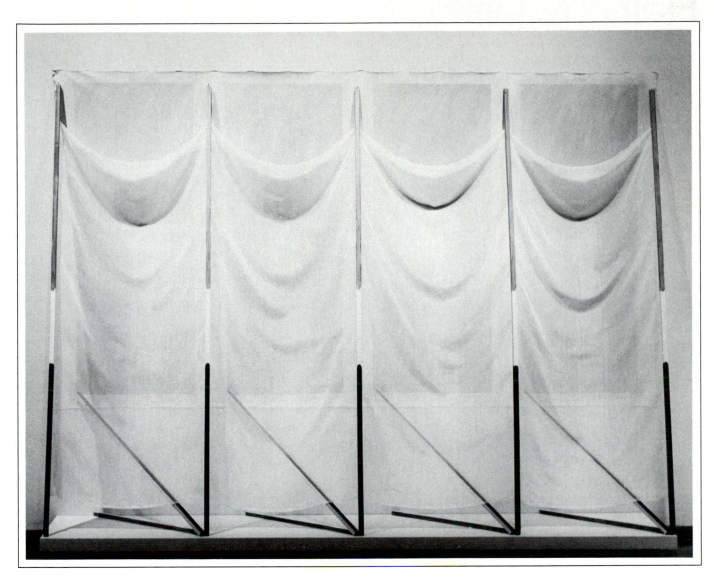

Veronica. 1983. Wood, canvas, gauze and light, 6′h x 8′w x 18″d. Photograph by Gil Gilbert.

Artist's Statement

"I have always been interested in the emotive breadth of music and dance, experienced in time. I am attempting to capture the essence of this experience in my light sculptures.

"The experiments with light polarization began in 1968 when I decided to adapt filters which had been made for use in scientific research to my work as an artist. I found that simple, geometric lines and forms have the capacity to suggest an endless variety of forms, space and light. They seem to have the borderless sensation of music or dance.

"Nature is also a source of imagery. Underlying geometric orders in crystal and plant structures, the color produced by light diffraction, reflection and transmission, provide a skeletal matrix for shape systems which move in harmonic progressions and contribute to the illusion of changing spatial depth."

Nolan Gilbert

Dorothy Gillespie

née Dorothy Merle
(Husband Bernard Israel)
Born June 29, 1920 Roanoke, Virginia

Education and Training
1938- Maryland Institute College of Art,
42 Baltimore, Maryland
1943- Art Students League, New York, New
44 York
1943- Clay Club Sculpture Center, New
44 York, New York
1943- Atelier 17, New York, New York
44

Selected Individual Exhibitions
1970, Loeb Student Center, Contemporary
71, Arts Gallery, New York University,
75, New York, New York
76
1975, Women's Interart Center, New York,
81 New York
1976, Fordham University at Lincoln Center,
80, New York, New York
84
1976, New School for Social Research,
79 New York, New York
1976, Caldwell College, Caldwell, New
80 Jersey
1977 Jersey City Museum, Jersey City, New
Jersey
1977 Aaron Berman Gallery, New York, New
York
1978 Art Gallery of Fells Point, Baltimore,
Maryland
1978 Sawhill Gallery, James Madison
University, Harrisonburg, Virginia
1979 Fort Wayne Museum of Art, Fort
Wayne, Indiana, catalog
1980 Virginia Miller Galleries, Coral Gables,
Florida
1980 Deacon Gallery, Wilmington, North
Carolina
1981, Somerhill Gallery, Durham, North
84 Carolina
1981 Fine Arts Gallery, University of
Arkansas at Little Rock, Little Rock,
Arkansas, catalog
1981, Meredith Contemporary Art, Baltimore,
85 Maryland
1981 University of Alabama in Tuscaloosa,
Tuscaloosa, Alabama, catalog
1982 College of Notre Dame of Maryland,
Baltimore, Maryland
1982 Fontana Gallery, Philadelphia,
Pennsylvania
1982 Museum of Art, Fort Lauderdale,
Florida, catalog
1982, Gallery One, Fort Worth, Texas
84
1982 Squibb Gallery, Princeton, New Jersey

1983 Roanoke College, Salem, Virginia
1983 Adelphi University, Garden City, New
York
1983 Washington County Museum of Fine
Arts, Hagerstown, Maryland
1983 Delaware Art Museum, Wilmington,
Delaware
1984 Lehigh University, Bethlehem,
Pennsylvania
1984 Abilene Christian University, Abilene,
Texas
1984 Meredith College, Raleigh, North
Carolina
1984 Asheville Art Museum, Asheville, North
Carolina
1985 Huntsville Museum of Art, Huntsville,
Alabama
1985 Academy of the Arts, Easton,
Maryland
1985 Reynolds House, Winston-Salem,
North Carolina

Selected Group Exhibitions
1973 "Women Choose Women," New York
Cultural Center, New York, New York,
catalog
1974 "Works in Progress," Women's Interart
Center, New York, New York, catalog
1974 "Women in Contemporary Art," Lehigh
University, Bethlehem, Pennsylvania
1975 "Works on Paper," Brooklyn Museum,
Brooklyn, New York, catalog
1976 "Visual Artists Coalition," New York
University, New York, New York,
catalog
1976 "Dorothy Gillespie, Alice Neel,
Charlotte Robinson, Sylvia Sleigh,"
Fendrick Gallery, Washington, D.C.,
catalog
1977 "Art Today USA," Iran American
Society, Teheran, Iran, catalog
1977 "Paper," Michael C. Rockefeller Arts
Center Gallery, Fredonia, New York,
catalog
1977 "Refractions: Seena Donneson,
Dorothy Gillespie, Phyllis Mark, Ronnie
Reder," Fort Lauderdale Museum of
the Arts, Fort Lauderdale, Florida,
catalog
1977 "Papier," Summit Art Center, Summit,
New Jersey, catalog
1978- "Sculpture in Color, New York Upper
79 East River A.R.E.A. Outdoor Sculpture
Exhibition," Roosevelt Island, New
York, catalog
1979 "Women Painters and Sculptors,"
Cummings Arts Center, Connecticut
College, New London, Connecticut,
catalog
1980 "Art for Architectural Spaces," The
Arts Gallery, Baltimore, Maryland
1980 "Sculpture 1980," Maryland Institute
College of Art, Baltimore, Maryland,
catalog
1980 "Energy," University of Arkansas at
Little Rock, Little Rock, Arkansas,
catalog
1982 "Ten Years of Public Art," Public Art
Fund, New York, New York, catalog

1982 "Gallery Invitational," Eva Mannus
Gallery, Atlanta, Georgia
1983 "Inaugural Permanent Collection
Exhibition," Radford University,
Radford, Virginia
1983 "Invitational Exhibtion," Philadelphia
College of Art, Philadelphia,
Pennsylvania
1984 "Ordinary and Extraordinary Uses:
Objects by Artists," Guild Hall
Museum, East Hampton, New York,
catalog
1985 "Multiscale Sculpture," St. Amand
Gallery, New York, New York

Selected Public Collections
Birmingham Museum of Art, Birmingham,
Alabama
Caldwell College, Caldwell, New Jersey
Corroon & Black, Washington, D.C.
Fort Wayne Museum of Art, Fort Wayne,
Indiana
Grey Art Gallery and Study Center, New
York University Art Collection, New York,
New York
Herbert F. Johnson Museum of Art, Ithaca,
New York
Hollywood Federal Bank, Coral Gables,
Florida
Huntsville Museum of Art, Huntsville,
Alabama
Museum of Art, Fort Lauderdale, Florida
Newark Museum, Newark, New Jersey
New School for Social Research, Human
Relations Center, New York, New York
North Carolina Museum of Art, Raleigh, North
Carolina
Ohio Dominican College, Columbus, Ohio
Radford University, Radford, Virginia
Roanoke Museum of Fine Arts, Roanoke,
Virginia
Solomon R. Guggenheim Museum, New
York, New York
Stadtmuseum und Stadtische
Kunstsammlungen, Darmstadt, Germany,
Federal Republic
Tel Aviv Museum, Helena Rubinstein Pavilion,
Tel Aviv, Israel

Selected Awards
1976 Honorary Doctorate of Fine Arts,
Caldwell College, Caldwell, New
Jersey
1981 Woman of the Year, James Madison
University, Harrisonburg, Virginia
1983 Distinguished Alumni Award, Maryland
Institute College of Art, Baltimore,
Maryland

Preferred Sculpture Media
Metal (rolled) and Paper

Additional Art Field
Painting

Related Professions
Guest Curator, Lecturer and Visiting Artist

Selected Bibliography

Edgar, Natalie. "Dorothy Gillespie." *Arts Magazine* vol. 52 no. 6 (February 1978) p. 15, illus.

Rembert, Virginia Pitts. "Dorothy Gillespie's Way: The Past Encountered." *Arts Magazine* vol. 56 no. 2 (October 1981) cover, pp. 148-153, illus.

Rembert, Virginia Pitts. "Dorothy Gillespie." *Arts Magazine* vol. 57 no. 8 (April 1983) p. 8, illus.

Shirey, David L. "Dorothy Gillespie." *Arts Magazine* vol. 52 no. 3 (November 1977) p. 23, illus.

Weinstein, Ann. "Dorothy Gillespie." *Arts Magazine* vol. 54 no. 2 (October 1979) p. 17, illus.

Mailing Address
549 West 52 Street
New York, New York 10019

Artist's Statement
"As a painter concerned with illusion rather than the making of an object in space, I must have at some point wanted to see what would happen if the illusion became reality and painting became three-dimensional. It was natural that I would take line, color and form from the canvas and place it in the viewer's space.

"I hope that the visual, philosophical statement of my work is the miracle of eternal change, the moment of motion, the knowledge that nothing remains the same for even a second. I attempt to portray imminent movement and energy, manipulating colors and materials available today so that the eye can carry some mystical message to the soul. Adding the remembrances of childhood—bouncing balls, roller coasters, yo-yos and shooting stars—state some of the joy and magic that I find so abundant in life."

Royale. 1984. Enamel on aluminum, 56″ diameter. Collection Huntsville Museum of Art, Huntsville, Alabama. Photgraph by Maynard Hicks.

Linnea Glatt

née Linnea Elizabeth
(Husband James B. Cinquemani, Jr.)
Born September 8, 1949 Bismarck, North
 Dakota

Education and Training
1971 B.S., Art Education, Moorhead State
 University, Moorhead, Minnesota
1972 M.A., Printmaking, University of Dallas,
 Irving, Texas

Selected Individual Exhibition
1976 D.W. Co-Op, Dallas, Texas

Selected Group Exhibitions
1973 "Faculty Exhibition," Dallas Art
 Institute, Dallas, Texas
1974 "Faculty Exhibition," Dallas County
 Community College, Dallas, Texas
1974 "Faculty Exhibition," Richland College,
 Dallas, Texas
1975 "Tarrant County Annual Exhibition,"
 Fort Worth Art Museum, Fort Worth,
 Texas
1976 "Valentine's Invitational," Frogmore
 Gallery, Dallas, Texas
1976 "Women in the Arts Festival,"
 University of Texas at Arlington,
 Arlington, Texas
1977 "Linnea Glatt and Ann Stautberg,
 D.W. Co-Op, Dallas, Texas
1978, "Dallas Art," Dallas City Hall,
 80 Dallas, Texas

1978 "Invitational Exhibition," Cedar Valley
 College, Lancaster, Texas
1979 "Linnea Glatt and Gilda Pervin,"
 Brookhaven College, Farmers Branch,
 Texas
1979 "Gift Wrap," DW Gallery, Dallas, Texas
1979 "Linnea Glatt and Marvin Coats," DW
 Gallery, Dallas, Texas
1979 "Fire: One Hundred Texas Artists,"
 Contemporary Arts Museum, Houston,
 Texas, catalog
1979 "12: Artists Working in North Texas,"
 Dallas Museum of Fine Arts, Dallas,
 Texas
1980 "Group Invitational," DW Gallery,
 Dallas, Texas
1981 "Invitational '81," Longview Museum
 and Arts Center, Longview, Texas
1982 "Linnea Glatt and Gene Bavinger," 500
 Exposition Gallery, Dallas, Texas
1983 "Showdown," Alternative Museum,
 New York, New York; Diverse Works,
 Houston, Texas, catalog
1983 "Third Annual Connemara Sculpture
 Exhibition," Connemara Conservancy,
 Allen, Texas
1983 "Construction/Site," DW Gallery,
 Dallas, Texas
1984 "Rooted in North Dakota," North
 Dakota Museum of Art, Grand Forks,
 North Dakota
1984 "Sculpture Invitational," The Art
 Center, Waco, Texas
1984 "Presenting Nine, Gihon Foundation
 Awards Exhibition," D-Art Visual Art
 Center, Dallas, Texas
1984 "A Place to Perform," Bath House
 Cultural Center, Dallas, Texas
1985 "Fifth Texas Sculpture Symposium,"
 Sited throughout Central Business
 District, Dallas, Texas and Connemara
 Conservancy, Allen, Texas (Sponsored
 by Texas Sculpture Symposium,
 Dallas, Texas), catalog

Selected Public Collections
Bath House Cultural Center, Dallas, Texas
Richland College, Dallas, Texas

Selected Private Collection
Laura Carpenter, Dallas, Texas

Selected Awards
1981 First Place, Design Art Competition,
 Lawton Arts and Humanities Council,
 Lawton, Oklahoma
1982 Anne Giles Kimbrough Fund Grant,
 Dallas Museum of Fine Arts, Dallas,
 Texas
1984 Artist in Residence, Bath House
 Cultural Center, Dallas, Texas; City of
 Dallas, Texas; Texas Commission on
 the Arts and National Endowment for
 the Arts

Preferred Sculpture Media
Varied Media

Teaching Position
Adjunct Assistant Professor of Sculpture,
Southern Methodist University, Dallas,
Texas

Selected Bibliography
Freudenheim, Susan. "Art: Linnea Glatt's
 Sculpted Sanctuaries." *Texas Homes* vol. 8
 no. 6 (June 1984) pp. 22-23, 25, illus.
Hickey, Dave. "Linnea Glatt and Patricia
 Tillman: Post-Modern Options." *Artspace*
 vol. 9 no. 3 (Summer 1985) pp. 28-31, illus.
Lippard, Lucy R. "Report from Houston:
 Texas Red Hots." *Art in America* vol. 67
 no. 4 (July-August 1979) pp. 30-31.
Raczka, Robert. "Linnea Glatt." *Artspace* vol.
 5 no. 3 (Summer 1981) pp. 21-23, illus.
Rifkin, Ned. "'Fire' or Flood?" *Artweek* vol. 10
 no. 10 (March 10, 1979) pp. 1, 16.
Rifkin, Ned. "An Uneven Dozen." *Artweek* vol.
 10 no. 34 (October 20, 1979) p. 3.

Gallery Affiliation
DW Gallery
3200 Main Street
Dallas, Texas 75226

Mailing Address
2412 Hardwick Street
Dallas, Texas 75208

Artist's Statement

"I spent my childhood in North Dakota. Many of my pieces trace their origins to the haystacks, rockpiles, farm shelters and other impressions from the Midwest. *Support System. A Place to Be Alone* is reminiscent of sites of that region. My sculpture has evolved from relatively small-scale cast wall panels of cement and plaster to room-size freestanding sculpture and large outdoor permanent installations. The intent of the work has altered to expose the inside of the sculpture inviting the viewer to enter or pass through."

Linnea Glatt

Support System. A Place to Be Alone. 1981. Galvanized metal, wood and concrete, 144"h x 48"w x 48"d. Installation view 1982. "Linna Glatt and Gene Bavinger," 500 Exposition Gallery, Dallas, Texas. Photograph by John Walker.

223

Martha Glowacki

née Martha Jane Appleyard
(Husband Thomas Robert Glowacki)
Born October 19, 1950 Milwaukee, Wisconsin

Education and Training
1972 B.S., Art Education, University of Wisconsin-Madison, Madison, Wisconsin
1978 M.F.A., Metalsmithing, University of Wisconsin-Madison, Madison, Wisconsin; study with Fred Fenster and Eleanor Moty

Selected Individual Exhibitions
1982 Kit Basquin Gallery, Milwaukee, Wisconsin
1983 Chautauqua Art Association Galleries, Chautauqua, New York
1984 Michigan Technological University, Houghton, Michigan

Selected Group Exhibitions
1977 "Copper, Brass, Bronze," University of Arizona, Tucson, Arizona, catalog
1979 "The Unpainted Portrait: Contemporary Portraiture in a Non-Traditional Media," John Michael Kohler Arts Center, Sheboygan, Wisconsin, catalog
1979 "National Metals Invitational," Visual Arts Center of Alaska, Anchorage, Alaska

1980 "Flux, Fusion, Fireworks," Contemporary Crafts Gallery, Portland, Oregon
1980 "Bell, Austin, Glowacki, Lyman and Pintor," Synopsis Gallery, Winnetka, Illinois
1980 "Young Americans: Metal," American Craft Museum, New York, New York, catalog
1981 "Wisconsin Directions 3: The Third Dimension," Milwaukee Art Museum, Milwaukee, Wisconsin, catalog
1981 "Contemporary Metals: Focus on Idea," Museum of Art, Washington State University, Pullman, Washington, catalog
1982 "Metals National Invitational," Western Carolina University, Cullowhee, North Carolina
1983 "National Metals Invitational," University of Wisconsin-Whitewater, Whitewater, Wisconsin
1983 "'83 Metal," Montana State University, Bozeman, Montana
1983 "Crafts: An Expanding Definition," John Michael Kohler Arts Center, Sheboygan, Wisconsin, catalog
1983 "Ornaments and Fabrications: The Art of Metalsmithing," Cohen Gallery, Denver, Colorado
1984 "The Alternative Image II," John Michael Kohler Arts Center, Sheboygan, Wisconsin, catalog
1984 "National Metal Invitational," University of Alabama in Birmingham, Birmingham, Alabama
1984 "Metals," University Gallery, Southwest Texas State University, San Marcos, Texas, catalog
1984 "Personal Sculpture," Esther Saks Gallery, Chicago, Illinois
1984 "Fourth Wisconsin Biennial Exhibition," Madison Art Center, Madison, Wisconsin, catalog
1985- "Wisconsin Survey-3-D Art Today,"
86 Traveling Exhibition, Memorial Union, University of Wisconsin-Madison, Madison, Wisconsin (Sponsored by *Wisconsin Academy Review*, Madison, Wisconsin), catalog

Selected Award
1982 Individual Artist's Fellowship, National Endowment for the Arts

Preferred Sculpture Media
Metal (soldered) and Varied Media

Additional Art Field
Photography

Related Profession
Art Instructor

Selected Bibliography
Ela, Janet. "Metallurgists Weld, Cast, Carve to Produce Art." *Wisconsin Academy Review* vol. 31 no. 2 (March 1985) pp. 61-71, illus.
Koplos, Janet. "Martha Glowacki, Fields of Reference." *Metalsmith* vol. 3 no. 3 (Summer 1983) pp. 19-22, illus.

Gallery Affiliation
Seuferer-Chosy Gallery
218 North Henry Street
Madison, Wisconsin 53703

Mailing Address
2325 Oakridge Avenue
Madison, Wisconsin 53704

Artist's Statement

"The landscape and the marks of man's presence, particularly in agricultural patterns and in built structures, are the themes of my work. The images are frozen in time but recall the shifting interrelationships of space, time and reality in nature. Metal permits precise, delicate control over the surface and form of the object. The sensuous quality of the material and the intimate scale are an integral part of my work."

Martha Glowacki

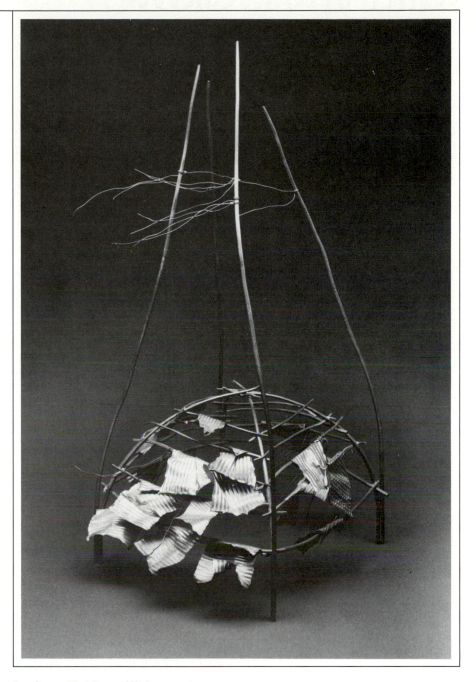

Four Corners Wind Dome. 1982. Bronze and copper, 16"h x 8"w x 8"d. Photograph by James E. Threadgill.

Kathryn A. Glowen

née Kathryn Anne Kernick
(Husband Ronald Gordon Glowen)
Born August 29, 1941 Seattle, Washington

Education and Training
1959- Washington State University, Pullman,
60 Washington
1960- University of Tulsa, Tulsa, Oklahoma
62
1975 Factory of Visual Art, Seattle,
 Washington
1977 Fiberworks Gallery, Berkeley,
 California; workshop in fiber
 constructions

Selected Individual Exhibitions
1983 Upper Rucker Studios, Everett,
 Washington
1983 Gallery II, Washington State
 University, Pullman, Washington

Selected Group Exhibitions
1975, "Northwest Crafts Biennial," Henry Art
77 Gallery, Seattle, Washington
1980, "Group Exhibition," Uptown Artworks
81 Gallery, Seattle, Washington
1980 "Natural Fibers," Bellevue Art Museum,
 Bellevue, Washington
1981 "The Box Show," Gallery Whidbey,
 Langley, Washington
1981 "The Farm Project," Frogbird Farm,
 Arlington, Washington
1983 "Northwest Designer Craftsmen,"
 Southwest King County Art Museum,
 Highline Community College, Midway,
 Washington

1983 "Seattle Exchange," Seattle Pacific
 University, Seattle, Washington;
 University of Nevada Reno, Reno,
 Nevada
1983- "Regional Crafts: A Contemporary
84 Perspective," Bellevue Art Museum,
 Bellevue, Washington
1984 "Northwest Designer Craftsmen."
 Northwest Craft Center Gallery,
 Seattle, Washington
1984 "Five Women Artists: Kathy Glowen,
 Jo Hockenhull, Nancy Kieffer, Carson
 Legree and Gloria Seborg," Spokane
 Falls Community College, Spokane,
 Washington
1984- "Country of Origin, USA: A Decade of
85 Contemporary Rugs," Traveling
 Exhibition, Textile Museum,
 Washington, D.C., catalog
1984 "Debra Sherwood, Laura Sindell, Hugh
 Webb and Kathryn Glowen," Whatcom
 Museum of History and Art,
 Bellingham, Washington
1984 "Images of Eclectic Energy," Cheney
 Cowles Memorial Museum, Spokane,
 Washington
1984 "Northwest Designer Craftsmen,"
 Contemporary Crafts Gallery, Tacoma,
 Washington
1985 "Northwest Designer Craftsmen,"
 Memorial Union Concourse, Oregon
 State University, Corvallis, Oregon
1985 "Northwest Designer Craftsmen," New
 Art Gallery, North Central Washington
 Museum, Wenatchee, Washington
1985 "O.K.—U.S.A. National Sculpture
 Exhibition," University Gallery,
 Cameron University, Lawton,
 Oklahoma, catalog

Selected Public Collection
Lower Columbia College, Applied Arts
 Building, Longview, Washington

Selected Private Collections
Hartley and Suzy Birstein, Vancouver, British
 Columbia, Canada
Dr. Ross and Marilyn Lysohir Coates,
 Pullman, Washington
Fel and Ginger Deleeuw, Seattle,
 Washington
Dr. and Mrs. John Patrick Heffron, Kirkland,
 Washington
Chester and Melissa Nelson, Mukilteo,
 Washington

Preferred Sculpture Media
Varied Media and Wood

Selected Bibliography
Norklun, Kathi. "Exhibitions: Kathy Glowen."
 Artweek vol. 14 no. 12 (March 26, 1983) p.
 4, illus.
Stevens, Rebeccah A. T. "Country of Origin,
 USA: A Decade of Contemporary Rugs."
 Fiberarts vol. 11 no. 3 (May-June 1984) pp.
 60-65, illus.

Mailing Address
Frogbird Farm
18404 Burn Road
Arlington, Washington 98223

Artist's Statement

"My current sculpture reflects my love of animals and nature—this is why I am an amateur naturalist. I am also influenced by organic materials and the colorful and decorative patterning of ethnic cultures. My sculpture takes the form of painted totems and assemblages which combine these interests. They are memory associations, such as childhood and rural shapes, adorned with metaphorical and nostalgic objects. The results are both whimsical and serious."

Kathryn A. Glowen

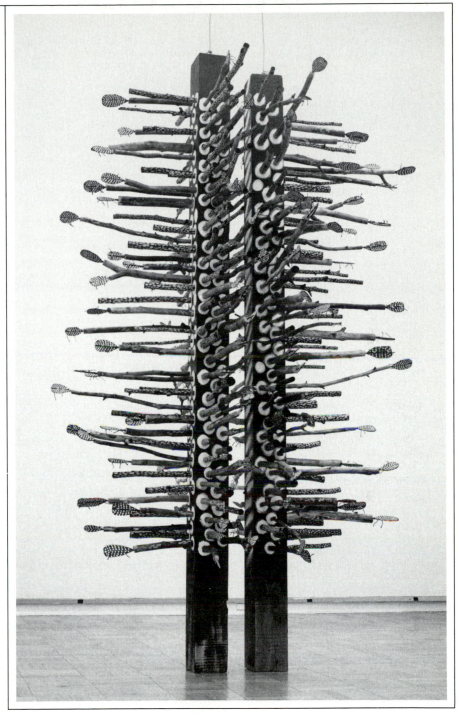

Guinea Totem. 1982-1983. Painted wood, 102"h x 60"w x 60"d. Photograph by Ron Glowen.

227

Betty Gold

née Betty Virginia Lee
Born February 15, 1935 Austin, Texas

Education and Training
1955- University of Texas at Austin, Austin,
56 Texas; study in art history
1966- Studio of Octavio Medellin, Dallas,
70 Texas; study in sculpture
1966- Studio of Ruth Tears, Dallas, Texas;
70 study in painting

Selected Individual Exhibitions
1972, Gargoyle Gallery, Aspen, Colorado
74,
76
1973 Rubicon Gallery, Los Altos, California
1974 Elaine Horwitch Gallery, Scottsdale,
Arizona
1974 Downtown Gallery, Honolulu, Hawaii
1975, Esther-Robles Gallery, Los Angeles,
77 California
1976 Central University of Iowa, Pella, Iowa
1976 Laguna Gloria Art Museum, Austin,
Texas
1977, Frances Aronson Gallery, Atlanta,
80 Georgia
1977, Charles W. Bowers Memorial Museum,
81 Santa Ana, California, catalog
1979 Landau/Alexander Gallery, Los
Angeles, California
1979 Phoenix Art Museum, Phoenix, Arizona
1980 New Orleans Museum of Art, New
Orleans, Louisiana
1980 Milwaukee Art Center, Milwaukee,
Wisconsin
1980 Palos Verdes Art Center, Rancho
Palos Verdes, California
1980 Shidoni Gallery, Tesuque, New Mexico
1980 Indianapolis Museum of Art,
Indianapolis, Indiana
1980 Baum/Silverman Gallery, Los Angeles,
California, catalog
1981 Pacific Gallery, Stockton, California
1981 Delaware Art Museum, Wilmington,
Delaware

1981 Palm Springs Desert Museum, Palm
Springs, California
1981 Archer M. Huntington Art Gallery,
Austin, Texas
1982 Jan Baum Gallery, Los Angeles,
California
1982 Deicas Art, La Jolla, California
1983 Patrick Gallery, Austin, Texas
1985 Boise State University, Boise, Idaho

Selected Group Exhibitions
1970 "Twelfth Annual Eight State Exhibition
of Painting and Sculpture," Oklahoma
Art Center, Oklahoma City, Oklahoma,
catalog
1974 "All Colorado Art Exhibition," Denver
Art Museum, Denver, Colorado,
catalog
1974 "Group Exhibition," Esther-Robles
Gallery, Los Angeles, California
1975 "Gallery Exhibition," Berenson Gallery,
Miami, Florida
1975 "Christmas Show," Gargoyle Gallery,
Aspen, Colorado
1980 "Sculpture: Proposals for Downtown
Los Angeles," Kirk de Gooyer Gallery,
Los Angeles, California
1981, "Annual Outdoor Sculpture Show,"
82 Shidoni Gallery, Tesuque, New
Mexico, catalog
1983- "Modern Mythology by 13 Sculptors,"
85 Fordham University, Bronx, New York
1984 "A Broad Spectrum: Contemporary
Los Angeles Painters and Sculptors
'84," Design Center, Los Angeles,
California, catalog

Selected Public Collections
American Film Institute, Los Angeles,
California
Apollo Corporation, Chicago, Illinois
Biloxi Library and Cultural Center, Biloxi,
Mississippi
Charles W. Bowers Memorial Museum, Santa
Ana, California
City of Los Angeles, Harbor Freeway,
Downtown, Los Angeles, California
Delaware Art Museum, Wilmington, Delaware
Greynolds Park, Miami, Florida
Hartwood Acre Park, Pittsburgh,
Pennsylvania
Indianapolis Museum of Art, Indianapolis,
Indiana
Milwaukee Art Museum, Milwaukee,
Wisconsin
New Orleans Museum of Art, New Orleans,
Louisiana
Newport Harbor Art Museum, Newport
Beach, California
Oakland Museum, Oakland, California
Pacific Design Center, Los Angeles,
California
Palm Springs Desert Museum, Palm Springs,
California
Phoenix Art Museum, Phoenix, Arizona
Radford University, Radford, Virginia
Unified Savings and Mortgage Company,
Carson, California
University of Texas at Austin, Austin, Texas

Selected Private Collections
Johnny Carson, Los Angeles, California
Mr. and Mrs. Sidney Feldman, Bay Harbor
Islands, Florida
Norman and Florence Horowitz, Encino,
California
Jack Shea, Palm Springs, California
Dr. and Mrs. Jack Wohlstadter, Los Angeles,
California

Preferred Sculpture Media
Metal (cast) and Metal (welded)

Additional Art Fields
Painting and Photography

Selected Bibliography
Ball, Maudette. "Angles and Curves in Steel."
Artweek vol. 11 no. 30 (September 20,
1980) p. 5, illus.
Brown, Betty Ann. "Harmonies of Duality."
Artweek vol. 15 no. 7 (February 18, 1984)
p. 5.
Pincus, Robert L. "Galleries: Wilshire Center."
Los Angeles Times (Friday, February 5,
1982) calendar section, p. 11, illus.
Temko, Susannah. "Reviews: Betty Gold at
Jan Baum, Los Angeles." Images & Issues
vol. 4 no. 6 (May-June 1984) p.56, illus.
Wortz, Melinda. "The Nation Los Angeles: Is
There Any Way Out?" Art News vol. 78 no.
6 (Summer 1979) pp. 158, 160.

Gallery Affiliation
Jan Baum Gallery
170 South La Brea Avenue
Los Angeles, California 90064

Mailing Address
1324 Pacific Avenue
Venice, California 90291

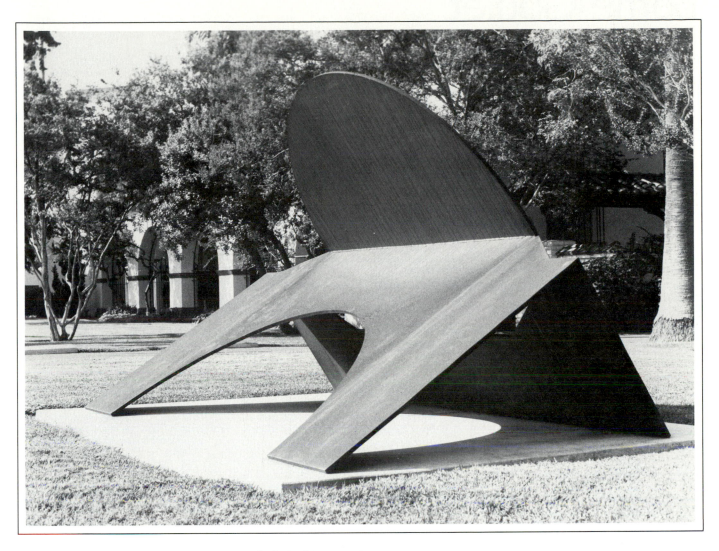

Monumental Holistic II. 1981. Welded steel, 7'h x 12'w x 8'd. Collection Charles W. Bowers Memorial Museum, Santa Anna, California.

Artist's Statement

"After leaving figurative work a decade ago, I have been solely involved with refining the language of the rectangle. The first series divided the rectangular solid into two or three separate shapes which fit together as parallel columns not unlike the yin and yang quality of Oriental art.

"In the second series I took a large flat surface, divided it into sections (from three to nine) and reassembled them, arriving at the term 'holistic.' Thus an object may achieve a reality greater than the sum of its parts; in effect it can exist independently. I have executed these thoughts not only in steel but in bronze, acrylic, drawings, collage and tapestries.

"I am presently concerned with the placement of rectangles forming a number of different sculptures from one basic pattern of shapes. I have adapted a new term for these works, *chōdo,* an ancient Chinese word meaning arrangement."

Betty Gold

Lorrie Goulet

née Josephine Helen Lorraine
Born August 17, 1925 Riverdale, New York

Education and Training
1932- Inwood Pottery Studios, New York,
36 New York; study in ceramic sculpture with Aimée La Prince Voorhees
1943- Black Mountain College, Black
44 Mountain, North Carolina; study in sculpture with José de Creeft

Selected Individual Exhibitions
1948, Clay Club Sculpture Center, New
55 York, New York
1951 Cheney Library, Hoosick Falls, New York
1959, The Contemporaries Gallery, New
62 York, New York
66,
68
1966 Rye Art Center, Rye Public Library, Rye, New York
1968 New School Associates Gallery, New School for Social Research, New York, New York
1969 Temple Emeth, Teaneck, New Jersey
1971 Kennedy Galleries, New York, New
73, York, catalog
75,
78,
80,
83,
86

Selected Group Exhibitions
1936 "Children's Exhibition," American Museum of Natural History, New York, New York
1948, "Annual Exhibition: Contemporary
49, American Sculpture, Watercolors and
50, Drawings," Whitney Museum of
53, American Art, New York, New York,
55 catalog
1948- "Audubon Artists Annual Exhibition,"
53, National Academy of Design, New
65, York, New York, catalog
66,
73,
77
1949, "Annual Exhibition," Clay Club
52, Sculpture Center, New York, New
53, York, catalog
54
1949, "Annual Exhibition of Contemporary
50, Painting and Sculpture," Society of the
51† Four Arts, Palm Beach, Florida
1949, "Palm Beach Art League Members
50, Exhibition," Norton Gallery and School
51 of Art, West Palm Beach, Florida, catalog

1950 "Twelve Women Sculptors," Philadelphia Art Alliance, Philadelphia, Pennsylvania, catalog
1950- "Annual Exhibition of Painting and
62 Sculpture," Pennsylvania Academy of the Fine Arts, Philadelphia, Pennsylvania, catalog
1951 "Three-Dimensional For Modern Living," DeCordova and Dana Museum and Park, Lincoln, Massachusetts
1957 "World Trade Fair," Zagreb, Yugoslavia and Barcelona, Spain
1958 "Art U.S.A. '58," Madison Square Garden, New York, New York, catalog
1959- "Sculptors Guild Annual Exhibition,"
74 Lever House, New York, New York, catalog
1960 "Second Biennial of American Painting and Sculpture," Detroit Institute of Arts, Detroit, Michigan, catalog
1961 "Mechanism-Organism," New School for Social Research, New York, New York, catalog
1963, "Annual Juried Competition,"
66, Westchester Art Society, White Plains,
67 New York
1963 "Mother and Child in Modern Art," American Federation of Art, New York, New York, catalog
1964 "Fifteenth Annual New England Exhibition," Silvermine Guild of Artists, New Canaan, Connecticut, catalog
1964 "Collector's Choice," Philbrook Art Center, Tulsa, Oklahoma, catalog
1965 "Black Mountain College Exhibition," Carroll Reece Museum, Johnson City, Tennessee, catalog
1965 "World's Fair," Fine Arts Pavilion, New York, New York
1965 "Sculpture 1965," Foresta Hodgson Wood Memorial, Scarborough-on-Hudson, New York, New York
1966, "Annual Exhibition," National Academy
75, of Design, New York, New York,
77 catalog
1966 "Annual Area Exhibition of Work by Artists of Washington & Vicinity," Corcoran Gallery of Art, Washington, D.C., catalog
1971 "Summer Exhibition," Van Saun Park, Paramus, New Jersey
1973- "Erotic Art," New School for Social
74 Research, New York, New York, catalog
1978 "Invitational Exhibition," National Arts Club, New York, New York, catalog
1978 "Six Couples," Summit Art Center, Summit, New Jersey
1978 "The American View: Art from 1770-1978," Kennedy Galleries, New York, New York, catalog
1981 "Art of America: Selected Painting and Sculpture 1770-1981," Kennedy Galleries, New York, New York, catalog
1983 "The American Tradition of Realism, Part II: Painting and Sculpture of the 20th Century," Kennedy Galleries, New York, New York, catalog

Selected Public Collections
Bronx Municipal Hospital, Nurses Residence and School, Bronx, New York
New Jersey State Museum, Trenton, New Jersey
New York Public Library, Grand Concourse, Bronx, New York
Police and Fire Station Headquarters, Bronx, New York
Sarah Roby Foundation, New York, New York
Wichita Art Museum, Wichita, Kansas

Selected Private Collections
Senator William Benton, New York, New York
Mr. and Mrs. Louis Friedenthal, New York, New York
Mr. and Mrs. Milton Goldhair, New York, New York
Dr. and Mrs. Arthur E. Kahn, New York, New York
Gloria Vanderbilt, New York, New York

Selected Awards
1949 First Prize, "Twelfth Annual Exhibition of Contemporary Painting and Sculpture," Society of the Four Arts, Palm Beach, Florida
1964 First Prize, "Annual Juried Competition," Westchester Art Society, White Plains, New York
1967 Solten Engel Memorial Award, "Audubon Artists Annual Exhibition," National Arts Club, New York, New York, catalog

Preferred Sculpture Media
Stone and Wood

Additional Art Fields
Drawing and Poetry

Teaching Position
Sculpture Instructor, Art Students League, New York, New York

Selected Bibliography
Eliscu, Frank. Slate and Soft Stone Sculpture. Philadelphia: Chilton, 1972.
Fort, Ilene Susan. "Arts Reviews: Lorrie Goulet." Arts Magazine vol. 55 no. 3 (November 1980) pp. 25-26, illus.
Lunde, Karl. "Lorrie Goulet: Themes of Woman." Arts Magazine vol. 50 no. 1 (September 1975) pp. 82-83, illus.
Lunde, Karl. "Lorrie Goulet." Arts Magazine vol. 57 no. 8 (April 1983) p. 12, illus.
Papers included in the Archives of American Art, Smithsonian Institution, New York, New York.

Gallery Affiliation
Kennedy Galleries
40 West 57 Street
New York, New York 10019

Mailing Address
241 West 20 Street
New York, New York 10011

Artist's Statement
"My sculpture is the concrete image of my emotion...the idea of my spirit—a communication of what I understand and experience in life as a person and as an artist. It is a synthesis of forms I have observed in nature and conceived in my imagination—what my intuition as well as my eye unveils to me.

"I have worked almost exclusively with the human figure, and have found the female image, by far, the more expressive of my concept. To me woman is the half of humanity that resembles the mountains...the sea...the clouds...and is more closely linked with cyclical and spherical aspects of terrestrial and celestial movements. She is the natural symbol of the earth and all growing things.

"To express in the flow and curve of the forms the rhythms of nature as I see and feel them has been my purpose. I have endeavored to combine matter and spirit, to blend the things in the world which can be seen with those that can only be sensed. All, I feel, in nature is one, and in that oneness is both the darkness and radiance of life—whole and harmonious in the largest sense. This is the feeling, the essence of my spirit and my vision, which I wish to impart to my sculptures."

Lorrie Goulet

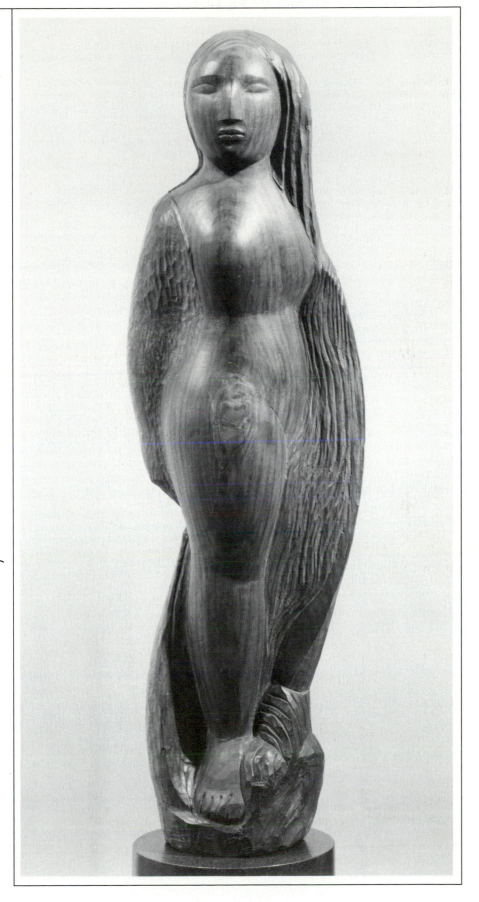

Salome. 1979. Wood, 35"h x 9"w x 9"d. Courtesy Kennedy Galleries, New York, New York. Photograph by Taylor & Dull.

Gloria Graham

née Gloria Griffing
Born February 1, 1940 Beaumont, Texas

Education and Training
1962 University of California, Berkeley, Berkeley, California; study in painting and sculpture
1962 B.F.A., Painting, Baylor University, Waco, Texas
1963 University of Wisconsin-Madison, Madison, Wisconsin; study in ceramics and painting
1964 Study in ceramic sculpture with Jacques Manessier, Paris, France
1965-66 University of New Mexico, Albuquerque, New Mexico; study in ceramics and painting

Selected Individual Exhibitions
1975 Motel Gallery, Albuquerque, New Mexico
1979 George Belcher Gallery, San Francisco, California
1980 Linda Durham Gallery, Santa Fe, New Mexico, catalog
1980 Scottsdale Center for the Arts, Scottsdale, Arizona, catalog
1983 Linda Durham Gallery, Santa Fe, New Mexico
1983 University of Nebraska Art Galleries, Sheldon Memorial Art Gallery, Lincoln, Nebraska
1984 Craig Cornelius Gallery, New York, New York

Selected Group Exhibitions
1975, "Annual Purchase Show," Art Museum, 76, University of New Mexico, 77 Albuquerque, New Mexico
1976 "Invitational Exhibition," Roswell Museum and Art Center, Roswell, New Mexico
1977 "New Mexico Crafts Biennial," Museum of International Folk Art, Santa Fe, New Mexico
1977 "Group Exhibition," Quay Gallery, San Francisco, California
1978 "Clay Objects, Gloria Graham; Paintings, Allan Graham," Smith Andersen Gallery, Palo Alto, California
1978 "Thirtieth Anniversary Show," Contemporary Arts Museum, Houston, Texas
1978 "Clay," Delahunty Gallery, Dallas, Texas
1979 "New Mexico in the Bay Area," Syntex Gallery, Palo Alto, California
1979 "One Space/Three Visions," Albuquerque Museum, Albuquerque, New Mexico, catalog
1979 "New Mexico: Space and Images," Craft and Folk Art Museum, Los Angeles, California
1980 "Ceramics: New Definitions," Museum of The Southwest, Midland, Texas
1980 "Here and Now: 35 Selected New Mexico Artists," Albuquerque Museum, Albuquerque, New Mexico, catalog
1981 "Six from Santa Fe," Moody Gallery, Houston, Texas
1981 "Rosalind Constable Invites, Festival of the Arts," Sweeney Convention Center, Santa Fe, New Mexico, catalog
1982 "In Place," Albuquerque Museum, Albuquerque, New Mexico, catalog
1983 "Chicago International Art Exposition 1983," Navy Pier, Chicago, Illinois (Represented by Linda Durham Gallery, Santa Fe, New Mexico), catalog

Selected Public Collections
Albuquerque Museum, Albuquerque, New Mexico
Denver Art Museum, Denver, Colorado
Museum of Fine Arts, Museum of New Mexico, Santa Fe, New Mexico
North Dakota Museum of Art, Grand Forks, North Dakota
Roswell Museum and Art Center, Roswell, New Mexico

Selected Private Collections
Mr. and Mrs. Stephen Albert, Millis, Massachusetts
William Dreyfus, New York, New York
Mr. and Mrs. Donald Magnin, San Francisco, California
Bruce Owen, San Francisco, California
Mr. and Mrs. Gifford Phillips, New York, New York

Selected Award
1977 Individual Craftsman's Fellowship, National Endowment for the Arts

Preferred Sculpture Media
Clay

Selected Bibliography
Peterson, William. "Reviews: Gallery Notes, New Mexico." *Artspace* vol. 5 no. 1 (December-Fall 1980) pp. 60-63, illus.
Peterson, William. "Reviews: Gloria Graham at Linda Durham, Santa Fe." *Artspace* vol. 7 no. 4 (Fall 1983) p. 63, illus.
Peterson, William. "Gloria Graham: Common Ground." *Artspace* vol. 9 no. 3 (Summer 1985) pp. 32-33, illus.
Price, V. B. "Gloria Graham." *Artspace* vol. 3 no. 3 (Spring 1979) pp. 20-24, illus.
Zwinger, Susan. "Gloria Graham." *American Ceramics* vol. 2 no. 4 (Winter 1984) pp. 54-55, illus.

Mailing Address
7218 Fourth Street NW
Albuquerque, New Mexico 87107

Artist's Statement

"What draws me into ceramic sculpture is simply form everchanging and clay ever-challenging. The combination allows a vehicle for ideas which I have not been able to maneuver as well in any other medium.

"I relish spontaneity and accident. The form of a piece is decisive while the surface remains open to whatever markings are derived from the firing. In order to jar myself from premeditated planning, I like to make many dissociated parts. At some later date they are combined with new work in order to create more immediate complex pieces.

"Technique is of minor consequence. Some parts are wheel-thrown or handbuilt, while others are formed by slumping clay over the nearest interesting object. Some of the final complexities of a piece often have evolved by solving problems in construction. I like the implication of those things close at hand as a source of form."

Gloria Graham

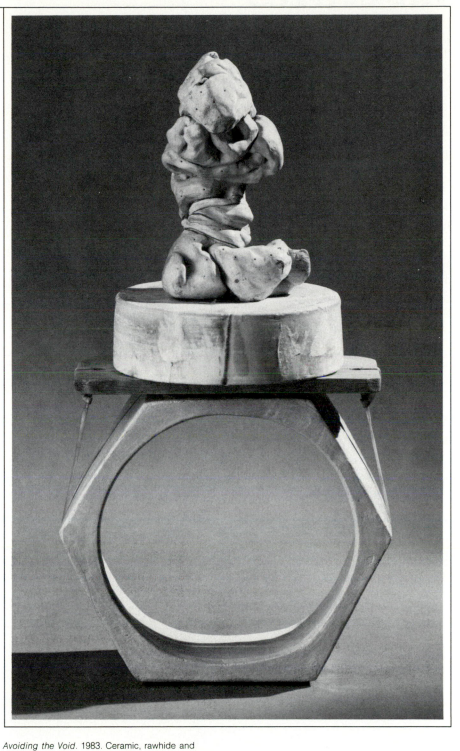

Avoiding the Void. 1983. Ceramic, rawhide and wooden board, 30"h x 16"w x 11"d. Photograph by Dick Kent.

Kā Graves

née Kathleen Dragunajtys
(Husband Keith Graves)
Born January 19, 1938 Detroit, Michigan

Education and Training
1974 A.A., General Studies, American
College, Paris, France
1976 B.F.A., Drawing, Arizona State
University, Tempe, Arizona
1978 Arizona State University, Tempe,
Arizona; study in fiberglass sculpture
with Bruce Rod
1979 M.F.A., Drawing, Arizona State
University, Tempe, Arizona

Selected Individual Exhibitions
1980 Memorial Union Gallery, Arizona State
University, Tempe, Arizona
1981, John Douglas Cline Gallery, Phoenix,
84 Arizona
1982 Scottsdale Center for the Arts,
Scottsdale, Arizona, catalog
1985 Fine Arts Center of Tempe, Tempe,
Arizona

Selected Group Exhibitions
1978 "Kā Graves and Rhonda Poe," Harry
Wood Gallery, Arizona State
University, Tempe, Arizona
1979 "Kā Graves and Rhonda Poe,"
Memorial Union Gallery, Arizona State
University, Tempe, Arizona
1980 "Kā Graves and Michael Barr,"
Lambert-Miller Gallery, Phoenix,
Arizona
1981 "Women in Contemporary Art," John
Douglas Cline Gallery, Phoenix,
Arizona

Selected Private Collections
John Douglas Cline, Scottsdale, Arizona
Zita Drake, Costa Mesa, California
Susan Hanch, Chicago, Illinois
Mark Pasek, St. Louis, Missouri
Marvin Schenck, Phoenix, Arizona

Preferred Sculpture Media
Varied Media

Additional Art Fields
Drawing and Painting

Teaching Position
Instructor, Drawing and Painting, Grand
Canyon College, Phoenix, Arizona

Selected Bibliography
Donnell-Kotrozo, Carol. "The Mythic Core."
Artweek vol. 13 no. 21 (June 5, 1982) p. 6,
illus.
Perlman, Barbara H. "PHOENIX: A 'Sun
Palace' in the Land of 'GOVT PROPERTY'
and Four-Wheel-Drive Cowboys." Art News
vol. 80 no. 10 (December 1981) pp.
119-121, illus.

Gallery Affiliation
John Douglas Cline Gallery
424 North Central Avenue
Phoenix, Arizona 85004

Mailing Address
921 West Lynwood
Phoenix, Arizona 85007

Artist's Statement

"My paintings, drawings and mixed media assemblages are celebrations of daily ceremonies, rituals, pageants and festivals, with an emphasis on ethnic and religious events. From a rich heritage through Polish and Hungarian parents, I have inherited a love of patterning, color, handmade clothing and costuming. Brought up as a Roman Catholic, I was accustomed to the beautiful brocaded robes, lace garments and headdresses of the clergymen, the medieval clothing of the priests and nuns, as well as the numerous ceremonial events.

"I have combined these influences with studies of various religions, art history and mythology to arrive at my own personal invented history that involves a pantheon of ancestors and deities, saints and chimaeras.

"My figures of children, adults, animals, some with masks and headdresses or facades, are all self-portraits. These works are my emissaries. They invite participation and communion in an ongoing celebration experienced by the individual viewers, an event known only to them."

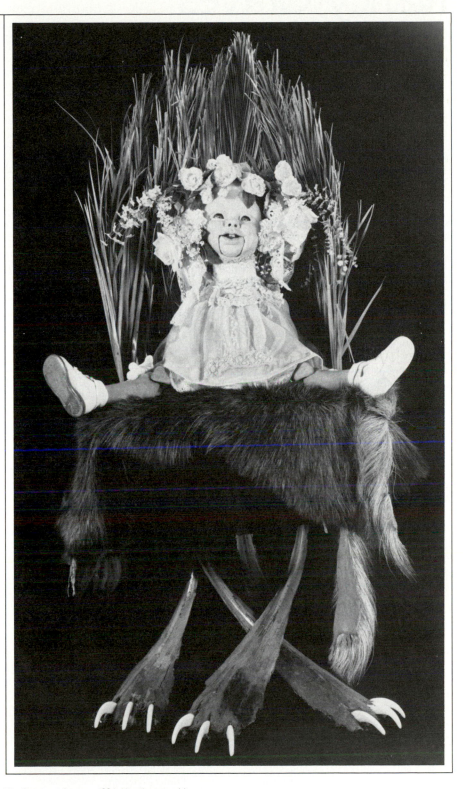

The Spryte of Spryng. 1984. Kinetic assemblage, 4'h x 3'w x 3'd. Photograph by Robert E. Sherwood.

Nancy Graves

née Nancy Stevenson
Born December 23, 1940 Pittsfield,
Massachusetts

Education and Training
1961 B.A., English Literature, Vassar
College, Poughkeepsie, New York
1962 B.F.A., Painting, School of Art and
Architecture, Yale University, New
Haven, Connecticut
1964 M.F.A., Painting, School of Art and
Architecture, Yale University, New
Haven, Connecticut

Selected Individual Exhibitions
1969 Whitney Museum of American Art,
New York, New York
1970, National Gallery of Canada, Ottawa,
71 Ontario, Canada
1971 Gallery Reese Palley, New York, New
York
1971 Neue Galerie Sammlung Ludwig,
Aachen, Germany, Federal Republic,
catalog
1971 Museum of Modern Art, New York,
New York
1972 Institute of Contemporary Art of The
University of Pennsylvania,
Philadelphia, Pennsylvania, catalog
1973 Berkshire Museum, Pittsfield,
Massachusetts
1978 Hammarskjöld Plaza Sculpture
Garden, New York, New York
1980, M. Knoedler & Co., New York, New
81, York, catalog
82,
84
1980- Albright-Knox Art Gallery, Buffalo,
81 New York, Traveling Exhibition to
museums throughout the United
States, retrospective and catalog
1982 M. Knoedler & Co., Zürich,
Switzerland
1983 Santa Barbara Contemporary Arts
Forum, Santa Barbara, California

Selected Group Exhibitions
1970 "1970 Annual Exhibition:
Contemporary American Sculpture,"
Whitney Museum of American Art,
New York, New York, catalog
1971 "Depth and Presence," Corcoran
Gallery of Art, Washington, D.C.
1971 "Six Sculptors," Museum of
Contemporary Art, Chicago, Illinois
1971 "Biennale de Paris des Jeunes
Artistes," Parc Floral, Paris, France
1972, "Documenta," Neue Galerie, Kassel,
77 Germany, Federal Republic
1974 "Kunst bleibt Kunst," Wallraf-Richartz-
Museum, Museum Ludwig, Cologne,
Germany, Federal Republic, catalog
1975 "Sculpture of the 1960s," Whitney
Museum of American Art, Downtown
Branch, New York, New York

1976 "200 Years of American Sculpture,"
Whitney Museum of American Art,
New York, New York, book
1977 "Strata: Nancy Graves, Eva Hesse,
Michelle Stuart, Jackie Winsor,"
Vancouver Art Gallery, Vancouver,
British Columbia, Canada, catalog
1978 "Peter Ludwig Collection,"
Contemporary Arts Museum, Teheran,
Iran
1978 "Art for Collectors," Toledo Museum of
Art, Toledo, Ohio
1979 "Weich und Plastik, Soft and Plastic,"
Kunsthaus, Zürich, Switzerland,
catalog
1980 "Eleventh International Sculpture
Conference," Area Galleries and
Institutions, Washington, D.C.
(Sponsored by International Sculpture
Center, Washington, D.C.)
1980 "Perceiving Modern Sculpture:
Selections for the Sighted and
Non-Sighted," Grey Art Gallery and
Study Center, New York University,
New York, New York
1981 "Bronze," Hamilton Gallery, New York,
New York
1981 "Twenty Artists: Yale School of Art
1950-1970," Yale University Art
Gallery, New Haven, Connecticut,
catalog
1982 "A Private Vision: Contemporary Art
from the Graham Gund Collection,"
Museum of Fine Arts, Boston,
Massachusetts, catalog
1982 "Metals: Cast-Cut-Coiled," Museum of
Art, Rhode Island School of Design,
Providence, Rhode Island
1982 "Casting: A Survey of Cast Metal
Sculpture in the 80s," Fuller Goldeen
Gallery, San Francisco, California,
catalog
1982 "In Our Time: Contemporary Arts
Museum 1948-1982," Contemporary
Arts Museum, Houston, Texas
1983 "1983 Biennial Exhibition:
Contemporary American Art," Whitney
Museum of American Art, New York,
New York, catalog
1983 "Modern Objects," Barbara Toll Fine
Arts Gallery, New York, New York
1983 "New Decorative Art," Berkshire
Museum, Pittsfield, Massachusetts,
catalog
1983- "American Accents," Traveling
85 Exhibition, The Gallery/Stratford,
Stratford, Ontario, Canada, catalog
1984- "Six in Bronze," Williams College
85 Museum of Art, Williamstown,
Massachusetts, catalog
1984 "American Women Artists Part I: 20th
Century Pioneers," Sidney Janis
Gallery, New York, New York, catalog
1984 "Art of the States: Works from a Santa
Barbara Collection," Santa Barbara
Museum of Art, Santa Barbara,
California, catalog
1984 "Citywide Contemporary Sculpture
Exhibition," Downtown Toledo, Ohio
(Sponsored by Arts Commission of
Greater Toledo, Ohio; Toledo Museum

of Art, Toledo, Ohio and Crosby
Gardens, Toledo, Ohio), catalog
1984 "Aspects of American Art of the
Future," Traveling Exhibition,
Wallraf-Richartz Museum, Museum
Ludwig, Cologne, Germany, Federal
Republic, catalog
1984 "Transformations," Katonah Gallery,
Katonah, New York
1984- "Primitivism in 20th Century Art:
85 Affinity of the Tribal and the Modern,"
Museum of Modern Art, New York,
New York, catalog
1984 "Hidden Desires, Six American
Sculptors," Neuberger Museum,
Purchase, New York; State University
of New York College at Purchase,
Purchase, New York
1984- "Works in Bronze, A Modern Survey,"
87 Traveling Exhibition, University Art
Gallery, Sonoma State University,
Rohnert Park, California, catalog
1984 "American Bronze Sculpture: 1850 to
the Present," Newark Museum,
Newark, New Jersey, catalog
1985 "Chromatics," Mendick Company, New
York, New York

Selected Public Collections
Akron Art Museum, Akron, Ohio
Albright-Knox Art Gallery, Buffalo, New York
Museum Moderner Kunst, Vienna, Austria
Museum of Modern Art, New York, New York
National Gallery of Canada, Ottawa, Ontario,
Canada
Neue Galerie Sammlung Ludwig, Aachen,
Germany, Federal Republic
Wallraf-Richartz-Museum, Museum Ludwig,
Cologne, Germany, Federal Republic
Whitney Museum of American Art, New York,
New York

Selected Private Collections
Mr. and Mrs. Barry Berkus, Santa Barbara,
California
Dr. and Mrs. Donald Fisher, Anderson,
California
Graham Gund Collection, Boston,
Massachusetts
Dr. J. H. Sherman, Baltimore, Maryland

Preferred Sculpture Media
Metal (cast)

Additional Art Fields
Drawing, Filmmaking, Printmaking and Stage
Design

Selected Bibliography

Amaya, Mario. "Artist's Dialogue: A Conversation with Nancy Graves." *Architectural Digest* vol. 39 no. 2 (February 1982) pp. 146, 150-151, 154-155, illus.

Anderson, Alexandra. "The New Bronze Age." *Portfolio* vol. 5 no. 2 (March-April 1983) pp. 79-83, illus.

Brooks, Valerie. "Where Sculptors Forge Their Art." *The New York Times* (Sunday, July 31, 1983) section 2, pp. 1, 24, illus.

Storr, Robert. "Natural Fictions." *Art in America* vol. 71 no. 3 (March 1983) pp. 118-121, illus.

200 Years of American Sculpture. New York: Whitney Museum of American Art, 1976.

Gallery Affiliation

M. Knoedler & Co.
19 East 70 Street
New York, New York 10021

Mailing Address

M. Knoedler & Co.
19 East 70 Street
New York, New York 10021

Artist's Statement

"I am interested in experimentation, working with different options and amplifying themes and attitudes about form. By the age of twelve I had come to think of art and natural history as one and had decided to make art my career. Through formal training and my own investigations, I developed an interest in naturalistic subject matter, creating sculptural objects of camels and their bone structures. Then I made films which recorded the natural rhythms of camels and birds and the moon itself (a fossil of the earth). I continued exploring the abstraction of natural forms in a series of paintings inspired by the camouflage of sea animals and insects in their natural environments and map-like drawings of the earth, similar to landscape paintings. More recent works translate into three dimensions a variety of two-dimensional forms from my earlier images as well as plants and other objects directly cast in bronze. The content is adapted to my concerns which are primarily those of creating a new way of seeing."

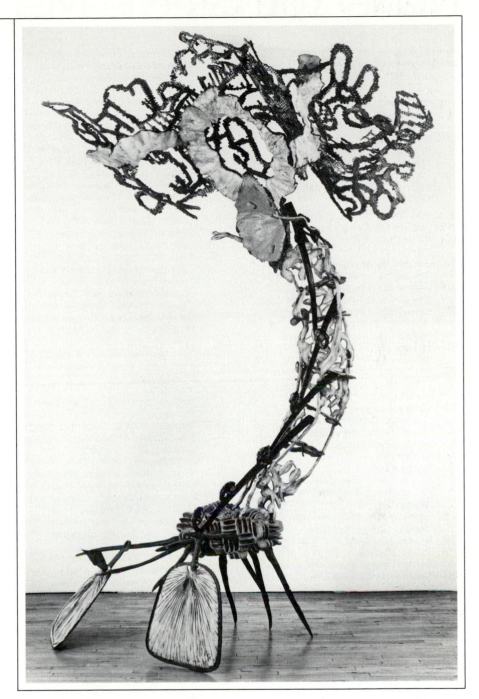

Cantileve. 1983. Bronze with polychrome patina, 98¾"h x 67"w x 55"d. Collection Whitney Museum of American Art, New York, New York. Courtesy M. Knoedler & Co., New York, New York. Photograph by Ken Cohen.

Marie Zoe Greene-Mercier

née Marie Zoe Mercier
(Husband Wesley Hammond Greene)
Born March 31, 1911 Madison, Wisconsin

Education and Training
1933 A.B., Fine Arts, Radcliffe College, Cambridge, Massachusetts
1937- New Bauhaus, Chicago, Illinois; study
38 in sculpture with Alexander Archipenko
1945- School of the Art Institute of Chicago;
46 study in sculpture with Albin Polášek

Selected Individual Exhibitions
1955 Department of Prints and Drawings, Art Institute of Chicago, Chicago, Illinois
1957 Galerie Duncan, Paris, France
1965 Galleria d'Arte Arno, Florence, Italy
1966 Galleria Numero, Milan, Italy
1968 Galleria Santo Stefano, Venice, Italy
1968, Centro Italo Americano, Trieste, Italy
70
1969 Galleria Gian Ferrari, Milan, Italy, catalog
1969 Galleria La Fenice, Venice, Italy
1970 New Forms Gallery, Athens, Greece
1971 Galerie de la Main de Fer, Perpignan, France, catalog
1972 Galleria Artivisive, Rome, Italy
1974 One Illinois Center, Chicago, Illinois (Sponsored by Metropolitan Structures, Incorporated, Chicago, Illinois)
1977 Centre Noroit, Arras, France
1977 Amerika Haus, Berlin, Germany, Federal Republic retrospective and catalog
1978 Galerie Musée de Poche, Paris, France
1979 Amerika Haus, Stuttgart, Germany, Federal Republic
1979, Alliance Française-Maison Française,
83 Chicago, Illinois
1981 Alliance Française, Washington, D.C.

Selected Group Exhibitions
1946 "Watercolors, Dorothy Frances Carter; Sculpture, Marie Zoe Greene," Photographic Stores Limited, Ottawa, Ontario, Canada
1947- "Fifty-Eighth Annual Exhibition of
48 American Paintings and Sculpture: Abstract and Surrealist American Art," Art Institute of Chicago, Chicago, Illinois, catalog
1948- "Professional Members' Annual
82 Exhibition," Arts Club of Chicago, Chicago, Illinois
1952 "165ᵉ Exposition Officielle des Beaux Arts," Grand Palais des Champs-Élysées, Paris, France, catalog

1952 "63ᵉ Exposition Société des Artistes Indépendants," Grand Palais des Champs-Élysées, Paris, France, catalog
1952 "Fifty-Sixth Annual Exhibition by Artists of Chicago and Vicinity," Art Institute of Chicago, Chicago, Illinois, catalog
1962, "Annuel Salon d'Automne," Grand
71- Palais des Champs-Élysées, Paris,
74 France
1965 "Annuel Salon de la Jeune Sculpture Contemporaine," Le Jardin du Musée National Auguste Rodin, Paris, France
1966, "Mostra Internazionale di Scultura
69- all'Aperto," Fondazione Pagani,
72 Legnano-Castellanza, Italy
1967 "Made with Paper," Museum of Contemporary Art, Chicago, Illinois
1968 "Salon International de Peinture et de Sculpture de la Femme," Casino de Cannes, Cannes, France
1970 "Salon International de Peinture et de Sculpture de la Femme," Hors Concours, Nice, France
1971 "Biennale Internazionale d'Arte 20 Premio del Fiorino," Palazzo Strozzi, Florence, Italy, catalog
1973- "Annuel Salon de Mai," Musée d'Art
78 Moderne de la Ville de Paris, Paris, France
1974 "Symposion 1974, Plastik 4: Stahl, Stein und Wort," Galerie Monika Beck, Homburg/Saar, Germany, Federal Republic
1975 "Festival International de Peinture et d'Art Graphico-Plastique," Place Saint-Germain-des-Pres, Paris, France
1978 "Triennale de la Sculpture Européenne," Le Jardin du Palais Royal, Paris, France, catalog
1979 "Dialogue Biennial Invitational Exhibition," Maison de l'UNESCO, Paris, France
1980 "Second International Sculpture Fair," Copley Plaza Hotel, Boston, Massachusetts
1980 "Eleventh International Sculpture Conference," Area Galleries and Institutions, Washington, D.C. (Sponsored by International Sculpture Center, Washington, D.C.)
1981 "Hoyt Cousins, Architect and Marie Zoe Greene-Mercier, Sculptor," Duxbury Studio, Duxbury, Massachusetts
1982, "Annual Exhibition by the Artist
84 Members, Paperworks + Sculpture," Arts Club of Chicago, Chicago, Illinois, catalog
1982 "Marie Zoe Greene-Mercier, Sculpture and Carl E. Schwartz, Paintings," Art and Sales Gallery, Art Institute of Chicago, Chicago, Illinois

Selected Public Collections
Alliance Française-Maison Française, Chicago, Illinois
Bauhaus-Archiv Museum, Berlin, Germany, Federal Republic

Collège d'Enseignement Secondaire Verlaine, Saint Nicolas-lez-Arras, France
First Baptist Church, Bloomington, Indiana
First Baptist Church, Chicago, Illinois
First National Bank, Chicago, Illinois
Grinnell College, Grinnell, Iowa
International Film Bureau, Chicago, Illinois
Landratsamt, Homburg/Saar, Germany, Federal Republic
Musée des Sables, Leucate, France
Museo d'Arte Moderna Cà Pesaro, Venice, Italy
Oberhessisches Museum, Giessen, Germany, Federal Republic
Radcliffe College, Cronkhite Graduate Center, Cambridge, Massachusetts
Roosevelt University, Chicago, Illinois
Smith, Hinchman & Grylls, Detroit, Michigan
Southwest Missouri State University, Springfield, Missouri
Stone Container Corporation, Chicago, Illinois
University of Chicago, David and Alfred Smart Gallery, Chicago, Illinois
Western Illinois University, Macomb, Illinois

Selected Private Collections
Mr. and Mrs. Lloyd Morain, Carmel, California
James W. Newell, New York, New York
Mr. and Mrs. Louis Skidmore, Jr., Houston, Texas
Conte M. Gazzano della Torre, Rome, Italy
Kenneth Warren, Chicago, Illinois

Selected Awards
1969 Grand Prize and Gold Medal, "Salon de Sculpture de la Femme," Casino de Cannes, Cannes, France
1977 Exhibition Grant, Amerika Haus, Berlin, Germany, Federal Republic and United States Information Service, Washington, D.C.
1979 Visual Artist Exhibition Grant, City of Bad Homburg, Germany, Federal Republic

Preferred Sculpture Media
Metal (cast) and Metal (welded)

Additional Art Fields
Collage and Drawing

Selected Bibliography
Elgar, Frank. Greene-Mercier. Paris: Le Musée de Poche, 1978. Text in French, English and German. (Distributed in the United States by International Book Company, Chicago, Illinois.)
Engelbrecht, Lloyd C. "Marie-Zoe Greene-Mercier: The Polyplane Collages." Art International vol. 22 no. 6 (October 1978) pp. 21-23, 52, illus.
Greene-Mercier, Marie Zoe. "The Role of Materials in My Geometric and Abstract Sculpture: A Memoir." Leonardo vol. 15 no. 1 (January 1982) pp. 1-6, illus.

Mussa, Italo. *Marie Zoe Greene-Mercier*.
 Rome: Sifra, 1968. Text in Italian and
 English. (Distributed in the United States
 by International Book Company, Chicago,
 Illinois.)
Redstone, Louis G. and Ruth R. Redstone.
 Public Art: New Directions. New York:
 McGraw-Hill, 1981.

Gallery Affiliation
Ruth Volid Gallery
225 West Illinois Street
Chicago, Illinois 60610

Mailing Address
1232 East 57 Street
Chicago, Illinois 60637

Artist's Statement
"My life as a sculptor has meant that I have
not only applied my native gifts to my house,
husband, and three children, but also that I
have looked outward to the environment in
my neighborhood, in my city, or whatever
center of human agglomeration might benefit
by my planning and my fabricating. Instead
of the small space of the heart, of the room,
of the house, even of the garden, my vision
has been granted the breathtaking
enlargement of all space in terms of my
central and originating core. It has become
the whole visible world. I have understood as
I might never have done, the vision of men
and women in other centuries who have
peopled the widest spaces available to them
with the products of their most secret and
innermost imaginings."

Marie Zoe Greene-Mercier

Reprinted with permission. *The Radcliffe
Quarterly* "Those Remarkable Women of
Radcliffe, A Selection of Alumnae Today:
Marie Zoe Greene-Mercier '33, Sculptor." vol.
64 no. 4 (December 1978) p. 28, illus.

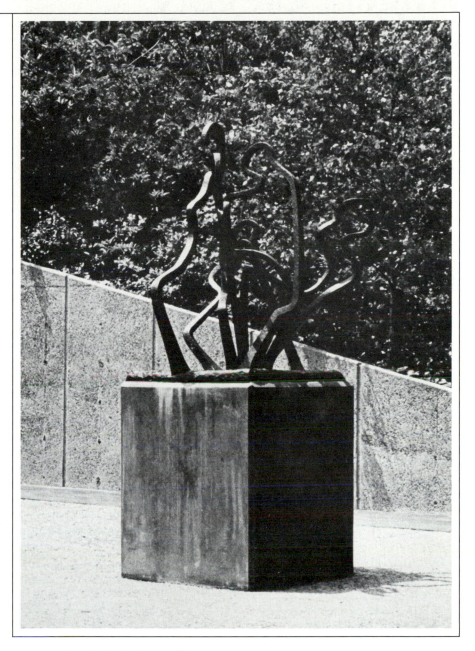

Orpheus and Eurydice II. 1965. Bronze, 62"h x
36"w x 36"d. Collection Radcliffe College,
Cronkhite Graduate Center, Cambridge,
Massachusetts. Photograph by Steven H. Greene.

Angela Gregory

Born October 18, 1903 New Orleans,
Louisiana

Education and Training
1923- Arts and Crafts Club, New Orleans,
25 Louisiana; study in sculpture with
 Albert Reicker
1924 Studio of Charles Keck, New York,
 New York; study in clay sculpture
1925 B.D., Newcomb College, New Orleans,
 Louisiana
1926 Certificate, Illustrative Advertising,
 New York School of Fine and Applied
 Art, Paris Branch, Paris, France
1926- Académie de la Grande Chaumière,
27 Paris, France; study in sculpture with
 Emile-Antoine Bourdelle
1926- Studio of Emile-Antoine Bourdelle,
28 Paris, France; additional study in
 sculpture
1940 M.A., Architecture, Tulane University,
 New Orleans, Louisiana

Selected Individual Exhibitions
1929 Arts and Crafts Club, New Orleans,
 Louisiana
1931 Museum of Fine Arts, Houston,
 Houston, Texas, catalog
1933, Isaac Delgado Museum of Art, New
34 Orleans, Louisiana, catalog
1940 Louisiana State Museum, New
 Orleans, Louisiana, catalog
1965 St. Mary's Dominican College, New
 Orleans, Louisiana
1971 Bienville Gallery, New Orleans,
 Louisiana
1978 Pine Street-Studio, New Orleans,
 Louisiana, retrospective
1981 Dean's Residence, Newcomb College,
 New Orleans, Louisiana, retrospective
 and catalog

Selected Group Exhibitions
1928 "Salon des Tuileries," Musée du Petit
 Palais, Paris, France
1929 "National Sculpture Society," California
 Palace of the Legion of Honor, San
 Francisco, California, catalog
1931 "Angela Gregory and F.
 Bunand-Sévastos, Arts Club,
 Washington, D.C.
1932 "National Sculpture Society," National
 Collection of Fine Arts, Smithsonian
 Institution, Washington, D.C., catalog

1938 "One Hundred and Thirty-Third Annual
 Exhibition of Painting and Sculpture,"
 Pennsylvania Academy of the Fine
 Arts, Philadelphia, Pennsylvania,
 catalog
1939 "World's Fair," New York, New York
1940 "National Sculpture Society," Whitney
 Museum of American Art, New York,
 New York, catalog
1942 "Sculpture of the Western
 Hemisphere," International Business
 Machines Corporation, New Orleans,
 Louisiana, catalog
1945 "Artists for Victory," Metropolitan
 Museum of Art, New York, New York
1966 "International Exhibition of
 Contemporary Medals," Numismatic
 Museum, Athens, Greece, catalog
1976 "Bicentennial Exhibition," National
 Sculpture Society, New York, New
 York, catalog
1979 "Angela Gregory, Sculpture; Selina E.
 Bres Gregory, Paintings," West Baton
 Rouge Museum, Port Allen, Louisiana
1981 "Retrospective Exhibition: Angela
 Gregory/ Newcomb '25; A Collection
 of the Works of Selina E. Bres
 Gregory/Newcomb '96," Art
 Department Gallery, Newcomb
 College, New Orleans, Louisiana,
 catalog
1984 "Louisiana Catholic Church Exhibition,
 Louisiana World Exposition," Vatican
 Pavilion, World's Fair, New Orleans,
 Louisiana

Selected Public Collections
Archdiocesan Administration Building, New
 Orleans, Louisiana
City of New Orleans, Civic Center, John
 McDonogh Monument, New Orleans,
 Louisiana
City of New Orleans, Place Bienville, Bienville
 Monument, New Orleans, Louisiana
City of Port Allen, Courthouse Grounds,
 General Henry Watkins Allen Monument,
 Port Allen, Louisiana
Historic New Orleans Collection, New
 Orleans, Louisiana
International Business Machines Corporation,
 New Orleans, Louisiana
Louisiana State Museum, New Orleans,
 Louisiana
St. Mary's Dominican College, John XXIII
 Library, New Orleans, Louisiana
Tulane University, Hutchinson Memorial
 Building, New Orleans, Louisiana
West Baton Rouge Museum, Port Allen,
 Louisiana

Selected Private Collections
Peter W. Breithoff, New Orleans, Louisiana
Mr. and Mrs. T. L. Crosby, Picayune,
 Louisiana
Mrs. William Stark, Ottawa, Ontario, Canada
Madame la Contesse du Taillis, Paris, France

Selected Awards
1968 Certificate of Merit for Achievement,
 Orleans Token and Medal Society,
 New Orleans, Louisiana
1981 Outstanding Alumna, School of
 Architecture, Tulane University, New
 Orleans, Louisiana
1982 Chevalier de l'Ordre des Arts et des
 Lettres, Minister of Culture,
 Republique Française

Preferred Sculpture Media
Clay and Stone

Additional Art Field
Watercolor

Teaching Position
Professor Emeritus, St. Mary's Dominican
 College, New Orleans, Louisiana

Selected Bibliography
Agard, Walter Raymond. *The New
 Architectural Sculpture*. New York: Oxford
 University Press, 1935.
Cocke, Edward J. *Monumental New Orleans*.
 Jefferson, Louisiana: Hope Publications,
 1974.
McInnes, V. Ambrose. *Taste and See:
 Louisiana Renaissance, Religion and the
 Arts*. New Orleans: Louisiana Renaissance,
 1977.
Papers included in the Southeastern
 Architectural Archive, Tulane University,
 Howard-Tilton Memorial Library, New
 Orleans, Louisiana.
Rose, Al. *Born in New Orleans: Notables of
 Two Centuries*. Tuscaloosa, Alabama:
 Portals Press, 1983.

Mailing Address
630 Pine Street-Studio
New Orleans, Louisiana 70118

John McDonogh Monument. 1933-1934. Bronze and granite, heroic size. Collection City of New Orleans, Civic Center, New Orleans, Louisiana. Photograph by Richard Ferriss.

Artist's Statement

"My exposure to art came at a young age. I was always fascinated by anything cut in stone or marble—to me that was sculpture. I was determined to do stone cutting. The great French sculptor Bourdelle inspired my love of stone, the major influence of my life and work. With architectural colleagues, I designed and executed sculpture for many buildings. In my portrait busts and monuments, I have attempted to maintain a strong tectonic quality while being primarily interested in portraying the sensitive, subtle quality of the individual."

Angela Gregory

Françoise Grossen

Born August 19, 1943 Neuchatel, Switzerland
(Swiss citizenship)

Education and Training
1962- School of Architecture, École
63 Polytechnique Fédérale de Lausanne,
 Lausanne, Switzerland
1967 Certificate, Textile Design, School of
 Arts and Crafts, Basel, Switzerland
1969 M.A., Fiber Art, University of
 California, Los Angeles, Los Angeles,
 California; study with Bernard Kester
1969- Apprenticeship in textile design,
70 Larsen Design Studio, New York, New
 York

Selected Individual Exhibitions
1968 Jack Lenor Larsen Showroom, New
 York, New York
1969 University of California, Los Angeles,
 Los Angeles, California
1970 San Diego State University, San
 Diego, California
1976 Museum Bellerive, Zürich, Switzerland,
 catalog
1976 Hadler Galleries, New York, New York,
 catalog
1976 Kaplan Baumann Gallery, Los
 Angeles, California
1978 Reed College, Portland, Oregon
1980 Art Institute of Pittsburgh Gallery,
 Pittsburgh, Pennsylvania
1983 Goldstein Gallery, St. Paul, Minnesota

Selected Group Exhibitions
1969 "Wall Hangings," Museum of Modern
 Art, New York, New York, catalog
1969, "Biennale Internationale de la
71, Tapisserie," Musée Cantonal des
73, Beaux-Arts, Lausanne, Switzerland,
75, catalog
77
1970 "The Magic of Fiber," Grand Rapids
 Art Museum, Grand Rapids, Michigan
1970 "Art in Other Media," Burpee Art
 Museum, Rockford, Illinois
1971- "Deliberate Entanglements," Traveling
72 Exhibition, F. S. Wight Art Gallery,
 University of California, Los Angeles,
 Los Angeles, California
1972 "Sculpture In Fiber," Museum of
 Contemporary Crafts, New York, New
 York
1972 "Fiber Structures," Denver Art
 Museum, Denver, Colorado
1974, "International Exhibition of Miniature
78, Textiles," Traveling Exhibition, British
80 Crafts Centre, London, Great Britain

1977 "The Material Dominant: Some Current
 Artists and Their Media," Museum of
 Art, Pennsylvania State
 University—University Park Campus,
 University Park, Pennsylvania
1977 "Fiberworks: The Americas and
 Japan," National Museum of Modern
 Art, Kyoto, Japan and Tokyo Museum
 of Modern Art, Tokyo, Japan, catalog
1977 "Fiberworks," Cleveland Museum of
 Art, Cleveland, Ohio, catalog
1977 "Compositions in Fiber: Françoise
 Grossen and Jolanta Owidzka,"
 Jacques Baruch Gallery, Chicago,
 Illinois
1978 "Third Textile Triennale," Centralne
 Muzeum, Lódž, Poland
1979 "Transformation: UCLA Alumni in
 Fiber," F. S. Wight Art Gallery,
 University of California, Los Angeles,
 Los Angeles, California
1979 "Recent Fiber," Davis Art Gallery,
 University of Akron, Akron, Ohio
1979 "Weich und Plastik, Soft and Plastic,"
 Kunsthaus, Zürich, Switzerland,
 catalog
1980 "Perceiving Modern Sculpture:
 Selections for the Sighted and
 Non-Sighted," Grey Art Gallery and
 Study Center, New York University,
 New York, New York
1981 "Zofia Butrymowicz and Françoise
 Grossen," Jacques Baruch Gallery,
 Chicago, Illinois
1981 "Old Traditions, New Directions,"
 Textile Museum, Washington, D.C.
1981- "The Art Fabric: Mainstream,"
83 Traveling Exhibition, San Francisco
 Museum of Modern Art, San
 Francisco, California, book
1982 "Twentieth-Century Decorative Art,"
 Metropolitan Museum of Modern Art,
 New York, New York
1982 "3 x 5: Works in Fiber," Modern Master
 Tapestries, New York, New York,
 catalog
1983 "The Artist's View," Hillwood Art
 Gallery, C. W. Post Center of Long
 Island University, Greenvale, New
 York
1984 "Stuff and Spirit: The Arts in Craft
 Media," Twining Gallery, New York,
 New York
1984 "Three-Dimensional Visiting Artists,"
 Thompson Gallery, Massachusetts
 College of Art, Boston, Massachusetts
1984 "Zeitgenössische Textilkunst,
 Contemporary Textile Art,"
 Kunstmuseum St. Gallen, St. Gallen,
 Switzerland
1984 "American Fiber: A New Aesthetic,"
 Diverse Works, Houston, Texas
1984 "Art in Fiber: A Review of Tapestries,
 Wallhangings and Sculpture," Jacques
 Baruch Gallery, Chicago, Illinois

Selected Public Collections
American Craft Museum, New York, New
York

American District Telegraph Company, World
Trade Center, New York, New York
Aramco Building, Dhahran, Saudi Arabia
Art Institute of Chicago, Chicago, Illinois
Bank of San Antonio, San Antonio, Texas
Citibank, 111 Wall Street, New York, New
York
Dreyfuss Fund, GM Building, New York, New
York
Dual-Lite, Newtown, Connecticut
Embarcadero Regency Hyatt, San Francisco,
California
Hotel Regency Hyatt, Montreal, Quebec,
Canada
Metropolitan Museum of Art, New York, New
York
Museum Bellerive, Zürich, Switzerland
Museum of Science and Industry, Chicago,
Illinois
North Texas State University, Student Union
Building, Denton, Texas
O'Hare Regency Hyatt House, Chicago,
Illinois
One Embarcadero Center, San Francisco,
California
Renwick Gallery of the National Museum of
American Art, Smithsonian Institution,
Washington, D.C.
Rudin Management, 560 Lexington Avenue,
New York, New York
San Mateo Fashion Island, Bullock's Court,
San Mateo, California
Secaucus Municipal Government Center,
Secaucus, New Jersey

Selected Private Collections
Mr. and Mrs. Donald Grauer, Highland Park,
Illinois
Mrs. Jack Kaplan, New York, New York
I. Magnin, San Francisco, California
Robert L. Pfannebecker Collection,
Lancaster, Pennsylvania
Professor Gazy Yasargil, Zürich, Switzerland

Selected Awards
1969 Art Council Award, University of
 California, Los Angeles, Los Angeles,
 California
1977 Individual Artist's Fellowship, National
 Endowment for the Arts
1981 Honor Award, Women in Design
 International, Ross, California

Preferred Sculpture Media
Fiber and Varied Media

Related Profession
Visiting Artist

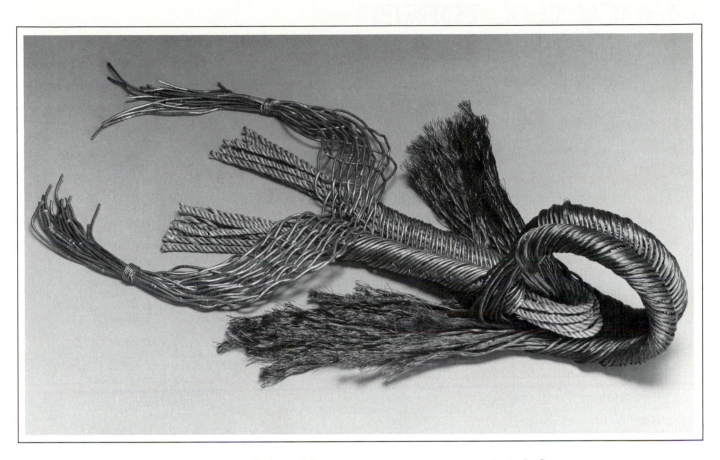

Grasshopper. 1978. Grass, metal and synthetic fiber, 4"h x 36"w x 12"d. Collection Metropolitan Museum of Art, New York, New York. Photograph by Edward J. Atman.

Selected Bibliography

Constantine, Mildred and Jack Lenor Larsen. *Beyond Craft: The Art Fabric*. New York: Van Nostrand Reinhold, 1972.

Constantine, Mildred and Jack Lenor Larsen. *The Art Fabric: Mainstream*. New York: Van Nostrand Reinhold, 1980.

Hall, Julie. *Tradition and Change: The New American Craftsman*. New York: E. P. Dutton, 1977.

Lucie-Smith, Edward. *Art In The Seventies*. Ithaca, New York: Cornell University Press, 1980.

Waller, Irene. *Textile Sculptures*. New York: Taplinger, 1977.

Gallery Affiliation

Jacques Baruch Gallery
900 North Michigan Avenue
Chicago, Illinois 60611

Mailing Address

135 Greene Street
New York, New York 10012

Artist's Statement

"I like the encounter with my large relief forms and panels to be twofold: the first, seen from a distance; the second, more attentive, should reveal new surprises. The work has evolved from monumental or 'body scale' forms hanging from the ceiling or wall supported to a series of independent floor sculptures with biomorphic associations. These elements assume creature forms and evoke associations from our common unconscious memory with many layers of meaning.

"The substance of my work is an enjoyment and fascination with the beauty of large-scale tubular, flexible material, positive and negative space, texture and mass. The work reaffirms throughout a human scale and a characteristic sense of hopefulness. It is my pleasure of working with my hands."

Françoise Grossen

243

Nancy Grossman

Born April 28, 1940 New York, New York

Education and Training
1962 B.F.A., Graphic Arts, Pratt Institute, Brooklyn, New York

Selected Individual Exhibitions
1964, Krasner Gallery, New York, New York
65,
67
1969, Cordier & Ekstrom, New York, New
71, York
76
1978 Church Fine Arts Gallery, University of Nevada Reno, Reno, Nevada
1980, Barbara Gladstone Gallery, New York,
82 New York
1981 Heath Gallery, Atlanta, Georgia
1984 Terry Dintenfass Gallery, New York, New York

Selected Group Exhibitions
1965 "New Acquisitions," Aldrich Museum of Contemporary Art, Ridgefield, Connecticut
1968 "1968 Annual Exhibition: Contemporary American Sculpture," Whitney Museum of American Art, New York, New York, catalog
1969 "Contemporary American Sculpture, Selection II," Whitney Museum of American Art, New York, New York, catalog
1970 "Highlights of the 1968-1969 Art Season," Aldrich Museum of Contemporary Art, Ridgefield, Connecticut, catalog
1971 "Face Coverings," Museum of Contemporary Crafts, New York, New York, catalog
1972 "Recent Figure Sculpture," Fogg Art Museum, Cambridge, Massachusetts, catalog
1972 "After Surrealism: Metaphors and Similes," John and Mabel Ringling Museum of Art, Sarasota, Florida, catalog
1973 "1973 Biennial Exhibition: Contemporary American Art," Whitney Museum of American Art, New York, New York, catalog
1973 "The Torso," Andrew Crispo Gallery, New York, New York
1974 "Painting and Sculpture Today 1974," Indianapolis Museum of Art, Indianapolis, Indiana, catalog
1974 "Invitational Exhibition," American Academy of Arts and Letters and National Institute of Arts and Letters, New York, New York
1974 "In Her Own Image," Samuel S. Fleisher Art Memorial, Philadelphia Museum of Art, Philadelphia, Pennsylvania

1974 "Women's Work: American Art 1974," Museum of the Philadelphia Civic Center, Philadelphia, Pennsylvania, catalog
1974 "Contemporary American Sculpture Lent by the Whitney Museum of American Art," Society of the Four Arts, Palm Beach, Florida, catalog
1976 "American Artists '76: A Celebration," Marion Koogler McNay Art Institute, San Antonio, Texas, catalog
1977 "Contemporary Women: Consciousness and Content," School of the Brooklyn Museum, Brooklyn, New York
1977 "Images of Horror and Fantasy," Bronx Museum of The Arts, Bronx, New York, catalog
1978 "Woman from Nostalgia to Now," Alex J. Rosenberg Gallery, New York, New York
1980 "American Sculpture: Gifts of Howard and Jean Lipman," Whitney Museum of American Art, New York, New York
1980 "Perceiving Modern Sculpture: Selections for the Sighted and Non-Sighted," Grey Art Gallery and Study Center, New York University, New York, New York
1981 "Bronze," Hamilton Gallery, New York, New York
1981 "Figuratively Sculpting," P.S. 1, Institute for Art and Urban Resources, Long Island City, New York
1981 "The Figure: A Celebration," University Art Galleries, University of North Dakota, Grand Forks, North Dakota
1982 "Neo-Objective Sculpture," Dart Gallery, Chicago, Illinois
1982 "Women's Art: Miles Apart," Aaron Berman Gallery, New York, New York; Valencia Community College, East Campus Gallery, Orlando, Florida, catalog
1982 "Body Language: Current Issues in Figuration," San Diego State University, San Diego, California
1982 "New Wave in Figurative Art," Baker Gallery, La Jolla, California
1983 "Gallery Sculptors," Terry Dintenfass Gallery, New York, New York
1983 "1984: A Preview," Ronald Feldman Fine Arts, New York, New York
1984 "An Other Vision: Selected Works by Women Artists in the Weatherspoon Collection," Weatherspoon Art Gallery, Greensboro, North Carolina, catalog
1984 "Six Sculptors," Bette Stoler Gallery, New York, New York
1984 "Dreams and Nightmares," Hirshhorn Museum and Sculpture Garden, Smithsonian Institution, Washington, D.C.
1984 "Crime and Punishment: Reflections of Violence in Contemporary Art," Triton Museum of Art, Santa Clara, California
1984 "A Celebration of American Women Artists Part II: The Recent Generation," Sidney Janis Gallery, New York, New York, catalog

1984 "About Face," Art Museum of South Texas, Corpus Christi, Texas
1984 "Modern Masks," Whitney Museum of American Art at Philip Morris, New York, New York
1984 "Sculpture Exhibition," Gallery Moos, Toronto, Ontario, Canada

Selected Public Collections
Albert Loeb Gallery Permanent Collection, Paris, France
Aldrich Museum of Contemporary Art, Ridgefield, Connecticut
Art Museum, Princeton University, Princeton, New Jersey
Baltimore Museum of Art, Baltimore, Maryland
Cornell University, Ithaca, New York
Dallas Museum of Art, Dallas, Texas
Galerie Rudolf Zwirner Permanent Collection, Cologne, Germany, Federal Republic
Makler Gallery Permanent Collection, Philadelphia, Pennsylvania
Minnesota Museum of Art, St. Paul, Minnesota
Museum Boymans-Van Beuningen, Rotterdam, Netherlands
National Museum of American Art, Smithsonian Institution, Washington, D.C.
Phoenix Art Museum, Phoenix, Arizona
Pratt Institute, New York, New York
University Art Museum, Berkeley, California
University of Utah, Salt Lake City, Utah
Weatherspoon Art Gallery, Greensboro, North Carolina
Whitney Museum of American Art, New York, New York

Selected Private Collections
Mr. and Mrs. Bruce Bethany, New York, New York
Mrs. Marcel Duchamp, New York, New York
Olga Hirshhorn, Washington, D.C.
Mrs. Henry R. Luce, New York, New York
Max Palevsky, Los Angeles, California

Selected Awards
1965 John Simon Guggenheim Memorial Foundation Fellowship
1974 Recipient of an Award in Art, "Exhibition of Works by Candidates for Art Awards," American Academy of Arts and Letters and National Institute of Arts and Letters, New York, New York, catalog
1984 Individual Artist's Fellowship, National Endowment for the Arts

Preferred Sculpture Media
Varied Media

Additional Art Fields
Drawing and Painting

Selected Bibliography

Blau, Douglas. "Nancy Grossman." *Arts Magazine* vol. 55 no. 6 (February 1981) p. 3, illus.

Diamonstein, Barbaralee. *Open Secrets, Ninety-Four Women in Touch with Our Time.* New York: Viking Press, 1970.

Kuspit, Donald B. "Reviews New York: Nancy Grossman (Terry Dintenfass)." *Artforum* vol. 23 no. 4 (December 1984) pp. 85-86, illus.

Nemser, Cindy. *Art Talk: Conversations with 12 Women Artists.* New York: Charles Scribner's Sons, 1975.

Rubinstein, Charlotte Streifer. *American Women Artists: From Early Indian Times to the Present.* Boston: G. K. Hall, 1982.

Gallery Affiliation

Terry Dintenfass Gallery
50 West 57 Street
New York, New York 10019

Mailing Address

105 Eldridge Street
New York, New York 10002

Artist's Statement

"The ways in which being an artist are regarded have changed historically. Once art was thought of as actual magic to affect the outcome of the hunt; later it was viewed in terms of formal solutions to philosophical-aesthetic problems; at other times it has been regarded as sheer personal expression. The *raison d'être* changes fashionably with the times. The deadly serious self-belief and intent of a Henri Rousseau were regarded as ludicrous by his contemporaries and by my contemporaries as quaint, but there are his beautiful and moving paintings for all time.

"I have always been loathe to talk about my art for this reason of word superficiality and word fashion. My work is my evidence of having existed, had feelings and intelligence—evidence of my choice of how I spent my life. The desire to make work, the energy generated by that desire, the knowledge and understanding are all there. My work is very precious to me and it is my only gift to you."

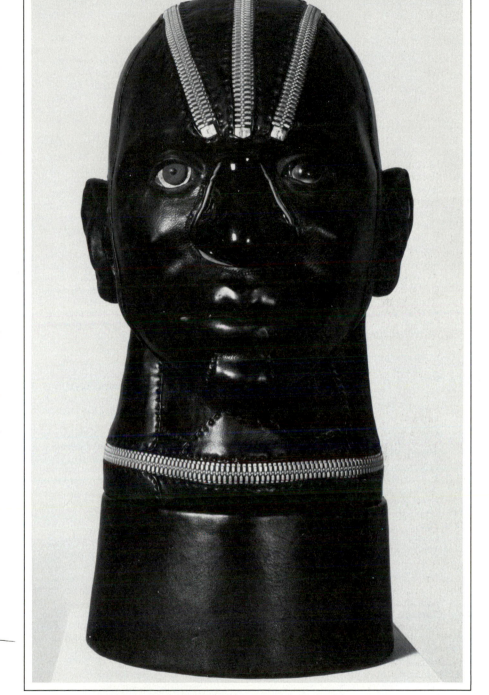

Rad. 1977-1980. Carved wood with mixed media, 16"h x 9½"w x 11"d. Courtesy Terry Dintenfass Gallery, New York, New York. Photograph by Bill Jacobson.

Aaronel deRoy Gruber

née Aaronel deRoy
(Husband Irving B. Gruber)
Born July 10, 1928 Pittsburgh, Pennsylvania

Education and Training
1937 Traphagen School of Design, New York, New York
1940 B.S., Art and Costume Design, Carnegie Institute of Technology, Pittsburgh, Pennsylvania

Selected Individual Exhibitions
1968 Millhouse-Bundy Performing and Fine Arts Center, Waitsfield, Vermont, catalog
1969 Galeria Juana Mordo, Madrid, Spain, catalog
1969, Bertha Schaefer Gallery, New York, 71 New York
1970 Galerie Simonne Stern, New Orleans, Louisiana
1971 Deson-Zaks Gallery, Chicago, Illinois
1972 Lowe Art Center, Syracuse University, Syracuse, New York, catalog
1974 Grand Rapids Art Museum, Grand Rapids, Michigan, catalog
1974, Electric Gallery, Toronto, Ontario, 77 Canada
1976 Michael C. Rockefeller Arts Center Gallery, Fredonia, New York
1976 Hunter Museum of Art, Chattanooga, Tennessee
1976 William Penn Memorial Museum, Harrisburg, Pennsylvania, retrospective
1977 Museum of Art, Carnegie Institute, Pittsburgh, Pennsylvania
1977 Gloria Luria Gallery, Bay Harbor Islands, Florida
1981 Pittsburgh Center for the Arts, Pittsburgh, Pennsylvania
1983 Slippery Rock University, Slippery Rock, Pennsylvania
1984 Arbitrage Art Gallery, New York, New York
1984 Peter Rose Gallery, New York, New York

Selected Group Exhibitions
1958- "Associated Artists of Pittsburgh 85 Annual Exhibition," Museum of Art, Carnegie Institute, Pittsburgh, Pennsylvania, catalog
1963- "Society of Sculptors Annual 85 Exhibition," Pittsburgh Center for the Arts, Pittsburgh, Pennsylvania
1965 "Future Great Artists: Brian O'Doherty Selects," Westchester Art Society, White Plains, New York
1966, "Collectors Show," DeCordova and 68, Dana Museum and Park, Lincoln, 69 Massachusetts
1968 "Made of Plastic," Flint Institute of Arts, Flint, Michigan, catalog
1969 "Kinetic Art," North Carolina Museum of Art, Raleigh, North Carolina
1969 "A Plastic Presence—Multiples," Jewish Museum, New York, New York, catalog

1969- "Objects: USA," Traveling Exhibition, 71 National Collection of Fine Arts, Smithsonian Institution, Washington, D.C.
1970- "Small Sculpture from the United 72 States," Traveling Exhibition, National Collection of Fine Arts, Smithsonian Institution, International Art Programme, Washington, D.C.
1971 "Artists at Work," Finch College Museum of Art, New York, New York
1971 "Transparent and Translucent Art," Museum of Fine Arts of St. Petersburg, Florida, St. Petersburg, Florida; Jacksonville Art Museum, Jacksonville, Florida, catalog
1971 "Collectors Opportunity," Jacksonville Art Museum, Jacksonville, Florida
1971- "New American Sculpture," Traveling 73 Exhibition (World Tour), United States Information Agency, Washington, D.C.
1973- "Creative America: Forty-Five 75 Sculptors," American Art Center, Tokyo, Japan; Hong Kong Museum of Art, Hong Kong, Hong Kong, catalog
1973- "Il Biennale Internationale de la Petite 74 Sculpture," Traveling Exhibition (Mediterranean), National Collection of Fine Arts, Smithsonian Institution, International Art Programme, Washington, D.C., catalog
1973 "Soft and Light," Taft Museum, Cincinnati, Ohio
1974 "IKI Art Fair," Düsseldorf, Germany, Federal Republic
1976- "Basel Art Fair," Basel, Switzerland 77
1977 "From Electrical Fire Spirits May Be Kindled," Vancouver Art Gallery, Vancouver, British Columbia, Canada
1979 "Twenty-Five Pennsylvania Women Artists," Southern Alleghenies Museum of Art, Loretto, Pennsylvania
1980- "A.R.E.A. Sculpture—Ward's Island," 81 Manhattan Psychiatric Center, Ward's Island, New York, catalog
1982 "Pennsylvania Treasures Exhibition," Governor's Gardens, Harrisburg, Pennsylvania
1982 "A Look Back—A Look Forward," Aldrich Museum of Contemporary Art, Ridgefield, Connecticut
1983 "Society of Sculptors Annual Open Exhibition," Burke Gallery, Kingsley Center, Pittsburgh, Pennsylvania
1985 "Fiftieth Anniversary Society of Sculptors Exhibition 1935-1985," Pittsburgh Plan for Art, Pittsburgh, Pennsylvania, catalog
1985 "Seventy-Fifth Anniversary Associated Artists of Pittsburgh Exhibition," Museum of Art, Carnegie Institute, Pittsburgh, Pennsylvania, catalog
1985 "Outdoor Sculpture Exhibition," Seton Hill College, Greensburg, Pennsylvania (In celebration of the Seventy-Fifth Anniversary Associated Artists of Pittsburgh, Pittsburgh, Pennsylvania)
1985 "Invited Painters and Sculptors: Members of Associated Artists of Pittsburgh," Westmoreland County Museum of Art, Greensburg, Pennsylvania
1985 "Seventy-Five Years of Pittsburgh Art," Pittsburgh Plan for Art, Pittsburgh, Pennsylvania, catalog

Selected Public Collections
Aldrich Museum of Contemporary Art, Ridgefield, Connecticut
Allegheny International, Pittsburgh, Pennsylvania
Chase Manhattan Bank, New York, New York
Chrysler Museum, Norfolk, Virigina
City of Pittsburgh, Fort Duquesne Park, Fort Duquesne Boulevard at Ninth Street, Pittsburgh, Pennsylvania
Flint Institute of Arts, Flint, Michigan
Frederick R. Weisman Collection, New York, New York
General Mills Corporation, Minneapolis, Minnesota
Grand Central Mall, Parkersburg, West Virginia
Grand Rapids Art Museum, Grand Rapids, Michigan
Kawamura Memorial Museum of Modern Art, Tokyo, Japan
Long Ridge Plaza, Rochester, New York
Michael C. Rockefeller Arts Center Gallery, Fredonia, New York
Millhouse-Bundy Performing and Fine Arts Center, Waitsfield, Vermont
Rose Art Museum, Brandeis University, Waltham, Massachusetts
Syracuse University, Syracuse, New York
University of Pittsburgh, Hillman Library, Pittsburgh, Pennsylvania

Selected Private Collections
Duane B. Hagadone, Coeur d'Alene, Idaho
Henry and Elsie Hillman, Pittsburgh, Pennsylvania
Joseph M. Katz, Pittsburgh, Pennsylvania
George R. Kravis, Tulsa, Oklahoma
Edward Lewis, Pittsburgh, Pennsylvania

Selected Awards
1968 Woman of the Year, *Pittsburgh Press*
1980 Artist in Residence, Ossabaw Foundation, Ossabaw Island, Georgia
1981 Artist of the Year, Pittsburgh Center for the Arts, Pittsburgh, Pennsylvania

Preferred Sculpture Media
Plastic and Metal (welded)

Additional Art Field
Painting

Related Professions
Art Administrator and Consultant

Selected Bibliography

Curran, Ann. "Six Sculptors." *Carnegie-Mellon Magazine* vol. 1 no. 1 (September 1982) pp. 6, 12, 15-16, illus.

Evert, Marilyn and Vernon Gay. *Discovering Pittsburgh's Sculpture*. Pittsburgh: University of Pittsburgh Press, 1983.

Miller, Donald. "Aaronel deRoy Gruber." *Arts Magazine* vol. 52 no. 9 (May 1978) p. 21, illus.

Mogelon, Alex and Norman Laliberté. *Art in Boxes*. New York: Van Nostrand Reinhold, 1974.

Roukes, Nicholas. *Sculpture in Plastic*. New York: Watson-Guptill, 1978.

Gallery Affiliations

Concept Art Gallery
1031 South Braddock Avenue
Pittsburgh, Pennsylvania 15218

Arbitrage Art Gallery
99 Spring Street
New York, New York 10013

Peter Rose Gallery
200 East 58 Street
New York, New York 10022

Mailing Address

2409 Marbury Road
Pittsburgh, Pennsylvania 15221

Artist's Statement

"Art to me is vision revealed through insight. My intention is that sculpture be pristine and a rewarding object of contemplation for the observer.

"My sculptures can be termed structural or constructivist—arranging multiple sections into an aesthetic whole in which balance, geometric forms, color, light and movement are important parts. As Donald Miller, *Pittsburgh Post-Gazette* Art Critic, stated in his June 4, 1981 review: 'They shimmer. They move. They glow.' There is an intended ambiguous balance with geometry, a component of the subject matter. As the sculpture performs spatially, there are two themes, roundness and squareness, that merge to form the motif—the rounded square.

"In the 1960s I started to work in steel and Plexiglas, occasionally in combination with neon. Kinetic movement gives life to some of the work but in the still pieces I endeavor to create this feeling through series progressions and interrelationships of color. The forms are then positioned to suggest motion and expansion. Often a form acts as a lens reflecting distorted images. These optical effects are somewhat like the distorted world in which we live."

Aaronel de Roy Gruber

Steelcityscape. 1977. Stainless steel, 18½'h x 7½'w x 12½'d. Collection City of Pittsburgh, Fort Duquesne Park, Fort Dusquesne Boulevard at Ninth Street, Pittsburgh, Pennsylvania. Photograph by Terry deRoy Gruber.

Barbara Grygutis

née Barbara Zion
(Husband Lawrence Joseph Evers)
Born November 7, 1946 Hartford,
 Connecticut

Education and Training
1968 B.F.A., Sculpture, University of
 Arizona, Tucson, Arizona; study with
 Donald Haskins
1970 Independent study and research in
 Japan
1971 M.F.A., Ceramics, University of
 Arizona, Tucson, Arizona; study in
 sculpture with John Heric

Selected Individual Exhibitions
1981, Dinnerware Artists Cooperative
 82, Gallery, Tucson, Arizona
 83,
 84

Selected Group Exhibitions
1978- "Women Artists: Clay, Fiber, Metal,"
 79 Traveling Exhibition, Bronx Museum of
 The Arts, Bronx, New York
1981 "Cowboys: The New Look," Marilyn
 Butler Fine Art, Scottsdale, Arizona
1983 "Ceramic Sculpture Invitational," Fine
 Arts Center of Tempe, Tempe,
 Arizona
1984 "Arizona Clay Sculpture," Gross
 Gallery, University of Arizona, Tucson,
 Arizona, catalog

Selected Public Collections
Alene Dunlap Smith Memorial Sculpture
 Garden, Tucson, Arizona
Cochise College, Sierra Vista, Arizona
Department of Law, State Capitol, Phoenix,
 Arizona
Flagstaff City Complex, Flagstaff, Arizona
The Lannan Foundation, West Palm Beach,
 Florida
La Placita Shopping Center Pedestrian Plaza,
 Tucson, Arizona
Pasternack Office Complex, Phoenix, Arizona
Radisson Suite Hotel, Tucson, Arizona
Tucson Museum of Art, Tucson, Arizona
Union Bank Branch Office, Tucson, Arizona
Valley National Bank, Payson, Arizona;
 Phoenix, Arizona and Tucson, Arizona

Selected Private Collections
Drungo Corporation, Phoenix, Arizona
Research Corporation, New York, New York
 and Tucson, Arizona
Mr. and Mrs. Werner Schirmer Collection,
 Tucson, Arizona and Düsseldorf, Germany,
 Federal Republic

Selected Awards
1975 Individual Artist's Fellowship, National
 Endowment for the Arts
1977 Art in Public Places Grant, National
 Endowment for the Arts
1979- Alene Dunlap Smith Memorial
 85 Sculpture Garden Project, Art in
 Public Places Grant, Arizona
 Commission on the Arts; Carson
 Concrete, Tucson, Arizona; Downtown
 Development Corporation, Tucson,
 Arizona; Franklin Trust, Tucson,
 Arizona; International Business
 Machines Corporation, Tucson,
 Arizona; Portland Cement and Tanner
 Corporation, Tucson, Arizona

Preferred Sculpture Media
Clay

Selected Bibliography
Cortright, Barbara. "On the Ceramist as
 Sculptor: Barbara Grygutis." *Artspace* vol.
 8 no. 1 (Winter 1983-1984) pp. 36-37, illus.
Hepworth, James R. "Reviews: Barbara
 Grygutis at Dinnerware Gallery, Tucson."
 Artspace vol. 5 no. 3 (Summer 1981) pp.
 55-56, illus.

Nigrosh, Leon I. *Claywork: Form and Idea in
 Ceramic Design.* Worcester,
 Massachusetts: Davis, 1975.
Perreault, John. "Impressions of Arizona." *Art
 in America* vol. 69 no. 4 (April 1981) pp.
 35-41, 44-45, illus.
Speight, Charlotte F. *Images in Clay
 Sculpture: Historical and Contemporary
 Techniques.* New York: Harper & Row,
 1983.

Mailing Address
273 North Main Avenue
Tucson, Arizona 85705

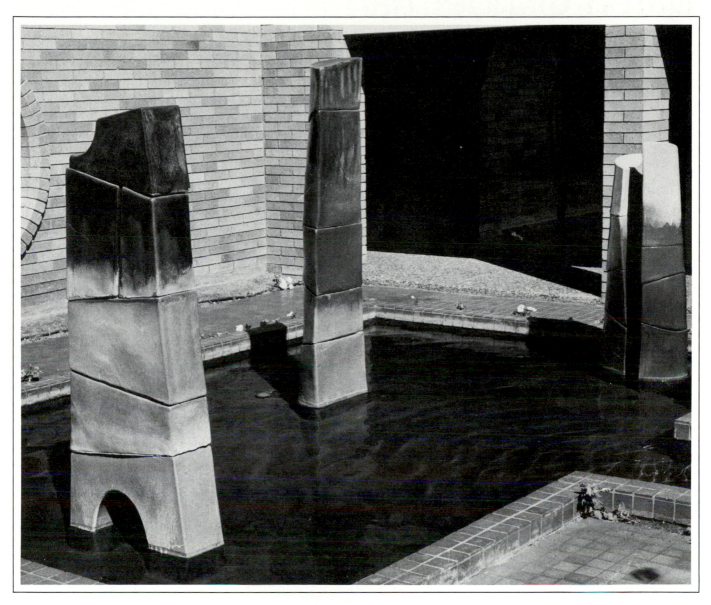

Strata. 1983. Stoneware, five units, 10′h; reflection pool, 20′w x 20′d. Collection Pasternack Office Complex, Phoenix, Arizona. Photograph by Sheila Kollasch.

Artist's Statement

"Perhaps the strongest influence on my career was Ruth Dury, a sculpture teacher I studied with from the ages of ten to fifteen. She was an Italian woman trained in the Italian tradition; we spent our hours copying the masters in small clay maquettes. My trip to Japan in 1970 was a second major influence. I had not seen in this country the reverence for clay as an artistic medium as in Japan. Functional wares were elevated to sculptural importance. From 1972-1978 my concern was incorporating function and sculpture in one piece. From 1979 my emphasis has shifted to pure form without concern for function as an element. While I have received training through university sculpture classes in the technical skills of welding, bronze casting, metalsmithing and working with plaster and plastics, my work with large-scale clay forms has been an evolutionary process based more on experimentation than on learned technical skill.

"Living in the Southwest continues to have a major impact on my work. My interest lies in the relationship between humans and the landscape. The landscape of this region is humbling, awesome and exciting."

Barbara Maggart

Karen Gunderman

née Karen Marie
Born February 15, 1951 New York, New York

Education and Training
1973 B.F.A., Ceramic Sculpture, Syracuse University, Syracuse, New York
1975 M.F.A., Ceramic Sculpture, University of Michigan, Ann Arbor, Michigan; study with Jacquelyn Rice and John Stephenson

Selected Individual Exhibitions
1979 Sinclair Galleries, Coe College, Cedar Rapids, Iowa
1979 Lawrence College, Appleton, Wisconsin

Selected Group Exhibitions
1978 "Young Americans: Clay/Glass," Museum of Contemporary Crafts, New York, New York; Tucson Museum of Art, Tucson, Arizona, catalog
1979 "National Drawing and Small Sculpture Show," Ball State University, Muncie, Indiana
1979 "Wisconsin Sculpture 1979," Charles A. Wustum Museum of Fine Arts, Racine, Wisconsin, catalog
1980 "American Clayworks/1980," Galerie Karl der Grosse, Zürich, Switzerland
1980 "Sixty-First Wisconsin Painters and Sculptors Exhibition," Fine Arts Galleries, University of Wisconsin-Milwaukee, Milwaukee, Wisconsin, catalog
1980 "Wisconsin Biennale 1980," Madison Art Center, Madison, Wisconsin, catalog
1980, "Annual Ceramics Invitational," Weber
84 State College, Ogden, Utah
1980 "Totems, Icons and Environments," Charles A. Wustum Museum of Fine Arts, Racine, Wisconsin, catalog
1980 "Clay at Clay County II," Plains Art Museum, Moorehead, Minnesota; University of North Dakota, Grand Forks, North Dakota; Second Crossings Gallery, Valley City, North Dakota, catalog

1981 "Paper and Clay National," Memphis State University, Memphis, Tennessee
1981 "Karen Gunderman and Diane Balsley," Bradley Galleries, Milwaukee, Wisconsin
1981 "Nature: Art," Friends' Gallery, Minneapolis Institute of Arts, Minneapolis, Minnesota
1981 "Wisconsin Directions 3: The Third Dimension," Milwaukee Art Museum, Milwaukee, Wisconsin, catalog
1982 "Alternatives in Wisconsin Clay," Charles A. Wustum Museum of Fine Arts, Racine, Wisconsin
1982 "Landscape in Art," Springfield Art Association, Springfield, Illinois
1983- "Clay for Walls: Surface Reliefs by
84 American Artists," Renwick Gallery of the National Museum of American Art, Smithsonian Institution, Washington, D.C., catalog
1983- "National Council on Education for the
84 Ceramic Arts Juried Members' Exhibition," Traveling Exhibition, Nexus Gallery, Atlanta, Georgia, catalog
1983 "Small Works National '83," Zaner Gallery, Rochester, New York, catalog
1983 "Chicago Vicinity Clay III," Lill Street Gallery, Chicago, Illinois, catalog
1984 "Wisconsin Directions 4," Milwaukee Art Museum, Milwaukee, Wisconsin, catalog
1984 "Personal Endeavors," Kresge Gallery, Minneapolis Institute of Arts, Minneapolis, Minnesota
1985 "9 From Wisconsin–Low Fire Clay," University of Wisconsin-Green Bay, Green Bay, Wisconsin
1985- "Wisconsin Survey-3-D Art Today,"
86 Traveling Exhibition, Memorial Union, University of Wisconsin-Madison, Madison, Wisconsin (Sponsored by Wisconsin Academy Review, Madison, Wisconsin), catalog

Selected Public Collections
Ceramics Monthly Permanent Collection, Columbus, Ohio
Plains Art Museum, Moorehead, Minnesota

Selected Private Collection
Karen Johnson Keland Collection, Racine, Wisconsin

Selected Awards
1980 Individual Artist's Fellowship, Wisconsin Arts Board
1982 Faculty Research Grant, University of Wisconsin-Milwaukee, Milwaukee, Wisconsin
1983 Special Project Grant, Wisconsin Arts Board

Preferred Sculpture Media
Clay

Teaching Position
Associate Professor, University of Wisconsin-Milwaukee, Milwaukee, Wisconsin

Selected Bibliography
Brite, Jane. "New Directions/Old Pleasures in Ceramic Art." Wisconsin Academy Review vol. 31 no. 2 (March 1985) pp. 34-42, illus.
Cooke, Colin. "Clay for Walls: Surface Reliefs by American Artists." Ceramics Review no. 84 (November-December 1983) pp. 26-27, illus.
"Karen Gunderman." Ceramics Monthly vol. 25 no. 7 (September 1977) p. 44, illus.
Lipofsky, Marvin. "Young Americans: Clay/ Glass." Craft Horizons vol. 38 no. 3 (June 1978) pp. 50-55, illus.
"News & Retrospect: Wisconsin Today." Ceramics Monthly vol. 31 no. 8 (October 1983) p. 67, illus.

Gallery Affiliation
Friends' Gallery
Minneapolis Institute of Arts
2400 Third Avenue South
Minneapolis, Minnesota 55404

Mailing Address
2123 East Park Place
Milwaukee, Wisconsin 53211

Artist's Statement

"My present series of ceramic sculpture has been strongly influenced by extensive travels in Ecuador and Peru. I am intrigued by the architectural ruins in these two countries, particularly the interplay of geometric form and softened/eroded/decayed areas within these structures.

"These influences in my sculpture have become active patterns of tiles, fragments, colors and lines, juxtaposed with highly textured surfaces. The textures range from jagged cuts and impressions of fossil-like forms to crusty dry glazes which are often brightly colored. The intended purpose is to create, in somewhat stabile and timeless forms, images which reinforce the stimulus I feel when viewing the ancient ruins. Although the pre-Columbian sites remain from a distant reality which I cannot entirely understand, they are rich in an endless variety of visual explorations."

Karen Gunderman

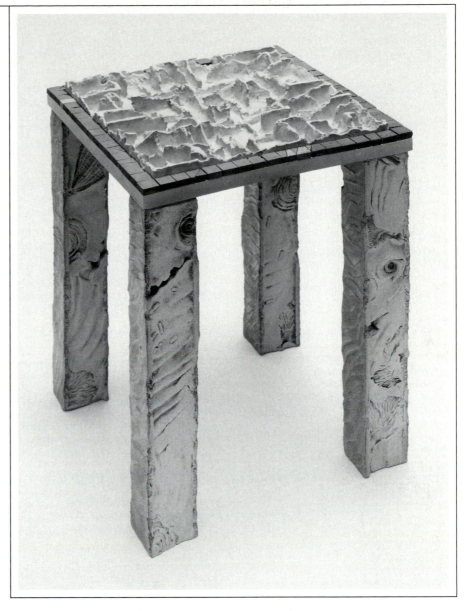

Chimu Path. 1983. Clay, 24"h x 17"w x 17"d.
Photograph by Alan Magayne-Roshak.

Virginia Gunter

née Virginia Frances
Born June 22, 1928 Cambridge,
 Massachusetts

Education and Training
1950 B.F.A., General Design,
 Massachusetts College of Art, Boston,
 Massachusetts

Selected Individual Exhibitions
1969 Laura Knott Gallery, Bradford College,
 Bradford, Massachusetts
1976 Center for Advanced Visual Studies,
 Massachusetts Institute of
 Technology, Cambridge,
 Massachusetts
1977 William P. Underwood Company,
 Westwood, Massachusetts
1977 Museum of Science, Boston,
 Massachusetts
1978 Pine Manor College, Newton,
 Massachusetts
1979 Lamson Library, Plymouth State
 College of the University System of
 New Hampshire, Plymouth, New
 Hampshire
1981 Art Colloquium Gallery, Salem,
 Massachusetts
1981 Museum School Gallery, School of the
 Museum of Fine Arts, Boston,
 Massachusetts

Selected Group Exhibitions
1972 "Boston Art Market," Institute of
 Contemporary Art, Boston,
 Massachusetts
1974 "Hanging Sculpture," Boston Visual
 Artists Union, Boston, Massachusetts
1975 "ARTTRANSITION," Center for
 Advanced Visual Studies,
 Massachusetts Institute of
 Technology, Cambridge,
 Massachusetts
1976 "Large Sculpture," Boston Visual
 Artists Union, Boston, Massachusetts
1977 "Thirteenth Annual Avant Garde
 Festival," World Trade Center, New
 York, New York
1978 "Boston 1978," Brockton Art
 Center/Fuller Memorial, Brockton,
 Massachusetts, catalog
1979 "Throbbing Needles II," Boston City
 Hall, Boston, Massachusetts
1979 "Allusive Illusions," Watson Gallery,
 Wheaton College, Norton,
 Massachusetts, catalog
1981 "Sky Art Conference," Center for
 Advanced Visual Studies,
 Massachusetts Institute of
 Technology, Cambridge,
 Massachusetts, catalog
1981 "Fiber from Form and Function,"
 Federal Reserve Bank Gallery, Boston,
 Massachusetts, catalog
1981 "Silver Threads and Golden Needles,"
 Watson Gallery, Wheaton College,
 Norton, Massachusetts, catalog
1983 "Artists Open Studios," Fort Point
 Studio, Boston, Massachusetts

Selected Public Collection
City of Needham, Cook's Bridge Public
 Housing Complex, Needham,
 Massachusetts

Selected Private Collection
David Rockefeller, Cambridge,
 Massachusetts

Selected Awards
1976 Fellow, Center for Advanced Visual
 Studies, Massachusetts Institute of
 Technology, Cambridge,
 Massachusetts
1977 Hitchinor Award for Sculpture,
 "Thirty-First New Hampshire Art
 Association Annual Exhibition," Currier
 Gallery of Art, Manchester, New
 Hampshire
1980 Artist in Residence, Art Colloquium
 Gallery, Salem, Massachusetts;
 Massachusetts Council on the Arts
 and Humanities

Preferred Sculpture Media
Varied Media

Additional Art Fields
Drawing and Photography

Related Professions
Consultant, Designer, Educator and Writer

Selected Bibliography
Kay, Jane Holtz. "The Nation Boston: Shaped
 in Situ." Art News vol. 75 no. 9 (November
 1976) pp. 106, 112-114.
Mattera, Joanne. "Throbbing Needles II."
 Fiberarts vol. 7 no. 2 (March-April 1980)
 pp. 71-72.
Mattera, Joanne. "Here Today, Gone
 Tomorrow: The Transitory Sculpture of
 Virginia Gunter." Fiberarts vol. 8 no. 2
 (March-April 1981) pp. 18-19, illus.
Taylor, Nora E. "N.E. Arts/Entertainment: Airy
 Forms Float Free in Science Museum." The
 Christian Science Monitor (Wednesday,
 April 13, 1977) p. 10, illus.

Mailing Address
18 Cleveland Street
Somerville, Massachusetts 02143

Color Sweep. 1983. Polychromed wood, 5'h x 200'w x 6"d. Collection City of Needham, Cook's Bridge Public Housing Complex, Needham, Massachusetts.

Artist's Statement

"My serious work began in 1969 when I started working with subtle materials, usually nets of various size mesh and fiber which capture light and its effects. These materials provide the ambiguities and sense of light/shadow that is a major influence in my work.

"I have been intrigued by shadows since childhood. They give information about the light source, changing or stabile, reflections, color and patterns. I have experimented with helium-filled weather balloons covered with net and other transparent and soft materials designed to move and float in the wind. Other pieces are suspended, hanging or wall relief works made in reaction to, or for, the specified environments or spaces available. I have begun to think about sculpture in materials that are permanent out-of-doors but which express the illusions and interaction of captured light in space."

Virginia Gunter

Chenoweth Hall

Born November 2, 1908 New Albany, Indiana

Education and Training
1931 B.M., Violin, University of Wisconsin-Madison, Madison, Wisconsin
1932- Columbia University, New York, New
36 York; study in the interrelationship of the arts with Dr. Edwin J. Stringham
1933- New School for Social Research,
40 New York, New York; study in the arts

Selected Individual Exhibitions
1956 Phillips Gallery, Philadelphia, Pennsylvania
1956, Gallery One, Carnegie Hall,
67, University of Maine at Orono, Orono,
79 Maine
1957 William A. Farnsworth Art Museum and Library, Rockland, Maine
1958- Maine Art Gallery, Annual Exhibition,
77 Wiscasset, Maine
1960 Northeast Harbor Neighborhood House, Northeast Harbor, Maine
1964 State House, Augusta, Maine
1965 Washington State Teachers College, Machias, Maine
1967 Haystack Mountain School of Crafts, Deer Isle, Maine
1967, Stonington Art Gallery, Stonington,
80 Connecticut
1968, University of Maine at Machias,
70, Machias, Maine
77
1970 Bar Harbor Gallery, Bar Harbor, Maine
1979 Cape Split Place Gallery, Addison, Maine
1979 Joan Whitney Payson Gallery of Art, Portland, Maine
1983 Jekyll Island Art Association, Jekyll Island, Georgia

Selected Group Exhibitions
1954 "New England Artists," Museum of Fine Arts, Boston, Massachusetts, catalog
1955 "Boston Society of Independent Artists," Shore Galleries, Boston, Massachusetts
1956 "Sculptors in Maine," Portland Museum of Art, Portland, Maine, catalog
1956 "New England Artists," DeCordova and Dana Museum and Park, Lincoln, Massachusetts
1958- "Artists of Maine Annual Exhibition,"
74 Artists of Maine Gallery, Gallery Two, Carnegie Hall, University of Maine at Orono, Orono, Maine
1962, "Maine State Festival," State House,
64 Augusta, Maine
1967 "July Show," Stonington Art Gallery, Stonington, Connecticut
1968 "Selected Sculptors," Contemporary Arts Gallery, Stonington, Connecticut
1978 "Susie Thompson and Chenoweth Hall," Cape Split Place Gallery, Addison, Maine
1978 "August Show," Stonington Art Gallery, Stonington, Connecticut
1978 "Chenoweth Hall, Sculpture and Berenice Abbott, Photographs," Cape Split Place Gallery, Addison, Maine
1979, "Hobe Sound Collection," Hobe
80, Sound Galleries South, Hobe Sound,
81, Florida; Hobe Sound Galleries North,
85 Portland, Maine, catalog
1981 "Jean Randall and Chenoweth Hall," Joan Whitney Payson Gallery of Art, Portland, Maine

Selected Public Collections
Cape Split Place Gallery, Marin Family Permanent Collection, Addison, Maine
Pierre Monteux Domaine School for Advanced Conductors and Orchestra Players, Hancock, Maine
University of Maine at Machias, Machias, Maine
University of Maine at Orono, Orono, Maine

Selected Private Collections
Miriam A. Colwell, Prospect Harbor, Maine and Jekyll Island, Georgia
Mr. and Mrs. H. C. Durbin, New Albany, Indiana
Mr. and Mrs. Robert Shetterly, East Blue Hill, Maine
Mr. and Mrs. Arthur Thompson, Sorrento, Maine
Louise Young, Arlington, Massachusetts

Preferred Sculpture Media
Stone and Wood

Additional Art Fields
Painting and Watercolor

Related Professions
Art Instructor, Musician and Writer

Selected Bibliography
Abbott, Berenice and Chenoweth Hall. *A Portrait of Maine*. New York: Macmillan, 1968.

Gallery Affiliations
Hobe Sound Galleries North
One Milk Street
Portland, Maine 04101

Hobe Sound Galleries South
Hobe Sound, Florida 33455

Payson Weisberg Gallery
822 Madison Avenue
New York, New York 10021

Mailing Address
Post Office Box 64
Prospect Harbor, Maine 04669

Pierre Monteux Memorial. 1970. Maine granite,
lucite and bronze, 11'h x 3'w x 3'd, including base.
Collection Pierre Monteux Domaine School for
Advanced Conductors and Orchestra Players,
Hancock, Maine. Photograph by Duette
Photographers.

Artist's Statement

"I work directly with chisel and mallet. My
methods of work are derived from my
studies, particularly of ancient Egyptian
carving. I carve in the primeval rock of the
states of Maine and Vermont and the tough
and noble woods of the world—mahogany,
South African violet kingwood, oak, walnut
and lignum vitae—which through centuries
were the hulls, pulleys and structure, the
'iron of ancient vessels.' In my work I do not
presume to destroy the nature and history of
the wood or stone but rather to enhance the
meaning in which one feels the thrill of
ancient beginnings and of essential
belonging."

Chenoweth Hall

Harmony Hammond

Born February 8, 1944 Chicago, Illinois

Education and Training
1961-63 Millikin University, Decatur, Illinois
1967 B.F.A., Painting, University of Minnesota Twin Cities Campus, Minneapolis, Minnesota

Selected Individual Exhibitions
1973, 84 A.I.R. Gallery, New York, New York
1979, 82 Lerner Heller Gallery, New York, New York
1981 WARM, Women's Art Registry of Minnesota, Minneapolis, Minnesota and Glen Hanson Gallery, Minneapolis, Minnesota, retrospective and catalog
1982 Real Art Ways, Hartford, Connecticut
1982 Klein Gallery, Chicago, Illinois
1984 Wadsworth Atheneum, Hartford, Connecticut
1985 Bernice Steinbaum Gallery, New York, New York

Selected Group Exhibitions
1973 "Soft as Art," New York Cultural Center, New York, New York, catalog
1974 "A Woman's Group," Nancy Hoffman Gallery, New York, New York
1975 "Primitive Presence in the Seventies," Vassar College Art Gallery, Poughkeepsie, New York, catalog
1977 "Touching on Nature," 55 Mercer, New York, New York
1977 "Contemporary Women: Consciousness and Content," School of the Brooklyn Museum, Brooklyn, New York
1978 "Out of the House," Whitney Museum of American Art, Downtown Branch, New York, New York, catalog
1978 "Overview: A.I.R. Five Year Retrospective," P.S. 1, Institute for Art and Urban Resources, Long Island City, New York, catalog
1979 "Galas," Woman's Building, Los Angeles, California, catalog
1980 "Fabric Into Art," Amelie A. Wallace Gallery, State University of New York College at Old Westbury, Old Westbury, New York, catalog
1980 "Discovery/Rediscovery," Sculpture Center, New York, New York
1980 "International Feminist Art," Traveling Exhibition, Haags Gemeentemuseum, The Hague, Netherlands, catalog
1981 "Transformations: Women in Art '70s-'80s," New York Coliseum, New York, New York, catalog
1981 "Luxuriances: Laura Blaw, Harmony Hammond, Janis Provisor," American Center, Paris, France, catalog
1981 "Home Work: The Domestic Environment Reflected in Work by Contemporary Women Artists," National Women's Hall of Fame, Seneca Falls, New York; Joe & Emily Lowe Art Gallery, Syracuse, New York; Henry Street Settlement Urban Life Center, New York, New York, catalog
1981 "Decorative Sculpture," Sculpture Center, New York, New York
1981 "Ten Years of Collecting," Denver Art Museum, Denver, Colorado
1982 "CAPS Sculpture," Traveling Exhibition, Hudson River Museum, Yonkers, New York, catalog
1982-83 "Women Artists: Indiana—New York Connection," Traveling Exhibtion, Snite Museum of Art, University of Notre Dame, Notre Dame, Indiana, catalog
1982 "Extended Sensibilities," New Museum, New York, New York, catalog
1983 "Her Own Space," Muse Gallery, Philadelphia, Pennsylvania, catalog
1983 "Descendants," Traveling Exhibition, University of North Dakota, Grand Forks, North Dakota
1983 "Connections: Bridges/Ladders/Ramps/Staircases/Tunnels," Institute of Contemporary Art of The University of Pennsylvania, Philadelphia, Pennsylvania, catalog
1983 "Floored," C. W. Post Center of Long Island University, Greenvale, New York, catalog
1983 "Life Signs," 55 Mercer, New York, New York
1984 "The New Culture: Women Artists of the '70s," Traveling Exhibition, State University of New York College at Cortland, Cortland, New York, catalog
1984 "Traditional Conflict: A Decade of Change 1963-1973," Studio Museum in Harlem, New York, New York, catalog

Selected Public Collections
Best Products, Richmond, Virginia
Denver Art Museum, Denver, Colorado
Everson Museum of Art, Syracuse, New York
Grenoble Mills, Incorporated, New York, New York
Indianapolis Museum of Art, Indianapolis, Indiana
Rendez-Vous International Sculpture Site, St. Jean-Port-Joli, Quebec, Canada

Selected Private Collections
Mr. and Mrs. Sydney Lewis, Richmond, Virginia
Lucy R. Lippard, New York, New York
Rosemary MacNamara, New York, New York
William and Norma Roth Collection, Winter Haven, Florida
Lily Tomlin, Los Angeles, California

Selected Awards
1979 Individual Artist's Fellowship, National Endowment for the Arts
1982 Creative Artists Public Service Grant, New York State Council on the Arts

Preferred Sculpture Media
Fiber and Varied Media

Additional Art Fields
Drawing, Graphics and Painting

Teaching Position
Instructor, New York Feminist Art Institute, New York, New York

Selected Bibliography
Langer, Sandra L. "Harmony Hammond: Strong Affections." *Arts Magazine* vol. 57 no. 6 (February 1983) pp. 122-123, illus.
Lippard, Lucy R. *From the Center: Feminist Essays on Women's Art*. New York: E. P. Dutton, 1976.
Lippard, Lucy R. "Binding/Bonding." *Art in America* vol. 70 no. 4 (April 1982) pp. 112-118, illus.
Ratcliff, Carter. "On Contemporary Primitivism." *Artforum* vol. 14 no. 3 (November 1975) pp. 57-65, illus.
Rubinstein, Charlotte Streifer. *American Women Artists: From Early Indian Times to the Present*. Boston: G. K. Hall, 1982.

Gallery Affiliation
Bernice Steinbaum Gallery
132 Greene Street
New York, New York 10012

Mailing Address
129 West 22 Street
New York, New York 10011

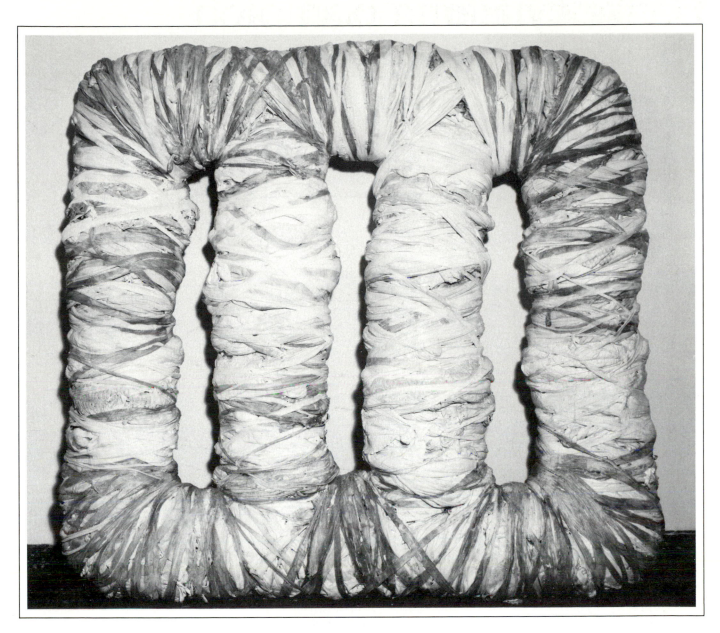

Swaddles. 1979. Cloth, wood, rhoplex, foam and latex rubber, 80"h x 90"w x 18"d. Collection Denver Art Museum, Denver, Colorado. Photograph by John Kasparian.

Artist's Statement

"Working with recycled fabric, I create abstract sculpture with strong figurative references. The fabric is wrapped around wood and metal armatures and then painted with a layered skin of acrylic, latex rubber and other materials. The resulting forms relate to images in non-Western art, women's traditional arts and to Eva Hesse's use of nontraditional materials in creating abstract art with emotional overtones. The elements of repetition, additive forms and choice of materials, imply self-generation, growth, connection and a reaching out beyond the personal. The binding and wrapping process is one of building from the inside or the deepest center of the self."

Harmony Hammond

Lucille Charlotte Hampton

Born July 22, 1922 New York, New York

Education and Training
1948- Columbia Bible College, Columbia,
50 South Carolina
1957 Diploma, General Studies, Brooklyn
 College, Brooklyn, New York
1965- New York University, New York, New
66 York; study in business administration
 and computer science

Selected Individual Exhibitions
1975 Lance International, Hudson,
 Massachusetts
1979 Gateway Art Gallery, Palm Beach,
 Florida

Selected Group Exhibitions
1970, "Annual Exhibition," Hudson Valley Art
73 Association, White Plains, New York,
 catalog
1971, "Allied Artists of America Annual
72 Exhibition," National Academy of
 Design, New York, New York, catalog
1972- "Catharine Lorillard Wolfe Art Club
85 Annual Exhibition," National Arts Club,
 New York, New York, catalog
1973- "American Artists Professional League
85 National Annual Exhibition,"
 Salmagundi Club, New York, New
 York, catalog

1975- "Showroom Exhibition," Lance
85 Corporation, New York, New York
1975 "Annual Exhibition," Pen Women of
 America, New York, New York
1975, "Annual Exhibition," National Academy
80 of Design, New York, New York,
 catalog
1976 "Daughters of the American Revolution
 Annual Exhibition," Lever House, New
 York, New York
1978, "Annual Western Exhibition," Sanford
79 Smith Gallery, New York, New York,
 catalog

Selected Public Collection
Lance Corporation, Hudson, Massachusetts

Selected Private Collections
Donald C. Cook, New York, New York
Dr. Alton Ochsner, New Orleans, Louisiana
Nelson Rockefeller Collection, New York,
 New York

Selected Awards
1973 Anna Hyatt Huntington Award,
 "American Artists Professional League
 Grand National Exhibition,"
 Salmagundi Club, New York, New
 York, catalog
1975 Anna Hyatt Huntington Horse Head
 Trophy, "Catharine Lorillard Wolfe Art
 Club Membership Exhibition," National
 Academy of Design, New York, New
 York, catalog
1976 Brenner Gold Medal Award, "Catharine
 Lorillard Wolfe Art Club Annual
 Exhibition," National Academy of
 Design, New York, New York, catalog

Preferred Sculpture Media
Metal (cast)

Selected Bibliography
American Artists of Renown. Gilmer, Texas:
 Wilson, 1981.
Broder, Patricia Janis. *Bronzes of the
 American West*. New York: Harry N.
 Abrams, 1974.
Mayer, Kay. "The Spiritual Side of Western
 Art." *Southwest Art* vol. 14 (June 1984) pp.
 63-73, illus.
Smith, Patricia Lynch. "Great Strength as a
 Sculptress." *Southwest Art* vol. 7 no. 6
 (November 1978) pp. 60-65, illus.

Gallery Affiliations
Kennedy Galleries
40 West 57 Gallery
New York, New York 10019

Grand Central Art Galleries
24 West 57 Street
New York, New York 10019

Nelson Rockefeller Collection
63 East 57 Street
New York, New York 10019

Mailing Address
1763 Second Avenue-17N
New York, New York 10128

Roundup. 1981. Bronze, 12"h x 21"w x 12"d.

Artist's Statement

"I chose to sculpt and paint the American West because I have a share in that heritage. My great grandmother was a full-blooded American Indian, so I not only have deep roots in this America, but I also have a responsibility to 'tell it like it was.' I do not want the next generation picking my bones for faulty documentation or to stand on its head quizzically debating my artistic intent. Therefore, I must invest many hours of research before I attempt a piece of work. It is my endeavor to reach beyond historic fact and recapture in my finished work that moment of motion and emotion so that the intensity of a buffalo hunt or the excitement of a bucking bronc will vibrate and be felt. . .then I will have shared.

"Although the gift of art came late in life for me, I want to share this gift by producing coherent art forms which give meaning to any culture. I have also rendered Biblical sculptures in bronze foretelling of Christ's second coming."

Lucille C. Hampton

Gay Powell Hanna

(Husband Richard Evertt Drennon)
Born October 30, 1952 Norfolk, Virginia

Education and Training
1970- Mary Washington College,
71 Fredericksburg, Virginia
1974 Old Dominion University, Norfolk,
Virginia; Summer Abroad Program,
Holland, Netherlands; study in art
history
1974 B.A., Studio Arts, Old Dominion
University, Norfolk, Virginia; study in
welded metal sculpture with Victor
Pickett
1976 M.F.A., Sculpture, University of
Georgia, Athens, Georgia; study with
William Thompson
1978- Apprenticeship to Athena Tacha,
79 Norfolk, Virginia; assistant in the
technical creation of concrete
sculpture
1980 University of Georgia, Athens,
Georgia; Studies Abroad Program,
Palazzo Vagnotti, Cortona, Italy; study
in art history
1980 Società Industria Commercio Marmi
Architettura Scultura, Carrara, Italy;
independent study in the technical
production of marble sculpture

Selected Individual Exhibitions
1975, Southeastern Center for
78, Contemporary Art, Winston-Salem,
79, North Carolina
80,
83
1980 Virginia Beach Arts Center, Virginia
Beach, Virginia
1983, Wilson Gallery, Norfolk, Virginia
84

Selected Group Exhibitions
1975 "Annual Juried Exhibition,"
Southeastern Center for Contem-
porary Art, Winston-Salem, North
Carolina
1979- "International Sculpture Competition
80 Finalists," Traveling Exhibition, Mercer
County Community College, Trenton,
New Jersey and Johnson Atelier
Technical Institute of Sculpture,
Princeton, New Jersey
1981 "McDonald Bang, Painting and Gay
Powell Hanna, Sculpture," Lewis Hall,
Eastern Virginia Medical School,
Norfolk, Virginia
1981- "Impressions: A Touch of Art, A
83 Tactile and Visual Exhibition by
Virginia Artists," Traveling Exhibition,
Portsmouth Community Arts Center,
Portsmouth, Virginia, catalog
1981 "1981 Biennial Exhibition of Piedmont
Painting and Sculpture," Mint Museum
of Art, Charlotte, North Carolina
1982 "Summer Salon, An Exhibition of
Miniature Work," Hermitage
Foundation Museum, Norfolk, Virginia
1983 "Alan Tiegreen, Paintings and Gay
Powell Hanna, Sculpture," Twentieth
Century Gallery, Williamsburg, Virginia
1984 "15 Contemporary Virginia Sculptors,"
Peninsula Fine Arts Center, Newport
News, Virginia, catalog
1984 "Railroad Square Artists and
Craftsmen," Gallery 621, Tallahassee,
Florida
1985 "Visions of Faith," Fine Arts Gallery,
Florida State University, Tallahassee,
Florida

Selected Public Collections
Aldersgate United Methodist Church,
Chesapeake, Virginia
Church of the Holy Family, Virginia Beach,
Virginia
City of Athens, Lyndon House Gallery,
University of Georgia, Athens, Georgia
City of Elizabeth City, Pool Street Park,
Elizabeth City, North Carolina
Georgia Center for Continuing Education,
Athens, Georgia
Lendman Associates, Virginia Beach, Virginia
Mutual Federal Savings & Loan, Norfolk,
Virginia
National Humanities Center, Research
Triangle Park, North Carolina
Norfolk Botanical Gardens, Norfolk, Virginia
Sovran Bank, Norfolk, Virginia
Virginia United Methodist Training Center,
Blackstone, Virginia
Woody, Incorporated, Richmond, Virginia

Selected Private Collections
Mr. and Mrs. Noel L. Dunn, Winston-Salem,
North Carolina
Mrs. Robert C. Goodman, Virginia Beach,
Virginia
Mr. and Mrs. E. Bradford Tazewell, Jr.,
Virginia Beach, Virginia

Mr. and Mrs. William L. Tazewell, Norfolk,
Virginia
Mr. and Mrs. John Willingham,
Winston-Salem, North Carolina

Selected Award
1978 Award of Excellence, "International
Azalea Festival," Norfolk Chamber of
Commerce, Norfolk, Virginia

Preferred Sculpture Media
Stone

Additional Art Fields
Drawing and Environmental Design

Related Professions
Art Instructor and Lecturer

Gallery Affiliation
Southeastern Center for Contemporary Art
750 Marguerite Drive
Winston-Salem, North Carolina 27106

Mailing Address
3205 Katherine Speed Court
Tallahassee, Florida 32303

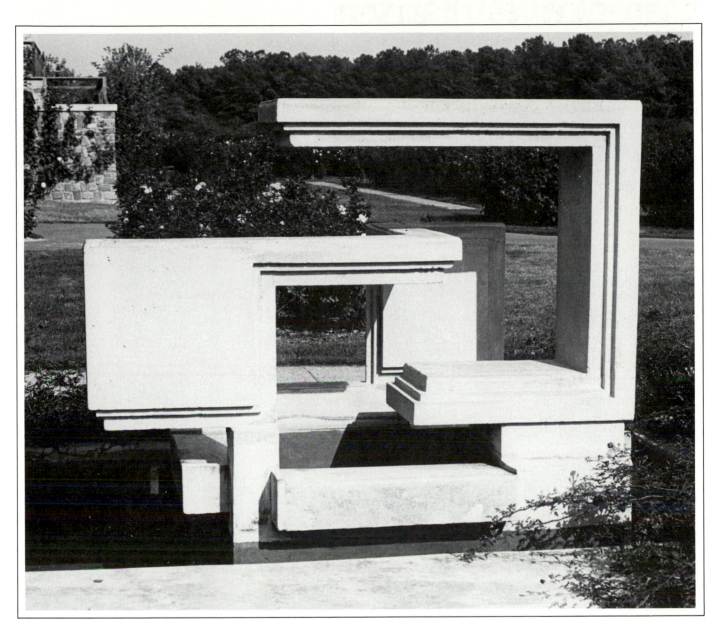

Fountain. 1981. Concrete, 6'h x 9'w x 18'd.
Collection Norfolk Botanical Gardens, Norfolk,
Virginia. Photograph by Carol Hanna Powell.

Artist's Statement

"Sculpture is my primary area of expression because of a natural affinity to assemble three-dimensional objects. My concept of art is the blending of spiritual and formal elements which transcend physical limitations. I am interested in a classical balance of composition and in achieving character through conceptual situations—specific subjects or places. Landscape, architecture and social context play roles in the selection of materials. They also are selected for their inherent beauty and durability.

"Stones were my playthings as a child. My great-grandmother's house had a rockpile in the backyard. Water and stones offer a simplicity of basic composition with rich subleties of texture, color and sound.

Fountain stone works have an ancient history in the celebration of civilized life. The power of water to sustain life can be an abstraction of psychological eminence."

Gary Powell Hanna

261

Florence P. Hansen

née Florence Lambert Peterson
(Husband Charles Willard Hansen, Jr.)
Born June 14, 1920 Salt Lake City, Utah

Education and Training
1943- University of Michigan, Ann Arbor,
45 Michigan; study in sculpture with
 Avard Tennyson Fairbanks
1947- University of Utah, Salt Lake City,
48 Utah; additional study in sculpture
 with Avard Tennyson Fairbanks

Selected Individual Exhibitions
1951 Salt Lake City Public Library, Salt
 Lake City, Utah
1982, Draper Bank and Trust, West Jordan,
83 Utah
1983 Cardon Jewelry, Logan, Utah
1983 Deseret Book, Salt Lake City, Utah
1984 Desert Book, Mesa, Arizona

Selected Group Exhibitions
1944, "Annual Exhibition of Sculpture,"
45 Michigan League Building, University
 of Michigan, Ann Arbor, Michigan,
 catalog
1981, "Pageant of the Arts Invitational
82 Exhibit," American Fork High School
83 Theater, American Fork, Utah, catalog
84,
85

1982 "Legacy of Art," Salt Lake Art Center,
 Salt Lake City, Utah, catalog
1983 "Sculptors of Utah," Springville
 Museum of Art, Springville, Utah,
 catalog
1984 "Women Artists of Utah," Springville
 Museum of Art, Springville, Utah,
 catalog
1985 "Women's Art Exhibition," Ernest L.
 Wilkinson Gallery, Brigham Young
 University, Provo, Utah
1985 "Days of 47 Western Art Heritage,"
 Salt Lake Art Center, Salt Lake City,
 Utah

Selected Public Collections
Church of Jesus Christ of Latter-Day Saints,
 Office Building Plaza, Salt Lake City, Utah
Church of Jesus Christ of Latter-Day Saints,
 Relief Society Building, Salt Lake City,
 Utah
Hansen Planetarium, Salt Lake City, Utah
Los Angeles Visitor's Center, Los Angeles,
 California
Museum of Church History and Art, Salt
 Lake City, Utah
Nauvoo Visitor's Center, Monument to
 Women Garden, Nauvoo, Illinois
Pioneer Memorial Museum, Salt Lake City,
 Utah
Skyline High School, Salt Lake City, Utah
State Capitol, Salt Lake City, Utah
University of Utah Naval Science Building,
 Salt Lake City, Utah

Selected Private Collections
Carl Taylor Burton, Salt Lake City, Utah
Lois Remington Hirschi, Sandy, Utah
Nancy Reagan, Washington, D.C.
Dr. Gary Stone, Stockton, California
Homer Quince Stringham, Salt Lake City,
 Utah

Selected Awards
1947 First Prize and Certificate of Honor,
 "Centennial Arts and Crafts Contest
 Adult Division," Centennial Exposition
 Arts and Crafts Building, Salt Lake
 City, Utah
1962 Best in Professional Quality, "Utah
 State Fair Exhibit," Utah State Fair
 Exposition Building, Salt Lake City,
 Utah
1967 Best Professional, "Utah Craftsmen's
 Council Arts and Crafts in Action
 Market," Pioneer Craft House, Salt
 Lake City, Utah

Preferred Sculpture Media
Clay and Metal (cast)

Related Profession
Sculptor, Hansen Classics Limited, Sandy,
Utah

Selected Bibliography
Flack, Dora D. Testimony in Bronze: The
Story of Florence Hansen and the Nauvoo
Monument to Women. Salt Lake City:
Olympus, 1980.

Gallery Affiliation
Voris Gallery
Hotel Utah
Salt Lake City, Utah 84070

Mailing Address
9627 Poppy Lane
Sandy, Utah 84070

Artist's Statement

"Art is a medium of expression. From preschool days I portrayed thoughts and feelings through drawings that I could not adequately express verbally. During my high school era, the art instructor, Cornelius Salisbury, introduced me to the world of three-dimensional art. It was then I first found the challenge and thrill in expressing through clay varied human experience. It was my appreciation of the monument *Winter Quarters* by Dr. Avard T. Fairbanks that led me to the University of Michigan to study under his most capable instruction.

"Capturing the likeness and personality of a subject is a delight: molding the delicate subleties of a child, forming the strength of a man or the unique qualities of a woman and adding the beautiful texture of the elderly as the character, developed over a lifetime, surfaces. Manipulating clay to achieve action, rhythm and harmony is to experience excitement. Historical themes and genre are my forte. It is my desire that my artistic endeavors will have a positive influence on those who view them."

Florence P. Hansen

Teaching with Love. 1978. Plastiline (cast in bronze 1978), 5½'h. Collection Nauvoo Visitor's Center, Monument to Women Garden, Nauvoo, Illinois. Photograph by Charles W. Hansen.

Jo Hanson

Born Carbondale, Illinois

Education and Training
1973 M.A., Art, San Francisco State University, San Francisco, California; study with Stephen De Staebler and Mel Henderson

Selected Individual Exhibitions
1969 Lucien Labaudt Gallery, San Francisco, California

1974 Corcoran Gallery of Art, Washington, D.C., catalog

1975 University of California, San Diego, La Jolla, California, catalog

1976 William Sawyer Gallery, San Francisco, California

1976 San Francisco Museum of Modern Art, San Francisco, California, catalog

1976 Peale House Galleries, Pennsylvania Academy of the Fine Arts, Philadelphia, Pennsylvania

1977 Southern Illinois University at Carbondale, Carbondale, Illinois

1977 Utah Museum of Fine Arts, Salt Lake City, Utah

1980 San Francisco Museum of Modern Art, San Francisco, California and San Francisco City Hall, San Francisco, California

1981 The Farm, San Francisco, California

1983 Base International, Lyons, France

Selected Group Exhibitions
1975, 78 "Artists' Soap Box Derby," San Francisco Museum of Modern Art, San Francisco, California, catalog

1975 "Sense of Reference: Explorations in Contemporary Realism," University of California, San Diego, La Jolla, California, catalog

1975 "Survey of Sculptural Directions in the Bay Area," De Anza College, Cupertino, California, catalog

1977 "Attitudes Toward Space: Environmental Art," Mount St. Mary's College, Los Angeles, California, catalog

1977 "Points of View," University of California, San Francisco, San Francisco, California, catalog

1977 "Visiting Faculty Exhibition," University of California, Berkeley, Berkeley, California

1978 "Aesthetics of Graffiti," San Francisco Museum of Modern Art, San Francisco, California, catalog

1978 "Beyond Realism," Otis Art Institute, Los Angeles, California

1980 "Out of the Ordinary," De Anza College, Cupertino, California

1980 "American Women Artists 1980," Museu Arte Contemporânea da Universidade de São Paulo, São Paulo, Brazil, catalog

1982 "On the Environment," Center for Music Experiment, University of California, San Diego, La Jolla, California

1982 "Twelfth International Sculpture Conference," Area Galleries and Institutions, Oakland, California and San Francisco, California (Sponsored by International Sculpture Center, Washington, D.C.)

1982 "In This Garden," San Jose Institute of Contemporary Art, San Jose, California

1983 "Events by Eight Artists," Rochester Institute of Technology, Rochester, New York

1983 "California Book Works," Otis-Parsons Exhibition Center, Los Angeles, California

Selected Public Collection
San Francisco Museum of Modern Art, San Francisco, California

Selected Awards
1977 Individual Artist's Fellowship, National Endowment for the Arts

1979 Regional Visual Arts Project Grant, Neighborhood Arts Program, San Francisco, California and National Endowment for the Arts

1980 Exhibition Commendation, San Francisco Board of Supervisors, San Francisco, California

Preferred Sculpture Media
Varied Media

Additional Art Fields
Photography and Printmaking

Related Profession
Commissioner, San Francisco Arts Commission, San Francisco, California

Selected Bibliography
California Artists Cook Book. New York: Abbeville Press, 1982.

Lacy, Suzanne. "Broomsticks and Banners: The Winds of Change." *Artweek* vol. 11 no. 17 (May 3, 1980) pp. 3-4, illus.

Newman, Thelma R. *Innovative Printmaking.* New York: Crown, 1977.

Perrone, Jeff. "Reviews San Francisco: Jo Hanson, San Francisco Museum of Modern Art." *Artforum* vol. 15 no. 2 (October 1976) pp. 66-67, illus.

Wortz, Melinda. "The Nation: Los Angeles." *Art News* vol. 76 no. 3 (March 1977) p. 92-93.

Gallery Affiliation
William Sawyer Gallery
3045 Clay Street
San Francisco, California 94118

Mailing Address
201 Buchanan Street
San Francisco, California 94102

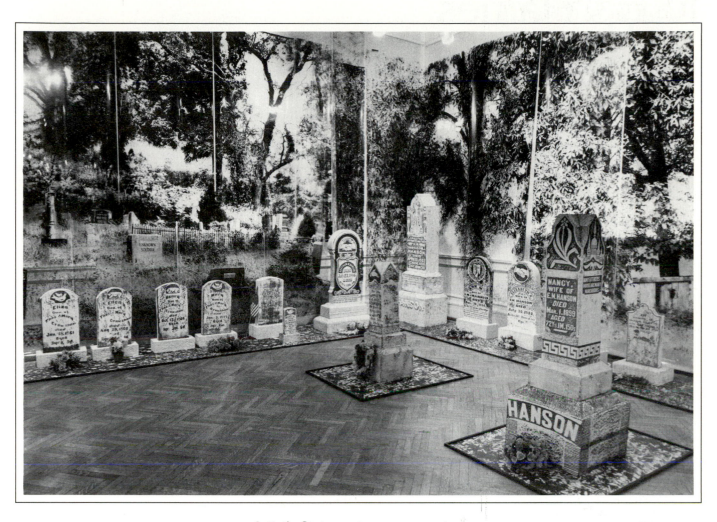

Crab Orchard Cemetery. 1974. Photo enlargement, silk-screen on styrofoam and audio tape, gallery size. Installation view 1974. Corcoran Gallery of Art, Washington, D.C., catalog.

Artist's Statement

"For an artist, the mind is a waking and sleeping procession of images and ideas and one longs to explore all of them. I am drawn to the records people make of their existence, the communication in the visual image that can span a moment or a millenium. Thus, my work tends to derive from shared experiences of ordinary living and wanting people to enter the work as well as view it.

"The idea is central in my approach but it usually develops in response to visual input. This involves me with such things as street trash, garden snails and tombstones and their setting. *Crab Orchard Cemetery* developed around my experiences in the original graveyard, a dream scene of summer foliage stirring in magic light, interwoven with sounds of birds and insects which are incorporated in the presentation of the cemetary. The result is work based in realism with emotional underpinning in which formal elements are tools but rarely subject matter."

Mags Harries

née Margaret Lucille
(Husband Lajos Sandor Héder)
Born April 6, 1945 Barry, Wales, Great Britain
(British citizenship)

Education and Training
1967 Diploma, Art and Design, Leicester
College of Art and Design, Leicester,
Great Britain
1970 M.F.A., Sculpture, Southern Illinois
University at Carbondale, Carbondale,
Illinois

Selected Individual Exhibitions
1971 Wheeler Gallery, Providence, Rhode
Island
1974 Terry Dintenfass Gallery, New York,
New York
1976 Harcus Krakow Rosen Sonnabend
Gallery, Boston, Massachusetts
1978 Radcliffe Institute, Radcliffe College,
Cambridge, Massachusetts
1980 Billiard Room Gallery, Cambridge,
Massachusetts
1982 DeCordova and Dana Museum and
Park, Lincoln, Massachusetts,
retrospective and catalog

Selected Group Exhibitions
1970 "Tenth Annual Mid-States Exhibition,"
Evansville Museum of Arts and
Science, Evansville, Illinois
1971 "Faculty Exhibition," Woods-Gerry
Gallery, Rhode Island School of
Design, Providence, Rhode Island
1972 "Things," Brockton Art Center/Fuller
Memorial, Brockton, Massachusetts
1973 "Objects and Spaces Made from Clay:
Mags Harries and Paul Heroux,"
Harcus Krakow Gallery, New York,
New York
1973 "Small Environments," Traveling
Exhibition, Southern Illinois University
at Carbondale, Carbondale, Illinois
1973 "Twenty-Fourth Annual New England
Exhibition," Silvermine Guild of Artists,
New Canaan, Connecticut, catalog
1973 "Boston Visual Artists Union Juried
Exhibition," Hayden Gallery, Massa-
chusetts Institute of Technology,
Cambridge, Massachusetts
1973 "Objects and Eight Women Realists,"
University of Massachusetts, Amherst,
Massachusetts
1974 "Boston Artists," Goethe Institute,
Boston, Massachusetts
1974 "Realist Vision Interior/Exterior,"
Harcus Krakow Gallery, Boston,
Massachusetts
1974 "Nine Brown Faculty," Bell Gallery, List
Art Center, Providence, Rhode Island
1975 "New England Women," DeCordova
and Dana Museum and Park, Lincoln,
Massachusetts, catalog
1975 "Fresh Art," Institute of Contemporary
Art, Boston, Massachusetts
1975 "Clay Sculpture," Milton Academy,
Milton, Massachusetts

1975 "The Presence and Absence of
Realism," State University of New York
College at Potsdam, Potsdam, New
York
1976 "Boston Bicentennial Art Collection,"
Institute of Contemporary Art, Boston,
Massachusetts
1976 "Documents," Boston Visual Artists
Union, Boston, Massachusetts
1977 "Collectors Collect Contemporary,"
Institute of Contemporary Art, Boston,
Massachusetts
1978 "Boston 1978," Brockton Art
Center/Fuller Memorial, Brockton,
Massachusetts, catalog
1979 "Artists on the Line," Carpenter Center
for the Visual Arts, Harvard University,
Cambridge, Massachusetts
1979 "Thirty Years of Box Construction,"
Sunne Savage Gallery, Boston,
Massachusetts, catalog
1979 "Impressions in Clay," Everson
Museum of Art, Syracuse, New York
1980 "Arts On The Line," Hayden Gallery,
Massachusetts Institute of Technol-
ogy, Cambridge, Massachusetts
1980 "An Invitational," Massachusetts
College of Art, Boston, Massachusetts
1980 "Art of the State: Sculpture
1975-1980," Federal Reserve Bank
Gallery, Boston, Massachusetts
1980 "Aspects of the 70s: Directions in
Realism," Danforth Museum,
Framingham, Massachusetts, catalog
1981 "Design for Moving People," Urban
Center, New York, New York
1981 "New England Relief," DeCordova and
Dana Museum and Park, Lincoln,
Massachusetts
1981 "Urban Environs, Local Visions,"
Hayden Gallery, Massachusetts
Institute of Technology, Cambridge,
Massachusetts
1982 "Cast Illusions," Wellesley College
Museum, Wellesley, Massachusettts
1982 "Small Bronzes," Helen Shlien Gallery,
Boston, Massachusetts
1982 "Bronze, A Group Exhibition of
Sculpture," Ben Shahn Gallery, William
Paterson College of New Jersey,
Wayne, New Jersey
1983 "The Place of Art in Public Places,"
Allegheny County Courthouse,
Pittsburgh, Pennsylvania
1983 "Fears and Affirmations," Van Buren/
Brazelton/Cutting/Gallery, Cambridge,
Massachusetts
1983 "Triennial Exhibition," Brockton Art
Museum/Fuller Memorial, Brockton,
Massachusetts
1984 "Four Inclined," Boston College,
Chestnut Hill, Massachusetts

Selected Public Collections
City of Boston, Boylston Place, Boston,
Massachusetts
City of Boston, Haymarket Square, Boston,
Massachusetts
City of Chelsea, Bellingham Square, Chelsea,
Massachusetts

City of Chelsea, Chelsea Square, Chelsea,
Massachusetts
DeCordova and Dana Museum and Park,
Lincoln, Massachusetts
Longfellow School, Cambridge,
Massachusetts
Massachusetts Bay Transportation Authority,
Porter Square Station, Cambridge,
Massachusetts
Southern Illinois University at Carbondale,
Carbondale, Illinois

Selected Private Collections
Graham Gund Collection, Cambridge,
Massachusetts
Portia Harcus, Boston, Massachusetts
Barbara Krakow, Brookline, Massachusetts
Mr. and Mrs. Roger Sonnabend, Boston,
Massachusetts
Mr. and Mrs. Michael Torf, Weston,
Massachusetts

Selected Awards
1976 Individual Artist's Fellowship,
Massachusetts Council on the Arts
and Humanities
1977 Fellowship, Radcliffe Institute for
Independent Study, Radcliffe College,
Cambridge, Massachusetts
1981 Design Excellence in Public Art, Art in
Transportation Awards Program,
United States Department of
Transportation and National
Endowment for the Arts

Preferred Sculpture Media
Varied Media

Additional Art Field
Drawing

Teaching Position
Faculty, School of the Museum of Fine Arts,
Boston, Massachusetts

Selected Bibliography
Allara, Pamela. "Boston: Shedding Its
Inferiority Complex." Art News vol. 78 no. 9
(November 1979) pp. 98-101, 104-105, illus.
Allara, Pamela. "The Nation: Boston, Mags
Harries." Art News vol. 82 no. 3 (March
1983) p. 109, illus.
Eckardt, Wolf Von. "Design: Toward More
Livable Cities." Time (November 2, 1981)
pp. 108, 110, illus.
Fleming, Ronald Lee and Renata von
Tscharner with George Melrod. Place
Makers: Public Art That Tells You Where
You Are. New York: Hastings House, 1981.
Stapen, Nancy. "Mags Harries." Art New
England vol. 3 no. 9 (November 1982) p. 3,
illus.

Mailing Address
388 Walden Street
Cambridge, Massachusetts 02138

Asaroton (detail). 1976. Bronze in concrete, 55'5"l x 10'w. Collection City of Boston, Haymarket Square, Boston, Massachusetts. Photograph by Greg Heins.

Artist's Statement

"Much of my recent work has been public art. My sculptures are placed in active well-used sites such as a subway center, a market place, a school corridor or an escalator. These sites are nontraditional so that the public can discover, react and by this discovery, possess the sculpture. The subject matter in its context becomes multiassociational from an involvement with the direct image to more metaphoric and poetic meanings. For example, the bronze objects represented in *Asaroton* are replicas of the discarded fruit and vegetables of the Produce Market. These pieces can be seen not only as facsimile but as archaelogy, a layering of real and object, and as an historical reference to the original Roman floor mosaics. Finding the sculpture can be a magical discovery, creating an immediate spontaneous reaction without the self-consciousness of approaching an art object. The sculpture also captures an element of time as it changes through the constant wearing and buffing by tires and feet, becoming more abstract and mystifying."

Mags Harries

Carole Harrison

Born October 30, 1933 Chicago, Illinois

Education and Training
1953 Monticello College, Alton, Illinois; study in sculpture with Hillis Arnold
1955 B.F.A., Sculpture, Cranbrook Academy of Art, Bloomfield Hills, Michigan; study with Glen Chamberlain
1956 M.F.A., Sculpture, Cranbrook Academy of Art, Bloomfield Hills, Michigan; additional study with Glen Chamberlain
1957 Central School of Arts and Crafts, London, Great Britain; study in aluminum and plaster sculpture with Robert Adams

Selected Individual Exhibitions
1958 Gallery Four, Detroit, Michigan
1959 Old Town Art Center, Chicago, Illinois
1961 Kasha Heman Gallery, Chicago, Illinois
1962 Traverse City Art Gallery, Traverse City, Michigan
1963, Gilman Gallery, Chicago, Illinois
65
1963 Midland Art Center, Midland, Michigan
1976 Kalamazoo Institute of Arts, Kalamazoo, Michigan
1978 Space Gallery, Western Michigan University, Kalamazoo, Michigan
1979 Ludlow-Hyland Gallery, New York, New York
1980 Kingscott Gallery, Kalamazoo, Michigan
1983 Milliken Gallery, Converse College, Spartanburg, South Carolina
1985 Sculpture Center, New York, New York

Selected Group Exhibitions
1955, "Annual Exhibition for Michigan Artists," Detroit Institute of Arts, Detroit, Michigan, catalog
59
1956, "Annual Drawing and Small Sculpture Show," Ball State University, Muncie, Indiana
65
1957 "Exhibition Momentum," Navy Pier, Chicago, Illinois
1960 "Second Biennial of American Painting and Sculpture," Detroit Institute of Arts, Detroit, Michigan, catalog
1960 "Chicago Representative," Old Town Art Center, Chicago, Illinois
1960 "New Horizons in Sculpture," McCormick Place Art Gallery, Chicago, Illinois
1960 "Young Americans," Detroit Artists Market, Detroit, Michigan

1964, "Annual Exhibition," Kalamazoo Institute of Arts, Kalamazoo, Michigan
65
1964 "Ninth Annual Exhibition of Small Sculpture," University of North Dakota, Grand Forks, North Dakota
1965 "Third Annual Tippecanoe Regional," Lafayette Art Center, Lafayette, Indiana
1966 "Contemporary Painting and Sculpture," Springfield Museum, Springfield, Illinois
1967 "Contemporary Painting and Sculpture," Lakeview Center for the Arts and Sciences, Peoria, Illinois
1975 "75 Women Artists in '75," State University of New York at Buffalo, Buffalo, New York
1975 "Mid-Michigan Annual Exhibition," Midland Art Center, Midland, Michigan
1975 "Western New York Women's Exhibition," State University of New York College at Fredonia, Fredonia, New York
1976 "Mainstreams '75," Grover M. Hermann Fine Arts Center, Marietta College, Marietta, Ohio, catalog
1979 "Decorative Art," Sculpture Center, New York, New York
1981 "Off the Wall," Ludlow-Hyland Gallery, New York, New York
1981, "National Association of Women Artists Annual Exhibition," Jacob K. Javits Federal Building, New York, New York, catalog
82
1982 "One Hundred and Fifty-Seventh Annual Exhibition," National Academy of Design, New York, New York, catalog
1983 "Forty-First Audubon Artists Annual Exhibition," National Arts Club, New York, New York, catalog
1983 "Seventieth Allied Artists of America Annual Exhibition," National Arts Club, New York, New York, catalog

Selected Public Collections
Art Center of Battle Creek, Battle Creek, Michigan
City of Oak Park, Illinois
Cranbrook Academy of Art Museum, Bloomfield Hills, Michigan
Hackley Art Museum, Muskegon, Michigan
Holland High School, Holland, Michigan
Hope College, Holland, Michigan
Kalamazoo Institute of Arts, Kalamazoo, Michigan
New Wilderness Foundation, New York, New York
Oak Park Public Library, Oak Park, Illinois
Steinman-Dudley Company, Kalamazoo, Michigan
Uptown Savings and Loan, Chicago, Illinois
Western Michigan University, Fine Arts Complex, Kalamazoo, Michigan

Selected Private Collections
Firestone Collection, Chicago, Illinois
Hugh Hefner, Chicago, Illinois
Mr. and Mrs. Kenneth Herrick, Tecumseh, Michigan

Mr. and Mrs. Herbert Scott, Kalamazoo, Michigan
Ruth Siegel, Chicago, Illinois

Selected Awards
1957 Fulbright Fellowship (England)
1960 Louis Comfort Tiffany Foundation Grant
1961 First Prize, "New Horizons in Sculpture," McCormick Place Art Gallery, Chicago, Illinois

Preferred Sculpture Media
Metal (cast) and Metal (welded)

Additional Art Field
Drawing

Related Professions
Art Instructor and Visting Artist

Selected Bibliography
Broner, Robert. "Gallery Notes: Sculpture Leads in Detroit." Art in America vol. 48 no. 1 (Spring 1960) p. 143.
Hendry, Fay L. Outdoor Sculpture in Kalamazoo. Okemos, Michigan: iota Press, 1980.
"News: Acquisitions." Art Journal vol. 34 no. 2 (Winter 1974-1975) p. 155, illus.

Gallery Affiliation
Sculpture Center
167 East 69 Street
New York, New York 10021

Mailing Address
140 Hill Station Road
Box EEE
Southampton, New York 11968

Artist's Statement

"Sculpture is an intricate structure developed by the artist through which is expressed awareness, sensitivities, perceptions and needs. Art is one of our most encompassing and direct means of communication.

"My sculptural concepts have always been concerned with human relationships: the person or persons in relation to each other, the landscape, animals and objects. The sculpture is abstract because people are abstract. Abstract forms facilitate describing the emotional and intellectual forces which compose our inner selves and shape relationships."

Carole Harrison

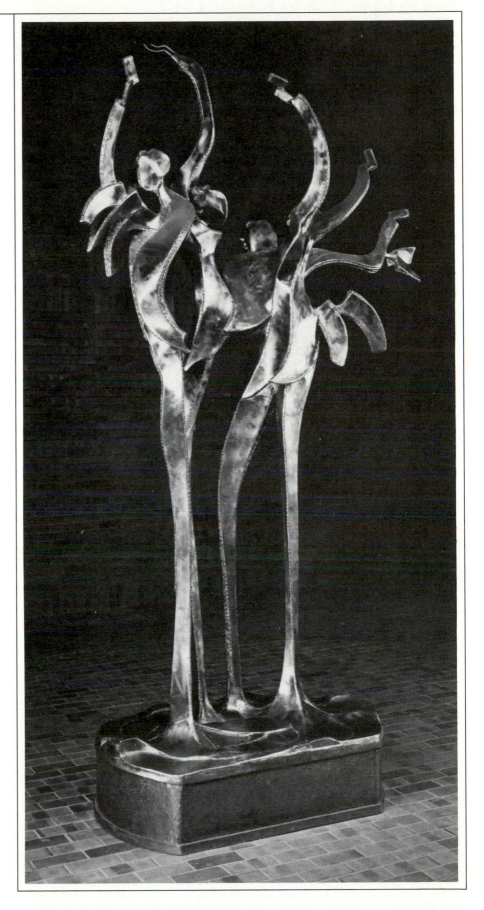

Motif. 1982. Welded copper and brass, 11'h x 5'2"w x 32"d. Collection Western Michigan University, Fine Arts Compex, Kalamazoo, Michigan. Photograph by T. W. Brayne.

Kathleen Hart

née Kathleen Shepherd
(Husband Richard Foreman Hart)
Born February 1, 1925 Milwaukee, Wisconsin

Education and Training
1943 Milwaukee Downer College,
 Milwaukee, Wisconsin; study in art
1944 Purdue University, West Lafayette,
 Indiana; study in electronics,
 engineering drawing and physics
1975 Oxbow Summer School of Painting,
 Saugatuck, Michigan
1976- School of the Art Institute of Chicago,
 79 Chicago, Illinois; study in kinetic and
 electronic sculpture with Steve
 Wahldeck
1978- School of the Art Institute of Chicago,
 79 Chicago, Illinois; study in sculpture
 with James Zanzi
1978 Conference Workshops, "Tenth
 International Sculpture Conference,"
 York University, Toronto, Ontario,
 Canada; study in large-scale plastics
 with Fred Eversley and fountains and
 hydrosculpture with Richard Chaix,
 Charles Moore and Richard
 Tsutakawa (Sponsored by
 International Sculpture Center,
 Washington, D.C.)

Selected Individual Exhibitions
1979 ARC Gallery, Chicago, Illinois
1980 Chicago Cultural Center, Chicago
 Public Library, Chicago, Illinois
1981 Roy Boyd Gallery, Chicago, Illinois
1981- Illinois State Museum, Springfield,
 82 Illinois
1983 Lakeview Museum of Arts and
 Sciences, Peoria, Illinois

Selected Group Exhibitions
1977 "Seventy-Sixth Exhibition by Artists of
 Art Institute of Chicago," Art Institute
 of Chicago, Chicago, Illinois, catalog
1978 "ARC Gallery Exhibition," Charles A.
 Wustum Museum of Fine Arts, Racine,
 Wisconsin
1978 "New Horizons in Art 1978," Chicago
 Cultural Center, Chicago Public
 Library, Chicago, Illinois

1979 "Image Aura Exhibition of Art,"
 Suburban Fine Art Center, Highland
 Park, Illinois
1979 "Free Street Theater Benefit Auction,"
 Richard Hunt Studio, Chicago, Illinois
1979 "ARC Gallery Exhibition at Barat,"
 Reicher Gallery, Barat College, Lake
 Forest, Illinois
1979 "Art and Science," Borg-Warner
 Gallery, Museum of Science and
 Industry, Chicago, Illinois
1979 "Past and Present Members," ARC
 Gallery, Chicago, Illinois, catalog
1979 "Opening Invitational Exhibition,"
 Randolph Street Gallery, Chicago,
 Illinois
1979 "A Day in the Life, National Invitational
 Exhibition of Women Artists," ARC
 Gallery, Chicago, Illinois, catalog
1980 "Five Artists, Techniques/Technology:
 Steve Wahldeck, Electronic Sculpture;
 Chuck Nilli, Atmospheric Painting;
 Sally Douglas, Wall Work; Carmela
 Rego, Performance; Mary Patera,
 Minimalist Sculpture; Kathleen Hart,
 Hydrosculpture," Suburban Fine Art
 Center, Highland Park, Illinois
1980 "Group Exhibition," Roy Boyd Gallery,
 Chicago, Illinois
1980 "Chicago International Art Exposition
 1980," Navy Pier, Chicago, Illinois
 (Represented by Roy Boyd Gallery,
 Chicago, Illinois), catalog
1980 "Site Encounter: Art in Public Places
 1980," Chicago Federal Center
 Museum, Chicago, Illinois
1980 "Art for the Earth," Norris Center for
 the Arts, Northwestern University,
 Evanston, Illinois
1980 "Invitational Exhibition in Honor of
 Joseph Randall Shapiro," Museum of
 Contemporary Art, Chicago, Illinois
1982 "Peace Museum Grand Opening
 Exhibition," Peace Museum, Chicago,
 Illinois
1983 "Selections from the Sales Rental
 Gallery," Lakeview Museum for the
 Arts and Sciences, Peoria, Illinois
1984 "Tenth Anniversary Exhibition of ARC
 Gallery; Chicago's Alternative
 Spaces," ARC Gallery, Chicago, Illinois
 and Museum of Contemporary Art,
 Chicago, Illinois, catalog

Selected Public Collections
Dr. George Kottemann Office, Peoria, Illinois
Harza Engineering Company, Chicago, Illinois
Hodag Chemical Company, Skokie, Illinois
Illinois State Museum, Springfield, Illinois
Museum of Science and Industry, Chicago,
 Illinois
Urban Investment and Development
 Company, Chicago, Illinois

Selected Private Collections
Geraldine Freund, Chicago, Illinois
Walter and Dawn Clark Netsch, Chicago,
 Illinois

Gerard Pook, Chicago, Illinois
Mr. and Mrs. Joseph Randall Shapiro, Oak
 Park, Illinois
Mr. and Mrs. Jack Witkowsky, Chicago,
 Illinois

Selected Awards
1980 Exhibition Grant, Illinois Art Council
1981 Exhibition Grant, Illinois State
 Museum, Springfield, Illinois

Preferred Sculpture Media
Varied Media

Additional Art Field
Watercolor

Gallery Affiliation
ARC Gallery
356 West Huron Street
Chicago, Illinois 60610

Mailing Address
191 Wentworth Avenue
Glencoe, Illinois 60022

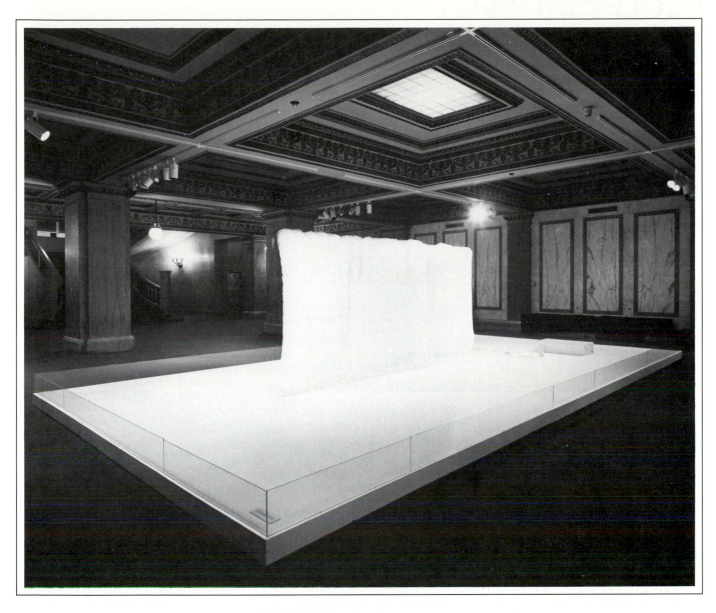

The Wall. 1980. Hydrosculpture, 8'h x 20'w x 4'd.
Installation view 1980. Chicago Cultural Center,
Chicago Public Library, Chicago, Illinois.
Photograph by Ron Gordon.

Artist's Statement

"My hydrosculptures are dedicated to
conservation. They recycle their contents,
can be solar generated (1-40 watts), use
non-threatening textures and scale, rainbow
spectrum colors and moving shapes often
accessible to the touch. Technological and
scientific principles are played against
man-made materials and occasional found
objects. The evolution of these forms,
dictated by nature, cross into psychological
and emotional areas of human activities,
bridging the art/public understanding.
Outdoors, unguarded, receiving considerable
attention and play, the sculptures have
remained unvandalized."

Cleo Hartwig

Born October 20, 1911 Webberville, Michigan

Education and Training
1930, School of the Art Institute of Chicago,
31 Chicago, Illinois; study in drawing
1932 A.B., Art Education, Western Michigan University, Kalamazoo, Michigan
1935 Summer Art Program (Hungary, Poland and Rumania), International School of Art, New York, New York; study in graphic design and woodblock printing
1937 New School for Social Research, New York, New York; study in stone carving with José de Creeft

Selected Individual Exhibitions
1943, Sculpture Center, New York, New
47 York, catalog
1949- Western Canada Art Circuit, Traveling
50 Exhibition (Canada), Calgary, Alberta, Canada
1965- Art Guild, Traveling Exhibition (United
66 States), New York, New York
1971 Montclair Art Museum, Montclair, New Jersey
1981 Sculpture Center, New York, New York

Selected Group Exhibitions
1938- "Annual Exhibition," National Academy
83 of Design, New York, New York, catalog
1942 "Artists for Victory: An Exhibition of Contemporary American Art," Metropolitan Museum of Art, New York, New York, catalog
1942 "Fifty-Third Annual Exhibition of American Paintings and Sculpture," Art Institute of Chicago, Chicago, Illinois, catalog
1944- "American Painting and Sculpture from
45 the Collection of the Museum," Newark Museum, Newark, New Jersey, catalog
1945- "Audubon Artists Annual Exhibition,"
83 National Arts Club, New York, New York, catalog
1946, "Annual Exhibition of Contemporary
48, Art," Nebraska Art Association,
49, Lincoln, Nebraska, catalog
50,
53
1948, "Annual Exhibition: Contemporary
49 American Sculpture, Watercolors and Drawings," Whitney Museum of American Art, New York, New York, catalog
1948- "Sculptors Guild Annual Exhibition,"
85 Lever House, New York, New York, catalog
1948 "George Cerny, Cleo Hartwig and Nina Winkel," Clay Club Sculpture Center, New York, New York
1949 "Fifth Summer Exhibition of Contemporary Art," University of Iowa, Iowa City, Iowa, catalog

1949 "Sculpture International," Philadelphia Museum of Art, Philadelphia, Pennsylvania, catalog
1950 "Twelve Women Sculptors," Philadelphia Art Alliance, Philadelphia, Pennsylvania, catalog
1951- "Annual Exhibition," National Sculpture
85 Society, New York, New York, catalog
1960 "Second Biennial of American Painting and Sculpture," Detroit Institute of Arts, Detroit, Michigan, catalog
1964 "Annual Exhibition of Painting and Sculpture," Pennsylvania Academy of the Fine Arts, Philadelphia, Pennsylvania, catalog
1965 "Women Artists of America 1707-1964," Newark Museum, Newark, New Jersey, catalog
1969 "Sculpture Since 1900," Montclair Art Museum, Montclair, New Jersey, catalog
1970 "Sculptors Guild: Sculpture in the Spring," University of Connecticut, Storrs, Connecticut
1970 "Society of Animal Artists Annual Juried Exhibition," Museum of Science, Boston, Massachusetts, catalog
1970 "Society of Animal Artists Annual Juried Exhibition," New York Zoological Society, New York, New York, catalog
1971 "American Natural History Art Exhibition," James Ford Bell Museum of Natural History, Minneapolis, Minnesota, catalog
1971 "Society of Animal Artists," Traveling Exhibition, National Museum of Natural History, Smithsonian Institution, Washington, D.C.
1972 "National Association of Women Artists Annual Exhibition," National Academy of Design, New York, New York, catalog
1972 "Vincent Glinsky and Cleo Hartwig," Sculpture Center, New York, New York
1974 "Festival of the Arts, Sculpture in the Garden," Southern Vermont Art Center, Manchester, Vermont, catalog
1975 "Society of Animal Artists Annual Juried Exhibition," Grand Central Art Galleries, New York, New York, catalog
1976- "Reflections: Images of America,"
77 Traveling Exhibition (Eastern and Western Europe), United States Information Agency, Washington, D.C.
1980 "A Newark Bestiary," Newark Museum, Newark, New Jersey, catalog
1981 "Sculpture in the Garden 1981," Sculptors Guild at the Enid A. Haupt Conservatory, New York Botanical Garden, Bronx, New York, catalog
1981 "Sculpture by Members of the Sculptors Guild," Canton Art Institute, Canton, Ohio
1981 "Animal Artists," White Plains Public Library, White Plains, New York, catalog
1982 "Society of Animal Artists Annual Juried Exhibition," Denver Museum of

Natural History, Denver, Colorado, catalog
1983 "Wildlife, Contemporary Animal Sculptors," King Gallery, New York, New York
1983 "Society of Animal Artists Annual Juried Exhibition," Mulvane Art Center, Topeka, Kansas, catalog
1984 "National Association of Women Artists Annual Exhibition," Jacob K. Javits Federal Building, New York, New York, catalog
1984 "Music Mountain Sculpture Exhibit," Music Mountain, Falls Village, Connecticut, catalog

Selected Public Collections
All Faiths Memorial Tower, Paramus, New Jersey
Brookgreen Gardens, Murrells Inlet, South Carolina
Chrysler Museum, Norfolk, Virginia
Continental Casualties Building, New York, New York
Detroit Institute of Arts, Detroit, Michigan
Lenox Hill Hospital, Children's Pavilion, New York, New York
Montclair Art Museum, Montclair, New Jersey
Mount Holyoke College, South Hadley, Massachusetts
National Academy of Design, New York, New York
National Museum of American Art, Smithsonian Institution, Washington, D.C.
Newark Museum, Newark, New Jersey
Pennsylvania Academy of the Fine Arts, Philadelphia, Pennsylvania
Southern Vermont Art Center, Manchester, Vermont
State University of New York College at Oswego, Oswego, New York
Western Michigan University, Kalamazoo, Michigan

Selected Private Collections
Dr. and Mrs. Otto L. Bendheim, Paradise Valley, Arizona
Mrs. William W. Crocker, Burlingame, California
John F. Lewis, Jr., Philadelphia, Pennsylvania
Milford C. Mumford, New York, New York
Mr. and Mrs. Richard Shields, New York, New York

Selected Awards
1973 Honorary Doctorate of Fine Arts, Western Michigan University, Kalamazoo, Michigan
1979 Ellin P. Speyer Prize, "Annual Exhibition," National Academy of Design, New York, New York, catalog
1984 Edith H. and Richard Proskauer Prize, "Annual Exhibition," National Sculpture Society, New York, New York, catalog

Preferred Sculpture Media
Stone and Wood

Quail. 1973. Marble, 9½"h x 11"w x 5½"d.
Photograph by Walter Russell.

Additional Art Field
Ceramic Sculpture

Selected Bibliography
Bell, Enid. "The Compatibles: Sculptors
 Hartwig & Glinsky." *American Artist* vol. 32
 no. 6 issue 316 (June 1968) pp. 44-49, 91,
 illus.
Glinsky, Vincent and Cleo Hartwig. "Direct
 Carving in Stone." *National Sculpture
 Review* (Summer 1965) pp. 23-25, illus.
Meilach, Dona Z. *Contemporary Stone
 Sculpture: Aesthetics, Methods,
 Appreciation.* New York: Crown, 1970.
Papers included in the Archives of American
 Art, Smithsonian Institution, New York,
 New York.
Schnier, Jacques Preston. *Sculpture in
 Modern America.* Berkeley: University of
 California Press, 1948.

Gallery Affiliation
Sculpture Center
167 East 69 Street
New York, New York 10021

Mailing Address
9 Patchin Place
New York, New York 10011

Artist's Statement
"My approach to sculpture is direct carving
without sketches or models. Carving a hard
stone or wood with hand tools is a slow
process and allows one to carefully study
and develop the masses and contours.
Fragments rather than rectangular blocks,
color, veining and density help determine the
subject matter. My preference for nature
forms as art subjects comes from an early
interest in small animals and birds as a child
in rural Michigan. I strive for a stylized or
highly simplified personal interpretation."

Cleo Hartwig

Maren Hassinger

née Maren Louise Jenkins
(Husband Peter William Hassinger)
Born June 16, 1947 Los Angeles, California

Education and Training
1969 B.A., Visual Arts, Bennington College, Bennington, Vermont; study with Michael Todd and Isaac Witkin
1969 Studio of Sidney Simon, New York, New York; assistant in the technical creation of sculpture
1973 M.F.A., Fiber Structure, University of California, Los Angeles, Los Angeles, California; study with Bernard Kester

Selected Individual Exhibitions
1980 Just Above Midtown/Downtown Gallery, New York, New York
1981 Gallery Six, Los Angeles County Museum of Art, Los Angeles, California
1985 Art Gallery, Los Angeles City College, Los Angeles, California
1985 Art Gallery, California State University Northridge, Northridge, California

Selected Group Exhibitions
1976 "Maren Hassinger/William Mahan," ARCO Center for the Visual Arts, Los Angeles, California
1977 "Studio Z: Individual Collective," Long Beach Museum of Art, Long Beach, California, catalog
1978 "New Talent Show," Zabriskie Gallery, New York, New York

1978 "Abstract Concerns," Art Space Gallery, Los Angeles, California
1979 "Transformation: UCLA Alumni in Fiber," F.S. Wight Art Gallery, University of California, Los Angeles, Los Angeles, California
1980 "Afro-American Abstraction," Traveling Exhibition 1982-1984, P.S. 1, Institute for Art and Urban Resources, Long Island City, New York, catalog
1980 "Project Grand Central," Waiting Room of Grand Central Station, New York, New York
1981- "Forever Free: Art by African-American
82 Women 1862-1980," Traveling Exhibition, Center for the Visual Arts Gallery, Illinois State University, Normal, Illinois, book-catalog
1981 "The Media, Style and Tradition of Ten California Artists," Loker Gallery, California Museum of Science and Industry, Los Angeles, California, catalog
1982 "Four," Los Angeles City College, Los Angeles, California
1982 "Magnus and Hassinger," Art Space Gallery, Los Angeles, California
1983 "Visual Conversations—East Coast/West Coast," S.P.A.R.C., Social and Public Art Resource Center, Venice, California
1984 "Transformation of the Minimal Style," Sculpture Center, New York, New York
1984 "East/West: Contemporary American Art," Museum of African American Art, Los Angeles, California, catalog

Selected Public Collections
Anaconda Industries Office Building, Rolling Meadow, Illinois
City of Los Angeles, San Diego Freeway Northbound, Mulholland Drive Exit, Los Angeles, California
Museum of African American Art, Los Angeles, California

Selected Awards
1980, Individual Artist's Fellowship,
84 National Endowment for the Arts
1983 Career Development Grant for Women Sculptors, Betty Brazil Memorial Fund, Tarrytown, New York

Preferred Sculpture Media
Varied Media

Additional Art Field
Dance in Performance Artworks

Related Professions
Art Instructor and Visiting Artist

Selected Bibliography
Mallinson, Constance. "Maren Hassinger: Nature Gone Mad." Images & Issues vol. 3 no. 3 (November-December 1982) pp. 53-54, illus.

"Maren Hassinger." The International Review of African American Art vol. 6 no. 1 (Spring 1984) pp. 34-41, illus.
Stein, Mark. "Steel Trees 'Grow' Along Freeways." Los Angeles Times (Thursday, November 29, 1979) pp. IX 1, IX 9, illus.
Wilson, William. "Art Review: Sculpture With a Poetic Fiber." Los Angeles Times (Monday, August 16, 1976) pp. IV 6, illus.
Wilson, William. "Of Cables and Collages in Artists' Wonderland." Los Angeles Times (Wednesday, May 27, 1981) Wednesday/Calendar, p. VI 1, illus.

Mailing Address
1108 South Gramercy Place
Los Angeles, California 90019

Artist's Statement

"The central issue of my sculpture is man's relation to nature in an increasingly mechanistic world. A medium I have chosen to develop this theme is wire rope. Strands of wire rope can be unplied and recombined into the likenesses of growing things. I also have used branches of my own devising, stones and, most recently, preserved leaves.

"My work has tended more and more to the site specific. I examine the area the art will occupy—the use and shape of the space and the quality of light—the entire gestalt of the environment. At times, these site specific installations have provided the inspiration for performances. Whether object, installation, or performance, I characteristically have preferred line, repetition and movement. Often a single motif is repeated over and over again to fill the space."

Maren Hassinger

12 Trees No. 2. 1979. Galvanized wire rope, 10'h x 150'w x 5'd. Collection City of Los Angeles, San Diego Freeway Northbound, Mulholland Drive Exit, Los Angeles, California. Photograph by Adam Avila.

Jan Havens

née Janis Burton Smith Haberthier
Born May 7, 1948 Norfolk, Virginia

Education and Training
1970 B.S., Ceramics, Atlantic Christian College, Wilson, North Carolina
1973 M.A., Ceramics, George Peabody College for Teachers, Nashville, Tennessee

Selected Individual Exhibitions
1978 Centennial Art Center, Nashville, Tennessee
1980 Tennessee Botanical Gardens and Fine Arts Center, Cheekwood, Nashville, Tennessee
1983 Southeastern Center for Contemporary Art, Winston-Salem, North Carolina
1985 Park Gallery, Louisville, Kentucky

Selected Group Exhibitions
1978 "Southeast Crafts 1978," Berea, Kentucky, catalog
1978 "Critters and Cohorts," Mindscape Gallery, Evanston, Illinois
1979 "Border States Invitational," Nexus Gallery, Atlanta, Georgia
1979 "Tennessee Artist Craftsmen Biennial," Tennessee Valley Authority, Knoxville, Tennessee
1979 "Ceramics Southeast," University of Georgia, Athens, Georgia
1980 "Eighth Biennial Crafts Exhibition," Joe L. Evins Appalachian Center for Crafts, Smithville, Tennessee, catalog
1980 "Spring Exhibition," Jackson Avenue Gallery of Contemporary Art, Knoxville, Tennessee
1981 "Invitational Exhibition," Greenwood Gallery, Washington, D.C.
1981 "The Animal Image: Contemporary Objects and the Beast," Renwick Gallery of the National Museum of American Art, Smithsonian Institution, Washington, D.C., catalog
1982 "Currents 1982," Middle Tennessee State University, Murfreesboro, Tennessee
1982 "Invitational Exhibition," Rare Discovery Gallery, Honolulu, Hawaii
1982 "Spotlight 1982," Arrowmont School of Arts and Crafts, Gatlinburg, Tennessee
1983 "Images/Impressions," Elizabeth Fortner Gallery, Santa Barbara, California
1984 "Tennessee Crafts," Bloomingdale's, New York, New York

Selected Public Collection
Radio City Music Hall, New York, New York

Selected Awards
1978 Merit Award, "Seventh Biennial Crafts Exhibition," Nashville Parthenon, Nashville, Tennessee
1979 Best of Show, "Tennessee Crafts Fair," Centennial Park, Nashville, Tennessee
1982 Merit Award, "Crafts Festival," John and Mabel Ringling Museum of Art, Sarasota, Florida

Preferred Sculpture Media
Clay and Varied Media

Selected Bibliography
"News & Retrospect: Jan Havens." *Ceramics Monthly* vol. 26 no. 7 (September 1978) p. 87, illus.

Nigrosh, Leon I. *Low Fire: Other Ways to Work in Clay*. Worcester, Massachusetts: Davis, 1980.

Seawright, Sandy. "Tennessee: Clay Fantasies by Jan Havens." *ArtCraft Magazine* vol. 1 no. 4 (June-July 1980) pp. 63-64, illus.

Mailing Address
1121 Graybar Lane
Nashville, Tennessee 37204

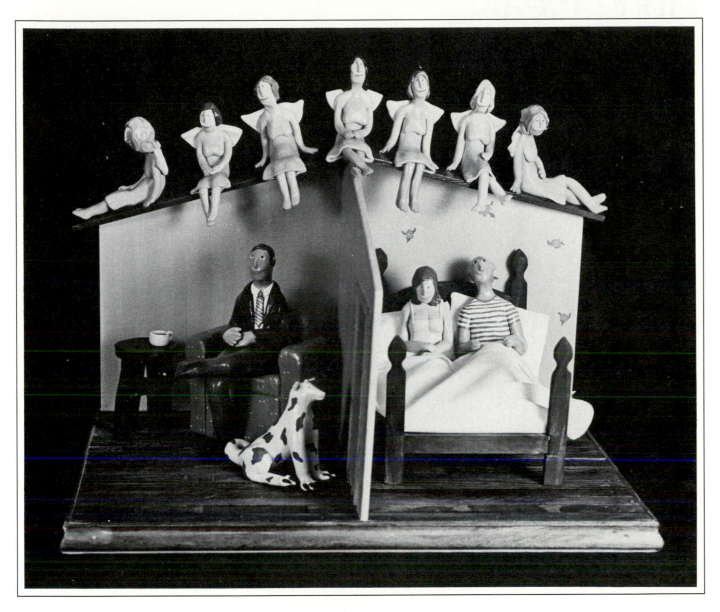

Immaculate Conception. 1983. Clay, paint and wood, 16″h x 13½″w x 21″d. Photograph by Barry Havens.

Artist's Statement

"I became interested in clay and the different textures I could create with this media while taking a required ceramics class in college. My sculptures were large, heavily textured animals with human attributes. I am now more interested in the smooth, sculptural quality of the clay.

"My approach to sculpture is primarily influenced by the imagery of the events of the world around me. In addition to animals, I depict people being people. Some of my pieces come into existence intuitively, evolving as I work. Humor has always been a major element in my work and many of my sculptures have a cartoon quality or playfulness. This particular piece is one of a series about God and the things He does. Although I am not especially religious, attending a church-related college probably has influenced my choice of this subject matter."

Jan Haven

277

Anne Healy

née Anne Laura
Born October 1, 1939 New York, New York

Education and Training
1962 B.A., English Literature and Theater, City University of New York Queens College, Flushing, New York

Selected Individual Exhibitions
1972, A.I.R. Gallery, New York, New York
74,
78,
81,
83
1974 Graduate Center, City University of New York, City College, New York, New York
1974 Hammarskjöld Plaza Sculpture Garden, New York, New York
1975, Zabriskie Gallery, New York, New York
78
1976 Contemporary Arts Center, Cincinnati, Ohio
1976 Suzette Schochet Gallery, Newport, Rhode Island
1976 Monumenta '76, Art Association of Newport, Newport, Rhode Island, catalog
1977 Art Museum of South Texas, Corpus Christi, Texas
1979 Alfred University, Alfred, New York
1980 Wordworks Gallery, San Jose, California
1982 Matrix Gallery, Sacramento, California
1983 Public Art Fund, New York, New York
1984 Rutgers University, Douglass College, New Brunswick, New Jersey, catalog
1985 Lakeside Park, Oakland, California

Selected Group Exhibitions
1971 "Brooklyn Bridge Festival," Brooklyn Bridge, New York, New York
1972 "Exterior Installation," Museum of Contemporary Crafts, New York, New York
1973 "Women Choose Women," New York Cultural Center, New York, New York, catalog
1973 "Soft as Art," New York Cultural Center, New York, New York
1974 "Painting and Sculpture Today 1974," Indianapolis Museum of Art, Indianapolis, Indiana, catalog
1974 "Monumenta, A Biennial Exhibition of Outdoor Sculpture," Area Locations, Newport, Rhode Island, catalog
1974 "Non-Traditional Sculpture: Healy, Stewart, Wilke," Smith College, Northampton, Massachusetts
1975 "The Year of the Woman: Reprise," Bronx Museum of The Arts, Bronx, New York
1975 "Site Sculpture: Hamrol, Healy, Tacha," Zabriskie Gallery, New York, New York; Graduate Center, City University of New York, City College, New York, New York

1975 "Sculpture Outdoors," Nassau County Museum of Fine Arts, Roslyn, New York, catalog
1976 "Site Sculpture II: Hamrol, Healy, Tacha," Zabriskie Gallery, New York, New York
1976 "Projects," Philadelphia College of Art, Philadelphia, Pennsylvania, catalog
1976 "Basel Art Fair," Basel, Switzerland
1976 "American Artists '76: A Celebration," Marion Koogler McNay Art Institute, San Antonio, Texas, catalog
1977 "Outdoor Environmental Art," New Gallery of Contemporary Art, Cleveland, Ohio, catalog
1977 "Site Sculpture: Hamrol, Healy, Miss, Tacha," Zabriskie Gallery, New York, New York
1977 "Contemporary Women: Consciousness and Content," School of the Brooklyn Museum, New York, New York
1977 "The Material Dominant," Pennsylvania State University-University Park Campus, University Park, Pennsylvania
1978 "Overview: Five Years of A.I.R.," P.S. 1, Institute for Art and Urban Resources, Long Island City, New York, catalog
1978 "Four Artists: Selected by Paul Shanley," Pennsylvania State University-University Park Campus, University Park, Pennsylvania, catalog
1979 "Paintings and Sculpture by Candidates for Art Awards," American Academy and Institute of Arts and Letters, New York, New York, catalog
1979 "Part 1, O.I.A. Sculpture," Ward's Island, New York, catalog
1979 "Exhibition of Work by Newly Elected Members and Recipients of Honors and Awards," American Academy and Institute of Arts and Letters, New York, New York, catalog
1980 "Southsite Project," Emily Lowe Gallery, Hempstead, New York, catalog
1980 "Quintessence: Alternative Spaces Residency Program," City Beautiful Council, Dayton, Ohio and Wright State University, Department of Art, Dayton, Ohio, catalog
1981 "Transformations: Women in Art '70s-'80s," New York Coliseum, New York, New York, catalog
1981 "Annual Three Rivers Arts Festival," Gateway Center, Pittsburgh, Pennsylvania, catalog
1982 "Wind Sculpture," Art Programs, Incorporated, San Francisco, California, catalog
1983 "Terminal New York," Harborside Industrial Center, Brooklyn, New York, catalog
1984 "Representative Works 1971-1984," Rutgers University, Douglass College, New Brunswick, New Jersey, catalog
1985 "Artists' Valentine's," Emanuel Walter Gallery, San Francisco Art Institute, San Francisco, California

1985 "Art From the Heart," University Art Gallery, Sonoma State University, Rohnert Park, California
1985 "Women Sculptors of the 1980s," Pratt Manhattan Gallery, New York, New York; Pratt Institute Gallery, Brooklyn, New York, catalog

Selected Public Collections
Allen Memorial Art Museum, Oberlin, Ohio
American Craft Museum, New York, New York
Art Museum of South Texas, Corpus Christi, Texas
City of Pittsburgh, Pennsylvania
Department of Cultural Affairs, New York, New York
Detroit General Hospital, Detroit, Michigan
Graduate Center, City University of New York, City College, New York, New York
Michigan State University, East Lansing, Michigan
Prudential Insurance Company of America, Newark, New Jersey
South Kitsap High School, Port Orchard, Washington

Selected Awards
1976 Sculpture Award, American Association of University Women, New York, New York
1979 Recipient of an Award in Art, American Academy and Institute of Arts and Letters, New York, New York
1983 Faculty Grant, Academic Senate Committee, University of California, Berkeley, Berkeley, California

Preferred Sculpture Media
Varied Media

Additional Art Fields
Drawing and Painting

Related Professions
Lecturer and Visiting Artist

Teaching Position
Assistant Professor, University of California, Berkeley, Berkeley, California

Selected Bibliography
Beardsley, John. *Art in Public Places: A Survey of Community-Sponsored Projects Supported by the National Endowment for the Arts.* Washington, D.C.: Partners for Livable Spaces, 1981.
Kingsley, April. "Women Choose Women." *Artforum* vol. 11 no. 7 (March 1973) pp. 69-73.

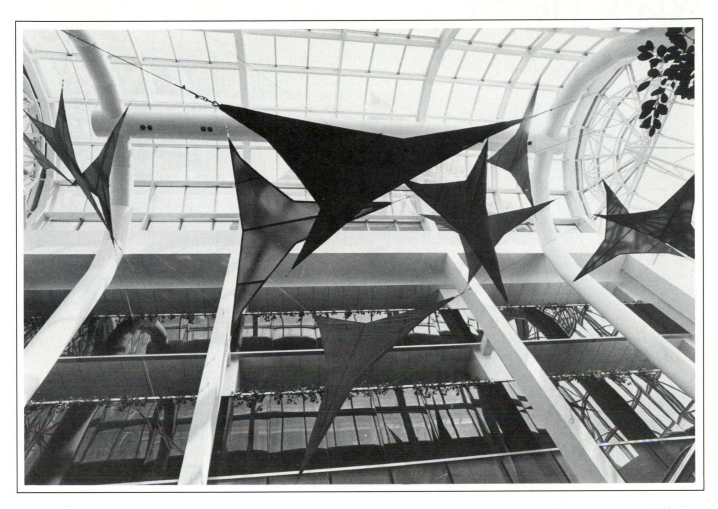

Slashing Tangents. 1984. Cloth and cable, 57′h x 30′w x 90′d. Collection Prudential Insurance Company of America, Newark, New Jersey. Photograph by New Jersey Newsphotos.

Munro, Eleanor C. *Originals: American Women Artists*. New York: Simon and Schuster, 1979.

Robins, Corinne. "Anne Healy: Ten Years of Temporal Sculpture Outdoors and In." *Arts Magazine* vol. 53 no. 2 (October 1978) pp. 129-131, illus.

Robins, Corinne. "Anne Healy." *Arts Magazine* vol. 56 no. 10 (June 1981) p. 21, illus.

Gallery Affiliation

A.I.R. Gallery
63 Crosby Street
New York, New York 10012

Mailing Address

2753 22 Street
San Francisco, California 94110

Artist's Statement

"I feel I am a shaman, a magician who creates enormous structures that weigh nothing and can be taken down in no time, to be put up again in a similar or in an entirely new way of dealing with the space/environment. My work is never, never the same, even if maintained in the same installation in 'permanent' materials. Each time the light, the shadows, the wind or the trees change, the piece alters in its relationship to these elements. Change IS permanence. The only true permanence is in the memory of the viewer. Art can be a pageant of celebration and magic."

Anne Healy

Mary Hecht

Born June 23, 1931 New York, New York
(Canadian and United States citizenship)

Education and Training
1948- Art Academy of Cincinnati, Cincinnati,
52 Ohio; study in drawing
1949, Art Students League, New York, New
52 York; study in drawing and painting
1950, Columbia University, New York, New
52 York; study in drawing and sculpture
1952 B.A., Sociology, University of
Cincinnati, Cincinnati, Ohio
1957 M.A., Sculpture, State University of
Iowa, Ames, Iowa
1958- Camberwell School of Art, London,
60 Great Britain; study in bronze casting

Selected Individual Exhibitions
1961, The Gallery, Glens Falls, New York
67
1962 Union of American Hebrew
Congregation, New York, New York
1970 Framehouse Gallery, Louisville,
Kentucky
1970 Miller Gallery, Cincinnati, Ohio
1971 Adams Gallery, Toronto, Ontario,
Canada
1972 St. Lawrence Centre, Toronto, Ontario,
Canada
1972 Indianapolis Museum of Art,
Indianapolis, Indiana
1973 Fairfield University, Fairfield,
Connecticut
1974, Evans Gallery, Toronto, Ontario,
75 Canada
1975 Scarborough College, University of
Toronto, Toronto, Ontario, Canada
1977 Prince Arthur Galleries, Toronto,
Ontario, Canada
1977 Lafayette Art Center, Lafayette,
Indiana
1979 MacDowell Gallery, Toronto, Ontario,
Canada
1980 Heritage Ganaraska Foundation, Port
Hope, Ontario, Canada
1980, McLaughlin College, York University,
84 Toronto, Ontario, Canada
1981 Goethe Institute, Toronto, Ontario,
Canada
1981 Ramapo College of New Jersey Art
Gallery, Mahwah, New Jersey; Hyde
Collection, Glens Falls, New York
1982 Gustafsson Galleries, Toronto, Ontario,
Canada
1982, Catholic Education Centre, Toronto,
83 Ontario, Canada
1984 Drian Gallery, London, Great Britain
1985 Justina M. Barnicke Gallery, Hart
House, University of Toronto, Ontario,
Canada

Selected Group Exhibitions
1962 "Summer Exhibition," Royal Academy
of Art, London, Great Britain
1964 "Mary Hecht and Bruce Church," The
Gallery, Glen Falls, New York
1972- "Art of the Ballet Annual Exhibition,"
77 O'Keefe Centre, Toronto, Ontario,
Canada
1972 "The Work of Mary Hecht and
Seymour Rosenthal," Milliken Gallery,
Indianapolis Museum of Art,
Indianapolis, Indiana
1976 "International Exhibition of Liturgical
Art and Architecture," Copley-Plaza
Hotel, Boston, Massachusetts
(Sponsored by Interfaith Forum on
Religion, Art and Architecture,
Washington, D.C.)
1976, "Annual Exhibition of Contemporary
84 Art," Geraldine Lithwick Gallery,
Montreal, Quebec, Canada
1979 "Going for a Song: Opera Society,"
O'Keefe Centre, Toronto, Ontario,
Canada
1981 "International Exhibition of Liturgical
Art and Architecture, Radisson Hotel,
Chicago, Illinois (Sponsored by
Interfaith Forum on Religion, Art and
Architecture, Washington, D.C.)
1982 "Sculptor's Society of Canada Annual
Exhibition," Central Hospital, Toronto,
Ontario, Canada
1982 "American Society of Contemporary
Artists Exhibition," Lowenstein Library
Gallery, Fordham University at Lincoln
Center, New York, New York
1983 "Sculptor's Society of Canada Annual
Exhibition," Bel Air Gallery, Toronto,
Ontario, Canada
1983 "American Medallic Sculpture Associa-
tion Exhibition," American Numismatic
Society, New York, New York
1983 "American Society of Contemporary
Artists Exhibition," Jacob K. Javits
Federal Building, New York, New York
1983 "Creative Artists in the Schools,"
Central Society for Education through
Art, Toronto, Ontario, Canada
1983, "Catharine Lorillard Wolfe Art Club
84 Annual Open Exhibition," National Arts
Club, New York, New York
1983 "Fédération International de la Medaille
XIX Congress," Palazzo Medici,
Florence, Italy
1984 "Sculptor's Society of Canada Annual
Exhibition," Francophone Centre,
Toronto, Ontario, Canada
1984 "American Medallic Sculpture
Association Exhibition," American
Numismatic Society, New York, New
York; American Numismatic
Association, Colorado Springs,
Colorado and San Francisco Old Mint,
San Francisco, California, catalog
1985 "Fédération International de la Medaille
XX Congress," Byggnadsstynelsen,
Stockholm, Sweden
1985 "VII Biennale: Internazionale Dantesca
di Ravenna," Centro Dantesco,
Ravenna, Italy

1985 "Society of Canadian Artists Annual
Exhibition," Merton Gallery, Toronto,
Ontario, Canada; Woodstock Art
Gallery, Woodstock, Ontario, Canada

Selected Public Collections
Fairfield University, Fairfield, Connecticut
Hamilton Art Gallery Permanent Collection,
Hamilton, Ontario, Canada
Indianapolis Museum of Art, Indianapolis,
Indiana
Iowa State University, Ames, Iowa
Lafayette Art Center, Lafayette, Indiana
Mount Sinai Hospital, New York, New York
Ramapo College of New Jersey, Mahwah,
New Jersey
Reconstructionist Rabbinical College,
Philadelphia, Pennsylvania
Rockland Community College, Suffern, New
York
Society for the Advancement of Judaism,
New York, New York

Selected Private Collections
Mr. and Mrs. Walter Bic, Toronto, Ontario,
Canada
Edgar F. Kaiser, Jr., Oakland, California and
Puget Sound, Washington
Sir Edward Pochin, Newbury, Great Britain
Mr. and Mrs. Victor Shields, Toronto, Ontario,
Canada
Mrs. David Vardi, Jerusalem, Israel

Selected Awards
1975, Individual Artist's Fellowship, Ontario
79 Arts Council
1983 Excaliber Bronze Award, "Catharine
Lorillard Wolfe Art Club Annual Open
Exhibition," National Arts Club, New
York, New York

Preferred Sculpture Media
Clay, Metal (cast) and Wood

Additional Art Field
Woodcuts

Related Profession
Magazine Illustrator

Teaching Positions
Tutor, McLaughlin College, York University,
Toronto, Ontario, Canada
Art Instructor, Inner City Angels, Toronto,
Ontario, Canada

Mailing Address
267 St. George Street-1004
Toronto, Ontario, Canada M5R 2P9

Artist's Statement

"I am a visual artist because I am one of the Homo sapiens born/called to be one. I sculpt because I have no sense of color . . . but have a sense of space and balance. I choose themes from myth and literature for my work because I am fascinated by religion and philosophy which are important in understanding relationships with ourselves and with our universe. I am attracted by those aspects of our minds which cannot be quantified and defy logic. In recent years, my work has evolved towards a heightened emphasis on elements of serenity.

"In retrospect I see that my work captures the moment of action both cerebral and physical—humor, anguish, bewilderment, great joy, contemplation, innocence, tenderness and poignancy. As I age the scope increases. I am in awe that I have created these sculptures."

Mary Hecht

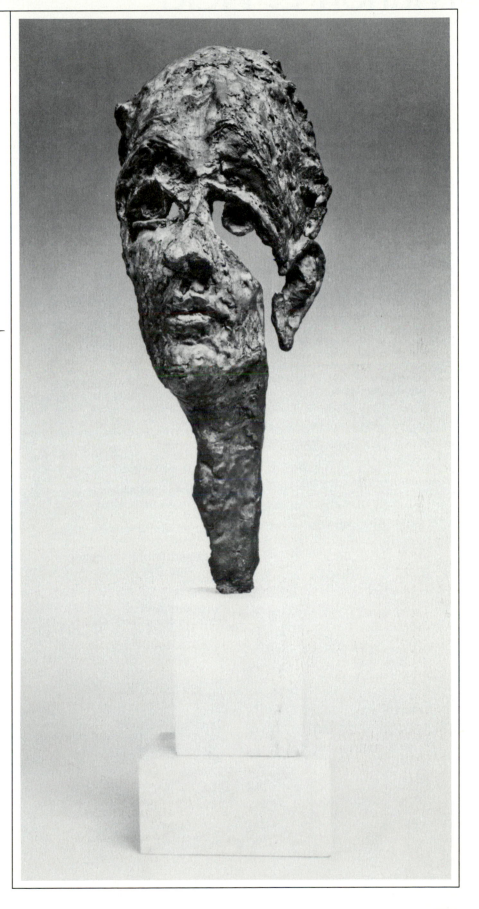

Poet. 1970. Bronze, 18"h x 6"w x 6"d. Photograph by Thomas E. Moore.

Marion E. Held

née Marion E. Chetron
Born December 24, 1939 New York, New York

Education and Training
1961 B.S., Art Education, New York University, New York, New York
1979 M.A., Fine Arts, Montclair State College, Upper Montclair, New Jersey; study in ceramic sculpture with Patricia Lay and William C. McCreath
1982 Haystack Mountain School of Crafts, Deer Isle, Maine; study in ceramic sculpture with Frank Boyden

Selected Individual Exhibitions
1976 Georgian Court College, Lakewood, New Jersey
1978 Gallery One, Montclair State College, Upper Montclair, New Jersey
1978 Gallery 84, New York, New York
1981 Broadway Gallery, Passaic County Community College, Paterson, New Jersey
1983 Maurice M. Pine Free Public Library, Fair Lawn, New Jersey
1985 Robeson Center Gallery, Rutgers University, University College-Newark, Newark, New Jersey

Selected Group Exhibitions
1977 "Artists Exhibition," Sculptors Five Gallery, Chatham, New Jersey
1978 "The Art in Craft," Rutgers University, Mason Gross School of the Arts, New Brunswick, New Jersey
1978 "Invitational Exhibition," Peters Valley Center, Layton, New Jersey
1979 "Festival of Art," Monmouth College, West Long Branch, New Jersey
1979-80 "Earth Song: Marion E. Held and Norman Lowrey," Korn Gallery, Drew University, Madison, New Jersey; Gallery 84, New York, New York
1981 "Clay/Sound/Forms: Earth Song and Shamanic Voices, Marion E. Held and Norman Lowrey," New Jersey State Museum, Trenton, New Jersey, catalog
1981 "Invitational Exhibition," Summit Art Center, Summit, New Jersey
1981 "Art Workers," Newark Museum, Newark, New Jersey
1981 "Third Biennial Exhibition New Jersey Artists," Newark Museum, Newark, New Jersey and New Jersey State Museum, Trenton, New Jersey, catalog
1982 "Spectrum," Fairleigh Dickinson University Florham-Madison Campus, Madison, New Jersey
1983 "Solid Directions," Morris Museum of Arts and Sciences, Morristown, New Jersey
1984 "Women's Caucus for Art National Juried Exhibition," Ralph L. Wilson Gallery, Alumni Memorial Building, Lehigh University, Bethlehem, Pennsylvania, catalog
1984 "Innovation," City Without Walls, Newark, New Jersey, catalog

Selected Public Collection
New Jersey State Museum, Trenton, New Jersey

Selected Award
1982 Emerging Talent, National Council on Education for the Ceramic Arts Conference, San Jose State University, San Jose, California

Preferred Sculpture Media
Clay

Teaching Position
Adjunct Faculty, Montclair State College, Upper Montclair, New Jersey
Art Instructor, Montclair Kimberley Academy, Montclair, New Jersey

Selected Bibliography
Malarcher, Patricia. "Crafts." *The New York Times* (Sunday, December 6, 1981) p. N.J. 24, illus.
Malarcher, Patricia. "Crafts: 2 Ways to Push Clay to Its Limits." *The New York Times* (Sunday, December 18, 1983) p. N.J. 24, illus.
Speight, Charlotte F. *Images in Clay Sculpture: Historical and Contemporary Techniques.* New York: Harper & Row, 1983.

Mailing Address
11 Colony Drive West
West Orange, New Jersey 07052

Artist's Statement

"Until recently my work was monumental in scale. At that time I produced totems built of three or four irregular stacked hollow segments, varying in height and width. The columns evoked pillars shaped by natural forces in the desert. Since then I have adapted the somewhat impersonal vertical forms into works which continue to be totems but are smaller, more spontaneous and more personally expressive. The forms have been inspired by my interest in human gesture and the fundamental, mysterious and subtle quality of the erotic. They speak of primitive symbolism and ancient cultures. I attempt to explain and relate aspects of myself to myself and others and, in so doing, pose some questions about the nature of human experience."

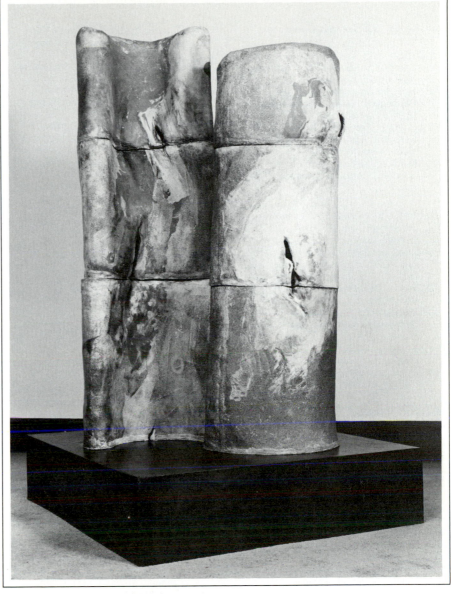

Goddess Monoliths. 1981. Stoneware, 59"h x 39"w x 14"d; pedestal, 10"h. Installation view 1981. "Clay/Sound/Forms:Earth Song and Shamanic Voices, Marion E. Held and Norman Lowrey," New Jersey State Museum, Trenton, New Jersey, catalog. Photograph by Elton Pope-Lance.

283

Nancy Helfant

Born June 2, 1936 Norwalk, Connecticut

Education and Training
1954- Central Connecticut State University,
56 New Britain, Connecticut
1958 B.S., Art Education, Southern Connecticut State University, New Haven, Connecticut
1964 Fulbright Fellowship, Accademia di Belle Arti, Rome, Italy; independent study in sculpture
1971 M.F.A., Sculpture, Rhode Island School of Design, Providence, Rhode Island

Selected Individual Exhibitions
1962, Silvermine Guild of Artists, New
67 Canaan, Connecticut
1969 Scudder Gallery, Paul Creative Arts Center, University of New Hampshire, Durham, New Hampshire
1970 Lenore Gray Gallery, Providence, Rhode Island
1974 Woods-Gerry Gallery, Rhode Island School of Design, Providence, Rhode Island
1977 Anderson Center for Arts, Hartwick College, Oneonta, New York, catalog
1984 Hunt Cavanagh Hall, Providence College, Providence, Rhode Island

Selected Group Exhibitions
1959 "Tenth Annual New England Exhibition," Silvermine Guild of Artists, New Canaan, Connecticut, catalog
1960 "Boston Arts Festival," Boston Public Garden, Boston, Massachusetts
1963 "Sculpture in the Collection of the Artist," Museum of Art, Rhode Island School of Design, Providence, Rhode Island, catalog
1964, "New England Art Today,"
65 Northeastern University, Boston, Massachusetts
1965 "New Talent," DeCordova and Dana Museum and Park, Lincoln, Massachusetts, catalog
1967 "Artists of Radcliffe Institute," Radcliffe College, Cambridge, Massachusetts
1967 "Arts Ogunquit," Ogunquit Art Association, Ogunquit, Maine, catalog

1968 "Surreal Images," DeCordova and Dana Museum and Park, Lincoln, Massachusetts, catalog
1969 "Hanging Objects," Lee Nordness Galleries, New York, New York
1971 "Two Sculptors: Moun/Helfant," University of Connecticut, Storrs, Connecticut, catalog
1973- "Traveling Exhibition," Dartmouth
74 College, Hanover, New Hampshire; Currier Gallery of Art, Manchester, New Hampshire; State University of New York College at Potsdam, Potsdam, New York (Sponsored by Roland Gibson Art Foundation, Potsdam, New York), catalog
1973, "Sculpture," Connecticut College, New
75 London, Connecticut, catalog
1975 "New England Women," DeCordova and Dana Museum and Park, Lincoln, Massachusetts, catalog
1975 "Fantasy," Skera Gallery, Amherst, Massachusetts
1976 "Creative Women," Barrington College, Barrington, Rhode Island
1976 "Tactile Arts," Smith College, Northampton, Massachusetts
1976 "Contemporary Quilt," Traveling Exhibition, Museum of Contemporary Crafts, New York, New York, catalog
1981 "Invited Artists," WARM, Women's Art Registry of Minnesota, Minneapolis, Minnesota
1983 "Dealer's Choice," Lily Iselin Gallery, Providence, Rhode Island
1983 "Three Artists, An Encore," Mary Ingraham Bunting Institute, Radcliffe College, Cambridge, Massachusetts
1983 "Quilts, Baskets, Sculpture," Newport Association of Art, Newport, Rhode Island
1985 "Faculty Exhibition," Watson Gallery, Wheaton College, Norton, Massachusetts
1985 "Eighth New England Arts Biennial," University of Massachusetts at Amherst, Amherst, Massachusetts

Selected Public Collections
Mary Ingraham Bunting Institute, Radcliffe College, Cambridge, Massachusetts
Wheaton College, Norton, Massachusetts

Selected Private Collections
Mr. and Mrs. David Aldrich, Providence, Rhode Island
Mr. and Mrs. William Bollenback, St. Paul, Minnesota
Dr. Harry Kozal, Boston, Massachusetts
Dr. Gunner Nirk, Barrington, Rhode Island
Mr. and Mrs. Howard Smith, Pittsburgh, Pennsylvania

Selected Awards
1962 Louis Comfort Tiffany Foundation Grant
1963 Fellowship, Radcliff Institute for Independent Study, Radcliff College, Cambridge, Massachusetts

1985 Proposal Grant, New England Arts Biennial Major Works Program, University of Massachusetts at Amherst, Amherst, Massachusetts

Preferred Sculpture Media
Metal (cast) and Wood

Teaching Position
Assistant Professor of Art, Wheaton College, Norton, Massachusetts

Selected Bibliography
Block, Jean Libman. "A Quilt is Built." *Craft Horizons* vol. 36 no. 2 (April 1976) pp. 30-35, illus.
"Vogue's Decorating Finds and Ideas for Fashions in Living." *Vogue* vol. 153 no. 10 (June 1969) p. 77, illus.

Mailing Address
116 Chestnut Street
Providence, Rhode Island 02903

Artist's Statement

"The *Women Tree Forest* is a summation of ideas, techniques and materials which have evolved in my work over the past twenty years. I began using the emerging female form in 1966. As studio demands and needs changed, I worked in manipulable cloth, laminated polyester resin, cast bronze and aluminum. The images could be combined or recombined to form various positions or interactions of figures which cast back their own shadows, yet remained trapped within their supports.

"The recent fabricated hardwood sculpture reflects my fascination with the mechanical, beautifully articulated, and lonely forms of old artists' mannequins, dolls and dress armour. The trapped silhouette/shadow figures, with implications of movement, have become an environment of over life-sized, freestanding, walking women. The sculptures are rearrangeable configurations on a single, pivoting axis. The women-tree-forest is intended to go beyond the visual statement into the strong emergence of women to fulfill their human potential."

Nancy Helfant

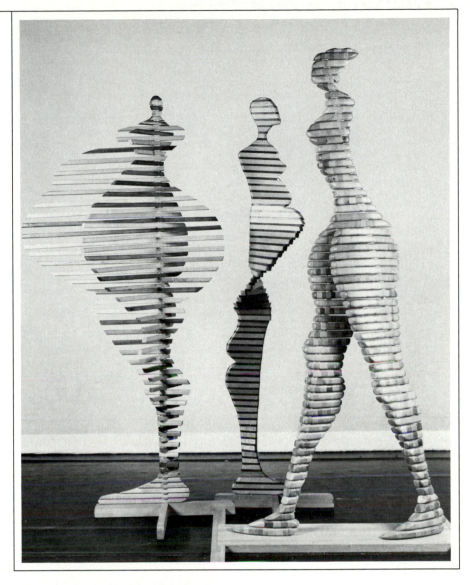

Women Tree Forest. 1984. *Double Women Tree III.* 1982. Left: Mixed hardwood, 8'h x 3'10"w x 3'6"d. *Walking Women Tree V.* 1983. Right: Mixed laminated hardwood, 8'6"h x 4'2"w x 1'd. *Women Tree I.* 1982. Background: Stripped maple and walnut, 8'h x 2'6"w x 1'4"d. Installation view 1985. "Faculty Exhibition," Watson Gallery, Wheaton College, Norton, Massachusetts. Photograph by Andy Howard.

Alison Helm

née Alison Lucy
Born July 7, 1956 Greenville, Mississippi

Education and Training
1979 B.F.A., Sculpture and Silversmithing, Cleveland Institute of Art, Cleveland, Ohio; study with Jerry Aidlin and Carl Floyd

1980- Syracuse University, Syracuse,
83 New York; intermittent workshops in bronze casting and welding with Anthony Caro and Kenneth Noland

1983 M.F.A., Sculpture, Syracuse University, Syracuse, New York; study with Roger Mack and Lawson Smith

Selected Individual Exhibitions
1981 Fairbanks Gallery, Syracuse, New York

1984 University of Pittsburgh, Pittsburgh, Pennsylvania

Selected Group Exhibitions
1980 "Autumn '80," Joe & Emily Lowe Art Gallery, Syracuse, New York

1981 "Invitational Show," Salisbury State College, Salisbury, Maryland

1981 "Twenty-Seventh Annual Drawing and Small Sculpture Show," Ball State University, Muncie, Indiana

1982 "Alison Helm, Von Allen and Judy Wood," Chapman Art Gallery, Cazenovia College, Cazenovia, New York

1982 "Syracuse Biennial," Everson Museum of Art, Syracuse, New York

1983 "Dean's Fellowship Exhibition," Crouse College, Syracuse University, Syracuse, New York

1983 "Fellowship Exhibition," Lubin House, New York, New York

1983 "West Virginia University Faculty Exhibition," Wiebe & Bonwell Galleries, Pittsburgh, Pennsylvania

1984 "Outdoor Sculpture Exhibition '84," Ellsworth Gallery, Simsbury, Connecticut

1984 "Summer Color," Kuban Gallery, Cleveland, Ohio

1984 "Regional Women Artists Invitational Show," Mountainlair Gallery, West Virginia University, Morgantown, West Virginia, catalog

1985 "Contemporary Art," Stiffel Fine Arts Center, Wheeling, West Virginia

Selected Public Collection
Ball State University, Muncie, Indiana

Selected Awards
1979 Agnus Gund Memorial Scholarship, Cleveland Institute of Art, Cleveland, Ohio

1980- Graduate Fellowship, Syracuse
82 University, Syracuse, New York

Preferred Sculpture Media
Varied Media and Wood

Additional Art Field
Metalsmithing

Teaching Position
Assistant Professor of Art, West Virginia University, Morgantown, West Virginia

Mailing Address
2020 Carnegie Street
Morgantown, West Virginia 26505

Artist's Statement

"I believe that the aesthetics of all the arts are intertwined within visual and philosophical references. The creative process involves feelings, recall and/or seeking the unusual. The three main elements in my present work are color, volume and illusion. I create a stagelike structure in order to combine depth and transparency in a fluctuating color intensity. Among these densities exist fragmented visual elements of life experiences. Feelings that allude to various shape references lead to a rich development and curious mix of consequences.

"Like dreams, the intuitive placement of objects and shapes can occasionally become the sources of new insight. Often pieces will occur spontaneously, impulsively and effortlessly and at other times, thoughtfully and deliberately. Sometimes the meaning of the work might not be clear until the product is completed."

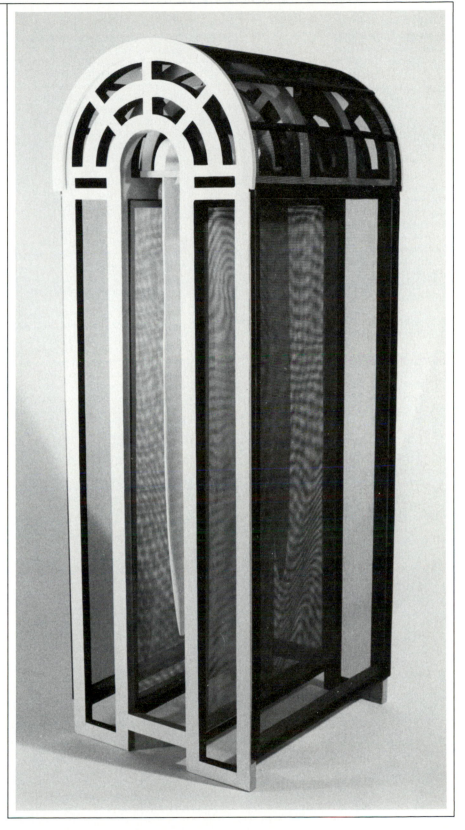

Fish Monument. 1984. Painted wood and screen, 3'h x 1'w x 1'd.

Phoebe Helman

née Phoebe Helman Rubin
(Husband Jack Sonenberg)
Born October 29, 1929 New York, New York

Education and Training
1947 Art Students League, New York, New York; study in painting
1948-49 Columbia University, New York, New York
1951 B.F.A., Painting, Washington University, St. Louis, Missouri

Selected Individual Exhibitions
1974 Max Hutchinson Gallery, New York, New York
1976 Manhattanville College, Purchase, New York
1977 Gallery 101, University of Wisconsin-River Falls, River Falls, Wisconsin
1977 Art Gallery, Menomonie, Wisconsin
1978 Sculpture Now, New York, New York
1979 University Gallery, Wright State University, Dayton, Ohio
1981 Andre Zarre Gallery, New York, New York

Selected Group Exhibitions
1969 "Phoebe Helman and Sylvia Stone," Emily Lowe Gallery, Hempstead, New York
1973, 75, 76, 81 "118 Artists," Landmark Gallery, New York, New York
1975 "Plastics," State University of New York College at Potsdam, Potsdam, New York
1976 "Sculptors: Pratt Faculty Exhibition," Pratt Institute, Brooklyn, New York
1976 "Year of the Women," Pratt Institute, Brooklyn, New York; City University of New York Borough of Manhattan Community College, New York, New York; Women's Interart Center, New York, New York
1976 "Lights, Color, Image," Women's Interart Center, New York, New York
1976 "Invitational: Contemporary Artists," Hudson River Museum, Yonkers, New York
1977 "Four Artists," City University of New York Herbert H. Lehman College, Bronx, New York

1977 "String Walls," Sculpture Now, New York, New York
1977 "Faculty Exhibition," Parsons School of Design, New York, New York
1977-79 "Projects/Urban Monuments," Traveling Exhibition, Akron Art Institute, Akron, Ohio
1979 "In Small Scale," Hamilton Gallery, New York, New York; Marian Locks Gallery, Philadelphia, Pennsylvania
1979 "Small Scale," Sculpture Now, New York, New York
1980 "19 at 26," Federal Plaza," New York, New York
1980 "Sitesights," Pratt Institute Gallery, Brooklyn, New York
1981 "Between Object and Illusion," Robeson Center Gallery, Rutgers University, University College-Newark, Newark, New Jersey
1981 "CAPS at the State Museum," New York State Museum, Albany, New York
1981 "CAPS at F.I.T.," Shirley Goodman Resource Center, Fashion Institute of Technology, New York, New York
1983 "Bridges—Connectors," Pratt Institute Gallery, Brooklyn, New York; Manhattan Center Gallery, Pratt Institute, New York, New York
1983-85 "1 + 1 = 2," Traveling Exhibition, Bernice Steinbaum Gallery, New York, New York
1984 "Ways with Wood," Kylie Hall, City University of New York Queens College, Flushing, New York

Selected Public Collections
Ciba-Geigy Corporation, Ardsley, New York
City of Raleigh, North Carolina
Fox, Glynn & Melamad, New York, New York
Home Insurance, Incorporated, New York, New York
Olympia and York, New York, New York
William A. Mercer, Incorporated, New York, New York

Selected Private Collections
Dr. Rita Frankiel, New York, New York
Dr. Arnold and Dr. Arlene Richards, New York, New York
Dr. and Mrs. Bernard Weinstein, Englewood, New Jersey

Selected Awards
1979 Creative Artists Public Service Grant, New York State Council on the Arts
1979 John Simon Guggenheim Memorial Foundation Fellowship
1983 Individual Artist's Fellowship, National Endowment for the Arts

Preferred Sculpture Media
Paper and Wood

Additional Art Fields
Drawing and Painting

Teaching Position
Adjunct Professor, Pratt Institute, Brooklyn, New York

Selected Bibliography
Bell, Jane. "New York Reviews: Phoebe Helman." *Art News* vol. 77 no. 9 (November 1978) pp. 181, 183.
Kuspit, Donald B. "Reviews of Exhibitions New York: Phoebe Helman at Sculpture Now." *Art in America* vol. 67 no. 3 (May-June 1979) p. 142.
Linker, Kate. "Public Sculpture II: Provisions for the Paradise." *Artforum* vol. 19 no. 10 (Summer-June 1981) pp. 37-42.
Robins, Corinne. "Phoebe Helman: Inner and Outer Energy." *Arts Magazine* vol. 52 no. 6 (February 1978) pp. 110-111, illus.
Robins, Corinne. "American Urban Art Triumphant: The Abstract Paintings of Arthur Cohen, Al Held, Phoebe Helman, and Frank Stella." *Arts Magazine* vol. 56 no. 9 (May 1982) pp. 86-89, illus.

Gallery Affiliation
Max Hutchinson Gallery
138 Greene Street
New York, New York 10012

Mailing Address
217 East 23 Street
New York, New York 10010

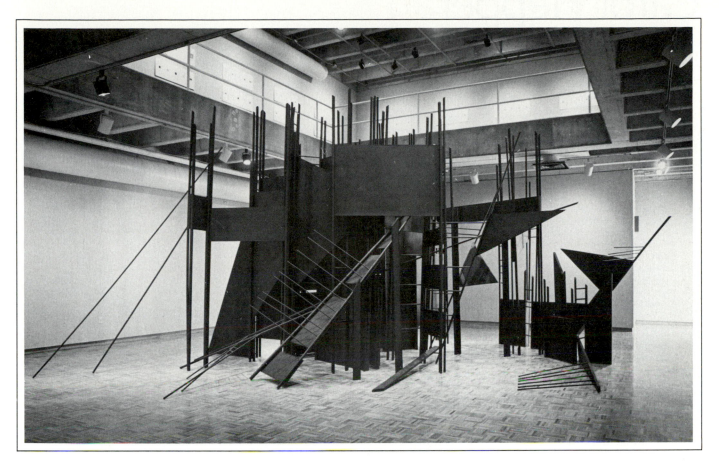

Through Way. 1978. Painted wood, 14'h x 35'w x
22'6"d. Installation view 1978. Sculpture Now, New
York, New York.

Artist's Statement

"The theme of my work is fragility and
resilience in life and art. My drawings,
paintings and room sized landscape
structures all constitute an autobiographical
statement. I am questioning existing art
language, proscribed boundaries and orders
to begin to speak anew. The mazes,
entrances and paths of my abstractions
affirm being able to live with checkpoints in
life, with tenuous connections and painfully
built-up sturdiness. The uniform blackness is
the strength of willingness to change rather
than indecisiveness.

 "I work with immediate materials—with
wood and paper—with forms which allow me
to establish a dialogue with my work and
which allow the work to become the result of
that dialogue. The source of my energy is
the voice of the self, the force and fragility of
that voice, and the hope that it is able to
shift into universality."

Phoebe Helman

Carol Hepper

Born October 23, 1953 McLaughlin, South Dakota

Education and Training
1975　B.S., Art Education, South Dakota State University, Brookings, South Dakota

Selected Individual Exhibitions
1979　Flagler College, St. Augustine, Florida
1980　Brookings Cultural Center, Brookings, South Dakota
1981　Coffman Gallery, University of Minnesota Twin Cities Campus, Minneapolis, Minnesota
1982　P.S. 1, Institute for Art and Urban Resources, Long Island City, New York
1982　WARM, Women's Art Registry of Minnesota, Minneapolis, Minnesota
1984　Ritz Gallery, South Dakota State University, Brookings, South Dakota

Selected Group Exhibitions
1977　"Salon of the Fifty States," Ligoa Duncan Gallery, New York, New York
1978　"Sixty-Seventh American Annual Exhibition," Art Association of Newport, Newport, Rhode Island
1979　"National Small Format, Mixed Media Show," Newspace Gallery, Corvallis, Oregon, catalog
1979　"Members Juried Exhibition," Jacksonville Art Museum, Jacksonville, Florida, catalog
1979　"Nature II," St. Augustine Art Association, St. Augustine, Florida
1980　"Faculty Exhibition," Flagler College, St. Augustine, Florida
1981　"South Dakota Biennial V," Traveling Exhibition, South Dakota Memorial Art Center, Brookings, South Dakota, catalog
1981　"Fifteenth Annual National Drawing and Small Sculpture Show," Joseph A. Cain Memorial Art Gallery, Del Mar College, Corpus Christi, Texas, catalog
1981　"Darkhorse," Foremost Gallery, Sioux Falls, South Dakota
1981　"Small Works," Lincoln Hall Gallery, Northern State College, Aberdeen, South Dakota
1982　"South Dakota Experimental Artists," 55 Mercer, New York, New York
1983　"The Descendants," North Dakota Museum of Art, Grand Forks, North Dakota, catalog
1983　"South Dakota Biennial VI," South Dakota Memorial Art Center, Brookings, South Dakota, catalog
1983　"New Perspectives in American Art: 1983 Exxon National Exhibition," Solomon R. Guggenheim Museum, New York, New York, catalog
1984　"West Coast Store Art," The Five and Dime, New York, New York
1984　"Sculpture Invitational," University Art Galleries, South Dakota State University, Vermillion, South Dakota, catalog
1985　"The Back Room," Civilization Gallery, New York, New York
1985　"Women of the American West," Bruce Museum, Greenwich, Connecticut, catalog

Selected Public Collections
Dannheisser Foundation, New York, New York
Solomon R. Guggenheim Museum, New York, New York

Selected Private Collections
Don Boyd, Brookings, South Dakota
Dr. Peter McCranie, Jacksonville, Florida
Enzo Torcolletti, St. Augustine, Florida
Earl Willis, New York, New York

Selected Awards
1981　Career Development Grant for Women Sculptors, Betty Brazil Memorial Fund, Tarrytown, New York
1984　South Dakota Governer's Award for Creative Achievement in the Arts
1984　Louis Comfort Tiffany Foundation Grant

Preferred Sculpture Media
Varied Media

Related Professions
Art Instructor and Visiting Artist

Selected Bibliography
Nadelman, Cynthia. "The New American Sculpture." Art News vol. 83 no. 1 (January 1984) pp. 63-70, illus.
Russell, John. "Younger Americans; Visitors From the Past." The New York Times (Friday, September 30, 1983) p. C20.

Mailing Address
Star Route 1 Box 103
McLaughlin, South Dakota 57642

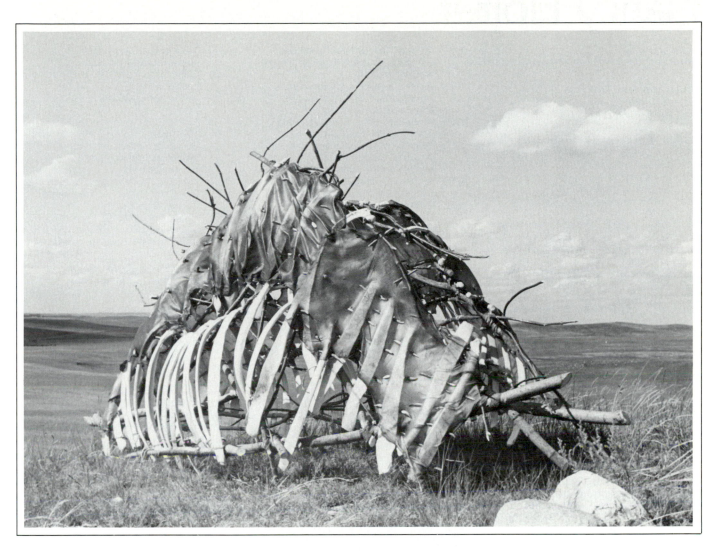

Pierced/Pegged. 1981. Mixed media, 44"h x 99"w x 56"d. Collection Dannheisser Foundation, New York, New York.

Artist's Statement

"The materials I use, animal hides, bones and tree limbs, are charged with previous life. In view of their inherent cycles, I am interested at which point and with what means I can transform this information. In earlier pieces I worked with weathering and decay, at times stopping the processing cycle of the hides to leave hair intact. In other work, singular elements of ribs and driftwood bonded to form a larger whole.

"Because the processing of the materials is very experimental, the transitions in the work reflect continual discoveries. The wet, white, opaque and flaccid skins shrink and become translucent when stretched and dried across a linear form. The linearity, tautness and translucency are recent developments. The bones, stained by earth pigments and wood, weathered by water and pierced by gnawing marks of coyotes, present evidence beyond the hand."

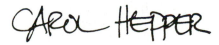

291

Nancy Holt

née Nancy Louise
Born April 5, 1938 Worcester, Massachusetts

Education and Training
1960 B.S., Biology, Jackson College, Tufts University, Medford, Massachusetts

Selected Individual Exhibitions
1972 Art Gallery, University of Montana, Missoula, Montana
1972 Art Center, University of Rhode Island, Kingston, Rhode Island
1973 LoGiudice Gallery, New York, New York
1974 Bykert Gallery, New York, New York
1974 Walter Kelly Gallery, Chicago, Illinois
1977 Franklin Furnace Archive, New York, New York,
1979, John Weber Gallery, New York, New
82, York
84
1979 Miami University Art Museum, Oxford, Ohio
1981 Saginaw Art Museum, Saginaw, Michigan
1982 David Bellman Gallery, Toronto, Ontario, Canada
1985 Flow Ace Gallery, Los Angeles, California

Selected Group Exhibitions
1969 "Language III," Dwan Gallery, New York, New York
1973 "C. 7,500," Traveling Exhibition, California Institute of the Arts, Valencia, California, catalog
1974 "Interventions in the Landscape," Hayden Gallery, Massachusetts Institute of Technology, Cambridge, Massachusetts
1974 "Painting and Sculpture Today 1974," Indianapolis Museum of Art, Indianapolis, Indiana, catalog
1974, "Artpark: The Program in Visual Arts,"
75 Artpark, Lewiston, New York, catalog
1975 "A Response to the Environment," Rutgers University, Douglass College, New Brunswick, New Jersey, catalog
1975 "A Sense of Reference," Mandeville Center for the Arts, University of California, San Diego, La Jolla, California, catalog
1975 "São Paulo Biennelle," São Paulo, Brazil
1977, "Biennial Exhibition: Contemporary
79, American Art," Whitney Museum of
81 American Art, New York, New York, catalog
1977 "Probing the Earth: Contemporary Land Projects," Hirshhorn Museum and Sculpture Garden, Smithsonian Institution, Washington, D.C., catalog
1977 "Works and Projects of the 70s," P.S. 1, Institute for Art and Urban Resources, Long Island City, New York

1979 "Art and Architecture, Space and Structure," Protetch-McIntosh Gallery, Washington, D.C.
1979 "Born in Boston," DeCordova and Dana Museum and Park, Lincoln, Massachusetts, catalog
1979 "Sculpture, Objects, Issues," Ohio State University, Columbus, Ohio
1980 "Aspects of the Seventies: Sitework," Wellesley College Museum, Wellesley, Massachusetts, catalog
1980 "Art Into Landscape," Harold Reed Gallery, New York, New York
1980 "Eleventh International Sculpture Conference," Area Galleries and Institutions, Washington, D.C. (Sponsored by International Sculpture Center, Washington, D.C.)
1980 "A Sense of Place: The American Landscape in Recent Art," Hampshire College Gallery, Amherst, Massachusetts, catalog
1980 "Architectural Sculpture," Los Angeles Institute of Contemporary Art, Los Angeles, California, catalog
1980 "Artists in the American Desert," Sierra Nevada Museum of Art, Reno, Nevada, catalog
1981 "Artists' Gardens and Parks," Hayden Gallery, Massachusetts Institute of Technology, Cambridge, Massachusetts; Museum of Contemporary Art, Chicago, Illinois
1981 "New Directions: Contemporary American Art," Sidney Janis Gallery, New York, New York, catalog
1981 "Alternatives in Retrospect: An Historical Overview 1969-1975," New Museum, New York, New York, catalog
1981 "Artists Make Architecture," Rosa Esman Gallery, New York, New York
1981 "Transition II: Landscape/Sculpture," Amelie A. Wallace Gallery, State University of New York College at Old Westbury, Old Westbury, New York, catalog
1981 "Natur—Skulptur, Nature—Sculpture," Württembergischer Kunstverein, Stuttgart, Germany, Federal Republic, catalog
1982 "Citysite Sculpture: Starting Line," Market Gallery, Toronto, Ontario, Canada, catalog
1982 "Post-Minimalism," Aldrich Museum of Contemporary Art, Ridgefield, Connecticut, catalog
1982 "The Monument Redefined: Gowanus Annual II," Gowanus Memorial Artyard, Brooklyn, New York, catalog
1983 "Independent Artists of Ireland Open Air Sculpture Exhibition," Marlay Park, Dublin, Ireland, catalog
1983 "Monuments and Landscapes: The New Public Art," McIntosh/Drysdale Gallery, Houston, Texas
1983 "The House that Art Built," Art Gallery, California State University Fullerton, Fullerton, California, catalog
1983 "Beyond the Monument," Hayden Gallery, Massachusetts Institute of

Technology, Cambridge, Massachusetts, catalog
1984 "Land Marks," Edith C. Blum Art Institute, Bard College Center, Annandale-on-Hudson, New York, catalog
1984- "Content: A Contemporary Focus
85 1974-1984," Hirshhorn Museum and Sculpture Garden, Smithsonian Institution, Washington, D.C., book-catalog
1984 "Projects: World's Fairs, Waterfronts, Parks and Plazas," Rhona Hoffman Gallery, Chicago, Illinois
1984 "Time: The Fourth Dimension in Art," Traveling Exhibition, Palais des Beaux-Arts, Brussels, Belgium, catalog

Selected Public Collections
Dark Star Park, Rosslyn, Virginia
Independent Artists of Ireland, Marlay Park, Dublin, Ireland
Laguna Gloria Art Museum, Austin, Texas
Miami University Art Museum, Oxford, Ohio
National Museum of American Art, Smithsonian Institution, Washington, D.C.
Ontario Arts Council, Toronto, Ontario, Canada
Wellesley College, Wellesley, Massachusetts
Western Washington University, Bellingham, Washington
Winter Olympic Site 1980, Lake Placid, New York

Selected Private Collections
Virginia Dwan, New York, New York
Richard Serra, New York, New York
Mr. and Mrs. Henry Uihlein, Lake Placid, New York

Selected Awards
1975 Creative Artists Public Service Grant, New York State Council on the Arts
1978 Individual Artist's Fellowship, National Endowment for the Arts
1978 John Simon Guggenheim Memorial Foundation Fellowship

Preferred Sculpture Media
Metal (welded), Stone and Varied Media

Additional Art Fields
Drawing and Photography

Related Professions
Film/Video and Writer

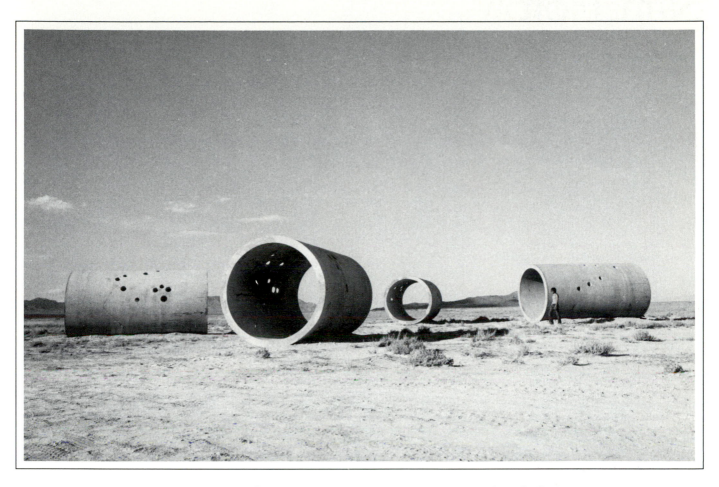

Sun Tunnels. 1973-1976. Concrete, total length 86';
each tunnel length 18'; outside diameter 9'3";
inside diameter 8'; wall thickness 7". Great Basin
Desert, Lucin, Utah.

Selected Bibliography
Beardsley, John. *Earthworks and Beyond:
 Contemporary Art in the Landscape*. New
 York: Abbeville Press, 1984.
Castle, Ted. "Nancy Holt, Siteseer." *Art in
 America* vol. 70 no. 3 (March 1982) pp.
 84-91, illus.
Lippard, Lucy R. *Overlay: Contemporary Art
 and the Art of Prehistory*. New York:
 Pantheon Press, 1983.
Marter, Joan M. "Nancy Holt's *Dark Star
 Park*." *Arts Magazine* vol. 59 no. 2
 (October 1984) pp. 137-139, illus.
Shaffer, Diana. "Nancy Holt: Spaces for
 Reflections or Projections." *Art in the Land:
 A Critical Anthology of Environmental Art*.
 New York: E. P. Dutton, 1983.

Gallery Affiliation
John Weber Gallery
142 Greene Street
New York, New York 10012

Mailing Address
799 Greenwich Street
New York, New York 10014

Artist's Statement
"My sculptures of concrete, brick,
stonemasonry, earth and steel evolve out of
their sites and are concerned with, among
other things, perception and space. Each
work draws the viewer within its structure,
creating a sense of transition from outside to
inside and often from light to dark. The
works surround and enclose but at the same
time frame and extend to the horizon in the
distance.

"Natural elements, sunlight, stars, water,
plants and earth, are part of the substance
of the works. Recent sculptures, which can
be walked through and turned on and off by
the viewer, are functional and use systems
of basic technology such as plumbing,
electricity, drainage and heating in often
complex, labyrinthine structures."

Nancy Holt

Sara Holt

(Husband Jean-Max Albert)
Born March 14, 1946 Los Angeles, California

Education and Training
1968 B.F.A., Sculpture and Painting,
University of Colorado at Boulder,
Boulder, Colorado

Selected Individual Exhibitions
1971 Musée d'Art Moderne de la Ville de
Paris, France, catalog
1972 Städtische Kunstsammlungen,
Ludwigshafen, Germany, Federal
Republic, catalog
1973 Galerie Lucien Durand, Paris, France
1979 Ufficio dell'Arte, Paris, France
1981 Galerie Vivian Veteau, Paris, France,
catalog
1983 Hôtel St. Simon, Angoulême, France,
catalog
1983 Galerie Q, Tokyo, Japan
1984 Hospice St. Charles, Rosny-Sur-Seine,
France, catalog

Selected Group Exhibitions
1970 "Salon de Mai," Centre Culturel de
Saint-Germain-en-Laye, Saint
Germain-en-Laye, France
1970 "Annuel Salon de la Jeune Sculpture
Contemporaine," Orangerie du
Luxembourg, Paris, France, catalog
1970 "Europlastique," Parc des Expositions,
Porte de Versailles, France, catalog
1971, "Salon de Mai," Salles New York,
72 Paris, France, catalog
1971 "Propositions Luminaires," Galerie
Atelier A, Paris, France
1972 "L'Art et les Technologies
Industrielles," Salle du Groupe,
Vitry-sur-Seine, France, catalog
1972 "Annuel Salon de la Jeune Sculpture
Contemporaine," Jardins de
l'UNESCO, Paris, France, catalog
1972 "Wool Art," Galerie Boutique-Germain,
Paris, France, catalog
1974 "Grandes Femmes Petits Formats,"
Galerie Iris Clert, Paris, France,
catalog

1975 "La Boule," Ranelagh, Paris, France,
catalog
1975 "La Couleur," Maison de la Culture,
Chalon-sur-Saone, France
1975 "L'Espace Intuitif," Maison pour Tous,
St. Quentin-en-Yvelines, France,
catalog
1976 "Boîtes," Musée d'Art Moderne de la
Ville de Paris, France, catalog
1976 "Arte Fiera," Galerie Rhinocéros,
Bologna, Italy
1977 "Masks as Metaphor: Contemporary
Artists' Invitational," Craft And Folk Art
Museum, Los Angeles, California
1977 "Salon Féminie-Dialogue," Maison de
l'UNESCO, Paris, France, catalog
1978 "Face aux Femmes," Maison de la
Culture, Le Havre, France, catalog
1982 "Symposium de Sculpture," Hôtel de
Ville, Caen, France
1982 "Pavillon d'Europe," Galerie de Seoul,
Seoul, Korea, Republic, catalog
1982 "Aléa(s)," Musée d'Art Moderne de la
Ville de Paris, France, catalog
1983 "Espace Ouvert, Espaces Construits,"
Port d'Austerlitz, Paris, France,
catalog
1983 "Expressions-Sculptures," Musée
National des Monuments Française,
Paris, France, catalog
1984 "La Part des Femmes dans l'Art
Contemporain," Galerie Municipale,
Vitry-sur-Seine, France, catalog
1985 "Peintures des Sculpteurs, Sculptures
des Peintres," Galerie M. H. Grinfeder,
Paris, France
1985 "Bourse d'Art Monumental," Galerie
Fernand Léger, Ivry-sur-Seine, France,
catalog

Selected Public Collections
Fonds National d'Art Contemporain, Paris,
France
Groupe Scolaire de Brevil,
Chevigny-Saint-Sauveur, France
Groupe Scolaire de la Madeleine, Joigny,
France
Groupe Scolaire Jules Ferry, Sens, France
Jardin des Plantes, Caen, France
Nice-Etoile, Nice, France
Quartier de la Noue, Bagnolet, France
Wilhelm-Hack-Museum, Ludwigshafen,
Germany, Federal Republic

Selected Private Collections
Horace and Vicki Baker, Pasadena, California
Erwin and Barbara Glass, Chicago, Illinois
Benjamin and Virginia Holt, South Pasadena,
California
George and Grace Tooby, Pasadena,
California
Jay and Ann Whipple, Chicago, Illinois

Selected Awards
1984 Exhibition Grant, Ministère de la
Culture, Rosny-sur-Seine, France
1985 Research Grant, Centre International
de Recherche sur le Verre,
Aix-en-Provence, France

Preferred Sculpture Media
Metal (welded) and Plastic (polyester resin)

Additional Art Field
Photography

Selected Bibliography
"Plastics in Art, Sara Holt-Sculptor:
Transparency in the Third Dimension."
Plastics vol. 3 no. 9 (August 1977) cover,
p. 4, illus.
Popper, Frank. *Art, Action and Participation*.
London: Studio Vista, 1975.
Restany, Pierre. *Plastics in Arts*. New York:
L. Amiel, 1974.
Schwartz, Ellen. "Paris Letter: November." *Art
International* vol. 16 no. 1 (January 20,
1972) pp. 54-58, illus.
Touraine, Liliane. "Paris." *Art International* vol.
15 no. 6 (Summer 1973) pp. 51-52, illus.

Mailing Address
1 Passage Rauch
75011 Paris, France

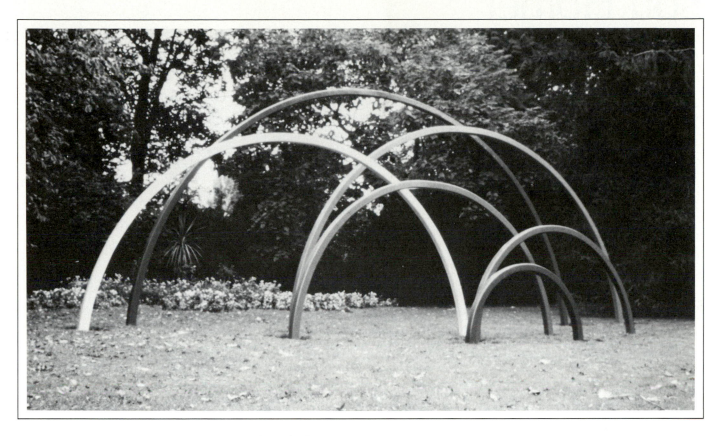

Exploded Rainbow. 1982. Painted forged steel, overall dimensions, 12'h x 33'w x 9'd; variable dimensions smallest unit, 3'h x 6'w x 4"d; to largest unit, 12'h x 24'w x 4"d. Collection Jardin des Plantes, Caen, France.

Artist's Statement

"My interest in the theory of light began in 1967 when I started casting transparent polyester resin sculptures. These sculptures, in primarily geometric forms of spheres, cubes, cones, cylinders, lenses, and prisms, were cast in many layers over a long period of time using only the pure colors of the spectrum. The concept for the rainbows evolved through varying layers of the three primary colors in order to produce the other colors. In 1972 I began to paint my steel sculptures using the same ideas of transparency, light, color, and space which I developed while working with resin.

"In 1969 I began photographing the sculpture. In 1973 I took my first long exposures and I realized that the light impressions accumulated on the film were similar to the layers of resin built up in time. I have continued to photograph many sources of light around me: cities, volcanic eruptions, the moon, stars and sun. Photography and sculpture have become the same thing, a capture of light."

Sara Holt

Lou Horner

née Mary Louise
(Husband Graham Egerton Higgs)
Born August 19, 1954 Nashville, Tennessee

Education and Training
1974 University of Kentucky, Lexington, Kentucky; study in ceramic sculpture
1977 B.S., Painting and Ceramic Sculpture, George Peabody College for Teachers, Nashville, Tennessee; study in ceramic sculpture with Robert Freagon and Glenda Frye
1978- University of Tennessee, Knoxville, 79 Knoxville, Tennessee; study in painting

Selected Individual Exhibition
1985 North Light Gallery, Carnegie Art Center, Covington, Kentucky

Selected Group Exhibitions
1979 "Second Regional Competition," Lauren Rogers Library and Museum of Art, Laurel, Mississippi
1980 "Tennessee Women Artists Exhibition," Appalachian Center for Crafts, Smithville, Tennessee
1982 "The Fan: New Form and New Function," Arrowmont School of Arts and Crafts, Gatlinburg, Tennessee, catalog

1982 "Lou Horner, Virginia Taylor Derryberry and Marcia Goldenstein," Sarratt Gallery, Vanderbilt University, Nashville, Tennessee
1983 "Out of Towners, National Invitational," 200 East Art Gallery, Knoxville, Tennessee
1983 "Faculty Select," Department of Art Gallery, University of Tennessee, Knoxville, Knoxville, Tennessee
1983 "Music City Biennial Exhibition," Cohen Gallery, Vanderbilt University, Nashville, Tennessee
1983 "200 East Art Gallery Members' Exhibition," Department of Art Gallery, Maryville College, Maryville, Tennessee
1984 "Return of 200 East Members Exhibition," 200 East Art Gallery, Knoxville, Tennessee
1984 "200 East Goes To Atomic City," Children's Museum of Oak Ridge, Oak Ridge, Tennessee
1984 "Sculptural Forms," Cumberland Gallery, Nashville, Tennessee
1985 "New Works: Lou Horner, Marilyn Murphy and Ted Zaupe," 200 East Art Gallery, Knoxville, Tennessee
1985 "LaGrange National," Lamar Dodd Art Center, LaGrange College, LaGrange, Georgia

Selected Private Collections
Gene and Virginia Taylor Derryberry, Knoxville, Tennessee
Christian M. Mounger, Nashville, Tennessee
Marilyn Murphy, Nashville, Tennessee
Carol Stein, Nashville, Tennessee
Mr. and Mrs. William A. Yetman, Dover, Massachusetts

Preferred Sculpture Media
Varied Media

Additional Art Field
Painting

Gallery Affiliation
Cumberland Gallery
2213 Bandywood Drive
Nashville, Tennessee 37215

Mailing Address
309 Hialeah Drive
Knoxville, Tennessee 37920

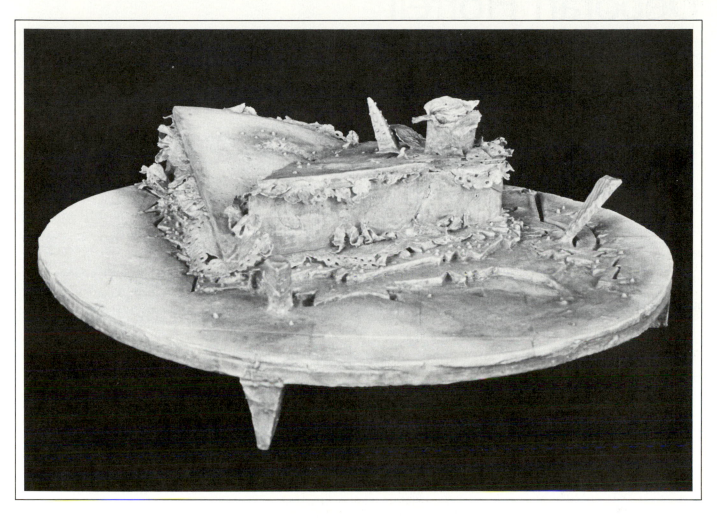

Cake Series No. 4. 1983. Mixed media, 3¼"h x 11"d.

Artist's Statement

"The imagery in my work expresses two daily personal activities, dining and the sensual interest in food preparation. I am primarily concerned with the visual rituals and the ironic tension signified by table manners. Art for me is a means of reenacting and creating memories of these rituals and customs, subliminally communicating the irony and do's and don'ts of the middle class dining experience."

Lou Horner

Deborah Horrell

née Deborah Ann
Born April 18, 1953 Phoenix, Arizona

Education and Training
1975 B.F.A., Ceramic Sculpture, Arizona
 State University, Tempe, Arizona;
 study with Randall Schmidt
1979 M.F.A., Ceramic Sculpture, University
 of Washington, Seattle, Washington;
 study with Howard Kottler

Selected Individual Exhibitions
1978 Arts Resource Center, Seattle,
 Washington
1979 Renshaw Gallery, Linfield College,
 McMinnville, Oregon
1983 John Michael Kohler Arts Center,
 Sheboygan, Wisconsin, catalog
1984 Lill Street Gallery, Chicago, Illinois

Selected Group Exhibitions
1976 "Southwest Fine Arts Biennial,"
 Museum of Fine Arts, Museum of New
 Mexico, Santa Fe, New Mexico
1977 "Four Corners Biennial," Phoenix Art
 Museum, Phoenix, Arizona
1977 "7 in 77 Invitational," Scottsdale Center
 for the Arts, Scottsdale, Arizona,
 catalog
1977 "Ceramic Conjunction," Long Beach
 Museum of Art, Long Beach,
 California
1978 "Mixed Metaphors Invitational," Tucson
 Museum of Art, Tucson, Arizona
1979 "Fine Arts Invitational," Bellevue Art
 Museum, Bellevue, Washington
1979 "Birds in Art," Tacoma Art Museum,
 Tacoma, Washington
1980 "Ceramic Sculpture Invitational,"
 Whatcom Museum of History and Art,
 Bellingham, Washington
1980- "American Porcelain: New Expressions
85 in an Ancient Art," Traveling
 Exhibition, Renwick Gallery of the
 National Museum of American Art,
 Smithsonian Institution, Washington,
 D.C., catalog

1981 "Porcelain: New Visions," Cooper/Lynn
 Gallery, New York, New York
1981 "Westwood Clay National," Downey
 Museum of Art, Downey, California
1981 "Paint on Clay: A Survey of the Use of
 Nonfired Surfaces on Ceramic Forms
 by Contemporary American Artists,"
 John Michael Kohler Arts Center,
 Sheboygan, Wisconsin, catalog
1981 "The Animal Image: Contemporary
 Objects and the Beast," Renwick
 Gallery of the National Museum of
 American Art, Smithsonian Institution,
 Washington, D.C., catalog
1982 "Animal Imagery," Meyer Breier Weiss
 Gallery, San Francisco, California
1982 "Imbued Clay Figures," Antonio Prieto
 Memorial Gallery, Mills College,
 Oakland, California
1982 "Pacific Currents/Ceramics 1982," San
 Jose Museum of Art, San Jose,
 California, catalog
1983 "Clay: A Medium for Personal
 Iconography," Elements Gallery, New
 York, New York
1984 "Clay: 1984, A National Survey
 Exhibition," Traver Sutton Gallery,
 Seattle, Washington
1984 "Ohio, A Ceramics Faculty," Ohio
 University, Athens, Ohio
1985 "Chicago International Art Exposition,"
 Navy Pier, Chicago, Illinois (Sponsored
 by Lill Street Gallery, Chicago, Illinois),
 catalog
1985 "National Council on Education for the
 Ceramic Arts Invitational," Museum of
 Fine Arts, Boston, Massachusetts
1985 "Women in the Arts," Fort Hayes
 Gallery, Columbus, Ohio

Selected Public Collections
Evergreen State College, Olympia,
 Washington
Kohler Company, Kohler, Wisconsin
Saks Fifth Avenue, San Francisco, California
Seattle Arts Commission, Seattle,
 Washington
Tucson Museum of Art, Tucson, Arizona

Selected Private Collections
Allan Chasanoff, Jericho, New York
Connie Edwards, Los Angeles, California
Pamela Harlow, Seattle, Washington
Peter Harris, Seattle, Washington
David Mushinsky, Washington, D.C.

Selected Awards
1979 Ford Foundation Travel Grant (Japan),
 University of Washington, Seattle,
 Washington
1982 Artist in Residence, Arts/Industry
 Program, Kohler Company, Kohler,
 Wisconsin
1985 Artist in Residence, Otsuka Chemical
 Company, Shigaroki, Japan and
 University Seed Program Grant, Ohio
 State University, Columbus, Ohio

Preferred Sculpture Media
Clay and Varied Media

Additional Art Field
Drawing

Teaching Position
Assistant Professor of Ceramics, Ohio State
 University, Columbus, Ohio

Selected Bibliography
Axel, Jan and Karen McCready. *Porcelain:
 Traditions and New Visions*. New York:
 Watson-Guptill, 1981.
Eder, Lynn. "Deborah Horrell." *Ceramics
 Monthly* vol. 29 no. 9 (November 1981) pp.
 46-47, illus.
Horrell, Deborah. "Clay Art in Industry."
 Ceramics Monthly vol. 31 no. 9 (November
 1983) pp. 48-49, illus.
Klemperer, Louise. "Nest of Bones: Deborah
 Horrell." *American Ceramics* vol. 2 no. 1
 (Winter 1983) pp. 18-25, illus.
Speight, Charlotte F. *Images in Clay
 Sculpture: Historical and Contemporary
 Techniques*. New York: Harper & Row,
 1983.

Mailing Address
449 East Tulane Road
Columbus, Ohio 43202

Artist's Statement

"*Flesh and Bones* is the climax of all the symbols with which I have worked. Bones have been a longtime concern since grade school when I made a sculpture of turkey bones. They have become a personal symbol, suggesting elements of existence as well as transition—flesh/bone, life/death. The intention in this sculpture was to define a personal nesting ground: a large nest of bones built on a relevant scale. It represents my home, my nest, my place from which to evolve. The silhouette and winged shadow suggest the transformation beyond humanity into a being capable of flight."

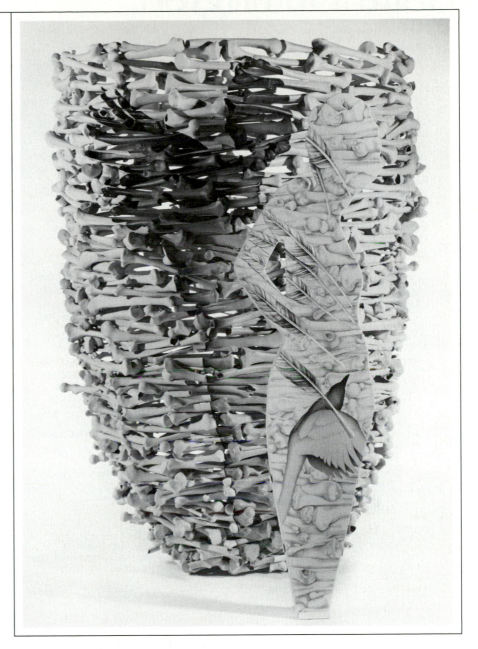

Flesh and Bones. 1982. Kohler porcelain, acrylic, graphite and Prismacolor pencil. Foreground: 63"h x 18"w x 1"d. Background: 72"h x 53"w x 60"d. Collection Kohler Company, Kohler, Wisconsin. Photograph by P. Richard Eells.

Anita Huffington

(Husband Hank Sutter)
Born December 25, 1934 Baltimore, Maryland

Education and Training
1953- University of North Carolina at
55 Greensboro, Greensboro, North
 Carolina
1961- Bennington College, Bennington,
62 Vermont
1964- University of South Florida, Tampa,
67 Florida
1973 B.A., Sculpture, City University of New
 York, City College, New York, New
 York; study with Charles Salerno
1975 M.F.A., Sculpture, City University of
 New York, City College, New York,
 New York; study with Juan Nickford
 and George Segal

Selected Individual Exhibition
1982 Arkansas Union Gallery, University of
 Arkansas, Fayetteville, Arkansas

Selected Group Exhibitions
1976 "International Women's Arts Festival,"
 Ford Foundation Auditorium, New
 York, New York
1978 "Artists' Invitational," U-Ark Arts
 Center, Fayetteville, Arkansas
1978 "Northwest Arkansas Artists Exhibit,"
 University of Arkansas, Fayetteville,
 Arkansas
1978- "Gallery Artists Annual Exhibition,"
81 Moulton Gallery, Fort Smith, Arkansas
1979 "Twenty-Second Annual Delta Art
 Exhibition," Arkansas Arts Center,
 Little Rock, Arkansas, catalog
1979, "Gallery Artists," Heights Gallery,
81, Little Rock, Arkansas
82
1979 "Women in the Arts," U-Ark Arts
 Center, Fayetteville, Arkansas
1979 "Anita Huffington and Robert Ross,"
 Jon Schader Gallery, Fayetteville,
 Arkansas
1979, "Sculptors," Jon Schader Gallery,
80 Fayetteville, Arkansas
1981, "Gallery Artists," Harris Gallery,
82 Houston, Texas
1981 "J. O. Buckley and Anita Huffington,"
 Arkansas Territorial Restoration
 Gallery, Little Rock, Arkansas
1982 "Great Garden Sculpture Show,"
 Sculptural Arts Museum, Atlanta,
 Georgia, catalog
1983, "Gallery Artists," Gallery 26 East,
84 Tulsa, Oklahoma

Selected Private Collections
James and Diane Blair, Fayetteville, Arkansas
Mr. and Mrs. Joseph Cohen, East Grand
 Rapids, Michigan
Mr. and Mrs. Barrett Hamilton, Little Rock,
 Arkansas
Robert Lynch, Galveston, Texas
Stephen and Eliza Shafer, New York, New
 York

Preferred Sculpture Media
Stone

Gallery Affiliation
Harris Gallery
1100 Bissonnet
Houston, Texas 77005

Mailing Address
Route 1 Box 152
Winslow, Arkansas 72959

Artist's Statement

"I do direct carving in stone. My sculpture is usually based upon the human form, primarily female nudes. I often carve torsos or fragments of the body, sometimes birds or animals. My sources are nature and art, the past, the present, the unknown. I try to share the totality of my life experience, sensual and spiritual, what cannot be expressed in words through archetypal images of woman or other life forms. The forms are simplified and reduced to essences or altered by inner perceptions, aesthetic or philosophical. My purpose is to reveal, to awaken, as art is a way to understanding."

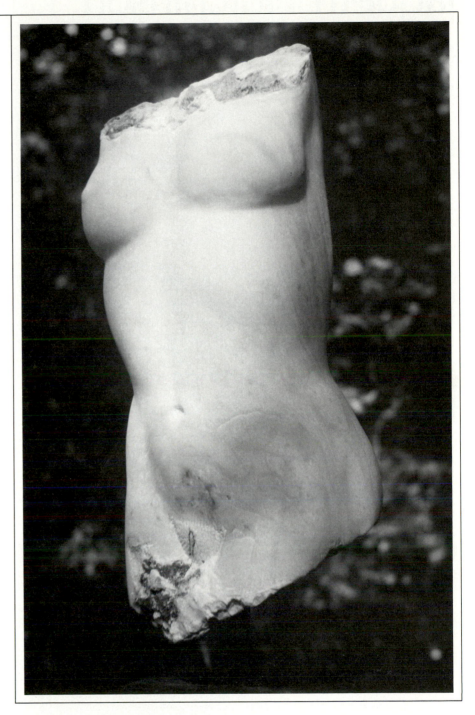

From the Sea. 1984. Pink Italian alabaster, 30"h x 10"w x 9"d. Photograph by Rosemary Post.

Jaqueth Hutchinson

née Jaqueth Knowlton
Born March 24, 1942 Boston, Massachusetts

Education and Training
1964 B.A., Sculpture, Bennington College, Bennington, Vermont; study with Anthony Caro, Lyman Kipp and David Smith

1964-65 Saint Martin's School of Art, London, Great Britain; study in sculpture with David Annesley, Michael Bowlas, Anthony Caro and Isaac Witkin

Selected Individual Exhibitions
1972 Parker Street Gallery, Boston, Massachusetts

1974 André Emmerich Gallery, New York, New York

1977 Harcus Krakow Gallery, Boston, Massachusetts

1979 Boston Psychoanalytic Institute, Boston, Massachusetts

1979 Atlantic Reception Gallery, Boston, Massachusetts

1981 Millerton Art Gallery, Millerton, New York

Selected Group Exhibitions
1973 "Boston Collects Boston," Museum of Fine Arts, Boston, Massachusetts; Institute of Contemporary Art, Boston, Massachusetts, catalog

1974 "Corporations Collect," DeCordova and Dana Museum and Park, Lincoln, Massachusetts

1974 "Wellesley College Art Exhibition," Wellesley College, Wellesley, Massachusetts

1976 "New England Invitational," Brockton Art Center/Fuller Memorial, Brockton, Massachusetts

1977 "New England Invitational of Sculpture and Painting," Silvermine Guild of Artists, New Canaan, Connecticut, catalog

1977 "Contemporary Masters," Rose Art Museum, Brandeis University, Boston, Massachusetts

1979 "Jaqueth Hutchinson and Katherine Porter," Alpha Gallery, Boston, Massachusetts

1981 "Six Young Artists," American Grafitti Gallery, Amsterdam, Netherlands

1982 "A Private Vision: Contemporary Art from the Graham Gund Collection," Museum of Fine Arts, Boston, Massachusetts, catalog

1982 "Boston Invitational," Thomas Segal Gallery, Boston, Massachusetts

1983-84 "Abstract Art in New England," Art Gallery, Plymouth State College of the University System of New Hampshire, Plymouth, New Hampshire; Danforth Museum, Framingham, Massachusetts; Stamford Museum and Nature Center, Stamford, Connecticut; Art Complex Museum, Duxbury, Massachusetts, catalog

1985 "Abstract Art New England, Revisited: Steve Brent, Bety Kohlberg and Jaqueth Hutchinson," Sound Shore Gallery, Port Chester, New York

1985 "Jody Klein, Jaqueth Hutchinson, Makoto Yabe," Van Buren/Brazelton/Cutting/Gallery, Cambridge, Massachusetts

Selected Public Collections
Berklee College of Music, Boston, Massachusetts

Federal Reserve Bank, Boston, Massachusetts

John F. Kennedy Institute of Politics, Harvard University, Cambridge, Massachusetts

National Shawmut Bank of Boston, Boston, Massachusetts

Sonesta International Hotel Corporation, Key Biscayne, Florida; New Orleans, Louisiana; Boston, Massachusetts; Cambridge, Massachusetts; South Hamilton, Bermuda and Amsterdam, Netherlands

Triangle Trust Corporation, Pine Plains, New York

Selected Private Collections
Lewis Cabot, Boston, Massachusetts

Mr. and Mrs. George de Menil, New York, New York

Guido Goldman, Boston, Massachusetts

Graham Gund Collection, Cambridge, Massachusetts

Mr. and Mrs. Roger Sonnabend, Boston, Massachusetts

Selected Award
1983 Sculpture Prize, Berklee College of Music, Boston, Massachusetts

Preferred Sculpture Media
Metal (welded) and Varied Media

Related Professions
Lecturer and Visiting Artist

Selected Bibliography
Allara, Pamela. "Boston: Shedding Its Inferiority Complex." *Art News* vol. 78 no. 9 (November 1979) pp. 98-101, 104-105, illus.

Frackman, Noel. "Arts Reviews: Jaqueth Hutchinson, André Emmerich (Downtown)." *Arts Magazine* vol. 49 no. 1 (September 1974) p. 56, illus.

Swan, John. "Regional Reviews Massachusetts: Danforth Museum/Framingham, Abstract Art in New England." *Art New England* vol. 4 no. 5 (April 1983) p. 8.

Gallery Affiliation
Obelisk Gallery
72 Mount Vernon Street
Boston, Massachusetts 02140

Mailing Address
4 Nichols Place
Cambridge, Massachusetts 02138

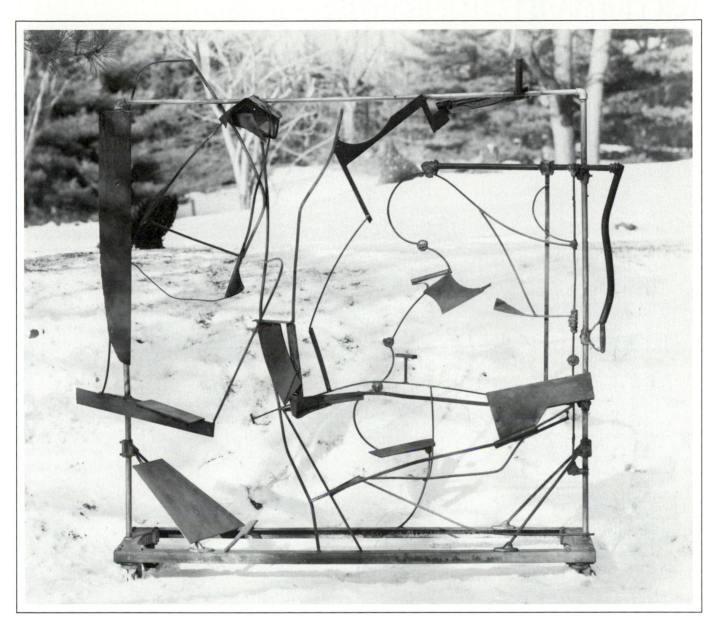

Mashomack. 1982. Steel and cast iron, 92"h x 94"w x 42"d. Collection Triangle Trust Corporation, Pine Plains, New York. Photograph by Jacquelyn Nooney.

Artist's Statement

"I do not think in terms of what my forms intend. I would not spend the day welding sculpture if words could express a meaning. Good sculpture is not about information or titles. It is about a search which requires nakedness in front of the work along with a willingness to look awkward, even ugly, and unknown."

Jacqueth Hutchison

Kim Irwin

née Kimberly Ann
(Husband William Collins McAllister)
Born April 5, 1947 Dayton, Ohio

Education and Training
1967 A.A., Medical Secretary, Centenary College for Women, Hackettstown, New Jersey
1974 B.F.A., Painting, University of North Carolina at Chapel Hill, Chapel Hill, North Carolina
1979 M.F.A., Design, East Carolina University, Greenville, North Carolina

Selected Group Exhibitions
1980 "Fibre Interchange/Clay Symposium II," Walter Phillips Gallery, Banff Centre, School of Fine Arts, Banff, Alberta, Canada
1980 "Crafts Invitational," Southeastern Center for Contemporary Arts, Winston-Salem, North Carolina
1981 "Sneak Preview," The Gallery, Durham, North Carolina
1981 "Art at the U.S. Conference of Mayors," U.S. Conference of Mayors Building, Washington, D.C. (In association with Washington Women's Art Center, Washington, D.C. and Center/Gallery, Carrboro, North Carolina)
1981 "Women Artists in North Carolina," East Carolina University, Greenville, North Carolina
1981 "Michele Hodgson, John Thomas, Kim Irwin and Bill McAllister," Field Gallery, West Tisbury, Massachusetts
1981 "13 from North Carolina," Foundry Gallery, Washington, D.C., catalog
1981 "Dream Theatre," High Point Arts Council, High Point, North Carolina
1981 "Tri-State Sculpture Conference Exhibition," University of South Carolina, Columbia, South Carolina, catalog
1982 "Center/Gallery Group Show," Meredith College, Raleigh, North Carolina
1982 "Works on Walls," Huntington Galleries, Huntington, West Virginia, catalog
1982 "Birth Days: A Celebration of the Passage of Time, Collaborative Room Installation with Kaola Allen and Bryant Holsenbeck," Center/Gallery, Carrboro, North Carolina

1982 "Ensemble: Collage and Mixed Media Works," Green Hill Art Gallery, Greensboro, North Carolina
1982 "Tri-State Sculpture Conference Exhibition," East Carolina University Museum of Art/Gray Art Gallery, Greenville, North Carolina, catalog
1982 "First Annual Exhibit of North Carolina Sculpture," Northern Telecom, Research Triangle Park, North Carolina, catalog
1982 "1982 New Members Exhibition," Piedmont Craftsmen, Winston-Salem, North Carolina
1983-84 "1982-1983 North Carolina Arts Council Artist Fellowship Exhibition: William Bernstein, Jim Collins, Kim Irwin, Clarence Morgan," Green Hill Center for North Carolina Art, Greensboro, North Carolina; St. John's Museum of Art, Wilmington, North Carolina; North Carolina Museum of Art, Raleigh, North Carolina, catalog
1983 "Artsplosure '83: Regional Sculpture Exhibition, Raleigh Arts Commission," Fayetteville Mall, Raleigh, North Carolina
1983 "Common Threads '83," Durham Art Guild, Durham, North Carolina
1983 "The United States of the Arts: The Contribution of the Arts Council 1963-1983," Sarah Lawrence Gallery, Sarah Lawrence College, Bronxville, New York
1983 "Alternative Devotional Objects," Somerhill Gallery, Durham, North Carolina
1984 "Exposition: Irwin, Kerfoot, Lauro and McAllister," Michael Karolyi Memorial Foundation, Vence, France
1984 "U.S.A. Portrait of the South," Traveling Exhibition, Palazzo Venezia, Rome, Italy, catalog
1985 "U.S.A. Portrait of the South: The North Carolina Exhibition," Somerhill Gallery, Durham, North Carolina; Green Hill Center for North Carolina Art, Greensboro, North Carolina; Asheville Art Museum, Asheville, North Carolina, catalog

Selected Public Collection
International Business Machines Corporation, Charlotte, North Carolina

Selected Private Collections
Judy Davis, Cary, North Carolina
Barbara Rhoades, Chapel Hill, North Carolina
Rosalind G. Thompson, Hillsborough, North Carolina

Selected Awards
1980 Fibre Interchange Program Scholarship, Banff Centre, School of Fine Arts, Banff, Alberta, Canada
1982 Individual Artist's Fellowship, North Carolina Arts Council

Preferred Sculpture Media
Fiber and Varied Media

Additional Art Field
Painting

Related Profession
Visiting Artist

Selected Bibliography
Eubanks, Georgann. "Kim Irwin: Fabric Fantasies." *The Arts Journal* vol. 5 no. 6 (March 1980) p. 10, illus.
Irwin, Kim. "The Banff Experience, Fiber Interchange 1980." *Fiberarts* vol. 8 no. 4 (July-August 1981) pp. 35-37, 42, illus.
Kessler, Jane. "Visual Arts: North Carolina Arts Council Artist Fellowship Exhibition." *The Arts Journal* vol. 9 no. 1 (October 1983) pp. 6-7, illus.

Gallery Affiliation
Hodges Taylor Gallery
227 North Tryon Street
Charlotte, North Carolina 28202

Mailing Address
Route 7 Box 56
Chapel Hill, North Carolina 27514

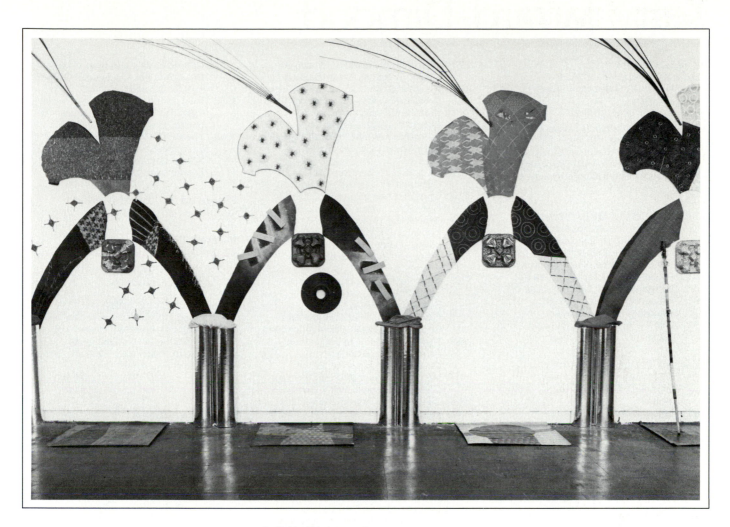

People Can Be Animals and Trees (detail). 1983.
Mixed media wall installation, 14'h x 34'w.
Installation view 1983. "1982-1983 North Carolina
Arts Council Artist Fellowship Exhibition: William
Bernstein, Jim Collins, Kim Irwin and Clarence
Morgan," Green Hill Center for North Carolina Art,
Greensboro, North Carolina; St. John's Museum of
Art, Wilmington, North Carolina; North Carolina
Museum of Art, Raleigh, North Carolina, catalog.
Photograph by Bill McAllister.

Artist's Statement

"My excitement becomes renewed by the
unpredictable and the endless possibilities of
new ideas, visions, materials and techniques.
Play and nonsense ('uncurbed invention') are
important to my process and imagery
because they are means to transcend the
boundaries of intellect. In addition to
analyzing and understanding, there are other
ways to experience the world.

"My work has evolved from painting on
canvas to three-dimensional construction
utilizing painting, sculpture and fiber
techniques along with various materials and
found objects. The abstract imagery is
derivative of life's ceremonies and rituals.
The construction of such objects results from
spontaneous and intuitive play using fabric,
wood, acrylic paint, rhophlex and
miscellaneous materials. Numerous
assemblages are then placed along interior
wall spaces in random arrangements of
repeated patterns, thus creating a renewed
celebration in the interplay of objects."

Kim Irwin

Terry Jarrard-Dimond

née Terry Sue Jarrard
(Husband Thomas William Dimond)
Born July 3, 1945 Slater, South Carolina

Education and Training
1969 B.A., Art, Winthrop College, Rock Hill, South Carolina
1979 M.F.A., Fiber Sculpture, College of Architecture, Clemson University, Clemson, South Carolina; study with Michael Vatalaro

Selected Individual Exhibitions
1978 Greenville County Museum of Art, Greenville, South Carolina
1982 Smith College Center, Francis Marion College, Florence, South Carolina
1983 McCarthy Art Gallery, Sacred Heart College, Belmont, North Carolina
1984 Tri-County Technical College, Pendleton, South Carolina
1984 Asheville Art Museum, Asheville, North Carolina

Selected Group Exhibitions
1979 "Southeastern Sculptors Juried Exhibition," Athens Art Center, Athens, Georgia
1980, "Greenville Artists Guild Juried
81 Exhibition," Greenville County Museum of Art, Greenville, South Carolina
1980 "Guild of South Carolina Artists Annual Exhibition," Spartanburg Arts Center, Spartanburg, South Carolina
1980 "Terry Jarrard-Dimond and Maggie McMahon," Anderson Art Center, Anderson, South Carolina
1981, "Annual Faculty Juried Exhibition,"
83 Museum School of Art, Greenville County Museum of Art, Greenville, South Carolina
1981 "Tri-State Sculpture Conference Exhibition," University of South Carolina, Columbia, South Carolina, catalog
1981 "Southern Exposure II," Art Center Association, The Water Tower, Louisville, Kentucky
1981 "The Clemson Connection," Coker College, Hartsville, South Carolina
1981 "Assemblages and Collage," Southeastern Center for Contemporary Art, Winston-Salem, North Carolina
1981 "Primary Art Juried Exhibition," Artistic Sass/Primary Art, Hilton Head Island, South Carolina

1981 "Ten Women Artists," Anderson Art Center, Anderson, South Carolina
1981 "Guild of South Carolina Artists Annual Exhibition," University of South Carolina McKissick Museums, Columbia, South Carolina
1982 "Convergence 1982," Seattle Pacific University Art Center, Seattle, Washington
1983 "North/South Carolina Fiber Competition," Queens College, Charlotte, North Carolina; Columbia College, Columbia, South Carolina
1983 "Woven Works: Tradition and Innovation," Traveling Exhibition, Lawton Gallery, University of Wisconsin-Green Bay, Green Bay, Wisconsin
1983 "First Regional Juried Art Exhibition," Spartanburg Arts Center, Spartanburg, South Carolina (Sponsored by Friends of the Arts, Spartanburg, South Carolina), catalog
1983 "Watercolors by Tom Dimond and Fabric Sculpture by Terry Jarrard-Dimond," Louise Gilbert Memorial Gallery, Mitchell Community College, Statesville, North Carolina
1983 "Terry Jarrard-Dimond and Anne Wenz," Upstairs Gallery, Tyron, North Carolina
1984 "Tom Dimond: Painting and Terry Jarrard-Dimond: Sculpture," Gallery One, Spirit Square Art Center, Charlotte, North Carolina
1984 "Southern Exposure IV," Ponder Fine Arts Center, Benedict College, Columbia, South Carolina
1984 "Terry Jarrard-Dimond: Sculpture and Sidney Cross: Prints," William Halsey Gallery, College of Charleston, Charleston, South Carolina
1984 "U.S.A. Portrait of the South," Traveling Exhibition, Palazzo Venezia, Rome, Italy, catalog
1985 "Terry Jarrard-Dimond: Sculpture and Tom Dimond: Painting," Spartanburg Day School, Spartanburg, South Carolina
1985 "Rome Exhibit: Portrait of South Carolina," Traveling Exhibition, Art and Music Center Gallery, Columbia College, Columbia, South Carolina, catalog
1985 "Pieceworks," Traveling Exhibition, Georgia Mountain Crafts, Gainsville, Georgia, catalog

Selected Public Collections
Clemson Architectural Foundation, Clemson, South Carolina
South Carolina State Art Collection, Columbia, South Carolina

Selected Awards
1982- Merit Award, "Second Fiber Structure
84 National Juried Exhibition," Exploratorium Gallery, California State University Los Angeles, Los Angeles, California; Braithwaite Fine Arts

Gallery, Cedar City, Utah; Sangre de Cristo Arts and Conference Center, Pueblo, Colorado, catalog
1982 Merit Award, "Annual Juried Exhibition," Shelby Art League, Shelby, North Carolina, catalog
1983 Special Merit Award, "First Annual Spartanburg Juried Exhibition," Spartanburg Arts Center, Spartanburg, South Carolina

Preferred Sculpture Media
Clay, Fiber and Varied Media

Related Professions
Art Instructor and Lecturer, South Carolina Arts Commission, Columbia, South Carolina

Selected Bibliography
Al-Hilali, Neda. "Exhibitions: Fiber as Structure, Los Angeles." *Artweek* vol. 13 no. 42 (December 11, 1982) p. 5.
Hyatt, Sharyn and Teresa Mangum. "The Ceremonial Structures: Thinking Clearly in Terms of Emotion." *Fiberarts* vol. 9 no. 4 (July-August 1982) pp. 66-68, illus.

Gallery Affiliation
Artistic Sass/Primary Art
14 Greenwood Drive-1406
Hilton Head Island, South Carolina 29928

Mailing Address
225 North Clemson Avenue
Clemson, South Carolina 29631

Artist's Statement

"The focal point of my work is the complexity of space and illusion within a shallow format. The pieces depict moments of personal ceremony relative to some aspects of a woman's existence. A *View Through Cleopatra's Window Box*, for example, is an interpretation of a powerful woman who could still function in the framework of being a beautiful woman.

"The sculptures, usually wall-hangings, are built upon skeletons of fencing wire and aluminum sheeting. Thin sheets of bendable metal are embellished with bands of cloth, either commercially printed or hand-dyed in intricate patterns. I may add glitter, sequins or paint, both before and after knotting the cloth to the wire. The interior space is defined by the subtle interplay of paint and prints which intersect the planes to create new dimensions."

Terry Jenard-Nemond

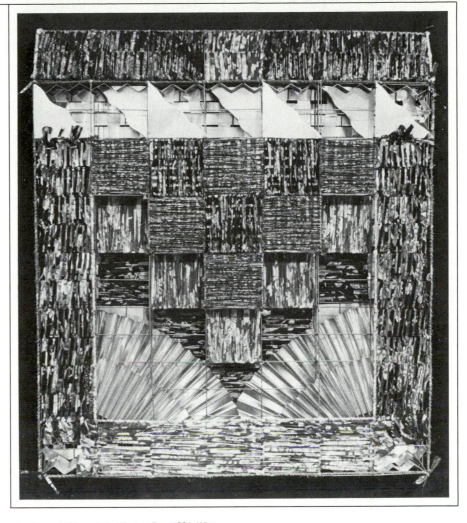

View Through Cleopatra's Window Box. 1981. Wire, aluminum and fabric, 32"h x 28"w x 4"d. Collection South Carolina State Art Collection, Columbia, South Carolina. Photograph by Fred Rollison.

Penelope Jencks

(Husband Sidney Hurwitz)
Born March 23, 1936 Baltimore, Maryland

Education and Training
1956 Hans Hofmann School, Provincetown, Massachusetts
1957 Skowhegan School of Painting and Sculpture, Skowhegan, Maine; study in sculpture with Harold Tovish
1958 B.F.A., Drawing and Painting, Boston University, Boston, Massachusetts
1959 School of the Museum of Fine Arts, Boston, Massachusetts; study in sculpture with Ernest Morenon
1960 Staatliche Akademie der Bildenden Künste, Stuttgart, Germany, Federal Republic

Selected Individual Exhibitions
1976 Fitchburg Art Museum, Fitchburg, Massachusetts
1977, Landmark Gallery, New York, New
81 York
1978 Art Institute of Boston, Boston, Massachusetts
1981, Helen Shlien Gallery, Boston,
85 Massachusetts

Selected Group Exhibitions
1966 "Young Talent," Massachusetts Council of Arts and Humanities, Boston, Massachusetts
1969 "Twenty-One Alumni," Boston University Art Gallery, Boston, Massachusetts
1971 "Jencks and Hurwitz," Thayer Academy, Braintree, Massachusetts
1974 "Fourteen Aspects of Realism," Boston Visual Artists Union, Boston, Massachusetts
1974 "Living American Artists and the Figure," Museum of Art, Pennsylvania State University-University Park Campus, University Park, Pennsylvania, catalog
1975 "Ceramic Sculpture," Milton Academy, Milton, Massachusetts
1977 "Skowhegan Benefit Exhibition," Kennedy Galleries, New York, New York
1977 "Women on Women," George Walter Vincent Smith Art Museum, Springfield, Massachusetts
1978 "Jencks and Hurwitz," Clark University Museum, Worcester, Massachusetts

1979 "Artists' Choice," Long Point Gallery, Provincetown, Massachusetts
1980 "Recipients of Awards in Sculpture, Massachusetts Artists Foundation," Federal Reserve Bank Gallery, Boston, Massachusetts
1980 "Aspects of the 70s: Directions in Realism," Danforth Museum, Framingham, Massachusetts, catalog
1981 "Penelope Jencks and Elizabeth Strasser," Helen Shlien Gallery, Boston, Massachusetts
1982 "Four Artists: Susan Lichtman, Penelope Jencks, Graham Campbell and Peter Markman," Rose Art Museum, Brandeis University, Waltham, Massachusetts
1983 "Triennial Exhibition," Brockton Art Museum/Fuller Memorial, Brockton, Massachusetts
1984 "Couples," Danforth Museum, Framingham, Massachusetts, catalog
1984 "Citywide Contemporary Sculpture Exhibition," Downtown Toledo, Ohio (Sponsored by Arts Commission of Greater Toledo, Ohio; Toledo Museum of Art, Toledo, Ohio and Crosby Gardens, Toledo, Ohio), catalog
1984 "The Figure: Again," Currier Gallery of Art, Manchester, New Hampshire
1984 "Aspects of the Human Form," Fitchburg Art Museum, Fitchburg, Massachusetts
1985 "Sculpture: Public Commissions/Private Works," Newton Arts Center, Newtonville, Massachusetts

Selected Public Collections
Batterymarch Corporation, Boston, Massachusetts
Brandeis University, Farber Library, Waltham, Massachusetts
Bunker Hill Pavilion, Charlestown, Massachusetts
City of Boston, Commonwealth Avenue Near Exeter Street, Boston, Massachusetts
City of Chelsea, Chelsea Square, Chelsea, Massachusetts
City of Danbury, Federal Courthouse, Danbury, Connecticut
Garrett Associates, Cambridge, Massachusetts
City of Toledo, Promenade Park, Toledo, Ohio

Selected Private Collections
Richard and Doris Held, Cambridge, Massachusetts
Charles Jencks, Los Angeles, California and London, Great Britain
Lady Claire Kesswick, London, Great Britain
Leonard and Dr. Andrea Paternaude, Brookline, Massachusetts
Dr. and Mrs. David Rush, Wellfleet, Massachusetts

Selected Awards
1975 Artist in Residence, MacDowell Colony, Peterborough, New Hampshire
1977 Massachusetts Artists Foundation Grant
1981 Commendation for Design Excellence, National Endowment for the Arts

Preferred Sculpture Media
Clay and Metal (cast)

Related Profession
Visiting Artist

Selected Bibliography
Birmelin, Blair. "Penelope Jencks: Sculpture." *The Massachusetts Review* vol. 24 no. 2 (Summer 1983) pp. 417-424. illus.
Fleming, Ronald Lee and Renata von Tscharner with George Melrod. *Place Makers: Public Art That Tells You Where You Are.* New York: Hastings House, 1981.
Parry, Marian. "An Interview with Penelope Jencks." *American Artist* vol. 37 no. 373 (August 1973) pp. 36-39, 64, illus.
Russell, John. "Art: Leon Polk Smith, Uptown and Downtown." *The New York Times* (Friday, March 20, 1981) p. C18.
Speight, Charlotte F. *Images in Clay Sculpture: Historical and Contemporary Techniques.* New York: Harper & Row, 1983.

Gallery Affiliation
Helen Shlien Gallery
14 Newbury Street
Boston, Massachusetts 02116

Mailing Address
202 Homer Street
Newton, Massachusetts 02159

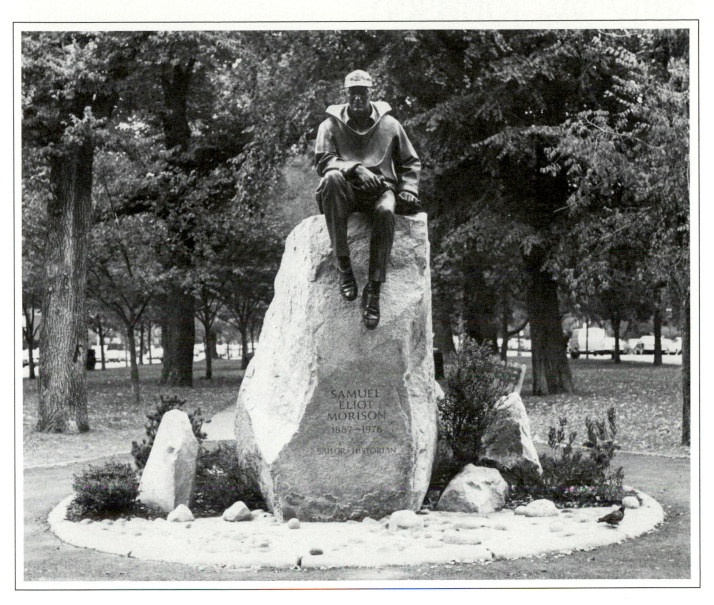

Samuel Eliot Morrison. 1982. Bronze and granite, 14'h x 15'w x 18'd. Collection City of Boston, Commonwealth Avenue Near Exeter Street, Boston, Massachusetts.

Artist's Statement

"My sculpture is primarily concerned with the figure and interpretations of specific individuals. I have always felt a strong affinity to the formal and monumental considerations of Egyptian sculpture and find myself attempting to incorporate these characteristics into my own work. I want to capture the elusive quality that distinguishes one person from another in a structure which is carefully and painstakingly engineered."

Penelope Jencks

Sally W. Johnson

née Sally Wood
(Husband James C. Johnson)
Born January 5, 1933 Cleveland, Ohio

Education and Training
1953 B.A., Biology, Birmingham-Southern
College, Birmingham, Alabama
1974- University of Alabama in Birmingham,
76 Birmingham, Alabama; study in art
history, drawing and printmaking
1979 University of Alabama in Birmingham,
Birmingham, Alabama; study in
computer graphic research
1983 Study in papermaking in Echizen,
Japan
1984 University of Alabama in Tuscaloosa,
Tuscaloosa, Alabama; study in
papermaking

Selected Individual Exhibitions
1978 Town Hall Gallery, Birmingham,
Alabama
1980 Biggin Hall Gallery, Auburn University,
Auburn, Alabama
1981 University of Arkansas at Little Rock,
Little Rock, Arkansas
1983 West Georgia College, Carrollton,
Georgia
1984 Birmingham Museum of Art,
Birmingham, Alabama, catalog
1984 Art Gallery, Jacksonville State
University, Jacksonville, Alabama
1985 Kennedy-Douglass Center for the
Arts, Florence, Alabama

Selected Group Exhibitions
1977 "International Women's Year,"
Traveling Exhibition, Birmingham
Museum of Art, Birmingham, Alabama
1979- "Sally Johnson, Computer Graphics
80 and Alan Erdmann, Electronic
Sculpture," Southeastern Center for
Contemporary Art, Winston-Salem,
North Carolina
1980 "Southern Exposure," Hanson Gallery,
New Orleans, Louisiana, catalog
1980 "Images 1980: An Exhibition of
Alabama Women Artists," University of
Montevallo Art Gallery, Montevallo,
Alabama, catalog
1981 "Works on Paper Invitational," Greater
Birmingham Arts Alliance,
Birmingham, Alabama
1981 "Southern Exposure II," Art Center
Association, The Water Tower,
Louisville, Kentucky
1981 "Alabama Art League Annual Juried
Exhibition," Montgomery Museum of
Fine Arts, Montgomery, Alabama,
catalog
1982 "Artists and Their Sources,"
Birmingham Museum of Art,
Birmingham, Alabama
1982 "7 Natures," Anniston Museum of
Natural History, Anniston, Alabama
1983 "Birmingham Biennial Exhibition,"
Birmingham Museum of Art,
Birmingham, Alabama, catalog
1983 "Sally Johnson and Enid Tidwell,"
University of Alabama in Huntsville,
Huntsville, Alabama
1984 "Off Center Exhibition Group,"
Anderson Gallery, Virginia
Commonwealth University, Richmond,
Virginia

Selected Public Collection
Birmingham Museum of Art, Birmingham,
Alabama

Selected Awards
1976 Honorable Mention, "Birmingham Art
Association Annual Juried Exhibition,"
Birmingham Museum of Art,
Birmingham, Alabama
1984 Artist in Residence, Alabama State
Council on the Arts and Humanities

Preferred Sculpture Media
Metal (welded) and Paper

Additional Art Fields
Drawing and Watercolor

Related Professions
Lecturer and Visiting Artist

Selected Bibliography
McPherson, Heather. "7 Natures: Anniston
Museum of Natural History, Anniston,
Alabama." *Art Papers* vol. 7 no. 1
(January-February 1983) pp. 24-25.

Gallery Affiliation
Maralyn Wilson Gallery
Cahaba Road
English Village
Birmingham, Alabama 35213

Mailing Address
1784 Shades Crest Road
Birmingham, Alabama 35216

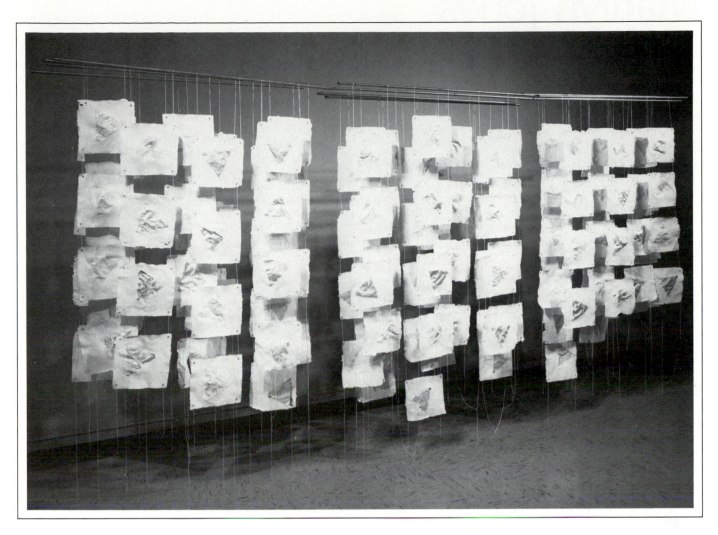

Paper Curtain. 1984. Handmade paper, aluminized computer paper and cotton string, 8′h x 10′w x 6″d. Installation view 1984. Birmingham Museum of Art, Birmingham, Alabama, catalog. Photograph reprinted by permission *The Birmingham News*.

Artist's Statement

"My present work is based on ideas developed from extensive exploration of geometric shapes which occupy space and are known as regular convex polyhedra or the platonic solids. Part of this study has involved collaboration with Jim Allen in computer graphic research using a method to filter shape as a prism filters light by breaking it into wavelengths. This computerized process, a kind of signal analysis employed in biological or medical research, has seemed to bridge the gap between advanced technology and producing something that might qualify as art.

"The resulting sculpture in different forms and media can be interpreted on many levels. Is it able to transport the mind to another realm? Are feelings generated in the viewer? Does it take me another step on the road which lies open for exploration?"

Sally W. Johnson

Marilyn Jones

née Marilyn Mae
(Husband Richard Forrest Marlowe)
Born September 27, 1946 Asheville, North
 Carolina

Education and Training
1969 B.S.A., Sculpture, Appalachian State
 University, Boone, North Carolina;
 study with George Jolley
1971 M.A., Sculpture and Printmaking, East
 Carolina University, Greenville, North
 Carolina; study in sculpture with
 Robert S. Edminston
1976 M.F.A., Sculpture and Photography,
 University of Alabama, University,
 Alabama; study in sculpture with
 Arthur Oakes

Selected Individual Exhibition
1984 Malone Fine Arts Building, Mississippi
 Gulf Coast Junior College, Perkinston
 Campus, Perkinston, Mississippi

Selected Group Exhibitions
1968 "Invitational Exhibition," Appalachian
 State University, Boone, North
 Carolina
1968 "Member Artists' Exhibition," Asheville
 Art Museum, Asheville, North Carolina
1968 "Twenty-Ninth Annual Juried
 Exhibition," Gallery of Contemporary
 Art, Winston-Salem, North Carolina
1969 "Asheville and Vicinity Artists,"
 Western Carolina University,
 Cullowhee, North Carolina, catalog

1969 "Seventeenth Annual Juried Show,"
 First Union National Bank, Asheville,
 North Carolina
1971 "North Carolina Artists Award Winners,
 1971," North Carolina Museum of Art,
 Raleigh, North Carolina
1971 "Sixteenth Durham Art Guild Annual
 Juried Art Show," Allied Arts Center,
 Durham, North Carolina
1974 "Invitational Exhibition," Art Gallery,
 University of Alabama, University,
 Alabama
1974, "Alabama Art League Annual Juried
 76 Exhibition," Montgomery Museum of
 Fine Arts, Montgomery, Alabama,
 catalog
1974, "Birmingham Art Association
 75 Members' Exhibition," Birmingham
 Museum of Art, Birmingham, Alabama
1975 "Chiaha Third Annual Art Show,"
 National City Bank, Rome, Georgia,
 catalog
1976 "Forty-Fourth Southeastern Painting
 and Sculpture Competition,"
 Southeastern Center for
 Contemporary Art, Winston-Salem,
 North Carolina
1982 "Fifth Annual Mississippi Juried
 Exhibition," University of Southern
 Mississippi, Hattiesburg, Mississippi

Selected Public Collections
East Carolina University, Greenville, North
 Carolina
Herndon Building Company, Raleigh, North
 Carolina
University of Alabama, Garland Hall Art
 Gallery, Fine Arts Department, University,
 Alabama
Western Carolina University, Cullowhee,
 North Carolina

Selected Private Collections
Mr. and Mrs. Charles Acres, Perkinston,
 Mississippi
Tania Milecevic, New York, New York
Mr. and Mrs. James Shallow, Greenville,
 North Carolina
Julius Shanklin, Jr., Raleigh, North Carolina
Mr. and Mrs. Charles Springman, Raleigh,
 North Carolina

Selected Awards
1970 Scholarship Award, Raleigh Woman's
 Club, Art Division, "Thirty-Third Annual
 North Carolina Artists Exhibition,"
 North Carolina Museum of Art,
 Raleigh, North Carolina, catalog
1975 Merit Award, "Forty-Sixth Alabama Art
 League Annual Juried Exhibition,"
 Montgomery Museum of Fine Arts,
 Montgomery, Alabama, catalog
1976 Sculpture Prize, "Decatur Art Guild
 Juried Art Exhibition," Decatur Art
 Guild, Decatur, Alabama, catalog

Preferred Sculpture Media
Metal (cast), Varied Media and Wood

Additional Art Field
Drawing

Mailing Address
Route 2 Box 21A
Wiggins, Mississippi 39577

Artist's Statement

"Art is a process involving the constant defining and redefining of individual experiences. By constructing a personal language through symbolism, I attempt to convey an understanding of my concept; yet through the juxtaposition and choice of symbols, the content is open to individual interpretation. Art is, and should be, a universal language.

"My overall theme is death. This theme is dealt with in varying degrees from birth (in drawings) to the funeral and burial process (in earth pieces) using materials of the dead, wood and stone. The decaying process is found in the skeleton structures with the underlying theme of preserved museum pieces. The philosophical interpretations of the symbols relate to a statement by Albert Schweitzer: 'The tragedy of life is what dies inside a man while he lives.'"

Marilyn Jones Marlowe

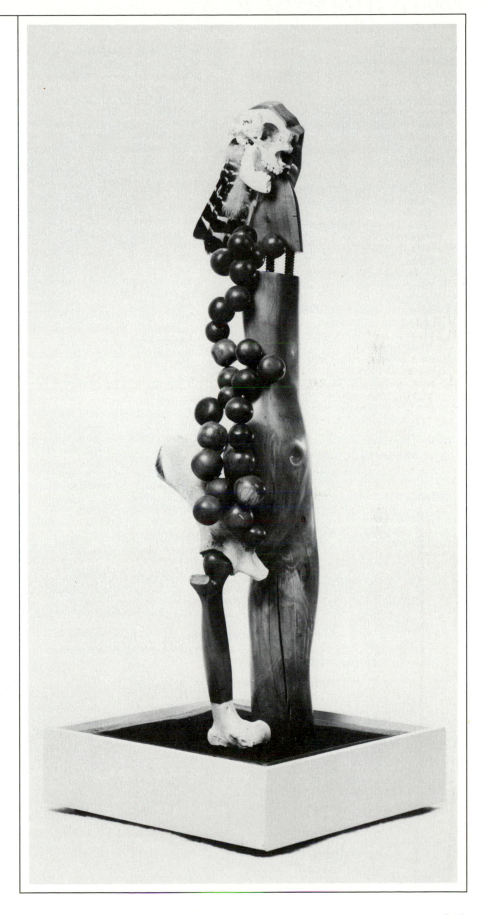

Self-Portrait No. I with Eaters. 1983. Wood, bone and feathers, 5'h x 22"w x 20"d. Photograph by Truett Haire.

Wiz Jones

née Helen Marion Frick
(Husband Howard W. Jones)
Born July 26, 1926 New York, New York

Education and Training
1947 Pennsylvania Academy of the Fine Arts, Philadelphia, Pennsylvania; study in painting
1948 B.F.A., Painting, Syracuse University, Syracuse, New York

Selected Individual Exhibitions
1956 America House Gallery, New York, New York
1960 Martin Schweig Gallery, St. Louis, Missouri
1967 Hall's Plaza and Downtown Gallery, Kansas City, Missouri
1967 Tennessee Fine Arts Center, Cheekwood, Nashville, Tennessee, catalog
1967 Gallery of Loretto-Hilton Center, St. Louis, Missouri, catalog
1980 Saint Louis Art Museum, St. Louis, Missouri, catalog
1982 Bonsack Gallery, John Burroughs School, St. Louis, Missouri
1985 Brentwood Gallery, St. Louis, Missouri

Selected Group Exhibitions
1952 "Fabrics: Choy, Jones and Jones," Newcomb College Art Department, New Orleans, Louisiana
1953 "Designer Craftsmen 1953," City Art Museum, St. Louis, Missouri
1953 "Young Designers 1953," Akron Art Institute, Akron, Ohio
1954, 55 "Young Americans 1954," America House Gallery, New York, New York
1955 "Fiber, Clay and Metal," Saint Paul School of Art, St. Paul, Minnesota
1956 "Design by the Yard," Cooper Union for the Advancement of Science and Art, New York, New York
1959 "American Craftsmen 1959," University of Illinois at Urbana-Champaign, Urbana, Illinois
1966 "Form, Figure, Fantasy in Wood: Louise Nevelson, David Hostetler and Wiz Jones," Flair Gallery, Cincinnati, Ohio
1968 "Objects Are . . .," Museum of Contemporary Crafts, New York, New York, catalog
1968 "The Door," Museum of Contemporary Crafts, New York, New York, catalog
1975 "Group Exhibition," Messing Gallery, Country Day School, St. Louis, Missouri
1981 "Collectors' Choice," Saint Louis Art Museum, St. Louis, Missouri
1983 "National Wood Invitational," Gallery at Craft Alliance, St. Louis, Missouri, catalog
1985 "Art St. Louis," *Globe-Democrat* Building, St. Louis, Missouri
1985 "Summer Invitational," Brentwood Gallery, St. Louis, Missouri

Selected Public Collection
Saint Louis Art Museum, St. Louis, Missouri

Selected Private Collections
Jean Boggs, Ottawa, Ontario, Canada
Morton D. May, St. Louis, Missouri
Mr. and Mrs. Joseph Pulitzer IV, St. Louis, Missouri
Peter Tunnard, London, Great Britain
Max Wasserman, Boston, Massachusetts

Preferred Sculpture Media
Varied Media and Wood

Additional Art Fields
Drawing and Photography

Selected Bibliography
Skrainka, Linda. "Wiz Jones: Boxes 1965-67; 1977-79, St. Louis Art Museum." *New Art Examiner* vol. 7 no. 6 (March 1980) p. 4, illus.

Gallery Affiliation
Brentwood Gallery
8240 Forsyth Boulevard
St. Louis, Missouri 63105

Mailing Address
12 North Newstead Avenue
St. Louis, Missouri 63108

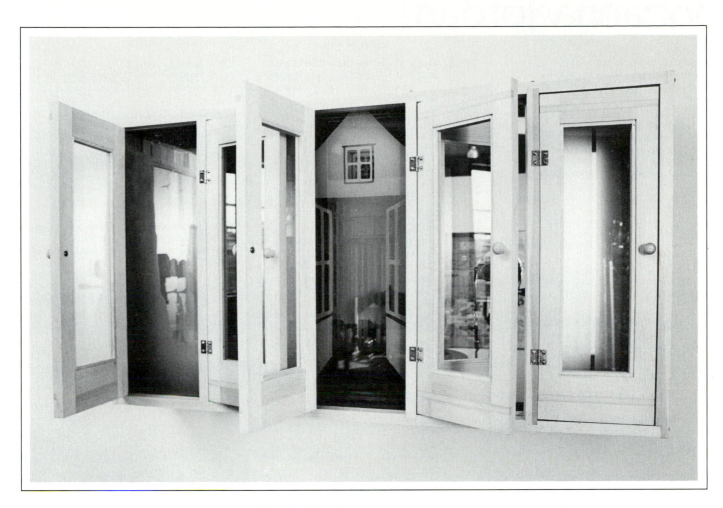

Grande Greve. 1982-1983. Wood, mirror, glass and brass, 22⅜"h x 40¼"w x 6½"d. Photograph by Howard W. Jones.

Artist's Statement

"A summer spent on a wild unspoiled beach on the west coast of Florida in 1959 started my involvement with three-dimensional art and particularly sculpture. I began picking up and putting together sun-bleached pieces of cut lumber, bits of wrecked boats and small objects. The Southwest also has had a great influence upon my sculpture and landscape drawings—its vast spaces are the essence of loneliness and isolation.

"I build my pieces myself and have learned skills of a cabinet maker and carpenter since my basic medium is wood. My earlier work seemed to suggest fantasy, whimsy, a sort of Alice in Wonderland quality. Lately it has become more spare, formal, involved with isolation, illusion and mystery. The imagery confined in space within wood and glass structures controls the process of viewing the interior."

Johanna Jordan

née Johanna Schneider
(Husband William Henry Jordan)
Born October 20, 1919 Philadelphia,
 Pennsylvania

Education and Training
1941 Certificate, Advertising, Philadelphia
 College of Art, Philadelphia,
 Pennsylvania
1957 University of Redlands, Redlands,
 California; study in painting
1961- Riverside Art Center and Museum,
63 Riverside, California; study in
 sculpture with John Svensen
1964 Pomona College, Claremont,
 California; study in bronze casting
 with John Mason
1967 San Bernardino Valley College, San
 Bernardino, California; study in
 welding

Selected Individual Exhibitions
1965 Lyon Gallery, Redlands, California
1966 Riverside Fine Arts Guild, Riverside,
 California
1972 Challis Galleries, Laguna Beach,
 California
1976 Eleven Eleven Gallery, Laguna Beach,
 California
1980 Abraxas Gallery, Newport Beach,
 California, catalog
1982 Abraxas Gallery, Newport Beach,
 California

Selected Group Exhibitions
1962 "40 Artists of Southern California,"
 Riverside Art Center and Museum,
 Riverside, California
1966, "All California Show," Laguna Beach
69, Museum of Art, Laguna Beach,
75 California
1968 "California South Six," San Diego
 Museum of Art, San Diego, California
1968 "Eleventh Annual Art Unlimited,"
 Downey Museum of Art, Downey,
 California
1971 "Eight Liberated Women," Laguna
 Beach Museum of Art, Laguna Beach,
 California
1974 "Invitational Exhibition," Laguna Beach
 Museum of Art, Laguna Beach,
 California
1975, "Invitational Sculpture Exhibition,"
78 Riverside Art Center and Museum,
 Riverside, California

1976 "Department of Airports Bicentennial
 Sculpture Competition," Los Angeles
 International Airport, Los Angeles,
 California
1977 "Selections from Private Collections,
 Orange County," Laguna Beach
 Museum of Art, Laguna Beach,
 California
1977 "Southern California 100," Laguna
 Beach Museum of Art, Laguna Beach,
 California, catalog
1979 "Sculpture Invitational," Saddleback
 Community College, Mission Viejo,
 California
1980 "National Sculpture Competition
 Exhibition," Robeson Center Gallery,
 Rutgers University, University
 College-Newark, Newark, New Jersey
1980 "The Artist As He Sees Himself,"
 Abraxas Gallery, Newport Beach,
 California
1981 "Three Artists: Karl Benjamin, Johanna
 Jordan, Terry Allen," Abraxas Gallery,
 Newport Beach, California
1983 "California Artists of Note," San
 Bernadino County Museum, Redlands,
 California
1984 "Art Connections '84, Orange County
 Sculpture: Source and Process,"
 Guggenheim Gallery, Chapman
 College, Orange, California, catalog
1984 "Sculpture, The Imaginative
 Approach," Edward-Dean Museum of
 Decorative Arts, Cherry Valley,
 California, catalog
1985 "The Feminine Eye: Eleanor Antin,
 Joan Brown, Johanna Jordan, Susan
 Rankaitis," Laguna Beach School of
 Art, Laguna Beach, California

Selected Public Collections
Equidon Corporation, Wateridge Project, San
 Diego, California
Jorco Chemical Company, Redlands,
 California
Louisiana Arts And Science Center, Baton
 Rouge, Louisiana
Oklahoma State University, Bartlett Center
 for the Studio Arts, Stillwater, Oklahoma
University of California, Irvine, Irvine,
 California

Selected Private Collections
Dr. Kingkhan Boriboon, Bloomfield Hills,
 Michigan
Fred Harpman, Hollywood, California
Dr. and Mrs. Jeffrey Mishell, Denver,
 Colorado
Mr. and Mrs. Steven Snyder, Pennsauken,
 New Jersey
Veloy Vigil, Taos, New Mexico

Selected Awards
1970 Best in Show, "Panorama '70," Laguna
 Beach Museum of Art, Laguna Beach,
 California
1971 First Award, "Second Annual
 Exhibition," St. Raymond's Dominican
 Retreat House, Thousand Oaks,
 California

1984 Special Award, "All California '84,"
 Laguna Beach Museum of Art,
 Laguna Beach, California

Preferred Sculpture Media
Metal (cast) and Metal (welded)

Selected Bibliography
California Art Review. Chicago: Krantz, 1981.
Ewing, Richard. "Reviews: Johanna Jordan at
 Abraxas Gallery." *Images & Issues* vol. 2
 no. 3 (September-October 1982) p. 61,
 illus.
Jordan, Johanna. "Polychromed,
 Multi-Positional, Sheet Aluminum
 Sculpture." *Leonardo* vol. 16 no. 1 (Winter
 1983) pp. 43-45, illus.
Lewis, Roger. "California Profiles: Johanna
 Jordan (Laguna Beach)." *Art Voices* vol. 4
 no. 1 (January-February 1981) p. 47, illus.

Mailing Address
1415 Sixth Street
Santa Monica, California 90401

Artist's Statement

"In the past I have explained my work in terms like asymmetry, universal dichotomies, and so on, but the truth is, I just like things to be clean and lean. I like simple, powerful forms. I like strong colors and I like contrasts. The contrast of straight lines against curved planes, the contrast of color on metal and, especially, the contrast of solid form against space. These are basic pleasures and they create my work."

Johanna Jordan

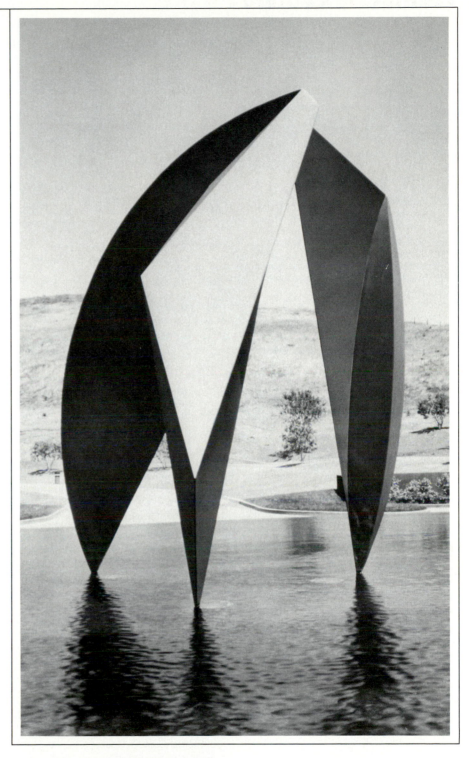

No. 180—Red and Pink. 1982. Stainless steel with porcelain, 8'h x 6'w x 6'd. Collection Equidon Corporation, Wateridge Project, San Diego, California. Photograph by Scott Malcolm.

Luise Kaish

née Luise Clayborn Meyers
(Husband Morton Kaish)
Born September 8, 1925 Atlanta, Georgia

Education and Training
1946 B.F.A., Visual Arts, Syracuse University, Syracuse, New York
1946- Escuela de Pintura y Escultura,
47 México, D.F., México
1951 M.F.A., Sculpture, Syracuse University, Syracuse, New York; study with Ivan Meštrović
1951- Instituto d'Arte, Florence, Italy;
52 independent study in bronze casting and stone carving

Selected Individual Exhibitions
1954 Memorial Art Gallery of the University of Rochester, Rochester, New York
1968, Staempfli Gallery, New York, New
81, York
84,
85
1969 Minnesota Museum of Art, St. Paul, Minnesota, catalog
1972 American Academy in Rome, Rome, Italy, catalog
1973 Jewish Museum, New York, New York, retrospective and catalog
1974 Hopkins Center, Dartmouth College, Hanover, New Hampshire, catalog
1985 University of Haifa, Haifa, Israel

Selected Group Exhibitions
1951 "American Sculpture 1951," Metropolitan Museum of Art, New York, New York
1952, "Annual Exhibition of Painting and
53, Sculpture," Pennsylvania Academy of
61, the Fine Arts, Philadelphia,
64 Pennsylvania, catalog
1955 "The New Decade: Thirty-Five American Painters and Sculptors," Whitney Museum of American Art, New York, New York, catalog
1955 "Paintings by Morton Kaish; Sculpture by Luise Kaish," Manhattanville College, Purchase, New York
1957, "Contemporary American Painting and
59, Sculpture," Krannert Art Museum,
61, Champaign, Illinois
63,
69
1958 "Bronzes by Luise Kaish; Etchings and Lithographs by Morton Kaish," Memorial Art Gallery of the University of Rochester, Rochester, New York
1959 "Recent Sculpture U.S.A.," Traveling Exhibition, Museum of Modern Art, New York, New York, catalog
1960, "Contemporary Painting and
73 Sculpture," American Academy of Arts and Letters, New York, New York

1960- "Sculptors Guild Annual Exhibition,"
79 Lever House, New York, New York, catalog
1962 "Women Artists in America Today," Mount Holyoke College, South Hadley, Massachusetts, catalog
1962, "Annual Exhibition: Contemporary
66 Sculpture and Drawings," Whitney Museum of American Art, New York, New York, catalog
1964 "Annual Exhibition: Contemporary American Sculpture," Whitney Museum of American Art, New York, New York, catalog
1965 "Women Artists of America 1707-1964," Newark Museum, Newark, New Jersey, catalog
1965 "Religious Art from Byzantium to Chagall," Albright-Knox Art Gallery, Buffalo, New York
1967 "Protest and Hope," New School Art Center, New York, New York
1967 "Bryant Park Sculpture Exhibition," Bryant Park, New York, New York
1967 "Recent Acquisitions," Whitney Museum of American Art, New York, New York
1970 "American Sculpture," University of Nebraska Art Galleries, Sheldon Memorial Art Gallery, Lincoln, Nebraska, catalog
1972 "American Women: 20th Century," Lakeview Center for the Arts and Sciences, Peoria, Illinois, catalog
1973 "K x 2, Paintings by Morton Kaish; Sculpture by Luise Kaish," United States Information Service of the U.S. Embassy, Rome, Italy
1975- "Jewish Experience in the Art of the
76 Twentieth Century," Jewish Museum, New York, New York
1979, "West/Art and The Law National
80 Competition," Traveling Exhibition, Minnesota Museum of Art, St. Paul, Minnesota
1981 "Sculpture in the Garden 1981," Sculptors Guild at the Enid A. Haupt Conservatory, New York Botanical Garden, Bronx, New York, catalog

Selected Public Collections
Atlantic Richfield Corporation, Los Angeles, California
Beth El Synagogue Center, New Rochelle, New York
B'nai Abraham, Essex City, New Jersey
Container Corporation of America, Chicago, Illinois
Continental Grain Company, New York, New York
Export Khleb, Moscow, Union of Soviet Socialist Republics
First Bank System, Minneapolis, Minnesota
General Mills Corporation, Minneapolis, Minnesota
Hebrew Union College, Jerusalem, Israel
High Museum of Art, Atlanta, Georgia
Holy Trinity Mission Seminary, Silver Spring, Maryland
Jewish Museum, New York, New York

Lowe Art Museum, Coral Gables, Florida
Metropolitan Museum of Art, New York, New York
Minnesota Museum of Art, St. Paul, Minnesota
Rochester Memorial Art Gallery, Rochester, New York
Syracuse University, Syracuse, New York
Temple Beth Shalom, Wilmington, Delaware
Temple B'rith Kodesh, Rochester, New York
Temple Israel, Westport, Connecticut
Whitney Museum of American Art, New York, New York

Selected Awards
1951 Louis Comfort Tiffany Foundation Grant
1959 John Simon Guggenheim Memorial Foundation Fellowship
1970 Rome Prize Fellowship, American Academy in Rome, Rome, Italy

Preferred Sculpture Media
Metal (cast), Metal (welded) and Varied Media

Additional Art Fields
Collage and Painting

Teaching Position
Professor of Sculpture and Chair, Division of Painting and Sculpture, Columbia University, New York, New York

Selected Bibliography
Dash, Robert W. "In the Galleries: Luise Kaish." *Arts* vol. 32 no. 7 (April 1958) p. 63.
Kampf, Avram. *Contemporary Synagogue Art: Developments In The United States, 1945-1965.* New York: Union of American Hebrew Congregations, 1966.
Kampf, Avram. *Jewish Experience in the Art of the Twentieth Century.* South Hadley, Massachusetts: Bergin & Garvey, 1984.
Lipsey, Roger. "Luise Kaish's Small Worlds." *Arts Magazine* vol. 56 no. 3 (November 1981) pp. 158-160, illus.
Martin, Richard. "Luise Kaish." *Arts Magazine* vol. 59 no. 2 (October 1984) p. 11, illus.

Gallery Affiliation
Staempfli Gallery
47 East 77 Street
New York, New York 10021

Mailing Address
610 West End Avenue
New York, New York 10024

Artist's Statement

"We are like the whirlwind of which in the center is the place of quiet. We search for the realities of our visions, the edge of the universe within ourselves—knowledge, reason, passion, the soul. Everything we do is in us and we discover it.

"The sculptor speaks through idea and presence. I feel, perceive—masses, curves, planes meeting and intersecting—the body, the land, the flower, all molecules of energy, continually changing, reshaped, revealed to the senses by the mysteries of light."

Luise Kaish

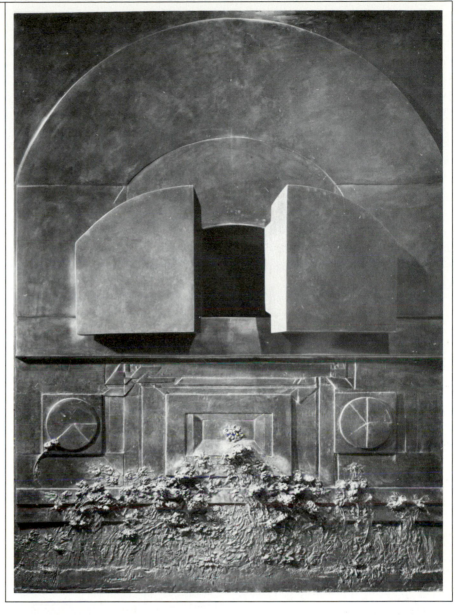

Holocaust. 1974-1975. Bronze, 80″h x 61″w x 15″d.
Collection Jewish Museum, New York, New York.
Photograph by Bruce C. Jones.

Rebecca Kamen

Born July 8, 1950 Philadelphia, Pennsylvania

Education and Training
1972 B.S., Sculpture, Pennsylvania State University-University Park Campus, University Park, Pennsylvania
1972 Pennsylvania State University-University Park Campus, University Park, Pennsylvania; study in sculpture with Klaus Ihlenfeld
1973 M.A., Sculpture, University of Illinois at Urbana-Champaign, Urbana, Illinois; study with Frank Gallo
1978 M.F.A., Sculpture, Rhode Island School of Design, Providence, Rhode Island; study with Lauren Ewing

Selected Individual Exhibitions
1972 Oglebay Institute-Mansion Museum, Wheeling, West Virginia
1972, Pennsylvania State University-
74 University Park Campus, University Park, Pennsylvania
1975 University of South Carolina, Columbia, South Carolina
1977 Woods-Gerry Gallery, Rhode Island School of Design, Providence, Rhode Island
1978 Sarah Doyle Women's Center Gallery, Brown University, Providence, Rhode Island
1979 Fine Arts Gallery, Catonsville Community College, Catonsville, Maryland
1979, Gallery 10, Washington, D.C.
82
1981 Catholic University, Washington, D.C.
1984 Washington and Lee University, Lexington, Virginia
1984 Gallery 111, Arlington Arts Center, Arlington, Virginia
1985 Second Street Gallery, Charlottesville, Virginia
1985 Montpelier Arts and Cultural Center, Laurel, Maryland
1985 Arnold & Porter, Washington, D.C.

Selected Group Exhibitions
1975 "South Carolina Arts Commission Invitational Exhibition," Lee Hall Gallery, Clemson University, Clemson, South Carolina
1977 "Group Exhibition," Oglebay Institute-Mansion Museum, Wheeling, West Virginia
1977 "Invitational Exhibition," Sarah Doyle Women's Center Gallery, Brown University, Providence, Rhode Island
1979 "A Multi-Media Exhibit of Members' Works Selected by Miriam Schapiro," Washington Women's Arts Center, Washington, D.C., catalog

1979 "5 Years of Exhibitions 1974-1979," Gallery 10, Washington, D.C., catalog
1980 "Miniature Exhibition and Fifth Anniversary," Foundry Gallery, Washington, D.C.
1980 "Sculpture Summer '80," Cramer Gallery, Washington, D.C.
1980 "Washington Sculptors," Washington Project for the Arts, Washington, D.C.
1980 "Group Exhibition," Foundry Gallery, Washington, D.C.
1981- "Collage & Assemblage," Traveling
84 Exhibition, Mississippi Museum of Art, Jackson, Mississippi, catalog
1982 "First Annual Art Exhibition and Sale, Brandeis University," National Women's Committee, Washington, D.C.
1983 "Outrageous," Nornberg Gallery of Art, St. Louis, Missouri
1983 "Fresh Paint," Pleiades Gallery, New York, New York
1983 "Constructions," School 33 Art Center, Baltimore, Maryland
1984 "Cityspaces: Alexandria Sculpture Festival," Area Locations, Alexandria, Virginia, catalog
1984 "Shipshapes!," Midtown Gallery, Washington, D.C.
1984 "Small Works: Area Exhibition," Foundry Gallery, Washington, D.C., catalog
1984 "Young Washington Artists," Baltimore Museum of Art, Baltimore, Maryland
1984 "Contemporary Perspectives 1984," Meredith Contemporary Art, Baltimore, Maryland
1985 "Talent," Baumgartner Galleries, Washington, D.C.

Selected Public Collections
Bellaire Clinic, Bellaire, Ohio
DeSanto/Naphtal Company, McLean, Virginia
Lancaster High School, Lancaster, South Carolina
Lynhaven Career and Vocational Center, Columbia, South Carolina
Pennsylvania State University-University Park Campus, University Park, Pennsylvania
Tri-County Technical College, Pendleton, South Carolina
Uniweave Company Showroom, Chicago, Illinois

Selected Private Collection
Albert Abramson, Washington, D.C.

Selected Awards
1983 Honorable Mention, "Alexandria Sculpture Festival," The Athenaeum, Northern Virginia Fine Arts Association, Alexandria, Virginia, catalog
1983 Merit Award, "Artspace 1983," Maryland Institute College of Art, Baltimore, Maryland
1984 Merit Award, "Sculpture '84," Washington Square Partnership and Public Art Trust, Washington, D.C.

Preferred Sculpture Media
Varied Media and Wood

Additional Art Field
Painting

Teaching Position
Associate Professor of Art, Northern Virginia Community College, Alexandria, Virginia

Selected Bibliography
Heller, Nancy G. "Arts Reviews Washington, D.C./Baltimore: Marilyn Horrom/Rebecca Kamen, Gallery 10." Arts Magazine vol. 57 no. 6 (February 1983) p. 48.
Lewis, Jo Ann. "Galleries." The Washington Post (Saturday, September 29, 1979) p. B3.
Lewis, Jo Ann. "Galleries: A Square of Sculpture." The Washington Post (Saturday, June 30, 1984) p. C3.
Perlmutter, Jack. "Reviews of the Shows and Exhibitions Washington: Collage on Paper at Corcoran Gallery of Art." Art Voices vol. 4 no. 4 (July-August 1981) pp. 83-84.
Wittenberg, Clarissa K. "Reviews of the Exhibitions Washington, D.C.: Lila Snow and Rebecca Kamen at Gallery 10." Art Voices/South vol. 3 no. 1 (January-February 1980) pp. 99-100, illus.

Gallery Affiliation
Meredith Contemporary Art
805 North Charles Street
Baltimore, Maryland 21201

Mailing Address
2224 North Pollard Street
Arlington, Virginia 22207

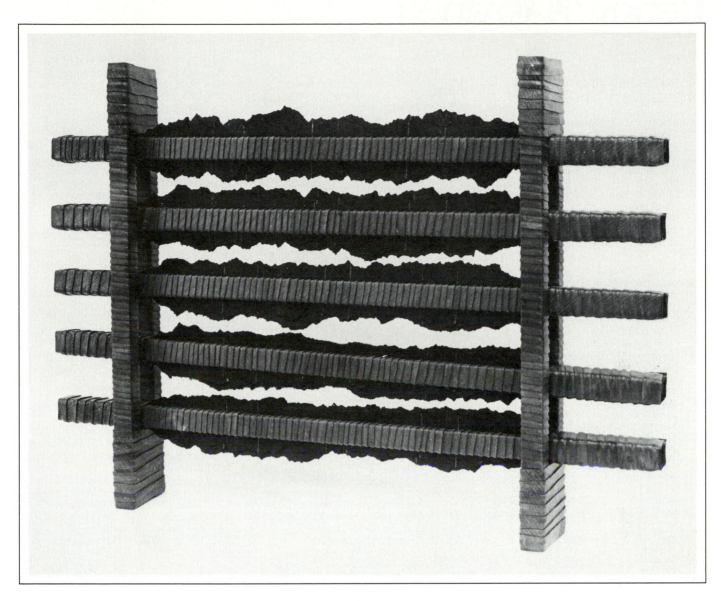

Untitled. 1980. Mixed media, 48"h x 47"w x 6"d.
Photograph by Jeff Dunn.

Artist's Statement

"The intention of my work is to conceal what most sculptors reveal. I began in welded sculpture but I have always had an interest in found materials: using natural materials is like an ecological recycling.

"Much of my sculpture is influenced by traditional Japanese packaging. There is a certain mystery evoked by the concealment of the inner object and its outer wrapping. My early sculpture consisted of tightly-wrapped black forms allowing only a certain level of internal perception. Recently, these forms have loosened their boundaries. What were once forbidding solid masses now are separated to reveal more of the internal structure. The interior is becoming the exterior."

Rebecca Kamen

Penny Kaplan

née Penny Leitner
(Husband Harold M. Kaplan)
Born December 16, 1930 New York, New
York

Education and Training
1950 Hunter College, New York, New York;
study in acting, radio and stage
1962 Studio of Miriam Schapiro,
Mamaroneck, New York; study in
painting
1963 Studio of Eleanore Lockspeiser, New
York, New York; study in painting
1970- Apprenticeship to Bert Numme, Mt.
75 Vernon, New York; study in welding
1976 Columbia University, New York, New
York; study in art history

Selected Individual Exhibitions
1975, 14 Sculptors Gallery, New York,
77 New York
1976 Mabel Smith Douglass Library,
Rutgers University, Douglass College,
New Brunswick, New Jersey
1979 Lowenstein Library Gallery and Robert
Moses Plaza, Fordham University at
Lincoln Center, New York, New York
1979 Pace University, College of White
Plains, White Plains, New York
1981 Fordham University at Lincoln Center,
New York, New York
1982 Saint Peter's Lutheran Church,
Citicorp Center, New York, New York
1983 Elaine Benson Gallery,
Bridgehampton, New York
1983 Bellevue Hospital, New York, New
York
1985 SoHo 20 Gallery, New York, New York

Selected Group Exhibitions
1971, "Annual New England Exhibition,"
74, Silvermine Guild of Artists, New
75 Canaan, Connecticut, catalog
1975 "Bicentennial Azalea Garden Sculpture
Exhibition," Philadelphia Museum of
Art, Philadelphia, Pennsylvania
1975 "Outstanding Women of 1975," Gallery
Without Walls, Saranac, New York
1976 "Invitational Exhibition," Hudson River
Museum, Yonkers, New York, catalog
1976 "12 From NOW," Museum Gallery,
White Plains, New York, catalog
1976 "The Roots of Creativity, Women
Artists Year 6," Mabel Smith Douglass
Library, Rutgers University, Douglass
College, New Brunswick, New Jersey,
catalog
1977 "What is Feminist Art?," Woman's
Building, Los Angeles, California
1977 "Environmental Sculpture," Fordham
University at Lincoln Center, New
York, New York, catalog

1977 "Group Exhibition," Gallery 10,
Washington, D.C.
1977, "Gallery Exhibition," Elaine Benson
78 Gallery, Bridgehampton, New York
1977 "Penny Kaplan, Sarah Capps and Dale
Threlkeld," Mitchell Museum, Mount
Vernon, Illinois, catalog
1977 "A.R.E.A. Outdoor Sculpture
Exhibition," Roosevelt Island, New
York, catalog
1978 "Art for Public Places," Bridge Gallery,
White Plains, New York
1978- "Sculpture in Color, New York Upper
79 East River A.R.E.A. Outdoor Sculpture
Exhibition," Roosevelt Island, New
York, catalog
1978 "90 by 30: A Festival of Small
Sculpture," Martha Jackson Gallery,
New York, New York, catalog
1979 "A Homage to David Smith: Prospect
Mountain Sculpture Exhibition,"
Prospect Mountain State Park, Lake
George, New York, catalog
1979- "Carl Andre, Penny Kaplan and
81 William King," Creedmoor Psychiatric
Center, Queens Village, New York
1980- "Sculpture Park at Creedmoor,"
81 Creedmoor Psychiatric Center,
Queens Village, New York, catalog
1980 "Eleventh International Sculpture
Conference," Area Galleries and
Institutions, Washington, D.C.
(Sponsored by International Sculpture
Center, Washington, D.C.)
1980 "Sculpture at Sands Point," Nassau
County Museum, Sands Point Park
and Preserve, Port Washington, New
York, catalog
1981 "Sculpture '81," Franklin Plaza and
International Garden Franklin Town,
Philadelphia, Pennsylvania
(Co-Sponsored by Cheltenham Art
Centre, Cheltenham, Pennsylvania)
1981 "Sculpturesites: Outdoor Sculpture,"
Roger Wilcox Sculpturesites,
Amagansett, New York, catalog
1981 "Women Artist Series Retrospective,"
Mabel Smith Douglass Library,
Rutgers University, Douglass College,
New Brunswick, New Jersey, catalog
1981 "A.R.E.A. Sculpture Exhibition," Shidoni
Gallery, Tesuque, New Mexico
1981- "Environmental Art Projects: 1981,"
82 Morris Museum of Arts and Sciences,
Morristown, New Jersey, catalog
1982 "Twelfth International Sculpture
Conference," Area Galleries and
Institutions, Oakland, California and
San Francisco, California (Sponsored
by International Sculpture Center,
Washington, D.C.)
1983 "A.R.E.A. Sculpture Exhibition,"
Traveling Exhibition, Desert Botanical
Garden, Phoenix, Arizona
1983 "Cyril David, Drawings and Penny
Kaplan, Sculpture," Guild Hall
Museum, East Hampton, New York,
catalog
1983 "Ten Year Retrospective," 14 Sculptors
Gallery, New York, New York

1984- "Sculpture at Hofstra," Emily Lowe
85 Gallery, Hempstead, New York
1984- "Sculpture Exhibition," Montgomery
85 College-Rockville Campus, Rockville,
Maryland
1985 "Art and the Environment, A.R.E.A.
Sculpture Exhibition," Lever House,
New York, New York

Selected Public Collections
Bellevue Hospital, New York, New York
Creedmoor Psychiatric Center, Queens
Village, New York
Everson Museum of Art, Syracuse, New York
Manhattan Psychiatric Center, Ward's Island,
New York
Nassau County Museum, Sands Point Park
and Preserve, Port Washington, New York
Octagon Center for the Arts, Ames, Iowa
Pace University, College of White Plains,
White Plains, New York
Westchester County Courthouse, White
Plains, New York

Selected Private Collections
Mr. and Mrs. Leroy Fadem, New Rochelle,
New York
Sam Jacob, New York, New York
Mr. and Mrs. George Kroner, Harrison, New
York

Selected Awards
1976 Competition Grant, New York State
Council on the Arts
1981 Competition Grant, Morris Museum of
Arts and Sciences, Morristown, New
Jersey; Interpace Corporation,
Parsippany, New Jersey and National
Endowment for the Arts
1983 Exhibition Grant, Guild Hall Museum,
East Hampton, New York

Preferred Sculpture Media
Metal (welded) and Varied Media

Additional Art Fields
Drawing, Painting and Paper (cast)

Related Profession
Visiting Artist

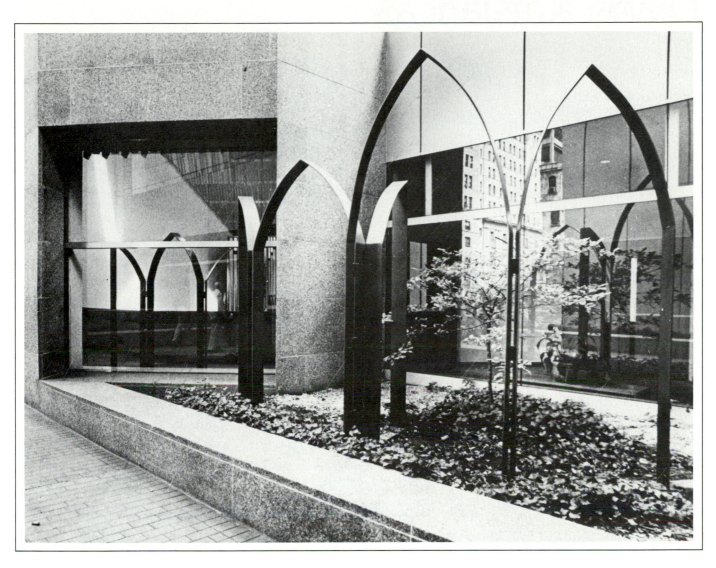

Fragmentary Reflection of Ancient Passages.
1982-1983. Painted steel, exterior section 10'h x
14'w x 4'd, interior section 8'h x 9'w x 4'd.
Installation view 1983. Saint Peter's Lutheran
Church, Citicorp Center, New York, New York.
Photograph by Howie Swetz.

Selected Bibliography

Alloway, Lawrence. "Art." *The Nation* vol. 227
no. 9 (September 23, 1978) pp. 284, 286.
Glueck, Grace. "New Sculpture Under the
Sun, From Staten I. To the Bronx." *The
New York Times* (Friday, August 3, 1979)
pp. C1, C15.
Glueck, Grace. "A Critic's Guide To the
Outdoor Sculpture Shows." *The New York
Times* (Friday, June 11, 1982) pp. C1, C21.
Shirey, David L. "Art and Nature Square Off
in a Park." *The New York Times* (Sunday,
July 6, 1980) p. L.I. 17.
"The 'Vasari' Diary: The 'Shoestrings' of
Peter." *Art News* vol. 82 no. 3 (March 1983)
p. 19, illus.

Gallery Affiliation

SoHo 20 Gallery
469 Broome Street
New York, New York 11013

Mailing Address

7 Steeple Chase Road
Greenwich, Connecticut 06830

Artist's Statement

"Impressions borrowed from ancient
architecture and archaelogical ruins play a
dominate role in my work. My visits to Egypt
and Sicily to study historic sites resulted in
the creation of both the Pyramid and Greek
Column series. Constructions dating back to
medieval times and Oriental shrines are the
major influences in my current sculptures
and drawings. In each structure, the external
form is peeled away leaving the equivalent of
a line drawing. These line drawings are then
translated into steel or wood maquettes
which serve as a three-dimensional
sketchbook. These maquettes, as well as my
drawings on paper, become the prototypes
for the completed outdoor and public
sculptures."

Penny Kaplan

323

Diane Katsiaficas

(Husband Robert M. Seng)
Born November 23, 1947 El Paso, Texas

Education and Training
1968 B.A., Chemistry, Smith College, Northampton, Massachusetts
1971- Camberwell School of Art, London,
72 Great Britain; study in painting
1974 M.A.T., Art Education, University of Washington, Seattle, Washington
1976 M.F.A., Painting, University of Washington, Seattle, Washington

Selected Individual Exhibitions
1979 Art Center Gallery, Seattle Pacific University, Seattle, Washington
1979 Viking Union Gallery, Western Washington University, Bellingham, Washington
1980 Yuma Art Center, Yuma, Arizona
1980 Erica Williams/Anne Johnson Gallery, Seattle, Washington
1981 Master's Gallery, San Diego State University, San Diego, California
1982 Space Gallery, Los Angeles, California
1982 Blackfish Gallery, Portland, Oregon
1983, Traver Sutton Gallery, Seattle,
85 Washington
1984 Seattle Art Museum, Seattle, Washington
1984 University of Puget Sound, Tacoma, Washington
1984 Sheppard Fine Art Gallery, University of Nevada Reno, Reno, Nevada
1984 Fine Arts Gallery, University of Nevada Las Vegas, Las Vegas, Nevada
1984 Columbia Basin College, Pasco, Washington

Selected Group Exhibitions
1979 "3 x 3," Cheney Cowles Memorial Museum, Spokane, Washington
1979 "Invitational Drawing Exhibition," Seattle Pacific University, Seattle, Washington
1979 "Washington Open," Seattle Art Museum, Seattle, Washington
1980 "Seven Environmental Works," University of Georgia Botanical Garden, Athens, Georgia
1980 "Natural Fibers," Bellevue Art Museum, Bellevue, Washington
1981 "Assemblages: The Private Icon," Henry Art Gallery, Seattle, Washington, catalog

1981 "The Farm Project," Frogbird Farm, Arlington, Washington
1981 "Wallpaper/Roompaper," Los Angeles Institute of Contemporary Art, Los Angeles, California
1982 "Art and Social Comment," The Gym, Marylhurst College for Lifelong Learning, Marylhurst, Oregon
1982 "Constructed Spaces," Whatcom Museum of History and Art, Bellingham, Washington
1982 "Making Paper: Papermaking USA History, Process, Art," American Craft Museum, New York, New York, catalog
1982 "Twelfth International Sculpture Conference," Area Galleries and Institutions, Oakland, California and San Francisco, California (Sponsored by International Sculpture Center, Washington, D.C.)
1983 "Living With the Volcano: Artists of Mount St. Helens," Museum of Art, Washington State University, Pullman, Washington
1983 "Of, On or About Paper, *USA Today*," USA Today Building, Arlington, Virginia, catalog
1983 "Contemporary Seattle Art," Bellevue Art Museum, Bellevue, Washington
1983 "Structure/Construction: Works in Paper/Fiber," Hoyt L. Sherman Gallery, Ohio State University, Columbus, Ohio, catalog
1984 "Paper Transformed," Turman Gallery, Indiana State University, Terre Haute, Indiana, catalog
1984 "National Handmade Paper Works," Cheney Cowles Memorial Museum, Spokane, Washington, catalog
1984 "Paper '84," Creative Arts Workshop, New Haven, Connecticut, catalog
1985 "Works of Substance: An Exhibition of Mixed Media & Paper Works," Sun Valley Center, Ketchum, Idaho

Selected Public Collections
Bellevue Art Museum, Bellevue, Washington
City of Seattle, Washington
City of Tacoma, Washington
Junior League of Seattle, Seattle, Washington
King County Arts Commission, King County, Washington
Pacific Northwest Bell, Seattle, Washington
Physio-Control Corporation, Redmond, Washington
Safeco Insurance Company of America, Seattle, Washington
Seattle Art Museum, Seattle, Washington
USA Today, Washington, D.C.
Yuma Art Center, Yuma, Arizona

Selected Award
1977 Fulbright/Deutscher Akademischer Austauschdienst (D.A.A.D.) Fellowship, Berlin, Germany, Federal Republic

Preferred Sculpture Media
Varied Media

Additional Art Field
Painting

Related Professions
Lecturer and Visiting Artist

Selected Bibliography
Gleason, Norma Catherine. "Exhibitions: Summer Sets." *Artweek* vol. 13 no. 29 (September 11, 1982) p. 8, illus.
Glowen, Ron. "Exhibitions: The Will to Order." *Artweek* vol. 11 no. 34 (October 18, 1980) p. 16, illus.
Guenther, Bruce. *50 Northwest Artists: A Critical Selection of Painters and Sculptors Working in the Pacific Northwest*. San Francisco: Chronicle Books, 1983.
Kangas, Matthew. "Exhibitions Down on the Farm: Environmental Sculpture Invitational." *Artweek* vol. 12 no. 29 (September 12, 1981) p. 3, illus.
Toale, Bernard. *The Art of Papermaking*. Worcester, Massachusetts: Davis, 1983.

Gallery Affiliation
Traver Sutton Gallery
2219 Fourth Avenue
Seattle, Washington 98121

Mailing Address
5420 Renton Avenue South
Seattle, Washington 98118

Shipping and Receiving. 1981. Handmade recycled paper, aquatint, slash wood, rope and nails, 12'h x 20'w x 25'd. Installation view 1981. "Wallpaper/ Roompaper," Los Angeles Institute of Contemporary Art, Los Angeles, California.

Artist's Statement

"My work focuses on a reordering of visual information about environments. In collecting information and materials (both natural and civilized castoffs), I have become more involved in using them to interpret particular site specific problems in the form of large-scale temporary installations which create their own architectural spaces. The works attempt to be both environmentally and politically engaged, calling into question the viewers' relationship to the landscape, both past and present."

Diane Katsiaficas

Lila Katzen

née Lila Pell
(Husband Philip Katzen)
Born December 30, 1932 Brooklyn, New York

Education and Training
1948 Cooper Union for the Advancement of Science and Art, New York, New York
1949 Art Students League, New York, New York
1950-52 Hans Hofmann School, Provincetown, Massachusetts
1952-53 Hans Hofmann School, New York, New York

Selected Individual Exhibitions
1968 National Museum of American Art, Smithsonian Institution, Washington, D.C.
1968 Georgia Museum of Art, University of Georgia, Athens, Georgia, catalog
1969 Santa Barbara Museum of Art, Santa Barbara, California
1970 Max Hutchinson Gallery, New York, New York
1970 Centro Venezolano Americano, Caracas, Venezuela
1972 Max Protetch Gallery, Washington, D.C.
1975 Everson Museum of Art, Syracuse, New York and Baltimore Museum of Art, Baltimore, Maryland, catalog
1977 University of Iowa Museum of Art, Iowa City, Iowa, catalog
1977 Southern Methodist University, Dallas, Texas
1978 Fordham University at Lincoln Center, New York, New York
1979-80 University of North Carolina at Chapel Hill, Chapel Hill, North Carolina; Museum of Fine Arts of St. Petersburg, Florida, St. Pertersburg, Florida; Norton Gallery and School of Art, West Palm Beach, Florida, catalog
1980, 82 Alex Rosenberg Gallery, New York, New York
1981 Bruce Museum, Greenwich, Connecticut
1983 Rose Art Museum, Brandeis University, Waltham, Massachusetts, catalog
1984-85 Alex Rosenberg Gallery, New York, New York; Huntsville Museum of Art, Huntsville, Alabama; Stamford Museum and Nature Center, Stamford, Connecticut
1986 Muscarelle Museum, College of William and Mary, Williamsburg, Virginia

Selected Group Exhibitions
1967 "Son et Lumière," Galerie Iris Clert, Paris, France
1967 "Luminism: A One Night Exhibition of Light Art," George Washington Hotel, New York, New York, catalog
1968 "Directions 1: Options—1968," Milwaukee Art Center, Milwaukee, Wisconsin
1969 "Plastic as Plastic," Museum of Contemporary Crafts, New York, New York, catalog
1969 "Superlimited: Books, Boxes and Things," Jewish Museum, New York, New York, catalog
1969 "The Artist & Space," National Gallery of Art, Washington, D.C.
1969 "Plastic Presence," Jewish Museum, New York, New York
1970, 78 "Painting and Sculpture Today," Indianapolis Museum of Art, Indianapolis, Indiana, catalog
1970 "Young Artists New York 1970," Greenwich Library, Greenwich, Connecticut, catalog
1970 "Explorations '70, São Paulo Biennale," National Collection of Fine Arts, Smithsonian Institution, Washington, D.C., catalog
1971 "Twenty-Six by Twenty-Six," Vassar College Art Gallery, Poughkeepsie, New York, catalog
1971 "Projected Art," Finch College Museum of Art, New York, New York
1972 "GEDOK American Woman Artist Show," Kunsthaus, Hamburg, Germany, Federal Republic, catalog
1973 "1973 Biennial Exhibition: Contemporary American Art," Whitney Museum of American Art, New York, New York, catalog
1973 "Outdoor Sculpture," Storm King Art Center, Mountainville, New York
1973-74 "Sculpture: Three New York Artists on Tour," New York Cultural Center, New York, New York; World Trade Center, New York, New York; La Guardia Airport, New York, New York; Pratt Institute, New York, New York, catalog
1974 "Monumenta, A Biennial Exhibition of Outdoor Sculpture," Area Locations, Newport, Rhode Island, catalog
1974 "Vera List Selects," Greenwich Library, Greenwich, Connecticut
1975 "Corporations Collect," Museum of Art, Carnegie Institute, Pittsburgh, Pennsylvania
1975 "Sculpture Outdoors," Nassau County Museum of Fine Arts, Roslyn, New York
1976 "Ninth International Sculpture Conference," Area Galleries and Locations, New Orleans, Louisiana (Sponsored by International Sculpture Center, Washington, D.C.)
1976 "Sculpture '76," Outdoor Locations, Greenwich, Connecticut, catalog
1976 "American Artists '76: A Celebration," Marion Koogler McNay Art Institute, San Antonio, Texas, catalog
1977 "Environmental Sculpture," Fordham University at Lincoln Center, New York, New York, catalog
1978 "90 by 30: A Festival of Small Sculpture," Martha Jackson Gallery, New York, New York, catalog
1978 "Camden Sculpture 1978," Walt Whitman International Poetry Center, Rutgers University, University College-Camden, Camden, New Jersey, catalog
1979 "A Homage to David Smith: Prospect Mountain Sculpture Exhibition," Prospect Mountain State Park, Lake George, New York, catalog
1983 "Women Artists Invitational 1983," Philadelphia College of Art, Philadelphia, Pennsylvania
1985 "Precious: An American Cottage Industry of the Eighties," Grey Art Gallery and Study Center, New York University, New York, New York

Selected Public Collections
Aldrich Museum of Contemporary Art, Ridgefield, Connecticut
Ball State University, Muncie, Indiana
Baltimore Museum of Art, Baltimore, Maryland
Birmingham Museum of Art, Birmingham, Alabama
City of Greenwich, Connecticut
Everson Museum of Art, Syracuse, New York
Fordham University at Lincoln Center, New York, New York
Georgia Museum of Art, University of Georgia, Athens, Georgia
Grand Rapids Art Museum, Grand Rapids, Michigan
Housatonic Museum of Art, Bridgeport, Connecticut
Milwaukee Art Museum, Milwaukee, Wisconsin
Museum of Fine Arts of St. Petersburg, Florida, St. Petersburg, Florida
National Gallery of Art, Washington, D.C.
National Museum of American Art, Smithsonian Institution, Washington, D.C.
Norton Gallery and School of Art, West Palm Beach, Florida
Rose Art Museum, Brandeis University, Waltham, Massachusetts
University of Iowa Museum of Art, Iowa City, Iowa
Wadsworth Atheneum, Hartford, Connecticut
William Benton Museum of Art, Storrs, Connecticut

Selected Private Collections
Edward Broida, New York, New York
Mr. and Mrs. Richard Frackman, Scarsdale, New York
Gertrude Perrin, New York, New York
Mr. and Mrs. Eugene Schwartz, New York, New York
Mr. and Mrs. Martin Sosnoff, New Canaan, Connecticut

Selected Awards
1967 Individual Artist's Grant, Architectural League of New York, New York, New York
1974 Creative Arts Award, American Association of University Women, New York, New York

1979 Significant Contribution to the
Greenwich Environment Award,
Greenwich Arts Council, Greenwich,
Connecticut

Preferred Sculpture Media
Metal (rolled) and Metal (welded)

Additional Art Fields
Collage and Drawing

Related Professions
Artist in Residence and Lecturer

Selected Bibliography
Ahlander, Leslie Judd. "Lila Katzen:
Free-Flowing Sculpture." *Arts Magazine*
vol. 55 no. 7 (March 1981) pp. 158-159,
illus.
Munro, Eleanor C. *Originals: American
Women Artists.* New York: Simon and
Schuster, 1979.
Nemser, Cindy. "Lila Katzen: A Human
Approach to Public Sculpture." *Arts
Magazine* vol. 49 no. 5 (January 1975) pp.
76-78, illus.
O'Beil, Hedy. "Arts Reviews: Lila Katzen,
Alex Rosenberg Gallery." *Arts Magazine*
vol. 59 no. 5 (January 1985) p. 41, illus.
Stevens, Elisabeth. "Lila Katzen." *Arts
Magazine* vol. 52 no. 10 (June 1978) p. 23,
illus.

Gallery Affiliation
Alex Rosenberg Gallery
20 West 57 Street
New York, New York 10019

Mailing Address
345 West Broadway
New York, New York 10013

Artist's Statement
"My sculpture comes into being with the use
of steel and various metals. I want to be able
to suspend steel, an intractable material, to
swing it into the air, to make it dance. But I
wish to involve the viewer into the kind of
seduction Bernini and Matisse exercised:
Bernini's columns and sculptures, *The
Ecstasy of St. Theresa* and *The Laocoön
Group*, the sense of opulence and grand
ease in Matisse's sculpture and painting.
However, it is natural for me to work in an
oeuvre of my time. The duality of the image
is my concern: the use of oppositions to
create a magical experience. This experience
is the fusion of different textures, materials
and conceptions in a scale informed by
historical dreams and musing. This is the
age of pluralism and I am a part of it."

Lila Katzen

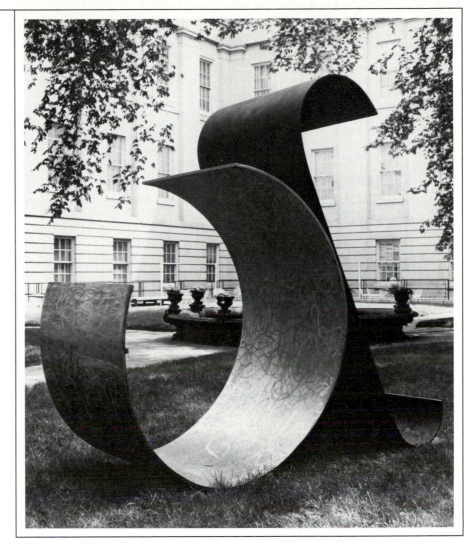

Curled Up C. 1979. CorTen and stainless steel,
7'7"h x 7'9"w x 3'4"d. Collection National Museum
of American Art, Smithsonian Institution,
Washington, D.C.

Margaret Keelan

née Margaret Florence Lillian
Born September 4, 1948 Regina,
Saskatchewan, Canada
(Canadian citizenship)

Education and Training
1970 B.A., Fine Arts, University of
Saskatchewan, Saskatoon,
Saskatchewan, Canada
1971- University of Saskatchewan,
72 Saskatoon, Saskatchewan, Canada;
study in ceramic sculpture with Joe
Fafard
1976 M.F.A., Ceramic Sculpture, University
of Utah, Salt Lake City, Utah; study
with Marilyn Levine

Selected Individual Exhibition
1980, Anna Gardner Gallery, Stinson Beach,
83 California

Selected Group Exhibitions
1979 "Fifty-Fourth Crocker-Kingsley Annual
Open Exhibition," E. B. Crocker Art
Gallery, Sacramento, California,
catalog
1979 "National Clay, Form, Function and
Fantasy," Long Beach Museum of Art,
Long Beach, California, catalog

1979 "Works in Clay," Horizon Gallery, Mill
Valley, California
1979 "California State Fair Art Show,"
Building No. 7, Exposition Center,
Sacramento, California
1979 "Ceramic Forecast," Anna Gardner
Gallery, Stinson Beach, California
1980 "Group Exhibition," Anna Gardner
Gallery, Stinson Beach, California
1980 "The Continental Clay Connection,"
Norman Mackenzie Art Gallery,
Regina, Saskatchewan, Canada,
catalog
1981 "Second Annual Invitational Ceramics
Introductions," California State
University Hayward, Hayward,
California
1981 "A Summer Salon," William Sawyer
Gallery, San Francisco, California
1981 "Jack Hanley—Paintings," Anna
Gardner Gallery, Stinson Beach,
California
1981 "The Human Figure," Pence Gallery,
Davis, California
1982 "Imbued Clay Figures," Antonio Prieto
Memorial Gallery, Mills College,
Oakland, California
1984 "Tenth Annual Ceramics Invitational,"
Weber Sate College, Ogden, Utah,
catalog
1984 "Margaret Keelan—Porcelain Torsos;
Pia Stern—Paintings," Anna Gardner
Gallery, Stinson Beach, California
1984 "Margaret Keelan, Sculpture; Art
Nelson, Wall Sculpture," Joseph
Chowning Gallery, San Francisco,
California

Selected Public Collections
Art Gallery of Hamilton Permanent Collection,
Hamilton, Ontario, Canada
Mendel Art Gallery Permanent Collection,
Saskatoon, Saskatchewan, Canada
University of Saskatchewan, Saskatoon,
Saskatchewan, Canada

Selected Private Collection
Fred and Mary Marer Collection, Los
Angeles, California

Selected Awards
1975, Senior Arts Grant, Canada Council
78
1975 Best in Ceramics, "Utah Designer
Craftsmen," Salt Lake Art Center, Salt
Lake City, Utah

Preferred Sculpture Media
Clay

Selected Bibliography
Burstein, Joanne. "Margaret Keelan."
American Ceramics vol. 2 no. 4 (Winter
1984) pp. 58-59, illus.
Simmons, Chuck. "Exhibitions: Clay
Inversion." Artweek vol. 13 no. 27 (August
28, 1982) p. 4.
Speight, Charlotte F. Images in Clay
Sculpture: Historical and Contemporary
Techniques. New York: Harper & Row,
1983.

Gallery Affiliation
Anna Gardner Gallery
3445 Shoreline Highway
Post Office Box 582
Stinson Beach, California 94970

Mailing Address
1219 Brookside Drive
San Pablo, California 94806

Artist's Statement

"I started with a removed and edited image of myself—women with no arms, legs or eyes. The posture is passive; the motion or tension is often suggested. I feel these figures reflect my interest in the many subtle, ambiguous and contradictory qualities of the human spirit: frustration, vunerability, feelings of oppression, and also feelings of power and optimism."

Margaret Keelan

Stele VI. 1983. Porcelain, 30″h x 9″w x 6″d.
Photograph by Sidney Levine.

Maurie Kerrigan

Born April 28, 1951 Jersey City, New Jersey

Education and Training
1973 B.F.A., Sculpture, Moore College of Art, Philadelphia, Pennsylvania; study with William Walton
1977 M.F.A., Sculpture, School of the Art Institute of Chicago, Chicago, Illinois; study with Whitney Halsted
1977 Independent Study Program, Whitney Museum of American Art, New York, New York

Selected Individual Exhibitions
1976, Étage, Philadelphia, Pennsylvania
78
1979 Eric Makler Gallery, Philadelphia, Pennsylvania
1981 Touchstone Gallery, New York, New York
1983, Jeffrey Fuller Fine Art, Philadelphia,
84 Pennsylvania
1985 Max Hutchinson Gallery, New York, New York

Selected Group Exhibitions
1975 "Bicentennial Azalea Garden Sculpture Exhibition," Philadelphia Museum of Art, Philadelphia, Pennsylvania
1977 "Seventy-Sixth Exhibition by Artists of Chicago and Vicinity," Art Institute of Chicago, Chicago, Illinois, catalog
1977 "Women in Art: Houston," Alley Theatre, Houston, Texas
1979 "Opens Friday," Moore College of Art, Philadelphia, Pennsylvania
1979 "Animal Images," Philadelphia College of Art, Philadelphia, Pennsylvania
1979 "Summer at the Morris Gallery," Pennsylvania Academy of the Fine Arts, Philadelphia, Pennsylvania
1979 "Philadelphia Artists Today," Touchstone Gallery, New York, New York
1979 "Twenty Artists," Eric Makler Gallery, Philadelphia, Pennsylvania
1979 "Gallery Artists," Touchstone Gallery, New York, New York
1980 "Anniversary Exhibition," Eric Makler Gallery, Philadelphia. Pennsylvania
1980 "Projects IV," Institute of Contemporary Art of The University of Pennsylvania, Philadelphia, Pennsylvania, catalog
1981 "Flora and Fauna," Jeffrey Fuller Fine Art, Philadelphia, Pennsylvania

1981 "Art as Object," Semaphore Gallery, New York, New York
1982- "Awards in the Visual Arts 1, An
83 Exhibition of Works by Recipients of First Annual Awards in the Visual Arts," National Museum of American Art, Smithsonian Institution, Washington, D.C.; Des Moines Art Center, Des Moines, Iowa; Denver Art Museum, Denver, Colorado, catalog
1982 "Renaissance Revisited," Tyler School of Art, Temple University, Philadelphia, Pennsylvania
1982 "Anti-Apocalypse," Ben Shahn Gallery, William Paterson College of New Jersey, Wayne, New Jersey
1982 "Projects Made in Philadelphia," Institute of Contemporary Art of The University of Pennsylvania, Philadelphia, Pennsylvania, catalog
1982 "Beast Show," P.S. 1, Institute for Art and Urban Resources, Long Island City, New York
1982 "S/300 Sculpture/Tricentennial/1982," Philadelphia Art Alliance and Rittenhouse Square, Philadelphia, Pennsylvania, catalog
1983 "Gallery Artists," Max Hutchinson Gallery, New York, New York
1984 "Return of the Narrative," Palm Springs Desert Museum, Palm Springs, California, catalog
1985 "CON=STRUCT=URES=1985," Reading Public Museum and Art Gallery, Reading, Pennsylvania, catalog

Selected Public Collections
Best Products, Richmond, Virginia
Continental Bank and Trust, Chicago, Illinois
The Lannan Foundation, West Palm Beach, Florida
National Museum of Women in the Arts, Washington, D.C.
Philadelphia Museum of Art, Philadelphia, Pennsylvania
Phillips Collection, Washington, D.C.

Selected Private Collections
Anne d'Harnoncourt, Philadelphia, Pennsylvania
Caroline Getty, Vancouver, Washington
Jay Massey, Philadelphia, Pennsylvania
Ann Percy, Vancouver, Washington
Stanley Shenker, New York, New York

Selected Awards
1981 Recipient of First Annual AVA Award, Program administered by Southeastern Center for Contemporary Art, Winston-Salem, North Carolina and funded through Equitable Life Assurance Society of the United States, New York, New York; Rockefeller Foundation, New York, New York and National Endowment for the Arts
1982 Individual Artist's Fellowship, Pennsylvania Council on the Arts

1983 Sculpture Award, "Sculpture/Penn's Landing," Port of History Museum, Philadelphia, Pennsylvania (Co-Sponsored by Cheltenham Art Centre, Cheltenham, Pennsylvania)

Preferred Sculpture Media
Wood

Additional Art Fields
Drawing and Fresco

Selected Bibliography
Flood, Richard. "Reviews Philadelphia: 'Material Pleasures,' The Fabric Workshop at ICA; 'Summer at the Morris Gallery,' Pennsylvania Academy of the Fine Arts." *Artforum* vol. 18 no. 2 (October 1979) pp. 74-77, illus.
McFadden, Sarah. "Report from Philadelphia." *Art in America* vol. 67 no. 3 (May-June 1979) pp. 21-29, 31, illus.
Silverthorne Jeanne. "Maurie Kerrigan." *Arts Magazine* vol. 54 no.4 (December 1979) p. 12, illus.
Slatkin, Wendy. "Maurie Kerrigan." *Arts Magazine* vol. 57 no. 9 (May 1983) p. 12, illus.
Wooster, Ann-Sargent. "Review of Exhibitions: Maurie Kerrigan at Touchstone." *Art in America* vol. 69 no. 10 (December 1981) pp. 147, 149, illus.

Gallery Affiliation
Max Hutchinson Gallery
138 Greene Street
New York, New York 10012

Mailing Address
422B South 21 Street
Philadelphia, Pennsylvania 19146

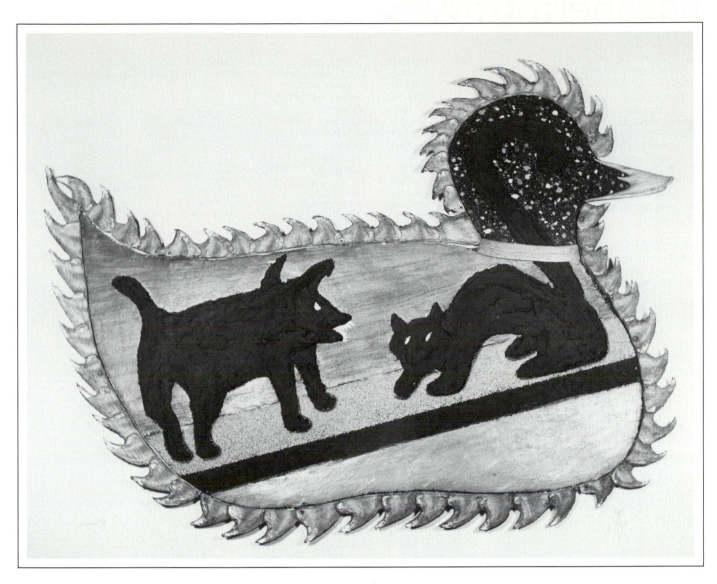

Mallard Confrontation. 1980. Wood, papier-mâché, tar and oil paint, 42″h x 56″w.

Artist's Statement

"There simply are no guarantees to any activity. The exceptions are change, boredom and death which come with the guarantee of isolation. Oddity arrests the creative urge to lock away forever in narrative montage this contradiction of commonality."

Maurie Kerrigan

Elizabeth C. King

née Elizabeth Chickering
(Husband Carlton Raymond Newton)
Born November 20, 1950 Ann Arbor,
Michigan

Education and Training
1972 B.F.A., Sculpture, San Francisco Art
Institute, San Francisco, California
1973 M.F.A., Sculpture, San Francisco Art
Institute, San Francisco, California;
study with William Geis and Alvin
Light
1980- Independent study and travel in
81 Europe

Selected Individual Exhibitions
1974 Hanson Fuller Gallery, San Francisco,
California
1978 80 Langton Street Gallery, San
Francisco, California, catalog
1980 Works Gallery, San Jose, California
1984 Peninsula Fine Arts Center, Newport
News, Virginia

Selected Group Exhibitions
1971 "Exhibition of Prints, Objects and
Small Sculpture," Emanuel Walter
Gallery, San Francisco Art Institute,
San Francisco, California
1971 "California Girls," Richmond Art
Center, Richmond, California
1971 "The Metal Experience," Oakland
Museum, Oakland, California
1972 "New Staff," Contemporary Art Center,
University of Kentucky, Lexington,
Kentucky
1974 "Surrealistic Objects," San Jose
Museum of Art, San Jose, California
1974- "Annual Faculty Exhibition," City
80 College of San Francisco, San
Francisco, California
1976 "Touching All Things: 35 Bay Area
Women Artists," Civic Arts Gallery,
Walnut Creek, California, catalog
1978 "Opening Exhibition," Rental Gallery,
San Francisco Museum of Modern Art,
San Francisco, California
1978 "Visiting Faculty Exhibition," Worth
Ryder Gallery, University of California,
Berkeley, Berkeley, California
1978 "Exposures," San Francisco Museum
of Modern Art, San Francisco,
California
1979 "Same Bed, Separate Studio," Falkirk
Community Cultural Center, San
Rafael, California
1979 "New Wood Sculpture," Rental Gallery,
San Francisco Museum of Modern Art,
San Francisco, California
1982 "Faculty Exhibition," College of William
and Mary, Williamsburg, Virginia
1984 "New Talent," Allan Stone Gallery, New
York, New York
1984 "The Faculty Image," Portsmouth
Community Arts Center, Portsmouth,
Virginia
1985 "Virginia Women Artists: Female
Experience in Art," Virginia Polytechnic
University and State University,
Blacksburg, Virginia, catalog

Selected Private Collections
William Geis, Cazadero, California
Lynn Hershman, San Francisco, California
Richard Reisman, San Francisco, California
Ross Weber, New York, New York

Selected Award
1983 Best of Show, "Juried Exhibition 1983,"
Peninsula Fine Arts Center, Newport
News, Virginia, catalog

Preferred Sculpture Media
Varied Media

Additional Art Field
Drawing

Teaching Position
Assistant Professor of Sculpture, Virginia
Commonwealth University, Richmond,
Virginia

Selected Bibliography
McDonald, Robert. "Expressions in Wood."
Artweek vol. 10 no. 20 (May 19, 1979) p. 6.

Gallery Affiliation
Allan Stone Gallery
48 East 86 Street
New York, New York 10017

Mailing Address
Virginia Commonwealth University
College of Arts
Richmond, Virginia 23284

Artist's Statement

"My impulse to make art comes as a response to the alive human body: how it works and moves, the mystery of its design and its substance, the mystery of its being and its perishing.

"As a figurative sculptor, I am interested in portrait-making as a way of intimately examining the human form. For both portrait heads and full figures I use various combinations of materials including porcelain, cast bronze and carved wood. I make eyes of blown glass. The physical properties of these materials—their weight, color and texture, how they handle, how they reflect or absorb light—are closely associated with the life and presence I want the pieces to possess as images and objects.

"All works are one-third to one-half life-size. The full figures require several years each to complete. They are articulated and movable, designed to precisely reproduce the mechanics of all moving joints in the human anatomy. Flexible spines, rotating shoulders, workable fingers and toes, movable eyes—each working part will hold any position in which it is placed."

Portrait of M. 1983. Porcelain and glass, 5½"h x 3¾"w x 3¾"d.

Katherine King

née Katherine Ann Seitz
Born September 1, 1943 Milwaukee,
Wisconsin

Education and Training
1965 B.S., Occupational Therapy and Art,
Lawrence University, Appleton,
Wisconsin
1968- American Center for Students and
70 Artists, Paris, France; study in
drawing and painting
1968- Atelier Carefour, Paris, France; study
70 in painting
1970- New York Studio School, New York,
71 New York; study in sculpture with
Nicolas Carone and Sidney Geist
1980 M.F.A., Sculpture, University of
Wisconsin-Milwaukee, Milwaukee,
Wisconsin; study in sculpture with
John Balsley and Frank Lutz

Selected Individual Exhibitions
1978 Water Street Gallery, Milwaukee,
Wisconsin
1980 Gallery Sight 225, Milwaukee,
Wisconsin
1983 Center Gallery, Madison, Wisconsin
1984 Artemisia Gallery, Chicago, Illinois
1985 Illinois Central College, East Peoria,
Illinois

Selected Group Exhibitions
1981 "Wisconsin Directions 3: The Third
Dimension," Milwaukee Art Museum,
Milwaukee, Wisconsin, catalog
1981 "Group Exhibition," Cudahy Gallery of
Wisconsin Art, Milwaukee Art
Museum, Milwaukee, Wisconsin
1981 "Group Exhibition," Mariners Gallery,
Marinette, Wisconsin
1981 "Midwest Artists Working in the
Tradition of Fantasy and Surrealism:
Other Realities," Creative
Communication Galleries, University of
Wisconsin-Green Bay, Green Bay,
Wisconsin and Edna Carlsten Gallery,
University of Wisconsin-Stevens Point,
Stevens Point, Wisconsin

1982, "Wisconsin Impressions," Cudahy
83 Gallery of Wisconsin Art, Milwaukee
Art Museum, Milwaukee, Wisconsin
1982 "Featured Sculpture," Mariners Gallery,
Marinette, Wisconsin
1983 "Twenty-Sixth Annual Beloit & Vicinity
Exhibition," Theodore Lyman Wright
Art Center, Beloit College, Beloit,
Wisconsin
1983 "Products of Society," NAB Gallery,
Chicago, Illinois
1983 "Wisconsin 1983 Sculpture," Edna
Carlsten Gallery, University of
Wisconsin-Stevens Point, Stevens
Point, Wisconsin, catalog
1983, "Wisconsin Focus," Cudahy Gallery of
84 Wisconsin Art, Milwaukee Art
Museum, Milwaukee, Wisconsin
1984 "Men and Women in the Arts VIII,"
West Bend Gallery of Fine Arts, West
Bend, Wisconsin, catalog
1984 "Juried Members Exhibition," Center
Gallery, Madison, Wisconsin
1984 "Erotica, Creating Beyond the Sexual,"
Fine Arts Gallery, University of
Wisconsin-Milwaukee, Milwaukee,
Wisconsin, catalog
1984 "Milking the Sacred Cow," Charles A.
Wustum Museum of Fine Arts, Racine,
Wisconsin, catalog
1985 "Installation Sculpture," Charles A.
Wustum Museum of Fine Arts, Racine,
Wisconsin, catalog
1985 "Group Exhibition," West Broadway
Gallery, New York, New York

Selected Public Collections
Informedia Corporation, Milwaukee,
Wisconsin
Milwaukee Art Museum, Milwaukee,
Wisconsin
Rudnick & Wolfe Corporation, Chicago,
Illinois and Tampa, Florida
University of Wisconsin-Milwaukee,
Milwaukee, Wisconsin

Selected Private Collections
Dr. E. Michael Krieg, Milwaukee, Wisconsin
Dr. James B. Vopat, Milwaukee, Wisconsin

Selected Awards
1983 Individual Artist's Fellowship,
Wisconsin Arts Board
1983, Research and Teaching Grant,
84 University of Wisconsin-Milwaukee,
Milwaukee, Wisconsin

Preferred Sculpture Media
Varied Media and Wood

Additional Art Field
Performance Sculpture

Related Profession
Conference and Workshop Presentations in
Art and Occupational Therapy

Selected Bibliography
Bright, Deborah. "Reviews Chicago: Products
of Society, NAB Gallery." New Art
Examiner vol. 10 no. 10 (Summer 1983) p.
15.
Katzman, Lisa. "Reviews Chicago: Katherine
King, Artemisia Gallery." vol. 11 no. 8 (May
1984) p. 2, illus.

Teaching Position
Assistant Professor, Department of Health
Sciences, University of
Wisconsin-Milwaukee, Milwaukee,
Wisconsin

Gallery Affiliation
Artemisia Gallery
9 West Hubbard Street
Chicago, Illinois 60610

Mailing Address
2063 North Cambridge Avenue
Milwaukee, Wisconsin 53202

Artist's Statement

"I am interested in the isolation and separation between levels of unconsciousness or the fine line separating reality, surreality and fantasy. My pieces contain light to 'illuminate' the struggle between order and chaos and our attempt to control deeper layers of reality denied, repressed or forgotten.

"The materials of each construction are determined as the piece develops its individual symbolic life: wood, paint, lights, sound and other inanimate or alive elements. The work also reflects the influence of pre-Renaissance illuminations and Renaissance perspective. Other influences include Giotto, Uccello, Matisse, Magritte, Kandinsky and Gorky."

Katherine King

Kitchen Disaster No. 1: The Eggs Wait. 1983.
Wood, paint, hand, light and tape recording of "Beautiful Dreamer," 40"h x 28"w x 10"d.
Photograph by Photographic Services, University of Wisconsin-Milwaukee, Milwaukee, Wisconsin.

Betty Klavun

née Elizabeth Beebe
Born April 21, 1916 Boston, Massachusetts

Education and Training
1938 B.A., Theater Design, Bennington College, Bennington, Vermont
1960 Studio of Fred Farr, New York, New York; study in sculpture
1960 School of the Brooklyn Museum, Brooklyn, New York; study in sculpture
1960 School of the Brooklyn Museum, Brooklyn, New York; study in sculpture with Reuben Kadish

Selected Individual Exhibitions
1963 Aegis Gallery, New York, New York
1964 New Canaan Library Gallery, New Canaan, Connecticut
1965 Bridge Gallery, New York, New York
1966 Wharf Gallery, Blue Hill, Maine
1968 J. Walter Thompson Gallery, New York, New York
1968, Bertha Schaefer Gallery, New York.
71, New York
72
1978 Stanley Moss Gallery, Watermill, New York
1980, Ingber Gallery, New York, New York
84,
85

Selected Group Exhibitions
1967 "Paper Show," Contemporary Crafts Museum, New York, New York
1967 "Invitational Exhibition," Museum of Art, Science and Industry, Bridgeport, Connecticut
1968 "Sculpture Exhibition," Monmouth Museum of Arts and Sciences, Monmouth, New Jersey
1969 "Exhibition of Works by Contemporary American Artists," National Institute of Arts and Letters, New York, New York, catalog
1969 "Gallery Exhibition," Hartford Art School, University of Hartford, Hartford, Connecticut
1972 "Small Sculpture," Ball State University, Muncie, Indiana
1972 "Outdoor Sculpture," Storm King Art Center, Mountainville, New York
1973, "Group Exhibition," Elaine Benson
80 Gallery, Bridgehampton, New York
1973, "National Association of Women
75 Artists Annual Exhibition," National Academy of Design, New York, New York, catalog

1973, "Sculptors Guild Annual Exhibition,"
74 Lever House, New York, New York, catalog
1973- "Sculpture: Three New York Artists on
74 Tour," New York Cultural Center, New York, New York; World Trade Center, New York, New York; La Guardia Airport, New York, New York; Pratt Institute, New York, New York, catalog
1974 "Sculpture in the Park, An Exhibition of American Sculpture," Van Saun Park, Paramus, New Jersey (Sponsored by Bergen County Parks Commission, Paramus, New Jersey), catalog
1975 "Gallery Exhibition," Wooster Community Art Center, Danbury, Connecticut
1975 "Women in Art," Gimbel's, New York, New York
1975 "Federation of Modern Painters and Sculptors," Traveling Exhibition, Union Carbide Gallery, New York, New York
1976- "Thirty-Fifth Anniversary Exhibition
78 Federation of Modern Painters and Sculptors," Traveling Exhibition, Gallery Association of New York State, New York, New York, catalog
1976, "Christmas Group Exhibition,"
79 Landmark Gallery, New York, New York
1977 "Artpark: The Program in Visual Arts," Artpark, Lewiston, New York, catalog
1978 "Gallery Invitational," Roy Biv Gallery, New York, New York
1978 "Group Exhibition," Laundry Gallery, East Hampton, New York
1979 "Art as Furniture, Furniture as Art," Ingber Gallery, New York, New York
1979, "O.I.A. Sculpture," Ward's Island,
80 New York, New York
1980 "Paintings and Sculpture by Candidates for Art Awards," American Academy and Institute of Arts and Letters, New York, New York, catalog
1980 "Federation of Modern Painters and Sculptors," Contemporary Arts Gallery, New York, New York
1983 "Forty-Third Anniversary Exhibition of Modern Painters and Sculptors," City Gallery, New York, New York, catalog
1984 "Music Mountain Sculpture Exhibit," Music Mountain, Falls Village, Connecticut, catalog
1984 "Elinor Poindexter Presents: Joellen Hall, Cile Down, Mary Lincoln Bonnell, Betty Klavun and Charlotte Park," 383 Broadway, New York, New York

Selected Public Collections
City of Scottsdale, Civic Center Plaza, Scottsdale, Arizona
General Theological Seminary, New York, New York
Manhattan Children's Psychiatric Center, Ward's Island, New York
Manhattan Laboratory Museum, New York, New York

New York Housing Authority, Betances Houses Childcare Center South, Bronx, New York

Selected Awards
1974 Individual Artist's Fellowship, National Endowment for the Arts
1977 Artist in Residence, Artpark, Lewiston, New York
1980 Exhibition Grant, Plumsock Foundation, Indianapolis, Indiana

Preferred Sculpture Media
Clay, Varied Media and Wood

Selected Bibliography
Bennetts, Leslie. "Children Keep Sculpture Alive, and Also in Need of Repairs." *The New York Times* (Monday, May 28, 1979) p. A10, illus.
Edgar, Natalie. "The Dream Space of Betty Klavun." *Craft Horizons* vol. 33 no. 1 (February 1973) pp. 26-28, illus.
Gollin, Jane. "Reviews & Previews: Betty Klavun (Bertha Schaefer)." *Art News* vol. 71 no. 8 (December 1972) p. 13.
Hoffman, Marilyn. "Artist Designs Sturdy 'Sculpture' Playhouses for Children." *The Christian Science Monitor* (Monday, March 30, 1981) p. 18, illus.
Munro, Eleanor C. *Originals: American Women Artists*. New York: Simon and Schuster, 1979.

Gallery Affiliation
Ingber Gallery
460 West Broadway
New York, New York 10014

Mailing Address
313 West 20 Street
New York, New York 10011

Artist's Statement

"I have two approaches to my work: table sculpture or hanging reliefs and environmental sculpture such as imaginary forts and castles in which children can enact adventure. My playground sculpture evolved from my background of stage design. This is the design of interacting space for the actors which is developed from the careful analysis of the play. It has been important to me to combine direction and movement with space, each emphasizing the other. Parks were a natural outgrowth to apply the relationship of space in the theater but as they were not in demand at the time, my feeling for fantasy turned to children. I feel strongly that children should have the kind of space to enact their fantasies which stimulates their discoveries and, in turn, thoughts of their futures. I also find particularly rewarding the discussion with them of the environment they would like. The combination of children moving about: running, jumping, walking, sitting, active and nonactive, all become a movement scenario within a suggested space."

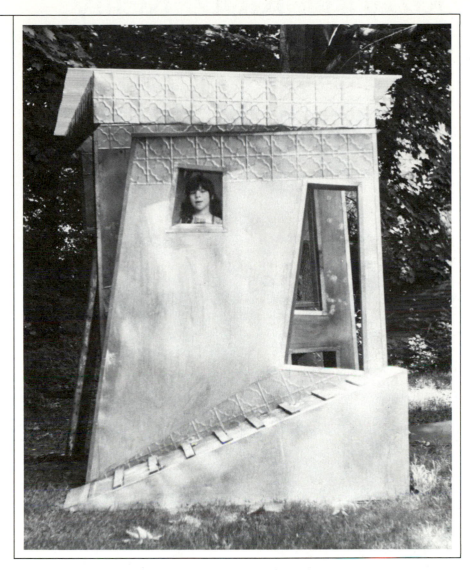

Ice House. 1979. Sheet metal and wood, 9'h x 11'w x 7½'d.

Suzanne Klotz-Reilly

née Suzanne Ruth Klotz
(Husband Michael Joseph Reilly)
Born October 15, 1944 Shawno, Wisconsin

Education and Training
1962-64 Washington University, St. Louis, Missouri
1966 B.F.A., Painting, Kansas City Art Institute, Kansas City, Missouri
1967 Art Education Certification, University of Missouri-Kansas City, Kansas City, Missouri
1972 M.F.A., Painting, Texas Tech University, Lubbock, Texas

Selected Individual Exhibitions
1976 Memorial Union Gallery, Arizona State University, Tempe, Arizona
1978 Scottsdale Center for the Arts, Scottsdale, Arizona, catalog
1980 Weir Gallery, Corpus Christi State University, Corpus Christi, Texas
1981 Phoenix Art Museum, Phoenix, Arizona, catalog
1982 Spencer Museum of Art, Lawrence, Kansas; Lambert-Miller Gallery, Phoenix, Arizona; Miracosta College, Oceanside, California, catalog
1983 Art Museum of South Texas, Corpus Christi, Texas; Jeremy Stone Gallery, San Francisco, California; Elaine Horwitch Galleries, Santa Fe, New Mexico, catalog
1984, 86 Elaine Horwitch Galleries, Scottsdale, Arizona
1985-87 Northern Arizona University Library, Flagstaff, Arizona, Traveling Exhibition to art centers and museums throughout the Southwest and Northwest United States, catalog
1985 Elaine Horwitch Galleries, Sedona, Arizona
1985 University of Texas at San Antonio, San Antonio, Texas
1985 Jeremy Stone Gallery, San Francisco, California

Selected Group Exhibitions
1973 "1973 Biennial Exhibition," New Orleans Museum of Art, New Orleans, Louisiana
1974 "The Fred and Mary Marer Collection: Thirtieth Annual Ceramics Exhibition," Lang Art Gallery, Scripps College, Claremont, California, catalog
1977, 78 "Arizona National," Scottsdale Center for the Arts, Scottsdale, Arizona
1978 "Contemporary Themes, Traditional Means," Malone Gallery, Loyola Marymount University, Los Angeles, California, catalog

1979 "Thirty Years of Box Construction," Sunne Savage Gallery, Boston, Massachusetts, catalog
1979 "Clay Now," Pratt Institute Gallery, Brooklyn, New York
1980 "Sixteenth Southwestern Invitational at Yuma," Yuma Art Center, Yuma, Arizona, catalog
1980 "Arizona Sculpture Invitational," Museum of Northern Arizona, Flagstaff, Arizona, catalog
1981-84 "Collage & Assemblage," Traveling Exhibition, Mississippi Museum of Art, Jackson, Mississippi, catalog
1982 "Arizona Invitational," Scottsdale Center for the Arts, Scottsdale, Arizona, catalog
1982 "Shrines/Altars," Objects Gallery, San Antonio, Texas
1982 "Sculpture Invitational," Northern Arizona University, Flagstaff, Arizona, catalog
1983 "Amazing! Scholarship Benefit Exhibition," Sun Valley Center, Ketchum, Idaho
1983 "Ceramic Sculpture Invitational," Fine Arts Center of Tempe, Tempe, Arizona
1983 "Regional Crafts Exhibition," Sebastian-Moore Gallery, Denver, Colorado, catalog
1983 "The Leading Edge, Santa Fe Festival of the Arts," Sweeney Convention Center, Santa Fe, New Mexico, catalog
1983 "Constructions," San Francisco International Airport, San Francisco, California
1983 "Sculptors of the Southwest," Sculpture Center, New York, New York, catalog
1984 "Arizona Clay Sculpture," Gross Gallery, University of Arizona, Tucson, Arizona, catalog
1984 "Return of the Narrative," Palm Springs Desert Museum, Palm Springs, California, catalog

Selected Public Collections
Arizona State University, Tempe, Arizona
Lamar Dodd Art Center, LaGrange College, LaGrange, Georgia
National Museum of American Art, Smithsonian Institution, Washington, D.C.
Northern Arizona University, Flagstaff, Arizona
Phoenix Art Museum, Phoenix, Arizona
Scottsdale Center for the Arts, Scottsdale, Arizona
Spencer Museum of Art, Lawrence, Kansas
Tucson Museum of Art, Tucson, Arizona
Yuma Art Center, Yuma, Arizona

Selected Private Collections
Wayne Andersen, Boston, Massachusetts
James K. Ballinger, Phoenix, Arizona
Charles C. Eldredge, Washington, D.C.
April Kingsley, New York, New York
Fred and Mary Marer Collection, Los Angeles, California

Selected Awards
1975, 79 Individual Craftman's Fellowship, National Endowment for the Arts
1983 Performance and Dance Fellowship, National Endowment for the Arts

Preferred Sculpture Media
Clay and Varied Media

Additional Art Fields
Drawing and Painting

Related Profession
Visiting Artist

Selected Bibliography
Bush, Donald. "Reviews of the Shows and Exhibitions, Arizona: Suzanne Klotz-Reilly at Phoenix Art Museum." Art Voices vol. 4 no. 6 (November-December 1981) pp. 59-60, illus.
Donnell-Kotrozo, Carol. "Profiles: Suzanne Klotz-Reilly (Phoenix, Arizona)." ArtCraft Magazine vol. 1 no. 2 (February-March 1980) p. 37, illus.
Donnell-Kotrozo, Carol. "Reviews: Suzanne Klotz-Reilly at the Phoenix Art Museum." Artspace vol. 5 no. 4 (Fall 1981) p. 59. illus.
Levine, Melinda. "Reviews of Exhibitions: Suzanne Klotz-Reilly at Jeremy Stone." Images & Issues vol. 4 no. 2 (September-October 1983) pp. 60-61, illus.
"Roaring Forks Trailer Park." Ceramics Monthly vol. 30 no. 1 (January 1982) pp. 58-62, illus.

Gallery Affiliations
Elaine Horwitch Galleries
4211 North Marshall Way
Scottsdale, Arizona 85251

Elaine Horwitch Galleries
129 West Palace Avenue
Santa Fe, New Mexico 87501

Mailing Address
2113 East Concorda Drive
Tempe, Arizona 85282

Floyd and Pearl. 1981. (Detail shed *Roaring Forks Trailer Park*). Mixed media, clay, wood and cloth, 4'h x 5½'w x 5'd. Installation view 1981. Phoenix Art Museum, Phoenix, Arizona, catalog. Photograph by Bob Reilly.

Artist's Statement

"Art provides a stimulus to examine ordinary and out of ordinary events with expanded vision. I have had to look into myself to find my own visual vocabulary to communicate ideas. I view my work as a means to enhance emotional and spiritual awareness as well as to use form, content and materials uniquely.

"The imagery in my work is basically derived from my attitudes towards everyday living, people, places and things. Some of the imagery in my drawing and painting is inspired by the honesty and simplification expressed in children's drawings. The sculpture environments represent symbolic feelings attached to the odds and ends of existence. By using various perspectives, simple materials which appear to have qualities opposite of what they naturally possess, harmoniously uniting dissimilar figures and objects, individual works create a visual situation that there is no more than one way to look at events. The more recent work reflects an interest in content beyond my immediate emotions to the concerns of social consciousness."

Suzanne Klotz-Reilly

Candace Knapp

Born February 28, 1948 Benton Harbor,
Michigan

Education and Training
1969 Skowhegan School of Painting and
Sculpture, Skowhegan, Maine
1971 B.F.A., Sculpture, Cleveland Institute
of Art, Cleveland, Ohio; study with
John Clague
1974 M.F.A., Sculpture, University of Illinois
at Urbana-Champaign, Urbana, Illinois;
study with Frank Gallo

Selected Individual Exhibitions
1977 Star of the Republic Museum,
Washington-On-The Brazos State
Historical Park, Washington, Texas
1978 College of the Mainland, Texas City,
Texas
1980 University of St. Thomas, Houston,
Texas
1980 Temple Junior College, Temple, Texas
1985 Dallas Public Library, Dallas, Texas

Selected Group Exhibitions
1975 "Houston Dimension X," Art League
Gallery, Houston, Texas
1975 "Houston Area Exhibition," Sarah
Campbell Blaffer Gallery, Houston,
Texas
1976 "Gallery Invitational," Kirby Lane
Gallery, Austin, Texas
1976 "Houston Designer Craftsmen
Exhibititon," Sarah Campbell Blaffer
Gallery, Houston, Texas
1977 "Invitational Exhibition," Art Resources,
Houston, Texas
1977 "Candace Knapp and Doug Sweet,"
O'Kane Gallery, University of Houston
Downtown Campus, Houston, Texas

1979 "Wood in Art," Masterson Junior
Gallery, Museum of Fine Arts,
Houston, Houston, Texas, catalog
1979 "Doors: Houston Artists," Alley
Theatre, Houston, Texas, catalog
1980 "Candace Knapp and Doug Sweet,"
Frank Wood Gallery, Houston, Texas
1981 "Impressions of Houston," O'Kane
Gallery, University of Houston
Downtown Campus, Houston, Texas,
catalog
1982 "A Celebration of Texas Sculpture,"
Sam Houston State University
Sculpture Center, Sam Houston State
University, Huntsville, Texas, catalog
1982 "Out In The Open, Outdoor Sculpture
Exhibition," Cravens Park, Houston,
Texas
1983 "Fourth Texas Sculpture Symposium,"
Area Galleries and Institutions, Austin,
Texas (Sponsored by College of Fine
Arts and Humanities, University of
Texas at Austin, Austin, Texas)
1983 "Holiday 1983," Rachel W. Davis
Gallery, Houston, Texas
1984 "Reflections," Rachel W. Davis Gallery,
Houston, Texas
1985 "Fifth Texas Sculpture Symposium,"
Sited throughout Central Business
District, Dallas, Texas and Connemara
Conservancy, Allen, Texas (Sponsored
by Texas Sculpture Symposium,
Dallas, Texas), catalog

Selected Public Collections
Christ the Redeemer Catholic Church,
Houston, Texas
Malone and Hyde Corporate Collection,
Memphis, Tennessee
St. John's Hospital, Nassau Bay, Texas
St. Luke the Evangelist Catholic Church,
Houston, Texas
St. Martin Lutheran Church, Houston, Texas
St. Theresa Catholic Church, Sugarland,
Texas
Woodway Bank, Houston, Texas

Selected Private Collections
Marjorie Dell Ario, Houston, Texas
Joy Cooper, Houston, Texas
Jerry Danburg, Houston, Texas
William and June Roever, Houston, Texas
Martin Silverman, Houston, Texas

Selected Awards
1971 Helen Greene Perry Traveling
Scholarship (Europe and West Africa),
Cleveland Institute of Art, Cleveland,
Ohio
1984 Best of Show in Sculpture, "Art South,
A Biennial Exhibition of Painting and
Sculpture," Memphis State University,
Memphis, Tennessee, catalog

Preferred Sculpture Media
Metal (cast) and Wood

Additional Art Fields
Art Furniture, Drawing, and Liturgical
Sculpture

Selected Bibliography
Meilach, Dona Z. *Creating Modern Furniture:
Trends, Techniques, Appreciation.* New
York: Crown, 1975.

Gallery Affiliation
Fine Arts Consultants
5201 Bayard Lane
Houston, Texas 77006

Mailing Address
Post Office Box 7932
Houston, Texas 77270

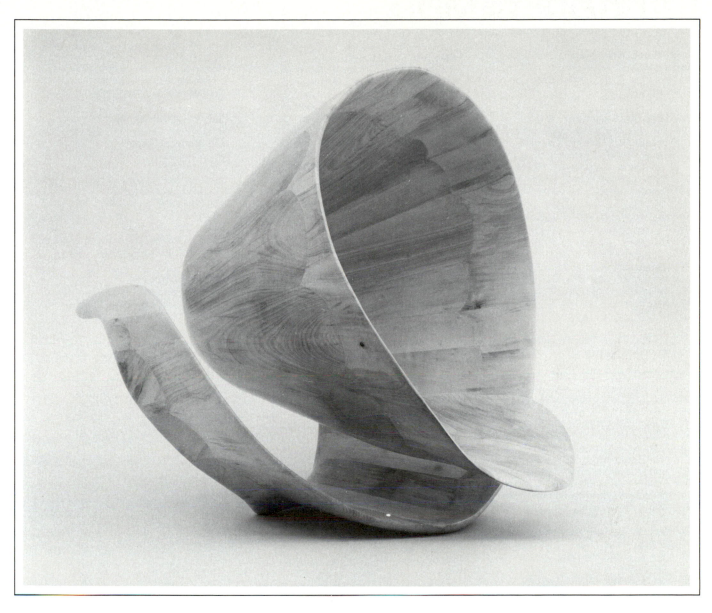

Unfolding. 1978. Laminated magnolia wood, 3'h x 3'w x 4'd. Photograph by Paul Hester.

Artist's Statement

"I do not copy nature but I am inspired by it. I am fascinated by trees and fish and clouds and insects and many other things. There are no logs that are the shape of most of the things I want to make. This is one reason why I laminate. I glue boards together until I have a block of wood slightly larger than the piece I intend. Then I start carving.

"Another reason is that laminating is much stronger if I want to make thin graceful extensions into space. I can position the grain of the wood to handle the stress. The direction of the grain is important for esthetic reasons also because it directs the eye. There seems to be a natural flow of energy in the direction of the grain, probably because the tree put so much energy into reaching upward. I try to be sensitive to the character of each kind of wood so that it will take on the form of the sculpture willingly and gracefully."

Candace Knapp

Ida Kohlmeyer

née Ida Renée Rittenberg
(Husband Hugh B. Kohlmeyer)
Born November 3, 1912 New Orleans,
Louisiana

Education and Training
1933 B.A., English Literature, Newcomb College, New Orleans, Louisiana
1956 M.F.A., Painting, Tulane University, New Orleans, Louisiana
1956 Hans Hofmann School, Provincetown, Massachusetts

Selected Individual Exhibitions
1972 Turman Gallery, Indiana State University, Terre Haute, Indiana, retrospective and catalog
1975 Birmingham Museum of Art, Birmingham, Alabama
1976, David Findley Galleries, New York,
78, New York
80,
82
1977, William Sawyer Gallery, San
80, Francisco, California
83,
85
1978 Auburn University, Auburn, Alabama
1978, Moody Gallery, Houston, Texas
82
1979 Elaine Horwitch Galleries, Scottsdale, Arizona
1982 Elaine Horwitch Galleries, Santa Fe, New Mexico
1983- Mint Museum of Art, Traveling
85 Exhibition, Charlotte, North Carolina, retrospective and catalog
1983, Arthur Roger Gallery, New Orleans,
85 Louisiana
1984 Gimpel Fils Gallery, London, Great Britain
1984 Gimpel & Weitzenhoffer Gallery, New York, New York
1984 Heath Gallery, Atlanta, Georgia
1985 Art Department Gallery, Newcomb College, New Orleans, Louisiana, retrospective and catalog

Selected Group Exhibitions
1978 "Aesthetics of Graffiti," San Francisco Museum of Modern Art, San Francisco, California, catalog
1980 "Patterns and . . .," First Women's Bank, New York, New York
1982 "Greatest Hits, Part II," Mississippi Museum of Art, Jackson, Mississippi
1984 "Sculpture Invitational," College of Wooster Art Museum, Wooster, Ohio
1985 "Lynda Benglis and Ida Kohlmeyer," Pensacola Museum of Art, Pensacola, Florida
1985 "Art Place/Canal Place," Canal Place, New Orleans, Louisiana

Selected Public Collections
Equitable Life Assurance Society of the United States, New York, New York
High Museum of Art, Atlanta, Georgia
K & B Corporate Collection, New Orleans, Louisiana
Sigal Corporation, Washington, D.C.
Westminister City Center Properties, 1515 Poydras Building, New Orleans, Louisiana

Selected Private Collections
Judith Hill, New Orleans, Louisiana
Erich Lasowsky, Zürich, Switzerland
M. C. Lykes, Metairie, Louisiana
Mr. and Mrs. James Mounger, New Orleans, Louisiana
Martyl Reinsdorff, Tucson, Arizona

Selected Awards
1978 Outstanding Alumna of Newcomb College, New Orleans, Louisiana
1980 Outstanding Achievement in the Visual Arts, National Women's Caucus for Art Conference, New Orleans, Louisiana
1984 Selected Woman of Achievement: Louisiana; "Louisiana World Exposition," Women's Pavilion, World's Fair, New Orleans, Louisiana

Preferred Sculpture Media
Metal (cast) and Wood

Additional Art Field
Painting

Selected Bibliography
Berman, Avis. "Women Artists '80: A Decade of Progress, But Could a Female Chardin Make a Living?" Art News vol. 79 no. 8 (October 1980) pp. 73-79, illus.
Donnell-Kotrozo, Carol. "Ida Kohlmeyer: Pictographic Grids That Feel." Arts Magazine vol. 54 no. 8 (April 1980) pp. 188-189, illus.
Green, Roger. "The Nation New Orleans: Ida Kohlmeyer Month." Art News vol. 84 no. 6 (Summer 1985) pp. 104-106, illus.
Wolff, Theodore F. "Ida Kohlmeyer: New Dimensions," Arts Magazine vol. 56 no. 8 (April 1982) pp. 98-100, illus.
Wolff, Theodore F. "Arts/Entertainment: Let's Have at Least Some Public Art That's Fun to be Near." The Christian Science Monitor (Tuesday, February 1, 1983) p. 19, illus.

Gallery Affiliations
Arthur Roger Gallery
3005 Magazine Street
New Orleans, Louisiana 70115

Gimpel & Weitzenhoffer Gallery
1040 Madison Avenue
New York, New York 10021

William Sawyer Gallery
3045 Clay Street
San Francisco, California 94115

Mailing Address
11 Pelham Avenue
Metairie, Louisiana 70005

Artist's Statement

"It is wonderfully strange how changes and fresh ideas glide into one's orbit of creative expression. And when the change is consummated, one wonders why it took so long in coming as I do about sculpture becoming very much a part of my thinking. The two-dimensional qualities of my painting seem natural transformed into three-dimensional forms.

"Although I began intimate scale painted constructions as early as 1969, I am involved with creating large-scale sculpture at this time in my career. The sculptures relate to the signs and symbols of my abstract paintings, brightly colored blue, orange, fuschia and green configurations of basic shapes with triangles, rods, lines and crescents. How to cope with the added dimension of depth and how to approach the materials has presented many challenges and almost stopped the process. Now I am dreaming of ways to occupy the atmosphere with three-dimensional constructions."

Ida Kohlmeyer

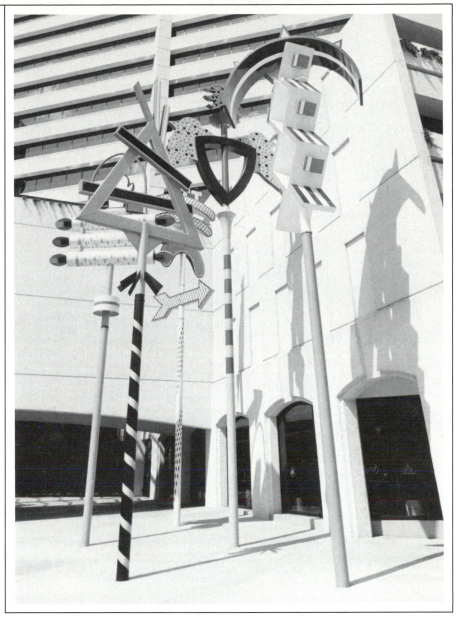

The Krewe of Poydras. 1983. Welded steel with catalyzed polyurethane enamel on Teflon bearings allowing for motion, five units, 43′- 45′h. Collection Westminister City Center Properties, 1515 Poydras Building, New Orleans, Louisiana. Photograph by Donn Young.

Linda Kramer

née Linda Lewis
Born March 25, 1937 New York, New York

Education and Training
1959 B.A., Painting, Scripps College, Claremont, California
1981 M.F.A., Sculpture, School of the Art Institute of Chicago, Chicago, Illinois; study with Richard Loving

Selected Individual Exhibitions
1982 Chicago Public Library Cultural Center, Chicago, Illinois
1982 Columbia College, Chicago, Illinois
1983 Reicher Gallery, Barat College, Lake Forest, Illinois
1984 Lawton Gallery, University of Wisconsin-Green Bay, Green Bay, Wisconsin
1984 Gross Gallery, University of Arizona, Tucson, Arizona
1985 Randolph Street Gallery, Chicago, Illinois

Selected Group Exhibitions
1973- "Annual Exhibition," Artemisia Gallery,
80 Chicago, Illinois
1977 "The Challenge of New Ideas: Contemporary Chicago Sculpture," Kalamazoo Institute of Arts, Kalamazoo, Michigan, catalog
1978 "Chicago: Self Portraits," Nancy Lurie Gallery, Chicago, Illinois, catalog
1978 "American Chairs: Form, Function and Fantasy," John Michael Kohler Arts Center, Sheboygan, Wisconsin, catalog

1978 "Painting and Sculpture Today 1978," Indianapolis Museum of Art, Indianapolis, Indiana, catalog
1979 "New Horizons in Art," North Shore Art League, Evanston, Illinois
1980 "The Chair as Metaphor," Lill Street Gallery, Chicago, Illinois
1980 "Thirty-Second Illinois Invitational," Illinois State Museum, Springfield, Illinois, catalog
1981 "Linda Kramer and Eleanor Ferris," Paul Waggoner Gallery, Chicago, Illinois
1982 "Voices From the Heartland," Phyllis Needlman Gallery, Chicago, Illinois
1982 "The Magical Mystery Tour," Los Angeles Municipal Art Gallery, Los Angeles, California
1983 "Fans," Hyde Park Art Center, Chicago, Illinois
1983, "Chicago Sculpture International,"
84 Navy Pier, Chicago, Illinois (Represented by Marianne Deson Gallery, Chicago, Illinois), catalog
1984 "Alternative Spaces: A History in Chicago," Museum of Contemporary Art, Chicago, Illinois, catalog
1984 "A Survey of Illinois Clay," Lakeview Museum of Art and Sciences, Peoria, Illinois, catalog

Selected Public Collections
Museum of Contemporary Art, Chicago, Illinois
Purdue University, West Lafayette, Indiana

Selected Private Collections
Ruth Horwitz Collection, Chicago, Illinois
Robert Middaugh, Chicago, Illinois
Bernard and Ruth Nath, Highland Park, Illinois
Robert Niedelman Collection, New York, New York
Orrin and Joanne Scheff, Highland Park, Illinois

Selected Awards
1977 Joseph N. Eisendrath Prize, "Seventy-Sixth Exhibition by Artists of Chicago and Vicinity," Art Institute of Chicago, Chicago, Illinois, catalog
1980 Arts and Riverwoods Award, "Seventy-Eighth Exhibition by Artists of Chicago and Vicinity," Art Institute of Chicago, Chicago, Illinois, catalog
1984 Jacob and Bessie Levy Prize, "Eightieth Exhibition by Artists of Chicago and Vicinity," Art Institute of Chicago, Chicago, Illinois, catalog

Preferred Sculpture Media
Clay

Related Profession
Visiting Artist

Selected Bibliography
Elliott, David. "Chicago Enjoys Its Own Eclecticism." *Art News* vol. 81 no. 5 (May 1982) pp. 90-94, illus.
Frueh, Joanna. "Review of Exhibitions: Chicago, Linda Kramer and Claire Prussian at Artemisia." *Art in America* vol. 65 no. 5 (September-October 1977) p. 121, illus.
Koplos, Janet. "Linda Kramer." *American Ceramics* vol. 2 no. 4 (Winter 1984) pp. 14-19, illus.
Meilach, Dona Z. *Box Environments, with Assemblage and Construction.* New York: Crown, 1975.

Mailing Address
370 Glendale Avenue
Winnetka, Illinois 60093

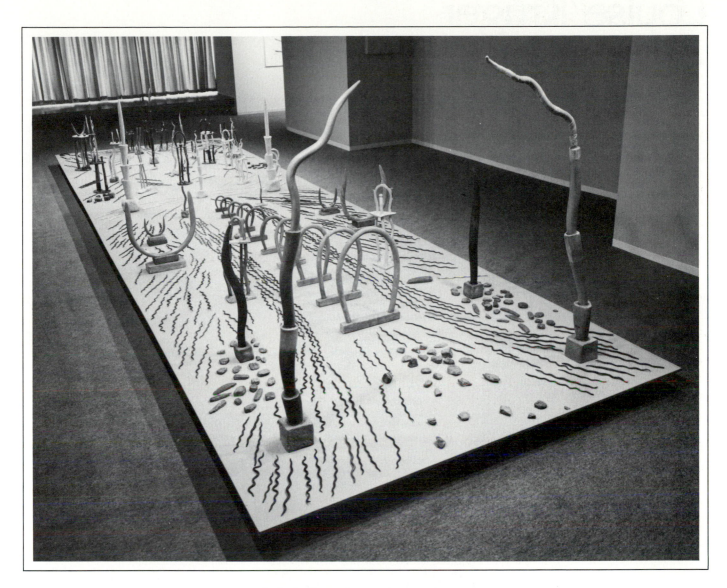

Current Energy. 1982. Plywood painted platform, 6″h x 28′w x 8′d; glazed ceramic units, variable heights to 6′. Installation view 1982. Columbia College, Chicago, Illinois. Photograph by Columbia College.

Artist's Statement

"Since 1982 I have produced five large-scale installation sculptures. All deal with types of energy and are from 10′ to 38′ in size. The sculptures are installed on low floating platforms which are painted to become an integral part of the ensembles. I use many individual ceramic units which suggest three-dimensional brush strokes when installed on the shaped platforms.

"I am consciously working with energy on historic, psychic, natural and cultural levels. I use intuition rather than feelings and work from action, not reaction, when making aesthetic decisions. The resulting work has become expansive, holistic, joyful, passionate and multi-dimensional."

Louise Kruger

Born August 5, 1924 Los Angeles, California

Education and Training
1942-45 Scripps College, Claremont, California
1950-51 Apprenticeship to ship builder Captain Sundquist, Barnegat Light, New Jersey; study in wood joinery
1957-58 Study in foundry techniques with F. Guastini, Pistoia, Italy
1970 Study in an Ashanti foundry with Chief Dwumfuor, Kumasi, Ghana

Selected Individual Exhibitions
1957, 59 Martha Jackson Gallery, New York, New York
1968 Robert Schoelkopf Gallery, New York, New York, catalog
1970 Robert Schoelkopf Gallery, New York, New York
1973 Green Mountain Gallery, New York, New York
1975 Squibb Gallery, Princeton, New Jersey
1976 Drew University, Madison, New Jersey
1977 Bowdoin College Museum of Art, Brunswick, Maine
1977 Cape Split Place, Addison, Maine
1978 Landmark Gallery, New York, New York
1979 Craft and Folk Art Museum, Los Angeles, California, catalog
1980 Condeso/Lawler Gallery, New York, New York, catalog
1980 Marcuse Pfeifer Gallery, New York, New York
1982, 84 Condeso/Lawler Gallery, New York, New York

Selected Group Exhibitions
1953 "New Talent," Museum of Modern Art, New York, New York
1957 "Sixty-Second Annual Exhibition of American Paintings and Sculpture," Art Institute of Chicago, Chicago, Illinois, catalog
1959 "Recent Sculpture U.S.A.," Traveling Exhibition, Museum of Modern Art, New York, New York, catalog
1960, 61, 62 "Annual Exhibition: Contemporary American Art," Whitney Museum of American Art, New York, New York catalog
1970 "American Sculpture," University of Nebraska Art Galleries, Sheldon Memorial Sculpture Garden, Lincoln, Nebraska, catalog
1975 "Sons & Others: Women Artists See Men," Queens Museum, Flushing, New York, catalog
1976 "Woodworks," Bowdoin College Museum of Art, Brunswick, Maine
1976 "Seventy-Six Maine Artists," Maine State Museum, Augusta, Maine
1977 "American Wood Sculpture," Queens Museum, Flushing, New York
1980-82 "Sculpture in the 70s: The Figure," Pratt Manhattan Gallery, New York, New York; Pratt Institute Gallery, Brooklyn, New York; Arkansas Arts Center, Little Rock, Arkansas; University of Oklahoma, Norman, Oklahoma; Arizona State University, Tempe, Arizona; Hood Museum of Art, Hanover, New Hampshire, catalog

Selected Public Collections
Brooklyn Museum, Brooklyn, New York
Museu de Arte Moderna de São Paulo, São Paulo, Brazil
Museum of Modern Art, New York, New York
New Britain Museum of American Art, New Britain, Connecticut
Prudential Insurance Company of America, North Central Home Office, Minneapolis, Minnesota

Selected Award
1975, 76 Individual Artist's Fellowship, National Endowment for the Arts

Preferred Sculpture Media
Wood

Additional Art Fields
Drawing and Photography

Selected Bibliography
Glueck, Grace. "Art: Sculptured Figures Of 70's at Pratt Gallery." *The New York Times* (Friday, November 7, 1980) p. C19.
Henry, Gerrit. "Louise Kruger: Expressions in Wood." *American Craft* vol. 40 no. 6 (December 1980-January 1981) pp. 26-29, illus.
Mainardi, Patricia. "Louise Kruger." *Arts Magazine* vol. 55 no. 7 (March 1981) p. 13, illus.
O'Beil, Hedy. "Arts Reviews: Louise Kruger." *Arts Magazine* vol. 52 no. 10 (June 1978) p. 48, illus.
Papers included in the Archives of American Art, Smithsonian Institution, New York, New York.

Gallery Affiliation
Marcuse Pfeifer Gallery
825 Madison Avenue
New York, New York 10021

Mailing Address
30 East Second Street
New York, New York 10003

Soccer Player. 1978. Cedar, 36"h. Collection New Britain Museum of American Art, New Britain, Connecticut.

Carol Kumata

née Carol Rae
Born December 30, 1949 Iowa City, Iowa

Education and Training
1974 B.G.S., Anthropology, University of Michigan, Ann Arbor, Michigan
1976 B.F.A., Jewelry and Silversmithing, Michigan State University, East Lansing, Michigan
1979 M.F.A., Jewelry and Silversmithing, University of Wisconsin-Madison, Madison, Wisconsin; study in metalsmithing with Fred Fenster and Eleanor Moty

Selected Individual Exhibitions
1981 Hewlett Gallery, Carnegie-Mellon University, Pittsburgh, Pennsylvania
1982 John Michael Kohler Arts Center, Sheboygan, Wisconsin, catalog
1983 Contemporary Crafts Gallery, Portland, Oregon
1985 Campbell Art Gallery, Sewickley Academy, Sewickley, Pennsylvania

Selected Group Exhibitions
1977 "Seventh Beaux Arts Designer Craftsmen," Columbus Gallery of Art, Columbus, Ohio, catalog
1978, "Marietta College Crafts National,"
79 Grover M. Hermann Fine Arts Center, Marietta College, Marietta, Ohio, catalog
1979 "New Metals," Montana State University, Bozeman, Montana
1979 "Functional Forms," Fairbanks Hall Gallery, Oregon State University, Corvallis, Oregon, catalog
1979- "Annual Faculty Exhibition," Hewlett
85 Gallery, Carnegie-Mellon University, Pittsburgh, Pennsylvania
1980 "Metals 1981," Towar Fine Arts Gallery, State University of New York College at Brockport, Brockport, New York, catalog
1980 "Five Decades: Recent Work by Alumni of the Department of Art," Elvehjem Museum of Art, Madison, Wisconsin, catalog
1980 "Metal/Non-Metal," Synopsis Gallery, Winnetka, Illinois
1980 "Second Annual Louisiana State University Metalsmithing Invitational," Anglo-American Art Museum, Baton Rouge, Louisiana
1980 "Young Americans: Metal," American Craft Museum, New York, New York, catalog

1980 "Pensacola Crafts Invitational," Visual Arts Gallery, Pensacola Junior College, Pensacola, Florida
1981 "Lake Superior '81, Fifth Biennial National Crafts Exhibition," Duluth Art Institute, Duluth, Minnesota
1981 "Down to Earth: Raw and Refined," Visual Arts Center of Alaska, Anchorage, Alaska
1981 "Fifth National Crafts Exhibition," Skidmore College, Saratoga Springs, New York
1981 "Contemporary Metals: Focus on Idea," Museum of Art, Washington State University, Pullman, Washington, catalog
1981 "National Crafts '81, Works by the 1981 National Endowment for the Arts Fellows," Greenville County Museum of Art, Greenville, South Carolina
1982 "Another View: National Metals Invitational," Visual Arts Center of Alaska, Anchorage, Alaska
1982 "Summervail Workshop Faculty Exhibition," Cohen Gallery, Denver, Colorado
1982 "Blossom Kent Faculty Exhibition," Kent State University, Kent, Ohio
1982 "Metals: Idea, Material, Technique," Cabrillo College Gallery, Aptos, California
1982 "National Metals Invitational," Belk Gallery, Western Carolina University, Cullowhee, North Carolina, catalog
1982 "Ninth Biennial National Invitational Crafts Exhibition," Center for the Visual Arts Gallery, Illinois State University, Normal, Illinois
1982 "Metal," Ten Arrow Gallery, Cambridge, Massachusetts
1982 "Young Americans: Award Winners," American Craft Museum, New York, New York, catalog
1983 "Selected Works," University of Michigan, Ann Arbor, Michigan
1983 "Chautauqua National Exhibition of American Art," Chautauqua Art Association Galleries, Chautauqua, New York, catalog
1983 "Metal Invitational," University of Wisconsin-Whitewater, Whitewater, Wisconsin
1983 "Faculty Exhibition," Haystack Mountain School of Crafts, Deer Isle, Maine
1983 "Faculty Exhibition," Arrowmont School of Arts and Crafts, Gatlinburg, Tennessee
1983 "Metalsmithing Invitational," Kipp Gallery, Indiana University of Pennsylvania, Indiana, Pennsylvania
1983 "Contemporary Metal," Georgia State University Art Gallery, Atlanta, Georgia
1983 "Ornaments and Fabrication: The Art of Metalsmithing," Cohen Gallery, Denver, Colorado
1984 "Tenth Biennial National Invitational Crafts Exhibition," Center for the Visual Arts Gallery, Illinois State University, Normal, Illinois

1984 "National Metals Invitational Exhibition," University Gallery, Department of Art, Southwest Texas State University, San Marcos, Texas, catalog
1984 "Multiplicity in Metal, Clay, Fiber: Ninth National Crafts Exhibition," Skidmore College, Saratoga Springs, New York, catalog
1984 "B. P. Rizo-Patron and Carol Kumata," Elaine Potter Gallery, San Francisco, California
1984 "A Mano Invitational," New Mexico State University, Las Cruces, New Mexico
1984 "Metals Invitational," Bowling Green State University, Bowling Green, Ohio

Selected Private Collection
Robert L. Pfannebecker Collection, Lancaster, Pennsylvania

Selected Awards
1981, Individual Craftsman's Fellowship,
84 National Endowment for the Arts

Preferred Sculpture Media
Metal (brazed) and Varied Media

Related Profession
Visiting Artist

Teaching Position
Associate Professor, Carnegie-Mellon University, Pittsburgh, Pennsylvania

Selected Bibliography
Higby, Wayne. "'Young Americans' in Perspective." *American Craft* vol. 42 no. 2 (April-May 1982) pp. 20-25, illus.
Koplos, Janet. "Carol Kumata." *Metalsmith* vol. 2 no. 2 (Spring 1982) pp. 27-29, illus.
"NEA 1981 Fellowship Recipients in Metalwork." *Metalsmith* vol. 2 no. 2 (Spring 1982) p. 23, illus.
"Portfolio: Carol Kumata." *American Craft* vol. 43 no. 4 (August-September 1983) p. 20, illus.

Mailing Address
356 South Evaline
Pittsburgh, Pennsylvania 15224

Artist's Statement

"I think of my work as visual metaphors. In each piece I attempt to express a particular emotional state or a philosophical stand. Much of the work is small in scale, creating an intimacy with the viewer. Often the use of architectural elements create interior environments. One of the constant themes has been the use of the container which suggests the dichotomy between the inside space and outside form. Although most of the pieces have been fabricated of sheet metal, each piece usually has included some mixed media such as stone, wood, straw and paint."

Emotional Outburst. Copper, steel and paint, 12"h x 8"w x 8"d. Photograph by David Aschkenas.

Ann Lacy

née Ann Wachtel
(Husband Timothy Austin Lacy)
Born June 30, 1945 St. Louis, Missouri

Education and Training
1967 B.A., Ceramics, Corcoran School of
Art, Washington, D.C. and George
Washington University, Washington,
D.C.; study with Teruo Hara

Selected Individual Exhibition
1982 Carlsbad Municipal Fine Arts &
Museum, Carlsbad, New Mexico

Selected Group Exhibitions
1976 "Artisan Group Show," Space Time
Rymes Gallery, San Francisco,
California
1981 "October Show, Albuquerque United
Artists," Albuquerque Public Library,
Albuquerque, New Mexico, catalog
1982 "New Mexico Artists in Residence,"
Armory for the Arts, Santa Fe, New
Mexico
1982, "Annual Outdoor Sculpture Show,"
83 Shidoni Gallery, Tesuque, New
Mexico, catalog
1982 "Art Alumni Invitational Exhibition,"
Dimock Gallery, George Washington
University, Washington, D.C., catalog
1982 "The New Look '82," Marilyn Butler
Fine Art, Scottsdale, Arizona
1982 "1982 Armory for the Arts,
Albuquerque United Artists," Armory
for the Arts, Santa Fe, New Mexico

1982 "Holiday Sculpture Show," Shidoni
Gallery and Coronado Galleries,
Coronado Bank, El Paso, Texas
1982 "The Animal Kingdom," Marcia Rodell
Gallery, Los Angeles, California
1983 "Clay in New Mexico," Art Museum,
University of New Mexico,
Albuquerque, New Mexico, catalog
1983 "The Leading Edge, Santa Fe Festival
of the Arts," Sweeney Convention
Center, Santa Fe, New Mexico,
catalog
1983 "Small Works by Gallery Artists,"
Marilyn Butler Fine Art, Santa Fe, New
Mexico
1984 "Reflections," Mariposa Gallery,
Albuquerque, New Mexico
1984 "Southwest/Midwest Exchange,"
Museum of Fine Arts, Museum of New
Mexico, Santa Fe, New Mexico; Lill
Street Gallery, Chicago, Illinois,
catalog
1984 "Women's Art Show," Arrott Art
Gallery, New Mexico Highlands
University, Las Vegas, New Mexico
1984 "Black and White, Group Show,"
Marilyn Butler Fine Art, Santa Fe, New
Mexico
1984 "Ashman, Bjork, Gehrke, Lacy and
Salmond," Jonson Gallery, University
of New Mexico, Albuquerque, New
Mexico
1985 "New Mexico Clay: Philosophies in
Contrast," Francis McCray Gallery,
Western New Mexico University, Silver
City, New Mexico
1985 "Kay Harvey and Ann Lacey: Santa Fe
Exhibition," Marilyn Butler Fine Art,
Santa Fe, New Mexico
1985 "Introductions '85: Paintings/Mixed
Media/Sculpture," Marilyn Butler Fine
Art, Scottsdale, Arizona

Selected Private Collections
Marilyn Butler, Scottsdale, Arizona
Mr. and Mrs. Charles Herman, Kansas City,
Missouri
Susan Cable Herter, Santa Fe, New Mexico
Dr. and Mrs. Barry Maron, Albuquerque, New
Mexico
Alice Zoloto, New York, New York

Selected Awards
1982 Award of Merit, "Craftswork IV, A
Juried Exhibition of New Mexico
Crafts," Downtown Center for the Arts,
Albuquerque, New Mexico
1982- Artist in Residence, New Mexico
84 Arts Division, Santa Fe, New Mexico

Preferred Sculpture Media
Clay and Metal (cast)

Additional Art Field
Drawing

Gallery Affiliations
Marilyn Butler Fine Art
149 East Alameda
Santa Fe, New Mexico 87501

Marilyn Butler Fine Art
4160 North Craftsman Court
Scottsdale, Arizona 85251

Mailing Address
Post Office Box 336
Pecos, New Mexico 87552

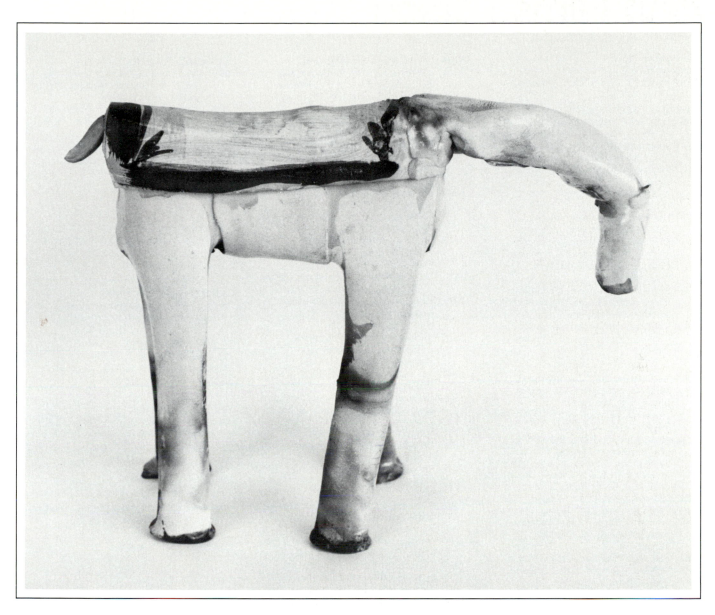

Guadalupe Mountain Series: Horse. 1982. Clay,
12"h x 15"w x 6"d.

Artist's Statement

"I have worked in clay since I was a young
child. At age eight, I attended Saturday
morning classes at the Saint Louis Art
Museum and roamed freely throughout the
museum with my drawing pad. Much later, I
studied ceramics with a Japanese potter,
lived and worked in a potters' village in the
Andes and studied historical ceramics in
South America, Mexico and Europe.

"I now live in northern New Mexico, a rural
area of mountains, plains and mesas. The
land is forested with piñon and juniper trees,
chamisa and wild flowers, rocks and clay.
This large, wild and empty region has had a
profound effect on my work. Originally I set
out to make large storage pots; this
eventually gave way to building horses, an
abstract and conceptual expression of their
presence in the landscape as well as an
archetypical form throughout human history.

"I usually work in a long series, reminiscent
of throwing tea bowls. My interest in horses
is primarily visual as I do not ride. Once, one
of the horses that I sketch escaped from the
field and wandered into my studio. I took
that as a good omen!"

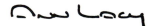

Gail Farris Larson

née Theresa Gail
(Husband Ronald Ivar Larson)
Born August 23, 1947 Tulsa, Oklahoma

Education and Training
1969 B.S., Art, Pittsburg State University, Pittsburg, Kansas; study in small-scale sculpture with Marjorie Schick
1971 M.A., Jewelry Design and Silversmithing, Pittsburg State University, Pittsburg, Kansas; additional study in small-scale sculpture with Marjorie Schick
1974 M.F.A., Jewelry Design and Silversmithing, Indiana University Bloomington, Bloomington, Indiana; study in small-scale sculpture with Distinguished Professor Alma Eikerman
1976 Idaho State University, Pocatello, Idaho; research grant in experimental electroforming metals
1983 University of Kansas, Lawrence, Kansas; research grant in refractory metals

Selected Individual Exhibitions
1972 John Michael Kohler Arts Center, Sheboygan, Wisconsin
1975 Texas Christian University, Fort Worth, Texas
1977 Museum of the Plains Indian and Crafts Center, Browning, Montana, catalog
1981 Sheppard Fine Arts Gallery, University of Nevada Reno, Reno, Nevada
1981 Colter Bay Indian Art Museum, Grand Teton National Park, Moose, Wyoming
1984 Art Barn Gallery, Middle Tennessee State University, Murfreesboro, Tennessee
1984 Sun Valley Center, Ketchum, Idaho
1985 University of North Dakota, Grand Forks, North Dakota

Selected Group Exhibitions
1974 "Goldsmith: 1974," Renwick Gallery of the National Collection of Fine Arts, Smithsonian Institution, Washington, D.C., catalog
1974 "Form 1974," Northern Illinois University, DeKalb, Illinois
1975-77 "Contemporary Crafts of the Americas," Traveling Exhibition, Colorado State University, Fort Collins, Colorado, book-catalog
1975 "Forms in Metal: 275 Years of Metalsmithing," Museum of Contemporary Crafts, New York, New York, catalog
1975 "National Metals Invitational," Humboldt State College, Arcada, California
1976 "Arizona National," Scottsdale Center for the Arts, Scottsdale, Arizona
1977 "Small Metals and Soft Sculpture," University Gallery, Boise State University, Boise, Idaho
1977 "American Metals," Philippines Designer Center, Manila, The Philippines, catalog
1980 "Louisiana State University Metalsmithing Invitational," Louisiana State University and Agricultural and Mechanical College, Baton Rouge, Louisiana
1981 "Metalsmith 1981 Invitational," University of Kansas, Lawrence, Kansas, catalog
1981 "Jewelry, Metals and Sculpture: Idaho Artists," Herrett Museum, Twin Falls, Idaho
1984 "Currents 1984," Middle Tennessee State University, Murfreesboro, Tennessee
1984 "Northwest Craftsmen," Contemporary Crafts Gallery, Tacoma, Washington
1985 "Alma Eikerman and Students: Retrospective Exhibition," Indiana University Art Museum, Bloomington, Indiana
1985 "Body Works and Wearable Sculpture," Visual Arts Center of Alaska, Anchorage, Alaska; University of Alaska Museum, Fairbanks, Alaska

Selected Public Collections
Idaho First Bank, Boise, Idaho
Indiana University Art Museum, Bloomington, Indiana
L. Gerald Sharbutt Law Office, Shawnee, Kansas
Museum of the Plains Indian and Crafts Center, Browning, Montana

Selected Private Collection
Distinguished Professor Alma Eikerman, Bloomington, Indiana

Selected Awards
1973 Merit Award, "Objects and Crafts 1973," Indianapolis Museum of Art, Indianapolis, Indiana
1976 Merit Award, "Objects: Idaho 1976," Boise Gallery of Art, Boise, Idaho

Preferred Sculpture Media
Metal (soldered) and Metal (welded)

Additional Art Field
Fiber

Teaching Position
Associate Professor and Acting Chair, Art Department, Idaho State University, Pocatello, Idaho

Selected Bibliography
Morton, Philip. *Contemporary Jewelry*. New York: Holt, Rinehart and Winston, 1976.

Gallery Affiliation
Silverworks
803 Mass Street
Lawrence, Kansas 66044

Mailing Address
340 South Lincoln
Pocatello, Idaho 83204

Artist's Statement

"I am an artist who uses metal to make a statement. The sculptural form of the container is intriguing because of the duality of function and aesthetic. I have recently begun to use combinations of metal such as copper, silver and refractory metals. The richness of surface gives the pieces a strong, structural feeling. Much of my work is influenced by designs in nature. I respond, particularly, to bulbous forms found in some vegetables, bones and in the air sacks that puff out at breeding time on the sage grouse.

"Metal has distinctive characteristics which are exciting and demanding. It is difficult to know at times if the artist controls the metal or if the material controls the artist. The sound of metal as I strike it with a hammer, the color it turns as it is heated, and the weight and smell are fundamental to my love of working with this media."

Gail Farris Larson

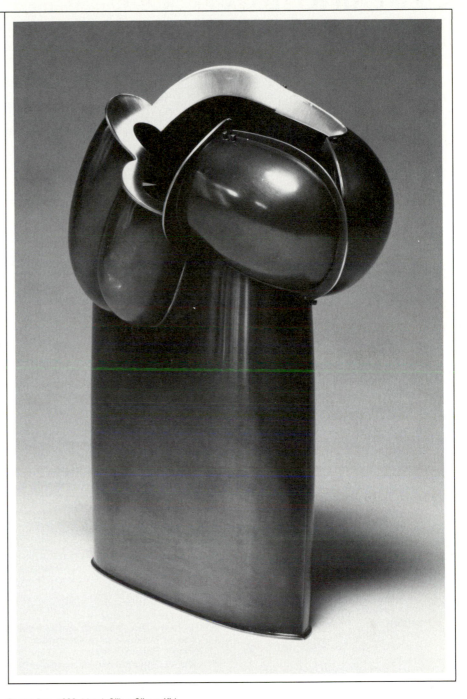

Secret Box. 1982. Metal, 8"h x 8"w x 4"d.
Photograph by James Evans Mueller.

353

Caroline Lee

née Caroline Noble
Born July 10, 1932 Chicago, Illinois

Education and Training
1953 B.A., University of Chicago, Chicago, Illinois
1957 B.F.A., Painting and Drawing, School of the Art Institute, Chicago, Illinois; study in sculpture with Edouard Chassaing
1958 Apprenticeship in sculpture, Fonderie André Susse, Paris, France
1958 Apprenticeship in welding, Oxhydrique Française, Paris, France

Selected Individual Exhibitions
1965 Galerie Lahumiére, Paris, France, catalog
1967 Galerie d'Eendt, Amsterdam, Netherlands, catalog
1968 Galerie Latina, Stockholm, Sweden
1971 Galerie Darthea Speyer, Paris, France, catalog
1972 Galerie d'Eendt, Amsterdam, Netherlands

Selected Group Exhibitions
1959-80 "Annuel Salon de la Jeune Sculpture Contemporaine," Le Jardin du Musée National Auguste Rodin, Paris, France
1965 "Sculpture du XX Siecle," Musée National Auguste Rodin, Paris, France
1966 "Sculpture Contemporaine de Quatre Nations," Galerie Les Contards, Lacoste, Vaucluse, France
1968 "Art Vivant," Fondation Maeght, St. Paul de Vence, France
1968 "Monumental Sculpture," Galerie Les Contardes, Lacoste, France
1968 "Sculpture Contemporaine," Chateau d'Ancy-le-Franc, Ancy-le-Franc, France
1970 "Sculpture Internationale Contemporaine," Musée Lamartine et Musée de l'Académie, Macon, France
1971 "IV Exposition Internationale de Sculpture Contemporaine," Musée National Auguste Rodin, Paris, France, catalog
1972 "Art et Technologie," Centre de Recherche des Arts Plastiques, Crest, France
1973 "Basel Art Fair," Basel, Switzerland (Represented by Galerie Les Contards, Lacoste, France)
1975 "Salon d'Art Internationale," Musée des Beaux Arts de Toulon, Toulon, France
1975 "Three Sculptors: Lee, Viseux, Schultz, International Air and Space Show," Le Bourget, Paris, France
1976 "Caroline Lee and Charles Semser," Maison de la Culture d'Orangis, Essonne, France
1976 "VIII Exposition Internationale d'Art Contemporaine d'Amiens," Musée des Beaux Arts, Amiens, France
1976 "Visions/Painting and Sculpture: Distinguished Alumni 1945 to Present," School of the Art Institute of Chicago, Chicago, Illinois, catalog
1977 "Salon Féminie-Dialogue," Maison de l'UNESCO, Paris, France
1977 "Forms et Couleurs," Musée des Beaux Arts, Clermont Ferrand, France
1979 "La Sculpture Contemporaine a l'Université," Université de Paris-Orsay, Paris, France
1980 "Art 80: Parly II," Centre Culturel de Saint-Germain-en-Laye, Saint-Germain-en-Laye, France
1981 "Triennale de la Sculpture Européenne," Le Jardin du Palais Royal, Paris, France, catalog
1981 "Sculptures sur Metal," Hôtel-de-Ville, La Rochelle, France, catalog
1982 "Journée Internationale des Femmes," Union des Femmes Française, Paris, France
1984 "La Part des Femmes dans l'Art Contemporain," Galerie Municipale, Vitry-sur-Seine, France, catalog

Selected Public Collections
Centre National d'Art Contemporain, Paris, France
Champs Roman, St. Martin d'Héres, Grenoble, France
Collège d'Enseignement Secondaire, Plozevet, France
Collège d'Enseignement Secondaire Jean Jacques Rousseau, Argenteuil, France
Collège d'Enseignement Secondaire Robert Delaunay, Gray, France
Collège d'Enseignement Secondaire St. Sever, Lourdes, France
Emhart Corporation, Hartford, Connecticut
Facultés de Médecine et de Pharmacie, Clermont Ferrand, France
J. Arthur et Tiffen Agence Immobilière, Paris, France
Kindergarten Anatole France, Vitry-sur-Seine, France
Marine Nationale de France, Toulon, France
Musée d'Art Moderne de la Ville de Paris, Paris, France
Place Croix de Chavaux, Montreuil, France
New Britain Museum of American Art, New Britain, Connecticut
Place de France, Sarcelles, France
St. Andrea de Reyes, Nantes, France
Village of Lacoste, Vaucluse, France

Selected Private Collections
William Copley, New York, New York
Will Hoogstraat, Amsterdam, Holland
Jacques London, Paris, France
Gunther Oppenheim, New York, New York
Darthea Speyer, Paris, France

Selected Awards
1961 Independent Research Grant, Cassandra Foundation, Paris, France
1980 Professional Achievement Award, Alumni Association, University of Chicago, Chicago, Illinois
1981 First Prize, "Concours pour un Monument: Hommage a la Resistance," City of Montreuil, France (Organized by the Mayor of Montreuil, France and Ministère de la Culture, Paris, France)

Preferred Sculpture Media
Metal (cast) and Metal (welded)

Additional Art Field
Drawing

Related Professions
Juror and Lecturer

Selected Bibliography
Boudaille, Georges. "Caroline Lee." Cimaise no. 107 (June-July-August 1972) pp. 42-50, illus.
Kenedy, R. C. "Paris Letter." Art International vol. 11 no. 10 (Christmas 1967) pp. 80-84, illus.
Kowal, Dennis and Dona Z. Meilach. Sculpture Casting: Mold Techniques and Materials, Metals, Plastics, Concrete. New York: Crown, 1972.
Schwartz, Ellen. "Paris Letter: November." Art International vol. 16 no. 1 (January 20, 1972) pp. 54-58, illus.
Wentinck, Charles. Modern and Primitive Art. Oxford: Phaidon, 1978.

Mailing Address
78 Rue des Amandiers
75020 Paris, France

Artist's Statement

"I had studied painting in college, with a growing interest in sculpture. I went to Europe on a painting fellowship, but taking with me my hammer and pliers.

"The foundries of Paris were my first teachers. I apprenticed to technicians whenever I could find them. Thanks to the openness and willingness of many French artisans, particularly Jean Westermeyer who had been an assistant to Jean Arp, these proved to be a marvelous, profitable series of unplanned apprenticeships. Aside from all I learned from professionals in special skills, I had the great fortune to have an assistant for my first architectural commission who was a superb craftsman. He taught me the basics in hammering, which has become an important technique in my work, as well as an infinite variety of subsidiary techniques in metal work. I do my own work, assisted, but all the essential parts of the sculpture that contain the key to its voice, I do myself."

Caroline Lee

La Maîtrise du Mal. 1978. Stainless steel and white concrete, 18½′h x 8½′w x 8′d. Collection Facultés de Médecine et de Pharmacie, Clermont Ferrand, France.

Doris Leeper

née Doris Marie
Born April 4, 1929 Charlotte, North Carolina

Education and Training
1951 B.A., Art History, Duke University, Durham, North Carolina

Selected Individual Exhibitions
1968 Hunter Museum of Art, Chattanooga, Tennessee
1968 Jacksonville Art Museum, Jacksonville, Florida
1968 Mint Museum of Art, Charlotte, North Carolina
1969, Bertha Schaefer Gallery, New York,
72 New York
1969 Duke University Museum of Art, Durham, North Carolina
1970 Loch Haven Art Center, Orlando, Florida
1973 Tampa Bay Art Center, Tampa, Florida
1975- High Museum of Art, Atlanta, Georgia;
76 Hunter Museum of Art, Chattanooga, Tennessee; Jacksonville Art Museum, Jacksonville, Florida; Greenville County Museum of Art, Greenville, South Carolina; Mint Museum of Art, Charlotte, North Carolina; John and Mabel Ringling Museum of Art, Sarasota, Florida, catalog
1976 Columbia Museums of Art & Science, Columbia, South Carolina
1977 Southeastern Center for Contemporary Art, Winston-Salem, North Carolina
1979- Loch Haven Art Center, Orlando,
80 Florida; Hunter Museum of Art, Chattanooga, Tennessee; Mississippi Museum of Art, Jackson, Mississippi; Museum of the Palm Beaches, West Palm Beach, Florida; Lemoyne Art Foundation, Tallahassee, Florida; Daytona Beach Community College, Daytona Beach, Florida, catalog
1979 Norton Gallery and School of Art, West Palm Beach, Florida
1980 Museum of Arts and Sciences, Daytona Beach, Florida
1980 Anniston Museum of Natural History, Anniston, Alabama
1984 Foster Harmon Galleries of American Art, Sarasota, Florida

Selected Group Exhibitions
1968 "Painting: Out From The Wall," Des Moines Art Center, Des Moines, Iowa, catalog
1968 "Florida 17," Pan American Union, Washington, D.C., catalog
1969 "North Carolina Sculpture Invitational," Duke University Museum of Art, Durham, North Carolina; William Hayes Ackland Memorial Art Center, Chapel Hill, North Carolina, catalog
1973 "15 Points of View," Museum of Arts and Sciences, Daytona Beach, Florida
1974 "The Artrain," Traveling Exhibition, National Endowment for the Arts, Washington, D.C.
1976 "35 Artists in the Southeast," High Museum of Art, Atlanta, Georgia, catalog
1977 "Florida 10 Plus 5," Art and Culture Center of Hollywood, Hollywood, Florida, catalog
1978 "Opening '78," Mississippi Museum of Art, Jackson, Mississippi, catalog
1982 "Women's Art: Miles Apart," Aaron Berman Gallery, New York, New York; East Campus Gallery, Valencia Community College, Orlando, Florida, catalog
1982 "50 National Women in Art," Edison Community College, Fort Myers, Florida
1984 "Central Florida Artists," North Miami Museum and Art Center, Miami, Florida
1984 "Major Florida Artists," Foster Harmon Galleries of American Art, Sarasota, Florida

Selected Public Collections
Central Florida Cultural Endeavors, Daytona Beach, Florida
CNA Insurance Company, Orlando, Florida
Cove Associates, West Palm Beach, Florida
Daniel Building, Jacksonville, Florida
Duke University Museum of Art, Durham, North Carolina
Equitable Life Assurance Society of the United States, New York, New York
Forum 303, Arlington, Texas
Hunter Museum of Art, Chattanooga, Tennessee
International City Corporation, Atlanta, Georgia
Jacksonville Art Museum, Jacksonville, Florida
Merritt Square, Merritt Island, Florida
Mississippi Museum of Art, Jackson, Mississippi
North Carolina National Bank, Charlotte, North Carolina
Orlando International Airport, Orlando, Florida
Park 436, Orlando, Florida
Roosevelt Mall, Jacksonville, Florida
Syntax Industries, Winter Park, Florida
Wachovia Bank, Charlotte, North Carolina

Selected Awards
1972 Individual Artist's Fellowship, National Endowment for the Arts
1977 Visual Artist Grant, Arts Council of Florida
1977 Visiting Artist Fellowship, Wake Forest University, Winston-Salem, North Carolina and Rockefeller Foundation Program

Preferred Sculpture Media
Metal (welded)

Additional Art Fields
Graphics and Painting

Selected Bibliography
Martin, Francis, Jr. "A Portfolio of Regional Artists: Doris Leeper (Eldora, Florida)." *Art Voices/South* vol. 2 no. 2 (March-April 1979) p. 35, illus.

Gallery Affiliation
Art Sources
1253 Southshore Drive
Orange Park, Florida 32073

Mailing Address
Post Office Box 2093
New Smyrna Beach, Florida 32070

Untitled. 1984. Epoxy over aluminum, 15'3"h x 13'3"w x 12'9"d. Barnett Centre, West Palm Beach, Florida. Collection Cove Associates, West Palm Beach, Florida. Photograph by David Zickl.

Artist's Statement

"My early work in painting was primarily landscapes of waterfronts and churches. I did not deliberately become a sculptor. One day it occurred to me that a drawing I was working on for a painting would be better in three dimensions and the idea became a wall-hung sculpture. And that was the beginning."

Doris Leeper

Barbara Lekberg

née Barbara Hult
(Husband Victor Tamerlis)
Born March 19, 1925 Portland, Oregon

Education and Training
1946 B.F.A., Sculpture, University of Iowa, Iowa City, Iowa; study in sculpture with Humbert Albrizio
1947 M.A., Art History, University of Iowa, Iowa City, Iowa
1948 Sculpture Center, New York, New York; study in foundry work and welding with Sahl Swarz

Selected Individual Exhibitions
1959, 65, 71, 75, 77 Sculpture Center, New York, New York, catalog
1965 Rutgers University, Douglass College, New Brunswick, New Jersey
1972 Fairfield University, Fairfield, Connecticut
1973 Birmingham Museum of Art, Birmingham, Alabama
1973 Columbia Museums of Art & Science, Columbia, South Carolina
1976 Colby College Museum of Art, Waterville, Maine
1978 Mount Holyoke College Art Museum, South Hadley, Massachusetts, retrospective and catalog
1978 Benbow Gallery, Newport, Rhode Island
1983 Sculpture Center, New York, New York
1984 Glass Art Gallery, Toronto, Ontario, Canada
1985 Percival Gallery, Des Moines, Iowa

Selected Group Exhibitions
1950-64 "Annual Exhibition of Painting and Sculpture," Pennsylvania Academy of the Fine Arts, Philadelphia, Pennsylvania, catalog
1951 "Direct Metal Sculpture," Sculpture Center, New York, New York
1952-56 "Annual Exhibition: Contemporary American Art," Whitney Museum of American Art, New York, New York, catalog
1956 "Leo Amino and Barbara Lekberg," Montclair Art Museum, Montclair, New Jersey
1959 "Recent Sculpture U.S.A.," Traveling Exhibition, Museum of Modern Art, New York, New York, catalog
1961 "Contemporary Sculpture," Indiana University Bloomington, Bloomington, Indiana, catalog
1964 "Religious Sculpture," University of Illinois at Urbana-Champaign, Urbana, Illinois, catalog
1965 "From Iowa Collections," University of Iowa, Iowa City, Iowa, catalog
1972 "Critics' Choice," Sculpture Center, New York, New York, catalog
1973-85 "Sculptors Guild Annual Exhibition," Lever House, New York, New York, catalog
1973-85 "Annual Exhibition," National Sculpture Society, New York, New York, catalog
1977 "Five College Art Faculties," University Gallery, University of Massachusetts at Amherst, Amherst, Massachusetts, catalog
1978 "Three Masters: Rebecca Conviser, David Ebner and Barbara Lekberg," Pelham Art Center, Pelham, New York
1978 "Hela Buchthal, Gloria Conklin and Barbara Lekberg," Bridge Gallery, White Plains, New York
1981 "Sculpture in the Garden 1981," Sculptors Guild at the Enid A. Haupt Conservatory, New York Botanical Garden, Bronx, New York, catalog
1981 "Sculpture by Members of the Sculptors Guild," Canton Art Institute, Canton, Ohio
1982, 84 "Annual Exhibition," National Academy of Design, New York, New York, catalog
1983 "Affects-Effects," Philadelphia College of Art, Philadelphia, Pennsylvania, catalog
1984 "Graduate Faculty," Castle Gallery, College of New Rochelle, New Rochelle, New York
1984-85 "Sculptors Guild Member Artists Outdoor Exhibition, Schulman Sculpture in the Park," White Plains Office Park, White Plains, New York
1984 "Music Mountain Sculpture Exhibit," Music Mountain, Falls Village, Connecticut, catalog
1985 "Diploma Portraits, Diploma Works 1981-1984," National Academy of Design, New York, New York

Selected Public Collections
Bayfield Clark Sea View Estate, Somerset, Bermuda
Beldon Stratford Hotel, Chicago, Illinois
Birmingham Museum of Art, Birmingham, Alabama
Davenport Art Gallery, Davenport, Iowa
Des Moines Art Center, Des Moines, Iowa
Drake University, Des Moines, Iowa
General Electric Corporation, Fairfield, Connecticut
George Washington University, Washington, D.C.
Grinnell College, Grinnell, Iowa
Little Fox Investors, Cupertino, California
Montclair Art Museum, Montclair, New Jersey
Mount Holyoke College Art Museum, South Hadley, Massachusetts
National Academy of Design, New York, New York
Nils Hult Associates, Eugene, Oregon
Reidl and Freede Building, Clifton, New Jersey
Socony-Mobil Building, New York, New York
Simpson College, Indianola, Iowa
Whitney Museum of American Art, New York, New York

Selected Private Collections
Mr. and Mrs. Lawrence A. Benenson, New York, New York
Mrs. Lawrence H. Bloedel, Williamstown, Massachusetts
Dr. Helen Boigon, New York, New York
Mr. and Mrs. Albert M. Kronick, Brooklyn, New York
Mr. and Mrs. R. Fred Richardson, Bloomfield, Connecticut

Selected Awards
1957, 59 John Simon Guggenheim Memorial Foundation Fellowship
1964 Honorary Doctorate of Fine Arts, Simpson College, Indianola, Iowa

Preferred Sculpture Media
Metal (cast) and Metal (welded)

Teaching Position
Faculty, Department of Sculpture, Philadelphia College of Art, Philadelphia, Pennsylvania

Selected Bibliography
Andersen, Wayne. *American Sculpture in Process: 1930/1970.* Boston: New York Graphic Society, 1975.
Chapin, Louis. "The Home Forum: Dancing in Bronze." *The Christian Science Monitor* (Wednesday, July 19, 1978) p. 20, illus.
Hale, Nathan Cabot. *Welded Sculpture.* New York: Watson-Guptill, 1968.
Lynch, John. *Metal Sculpture: New Forms, New Techniques.* New York: Viking Press, 1974.
Raynor, Vivien. "Art: Noise in the Attic, Barbara Lekberg (Sculpture Center)." *The New York Times* (Friday, December 9, 1977) p. C19.

Gallery Affiliation
Sculpture Center
167 East 69 Street
New York, New York 10021

Mailing Address
911 Stuart Avenue
Mamaroneck, New York 10543

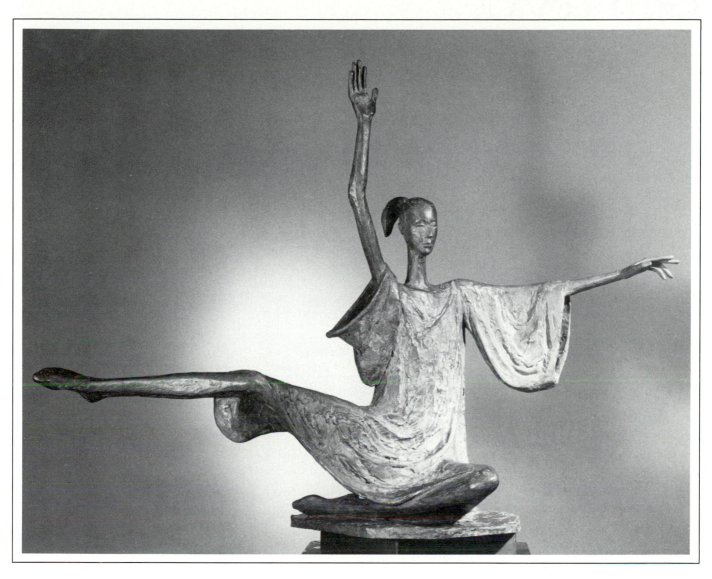

Equilibrium. 1984. Bronze, 31"h x 38"w x 12"d.
Photograph by Jene Nickford.

Artist's Statement

"From earliest childhood I have been
entranced by the way things move: the slow
unfolding of plants, the shadows of leaves
shimmering on a wall, the billowing of sheets
in the wind. And especially I have watched
and wondered at the way people move as
their gestures reflect the thrust and recoil of
an inner state.

"It is this emotionally impelled gesture for
which I have tried to find a formal equivalent:
a shape in bronze or steel which transmutes
a state of being into a sculptural metaphor. I
have often used drapery to abstract and
intensify the direction of the moving
figure-shape. The discovery that welded
steel and bronze could sustain such moving
forms in space provided an early and
continuing joy in the welding technique.

Lately, I have been drawn to the expressive
possibilities of the modeled surface, and use
clay, wax or plaster as preparation for
bronze casting. But whatever the technique,
for me it is always in the service of
life-enhancing movement, disciplined and
free."

Barbara Lekberg

Ellen Levick

née Ellen Kathy
(Husband Carl Martahus)
Born August 22, 1953 Greensburg,
 Pennsylvania

Education and Training
1976 B.A., Ceramic Sculpture and
 Metalsmithing, Seton Hill College,
 Greensburg, Pennsylvania; study with
 Josefa Filkosky
1983 M.F.A., Ceramic Sculpture,
 Carnegie-Mellon University, Pittsburgh,
 Pennsylvania; study with Edward
 Eberle and Douglas Pickering

Selected Individual Exhibitions
1976 Kennedy Gallery, Saint Vincent
 College, Latrobe, Pennsylvania
1985 Pittsburgh Design Center, Pittsburgh,
 Pennsylvania

Selected Group Exhibitions
1983 "Prospective Artists," Pittsburgh Plan
 for Art, Pittsburgh, Pennsylvania
1983 "Ellen Levick and David Learn," Laurel
 Design Center, Greensburg,
 Pennsylvania
1984 "Totems," Elaine Starkman Gallery,
 New York, New York
1984 "Alternatives," Studio Old Duquesne
 Brewery, Pittsburgh, Pennsylvania
1985 "Four Women Ceramic Artists: Valda
 Cox, Barbara Ford, Carolyn Olbum,
 Ellen Levick," Harlan Gallery, Seton
 Hill College, Greensburg, Pennsylvania
1985 "Outdoor Sculpture Exhibition," Seton
 Hill College, Greensburg, Pennsylvania
 (In celebration of the Seventy-Fifth
 Anniversary Associated Artists of
 Pittsburgh, Pennsylvania)

Selected Public Collection
Michael Berger Gallery Permanent Collection,
 Pittsburgh, Pennsylvania

Selected Private Collections
Mary Lou Bartolomucci, Irwin, Pennsylvania
Lee Davis, New York, New York
Mr. and Mrs. Mervin Mallet, Pittsburgh,
 Pennsylvania
Mr. and Mrs. Robert Odell, Washington, D.C.
Mr. and Mrs. Allen Prince, Boca Raton,
 Florida

Preferred Sculpture Media
Clay and Varied Media

Related Profession
Ellen Levick Studio and Jewelry Design
 Pittsburgh, Pennsylvania

Teaching Position
McKee Place, Pittsburgh, Pennsylvania

Gallery Affiliation
Elaine Starkman Gallery
465 West Broadway
New York, New York 10012

Mailing Address
5407 Beacon Street
Pittsburgh, Pennsylvania 15217

Artist's Statement

"After graduating from college, I worked several years as a teacher in Iran. The observation and experience of rural life in Iran, Afghanistan, Turkey, Egypt, India and Sri Lanka was a great inspiration to the man/animal theme developing in my work.

"Many believe that within the human dwells the spirit of an animal and within the animal develops an almost-human spirit. It is within this frame of reference that my own image forms of adult and animal subjects are determined. In some of the figures the body is formed like that of a human but the animal spirit struggles to free itself. In other pieces, the animal is more literal. I challenge the viewer to awaken to the imaginary instinctual cry emitted from within the hearts of the figures and the common characteristics which all creatures share."

Bird Man Totem. 1983. Ceramic, 36"h x 15"w x 12"d. Photograph by Carl Martahus.

Marilyn Levine

née Marilyn Anne Hayes
Born December 22, 1935 Medicine Hat,
 Alberta, Canada
(Canadian citizenship)

Education and Training
1957 B.Sc., Chemistry, University of
 Alberta, Edmonton, Alberta, Canada
1959 M.Sc., Chemistry, University of
 Alberta, Edmonton, Alberta, Canada
1961- University of Regina, Regina,
 64 Saskatchewan, Canada; study in
 drawing and painting
1964- University of Regina, Regina,
 65 Saskatchewan, Canada; study in
 ceramics with Jack Sures
1970 M.A., Sculpture, University of
 California, Berkeley, California
1971 M.F.A., Sculpture, University of
 California, Berkeley, California

Selected Individual Exhibitions
1971, Fuller Goldeen Gallery, San Francisco,
 75, California
 80,
 83
1973 Bernard Danenberg Galleries, New
 York, New York, catalog
1974 Norman Mackenzie Art Gallery,
 Regina, Saskatchewan, Canada,
 retrospective and catalog
1974, O.K. Harris Works of Art, New York,
 76, New York
 79,
 81,
 84
1975 Peale House Galleries, Pennsylvania
 Academy of the Fine Arts,
 Philadelphia, Pennsylvania
1979 Exhibit A, Evanston, Illinois
1981 Institute of Contemporary Art, Boston,
 Massachusetts, retrospective and
 catalog
1981 Galerie Alain Blondel, Paris, France
1985 University of the Pacific, Stockton,
 California
1985 San Francisco International Airport,
 San Francisco, California

Selected Group Exhibitions
1970 "Survey 1970: Realism," Montreal
 Museum of Fine Arts, Montreal,
 Quebec, Canada, catalog
1971 "Clayworks: 20 Americans," Museum
 of Contemporary Crafts, New York,
 New York
1971 "Contemporary Ceramic Art: Canada,
 USA, México and Japan," National
 Museum of Modern Art, Kyoto, Japan;
 Museum of Modern Art, Tokyo, Japan,
 catalog
1971 "New Realist Sculptors," Bernard
 Danenberg Galleries, New York, New
 York

1972 "Painting and Sculpture Today 1972,"
 Indianapolis Museum of Art,
 Indianapolis, Indiana, catalog
1972 "A Decade of Ceramic Art 1962-1972:
 From the Collection of Professor and
 Mrs. R. Joseph Monsen," San
 Francisco Museum of Art, San
 Francisco, California, catalog
1973 "Six Ceramic Artists," Norman
 Mackenzie Art Gallery, Regina,
 Saskatchewan, Canada
1973 "Canada Trajectories," Musée d'Art
 Moderne de la Ville de Paris, France,
 catalog
1973 "The Super-Realist Vision," DeCordova
 and Dana Museum and Park, Lincoln,
 Massachusetts
1973 "Real Cool/Cool Real," Duke University
 Museum of Art, Durham, North
 Carolina
1973 "Hyperrealisme," Galerie Isy Brachot,
 Brussels, Belgium
1974 "New Photo Realism: Painting and
 Sculpture of the 1970s," Wadsworth
 Atheneum, Hartford, Connecticut,
 catalog
1974 "Clay," Whitney Museum of American
 Art, Downtown Branch, New York,
 New York, catalog
1975 "The Plastic Earth and Extraordinary
 Vehicles," John Michael Kohler Arts
 Center, Sheboygan, Wisconsin
1975 "Clay U.S.A.," Fendrick Gallery,
 Washington, D.C.
1975 "The New Realism: Rip-Off or Reality,"
 Edwin A. Ulrich Museum of Art,
 Wichita State University, Wichita,
 Kansas
1975 "Realismus und Realität, Realism and
 Reality," Kunstreserent der Stadt,
 Darmstadt, Germany, Federal
 Republic
1975- "Homage to the Bag," Traveling
 76 Exhibition, Museum of Contemporary
 Crafts, New York, New York, catalog
1976 "Contemporary Clay: Ten
 Approaches," Dartmouth College,
 Hanover, New Hampshire
1977 "The Object as Poet," Renwick Gallery
 of the National Collection of Fine Arts,
 Smithsonian Institution, Washington,
 D.C., catalog
1977 "Contemporary Ceramic Sculpture,"
 William Hayes Ackland Memorial Art
 Center, Chapel Hill, North Carolina,
 catalog
1977 "Illusion and Reality," Traveling
 Exhibition, Australian National Gallery,
 Canberra, Australia, catalog
1977 "The Chosen Object: European and
 American Still Life," Joslyn Art
 Museum, Omaha, Nebraska
1978 "Nine West Coast Clay Sculptors,"
 Everson Museum of Art, Syracuse,
 New York, catalog
1979 "Reality of Illusion," Traveling
 Exhibition, University of Southern
 California, Los Angeles, California,
 catalog

1979- "A Century of Ceramics in the United
 80 States, 1878-1978," Everson Museum
 of Art, Syracuse, New York, book
1979 "West Coast Clay Spectrum," Security
 Pacific Bank, Los Angeles, California,
 catalog
1979 "Illusion and Material," Ben Shahn
 Gallery, William Paterson College of
 New Jersey, Wayne, New Jersey
1979 "Reflections of Realism," Albuquerque
 Museum, Alburquerque, New Mexico
1980 "Aspects of the Seventies," Danforth
 Museum, Framingham, Massachusetts
1980 "New Clay Forms," Institute of
 Contemporary Art of the University of
 Virginia, Charlottesville, Virginia
1980 "Sculpture in California 1975-1980,"
 San Diego Museum of Art, San Diego,
 California, catalog
1980 "The Continental Clay Connection,"
 Norman Mackenzie Art Gallery,
 Regina, Saskatchewan, Canada,
 catalog
1981- "Real, Really Real, SUPER REAL:
 82 Directions in Contemporary American
 Realism," Traveling Exhibition, San
 Antonio Museum of Art, San Antonio,
 Texas, catalog
1981- "Contemporary American Realism
 82 Since 1960," Traveling Exhibition,
 Pennsylvania Academy of the Fine
 Arts, Philadelphia, Pennsylvania,
 catalog
1981 "Ritual and Function: Contemporary
 Ceramics," Museum of Art, Rhode
 Island School of Design, Providence,
 Rhode Island, catalog
1982 "The West as Art," Palm Springs
 Desert Museum, Palm Springs,
 California, catalog
1982 "Art and/or Craft; USA and Japan,"
 Traveling Exhibition, MRO Hall,
 Hokuriku Broadcasting Station,
 Kanazawa, Japan, catalog
1983 "Trompe-l'Oeil," Galerie Alain Blondel,
 Paris, France
1983 "Hyperrealisme et Trompe-l'Oeil:
 Réalités Objectives ou Réalités
 Illusoires," Abbaye Saint-André,
 Maymac, Corrèze, France, catalog
1983- "Contemporary Trompe-l'Oeil Painting
 85 and Sculpture," Traveling Exhibition,
 Boise Gallery of Art, Boise, Idaho,
 catalog
1983 "Material Illusion/Unlikely Material," Taft
 Museum, Cincinnati, Ohio, catalog
1983 "American Super Realism from the
 Morton G. Neumann Family
 Collection," Terra Museum of
 American Art, Evanston, Illinois,
 catalog
1984 "Games of Deception: When Nothing
 Is As It Appears," Shirley Goodman
 Resource Center, Fashion Institute of
 Technology, New York, New York

Selected Public Collections

Ackland Art Museum, Chapel Hill, North Carolina
Art Museum, University of New Mexico, Alburquerque, New Mexico
Australian National Gallery, Canberra, Australia
Canadian Government Expositions Centre, Ottawa, Ontario, Canada
Everson Museum of Art, Syracuse, New York
Fine Arts Museum of The South at Mobile, Mobile, Alabama
Glenbow Museum, Calgary, Alberta, Canada
Henry Art Gallery, Seattle, Washington
John Michael Kohler Arts Center, Sheboygan, Wisconsin
Montreal Museum of Fine Arts, Montreal, Quebec, Canada
Museo de Arte Moderno de Bogotá, Bogotá, Columbia
Museo Internazionale delle Ceramiche, Faenza, Italy
Museum of Modern Art, Tokyo, Japan
National Museum of Modern Art, Kyoto, Japan
Nelson-Atkins Museum of Art, Kansas City, Missouri
Norman Mackenzie Art Gallery, Regina, Saskatchewan, Canada
Oakland Museum, Oakland, California
Purdue University, West Layfayette, Indiana
Red Deer College, Red Deer, Alberta, Canada
San Francisco Museum of Modern Art, San Francisco, California
Sheridan College School of Design, Toronto, Ontario, Canada
University Art Collections, Arizona State University, Tempe, Arizona
University Art Museum, Berkeley, California
University of Saskatchewan, Saskatoon, Saskatchewan, Canada
Utah Museum of Fine Arts, Salt Lake City, Utah
Virginia Museum of Fine Arts, Richmond, Virginia

Selected Private Collections

Mr. and Mrs. Barry Berkus, Santa Barbara, California
Allan Chasanoff, Jericho, New York
Mr. and Mrs. Ivan Karp, New York, New York
Mr. and Mrs. Sydney Lewis, Richmond, Virginia
Louis K. Meisel, New York, New York
Professor and Mrs. R. Joseph Monsen Collection, Seattle, Washington

Press Bag. 1982. Ceramic and mixed media, 4"h x 11"w x 7½"d. Photograph by Sidney Levine.

Selected Awards

1969 Arts Bursary Grant, Canada Council
1977 Senior Arts Grant, Canada Council
1980 Individual Artist's Fellowship, National Endowment for the Arts

Preferred Sculpture Media

Clay

Related Professions

Lecturer and Visiting Artist

Selected Bibliography

Clark, Garth. *A Century of Ceramics in the United States, 1878-1978: A Study of Its Developments.* New York: E. P. Dutton, 1979.
Donnell-Kotrozo, Carol. "Material Illusion: On the Issue of Ersatz Objects." *Arts Magazine* vol. 58 no. 7 (March 1984) pp. 88-91, illus.
Foote, Nancy. "The Photo-Realists: 12 Interviews." *Art in America* vol. 60 no. 6 (November-December 1972) pp. 84-85, illus.
Perreault, John. "False Objects: Duplicates, Replicas and Types." *Artforum* vol. 16 no. 6 (February 1978) pp. 24-27, illus.
Peterson, Susan. "The Ceramics of Marilyn Levine." *Craft Horizons* vol. 37 no. 1 (February 1977) pp. 40-43, 63-64, illus.

Gallery Affiliations

Fuller Goldeen Gallery
228 Grant Avenue
San Francisco, California 94108

O. K. Harris Works of Art
383 West Broadway
New York, New York 10012

Mailing Address

950 Sixty-First Street
Oakland, California 94608

Artist's Statement

"To tell the truth, I really do not like artist's statements very much. Sometimes I try to oblige by writing a few words that relate in some way to my work. It is very difficult to do because, if I write about the work itself, the implication is that anything that is not said is not there. In other words, the statement only serves to confine and restrict the work. The only way out is to write something not about the work, but parallel to the work. Even then the words are apt to become an intellectual barrier unless they become a work of art in their own right. Today, I am not able to compose a work of art from words. I probably never will be able to do so."

Marilyn Levine

Mary Lewis

Born June 18, 1926 Portland, Oregon

Education and Training
1949- University of Oregon, Eugene,
50 Oregon; teaching assistant in
 sculpture to Mark Sponenburgh
1949 B.S., Sculpture, University of Oregon,
 Eugene, Oregon; study with Mark
 Sponenburgh
1951- Syracuse University, Syracuse, New
53 York; technical assistant in sculpture
 to Ivan Meštrović
1953 M.F.A., Sculpture, Syracuse
 University, Syracuse, New York; study
 with Ivan Meštrović

Selected Individual Exhibitions
1981 Lower Columbia College Fine Arts
 Gallery, Longview, Washington and
 Longview Public Library, Longview,
 Washington, retrospective
1984 Shoen Library, Marylhurst College for
 Lifelong Learning, Marylhurst, Oregon

Selected Group Exhibitions
1951, "Artists of Oregon," Portland Art
69 Museum, Portland, Oregon, catalog
1952 "Twenty-Sixth Annual Exhibition,"
 Syracuse Museum of Fine Arts,
 Syracuse, New York, catalog
1959 "2000 Years of Horse and Rider in the
 Arts of Pakistan," National College of
 Arts, Lahore, Pakistan, catalog
1961, "Annual New England Exhibition,"
63 Silvermine Guild of Artists, New
 Canaan, Connecticut, catalog
1963 "Sixty-Second Annual Exhibition," New
 Haven Paint & Clay Club, John Slade
 Ely House, New Haven, Connecticut,
 catalog
1964 "Invitational Exhibition," New Haven
 Paint & Clay Club, John Slade Ely
 House, New Haven, Connecticut
1966 "Art of Our Time," Temple Israel,
 Waterbury, Connecticut, catalog
1967 "Plaza/7 Third Annual Arts Festival
 Regional," Hartford National Bank &
 Trust Towers, Hartford, Connecticut,
 catalog

Selected Public Collections
Children's Hospital Medical Center, Prouty
 Garden, Boston, Massachusetts
St. John's Hospital, Longview, Washington
St. Joseph's Church Chapel, Roseburg,
 Oregon
Waterbury Club, Waterbury, Connecticut

Selected Awards
1950- Mabel Merwin Fellowship for study
51 with Ivan Meštrović, American
 Association of University Women,
 Oregon Division, Portland, Oregon
1953 Travel Scholarship (Europe), Louis
 Comfort Tiffany Foundation Grant
1958- Fulbright Foundation Lecture Grant,
60 National College of Arts, Lahore,
 Pakistan and United States
 Government, Washington, D.C.

Preferred Sculpture Media
Stone and Wood

Additional Art Field
Two-Dimensional Designing

Mailing Address
74394 Wortman Road
Rainier, Oregon 97048

Artist's Statement

"Regardless of how talented the individual, to be an artist requires dedication, discipline, self-sacrifice and uncompromising hard work. In spite of obstacles or fame and monetary gain, one creates because one must. My intent is to interpret an idea, a feeling, perhaps an unappreciated form in nature by reducing it to the essence and working directly with the dictates of permanent materials in an honest, imaginative way. My hope is to make significant contributions— liturgical and secular—that will delight, inspire or in some way touch the heart and uplift the soul."

Mary Lewis

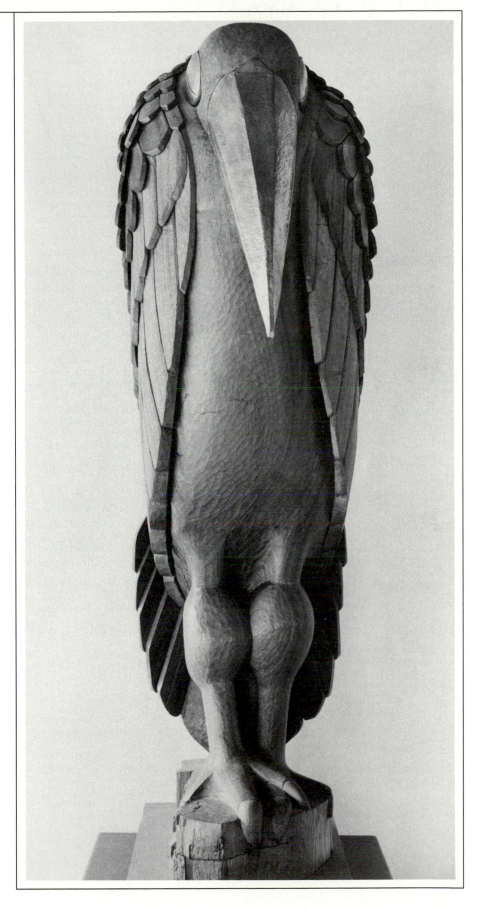

Obadiah. 1964. Mahogany and copper, 4'h. Collection Waterbury Club, Waterbury, Connecticut. Photograph by Alex Darrow.

Dona Lee Lief

née Dona Lee Keith
(Husband Thomas Parrish Lief)
Born February 14, 1941 Long Beach,
 California

Education and Training
1966 B.F.A., Painting, Newcomb College,
 New Orleans, Louisiana
1968 M.F.A., Painting, Tulane University,
 New Orleans, Louisiana

Selected Individual Exhibitions
1980 Alternatives Art Gallery, New Orleans,
 Louisiana
1982 New Orleans Academy of Fine Arts,
 New Orleans, Louisiana

Selected Group Exhibitions
1975 "Selections from New Orleans,"
 Louisiana State University and
 Agricultural and Mechanical College,
 Baton Rouge, Louisiana, catalog
1978 "Animal Fantasies," Contemporary Arts
 Center, New Orleans, Louisiana
1979 "Third National Cone Box Show,"
 University of Kansas, Lawrence,
 Kansas, catalog
1980 "Thirty-Fourth Annual Louisiana State
 Art Exhibition for Professional Artists,"
 Jay R. Broussard Memorial Gallery,
 Old State Capitol, Baton Rouge,
 Louisiana

1980 "Louisiana Premiere: Women Artists,"
 Hanson Gallery, New Orleans,
 Louisiana, catalog
1980 "Louisiana Sculpture Biennial,"
 Contemporary Arts Center, New
 Orleans, Louisiana, catalog
1981 "Art Cars Preview," Newcomb College,
 New Orleans, Louisiana
1982 "Art Cars," P.S. 1, Institute for Art and
 Urban Resources, Long Island City,
 New York
1982 "Art Cars Exhibition," Tweed Gallery,
 Plainfield, New Jersey
1983 "Art Cars National Juried Exhibition,"
 Contemporary Arts Center, New
 Orleans, Louisiana, catalog
1983 "Art Cars National Juried Exhibition,"
 Barbara Gillman Gallery, Miami,
 Florida, catalog
1983 "The Dog Show," Galerie Jules
 LaForgue, New Orleans, Louisiana
1983 "Louisiana Twelve," Masur Museum of
 Art, Monroe, Louisiana
1984 "Tampering with Utopia," New Orleans
 Academy of Fine Arts, New Orleans,
 Louisiana
1984, "Art for Art's Sake," Contemporary
85 Arts Center, New Orleans, Louisiana
1984 "Narcissism," Galerie Jules LaForgue,
 New Orleans, Louisiana
1985 "O.K.—U.S.A. National Sculpture
 Exhibition," University Gallery,
 Cameron University, Lawton,
 Oklahoma, catalog
1985 "Art Place/Canal Place," New Orleans,
 Louisiana

Selected Public Collection
Louisiana Nature Center, New Orleans,
 Louisiana

Selected Private Collections
Mr. and Mrs. Shirley Braselman, New
 Orleans, Louisiana
Mr. and Mrs. James Coleman, Sr., New
 Orleans, Louisiana
Mr. and Mrs. Timothy Slater, New Orleans,
 Louisiana
Louis and Denise Chenel Vallen, New
 Orleans, Louisiana
Ralph and Emery Clark Whalen, New
 Orleans, Louisiana

Selected Awards
1981 Merit Award, "Second Annual
 Louisiana Women's Art Exhibition,"
 Scheurich Gallery, New Orleans,
 Louisiana
1982 Individual Artist's Fellowship,
 Contemporary Arts Center, New
 Orleans, Louisiana and National
 Endowment for the Arts
1984 Merit Award, "Tenth Annual National
 Miniature Show," Gallery La Luz, La
 Luz, New Mexico, catalog

Preferred Sculpture Media
Clay and Varied Media

Additional Art Field
Painting

Gallery Affiliation
Mario Villa Gallery
3908 Magazine Street
New Orleans, Louisiana 70125

Mailing Address
1521 Hillary Street
New Orleans, Louisiana 70118

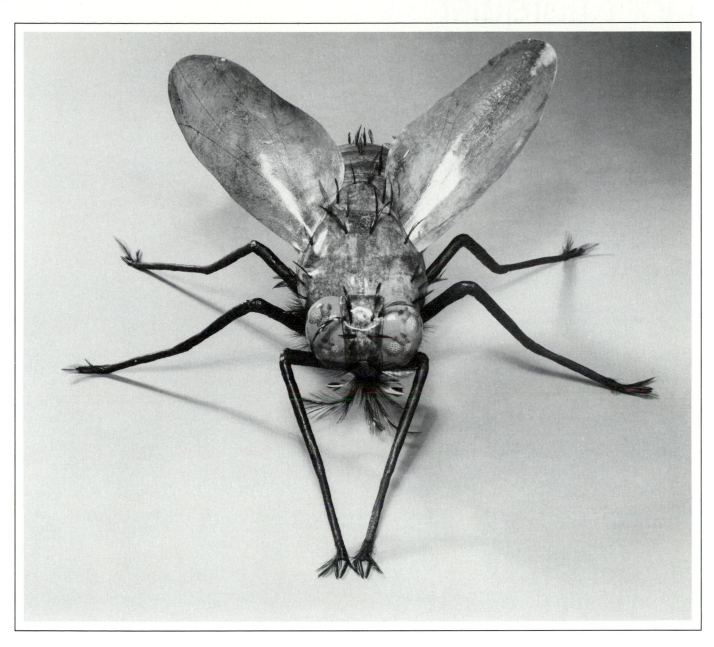

Fruit Fly. 1984. Ceramic and mixed media, 9″h x 16¾″w x 16½″d. Photograph by S. Ray Kutos.

Artist's Statement

"While watching my mother paint the New Mexico landscape, I decided at the early age of five to become an artist. In college I majored in painting and followed in the direction of the color field painters of the 1960s. My attention slowly shifted from the flat surface of the canvas and its abstract imagery to sculpture and objects found in nature. In the summer of 1973, after taking a ceramics course at a local gallery, I decided to work in clay not only because it fulfilled a creative urge to sculpt, but also because it was fun. Childhood memories of desert wildlife began to emerge in the form of realistically detailed ceramic animals and insects. The playful qualities of both clay and nature continue to influence my attitude towards art and life. Combining fantasy with realism, I have recently created a series of ceramic puns reflecting the humorous and whimsical side of nature."

Dona Lee Luy

Janet Lofquist

née Janet Faye
Born October 24, 1952 Glenwood, Minnesota

Education and Training
1976 B.F.A., Intermedia, Minneapolis
College of Art and Design,
Minneapolis, Minnesota; study in
sculpture with Kinji Akagawa, Siah
Armajani and Joseph Breidel

Selected Individual Exhibitions
1977 Northwestern National Bank Building,
St. Paul, Minnesota
1977 Coffman Union Gallery 1, University of
Minnesota Twin Cities Campus,
Minneapolis, Minnesota
1981 Kiehle Gallery, St. Cloud State
University, St. Cloud, Minnesota
1982 Artemisia Gallery, Chicago, Illinois

Selected Group Exhibitions
1977 "St. Paul Art Collective at Union
Depot," Great Space of St. Paul's
Depot, Imprimatur Gallery, St. Paul,
Minnesota
1978 "Lines of Communication," Minnehaha
Creek Gallery, Minneapolis, Minnesota

1978 "Sacred Earth," Artists Registry Gallery
1, Robbinsdale, Minnesota
1978 "Into Outside: Outdoor Sculpture and
Environmental Projects," Minneapolis
Institute of Arts, Minneapolis,
Minnesota
1979 "In Situ," St. Paul Art Collective at
Landmark Center, St. Paul, Minnesota,
catalog
1980 "Environmental Art and Sculpture
Exhibition," Minneapolis Central
Riverfront and Seward Neighborhood,
Minneapolis, Minnesota, catalog
1981 "Sculpture: Points of View," Gallery
101, University of Wisconsin-River
Falls, River Falls, Wisconsin
1981 "Minneapolis-II, An Exhibition of
Minneapolis Area Art," Dayton's
Gallery 12, Minneapolis, Minnesota,
catalog
1982 "Projects, Unseen or Unrealized,"
Minnesota Gallery, Minneapolis
Institute of Arts, Minneapolis,
Minnesota
1982 "Group Exhibition," Artemisia Gallery,
Chicago, Illinois
1983 "New Directions/Eleven Artists:
Centennial Alumni Exhibition,"
Minneapolis College of Art and
Design, Minneapolis, Minnesota,
catalog
1984 "Gallery Artists," M.C. Gallery,
Minneapolis, Minnesota
1984 "Interior/Exterior: Dwellings," M.C.
Gallery, Minneapolis, Minnesota
1984 "Group Exhibition," M.C. Gallery,
Minneapolis, Minnesota
1984 "Five Jerome Artists," Minneapolis
College of Art and Design,
Minneapolis, Minnesota, catalog
1984 "Constructed Image, Constructed
Object," Alternative Museum, New
York, New York, catalog
1985 "Preview '85: New Forms," Jewish
Community Center, Minneapolis,
Minnesota

Selected Awards
1980 Project Grant, Minnesota State Arts
Board
1981 Individual Artist's Fellowship, National
Endowment for the Arts
1983 Emerging Artist's Fellowship, Jerome
Foundation, Minneapolis, Minnesota

Preferred Sculpture Media
Varied Media

Selected Bibliography
Hegeman, William R. "Minnesota Twin Cities
Sculptors Define Own Issues." *New Art
Examiner* vol. 7 no. 1 (October 1979) p. 2,
illus.

Mailing Address
126 North 3 Street-504
Minneapolis, Minnesota 55401

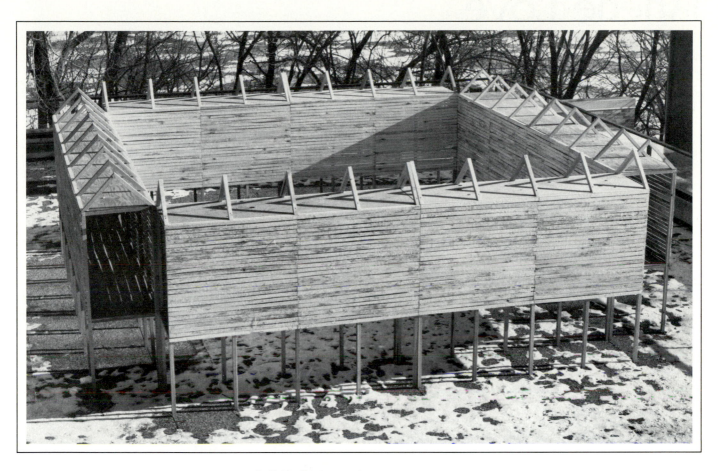

Untitled. 1981. Wood, 7'h x 20'w x 20'd. Installation view 1981. Kiehle Gallery, St. Cloud State University, St. Cloud, Minnesota.

Artist's Statement
"The intent of my sculpture is to examine the nature of dialogue and how this suggests an interaction with the viewer within the context of art. The psychology contained within the implied dialogue, both in the creative process for the artist and the externalized result, becomes the interactive link between the artist and viewer."

Arlene Love

(Husband Lee Lippman)
Born Philadelphia, Pennsylvania

Education and Training
1953 B.F.A., Sculpture, Tyler School of Art, Temple University, Philadelphia, Pennsylvania; study with Raphael Sabatini
1953 B.S.E., Sculpture, Tyler School of Art, Temple University, Philadelphia, Pennsylvania

Selected Individual Exhibitions
1963, Philadelphia Art Alliance, Philadelphia,
70, Pennsylvania
79
1967 Terry Dintenfass Gallery, New York, New York
1974 Bucks County Community College, Newtown, Pennsylvania
1974 Langman Gallery, Jenkintown, Pennsylvania
1976 Gloucester County College, Sewell, New Jersey, retrospective
1979 Pennsylvania Academy of the Fine Arts, Philadelphia, Pennsylvania, catalog
1980 A. J. Wood Gallery, Philadelphia, Pennsylvania
1982 Museum of the Surreal and Fantastique, New York, New York
1983 Keystone Junior College, La Plume, Pennsylvania
1983 Portico Gallery, Philadelphia, Pennsylvania
1984 North Dakota Museum of Art, Grand Forks, North Dakota

Selected Group Exhibitions
1954, "Annual Exhibition of Painting and
62 Sculpture," Pennsylvania Academy of the Fine Arts, Philadelphia, Pennsylvania, catalog
1957 "Trends in Philadelphia Sculpture," Philadelphia Art Alliance, Philadelphia, Pennsylvania
1959 "Recent Sculpture U.S.A.," Traveling Exhibition, Museum of Modern Art, New York, New York, catalog
1962 "Third Philadelphia Art Festival," Philadelphia Museum of Art, Philadelphia, Pennsylvania
1963 "Philadelphia Women in the Arts," Moore College of Art, Philadelphia, Pennsylvania, catalog
1964 "Sculpture '73," Drexel Institute of Technology, Philadelphia, Pennsylvania, catalog
1966 "Invitational Regional Sculpture and Print Exhibition," Philadelphia Art Alliance, Philadelphia, Pennsylvania

1967 "Self Portraits by Philadelphia Artists," Philadelphia Art Alliance, Philadelphia, Pennsylvania
1970 "The Mind's Eye," Division of Education, Philadelphia Museum of Art, Philadelphia, Pennsylvania
1971 "Tyler Directions '71," Museum of the Philadelphia Civic Center, Philadelphia, Pennsylvania
1971 "From Life," University of Rhode Island, Kingston, Rhode Island
1972 "23 Sculptors," Philadelphia Museum of Art, Philadelphia, Pennsylvania
1972 "Some Plastic People," Max Hutchinson Gallery, New York, New York
1972 "Unmanly Art," Suffolk Museum, Stony Brook, New York, New York, catalog
1973 "Eleventh Regional Sculpture Exhibition," Museum of the Philadelphia Civic Center, Philadelphia, Pennsylvania
1974 "Ten Artists Viewed and Interviewed," Cheltenham Art Centre, Cheltenham, Pennsylvania, catalog
1974 "In Her Own Image," Samuel B. Fleisher Art Memorial Gallery, Philadelphia, Pennsylvania, catalog
1974 "The Tyler Show: Working Women Artists from the Tyler School of Art," Samuel Paley Library, Temple University, Philadelphia, Pennsylvania, catalog
1975 "Four Artists," Wharton School, University of Pennsylvania, Philadelphia, Pennsylvania
1979 "American Art in Leather," Traveling Exhibition, Coach Leatherware, New York, New York
1979 "Twenty-Five Pennsylvania Women Artists," Southern Alleghenies Museum of Art, Loretto, Pennsylvania
1979 "Skin Forms: Innovations in Leather," Traveling Exhibition, Herbert F. Johnson Museum of Art, Ithaca, New York, catalog
1981 "Leather Forms," Grossmont College Gallery, El Cajon, California
1981 "About Faces," Southern Ohio Museum And Cultural Center, Portsmouth, Ohio
1981 "Sculpture '81," Franklin Plaza and International Garden Franklin Town, Philadelphia, Pennsylvania (Co-Sponsored by Cheltenham Art Centre, Cheltenham, Pennsylvania)
1981 "Sculpture '81," Temple University, Main Campus, Philadelphia, Pennsylvania (Co-Sponsored by Cheltenham Art Centre, Cheltenham, Pennsylvania), catalog
1982 "Forms of Leather," Arrowmont School of Arts and Crafts, Gatlinburg, Tennessee
1982 "Body Language: A Notebook of Contemporary Figuration," University Art Gallery, San Diego State University, San Diego, California, catalog
1983 "Women: Self Image, National Women's Caucus for Art," Traveling

Exhibition, Philadelphia Art Alliance, Philadelphia, Pennsylvania
1984 "Leather Arts Network International Exhibition," Sawtooth Center for Visual Design, Winston-Salem, North Carolina
1984, "Summer Invitational," Elaine Benson
85 Gallery, Bridgehampton, New York
1985 "Gallery Artists," Portico Gallery, Philadelphia, Pennsylvania
1985 "Art Works—Three Dimensions," Beaver College, Glenside, Pennsylvania

Selected Public Collections
Coach Leatherware Collection of American Art in Leather, New York, New York
Franklin and Marshall College, Lancaster, Pennsylvania
Franklin Town Corporation, Philadelphia, Pennsylvania
Monell Chemical Senses Center, University of Pennsylvania, University City Science Center, Philadelphia, Pennsylvania
Ohev Sholom Synagogue, Chester, Pennsylvania
191 Presidential Boulevard, Bala-Cynwyd, Pennsylvania
University of Scranton, Scranton, Pennsylvania
Wells-Fargo Security Division, Philadelphia, Pennsylvania

Selected Private Collections
Jack Dreyfuss, New York, New York
Helen Williams Drutt, Philadelphia, Pennsylvania
Françoise Fineman, Vineland, New Jersey
Mr. and Mrs. Allan Rothman, West Chester, Pennsylvania
Allan Stone, New York, New York

Selected Awards
1960 Louis Comfort Tiffany Foundation Grant
1961 Jerome Rodale Award, "Fifteenth Annual Tyler Alumni Exhibition," Tyler School of Art, Temple University, Philadelphia, Pennsylvania

Preferred Sculpture Media
Leather, Metal (cast) and Plastic (polyester resin)

Additional Art Field
Monotype

Related Profession
Consultant and Sculptor, Fine Arts Advisory Board, Redevelopment Authority of the City of Philadelphia, Pennsylvania

Selected Bibliography

Byrd, Joan Falconer. "Forms of Leather." *American Craft* vol. 42 no. 3 (June-July 1982) pp. 26-29, illus.

Hollander, Harry B. *Plastics for Artists and Craftsmen*. New York: Watson-Guptill, 1972.

McFadden, Sarah. "Report from Philadelphia." *Art in America* vol. 67 no. 3 (May-June 1979) pp. 21-27, 29, 31, illus.

Newman, Thelma R. *Plastics As An Art Form*. Philadelphia: Chilton, 1969.

Stein, Judith E. "Review of Exhibitions: Philadelphia, Arlene Love at Langman, Jenkintown." *Art in America* vol. 62 no. 5 (September-October 1974) p. 115, illus.

Gallery Affiliation

Lawrence Oliver Gallery
1625 Pine Street
Philadelphia, Pennsylvania 19107

Mailing Address

1006 Spruce Street
Philadelphia, Pennsylvania 19107

Artist's Statement

"I have always been dedicated to the modelled figure as a means of expressing my investigations of the interior life and sculptural form. My use of the female figure has moved through archetypal victim to archetypal goddess in formal means that confront the context of personal and collective existence. I am obsessed with images which evoke these obscured remnants of sights and dreams that come from our subjective vision and address nonverbalized feelings with a sensation of recognition.

"I was an early pioneer in the development of cast resins as a method of eliminating limitations of color, opacity, structure, weight and cost of basic sculpture materials. In the mid 1970s, I began using leather surfaces—skin as skin—as an aesthetic tool for evolving from narrative imagery to process and metaphor."

Arlene Love

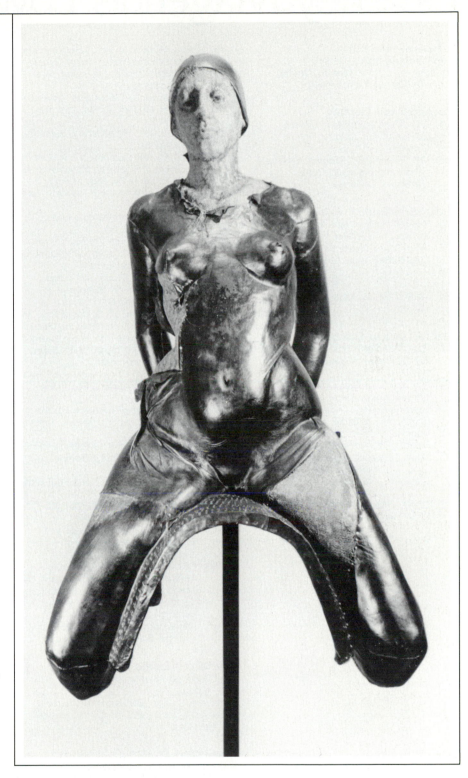

Lilith. 1982. Leather over fiberglass, steel mounting and stand, 90"h x 29"w x 33"d.

Beverley Magennis Lowney

née Beverley Helen Kurtz
(Husband Bruce Stark Lowney)
Born February 5, 1942 Toronto, Ontario,
 Canada (Canadian citizenship)

Education and Training
1964　A.O.C.A., Material Arts, Ontario
　　　College of Art, Toronto, Ontario,
　　　Canada
1968　M.A., Ceramics, Claremont Graduate
　　　School and University Center,
　　　Claremont, California

Selected Individual Exhibitions
1976　Roswell Museum and Art Center,
　　　Roswell, New Mexico
1977　Hill's Gallery, Santa Fe, New Mexico
1978,　BFM Gallery, New York, New York
　79,
　81
1984　Wildine Gallery, Albuquerque, New
　　　Mexico

Selected Group Exhibitions
1974　"Clay," Whitney Museum of American
　　　Art, Downtown Branch, New York,
　　　New York, catalog
1974　"The Fred and Mary Marer Collection:
　　　Thirtieth Annual Ceramics Exhibition,"
　　　Lang Art Gallery, Scripps College,
　　　Claremont, California, catalog
1975　"National Multi-Media Exhibition,"
　　　Fairtree Gallery, New York, New York
1975,　"Annual Ceramics Exhibition,"
　84　Lang Art Gallery, Scripps College,
　　　Claremont, California
1975　"Folk Influences in Contemporary
　　　Crafts," Fairtree Gallery, New York,
　　　New York

1976　"One Hundred Artists Commemorate
　　　Two Hundred Years," Xerox Square
　　　Exhibition Center, Rochester, New
　　　York, catalog
1976　"20th Birthday Celebration," Museum
　　　of Contemporary Crafts, New York,
　　　New York
1978　"Landscape," Hill's Gallery, Santa Fe,
　　　New Mexico
1978　"The Roswell Compound Exhibition,"
　　　Museum of Fine Arts, Museum of New
　　　Mexico, Santa Fe, New Mexico
1979　"Shades of White," Hill's Gallery, Santa
　　　Fe, New Mexico
1979　"Clay Now," Pratt Institute Gallery,
　　　Brooklyn, New York
1979　"One Space/Three Visions,"
　　　Albuquerque Museum, Albuquerque,
　　　New Mexico, catalog
1979　"New Mexico: Space and Images,"
　　　Craft and Folk Art Museum, Los
　　　Angeles, California
1980　"Here and Now: 35 Selected New
　　　Mexico Artists," Albuquerque Museum,
　　　Albuquerque, New Mexico, catalog
1981　"Southwest Exhibition," BFM Gallery,
　　　New York, New York
1982　"Low Fire Ceramics Invitational," Hand
　　　and the Spirit Gallery, Scottsdale,
　　　Arizona
1982　"Bruce Lowney/Beverley Magennis
　　　Lowney," Governor's Gallery, Santa
　　　Fe, New Mexico
1983　"Ceramic Sculpture Invitational," Fine
　　　Arts Center of Tempe, Tempe,
　　　Arizona
1983　"The Leading Edge, Santa Fe Festival
　　　of the Arts," Sweeney Convention
　　　Center, Santa Fe, New Mexico,
　　　catalog
1984　"Beverley Magennis Lowney and
　　　Georgia Sartoris," Robischon Gallery,
　　　Denver, Colorado
1984　"Southwest/Midwest Exchange,"
　　　Museum of Fine Arts, Museum of New
　　　Mexico, Santa Fe, New Mexico; Lill
　　　Street Gallery, Chicago, Illinois,
　　　catalog
1985　"Non-Functional Ceramics," St. John's
　　　College, Santa Fe, New Mexico

Selected Public Collections
Albuquerque Museum, Albuquerque, New
　Mexico
Pomona College, Claremont, California
Roswell Museum and Art Center, Roswell,
　New Mexico

Selected Private Collections
Donald Anderson, Roswell, New Mexico
Ray and Barbara Graham, Albuquerque, New
　Mexico
Fred and Mary Marer Collection, Los
　Angeles, California
Betty Scheinbaum, Los Angeles, California
Harold and Bernice Steinbaum, New York,
　New York

Selected Awards
1975　Artist in Residence, Roswell Museum
　　　and Art Center, Roswell, New Mexico
1976　Artist in the Schools Grant, National
　　　Endowment for the Arts
1983　Merit Award, "Clay in New Mexico,"
　　　Fine Arts Gallery, University of New
　　　Mexico, Albuquerque, New Mexico

Preferred Sculpture Media
Clay

Additional Art Field
Drawing

Selected Bibliography
Zwinger, Susan. "Bruce Lowney/Beverley
　Magennis Lowney." *Artspace* vol. 6 no. 2
　(Spring 1982) pp. 74-75, illus.

Mailing Address
300 Gene Avenue NW
Albuquerque, New Mexico 87107

Artist's Statement

"I am comfortable with clay intuitively. In the past I built landscapes with houses, trees, trains, orchards and clouds until the shapes of these forms led me to pure form and design. Abstract forms control my tendency towards sentimental imagery. The building process is not spontaneous and each piece requires planning and detailed work drawings. Most of the sculptures are five-to-six feet high in bright, saturated and shiny glazes with identical front and back sides. The intention of the scale is to invite personal closeness and familiarity.

"I do not have a pervasive philosophy or point of view that dictates what I make. I want my work to be technically sophisticated and formally well-designed, to convey a sense of celebration and innocence."

Beverly Magennis Lowney

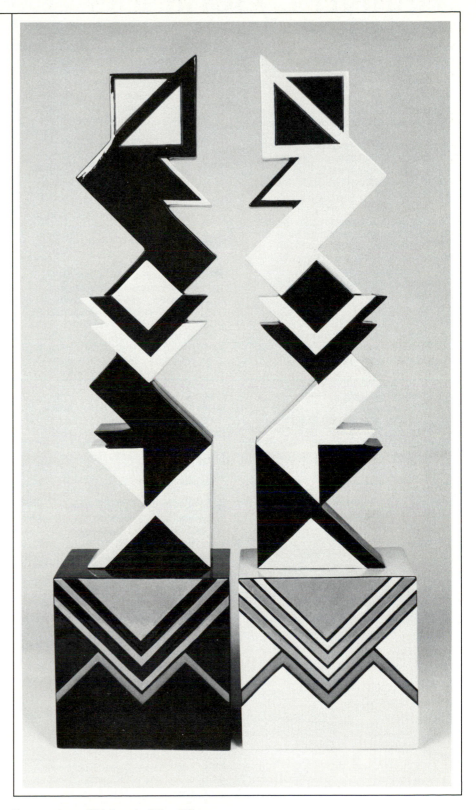

Correspondence. 1984. Ceramic, 37"h x 19"w x 9"d.

Marilyn Lysohir

née Marilyn Kathleen
(Husband Ross Alexander Coates)
Born December 3, 1950 Sharon,
 Pennsylvania

Education and Training
1970- Centro Internazionale di Studi, Verona,
71 Italy; study in art history and language
1972 B.A., Art Education and Ceramics,
 Ohio Northern University, Ada, Ohio
1979 M.F.A., Ceramics and Sculpture,
 Washington State University, Pullman,
 Washington

Selected Individual Exhibitions
1979 Eastern Washington State University,
 Cheney, Washington
1980, Foster/White Gallery, Seattle,
82 Washington
1984, Asher/Faure Gallery, Los Angeles,
86 California

Selected Group Exhibitions
1978 "Thirtieth Spokane Annual Art
 Exhibition," Cheney Cowles Memorial
 Museum, Spokane, Washington,
 catalog
1979, "Invitational Sculpture Show,"
80 Foster/White Gallery, Seattle,
 Washington
1979 "Fire Arts," Bellevue Art Museum,
 Bellevue, Washington
1980 "Sculpture 1980," Maryland Institute
 College of Art, Baltimore, Maryland,
 catalog

1980 "Entre Nous," Cooperative Exhibit with
 Vancouver, B.C. and Seattle,
 Washington—National Mayors
 Conference, Seattle Civic Opera
 House, Seattle, Washington
1980 "The Small Show," Foster/White
 Gallery, Seattle, Washington
1981 "Washington Women in Art," Eastern
 Washington University, Cheney,
 Washington
1981 "Sculpture: Another View," Cheney
 Cowles Memorial Museum, Spokane,
 Washington
1982 "Clay: A Pullman Perspective,"
 Spokane Falls Community College,
 Spokane, Washington
1982 "Pacific Currents/Ceramics 1982," San
 Jose Museum of Art, San Jose,
 California, catalog
1983 "Ceramic Echoes: Historical
 References in Contemporary
 Ceramics," Nelson-Atkins Museum of
 Art, Kansas City, Missouri, catalog
1983 "Small Figures Group Show," Garth
 Clark Gallery, Los Angeles, California
1983 "Living with the Volcano: Artists of
 Mount St. Helens," Museum of Art,
 Washington State University, Pullman,
 Washington
1984 "Clay: 1984, A National Survey
 Exhibition," Traver Sutton Gallery,
 Seattle, Washington
1984 "Artist Cups," East End Gallery,
 Provincetown, Massachusetts
1985 "Invitational Group Exhibition,"
 Foster/White Gallery, Seattle,
 Washington

Selected Public Collections
Bainbridge Island School District, Ordway
 Elementary School, Bainbridge Island,
 Washington
Butler Institute of American Art, Youngstown,
 Ohio
Linyen Restaurant, Seattle, Washington
Ohio Northern University, Ada, Ohio

Selected Private Collections
Betty Asher, Los Angeles, California
Klaus and Gisela Groenke, Berlin, Germany,
 Federal Republic
Edward and Nancy Reddin Kienholz, Hope,
 Idaho
Mr. and Mrs. Robert Morse III, Vancouver,
 British Columbia, Canada
Mr. and Mrs. Louis Taubman, Los Angeles,
 California

Selected Award
1975 First Place in Three-Dimensional Art,
 "Lima Area Artist Exhibit," Lima Art
 Center, Lima, Ohio

Preferred Sculpture Media
Clay and Varied Media

Teaching Position
Adjunct Assistant Professor, Washington
 State University, Pullman, Washington

Selected Bibliography
Okazaki, Arthur. "Marilyn Lysohir." American
 Ceramics vol. 4 no. 1 (Spring 1985) pp.
 60-67, illus.
Speight, Charlotte F. Images in Clay
 Sculpture: Historical and Contemporary
 Techniques. New York: Harper & Row,
 1983.
Watkinson, Patricia Grieve. "Mount St.
 Helens: An Artistic Aftermath." Art Journal
 vol. 44 no. 3 (Fall 1984) pp. 259-269.

Gallery Affiliation
Asher/Faure Gallery
612 North Almont Drive
Los Angeles, California 90069

Mailing Address
Washington State University
Department of Fine Arts
Pullman, Washington 99164

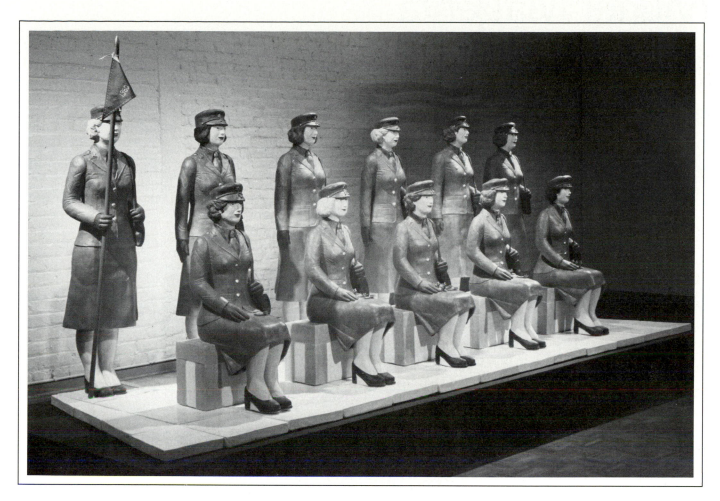

The B.A.M.S. 1980. Clay, seated figures, 32"h x 14"w x 15"d; standing figures, 48"h x 10½"w x 10½"d; overall dimensions, 48"h x 142"w x 48"d. Photograph by Ed Marquand.

Artist's Statement

"Ever since I began to work in clay in 1969, my pieces have been figurative and situational. The initial impetus for the work always comes from personal experiences and observations; however, the end result is never a simple narrative account. I feel most comfortable when my work can be enjoyed on several levels of meaning and especially when those meanings can be simultaneously experienced.

"I prefer to make my pieces life-size. This scale necessitates that the pieces be designed in smaller units for portability and with internal clay structural supports. The external surfaces are carved and decorated with burnished colored clays and/or commercial glazes. In the most recent works I have combined other materials with the finished ceramics and find the juxtapositions useful."

Muriel Magenta

née Muriel Gellert
(Husband Gerald Zimmerman)
Born December 4, 1932 New York, New York

Education and Training
1953 B.A., Painting, Queens College, Flushing, New York
1962 M.A., Art History, Arizona State University, Tempe, Arizona
1965 M.F.A., Painting, Arizona State University, Tempe, Arizona
1970 Ph.D., Art Education, Arizona State University, Tempe, Arizona

Selected Individual Exhibitions
1972, 74, 76 Memorial Union Gallery, Arizona State University, Tempe, Arizona
1975-77 Phoenix Art Museum, Phoenix, Arizona
1978 University Art Galleries, University of Southern California, Los Angeles, California
1979 Student Union Art Gallery, University of Arizona, Tucson, Arizona
1979 Gross Gallery, University of Arizona, Tucson, Arizona
1979 Marian Locks Gallery, Philadelphia, Pennsylvania
1981 Yares Gallery, Scottsdale, Arizona
1983 Gammage Center for the Performing Arts, Arizona State University, Tempe, Arizona
1984 University of Arkansas, Fayetteville, Arkansas
1985 Los Angeles Contemporary Exhibitions, Los Angeles, California

Selected Group Exhibitions
1973 "Arizona State University Art Faculty Exhibition," Sedona Art Center, Sedona, Arizona
1974 "Raw Materials: Art in Progress," Art Department Gallery, Arizona State University, Tempe, Arizona
1975 "Women/Arizona '75," Tucson Museum of Art, Tucson, Arizona
1975, 76 "Southwest Invitational," Yuma Art Center, Yuma, Arizona
1976 "Arizona State University Art Faculty Exhibition," Scottsdale Center for the Arts, Scottsdale, Arizona
1976 "Ongoing Fantasies," Art Department Gallery, Arizona State University, Tempe, Arizona
1976 "Governor's Invitational: Women Artists of Arizona," State Capitol, Phoenix, Arizona
1978 "First Annual Exhibition: Arizona Women's Caucus for Art," Prescott Fine Arts Association, Prescott, Arizona; Memorial Union Gallery, Arizona State University, Tempe, Arizona
1978 "Muriel Magenta and Karen Stone," Womanswork Gallery, Mesa, Arizona
1979 "Four Artists in Residence Exhibition," Department of Art Gallery, University of Wisconsin-Madison, Madison, Wisconsin
1979 "Arizona Women's Caucus for Art Exhibition," State Capitol, Phoenix, Arizona; Scottsdale Community College Library, Scottsdale, Arizona
1981 "Retrospective Exhibition: Tenth Anniversary Year, Women Artist Series," A.I.R. Gallery, New York, New York; Mabel Smith Douglass Library, Rutgers University, Douglass College, New Brunswick, New Jersey
1981 "Woman and Art," Suzanne Brown Gallery, Scottsdale, Arizona, catalog
1982 "Fabric/Fiber," Brown-Lupton Student Center Gallery and Moudy Exhibition Space, Texas Christian University, Fort Worth, Texas
1983 "Triple Focus," Fine Arts Center of Tempe, Tempe, Arizona
1983 "Women Artists of the Southwest," Women's Interart Center, New York, New York
1984 "Wedding Show," Tweed Gallery, Plainfield, New Jersey

Selected Awards
1974 Faculty Research Grant, Arizona State University, Tempe, Arizona
1975 Environmental Sculpture Installation, Phoenix Art Museum, Phoenix, Arizona
1979 Traveling Exhibition Grant, University of Arizona, Tucson, Arizona

Preferred Sculpture Media
Varied Media

Additional Art Fields
Film/Video, Graphics and Photography

Teaching Position
Professor, School of Art, Arizona State University, Tempe, Arizona

Selected Bibliography
Askey, Ruth. "Muriel Magenta on Bridal Myths." Artweek vol. 9 no. 37 (November 4, 1978) p. 4, illus.
Donnell-Kotrozo, Carol. "Women and Art." Arts Magazine vol. 55 no. 7 (March 1981) p. 11.
Donnell-Kotrozo, Carol. "Profiles: A Portfolio of Regional Artists, Muriel Magenta (Scottsdale, Arizona)." Art Voices vol. 4 no. 6 (November-December 1981) p. 26, illus.
Donnell-Kotrozo, Carol. "Film: Defending Hair." Artweek vol. 14 no. 25 (July 16, 1983) p. 9, illus.
Perlman, Barbara H. "The Nation Scottsdale: Hiding from Infinity." Art News vol. 78 no. 7 (September 1979) pp. 139-140, 142, 144, 146.

Gallery Affiliation
Yares Gallery
3625 Bishop Lane
Scottsdale, Arizona 85251

Mailing Address
8322 East Virginia Avenue
Scottsdale, Arizona 85257

In Defense of a Hairdo. 1983. Urethane foam, dynel and chain link, 12'h x 20'w x 20'd. Installation view 1983. Gammage Center for the Performing Arts, Arizona State University, Tempe, Arizona.

Artist's Statement

"My work in sculpture began in 1970 when I became interested in high relief in order to add three-dimensional qualities to my paintings. By 1972 the work had come off the wall taking the direction of installations and environments. Art for me quickly became any communication through imagery. All approaches to content, process and media are appropriate and interrelated. I work with art that is live, art that has sound, and art that involves a collaboration of people. Thus far, my installation sculpture has incorporated film, video and performance."

Muriel Magenta

Marlene Malik

née Marlene Shanus
(Husband Suren S. Malik)
Born April 1, 1940 Chicago, Illinois

Education and Training
1958- School of the Art Institute of Chicago,
60 Chicago, Illinois
1976 B.F.A., Painting and Psychology,
University of Rhode Island, Kingston,
Rhode Island
1979 M.F.A., Sculpture, Rhode Island
School of Design, Providence, Rhode
Island; study with Lauren Ewing

Selected Individual Exhibitions
1976 All India Fine Arts Gallery, New Delhi,
India
1980 Hera Gallery, Wakefield, Rhode Island
1980 Bell Gallery, List Art Center, Brown
University, Providence, Rhode Island
1980 Northern Virginia Community College,
Alexandria, Virginia
1981 Anyart Gallery, Providence, Rhode
Island
1981 Goodrich Gallery, Williams College,
Williamstown, Massachusetts
1982 Gallery East, Art Institute of Boston,
Boston, Massachusetts
1984 Fieldston School, Bronx, New York
1985 Main Gallery, Fine Arts Center,
University of Rhode Island, Kingston,
Rhode Island
1985 Cantor Gallery, College of the Holy
Cross, Worcester, Massachusetts

Selected Group Exhibitions
1976 "SoHo 20/Hera," SoHo 20 Gallery, New
York, New York
1978 "Glass in Sculpture," Hera Gallery,
Wakefield, Rhode Island, catalog
1979 "Hera/Fifth Year," Hera Gallery,
Wakefield, Rhode Island, catalog
1980 "Eighty-Sixth Annual Exhibition," Art
Association of Newport, Newport,
Rhode Island
1980 "Group Exhibition," Muse Gallery,
Philadelphia, Pennsylvania
1980 "Marlene Malik and Peggy Diggs,"
Hera Gallery, Wakefield, Rhode Island
1981 "Environmental Interplay/7 Sculptors,"
Alternative Museum, New York, New
York, catalog
1982 "Faculty Exhibition," Bell Gallery, List
Art Center, Brown University,
Providence, Rhode Island, catalog
1982 "Anniversary Exhibition," Hera Gallery,
Wakefield, Rhode Island
1983 "Interim I: An Exhibition of
Contemporary Outdoor Sculpture,"
Chesterwood, Stockbridge,
Massachusetts
1984 "Inaugural Exhibition," Gallery I,
Providence, Rhode Island
1985 "Artpark: The Program in Visual Arts,"
Artpark, Lewiston, New York, catalog

Selected Awards
1976 Individual Artist's Fellowship, Rhode
Island State Council on the Arts
1978 Special Project Grant, Rhode Island
State Council on the Arts

Preferred Sculpture Media
Brick, Plaster and Wood

Teaching Position
Visiting Assistant Professor of Art, Brown
University, Providence, Rhode Island

Selected Bibliography
Balken, Debra Bricker. "Regional Reviews
Massachusetts: Marlene Malik, Goodrich
Gallery, Williams College, Williamstown."
New Art Examiner vol. 9 no. 5 (February
1982) p. 17.
Lubell, Ellen. "Arts Reviews: Hera." Arts
Magazine vol. 51 no. 1 (September 1976)
p. 20.
Pevsner, Laura. "Regional Reviews: Rhode
Island: Hera Gallery/Wakefield, Marlene
Malik, Peggy Diggs." Art New England vol.
1 no. 10 (November 1980) pp. 10, 19, illus.
Roth, Jacquelyn. "Rhode Island Profiles: Five
Artists." Art New England vol. 4 no. 5 (April
1983) p. 4, illus.
Strauss, John. "Regional Reviews Rhode
Island: Anyart Gallery/Providence, Marlene
Malik: Installation." Art New England vol. 2
no. 5 (April 1981) p. 10, illus.

Gallery Affiliation
Hera Gallery
Main Street
Wakefield, Rhode Island 02879

Mailing Address
50 Biscuit City Road
Kingston, Rhode Island 02881

It's About the Quiet in Saunderstown. 1981. Wood and brick, 5'h x 6'w x 1½'d. Installation view 1981. Anyart Gallery, Providence, Rhode Island.

Artist's Statement

"My involvement with structures and architectural spaces which resemble shelters arises from an absorbing need to understand 'familial' concerns and 'place.' Adopting a vocabulary of elementary forms (the brick, the 2 x 4), I am concerned with the relationship between inside and outside, house and home, and the dichotomy of the shelter experience.

"The notion of shelter reflects a need for warmth, protection and refuge, a sanctuary about our physical covering—our home, clothing, public buildings—can be illusions. Walls which protect also can confine; a shelter can be a prison, a barrier and, sometimes, an oppressor.

"I find other fields of study, anthropology, archaeology and sociology, useful sources on structural living systems. I am pleased when my work communicates these influences."

Marlene Malik

Georganna Pearce Malloff

née Georganna Pearce
Born May 4, 1936 Detroit, Michigan

Education and Training
1954- Scripps College, Claremont, California
55
1960 B.F.A., Printmaking and Sculpture, University of Michigan, Ann Arbor, Michigan; study in sculpture with Joe Gotto and Paul Suttman
1963 San Francisco Art Institute, San Francisco, California; study in sculpture with Victor Arnatoff

Selected Individual Exhibitions
1976 Brackendale Gallery, Squamish, British Columbia, Canada
1979 Bay Window Gallery, Mendocino, California
1979 California State University, Fresno, Fresno, California
1980 Vancouver East Cultural Centre, Vancouver, British Columbia, Canada
1980 Tile House, Tucson, Arizona
1982 Mendocino County Museum, Willets, California, catalog
1984 Gallery of the Hicks Art Center, Bucks County Community College, Newtown, Pennsylvania

Selected Group Exhibitions
1964 "Group Exhibition of Ceramic Sculptures 1964," Traveling Exhibition, Galerie de Tours, Los Angeles, California
1965 "Regional Artists of Mendocino County," Bay Window Gallery, Mendocino, California
1980 "Women Artists of British Columbia," Move Gallery, Vancouver, British Columbia, Canada
1981 "Buddist Contemporary Images," City of Ten Thousand Buddhas, Talmage, California

1981, "Woodworkers Exhibition," Mendocino
82 Woodworkers Association, Mendocino, California
1982 "Twelfth International Sculpture Conference," Area Galleries and Institutions, Oakland, California and San Francisco, California (Sponsored by International Sculpture Center, Washington, D.C.)
1982 "'New Metals, New Works' by Florence Resnikoff and 'East Meets West,' Carved Wood Sculpture by Georganna Malloff," Graduate Center Gallery, California College of Arts and Crafts, Oakland, California, catalog
1982 "Energy Art," Foothills Art Center, Golden, California
1983 "Visionary Artists," Crane Dance Gallery, Ft. Bragg, California
1984 "Magabark, Collaborative Works by Poets and Visual Artists," Falkirk Community Art Center, San Rafael, California
1985 "Paintings, Sculpture & Photographs," Mussair Arts Center, New York, New York

Selected Public Collections
California College of Arts and Crafts, Oakland, California
Catholic Libre Church, Vancouver, British Columbia, Canada
City of Ottawa, Ontario, Canada
Civic Center, Mackenzie, British Columbia, Canada
Coquitlam Town Centre, Coquitlam, British Columbia, Canada
Friendship Gardens, City Hall, New Westminster, British Columbia, Canada
Galerija Samorastnikov Trebnje, Trebinje, Yugoslavia
Harbourfront Contemporary Art Gallery and Park, Toronto, Ontario, Canada
John and Mabel Ringling Museum of Art, Sarasota, Florida
Sointula Community Center, Sointula, British Columbia, Canada
Township Corporate Development, Miami, Florida
University of California, Santa Cruz, Santa Cruz, California

Selected Private Collections
Thomas W. Buckner, New York, New York
Helen Hager, Pacific Palisades, California
Ellen Lahey, Ottawa, Ontario, Canada
Francis Moore, Tucson, Arizona
Dorothy Weicker, Berkeley, California

Selected Award
1984 Artist in Residence, Johnson Atelier Technical Institute of Sculpture, Princeton, New Jersey

Preferred Sculpture Media
Stone and Wood

Additional Art Fields
Drawing, Metal (cast) and Painting

Related Professions
Community Creation Poles and Visiting Artist

Selected Bibliography
Bertorelli, Paul. "Notes and Comment: Gaggle of Gouges" and "Cosmic Maypoles." *Fine Woodworking* no. 46 (May-June 1984) pp. 104, 106, 108, illus.
Boericke, Art. *Handmade Houses: A Guide to the Woodbutcher's Art.* San Francisco: Scrimshaw Press, 1973.
Brower, Kenneth. *The Starship and the Canoe.* New York: Holt, Rinehart and Winston, 1978.
Meilach, Dona Z. *Woodworking, The New Wave: Today's Design Trends in Objects, Furniture, and Sculpture, with Artist Interviews.* New York: Crown, 1981.
Weills, Christopher. "70 Feet of Magic." *The Goodfellow Review of Crafts* vol. 6 no. 3 (May-June 1980) pp. 680-681, illus.

Mailing Address
Post Office Box 113
Caspar, California 95420

Artist's Statement

"My evolvement into a unitive vision of organic sculpture began when I settled in the redwood forest of Mendocino County in 1962. My primary materials became themes of eros and paradise. Explorations of environmental relationships between humanity and the cosmos led to the creation of sculpture gardens. Influenced by Jungian concepts of individuation, the comparative mythologies of Joseph Campbell and the French traditions of sculpture, I aspired to infuse in the work a magical presence and, in the viewer, life-affirming energies through transformational symbols.

"In 1976 after a five-year retreat homesteading a British Columbia island, I became involved in the collective dynamics of group sculpture through carving the *Cosmic Maypole Totem* for the United Nations Conference in Habitat, Vancouver, British Columbia. I am presently exploring sculptural forms of the four elements—air, earth, water and fire—ideally to become meditational fountains, energetic reflections on the wellsprings of the life force."

Georganna Malloff

Fern Bodhisattva. 1981. Redwood, 8'h x 4'w x 4"d.
Photograph by Thomas D. Gillaspy.

Jean Mandeberg

Born August 7, 1950 Detroit, Michigan

Education and Training
1972 B.A., Art History, University of Michigan, Ann Arbor, Michigan
1977 M.F.A., Metalsmithing and Jewelry, Idaho State University, Pocatello, Idaho; study in small-scale metal sculpture with Gail Farris Larson
1981 Olympia Technical Community College, Olympia, Washington; study in welding

Selected Individual Exhibition
1981 Factory of Visual Art, Seattle, Washington

Selected Group Exhibitions
1979 "Governor's Invitational," Traveling Exhibition, Washington State Capitol Museum, Olympia, Washington, catalog
1979 "Big Sky Biennial," Idaho State University, Pocatello, Idaho
1979 "Spokane Annual Art Exhibition," Cheney Cowles Memorial Museum, Spokane, Washington, catalog
1980 "National Invitational," Visual Arts Center of Alaska, Anchorage, Alaska
1980 "Metals Confabulation," Oregon School of Arts and Crafts, Portland, Oregon
1980 "National Juried Exhibition," University of Houston Lawndale Annex, Houston, Texas, catalog
1980 "Young Americans: Metal," American Craft Museum, New York, New York, catalog
1981 "Contemporary Metal," Yellowstone Art Center, Billings, Montana
1981 "National Metals Invitational," Humboldt State University, Arcata, California
1981 "Jean Mandeberg and Deborah Nore," Alaska State Museum, Juneau, Alaska
1982 "Jean Mandeberg and Sandra Percival," Evergreen State College, Olympia, Washington
1982 "Washington Craft Forms: An Historical Perspective 1950-1980," Washington State Capitol Museum, Olympia, Washington, catalog
1982 "Northwest Invitational," University of Montana Gallery, Missoula, Montana
1982 "Group Exhibition," Traver Sutton Gallery, Seattle, Washington
1983 "Group Exhibition," Eastern Washington University, Cheney, Washington
1983 "Northwest Designer Craftsmen," Southwest King County Art Museum, Highline Community College, Midway, Washington
1983 "Small Works National '83," Zaner Gallery, Rochester, New York, catalog
1984 "Introspectives: A National Exhibition of Autobiographical Works by Women Artists," Pyramid Arts Center, Rochester, New York, catalog
1984 "Northwest Designer Craftsmen," Northwest Craft Center Gallery, Seattle, Washington
1985 "Group Exhibition," Marianne Partlow Gallery, Olympia, Washington

Selected Public Collections
Clearwater Corrections Center, Forks, Washington
Monroe High School, Monroe, Washington
Idaho State University, Pocatello, Idaho

Selected Awards
1975 Honor Award, "Object Idaho," Boise Gallery of Art, Boise, Idaho
1978 Merit Award, "Thirty-Seventh Annual Cedar City National Art Exhibition," Braithwaite Fine Arts Gallery, Cedar City, Utah
1984 Exhibition Grant, Evergreen Foundation, Evergreen State College, Olympia, Washington

Preferred Sculpture Media
Metal (welded) and Varied Media

Teaching Position
Faculty, Evergreen State College, Olympia, Washington

Mailing Address
114 North Sherman
Olympia, Washington 98502

Thinking Cap No. 2. 1981. Aluminum, copper, sterling silver and rubber, 10½"h x 10"w x 16"d. Collection Clearwater Corrections Center, Forks, Washington. Photograph by Tracy Hamby.

Artist's Statement

"I approach three-dimensional work with the technical training and perspective of a metalsmith and the formal and conceptual commitment of a sculptor. I am searching for forms which have presence and authority, forms that become more than the personal experience and humor I bring to them. Some artists make art to find order in the world; I make art to find a way to influence the world."

Jean Mandeberg

Berta Margoulies

Born September 7, 1907 Lowitz, Poland

Education and Training
1927 B.A., Anthropology, Hunter College, New York, New York
1928 Art Students League, New York, New York
1929 Académie Julien, Paris, France
1929 Académie Collarossi, Paris, France

Selected Individual Exhibitions
1949 ACA Gallery, New York, New York
1964 Forum Gallery, New York, New York
1972 Heritage Arts, Orange, New Jersey

Selected Group Exhibitions
1934, "Annual Exhibition of Painting and
44, Sculpture," Pennsylvania Academy of
50, the Fine Arts, Philadelphia,
51, Pennsylvania, catalog
52,
53
1936, "Annual Exhibition: Contemporary
40, American Sculpture," Whitney
43, Museum of American Art,
47, New York, New York, catalog
48,
53,
54,
55
1936, "Annual Exhibition of American
38, Paintings and Sculpture," Art Institute
41, of Chicago, Chicago, Illinois, catalog
43,
47,
53
1936 "Annual Area Exhibition," Corcoran Gallery of Art, Washington, D.C., catalog
1938- "Sculptors Guild Annual Exhibition,"
84 Lever House, New York, New York, catalog
1940, "Sculpture International," Philadelphia
49 Museum of Art, Philadelphia, Pennsylvania, catalog
1942 "Artists for Victory: An Exhibition of Contemporary American Art," Metropolitan Museum of Art, New York, New York, catalog
1944, "Annual Exhibition of Contemporary
58 Art," Nebraska Art Association, Lincoln, Nebraska, catalog
1946 "National Association of Women Artists Annual Exhibition," National Academy of Design, New York, New York, catalog

1949, "Exhibition of Works by Contemporary
50, American Artists," American Academy
51, of Arts and Letters, New York, New
52 York, catalog
1949 "Fifth Summer Exhibition of Contemporary Art," University of Iowa, Iowa City, Iowa, catalog
1951 "Pittsburgh International Exhibition of Painting and Sculpture," Museum of Art, Carnegie Institute, Pittsburgh, Pennsylvania, catalog
1952, "Annual New Jersey State Exhibition,"
53, Montclair Art Museum, Montclair, New
56, Jersey, catalog
66,
69,
72
1954 "National Gold Medal Exhibition," Architectural League of New York, New York
1959 "Paintings and Sculpture by Finalists in the Mary Roebling Art Scholarship Award," New Jersey State Museum, Trenton, New Jersey
1960 "Annual Exhibition of American Painting and Sculpture," Detroit Institute of Arts, Detroit, Michigan, catalog
1965 "Painters and Sculptors Society of New Jersey," Jersey City Museum, Jersey City, New Jersey
1965, "Annual Juried Exhibition of Paintings,
67 Sculpture and Graphics by New Jersey Artists," New Jersey State Museum, Trenton, New Jersey, catalog
1965 "Women Artists of America 1707-1964," Newark Museum, Newark, New Jersey, catalog
1966 "New Jersey Painters and Sculptors Exhibition," Newark Museum, Newark, New Jersey
1971, "Sculpture in the Park, An Exhibition
74 of American Sculpture," Van Saun Park, Paramus, New Jersey (Sponsored by Bergen County Parks Commission, Paramus, New Jersey), catalog
1981 "Sculpture in the Garden 1981," Sculptors Guild at the Enid A. Haupt Conservatory, New York Botanical Garden, Bronx, New York, catalog
1984 "Music Mountain Sculpture Exhibit," Music Mountain, Falls Village, Connecticut, catalog

Selected Public Collections
Des Moines Art Center, Des Moines, Iowa
International Lithographer's Union, Washington, D.C.
Office of the United States Postmaster General, Washington, D.C.
Whitney Museum of American Art, New York, New York
Willamette University, Salem, Oregon
Wyandotte County Museum, Bonner Springs, Kansas

Selected Private Collections
Mr. and Mrs. Mort Berman, Brooklyn, New York
Wilbur Daniels, New York, New York
Peabody Gardner Collection, Boston, Massachusetts
Ittleson Collection, New York, New York
Mr. and Mrs. Richard Leeds, Great Neck, New York

Selected Awards
1929 Fellowship, Gardner Foundation, Boston, Massachusetts
1944 Recipient of an Award in Art, "Exhibition of Works by Newly Elected Members and Recipients of Arts and Letters Grants," American Academy of Arts and Letters and National Institute of Arts and Letters, New York, New York, catalog
1946 John Simon Guggenheim Memorial Foundation Fellowship

Preferred Sculpture Media
Metal (cast), Stone and Varied Media

Selected Bibliography
Lowengrund, Margaret. "Elemental Form." *Art Digest* vol. 23 no. 13 (April 1, 1949) p. 13, illus.
Rich, Jack C. *The Materials and Methods of Sculpture*. New York: Oxford University Press, 1947.
Roller, Marion. "The Challenge of Space." *National Sculpture Review* vol. 31 no. 1 (Spring 1982) pp. 8-13, illus.
Rubinstein, Charlotte Streifer. *American Women Artists: From Early Indian Times to the Present*. Boston: G. K. Hall, 1982.
"S. P." "New Shows: One by One." *The New York Times* (Sunday, March 27, 1949) art, p. 8X.

Gallery Affiliation
Forum Gallery
1018 Madison Avenue
New York, New York 10021

Mailing Address
Tinc Road
R. D. Flanders, New Jersey 07836

Artist's Statement

"My sculpture expresses my interest in people and their human condition which has been influenced by my personal experiences in two major wars here and abroad. These themes are reflected in the titles of my work: *Mine Disaster*, *Flight*, *Displaced*, *Panic*, *Strike*, *War Bride* and *Women Waiting*.

"I use natural materials: wood, stone, terra cotta and bronze, whichever is appropriate for the subject matter. When the subject calls for personal individual searching, the modeling is sensitive and intimate. The forms are more abstracted in group compositions in order to maintain the full impact of the work without the distraction of detail. I often enhance the composition by introducing some architectural element."

Berta Margoulies

Lost Lady. Bronze, 6'h. Photograph by Michael O'Hare.

Marisol

née Marisol Escobar
Born May 22, 1930 Paris, France

Education and Training
1949 École des Beaux Arts, Paris, France
1950 Art Students League, New York, New York
1950 Hans Hofmann School, New York, New York
1950- New School for Social Research, New
53 York, New York

Selected Individual Exhibitions
1958 Leo Castelli Gallery, New York, New York
1962, Stable Gallery, New York, New York
64
1966, Sidney Janis Gallery, New York, New
83 York
1967 Hanover Gallery, London, Great Britain
1967, Sidney Janis Gallery, New York, New
73, York, catalog
75,
81,
84
1968 Museum Boymans-Van Beuningen, Rotterdam, Netherlands
1968 Guild Hall Museum, East Hampton, New York, catalog
1971 Worcester Art Museum, Worcester, Massachusetts, catalog
1974 Trisolini Gallery, Ohio University, Athens, Ohio; Columbus Gallery of Art, Columbus, Ohio, catalog
1974 Estudio Actual, Caracas, Venezuela
1975 Makler Gallery, Philadelphia, Pennsylvania
1977 Contemporary Arts Museum, Houston, Texas

Selected Group Exhibitions
1961- "The Art of Assemblage," Museum of
62 Modern Art, New York, New York; Dallas Museum for Contemporary Arts, Dallas, Texas; San Francisco Museum of Art, San Francisco, California, book
1962, "Annual Exhibition: Contemporary
64, American Sculpture and Prints,"
66 Whitney Museum of American Art, New York, New York, catalog
1963 "The Art of Things," Jerrold Morris International Gallery, Toronto, Ontario, Canada
1964 "Painting and Sculpture of a Decade," Tate Gallery, London, Great Britain; Institute of Contemporary Art of The University of Pennsylvania, Philadelphia, Pennsylvania
1964, "Pittsburgh International Exhibition of
67, Painting and Sculpture," Museum of
70 Art, Carnegie Institute, Pittsburgh, Pennsylvania, catalog
1965 "Women Artists of America 1707-1964," Newark Museum, Newark, New Jersey, catalog

1966 "Latin American Art Since Independence," Traveling Exhibition, Museum of Modern Art, New York, New York
1966 "Art of the United States: 1670-1966," Whitney Museum of American Art, New York, New York, catalog
1967 "American Sculpture of the Sixties," Los Angeles County Museum of Art, Los Angeles, California; Philadelphia Museum of Art, Philadelphia, Pennsylvania, book-catalog
1968 "The Sidney and Harriet Janis Collection," Museum of Modern Art, New York, New York
1968 "Art of Ancient and Modern Latin America," Isaac Delgado Museum of Art, New Orleans, Louisiana
1969 "Ars 69-Helsinki," Art Gallery of Ateneum, Helsinki, Finland
1970 "L'Art Vivant Americain," Galerie Maeght, Paris, France
1972 "Women in Art," Brainerd Art Gallery, Potsdam, New York, catalog
1972 "American Women: 20th Century," Lakeview Center for the Arts and Sciences, Peoria, Illinois, catalog
1972 "Unmanly Art," Suffolk Museum, Stony Brook, New York, catalog
1975 "Realism and Reality," Kunsthalle, Darmstadt, Germany, Federal Republic
1976 "The Golden Door: Artist-Immigrants of America 1876-1976," Hirshhorn Museum and Sculpture Garden, Smithsonian Institution, Washington, D.C.
1977 "American Artists '76: A Celebration," Marion Koogler McNay Art Institute, San Antonio, Texas, catalog
1979 "Women Artists in Washington Collections," Women's Caucus for Art and University of Maryland Art Gallery, College Park, Maryland, catalog
1981 "Bronze," Hamilton Gallery, New York, New York
1983 "Bronze Sculpture in the Landscape," Wave Hill, Bronx, New York, catalog
1984 "American Women Artists Part I: 20th Century Pioneers," Sidney Janis Gallery, New York, New York, catalog
1984 "New Portrait," P.S. 1, Institute for Art and Urban Resources, Long Island City, New York

Selected Public Collections
Albright-Knox Art Gallery, Buffalo, New York
Art Institute of Chicago, Chicago, Illinois
Arts Club of Chicago, Chicago, Illinois
Brooks Memorial Art Gallery, Memphis, Tennessee
Hakone Open Air Museum, Hakone, Japan
John and Mabel Ringling Museum of Art, Sarasota, Florida
Museo de Arte Contemporáneo de Caracas, Caracas, Venezuela
Museum of Contemporary Art, Chicago, Illinois

Museum of Modern Art, New York, New York
Rose Art Museum, Brandeis University, Waltham, Massachusetts
Wallraf-Richartz-Museum, Museum Ludwig, Cologne, Germany, Federal Republic
Whitney Museum of American Art, New York, New York

Selected Private Collections
Harry N. Abrams Collection, New York, New York
Evan M. Frankel, East Hampton, New York
Sidney Janis Collection, New York, New York
Seymour H. Knox, Buffalo, New York
Mrs. Robert B. Mayer, Chicago, Illinois

Selected Awards
1969 First Prize, "Modern International Sculpture," Hakone Open Air Museum, Hakone, Japan
1978 Recipient of an Award in Art, American Academy and Institute of Arts and Letters, New York, New York, catalog

Preferred Sculpture Media
Varied Media and Wood

Additional Art Field
Drawing

Selected Bibliography
Bachmann, Donna G. and Sherry Piland. *Women Artists: An Historical, Contemporary, and Feminist Bibliography.* Metuchen, New Jersey: Scarecrow Press, 1978.
Berman, Avis. "Marisol's Movers and Shakers." *Smithsonian* vol. 14 no. 11 (February 1984) pp. 54-63, illus.
Fine, Elsa Honig. *Women & Art: A History of Women Painters and Sculptors from the Renaissance to the 20th Century.* Montclair, New Jersey: Allanheld & Schram/Prior, 1978.
Lippard, Lucy R. *Pop Art.* New York: Praeger, 1966.
Rubinstein, Charlotte Streifer. *American Women Artists: From Early Indian Times to the Present.* Boston: G. K. Hall, 1982.

Gallery Affiliation
Sidney Janis Gallery
110 West 57 Street
New York, New York 10019

Mailing Address
Sidney Janis Gallery
110 West 57 Street
New York, New York 10019

The Last Supper. 1982-1984. Wood, brownstone, plaster, paint and charcoal, 121"h x 358"w x 67"d. Courtesy Sidney Janis Gallery, New York, New York. Photograph by Allan Finkelman.

Jimilu Mason

Born October 19, 1930 Las Cruces, New Mexico

Education and Training
1951 A.A., Sculpture, American University, Washington, D.C.; study with William Calfee
1953 B.A., Sculpture, George Washington University, Washington, D.C.; study with Heinz Warneke

Selected Individual Exhibitions
1974 The Athenaeum, Northern Virginia Fine Arts Association, Alexandria, Virginia, catalog
1978 Shippensburg State College, Shippensburg, Pennsylvania, catalog

Selected Group Exhibitions
1953 "Society of Washington Artists Annual Exhibition," National Museum of Natural History, Smithsonian Institution, Washington, D.C.
1956-62 "Annual Area Exhibition of Work by Artists of Washington & Vicinity," Corcoran Gallery of Art, Washington, D.C., catalog
1958 "Group Exhibition," Potter's House Gallery, Washington, D.C.
1958 "Annual Exhibition of Painting and Sculpture," Traveling Exhibition, Pennsylvania Academy of the Fine Arts, Philadelphia, Pennsylvania, catalog
1958 "Annual Exhibition of Painting and Sculpture," Traveling Exhibition, Detroit Institute of Arts, Detroit, Michigan
1976 "7 Artists in the Park," Art Barn, Washington, D.C.

Selected Public Collections
All Souls Unitarian Church, Washington, D.C.
American Veterans Association Building, Washington, D.C.
Audie L. Murphy Memorial Hospital, San Antonio, Texas
Brooklyn Institute of Technology, Brooklyn, New York
Federal Bar Association, Washington, D.C.
Georgetown University, Inter-Culture Center, Washington, D.C.
H. R. Davies Memorial Hospital, San Francisco, California
Illinois School for the Blind, Jacksonville, Illinois
Johnson Products Company, Chicago, Illinois
Johnson Wax Corporation, Racine, Wisconsin
Kanawha Valley Bank, Charleston, West Virginia
Keystone National Bank, Punxsutawney, Pennsylvania
Lodge of the Fisherman, Lynchburg, Virginia
Lyndon Baines Johnson Library and Museum, Austin, Texas
Lyndon Baines Johnson Memorial Park, Stonewall, Texas
Market Square, Alexandria, Virginia
National League of American Pen Women, Washington, D.C.
National Portrait Gallery, Smithsonian Institution, Washington, D.C.
National Shrine of the Immaculate Conception, Washington, D.C.
National Society of Arts and Letters, Washington, D.C.
North Carolina Museum of Art, Raleigh, North Carolina
Quality Bakers of America Cooperative, Bedford, Massachusetts
Richard Russell Memorial Hospital, Winder, Georgia
Rouse Company, Columbia Mall, Columbia, Maryland
St. Francis of Assisi Church, Quantico, Virginia
Sam Rayburn Foundation Library, Bonham, Texas
San Francisco General Hospital, San Francisco, California
State Capitol, Austin, Texas
State Capitol, Denver, Colorado
Supreme Court of the United States, Washington, D.C.
Tucker Associates, Chicago Ridge Mall, Chicago, Illinois
United States Capitol, Washington, D.C.
University of Georgia, Athens, Georgia
Wadsworth Veterans Administration Hospital, Los Angeles, California

Selected Private Collections
Eleanor Ettinger, New York, New York
Hibbert F. Johnson, Racine, Wisconsin
Mr. and Mrs. David Lloyd Kreeger, Washington, D.C.
James Rouse, Columbia, Maryland
Mrs. Harold Zellerbach, San Francisco, California

Selected Awards
1961 Honorable Mention, "Annual Area Exhibition of Work by Artists of Washington & Vicinity," Corcoran Gallery of Art, Washington, D.C., catalog
1970 National Design Award, Housing and Urban Development, Washington, D.C.

Preferred Sculpture Media
Metal (cast) and Metal (welded)

Mailing Address
415 Jefferson Street
Alexandria, Virginia 22314

Cabriole. 1980. Bronze, 12'h x 15'w x 5'5"d. Collection Kanawha Valley Bank, Charleston, West Virginia. Courtesy Department of Culture and History, State of West Virginia, Charleston, West Virginia. Photograph by Rick Lee.

Artist's Statement

"I believe the *raison d'être* of our existence is to become creative, compassionate human beings. Striving for creative solutions in life and in art is an integrating activity both within ourselves and others. This experience is not solely reserved for the privileged efforts of those who make art.

"The creative process in any area of life is difficult. If we willingly embrace our agony of struggle, our groping indecision, aloneness, insecurity and fear, the process of decision will grow. And out of this continuing practice will come the sometimes quiet, sometimes explosive joy of resolution and communication."

[signature]

Molly Mason

née Molly Ann
Born August 2, 1953 Cedar Rapids, Iowa

Education and Training
1973 B.F.A., Sculpture, Ceramics and Education, University of Iowa, Iowa City, Iowa
1975 M.A., Sculpture and Ceramics, University of Iowa, Iowa City, Iowa
1976 M.F.A., Sculpture and Ceramics, University of Iowa, Iowa City, Iowa

Selected Individual Exhibitions
1977 Minneapolis Institute of Arts, Minneapolis, Minnesota, catalog
1978 University of Minnesota, Morris, Morris, Minnesota
1981 Triton Museum of Art, Santa Clara, California
1984, Tilden-Foley Gallery, New Orleans,
85 Louisiana

Selected Group Exhibitions
1975 "Fourth Marietta College Crafts National '75," Grover M. Hermann Fine Arts Center, Marietta College, Ohio, catalog
1975 "Second Annual National Clay and Sculpture Exhibition," Stockton State College, Pomona, New Jersey
1976 "Clay and Paper Exhibition," Octagon Center for the Arts, Ames, Iowa
1977 "Sculpture and Photography," Golden West College, Los Angeles, California
1977 "Fourteenth Annual Manisphere International Juried Exhibition," Winnipeg Art Gallery, Winnipeg, Manitoba, Canada, catalog
1978 "Introductions '78," Hansen Fuller Gallery, San Francisco, California
1978 "4 x 4," ARC Gallery, Chicago, Illinois
1979 "New Works," University of New Mexico, Albuquerque, New Mexico
1979, "Faculty Exhibition," Art Museum,
80, University of New Mexico,
81 Albuquerque, New Mexico
1980- "Southwest Artists Invitational," BFM
81 Gallery, New York, New York
1980 "Here and Now: 35 Artists in New Mexico," Albuquerque Museum, Albuquerque, New Mexico, catalog
1982 "Invitational Exhibition," BFM Gallery, New York, New York
1982 "Group Exhibition," Taylor Gallery, Taos, New Mexico
1982, "Newcomb Department of Art Faculty
84 Exhibition," Tulane University, New Orleans, Louisiana
1983 "New Works," Contemporary Arts Center, New Orleans, Louisiana
1983 "Water Images Exhibition," Matrix Gallery, Austin, Texas
1983 "Art for Art's Sake," Contemporary Arts Center, New Orleans, Louisiana
1983 "Birmingham Biennial Exhibition," Birmingham Museum of Art, Birmingham, Alabama, catalog
1984 "Group Exhibition," Tilden-Foley Gallery, New Orleans, Louisiana
1984 "Group Exhibition," Barbara Gillman Gallery, Miami, Florida
1984 "Louisiana Major Works Exhibition, Louisiana World Exposition," World's Fair, New Orleans, Louisiana

Selected Public Collection
City of Albuquerque, Albuquerque, New Mexico

Selected Private Collections
Phelan and Fay Bright, New Orleans, Louisiana
Michael Brown, New Orleans, Louisiana
Frank Friedler, New Orleans, Louisiana
Thomas and Barbara Lemann, New Orleans, Louisiana
Bennett Spelce, Austin, Texas

Selected Awards
1982 Artist in Residence, Millay Colony for the Arts, Austerlitz, New York
1984 Research Project Grant, American Association of University Women, New York, New York
1985 Individual Artist's Fellowship, Division of the Arts, State of Louisiana

Preferred Sculpture Media
Concrete, Metal (welded) and Wood

Teaching Position
Assistant Professor, State University of New York College at Stony Brook, Stony Brook, New York

Selected Bibliography
"Introductions '78." Ceramics Monthly vol. 26 no. 8 (October 1978) pp. 64-65, illus.
McCarthy, Bridget Beattie. Architectural Crafts: A Handbook and a Catalog. Seattle: Madrona, 1982.
"Reviews Gallery Notes, New Mexico: Here and Now at the Albuquerque Museum." Artspace vol. 5 no. 1 (December-Fall 1980) p. 60.

Gallery Affiliation
Tilden-Foley Gallery
4119 Magazine Street
New Orleans, Louisiana 70118

Mailing Address
State University of New York College at Stony Brook
Deparment of Art
Stony Brook, New York 11794

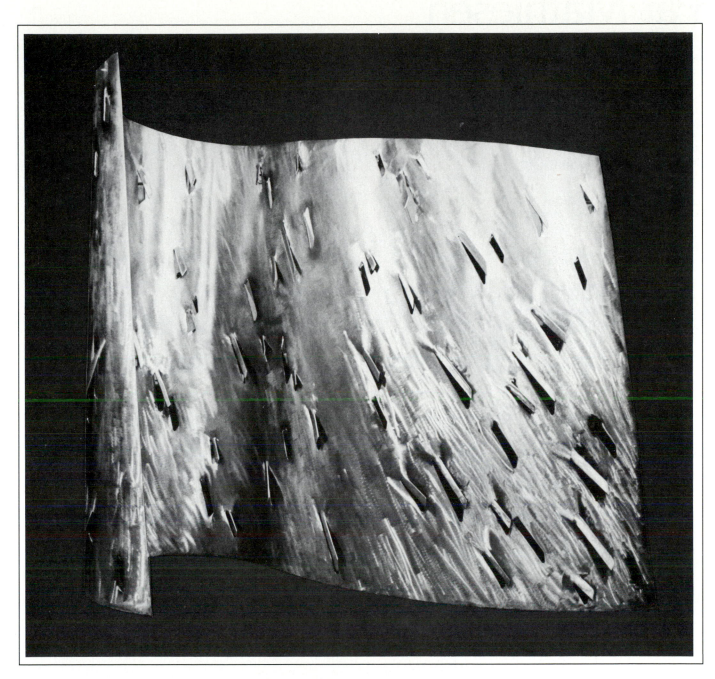

Rainchamber. 1984. Stainless steel and copper plate, 90″h x 120″w x 40″d.

Artist's Statement

"A major goal of my recent work is that the sculpture be a constantly renewing challenge to the viewer, one which changes and grows as the work is experienced through time rather than becoming a closed or finite system. This concern has often led to large-scale works which may be composed of a number of elements. The smaller, more intricate features not only enrich the whole sculpture but serve as counterpoints to the work in its entirety.

"An important element in my sculpture is the idea of territory, the power of a work to impose its own definitions of time and space by means of the viewer's sensory involvement. The scale and the detailed aspects of many of my works reflect this concern as does the desire that each work possess an internal frame. I am interested in creating an 'architecture' for the spirit which allows all parts of the sculpture to be seen as if the layers constitute levels of consciousness or memory. As a sculptor, I attempt to create dialogues between the interior and exterior, the spaces and shadows of the structures. These works have evolved as a complement to ideas concerning, in part, growth and transformation, time, cyclical change and myth."

molly mason

Pat Mathiesen

née Patricia Ann Harmon-Bernard
Born January 15, 1934 North Hollywood,
California

Education and Training
Self-Taught

Selected Individual Exhibition
1984　Empire Federal Savings and Loan,
Bozeman, Montana

Selected Group Exhibitions
1971-　"Annual Contemporary Western Art
85　　Show," Mountain Oyster Club, Tucson,
Arizona
1973　"Selections from Private Arizona
Collections," Tucson Art Center,
Tucson, Arizona
1975　"Solon H. Borglum Memorial Sculpture
Exhibition," National Cowboy Hall of
Fame and Western Heritage Center,
Oklahoma City, Oklahoma

1976　"The West Returns to Grand Central,"
Grand Central Galleries, New York,
New York
1979　"Throwing a Wide Loop: Pat
Mathiesen, Gary Carter and Sam
Senkow," Montana Historical Society,
Helena, Montana
1982,　"National Western Artist Show,"
83　　Lubbock Memorial Civic Center,
Lubbock, Texas
1983,　"Western Heritage Art Classic,"
84　　Western Heritage Center, Billings,
Montana

Selected Public Collections
American Quarter Horse Association,
Amarillo, Texas
Madison Valley Bank, Ennis, Montana
Mountain Oyster Club, Tucson, Arizona
Turf Paradise Race Track, Phoenix, Arizona

Selected Private Collections
Senator and Mrs. Barry Goldwater, Paradise
Valley, Arizona
John K. Goodman, Tucson, Arizona
Robert H. Kieckhefer, Prescott, Arizona
B. F. Phillips, Dallas, Texas
John P. Rubel, Phoenix, Arizona

Preferred Sculpture Media
Clay and Metal (cast)

Selected Bibliography
Goodman, John K. "Pat Mathiesen: Akin to
Her Environment." *Southwest Art* vol. 10
no. 10 (March 1981) pp. 78-83, illus.
Samuels, Peggy and Harold Samuels.
Contemporary Western Artists. Houston:
Southwest Art, 1982.

Gallery Affiliation
May Gallery
7149 Main Street
Scottsdale, Arizona 85251

Mailing Address
Star Route Box 150
West Yellowstone, Montana 59758

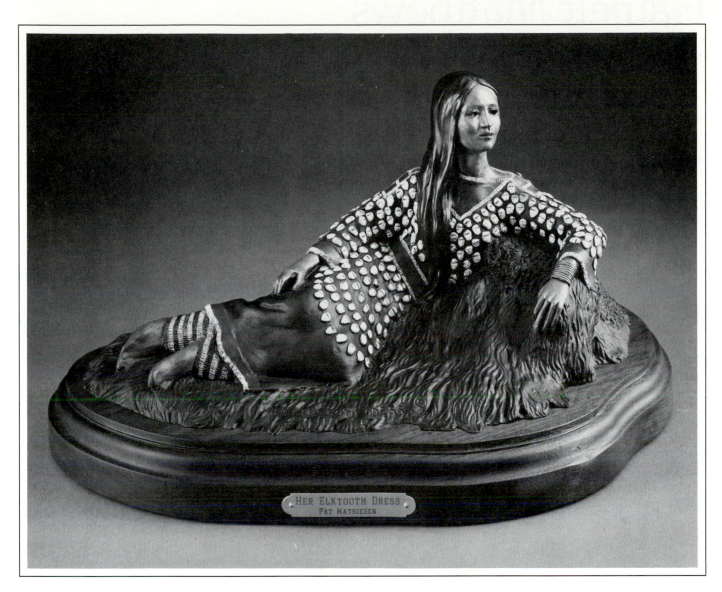

Her Elktooth Dress. Polychromed bronze, 8"h x 16"w. Photograph by Dean Miller.

Artist's Statement

"Art gives meaning to my life. I am inspired by the Montana environment and the Southwestern Indians. I struggle constantly to overcome a lack of formal training with sensitivity and determination. My greatest joy is to attempt to bring to life the strength, courage and beauty of the subjects I admire."

Pat Mathiesen

Harriett Matthews

Born June 21, 1940 Kansas City, Missouri

Education and Training
1960 A.F.A., Art, Sullins Junior College, Bristol, Virginia
1962 B.F.A., Sculpture, University of Georgia, Athens, Georgia
1964 M.F.A., Sculpture, University of Georgia, Athens, Georgia; study with Leonard DeLonga

Selected Individual Exhibitions
1970 Design Studio, Wickford, Rhode Island
1974 Vanderbilt University, Nashville, Tennessee
1974, College of the Atlantic, Bar Harbor,
75 Maine
1975 Frost Gully Gallery, Portland, Maine
1977 Gallery One, University of Maine at Orono, Orono, Maine
1977 Hebron Academy, Hebron, Maine
1977 Joan Whitney Payson Gallery of Art, Portland, Maine
1978 Unity College Gallery, Unity, Maine
1979 Treat Gallery, Bates College, Lewiston, Maine
1982 Art Gallery, University of Southern Maine, Gorham, Maine
1983 Montpelier Cultural Arts Center, Laurel, Maryland
1983 Sandford Gallery, Clarion State College, Clarion, Pennsylvania

Selected Group Exhibitions
1975 "New England Women," DeCordova and Dana Museum and Park, Lincoln, Massachusetts, catalog
1975 "Group Show," Maine Coast Artists Gallery, Rockport, Maine
1976 "Maine Sculpture 1976," University of Maine at Portland-Gorham, Gorham, Maine
1976 "76 Maine Artists," Maine State Museum, Augusta, Maine, catalog
1976 "Expressions from Maine," Traveling Exhibition, Hobe Sound Galleries South, Hobe Sound, Florida, catalog
1976 "Sixth Annual Art Exhibition," Bridgeton Art Gallery, Bridgeton, Maine
1977 "Collection from the Frost Gully Gallery," Unity College Gallery, Unity, Maine
1977 "Drawing and Sculpture Exhibit," Kutztown State College, Kutztown, Pennsylvania
1979 "Spectra I," Joan Whitney Payson Gallery of Art, Portland, Maine
1979 "First Maine Biennial," Bowdoin College Museum of Art, Brunswick, Maine
1979 "Teachers in Art," Maine Coast Artists Gallery, Rockport, Maine
1980 "Art in Embassies Program," United States Embassy, Ottawa, Ontario, Canada, catalog
1981 "Ten Maine Sculptors," Carnegie Hall, University of Maine at Orono, Orono, Maine
1982 "Last National Sculpture Show," University of Georgia, Athens, Georgia, catalog

Selected Public Collections
Casco Bank, Portland, Maine
Colby College Museum of Art, Waterville, Maine
University of Georgia, Athens, Georgia

Selected Private Collections
Mr. and Mrs. John Braude, Cincinnati, Ohio
Willard Cummings Estate, New York, New York
Mr. and Mrs. Louis DuBuque, Greenwich, Connecticut
John E. Kirkpatrick, Tulsa, Oklahoma
Mr. and Mrs. J. R. Witt, Oklahoma City, Oklahoma

Selected Awards
1968, Summer Research Grant, Colby
74 College, Waterville, Maine
1980 Ingram Merrill Grant, Recognition in Sculpture and Teaching, Maine Association for Women in the Fine and Applied Arts

Preferred Sculpture Media
Metal (welded)

Teaching Position
Professor of Art, Colby College, Waterville, Maine

Selected Bibliography
Meader, Abbott. "Profiles: Harriett Matthews (Clinton, Maine)." *ArtCraft Magazine* vol. 1 no. 6 (October-November 1980) p. 45, illus.

Mailing Address
RFD 2
Clinton, Maine 04927

Matera. 1982. Welded steel, wood, Plexiglas tube and fossils, 20″h x 35″w x 35″d.

Artist's Statement

"My work has evolved over the years to express an interpretation of natural forms and the interaction of time and nature with man-made forms. I often combine elements of natural geographic formations with abstract forms of ancient archaelogical sites to create new visual structures with their own aesthetic integrity."

Louise McCagg

née Louise Duncan Heublein
(Husband William Ogden McCagg, Jr.)
Born July 22, 1936 Hartford, Connecticut

Education and Training
1959 B.A., English Literature, Barnard College, New York, New York
1959, Art Students League, New York, New
62- York; study in etching
63
1971 M.F.A., Sculpture, Michigan State University, East Lansing, Michigan; study with Robert Weil

Selected Individual Exhibitions
1976 Fiatal Müvészek Klubja, Budapest, Hungary
1976 Rollie McKenna Studio, Stonington, Connecticut
1977 Warner Communications Gallery, New York, New York
1978 George Sherman Union Gallery, Boston University, Boston, Massachusetts
1981 Center for Creative Arts, Central Michigan University, Mount Pleasant, Michigan
1982 Lyman Allyn Museum, New London, Connecticut

Selected Group Exhibitions
1976 "Fifteen Contemporary Michigan Sculptors," City-Wide Open Air Installation, East Lansing, Michigan, catalog
1979 "Group Exhibition," Stonington Art Gallery, Stonington, Connecticut
1980 "Metal and Glass: Three Women," Freeman Gallery, East Lansing, Michigan
1980 "Seventeen Mid-Michigan Women Artists," Two Doors Down Gallery, Lansing, Michigan
1981 "O.I.A. Contemporary Expression," Brooklyn Federal Courthouse, Brooklyn, New York
1982 "Ten Women Artists," Cummings Art Center, New London, Connecticut
1983 "Second Michigan Fine Arts Competition," Birmingham Bloomfield Art Association, Birmingham, Michigan, catalog
1983 "Eighth Michigan Biennial," Kresge Art Center Gallery, East Lansing, Michigan, catalog
1985 "Louise McCagg and Richard McDermott Miller," Warner Communications Gallery, New York, New York

Selected Public Collections
Dana Hall School, Wellesley, Massachusetts
Ingham County Drain Building, Mason, Michigan
Lyman Allyn Museum, New London, Connecticut

Selected Private Collections
Mr. and Mrs. Miklos Erdely, Budapest, Hungary
Rosalie Thorne McKenna, Stonington, Connecticut
Nancy Stuart, Rochester, New York
Mr. and Mrs. George C. White, New York, New York and Waterford, Connecticut
Dr. and Mrs. Truman Woodruff, East Lansing, Michigan

Preferred Sculpture Media
Clay and Metal (cast)

Additional Art Field
Monoprint

Gallery Affiliation
Dimensions in Art
300 South Washington Avenue
Lansing, Michigan 48933

Mailing Address
6204 Coleman Road
East Lansing, Michigan 48823

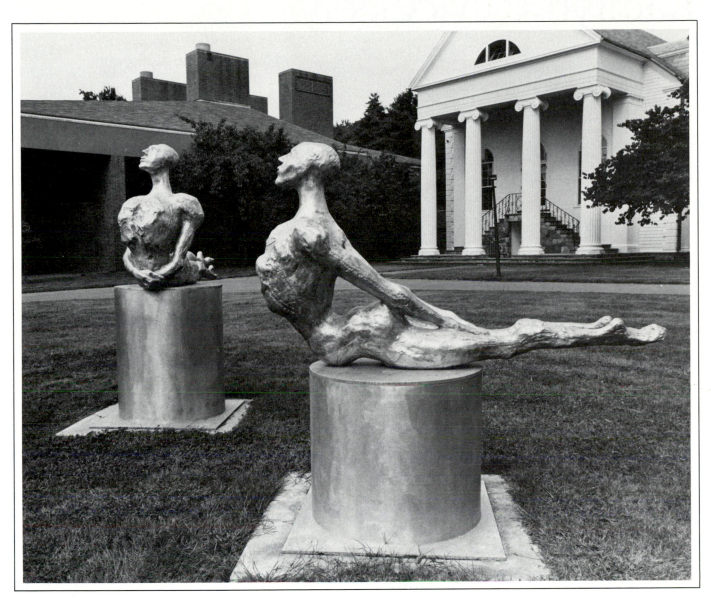

The Grandmother Steps. 1981. *The Visual Arts.* Left: Aluminum, 33"h x 58"w, base 32"h, 26"diameter. *The Literary Arts.* Right: Aluminum, 34"h x 58"w, base 23"h, 26"diameter. Collection Dana Hall School, Wellesley, Massachusetts.

Artist's Statement

"My approach to life has been through art: it has given me a sense of self. I have for years pursued a sculptural expressionism of the human form which is based on a moderate abstraction of anatomy. I work from clay to metal, casting the work myself in my studio foundry.

"Each figure of *The Grandmother Steps* symbolizes an aspect of the endeavors of our effective foremothers: one, the visual arts; the other, the literary arts. Quotations from women in these respective fields are inscribed on the sculpture. The work entreats a quest for endless self-accomplishment through learning. Perhaps viewers will be enticed by the quotations to discover more about the artists who are represented, artists who tussle with the oldest human questions: who are we, where are we going, why?"

397

Kathryn L. McCleery

née Kathryn Louise
Born May 17, 1942 Albany, New York

Education and Training
1965 B.S.Ed., Art and English, Central Michigan University, Mount Pleasant, Michigan
1968 M.F.A., Ceramic Sculpture and Jewelry, Michigan State University, East Lansing, Michigan
1984 Research in architecture and ceramic art with Maallem Lahcen at the invitation of the Government of Morocco
1985 Kagyu Shenpen Kunchab, Santa Fe, New Mexico; research grant in the Tibetan use of visualization and teaching methods

Selected Individual Exhibitions
1976 Linha Gallery, Minot, North Dakota
1982 Rourke Art Gallery, Moorhead, Minnesota
1982 Browning Art Gallery, Grand Forks, North Dakota
1983 Visual Arts Gallery, Hughes Fine Arts Center, University of North Dakota, Grand Forks, North Dakota
1984 Élan Art Gallery, Bismarck, North Dakota
1985 Plains Art Museum, Moorhead, Minnesota

Selected Group Exhibitions
1976 "Indian Images: An Exhibition of Contemporary American Art," Traveling Exhibition, University of North Dakota, Grand Forks, North Dakota (Sponsored by Affiliated State Arts Agencies of the Upper Midwest, Minneapolis, Minnesota; North Dakota American Revolution Bicentennial Commission and National Endowment for the Arts)
1976, "Faculty Exhibition," Visual Arts
78 Gallery, Hughes Fine Arts Center, University of North Dakota, Grand Forks, North Dakota

1979 "North Dakota Made," North Dakota Museum of Art, Grand Forks, North Dakota
1980, "Faculty Biennial Exhibition," Visual
82, Arts Gallery, Hughes Fine Arts Center,
84 University of North Dakota, Grand Forks, North Dakota
1980 "State 1, Eighty 1," Bismarck Art Association, Bismarck, North Dakota
1981, "Invitational Exhibition," Yellowstone
82 Art Center, Billings, Montana
1982, "Annual Midwestern Invitational,"
83, Rourke Art Gallery, Moorhead,
84, Minnesota, catalog
85
1982 "Gallery Invitational," Paul'ard Galleries, Naples, Florida
1982 "Heart Invitational," Plains Art Museum, Moorhead, Minnesota
1983 "Red River Annual," Plains Art Museum, Moorhead, Minnesota, catalog
1983 "Biennial National Art Exhibition," Second Crossing Gallery, Valley City, North Dakota, catalog
1983 "Clay/Fiber as Medium '83," Octagon Center for the Arts, Ames, Iowa
1983 "Fall Exhibition," Bismarck Art Association, Bismarck, North Dakota
1983 "McCleery, McCleery and McElroy," Browning Art Gallery, Grand Forks, North Dakota
1983 "Group Invitational," Plains Art Museum, Moorhead, Minnesota
1984 "Kathryn L. McCleery and Phil Docken," Minnesota Museum of Art, St. Paul, Minnesota
1984 "Group Invitational," North Dakota Museum of Art, Grand Forks, North Dakota

Selected Public Collections
Grand Forks Clinic, Grand Forks, North Dakota
University of North Dakota, Memorial Union Building, Grand Forks, North Dakota

Selected Private Collection
Elizabeth Zinzer, Grand Forks, North Dakota

Selected Awards
1977, Faculty Research Grant, University of
84 North Dakota, Grand Forks, North Dakota
1981 Second Award Medal, "Annual Midwestern Invitational," Rourke Art Gallery, Moorhead, Minnesota, catalog

Preferred Sculpture Media
Clay, Metal (cast) and Varied Media

Additional Art Field
Jewelry

Teaching Position
Associate Professor of Ceramics, University of North Dakota, Grand Forks, North Dakota

Selected Bibliography
Sikes, Toni Fountain. *Architectural Details in Clay, Fiber, Glass, Metal and Wood.* Madison, Wisconsin: Stanton and Lee, 1986.

Gallery Affiliation
Browning Art Gallery
22 North Fourth Street
Grand Forks, North Dakota 58201

Mailing Address
1517 University Avenue
Grand Forks, North Dakota 58201

Artist's Statement

"My sculpture combines ritual objects with toylike qualities which exist between the realms of mystery and play. As a small child I loved beautiful handmade creations with a spirit of their own. I have always worked with my hands and created things—or they have created me. My work is an attempt to evoke the strong sense of delight one experiences before objects of strength and integrity."

Kathryn L. McCleery

Dark Moon. 1983. Stoneware, gold and metallic lusters, copper threads, glass beads and crypt containing irridescent ceramic beetle, 13"h x 7"w x 7"d. Photograph by Gerald D. Olson.

Geraldine McCullough

née Geraldine Hamilton
(Husband Lester McCullough)
Born December 1, 1922 Kingston, Arkansas

Education and Training

1948 B.A.E., School of the Art Institute of Chicago, Chicago, Illinois

1955 M.A.E., Sculpture, School of the Art Institute of Chicago, Chicago, Illinois; study with Egon Wiener

Selected Individual Exhibitions

1967 Ontario East Gallery, Chicago, Illinois

1970 Schenectady Museum and Planetarium, Schenectady, New York

1973 Johnson Publishing Company, Chicago, Illinois

1976 Studio Museum in Harlem, New York, New York

1981 Fermi Laboratory, Batavia, Illinois

Selected Group Exhibitions

1969 "Group Exhibition: Sculpture," Brooklyn Museum, Brooklyn, New York

1972 "Twenty-Fifth Illinois Invitational," Illinois State Museum, Springfield, Illinois, catalog

1975 "Afro-American Art: Sculpture," Herbert F. Johnson Museum of Art, Ithaca, New York

1976 "Twentieth Century Black American Artists," San Jose Museum of Art, San Jose, California

1978 "First Open Air Museum," Chicago Loop Area Locations, Chicago, Illinois (Sponsored by State of Illinois, Art in Public Places Program and Illinois Arts Council)

1981 "Second Annual Atlanta Life National Art Competition and Exhibition," Atlanta Life Insurance, Atlanta, Georgia, catalog

Selected Public Collections

Amway Corporation, Machinac, Michigan

Atlanta Life Insurance, Atlanta, Georgia

Bennett Mill Park, Geneva, Illinois

City of Atlanta, Georgia

Concordia College, River Forest, Illinois

Delta Sigma Theta Sorority National Headquarters, Washington, D.C.

DuSable Museum of African American History, Chicago, Illinois

Herbert F. Johnson Museum of Art, Ithaca, New York

Johnson Publishing Company, Chicago, Illinois

Lovejoy Manufacturing Company, Downers Grove, Illinois

Maywood Village Hall, Maywood, Illinois

Oak Park Village Hall, Oak Park, Illinois

Peace Museum, Chicago, Illinois

San Jose Museum of Art, San Jose, California

Westside Development Company, Martin Luther King, Jr. Plaza, Chicago, Illinois

Selected Private Collections

John H. Johnson, Chicago, Illinois

Dr. Erich Nussbaum, Schenectady, New York

Dr. William Shack, Berkeley, California

Dr. Arthur Shima, Oak Park, Illinois

Whitney Young Family Collection, Chicago, Illinois

Selected Awards

1964 George D. Widener Memorial Gold Medal, "One Hundred and Fifty-Ninth Annual Exhibition of Painting and Sculpture," Pennsylvania Academy of the Fine Arts, Philadelphia, Pennsylvania, catalog

1970 First Place, "1970 Alumni Exhibition of the School of the Art Institute of Chicago," School of the Art Institute of Chicago, Chicago, Illinois

1982 First Place, "Third Annual Atlanta Life National Art Competition and Exhibition," Atlanta Life Insurance, Atlanta, Georgia, catalog

Preferred Sculpture Media

Metal (cast), Metal (welded) and Plastic (polyester resin)

Teaching Position

Professor of Art and Chair, Department of Art, Rosary College, River Forest, Illinois

Selected Bibliography

Adams, Russell L. *Great Negroes, Past and Present*. Chicago: Afro-American, 1969.

Bach, Ira J. and Mary Lackritz Gray. *A Guide to Chicago's Public Sculpture*. Chicago: University of Chicago Press, 1983.

Bims, Hamilton. "A Sculptor Looks At Martin Luther King." *Ebony* vol. 28 no. 6 (April 1973) pp. 95-96, 98, 102, 104-105, illus.

Canaday, John. "Art: Debutante and a Grand Old Man." *The New York Times* (Thursday, January 16, 1964) p. L22.

Mailing Address

117 South Lombard Avenue
Oak Park, Illinois 60302

Artist's Statement

"I find it very difficult to write about myself and even harder to write about '*my* art world.' I can only say that from a very early age I knew exactly what I wanted to be—and that was an 'Artist.' I have never felt the road would be an easy one, and I was, and am, always mindful that *I* must be qualified, that I must always work hard to be a better artist, for myself, then hopefully for others.

"From the earliest times until today human beings the world over have given expression to experiences in concrete, tangible form because this has always been essential to well-being. Yet, with its mysterious, intangible, indefinable nature, to write about one's own reasons, one's own creativity, one's own inner strength, one's personal world of the art object is much like the first utterance of the Taoist—'The Tao that is spoken is not the Tao.'"

Geraldine McCullough

Dr. Martin Luther King, Jr.: Our King. 1973. Bronze, 7′h x 2½′w x 2½′d. Collection Westside Development Company, Martin Luther King, Jr. Plaza, Chicago, Illinois. Photograph by Emil Warncke.

Linda Williams McCune

née Linda Gail Williams
(Husband William Derryman McCune II)
Born September 29, 1950 Dyersburg,
Tennessee

Education and Training
1974 B.F.A., Painting and Drawing,
 University of Tennessee, Knoxville,
 Knoxville, Tennessee
1976 Elementary and Secondary Art
 Education Certification, University of
 Tennessee, Knoxville, Knoxville,
 Tennessee
1982 M.F.A., Painting and Sculpture,
 University of South Carolina,
 Columbia, South Carolina

Selected Individual Exhibitions
1983 Columbia Museums of Art & Science,
 Columbia, South Carolina
1985 Nexus Gallery, Atlanta, Georgia
1985 Greenville County Museum of Art,
 Greenville, South Carolina

Selected Group Exhibitions
1981- "Collage & Assemblage," Mississippi
84 Museum of Art, Jackson, Mississippi;
 Tampa Museum, Tampa, Florida;
 Alexandria Museum, Visual Art Center,
 Alexandria, Louisiana; Roanoke
 Museum of Fine Arts, Roanoke,
 Virginia; Roberson Center For The
 Arts And Sciences, Binghamton, New
 York; Tucson Museum of Art, Tucson,
 Arizona; Hunter Museum of Art,
 Chattanooga, Tennessee, catalog
1983 "The Figure: New Form and New
 Function," Arrowmont School of Arts
 and Crafts, Gatlinburg, Tennessee,
 catalog
1984 "Celebration of the South," Historic
 Columbia Foundation Carriage House,
 Robert Mills House, Columbia, South
 Carolina
1984 "Artist and Scientist Conference on
 Nuclear Disarmament," Savan River
 Plant, Aiken, South Carolina and
 Trinity United Methodist Church
 Auditorium, Aiken, South Carolina

Preferred Sculpture Media
Varied Media

Additional Art Fields
Drawing and Painting

Related Profession
Art Instructor

Selected Bibliography
Langer, Sandra L. "Reviews Linda Williams
 McCune, Jerome Witkin: The Columbia
 Museum of Art, Columbia, South Carolina."
 Art Papers vol. 7 no. 5
 (September-October 1983) p. 16, illus.
Lieberman, Laura C. "Reviews Collage and
 Assemblage: Mississippi Museum of Art,
 Jackson, Mississippi." *Art Papers* vol. 5 no.
 6 (November-December 1981) pp. 18-19.

Mailing Address
Route 1 Box 361
Allendale, South Carolina 29810

Artist's Statement

"My assemblages are biographical and autobiographical works relating to particular memories of special people and places. They are relics or reliquaries which are part of a ceremonial association between past actions and experiences magnified by their importance within the bonds of family relationships. Four themes in these figurative representations are the genesis of my ideas: memory, self-concept, sanity and insanity involving the relationship of cancellation, defeats and destruction to the quality of life.

"I combine traditional handwork, craft techniques, furniture and building construction methods with my academic training in painting, drawing and sculpture. Elements of each work are scavenged from remembered places, searched for in abandoned houses and junkyards, to most closely approximate the particular item needed for the special meanings inferred. The finished work is most successful when it transcends my traditions and joins with broadly understood and interpreted visual metaphors and symbols."

Slew Series: Ruby No. 4. 1982. Mahogany, etched glass, cloth, wallpaper, family documents, artificial grapevines, Dyer County dirt, metallic threads and oil paint, 35"h x 22"w x 17"d, base 36"h x 24"w x 19"d. Photograph by Hunter Clarkson and Joe Topper.

Joyce McDaniel

née Joyce Lea Kirchner
(Husband Paul R. McDaniel)
Born February 5, 1936 Oklahoma City,
Oklahoma

Education and Training
1958 B.B.A., Finance, University of
Oklahoma, Norman, Oklahoma
1973 B.A., Fine Arts, Boston College,
Boston, Massachusetts
1976 M.A., Art History, Wellesley College,
Wellesley, Massachusetts
1982 M.F.A., Sculpture, School of the
Museum of Fine Arts, Boston,
Massachusetts and Tufts University,
Medford, Massachusetts

Selected Individual Exhibitions
1981 Hess Gallery, Pine Manor College,
Chestnut Hill, Massachusetts
1982 Gallery Eleven, Tufts University,
Medford, Massachusetts
1982 Gallery 410, University of Lowell,
Lowell, Massachusetts
1983 Immig Gallery, Emmanuel College,
Boston, Massachusetts

Selected Group Exhibitions
1977, "New England Exhibition of Sculpture
79, and Painting," Silvermine Guild of
80 Artists, New Canaan, Connecticut,
catalog
1978, "Faculty Exhibition," Gallery 410,
79 University of Lowell, Lowell,
Massachusetts
1979 "School of the Museum of Fine Arts
Annual Exhibition," Boston Center for
the Arts, Boston, Massachusetts
1980 "Boston Artists Celebrate Boston,
Boston Visual Artists Union," Boston
Center for the Arts, Boston,
Massachusetts

1980 "Open Show," Boston Visual Artists
Union, Boston, Massachusetts
1980 "Museum School at Milton Academy,"
Nesto Gallery, Milton Academy, Milton,
Massachusetts
1980 "Recent Sculpture: School of the
Museum of Fine Arts," Museum
School Gallery, School of the Museum
of Fine Arts, Boston, Massachusetts
1981 "Sculpture," Montserrat School of
Visual Art, Beverly, Massachusetts
1982 "Martha Lloyd and Joyce McDaniel,"
Gallery NAGA, Boston, Massachusetts
1982 "City Hall Show, Boston Visual Artists
Union," Boston City Hall, Boston,
Massachusetts
1983- "Abstract Art in New England," Art
84 Gallery, Plymouth State College of the
University System of New Hampshire;
Danforth Museum, Framingham,
Massachusetts; Stamford Museum
and Nature Center, Stamford,
Connecticut; Art Complex Museum,
Duxbury, Massachusetts, catalog
1983 "Joyce McDaniel and Greg Lefevre,"
Clark Gallery, Lincoln, Massachusetts
1983 "Interim I: An Exhibition of
Contemporary Outdoor Sculpture,"
Chesterwood, Stockbridge,
Massachusetts
1984 "Invitational Exhibition of
Contemporary Painting and Sculpture
by Boston Area Artists," Brockton Art
Museum/Fuller Memorial, Brockton,
Massachusetts

Selected Private Collections
David and Verta Driver, Seattle, Washington
Meri Goyette, Boston, Massachusetts
Steven and Barbara Grossman, Brookline,
Massachusetts
Sarah Supplee, Lowell, Massachusetts

Selected Awards
1979 Sculpture Prize, "Boit Exhibition,"
Museum School Gallery, School of the
Museum of Fine Arts, Boston,
Massachusetts
1984 Individual Artist's Fellowship, National
Endowment for the Arts

Preferred Sculpture Media
Metal (welded) and Wood

Teaching Position
Associate Instructor of Sculpture and Faculty
Coordinator, M.F.A. Program, School of the
Museum of Fine Arts, Boston,
Massachusetts

Selected Bibliography
Lighthill, Amy. "Regional Reviews
Massachusetts, Gallery NAGA/Boston:
Martha Lloyd; Joyce McDaniel." *Art New
England* vol. 3 no. 5 (April 1982) p. 8, illus.
Swan, John. "Regional Reviews
Massachusetts, Danforth
Museum/Framingham: Abstract Art in New

England." *Art New England* vol. 4 no. 5
(April 1983) p. 8, illus.

Gallery Affiliation
Clark Gallery
Box 339
The Mall at Lincoln Station
Lincoln, Massachusetts 01773

Mailing Address
27 Orient Avenue
Newton, Massachusetts 02159

Idabel. 1982. Welded steel, 45″h x 44″w x 52″d.
Photograph by Sharon White.

Artist's Statement

"Sculpture is a process of discovery, discovery of underlying forces and forms operative in nature and in human experience. My purpose is not to borrow from the visible world but rather to perceive and to reveal dynamic forces active in life and in nature by creating totally new forms. I explore seemingly paradoxical notions by using welded steel which is heavy, yet can appear light; is rigid, yet malleable to create precariously balanced, open forms which are stable, yet not static."

Joyce McDaniel

Isabel McIlvain

Born December 21, 1943 West Chester, Pennsylvania

Education and Training
1966 B.A., Art, Smith College, Northampton, Massachusetts
1969- Study in painting with Michael Aviano, 70 New York, New York
1972 M.F.A., Sculpture, Pratt Institute, Brooklyn, New York

Selected Individual Exhibitions
1975, Washington and Lee University, 79 Lexington, Virginia
1977 Gallery 4 x 10, New York, New York
1977 Sweet Briar College, Sweet Briar, Virginia
1978 Haverford College, Haverford, Pennsylvania
1980 Bridgewater College, Bridgewater, Virginia
1980 Roanoke College, Salem, Virginia
1982, Robert Schoelkopf Gallery, New York, 85 New York
1982 University of Virginia Art Museum, Charlottesville, Virginia

Selected Group Exhibitions
1975 "The Spring Purchase Exhibition," Weatherspoon Art Gallery, Greensboro, North Carolina
1976 "Sculptors Guild Annual Exhibition," Lever House, New York, New York, catalog
1979 "The Figure in Sculpture," Virginia Museum of Fine Arts, Richmond, Virginia
1980- "Sculpture in the 70s: The Figure," 82 Pratt Manhattan Gallery, New York, New York; Pratt Institute Gallery, Brooklyn, New York; Arkansas Arts Center, Little Rock, Arkansas; University of Oklahoma, Norman, Oklahoma; Arizona State University, Tempe, Arizona; Hood Museum of Art, Hanover, New Hampshire, catalog

1981- "Real, Really Real, SUPER REAL: 82 Directions in Contemporary American Realism," San Antonio Museum of Art, San Antonio, Texas; Indianapolis Museum of Art, Indianapolis, Indiana; Tucson Museum of Art, Tucson, Arizona; Museum of Art, Carnegie Institute, Pittsburgh, Pennsylvania, catalog
1981 "Contemporary American Realism Since 1960," Traveling Exhibition, Pennsylvania Academy of the Fine Arts, Philadelphia, Pennsylvania, catalog
1982 "20 Sculptors," Institute of Contemporary Art of the Virginia Museum of Fine Arts, Richmond, Virginia
1982 "American Landscape Art," University of Virginia Art Museum, Charlottesville, Virginia
1983 "Faces Since the 50s," Center Gallery, Bucknell University, Lewisburg, Pennsylvania, catalog

Selected Public Collections
Sweet Briar College, Sweet Briar, Virginia
Washington and Lee University, Lexington, Virginia
Weatherspoon Art Gallery, Greensboro, North Carolina

Selected Private Collections
Peter Agostini Collection, New York, New York
The FORBES Magazine Collection, New York, New York
Graham Gund Collection, Boston, Massachusetts
Brad and Marjorie Lee, Philadelphia, Pennsylvania
Mr. and Mrs. Sydney Lewis, Richmond, Virginia

Selected Awards
1966 Alpha Award Scholarship, Smith College, Northampton, Massachusetts
1980 Glenn Grant, Washington and Lee University, Lexington, Virginia
1983 Individual Artist's Fellowship, Massachusetts Council on the Arts and Humanities

Preferred Sculpture Media
Clay and Metal (cast)

Teaching Position
Assistant Professor, Boston University, Boston, Massachusetts

Selected Bibliography
Bass, Ruth. "New York Reviews: Alive and Well in the '70s." Art News vol. 80 no. 2 (February 1981) p. 214.
Glueck, Grace. "Art: Sculptured Figures Of 70's at Pratt Gallery." The New York Times (Friday, November 7, 1980) p. C19.

Goodyear, Frank H. Contemporary American Realism Since 1960. Boston: New York Graphic Society, 1981.
Stolbach, Michael Hunt. "Arts Reviews: Artists' Choice." Arts Magazine vol. 55 no. 3 (November 1980) pp. 23-24, illus.
Zimmer, William. "Arts Reviews: Isabel McIlvain." Arts Magazine vol. 51 no. 10 (June 1977) p. 37.

Gallery Affiliation
Robert Schoelkopf Gallery
50 West 57 Street
New York, New York 10019

Mailing Address
214 Bedford Street
Boston, Massachusetts 01742

Artist's Statement

"For me, the initial impulse to make a sculpture comes from a sense of beauty in something natural, a connectedness and significance. It is therefore important to me to make objects with this reference. It allows the beauty in a small sculpture to expand from its location to a much bigger sense of the beauty of all life.

"I have wanted above all to have biological life be beautiful. I want it to be the biology of evolution, with its irregularities and assymetrical development, its amazing variety, rather than the regular, conceptual, ordered, and 'properly' proportioned classical forms of a thinking 'creator.' I have thought of my work as expressing a reality which is characterized by a structure and order veiled with incidental chaos. This chaos, or the accidents on the structure, permits the evolution and its elegant complexity. In addition, the chaos, in its struggle with the structure, provides a visual analogy with the events and emotions of experience.

"It is difficult to define because the feelings I am trying to elicit in the viewer, my feelings, are feelings. Like the rest of reality, they have some structure but are surrounded by a haze. The haze, which is not definable, is like the veil of chaos over the structure of natural forms. It is essential to the feeling, to the mysteriousness. My effort to express the feeling of life which has no expository definition is the purpose of art. In the end, I am making things because they are, to me, intensely meaningful and beautiful."

Isabel McIlwain

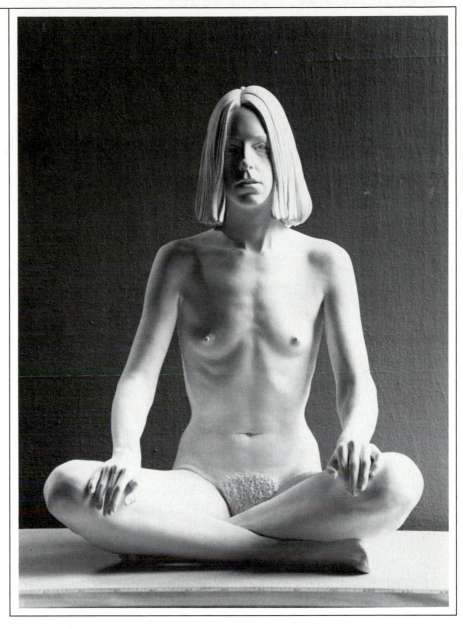

Seated Figure (Jean). 1981. Hydrocal, 15"h.

Sally McKenna

née Sally Jane Gerhardt
Born December 28, 1943 Milwaukee,
 Wisconsin

Education and Training
1972 B.A., Art, Arizona State University,
 Tempe, Arizona
1973 B.A., Art Education, Arizona State
 University, Tempe, Arizona; study in
 sculpture with Ben Goo
1975- Scottsdale Vocational-Technical
76 Training Center, Scottsdale, Arizona;
 study in welding techniques

Selected Individual Exhibitions
1977 United Bank, Tempe, Arizona
1981 Phoenix College, Phoenix, Arizona

Selected Group Exhibitions
1978 "Ninth Scottsdale Arts Festival,"
 Scottsdale Center for the Arts,
 Scottsdale, Arizona
1978 "State of Arizona Crafts '78,"
 Scottsdale Center for the Arts,
 Scottsdale, Arizona
1978 "Pacific States Crafts Show and Fair,"
 Pier 10, San Francisco, California
1978 "Arizona Designer Craftsmen," Phoenix
 College, Phoenix, Arizona
1979 "Premier Exhibition," Alley Gallery,
 Scottsdale, Arizona
1980, "Crafts for the Elegant 80s," Cary
81 Windsor Gallery, Richmond, Virginia
1980 "Arizona Designer Craftsmen,"
 Memorial Union Gallery, Arizona State
 University, Tempe, Arizona
1980 "Winter Olympic Art Festival," Olympic
 Village, Lake Placid, New York

1980 "National Crafts Invitational," Mullaly
 Matisse Gallery, Birmingham, Michigan
1980 "Southwestern Crafts Invitational,"
 Contemporary Artisans Gallery, San
 Francisco, California
1980 "Premier Exhibition," Joy Tash Gallery,
 Scottsdale, Arizona
1981 "Sculptural Breakthroughs," Mindscape
 Gallery, Evanston, Illinois
1982 "The Craftsman's Palette: Designed
 For Color," Craftsmen's Gallery,
 Scarsdale, New York
1983 "Sally McKenna and Dennis
 Numkena," Von Grabill Gallery,
 Scottsdale, Arizona
1983 "National Fiber Invitational," Fine Arts
 Center of Tempe, Tempe, Arizona
1983 "Arizona Women's Fine Arts
 Invitational," Fine Arts Center of
 Tempe, Tempe, Arizona
1984 "Sally McKenna, Sculpture; Dorna,
 Paintings and Ed Nesteruk, Glass," J.
 Rosenthal Fine Art, Chicago, Illinois

Selected Public Collections
American Telephone and Telegraph, Denver,
 Colorado
Amoco Corporation, Denver, Colorado
Broadway Southwest, Tucson, Arizona
City of Glendale, City Hall, Glendale, Arizona
Courson Oil Company, Perryton, Texas
Cox and Cox Oil Company, Denver, Colorado
Crested Butte Mountain Resort, Crested
 Butte, Colorado
First Vermont Bank, Brattleboro, Vermont
Frio Oil Company, Denver, Colorado
Great Western Life, Denver, Colorado
Imperial Savings and Loan, San Diego,
 California
Mountain Bell Corporation, Tucson, Arizona
Petro Lewis Corporation, Denver, Colorado
Siteman Organization, St. Louis, Missouri
Subaru Corporation, Denver, Colorado
Woodlands Academy of the Sacred Heart,
 Lake Forest, Illinois
Zickefoose Dagg and Partners, Calgary,
 Alberta, Canada

Selected Private Collections
Dr. and Mrs. Robert Charnetsky, Litchfield
 Park, Arizona
Mr. and Mrs. Jack Keller, Phoenix, Arizona
John McCullough, Chicago, Illinois
Mr. and Mrs. Michael Watts, Paradise Valley,
 Arizona
Mary Ann Willis, Anna, Illinois

Preferred Sculpture Media
Fiber, Metal (welded) and Varied Media

Additional Art Fields
Drawing and Painting

Selected Bibliography
Miles, Candice St. Jacques. "Gallery: Sally
 McKenna Walker's Sculpture: Tension
 Resolved Through Balance." *Fiberarts* vol.
 11 no. 4 (July-August 1984) pp. 14-15,
 illus.

Gallery Affiliations
A R T Beasley
2802 Juan Street
San Diego, California 92110

Carson-Sapiro Art Gallery
2601 Blake Street
Denver, Colorado 80205

J. Rosenthal Fine Art
212 West Superior-200
Chicago, Illinois 60610

Mailing Address
Star Route 2 Box 321
Cave Creek, Arizona 85331

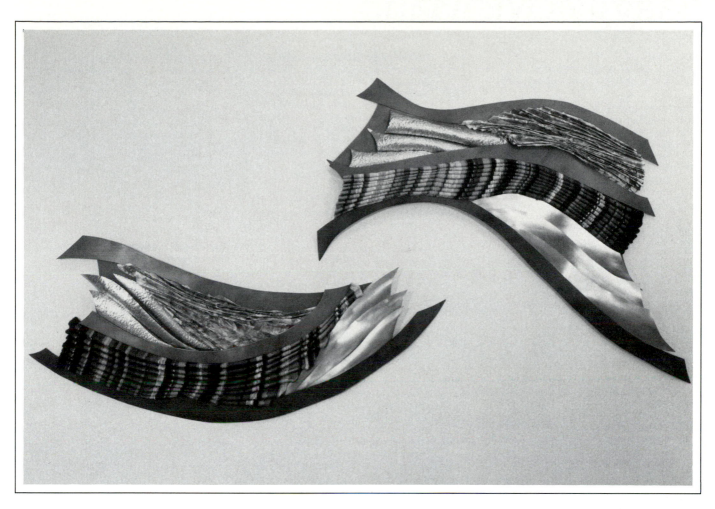

Canyon Duet. 1984. Steel, copper, veiled paper and fiber. Left: 5½″h x 2½″w x 3″d. Right: 5½″h x 3½″w x 4″d. Collection City of Glendale, City Hall, Glendale, Arizona. Photograph by Robert E. Sherwood.

Artist's Statement

"My sculpture has mirrored the development of my own personality and maturation. My main art influences are found in my childhood. The technical skills which demanded mastery were achieved through a family heritage of textile skills, art school training and technical school exposure. The formal art training was valuable in redefining a natural gift for design and color.

"My technical capabilities of assembling sculpture grew with the need for greater complexity of design. The possibilities of creating my own fabric that was heavy enough to hold its own soft fold and vibrant enough to assuage my desire for color began with a flat tightly constricted pod form and a traditional steel enclosed rectangle. Implied in my work is the containment and restriction of energy found in natural life forms and elemental forces and the promise of eventual fruition.

"The paradox of the sculptor's art is that the physical means of its creation are hidden to the viewer. Emotionally sculpture will always be for me a wave of the magician's wand."

Sally McKenna

409

Maggie McMahon

née Margaret Anne McNaught
(Husband Edward Howard McMahon, Jr.)
Born June 9, 1946 Arlington, Massachusetts

Education and Training
1964-65 Rutgers University, Douglass College, New Brunswick, New Jersey
1970 B.S., Fine Art, New York University, New York, New York
1981 M.F.A, Ceramics and Sculpture, College of Architecture, Clemson University, Clemson, South Carolina; study in sculpture with John Acorn

Selected Individual Exhibitions
1980 Anderson Art Center, Anderson, South Carolina
1981 Lander College Art Gallery, Greenwood, South Carolina
1982 Fine Arts Center Gallery, Francis Marion College, Florence, South Carolina, catalog
1983 Winthrop College, Rock Hill, South Carolina
1983 Gallery One, Spirit Square Art Center, Charlotte, North Carolina
1984 Milliken Gallery, Converse College, Spartanburg, South Carolina, catalog
1984 Cecelia Coker Bell Art Gallery, Coker College, Hartsville, South Carolina
1985 Trustees Gallery, Columbia Museum of Arts & Sciences, Columbia, South Carolina, catalog
1985 Arthur Vincent Gallery, Columbia, Missouri

Selected Group Exhibitions
1979 "Forty-Seventh Southeastern Painting and Sculpture Competition," Southeastern Center for Contemporary Art, Winston-Salem, North Carolina
1979 "Selections from Southeastern Center for Contemporary Art," University of Georgia, Athens, Georgia
1980 "Nine," Anderson Art Center, Anderson, South Carolina
1980 "Upper Savannah Three-Dimensional Exhibition," Lander College Art Gallery, Greenwood, South Carolina
1980 "Annual Juried Exhibition," Pickens County Art Museum, Pickens, South Carolina
1980 "National Paper and Clay Exhibition," Memphis State University, Memphis, Tennessee, catalog
1980 "Ceramics Southeast," University of Georgia, Athens, Georgia, catalog
1980 "Tradition in the Making," Atlanta College of Art Gallery, Atlanta, Georgia; Madison-Morgan Cultural Center, Madison, Georgia, catalog
1980 "Terry Jarrard-Dimond and Maggie McMahon," Anderson Art Center, Anderson, South Carolina
1981 "Southeast College Art Conference Ceramics Invitational," University Museums, University, Mississippi
1981 "Southern Exposure II," Art Center Association, The Water Tower, Louisville, Kentucky
1982 "Tri-State Sculptors Invitational," Horace Williams House, Chapel Hill, North Carolina
1982 "National Drawing and Small Sculpture Show," Ball State University, Muncie, Indiana, catalog
1983 "Fourth Biennial Paper and Clay Exhibition," University Gallery, Communication and Fine Arts Building, Memphis State University, Memphis, Tennessee, catalog
1983 "South Carolina Arts Commission Annual Juried Exhibition," Columbia College, Columbia, South Carolina, catalog
1983 "Clamps/Closures/Constraints," Gallery One, Spirit Square Art Center, Charlotte, North Carolina
1984 "National Women's Art Exhibition, Louisiana World Exhibition," World's Fair, New Orleans, Louisiana
1984 "Southeastern Women's Caucus for Art Invitational Exhibition: Caryl Toth, Maggie McMahon, Kathleen Jardine and Ann Wenz," Rowe Art Gallery, Rowe Arts Center, University of North Carolina, Charlotte, North Carolina
1984 "Five-Fold," Holly Magill Gallery, Greenville County Museum of Art, Greenville, South Carolina
1984 "U.S.A. Portrait of the South," Traveling Exhibition, Palazzo Venezia, Rome, Italy, catalog
1984 "Tri-State Sculptors," Queens College, Charlotte, North Carolina (Sponsored by Mint Museum of Art, Charlotte, North Carolina; Queens College, Charlotte, North Carolina and Tri-State Sculptors), catalog
1984 "Ceramics Invitational," Southeastern Center for Contemporary Art, Winston-Salem, North Carolina
1985 "Rome Exhibit: Portrait of South Carolina," Traveling Exhibition, Art and Music Center Gallery, Columbia College, Columbia, South Carolina, catalog

Selected Public Collection
South Carolina State Art Collection, Columbia, South Carolina

Selected Awards
1982 Juror's Award, "Ceramics Southeast," University of Georgia, Athens, Georgia
1984 Juror's Award, "Southern Exposure IV," Ponder Fine Arts Center, Benedict College, Columbia, South Carolina
1985 Regional Fellowship for Emerging Artists, Southern Arts Federation, Atlanta, Georgia and National Endowment for the Arts

Preferred Sculpture Media
Varied Media

Additional Art Field
Functional Ceramics

Related Profession
Art Instructor

Gallery Affiliation
Hodges Taylor Gallery
227 North Tryon Street
Charlotte, North Carolina 28202

Mailing Address
1053 Sunset Drive
Signal Mountain, Tennessee 37377

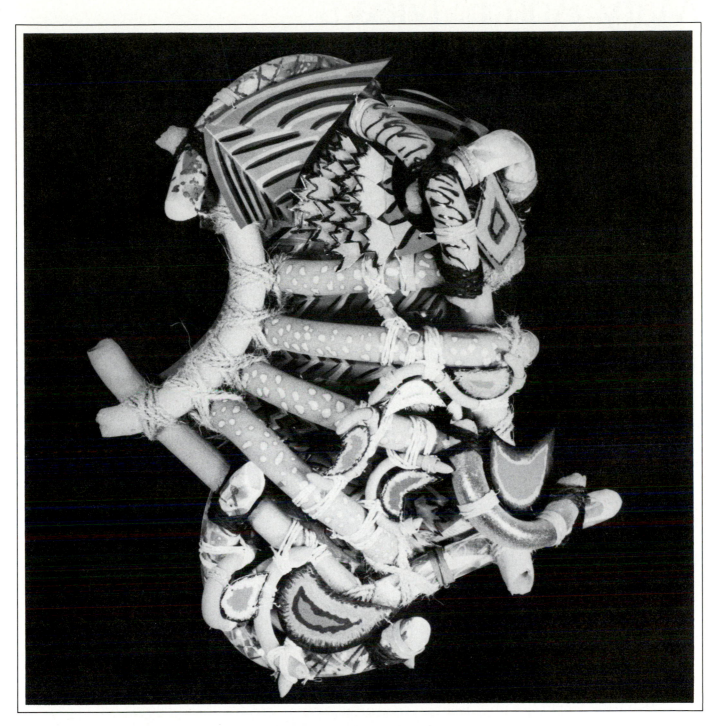

Secret Survivor. 1984. Mixed media, 26"h x 24"w x 8"d. Photograph by Carl Bergman.

Artist's Statement

"The skeletons of my structures are constructed from clay and fiber. The flat painted areas are either paper or metal. Occasionally the metal planes are encrusted with beads, fiber or additional metal pieces. The objects have their roots in my experiences and need to comprehend the structure of the physical world. They also function as connective tissue between myself and those makers of other places and times. The activity of building these structures gives me a feeling of power, control and understanding of my life and environment."

Maggie M. Anton

411

Mary Ann E. Mears

née Mary Ann E. Elizabeth
(Husband Robert Campbell Embry, Jr.)
Born September 5, 1946 Chatham, New
 Jersey

Education and Training
1968 B.A., Studio Art, Mount Holyoke
 College, South Hadley,
 Massachusetts; study in sculpture
 with Leonard DeLonga
1971 M.A., Creative Arts, New York
 University, New York, New York; study
 in sculpture with Richard Budelis and
 James Wines

Selected Individual Exhibitions
1973 University of Baltimore, Baltimore,
 Maryland
1982 C. Grimaldis Gallery, Baltimore,
 Maryland

Selected Group Exhibitions
1970- "Annual Faculty Exhibition,"
 76 Community College of Baltimore,
 Baltimore, Maryland
1974 "Artists Equity Exhibition," Holtzman
 Art Gallery, Towson State University,
 Baltimore, Maryland
1974 "Exhibition of Work by Women Artists,"
 Johns Hopkins University, Baltimore,
 Maryland
1974 "Group Exhibition," The Mansion,
 Fairleigh Dickinson University
 Florham-Madison Campus, Madison,
 New Jersey
1974 "Sculpture Exhibition," Montgomery
 College-Rockville Campus, Rockville,
 Maryland
1974 "Maryland Biennial '74," Baltimore
 Museum of Art, Baltimore, Maryland,
 catalog
1975 "The Moving Eye," Baltimore Museum
 of Art, Baltimore, Maryland
1975, "Baltimore Arts Festival," Hopkins
 79 Plaza, Baltimore, Maryland
1975 "Third Annual Washington Area
 Outdoor Sculpture Exhibition," Textile
 Museum, Washington, D.C.
1975 "Invitational Sculpture Exhibition," Inner
 Harbor Sculpture Garden, Baltimore,
 Maryland
1976 "Mayor's Bicentennial Ball for the Arts
 Art Exhibition," Baltimore Convention
 Center, Baltimore, Maryland

1980 "Recent Works by Tammra Sigler and
 Mary Ann Mears," Tuttle Gallery,
 McDonogh School, Baltimore,
 Maryland
1980 "Sculpture 1980," Maryland Institute
 College of Art, Baltimore, Maryland,
 catalog
1980, "Mayor's Ball for the Arts Art
 84 Exhibition," Baltimore Convention
 Center, Baltimore, Maryland
1981 "Six from Mount Holyoke," Mount
 Holyoke College Art Museum, South
 Hadley, Massachusetts
1981 "Maryland Artists," University of
 Maryland University College, College
 Park, Maryland, catalog
1981 "Works by Maryland Artists for Hyatt
 Regency, Baltimore," Maryland State
 Arts Council, Baltimore, Maryland,
 catalog
1982 "Sculpture '82," Beaver College,
 Glenside, Pennsylvania (Co-Sponsored
 by Cheltenham Art Centre,
 Cheltenham, Pennsylvania)
1982 "Portrait of a Young Gallery: Year
 Five," C. Grimaldis Gallery, Baltimore,
 Maryland
1983- "1983-1984 Sculpture Garden II," South
 84 Beach Psychiatric Center, Staten
 Island, New York
1984 "Sculpture Garden Two," Snug Harbor
 Cultural Center, Staten Island, New
 York
1984 "Sculpture Garden Two, Maquettes
 and Drawings from South Beach,"
 Newhouse Gallery, Staten Island, New
 York
1984 "Past and Present: A Goucher Faculty
 Selection," Rosenberg Gallery,
 Goucher College, Towson, Maryland
1984, "Benefit Art Sale," Maryland Art Place,
 85 Baltimore, Maryland, catalog

Selected Public Collections
Bethesda Metro Center, Columbia, Maryland
City of Baltimore, Inner Harbor, Baltimore,
 Maryland
City of Kawasaki, Japan
Ella Grasso Regional Center, Stratford,
 Connecticut
Fort Worthington Recreation Center and
 Library, Baltimore, Maryland
Hyatt Regency Hotel, Baltimore, Maryland
Northeast Middle School, Baltimore, Maryland
Notre Dame School for Girls, Baltimore,
 Maryland
Rainbow Centre, Niagara Falls, New York
Snowden Center, Columbia, Maryland
Trapper's Alley, Detroit, Michigan
United Iron & Metal Company, Baltimore,
 Maryland
White Marsh Mall, White Marsh, Maryland

Selected Private Collections
Mr. and Mrs. Paul L. Cordish, Baltimore,
 Maryland
Howard N. Fox, College Park, Maryland
Mr. and Mrs. Thomas P. Perkins III, Baltimore,
 Maryland

Mr. and Mrs. Sidney Silber, Lutherville,
 Maryland
Mr. and Mrs. Lawrence B. Simons,
 Washington, D.C.

Selected Awards
1975 Merit Award, "Easton Academy of the
 Arts Annual Juried Exhibition,"
 Academy of the Arts, Easton,
 Maryland
1976 Merit Award, "Baltimore Arts Festival,"
 Hopkins Plaza, Baltimore, Maryland
1976 Merit Award, "1976 Biennial
 Exhibition," Baltimore Museum of Art,
 Baltimore, Maryland, catalog

Preferred Sculpture Media
Metal (welded)

Additional Art Fields
Drawing and Printmaking

Selected Bibliography
Stevens, Elisabeth. "Baltimore Renovates,
 Rebuilds and Revitalizes." Art News vol. 81
 no. 8 (October 1982) pp. 94-97.

Gallery Affiliation
C. Grimaldis Gallery
928 North Charles Street
Baltimore, Maryland 21202

Mailing Address
903 Poplar Hill Road
Baltimore, Maryland 21210

Artist's Statement

"The main focus of my work is site specific sculpture created for public spaces. The challenge of responding to new sites in a sensitive and creative way has led me from freestanding sculpture to wall supported pieces and freely suspended works. My pieces are abstract, ranging from organic to geometric, open to closed and volumetric to linear forms. They evoke a variety of images while attempting to capture a sense of energy and life."

Larks en Ciel. 1982. Painted aluminum, 40'h x 112'w x 50'd. Collection Rainbow Centre, Niagara Falls, New York. Photograph by Patricia Layman Bazelon.

Mary Michie

née Mary Miller
(Husband Norman Dalgarno Michie)
Born August 8, 1922 Ripon, Wisconsin

Education and Training
1943 B.A., Liberal Arts, Ripon College, Ripon, Wisconsin
1950- Central School of Arts and Crafts, 52 London, Great Britain
1962 M.S., Art Education and Sculpture, University of Wisconsin-Madison, Madison, Wisconsin; study in sculpture with Leo Steppat
1978 Kantaroff Studio, Toronto, Ontario, Canada; seminar in sculpture with Marion Kantaroff

Selected Individual Exhibitions
1970 University College, Nairobi, Kenya
1971 Madison Art Center, Madison, Wisconsin
1978 Warehouse Museum, Richland Center, Wisconsin

Selected Group Exhibitions
1958 "Painting and Sculpture Midwest Biennial," Walker Art Center, Minneapolis, Minnesota, catalog
1961, "Wisconsin Painters and Sculptors
63, Annual Exhibition of Wisconsin Art,"
64, Milwaukee Art Center, Milwaukee,
65 Wisconsin, catalog
1962 "Alfred A. Strelsin Brotherhood of Man Invitational," Jewish Community Center, Milwaukee, Wisconsin, catalog
1963 "Ninth Annual Drawing and Small Sculpture Show," Ball State Teachers College, Muncie, Indiana, catalog
1968 "Robin Anderson and Mary Michie," New Stanley Gallery, Nairobi, Kenya, catalog
1969 "American Artists in Kenya," New Stanley Gallery, Nairobi, Kenya, catalog
1972 "Wisconsin Women Invitational," University of Wisconsin-Milwaukee, Milwaukee, Wisconsin
1974 "Two Artists in Africa: Mary Michie and Hester Merwin Ayres," Merwin Gallery, Alice Millar Center for the Fine Arts, Illinois Wesleyan University, Bloomington, Illinois

1976 "Mary Michie and Marylou Williams," Bradley Galleries, Milwaukee, Wisconsin
1981 "American Art: The Challenge of the Land," Pillsbury Center, Minneapolis, Minnesota, catalog
1981 "New Faces/New Forms Invitational," Fanny Garver Gallery, Madison, Wisconsin
1983 "Madison Multiples," Seuferer-Chosy Gallery, Madison, Wisconsin
1984 "Sixtieth Annual National April Salon," Springville Museum of Art, Springville, Utah, catalog
1984 "XVIII Prix International d'Art Contemporain de Monte-Carlo," Hall du Centenaire, Monte Carlo, Monaco, catalog
1984 "Ways of Working," Madison Art Center, Madison, Wisconsin, catalog
1985 "Ninety-Sixth National Association of Women Artists Annual Exhibition," Jacob K. Javits Federal Building, New York, New York, catalog
1985- "Wisconsin Survey-3-D Art Today,"
86 Traveling Exhibition, Memorial Union, University of Wisconsin-Madison, Madison, Wisconsin (Sponsored by *Wisconsin Academy Review*, Madison, Wisconsin), catalog

Selected Public Collections
Beth Israel Synagogue, Madison, Wisconsin
City-County Building, Madison, Wisconsin
Marshfield Clinic/Health Center, Marshfield, Wisconsin
Milwaukee Art Museum, Milwaukee, Wisconsin
Rahr West Museum, Manitowoc, Wisconsin
St. Paul's Catholic Center, Madison, Wisconsin
Tomah Public Library, Tomah, Wisconsin
University Clinical Science Center, Madison, Wisconsin
University of Wisconsin-Stevens Point, Stevens Point, Wisconsin
Wisconsin School for the Visually Handicapped, Janesville, Wisconsin

Selected Private Collections
Gerald and Joyce Bartell, Madison, Wisconsin
Jack Block, Nairobi, Kenya
Richard Hughes, London, Great Britain and Nairobi, Kenya
Alfred and Mary Kahn, Ithaca, New York
Lee Weiss, Madison, Wisconsin

Selected Awards
1957 Sculpture Award, "Forty-Third Wisconsin Painters and Sculptors Annual Exhibition of Wisconsin Art," Milwaukee Art Institute, Milwaukee, Wisconsin, catalog
1962 Sculpture Award, "Painting and Sculpture Midwest Biennial Exhibition," Walker Art Center, Minneapolis, Minnesota, catalog

1982 Visual Arts Grant, Wisconsin Arts Board and National Endowment for the Arts

Preferred Sculpture Media
Metal (cast)

Additional Art Fields
Paper (cast) and Photo-Serigraphs

Selected Bibliography
Ela, Janet. "Metallurgists Weld, Cast, Carve to Produce Art." *Wisconsin Academy Review* vol. 31 no. 2 (March 1985) pp. 61-71, illus.
Heddle, Linda. "Wisconsin Women in the Arts; After Two Years." *Arts in Society* vol. 12 no. 2 (Summer-Fall 1975) pp. 296-301, illus.
Michie, Mary. "Encounter With an African Potter." *Ceramics Monthly* vol. 25 no. 10 (December 1977) pp. 32-35, illus.
Michie, Mary. "Travel: Search for a Kenya Craftsman." *The Christian Science Monitor* (Tuesday, November 28, 1978) p. 18.

Gallery Affiliations
Bradley Galleries
2639 North Downer Avenue
Milwaukee, Wisconsin 53211

Seuferer-Chosy Gallery
218 North Henry Street
Madison, Wisconsin 53703

Mailing Address
212 Bordner Drive
Madison, Wisconsin 53705

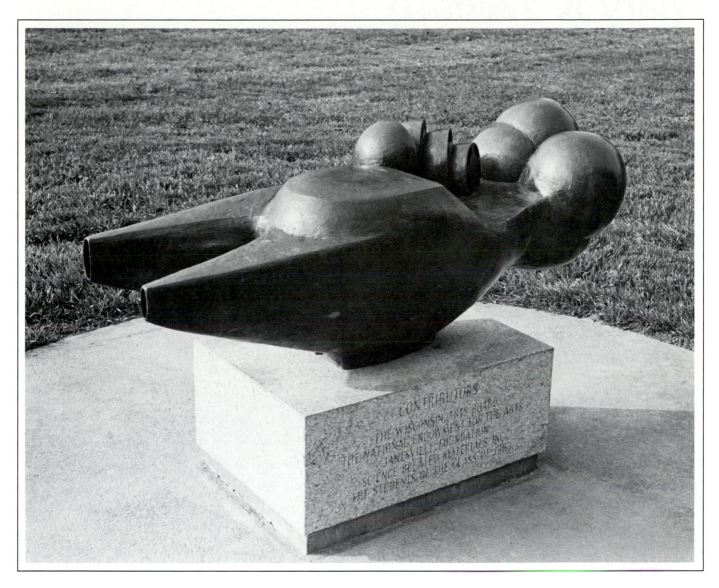

Spaceship. 1983. Bronze, 3'h x 5'w x 2½'d, including base. Collection Wisconsin School for the Visually Handicapped Janesville, Wisconsin.

Artist's Statement

"For as long as I can remember, sculpture has been important to me. I grew up on a prairie farm in Wisconsin. Perhaps the feeling of space in the environment and working with machinery prepared me for the pleasure as well as the physical challenge of sculpture. I have been fortunate in the friendships that have developed from my work, both as a student in England and graduate school in Wisconsin and when working in East Africa. I hope that an object which I have made, whether nonobjective or figurative, will stand forever, conveying its message of evocative form in a silent voice."

Mary R. Mintich

née Mary Ringelberg
(Husband George Mintich)
Born Detroit, Michigan

Education and Training
A.B., Merchandising and Art, Indiana University Bloomington, Bloomington, Indiana
M.F.A., General Studio, University of North Carolina at Greensboro, Greensboro, North Carolina

Selected Individual Exhibitions
1973 North Carolina National Bank, Charlotte, North Carolina, catalog
1975, Southeastern Center for
77, Contemporary Art, Winston-Salem,
78, North Carolina
83
1982 North Carolina Department of Cultural Resources, Raleigh, North Carolina
1983 Waterworks Gallery, Salisbury, North Carolina
1984 St. John's Museum of Art, Wilmington, North Carolina
1985 Converse College, Spartanburg, South Carolina

Selected Group Exhibitions
1966, "Annual Piedmont Craft Exhibition,"
71 Mint Museum of Art, Charlotte, North Carolina, catalog
1966, "Annual Ceramic National Exhibition,"
68 Everson Museum of Art, Syracuse, New York, catalog
1973 "Semi-Annual Southeastern Painting and Sculpture Competition," Gallery of Contemporary Art, Winston-Salem, North Carolina
1973 "National Community Art Competition," Department of Housing and Urban Development, Washington, D.C., catalog
1974 "Southeastern Regional Invitational," Greenville County Museum of Art, Greenville, South Carolina, catalog
1975 "Spring Mills Art of Carolinas Annual Exhibition," Traveling Exhibition, Spring Mills, Lancaster, South Carolina, catalog
1975 "Semi-Annual Juried Exhibition," Southeastern Center for Contemporary Art, Winston-Salem, North Carolina
1975 "David Freeman and Mary Mintich," Mint Museum of Art, Charlotte, North Carolina
1976 "Invitational Sculpture Exhibition," University of North Carolina at Charlotte, Charlotte, North Carolina
1976 "Annual North Carolina Artists Exhibition," North Carolina Museum of Art, Raleigh, North Carolina, catalog
1977 "North Carolina Invitational Exhibition," Southeastern Center for Contemporary Art, Winston-Salem, North Carolina

1977 "Annual Juried Exhibition," Shelby Art League, Shelby, North Carolina, catalog
1978 "12 North Carolina Women Artists," Bryan Rotunda, Meredith College, Raleigh, North Carolina
1978 "Mintich, Sculpture and Freeman, Painting," Myers Center Gallery, Gaston College, Gastonia, North Carolina
1978 "Freeman, Mintich and Lewandowski," Round Gallery, Mint Museum of Art, Charlotte, North Carolina
1978- "Sculpture on the Grounds," Mint
83 Museum of Art, Charlotte, North Carolina
1978 "Guild of South Carolina Artists Annual Exhibition," Columbia Museums of Art & Science, Columbia, South Carolina
1978 "Mostra d'Arte Università della Georgia," Palazzo Vagnotti, Cortona, Italy
1979 "Artists in Residence at Cortona," Visual Arts Gallery, University of Georgia, Athens, Georgia
1979 "David Freeman and Mary Mintich," Winthrop College, Rock Hill, South Carolina
1979 "North Carolina Sculpture '79," Weatherspoon Art Gallery, Greensboro, North Carolina, catalog
1980 "Southern Exposure," Hanson Gallery, New Orleans, Louisiana, catalog
1980 "Freeman, Martyka and Mintich," People Place, Spirit Square Art Center, Charlotte, North Carolina
1980, "Faculty Exhibition," Winthrop College,
83, Rock Hill, South Carolina
85
1980 "20 North Carolina Sculptors," Green Hill Art Gallery, Greensboro, North Carolina
1981 "Rooms-An Environment," Davidson College, Davidson, North Carolina
1981 "Freeman, Martyka and Mintich," University of South Carolina McKissick Museums, Columbia, South Carolina
1981 "Mary Mintich, Sculpture and David Freeman, Paintings: Recent Works," Greenville County Museum of Art, Greenville, South Carolina
1981 "Mercy Festival Art Exhibition," Sacred Heart College, Belmont, North Carolina
1981 "Winthrop Faculty Exhibition," Museum of York County, Rock Hill, South Carolina
1982 "The Box Exhibition," Spirit Square Art Center, Charlotte, North Carolina
1982 "Sculpture: Mary Mintich and Tim Murray," Rudolph E. Lee Gallery, Clemson University, Clemson, South Carolina
1982 "Magic in Art," Spirit Square Art Center, Charlotte, North Carolina
1982 "Focus/Sculpture: Raleigh Arts Commission Festival," Fayetteville Mall, Raleigh, North Carolina
1982 "First Annual Exhibit of North Carolina Sculpture," Northern Telecom, Research Triangle Park, North Carolina, catalog

1982 "Tri-State Sculpture Conference Exhibition," East Carolina University Museum of Art/Gray Art Gallery, Greenville, North Carolina, catalog
1983 "Clamps/Closures/Constraints," Gallery One, Spirit Square Art Center, Charlotte, North Carolina
1984 "Southeastern Outdoor Sculpture Invitational Exhibition," Greenville County Museum of Art, Greenville, South Carolina, catalog
1984 "U.S.A. Portrait of the South," Traveling Exhibition, Palazzo Venezia, Rome, Italy, catalog
1985 "U.S.A. Portrait of the South: The North Carolina Exhibition," Somerhill Gallery, Durham, North Carolina; Green Hill Center for North Carolina Art, Greensboro, North Carolina; Asheville Art Museum, Asheville, North Carolina, catalog
1985 "George Bireline, Richard Kinnaird, Jon Kuhn and Mary Mintich," Green Hill Center for North Carolina Art, Greensboro, North Carolina
1985 "After Her Own Image: Women's Work 1985, National Juried Exhibition," Salem College, Winston-Salem, North Carolina, catalog

Selected Public Collections
Everson Museum of Art, Syracuse, New York
Mint Museum of Art, Charlotte, North Carolina
North Carolina Arts Council, Waterworks Gallery, Salisbury, North Carolina
North Carolina National Bank, Radisson Plaza, Charlotte, North Carolina
R. J. Reynolds Industries World Headquarters, Winston-Salem, North Carolina
St. John's Museum of Art, Wilmington, North Carolina

Preferred Sculpture Media
Varied Media

Teaching Position
Associate Professor of Art, Winthrop College, Rock Hill, South Carolina

Gallery Affiliations
Gilliam and Pedan Gallery
1322 New Hope Church Road
Raleigh, North Carolina 27609

Hodges Taylor Gallery
277 North Tryon Street
Charlotte, North Carolina 28202

Mailing Address
Post Office Box 913
Belmont, North Carolina 28102

Artist's Statement

"I am entranced by the miracle of birth—the transmission of energy in another form from the most mysterious source. Any works I have done that ultimately may be important have also emerged mysteriously from deep within a source—my source—and have an energy—my energy. These have not been intellectually designed but flowed from my being only at times when I have been capable of allowing it to happen. Only at these times—in this way—do I allow vulnerability and totally share myself. Although the means are less important, I currently interact material with material and viewer with form by contrasting varied media with reflective steel. I am concerned with form, visual energy and unexpected subleties."

Monument To Whom It May Concern. 1983. CorTen, stainless steel, enameled copper and redwood, 72"h x 48"w x 24"d.

Mary Miss

Born May 27, 1944 New York, New York

Education and Training
1966 B.A., Art, University of California, Santa Barbara, Santa Barbara, California
1968 M.F.A., Sculpture, Rinehart School of Sculpture, Maryland Institute College of Art, Baltimore, Maryland

Selected Individual Exhibitions
1971, 55 Mercer, New York, New York
72
1975 Galleria Salvatore Ala, Milan, Italy
1975 Rosa Esman Gallery, New York, New York
1976 Museum of Modern Art, New York, New York, catalog
1978 Nassau County Museum of Fine Arts, Roslyn, New York, catalog
1979 Minneapolis College of Art and Design, Minneapolis, Minnesota
1980 Max Protech Gallery, New York, New York
1980 Fogg Art Museum, Cambridge, Massachusetts, catalog
1981 Brown University, Providence, Rhode Island; University of Rhode Island, Kingston, Rhode Island
1981 Museum of Art, Rhode Island School of Design, Providence, Rhode Island
1982 Laumeier International Sculpture Park And Gallery, St. Louis, Missouri
1983 University of California, Santa Barbara, Santa Barbara, California
1983 San Diego State University, San Diego, California
1983 Institute of Contemporary Art, London, Great Britain, catalog
1984 Protech-McNeil Gallery, New York, New York, retrospective

Selected Group Exhibitions
1970 "1970 Annual Exhibition: Contemporary American Sculpture," Whitney Museum of American Art, New York, New York, catalog
1971 "Twenty-Six Contemporary Women Artists," Aldrich Museum of Contemporary Art, Ridgefield, Connecticut, catalog
1972 "GEDOK American Woman Artist Show," Kunsthaus, Hamburg, Germany, Federal Republic, catalog
1973, "Biennial Exhibition: Contemporary
81 American Art," Whitney Museum of American Art, New York, New York, catalog
1973 "Four Young Americans," Allen Memorial Art Museum, Oberlin, Ohio, catalog
1973 "Waves," Cranbrook Academy of Art, Bloomfield Hills, Michigan
1974 "Interventions in Landscape: Projects/Documentation/Film/Video," Hayden Gallery, Massachusetts Institute of Technology, Cambridge, Massachusetts

1974 "Seven Sculptors: New Involvement with Materials," Institute of Contemporary Art, Boston, Massachusetts
1974 "Gallery Exhibition," Rose Esman Gallery, New York, New York
1976 "Rooms," P.S. 1, Institute for Art and Urban Resources, Long Island City, New York
1976 "New York—Downtown Manhattan: SoHo, Berlin Festival," Akademie der Kunst, Berlin, Germany, Democratic Republic
1976 "Four Sculptors," Williams College Museum of Art, Williamstown, Massachusetts, catalog
1976 "Artpark: The Program in Visual Arts," Artpark, Lewiston, New York, catalog
1977 "Site Sculpture, Hamrol, Healy, Miss, Tacha," Zabriskie Gallery, New York, New York
1977 "Contact: Women and Nature," Greenwich Library, Greenwich, Connecticut
1977 "Women in Architecture," Brooklyn Museum, Brooklyn, New York
1977 "Nine Artists: Theodoran Awards," Solomon R. Guggenheim Museum, New York, New York, catalog
1977 "Outdoor Environmental Art," New Gallery of Contemporary Art, Cleveland, Ohio, catalog
1978 "Inaugural Exhibition," Max Protech Gallery, New York, New York
1978 "Architectural Analogues," Whitney Museum of American Art, Downtown Branch, New York, New York, catalog
1979 "Art and Architecture, Space and Structure," Protech-McIntosh Gallery, Washington, D.C.
1979 "The Minimal Tradition," Aldrich Museum of Contemporary Art, Ridgefield, Connecticut
1979 "Quintessence: Alternative Spaces Residency Program," City Beautiful Council, Dayton, Ohio and Wright State University, Department of Art, Dayton, Ohio, catalog
1980 "Eleventh International Sculpture Conference," Area Galleries and Institutions, Washington, D.C. (Sponsored by International Sculpture Center, Washington, D.C.)
1980 "Drawings/Structures," Institute of Contemporary Art, Boston, Massachusetts
1980 "Painting and Sculpture Today 1980," Indianapolis Museum of Art, Indianapolis, Indiana, catalog
1980 "Architectural Sculpture," Los Angeles Institute of Contemporary Art, Los Angeles, California, catalog
1980 "A Sense of Place," Hampshire College, Amherst, Massachusetts
1980 "Collector's Choice," Des Moines Art Center, Des Moines, Iowa
1981 "Artists' Gardens and Parks," Hayden Gallery, Massachusetts Institute of Technology, Cambridge, Massachusetts; Museum of Contemporary Art, Chicago, Illinois

1981 "Natur-Skulptur, Nature-Sculpture," Württembergischer Kunsteverein, Stuttgart, Germany, Federal Republic, catalog
1982 "Stadt und Utopie: Modelle Idealer Gemeinschaften, City and Utopia: Model Ideal Community," Neuer Berliner Kunstverein, Berlin, Germany, Democratic Republic, catalog
1983 "Connections: Bridges/Ladders/Ramps/Staircases/Tunnels," Institute of Contemporary Art of The University of Pennsylvania, Philadelphia, Pennsylvania, catalog
1983 "Objects, Structures, Artifice: American Sculpture 1970-1982," University of South Florida, Tampa, Florida; Bucknell University, Lewisburg, Pennsylvania
1984 "MetaManhattan," Whitney Museum of American Art, Downtown Branch, New York, New York
1984 "A Celebration of American Women Artists Part II: The Recent Generation," Sidney Janis Gallery, New York, New York, catalog
1984 "Projects: World's Fairs, Waterfronts, Parks and Plazas," Rhona Hoffman Gallery, Chicago, Illinois

Selected Public Collections
Allen Memorial Art Museum, Oberlin, Ohio
Rhode Island School of Design, Providence, Rhode Island

Selected Awards
1973 Creative Artists Public Service Grant, New York State Council on the Arts
1982 Creative Arts Award, Brandeis University, Waltham, Massachusetts
1984 Individual Artist's Fellowship, National Endowment for the Arts

Preferred Sculpture Media
Varied Media and Wood

Additional Art Field
Drawing

Related Profession
Lecturer

Teaching Positions
Instructor, Cooper Union for the Advancement of Science and Art, New York, New York
Instructor, School of Visual Arts, New York, New York

Selected Bibliography
Anderson, Laurie. "Mary Miss." *Artforum* vol. 12 no. 3 (November 1973) pp. 64-65, illus.
Foote, Nancy. "Monument—Sculpture—Earthwork." *Artforum* vol. 28 no. 2 (October 1979) pp. 32-37, illus.

Staged Gates. 1979. Wood, 12'h x 50'w x 120'd.
Installation view 1979. "Quintessence: Alternative
Spaces Residency Program," City Beautiful Council,
Dayton, Ohio and Wright State University,
Department of Art, Dayton, Ohio, catalog.
Photograph by Susan Zurcher.

Kingsley, April. "Six Women at Work in the
 Landscape." *Arts Magazine* vol. 52 no. 8
 (April 1978) pp. 108-112, illus.
Lippard, Lucy R. "Mary Miss: An Extremely
 Clear Situation." *Art in America* vol. 62 no.
 2 (March-April 1974) pp. 76-77, illus.
Onorato, Ronald J. "Illusive Spaces: The Art
 of Mary Miss." *Artforum* vol. 17 no. 4
 (December 1978) pp. 28-33, illus.

Gallery Affiliation

Max Protetch Gallery
37 West 57 Street
New York, New York 10019

Mailing Address

Canal Street Station
Box 304
New York, New York 10013

Artist's Statement

"The development of my interest in public
sculpture has been a gradual one. The
earliest works were small-scale constructions
that depended on their skeletal forms and
common materials (screen, canvas and pipe)
to form a content. The sculptures expanded
in scale as I began to work on outdoor
projects. I placed them in open fields, on
hillsides and in rural settings in an attempt
to avoid the limited situations usually offered
for sculpture. Part of this impulse was
related to my experience of the western
landscape as a child. The freestanding
object (monolith) is easily overpowered in
that environment. Instead of working within a
closed framework of increasingly limited
references (galleries and museums), I could
extend the formal issues of visual language
to a broader context.

"I had become increasingly interested in
construction sites, mines and power plants
as sources of imagery. During this time I
became more aware of the public attitude
toward these pieces. I began to look to
historical sources in how to reintroduce
historical ideas about space, place and scale
into our own landscape. With the ideas that
have developed in the sited works, the
importance of the viewer, the integration of
site, the use of architectural sources, it does
not seem appropriate to return to the image
of sculpture as a confined object or statue.
Within our own environment there are
equivalent visual forms of great complexity
which can provide an accessible public
language."

Mary Miss

Elisabeth Model

née Elisabeth Dittmann
Born May 6, 1903 Bayreuth, Germany,
Federal Republic

Education and Training
1917- Studio of Professor Cericioli, Bayreuth,
18 Germany, Federal Republic; study in
drawing and pastels
1919- Atelier Walter Thor, Munich, Germany,
1920; Federal Republic; study in drawing
22 and painting
1928 Akademie der Bildenden Künste,
Amsterdam, Netherlands; study in
clay portraiture with Professor Jürgens
1934- Studio of Moissi Kogan, Amsterdam,
36 Netherlands and Paris, France; study
in plaster sculpture

Selected Individual Exhibitions
1937, Galerie Santee Landweer, Amsterdam,
38, Netherlands, catalog
40
1946 Norlyst Gallery, New York, New York
1946 Pinacoteca Gallery, New York, New
York
1953 Katonah Gallery, Katonah, New York
1954 Café Gallery, Wilmington, Delaware
1955 R Street Gallery, Institute of Chinese
Culture, Washington, D.C., catalog
1959, Bodley Gallery, New York, New York
63,
68

Selected Group Exhibitions
1939- "International Women's Exhibition,"
40 Riverside Museum, New York, New
York
1943 "Art in Exile: Banned European Art,"
New York Public Library, New York,
New York
1945 "Dutch Artists in New York,"
Rockefeller Center, New York, New
York, catalog
1949 "Boston Society of Independent
Artists," Boston City Hall, Boston,
Massachusetts
1950- "Federation of Modern Painters and
85 Sculptors Annual Exhibition," Area
Galleries and Institutions, New York,
New York, catalog
1951 "One Hundred and Forty-Fifth Annual
Exhibition of Painting and Sculpture,"
Pennsylvania Academy of the Fine
Arts, Philadelphia, Pennsylvania,
catalog

1952 "Annual Area Exhibition of Work by
Artists of Washington & Vicinity,"
Corcoran Gallery of Art, Washington,
D.C., catalog
1952 "Brooklyn Society of Artists," Riverside
Museum, New York, New York
1954 "New York Society of Ceramic Arts,"
American Museum of Natural History,
New York, New York
1963 "Group Exhibition," Galleria L'Obelisco,
Rome, Italy
1967 "Group Invitational," Contemporary
Gallery, Dallas, Texas
1967 "American Society of Contemporary
Artists," Lever House, New York, New
York
1971 "Sculptors Guild Invitational
Exhibition," Lever House, New York,
New York, catalog
1975 "Harold Weston Memorial Exhibition,"
Edwin A. Ulrich Museum of Art,
Wichita State University, Wichita,
Kansas
1975 "Federation of Modern Painters and
Sculptors," Traveling Exhibition, Union
Carbide Gallery, New York, New York
1976- "Thirty-Fifth Anniversary Exhibition
78 Federation of Modern Painters and
Sculptors," Traveling Exhibition,
Gallery Association of New York
State, New York, New York, catalog
1980 "Federation of Modern Painters and
Sculptors," Contemporary Arts Gallery,
New York, New York
1983 "Forty-Third Anniversary Exhibition
Federation of Modern Painters and
Sculptors," City Gallery, New York,
New York, catalog

Selected Public Collections
Corcoran Gallery of Art, Washington, D.C.
Edwin A. Ulrich Museum of Art, Wichita
State University, Wichita, Kansas
Hirshhorn Museum and Sculpture Garden,
Smithsonian Institution, Washington, D.C.
Rose Art Museum, Brandeis University,
Waltham, Massachusetts
St. Lawrence University, Griffith Art Center,
Canton, New York
Wadsworth Atheneum, Hartford, Connecticut

Selected Private Collections
Wayne Abercrombie, Hadley, Massachusetts
Senator William Benton, New York, New York
Rafael Cabrera, Toronto, Ontario, Canada
Cass Canfield, Bedford Village, New York
William Weinberg, Scarsdale, New York

Selected Awards
1950 Medal of Honor, "National Association
of Women Artists Annual Exhibition,"
National Academy of Design, New
York, New York, catalog
1957 First Prize, "Brooklyn Society of
Artists," Riverside Museum, New York,
New York
1958 First Prize, "Annual Exhibition,"
Westchester Guild of Art, White
Plains, New York

Preferred Sculpture Media
Stone and Wood

Additional Art Fields
Drawing and Watercolor

Related Profession
Executive Board Member, Federation of
Modern Painters and Sculptors, New York,
New York

Selected Bibliography
Lowe, Jeannette. "Women Painters of Ten
Nations: International Feminine Show
Current at the Riverside Museum." Art
News vol. 38 no. 4 (October 28, 1939) pp.
15, 25, illus.
Meilach, Dona Z. Contemporary Stone
Sculpture: Aesthetics, Methods,
Appreciation. New York: Crown, 1970.
Meilach, Dona Z. Sculpture Casting: Mold
Techniques and Materials, Metals, Plastics,
Concrete. New York: Crown, 1972.

Mailing Address
340 West 72 Street
New York, New York 10023

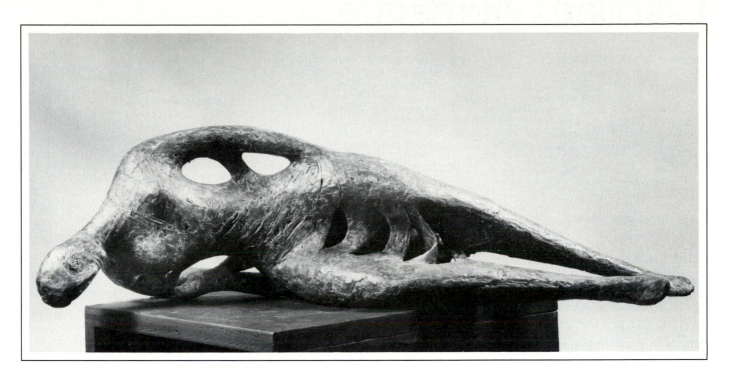

The Fall. 1973. Bronze, 17"h x 22½"w x 6¼"d.
Photograph by Otto E. Nelson.

Artist's Statement

"Chronologically my career in art began at the age of eight with the discovery that I could draw! And when, four years later, my mother presented me with a book on Greek sculpture, art was my life.

"Many years later, after studies in Munich and Amsterdam, and after having stopped painting, a chance meeting in an Amsterdam gallery with Moissi Kogan, the Russian sculptor, changed my artist life altogether. He encouraged me in sculpture and wanted me to continue in his words, 'his way of work and to fulfill his dream of simplicity and purity in sculpture.' I worked in the usual methods and I carved, first wood, then stone. World War II destroyed our world and miraculously we, the family, arrived in the United States in 1941. I was invited to participate in several exhibitions of 'art in exile' and in 1946 I had my first one-woman show in New York.

"I believe in the integrity of life, in the harmony that only art can give to our existence and, most of all, in intuition. It inspires me to create my images in three-dimensional forms. Gratefully I pay homage to Moissi Kogan, to the Greeks and to Aristide Maillol, whom I knew, and to Henry Moore, whose humanity shines through everything he creates."

Caroline Montague

Born June 18, 1941 Roanoke, Virginia

Education and Training
1965 A.B., Ceramics, East Carolina University, Greenville, North Carolina
1966 M.F.A., Ceramics, Instituto Allende de Universidad de Guanajuato, San Miguel de Allende, Guanajuato, México
1976 Ph.D., Advanced Art Teaching on the College and University Level, North Texas State University, Denton, Texas

Selected Individual Exhibitions
1972 Arkansas Arts Center, Little Rock, Arkansas
1972 Huntsville Art Center, Huntsville, Alabama
1972 Montgomery Museum of Fine Arts, Montgomery, Alabama
1972 Auburn University, Auburn, Alabama
1978 Peachtree Center Gallery, Atlanta, Georgia
1980 Armstrong State College, Savannah, Georgia
1981 University of Alabama in Huntsville, Huntsville, Alabama
1981 Virginia Commonwealth University, Richmond, Virginia
1983 14 Sculptors Gallery, New York, New York
1984 Chastain Arts Center, Atlanta, Georgia
1985 Chattahoochee Valley Art Association, LaGrange, Georgia

Selected Group Exhibitions
1966 "Southeastern Ceramics Exhibition," High Museum of Art, Atlanta, Georgia, catalog
1966 "Twenty-Fourth Annual Ceramic National Exhibition," Everson Museum of Art, Syracuse, New York, catalog
1968 "Piedmont Painting and Sculpture Exhibition," Mint Museum of Art, Charlotte, North Carolina, catalog

1968 "Award Winners Invitational," North Carolina Museum of Art, Raleigh, North Carolina, catalog
1971 "Southwestern Craftsmen Exhibition," Witte Memorial Museum, San Antonio, Texas, catalog
1975 "Eighteenth Annual Delta Art Exhibition," Arkansas Arts Center, Little Rock, Arkansas, catalog
1976 "Six Texans," Contemporary Gallery, Dallas, Texas
1977 "Fourteen Sculptors," High Museum of Art, Atlanta, Georgia, catalog
1978- "Artists in Georgia," High Museum of
79 Art, Atlanta, Georgia, catalog
1980 "Thirteen Minus One: Atlanta Sculptors Guild Exhibition," Central City Park, Atlanta, Georgia and Richard B. Russell Federal Building, Atlanta, Georgia
1980 "Invitational Sculpture Exhibition," Agnes Scott College, Decatur, Georgia
1981 "A Fabric in the Making," Georgia State University, Atlanta, Georgia, catalog
1982 "Sculpture '82," Franklin Plaza and International Garden Franklin Town, Philadelphia, Pennsylvania (Co-Sponsored by Cheltenham Art Centre, Cheltenham, Pennsylvania)
1982 "Great Garden Sculpture Show," Sculptural Arts Museum, Atlanta, Georgia, catalog
1984- "Sculpture Tour," Traveling Exhibition,
86 University of Tennessee, Knoxville, Knoxville, Tennessee
1985 "LaGrange National," Lamar Dodd Art Center, LaGrange College, LaGrange, Georgia
1985 "Art Works—Three Dimensions," Beaver College, Glenside, Pennsylvania

Selected Public Collections
Auburn University, Auburn, Alabama
Butler Shoe Corporation, Atlanta, Georgia
Considine Condominium Corporation, Atlanta, Georgia
Digital Communications Association, Norcross, Georgia
East Carolina University, Greenville, North Carolina
Equitable Life Assurance Society of the United States, Atlanta, Georgia
Fugua Industries, New York, New York
General Electric Corporation, Roanoke, Virginia
Hamline University, St. Paul, Minnesota
Lincoln Properties, Atlanta, Georgia
Metropolitan Atlanta Rapid Transit Authority, Brookhaven Station, Atlanta, Georgia
Moore Group, Atlanta, Georgia
New York Life Insurance, Atlanta, Georgia
North Carolina Museum of Art, Raleigh, North Carolina
North Hills Shopping Center, Atlanta, Georgia
Sovran Bank, Roanoke, Virginia

Selected Private Collection
Mrs. Bob Ray, Tyler, Texas

Selected Award
1965, Sculpture Award, "North Carolina
67 Artists Annual," North Carolina Museum of Art, Raleigh, North Carolina, catalog

Preferred Sculpture Media
Metal (welded) and Varied Media

Additional Art Field
Drawing

Selected Bibliography
Weinstein, Ann. "Profiles: Caroline Montague (Atlanta, Georgia)." *Art Voices/South* vol. 1 (September-October 1978) p. 19, illus.

Mailing Address
312 North Highland Avenue NE
Atlanta, Georgia 30307

Artist's Statement

"My work is concerned with movement; one appearance of energy merging into another. I am interested in relationships between the physical, mental and mystical states. My sculptures are abstract proposals recording peripheral images of movements, sounds, changes, shifts and layers. They are small fragments, moments in time. The progression is not fixed; it is a continuum. In the process of creating sculpture the initial thought or feeling is combined with an intuitive sense of placement and space."

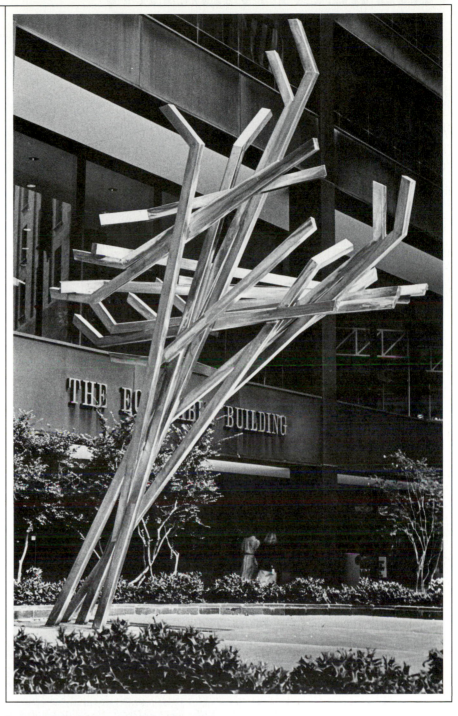

Peachtree. 1981. Stainless steel, 18'h x 10'w x 8'd. Collection Equitable Life Assurance Society of the United States, Atlanta, Georgia.

Kathleen Mulcahy

née Kathleen Ann
(Husband Ron Desmett)
Born June 23, 1950 Newark, New Jersey

Education and Training
1972 B.A., Art Education, Kean College of
New Jersey, Newark, New Jersey
1974 M.F.A., Glass Art, Alfred University,
Alfred, New York; study with Andre
Billeci, Eric Hilton and Thomas
Lacagnina

Selected Individual Exhibitions
1978 Hewlett Gallery, Carnegie-Mellon
University, Pittsburgh, Pennsylvania
1979 Lafayette College, Easton,
Pennsylvania
1980 Museum of Art, Carnegie Institute,
Pittsburgh, Pennsylvania

Selected Group Exhibitions
1976- "Annual Faculty Exhibition," Hewlett
80 Gallery, Carnegie-Mellon University,
Pittsburgh, Pennsylvania
1977- "Associated Artists of Pittsburgh
81 Annual Exhibition," Museum of Art,
Carnegie Institute, Pittsburgh,
Pennsylvania, catalog
1977 "The Glassmaker: Historic and
Contemporary Invitational Exhibition,"
Pensacola Junior College, Pensacola,
Florida
1979, "Annual Glass National Invitational,"
80, Habatat Galleries, Dearborn, Michigan
82
1979 "Beaux Arts Designer Craftsmen,"
Columbus Museum of Art, Columbus,
Ohio
1980 "Containers 1980," Fort Wayne
Museum of Art, Fort Wayne, Indiana
1980 "Color Sightings," Boston Athenaeum,
Boston, Massachusetts
1981 "Masters in Glass," Craftsmen's
Gallery, Scarsdale, New York
1981 "Annual Ohio Ceramic and Sculpture
Show," Butler Institute of American
Art, Youngstown, Ohio

1981 "The Bowl Classic Form: New
Expressions," Greenwood Gallery,
Washington, D.C.
1981 "Glass of 1981," Gallery 173, Wilmette,
Illinois
1981 "National Glass Invitational," Pittsburgh
Center for the Arts, Pittsburgh,
Pennsylvania
1981 "Kathleen Mulcahy and Ron Desmett,
Collaborations in Glass," Rudolph E.
Lee Gallery, College of Architecture,
Clemson University, Clemson, South
Carolina
1981 "National Glass Invitational," Erie Art
Center, Erie, Pennsylvania
1981 "Annual Three Rivers Arts Festival,"
Gateway Center, Pittsburgh,
Pennsylvania, catalog
1981 "Explorations in Glass," Southern
Alleghenies Museum of Art, Loretto,
Pennsylvania, catalog
1981 "American Art at Its Best," American
Art, Incorporated, Atlanta, Georgia
1982 "Born of Fire III," Artistic Sass/ Primary
Art, Hilton Head Island, South Carolina
1982 "Fourth National Glass Exhibition,"
Contemporary Artisans Gallery, San
Francisco, California
1982 "New Directions in Glass," Horizon
Gallery, Mill Valley, California
1982 "Kathleen Mulcahy and Ron Desmett,"
Pittsburgh Plan for Art, Pittsburgh,
Pennsylvania
1982, "Associated Artists of Pittsburgh
84 Juried Exhibition," Museum of Art,
Carnegie Institute, Pittsburgh,
Pennsylvania
1983 "Glass National," Heller Gallery, New
York, New York
1984 "National Glass Sculpture Juried
Exhibition," Perception Galleries,
Houston, Texas
1985 "Sculpture Glass Invitational," Erie Art
Museum, Erie, Pennsylvania;
Bowman-Penelec-Megahan Art
Galleries, Allegheny College,
Meadville, Pennsylvania
1985 "Exhibition 280," Huntington Galleries,
Huntington, West Virginia, catalog
1985 "Contemporary Crafts Exhibition,"
Oglebay Institute-Mansion Museum,
Fine Arts Center, Wheeling, West
Virginia
1985 "State of the Art, National Glass
Exhibition," Concept Art Gallery,
Pittsburgh, Pennsylvania
1985 "Seventy-Five Years of Pittsburgh Art/
Influences," Hewlett Gallery, Carnegie-
Mellon University, Pittsburgh,
Pennsylvania

Selected Public Collections
Corning Museum of Glass, Corning, New
York
Westmoreland County Museum of Art,
Greensburg, Pennsylvania

Selected Awards
1980 Individual Artist's Fellowship, National
Endowment for the Arts
1983 Individual Artist's Fellowship,
Pennsylvania Council on the Arts
1983 Lusk Memorial Fellowship for Creative
Research (Italy), Fulbright Travel Grant

Preferred Sculpture Media
Glass and Varied Media

Teaching Position
Associate Professor of Art, Carnegie-Mellon
University, Pittsburgh, Pennsylvania

Mailing Address
RD 3 Box 3AB
Oakdale, Pennsylvania 15071

Artist's Statement

"Abstract and symbolic portraits, assuming organic and amorphic forms, are my continuing concerns as an artist. Glass lends itself to metaphorical statements about the nature of beauty and the paradox between personal struggle and conflict. The work in process at first appears off-balance, awkward or ugly, because of its changeable nature from sensuous molten form to cold sharp edges. Rejecting the merely decorative sculptural object, I am interested in beauty, not in the physical sense, but in the intrinsic element which develops from within the human condition and how that image manifests itself in my work."

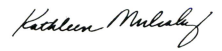

Crossings. 1982. Handblown glass, etched and sandblasted, 22"h x 14"w. Photograph by David Aschkenas.

Catherine Mulligan

née Catherine Ellen Esmond
(Husband Patrick B. Mulligan)
Born May 9, 1934 Wells County, Indiana

Education and Training
1956 B.S., Home Economics and Science, Purdue University, West Lafayette, Indiana
1976 M.S., Sculpture and Art History, Moorhead State University, Moorhead, Minnesota; study in sculpture with Lyle Laske
1983 Saint John's University, Collegeville, Minnesota; study in Japanese kiln techniques with Richard Bresnahan, Jr.

Selected Individual Exhibitions
1975 Center for the Arts Gallery, Moorehead State University, Moorehead, Minnesota
1976 Union Art Gallery, Northern State College, Aberdeen, South Dakota
1977 Linha Gallery, Minot, North Dakota
1977, Plains Art Museum, Moorhead,
80, Minnesota, catalog
83
1980 Harnett Hall Gallery, Minot State College, Minot, North Dakota
1981 Visual Arts Gallery, Hughes Fine Arts Center, University of North Dakota, Grand Forks, North Dakota
1981 Raugust Gallery, Jamestown, North Dakota
1982 Élan Art Gallery, Bismarck, North Dakota
1982 Dacotah Prairie Museum, Aberdeen, South Dakota
1982 Minot Art Gallery, Minot, North Dakota
1983 Cannon Gallery, Bismarck Junior College, Bismarck, North Dakota
1983 Student Center Gallery, Southwest State University, Marshall, Minnesota
1983- Affiliated State Arts Agencies of the
85 Upper Midwest, Minneapolis, Minnesota and North Dakota Council on the Arts, Fargo, North Dakota, Traveling Exhibition, catalog
1984 Benedicta Arts Center Gallery, College of Saint Benedicta, St. Joseph, Minnesota
1984 Luther College, Decorah, Iowa

Selected Group Exhibitions
1970- "Red River Annual," Plains Art
85 Museum, Moorhead, Minnesota, catalog
1971, "Annual Manisphere International
72, Juried Exhibition," Winnipeg Art
73, Gallery, Winnipeg, Manitoba, Canada,
74 catalog

1974 "Imagination 74," Moorhead State University, Moorhead, Minnesota
1974 "Selected International Works," Alberta College of Art Gallery, Calgary, Alberta, Canada
1974 "Twentieth Annual Drawing and Small Sculpture Show," Ball State University, Muncie, Indiana, catalog
1974- "Annual Midwestern Invitational,"
85 Rourke Art Gallery, Moorhead, Minnesota, catalog
1975 "International Exhibition," Assinaboine Park Conservatory, Winnipeg, Manitoba, Canada
1976 "The Midwestern," Traveling Exhibition, Winnipeg Art Gallery, Winnipeg, Manitoba, Canada
1976 "Northwestern Biennial III," South Dakota Memorial Art Center, Brookings, South Dakota, catalog
1977, "Biennial National Art Exhibition,"
83 Second Crossing Gallery, Valley City, North Dakota, catalog
1977, "American Association of University
81, Women Annual Exhibition," Center
82, Room, Wahpeton School of Science,
83, Wahpeton, North Dakota
84
1978 "Women Invite Women, An International Exhibition," WARM, Women's Art Registry of Minnesota, Minneapolis, Minnesota, catalog
1978 "Alabaster, An Exhibition of Stone Sculpture," Center for the Arts Gallery, Moorhead State University, Moorhead, Minnesota, catalog
1978- "Artists of North Dakota Exhibition,"
79 Traveling Exhibition, University of North Dakota, Grand Forks, North Dakota, catalog
1979 "National Sculpture 1979," Traveling Exhibition, Gallery 303, Georgia Southern College, Statesboro, Georgia, catalog
1979- "First International Sculpture
80 Competition," Traveling Exhibition, Johnson Atelier Technical Institute of Sculpture, Princeton, New Jersey; Mercer County Community College, Trenton, New Jersey
1980 "Four Artists," Minneapolis Institute of Arts," Minneapolis, Minnesota, catalog
1981 "Heart Exhibition," Berg Art Center Gallery, Concordia College, Moorhead, Minnesota
1982, "Heart Invitational," Plains Art Museum,
84 Moorhead, Minnesota
1982, "Women Artists and the Environment,"
83 Gallery of Visual Arts, University of Montana, Missoula, Montana

Selected Public Collections
Blue Cross and Blue Shield, Fargo, North Dakota
North Dakota State University, Fargo, North Dakota
Plains Art Museum, Moorhead, Minnesota

Selected Private Collections
Susan Freeman, Fargo, North Dakota
Mrs. Robert A. Lusk, Huron, South Dakota
Gene A. Sanders, Scottsdale, Arizona
Ernest Slingsby, Washington, D.C.
Carinda Swann, Cold Spring, New York

Selected Awards
1975, First Award Medal, "Annual
76 Midwestern Invitational," Rourke Art Gallery, Moorhead, Minnesota, catalog
1983 Third Award Medal, "Annual Midwestern Invitational," Rourke Art Gallery, Moorhead, Minnesota, catalog

Preferred Sculpture Media
Plastic and Varied Media

Additional Art Field
Drawing

Related Profession
Art Coordinator and Sculptor in Residence, Fargo Public Schools Creative Arts Project, Fargo, North Dakota

Teaching Position
Lecturer, North Dakota State University, Fargo, North Dakota

Gallery Affiliation
Suzanne Kohn Gallery
1690 Grand Avenue
St. Paul, Minnesota 55105

Mailing Address
1350 North Ninth Street
Fargo, North Dakota 58102

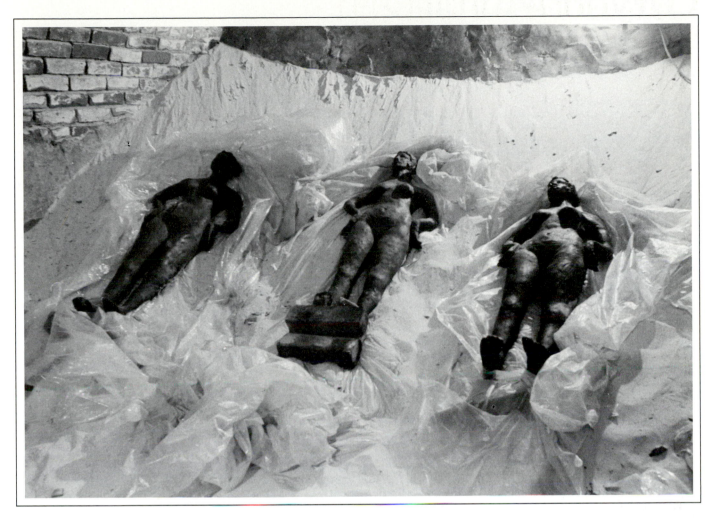

Generation (in progress). 1984. Silica sand, clay and clear polyvinyl plastic, each figure, 40"h x 16"w x 12"d; overall dimensions variable to installation. Photograph by James R. Dean.

Artist's Statement

"The primary sources of enrichment in my work are my children and my environment. Born in Wells County, Indiana amidst the fertile cornbelt of the Midwest, I have been influenced by the energy of the landscape. I empathize with the prairie sensibility, the strength of the land and the beautiful color and form. I like the minimal, the large extended masses and plains.

"My sculpture draws upon the theme of regeneration in nature. In most of my work, symbolic elements of organic life offer clues to relationships of harmony, isolation and introspection. I incorporate materials such as bronze, alabaster, glass, ceramic, paint and cast resin of translucent color to achieve a union of mass and light which energizes the physical forms.

"Sculpture is a continuing idea process, a seeing quality, a saying in visual form; it is the language I know best."

Gwynn Murrill

née Gwynn Ellen
(Husband David Frank Faron)
Born June 15, 1942 Ann Arbor, Michigan

Education and Training
1967 B.A., Art, University of California, Los
 Angeles, Los Angeles, California
1972 M.F.A., Painting, University of
 California, Los Angeles, Los Angeles,
 California

Selected Individual Exhibitions
1972 Rico Mizuno Gallery, Los Angeles,
 California
1977 Nicholas Wilder Gallery, Los Angeles,
 California
1979 Los Angeles Institute of Contemporary
 Art, Los Angeles, California
1980 Creative Studies Gallery, University of
 California, Santa Barbara, Santa
 Barbara, California
1981, Asher/Faure Gallery, Los Angeles,
 83, California
 85
1982 Los Angeles Municipal Art Gallery,
 Los Angeles, California
1985 Contemporary Arts Center, Honolulu,
 Hawaii
1985 Peter Strauss Bank, Agoura, California

Selected Group Exhibitions
1974 "Artists Selected by Other Artists:
 Gwynn Murrill, Judy Pfaff and Donald
 Wynn," Artists Space, New York, New
 York
1976 "L.A. Eight, Painting and Sculpture,"
 Los Angeles County Museum of Art,
 Los Angeles, California, catalog
1979 "Robert Bassler, Gwynn Murrill and
 John Okulick," Conejo Art Museum,
 Thousand Oaks, California
1980 "Three Creative Wood Carvers: Frank
 E. Cummings III, Gwynn Murrill and
 Martha Rising, Palos Verdes Art
 Center, Rancho Palos Verdes,
 California
1980 "Fellows Exhibition," American
 Academy in Rome, Rome, Italy,
 catalog

1982 "Contemporary Californians VIII:
 Gwynn Murrill and Martha Alf," Laguna
 Beach Museum of Art, Laguna
 Beach, California, catalog
1982 "Relationships: 8 Artists/8 Viewpoints,"
 Palos Verdes Art Center, Rancho
 Palos Verdes, California
1982 "Body Language," San Diego State
 College, San Diego, California, catalog
1982 "LAUA '82, An Artist's Living Space,"
 Japanese American Cultural and
 Community Center, Los Angeles,
 California
1983 "20 Years of Young Talent Winners,"
 Los Angeles County Museum of Art,
 Los Angeles, California, catalog
1984 "Wood Renditions," Security Pacific
 Bank, Los Angeles, California
1985 "Art in the Valley," Los Angeles Valley
 College, Van Nuys, California
1985 "Statements of Wood," California State
 University Northridge, Northridge,
 California
1985 "Animals in Sculpture," San Francisco
 International Airport, San Francisco,
 California

Selected Public Collections
Los Angeles County Museum of Art, Los
 Angeles, California
Security Pacific Bank, Los Angeles, California

Selected Private Collections
Johnny Carson, Los Angeles, California
Christoffe Deminel, New York, New York
Sam Francis, Santa Monica, California
Suzanne Muchnic, Playa del Rey, California
Nicolas Wilder, New York, New York

Selected Awards
1979 New Talent Award, Los Angeles
 County Museum of Art, Los Angeles,
 California
1979 Rome Prize Fellowship, American
 Academy in Rome, Rome, Italy
1984 Individual Artist's Fellowship, National
 Endowment for the Arts

Preferred Sculpture Media
Clay, Metal (cast) and Wood

Additional Art Fields
Drawing and Painting

Selected Bibliography
Ballatore, Sandy. "Eight Los Angeles Artists."
 Artweek vol. 7 no. 18 (May 1, 1976) pp. 1,
 24, illus.
Clothier, Peter. "Review of Exhibitions Los
 Angeles, Gwynn Murrill at Asher Faure."
 Art in America vol. 71 no. 10 (November
 1983) p. 235, illus.
McCloud, Mac. "Exhibitions: The Rich
 Possibilities of Wood." *Artweek* vol. 15 no.
 10 (March 10, 1984) p. 3-4, illus.

Muchnic, Suxanne. "The Art Galleries: La
 Cienega Area." *Los Angeles Times* (Friday,
 April 26, 1985) part VI, p. 4.
Wortz, Melinda. "The Nation Los Angeles:
 Gwynn Murrill, Asher Faure." *Art News* vol.
 82 no. 9 (November 1983) pp. 131-132,
 illus.

Gallery Affiliation
Ashler/Faure Gallery
612 North Almont Drive
Los Angeles, California 90069

Mailing Address
29012 Crest Drive
Agoura, California 91301

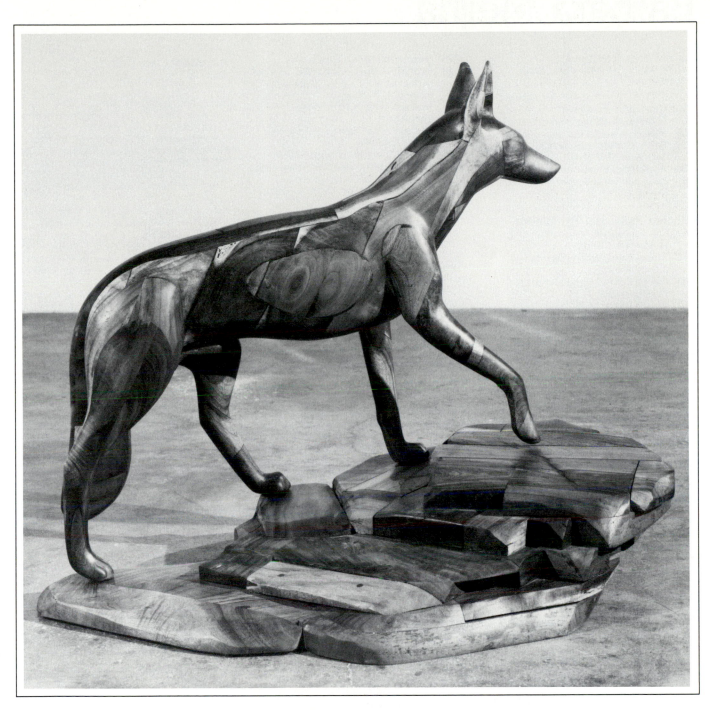

Coyote Series: Coyote II. 1984. Koa wood, 35½"h x 50"w x 27"d. Installation view 1985. Asher/Faure Gallery, Los Angeles, California. Photograph by Janice Felgar.

Artist's Statement

"My early influence and background are in painting and drawing. I never meant to be a sculptor. In fact I thought it was dumb to make something three-dimensional that was not functional. I became somewhat interested in sculpture when I went to Europe at age twenty-one and saw the works of Michaelangelo, Donatello and Rodin. But at the time I really was more interested in Impressionistic and Spanish paintings.

"The only reason I made my first sculpture of a wooden rocking horse was because I had to take a sculpture class in order to get my B.A. degree. I taught myself the technique I still use today for wood sculpture. My teacher, John McCracken, an abstract sculptor, had less of an idea about how to make figurative sculpture than I did. It took me three consecutive classes to finish the sculpture. Since I had spent all that time learning how to build a sculpture out of laminated wood, I decided it would be a waste of time if I did not make another. I still paint but sculpture seems to come so naturally to me. I am beginning to resign myself to the fact that I am really a sculptor."

Gwynn Murrill

429

Barbara Neijna

(Husband Roberto Martinez)
Born September 24, 1937 Philadelphia,
Pennsylvania

Education and Training
1950- Philadelphia Museum School of Art,
55 Philadelphia, Pennsylvania
1959 B.F.A., Sculpture, Syracuse University,
Syracuse, New York
1960- Accademia di Belle Arti, Brera, Milan,
61 Italy; study in sculpture with Marino
Marini

Selected Individual Exhibitions
1962 Fort Lauderdale Art Center, Fort
Lauderdale, Florida
1963 James David Gallery, Bay Harbor
Islands, Florida
1980 Museum of Art, Fort Lauderdale,
Florida, catalog
1982 South Gallery, Miami-Dade Public
Library, Miami, Florida
1984 Gloria Luria Gallery, Bay Harbor
Islands, Florida, catalog
1985 Gloria Luria Gallery, Bay Harbor
Islands, Florida

Selected Group Exhibitions
1960, "Annual Hortt Memorial Exhibition,"
61, Fort Lauderdale Museum of the Arts,
74, Fort Lauderdale, Florida, catalog
75,
77
1964 "Tenth Annual Drawing and Small
Sculpture Show," Ball State Teachers
College, Muncie, Indiana
1965 "Twentieth Southeastern Annual
Exhibition," High Museum of Art,
Atlanta, Georgia
1965 "Four Floridians," Florida Atlantic
University, Boca Raton, Florida
1973 "Florida Invitational Bal du Musée,"
Museum of Art, Fort Lauderdale,
Florida
1973 "Best of Florida," Harmon Gallery,
Naples, Florida
1975 "Year of the Woman," Miami-Dade
Community College, Miami, Florida
1976 "35 Artists in the Southeast," High
Museum of Art, Atlanta, Georgia,
catalog
1978 "Sculpture Park Miami '78," Miami
Bicentennial Park, Miami, Florida,
catalog
1979 "Grand et Jeune d'Aujourd'hui," Grand
Palais des Champs-Élysées, Paris,
France

1980- "Across the Nation: Fine Art for
81 Federal Buildings 1972-1979," National
Collection of Fine Arts, Smithsonian
Institution, Washington, D.C.; Hunter
Museum of Art, Chattanooga,
Tennessee
1981 "Group Artists," Bonino Gallery, New
York, New York
1982 "Women's Art: Miles Apart," Aaron
Berman Gallery, New York, New York;
East Campus Gallery, Valencia
Community College, Orlando, Florida,
catalog
1982 "Meadow Brook Invitational II: Outdoor
Sculpture," Meadow Brook Art Gallery,
Rochester, Michigan, catalog

Selected Public Collections
Blue Cross and Blue Shield of Florida, Coral
Gables, Florida
Central Business District Park Facility, Fort
Lauderdale, Florida
City Hall of Miami Beach, Miami Beach,
Florida
City of Miami, Heavy Equipment Facility,
Miami, Florida
Columbus Museum of Art, Columbus, Ohio
Continental Building, Coral Gables, Florida
High Museum of Art, Atlanta, Georgia
Independence Place, Redevelopment
Authority of Philadelphia/Greenwood
Group, Philadelphia, Pennsylvania
International Plaza Miami, Miami, Florida
Metropolitan Atlantic Rapid Transit Authority,
Garnet Station, Atlanta, Georgia
Museum of Art, Fort Lauderdale, Florida
Omni International, Miami, Florida
Pittsburgh Light Rail Transit Authority, Penn
Park Station, Pittsburgh, Pennsylvania
Strom Thurmond Federal Building, Columbia,
South Carolina
Tampa-Hillsborough County Public Library,
Tampa, Florida
Theater of the Performing Arts, Miami Beach,
Florida

Selected Private Collections
Mr. and Mrs. Richard Aiken, Atlanta, Georgia
Mr. and Mrs. Paul Berg, Miami, Florida
George S. Bolge, Fort Lauderdale, Florida
David Brillembourg, Caracas, Venezuela
Donald B. Kuspit, New York, New York

Selected Awards
1959 Louis Comfort Tiffany Foundation
Fellowship
1973 Best in Show, "Annual Hortt Memorial
Exhibition," Fort Lauderdale Museum
of the Arts, Fort Lauderdale, Florida,
catalog
1976 Individual Artist's Fellowship, Tampa-
Hillsborough County Public Library,
Tampa, Florida and National
Endowment for the Arts

Preferred Sculpture Media
Metal (welded) and Varied Media

Additional Art Field
Drawing

Selected Bibliography
Edwards, Ellen. "South Florida: No Longer a
Last Resort for Art." Art News vol. 78 no.
10 (December 1979) pp. 78-81, 84, illus.
Fundaburk, Emma Lila and Thomas G.
Davenport, comps. Art in Public Places in
the United States. Bowling Green, Ohio:
Bowling Green University Popular Press,
1975.
Kohen, Helen L. "Art Looks for a Place in the
Sun." Art News vol. 82 no. 2 (February
1983) pp. 62-65.
Kuspit, Donald B. "Review of Exhibitions Ft.
Lauderdale: Barbara Neijna at the Museum
of Art." Art in America vol. 69 no. 3 (March
1981) p. 133, illus.
Thalacker, Donald W. The Place of Art in the
World of Architecture. New York: Chelsea
House, 1980.

Gallery Affiliation
Gloria Luria Gallery
1033 Kane Concourse
Bay Harbor Islands, Florida 33154

Mailing Address
904 Anastasia Avenue
Coral Gables, Florida 33134

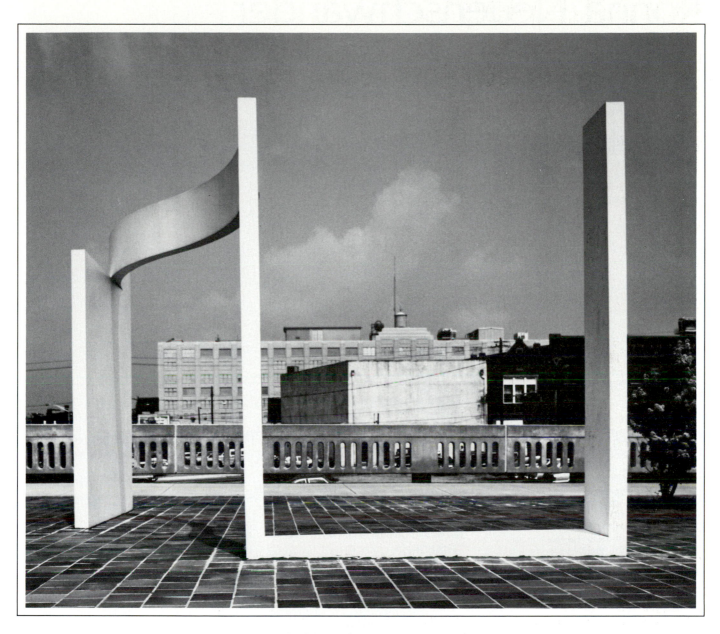

One Side or the Other. 1978-1983. Aluminum ¼″
plate with polyurethane finish, 12′h x 15′w x 15′d.
Collection Metropolitan Atlanta Rapid Transit
Authority, Garnet Station, Atlanta, Georgia.

Artist's Statement

"I was trained in all mediums: modeling,
carving in wood and stone, lost wax and
direct wax techniques for bronze and mig
and tig welding of all metals. I always felt it
was necessary to know in order to forget . . .
results should go beyond technique and
fettish finish. For the past twenty years, I
have primarily worked with welded aluminum,
coated with a white polyurethane paint
system. The metal, being lightweight, gives
me the opportunity to work in any scale and
also allows me to work alone when I choose.
The white painted surface gives dominance
and penetration of space. This became
apparent after moving to Florida where it
seemed that the tropical light would polarize
the entire environment. However, the white
of the imposed form in the blinding light of
the sun takes on new energy and creates
another boundry of opposition. This
white-control in space is not limited to the
southern edge of the world; it is basic and
universal. The environment is subjected to its
own energy because of the intervention.

"I am not interested in the material
possessing an identity separate from the
form itself. My work must read in totality as
a site specific non-enclosure rather than
elements made of a particular kind of metal
or paint."

431

Ronna Neuenschwander

Born April 24, 1954 Hoxie, Kansas

Education and Training
1976 B.F.A., Design, University of Kansas, Lawrence, Kansas

Selected Individual Exhibitions
1978 Buckley Center Gallery, University of Portland, Portland, Oregon
1981 Contemporary Crafts Gallery, Portland, Oregon
1984 Dawson Gallery, Rochester, New York

Selected Group Exhibitions
1978 "Illusionistic Realism in Contemporary Ceramics," Wentz Gallery, Pacific Northwest College of Art, Portland, Oregon
1979 "Third National Cone Box Show," University of Kansas, Lawrence, Kansas, catalog
1979 "National Clay/Form, Function, Fantasy," Long Beach Gallery, Long Beach, California, catalog
1979 "Northwest Regional Ceramics Exhibition," Hoffman Gallery, Oregon School of Arts and Crafts, Portland, Oregon
1980 "Westwood Clay National 1980," Otis Art Institute, Los Angeles, California, catalog
1980 "Contemporary Ceramics: A Response to Wedgwood," Traveling Exhibition, Museum of the Philadelphia Civic Center, Philadelphia, Pennsylvania
1981, "Oregon Biennial," Portland Art
83 Museum, Portland, Oregon, catalog
1981 "The Animal Image: Contemporary Objects and the Beast," Renwick Gallery of the National Museum of American Art, Smithsonian Institution, Washington, D.C., catalog

1981 "National Cone Box Show," Purdue University, West Lafayette, Indiana
1982 "Pacific North-West," Craft International Gallery, Tokyo, Japan
1982 "Animal Kingdom," Marcia Rodell Gallery, Los Angeles, California
1983 "Clay: A Medium for Personal Iconography," Elements Gallery, New York, New York
1983 "Ceramic Sculpture," Hoffman Gallery, Oregon School of Arts and Crafts, Portland, Oregon
1983 "Third International Ceramics Symposium of the Institute of Ceramic History," Morgan Art Gallery, Kansas City, Kansas
1984 "Clay: 1984, A National Survey Exhibition," Traver Sutton Gallery, Seattle, Washington
1985 "Ronna Neuenschwander and Anne Perrigo," The Gym, Marylhurst College for Lifelong Learning, Marylhurst, Oregon

Selected Public Collections
Eastern State Hospital, Department of Social and Health Services, Medical Lake, Washington
Mt. Scott and Montana Clinics of Kaiser-Permanente Hospitals, Portland, Oregon
Purdue University, West Lafayette, Indiana
University of Kansas, Lawrence, Kansas
Washington Park Zoo, Portland, Oregon

Selected Private Collections
Ernest and Ilo Bonyhadi, Portland, Oregon
Allan Chasanoff, Jericho, New York
Barry Merrit, Rochester, New York
George and Dorothy Saxe, Menlo Park, California
John and Joan Shipley, Portland, Oregon

Selected Awards
1980 Ceramist in Residence, Contemporary Crafts Association, Portland, Oregon and Oregon Arts Commission
1982 Individual Artist's Fellowship, Oregon Arts Commission

Preferred Sculpture Media
Clay

Selected Bibliography
Klemperer, Louise. "Ronna Neuenschwander." *American Ceramics* vol. 1 no. 1 (Spring 1982) p. 51, illus.
McLean, Cheryl R. "Ronna Neuenschwander." *Ceramics Monthly* vol. 30 no. 4 (April 1982) pp. 36-37, illus.
"Ronna Neunschwander." *Calyx* vol. 5 no. 1 (June 1980) pp. 53, 55, 57, illus.
Speight, Charlotte F. *Images in Clay Sculpture: Historical and Contemporary Techniques.* New York: Harper & Row, 1983.

Gallery Affiliations
Contemporary Crafts Gallery
3934 SW Corbett Avenue
Portland, Oregon 97201

Dawson Gallery
100 Alexander Street
Rochester, New York 14620

Mailing Address
1913 NW 24 Avenue
Portland, Oregon 97210

Artist's Statement

"I do not consider myself a history buff but I am an avid collector of the overlooked and obscure in history. This tendency, along with a delight for the humorous and absurd, has influenced my approach to ceramic sculpture. My interest lies not only in relating contemporary attitudes and cultural trends but placing them in broader historical contexts. Underlying historic events are often altered through 'artistic license' in much the same way I alter clay figures (deforming/reforming, subtracting/adding), creating not only new images, but new histories as well."

Ronna Neuenschwander

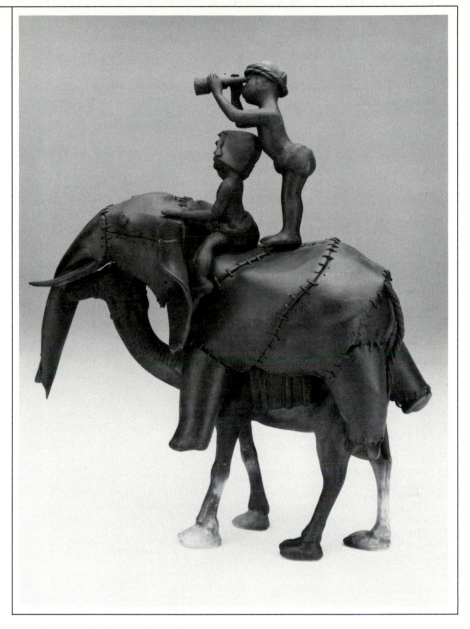

Queen Semiramis' War Elephant No. 4. 1981.
Earthenware, 15"h x 14"w x 7"d. Photograph by
Jerome Hart.

433

Louise Nevelson

née Louise Berliawsky
Born September 23, 1899 Kiev, Union of
Soviet Socialist Republics
The summary of Mrs. Nevelson's career
focuses on selected major events. For
extensive biographical and bibliographical
material, consult the Selected Bibliography.

Education and Training
1929- Art Students League, New York, New
30 York
1931 Hans Hofmann School, Munich,
 Germany, Federal Republic

Selected Individual Exhibitions
1960 David Herbert Gallery, New York, New
 York, catalog
1960 Galerie Daniel Cordier, Paris, France,
 catalog
1961 Martha Jackson Gallery, New York,
 New York, catalog
1961 Staatliche Kunsthalle, Baden-Baden,
 Germany, Federal Republic, catalog
1963 Hanover Gallery, London, Great
 Britain, catalog
1964 Pace Gallery, Boston, Massachusetts;
 Pace Gallery, New York, New York,
 catalog
1964 Galerie Gimpel-Hanover, Zürich,
 Switzerland, catalog
1964 Galleria d'Arte Contemporanea,
 Torino, Italy, catalog
1967 Whitney Museum of American Art,
 New York, New York, retrospective
 and catalog
1967 Galerie Daniel Gervis, Paris, France,
 catalog
1969 Galleria Civica d'Arte Moderna, Torino,
 Italy, catalog
1969, Pace Gallery, New York, New York,
74, catalog
76,
80,
83,
85
1969 Galerie Jeanne Bucher, Paris, France,
 catalog
1969 Rijksmuseum Kröller-Müller, Otterloo,
 Netherlands, catalog
1969 Museum of Fine Arts, Houston,
 Houston, Texas, retrospective and
 catalog
1970 University Art Museum, University of
 Texas at Austin, Austin, Texas,
 retrospective and catalog
1973- Walker Art Center, Minneapolis,
75 Minnesota, Traveling Exhibition to
 museums throughout the United
 States, retrospective and book
1974 Palais des Beaux-Arts, Brussels,
 Belgium

1974, Makler Gallery, Philadelphia,
76, Pennsylvania
79,
81,
84
1975 Galleria d'Arte Spagnoli, Florence,
 Italy, catalog
1977 Neuberger Museum, Purchase, New
 York, catalog
1979 William A. Farnsworth Art Museum
 and Library, Rockland, Maine,
 retrospective and catalog
1980 Phoenix Art Museum, Phoenix,
 Arizona, retrospective and catalog
1980 Whitney Museum of American Art,
 New York, New York, retrospective
 and book
1981 Pace Gallery, New York, New York;
 Wildenstein Galleries, London, Great
 Britain, catalog
1981 Galerie de France, Paris, France,
 retrospective
1982 Wildenstein Galleries, Tokyo, Japan
1983 Grey Art Gallery and Study Center,
 New York University, New York, New
 York
1984 Barbara Krakow Gallery, Boston,
 Massachusetts
1984, Hokin Gallery, Miami, Florida
85
1984 Storm King Art Center, Mountainville,
 New York
1984 Burchfield Center-Western New York
 Forum for American Art, Buffalo, New
 York

Selected Public Collections
Aldrich Museum of Contemporary Art,
 Ridgefield, Connecticut
Art Institute of Chicago, Chicago, Illinois
Birmingham Museum of Art, Birmingham,
 Alabama
Chrysler Museum, Norfolk, Virginia
City of Scottsdale, Arizona
Cleveland Museum of Art, Cleveland, Ohio
Corcoran Gallery of Art, Washington, D.C.
Dallas Museum of Art, Dallas, Texas
Delaware Art Museum, Wilmington, Delaware
Detroit Institute of Arts, Detroit, Michigan
Embarcadero Center Plaza, San Francisco,
 California
High Museum of Art, Atlanta, Georgia
Hirshhorn Museum and Sculpture Garden,
 Smithsonian Institution, Washington, D.C.
Israel Museum, Jerusalem, Israel
Jewish Museum, New York, New York
La Jolla Museum of Contemporary Art, La
 Jolla, California
Los Angeles County Museum of Art, Los
 Angeles, California
Louise Nevelson Plaza, New York, New York
Metropolitan Museum of Art, New York, New
 York
Minnesota Museum of Art, Minneapolis,
 Minnesota
Montreal Museum of Fine Arts, Montreal,
 Quebec, Canada
Musée d'Art Moderne de la Ville de Paris,
 Paris, France

Musée de Peinture et de Sculpture,
 Grenoble, France
Museum Boymans-Van Beuningen,
 Rotterdam, Netherlands
Museum of Art, Carnegie Institute,
 Pittsburgh, Pennsylvania
Museum of Contemporary Art, Chicago,
 Illinois
Museum of Modern Art, New York, New York
National Gallery of Scotland, Edinburgh,
 Scotland
Nelson-Atkins Museum of Art, Kansas City,
 Missouri
Newark Museum, Newark, New Jersey
New Orleans Museum of Art, New Orleans,
 Louisiana
Nordjyllands Kunstmuseum, Ålborg, Denmark
Phoenix Art Museum, Phoenix, Arizona
Princeton University, Princeton, New Jersey
Rijksmuseum Kröller-Müller, Otterloo,
 Netherlands
Saint Louis Art Museum, St. Louis, Missouri
Saint Peter's Lutheran Church, Citicorp
 Center, New York, New York
Solomon R. Guggenheim Museum, New
 York, New York
Tate Gallery, London, Great Britain
University of Massachusetts at Amherst,
 Amherst, Massachusetts
Walker Art Center, Minneapolis, Minnesota
Whitney Museum of American Art, New York,
 New York
William A. Farnsworth Art Museum and
 Library, Rockland, Maine
Yale University, New Haven, Connecticut

Selected Awards
1973 Honorary Doctorate of Fine Arts,
 Smith College, Northampton,
 Massachusetts
1977 Honorary Doctorate of Fine Arts,
 Columbia University, New York, New
 York
1983 Recipient of Gold Medal for Sculpture,
 American Academy and Institute of
 Arts and Letters, New York, New York

Preferred Sculpture Media
Metal (welded) and Wood

Additional Art Fields
Collage and Printmaking
Yale University, New Haven, Connecticut

Selected Bibliography

For a comprehensive biography of major exhibitions and collections from 1934 to 1976, refer to Arnold B. Glimcher's *Louise Nevelson*, New York: E. P. Dutton, 1976.

For a comprehensive chronological biography from 1899 to 1979 and annotated bibliography from 1955 to 1978, refer to Louise Nevelson's *Louise Nevelson: Atmospheres and Environments*, New York: Clarkson N. Potter, 1980.

For a comprehensive chronological biography from 1899 to 1983 and selected bibliography (exhibitions, interviews, publications and films from 1943 to 1983), refer to Jean Lipman's *Nevelson's World*, New York: Hudson Hills Press, 1983.

Hughes, Robert. "Sculpture's Queen Bee." *Time* (January 12, 1981) pp. 66-72, illus.

Munro, Eleanor C. *Originals: American Women Artists*. New York: Simon and Schuster, 1979.

Gallery Affiliation
Pace Gallery
32 East 57 Street
New York, New York 10022

Mailing Address
29 Spring Street
New York, New York 10012

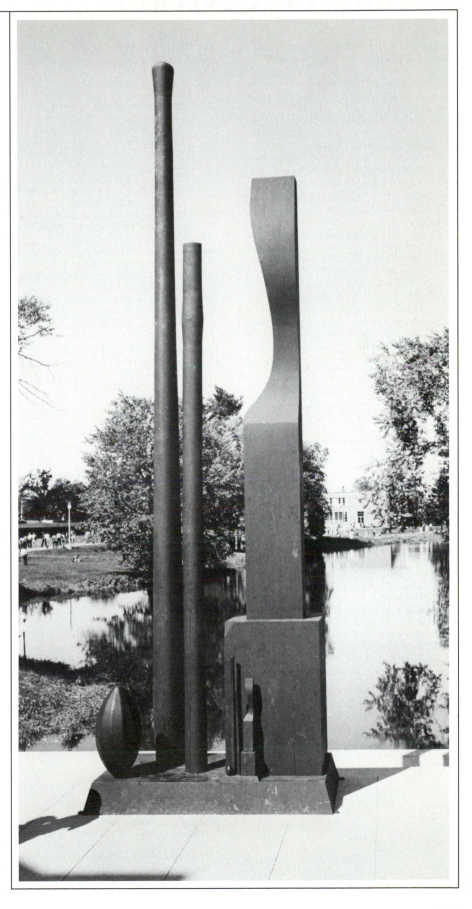

Louise Nevelson

Voyage. 1975. CorTen steel painted black, 30'h x 9'w x 5'7"d. Collection University of Massachusetts at Amherst, Amherst, Massachusetts. Courtesy Pace Gallery, New York, New York.

Marilyn Newmark

(Husband Leonard John Meiselman)
Born July 20, 1928 New York, New York

Education and Training
1945- Adelphi University, Garden City, New
47 York; study in art
1947- Studio of Paul Brown, Garden City,
57 New York, New York; study in horse
anatomy and composition
1949 Alfred University, Cornell, New York;
study in ceramic sculpture

Selected Individual Exhibitions
1976 Fasig Tipton Pavilion, Saratoga, New
York
1977, New York Racing Association, Elmont,
79 New York
1980 Cultural and Performing Arts Division,
Town of Oyster Bay, New York

Selected Group Exhibitions
1970- "Catharine Lorillard Wolfe Art Club
85 Annual Exhibition," National Arts Club,
New York, New York, catalog
1970- "Annual Exhibition," National Sculpture
85 Society, New York, New York, catalog
1970- "Allied Artists of America Annual
85 Exhibition," National Arts Club, New
York, New York, catalog
1971- "Annual Exhibition," Hudson Valley Art
85 Association, White Plains, New York,
catalog
1971- "Annual Exhibition," National Academy
82 of Design, New York, New York,
catalog
1971- "American Artists Professional League
85 National Annual Exhibition,"
Salmagundi Club, New York, New
York, catalog
1971 "American Natural History Art
Exhibition," James Ford Bell Museum
of Natural History, Minneapolis,
Minnesota, catalog
1974- "Annual Exhibition," Pen and Brush,
85 New York, New York, catalog
1976- "Reflections: Images of America,"
77 Traveling Exhibition (Eastern and
Western Europe), United States
Information Agency, Washington, D.C.
1980 "Annual Exhibition," Massachusetts
Academic Artists Association,
Springfield, Massachusetts, catalog

1980, "North American Sculpture Exhibition,"
81 Foothills Art Center, Golden, Colorado,
catalog
1980, "American Academy of Equine Art
81 Annual Juried Exhibition," Morven Park
International Equestrian Institute,
Leesburg, Virginia, catalog
1981- "Society of Animal Artists Annual
82 Juried Exhibition," Academy of Natural
Sciences of Philadelphia, Philadelphia,
Pennsylvania, catalog
1983 "Society of Animal Artists Annual
Juried Exhibition," Mulvane Art Center,
Topeka, Kansas, catalog
1984 "American Academy of Equine Art
Annual Juried Exhibition," Marita White
Gallery, Louisville, Kentucky
1984 "American Academy of Equine Art
Annual Juried Exhibition,"
Headley-Whitney Museum, Lexington,
Kentucky
1984 "Society of Animal Artists Exhibition,"
Cleveland Museum of Natural History,
Cleveland, Ohio, catalog

Selected Public Collections
American Saddle Horse Museum Association,
Louisville, Kentucky
International Museum of the Horse,
Lexington, Kentucky
National Museum of Racing, Saratoga
Springs, New York
New York Racing Association, Elmont, New
York

Selected Private Collection
Joe L. Allbritton, Houston, Texas
Richard Crompton III, Coatesville,
Pennsylvania
Mrs. J. W. Galbreath, Cincinnati, Ohio
Mrs. A. B. Hancock, Jr., Paris, Kentucky
Mr. and Mrs. Ogden Phipps, Jr., Old
Westbury, New York

Selected Awards
1977 Gold Medal, "American Artists
Professional League Grand National
Exhibition," Salmagundi Club, New
York, New York, catalog
1981 Gold Medal of Honor, "Sixty-Eighth
Allied Artists of America Annual
Exhibition," National Arts Club, New
York, New York, catalog
1982 Artists' Fund Prize for Finest
Sculpture in Exhibition, "One Hundred
and Fifty-Seventh Annual Exhibition,"
National Academy of Design, New
York, New York, catalog

Preferred Sculpture Media
Metal (cast)

Selected Bibliography
Cleary, Fritz. "Reality Reflected." *National
Sculpture Review* vol. 26 no. 1 (Spring
1977) pp. 8-17, 25, illus.
Dunwiddie, Charlotte. "American Animaliers."
National Sculpture Review vol. 26 no. 4
(Winter 1977-1978) pp. 8-19, illus.

"Images of America, USIA Sends Exhibition
Abroad." *National Sculpture Review* vol. 25
no. 1 (Spring 1976) pp. 18-19, illus.
Malmstrom, Margit. "The Bronze Horses of
Marilyn Newmark." *American Artist* vol. 35
no. 4 issue 346 (April 1971) pp. 28-33, 80,
81, illus.
"Of Equines and Equestrians." *National
Sculpture Review* vol. 33 no. 4 (Winter
1984-1985) pp. 14-15, illus.

Gallery Affiliation
Arthur Ackermann & Son
50 East 57 Street
New York, New York 10022

Mailing Address
Woodhollow Road
East Hills, New York 11577

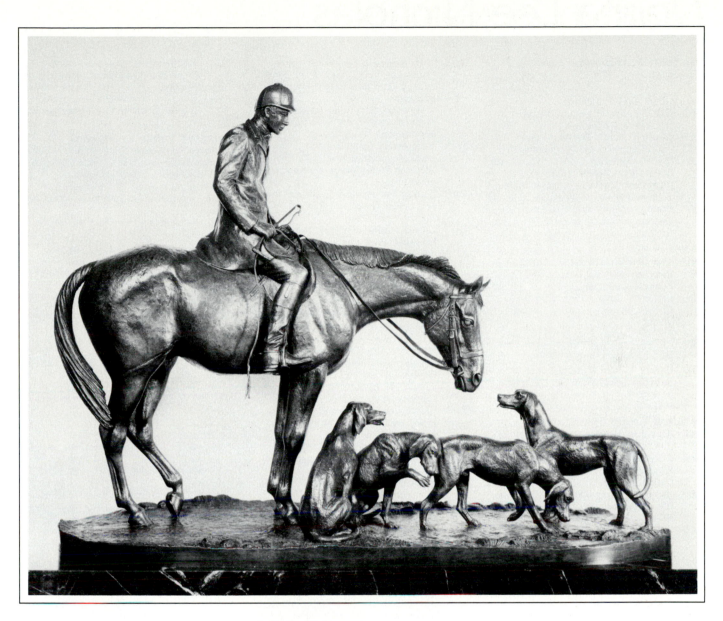

Day's End. 1970. Bronze, 17½"h x 23"w x 8¼"d.
Photograph by Eric Pollitzer.

Artist's Statement

"My love of horses, which became evident
when I was six, has motivated me to use
these animals as my subject. A horse was
the first thing I ever drew; at the age of
seven I began to ride. I pursued sculpting
horses while in my early teens and through
formal study at Alfred University. For many
years I was a friend and protégé of the artist
Paul Brown and his style in painting horses
has in many instances influenced my work.

"I begin with titles I think of or sights I
have seen. Bronze, because of its timeless
quality, sturdiness and ability for very fine
detail, is the perfect medium to express the
beauty and elegance of the horse."

Marilyn Neumark

Donna Lee Nicholas

Born March 30, 1938 South Pasadena, California

Education and Training
1959 B.A., Painting, Pomona College, Claremont, California
1960- Studio of Hiroaki Morino, Kyoto,
62 Japan; apprenticeship in ceramics
1966 M.F.A., Ceramics, Claremont Graduate School and University Center, Claremont, California; study with Paul Soldner and Henry Takemoto
1967 Michigan State University, East Lansing, Michigan; study in fiberglass sculpture

Selected Individual Exhibitions
1965 Pomona Valley Art Association, Pomona, California
1969 Left Bank Gallery, Flint, Michigan
1970 Edward Sherbeyn Gallery, Chicago, Illinois
1974 Erie Art Center, Erie, Pennsylvania
1976 Chatham College, Pittsburgh, Pennsylvania
1980 Gallery II, State University of New York College at Fredonia, Fredonia, New York

Selected Group Exhibitions
1967, "Flint Annual Exhibition," Flint Institute
68 of Arts, Flint, Michigan
1969 "Fifty-Seventh Michigan Artists Exhibition," Detroit Institute of Arts, Detroit, Michigan
1969, "Annual Drawing and Small Sculpture
72, Show," Ball State University, Muncie,
75 Indiana
1970 "Thirty-Eighth Annual Outdoor Sculpture Invitational," Blossom Music Center, Kent, Ohio
1970 "Western Pennsylvania Potters," Thiel College, Greenville, Pennsylvania
1971 "Projections '71," 68 Ton Gallery, Alexandria, Virginia
1971, "Annual Ceramics Exhibition," Lang Art
84 Gallery, Scripps College, Claremont, California
1971, "Annual Three Rivers Arts Festival,"
72, Gateway Center, Pittsburgh,
74 Pennsylvania, catalog
1971 "Twenty-Third Annual Ohio Ceramic and Sculpture Show," Butler Institute of American Art, Youngstown, Ohio
1971 "For Men Only," Lee Nordness Gallery, New York, New York
1972 "Salt Glaze Ceramics," Museum of Contemporary Crafts, New York, New York, catalog
1973 "Ceramics International 1973," Alberta College of Art, Calgary, Alberta, Canada, catalog
1973 "Seventh Annual National Drawing and Small Sculpture Show," Del Mar College, Corpus Christi, Texas

1973 "Two Women in Ceramic Sculpture: Donna Lee Nicholas and Mary Carolyn Judson," Xochipilli Gallery, Rochester, Michigan
1974 "Claythings: East Coast Invitational," Moore College of Art, Philadelphia, Pennsylvania
1975 "First Annual Sculptural and Semifunctional Ceramic Invitational," Stockton State College, Pomona, New Jersey
1975 "Central Pennsylvania Festival of the Arts Juried Sculpture Exhibition," Pennsylvania State University-University Park Campus, University Park, Pennsylvania
1976 "50 American Artists," Louisiana State University and Agricultural and Mechanical College, Baton Rouge, Louisiana
1976 "The Object as Poet," Renwick Gallery of the National Collection of Fine Arts, Smithsonian Institution, Washington, D.C., catalog
1977 "Contemporary Ceramic Sculpture," William Hayes Ackland Memorial Art Center, University of North Carolina at Chapel Hill, Chapel Hill, North Carolina, catalog
1977 "Donna Lee Nicholas and Mary Jane Kidd," Waterford Art Center, Waterford, Pennsylvania
1977, "Group Exhibition," Robert Kidd
78, Gallery, Birmingham, Michigan
79
1977 "December Twelve," Exhibit A, Evanston, Illinois
1978 "Donna Lee Nicholas and Mary Jane Kidd," Pittsburgh Center for the Arts, Pittsburgh, Pennsylvania
1978- "Women Artists: Clay, Fiber, Metal,"
79 Traveling Exhibition, Bronx Museum of The Arts, New York, New York
1979- "A Century of Ceramics in the United
80 States 1878-1978," Everson Museum of Art, Syracuse, New York; Renwick Gallery of the National Collection of Fine Arts, Smithsonian Institution, Washington, D.C., book
1979 "Ceramic Invitational," Pratt Institute, Brooklyn, New York
1979 "Clay at Clay County II," Plains Art Museum, Moorhead, Minnesota, catalog
1981 "Low-Fire Clay Sculpture," Holtzman Art Gallery, Towson State University, Baltimore, Maryland, catalog
1982 "Sixth Biennial Sculpture Exhibition," Allegheny College, Meadville, Pennsylvania, catalog
1982 "Clay Invitational," GMB Gallery, Birmingham, Michigan
1983 "American Clay Artists," Rosenfeld Gallery, Philadelphia, Pennsylvania, catalog
1983 "Artlink Exhibition," Purdue University, West Lafayette, Indiana
1983 "Clay National," Erie Art Museum, Erie, Pennsylvania, catalog

1984 "Northwest Pennsylvania Artists' Association Invitational," University of Pittsburgh, Pittsburgh, Pennsylvania
1984 "Sixty-First Annual Spring Exhibition," Erie Art Museum, Erie, Pennsylvania

Selected Public Collections
California Polytechnic State University San Luis Obispo, San Luis Obispo, California
Erie Art Museum, Erie, Pennsylvania
Flint Institute of Arts, Flint, Michigan
Joe & Emily Lowe Art Gallery, Syracuse, New York
Plains Art Museum, Moorhead, Minnesota

Selected Private Collection
Robert L. Pfannebecker Collection, Lancaster, Pennsylvania

Preferred Sculpture Media
Clay

Additional Art Field
Painting

Teaching Position
Professor of Art, Edinboro University, Edinboro, Pennsylvania

Selected Bibliography
Clark, Garth. *A Century of Ceramics in the United States 1878-1978: A Study of its Development.* New York: E. P. Dutton, 1979.
Conrad, John W. *Contemporary Ceramic Techniques.* Englewood Cliffs, New Jersey: Prentice-Hall, 1979.
Nigrosh, Leon I. *Low Fire: Other Ways to Work in Clay.* Worcester, Massachusetts: Davis, 1980.
Wechsler, Susan. *Low-Fire Ceramics: A New Direction in American Clay.* New York: Watson-Guptill, 1981.
Woody, Elsbeth S. *Handbuilding Ceramic Forms.* New York: Farrar, Straus, Giroux, 1978.

Gallery Affiliation
GMB Gallery
344 Hamilton Row
Birmingham, Michigan 48011

Mailing Address
119 Valley View Drive
Edinboro, Pennsylvania 16412

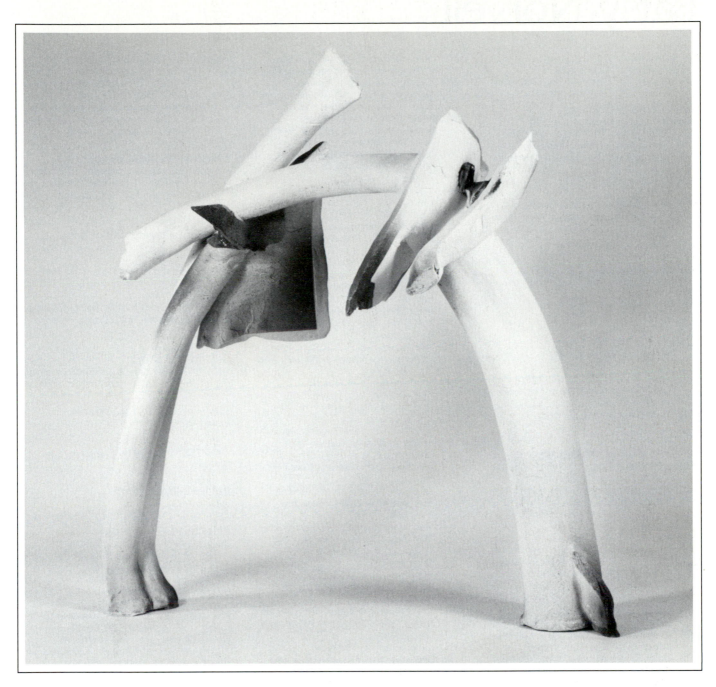

Arc II. 1977. Low fire clay and mat glazes, 28"h x 25"w x 10"d.

Artist's Statement

"My sculpture reflects concerns which have developed over my twenty years' involvement with clay. I am interested in form/space relationships which are dynamic and tenuous and evoke the energy and tensions I observe in nature, some forms of dance and Japanese calligraphy. I use dry, vibrant glaze colorations to complement these relationships and to create a surface liveliness, resulting in sculptural forms with painterly qualities."

Donna Nicholas

439

Patsy Norvell

née Patricia Ann
(Husband Robert S. Zakanitch)
Born July 13, 1942 Greenville, South Carolina

Education and Training
1964 B.A., Graphics, Sculpture and
Mathematics, Bennington College,
Bennington, Vermont; study in
sculpture with Anthony Caro, Lyman
Kipp, David Smith and Tony Smith
1964 Apprenticeship to David Smith, Bolton
Landing, New York
1970 M.A., Sculpture, City University of
New York Hunter College, New York,
New York; study with Robert Morris
and Tony Smith

Selected Individual Exhibitions
1973, A.I.R. Gallery, New York, New York
75,
78,
80,
82
1979 Vassar College Art Gallery,
Poughkeepsie, New York,
retrospective and catalog
1980 Avery Fisher Hall, Lincoln Center for
the Performing Arts, New York, New
York
1984 Matthews Hamilton Gallery,
Philadelphia, Pennsylvania

Selected Group Exhibitions
1972 "13 Women Artists," 117 Prince Street
Gallery, New York, New York
1972 "New York Women Artists," University
Art Gallery, State University of New
York at Albany, Albany, New York,
catalog
1973 "Of Paper," Newark Museum, Newark,
New Jersey
1974 "Painting and Sculpture Today 1974,"
Indianapolis Museum of Art,
Indianapolis, Indiana, catalog
1975 "Primitive Presence in the Seventies,"
Vassar College Art Gallery,
Poughkeepsie, New York, catalog
1975 "Spare," Central Hall Gallery, Port
Washington, New York, catalog
1976 "Abstraction: Alive and Well," Brainerd
Art Gallery, Potsdam, New York,
catalog
1976 "Rooms," P.S. 1, Institute for Art and
Urban Resources, Long Island City,
New York, catalog
1977 "Wood," Nassau County Museum of
Fine Arts, Roslyn, New York, catalog
1978 "Out of the House," Whitney Museum
of American Art, Downtown Branch,
New York, New York
1978 "Overview: A.I.R. Five Year
Retrospective," P.S. 1, Institute for Art
and Urban Resources, Long Island
City, New York, catalog
1978 "Contemporary Sculpture," Robert
Freidus Gallery, New York, New York
1978 "Art on the Beach," Battery Park
Landfill, Battery Park City, New York

1979 "Part I and Part II, O.I.A. Sculpture,"
Ward's Island, New York, catalog
1979 "Presence of Nature," Whitney
Museum of American Art, Downtown
Branch, New York, New York
1980 "Hair," Cooper-Hewitt Museum,
Smithsonian Institution, New York,
New York, catalog
1980 "Structure, Narrative, Decoration,"
McIntosh-Drysdale Gallery,
Washington, D.C.
1981 "Decorative Sculpture," Sculpture
Center, New York, New York
1981- "Usable Art," Traveling Exhibition,
82 State University of New York College
at Plattsburgh, Plattsburgh, New York,
catalog
1981- "Home Work," National Women's Hall
82 of Fame, Seneca Falls, New York; Joe
& Emily Lowe Art Gallery, Syracuse,
New York; Amelie A. Wallace Gallery,
State University of New York College
at Old Westbury, Old Westbury, New
York, catalog
1981 "Gardens of Delight," Cooper-Hewitt
Museum, Smithsonian Institution, New
York, New York
1981 "The Image of the House in
Contemporary Art," University of
Houston Lawndale Annex, Houston,
Texas, catalog
1981 "Transitions II: Landscape/Sculpture,"
Amelie A. Wallace Gallery, State
University of New York College at Old
Westbury, Old Westbury, New York,
catalog
1981- "Sculpture Invitational at Zabriskie
82 521," Zabriskie Gallery, New York,
New York
1982 "Partitions," Manhattan Center Gallery,
Pratt Institute, New York, New York
1982- "A Collaboration/Norvell and
83 Zakanitch," Sidney Janis Gallery, New
York, New York; Norton Gallery and
School of Art, West Palm Beach,
Florida, catalog
1983 "Content in Abstraction: The Uses of
Nature," High Museum of Art, Atlanta,
Georgia, catalog
1983 "Ornamentalism: The New
Decorativeness in Architecture and
Design," Hudson River Museum,
Yonkers, New York; Archer M.
Huntington Art Gallery, Austin, Texas
1983 "Transparent Structures," Thorpe
Intermedia Gallery, Sparkill, New York
1983 "New Decorative Works from the
Collection of Norma and William Roth,"
Loch Haven Art Center, Orlando,
Florida; Jacksonville Art Museum,
Jacksonville, Florida, catalog
1983 "Ornamentalism," Harcus Gallery,
Boston, Massachusetts
1983- "1 + 1 = 2," Traveling Exhibition,
85 Bernice Steinbaum Gallery, New York,
New York, catalog
1984 "A Celebration of American Women
Artists Part II: The Recent Generation,"
Sidney Janis Gallery, New York, New
York, catalog

1984- "The Folding Image: Screens by
85 Western Artists of the 19th and 20th
Centuries," Renwick Gallery of the
National Museum of American Art,
Smithsonian Institution, Washington,
D.C.; Yale University Art Gallery, New
Haven, Connecticut, catalog

Selected Public Collections
Federal Courthouse, Bridgeport, Connecticut
Rutgers University, Douglass College,
Nicholas Recital Hall, New Brunswick, New
Jersey

Selected Private Collections
Mr. and Mrs. Stanford Alexander, Houston,
Texas
Mr. and Mrs. Eddo Bult, New York, New York
Jason and Diana Buroughs McCoy, New
York, New York
Mr. and Mrs. Peter Morrin, Atlanta, Georgia
William and Norma Roth, Winter Haven,
Florida

Selected Award
1976 Individual Artist's Fellowship, National
Endowment for the Arts

Preferred Sculpture Media
Varied Media

Additional Art Field
Drawing

Related Profession
Visiting Artist

Selected Bibliography
Brach, Paul. "Review of Exhibitions New
York: Patsy Norvell and Robert Zakanitch
at Janis." *Art in America* vol. 71 no. 2
(February 1983) p. 130, illus.
Gutman, Thea. "Patsy Norvell." *Arts Magazine*
vol. 54 no. 3 (November 1979) p. 8, illus.
Heit, Janet. "Patsy Norvell." *Arts Magazine*
vol. 54 no. 10 (June 1980) p. 23, illus.
Jensen, Robert and Patricia Conway.
*Ornamentalism: The New Decorativeness
in Architecture and Design.* New York:
Clarkson N. Potter, 1982.
Robins, Corinne. "Patsy Norvell." *Arts
Magazine* vol. 50 no. 9 (May 1976) p. 14,
illus.

Gallery Affiliation
A.I.R. Gallery
63 Crosby Street
New York, New York 10012

Mailing Address
78 Greene Street
New York, New York 10012

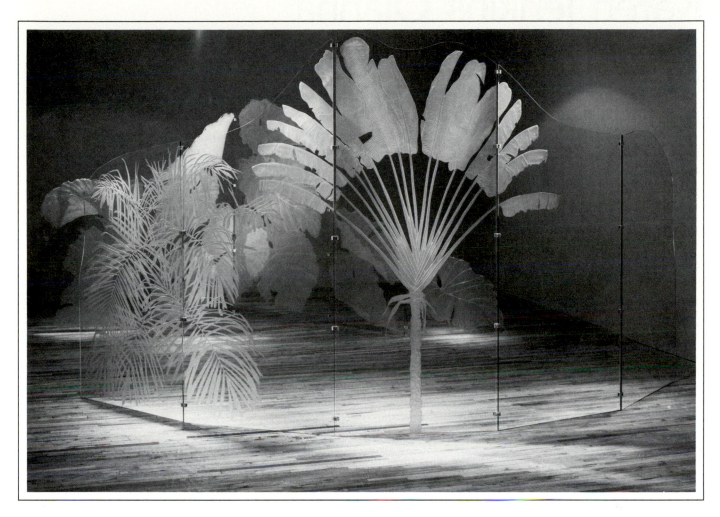

Traveler. 1982. Sandblasted glass, five panels, each 94"h x 38"w x ⅜"d. Installation view 1982 (in front of *Jungle Wall*). A.I.R. Gallery, New York, New York. Photograph by Kevin Noble.

Artist's Statement

"My work is involved with the definition and division of space and the establishment of an environmental setting or situation. In my outdoor sculpture, I have often used ready-made and fabricated fencing materials as well as plants and flowers. *Lifeline*, an autobiographical piece, combined the evolution of time and narrative with spatial concerns experienced by walking through the site and setting. The most recent outdoor piece involves an intimate columned arbor with extensive seasonal plantings. Recently I have worked with large glass panels, sandblasted with plant images, which act as spatial dividers and provide an illusionary environment."

Karen Jenkins Olanna

née Karen Louise Jenkins
(Husband Melvin Olanna)
Born March 2, 1953 Seattle, Washington

Education and Training
1973- University of Alaska, Fairbanks,
75 Fairbanks, Alaska; study in wood
carving with Ronald Senungetuk
1976- Solid Arts Studio, Shishmaref, Alaska;
84 study in stone and wood carving with
Melvin Olanna
1985- Independent study in sculpture in
86 France

Selected Individual Exhibitions
1976 Alaska State Museum, Juneau, Alaska
1978 N. N. Gallery, Seattle, Washington

Selected Group Exhibitions
1975 "Group Exhibition," Bear Gallery,
Alaskaland Civic Center, Fairbanks,
Alaska
1977 "Juried Art Exhibition," Baranof Arts
and Crafts Association, Sitka, Alaska
1980 "Gallery Artists," The Gathering,
Ketchikan, Alaska
1981 "Melvin and Karen Olanna Sculptures,"
Art Works, Fairbanks, Alaska
1982, "Wood, Stone and Horn Carvings,"
83 Artique Limited, Anchorage, Alaska
1983 "Gallery Exhibition," Stonington
Gallery, Anchorage, Alaska; Ketchum,
Idaho; Seattle, Washington
1984 "Horn, Stone and Wood Carvings,"
Stonington Gallery, Seattle,
Washington

Selected Public Collections
Alaska Constitution Park, Fairbanks, Alaska
University of Alaska, Fairbanks, Fairbanks,
Alaska
Women's Correctional Center, Eagle River,
Alaska

Selected Awards
1975 Academic Talent Grant, University of
Alaska, Fairbanks, Fairbanks, Alaska
1976 Outstanding Art Student, University of
Alaska, Fairbanks, Fairbanks, Alaska
1978 First Prize, "Juried Art Exposition,"
Nome Winter Carnival, Nome, Alaska

Preferred Sculpture Media
Horn, Metal (cast) and Stone

Additional Art Field
Painting

Gallery Affiliation
The Gathering
28 Creek Street
Ketchikan, Alaska 99772

Mailing Address
General Delivery
Shishmaref, Alaska 99772

Artist's Statement

"Beginning wood carving of pictorial scenes on a remote Norweigan farm and now living in an Eskimo village on the Bering Sea, I feel the contribution of regional influences in traditional materials adds richness to the history of art. My education has given me respect for fine craftsmanship which exacts the limits of stone, wood and horn. Living in the Artic, reindeer and moose horn are the only readily available media. I choose materials best able to withstand Alaska's extreme environment.

"I strive for voluminous forms which transcend a folk art emphasis to abstractions signifying the mysteries of life. Stone, especially marble, best renders volume in space: to create poetic form is the heart of my work."

Karen Jenkins Olanna

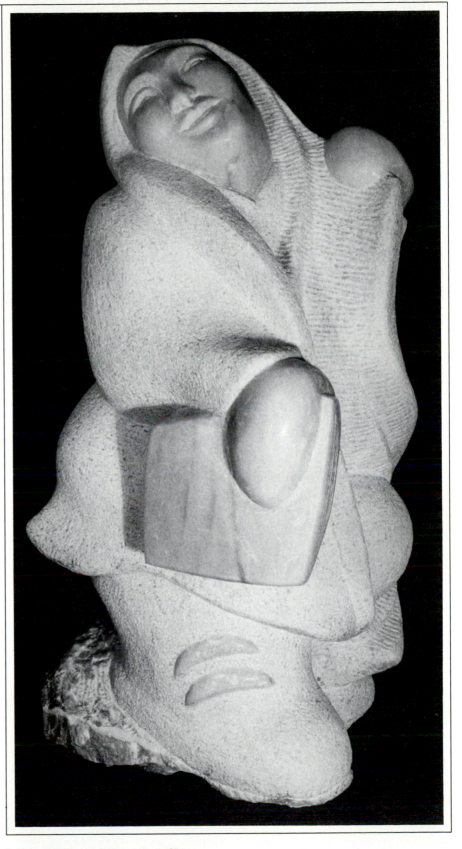

Student. 1984. Marble, 2'6"h x 14"w x 16"d.
Collection University of Alaska, Fairbanks,
Fairbanks, Alaska. Photograph by Emily Grice.

443

Jeanette M. Oliver

née Jeanette Mildred Gilliam
Born July 17, 1939 Burlington, North Carolina

Education and Training
1959-61 Traphagen School of Fashion, New York, New York
1960-61 Art Students League, New York, New York
1967 School of Fine Arts, Los Angeles, California; study in sculpture with Morton Dimonstein
1980 B.F.A., Sculpture, University of North Carolina at Greensboro, Greensboro, North Carolina; study with Peter Agostini

Selected Individual Exhibitions
1981 Durham Arts Council, Durham, North Carolina
1981 Danville Museum of Fine Arts & History, Danville, Virginia
1982 West Gallery, Duke University, Durham, North Carolina
1982 Davidson College Art Gallery, Davidson, North Carolina
1982 Second Street Gallery, Charlottesville, Virginia
1983 Sculpture Garden, Southeastern Center for Contemporary Art, Winston-Salem, North Carolina

Selected Group Exhibitions
1980 "Southeast Sculpture Exhibition," Lyndon House Gallery, Univerisity of Georgia, Athens, Georgia
1981, 83 "Biennial Exhibition of Piedmont Painting and Sculpture," Mint Museum of Art, Charlotte, North Carolina, catalog
1981 "City Art 1981," Studio Gallery, Washington, D.C.
1982 "Tri-State Sculptors Invitational," Horace Williams House, Chapel Hill, North Carolina
1982 "Artsplosure '82: Regional Sculpture Exhibition, Raleigh Arts Commission," Fayetteville Mall, Raleigh, North Carolina
1982 "First Annual Exhibit of North Carolina Sculpture," Northern Telecom, Research Triangle Park, North Carolina, catalog
1982 "Sculpture Garden 1982," Winston-Salem State University, Winston-Salem, North Carolina, catalog
1982 "Tri-State Sculpture Conference Exhibition," East Carolina University Museum of Art/Gray Art Gallery, Greenville, North Carolina, catalog
1983 "Art-7 International Art Exposition," Washington Convention Center, Washington, D.C.
1983 "Alternative Devotional Objects," Somerhill Gallery, Durham, North Carolina
1983 "Tri-State Sculpture 1983," Green Hill Center for North Carolina Art, Greensboro, North Carolina, catalog
1983 "Outdoor Sculpture Exhibition," Queens College, Charlotte, North Carolina
1983 "Twenty-Fifth Annual Spring Art Show," Lancaster Armory, Lancaster, South Carolina

Selected Public Collection
Duke University, Fuqua School of Business, Durham, North Carolina

Preferred Sculpture Media
Metal (welded)

Gallery Affiliation
Somerhill Gallery
5504 Chapel Hill Boulevard
Durham, North Carolina 27707

Mailing Address
104 Barnhardt Street
Greensboro, North Carolina 27406

Artist's Statement

"My attention to steel began in the local steel scrapyard. The very sight of odd industrial steel shapes piled up in a heap, bent and distorted, was so intriguing to me that soon after, I took up welding. I had begun as a painter and I continued to reach for bridging the gap between the two mediums by letting the spontaneity and plastic qualities of brush strokes carry over into the steel. The open form acquires an energy that is nearly in motion.

"To plan a piece, I work for days with ink and brush on mylar. The sheer rawness of the rapid movements of arm and brush take over and the speed assumes a violence which comes through in the shapes. The collage image is blown up from 1 foot to 8 foot scale, then I began cutting these shapes in steel plate."

Jeanette M. Oliver

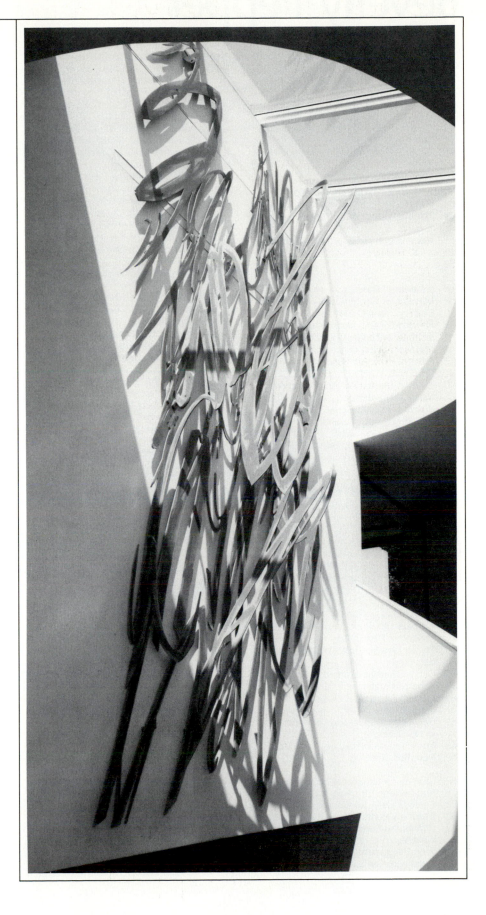

Duluth. 1984. Steel, 225½"h x 88½"w x 32½"d. Collection Duke University, Fuqua School of Business, Durham, North Carolina. Photograph by Ted Davison.

Beverly Pepper

(Husband Curtis Bill Pepper)
Born December 20, 1924 New York, New York

Education and Training
1941 B.A., Industrial and Advertising Design, Pratt Institute, Brooklyn, New York
1946 Art Students League, New York, New York

Selected Individual Exhibitions
1961 Galleria Pogliana, Rome, Italy, catalog
1962 Thibaut Gallery, New York, New York, catalog
1965, Marlborough Galleria d'Arte, Rome,
68, Italy, catalog
69,
72
1968 Galleria La Bussola, Turin, Italy
1969 Museum of Contemporary Art, Chicago, Illinois, catalog
1969 Hayden Gallery, Massachusetts Institute of Technology, Cambridge, Massachusetts, catalog
1969 Albright-Knox Art Gallery, Buffalo, New York, catalog
1970 Everson Museum of Art, Syracuse, New York, catalog
1971 Piazza Margana, Rome, Italy, catalog
1972 Qui Arte Contemporanea, Rome, Italy, catalog
1973 Tyler School of Art, Temple University Abroad, Rome, Italy, retrospective and catalog
1975 Hammarskjöld Plaza Sculpture Garden, New York, New York
1975, André Emmerich Gallery, New York,
77, New York
79,
80
1976 San Francisco Museum of Modern Art, San Francisco, California,
1977 Seattle Art Museum, Seattle, Washington
1977, Indianapolis Museum of Art,
78 Indianapolis, Indiana
1978 Art Museum, Princeton University, Princeton, New Jersey
1979 Piazza Mostra, Todi, Perugia, Italy, catalog
1980, Gimpel-Hanover-Emmerich Galerien,
83 Zürich, Switzerland
1981 Makler Gallery, Philadelphia, Pennsylvania
1981 Davenport Art Gallery, Davenport, Iowa, catalog
1982, André Emmerich Gallery, New York,
83, New York, catalog
84
1982 Laumeier International Sculpture Park And Gallery, St. Louis, Missouri
1982 Yares Gallery, Scottsdale, Arizona
1982 Galleria Il Ponte, Rome, Italy, catalog
1983 Huntington Galleries, Huntington, West Virginia
1984, John Berggruen Gallery, San
85 Francisco, California

Selected Group Exhibitions
1961 "The Quest and the Quarry," Rome-New York Art Foundation, Rome, Italy, catalog
1962 "Sculpture nella Citta," Spoleto, Italy
1964 "Sculpture nel Metallo," Galleria Civica d'Arte Moderna, Turin, Italy
1968 "Plus by Minus: Today's Half-Century," Albright-Knox Art Gallery, Buffalo, New York, catalog
1970 "Omaggio a Roma," Galleria Nazionale d'Arte Moderna, Rome, Italy
1970 "Twelfth Arts Festival," Jacksonville Museum of Art, Jacksonville, Florida
1972 "XXIII Venice Biennale," Venice, Italy
1974 "Twentieth Century Monumental Sculpture," Marlborough Gallery, New York, New York
1975 "Monumental Sculpture in the 1970s," Janie C. Lee Gallery, Houston, Texas
1975 "Renaissance in Parkersburg," Parkersburg Art Center, Parkersburg, West Virginia
1976 "Ninth International Sculpture Conference," Area Galleries and Institutions, New Orleans, Louisiana (Sponsored by International Sculpture Center, Washington, D.C.)
1977 "Artisti Stranieri Operanti in Italia," Quadriennale Nazionale d'Arte di Roma, Rome, Italy
1977 "XI Biennale Internazionale della Piccola Sculptura," Palazzo della Ragione, Padova, Italy
1979 "Art in Architecture Program," United States General Services Administration, Washington, D.C.
1980 "Art in Embassies, Collection of Ambassador and Mrs. Warren Manshel," State Museum of Art, Copenhagen, Denmark, catalog
1980 "Sculpture at Sands Point," Nassau County Museum, Sands Point Park and Preserve, Port Washington, New York, catalog
1980 "Eleventh International Sculpture Conference," Area Galleries and Institutions, Washington, D.C. (Sponsored by International Sculpture Center, Washington, D.C.)
1980- "Across the Nation: Fine Art for
81 Federal Buildings, 1972-1979," National Collection of Fine Arts, Washington, D.C.; Hunter Museum of Art, Chattanooga, Tennessee
1982 "Casting: A Survey of Cast Metal Sculpture in the 80s," Fuller Golden Gallery, San Francisco, California, catalog
1983 "Bronze at Washington Square," Washington Square Partnership and Public Art Trust, Washington, D.C., catalog
1983 "Sculpture: The Tradition in Steel," Nassau County Museum of Fine Arts, Roslyn, New York
1983- "Iron Cast/Cast Iron," Pratt Manhattan
84 Gallery, New York, New York; Pratt Institute Gallery, Brooklyn, New York
1984 "L'Arte del Disegno," Il Ponte Editrice d'Arte, Rome, Italy
1984- "Works in Bronze, A Modern Survey,"
87 Traveling Exhibition, University Art Gallery, Sonoma State University, Rohnert Park, California, catalog
1985 "The Artist as Social Designer," Los Angeles Museum of Contemporary Art, Los Angeles, California
1985 "An Affair of the Heart," Albright-Knox Art Gallery, Buffalo, New York

Selected Public Collections
Albertina Museum, Vienna, Austria
Albright-Knox Art Gallery, Buffalo, New York
American Telephone and Telegraph Headquarters, Bedminster, New Jersey
Atlantic Richfield Company, Los Angeles, California
Carborundum Corporation, Niagara Falls, New York
Dartmouth College, Hanover, New Hampshire
Davenport Art Gallery, Davenport, Iowa
Everson Museum of Art, Syracuse, New York
Federal Reserve Bank, Philadelphia, Pennsylvania
Galleria Civica d'Arte Moderna, Turin, Italy
Galleria d'Arte Moderna, Florence, Italy
Hirshhorn Museum and Sculpture Garden, Smithsonian Institution, Washington, D.C.
Indianapolis Museum of Art, Indianapolis, Indiana
Instituto Italiano di Cultura, Stockholm, Sweden
Jacksonville Art Museum, Jacksonville, Florida
Laumeier International Sculpture Park And Gallery, St. Louis, Missouri
Massachusetts Institute of Technology, Cambridge, Massachusetts
Metropolitan Museum of Art, New York, New York
Milwaukee Art Museum, Milwaukee, Wisconsin
Museum of Modern Art, New York, New York
North Park Shopping Center, Dallas, Texas
Parkersburg Art Center, Parkersburg, West Virginia
Power Institute of Fine Arts, Sydney, Australia
Rutgers University, New Brunswick, New Jersey
Smith College, Northampton, Massachusetts
Walker Art Center, Minneapolis, Minnesota
Worcester Art Museum, Worcester, Massachusetts

Selected Private Collections
Mr. and Mrs. Barry Berkus, Santa Barbara, California
Mr. and Mrs. Marshall Cogan, New York, New York
Mr. and Mrs. Raymond D. Nasher, Dallas, Texas
Mr. and Mrs. Baron Elie de Rothschild, Paris, France

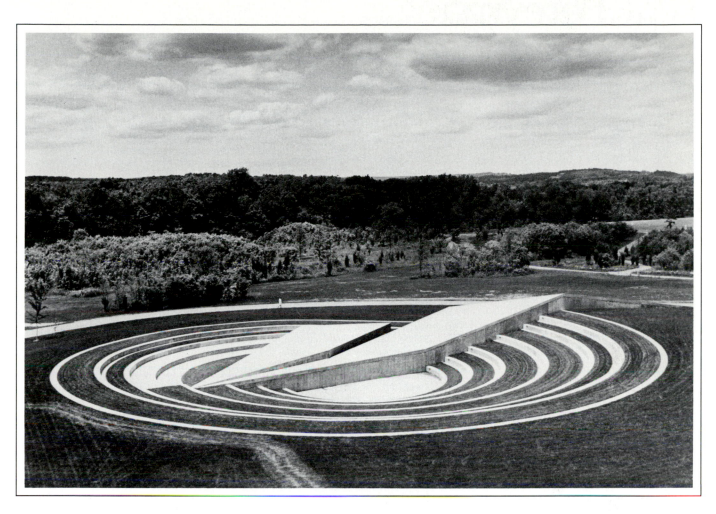

Amphisculpture. 1974-1977. Poured concrete and ground covering, 8'h x 14'd, 270' diameter. Collection American Telephone and Telegraph Headquarters, Bedminster, New Jersey. Photograph by Gianfranco Gorgoni.

Selected Awards
1982 Honorary Doctorate of Fine Arts, Pratt Institute, Brooklyn, New York
1983 Honorary Doctorate of Fine Arts, Maryland Institute College of Art, Baltimore, Maryland

Preferred Sculpture Media
Concrete, Metal (cast) and Metal (welded)

Additional Art Field
Drawing

Related Professions
Artist in Residence and Lecturer

Selected Bibliography
Andersen, Wayne. *American Sculpture in Process: 1930/1970*. Boston: New York Graphic Society, 1975.

Barnes, Helen. "Torre Olivola in Umbria: The Studio/Home of Sculptress Beverly Pepper." *Architectural Digest* vol. 35 no. 8 (October 1978) pp. 62-69, illus.

Munro, Eleanor C. *Originals: American Women Artists*. New York: Simon and Schuster, 1979.

Rose, Barbara E. *American Art Since 1900*. New York: Praeger, 1975.

Thalacker, Donald W. *The Place of Art in the World of Architecture*. New York: Chelsea House, 1980.

Gallery Affiliation
André Emmerich Gallery
41 East 57 Street
New York, New York 10022

Mailing Address
Torre Gentile di Todi
Perugia, Italy 06059

Artist's Statement
"My work has long been fed by an emotional source rooted in my need to impart a sense of interior logic to my sculpture. Within my abstract language of form, I want to make an object which has a powerful physical presence, but is inwardly turned—seemingly capable of intense self-absorption. The work may create a relationship which is very simple, yet somehow beyond the viewer's grasp."

447

Aka Pereyma

née Aka Bohumyla Klym
(Husband Constantine Pereyma)
Born September 30, 1927 Siedlce, Poland

Education and Training
1963- School of the Art Institute of Chicago,
64 Chicago, Illinois; study in ceramics,
 painting and sculpture
1966 Diploma, Sculpture, School of the
 Dayton Art Institute, Dayton, Ohio
1967 Hobart School of Welding Technology,
 Troy, Ohio; study in welding with
 Richard Stankiewicz

Selected Individual Exhibitions
1965 Troy Public Library, Troy, Ohio
1967 Ohio University, Athens, Ohio
1968, University of Dayton, Dayton, Ohio
85
1969 Robert McLaughlin Gallery, Civic
 Centre, Oshawa, Ontario, Canada
1970 Springfield Art Center, Springfield,
 Ohio
1972 Ukrainian Artists Association, Detroit,
 Michigan
1972 Niagara Falls Art Gallery, Niagara
 Falls, Ontario, Canada
1973 Edward H. Butler Library, State
 University of New York at Buffalo,
 Buffalo, New York
1973, Ukrainian Artists Association, New
83 York, New York
1973 Gallery 200, Columbus, Ohio
1976 Antioch College, Yellow Springs, Ohio
1976, Miami University, Oxford, Ohio
86
1976 Contemporary Arts Center, Cincinnati,
 Ohio
1978 Ukrainian-Canadian Art Foundation,
 Toronto, Ontario, Canada
1979 Hobart School of Welding Technology,
 Troy, Ohio
1982 Trinity Episcopal Church, Troy, Ohio
1984 United Methodist Church, Piqua, Ohio

Selected Group Exhibitions
1965 "All Ohio Graphic and Ceramics,"
 Dayton Art Institute, Dayton, Ohio,
 catalog
1966, "All Ohio Painting and Sculpture,"
68, Dayton Art Institute, Dayton, Ohio,
70, catalog
74
1970- "Big Outdoor Sculpture Exhibit,"
73 Blossom Music Center, Kent, Ohio
1973 "Annual Ohio Ceramic and Sculpture
 Show," Butler Institute of American
 Art, Youngstown, Ohio
1974 "Group Show," Ukrainian Institute of
 Modern Art, Chicago, Illinois, catalog
1976 "Ukrainian Heritage," Minneapolis
 Institute of Arts, Minneapolis,
 Minnesota
1977 "Invitational Exhibition," Malton Gallery,
 Cincinnati, Ohio
1977 "Shape Show," Akron Art Institute,
 Akron, Ohio
1978 "Wood Sculpture Invitational," Missouri
 Southern State College, Joplin,
 Missouri, catalog
1979 "Liturgical Art Invitational Exhibition,"
 Capital University, Columbus, Ohio
1979 "Tactile Art Show," Earlham College,
 Richmond, Indiana, catalog

Selected Public Collections
City of Troy, Public Square, Troy, Ohio
Hobart Brothers Technical Center, Troy, Ohio
Miami University-Middletown Campus,
 Middletown, Ohio
Robbins Myers Company, Dayton, Ohio
Ukrainian Institute of Modern Art, Chicago,
 Illinois

Selected Private Collections
Stephen Clark, Miami, Florida
Mr. and Mrs. George Hawk, Dayton, Ohio
Mr. and Mrs. George Kuser, New York, New
 York
Dr. and Mrs. Bohdan Osadsa, Cleveland,
 Ohio
Ann Smith, Kitty Hawk, North Carolina

Preferred Sculpture Media
Clay, Metal (welded) and Wood

Additional Art Fields
Decorative Ceramics and Painting

Teaching Position
Program Coordinator, Welding for Artists,
 Hobart School of Welding Technology,
 Troy, Ohio

Selected Bibliography
Campen, Richard N. *Outdoor Sculpture In
 Ohio*. Chagrin Falls, Ohio: West Summit
 Press, 1980.

Gallery Affiliations
Duck Blind Art Gallery
Box 222 in the Village of Duck
Kitty Hawk, North Carolina 27949

Malton Gallery
2709 Observatory Avenue
Cincinnati, Ohio 45208

Mailing Address
3200 Cathcart Road
Troy, Ohio 45373

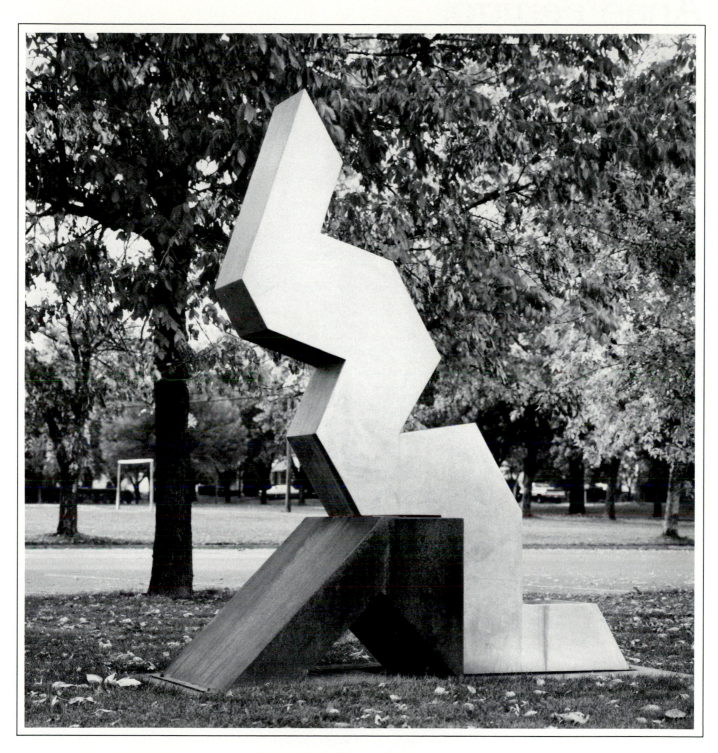

Jacob's Ladder. 1974. CorTen and aluminum, 13′h x 6′w x 4′d. Collection Hobart Brothers Technical Center, Troy, Ohio. Photograph by Glen R. Eppleston.

Artist's Statement

"I enjoy and need to incorporate in my everyday life the influence of the traditions and artistic expressions of my Ukrainian heritage. This enjoyment I consciously use as a point of departure in my artwork. I develop my compositions intuitively depending on my knowledge of Ukrainian folk art, especially the patterns of Ukrainian Easter eggs."

Alta Pereyma

449

Anne Perrigo

Born March 17, 1953 Argentia,
Newfoundland, Canada

Education and Training
1970- Cypress College, Cypress, California;
72 study in art
1971- University of California, Irvine, Irvine,
72 California; study in art
1972- University of New Mexico,
73 Albuquerque, New Mexico; study in
 art
1976 B.F.A., Ceramic Sculpture, University
 of Washington, Seattle, Washington;
 study with Howard Kottler and Patti
 Warashina
1978 M.F.A., Ceramic Sculpture, University
 of California, Davis, Davis, California

Selected Individual Exhibition
1984 Saint Martin's College, Lacey,
 Washington

Selected Group Exhibitions
1979 "Anne Perrigo, Joyce Moty and
 Suzanne Ferris," Penryn Gallery,
 Seattle, Washington
1981 "Paint on Clay: A Survey of the Use of
 Nonfired Surfaces on Ceramic Forms
 by Contemporary American Artists,"
 John Michael Kohler Arts Center,
 Sheboygan, Wisconsin, catalog
1982 "Factory of Visual Art Faculty
 Exhibition," Arts NW Gallery, Seattle,
 Washington
1982 "Intellectual Warmth: Ten Seattle
 Artists," Jackson Street Gallery,
 Seattle, Washington
1982 "Animal Imagery," Meyer Breier Weiss
 Gallery, San Francisco, California
1982 "Thirty-Eighth Annual Ceramics
 Exhibition," Lang Art Gallery, Scripps
 College, Claremont, California

1982 "Westwood Clay National," Downey
 Museum of Art, Downey, California
1983 "Anne Perrigo, C. W. Potts and Bill
 Reed," Jackson Street Gallery, Seattle,
 Washington
1983 "Bumberbiennale: Art Since Century
 21: 1963-1983," Bumbershoot Gallery,
 Seattle, Washington
1983 "Seattle Arts Commission Presents:
 Selected Works from Recent
 Purchases," Seattle Center House,
 Seattle, Washington
1983- "Regional Crafts: A Contemporary
84 Perspective," Bellevue Art Museum,
 Bellevue, Washington
1984 "Anne Perrigo and Fay-Linda Kodis,"
 Northwest Artists Workshop, Portland,
 Oregon
1984 "International Tea Party,"
 Contemporary Crafts Gallery, Portland,
 Oregon
1984 "Works in Clay: Jean Behnke, Anne
 Perrigo and Maggie Smith," Jackson
 Street Gallery, Seattle, Washington
1984 "Clay: 1984, A National Survey
 Exhibition," Traver Sutton Gallery,
 Seattle, Washington
1984 "Medicine Bundle," Jackson Street
 Gallery, Seattle, Washington
1984 "Group Exhibition," Corvallis Arts
 Center, Corvallis, Oregon
1985 "O.K.—U.S.A. National Juried
 Sculpture Exhibition," University
 Gallery, Cameron University, Lawton,
 Oklahoma, catalog
1985 "Ronna Neuenschwander and Anne
 Perrigo," The Gym, Marylhurst College
 for Lifelong Learning, Marylhurst,
 Oregon
1986 "Anne Perrigo and Lauren Grossman,"
 Jackson Street Gallery, Seattle,
 Washington

Selected Public Collection
Seattle City Light Portable Works Collection,
Seattle, Washington

Selected Awards
1975 Milnora Roberts Scholarship,
 University of Washington, Seattle,
 Washington
1984 Artist in Residence, Arts/Industry
 Program, Kohler Company, Kohler,
 Wisconsin
1985 Ceramicist in Residence,
 Contemporary Crafts Association,
 Portland, Oregon and Oregon Arts
 Commission

Preferred Sculpture Media
Clay and Varied Media

Additional Art Field
Drawing

Related Profession
Artist in Residence, Washington State Public
Schools and Washington State Arts
Commission

Selected Bibliography
Kangas, Matthew. "Anne Perrigo." *American
Ceramics* vol. 4 no. 1 (Spring 1985) pp.
70-71, illus.

Mailing Address
117 Twin View Drive
Sequim, Washington 98382

Artist's Statement

"The only difference between a Henry James novel and the 1950s *Modern Romance* is style—the issues are the same. Eight years ago a friend gave me a whole stack of W.W. II era *True Confession* and *Real Story* magazines with lurid photos illustrating *Paid to Marry Me, Old Enough to Know Better* and *Desperate For A Date*. This break came just in time, for I was *Tired of Cute, Too Old to Make Schlock* and *Desperate For Content*.

"I love real life events wrapped in clichés. No mood too tragic, no moment too tender, that has not been exploited in pulp. Rather than fragile *angst,* I like 'em with a humor that breaks through that veneer of good taste and emotional control."

Anne Perrigo

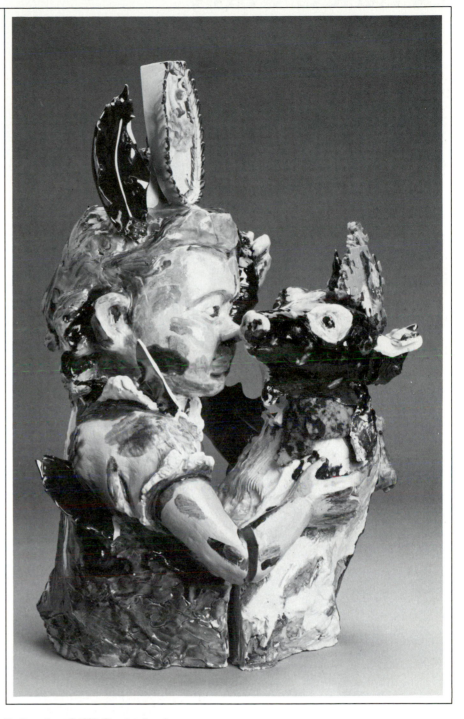

Do Dogs Dream? 1983. Clay, low fire glaze, cardboard and found ceramics, 36"h x 24"w x 15"d. Photograph by Roger C. Schreiber.

451

Beatrice Perry

née Beatrice Gaidzik
(Husband Hart Perry)
Born Evanston, Illinois

Education and Training

1936-37 School of the Art Institute of Chicago, Chicago, Illinois; study in sculpture
1938-39 Skidmore College, Saratoga Springs, New York; study in ceramic sculpture with Maryetta Davidson
1940-41 Study in sculpture with Franz Plunder, Chicago, Illinois
1941-42 Study in sculpture with William Calfee, Washington, D.C.
1955-56 Study in sculpture with James Cahill, Washington, D.C.
1972-73 Assistant in sculpture to Martin Chirino, Germantown, New York

Selected Individual Exhibition

1979 Genesis Gallery, New York, New York, catalog

Selected Group Exhibitions

1974 "Summer Exhibition," Benson Gallery, Bridgehampton, New York
1981 "Salute to American Sculpture," Saks Fifth Avenue, New York, New York
1984 "Ordinary and Extraordinary Uses: Objects by Artists," Guild Hall Museum, East Hampton, New York, catalog
1984 "Land Marks," Edith C. Blum Art Institute Center, Bard College, Annandale-on-Hudson, New York, catalog
1985 "Curator's Choice: Screens & Scrolls," Academy of the Arts, Easton, Maryland

Selected Public Collections

Bard College, Annandale-on-Hudson, New York
Community Hospital, Munster, Indiana
Neiman Marcus Sculpture Garden, Las Vegas, Nevada
Siloam Presbyterian Church, Brooklyn, New York
Time, Incorporated, Washington, D.C.

Selected Private Collections

Mr. and Mrs. Edwin A. Bergman, Chicago, Illinois
Edwin Ehrlich Collection, Merrick, New York
Richard Hodgson, Aspen, Colorado
Bernard and Ruth Nath, Highland Park, Illinois
Upjohn Collection, Kalamazoo, Michigan

Preferred Sculpture Media

Metal (forged), Metal (welded) and Varied Media

Gallery Affiliation

Joyce Pomeroy Schwartz
Works of Art for Public Spaces
17 West 54 Street
New York, New York 10019

Mailing Address

Southwood
Woods Road
Germantown, New York 12526

Artist's Statement

"I was born and grew up on the shores of Lake Michigan. My life as a sculptor has been determined by my awareness of the geological upheavals which formed my native landscape and the tremendous visual impact of trees, telephone poles, steel mills and clouds moving against the prairie sky. In my early teens, exposure to members of Moholy-Nagy's Bauhaus Group was electrifying. Later, under Franz Plunder, I came to understand the magic of the 'Golden Mean' considered by the Pythagoreans of ancient Greece to be the most beautiful of proportions. My sculpture finds its sources in this classical sense of relationships, gleaned from nature, and what Noguchi calls the 'transformation of nature.'

"I think of art as a positive factor in civilization rather than a hopeless reflection of its weaknesses. I believe the Bauhaus influence has, among other things, left me with a distrust of the self-indulgent and the pretentious in art and with an inner drive which pushes me into the search for new aesthetic frontiers.

"I work in welded steel because it can represent many of the ideas that interest me—the landscape and the elemental forces of fire, wind and water. It offers a variety of natural color and has the strength and surface suitable for large outdoor sculpture. I am deeply concerned with public art as a catalyst in the community for social and aesthetic possibilities."

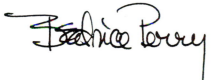

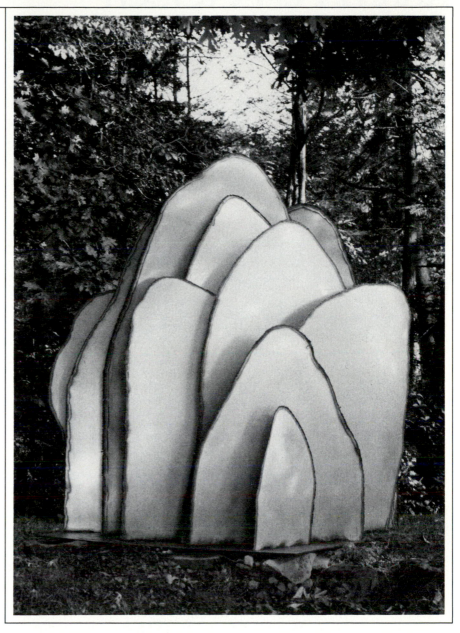

China. 1983. Stainless steel, 6'3"h x 5½'w x 4'd.

453

Karen A. Petersen

née Karen Anne
Born April 27, 1942 Escanaba, Michigan

Education and Training
1965 B.S.D., Sculpture, University of
Michigan, Ann Arbor, Michigan; study
with Paul Suttman
1981- Parsons School of Design, New York,
82 New York; study in sculpture with
Chaim Gross

Selected Individual Exhibitions
1974 Cedar Crest College, Allentown,
Pennsylvania
1976 Franconia College, Franconia, New
Hampshire
1977, Wiley Gallery, Hartford, Connecticut
79,
80
1981 Suzette Schochet Gallery, Newport,
Rhode Island
1984 Miriam B. Butterworth Art Gallery,
Hartford College for Women, Hartford,
Connecticut

Selected Group Exhibitions
1976 "Group Exhibition," Gallery M,
Farmington, Connecticut
1976 "Group Exhibition," Mary Roy Gallery,
Watch Hill, Rhode Island
1977 "Connecticut Artists 33," University of
Connecticut, Waterbury, Connecticut
1978, "Group Exhibition," Main Street
79 Gallery, Nantucket, Massachusetts
1979, "Connecticut Women Artists," Slater
80, Memorial Museum, Norwich,
81 Connecticut
1981, "Gallery Artists," Prime Art Gallery,
82, Hartford, Connecticut
83
1982 "Group Exhibition," Ellsworth Gallery,
West Hartford, Connecticut
1982 "Annual Outdoor Sculpture Exhibition,"
Arlene McDaniel Galleries at Glenhill
Nursery, West Hartford, Connecticut

Selected Public Collections
Hartford College for Women, Hartford,
Connecticut
Roy Machinery & Sales, Farmington,
Connecticut
Seymour Sard Corporation, West Hartford,
Connecticut
Westfield Nursing Home, Westfield,
Massachusetts

Selected Private Collections
Peter R. Blum, Hartford, Connecticut
Jack Dollard, Hartford, Connecticut
Dr. James Graydon, Hartford, Connecticut
Marcia Savage, Hartford, Connecticut

Preferred Sculpture Media
Clay, Metal (cast) and Metal (welded)

Additional Art Field
Painting

Related Profession
Director, Miriam B. Butterworth Art Gallery,
Hartford College for Women, Hartford,
Connecticut

Teaching Position
Assistant Professor of Art, Hartford College
for Women, Hartford, Connecticut

Gallery Affiliation
Munson Gallery
33 Whitney Avenue
New Haven, Connecticut 06511

Mailing Address
43 South Highland Street
West Hartford, Connecticut 06119

Artist's Statement

"I was trained as a sculptor in college but following graduation, painting displaced sculpture when there was never a place for a sculpture studio. I began seriously to concentrate on sculpture in 1978.

"I enjoy the challenge of creating public sculpture which involves site, aesthetic and engineering concepts and permanent installation considerations. My outdoor sculpture in steel, bronze and aluminum vary in size from large-scale works to smaller versions with similar themes.

"I have alternated between realism and abstract art, always pursuing clarity of form and design in the overall construction. My new work reflects a period of study when I worked directly from the model. These studies are based primarily on the female figure but their message is universal."

Karen A. Petersen

Genesis. 1984. Bronze, 24"h x 22"w x 18"d.
Photograph by Charles Reich.

Judy Pfaff

Born September 22, 1946 London, Great Britian

Education and Training
1965 Wayne State University, Detroit, Michigan
1968 Southern Illinois University at Edwardsville, Edwardsville, Illinois
1971 B.F.A., Painting and Sculpture, Washington University, St. Louis, Missouri
1973 M.F.A., Painting and Sculpture, Yale University, New Haven, Connecticut

Selected Individual Exhibitions
1974 Webb & Parsons Gallery, Bedford, New York
1974 Artists Space, New York, New York
1977 Theatre Lobby Gallery, University of South Florida, Tampa, Florida
1978 Los Angeles Contemporary Exhibitions, Los Angeles, California
1980, Holly Solomon Gallery, New York, New
83 York
1981 John and Mabel Ringling Museum of Art, Sarasota, Florida, catalog
1982 University of Massachusetts at Amherst, Amherst, Massachusetts
1983 Albright-Knox Art Gallery, Buffalo, New York
1984 Daniel Weinberg Gallery, Los Angeles, California

Selected Group Exhibitions
1975, "Biennial Exhibition: Contemporary
81 American Art," Whitney Museum of American Art, New York, New York, catalog
1976 "New Work/New York," California State University Los Angeles, Los Angeles, California, catalog
1977 "Space Window," Woods-Gerry Gallery, Rhode Island School of Design, Providence, Rhode Island, catalog
1979 "Two Decades of Abstraction: New Abstraction," University of South Florida Art Galleries, Tampa, Florida, catalog
1979 "Sculptural Perspectives," University Art Museum, Santa Barbara, Santa Barbara, California, catalog
1979 "Pfaff, Provisor, Atica, Wells," Holly Solomon Gallery, New York, New York
1979 "Ten Artists/Artists Space," Neuberger Museum, Purchase, New York
1979 "Sixth Anniversary Exhibition," Artists Space, New York, New York

1980 "Extensions: Jennifer Bartlett, Lynda Benglis, Robert Longo, Judy Pfaff," Contemporary Arts Museum, Houston, Texas, catalog
1980 "Walls!" Contemporary Arts Center, Cincinnati, Ohio, catalog
1981 "Directions 1981," Hirshhorn Museum and Sculpture Garden, Smithsonian Institution, Washington, D.C.; Sarah Campbell Blaffer Gallery, Houston, Texas, book-catalog
1981 "Westkunst Heute: Zeitgenössisch Kunst seit 1939," Museen der Stadt Köln, Cologne, Germany, Federal Republic, catalog
1981- "Body Language: Figurative Aspects
82 of Recent Art," Hayden Gallery, Massachusetts Institute of Technology, Cambridge, Massachusetts; Fort Worth Art Museum, Fort Worth, Texas; University of South Florida Art Galleries, Tampa, Florida; Contemporary Arts Center, Cincinnati, Ohio
1981 "35 Artists Return to Artists Space: A Benefit Exhibition," Artists Space, New York, New York
1982 "Group Show," Holly Solomon Gallery, New York, New York
1982 "Energie New York," ELAC Centre d'Exchanges, Lyons, France, catalog
1982 "Dynamix," Traveling Exhibition, Contemporary Arts Center, Cincinnati, Ohio, catalog
1982 "Guy Goodwin, Bill Jensen, Louise Fischman, Stuart Diamond, Judy Pfaff," Bennington College, Bennington, Vermont
1982, "Venice Biennale," Venice, Italy,
84 catalog
1982 "New York Now," Traveling Exhibition, Kestner-Gesellschäft, Hannover, Germany, Federal Republic, catalog
1983 "Back to the USA," Kunstmuseum, Lucerne, Switzerland; Rheinisches Landesmuseum, Bonn, Germany, Federal Republic; Kunstverein, Stuttgart, Germany, Federal Republic, catalog
1984 "An International Survey of Recent Painting and Sculpture," Museum of Modern Art, New York, New York, catalog

Selected Awards
1976 Creative Artists Public Service Grant, New York State Council on the Arts
1979 Individual Artist's Fellowship, National Endowment for the Arts
1983 John Simon Guggenheim Memorial Foundation Fellowship

Preferred Sculpture Media
Varied Media

Additional Art Field
Drawing

Selected Bibliography
Auping, Michael. "Judy Pfaff: Turning Landscape Inside Out." *Art Magazine* vol. 57 no. 1 (September 1982) pp. 74-76, illus.
Collings, Betty. "Judy Pfaff." *Arts Magazine* vol. 55 no. 3 (November 1980) p. 4, illus.
Gardner, Paul. "Blissful Havoc." *Art News* vol. 82 no. 6 (Summer 1983) pp. 68-74, illus.
Saunders, Wade. "Review of Exhibitions New York: Judy Pfaff at Holly Solomon." *Art in America* vol. 68 no. 9 (November 1980) pp. 135-136, illus.
Schwartz, Ellen. "Artists the Critics Are Watching, Report from New York: Judy Pfaff, Sculpture May Never Be The Same Again." *Art News* vol. 80 no. 5 (May 1981) cover, pp. 79-80, illus.

Gallery Affiliation
Holly Solomon Gallery
724 Fifth Avenue
New York, New York 10019

Mailing Address
Holly Solomon Gallery
724 Fifth Avenue
New York, New York 10019

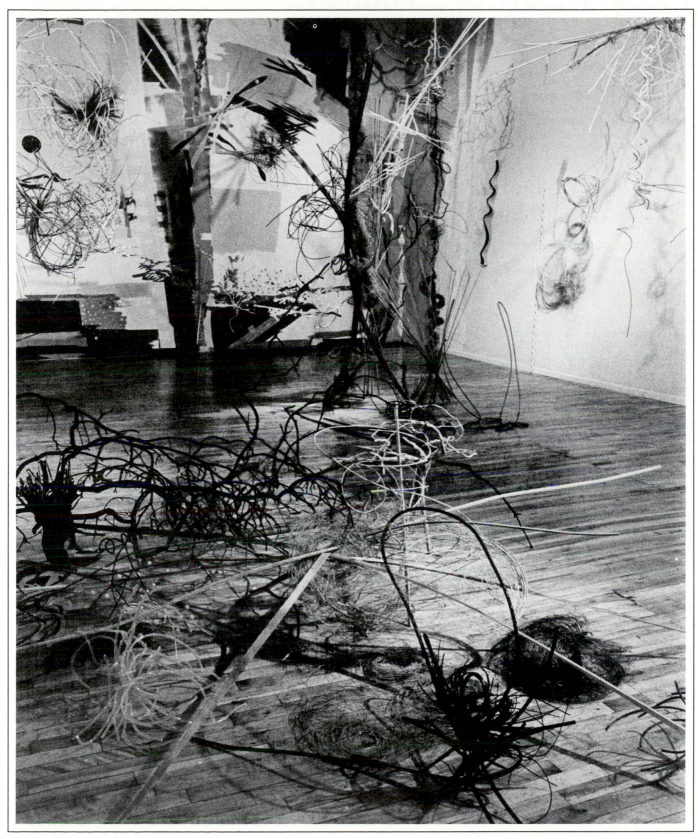

Deep Water (detail). 1980. Mixed media, room size.
Installation view 1980. Holly Solomon Gallery, New
York, New York. Photograph by Julius Kozlowski.

457

Helen Evans Phillips

née Helen Evans
(Husband Joe Gwin Phillips)
Born April 18, 1938 Cincinnati, Ohio

Education and Training
1961 B.S., Drawing and Painting, Memphis
 State University, Memphis, Tennessee
1965 Private study in ceramics with
 Eisaburo Arakaki, Okinawa, Japan
1967 University of Hawaii at Mamoa,
 Honolulu, Hawaii; study in ceramics
1975 M.F.A., Ceramics, University of
 Florida, Gainesville, Florida
1980 Additional study with Eisaburo
 Arakaki, Okinawa, Japan

Selected Individual Exhibitions
1978 North West Arkansas Ceramics
 Association, Fayetteville, Arkansas
1983 Craft Alliance, Shreveport, Louisiana
1984 University of Arkansas at Pine Bluff,
 Pine Bluff, Arkansas

Selected Group Exhibitions
1977, "National Cone Box Show," University
79 of Kansas, Lawrence, Kansas, catalog
1977, "Toys Designed by Artists," Arkansas
80 Arts Center, Little Rock, Arkansas
1978, "Annual Delta Art Exhibition," Arkansas
79 Arts Center, Little Rock, Arkansas,
 catalog
1979 "National Sculpture 1979," Traveling
 Exhibition, Gallery 303, Georgia
 Southern College, Statesboro,
 Georgia, catalog

1979, "Annual National Drawing and Small
82, Sculpture Show," Joseph A. Cain
84 Memorial Art Gallery, Del Mar College,
 Corpus Christi, Texas, catalog
1979 "Small Format Mixed Media
 Exhibition," Newspace Gallery,
 Corvallis, Oregon, catalog
1980 "National Sculpture 1980," Traveling
 Exhibition, McKissick Museum of Art,
 University of South Carolina,
 Columbia, South Carolina, catalog
1980 "Containers 1980," Fort Wayne
 Museum of Art, Fort Wayne, Indiana,
 catalog
1981 "Southeast College Art Association
 Ceramic Invitational," University of
 Mississippi, University, Mississippi
1981 "Itawamba Sculpture Invitational," Fine
 Arts Center, Itawamba Junior College,
 Fulton, Mississippi, catalog
1981 "National Cone Box Show," Purdue
 University, West Lafayette, Indiana
1982 "National Ceramic Invitational,"
 Arkansas State University, State
 University, Arkansas
1983 "Small Works 1983," University of
 Massachusetts at Amherst, Amherst,
 Massachusetts, catalog
1984 "Art South," Memphis State University,
 Memphis, Tennessee, catalog
1984 "Ceramics Competition 1984," Angelo
 State University, San Angelo, Texas,
 catalog
1984 "Small Sculpture," Las Vegas Art
 Museum, Las Vegas, Nevada
1985 "Architectural Elements," Ohio
 University, Athens, Ohio
1985 "American Ceramic National," Downey
 Museum of Art, Downey, California
1985 "Thirty-First Annual Drawing and Small
 Sculpture Show," Ball State University,
 Muncie, Indiana

Selected Public Collections
Arkansas Arts Center, Little Rock, Arkansas
Orton Foundation, Columbus, Ohio

Selected Private Collections
John Barker, Little Rock, Arkansas
Sanford Besser, Little Rock, Arkansas
Allan Chasanoff, Jericho, New York
Hughes Kennedy, Birmingham, Alabama
Michael Rohdo, Houston, Texas

Selected Award
1977, Faculty Research Grant, University of
80 Central Arkansas, Conway, Arkansas
1982 First in Sculpture, "Fine/Function: A
 Mastery of Craft," Lafayette Natural
 History Museum & Planetarium,
 Lafayette, Louisiana

Preferred Sculpture Media
Clay and Varied Media

Additional Art Field
Textiles

Teaching Position
Associate Professor of Art, University of
Central Arkansas, Conway, Arkansas

Gallery Affiliation
Gallery TWO NINE ONE
One Rhodes Center North
Atlanta, Georgia 30309

Mailing Address
408 McAdoo
Little Rock, Arkansas 72205

Sentinel. 1984. Clay, 15″h x 12″w x 6″d.

Artist's Statement

"Fragmentation, a way of life for me, is very much a part of my work. I attempt to pull these fragments together to make the piece an 'occasion' for the viewer, hopefully one which emits a certain sense of order. Creation, growth, destruction, isolation and death are part of the language of my forms.

Clay, the most plastic of materials, yet when fired the most durable, allows for expression and flexibility of form in a lasting medium."

Helen E. Phillips

459

Marianna Pineda

née Marianna Packard
(Husband Harold Tovish)
Born May 10, 1925 Evanston, Illinois

Education and Training
1942 Cranbrook Academy of Art, Bloomfield Hills, Michigan; study in sculpture with Carl Milles
1942- Bennington College, Bennington,
43 Vermont; study in sculpture with Simon Moselsio
1943- University of California, Berkeley,
44 Berkeley, California; study in sculpture with Raymond Puccinelli
1943- Studio of Raymond Puccinelli, San
44 Francisco, California; apprenticeship in sculpture
1944- Columbia University, New York, New
46 York; study in sculpture with Oronzio Maldarelli
1949- Zadkine School of Sculpture and
50 Drawing, Paris, France; study with Ossip Zadkine

Selected Individual Exhibitions
1952 Walker Art Center, Minneapolis, Minnesota
1953, Swetzoff Gallery, Boston,
64 Massachusetts
1954 DeCordova and Dana Museum and Park, Lincoln, Massachusetts
1963 Premier Gallery, Minneapolis, Minnesota
1970 Honolulu Academy of Arts, Honolulu, Hawaii, catalog
1972 Alpha Gallery, Boston, Massachusetts
1972 Newton College of the Sacred-Heart, Newton, Massachusetts, retrospective
1974 Bumpus Gallery, Duxbury, Massachusetts
1982 Contemporary Arts Center, Honolulu, Hawaii
1984 Pine Manor College, Chestnut Hill, Massachusetts

Selected Group Exhibitions
1947 "Thirty-First Annual Exhibition," Brooklyn Museum, Brooklyn, New York
1950 "American Painters and Sculptors," Galerie 8, Paris, France
1951 "Biennial Regional Exhibition," Walker Art Center, Minneapolis, Minnesota
1951 "American Sculpture," Metropolitan Museum of Art, New York, New York, catalog
1953- "Annual Exhibition: Contemporary
59 American Sculpture," Whitney Museum of American Art, New York, New York, catalog
1955 "Seventy-Fourth Annual Exhibition of Painting and Sculpture," San Francisco Museum of Art, San Francisco, California (Sponsored by San Francisco Art Association, San Francisco, California)
1957 "United Nations Exhibition," California Palace of the Legion of Honor, San Francisco, California

1957, "Annual Exhibition of American
61 Paintings and Sculpture," Art Institute of Chicago, Chicago, Illinois, catalog
1958 "Pittsburgh International Exhibition of Painting and Sculpture," Museum of Art, Carnegie Institute, Pittsburgh, Pennsylvania, catalog
1959 "Recent Sculpture U.S.A.," Traveling Exhibition, Museum of Modern Art, New York, New York, catalog
1960 "Recent Sculpture," Museum of Fine Arts, Boston, Massachusetts
1961 "View," Traveling Exhibition, Institute of Contemporary Art, Boston, Massachusetts
1962 "Women Artists in America Today," Mount Holyoke College, South Hadley, Massachusetts, catalog
1964 "American Art Today," Pavilion of Fine Arts, World's Fair, New York, New York, catalog
1964 "New England in Five Parts: Sculpture," DeCordova and Dana Museum and Park, Lincoln, Massachusetts
1966, "Outdoor Sculpture," DeCordova and
72 Dana Museum and Park, Lincoln, Massachusetts
1966- "Sculptors Guild Annual Exhibition,"
85 Lever House, New York, New York, catalog
1974 "Living American Artists and the Figure," Pennsylvania State University-University Park Campus, University Park, Pennsylvania, catalog
1975 "New England Women," DeCordova and Dana Museum and Park, Lincoln, Massachusetts, catalog
1976 "Contemporary Issues: Works by Women," Traveling Exhibition, Woman's Building, Los Angeles, California
1978 "Artists in Boston," Brockton Art Center/Fuller Memorial, Brockton, Massachusetts
1982 "Browne Fund Initiative for Public Art," Boston City Hall, Boston, Massachusetts
1982 "Small Bronzes," Helen Shlien Gallery, Boston, Massachusetts
1982 "Boston Portraits," Boston University Art Gallery, Boston, Massachusetts
1982 "One Hundred and Fifty-Eighth Annual Exhibition," National Academy of Design, New York, New York, catalog
1983 "Portrait Sculpture, Contemporary Points of View," Bethune Gallery, State University of New York College at Buffalo, Buffalo, New York, catalog
1984 "Aspects of the Human Form," Fitchburg Art Museum, Fitchburg, Massachusetts
1984 "The Full Circle: Images of Maternity and Birth," Newton Arts Center, Newtonville, Massachusetts
1985 "Sculpture: Public Commissions/Private Works," Newton Arts Center, Newtonville, Massachusetts

Selected Public Collections
Addison Gallery of American Art, Andover, Massachusetts
Bowdoin College, Brunswick, Maine
City of Boston, Massachusetts
Dartmouth College, Hanover, New Hampshire
Mount Holyoke College, South Hadley, Massachusetts
Munson-Williams-Proctor Institute, Utica, New York
Museum of Fine Arts, Boston, Massachusetts
Radcliffe College, Cambridge, Massachusetts
State of Hawaii, Honolulu, Hawaii
Sumner Street Housing for the Elderly, East Boston, Massachusetts
Wadsworth Atheneum, Hartford, Connecticut
Walker Art Center, Minneapolis, Minnesota
Williams College Museum of Art, Williamstown, Massachusetts

Selected Private Collections
Mrs. Lester Dana, Boston, Massachusetts
Dr. Ernest Kahn, Cambridge, Massachusetts
Albert A. List Family Collection, Greenwich, Connecticut
Eleanor Rigelhaupt, Boston, Massachusetts
Mr. and Mrs. Mitchell Wilder, Williamsburg, Virginia

Selected Awards
1960 Grand Prize, "Annual Boston Arts Festival," Boston Public Garden, Boston, Massachusetts, catalog
1962 Fellowship, Radcliffe Institute for Independent Study, Radcliffe College, Cambridge, Massachusetts
1983 Fellowship, National Academy of Design, New York, New york

Preferred Sculpture Media
Clay, Metal (cast) and Wood

Additional Art Fields
Drawing and Portraiture

Teaching Position
Visiting Associate Professor, Boston University, Boston, Massachusetts

Selected Bibliography
Goldstein, Nathan. *The Art of Responsive Drawing*. Englewood Cliffs, New Jersey: Prentice-Hall, 1977.
Kirsch, Dwight. "New Talent in the U.S.A.: The Upper West." *Art in America* vol. 43 no. 1 (February 1955) pp. 47-49, illus.
Preble, Duane. *We Create Art, Art Creates Us*. San Francisco: Canfield Press, 1976.
Preble, Duane. *Artforms*. New York: Harper & Row, 1978.
Rubinstein, Charlotte Streifer. *American Women Artists: From Early Indian Times to the Present*. Boston: G. K. Hall, 1982.

Gallery Affiliation
Martin Sumers Gallery
50 West 57 Street
New York, New York 10021

Mailing Address
380 Marlborough Street
Boston, Massachusetts 02115

Artist's Statement
"My sculptural ideas issue from two main sources: Life Experienced and Life Observed. The first source informs my reaction as a woman and inspires such subjects as maturation, pregnancy, motherhood and aging: women as authority figures, lovers, mourners and dreamers. I approached these themes some twenty years ago with little political consciousness. They persist today with greater awareness and emphasis. The second source is vital to *all* artists. Ideally, it nourishes a compassionate vision and results in an act of imaginative form-making which transcends gender, culture and time itself.

"I confess to the old, old desire to leave a record which will outlast myself and what I celebrate. In this sense I am a traditionalist: I would like to do work not necessarily in the old manner but fit to join the speaking past in its dialogue with the future."

Marianna Pineda

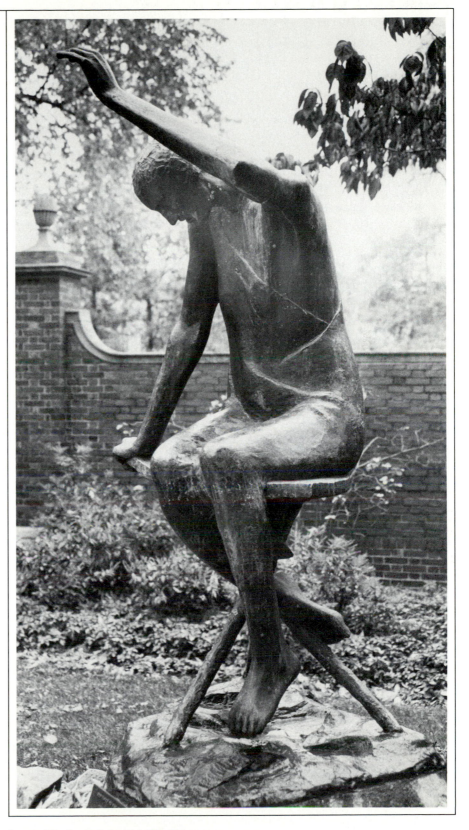

Aspect of the Oracle: Portentous. 1968. Bronze unique, 5'11"h. Collection Radcliffe College, Cambridge, Massachusetts. Photograph by Nina Tovish.

Jody Pinto

Born April 8, 1942 New York, New York

Education and Training
1968 Certificate, Painting, Pennsylvania Academy of the Fine Arts, Philadelphia, Pennsylvania
1973 B.F.A., Academics, Philadelphia College of Art, Philadelphia, Pennsylvania

Selected Individual Exhibitions
1977 Nexus Gallery, Philadelphia, Pennsylvania
1978, Hal Bromm Gallery, New York, New
79, York
80,
81,
83
1979 112 Greene Street Gallery, New York, New York
1979 Richard Demarco Gallery, Edinborough, Scotland
1979 Marian Locks Gallery, Philadelphia, Pennsylvania, catalog
1980 California State University Northridge, Northridge, California
1980 Morris Gallery, Pennsylvania Academy of the Fine Arts, Philadelphia, Pennsylvania
1980 Swarthmore College, Swarthmore, Pennsylvania
1980 Wilkes College, Wilkes-Barre, Pennsylvania
1980 College of Wooster, Wooster, Ohio
1980 University of Oklahoma, Norman, Oklahoma
1981 Kutztown State College, Kutztown, Pennsylvania
1984 Institute of Contemporary Art of The University of Pennsylvania, Philadelphia, Pennsylvania
1985 Bucks County Community College, Newtown, Pennsylvania
1985 Hammarskjöld Plaza Sculpture Garden, New York, New York

Selected Group Exhibitions
1975 "Artpark: The Program in Visual Arts," Artpark, Lewiston, New York, catalog
1976 "Philadelphia/Houston Exchange," Institute of Contemporary Art of The University of Pennsylvania, Philadelphia, Pennsylvania, catalog
1977 "Ground," P.S. 1, Institute for Art and Urban Resources, Long Island City, New York

1978- "Dwellings," Institute of Contemporary
79 Art of The University of Pennsylvania, Philadelphia, Pennsylvania; Neuberger Museum, Purchase, New York, catalog
1978 "Quintessence: Alternative Spaces Residency Program," City Beautiful Council, Dayton, Ohio and Wright State University, Department of Art, Dayton, Ohio, catalog
1979 "1979 Biennial Exhibition: Contemporary American Art," Whitney Museum of American Art, New York, New York, catalog
1979 "Custom and Culture Part II," U.S. Custom House, New York, New York
1979 "Masks, Tents, Vessels, Talismans," Institute of Contemporary Art of The University of Pennsylvania, Philadelphia, Pennsylvania, catalog
1980 "Venice Biennale," Venice, Italy, catalog
1980 "New York: 1980," Galleria Banco, Brescia, Italy
1980 "Made in Philadelphia III," Institute of Contemporary Art of The University of Pennsylvania, Philadelphia, Pennsylvania
1980 "Architectural References," Los Angeles Institute of Contemporary Art, Los Angeles, California, catalog
1980 "Tel Hasi '80 Conference," Tel Hasi Region, Upper Galilee, Israel, catalog
1981 "In and Out of Kutztown 1974-1981," Kutztown State College, Kutztown, Pennsylvania, catalog
1981 "Annual Three Rivers Arts Festival," Gateway Center, Pittsburgh, Pennsylvinia, catalog
1982 "Art on the Beach," Battery Park Landfill, Battery Park City, New York
1983 "1983 Hazlett Memorial Awards Exhibition for the Visual Arts," Southern Alleghenies Museum of Art, Loretto, Pennsylvania; University of Pittsburgh, Pittsburgh, Pennsylvania; Allentown Art Museum, Allentown, Pennsylvania, catalog
1984 "Land Marks," Edith C. Blum Art Institute, Bard College Center, Annandale-on-Hudson, New York, catalog
1985- "Philadelphia Tricentennial Exhibition,"
86 Fairmount Park Art Association, Philadelphia, Pennsylvania

Selected Public Collections
City of Toledo, Promenade Park, Toledo, Ohio
Fairmount Park Art Association, Philadelphia, Pennsylvania
Neuberger Museum, Purchase, New York
Swarthmore College, Swarthmore, Pennsylvania
Tel Hasi Region, Upper Galilee, Israel

Selected Awards
1979 Individual Artist's Fellowship, National Endowment for the Arts
1980 Individual Artist's Fellowship, Pennsylvania Council on the Arts
1982 Individual Artist's Fellowship, New Jersey State Council on the Arts

Preferred Sculpture Media
Varied Media and Wood

Additional Art Field
Drawing

Related Profession
Visiting Critic

Teaching Positions
Faculty, Pennsylvania Academy of the Fine Arts, Philadelphia, Pennsylvania
Adjunct Faculty, Rhode Island School of Design, Providence, Rhode Island

Selected Bibliography
Lavin, Maude. "Jody Pinto." Arts Magazine vol. 55 no. 6 (February 1981) p. 5, illus.
Lippard, Lucy R. "Complexes: Architectural Sculpture in Nature." Art in America vol. 67 no. 1 (January-February 1979) pp. 86-97, illus.
Lippard, Lucy R. Overlay: Contemporary Art and the Art of Prehistory. New York: Pantheon, 1983.
Nadelman, Cynthia. "New York Reviews: Jody Pinto, Hal Bromm Gallery." Art News vol. 82 no. 6 (Summer 1983) p. 200, illus.
Silverthorne, Jeanne. "Review of Exhibitions Philadelphia: Jody Pinto at Marian Locks and Marian Locks East." Art in America vol. 68 no. 3 (March 1980) p. 127, illus.

Gallery Affiliation
Hal Bromm Gallery
90 West Broadway
New York, New York 10007

Mailing Address
124 Chambers Street
New York, New York 10007

Artist's Statement

"I grew up near the ocean and also in New York City so I have always had an awareness of control and scale in man-made and natural landscape. I have felt that the central source of information (conscious or unconscious) is the body and it is through that sensibility that I approach landscape (city or suburban). My work, whether it is drawing or construction, involves these sensibilities as well as my family heritage, very visual Catholic Irish-Italian upbringing and childhood experiences.

"My work is architectural and encourages physical participation. It involves a process of merging formal structures with charged emotional content: ambiguity, personification, the energy in violence and anger. Constructing a work in a specific place is like engaging in a conversation and through that exchange, producing a physical idea. The development of a project and its completion is the result of a dialogue between my original concept and the elements of a particular site. Practical elements in terms of public usage, awareness and discovery are essential aspects of that conversation."

Split Tongue Pier. 1980. Spruce and pine, 2′w x 48′d. Installation view 1980. Swarthmore College, Swarthmore, Pennsylania. Photograph by Drew Vaden.

463

Joan Webster Price

née Joan Diane Webster
(Husband Herbert Price)
Born January 8, 1931 Camden, New Jersey

Education and Training
1954 B.F.A., Sculpture, Tyler School of Art, Temple University, Philadelphia, Pennsylvania; study with Boris Blai and Raphael Sabatini
1954 B.S. Ed., Sculpture, Tyler School of Art, Temple University, Philadelphia, Pennsylvania; additional study with Boris Blai and Raphael Sabatini
1958 M.A., Painting and Sculpture, Teachers College, Columbia University, New York, New York; study in sculpture with William Mahoney
1971 Ed.D., Light Art and Technology, Teachers College, Columbia University, New York, New York; study with Bernard Kahn

Selected Individual Exhibitions
1974, Westbroadway Gallery, New York,
75 New York
1975 Bronx Museum of The Arts, New York, New York
1981 Snug Harbor Cultural Center, Staten Island, New York

Selected Group Exhibitions
1973 "Faculty Exhibition," City University of New York, City College, New York, New York, catalog
1975 "Twenty-First Annual Exhibition: Contemporary American Painting," Ralph L. Wilson Gallery, Alumni Memorial Building, Lehigh University, Bethlehem, Pennsylvania, catalog
1975 "Nine Artists at Work," Bronx Museum of The Arts, Bronx, New York, catalog
1976 "The Exchange Show," Boston Visual Artists Union, Boston, Massachusetts
1976 "The Year of the Woman: Reprise," Bronx Museum of The Arts, Bronx, New York, catalog
1977 "The Magic Circle," Bronx Museum of The Arts, Bronx, New York, catalog
1977 "American Abstract Artists," William Paterson College of New Jersey, Wayne, New Jersey

1978 "Women Artists '78," Graduate Center, City University of New York, City College, New York, New York, catalog
1978 "Staten Island Sculpture Alliance," Snug Harbor Cultural Center, Staten Island, New York
1978 "Art Works," Lowenstein Library Gallery, Fordham University at Lincoln Center, New York, New York
1979 "American Abstract Artists: The Language of Abstraction," Betty Parsons Gallery, New York, New York; Marilyn Pearl Gallery, New York, New York, catalog
1979 "Doors, Chairs and Windows," Snug Harbor Cultural Center, Staten Island, New York
1980 "University Council for Art Education," Contemporary Art Gallery, New York University, New York, New York
1980 "O.I.A. Sculpture Garden," Manhattan Psychiatric Center, Ward's Island, New York
1980 "Boxes Invitational," Snug Harbor Cultural Center, Staten Island, New York
1981 "Art in Architecture: Women's Caucus for Art, New Jersey," New Jersey Society of Architects, Woodbridge, New Jersey
1981 "Transitions: American Abstract Artists," Summit Art Center, Summit, New Jersey
1982 "Abstraction in Action: American Abstract Artists," City Gallery, New York, New York
1982 "On and Off the Wall," Community Gallery, Newark Museum, Newark, New Jersey
1983 "American Abstract Artists," Weatherspoon Art Gallery, Greensboro, North Carolina; Moody Gallery of Art, University of Alabama, University, Alabama, catalog
1983 "Faculty and Alumni Art Exhibition," Davis Center, City University of New York, City College, New York, New York
1983- "Modern Mythology by 13 Sculptors,"
85 Fordham University, Bronx, New York
1984 "In-A-Sense: Twenty-Seven New Jersey Artists," Bergen Museum of Art and Science, Paramus, New Jersey, catalog
1984 "The Curve of a Plane II," 22 Wooster Gallery, New York, New York

Selected Private Collections
Dr. and Mrs. Irving Bronsky, Haifa, Israel
Mary Knapp, Midland Park, New Jersey
Mrs. Max Altman Kreps, Sarasota, Florida
Florence Peterson, New York, New York
Ina Resnicek, Brooklyn, New York

Selected Award
1984 Artist in Residence, Virginia Center for the Creative Arts, Sweetbriar, Virginia

Preferred Sculpture Media
Varied Media

Additional Art Fields
Environmental Design and Technology

Teaching Position
Professor, City University of New York, City College, New York, New York

Selected Bibliography
Baier, Sally. "Reports: Sun Altar." *Landscape Architecture* vol. 70 no. 6 (November 1980) pp. 639-640, illus.
Moore, Sylvia. "The Magic Circle." *Feminist Art Journal* vol. 6 no. 2 (Summer 1977) p. 54.
Rousseau, Irene. "American Abstract Artists." *Arts Magazine* vol. 56. no. 1 (September 1981) p. 20.
Rousseau, Irene. "Abstraction In Action." *Arts Magazine* vol. 56 no. 9 (May 1982) p. 16
Stein, Judith E. "Women Artists '78." *Art Journal* vol. 37 no. 4 (Summer 1978) pp. 332-333.

Mailing Address
35 Ridgewood Terrace
Maplewood, New Jersey 07040

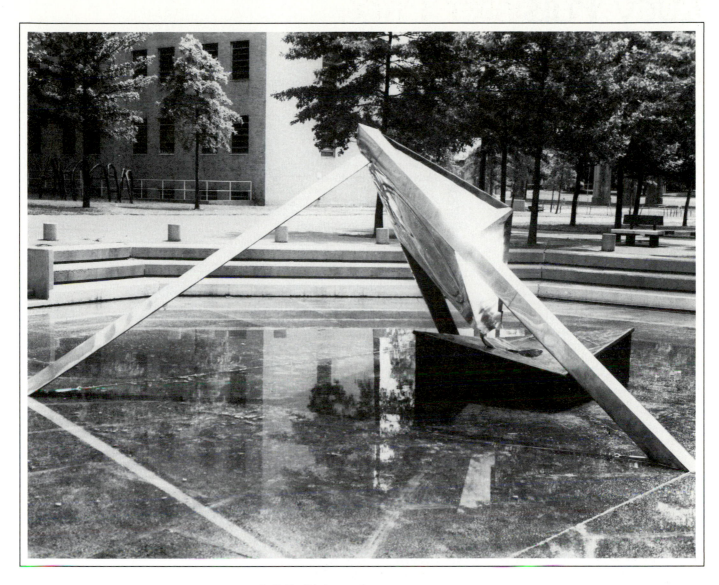

Sun Altar. 1980. Wood, cooper and water, 10′h x 22′w x 20′d. Installation view 1980. "O.I.A. Sculpture Garden," Manhattan Psychiatric Center, Ward's Island, New York.

Artist's Statement

"Though I have been and continue to be an artist who works mainly in abstraction, my work in sculpture revolves on the aesthetic possiblities and availability of contemporary technology and materials. Since 1977 I have used the energy and light of the sun to integrate the symbolic, the aesthetic and the functional in solar water sculpture. The circle and arch themes reflect the physical and mythical imagery of the sun itself. The sculpture incorporates a solar heating element which produces steaming mists above a pool as sun-warmed water flows from the sculpture. As prehistoric monuments have joined aesthetic magnificence, celestial observation and public inspiration, the sculpture is designed for an artistic as well as practical application to warm fountains, pools or greenhouses."

Joan Webster Price

465

Lucy Puls

née Lucy Ann
(Husband Daniel Babior)
Born May 4, 1955 Milwaukee, Wisconsin

Education and Training
1977 B.S., Art, University of Wisconsin-Madison, Madison, Wisconsin
1977- Tyler School of Art, Temple University,
78 Philadelphia, Pennsylvania
1980 M.F.A., Sculpture, Rhode Island School of Design, Providence, Rhode Island

Selected Individual Exhibitions
1981 Woods-Gerry Gallery, Rhode Island School of Design, Providence, Rhode Island
1983 Wheeler Gallery, Providence, Rhode Island
1984 Asheville Art Museum, Asheville, North Carolina
1985 Southwestern Center for Contemporary Art, Winston-Salem, North Carolina
1985 Waterworks Gallery, Salisbury, North Carolina
1985 Tate Center Gallery, University of Georgia, Athens, Georgia

Selected Group Exhibitions
1978, "Metals Program Exhibition,"
79 Woods-Gerry Gallery, Rhode Island School of Design, Providence, Rhode Island
1979- "Annual Summer Faculty Exhibition,"
83 Woods-Gerry Gallery, Rhode Island School of Design, Providence, Rhode Island

1980 "Copper II," University of Arizona Museum of Art, Tucson, Arizona
1980 "A Case for Boxes," Museum of Art, Rhode Island School of Design, Providence, Rhode Island
1981 "Faculty Exhibition," Museum of Art, Rhode Island School of Design, Providence, Rhode Island
1981 "Metals '81 Invitational," State University of New York College at Brockport, Brockport, New York
1982, "Faculty Exhibition," Western Carolina
83, University, Cullowhee, North Carolina
84
1982, "October Show," Asheville Art
83, Museum, Asheville, North Carolina
84
1982, "Group Exhibition," Image South
83 Gallery, Atlanta, Georgia
1983 "First Regional Juried Art Exhibition," Spartanburg Arts Center, Spartanburg, South Carolina (Sponsored by Friends of the Arts, Spartanburg, South Carolina), catalog
1983, "Annual Exhibit of North Carolina
84 Sculpture," Northern Telecom, Research Triangle Park, North Carolina, catalog
1983 "Tri-State Sculpture 1983," Green Hill Center for North Carolina Art, Greensboro, North Carolina, catalog
1984 "U.S.A. Portrait of the South," Traveling Exhibition, Palazzo Venezia, Rome, Italy, catalog
1984 "1984 Tri-State Sculptors," Queens College, Charlotte, North Carolina (Sponsored by Mint Museum of Art, Charlotte, North Carolina; Queens College, Charlotte, North Carolina and Tri-State Sculptors), catalog
1984 "Group Exhibition," Jailhouse Gallery, Morgantown, North Carolina
1984 "Tri-State Sculpture," Gaston County Art and History Museum, Dallas, North Carolina
1984 "Twelfth Annual Competition for North Carolina Artists," Fayetteville Museum of Art, Fayetteville, North Carolina
1985 "U.S.A. Portrait of the South: The North Carolina Exhibition," Somerhill Gallery, Durham, North Carolina; Green Hill Center for North Carolina Art, Greensboro, North Carolina; Asheville Art Museum, Asheville, North Carolina, catalog
1985 "Southern Exposure: Not a Regional Exhibition, Part II," Alternative Museum, New York, New York, catalog

Selected Public Collections
Fayetteville Museum of Art, Fayetteville, North Carolina
North Carolina Arts Council, Raleigh, North Carolina
Northern Telecom, Research Triangle Park, North Carolina

Selected Awards
1982 Second Prize, Three-Dimensional, "October Show," Asheville Art Museum, Asheville, North Carolina
1983, First Prize, Three-Dimensional,
84 "October Show," Asheville Art Museum, Asheville, North Carolina

Preferred Sculpture Media
Metal (cast) and Wood

Additional Art Fields
Drawing and Photography

Teaching Position
Assistant Professor, Western Carolina University, Cullowhee, North Carolina

Selected Bibliography
"Crafts, A Salute to Metalsmiths: Lucy Puls." *The Arts Journal* vol. 7 no. 12 (September 1982) p. 7, illus.

Mailing Address
Post Office Box 1449
Cullowhee, North Carolina 28723

Artist's Statement

"My sculpture is based on the interaction of line, volume without mass, balance, fragility and 'flattening' of three-dimensionality as a way of expressing ideas on the dynamics of small social structures."

Lucy Puls

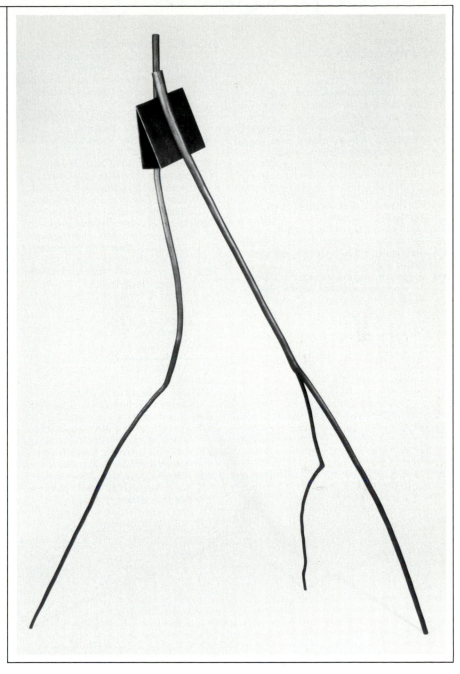

Big Step. 1983. Wood and paint, 94"h x 65"w x 24"d. Photograph by Dan Babior.

Laurel J. Quarberg

née Laurel Joyce
Born September 13, 1954 Norfolk, Virginia

Education and Training

1975 B.F.A., Painting and Printmaking, Virginia Commonwealth University, Richmond, Virginia
1982 M.F.A., Visual Studies, Old Dominion University, Norfolk, Virginia and Norfolk State University, Norfolk, Virginia

Selected Individual Exhibitions

1980 Portsmouth Community Arts Center, Portsmouth, Virginia
1982 Bache Gallery, Norfolk, Virginia
1985 University of Georgia, Athens, Georgia
1985 Peninsula Fine Arts Center, Newport News, Virginia
1985 Sculpture Court, Southeastern Center for Contemporary Art, Winston-Salem, North Carolina

Selected Group Exhibitions

1979 "Freshworks," Harold Decker Galleries, Virginia Beach, Virginia
1980 "Wright, Quarberg and All That Color," Harold Decker Galleries, Virginia Beach, Virginia
1980 "Four Women Artists," United Virginia Bank, Norfolk, Virginia
1981 "Double Take," Virginia National Bank Gallery, Norfolk, Virginia
1981 "Tidewater Artist Association Invitational," Portsmouth Community Arts Center, Portsmouth, Virginia
1982 "Group Exhibition," Ephebi Gallery, Washington, D.C.
1982 "20 Sculptors," Institute of Contemporary Art of the Virginia Museum of Fine Arts, Richmond, Virginia
1983 "From Norfolk," Peninsula Fine Arts Center, Newport News, Virginia
1983 "Virginia Traversed," University Union Art Gallery, Virginia Polytechnic Institute and State University, Blacksburg, Virginia
1984 "Quarberg, Wilson, Wright: Recent Works," Lewis Hall Gallery, Eastern Virginia Medical College, Norfolk, Virginia
1984 "Faculty Exhibition," Greenville County Museum School of Art, Greenville, South Carolina
1985 "Sculpture '85," Winthrop College, Rock Hill, South Carolina
1985 "Women Sculptors," Norfolk State University, Norfolk, Virginia
1985 "Virginia Sculptors," Portsmouth Community Arts Center, Portsmouth, Virginia, catalog

Selected Public Collection

Peninsula Fine Arts Center, Newport News, Virginia

Selected Award

1982 Sculpture Award, "Juried Exhibition 1982," Peninsula Fine Arts Center, Newport News, Virginia, catalog

Preferred Sculpture Media

Varied Media

Additional Art Field

Drawing

Mailing Address

606 Carolina Avenue
Norfolk, Virginia 23508

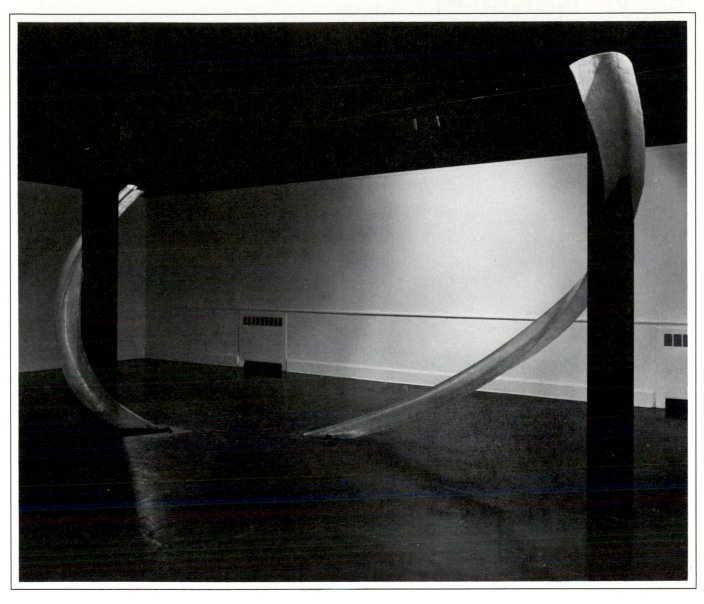

Just Beyond Here. 1982. Fiberglass cloth, resin and wood, 8'h x 21'w. Installation view 1982. "20 Sculptors," Institute of Contemporary Art of the Virginia Museum of Fine Arts, Richmond, Virginia. Photograph by Brenda Wright.

Artist's Statement

"My work explores the use of simple materials and the physicality they can convey. I started with flat, painted illusions of planes of color folding in atmospheric spaces. Then I began actually folding materials. This step led to the works becoming more three-dimensional and a new interest in the physical properties of the materials and the natural forces which shape them. I have moved from paper to metal to screen wire and finally to cloth in search of a media which allows me to shape freely while maintaining a sense of spontaniety without a long, complex fabrication process.

"The simplicity of the process and the fragile appearance of the finished piece adds to the sense of immediacy and creates the illusion of a surface momentarily transformed. These works are at once soft and hard, rough and smooth, gentle and abrasive. My concern are these contradicting sensations."

V. V. Rankine

née Elvine Richard
(Husband Rufus King)
Born July 27, 1920 Boston, Massachusetts

Education and Training
1941- Phillips Gallery Art School,
42 Washington, D.C.; study in drawing
and painting
1944- Amédée Ozenfant School, New York,
46 New York; study in drawing and
painting
1947- Black Mountain College, Black
48 Mountain, North Carolina; study in
painting with Joseph Albers and
Willem De Kooning and sculpture with
Peter Grippe

Selected Individual Exhibitions
1969, Jefferson Place Gallery, Washington,
70, D.C.
73
1969, Betty Parsons Gallery, New York,
70, New York
78,
81
1969, Elaine Benson Gallery,
71, Bridgehampton, New York
73,
82,
83
1978 Fraser's Stable Gallery, Washington,
D.C.
1982 Barbara Fiedler Gallery, Washington,
D.C.
1982 Phoenix II Gallery, Washington, D.C.

Selected Group Exhibitions
1964 "Betty Parsons Gallery Private
Collection," Finch College Museum of
Art, New York, New York, catalog
1968 "Betty Parsons Private Collection,"
Cranbrook Academy of Art Museum,
Bloomfield Hills, Michigan; Brooks
Memorial Art Gallery, Memphis,
Tennessee, catalog
1969 "Painting and Sculpture Today 1969,"
Indianapolis Museum of Art,
Indianapolis, Indiana, catalog
1969 "Blocked Metaphors," Cordier &
Ekstrom Gallery, New York, New York
1969- "Washington Artists," John and Mable
70 Ringling Museum of Art, Sarasota,
Florida
1970 "Washington: Twenty Years," Baltimore
Museum of Art, Baltimore, Maryland,
catalog

1970 "New Sculpture: Baltimore,
Washington, Richmond," Corcoran
Gallery of Art, Washington, D.C.,
catalog
1971 "Transparent and Translucent Art,"
Museum of Fine Arts of St.
Petersburg, Florida, St. Petersburg,
Florida; Jacksonville Art Museum,
Jacksonville, Florida, catalog
1972 "23 Sculptors of the Region," Guild
Hall Museum, East Hampton, New
York
1973 "Sources of Inspiration," Betty Parsons
Gallery, New York, New York
1978 "Outdoor Sculpture 1978," Northern
Virginia Community College,
Annandale, Virginia, catalog
1978 "Art as Furniture, Furniture as Art,"
Ingber Gallery, New York, New York
1979 "Second Annual Invitational Exhibit:
Sculpture," Art Barn, Washington, D.C.
1979 "Women Artists of Eastern Long
Island," Guild Hall Museum, East
Hampton, New York, catalog
1980 "Eleventh International Sculpture
Conference," Area Galleries and
Institutions, Washington, D.C.
(Sponsored by International Sculpture
Center, Washington, D.C.)
1981 "Recent Acquisitions," Guild Hall
Museum, East Hampton, New York
1982 "Twelfth International Sculpture
Conference," Area Galleries and
Institutions, Oakland, California and
San Francisco, California (Sponsored
by International Sculpture Center,
Washington, D.C.)
1983 "Group Two," Betty Parsons Gallery,
New York, New York
1984 "Washington Sculpture: Prospects &
Perspective," Georgetown Court
Artists' Space, Washington, D.C.
1984 "Ordinary and Extraordinary Uses:
Objects by Artists," Guild Hall
Museum, East Hampton, New York,
catalog
1984 "Sculpture '84," Washington Square
Partnership and Public Art Trust,
Washington, D.C.
1985 "Translucid Sculpture," Washington
Square Partnership and Public Art
Trust, Washington, D.C., catalog
1985 "Nine Sculptors," Gallery 10,
Washington, D.C.

Selected Public Collections
Corcoran Gallery of Art, Washington, D.C.
Guild Hall Museum, East Hampton, New York
Indianapolis Museum of Art, Indianapolis,
Indiana
National Museum of American Art,
Smithsonian Institution, Washington, D.C.
Oklahoma Museum of Art, Oklahoma City,
Oklahoma
Robert Owen Shrine, Historic New Harmony,
New Harmony, Indiana
Woodward Foundation, Washington, D.C.

Selected Private Collections
Bullock Collection, San Francisco, California
Elizabeth French, Washington, D.C.
Jon A. Jerde Collection, Los Angeles,
California
Dr. Russell Patterson Collection, New York,
New York
B. H. Wragge Collection, New York, New
York

Selected Award
1978 Honorable Mention, "Twenty-First Area
Exhibition: Sculpture," Corcoran
Gallery of Art, Washington, D.C.,
catalog

Preferred Sculpture Media
Plastic and Wood

Additional Art Field
Drawing

Related Profession
Visiting Artist

Selected Bibliography
Frackman, Noel. "Arts Reviews: V. V.
Rankine/Maria Gooding/John
Cunningham." Arts Magazine vol. 52 no. 10
(June 1978) pp. 36-38, illus.
Kramer, Hilton. "Art: Fallen From Fashion,
Primitives Still Appeal." The New York
Times (Saturday, February 1, 1969), p. 23.
Lewis, Jo Ann. "Galleries: Shapes of
Somberness." The Washington Post
(Saturday, January 16, 1982), p. C3, illus.
Richard, Paul. "Minimal Likeness." The
Washington Post (Sunday, March 30,
1969), p. K4, illus.
Russo, Alexander. Profiles on Women Artists.
Frederick, Maryland: University
Publications of America, 1985.

Mailing Address
3524 Williamsburg Lane NW
Washington, D.C. 20008

Artist's Statement

"I began as an abstract painter but soon was painting on the shaped canvas, seeking a sharper definition of form. I began making plywood boxlike reliefs in bright primary colors, exploring the boundary between painting and sculpture. Next I experimented with geometrical sculptural constructions in transparent and/or opaque sanded Plexiglas. The works soon came off the wall becoming freestanding sculptures. Hilton Kramer called them 'architectural paradigms.' I have since turned to burnished Plexiglas figures in black, mythic in character, spare and severe."

V.V. Rankine

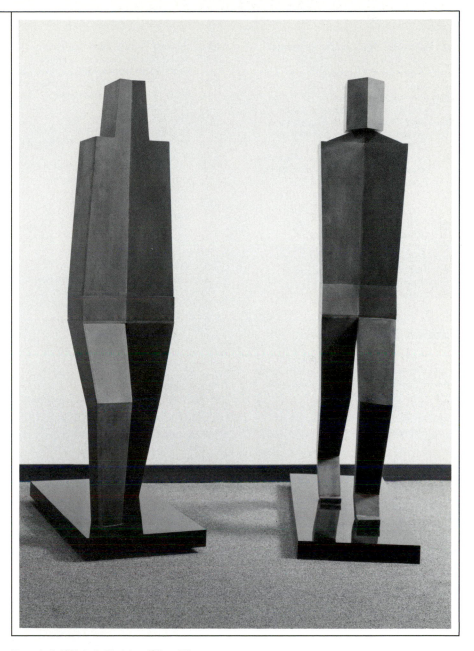

Homanie II. 1981. Left: Plexiglas, 69"h x 20"w x 9½"d. *Homanie I*. 1981. Right: Plexiglas, 72"h x 18"w x 10"d. Photograph by Quick Silver.

Evelyn Raymond

Born March 20, 1908 Duluth, Minnesota

Education and Training
1928- Minneapolis School of Art,
30 Minneapolis, Minnesota; study in sculpture with Charles S. Wells
1928- Saint Paul School of Art, St. Paul,
30 Minnesota; study in painting with Cameron Booth
1932 Art Students League, New York, New York; study in sculpture with William Zorach

Selected Individual Exhibitions
1948 Walker Art Center, Minneapolis, Minnesota
1968 Hennepin Avenue Methodist Church, Minneapolis, Minnesota
1982 Fairview Hospital, Minneapolis, Minnesota
1983 College of St. Thomas, St. Paul, Minnesota

Selected Group Exhibitions
1941 "Three Women Sculptors," Walker Art Center, Minneapolis, Minnesota
1941, "Annual Exhibition of Fine Arts," Fine
43, Art Galleries, Minnesota State Fair, St.
44 Paul, Minnesota
1944- "Annual Regional Sculpture Exhibition,"
47 Walker Art Center, Minneapolis, Minnesota, catalog
1946, "Society of Minnesota Sculptors
47 Spring Salon," Woman's Club of Minneapolis, Minneapolis, Minnesota
1949 "For Common Learnings," Minneapolis Institute of Arts, Minneapolis, Minnesota
1956 "Biennial of Paintings, Prints, Sculpture—Upper Midwest," Walker Art Center, Minneapolis, Minnesota, catalog
1958 "History of Minnesota," Centennial Hall, IDS Building, Minneapolis, Minnesota
1973 "Encounter with Artists/12: Evelyn Raymond and Marjorie Kreilick, Minnesota Museum of Art, St. Paul, Minnesota

Selected Public Collections
College of St. Thomas, St. Paul, Minnesota
Fairview Hospital, Minneapolis, Minnesota
International Falls High School Stadium, International Falls, Minnesota
Lutheran Church of the Good Shepherd, Edina, Minnesota
Minnesota Historical Society, St. Paul, Minnesota
Minnesota Museum of Art, St. Paul, Minnesota
St. Austin's Catholic Church, Minneapolis, Minnesota
St. George's Episcopal Church, Minneapolis, Minnesota
St. Joseph's Catholic Church, Hopkins, Minnesota
St. Olaf College, Northfield, Minnesota
St. Paul's Church-on-the-Hill, St. Paul, Minnesota
Sanex, South St. Paul, Minnesota
Sebeka High School Stadium, Sebeka, Minnesota
United States Capitol, Washington, D.C.
University of Minnesota Twin Cities Campus, Bierman Field Athletic Building, Minneapolis, Minnesota
Walker Art Center, Minneapolis, Minnesota

Selected Private Collections
Elmer L. Andersen, St. Paul, Minnesota
Mr. and Mrs. George McConnell, Naples, Florida
Mr. and Mrs. Carl N. Platou, Wayzata, Minnesota
Roger Schmuck, Rochester, Minnesota
Mr. and Mrs. H. P. Skoglund, Minneapolis, Minnesota

Selected Awards
1958 First American Woman Sculptor to Place a Statue of a Woman in the United States Capitol, Washington, D.C., Minnesota Statehood Centennial Commission
1976 Improving the Quality of Life in Minnesota, Minnesota Legislature Blue Book
1976 Contributions to the Quality of Life in Minnesota, Minnesota Bicentennial Commission

Preferred Sculpture Media
Metal (cast), Metal (welded) and Stone

Related Profession
Sculpture Instructor

Selected Bibliography
Paine, Sylvia. "Evelyn Raymond." *WARM Journal* (Autumn 1982) pp. 4-7, illus.
United States 86th Congress, 2d Session. *Acceptance of the Statue of Maria L. Sanford presented by the State of Minnesota.* Washington, D.C.: United States Government Printing Office, 1960.

Gallery Affiliation
Vern Carver Gallery
1018 La Salle Avenue
Minneapolis, Minnesota 55403

Mailing Address
3730 Monterey Drive
Minneapolis, Minnesota 55416

Artist's Statement

"Sculpture is to the eyes what music is to the ears, though the arts are not the same. The eye delights in the arrangement of forms revealing balance and variety. The awareness of space versus solids plus subtle textures can give visual satisfaction to the inner man as can music. The painter can use color but sculpture is form.

"So often content overpowers the form. I melt and weld both together because sculpture should excite the eye. Every composition I think of as monumental. Sculpture comes naturally to women because women sense the earthiness, the closeness to nature of their materials."

Evelyn Raymond

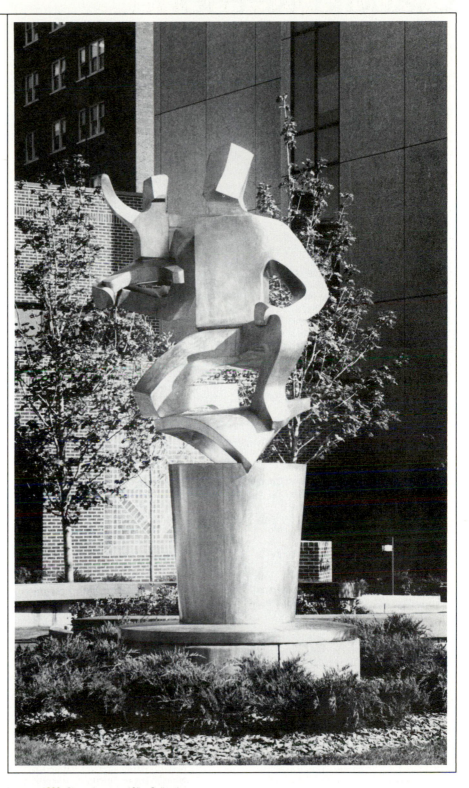

Legacy. 1982. Sheet bronze, 16'h. Collection Fairview Hospital, Minneapolis, Minnesota. Courtesy Fairview Community Hospitals, Minneapolis, Minnesota. Photograph by Jeffrey Grosscup.

473

Claudia Reese

Born May 1, 1949 Des Moines, Iowa

Education and Training
1970 B.A., Art, Connecticut College, New London, Connecticut
1974 M.F.A., Ceramic Sculpture, Indiana University Bloomington, Bloomington, Indiana; study with John Goodheart and Karl Martz

Selected Individual Exhibitions
1975 Iowa Wesleyan College, Mount Pleasant, Iowa
1975 Fine Arts Gallery, Ottumwa Heights College, Ottumwa, Iowa
1976 Guldelsky Gallery, Maryland College of Art and Design, Silver Spring, Maryland
1976 Fine Arts Gallery, Mercer University, Macon, Georgia
1976 Mariani Gallery, University of Northern Colorado, Greeley, Colorado
1982 Objects Gallery, San Antonio, Texas
1984 Willingheart Gallery, Austin, Texas
1985 Mattingly Baker Gallery, Dallas, Texas

Selected Group Exhibitions
1975 "National Ceramic Sculpture Invitational," Rebecca Cooper Gallery, Washington, D.C.
1975 "Five on Fire," Moreau Gallery, Saint Mary's College, Notre Dame, Indiana
1975 "First Annual Women's Ceramic Exhibition," Woman's Building, Los Angeles, California
1975 "Faculty Exhibition," Maryland College of Art and Design, Silver Spring, Maryland
1976 "Religious Images and Self Portraits," Washington Women's Arts Center, Washington, D.C.
1976 "Faculty Exhibition," Montgomery College-Takoma Park Campus, Takoma Park, Maryland
1976 "Group Exhibition," O'Shaughnessy Gallery, University of Notre Dame, Notre Dame, Indiana
1977 "From the Center," Traveling Exhibition, Washington Women's Arts Center, Washington, D.C.
1977 "Fifth Annual Clay Invitational," Millersville State College, Millersville, Pennsylvania
1977 "Indiana Ceramics Exhibition," University of Evansville, Evansville, Indiana
1978 "Texas Sculpture Exhibition," Laguna Gloria at First Federal Bank, Austin, Texas
1978 "Ceramic Sculpture," Bruce Gallery, Edinboro State College, Edinboro, Pennsylvania
1979 "Thirteen Annual National Drawing and Small Sculpture Show," Del Mar College, Corpus Christi, Texas
1979 "Vital Signs," Aperture Gallery, Austin, Texas

1979 "Austin Contemporary Art," Laguna Gloria at First Federal Bank, Austin, Texas and Trinity House Cooperative Gallery, Austin, Texas
1979 "Texas Silver, Mud and Paper," Contemporary Arts Center, New Orleans, Louisiana
1979 "Amarillo Competition," Amarillo Art Center, Amarillo, Texas
1979-81 "Women-in-Sight: New Art in Texas," Traveling Exhibition, Dougherty Cultural Arts Center, Austin, Texas, catalog
1979 "New Works: Claudia Reese and Melissa Miller," Laguna Gloria Art Museum, Austin, Texas
1980 "Westwood Clay National 1980," Otis Art Institute, Los Angeles, California, catalog
1980 "Small Works: Fourth Annual Competition," New York University, New York, New York
1980 "Group Exhibition," Randolph Street Gallery, Chicago, Illinois
1980-81 "Texas Made," Traveling Exhibition, Corpus Christi State University, Corpus Christi, Texas
1980 "Gallery Artists," Objects Gallery, San Antonio, Texas
1981 "Interior-Exterior National Invitational Exhibition," Wichita Art Museum, Wichita, Kansas
1981 "The Animal Image: Contemporary Objects and the Beast," Renwick Gallery of the National Museum of American Art, Smithsonian Institution, Washington, D.C., catalog
1981 "Ceramic Sculpture National Invitational," Berkeley-Lainson Gallery, Denver, Colorado
1981 "New Works: Fixed Images," Editions Limited Gallery, Indianapolis, Indiana
1981 "Recent Works in Paper and Clay: Margaret Prentice and Claudia Reese," Gallery 2, Creative Arts Building, Purdue University, West Lafayette, Indiana
1982 "Currents '82," Middle Tennessee State University, Murfreesboro, Tennessee
1982 "Limited Editions," Elements Gallery, New York, New York
1983 "Sculpture: Five Texas Artists Working in Clay," Mattingly Baker Gallery, Dallas, Texas
1983 "Tabletop Show," Adesso Gallery, Chicago, Illinois
1983 "Art for Eating," Elements Gallery, Greenwich, Connecticut
1983 "Worked Surfaces," Elizabeth Fortner Gallery, Santa Barbara, California
1983 "Fourth Texas Sculpture Symposium," Area Galleries and Institutions (Sponsored by College of Fine Arts and Humanities, University of Texas at Austin, Austin, Texas)
1983 "Texas Clay," Southwest Texas State University, San Marcos, Texas; University of Texas at San Antonio, San Antonio, Texas

1984 "New Talent in Texas," Brown-Lupton Student Center Gallery and Moudy Exhibition Space, Texas Christian University, Fort Worth, Texas, catalog
1984 "June Show," Carol Hooberman Gallery, Birmingham, Michigan
1984 "Spring Themes," Maple Hill Gallery, Portland, Maine
1985 "Figure It Out," Laguna Gloria Art Museum, Austin, Texas
1985 "Seven Texas Sculptors," Mattingly Baker Gallery, Dallas, Texas
1985 "Fifth Texas Sculpture Symposium," Sited throughout Central Business District, Dallas, Texas and Connemara Conservancy, Allen, Texas (Sponsored by Texas Sculpture Symposium, Dallas, Texas), catalog

Selected Public Collections
Matthews & Branscomb, San Antonio, Texas
University of Evansville, Evansville, Indiana

Selected Private Collections
Binnie Kinney, New Orleans, Louisiana
Mr. and Mrs. Thomas B. Lemann, New Orleans, Louisiana
Claire List, Washington, D.C.
June Mattingly, Dallas, Texas
Hadley Sleight, Austin, Texas

Selected Award
1980 Woodsmall Foundation Award of Excellence, "Clayfest '80," Herron School of Art, Indianapolis, Indiana

Preferred Sculpture Media
Clay

Additional Art Field
Drawing

Related Profession
Visiting Artist

Selected Bibliography
Kutner, Janet. "Texas Clay." *American Ceramics* vol. 3 no. 3 (Fall 1984) pp. 36-43, illus.
Manroe, Candace Ord. "Collecting: Contemporary Ceramics, The Renaissance of Clay." *Texas Homes* vol. 6 no. 9 (October 1982) pp. 41, 43-46, 48, illus.
Platt, Susan. "Women in Sight: Issues of Quality, Quantity and Politics." *Artweek* vol. 10 no. 39 (November 24, 1979) p. 13.
Stavinoha, Susan. "Decorative Arts: Art on a Platter." *Texas Homes* vol. 8 no. 4 (April 1984) pp. 33-34, illus.
Theobald, Sharon A. "Reviews Midwest Indiana: Claudia Reese and Margaret Prentice, Gallery 2, Purdue University." *New Art Examiner* vol. 8 no. 6 (May 1981) p. 23.

Gallery Affiliations

Willingheart Gallery
615A East Sixth Street
Austin, Texas 78701

Mattingly Baker
3000 McKinney Avenue
Dallas, Texas 75204

Mailing Address

2816 Saratoga
Austin, Texas 78733

Artist's Statement

"I feel the enduring connection and immediate expressiveness between the past and the present in pre-historic Chinese terra cotta figures, 18th century Meissen figurines and African carved images. I view my large-scale figures as cultural and temporal crossovers, caught in a state of metamorphosis, alternately ancient and contemporary, male and female, human and animal."

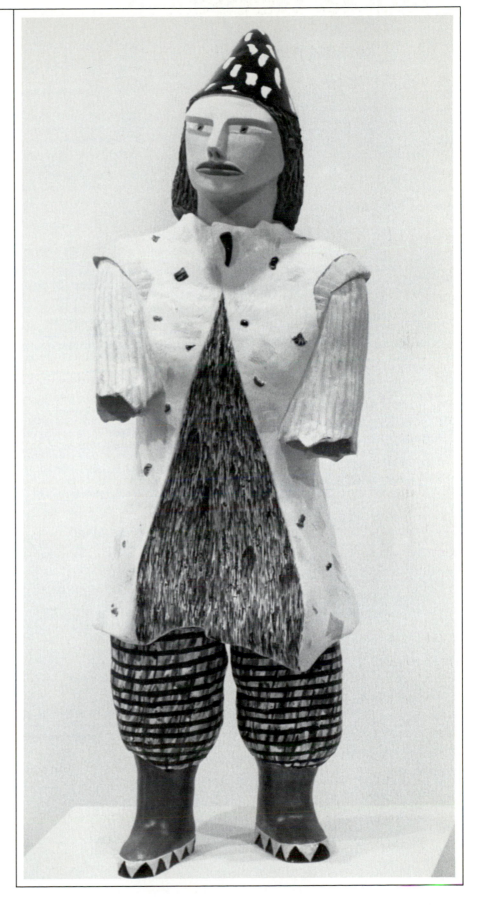

Red Shoe Series. 1982-1983. Clay, 50"h x 17"w x 12"d. Courtesy Mattingly Baker Gallery, Dallas, Texas.

Patricia A. Renick

née Patricia Ann
Born January 26, 1932 Lakeland, Florida

Education and Training
1954 B.S., Art Education, Florida State University, Tallahassee, Florida
1968 M.A., Art Education, Ohio State University, Columbus, Ohio
1969 M.F.A., Printmaking and Sculpture, Ohio State University, Columbus, Ohio; study in sculpture with John Freeman

Selected Individual Exhibitions
1970 Closson's Gallery, Cincinnati, Ohio
1974 Cincinnati Art Museum, Cincinnati, Ohio, catalog
1977 Contemporary Arts Center, Cincinnati, Ohio, catalog
1980 Rike Center Gallery, University of Dayton, Dayton, Ohio
1982 Northern Kentucky University, Highland Heights, Kentucky

Selected Group Exhibitions
1972 "Invitational Exhibition," Cincinnati Art Museum, Cincinnati, Ohio, catalog
1972 "Eat Art," Contemporary Arts Center, Cincinnati, Ohio
1972, 73 "You Name It," Taft Museum, Cincinnati, Ohio
1972 "A Generation of Sculpture," Closson's Gallery, Cincinnati, Ohio
1973 "Women in the Arts," Xavier University, Cincinnati, Ohio
1973 "New Directions," Closson's Gallery, Cincinnati, Ohio
1973 "Light and Motion," Living Arts Center, Dayton, Ohio
1974 "Regional Artists," Contemporary Arts Center, Cincinnati, Ohio
1974 "The Stegowagenvolkssaurus," Brodie Science and Engineering Complex, University of Cincinnati, Cincinnati, Ohio
1975 "Sculpture for a New Era," Chicago Federal Center, Chicago, Illinois
1976 "Artist's Initiative," Contemporary Arts Center, Cincinnati, Ohio
1976 "Fourteen Cincinnati Artists," Peachtree Center Gallery, Atlanta, Georgia
1976 "Cincinnati 13 + One," Tampa Bay Art Center, Tampa, Florida
1979 "Strategies: Artists in the 80s." Contemporary Arts Center, Cincinnati, Ohio
1980 "First International Festival of Women Artists," Ny Carlsberg Glyptotek, Copenhagen, Denmark, catalog
1984 "Floating Sculpture," Tangeman Fine Arts Gallery, University of Cincinnati, Cincinnati, Ohio

Selected Awards
1975 Corbett Award for Outstanding Contributions by an Individual Artist to the Cultural Vitality of Cincinnati, Arts Council of the Ohio River Valley and *The Cincinnati Post*, Cincinnati, Ohio
1980 Faculty Research Grant, University of Cincinnati, Cincinnati, Ohio
1981 Individual Artist's Fellowship, Ohio Arts Council

Preferred Sculpture Media
Plastic (fiberglass), Varied Media and Wood

Additional Art Field
Printmaking

Teaching Position
Professor of Fine Arts, University of Cincinnati, Cincinnati, Ohio

Selected Bibliography
Bloomfield, Maureen. "Suspended Sequences." *Dialogue* vol. 7 no. 3 (May-June 1984) pp. 30-31.
Clark, Gilbert. "Other Aspects of the Life: An Interview with Patricia Renick." *Art Education* vol. 36 no. 5 (September 1983) pp. 9-13, illus.
Miller, Julie Ann. "Off the Beat: Better Sculpture through Chemistry." *Science News* vol. 117 no. 24 (June 14, 1980) p. 378, illus.
Stratton, Jim. *Pioneering In The Urban Wilderness*. New York: Urizen Books, 1977.

Gallery Affiliation
Closson's Gallery
401 Race Street
Cincinnati, Ohio 45202

Mailing Address
343 Probasco Street
Cincinnati, Ohio 45220

Life Boats/Boats about Life. 1979-1980. Wood,
aluminum and fiberglass, 1'-1½'h x 5'-6½'w x 1'-1½'d.
Photograph by Colophon and Robert Witanowski.

Artist's Statement

"My earlier work involved figurative forms
with mechanical objects. Using a
Volkswagen as a substructure, the first of
two dinosaur projects was a statement on
the energy crisis and the coming extinction
of the automobile for ecological and
economic reasons. The second, incorporating
a helicopter as the substructure, expressed
my hope for the eventual obsolescence of
war in modern society.

"Later works have turned from monumental
social comment to introspection and
personal imagery. These sculptures
externalize the symbolism of the boat as a
metaphor for women. Suspended in space
and lighted from above, these forms and
their shadows create an allegorical ambiance
about the contradictory and conflicting
stages of women's life experiences.

"Recent images merge nude female forms
with the boats; their content is
autobiographical. The figures are female
models yet, at the same time, androgynous.
While the work addresses feminine issues, it
is a metaphor for transport, the passage of
the spirit, the voyage to life, to death, and
through life and death."

Patricia A. Renick

Nancy du Pont Reynolds

née Nancy du Pont
(Husband William Glasgow Reynolds)
Born December 28, 1919 Greenville,
Delaware

Education and Training
1938 Goldey Beacom College, Wilmington,
Delaware

Selected Individual Exhibitions
1963 Rehoboth Art League, Rehoboth
Beach, Delaware
1966 Pennsylvania Military College, Chester,
Pennsylvania
1975 Caldwell, Incorporated, Wilmington,
Delaware

Selected Group Exhibitions
1937, "Delaware Art Show," Delaware Art
38, Museum, Wilmington, Delaware
40,
41,
48,
50,
62,
65

1943 "Annual Area Exhibition of Work by
Artists of Washington & Vicinity,"
Corcoran Gallery of Art, Washington,
D.C., catalog
1969 "Annual Exhibition," National Academy
of Design, New York, New York,
catalog
1973, "Society of Burr Artists Exhibition,"
74, Lever House, New York, New York
75
1979 "Mid-Atlantic Regional Exhibition of
Small Sculpture," John M. Clayton
Hall, University of Delaware, Newark,
Delaware, catalog

Selected Public Collections
Children's Bureau, Wilmington, Delaware
Goldsborough Building, Wilmington,
Delaware
Longwood Gardens, Kennett Square,
Pennsylvania
Luther Towers Building, Wilmington,
Delaware
Stevenson Center for the Natural Sciences,
Sarah Stevenson Science Library,
Vanderbilt University, Nashville, Tennessee
Traveler's Aid and Family Society Building,
Wilmington, Delaware

Selected Award
1974 Alumni Medal of Merit for Art,
Westover School, Middlebury,
Connecticut

Preferred Sculpture Media
Metal (cast) and Plastic

Additional Art Field
Two-Dimensional Design

Related Profession
Historical Preservation and Research

Mailing Address
Foxwood
Old Kennett Road
Greenville, Delaware 19807

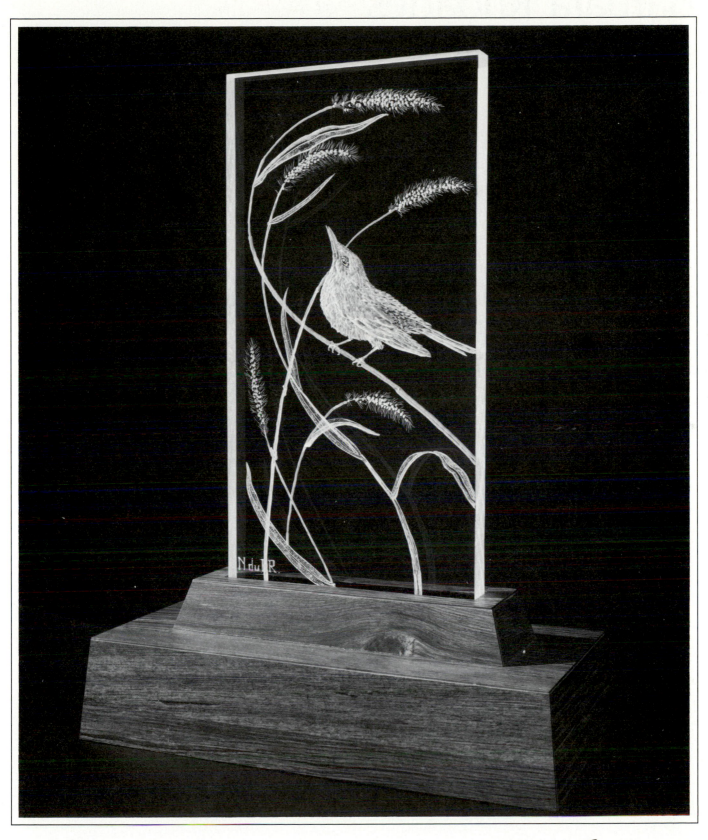

Blithe Sprite. 1979. Carved lucite, 18"h x 9"w.
Photograph by Lubitsh & Bungarz.

Nancy du Pont Reynolds

479

Barbara Rhoades

née Barbara Heggie
Born January 17, 1950 Lake Forest, Illinois

Education and Training
1972 B.A., Studio Art, Northwestern University, Evanston, Illinois; study in sculpture with Jack Burnham and Amy Goldin
1975- University of North Carolina at Chapel
80 Hill, Chapel Hill, North Carolina; independent study in sculpture with Jerry Noe
1978 M.A.T., Art Education, University of North Carolina at Chapel Hill, Chapel Hill, North Carolina; additional study in sculpture with Jerry Noe
1981 Penland School of Crafts, Penland, North Carolina; study in glass-blowing sculpture techniques with Henry Halem and Dick Ritter
1984 Fellowship Program, Atlantic Center for the Arts, New Smyrna Beach, Florida; collaborative workshop with Miriam Schapiro

Selected Individual Exhibitions
1981 Chowan College, Murfreesboro, North Carolina
1982 Center/Gallery, Carrboro, North Carolina
1984 Waterworks Gallery, Salisbury, North Carolina

Selected Group Exhibitions
1979 "North Carolina Sculpture '79," Weatherspoon Art Gallery, Greensboro, North Carolina, catalog
1980 "Nine Women Artists in North Carolina," High Point Arts Council, High Point, North Carolina
1980 "20 North Carolina Sculptors," Green Hill Art Gallery, Greensboro, North Carolina
1980 "Let There Be Light: Noe, Cooperstein and Rhoades," Durham Art Council Galleries, Durham, North Carolina
1981 "Summer Scenes—Summer Places," Center Gallery, Carrboro, North Carolina
1982, "Annual Exhibit of North Carolina
83 Sculpture," Northern Telecom, Research Triangle Park, North Carolina, catalog
1983 "Artsplosure '83: Regional Sculpture Exhibition, Raleigh Arts Commission," Fayetteville Mall, Raleigh, North Carolina
1983 "Mixed Media Show," Atlantic Christian College, Wilson, North Carolina
1983 "Tri-State Sculpture 1983," Green Hill Center for North Carolina Art, Greensboro, North Carolina, catalog
1983 "Bayersdorfer, Gressman and Rhoades, Sculpture," Old Dominion University, Norfolk, Virginia
1984 "4 x 4 by Floor," Center/Gallery, Carrboro, North Carolina

Selected Award
1982 "Merit Award Mixed Media," "Eleventh Annual Competition for North Carolina Artists," Fayetteville Museum of Art, Fayetteville, North Carolina

Preferred Sculpture Media
Glass, Neon and Varied Media

Related Professions
Art Instructor and Neon Design Consultant

Selected Bibliography
Greenberg, Blue. "North Carolina's Center Gallery: A Progressive Woman's Co-Op." *Art Voices/South* vol. 3 no. 2 (March-April 1980) pp. 52-54.

Mailing Address
Route 5 Box 365B
Chapel Hill, North Carolina 27514

Artist's Statement

"The intent of my work is a highly energetic environment which represents light and the passage of time. I began by placing neon in one-way mirrored environments. Not only did this achieve an independence of lighting, it increased the intensity of light and involved the audience in its reflective quality. From there I moved to audience triggered electric eyes. The viewer's path and/or approach to the artwork would trigger a response in the neon, varying the sequences of color. Then time became an ingredient in the process. I time-sequenced the work in order to add the spontaneity of perception to the viewer's interpretation. Dotted lines, flashing lights, cracking shells and disintegrating ladder rungs symbolize the moment when the object borders on non-object."

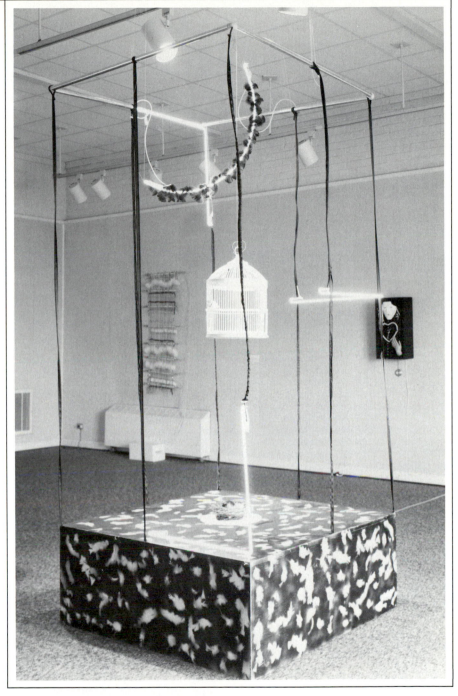

Couldn't Keeper. 1984. Neon and mixed media, 9'h x 4'w x 4'd. Installation view 1984. Waterworks Gallery, Salisbury, North Carolina. Photograph by Janet Pritchard.

Jacquelyn Rice

née Jacquelyn Ione Bowersox
(Husband William Rice)
Born June 17, 1941 Orange, California

Education and Training
1968 B.F.A., Ceramics, University of
Washington, Seattle, Washington
1970 M.F.A., Ceramics, University of
Washington, Seattle, Washington;
study with Howard Kottler and Robert
H. Sperry

Selected Individual Exhibitions
1976, Exhibit A, Evanston, Illinois
79,
81
1977 Helen Drutt Gallery, Philadelphia,
Pennsylvania
1983, Hadler/Rodriguez Galleries, New York,
84 New York

Selected Group Exhibitions
1969 "Young Americans," American Craft
Council, New York, New York
1972 "Clay, Fiber, Glass," Kemper Gallery,
Kansas City, Missouri
1972 "Twenty-Eighth National Exhibition of
Ceramic Art," Lang Art Gallery,
Scripps College, Claremont, California
1972 "A Decade of Ceramic Art 1962-1972:
From the Collection of Professor and
Mrs. R. Joseph Monsen," San
Francisco Museum of Art, San
Francisco, California, catalog
1973 "Seventh Biennial Beaux Arts Designer
Craftsmen," Columbus Gallery of Art,
Columbus, Ohio
1974 "Clay Magic," Stephens College,
Columbia, Missouri
1974 "Decalcomania," Traveling Exhibition,
Memorial Art Gallery of The University
of Rochester, Rochester, New York
1974 "Ceramics U.S.A. Circa 1975,"
Playhouse Square Gallery, Cleveland,
Ohio
1974 "Survey," Cranbrook Academy of Art
Museum, Bloomfield Hills, Michigan

1975 "The Plastic Earth and Extraordinary
Vehicles," John Michael Kohler Arts
Center, Sheboygan, Wisconsin
1975 "Clay U.S.A.," Fendrick Gallery,
Washington, D.C., catalog
1975 "Jacquelyn Rice and Lizbeth Stewart,"
Helen Drutt Gallery, Philadelphia,
Pennsylvania
1975 "Group Exhibition," Exhibit A,
Evanston, Illinois
1976 "Soup Tureens: 1976," Traveling
Exhibition, Campbell Museum,
Camden, New Jersey, catalog
1977 "Contemporary Ceramic Sculpture,"
William Hayes Ackland Memorial Art
Center, University of North Carolina at
Chapel Hill, Chapel Hill, North
Carolina, catalog
1977 "Invitational Box Show," John Michael
Kohler Arts Center, Sheboygan,
Wisconsin
1977 "Jacquelyn Rice and John
Stephenson," Union Gallery, University
of Michigan, Ann Arbor, Michigan
1977 "National Crafts Exhibition," Marian
Locks Gallery, Philadelphia,
Pennsylvania
1978 "Clay from Molds: Multiples, Altered
Castings, Combinations," John
Michael Kohler Arts Center,
Sheboygan, Wisconsin, catalog
1979 "Clay Attitudes," Queens Museum,
Flushing, New York, catalog
1981 "Paint on Clay: A Survey of the Use of
Nonfired Surfaces on Ceramic Forms
by Contemporary American Artists,"
John Michael Kohler Arts Center,
Sheboygan, Wisconsin, catalog
1983 "Ornamentalism: The New
Decorativeness in Architecture and
Design," Hudson River Museum,
Yonkers, New York; Archer M.
Huntington Art Gallery, Austin, Texas
1984 "Gallery Artists," Hadler/Rodriguez
Galleries, New York, New York
1984 "Group Invitational," Dorothy Weiss
Gallery, San Francisco, California

Selected Public Collections
Henry Art Gallery, Seattle, Washington
The Lannan Foundation, West Palm Beach,
Florida
Wichita Art Association, Wichita, Kansas

Selected Private Collections
Professor and Mrs. R. Joseph Monsen
Collection, Seattle, Washington
Lee Nordness, New York, New York
Robert L. Pfannebecker Collection,
Lancaster, Pennsylvania
Alice Westphal, Evanston, Illinois

Selected Awards
1973, Individual Artist's Fellowship,
77 National Endowment for the Arts
1979 Individual Artist's Fellowship, Rhode
Island State Council on the Arts

Preferred Sculpture Media
Clay and Wood

Additional Art Field
Collage

Related Professions
Lecturer and Visiting Artist

Teaching Position
Head of Ceramics Program, Associate
Professor, Rhode Island School of Design,
Providence, Rhode Island

Selected Bibliography
Harrington, LaMar. *Ceramics in the Pacific
Northwest: A History.* Seattle: University of
Washington Press, 1979.

Gallery Affiliation
Hadler/Rodriguez Galleries
38 East 57 Street
New York, New York 10022

Mailing Address
44 Washington Road
Barrington, Rhode Island 02806

Artist's Statement

"In writing a statement of purpose I find myself quickly caught up in academic rhetoric which ultimately says little about my work or what motivates me. I work very intuitively, make things I like, seeming to jump from idea to idea. Only in looking at work from many years do the themes seem like connected rhythms. I really like the analogy of music to my work, as both express hidden feelings and thoughts. One time at a lecture I was giving, someone from the audience asked what keeps me going, and my answer was 'high desire.' Where this 'high desire' and ability for labor intensive work comes from can only be guessed; as a child my mother and I worked every summer on my grandfather's farm in Wenatchee, Washington, picking cherries. This was hard, hot work and certainly laid the foundation for long term endurance. What I love most about being an artist is the feeling that anything goes; that there are no answers, just a search."

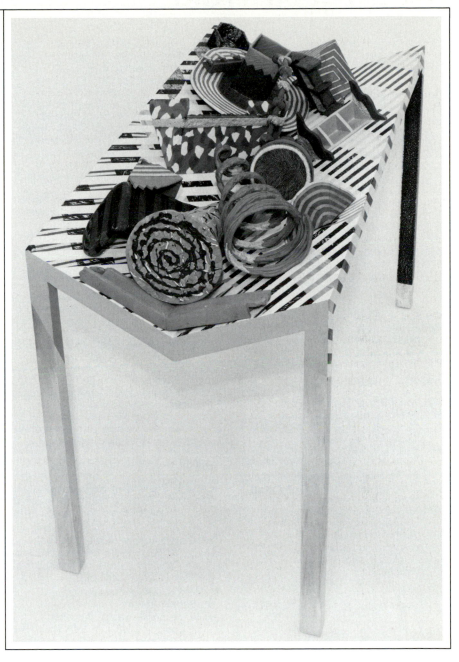

Bibelots. 1982. Terra cotta and painted wood, 4'h x 2½'w x 3'd. Photograph by William Rice.

Paula Jean Rice

(Husband Donald Lester Reitz)
Born April 14, 1944 Northampton,
Massachusetts

Education and Training
1966 B.S., Painting and Sculpture,
University of Michigan, Ann Arbor,
Michigan; study in sculpture with John
Rush
1971 M. Ed., Art Education, Pennsylvania
State University-University Park
Campus, University Park,
Pennsylvania
1975 University of Notre Dame, Notre
Dame, Indiana; workshop in ceramics
with Steven and Susan Kemenyffy,
Don Reitz and Ken Vavrek
1979 M.F.A., Ceramic Sculpture, University
of Wisconsin-Madison, Madison,
Wisconsin; study with Deborah
Butterfield and Don Reitz

Selected Individual Exhibitions
1980 Hopkins Gallery of Fine Art, Ohio
State University, Columbus, Ohio
1981 Center Gallery, Madison, Wisconsin
1985 Octagon Center for the Arts, Ames,
Iowa

Selected Group Exhibitions
1980 "Midwest Craft Competitive
Competition," Rochester Art Center,
Rochester, Minnesota
1981 "Paint on Clay: A Survey of the Use of
Nonfired Surfaces on Ceramic Forms
by Contemporary American Artists,"
John Michael Kohler Arts Center,
Sheboygan, Wisconsin, catalog
1981 "Clay as Art IV," Northern Arizona
University, Flagstaff, Arizona
1981 "Sixtieth Wisconsin Designer
Craftsmen Exhibition,"
Bergstrom-Mahler Museum, Neenah,
Wisconsin

1981 "The Work of Paula Rice and Don
Reitz," Northern Michigan University,
Marquette, Michigan
1981 "Viewing Wisconsin '81," Cudahy
Gallery of Wisconsin Art, Milwaukee
Art Museum, Milwaukee, Wisconsin
1982 "Sixty-First Wisconsin Designer
Craftsmen Exhibition," Rahr West
Museum, Manitowoc, Wisconsin
1982 "Thirteen Annual Invitational,"
Grossman Gallery, University of
Wisconsin-Whitewater, Whitewater,
Wisconsin
1982- "Intimate Spaces," Traveling Exhibition,
83 Gallery 1, San Jose State University,
San Jose, California, catalog
1983 "Summer Faculty Exhibition," Hopkins
Gallery of Fine Art, Ohio State
University, Columbus, Ohio
1983 "Wisconsin Today," Cudahy Gallery of
Wisconsin Art, Milwaukee Art
Museum, Milwaukee, Wisconsin
1984 "LaGrange National," Lamar Dodd Art
Center, LaGrange College, LaGrange,
Georgia
1984 "The Photographer and the Artist: The
Transformed Image," Elvehjem
Museum of Art, Madison, Wisconsin,
catalog
1984 "Fire and Light," Somerstown Studios
and Gallery, Somers, New York
1984 "Don Reitz and Paula Jean Rice:
Ceramic Sculpture," Theodore Lyman
Wright Art Center, Beloit College,
Beloit, Wisconsin
1985 "Forty-First Annual Ceramics
Exhibition," Lang Art Gallery, Scripps
College, Claremont, California
1985 "Ceramic Art of the 70s: A Review of
a Decade," Exhibit A, Chicago, Illinois

Selected Private Collections
Daniel Dahlquist, Wisconsin Dells, Wisconsin
Dr. and Mrs. James W. Voell, Silver Spring,
Maryland

Selected Award
1979 Honorable Award, "Wisconsin
Designer Craftsmen Exhibition," Paine
Art Center and Arboretum, Oshkosh,
Wisconsin

Preferred Sculpture Media
Clay and Varied Media

Additional Art Fields
Drawing and Painting

Selected Bibliography
Kleinsmith, Gene. *Clay's The Way*. Victorville,
California: Victor Valley College, 1981.
"News & Retrospect: Paula Rice." *Ceramics
Monthly* vol. 30 no. 2 (February 1982) pp.
91, 93, illus.
"Studios: Portraits of Workspace." *Ceramics
Monthly* vol. 27 no. 6 (June 1979) pp.
39-45, illus.

Gallery Affiliations
Martha Schneider Gallery
2055 Green Bay Road
Highland Park, Illinois 60035

Holsten Gallery
Elm Street
Stockbridge, Massachusetts 01262

Mailing Address
6000 Highway TT
Marshall, Wisconsin 53559

The Wild West. 1984. Ceramic, 18"h x 21"w x 17"d.
Photograph by Dean Nagle.

Artist's Statement

"I create to reveal the world to myself; my work is a kind of spiritual odyssey. It fulfills a personal need to explore and confirm suspected invisible realities and render their physical forms in the world we know. Animals are remarkably good devices to express this perspective because they reveal their inner emotional states more clearly and insistently than do humans. In my work, whether animal or human forms or a combination, I seek that certain awkward stance, graceless yet dignified; tense, with a suggestion of interrupted or imminent movement."

Paula Dean Rice

485

Sonja O. Rieger

née Sonja Osborn
Born January 20, 1953 Ansbach, Germany,
 Federal Republic

Education and Training
1976 B.A., Sculpture, University of
 Massachusetts at Amherst, Amherst,
 Massachusetts; study with Dale
 Schleappi
1978 Seminar Program, Whitney Museum of
 American Art, New York, New York;
 lectures by contemporary artists
1979 M.F.A., Sculpture and Photography,
 Rutgers University, Mason Gross
 School of the Arts, New Brunswick,
 New Jersey; study in sculpture with
 Gary Keuhn

Selected Individual Exhibitions
1979 Rutgers University, Douglass College,
 New Brunswick, New Jersey
1982 Visual Arts Gallery, University of
 Alabama in Birmingham, Birmingham,
 Alabama
1983 Birmingham-Southern College,
 Birmingham, Alabama

Selected Group Exhibitions
1980 "Southern Exposure," Hanson Gallery,
 New Orleans, Louisiana, catalog
1980 "Upfront Invitational," Upfront Building,
 Memphis, Tennessee
1980 "Images 1980: An Exhibition of
 Alabama Women Artists," University of
 Montevallo Art Gallery, Montevallo,
 Alabama, catalog
1981 "Jacksonville Art Festival," Jacksonville
 Art Museum, Jacksonville, Florida
1982 "Faculty Exhibition," Visual Arts
 Gallery, University of Alabama in
 Birmingham, Birmingham, Alabama

Selected Public Collection
Visual Arts Gallery, University of Alabama in
 Birmingham, Birmingham, Alabama

Selected Award
1980 Merit Award, "Southeast Sculpture
 Exhibition," Lyndon House Gallery,
 University of Georgia, Athens, Georgia

Preferred Sculpture Media
Glass and Varied Media

Additional Art Field
Photography

Teaching Position
Associate Professor, University of Alabama in
 Birmingham, Birmingham, Alabama

Selected Bibliography
Kahan, Mitchell. "Photographs by
 'Photographers' and 'Artists'." *Art Papers*
 vol. 7 no. 4 (August 1983) pp. 3, 16, 18-19,
 illus.
McPherson, Heather. "Reviews Sonja Rieger,
 University of Alabama, Visual Arts Gallery,
 Birmingham, Alabama." *Art Papers* vol. 7
 no. 1 (January-February 1983) p. 20-21,
 illus.

Gallery Affiliation
Fay Gold Gallery
3221 Cains Hill Place
Atlanta, Georgia 30305

Mailing Address
2908 10 Court South
Birmingham, Alabama 35205

Artist's Statement

"My sculptures and photographs are influenced by the observations of light passing through windows and space and traversing floors and walls. The sculptural works substitute glass and paint where light would normally appear. The materials are a means of transforming our experience of reality.

"The underlying premise of my work is to construct metaphors which analyze our surroundings. One element is contrasted with another and in the process new meanings and perceptions are created. Thus substitution, juxtaposition, alteration, displacement and change of context are themes of my work."

John's Window. 1982. Found object and glass, 8'h x 2'w x 6'd. Collection Visual Arts Gallery, University of Alabama in Birmingham, Birmingham, Alabama.

B. P. Rizo-Patron

née Beth Ann Potter
(Husband Gonzalo Rizo-Patron)
Born October 1, 1952 Toledo, Ohio

Education and Training
1974 B.A., Fine Arts, Cedar Crest College, Allentown, Pennsylvania
1977 M.F.A., Metalsmithing, State University of New York College at New Paltz, New Paltz, New York; study with Robert Ebendorf

Selected Individual Exhibitions
1981 Clifford Gallery, Arts and Crafts Center of Pittsburgh, Pittsburgh, Pennsylvania
1983 Gallery Eleven, Slippery Rock State College, Slippery Rock, Pennsylvania

Selected Group Exhibitions
1976 "Miniatures," Fairtree Gallery, New York, New York
1977 "Metals," Phoenix Art Museum, Phoenix, Arizona
1978 "National Metals Invitational," Creative Arts Workshop Gallery, New Haven, Connecticut
1979 "Associated Artists of Pittsburgh Annual Exhibition," Museum of Art, Carnegie Institute, Pittsburgh, Pennsylvania, catalog

1979 "Annual Three Rivers Arts Festival," Gateway Center, Pittsburgh, Pennsylvania, catalog
1982 "S/300 Sculpture/Tricentennial/1982," Philadelphia Art Alliance and Rittenhouse Square, Philadelphia, Pennsylvania, catalog
1982 "Group A Annual Exhibition," Marshall Galleries, Pittsburgh Center for the Arts, Pittsburgh, Pennsylvania
1983 "1983 Invitational Metal Exhibition," Fine Arts Gallery, Montana State University, Bozeman, Montana
1983 "Sculpture/Penn's Landing," Port of History Museum, Philadelphia, Pennsylvania (Co-Sponsored by Cheltenham Art Centre, Cheltenham, Pennsylvania), catalog
1984 "Small Sculpture Exhibition," Traveling Exhibition, Carter Art Gallery, Central Michigan University, Mount Pleasant, Michigan, catalog
1984 "Women's Caucus for Art National Juried Exhibition," Ralph L. Wilson Gallery, Alumni Memorial Building, Lehigh University, Bethlehem, Pennsylvania, catalog
1984 "Focused Fragments, Women's Caucus for Art/ New Jersey," Walters Hall Art Gallery, Rutgers University, Douglass College, New Brunswick, New Jersey, catalog
1984 "B. P. Rizo-Patron and Carol Kumata," Elaine Potter Gallery, San Francisco, California

Selected Awards
1980 Individual Artist's Fellowship, Pennsylvania Council on the Arts
1982 Merit Award, "Fifteenth Annual Marietta College Competitive Exhibition of Painting and Sculpture," Grover M. Hermann Fine Arts Center, Marietta College, Marietta, Ohio, catalog
1983 Individual Artist's Fellowship, New Jersey State Council on the Arts

Preferred Sculpture Media
Varied Media

Additional Art Field
Art Criticism

Related Profession
Art Instructor

Gallery Affiliation
Elaine Potter Gallery
336 Hayes Street
San Francisco, California 94102

Mailing Address
2153 Pennington Road
Trenton, New Jersey 08638

Artist's Statement

"My current work involves combinations of materials, scale expansion and some technical experimentation. I attempt to confront contemporary existence and to present my personal reactions to life experiences. My sculpture deals with themes/issues through manipulation of visual metaphors and symbolic references. I try to exploit the intrinsic qualities of various materials/found objects in an effort to manifest my intent. I term my work Super-Referential as opposed to being thought of as Abstract/Non-Representational. In this regard, I do not decorate . . . I investigate. We live in an awesomely complex technological age which almost requires that our minds be stretched to their limits. Toward that end, I endeavor to do my part through my work as a visual artist."

B.P. Rizo-Patron

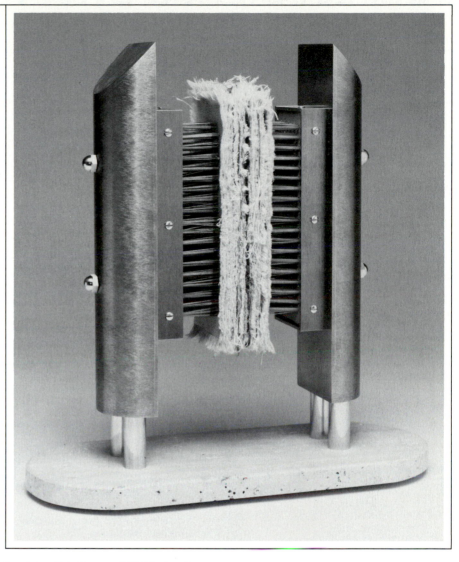

Caught in a Tight Squeeze. 1983. Mixed media, 18"h x 14"w x 6"d. Photograph by Elton Pope-Lance.

489

Aminah Brenda Lynn Robinson

née Brenda Lynn
Born February 18, 1940 Columbus, Ohio

Education and Training
1956- Columbus College of Art and Design,
60 Columbus, Ohio
1960- Ohio State University, Columbus, Ohio
61
1961- Franklin University, Columbus, Ohio
62
1962- Bliss College, Columbus, Ohio
63
1966- Keesler Technical Training Center,
68 Biloxi, Mississippi
1970- University of Puerto Rico,
71 Regional College, Aquadilla, Puerto
 Rico

Selected Individual Exhibitions
1979 Main Library, Ohio State University,
 Columbus, Ohio
1980 Cultural Arts Center, Columbus, Ohio
1980 Kojo Photo Art Studio, Columbus,
 Ohio, catalog
1980 Central State University, Wilberforce,
 Ohio
1981 St. Stephen's Church, Columbus,
 Ohio
1982 Gund Gallery, Ohio Arts Council,
 Columbus, Ohio
1982 Pan American Institute, Kent State
 University, Kent, Ohio
1982 Dunlap Gallery, Battelle Fine Arts
 Center, Otterbein College, Westerville,
 Ohio
1982 Franklin University, Columbus, Ohio,
 catalog
1983 Collectors Gallery, Columbus Museum
 of Art, Columbus, Ohio
1983 Worthington Public Library,
 Worthington, Ohio
1983 Carl Solway Gallery, Cincinnati, Ohio
1984 Esther Saks Gallery, Chicago, Illinois
1985 Kathryn Markel Gallery, New York,
 New York

Selected Group Exhibitions
1976, "People's Art Show," Governor's
77 Mansion, Columbus, Ohio
1979, "Black Expressions," Columbus Model
80 Neighborhood Facility, Columbus,
 Ohio
1981 "Afro-American Art from the Collection
 of Ursel White Lewis," Franklin
 University, Columbus, Ohio
1982 "Barbara Chavous and Aminah,"
 Gallery 200, Columbus, Ohio

1982 "Pages in History, Series One: Part
 One," Dunlap Gallery, Battelle Fine
 Arts Center, Otterbein College,
 Westerville, Ohio
1982 "With a Little Help from My Friends,"
 Franklin University, Columbus, Ohio
1982 "Ode to the Box," Franklin University,
 Columbus, Ohio
1982 "Pages in History, Series One: Part
 Two," Franklin University, Columbus,
 Ohio
1982- "Selections: Six in Ohio," Traveling
84 Exhibition, Contemporary Arts Center,
 Cincinnati, Ohio
1983 "Rodney Ripps, Diane Keaton and
 Aminah Brenda Lynn Robinson," Carl
 Solway Gallery, Cincinnati, Ohio
1983 "Chicago International Art Exposition
 1983," Navy Pier, Chicago, Illinois
 (Represented by Carl Solway Gallery,
 Cincinnati, Ohio), catalog
1983 "Women in the Arts," Cultural Arts
 Center, Columbus, Ohio
1983- "Ohio Arts Council Fellowship
84 Recipients," Traveling Exhibition,
 Schumacher Gallery, Capitol
 University, Columbus, Ohio
1984 "Salute To Black Women, Eta Phi Beta
 Sorority," Hyatt on Capitol Square,
 Columbus, Ohio, catalog
1984 "How I Spent My Summer Vacation:
 New Work by Gallery Artists," Kathryn
 Markel Gallery, New York, New York
1984 "Focus on Art: Figurative Art," Central
 Trust Center Bank, Cincinnati, Ohio
1985 "Books as Sculpture," Robeson Center
 Gallery, Rutgers University, University
 College-Newark, Newark, New Jersey
1985 "Exhibition: Black Heritage, Focus:
 Family & Community," Dunlap Gallery,
 Battelle Fine Arts Center, Otterbein
 College, Westerville, Ohio

Selected Public Collections
Atlantic Richfield Company, Los Angeles,
 California
Capitol University, Schumacher Gallery,
 Columbus, Ohio
Central State University, Xenia, Ohio
Columbus Technical Institute, Columbus,
 Ohio
Otterbein College, Westerville, Ohio

Selected Private Collections
Mrs. Ursel White Lewis, Columbus, Ohio
Dr. Marvin Sackner, New York, New York
Esther Saks, Chicago, Illinois
Mr. and Mrs. Carl Solway, Cincinnati, Ohio
Robinson-Zimmerman Collection, Columbus,
 Ohio

Selected Awards
1979 Travel Grant (Africa), Art for
 Community Expression, Columbus,
 Ohio
1979 Individual Artist's Fellowship, Ohio
 Arts Council
1984 Individual Artist in the Visual Arts,
 Governor's Award for the Arts in Ohio,
 Columbus, Ohio

Preferred Sculpture Media
Clay, Varied Media and Wood

Additional Art Fields
Drawing, Fiber and Painting

Related Professions
Lecturer and Visiting Artist

Teaching Position
Arts Specialist, City Recreation and Parks
 Department, Columbus, Ohio

Selected Bibliography
Bloomfield, Maureen. "Commentary, Dark
 Mirrors: The Art of Disclosure." *Dialogue*
 vol. 5 no. 3 (January-February 1983) pp.
 7-8.
Kelm, Bonnie. "Commentary: The Sounds of
 Transcendence." *Dialogue* vol. 4 no. 4
 (March-April 1982) pp. 12-13, illus.
Rogers-Lafferty, Sarah. "Selections: Six in
 Ohio, November 18-December 31."
 Dialogue vol. 5 no. 2 (November-December
 1982) p. 37.
"Seven + 7 = 14." *Dialogue* vol. 4 no. 1
 (September-October 1981) p. 40, illus.

Gallery Affiliations
Carl Solway Gallery
314 West Fourth Street
Cincinnati, Ohio 45202

Esther Saks Gallery
311 West Superior Street
Chicago, Illinois 60610

Mailing Address
791 Sunbury Road
Columbus, Ohio 43219

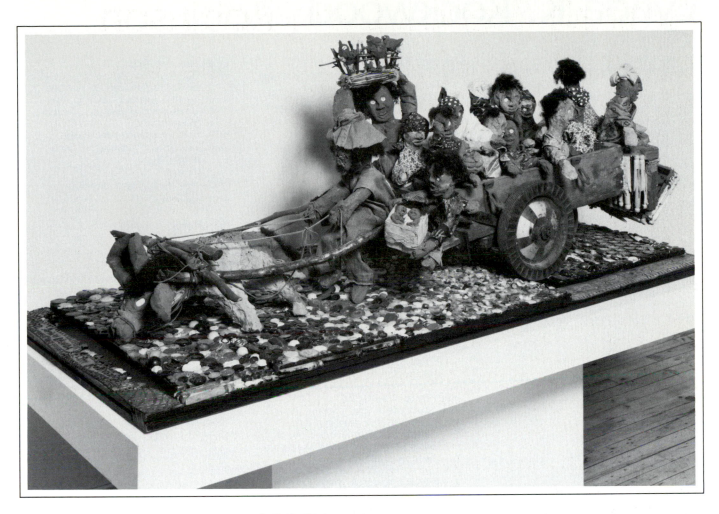

John T. Ward Transporting Fugitive Slaves *to Freedom in Columbus, Ohio, Early 1800s.* 1982. Homemade clay, mixed media and music boxes, 28"h x 63"w x 24"d. Courtesy Esther Saks Gallery, Chicago, Illinois. Photograph by Michael Tropea.

Artist's Statement

"All my life I have always done what I do today. As a youngster of four or five, my mother taught my sisters and me to spin and dye yarn and then use it in quilting or any of the needlecrafts. My father used to hunt small game and showed us the secrets of cutting the tail and paws and neck of the rabbit to make rabbit skin glue. It was a way of life for the family. Art, as people say it is today, was a way of life for the Robinson Family in Poindexter Village.

"I cannot ever remember not drawing and painting or making soap and paper. I created in many forms and made drawings of what was around me—the family, neighbors, friends—people of the Poindexter Village Community. I still am documenting and recording in books, graphics, tapestries and sculpture the Poindexter Village Community as well as Afro-Americans throughout the country. It is a love for the work, a love for youth whom I hope will continue the work."

aminah Brenda Lynn Robinson

491

Lynda K. Rockwood

née Lynda Kay
Born January 18, 1949 Morton, Washington

Education and Training
1972 B.A., Broad Area Art, Central Washington University, Ellensburg, Washington; study in cast and welded sculpture with Christos J. Papadopoulos
1973 M.A., Photography, Central Washington University, Ellensburg, Washington
1974 University of Colorado at Boulder, Boulder, Colorado
1978 M.F.A., Sculpture, University of Washington, Seattle, Washington

Selected Individual Exhibitions
1981 Sarah Spurgeon Gallery, Central Washington University, Ellensburg, Washington
1985 Evergreen Galleries, Olympia, Washington

Selected Group Exhibitions
1976 "Faculty Exhibition," Factory of Visual Arts, Seattle, Washington
1978 "December Exhibition," Polly Friedlander Gallery, Seattle, Washington
1978 "Invitational Exhibition," Women's Cultural Center, Seattle, Washington
1978 "Marymoor Park Lawn Show," Marymoor Park, Redmond, Washington
1978, 79, 80 "Mercer Island Visual Arts," Mercer Island, Washington
1978, 79, 80, 83 "Annual Summer Exhibition," Pacific Northwest Arts and Crafts Fair, Bellevue, Washington
1979, 81, 83 "Annual Painting and Sculpture Exhibition," Tacoma Art Museum, Tacoma, Washington
1980 "Grant Exhibition," 200 Plus One Club, Rainier Bank Tower, Seattle, Washington
1981 "Third Annual Exhibition," Contemporary Arts East, Redmond, Washington
1981, 82 "Poncho 20," Seattle Art Museum, Seattle, Washington
1982 "10 Seattle Artists," Jackson Street Gallery, Seattle, Washington
1983 "Washington's Art in Public Places," Washington State Capitol Museum, Olympia, Washington
1984 "Introspectives: A National Exhibition of Autobiographical Works by Women Artists," Pyramid Arts Center, Rochester, New York, catalog

Selected Public Collection
Valley View Jr. High School, Snohomish, Washington

Selected Awards
1976 Ruth Nettleton Scholarship, University of Washington, Seattle, Washington
1976 Sarah L. Denny Fellowship Award, University of Washington, Seattle, Washington
1977 Ford Foundation Scholarship, University of Washington, Seattle, Washington

Preferred Sculpture Media
Metal (welded)

Additional Art Field
Photography

Related Professions
Artist Consultant, Photography and Sculpture Instructor

Teaching Position
Highline Community College, Midway, Washington

Mailing Address
Post Office Box 318
Medina, Washington 98039

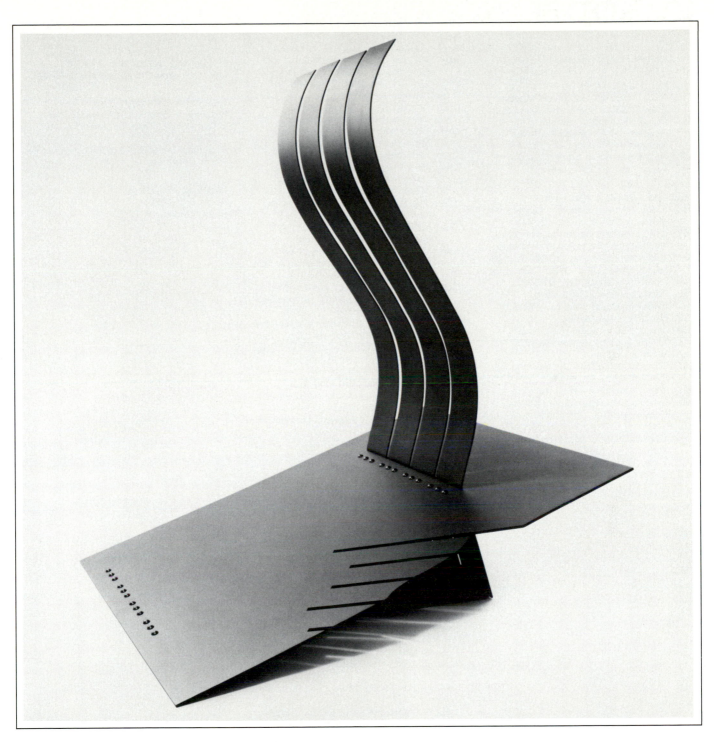

Black Plane. 1978. Anodized aluminum, 4'6"h x 4'w x 3'3"d. Photograph by Steven Young.

Artist's Statement

"I pursue discovery, challenge and change. As a reflection of these pursuits I produce objects and images. My present direction contains components of line, soft curves and earth elements. I prefer carrying out these works in metal fabrication in which I have a strong natural technical ability. The scale of my work shifts in conjunction with concept, material and environment. My work has been influenced by minimalism, constructivism and land projects."

Jo Roper

Born October 11, 1923 Springfield, Missouri

Education and Training
1945 B.S., Education, Southwest Missouri State College, Springfield, Missouri
1949 M.F.A., Sculpture, Cranbrook Academy of Art, Bloomfield Hills, Michigan
1950 Apprenticeship in bronze foundry, Yellow Springs, Ohio

Selected Group Exhibitions
1950 "Denver Annual Exhibition," Denver Art Museum, Denver, Colorado
1950 "Invitational Exhibition," Museum of New Mexico, Santa Fe, New Mexico
1951 "Mid-America Annual," William Rockhill Nelson Gallery and Atkins Museum of Fine Arts, Kansas City, Missouri
1952 "Santa Fe Annual," Traveling Exhibition, Museum of New Mexico, Santa Fe, New Mexico
1952 "Invitational Exhibition," Cranbrook Academy of Art, Bloomfield Hills, Michigan
1957 "Church Art Today," Grace Cathedral, San Francisco, California
1959- "Fiber, Clay and Metal," Traveling
62 Exhibition (Europe), Saint Paul Art Gallery, St. Paul, Minnesota
1960 "Designer Craftsmen," Museum of Contemporary Crafts, New York, New York
1962 "Fiber, Clay and Metal," Traveling Exhibition (South America), Saint Paul Art Gallery, St. Paul, Minnesota

1962 "Ancient Legacies," Museum of Fine Arts, Houston, Houston, Texas
1962 "Crafts Invitational," Fort Worth Art Museum, Fort Worth, Texas
1962 "Crafts Exhibit," Witte Memorial Museum, San Antonio, Texas
1963 "Craftsmen of the Central States," Museum of Contemporary Crafts, New York, New York
1963 "New Mexico Designer Craftsmen," Museum of International Folk Art, Santa Fe, New Mexico
1964 "Invitational Exhibition," Krannert Art Museum, Champaign, Illinois
1966 "Craftsmen Invitational," Henry Art Gallery, Seattle, Washington
1966 "Invitational Sculpture Exhibition," Museum of Fine Arts, Museum of New Mexico, Santa Fe, New Mexico
1966 "Craftsmen USA '66," Los Angeles County Museum of Art, Los Angeles, California
1967 "Inter-Mountain Crafts Invitational," Salt Lake Art Center, Salt Lake City, Utah
1968 "National Invitational Crafts Exhibition," Art Museum, University of New Mexico, Albuquerque, New Mexico
1968 "Third Biennial Craft Exhibition," Albuquerque Museum, Albuquerque, New Mexico
1968 "New Mexico Craftsmen," Museum of International Folk Art, Santa Fe, New Mexico

Selected Public Collections
Abilene Public Library, Abilene, Texas
Art Center of the Ozarks, Springdale, Arkansas
Cyprus High School Auditorium, Magna, Utah
Dugway Junior and Senior High School, Dugway, Utah
Hotel Excelsior Lobby, Tulsa, Oklahoma
Lubbock National Bank, Lubbock, Texas
Mesa College Library, Grand Junction, Colorado
Museum of International Folk Art, Santa Fe, New Mexico
New Mexico Highlands University, Las Vegas, New Mexico
Roosevelt Elementary School, Salt Lake City, Utah
Salt Lake City Public Library, Salt Lake City, Utah
Texas Woman's University, Denton, Texas
Williams Tower, Tulsa, Oklahoma

Selected Awards
1951 Honorable Mention, "Denver Annual Exhibition," Denver Art Museum, Denver, Colorado
1962 Crafts Award, "Christocentric Arts Festival," Krannert Art Museum, Champaign, Illinois
1966 National Merit Award, "Craftsmen U.S.A. 1966," Museum of Contemporary Crafts, New York, New York

Preferred Sculpture Media
Concrete, Metal (cast) and Metal (raised)

Selected Bibliography
"Education: Libraries, How Not to Waste Knowledge." *Time* (September 3, 1965) pp. 52-57, illus.
Redstone, Louis G. *Art In Architecture.* New York: McGraw-Hill, 1968.

Mailing Address
Route 5 Box 800
Rogers, Arkansas 72756

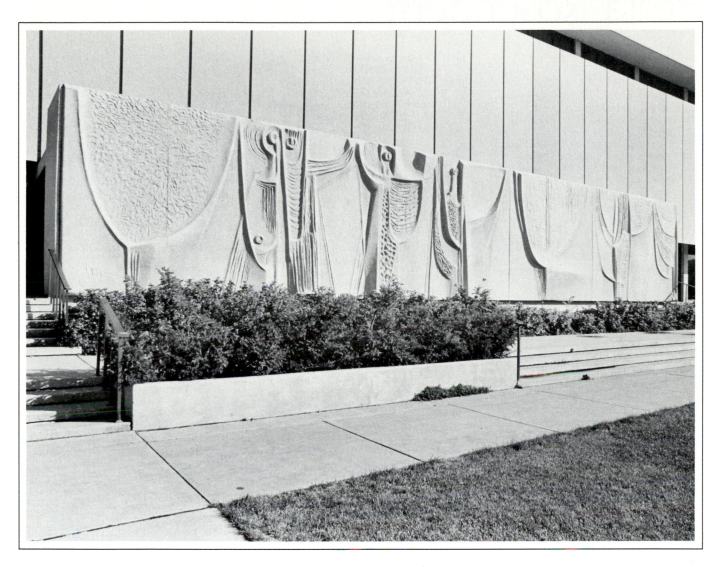

Sculptured Wall. 1964. Cast concrete, 12'h x 68'w x 18"d. Collection Salt Lake City Public Library, Salt Lake City, Utah. Courtesy Salt Lake City Public Library, Salt Lake City, Utah.

Artist's Statement

"A sculptor responds to all influences including the marketplace. My work ranges from small figures to architectural walls of concrete and monumental granite constructions. Larger works appear more abstract but these, too, are based on figurative and natural forms. Whether gold or granite, my intention is consistency. I look forward to each commission as a challenge and the opportunity to be a better sculptor."

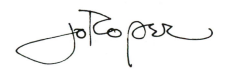

Yetta Rosenberg

née Yetta Schiffman
(Husband William Irving Katz)
Born March 19, 1905 New York, New York

Education and Training
1924- Cleveland School of Art, Cleveland,
25 Ohio; study in painting
1953- Cleveland Institute of Art, Cleveland,
56 Ohio; study in ceramics
1978 Cleveland Institute of Art, Cleveland,
Ohio; study in painting

Selected Individual Exhibitions
1970 Avant-Garde Art Gallery, Cleveland,
Ohio
1976 Mather Gallery, Thwing Center, Case
Western Reserve University,
Cleveland, Ohio
1981 Irvin and Company, Cleveland, Ohio

Selected Group Exhibitions
1929- "Annual May Show," Cleveland
77 Museum of Art, Cleveland, Ohio,
catalog
1935- "Annual Ceramic National Exhibition,"
41 Syracuse Museum of Fine Arts,
Syracuse, New York, catalog
1937- "Annual Ohio Ceramic and Sculpture
72 Show," Butler Institute of American
Art, Youngstown, Ohio
1937 "Second Annual Contemporary Crafts
Exhibition," Philadelphia Art Alliance,
Philadelphia, Pennsylvania, catalog
1939 "Golden Gate International Exposition,"
San Francisco Museum of Art, San
Francisco, California, catalog

1940 "Gallery Exhibition," Arts and Crafts
Guild, Philadelphia, Pennsylvania
1941 "Contemporary Ceramics of the
Western Hemisphere," Traveling
Exhibition (Canada, South America
and United States), Syracuse Museum
of Fine Arts, Syracuse, New York,
catalog
1943 "Cleveland Artists," Ten Thirty Gallery,
Cleveland, Ohio
1958 "Twentieth Anniversary Ceramic
International Exhibition," Syracuse
Museum of Fine Arts, Syracuse, New
York, catalog
1971 "Tri-State Exhibition," College of Mt.
St. Joseph, Cincinnati, Ohio
1971 "Fifteenth National Art Round-Up," Las
Vegas Art League Galleries, Las
Vegas, Nevada
1971 "Preview '71," Studio San Giuseppe,
College of Mt. St. Joseph, Cincinnati,
Ohio, catalog
1972 "Yetta Rosenberg, Sculpture; Barbara
Smith, Etchings and Block Prints,"
Women's City Club, Cleveland, Ohio
1972 "John Lieb, Yetta Rosenberg, Eleanor
Stillman and Charles Laszlo,"
Avant-Garde Art Gallery, Cleveland,
Ohio
1973 "Barbara Smith, Yetta Rosenberg and
Ivy Goldhamer Stone," B. K. Smith
Gallery, Lake Erie College, Painesville,
Ohio
1973- "Annual All Ohio Show," Canton Art
74 Institute, Canton, Ohio, catalog
1975 "An Exhibit of Marble and Stone
Sculpture by Yetta Rosenberg;
Graphics and Mixed Media by Barbara
Smith," Patterson Library Art Gallery,
Westfield, New York
1975 "Cleveland Women Artists: Karen
Eubel, Rose Ann Sassano, Phyllis
Seltzer, Phyllis Sloane and Yetta
Rosenberg," Allegheny College,
Meadville, Pennsylvania, catalog
1981 "Phyllis Sloane and Yetta Rosenberg,"
Gallerie La Place, Beachwood, Ohio
1982, "Annual Invitational Art Exhibition,"
83 One Bratenahl Place, Cleveland, Ohio

Selected Public Collections
The Suburban Temple, Beachwood, Ohio
The Temple Branch, Pepper Pike, Ohio

Selected Private Collections
Noah L. Butkin, Cleveland, Ohio
David Leach, Cleveland, Ohio
Sherman Lee, Cleveland, Ohio
William Mathewson Milliken, Cleveland, Ohio
Mrs. Frank Porter, Cleveland, Ohio

Selected Awards
1937 Honorable Mention, "Annual Ceramic
National Exhibition," Syracuse Museum
of Fine Arts, Syracuse, New York,
catalog

1974 Professional Award, Fine Arts Division,
"Ohio State Fair Fine Arts Exhibition,"
Cox Fine Arts Building, Columbus,
Ohio, catalog
1982 Award of Honor, "National League of
American Pen Women Art Exhibition,"
Colony Square Hotel, Atlanta, Georgia

Preferred Sculpture Media
Clay and Stone

Additional Art Field
Metal (cast)

Selected Bibliography
Campen, Richard N. *Outdoor Sculpture in
Ohio*. Chagrin Falls, Ohio: West Summit
Press, 1980.

Gallery Affiliation
Kuban Gallery
2037 East 14 Street
Cleveland, Ohio 44115

Mailing Address
16605 Aldersyde Drive
Cleveland, Ohio 44120

496

Artist's Statement

"Although I attended the Cleveland Institute of Art for painting, I found myself attracted to ceramic sculpture in which I could use color as well as form. After many years of joy and some success, I discovered a piece of marble. My first effort—using crude hardware store screw drivers for chisels, a hammer and sandpaper—was bought by a collector. That proved the end of the clay period and the beginning of my love affair with stone.

"I am happy with hard surfaces which I can develop into sensuous curves and rhythms. Working directly in stone (and lately wax maquettes for bronze) helps to expose my thoughts and feelings in abstractions related to nature."

Yetta Rosenberg

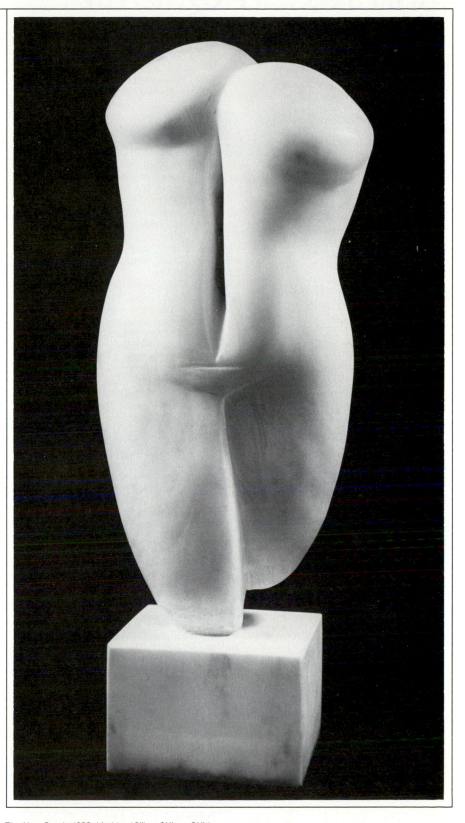

The New Greek. 1982. Marble, 16"h x 6½"w x 3½"d.
Photograph by John De Vard.

497

Jann Rosen-Queralt

née Jann Rosen
Born November 28, 1951 Detroit, Michigan

Education and Training
1972- Apprenticeship to Señor Grau Garriga,
73 Barcelona, Spain; study in three-dimensional tapestry construction
1976 B.F.A., Textile Design, School of Visual and Performing Arts, Syracuse University, Syracuse, New York
1976 M.F.A., Fiber and Sculpture, Cranbrook Academy of Art, Bloomfield Hills, Michigan; study in fiber with Gerhardt Knodel and sculpture with Michael Hall
1982 Institute of Lightweight Structures, Stuttgart, Germany, Federal Republic; independent research in architecture

Selected Individual Exhibition
1985 Academy of the Arts, Easton, Maryland

Selected Group Exhibitions
1974 "Fingerlakes Exhibition," Memorial Art Gallery of the University of Rochester, Rochester, New York
1975 "Beaux Arts Designer Craftsmen," Columbus Gallery of Art, Columbus, Ohio
1976 "Convergence '76," Heinz Gallery of the Museum of Art, Carnegie Institute, Pittsburgh, Pennsylvania, catalog
1977 "The Art of Basketry," Florence Duhl Gallery, New York, New York
1977 "Protofibers," Joe & Emily Lowe Art Gallery, Syacuse, New York, catalog
1978 "Interweave '78," Ingam Gallery, University of Toledo, Toledo, Ohio, catalog

1979 "Installations: The First Exhibit by the Contemporary Art Institute of Detroit," Contemporary Art Institute of Detroit, Detroit, Michigan, catalog
1979 "Jann Rosen-Queralt and Philip Campbell," South Art Gallery, Central Michigan University, Mount Pleasant, Michigan
1980 "Fiberworks: Michigan," Flint Institute of Arts, Flint, Michigan
1980 "Sculpture in the Environment," Ferris State College, Big Rapids, Michigan
1980 "Focus Extended," Detroit Focus Gallery, Detroit, Michigan
1982 "Pyramid Invitational," Gallery 409, Eubie Blake Cultural Center, Baltimore, Maryland
1982 "Jann Rosen-Queralt and Cynthia M. Young," Foundry Gallery, Washington, D.C.
1982 "S/300 Sculpture/Tricentennial/1982," Philadelphia Art Alliance and Rittenhouse Square, Philadelphia, Pennsylvania, catalog
1982 "Artscape: Visual Arts Exhibitions," Mount Royal Avenue, Baltimore, Maryland (Organized by Mayor's Advisory Committee on Art and Culture, Baltimore, Maryland)
1982 "K-18 Stoffwechsel: Internationale Kunstausselung," Halle K-18, Gesamthochschule Kassel, Kassel, Germany, Federal Republic
1982 "Artists' Choice," Maryland Art Place, Baltimore, Maryland
1983 "Maryland Artists Exhibition," Morgan State University, Baltimore, Maryland
1983 "Sculpture/Penn's Landing," Port of History Museum, Philadelphia, Pennsylvania (Co-Sponsored by Cheltenham Art Centre, Cheltenham, Pennsylvania)
1984 "Parallel Motion: Recent Works, Jann Rosen-Queralt and Susan Waters-Eller," Gallery 409, Eubie Blake Cultural Center, Baltimore, Maryland
1984 "Cityspaces: Alexandria Sculpture Festival," Area Locations, City of Alexandria, Virginia, catalog

Selected Public Collections
Amy Zell Ellsworth-Dancecentral Studio, Cambridge, Massachusetts
Your Heritage House, Detroit, Michigan

Selected Award
1982 Faculty Research Travel Grant (Germany), Alliance of Independent Colleges of Art, Washington, D.C.

Preferred Sculpture Media
Varied Media

Additional Art Field
Design

Teaching Position
Coordinator, Fiber Arts Department and Instructor, Foundation Department, Maryland Institute College of Art, Baltimore, Maryland

Selected Bibliography
Fiber Structures. New York: Van Nostrand Reinhold, 1976.
Hammel, Lisa. "16 Artists Put All of Their Craft Into 60 Baskets." *The New York Times* (Friday, February 18, 1977) p. C18.

Mailing Address
1403 Clipper Heights
Baltimore, Maryland 21211

Crescent Span. 1982. Wood and vinyl. Foreground: 6"h x 26"w x 12"d. Background: 6½"h x 30"w x 22"d. Photograph by Frank Wheat.

Artist's Statement

"The central theme of my work involves gesture created by skeletal and stressed membranes. The forms are derived from observations of integrated systems present in dinosaur fragments, old sailing vessels and architecture. Each of these points of departure embodies a historical sense of place as well as the formal qualities of balance, movement and repetition. The resulting sculptural forms possess characteristics of a metamorphical and ephemeral nature that reflect the fragilities and rigors of survival and adaptation. These qualities in consort with the physical presence of the work are analogous to the play I sense between fantasy and reality."

Jann Rosen-Queralt

Amalie Rothschild

née Amalie Rosenfeld
(Husband Randolph S. Rothschild)
Born January 1, 1916 Baltimore, Maryland

Education and Training
1934 Diploma, Fashion Illustration, Maryland Institute School of Fine and Practical Arts, Baltimore, Maryland
1934 New York School of Fine and Applied Art, New York, New York
1937 Studio of Richard Dicus, Baltimore, Maryland; study in painting
1940-41 Studio of Herman Maril, Baltimore, Maryland; study in painting
1945 Studio of Max Schallinger, Baltimore, Maryland; study in painting
1958-59 Baltimore Museum of Art, Baltimore, Maryland; study in sculpture with Frieda Sohn

Selected Individual Exhibitions
1964 Goucher College, Towson, Maryland
1971 Baltimore Museum of Art, Baltimore, Maryland
1972 Jacob Ladder Gallery, Washington, D.C.
1975 National Academy of Sciences, Washington, D.C.
1978, 80 B. R. Kornblatt Gallery, Baltimore, Maryland
1982 Meredith Contemporary Art, Baltimore, Maryland
1982 Baltimore Artscape, Baltimore, Maryland
1984 Academy of the Arts, Easton, Maryland; Washington County Museum of Fine Arts, Hagerstown, Maryland, retrospective and catalog
1985 C. Grimaldis Gallery, Baltimore, Maryland
1985 Western Maryland College, Westminster, Maryland

Selected Group Exhibitions
1980 "Sculpture 1980," Maryland Institute College of Art, Baltimore, Maryland, catalog
1981 "Dimensions in Abstraction," Goucher College, Towson, Maryland
1982 "S/300 Sculpture/Tricentennial/1982," Philadelphia Art Alliance and Rittenhouse Square, Philadelphia, Pennsylvania, catalog
1982 "Inaugural Exhibition," Maryland Art Place, Baltimore, Maryland
1985 "Translucid Sculpture," Washington Square Partnership and Public Art Trust, Washington, D.C., catalog

Selected Public Collections
Federal Reserve Bank of Richmond, Richmond, Virginia
Honolulu Academy of Arts, Honolulu, Hawaii
Towson State University, Baltimore, Maryland
University of Maryland at College Park, College Park, Maryland
Washington County Museum of Fine Arts, Hagerstown, Maryland

Selected Private Collections
Marcella Louis Breuner, Chevy Chase, Maryland
Mr. and Mrs. George Dalsheimer, Baltimore, Maryland
Elliott Galkin, Baltimore, Maryland
Mr. and Mrs. Robert H. Levi, Lutherville, Maryland
Dr. and Mrs. Sidney Lieberman, Baltimore, Maryland

Selected Award
1980 Exhibition Grant, Maryland State Arts Council and Maryland State Humanities Council

Preferred Sculpture Media
Plastic (Plexiglas) and Wood

Additional Art Fields
Drawing, Painting and Paper (handmade)

Related Profession
Art Instructor

Selected Bibliography
Johnson, Lincoln F., Jr. "Reviews of the Exhibitions Maryland: Amalie Rothschild at B. R. Kornblatt Gallery (Baltimore, Maryland)." *Art Voices/South* vol. 1 no. 3 (May-June 1978) p. 36, illus.

Gallery Affiliation
C. Grimaldis Gallery
928 North Charles Street
Baltimore, Maryland 21201

Mailing Address
2909 Woodvalley Drive
Baltimore, Maryland 21208

Artist's Statement

"I have been an artist since childhood—always drawing and 'making things.' My debut as a professional was in fashion illustration and commercial art before I turned to painting in oils. The sculpture followed a strong hard edge formalist development in painting which matured around 1967. I am a self-taught constructivist sculptor having gradually transformed a painting studio into a machine shop. After experimenting in media such as bone, tree bark, wax, stone and plaster, I found a compatible direction in geometric form assembled mainly from scrap metal and Plexiglas. These sculptures were created in a context of material to idea. Recently the method reversed in particle board sculptures evolving from idea to material.

"My interest in structure and design—both natural and man-made, past and present, spanning many cultures—informs my work. It is created with utmost concern for craft and probity, distilling the essence of form and expression."

Amalie Rothschild

Amun-Amunet. 1979. Particle board and gold leaf, each unit, 43"h x 12"w x 15"d. Photograph by Henry Berney.

Ann Rozhon

née Ann Augusta
(Husband Joseph Francis Galvin)
Born January 25, 1955 Middletown,
Connecticut

Education and Training
1970- Apprenticeship to Joanne Falbo,
73 Westbrook, Connecticut; assistant in
the technical creation of ceramic
sculpture
1977 B.F.A., Sculpture, Rhode Island School
of Design, Providence, Rhode Island;
study with Robert Louis Strini and
Joan Thorne
1982 Roger Williams Park Zoo, Providence,
Rhode Island; exhibition designer in
the creation of large-scale sculpture
relating to animal habitat
1983 Studio of Patricia Vecchione,
Providence, Rhode Island; study in
fiberglass sculpture
1983 Rhode Island School of Design,
Providence, Rhode Island; study in
painting
1984 Providence Journal Building,
Providence, Rhode Island; co-sculptor
in architectural facade reconstruction

Selected Group Exhibitions
1977 "Ann Rozhon, Robynn Smith and
Marie Thibeault," Woods-Gerry Gallery,
Rhode Island School of Design,
Providence, Rhode Island
1979 "Ann Rozhon and Ruth Dealy,"
Benbow Gallery, Newport, Rhode
Island
1979 "Save the Bay Invitational," Start
Gallery, Newport, Rhode Island
1979 "Sixty-Eighth Annual Exhibition," Art
Association of Newport, Newport,
Rhode Island
1979 "Ann Rozhon and David LeClerk,"
Gallery 150, Newport, Rhode Island
1981 "Annual Juried Exhibition," Bristol Art
Museum, Bristol, Rhode Island
1984 "Raid on the Capital Investment
Corporation," University of Rhode
Island, Kingston, Rhode Island
1985 "Atelier '85," Verlaine, Incorporated,
Providence, Rhode Island

Selected Public Collection
Abedon, Michaelson, Stanzler and Biener,
Providence, Rhode Island

Selected Private Collections
Peter B. Ceppi, Jamestown, Rhode Island
Christopher Crowell, Essex, Connecticut
John Christian Jorgensen, New York, New
York

Selected Awards
1980 Creative Artist Grant, Burlingham
Foundation, Jamestown, Rhode Island
1981 Centennial Prize, "Centennial
Sculpture Exhibition," Providence Art
Club, Providence, Rhode Island

Preferred Sculpture Media
Plastic (fiberglass)

Additional Art Fields
Painting and Photography

Related Profession
Architectural Sculpture Renovation

Mailing Address
126 Sayles Avenue
Pascoag, Rhode Island 02859

Artist's Statement

"My sculpture is a visual conversation with the viewer; an image extracted from one day, a specific time or a remembered moment. The figure is a vehicle for an allegory involving my experience and associations.

"My approach to sculpture is through painting; the sculptural material is unimportant—only that be lightweight. I prefer a luminous and vibrant surface which is achieved by heavy layers of oil paint. I am particularly inspired by the paintings of Bonnard whose use of color and form within a deceptively simple genre is extremely evocative."

Ann Rozhon

White Sky. 1983. Fiberglass and oil paint, 8'h x 3'w x 1'd. Installation view 1984. "Raid on the Capital Investment Corporation," University of Rhode Island, Kingston, Rhode Island.

Laura Ruby

Born December 7, 1945 Los Angeles, California

Education and Training
1967 B.A., English, University of Southern California, Los Angeles, California
1969 M.A., English, San Francisco State College, San Francisco, California
1978 M.F.A., Sculpture and Ceramics, University of Hawaii at Manoa, Honolulu, Hawaii

Selected Individual Exhibitions
1975 Hand and Eye Gallery, Honolulu, Hawaii
1978 Wailea Art Gallery, Wailea, Hawaii
1983 Contemporary Arts Center, Honolulu, Hawaii, catalog
1984 Muskegon Museum of Art, Muskegon, Michigan
1984 Utah Museum of Natural History, Salt Lake City, Utah

Selected Group Exhibitions
1974, "Artists of Hawaii: Annual Exhibition,"
75, Honolulu Academy of Arts, Honolulu,
77, Hawaii
79,
80
1974 "Cerritos Ceramic Annual," Cerritos College Art Gallery, Norwalk, California, catalog
1974 "Annual Regional Southern California Juried Art Exposition," State Fairgrounds, Del Mar, California, catalog

1980 "Sculpture Hawaii," Amfac Plaza Exhibition Room, Honolulu, Hawaii
1981 "Westwood Clay National," Downey Museum of Art, Downey, California, catalog
1981 "Small Works National '81," Zaner Gallery, Rochester, New York, catalog
1982 "First International Shoebox Sculpture Exhibition," Traveling Exhibition, University of Hawaii Art Gallery, Honolulu, Hawaii, catalog
1982 "Nature Interpreted," Cincinnati Museum of Natural History, Cincinnati, Ohio
1982 "Shreveport Biennial National Exhibition," Meadows Museum of Art of Centenary College, Shreveport, Louisiana, catalog
1983 "Easter Art Festival," Ala Moana Center, Honolulu, Hawaii
1983 "First Clay National," Traveling Exhibition, Erie Art Museum, Erie, Pennsylvania, catalog
1983 "Seventeenth Annual National Drawing and Small Sculpture Show," Joseph A. Cain Memorial Art Gallery, Del Mar College, Corpus Christi, Texas, catalog
1984 "American Association of University Women Annual Exhibition," Greeley National Bank, Greeley, Colorado
1984 "Environmental/Installation Exhibition," University of Hawaii Art Gallery, Honolulu, Hawaii

Selected Public Collections
Castle & Cooke, Honolulu, Hawaii
Contemporary Arts Center, Honolulu, Hawaii
Erie Art Museum, Erie, Pennsylvania
Hawaii State Foundation on Culture and the Arts, University of Hawaii at Hilo, Hilo, Hawaii
Musicians' Association of Hawaii, Honolulu, Hawaii
Wailea Art Gallery Permanent Collection, Wailea, Hawaii

Selected Private Collections
Mr. and Mrs. Seth Abraham, New York, New York
Windsor G. Hackler, Honolulu, Hawaii
General and Mrs. Austin C. Shofner, Shelbyville, Tennessee
Giulio and Jill Venezian, College Station, Texas
Alex Weinstein, Honolulu, Hawaii

Selected Awards
1974 Best in Show, "Redondo Beach Festival of the Arts," Redondo Beach, California
1976 Juror's First Place Award, "Easter Art Festival," Ala Moana Center, Honolulu, Hawaii

Preferred Sculpture Media
Clay and Varied Media

Additional Art Field
Serigraphy

Teaching Position
Instructor, Department of Art, University of Hawaii at Manoa, Honolulu, Hawaii

Selected Bibliography
Senecal, Peter F. *Leaders of Hawaii, 1983*. Honolulu, Hawaii: Senecal and Associates, 1983.

Mailing Address
509 University Avenue-902
Honolulu, Hawaii 96826

China Arch—A Site of Passage. 1984. Bamboo and wood, 14'h x 19½'w x 4'd. Installation view 1984. "Environmental/Installation Exhibition." University of Hawaii Art Gallery, Honolulu, Hawaii.

Artist's Statement

"A particular sculpture is initiated first by an idea. I employ a variety of media appropriate to the theme or concept. Such themes include neolithic stone monuments and other forms derived from Hawaiian and Asian cultures.

In this sculpture, *China Arch—A Site of Passage*, the ancient architectural structure, the arch (as for example in the Barrier Gate between Macau and China) is an entrance-way and a barrier, a passageway and a transition, creating insiders and outsiders. In China many structures have acquired a recent skin of bamboo scaffolding, whether temporary or permanent. A structure with such a bamboo facade is itself in transition."

Laura Ruby

505

Priscilla K. Sage

née Priscilla Kepner
(Husband Charles Russell Sage)
Born September 16, 1936 Allentown,
Pennsylvania

Education and Training
1958 B.S., Art, Pennsylvania State
University-University Park Campus,
University Park, Pennsylvania
1959- Columbia University, New York, New
60 York; study in design and printmaking
1962- Iowa State University, Ames, Iowa;
63 study in textiles
1981 M.F.A., Sculpture, Drake University,
Des Moines, Iowa

Selected Individual Exhibitions
1964 Grinnell College, Grinnell, Iowa
1965 Iowa State University, Ames, Iowa
1965 Kutztown State College, Kutztown,
Pennsylvania
1965, Montclair State College, Upper
67 Montclair, New Jersey
1965 Wesleyan University, Middletown,
Connecticut
1966 Newark State College, Union, New
Jersey
1966 Jersey City State College, Jersey City,
New Jersey
1966, Birger Sandzen Memorial Gallery,
71 Lindsborg, Kansas
1967, Octagon Center for the Arts, Ames,
69 Iowa
1968 Galeria del Sol, Santa Barbara,
California
1970 Charles H. MacNider Museum, Mason
City, Iowa
1971 Pennsylvania State
University-University Park Campus,
University Park, Pennsylvania
1972, Simpson College, Indianola, Iowa
84
1973 Cedar Rapids Art Center, Cedar
Rapids, Iowa
1973 Smith Park Gallery, St. Paul,
Minnesota
1974 Mankato State College, Mankato,
Minnesota
1975 University of Northern Iowa, Cedar
Falls, Iowa
1979 Waterloo Recreation and Arts Center,
Waterloo, Iowa, catalog
1980 Mount Mercy College, Cedar Rapids,
Iowa
1981 BFM Gallery, New York, New York
1982 Johnson County Art Center, Iowa City,
Iowa
1985 Gordon Fennell Gallery, Coe College,
Cedar Rapids, Iowa

Selected Group Exhibitions
1963- "Iowa Artist Annual Exhibition," Des
82 Moines Art Center, Des Moines, Iowa
1970 "Midwest Regional Exhibition," Cedar
Rapids Art Center, Cedar Rapids,
Iowa
1971 "Feathered Splendor," John Michael
Kohler Arts Center, Sheboygan,
Wisconsin

1971, "Beaux Arts Designer Craftsmen,"
73, Columbus Gallery of Art, Columbus,
75 Ohio
1972 "Gallery Artists Grand Opening
Exhibition," Fairtree Gallery, New York,
New York
1973 "Art and Technology," Octagon Center
for the Arts, Ames, Iowa
1975 "Ten Iowa Women," Cedar Rapids Art
Center, Cedar Rapids, Iowa
1975 "Fiber Artists," One Hundred and
Eighteen: An Art Gallery, Minneapolis,
Minnesota
1976 "Ten Years of Exhibitions," Charles H.
MacNider Museum, Mason City, Iowa
1976 "Tenth Anniversary Exhibition,"
Octagon Center for the Arts, Ames,
Iowa
1976 "'76 1 + 1, Women's Invitational
Exhibition," Brunnier Gallery and
Museum, Ames, Iowa
1977 "Northwestern Crafts II," South Dakota
Memorial Art Center, Brookings, South
Dakota
1977 "Soft Art, Iowa State Arts Council,"
Traveling Exhibition, Gordon Fennell
Gallery, Coe College, Cedar Rapids,
Iowa
1978 "Priscilla Sage and Gaylord Torrence,"
University of Nebraska at Omaha,
Omaha, Nebraska
1978- "Women Artists: Clay, Fiber, Metal,"
79 Traveling Exhibition, Bronx Museum of
The Arts, Bronx, New York
1978 "Intersew International Exhibition,"
Palace Museum, Monaco-Ville,
Monaco (Represented by BFM
Gallery, New York, New York), catalog
1979 "Beds, Sweet Dreams and Other
Things," Brunnier Gallery and
Museum, Ames, Iowa
1980 "Winter Olympic Art Festival," Olympic
Village, Lake Placid, New York
1982- "The New Plastics: Fiber in Today's
83 Technology," Visual Arts Center of
Alaska, Anchorage, Alaska, catalog
1983 "Contemporary Fiber: An International
Exhibition," Talley Gallery, Bemidji
State University, Bemidji, Minnesota
1984 "Fibers: On and Off the Wall," Lincoln
Gallery, Ames, Iowa
1984 "American Arts Festival Exhibition,"
Yamanashi Prefecture Museum, Kōfu,
Japan
1985 "A Show of Fans," Society of Arts and
Crafts, Boston, Massachusetts

Selected Public Collections
Banc Iowa, Cedar Rapids, Iowa
Cedar Rapids Art Center, Cedar Rapids,
Iowa
City of Kōfu, Yamanashi Perfecture, Kōfu,
Japan
Hoover State Office Building, Des Moines,
Iowa
Iowa City Public Library, Iowa City, Iowa
Iowa State University, C. Y. Stephens
Auditorium, Ames, Iowa
Kutztown State College, Kutztown,
Pennsylvania

Mankato State University, Mankato,
Minnesota
National Bank of Waterloo, Waterloo, Iowa
Wallace State Office Building, Des Moines,
Iowa
Waterloo Recreation and Arts Center,
Waterloo, Iowa

Selected Private Collections
Lawrence Bultenweisser, New York, New
York
Joan Mannheimer Collection, Des Moines,
Iowa
John and Robin Murray, Lubbock, Texas
Mary Shideler, Boulder, Colorado
Phillip and Jane Zaring, Ames, Iowa

Selected Awards
1966 Textile Award, "Annual Decorative Arts
and Ceramic Exhibition," Wichita Art
Association, Wichita, Kansas, catalog
1968 Textile Award, "Ten West," Walnut
Creek Civic Center, Walnut Creek,
California
1978 Esther and Edith Younker Award,
"Iowa Artist Annual Exhibition," Des
Moines Art Center, Des Moines, Iowa

Preferred Sculpture Media
Fiber

Teaching Position
Instructor, Drake University, Des Moines,
Iowa
Instructor, Iowa State University, Ames, Iowa

Selected Bibliography
Clardy, Andrea. "Priscilla Sage." *Fiberarts* vol.
5 no. 2 (March-April 1978) pp. 26-28, illus.
Malarcher, Patricia. "Plastics in Fiber: A
Persistent Presence." *Fiberarts* vol. 12 no.
1 (January-February 1985) pp. 56-61, illus.
Meilach, Dona Z. *Soft Sculpture and Other
Soft Art Forms, with Stuffed Fabrics,
Fibers and Plastics.* New York: Crown,
1974.
"Priscilla Sage, Small Paintings and Fiber
Sculpture." *Fiberarts* vol. 8 no. 3 (April-May
1981) p. 69, illus.
White, Patrick E. "Reviews Midwest Iowa:
Priscilla Sage, Barborka Gallery, Simpson
College, Indianola." *New Art Examiner* vol.
12 no. 2 (November 1984) p. 64, illus.

Gallery Affiliation
Artworks
2403 Indian Hill Road SE
Cedar Rapids, Iowa 52403

Mailing Address
435 Welch Avenue
Ames, Iowa 50010

Artist's Statement

"To create a sculpture, I first build (and then discard) numbers of small paper models until I find a form that seems to work. Next, a full scale, white fabric model is built and revised until that particular form appears feasible. The sculpture is constructed by covering ½" polyurethane with a skin of silver mylar polyester fabric. This material is then pleated to create variations of spiral forms which employ no wires or internal supports. The sculpture is suspended from one point enabling it to move in space. The finished work is as light as possible so that the slightest air currents cause constant changes in movement, shapes and colors. The choice of light reflective surfaces, painted with dyes, unifies form and color in the shimmer of light and motion."

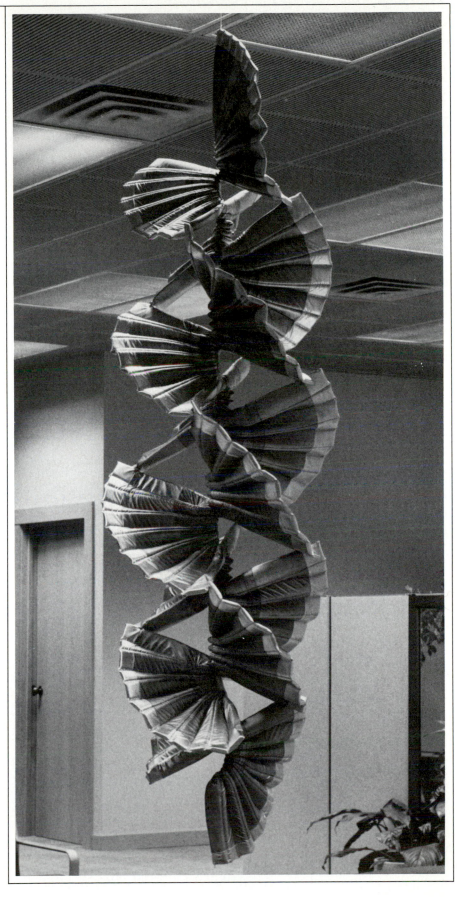

Triune Helix I. 1984. Mylar fabric dyed with disperse dyes, 6'h x 2'w. Collection Banc Iowa, Cedar Rapids, Iowa. Photograph by Rodney O. Bradley.

Diane Samuels

Born September 29, 1948 New York, New York

Education and Training
1970 B.F.A., Fiber, Carnegie-Mellon University, Pittsburgh, Pennsylvania; study with Marg Johansen
1975 Diploma, Art Administration, Institute in Art Administration, Harvard University, Cambridge, Massachusetts
1976 M.F.A., Fiber, Carnegie-Mellon University, Pittsburgh, Pennsylvania; study with Louise Holeman-Pierucci
1983 International Center of Photography, New York, New York

Selected Individual Exhibitions
1981 Entrance Gallery, Museum of Art, Carnegie Institute, Pittsburgh, Pennsylvania
1981 Fiberworks Gallery, Berkeley, California
1982 Gallery 407, Pittsburgh Plan for Art, Pittsburgh, Pennsylvania
1982 Mattress Factory, Pittsburgh, Pennsylvania
1984 Rochester Institute of Technology, Rochester, New York
1985 La Galleria Dell' Occhio, New York, New York
1985 A.I.R. Gallery, New York, New York

Selected Group Exhibitions
1972- "Associated Artists of Pittsburgh
79 Annual Exhibition," Museum of Art, Carnegie Institute, Pittsburgh, Pennsylvania, catalog
1973 "Second Biennial Lake Superior National," Tweed Museum of Art, Duluth, Minnesota
1973- "Annual Faculty Exhibition," Arts and
76 Crafts Center, Pittsburgh, Pennsylvania
1976- "Annual Faculty Exhibition," Slippery
78 Rock State College, Slippery Rock, Pennsylvania
1976 "Frontiers in Contemporary American Weaving," Lowe Art Museum, Coral Gables, Florida
1976 "Convergence '76," Heinz Gallery of the Museum of Art, Carnegie Institute, Pittsburgh, Pennsylvania, catalog
1977, "Marietta College Crafts National,"
78, Grover M. Hermann Fine Arts Center,
81 Marietta College, Marietta, Ohio, catalog

1977 "Annual Three Rivers Arts Festival," Gateway Center, Pittsburgh, Pennsylvania, catalog
1978 "Fiber 10," Wallnuts Gallery, Philadelphia, Pennsylvania; Chautauqua Art Association Galleries, Chautauqua, New York; Eastern Mennonite College, Harrisonburg, Virginia; James Madison University, Harrisonburg, Virginia; Museum of Art, Carnegie Institute, Pittsburgh, Pennsylvania, catalog
1979 "Contemporary Fiber," Southern Alleghenies Museum of Art, Loretto, Pennsylvania
1979 "Clay Plus," Chatham College, Pittsburgh, Pennsylvania
1979 "Collaboration," Associated Artists of Pittsburgh, Pittsburgh, Pennsylvania
1979 "Connections," Taos Fiber Gallery, Taos, New Mexico
1980 "23 at 500," Mattress Factory, Pittsburgh, Pennsylvania
1980 "Seeing the Unseen," Courthouse Gallery, Pittsburgh, Pennsylvania
1980 "Walls, Ceilings, Floors," Pittsburgh Center for the Arts, Pittsburgh, Pennsylvania
1980- "Annual Faculty Exhibition,"
85 Carnegie-Mellon University, Pittsburgh, Pennsylvania
1981 "Mid-Atlantic Images at the National U.S. Conference of Mayors," Bally's Park Place Casino Hotel, Atlantic City, New Jersey
1981 "Small Works National '81," Zaner Gallery, Rochester, New York, catalog
1982 "The World in 24 Hours," International Arts Festival, Linz, Austria
1983 "Urban Pulses: The Artist and the City," University of Pittsburgh, Pittsburgh, Pennsylvania
1984 "A.I.R. Affiliates," A.I.R. Gallery, New York, New York

Selected Public Collections
Museum of Art, Carnegie Institute, Pittsburgh, Pennsylvania
Pennsylvania State University-Uniontown Campus, Uniontown, Pennsylvania

Selected Private Collections
Bisiani Collection, Milan, Italy
Barbara Luderowski, Pittsburgh, Pennsylvania

Selected Awards
1977 Sculpture Award, "Associated Artists of Pittsburgh Annual Exhibition," Museum of Art, Carnegie Institute, Pittsburgh, Pennsylvania, catalog
1980 Sculpture Award, "Society of Sculptors Annual Exhibition," Pittsburgh Center for the Arts, Pittsburgh, Pennsylvania

Preferred Sculpture Media
Fiber and Wood

Additional Art Field
Photography

Teaching Position
Visiting Artist, Carnegie-Mellon University, Pittsburgh, Pennsylvania

Selected Bibliography
"Diane Samuels, Sculpture." *Carnegie Magazine* vol. 55 no. 2 (February 1981) p. 7, illus.
King, Elaine A. "Reviews East Coast Pennsylvania: Diane Samuels, The Mattress Factory." *New Art Examiner* vol. 10 no. 1 (November 1982) p. 19.
McCombie, Mel. "Reviews East Coast Pittsburgh: Diane Samuels, Pittsburgh Plan for Art." *New Art Examiner* vol. 9 no. 6 (March 1982) p. 15, illus.

Gallery Affiliations
Pittsburgh Plan for Art
407 South Craig Street
Pittsburgh, Pennsylvania 15213

A.I.R. Gallery
63 Crosby Street
New York, New York 10012

Mailing Address
330 Sampsonia Way
Pittsburgh, Pennsylvania 15212

Artist's Statement

"I make fragile tenuously balanced sculptures of wood and metal. A massive shape can be supported by very delicate linear shapes. Beginning with spatial drawings, the images are inspired by my immediate neighborhood, Cycladic art and ancient architecture."

Diane Samuels

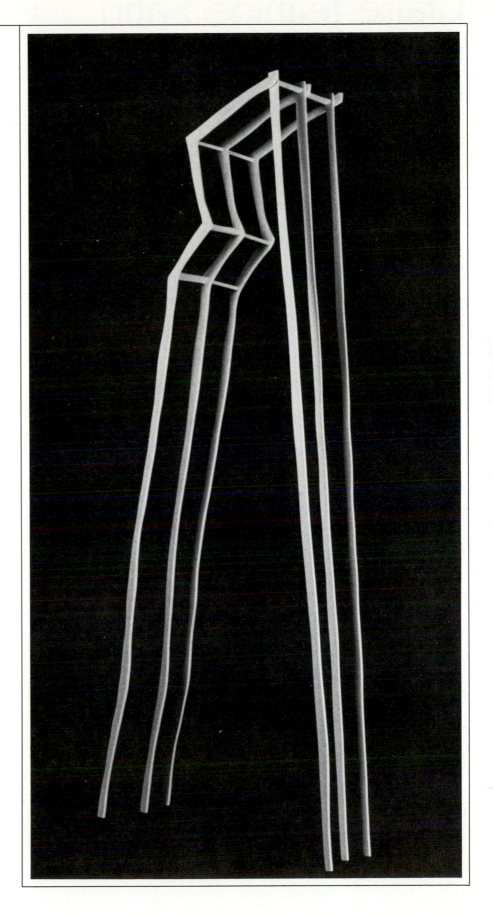

Untitled. 1983. Basswood, 23"h x 4"w x 12"d.

Claire Jeanine Satin

Born January 9, 1941 New York, New York

Education and Training
1950- Brooklyn Museum Art School,
52 Brooklyn, New York; study in drawing
 and sculpture
1959 Brooklyn College, Brooklyn, New York;
 study in art education
1961 B.A., Sculpture, Sarah Lawrence
 College, Bronxville, New York; study
 with Theodore Roszak
1963 University of Colorado at Boulder,
 Boulder, Colorado; study in sculpture
1964 University of Wisconsin-Madison,
 Madison, Wisconsin; study in art
 history and sculpture
1965 New School for Social Research, New
 York, New York; study in sculpture
1968 M.F.A., Sculpture, Pratt Institute,
 Brooklyn, New York; study with Calvin
 Albert
1972 Barry University, Miami, Florida; study
 in art education

Selected Individual Exhibitions
1978 Gallery at 24, Miami, Florida
1979 Art and Culture Center of Hollywood,
 Hollywood, Florida, catalog
1980 Frances Wolfson Art Gallery, Miami-
 Dade Community College, New World
 Center Campus, Miami, Florida,
 retrospective and catalog
1982 Center for Book Arts, New York, New
 York
1984 Gallery One, Fort Worth, Texas
1985 Gloria Luria Gallery, Bay Harbor
 Islands, Florida
1985 Kruger Gallery, New York, New York

Selected Group Exhibitions
1969 "New England Twentieth-Century
 Exhibition," Silvermine Guild of Artists,
 New Canaan, Connecticut
1971 "New Jersey Painters and Sculptors
 Exhibition," Newark Museum, Newark,
 New Jersey
1973- "Annual Hortt Memorial Exhibition,"
83 Museum of Art, Fort Lauderdale,
 Florida, catalog
1975 "Women Artists Third Century,"
 Burdine's Gallery, Miami, Florida,
 catalog
1976 "Professional Women Artists of
 Florida," Lowe Art Museum, Coral
 Gables, Florida, catalog
1976 "Sculptors of Florida," Metropolitan
 Museum and Art Center, Coral
 Gables, Florida
1977 "American Craft Council Southeast
 Regional Exhibition," Metropolitan
 Museum and Art Center, Coral
 Gables, Florida, catalog
1980 "Southern Exposure," Hanson Gallery,
 New Orleans, Louisiana, catalog

1981 "Beyond the Art of Papermaking,"
 Suzanne Gross Gallery, Philadelphia,
 Pennsylvania
1981 "Constructions and Assemblages,"
 Southeastern Center for
 Contemporary Art, Winston-Salem,
 North Carolina
1981 "One of a Kind Artists Books," Walker
 Art Center, Minneapolis, Minnesota
1981, "Group Exhibition," Gallery One,
82, Fort Worth, Texas
83
1982 "Gallery Exhibition," Albright-Knox Art
 Gallery, Buffalo, New York
1982 "Seven in Miami," Metropolitan
 Museum and Art Center, Coral
 Gables, Florida, catalog
1982 "The New Explosion: Paper Art," Fine
 Arts Museum of Long Island,
 Hempstead, New York, catalog
1982 "National Invitational," Ben Shahn
 Gallery, William Paterson College of
 New Jersey, Wayne, New Jersey,
 catalog
1982 "Directors' Choice," Aaron Berman
 Gallery, New York, New York
1982 "Women's Art: Miles Apart," Aaron
 Berman Gallery, New York, New York;
 East Campus Gallery, Valencia
 Community College, Orlando, Florida,
 catalog
1983- "International Artists Books," Traveling
85 Exhibition, Karl-Ernst-Osthaus
 Museum, Hagen, Germany, Federal
 Republic
1983 "Fifteen Southeastern Artists," Visual
 Arts Gallery, Florida State University,
 Tallahassee, Florida
1983 "Made with Paper," Nina Freudenheim
 Gallery, Buffalo, New York
1983 "The New Explosion: Paper Art,"
 C.D.S. Gallery, New York, New York;
 Byer Museum of the Arts, Evanston,
 Illinois, catalog
1983- "Word Imagery in the 20th Century,"
84 Fine Arts Museum of Long Island,
 Hempstead, New York, catalog
1984 "New Ideas in Paper," Mead Art
 Museum, Amherst, Massachusetts,
 catalog
1984 "Contemporary Paperworks," Hurlbutt
 Gallery, Greenwich Library,
 Greenwich, Connecticut
1984 "Broward Public Library Foundation
 Artists Exhibition," Main Library, Fort
 Lauderdale, Florida, catalog

Selected Public Collections
Corporate Communications and Marketing
 Company, Tampa, Florida
Cypress Savings Association, Plantation,
 Florida
Houston General Life Insurance, Fort Worth,
 Texas
Miami-Dade Public Library, Miami, Florida
Museum of Art, Fort Lauderdale, Florida
Swiss Air Corporation, Zürich, Switzerland

Selected Private Collections
George S. Bolge, Fort Lauderdale, Florida
Jean Brown Archive, Tyringham,
 Massachusetts
Dr. Armand Christ-Janer, Columbia, Missouri
Robert Wood Garrett, Fort Lauderdale,
 Florida
Marvin and Ruth Sackner Archive, Miami
 Beach, Florida

Selected Awards
1968 Louis Comfort Tiffany Foundation
 Grant
1978 Hortt Memorial Award, "Annual Hortt
 Memorial Exhibition," Museum of Art,
 Fort Lauderdale, Florida, catalog
1984 Broward Cultural Arts Award for
 Artistic Achievement, Broward Arts
 Council, Fort Lauderdale, Florida

Preferred Sculpture Media
Paper and Varied Media

Additional Art Field
Artists Books

Related Profession
Art Instructor

Selected Bibliography
Bass, Ruth. "New York Reviews: Women's
 Art Miles Apart, Aaron Berman." *Art News*
 vol. 81 no. 6 (Summer 1982) p. 194.
Glueck, Grace. "Art, In the Arts: Critics'
 Choices." *The New York Times* (Sunday,
 March 6, 1983) section 2A, p. 3.
Kohen, Helen L. "Forecast: Bright Days for
 Art in South Florida." *Art News* vol. 79 no.
 10 (December 1980) pp. 96-99, illus.
Kohen, Helen L. "The South: Art Looks for a
 Place in the Sun." *Art News* vol. 82 no. 2
 (February 1983) pp. 62-65.
Langer, Sandra L. "Reviews of the
 Exhibitions: Florida, Claire Jean Satin at
 Gallery 24." *Art Voices/South* vol. 1 no. 5
 (September-October 1978) pp. 56-57, illus.

Gallery Affiliations
Sadler Galleries
421 South Andrews Avenue
Fort Lauderdale, Florida 33301

William Campbell Contemporary Art
4935 Byers Street
Fort Worth, Texas 76107

Mailing Address
600 NE Second Street
Dania, Florida 33004

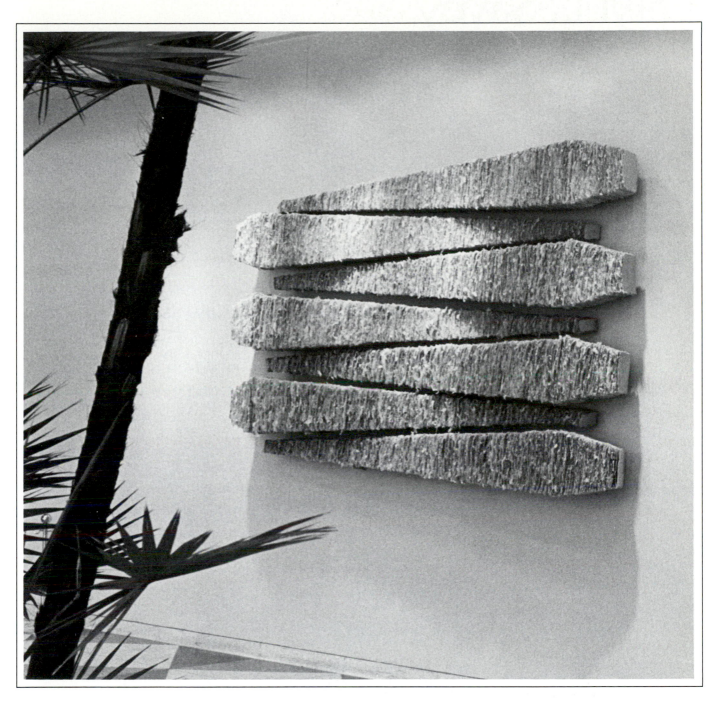

In Situ Interlock. 1983. Handmade paper, dye, mylar and wood, 7'h x 10'w x 15"d. Installation view 1984. "Broward Public Library Foundation Artists Exhibition," Main Library, Fort Lauderdale, Florida, catalog.

Artist's Statement

"I am a sculptor working comfortably with a wide spectrum of materials and ideas. Although I am often seduced by the appeal of materials, my interest is toward synthesizing the material form with the concept into a total amalgam. The material not only speaks of its own nature, but more importantly transcends itself into concept.

"The recent diversity of my work assumes three major directions: unique bookworks, a body of works based upon the KANJI or ancient Japanese music notations, and the creation of architectural scale structures. These large constructions deal with laws of nature, images evoked by common memory and ideas of visual perception. The formal presentation of these visualized experiences is the constant flux and infinite variety of form/line/surface/value within a geometricized structure. This fuses the sensual and the intellect; the emotional/ animate and the objective/analytical into energized affecting objects."

511

Chryl L. Savoy

née Chyrl Lenore
Born May 23, 1944 New Orleans, Louisiana

Education and Training

1966 B.A., Fine Arts, Louisiana State University and Agricultural and Mechanical College, Baton Rouge, Louisiana; study in sculpture with Armin Scheler

1966- Accademia di Belle Arti, Florence, 67 Italy; study in clay sculpture with Professor Berti and Professor Gallo

1970 M.F.A., Sculpture, Wayne State University, Detroit, Michigan; study with George Zambrzycki

1972 Diploma, Welding, State of Louisiana T.H. Harris Vocational-Technical School, Opelousas, Louisiana; study with Herman Savoie

Selected Individual Exhibitions

1972 New Orleans Museum of Art, New Orleans, Louisiana, catalog

1982 Fletcher Gallery, School of Art and Architecture, University of Southwestern Louisiana, Lafayette, Louisiana

1983 Maison du Quebec, Lafayette, Louisiana

1985 Lafayette City Club, Lafayette, Louisiana

Selected Group Exhibitions

1970 "Group Exhibition," Detroit Artists Market, Detroit, Michigan

1971 "Fifty-Eighth Exhibition for Michigan Artists," Detroit Institute of Arts, Detroit, Michigan, catalog

1971 "Twenty-Seventh Annual State Art Exhibition for Professional Artists," Louisiana Arts Commission Galleries, Old State Capitol, Baton Rouge, Louisiana

1971 "Fourteenth Annual Delta Art Exhibition," Arkansas Arts Center, Little Rock, Arkansas

1973 "Seventh Annual National Drawing and Small Sculpture Show," Del Mar College, Corpus Christi, Texas

1973 "Thirteenth Annual Piedmont Painting and Sculpture Exhibition," Mint Museum of Art, Charlotte, North Carolina

1974 "Louisiana State University in Shreveport, Faculty Exhibition," Library Art Gallery, Centenary College of Louisiana, Shreveport, Louisiana

1974 "Group Sculpture Exhibition," Library Art Gallery, Centenary College of Louisiana, Shreveport, Louisiana

1978 "Nine Sculptors/An Invitational," Brown Scurlock Gallery, Beaumont, Texas

1979 "Ten South Louisiana Artists/An Invitational," Jay R. Broussard Memorial Gallery, Old State Capitol, Baton Rouge, Louisiana

1980 "Modern Art for Children of All Ages," Art Center for Southwestern Louisiana, Lafayette, Louisiana

1981, "Faculty Exhibition," Union Art Gallery, 82, University of Southwestern Louisiana, 84 Lafayette, Louisiana

Selected Public Collections

Catholic Mission, Willowvale, Transkei, South Africa
Mamou High School, Mamou, Louisiana
Our Lady of the Bayous Convent, Abbeville, Louisiana
Our Lady Star of the Sea, Cameron, Louisiana

Selected Private Collections

Mr. and Mrs. Robert E. Curtis, Grosse Pointe Park, Michigan
Lillian Hall, Shreveport, Louisiana
Dr. and Mrs. Ronald Padgett, Opelousas, Louisiana
Sam Recile, New Orleans, Louisiana
Paul Tate, Sr., Mamou, Louisiana

Selected Awards

1971 Individual Exhibition Award, New Orleans Museum of Art, New Orleans, Louisiana, "Biennial Exhibition of Artists of the Southeast and Texas," Isaac Delgado Museum of Art, New Orleans, Louisiana, catalog

1973 Honorable Mention, "Thirteenth Annual Piedmont Painting and Sculpture Exhibition," Mint Museum of Art, Charlotte, North Carolina, catalog

1973 Mr. and Mrs. Samuel Wiener Sculpture Award, "Fifty-First Regional Exhibition," Barnwell Garden and Art Center, Shreveport, Louisiana

Preferred Sculpture Media

Varied Media and Wood

Additional Art Fields

Drawing and Painting

Teaching Position

Instructor in Fine Arts, University of Southwestern Louisiana, Lafayette, Louisiana

Mailing Address

Post Office Box 573
Youngsville, Louisiana 70592

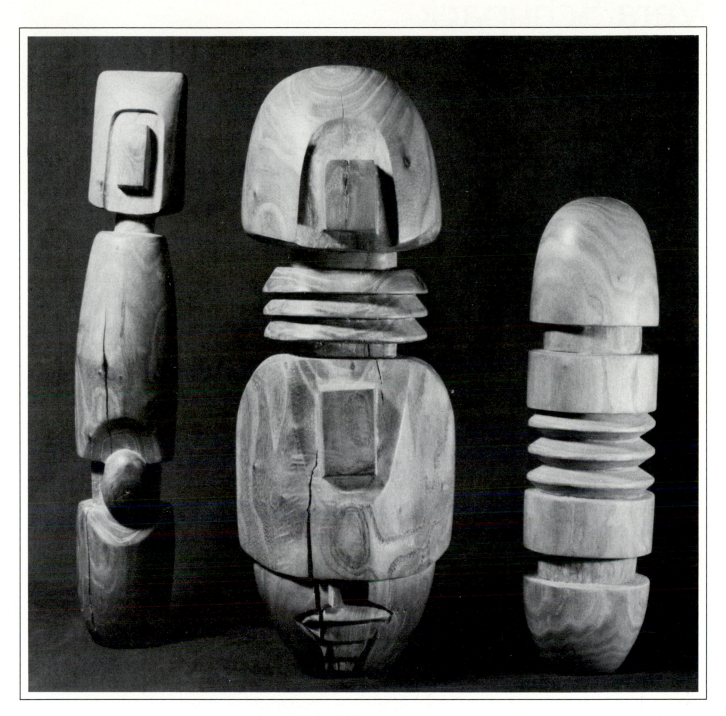

Goddess Series. 1980-1982. Catalpa and bois d'arc wood. Left: 18½"h x 3"w x 3"d. Center: 18½"h x 7"w x 5½"d. Right: 14"h x 4"w x 3½"d.

Artist's Statement

"With today's emphasis on technology, new media and environment, my response is simple, assertive and, hopefully, positive. I still see the need and love for organic material and yet I have not wanted to force it into a lopsided existence. Rather, the realm of wonder, spontaneity and desire for the extraordinary have pushed me joyously to rediscover the potential of wood and its form, function and meaning. I have carved pieces which exist as separate entities. I have carved pieces and assembled them together, eliminating bases, relating the sculpture to the environment and human scale. I have found lumber and objects and cut, sawed and constructed forms that hold past and present, tradition and experimentation, in a renewal of the depth and value of being."

Cheryl L. Savoy

Vera Schupack

née Vera Eisenberg
(Husband Morris Schupack)
Born February 4, 1923 New York, New York

Education and Training
1949 B.S., Arts and Crafts, New York
 University, New York, New York
1962- Stamford Museum and Nature Center,
65 Stamford, Connecticut; study in
 sculpture with Wallace Rosenbauer
1967 Study in welded sculpture techniques
 with Jean Woodham, Westport,
 Connecticut
1969 Study in cast sculpture techniques
 with Barbara Lekberg, Stamford,
 Connecticut

Selected Individual Exhibitions
1975 Museum of Art, Science and Industry,
 Bridgeport, Connecticut
1976, Silvermine Guild Center For The Arts,
83 New Canaan, Connecticut
1978 Pindar Gallery, New York, New York
81,
83
1985 Arts Council of Norwalk, Norwalk,
 Connecticut

Selected Group Exhibitions
1980 "Recent Sculpture," Westport-Weston
 Arts Council, Westport, Connecticut
1983 "Three-Dimensional Wall Spectaculars,"
 Branchville Soho Gallery, Georgetown,
 Connecticut
1983 "Trustees' Choices," Aldrich Museum
 of Contemporary Art, Ridgefield,
 Connecticut
1983 "Sculptors Guild Member Artists
 Exhibition," Lever House, New York,
 New York
1985 "Four Winners from the 1984
 Connecticut Painters and Sculptors
 Competition: Deborah Frizzell, Christy
 Gallagher, James Gaulin and Vera
 Schupack," Stamford Museum and
 Nature Center, Stamford, Connecticut

Selected Public Collection
General Electric Corporate Headquarters,
 Fairfield, Connecticut

Selected Private Collections
Takao Ariga, Tokyo, Japan
Ruth Finch, New Canaan, Connecticut
Katsuhisa Mizuma, Tokyo, Japan
Eugene and Jacqueline Moss, Stamford,
 Connecticut
Professor and Mrs. Charles Wolfson, Ann
 Arbor, Michigan

Selected Award
1975 Ruth Finch Award, "Twenty-Fifth
 Annual New England Exhibition,"
 Silvermine Guild of Artists, New
 Canaan, Connecticut, catalog

Preferred Sculpture Media
Metal (cast) and Varied Media

Selected Bibliography
Moss, Jacqueline. "Vera Schupack." *Arts
 Magazine* vol. 55 no. 7 (March 1981) p. 12,
 illus.

Mailing Address
37 Splitrock Road
South Norwalk, Connecticut 06854

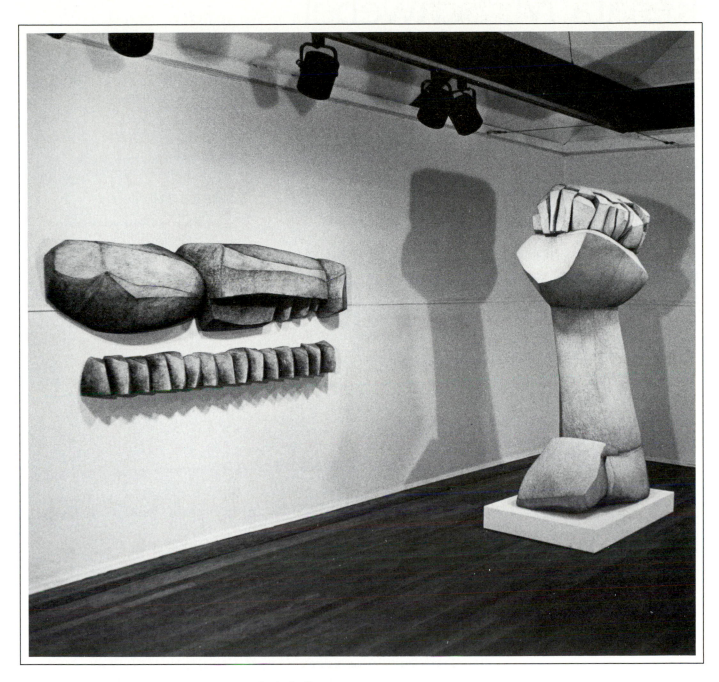

Meditation. 1981. Left: Canvas covered urethane foam, 30"h x 72"w x 8"d. *Eulogy.* 1981. Right: Canvas covered urethane foam, 73"h x 36"w x 24"d. Installation view 1983. Silvermine Guild Center For The Arts, New Canaan, Connecticut.

Artist's Statement

"I strive to make my sculpture assume a life of its own. It is important that the work express a sense of movement and energy and mood—without literal reference to known shapes. I want the beholder to become a participant in the process of discovering the sensual link between his/her understanding and the piece."

Vera Schupack

Renata M. Schwebel

née Renata Manasse
(Husband Jack P. Schwebel)
Born March 6, 1930 Zwickau, Germany,
Democratic Republic

Education and Training
1953 B.A., Sculpture, Antioch College, Yellow Springs, Ohio; study with Amos E. Mazzolini
1961 M.F.A., Sculpture, Columbia University, New York, New York; study with Oronzio Malderelli
1961- Studio of Helen Beling, New Rochelle,
65 New York and White Plains, New York; study in sculpture
1968 Art Students League, New York, New York; study in welding with John Hovannes
1972 Hobart School of Welding Technology, Troy, Ohio

Selected Individual Exhibitions
1975 Greenwich Art Barn, Greenwich, Connecticut
1979 Sculpture Center, New York, New York
1980 New Rochelle Library Gallery, New Rochelle, New York
1981 Pelham Art Center, Pelham, New York

Selected Group Exhibitions
1964, "Connecticut Academy of Fine Arts
75 Juried Exhibition," Wadsworth Atheneum, Hartford, Connecticut
1970- "Audubon Artists Annual Exhibition,"
85 National Arts Club, New York, New York, catalog
1972 "Sculpture Competition," Hudson River Museum, Yonkers, New York
1972, "Annual New England Exhibition,"
76, Silvermine Guild Center of Artists,
80 New Canaan, Connecticut, catalog
1973- "National Association of Women
85 Artists Annual Exhibition," Jacob K. Javits Federal Building, New York, New York, catalog

1974 "Columbus Park Sculpture Competition," Hudson River Museum, Yonkers, New York
1974- "Sculptors Guild Annual Exhibition,"
85 Lever House, New York, New York, catalog
1974 "Connecticut Academy of Fine Arts Exhibition," New Britain Museum of American Art, New Britain, Connecticut
1976 "Bicentennial Exhibition of Art," County Center, White Plains, New York
1976 "Sculpture Park Competition," Bridge Gallery, White Plains, New York
1977 "Christmas in New York, Artists Equity Exhibition," Union Carbide Gallery, New York, New York
1978 "The Many Talents of the Sculptors Guild," General Electric Gallery, Fairfield, Connecticut
1980 "Recent Sculpture," Westport-Weston Arts Council, Westport, Connecticut
1981 "Member Artists Exhibition," American Academy and Institute of Arts and Letters, New York, New York
1981 "Sculpture in the Garden 1981," Sculptors Guild at the Enid A. Haupt Conservatory, New York Botanical Garden, Bronx, New York, catalog
1981 "National Association of Women Artists: U.S.A.," Traveling Exhibition (Egypt and Israel), American Cultural Center, New York, New York, catalog
1984- "Sculptors Guild Member Artists
85 Outdoor Exhibition, Schulman Sculpture in the Park," White Plains Office Park, White Plains, New York
1984 "Music Mountain Sculpture Exhibit," Music Mountain, Falls Village, Connecticut, catalog

Selected Public Collections
Antioch College, Yellow Springs, Ohio
Clark-Schwebel Fiber Glass Corporation, Anderson, South Carolina
Colt Industries, New York, New York
Columbia University, New York, New York
Comcraft Industries, Nairobi, Kenya
Heinrich Grüber Haus, Berlin, Germany, Federal Republic
Southwest Bell Telephone Company, Houston, Texas

Selected Private Collections
Max Frankel, New York, New York
David and Barbara Hirschhorn, Baltimore, Maryland
William Marsteller, Palm Beach, Florida and New York, New York
Peter Sichel, New York, New York
Sir Ernest Vasey, Nairobi, Kenya

Selected Awards
1980 Chaim Gross Foundation Award, "Audubon Artists Annual Exhibition," National Arts Club, New York, New York, catalog

1981 Medal of Honor, "National Association of Women Artists Annual Exhibition," Jacob K. Javits Federal Building, New York, New York, catalog
1982 Medal of Honor, "Audubon Artists Annual Exhibition," National Arts Club, New York, New York, catalog

Preferred Sculpture Media
Clay, Metal (welded) and Wood

Selected Bibliography
Benton, Suzanne. *The Art of Welded Sculpture*. New York: Van Nostrand Reinhold, 1975.
Padovano, Anthony. *The Process of Sculpture*. Garden City, New York: Doubleday, 1981.
"Sculpture to Grace A Garden Is Shown." *The New York Times* (Thursday, May 7, 1981) p. C3.

Gallery Affiliation
Sculpture Center
167 East 69 Street
New York, New York 10021

Mailing Address
36 Silver Birch Drive
New Rochelle, New York 10804

Artist's Statement

"Although my early training was along academic figurative lines, working primarily in clay, it was during my college days that I had the opportunity to work at the Mazzolini Art Foundry and so discover the joy of metal. Years later, I returned to this material, but instead of casting, it was direct; instead of bronze, it was stainless steel and aluminum; instead of figurative, abstract.

"Yet I find it difficult, even impossible, to restrict myself to one medium or one way of expression for any great length of time. After weighty materials, I turn to light ones; after somberness, to humor. This is not a very fashionable thing to do, as others find it convenient to pigeonhole artists. But, alas, I work in steel and aluminum, clay, acrylic sheet and wood. I seem to work in cycles, always returning to metal, to basic shapes and juxtaposition. But in between, faces and figures do creep in, and they are always welcome."

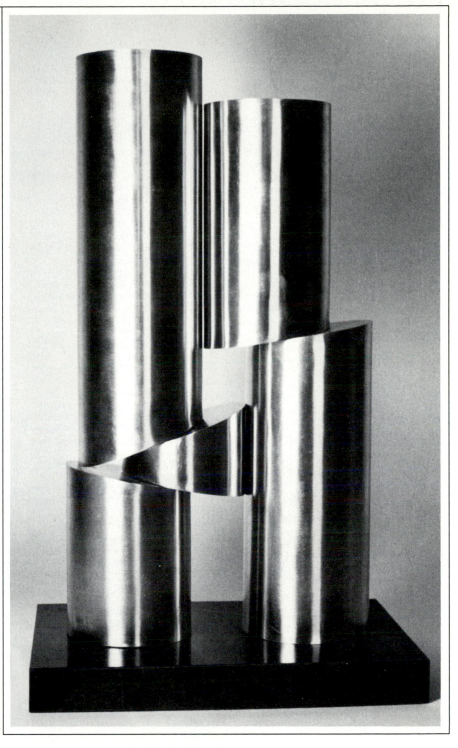

Segmented Columns. 1975. Stainless steel, 21"h x 11"w x 4½"d.

Jill Sebastian

née Jill Charlotte
(Husband Ronald Joseph Ritticks)
Born March 24, 1950 Libertyville, Illinois

Education and Training
1968- University of Wisconsin-Madison,
70 Madison, Wisconsin; study in
sculpture with Jerry Johnson
1971- Northern Illinois University, DeKalb,
72 Illinois; study in sculpture with Bruce
White
1973 B.F.A., Sculpture and Drawing,
University of Wisconsin-Milwaukee,
Milwaukee, Wisconsin; study in
sculpture with Frank G. Lutz
1979 M.F.A., Sculpture and Drawing,
University of Wisconsin-Milwaukee,
Milwaukee, Wisconsin; study in
sculpture with John Balsley and Frank
G. Lutz
1979- University of Wisconsin-Milwaukee,
81 Milwaukee, Wisconsin; study in
contemporary art history and film

Selected Individual Exhibitions
1979 University of Wisconsin-Green Bay,
Green Bay, Wisconsin and University
of Wisconsin-Milwaukee, Milwaukee,
Wisconsin
1980 Woodland Pattern Gallery, Milwaukee,
Wisconsin
1980 University of Wisconsin-Waukesha,
Waukesha, Wisconsin
1981 Perihelion Galleries, Milwaukee,
Wisconsin
1983 Kit Basquin Gallery, Milwaukee,
Wisconsin
1983 State Street Gallery, Madison Art
Center, Madison, Wisconsin
1983 Purdue University, West Lafayette,
Indiana
1984 Charles A. Wustum Museum of Fine
Arts, Racine, Wisconsin
1984 Factory Place, Los Angeles, California
1985 Bertha Urdang Gallery, New York,
New York

Selected Group Exhibitions
1978 "Shreveport Art Guild National,"
Meadows Museum of Art of Centenary
College, Shreveport, Louisiana
1978, "Wisconsin Biennial," Madison Art
80 Center, Madison, Wisconsin, catalog
1978 "Group Exhibition," Bertha Urdang
Gallery, New York, New York
1979, "Rockford and Vicinity Show," Burpee
81 Art Museum/Rockford Art Association,
Rockford, Illinois
1979 "New Talent," Bertha Urdang Gallery,
New York, New York
1980 "Wisconsin Painters and Sculptors,"
University of Wisconsin-Milwaukee,
Milwaukee, Wisconsin
1980 "Wisconsin Sculpture," Charles A.
Wustum Museum of Fine Arts, Racine,
Wisconsin, catalog
1980 "Four Sculptors: Sebastian, Funk,
Donhauser, Tasch," St. Norbert
College, De Pere, Wisconsin
1980 "Sixth Annual Exhibition," Minneapolis
Institute of Arts, Minneapolis,
Minnesota
1981 "Wisconsin Directions 3: The Third
Dimension," Milwaukee Art Museum,
Milwaukee, Wisconsin, catalog
1983 "New Work," Cudahy Gallery of
Wisconsin Art, Milwaukee Art
Museum, Milwaukee, Wisconsin
1983 "Art Street: Sculpture Exhibition,"
Neville Public Museum of Brown
County, Green Bay, Wisconsin,
catalog
1983 "Object: Book," Cantor-Lemburg
Gallery, Birmingham, Michigan
1984 "Wisconsin Directions IV," Milwaukee
Art Museum, Milwaukee, Wisconsin,
catalog
1984 "6 Sculptors: Billingsley, Block,
Emmons, Sebastian, Toman and
White," Milwaukee Institute of Art and
Design, Milwaukee, Wisconsin, catalog

Selected Public Collections
First Bank of Milwaukee, Milwaukee,
Wisconsin
Synthesis, Incorporated, Chicago, Illinois

Selected Private Collections
Kit Basquin, Milwaukee, Wisconsin
Jane Brite, Milwaukee, Wisconsin
Robert and Edith Harrold, Milwaukee,
Wisconsin
Jane Langley, Los Angeles, California
Bertha Urdang, New York, New York

Selected Awards
1981 Individual Artist's Fellowship,
Wisconsin Arts Board
1982 Project Grant, Wisconsin Arts Board
1982 County Arts Grant, Milwaukee Artists
Foundation, Milwaukee, Wisconsin

Preferred Sculpture Media
Varied Media and Wood

Additional Art Fields
Drawing and Painting

Teaching Position
Assistant Professor and Chair, Department of
Sculpture, University of Denver, Denver,
Colorado

Selected Bibliography
Buth-Furness, Christine. "Reviews Midwest
Wisconsin: Jill Sebastian, Kit Basquin
Gallery, Milwaukee, Wisconsin; Perihelion
Galleries, Milwaukee, Wisconsin." *New Art
Examiner* vol. 10 no. 7 (April 1983) p. 21,
illus.
Mominee, John. "Woodworkers Render
Primitive Power or Modern Humor."
Wisconsin Academy Review vol. 31 no. 2
(March 1985) p. 26, illus.

Gallery Affiliations
Bertha Urdang Gallery
23 East 74 Street
New York, New York 10021

Cantor-Lemberg Gallery
538 North Woodward Avenue
Birmingham, Michigan 48011

Mailing Address
1856 South Hoyt Street
Lakewood, Colorado 80226

Artist's Statement

"The intent of my work are multiple statements articulating the oral, the written, the spatial and the visual. I combine these phenomena with perspective, geometry and narrative drawings taken from events in my life in constructions, installations and movable spiral forms that are variations on the book.

"Pencil and ink drawings on vellum are superimposed on wooden bars, then cut and sliced, much like editing a film, and adhered to the surface of the sculpture in a way which transforms the original text. If unread, books have a distinct wholeness; written text has its own illusion and texture. The viewer creates a mental picture suggested by the presence of paper and markings. Segments of the written word and drawing—the flat plane and the spatial—become sculptural form."

Neg. 1982. Wood, ink and vellum, 18"h x 10"w x 10"d.

Diana Shaffer

(Husband Ronald G. Watson)
Born February 10, 1951 Corning, New York

Education and Training
1973 B.A., Fine Arts, Mount Holyoke
College, South Hadley, Massachusetts
1975 M.F.A., Sculpture, Cranbrook
Academy of Art, Bloomfield Hills,
Michigan; study with Michael Hall

Selected Individual Exhibitions
1976 Aquinas College, Grand Rapids,
Michigan
1977 One Illinois Center, Chicago, Illinois
1979 Grand Rapids Art Museum, Grand
Rapids, Michigan
1981 Race Street Gallery, Grand Rapids,
Michigan
1983 Texas Christian University, Fort Worth,
Texas

Selected Group Exhibitions
1973 "Michigan Annual," Flint Institute of
Arts, Flint, Michigan
1975 "Bill King and Friends," Cranbrook
Academy of Art Museum, Bloomfield
Hills, Michigan
1977 "Sculpture on the Plaza," Calder Plaza,
Grand Rapids, Michigan
1977 "An Evening Without Feathers," Front
Street Gallery, Grand Rapids,
Michigan

1979 "Curvilinear Variations on a Theme,"
Contemporary Art Workshop, Chicago,
Illinois
1981 "Seventh Michigan Biennial," Kresge
Art Center Gallery, Michigan State
University, East Lansing, Michigan,
catalog
1981 "Six from Mount Holyoke," Mount
Holyoke College Art Museum, South
Hadley, Massachusetts
1981 "Celebration on the Grand," DeVos
Hall, Performing Arts Center, Grand
Rapids, Michigan
1982 "Six Artists from Michigan," San Jose
Institute of Contemporary Art, San
Jose, California
1982 "Numbers and Geometrics," Boston
Visual Artists Union, Boston,
Massachusetts
1982 "Cranbrook USA," Cranbrook Academy
of Art Museum, Bloomfield Hills,
Michigan, catalog
1983 "Showdown," Alternative Museum,
New York, New York; Diverse Works,
Houston, Texas, catalog
1984 "Ronald Watson and Diana Shaffer,"
Fort Worth Gallery, Fort Worth, Texas
1985 "Fifth Texas Sculpture Symposium,"
Sited throughout Central Business
District, Dallas, Texas and Connemara
Conservancy, Allen, Texas (Sponsored
by Texas Sculpture Symposium,
Dallas, Texas), catalog

Selected Public Collection
Mutual Home Company, Grand Rapids,
Michigan

Selected Awards
1980 Summer Fellowship for College
Teachers, National Endowment for the
Humanities
1981 Creative Artist Grant, Michigan
Council for the Arts
1981 Artist Apprentice Grant, Michigan
Council for the Arts

Preferred Sculpture Media
Varied Media

Related Professions
Visiting Artist and Writer

Additional Art Field
Drawing

Teaching Position
Adjunct Assistant Professor of Sculpture,
Southern Methodist University, Dallas,
Texas

Selected Bibliography
Riedy, James L. *Chicago Sculpture*. Urbana,
Illinois: University of Illinois Press, 1981.
Shaffer, Diana. "Three Environmental
Sculptures." *Leonardo* vol. 10 no. 3
(October 1977) pp. 223-224, illus.

Gallery Affiliation
Fort Worth Gallery
901 Boland Street
Fort Worth, Texas 76107

Mailing Address
SW Studio
1015 Arch Adams
Fort Worth, Texas 76107

520

Artist's Statement

"I conceive of the art of sculpture as the creation of a language-like system, originating in the comprehension of the specifically sculptural or three-dimensional qualities in works of art. A work of sculpture shapes pliable material and molds the plastic elements; it successfully arranges the basic components of line, form, texture, color and light into a cohesive and variegated pattern. It expresses a sensitivity to touch and vision, to sensations of weight and volume and to purely optical phenomena. A convincing work of sculpture presupposes an accurate analysis of the internal structure of volumes and an intuitive or learned appreciation of their expressive potential. As a sculptor, I struggle to understand the qualities contained in exemplary works and to achieve those in my own."

Diana Shaffer

Golden Column. 1981. Painted steel, 9'6"h x 6'w x 6'd. Photograph by Luther Smith.

Mary Shaffer

Born October 3, 1943 Walterboro, South Carolina

Education and Training
1965 B.F.A., Painting and Illustration, Rhode Island School of Design, Providence, Rhode Island

Selected Individual Exhibitions
1975 Warren Benedek Gallery, New York, New York
1975, O.K. Harris Works of Art, New York,
77, New York
79,
82,
85
1977 Fine Arts Gallery, Murray State University, Murray, Kentucky
1978 Woods-Gerry Gallery, Rhode Island School of Design, Providence, Rhode Island
1979 Fine Arts Gallery, University of Rhode Island, Kingston, Rhode Island
1980 Mandell Gallery, Los Angeles, California
1980 Douglas Heller Gallery, New York, New York
1981 Gallery SM, Frankfurt, Germany, Federal Republic
1981 Galerie von Finkelstein, Hannover, Germany, Federal Republic
1981 Museum Bellerive, Zürich, Switzerland, catalog
1985 Habatat Galleries, Lathrup Village, Michigan and Coral Gables, Florida

Selected Group Exhibitions
1978 "Painting and Sculpture Today 1978." Indianapolis Museum of Art, Indianapolis, Indiana, catalog
1978 "Glass America 1978," Lever House, New York, New York
1979- "New Glass: A Worldwide Survey,"
84 Corning Museum of Glass, Corning, New York; Toledo Museum of Art, Toledo, Ohio; Renwick Gallery of the National Museum of American Art, Smithsonian Institution, Washington, D.C.; Metropolitan Museum of Art, New York, New York; San Francisco Municipal Airport, San Francisco, California; Victoria and Albert Museum, London, Great Britain; Musée des Arts Décoratifs, Paris, France; Seibu Gallery, Tokyo, Japan, catalog

1979 "Sculptures et Volumes de Verre," Musée-Château d'Annecy, Annecy, France; Galerie des Tanneurs, Tours, France, catalog
1981 "Sensibilities," Thorpe Intermedia Gallery, Sparkill, New York
1981 "Mind, Memory and Matter," Traveling Exhibition, Honolulu Academy of Arts, Honolulu, Hawaii
1981 "Glass in the Modern World," National Museum of Modern Art, Kyoto, Japan; Tokyo National Museum of Modern Art, Tokyo, Japan, catalog
1981 "Glass Routes," DeCordova and Dana Museum and Park, Lincoln, Massachusetts, catalog
1982 "Symposium International du Verre en France Sars Poteries 1982," Musée de Verre et l'Atelier du Verre de Sars Poteries, Sar Poteries, France, catalog
1982 "4 Artists 4 Views," Jesse Besser Museum, Alpena, Michigan, catalog
1983 "Sculptural Glass," Tucson Museum of Art, Tucson, Arizona; Owens-Illinois World Headquarters Building, Toledo, Ohio, catalog
1984- "Americans in Glass 1984," Leigh
86 Yawkey Woodson Art Museum, Wausau, Wisconsin; Kunstmuseum, Düsseldorf, Germany, Federal Republic; Kestner-Museum, Hannover, Germany, Federal Republic; Kunstindustrimuseet, Copenhagen, Denmark; Kjarvalsstadir Gallery, Reykjavik, Iceland; City Art Gallery, Manchester, Great Britain,; Museum für Kunsthandwerk, Frankfurt, Germany, Federal Republic; Gemeentemuseum Arnhem, Arnhem, Netherlands; Museum Bellerive, Zürich, Switzerland; Hallands Länsmuseer, Varberg, Sweden, catalog

Selected Public Collections
Corning Museum of Glass, Corning, New York
Huntington Galleries, Huntington, West Virginia
The Lannan Foundation, West Palm Beach, Florida
Museum Bellerive, Zürich, Switzerland
Musée de Verre et l'Atelier du Verre de Sars Poteries, Sar Poteries, France
National Museum of Modern Art, Kyoto, Japan

Selected Private Collections
Charles Irwin, New York, New York
Ivan and Marilyn Karp, New York, New York
Edward and Jan Mauro, Jr., Providence, Rhode Island
Martin and Jean Mensch, New York, New York
Ben Mildwoff, New York, New York

Selected Awards
1974 Individual Artist's Fellowship, National Endowment for the Arts

1979 Faculty Research Grant, Wellesley College, Wellesley, Massachusetts
1981 Merit Award, "Glaspris '81," Kassel Culture Commission, Kassel, Germany, Federal Republic

Preferred Sculpture Media
Glass and Varied Media

Related Profession
Director, Union Gallery, University of Maryland at College Park, College Park, Maryland

Selected Bibliography
Ballerini, Julia. "Mary Shaffer's Glass." *Craft Horizons* vol. 34 no. 1 (February 1979) pp. 24-27, illus.
Diamonstein, Barbaralee. *Handmade in America: Conversations with Fourteen Craftmasters.* New York: Harry N. Abrams, 1983.
Hunter-Stiebel, Penelope. "Contemporary Art Glass: An Old Medium Gets a New Look." *Art News* vol. 80 no. 6 (Summer 1981) pp. 130-135, illus.
Kingsley, April. "Six Women at Work in the Landscape." *Arts Magazine* vol. 52 no. 8 (April 1978) pp. 108-112, illus.
Robbins, Christine. "Sculptural Glass." *American Craft* vol. 43 no. 4 (August-September 1983) pp. 5-10, illus.

Gallery Affiliation
O.K. Harris Works of Art
383 West Broadway
New York, New York 10003

Mailing Address
3051 Legation Street NW
Washington, D.C. 20015

Water-Way. 1983. Glass, tile and metal, 60"h x 166"w x 30"d. Collection Huntington Galleries, Huntington, West Virginia. Photograph by Remi Muratore.

Artist's Statement

"In my present work, glass and metal are interdependent, with the glass flowing from severely solid, protective metal forms. The only vulnerabilities of the metal are the secretive openings through which the glass shapes are poured. The inherent nature of the materials and gravity and heat help form the sculpture. Each work is made for different reasons. Some are based on the dichotomy between numerical or constructive logic; others are formed through instinctive play using emotions as the building blocks."

523

Barbara K. Shanklin

née Barbara Kathrine
(Husband Alfred Carrol Woodward)
Born December 17, 1947 Lawrence, Kansas

Education and Training
1966- Kansas City Art Institute and School
67 of Design, Kansas City, Missouri
1970 B.F.A., Sculpture and Goldsmithing,
 University of Kansas, Lawrence,
 Kansas; study in goldsmithing with
 Carlyle F. Smith and sculpture with
 Eldon C. Tefft
1970- Det Kongelige Danske Kunstakademi,
77 Copenhagen Denmark; study in
 sculpture with Mogens Bøggild, Svend
 Wiig Hansen, Erik Lynge and Åage
 Petersen

Selected Individual Exhibitions
1970, Main Public Library, Kansas City,
73 Missouri
1981 Bikuben Bank, Copenhagen, Denmark

Selected Group Exhibitions
1975 "Forårsudstilling, Spring Exhibition,"
 Udstillingbygning ved Charlottenborg,
 Copenhagen, Denmark, catalog
1975 "Skulptur, Sculpture," Clausens
 Kunsthandel, Copenhagen, Denmark
1975, "Kunstnernes Efterårsudstilling, Artists
76, Fall Exhibition," Den Frie
77 Udstillingbygning, Copenhagen,
 Denmark, catalog
1975 "Sammenslutningen Gevind, Artists
 Group Thread," Udstillingbygning ved
 Charlottenborg, Copenhagen,
 Denmark
1976 "Skulptur på Sletten, Sculpture on the
 Plains," Danmarks Tekniske Højskole,
 Lyngby, Denmark
1976 "Ung Skandanavisk Könst, Young
 Scandinavian Art," Renströmske
 Museet, Göteborg, Sweden, catalog
1977, "Skulptur i Odense Eventyrhaven,
79 Sculpture in Odense Adventure
 Garden," Eventyrhaven, Odense,
 Denmark, catalog
1977 "Ung Kunst, Young Art," Tårnby
 Rådhus, Tårnby, Denmark
1978 "Billedhuggerne, The Sculptors," Spirit
 den Helligånd Kirke, Copenhagen,
 Denmark, catalog
1978 "Skulptur i Kongens Have, Sculpture
 in the King's Garden," Rosenborg
 Slots Have, Copenhagen, Denmark
1979 "Udfoldelser, Unfoldings,"
 Kunstindustrimuseet," Copenhagen,
 Denmark; Nordjyllands Kunstmuseum,
 Ålborg, Denmark, catalog
1979 "Billedhuggerne, The Sculptors," Spirit
 den Helligånd Kirke, Copenhagen,
 Denmark; Randers Kunstmuseum,
 Randers, Denmark; Kloster Cismar,

Grömitz, Germany, Federal Republic,
 catalog
1979, "Pol '66, Poll '66," Den Frie
80, Udstillingbygning, Copenhagen,
81 Denmark, catalog
1980 "Barbara K. Shanklin, Sculptor;
 Jun-ichi Inove, Sculptor and Hans
 Berg, Painter," Jens Nielsens Museum,
 Holstebro, Denmark
1980 "Barbara K. Shanklin, Sculptor and
 Tytta Andersson, Painter," Den Frie
 Udstillingbygning, Copenhagen,
 Denmark
1980 "Genåbnings Udstilling, Re-Opening
 Exhibition," Udstillingbygning ved
 Charlottenborg, Copenhagen,
 Denmark
1981 "Déploiements/Unfoldings," L'Institut
 Franco-Américain, Rennés, France
1981 "Oktober Udstilling, October
 Exhibition," Tuborg, Copenhagen,
 Denmark, catalog
1981 "Kunstudstilling, Art Exhibition,"
 Kunstforening, Allerød, Denmark
1982- "Udfoldelser, Unfoldings: Lorilea
83 Jaderborg, Olivia Cole Collin and
 Barbara Shanklin," Traveling
 Exhibition, Sammenslutningen Af
 Danske Kunstforeninger, Copenhagen,
 Denmark, catalog
1982 "Skulpturstalden, Sculpture Stall,"
 Galleri Skt. Agnes, Roskilde, Denmark
1982 "Efterårsudstilling, Fall Exhibition,"
 Udstillingbygning ved Charlottenborg,
 Copenhagen, Denmark, catalog
1983 "Kunstner for Fred, Artists for Peace,"
 Udstillingbygning ved Charlottenborg,
 Copenhagen, Denmark, catalog
1983 "Den Flexible, The Flexible,"
 Udstillingbygning ved Charlottenborg,
 Copenhagen, Denmark, catalog
1984 "Barbara K. Shanklin, Sculptor and
 Hans Berg, Painter," Galleri Hia
 Riemer, Hellerup, Denmark
1984, "Dansk Billedhuggersamfunds
85 Stationar Udstilling, Danish Sculptors
 Society Stationary Exhibition,"
 Elmegård, Stœrkende, Denmark
1984 "Dansk Billedhuggersamfunds
 Udstilling i Kongens Have, Danish
 Sculptors Society Exhibition in the
 King's Garden," Rosenborg Slots
 Have, Copenhagen, Denmark, catalog
1984 "Decembur Udstilling, December
 Exhibition," Albertslund Rådhus,
 Albertslund, Denmark
1985 "17 Billedhugger, 17 Sculptors, "
 Galleri Skt. Agnes, Roskilde, Denmark
1985 "Norsk/Dansk Skulptur Udstilling,
 Norwegian/Danish Sculpture
 Exhibition," Stevanger Kunstforening,
 Stevanger, Norway
1985 "Dansk Billedhuggersamfunds' 80 Ars
 Jubeliums' Vandreudstilling, Danish
 Sculptors Society 80th Anniversary
 Exhibition," Traveling Outdoor
 Sculpture Exhibition, Ålborg,
 Skanderborg, Århus, Odense,
 Roskilde, Denmark, catalog

1985 "Barbara K. Shanklin, Sculptor and
 Yetty Sutjihati Mikkelsen, Painter,"
 Holbœks Kunstforening, Holbœk,
 Denmark

Selected Public Collections
A/S Superfos, Vedbœk, Denmark
British Broadcasting Company, London,
 Great Britain
City of Odense, Denmark
Forstadernes Bank, Glostrup, Denmark
Gallop Banden ved Charlottenlund,
 Charlottenlund, Denmark
Hvidovre Kommune Kunst Fond, Hvidore,
 Denmark
Kastrupgaardsamlingen, Kastrup, Denmark
Køge Central Syghus, Køge, Denmark
Krogstenshave Plejehjem, Hvidore, Denmark
Ny Carlsberg Fond, Copenhagen, Denmark
Odense Hovedbibliotek, Odense, Denmark
Pilegård Skole, Tårnby, Denmark
Skolen på Lollandsvej, Fredriksberg,
 Denmark
Skt. Clemmens Skole, Odense, Denmark
Solgavn Plejehjem, Viborg, Denmark
Svendebjergård Plejehjem, Hvidovre,
 Denmark

Selected Private Collections
Jan and Olivia Collin, Luxembourg,
 Luxembourg
Robert and Lorilea Jaderborg Hoffsteder,
 Copenhagen, Denmark
Henrik and Gerda Koop, Albertslund,
 Denmark
Erik and Inger Vejstrup, Copenhagen,
 Denmark
Lau Thørbjørn-Petersen, Copenhagen,
 Denmark

Selected Awards
1971 Heinrik Kauffmann Scholarship Award,
 American-Scandinavian Foundation
1976 Marie Illum Scholarship Award, Danish
 League of Women Voters
1983 Scholarship Award, Glass Dealers
 Foundation, Copenhagen, Denmark

Preferred Sculpture Media
Metal (cast) and Stone

Additional Art Field
Goldsmithing

Related Profession
Board Member, Dansk Billedhuggersamfund,
 Danish Sculptors Society, Copenhagen,
 Denmark

524

Selected Bibliography
Dansk Kunst. Copenhagen:
Kunstbogklubben, 1984. Text in Danish.
3 Year Art Book. Copenhagen: Grœs, 1983.
Text in English and Danish.

Gallery Affiliations
Galleri Hia Riemer
Strandvejen 114-2900
Hellerup, Denmark

Galleri Skt. Agnes
Skomagergade 8
4000 Roskilde, Denmark

Mailing Address
Haraldsgade 32 Stuen
2200 Copenhagen N, Denmark

Artist's Statement
"Since the early 1970s I have worked almost
exclusively in directly carved stone with a
preference for marble. Although I seldom
make models as a basis for sculpture, I do
use a form of calligraphic drawing and
observance of natural shapes.

"The contrasts of supple movement and
tensile strength, for example, in unfurling
seedlings, leaves and flowers, shells and
bones are a continuing challenge and source
of direction. Most of the shells I observe are
the uninhabited record of growth and life in
a fluid media. Some of the most inspiring are
fragments which are broken or worn so that
the inner volume of the form is revealed. My
use of abstract forms to express positive
and negative spatial relationships are
especially derived from these studies.
Through sight and touch, the tangible
medium of stone is a bridge to return and
recreate images within the observer's own
idea context."

Barbara K. Shanklin

By the Sea. 1978-1979. Marble, 61"h x 69"w x
46"d. Collection A/S Superfos, Vedbœk, Denmark.

Sandra L. Shannonhouse

née Sandra Lynne Riddell
(Husband Robert C. Arneson)
Born May 19, 1947 Petaluma, California

Education and Training
1959 B.S., Design, University of California, Davis, Davis, California
1969- Accademia Italiana de Costume e di
70 Moda, Rome, Italy
1973 M.F.A., Design for Theater, University of California, Davis, Davis, California

Selected Individual Exhibitions
1971, Candy Store Gallery, Folsom,
74, California
75,
76
1975, Quay Gallery, San Francisco,
78, California
80
1979 Memphis Academy of Arts, Memphis, Tennessee
1980 Pence Gallery, Davis, California
1982 Stephen Wirtz Gallery, San Francisco, California
1984 Stephen Wirtz Gallery, San Francisco, California, catalog

Selected Group Exhibitions
1972 "A Decade of Ceramic Art 1962-1972: From the Collection of Professor and Mrs. R. Joseph Monsen," San Francisco Museumn of Art, San Francisco, California, catalog
1973 "Statements," Oakland Museum, Oakland, California, catalog
1975 "Clay U.S.A.," Fendrick Gallery, Washington, D.C., catalog
1975 "National Ceramic Sculpture Invitational," Rebecca Cooper Gallery, Washington, D.C.
1976 "Thirty-Second Annual Ceramics Exhibition," Lang Art Gallery, Scripps College, Claremont, California
1977 "California Clay II," Braunstein/Quay Gallery, New York, New York
1977 "Off the Beaten Path," Brainerd Art Gallery, Potsdam, New York
1977 "An Exhibition of Bay Area Ceramics," Fine Arts Museum of San Francisco, San Francisco, California
1978, "Robert Arneson and Sandra
80 Shannonhouse," Candy Store Gallery, Folsom, California

1979 "Clay Attitudes," Queens Museum, Flushing, New York, catalog
1979 "Large Scale Ceramic Sculpture," Richard L. Nelson Gallery, University of California, Davis, Davis, California, catalog
1979 "Northern California Clay Routes: Sculpture Now," San Francisco Museum of Modern Art, San Francisco, California, catalog
1980- "American Porcelain: New Expressions
85 in an Ancient Art," Traveling Exhibition, Renwick Gallery of the National Museum of American Art, Smithsonian Institution, Washington, D.C., catalog
1980 "8 for the 80s: California Clay," Quay Gallery, San Francisco, California, catalog
1981 "California Clay," LRC Gallery, College of the Siskiyous, Weed, California, catalog
1981 "Centering on Contemporary Clay: American Ceramics from the Joan Mannheimer Collection," University of Iowa Museum of Art, Iowa City, Iowa, catalog
1981 "Welcome to the Candy Store," Crocker Art Museum, Sacramento, California, catalog
1982 "Continuum," Michael Himovitz Gallery, Carmichael, California
1982 "Pacific Currents/Ceramics 1982," San Jose Museum of Art, San Jose, California, catalog
1983 "The Plaza Salutes," The Plaza, Kansas City, Missouri
1983 "Dealers' Choice: San Francisco/Los Angeles," Area Galleries, San Francisco, California and Los Angeles, California (Sponsored by Eaton/Shoen Gallery, San Francisco, California and Kirk de Gooyer Gallery, Los Angeles, California), catalog
1983 "Northern California: Focus on the Figure," Brentwood Gallery, St. Louis, Missouri
1983- "1 + 1 = 2," Traveling Exhibition,
85 Bernice Steinbaum Gallery, New York, New York, catalog
1984- "Works in Bronze, A Modern Survey,"
87 Traveling Exhibition, University Art Gallery, Sonoma State University, Rohnert Park, California, catalog

Selected Public Collections
Prudential Insurance Company of America, Newark, New Jersey
Utah Museum of Fine Arts, Salt Lake City, Utah

Selected Private Collections
Dr. and Mrs. S. S. Epstein, Chicago, Illinois
Mr. and Mrs. Eric Lidow, Los Angeles, California
Joan Mannheimer Collection, Des Moines, Iowa
Professor and Mrs. Joseph R. Monsen Collection, Seattle, Washington

Mr. and Mrs. Richard Swig, San Francisco, California

Selected Award
1985 Artist in Residence, Johnson Atelier Technical Institute of Sculpture, Princeton, New Jersey

Preferred Sculpture Media
Clay and Metal (cast)

Related Profession
Visiting Artist

Selected Bibliography
Axel, Jan and Karen McCready. *Porcelain: Traditions and New Visions*. New York: Watson-Guptill, 1981.
Ballatore, Sandy. "The California Clay Rush." *Art in America* vol. 64 no. 4 (July-August 1976) pp. 84-88.
Cebulski, Frank. "Exhibitions: Sculpture and Dance." *Artweek* vol. 13 no. 25 (July 31, 1982) p. 5, illus.
McCloud, Mac. "Reviews of Exhibitions: 'Dealers' Choice' at Kirk de Gooyer Gallery, Los Angeles." *Images & Issues* vol. 4 no. 2 (September-October 1983) pp. 56-57, illus.

Gallery Affiliation
Stephen Wirtz Gallery
345 Sutter Street
San Francisco, California 94108

Mailing Address
110 East E Street
Benicia, California 94510

Artist's Statement

"In earlier porcelain and mixed media constructions, I explored the essential elements of the human body and their relationships to one another. In another series the figures expressed the skeletal, decorticated form joined with specific kinds of shoes, hats and accessories to convey the sense of a unique 'person.' This series of life-size bronze sculptures is an extension of many of the ideas begun with the anatomical series. The skeletal shapes are no longer suspended but stand firmly on the ground. More visual clues have evolved through gesture to express the seemingly abstracted individual's personality, function and purpose. At the same time all but the most crucial and essential information has been eliminated to describe the essence of various states of energy and ecstasy—a visual integration of the internal and external."

Sandra R. Shannonhouse

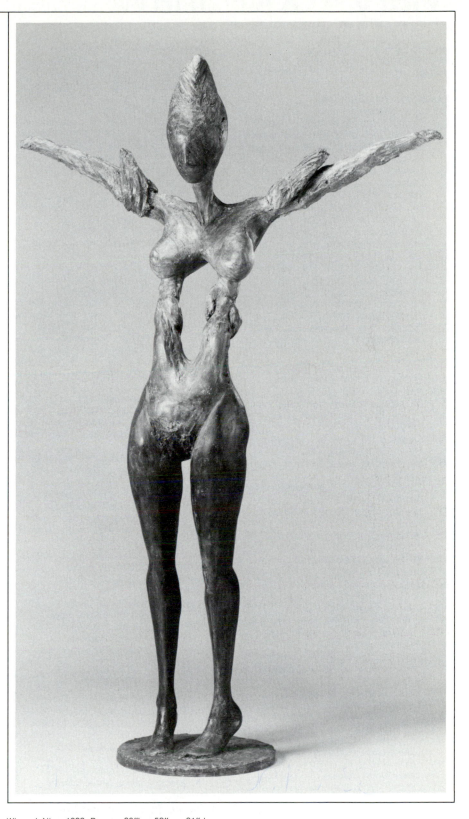

Winged Alice. 1983. Bronze, 80"h x 52"w x 21"d.
Photograph by M. Lee Fatherree.

527

Mary Todd Shaw

née Mary Elizabeth Todd
(Husband Edward Harrison Shaw)
Born February 9, 1921 Gadsden, Alabama

Education and Training
1942 Atlanta College of Art, Atlanta, Georgia; study in painting
1963 Virginia Polytechnic Institute and State University, Blacksburg, Virginia; study in sculpture with Dean Carter
1972 University of North Carolina at Greensboro, Greensboro, North Carolina; study in lithography
1974 B.C.A., Graphics, University of North Carolina at Charlotte, Charlotte, North Carolina
1979 University of Georgia, Athens, Georgia; Studies Abroad Program, Palazzo Vagnotti, Cortona, Italy; study in marble sculpture with John D. Kehoe
1983 Sawtooth Center for Visual Design, Winston-Salem, North Carolina; Studies Abroad Program, Castello di San Martino, Vittorio Veneto, Italy; study in painting

Selected Individual Exhibitions
1965 University of North Carolina at Charlotte, Charlotte, North Carolina
1965 Furman University, Greenville, South Carolina
1965 Columbia Museums of Art & Science, Columbia, South Carolina
1967 Mint Museum of Art, Charlotte, North Carolina
1972 Herman Art Gallery, Statesville, North Carolina
1973 Queens College, Charlotte, North Carolina
1975 Harold Decker Galleries, Norfolk, Virginia
1976 Spring Mills Gallery, Fort Mill, South Carolina
1977, Spirit Square Art Center, Charlotte,
81 North Carolina
1978, The Arts Center, Statesville,
81 North Carolina
1979 Davidson College, Davidson, North Carolina
1982 Gallery B, Southeastern Center for Contemporary Art, Winston-Salem, North Carolina
1983 Mitchell Community College, Statesville, North Carolina
1983 Lancaster Art Center, Lancaster, South Carolina
1983 Art Center, Paul Klapper Library, Queens College, Flushing, New York
1984 Beam Art Center, Gaston College, Dallas, North Carolina
1984 Center Gallery, Carrboro, North Carolina
1986 Converse College, Spartanburg, South Carolina

Selected Group Exhibitions
1966, "National Association of Women
78, Artists Annual Exhibition," Jacob K.
84 Javits Federal Building, New York, New York, catalog
1968 "Twenty-Ninth Annual Juried Exhibition," Gallery of Contemporary Art, Winston-Salem, North Carolina
1969, "Springs Mills Art of Carolinas Annual
74, Exhibition," Traveling Exhibition,
79 Spring Mills, Lancaster, South Carolina, catalog
1976 "Mechlenburg Artists, A Bicentennial Tribute," Queens College, Charlotte, North Carolina, catalog
1979 "Mostra d'Arte Università della Georgia," Palazzo Vagnotti, Cortona, Italy
1980 "Artists in Residence at Cortona," Visual Arts Gallery, University of Georgia, Athens, Georgia
1980 "Paul Epley, Mary Todd Shaw, Bambi Walsh," Round Gallery, Mint Museum of Art, Charlotte, North Carolina
1980 "200 Art Show," Traction Gallery, Los Angeles, California
1980 "20 North Carolina Sculptors," Green Hill Art Gallery, Greensboro, North Carolina
1981 "Open Juried Exhibition," Spirit Square Art Center, Charlotte, North Carolina
1982 "Tri-State Sculptors Invitational," Horace Williams House, Chapel Hill, North Carolina
1982 "The Box Exhibition," Spirit Square Art Center, Charlotte, North Carolina
1982 "Magic in Art," Spirit Square Art Center, Charlotte, North Carolina
1982 "Eleventh Annual Competition for North Carolina Artists," Fayetteville Museum of Art, Fayetteville, North Carolina
1983 "First Regional Juried Art Exhibition," Spartanburg Arts Center, Spartanburg, South Carolina (Sponsored by Friends of the Arts, Spartanburg, South Carolina), catalog
1984 "Twenty-Seventh Irene Leache Memorial Biennial Exhibition," Chrysler Museum, Norfolk, Virginia, catalog
1984 "1984 Invitational Black and White Exhibition," Spirit Square Art Center, Charlotte, North Carolina
1984 "1984 Tri-State Sculptors," Queens College, Charlotte, North Carolina (Sponsored by Mint Museum of Art, Charlotte, North Carolina; Queens College, Charlotte, North Carolina and Tri-State Sculptors), catalog
1985 "The Box Exhibition," Southeastern Center for Contemporary Art, Winston-Salem, North Carolina

Selected Public Collections
Asheville Art Museum, Asheville, North Carolina
Barclays American Corporation, Charlotte, North Carolina
Branch Banking and Trust Company, Charlotte, North Carolina
Columbia Museums of Art & Science, Columbia, South Carolina
First Citizens Bank, Charlotte, North Carolina
Gibbes Art Gallery, Charleston, South Carolina
Hickory Museum of Art, Hickory, North Carolina
International Business Machines Corporation, Charlotte, North Carolina
Mint Museum of Art, Charlotte, North Carolina
North Carolina National Bank, Charlotte, North Carolina
Southeastern Savings and Loan, Charlotte, North Carolina

Selected Private Collections
David Van Hook, Columbia, South Carolina
Arnold Levinson, Columbia, South Carolina
Dr. and Mrs. Arthur Rockey, Charlotte, North Carolina
Robert Stewart, New York, New York
Mr. and Mrs. John Weil, Charlotte, North Carolina

Selected Awards
1979 Artist in Residence, University of Georgia, Athens, Georgia; Studies Abroad Program, Palazzo Vagnotti, Cortona, Italy
1981 Artist in Residence, Corporation of Yaddo, Saratoga Springs, New York
1984 Artist in Residence, Virginia Center for the Creative Arts, Sweet Briar, Virginia

Preferred Sculpture Media
Stone, Varied Media and Wood

Additional Art Fields
Metal (cast), Painting and Printmaking

Related Profession
Art Instructor

Selected Bibliography
Meilach, Dona Z. and Elvie Ten Hoor. *Collage and Assemblage: Trends and Techniques.* New York: Crown, 1973.

Mailing Address
6611 Burlwood Road
Charlotte, North Carolina 28211

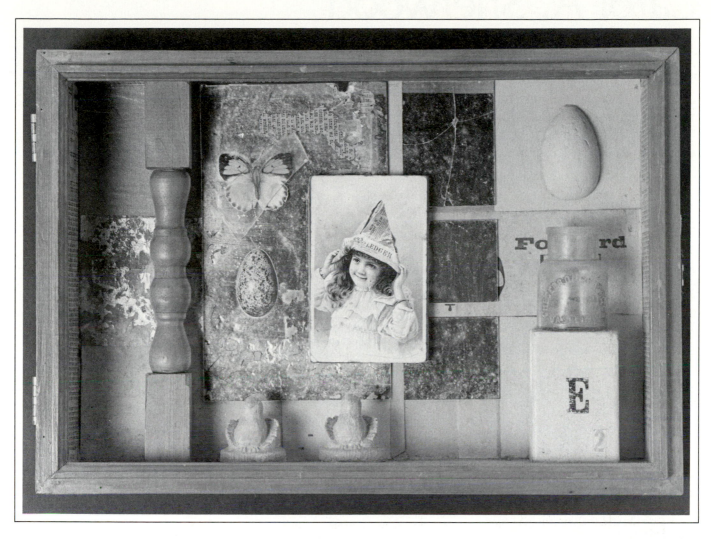

The Ledger. 1978. Collage, wood, hydrocal, mirrors, gold leaf and gesso, 11½"h x 16½"w x 3"d. Photograph by Jeff Willhelm.

Artist's Statement

"My boxes started in 1962 with a fossil from my son's rock collection and a broken doll found in an old trunk under my mother's house. Not wanting to dispose of these found objects, I sought advice from the local lumberyard and my first two boxes, *Voice* and *Self-Portrait*, were born. I still like them. Since that time I have created a variety of three-dimensional assemblages from my visual stream of consciousness, using hand-modeled objects in Italian plasticine cast in hydrocal or collages of colored papers, serigraphs and etchings. Earlier boxes did use found objects but now they are primarily composed of my own creative content. I have altered their sizes and shapes during the years but still find the dimensions of the original boxes the most pleasing.

"My work begins with a concept without a preconceived solution. The process of constructing is always an adventure with an unexpected ending. I prefer not to offer interpretations of the work which locks it into specific meaning. My boxes are visual expressions which are experienced differently by each viewer."

MARY TODD SHAW

Carol A. Sherwood

née Carol Anne O'Hara
(Husband Robert Edward Sherwood)
Born August 16, 1944 Buffalo, New York

Education and Training
1968- Studio of Jules Beaumont, Buffalo,
70 New York; study in clay and bronze
sculpture
1970- Griffith Institute for the Visual Arts,
71 Buffalo, New York; study in sculpture
and ceramics with Larry Griffith and
Ronald La Fleur
1971- Earthworks Studio, Buffalo, New York;
73 study in ceramics
1979 A.A., Ceramics, Sculpture and
Drawing, Mesa College, Mesa, Arizona
1982 B.A., Ceramics and Design, Arizona
State University, Tempe, Arizona;
study in ceramic sculpture with
Donald Schaumburg

Selected Individual Exhibitions
1983 John Douglas Cline Gallery, Phoenix,
Arizona
1984 Elaine Horwitch Galleries, Santa Fe,
New Mexico

Selected Group Exhibitions
1980 "Verde," Arizona State University,
Tempe, Arizona and Verde Valley Fine
Art Center, Jerome, Arizona
1980 "Exhibition '80, Arizona Women's
Caucus for Art," First InnerState Bank,
Phoenix, Arizona
1981 "The Best of Ceramics," Arizona State
University, Tempe, Arizona
1981 "Fountain Hills Annual," Fountain Hills
Center, Fountain Hills, Arizona
1981 "Clay and Glass," John Douglas Cline
Gallery, Phoenix, Arizona
1982 "Triad: Three-Person Sculpture
Exhibition," John Douglas Cline
Gallery, Phoenix, Arizona
1982 "Vahki Juried Competition 1982," Mesa
Art Center Gallery, Mesa, Arizona

1982 "Tucson Biennial," Tucson Museum of
Art, Tucson, Arizona, catalog
1983, "Traveling Exhibition," Arizona
84 Commission on the Arts, Phoenix,
Arizona
1983 "Arizona State Capitol Show," Phoenix
Artists Coalition, Phoenix, Arizona
1983 "Ceramic Sculpture Invitational," Fine
Arts Center of Tempe, Tempe,
Arizona
1983 "Marietta College Crafts National,"
Grover H. Hermann Fine Arts Center,
Marietta College, Marietta, Ohio,
catalog
1984 "Arizona Contemporary Artists,"
Scottsdale Center for the Arts,
Scottsdale, Arizona
1984 "Arizona Clay Sculpture," Gross
Gallery, University of Arizona, Tucson,
Arizona, catalog
1984 "Biennale Internationale de Céramique
d'Art," Picasso Museum, Cannes,
France, catalog
1984 "Twenty-Seventh Chautauqua National
Exhibition of American Art,"
Chautauqua Art Association Galleries,
Chautauqua, New York, catalog
1985 "Second Exotic Invitational," Alwun
House Gallery, Phoenix, Arizona
1985 "Nina Beall, Rudy Fernandez, Carol
Sherwood and Lynn Taber-Borcherdt,"
Elaine Horwitch Galleries, Scottsdale,
Arizona
1985 "Southwest '85," Museum of Fine Arts,
Museum of New Mexico, Santa Fe,
New Mexico

Selected Public Collections
Gazette Newspapers, Phoenix, Arizona
Great Western Bank, Phoenix, Arizona
Mission Palms Center, Tempe, Arizona
Tucson Symphony, Tucson, Arizona
Valley National Bank, Phoenix, Arizona
Yuma Art Center, Yuma, Arizona

Selected Private Collections
Dr. Joseph Cooper, Phoenix, Arizona
Susan Hanch, Chicago, Illinois
Mr. and Mrs. Leonard Hantover, Phoenix,
Arizona
Mr. and Mrs. David Roberts, Santa Cruz,
California
Camil Van Hulse, Tucson, Arizona

Selected Awards
1983- First Place, "Seventeenth
84 Southwestern Invitational," Traveling
Exhibition, Yuma Art Center, Yuma,
Arizona, catalog
1984 Award for Excellence in Art, Woman
Image Now, Arizona State University,
Tempe, Arizona
1984 Governor's Award for the Arts,
Arizona Commission on the Arts,
catalog

Preferred Sculpture Media
Clay

Selected Bibliography
Monson, Karen. "Arts: Giving Art to Art
Supporters." *Phoenix Magazine* vol. 19 no.
6 (June 1984) pp. 63-64.
Rigberg, Lynn R. "Carol Sherwood." *Arts
Magazine* vol. 59 no. 5 (January 1985) p.
3, illus.

Gallery Affiliations
Elaine Horwitch Galleries
4211 North Marshall Way
Scottsdale, Arizona 85251

Elaine Horwitch Galleries
129 West Palace Avenue
Santa Fe, New Mexico 87501

Mailing Address
1633 South River Drive
Tempe, Arizona 85281

Artist's Statement

"My first serious training in sculpture was in 1969 when I studied with Jules Beaumont. This training instilled a love of form and line which I transmit in my work today. I began working with clay when I found that I was not near a foundry to cast my waxes. Clay turned out to be a plastic and versatile material that I could manipulate to develop sculptural statements. When I felt traditional ceramic colors and glazed surface treatments limited me artistically, I began to work on the unglazed surface like a canvas, using oils, acrylics, stains and graphite.

"The sculptures are two to three feet tall and take the shape of abstracted torsos with necks and shoulders representing the human form in a vertical position. The personal side of my work is concerned with life forces and beginning our civilization in space. Titles such as *Life Forms* suggest the shell and cocoon forms on the front of the sculpture to be the beginnings of life. The lesser images floating in the illusionistic setting represent space and the unknown. Other titles such as *Natural Events* and *Seeding the Cosmos III* are female forms and counterpart to the large aggressive colorful male forms. The pieces become symbols for individual presences with the potentialities for unlimited growth and survival."

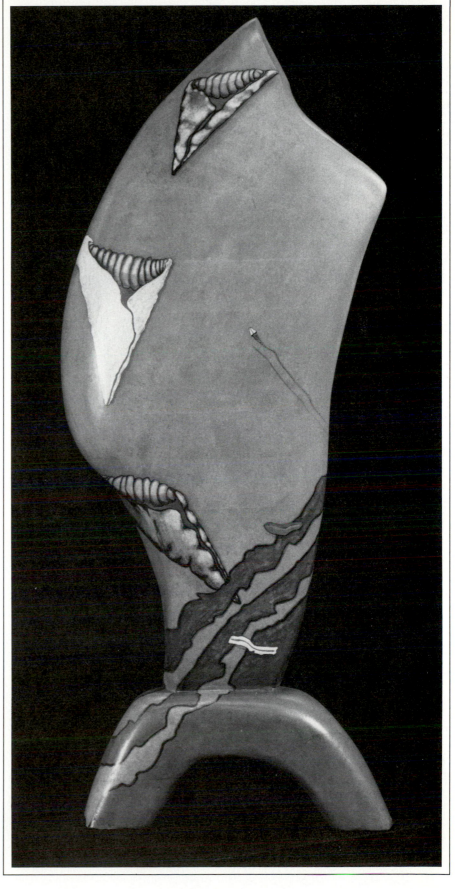

Life Forms. 1985. Handbuilt clay painted with oils, acrylics, stains and graphite, 38"h x 12"w x 6"d. Photograph by Robert E. Sherwood.

Karen Shirley

Born February 26, 1938 Belle Plaine City, Iowa

Education and Training
1961 B.A., Visual Arts, Antioch College, Yellow Springs, Ohio
1967 M.F.A., Ceramics, Mills College, Oakland, California

Selected Individual Exhibitions
1977 University of Akron, Akron, Ohio
1978 Ohio State University, Columbus, Ohio, catalog
1978 Ashland College, Ashland, Ohio
1981 Wright State University, Dayton, Ohio
1982 Columbus Museum of Art, Columbus, Ohio, catalog

Selected Group Exhibitions
1973 "Antioch Faculty Exhibition," Contemporary Arts Center, Cincinnati, Ohio
1974 "All Ohio Painting and Sculpture," Dayton Art Institute, Dayton, Ohio, catalog
1979 "Regional Fellowship Exhibition," Traveling Exhibition, Wright State University, Dayton, Ohio, catalog
1980 "Five Ohio Sculptors," Contemporary Arts Center, Cincinnati, Ohio
1980 "Stacked, Packed & Hung," N.A.M.E. Gallery, Chicago, Illinois; New Gallery of Contemporary Art, Cleveland, Ohio, catalog
1980-81 "Scapes: Seven Ohio Landscape Artists-Milhoan, Peak, Puhalla, Shirley, Spaid, Tacha, Tyrrell," Traveling Exhibition, Tangeman Fine Arts Gallery, University of Cincinnati, Cincinnati, Ohio, catalog
1980 "Three Installations," New Gallery of Contemporary Art, Cleveland, Ohio
1981 "Natur-Skulptur, Nature-Sculpture," Württembergischer Kunstverein, Stuttgart, Germany, Federal Republic, catalog
1983 "The Works," Traveling Exhibition, Ohio Foundation on the Arts, Columbus, Ohio

Selected Public Collection
State Office Tower, Columbus, Ohio

Selected Awards
1972 Ford Foundation Travel Grant (Japan)
1978 Regional Artist's Fellowship, Ohio Arts Council and National Endowment for the Arts
1979 Individual Artist's Fellowship, Ohio Arts Council

Preferred Sculpture Media
Varied Media

Additional Art Field
Drawing

Teaching Position
Professor, Department of Visual Arts, Antioch College, Yellow Springs, Ohio

Selected Bibliography
Columbus Museum of Art. "The Ohio Series: Karen Shirley, December 5-January 9." *Dialogue* vol. 5 no. 2 (November-December 1982) p. 25, illus.
Day, Holliday T. "Midwest Art: A Special Report, Indianapolis, Cincinnati, and Dayton." *Art in America* vol. 67 no. 4 (July-August 1979) pp. 68-71, illus.
Franz, Gina. "Robert Pincus—Witten's 'Six in Ohio'." *New Art Examiner* vol. 6 no. 6 (March 1979) section two, pp. 21, 26, illus.
Franz, Gina. "Reviews Midwest Ohio: Karen Shirley at Columbus Museum of Art." *New Art Examiner* vol. 10 no. 5 (February 1983) p. 22.
Morgan, Ann Lee. "Reviews Chicago: Stacked, Packed and Hung, N.A.M.E. Gallery." *New Art Examiner* vol. 7 no. 8 (May 1980) p. 14.

Mailing Address
790 Wright Street
Yellow Springs, Ohio 45387

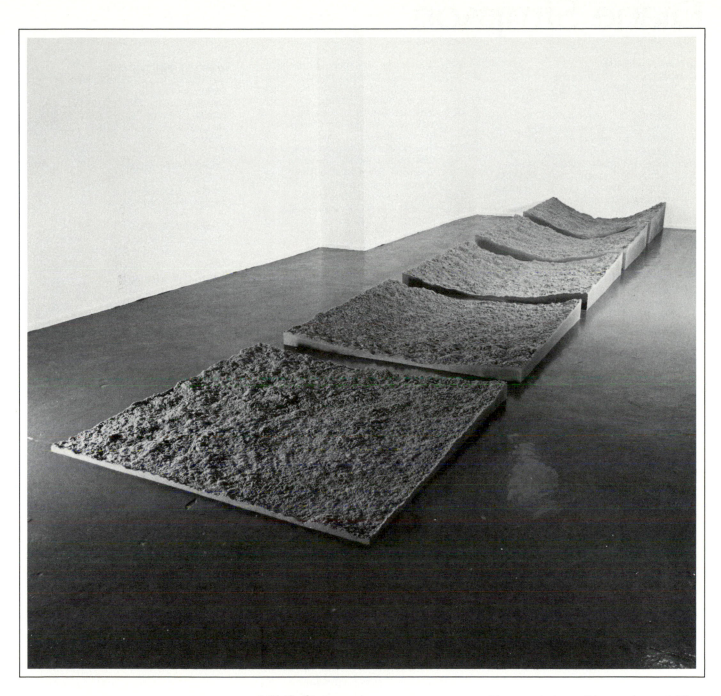

Valley Banks. 1980. Tamped sand, 24'w x 4'd. Installation view 1980. "Stacked, Packed & Hung." New Gallery of Contemporary Art, Cleveland, Ohio, catalog. Photograph by Anselm Talalay.

Artist's Statement

"The work which I have exhibited within the past six or so years has been directly related to the Ohio landscape. These exhibitions have been site specific, temporary installations. The material which I have used is common mason sand obtained within the geographic location of the installation site.

"Each of these installations has attempted to present the essence of an event of the landscape as a frozen moment. My interest is in exploring, observing, and documenting subtle differences within moments and how these differences relate to passages of time.

These works have all been ephemeral. When dismantled the frozen moment they depict becomes a memory."

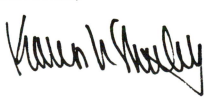

Diane Simpson

née Diane Rae Klafter
(Husband Kenneth H. Simpson)
Born April 25, 1935 Joliet, Illinois

Education and Training
1971 B.F.A., Drawing, Painting and Printmaking, School of the Art Institute of Chicago, Chicago, Illinois
1978 M.F.A., Sculpture, School of the Art Institute of Chicago, Chicago, Illinois; study with Whitney Halstead, Barbara Rossi and Ray Yoshida

Selected Individual Exhibitions
1974 ARC Gallery, Chicago, Illinois
1978 Barat College, Lake Forest, Illinois
1979 Artemisia Gallery, Chicago, Illinois
1980, Phyllis Kind Gallery, New York, New
83 York
1981 Illinois Wesleyan University, Bloomington, Illinois

Selected Group Exhibitions
1977 "Illinois Women Artists," Illinois State Museum, Springfield, Illinois; Northern Illinois University, DeKalb, Illinois; Galesburg Art Center, Galesburg, Illinois
1979 "Chicago Alternative," Herron School of Art Gallery, Indianapolis, Indiana and Indiana University-Purdue University at Indianapolis, Indianapolis, Indiana, catalog
1979 "New Dimensions: Volume and Space," Museum of Contemporary Art, Chicago, Illinois, catalog
1979 "Thirty-First Invitational Exhibition," Illinois State Museum, Springfield, Illinois, catalog

1979- "100 Artists: 100 Years," Art Institute
80 of Chicago, Chicago, Illinois, catalog
1980 "Chicago Art Prospective," Navy Pier, Chicago, Illinois, catalog
1981 "Selected Sculpture," Ukrainian Institute of Modern Art, Chicago, Illinois, catalog
1981- "Seventy-Ninth Exhibition by Artists of
83 Chicago and Vicinity," Traveling Exhibition, Art Institute of Chicago, Chicago, Illinois, catalog
1982 "Ten Years Later: An Exhibition of Women Artists," Ukrainian Institute of Modern Art, Chicago, Illinois, catalog
1983 "Artists Choose Artists," Hyde Park Art Center, Chicago, Illinois
1984 "Alternative Spaces: A History in Chicago," Museum of Contemporary Art, Chicago, Illinois, catalog
1984 "Chicago International Art Exposition 1984," Navy Pier, Chicago, Illinois (Represented by Phyllis Kind Gallery, Chicago, Illinois), catalog
1984 "Artemisia: Ten Years 1973-1983," Artemisia Gallery, Chicago, Illinois, catalog
1985 "Sculpture-Overview 1985," Evanston Art Center, Evanston, Illinois, catalog

Selected Public Collections
Crocker National Bank, San Francisco, California
Illinois State Museum, Springfield, Illinois

Selected Private Collections
John and Mary Gedo, Chicago, Illinois
Robert A. Lewis, Chicago, Illinois

Selected Awards
1978 E. Garrison Prize, "Seventy-Seventh Exhibition by Artists of Chicago and Vicinity," Art Institute of Chicago, Chicago, Illinois, catalog
1980- Walter M. Campana Prize,
81 "Seventy-Eighth Exhibition by Artists of Chicago and Vicinity," Art Institute of Chicago, Chicago, Illinois, catalog
1983 Individual Artist's Fellowship, Illinois Arts Council

Preferred Sculpture Media
Varied Media and Wood

Additional Art Fields
Drawing and Printmaking

Selected Bibliography
Nye, Mason. "Reviews Diane Simpson, Artemisia Gallery." *New Art Examiner* vol. 6 no. 5 (February 1979) p. 12, illus.
Pieszak, Devonna. "Diane Simpson." *Arts Magazine* vol. 54 no. 8 (April 1980) p. 19, illus.

Gallery Affiliations
Phyllis Kind Gallery
313 West Superior Street
Chicago, Illinois 60610

Phyllis Kind Gallery
136 Greene Street
New York, New York 10012

Mailing Address
709 Elmwood Avenue
Wilmette, Illinois 60041

Artist's Statement

"My forms refer to a diverse variety of objects ranging from vernacular architectural or industrial forms to human body coverings. These forms are altered through a series of isometric drawings (oblique and parallel angles). This two-dimensional system for describing spatial objects is then applied to the three-dimensional constructions, upsetting their sense of logic and reality and presenting contradictions to be resolved. For example, regulated surface patterns conflict with the asymmetrical orientation of the objects and the volume usually associated with 'real' objects becomes flattened and illusory."

Diane Simpson

Samurai No. 9. 1983. Wood and wood stain, 76¾"h x 50"w x 12"d. Collection Illinois State Museum, Springfield, Illinois. Photograph by William H. Bengtson.

Linda Thern Smith

née Linda Kay Thern
(Husband Ralph David Smith)
Born February 17, 1946 Omar, West Virginia

Education and Training
1968 Solano Community College, Vallejo, California
1970-71 Kent State University, Kent, Ohio
1972 Southern Illinois University at Edwardsville, Edwardsville, Illinois
1973 Miami-Dade Community College, Miami, Florida
1975 B.F.A., Painting, Florida International University, Miami, Florida
1976 Montgomery College-Rockville Campus, Rockville, Maryland; workshop in ceramic sculpture with Paul Soldner
1977 M.F.A., Ceramic Sculpture, George Washington University, Washington, D.C.
1977 George Washington University, Washington, D.C.; workshop in ceramic sculpture with Jan Axel
1979 Howard University, Washington, D.C.; workshop in ceramic sculpture with Wayne Higby

Selected Individual Exhibitions
1979, 83 Studio Gallery, Washington, D.C.
1981 Fredericksburg Center for Creative Arts, Fredericksburg, Virginia

Selected Group Exhibitions
1978 "Plain Brown Wrapper Invitational," St. John's College Gallery, Annapolis, Maryland
1978 "Sculpture, Inside/Out," Studio Gallery, Washington, D.C.
1979 "Painting and Sculpture Juried Exhibition," Washington Women's Arts Center, Washington, D.C., catalog
1979 "Clay and Line," Washington Women's Arts Center, Washington, D.C.
1980 "Westwood Clay National 1980," Otis Art Institute, Los Angeles, California, catalog
1980 "Eleventh International Sculpture Conference," Area Galleries and Institutions, Washington, D.C. (Sponsored by International Sculpture Center, Washington, D.C.)
1981 "Clay Invitational," Art Latitude Gallery, New York, New York
1981 "City Art 1981," Area Galleries and Locations, Washington, D.C.
1981 "Mixed Media Exhibition," Arlington Art Center, Arlington, Virginia
1981 "Clay as Art and as Function," Gallery 10, Washington, D.C., catalog
1981-84 "Collage & Assemblage," Traveling Exhibition, Mississippi Museum of Art, Jackson, Mississippi, catalog
1982 "Copy Cat Show," Franklin Furnance Archive, New York, New York, catalog
1982 "Art Alumni Invitational Exhibition," Dimock Gallery, George Washington University, Washington, D.C., catalog
1982 "Grand Re-Opening Exhibition," Studio Gallery, Washington, D.C.
1983 "Miniature Show," Foundry Gallery, Washington, D.C.
1983 "Studio Gallery Invitational," Montgomery College-Rockville Campus, Rockville, Maryland
1983 "Women's Caucus for Art Exhibition," Moore College of Art, Philadelphia, Pennsylvania
1983 "Ralph Logan and Linda Thern Smith," Studio Gallery, Washington, D.C.
1983 "Alexandria Sculpture Festival," Area Locations, Alexandria, Virginia, catalog
1984 "Shipshapes!," Midtown Gallery, Washington, D.C.
1984 "Wood and Fibre," Art Barn, Washington, D.C.
1984-85 "Boxformations," Foundry Gallery, Washington, D.C.; Marlboro Gallery, Prince George's Community College, Largo, Maryland, catalog

Selected Public Collections
Butler Institute of American Art, Youngstown, Ohio
George Washington University, Washington, D.C.
Hunter Museum of Art, Chattanooga, Tennessee
Roanoke Museum of Fine Arts, Roanoke, Virginia

Selected Award
1980 Artist in Residence, Virginia Center for the Creative Arts, Sweet Briar, Virginia

Preferred Sculpture Media
Clay and Varied Media

Additional Art Field
Drawing

Related Profession
Contemporary Art Criticism

Selected Bibliography
Forgey, Benjamin. "Arts Galleries: 'In Pursuit of the Perfect Print' and 'Foundry Gallery.'" The Washington Post (Thursday, July 22, 1982) p. E7.
Friedman, Kenneth S. "Meaning in Clay: A Barrier Becomes a Path." Women Artists News vol. 6 no. 1 (May 1980) pp. 10-11.
Miller, Lenore D. "Brown Wrapper: A Collaboration of Four Artists." Art Voices/South vol. 2 no. 2 (March-April 1979) pp. 56-60, illus.
"News & Retrospect: Linda Thern Smith." Ceramics Monthly vol. 28 no. 1 (January 1980) p. 95, illus.
Tannous, David. "Report from Washington: The 11th International Sculpture Conference." Art in America vol. 68 no. 9 (November 1980) pp. 39-41, 43, 45.

Gallery Affiliation
Studio Gallery
420 Seventh Street NW
Washington, D.C. 20004

Mailing Address
8334 Cathedral Forest Drive
Fairfax Station, Virginia 22039

Artist's Statement

"Narration has been important in my life and work. I have always been interested in stories and backgrounds and I endeavor to make art which holds content. As befits a storyteller, I have continually thought of myself as an artist. Even as a very young child I drew in colored chalk for the primary classes. Interest in three-dimensionality came later through watching my father work in his garage woodshop.

"These early impressions have stayed with me and manifest themselves in my sculpture which is additive in method. It is of enormous satisfaction and great value to assemble, construct and bring together diverse parts into a whole, especially if those parts, when assembled, tell a good story.

"My sculptures in assemblage involve elements of paradox on multiple levels. In most works, handmade expressionistic forms of clay are placed in juxtaposition with materials or items intuitively selected from a found context. Incorporating the commolace with the unusual can beguile the viewer into a reconsideration of their function or presence. Although the sculptures are actually very seleċive in materials and image, they seem like eclectic relics of an autobiographical narrative, sometimes with humor, sometimes distinctly without."

Linda Thern Smith

Lady's Silent Butler. 1977. Porcelain, satin, lace, silver flatware and wood, 30"h x 19"w x 17"d.
Photograph by Claudia Smigrod.

Mara Smith

Born July 31, 1945 Houston, Texas

Education and Training
1969 B.S., Interior Design, Texas Woman's University, Denton, Texas
1980 M.F.A., Ceramic Sculpture, Texas Woman's University, Denton, Texas; study with J. Brough Miller

Selected Individual Exhibition
1978 Richland College, Dallas, Texas

Selected Group Exhibitions
1977 "Women in Art: Mara Smith and Corky Stuckenbruck," Tarrant County Junior College, Fort Worth, Texas
1977 "Regional Painting and Sculpture Exhibition," Richardson Civic Art Society, Richardson, Texas
1978 "Mara Smith and David Hendley," Wichita Falls Museum and Art Center, Wichita Falls, Texas
1979 "Air, Earth, Fire and Fiber," Austin College, Sherman, Texas
1980 "The Medicine Show," University of Texas at Arlington, Arlington, Texas

Selected Public Collections
American Bank and Trust Company Building, Reading, Pennsylvania
Classic Acres Thoroughbred Farm, Ocala, Florida
Continental Western Life Building, Des Moines, Iowa
Endicott Clay Products Company, Endicott, Nebraska
Fire Station No. 2, Tulsa, Oklahoma
First National Bank, Washington, Kansas
Hamilton Lakes Hotel and Office Center, Itasca, Illinois
Iowa State Savings Bank, Creston, Iowa
Las Colinas Canal Plaza Urban Center, Irving, Texas
Loew's Anatole Hotel, Dallas, Texas
Normandale Lake Office Building, Bloomington, Minnesota
North Iowa Area Community College, Mason City, Iowa
Pacific Northwest Bell Telephone Building, Seattle, Washington
Waverly Hotel, Atlanta, Georgia

Selected Private Collections
The Honorable and Mrs. Dolph Briscoe, Uvalde, Texas
Mr. and Mrs. Trammell Crow, Sr., Dallas, Texas
Mr. and Mrs. Roger Judd, Fairbury, Nebraska
Mr. and Mrs. Samuel K. Knight, Ocala, Florida
Mr. and Mrs. William Stone, Endicott, Nebraska

Preferred Sculpture Media
Clay and Varied Media

Additional Art Field
Jewelry

Selected Bibliography
Brolin, Brent C. and Jean Richards. *Sourcebook of Architectural Ornament: Designers, Craftsmen, Manufacturers and Distributors of Custom and Ready-Made Exterior Ornament*. New York: Van Nostrand Reinhold, 1982.
Fleming, Ronald Lee and Renata von Tscharner, with George Melrod. *Place Makers: Public Art That Tells You Where You Are*. New York: Hastings House, 1981.
Redstone, Louis G. *Masonry in Architecture*. New York: McGraw-Hill, 1984.

Mailing Address
Route 3 Box 358AA
Denton, Texas 76205

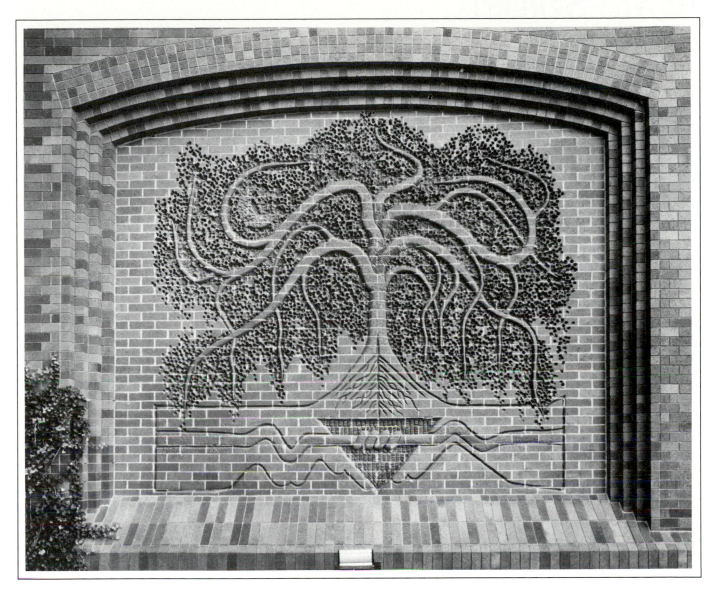

World Tree. 1978. Clay, 15'h x 18'w. Collection
Loew's Anatole Hotel, Dallas, Texas. Photograph by
Carolyn Brown.

Artist's Statement

"Clay is a transformational media; my
personal evolution is indifferent. The body of
the language I pursue in brick is the ability
of clay to shape and form human time. The
fascination with the rhythms of clay to
artifact cultures draws me into confrontation
with patterns of an historical, mythological or
abstractional nature. By polarizing images of
my own time with the ancient past, I hope to
lead others into the same mystery."

R. G. Solbert

née Romaine Gustava
Born September 7, 1925 Washington, D.C.

Education and Training
1946 B.A., Romance Languages and
Literature, Vassar College,
Poughkeepsie, New York
1947 M.F.A., Painting, Cranbrook Academy
of Art, Bloomfield Hills, Michigan

Selected Individual Exhibitions
1975 Vermont Artisans Gallery, Strafford,
Vermont
1981, Charles Fenton Gallery, Woodstock,
82 Vermont
1983 Living/Learning Center, University of
Vermont, Burlington, Vermont
1985 Pindar Gallery, New York, New York

Selected Group Exhibitions
1979 "Nine Vermont Artists,"
Millhouse-Bundy Performing and Fine
Arts Center, Waitsfield, Vermont
1980 "Group Exhibition," Frame of Mind
Gallery, Burlington, Vermont
1980 "Four at The Arsenal," The Arsenal,
New York, New York
1981 "Four Artists," Francis Colburn Gallery,
University of Vermont, Burlington,
Vermont
1981 "A Weaver and a Sculptor,"
Millhouse-Bundy Performing and Fine
Arts Center, Waitsfield, Vermont
1981 "Five Sculptors in Metal," Chadler
Gallery, Randolph, Vermont
1982 "Pocketbooks," Governor's Corridor,
Montpelier, Vermont
1982 "Women's Art—Women's Lives: An
Invitational Exhibition of Vermont
Women Artists," Brattleboro Museum
and Art Center, Brattleboro, Vermont
1983 "Open Studios," Artists Studios,
Burlington, Vermont
1983 "10 x 10 x 10," AVA Gallery, Hanover,
New Hampshire
1985 "Four Artists," AVA Gallery, Hanover,
New Hampshire
1985 "Gallery Artists," Pindar Gallery, New
York, New York

Preferred Sculpture Media
Stone and Wood

Additional Art Fields
Drawing and Painting

Gallery Affiliation
Pindar Gallery
127 Greene Street
New York, New York 10012

Mailing Address
29 South Main
Randolph, Vermont 05060

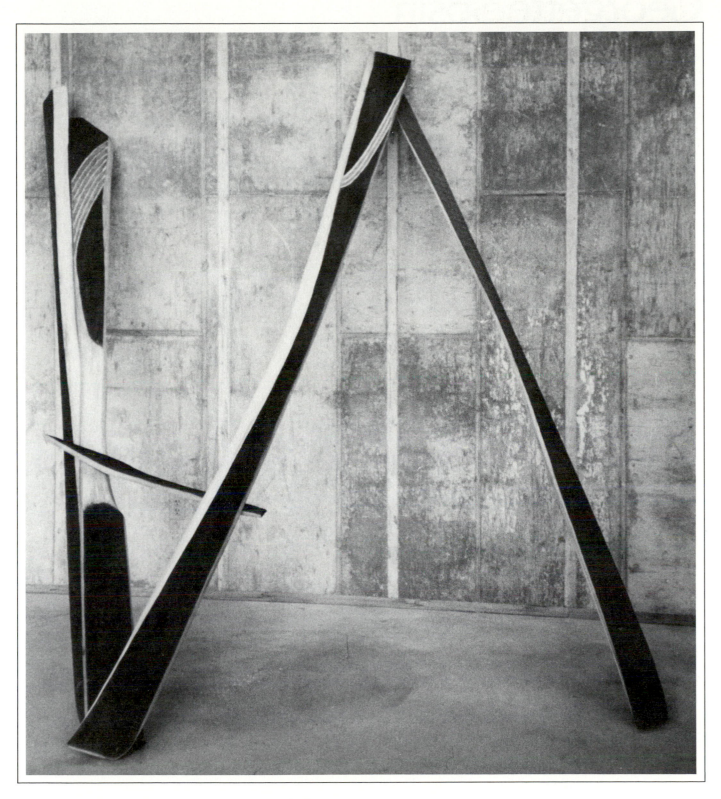

Untitled. 1983. Painted basswood, 9'h x 8'w x 7'd.
Installation view 1983. Living/Learning Center,
University of Vermont, Burlington, Vermont.

Artist's Statement

"I prefer creating rather than writing about
my work. Painting and sculpture have always
been an inner capacity for me to develop
with passion. There is no end—only an
evolving continuity that must be followed."

541

Georgette Sosin

née Georgette Madeleine Heyman
(Husband Henry Sosin)
Born October 9, 1934 Strasbourg, France

Education and Training
1952 University of Rochester, Rochester, New York; study in sculpture with William Erich
1953- Sarah Lawrence College, Bronxville, 54 New York
1956 B.F.A., University of Louisville, Louisville, Kentucky; study in sculpture with Edgard Pillet

Selected Individual Exhibitions
1972 Martin Gallery, Minneapolis, Minnesota
1973 Unitarian Society, Minneapolis, Minnesota
1976 Concordia College, St. Paul, Minnesota
1977 Art Lending Gallery, Minneapolis, Minnesota

Selected Group Exhibitions
1955, "Juried State Exhibition," J. B. Speed
56 Art Museum, Louisville, Kentucky, catalog
1975 "Annual Liturgical Art in Architecture Exhibit," Hilton Hotel Palacio del Rio, San Antonio, Texas (Sponsored by Interfaith Forum on Religion, Art and Architecture, Washington, D.C.), catalog
1976 "Minnesota Society of Sculptors," Howard Conn Gallery, Minneapolis, Minnesota
1977 "National Invitational Exhibition," WARM, Women's Art Registry of Minnesota, Minneapolis, Minnesota, catalog
1977 "Minnesota Society of Sculptors," Northern States Power Building, Minneapolis, Minnesota
1978 "Regional Invitational," C. G. Rein Gallery, Minneapolis, Minnesota
1978 "Group Invitational," West Lake Gallery, Minneapolis, Minnesota

Selected Public Collections
Adath Jeshuran Congregation, Minneapolis, Minnesota
Coast to Coast Corporation, Minneapolis, Minnesota
Mount Sinai Hospital, Minneapolis, Minnesota
Mount Zion Synagogue, St. Paul, Minnesota
Ramsey County Adult Detention Center Plaza, St. Paul, Minnesota
St. Paul Structural Steel, St. Paul, Minnesota
Temple Israel, Minneapolis, Minnesota
University of Louisville, Louisville, Kentucky

Selected Private Collections
Nancy Wilkie Anderson, Minneapolis, Minnesota
Dr. and Mrs. Eugene Bernstein, La Jolla, California
Mr. and Mrs. James Brown, Minneapolis, Minnesota
Bettye Olson, St. Paul, Minnesota
Dr. and Mrs. Ivan Shloff, St. Paul, Minnesota

Preferred Sculpture Media
Metal (cast), Metal (welded) and Varied Media

Selected Bibliography
Minnesota Woman's Yearbook. Minneapolis: Sprague, 1984-1985.

Mailing Address
7400 Chanhassen Road
Chanhassen, Minnesota 55317

Artist's Statement

"Creating large-scale sculpture is very demanding physically and mentally. Having fabricated large pieces with the help of a skilled assistant, I can testify to the hard work involved. Aside from the physical labor, there are many months of preliminary planning concerning the details of construction and installation. The completed sculpture is the result of collaborating with engineers, construction workers, architects and many other individuals who contribute their expertise to the project. It is this aspect of large-scale work which I especially enjoy. Because the artist is often asked to submit a proposal after a building or plaza has been completed, it is a challenge to visually integrate the sculpture into its existing surroundings. Achieving harmony with the environment is a primary concern while still preserving the integrity of the sculpture.

"Movement is an important theme in my work. The eye is led over and around surfaces in space in forms which suggest motion. This activity engages the viewer in a visual dialogue with the sculpture. As a musical composition moves us through time from note to note, a sculpture moves us through space from form to form. In this process we are temporarily absorbed and merged with the harmonies, rhythms and movement in the work."

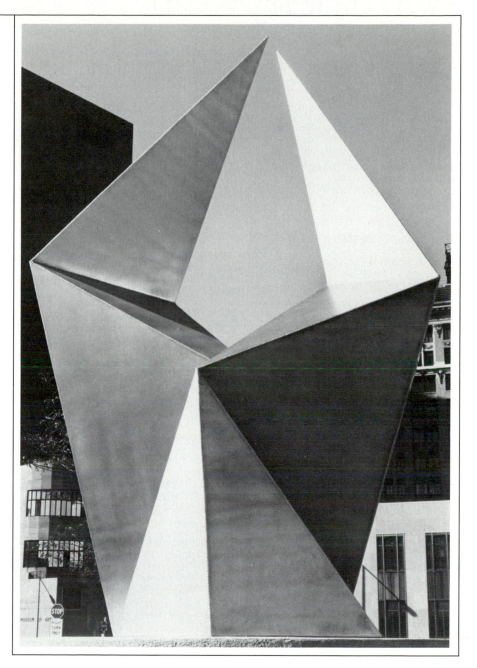

Sky. 1981. Aluminum, 16½'h including base.
Collection Ramsey County Adult Detention Center
Plaza, St. Paul, Minnesota.

543

Ann Sperry

née Ann Samols
(Husband Paul Sperry)
Born Bronx, New York

Education and Training
B.A., Sculpture, Sarah Lawrence College, Bronxville, New York; study with Theodore Roszak

Selected Individual Exhibitions
1968, Elaine Benson Gallery,
69, Bridgehampton, New York
70,
72,
75
1970, Patricia Moore Gallery, Aspen,
73 Colorado
1970, Jacqueline Anhalt Gallery, Los
72 Angeles, California
1971 Reese-Palley Gallery, San Francisco, California
1974 Leslie Rankow Gallery, New York, New York
1980 Smith Andersen Gallery, Palo Alto, California
1980, Lerner Heller Gallery, New York, New
82 York
1981 College of Saint Rose, Albany, New York
1981 Herter Gallery, University of Massachusetts at Amherst, Amherst, Massachusetts
1982 Robert Hull Fleming Museum, Burlington, Vermont

Selected Group Exhibitions
1963 "Donner a Voir 3," Galerie Creuze, Paris, France
1965 "Pop et l'Aristo," Galerie de Verneuil, Paris, France
1970 "Electra '70," Lever House, New York, New York
1972, "Gallery Artists," Leslie Rankow
73, Gallery, New York, New York
75
1973 "Gold," Metropolitan Museum of Art, New York, New York
1975 "Women Artists, Here & Now," Ashawagh Hall, Springs, New York
1976 "Year of the Woman: Reprise," Bronx Museum of The Arts, Bronx, New York, catalog
1977 "Group Exhibition," Mitzi Landau Gallery, Los Angeles, California
1978 "Women Artists '78," Graduate Center, City University of New York, New York, New York

1978 "Painting and Sculpture Today 1978," Indianapolis Museum of Art, Indianapolis, Indiana, catalog
1978 "Carol Kreeger Davidson/Leah Rhodes/Ann Sperry," Galerie Denise René, New York, New York
1979 "Nine Points of View: Sculpture," Sonoma State University, Rohnert Park, California
1979 "Collaborations & Amplifications," Salt Lake Art Center, Salt Lake City, Utah
1979 "Artists of the 70s," Webb & Parsons Gallery, New Canaan, Connecticut
1979 "Artists from Helicon Nine," First Women's Bank, New York, New York
1980 "New York Gallery Show," Adley Gallery, Sarasota, Florida
1980 "The First Ten Years," Lerner Heller Gallery, New York, New York
1980 "New Talent/New York," New Gallery of Contemporary Art, Cleveland, Ohio
1981 "Decorative Sculpture," Sculpture Center, New York, New York
1981 "Seventh Annual Outdoor Sculpture Show," Shidoni Gallery, Tesuque, New Mexico, catalog
1981 "A.R.E.A. Sculpture on Shoreline Sites," Manhattan Psychiatric Center, Ward's Island, New York, catalog
1982 "Small Scale Sculpture," Smith Andersen Gallery, Palo Alto, California
1982 "Contemporary Artists Series: Sculpture," Stedman Art Gallery, Rutgers University, University College-Camden, Camden, New Jersey, catalog
1983 "FUBA Collection," Federated Union of Black Artists, Johannesburg, South Africa
1983 "Found Objects," Marisa del Re Gallery, New York, New York
1983 "Recent Acquisitions," Storm King Art Center, Mountainville, New York
1983 "Ornaments as Sculpture," Sculpture Center, New York, New York
1984 "Ann Sperry/Barbara Zucker: A Decade of Work," Hillwood Art Gallery, C. W. Post Center of Long Island University, Greenvale, New York, retrospective and catalog
1984 "Chromatics," Mendik Company, New York, New York
1984- "Staged/Stages," Traveling Exhibition,
85 Bernice Steinbaum Gallery, New York, New York, catalog
1985 "Art and the Environment, A.R.E.A. Sculpture Exhibition," Lever House, New York, New York
1985 "Born in the Bronx," City University of New York Herbert H. Lehman College, Bronx, New York

Selected Public Collections
Atlantic Richfield Company, Los Angeles, California
Captiva Corporation, Denver, Colorado
Everson Museum of Art, Syracuse, New York
FUBA Collection, Johannesburg, South Africa
Peat, Marwick, Mitchell, Denver, Colorado

Rose Art Museum, Brandeis University, Waltham, Massachusetts
Storm King Art Center, Mountainville, New York
University of Nebraska-Lincoln, Lincoln, Nebraska
Waters Edge, Orlando, Florida
Witco Corporation, New York, New York

Selected Private Collections
Mr. and Mrs. Armand Bartos, New York, New York
Mr. and Mrs. E. J. Kahn, Jr., New York, New York
Mr. and Mrs. George Klein, New York, New York
Maestro James Levine, New York, New York
Mr. and Mrs. Frederick Mayer, Denver, Colorado

Preferred Sculpture Media
Metal (welded)

Related Profession
Visiting Artist

Selected Bibliography
Glueck, Grace. "Guide to What's New in Outdoor Sculpture." The New York Times (Friday, September 12, 1980) pp. C1, C20.
Glueck, Grace. "Art: Nam June Paik Has Show at Whitney (Ann Sperry, Lerner Heller Gallery)." The New York Times (Friday, May 7, 1982) p. C22.
Olson, J. M. Roberta. "Arts Reviews: Ann Sperry." Arts Magazine vol. 49 no. 2 (October 1974) pp. 68-69.
Stein, Judith E. "Flowering: The Recent Sculpture of Ann Sperry." Arts Magazine vol. 56 no. 8 (April 1982) pp. 68-69, illus.
Tannenbaum, Judith. "Arts Reviews: Carol Kreeger Davidson/Leah Rhodes/Ann Sperry." Arts Magazine vol. 52 no. 7 (March 1978) p. 21.

Gallery Affiliation
Smith Andersen Gallery
200 Homer Avenue
Palo Alto, California 94301

Mailing Address
115 Central Park West
New York, New York 10023

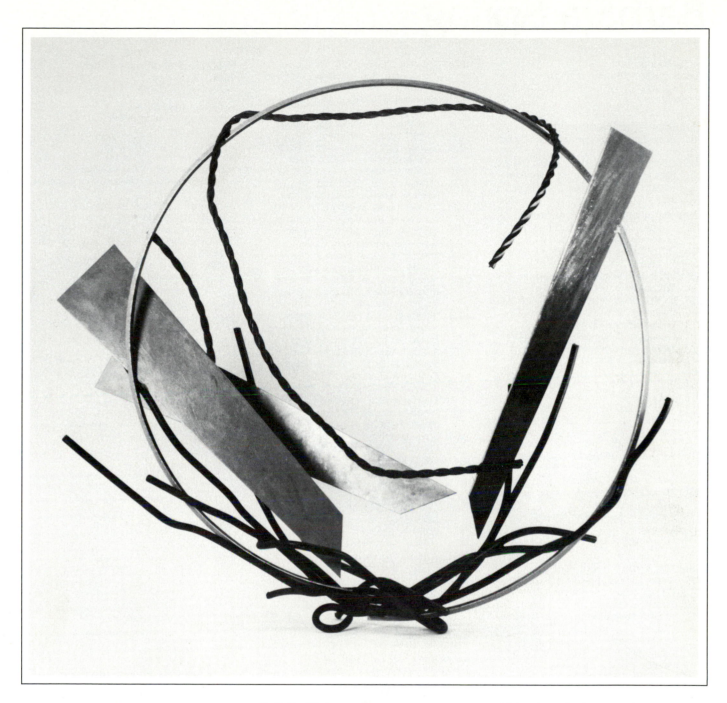

Riverrun III. 1981. Welded and painted steel, 53½"h x 59½"w x 18"d. Collection Peat, Marwick, Mitchell, Denver, Colorado. Photograph by Don Hunstein.

Artist's Statement

"I work in rusted and welded steel— arrangements of cut and bent elements in seemingly fragile configurations. I find the materials for my work in junkyards, scrap piles and supply houses. My scavenging explorations relate to my childhood when I often accompanied my mother in her hunt for fabrics.

"Steel, for me, expresses the patterns of life and growth. It is an exciting medium which enables me to create fluid, organic unfolding forms. I enjoy coupling industrial steel with soft pastel and metallic color which softens the forms and introduces a textural quality and an element of illusiveness."

545

Barbara Spring

née Barbara Jackson
(Husband William Whelan Spring)
Born February 16, 1917 Essex, Great Britain
(British citizenship)

Education and Training
1934 Gravesend School of Art, Kent, Great Britain
1935- Central School of Art, London, Great
39 Britain; study in sculpture with John Sagar

Selected Individual Exhibitions
1962 Lucien Labaudt Gallery, San Francisco, California
1964 Hollis Gallery, San Francisco, California
1964 Richmond Art Center, Richmond, California
1966 E. B. Crocker Art Gallery, Sacramento, California
1972 William Sawyer Gallery, San Francisco, California, retrospective
1976, William Sawyer Gallery, San
79, Francisco, California
82,
85
1977 California State University Los Angeles, Los Angeles, California
1977 Berkeley Art Center, Berkeley, California
1978 Monterey Peninsula Museum of Art Association, Monterey, California
1980 Walnut Creek Civic Arts Gallery, Walnut Creek, California
1981 Newport Harbor Art Museum, Newport Beach, California
1983 Lambert-Miller Gallery, Phoenix, Arizona
1984 TLK Gallery, Costa Mesa, California

Selected Group Exhibitions
1970 "Expo '70," San Francisco Pavilion, Osaka, Japan
1970- "Small Sculpture from the United
72 States," Traveling Exhibition, National Collection of Fine Arts, Smithsonian Institution, International Art Programme, Washington, D.C., catalog

1971 "Centennial Exhibition," San Francisco Art Institute, San Francisco, California, catalog
1973 "Statements," Oakland Museum, Oakland, California, catalog
1974 "Sculpture '74," Esther Baer Gallery, Santa Barbara, California
1974 "Canaparo & Spring," Walnut Creek Civic Arts Gallery, Walnut Creek, California, catalog
1975 "Animals in Art," Craft and Folk Art Museum, Los Angeles, California
1975 "Contemporary Sculpture," Richmond Art Center, Richmond, California
1975 "Rainbow Show," William Sawyer Gallery, San Francisco, California
1976 "Images of Cups," Smith Andersen Gallery, San Francisco, California
1977 "Wood Sculpture of the Americas '77," Klee Wyck Park, Vancouver, British Columbia, Canada
1978 "Artists Working in Wood," Richard L. Nelson Gallery, University of California, Davis, Davis, California, catalog
1983 "Barbara Spring and Dolan Ellis," Scottsdale Center for the Arts, Scottsdale, Arizona
1983 "Barbara Spring and Irvin Tepper," TLK Gallery, Costa Mesa, California
1983 "All Dimensions," TLK Gallery, Costa Mesa, California
1984 "You Gotta Have Art," Laguna Beach Museum of Art, Laguna Beach, California
1984 "Return of the Narrative," Palm Springs Desert Museum, Palm Springs, California, catalog
1985 "Art in the San Francisco Bay Area, 1945-1980," Oakland Museum, Oakland, California, book

Selected Public Collections
Asher-Faure Gallery Permanent Collection, Los Angeles, California
Capitol Group, Los Angeles, California
City of San Francisco, McClarren Park, San Francisco, California
Home Savings & Loan, Beverly Hills, Los Angeles, California
Los Angeles County Museum of Art, Los Angeles, California
Monterey Peninsula Museum of Art Association, Monterey, California
Oakland Museum, Oakland, California
San Francisco Arts Commission, San Francisco, California
West Vancouver Public Library, West Vancouver, British Columbia, Canada

Selected Private Collections
David Anderson, New York, New York
Suzanne Muchnic, Los Angeles, California
Dr. and Mrs. Richard Newquist, Santa Ana, California
William Sawyer, San Francisco, California
Mr. and Mrs. E. V. Staude, Big Sur, California

Preferred Sculpture Media
Wood

Related Professions
Lecturer and Visiting Artist

Selected Bibliography
Albright, Thomas. Art in the San Francisco Bay Area, 1945-1980: An Illustrated History. Berkeley: University of California Press, 1985.
"A Woman For Wood." Artweek vol. 3 no. 14 (April 1, 1972) pp. 1, 12, illus.
Kehlman, Robert. "Barbara Spring's People." Artweek vol. 10 no. 21 (June 2, 1979) p. 14, illus.
Meilach, Dona Z. Woodworking: The New Wave. New York: Crown, 1981.

Gallery Affiliation
William Sawyer Gallery
3045 Clay Street
San Francisco, California 94115

Mailing Address
Big Sur, California 93920

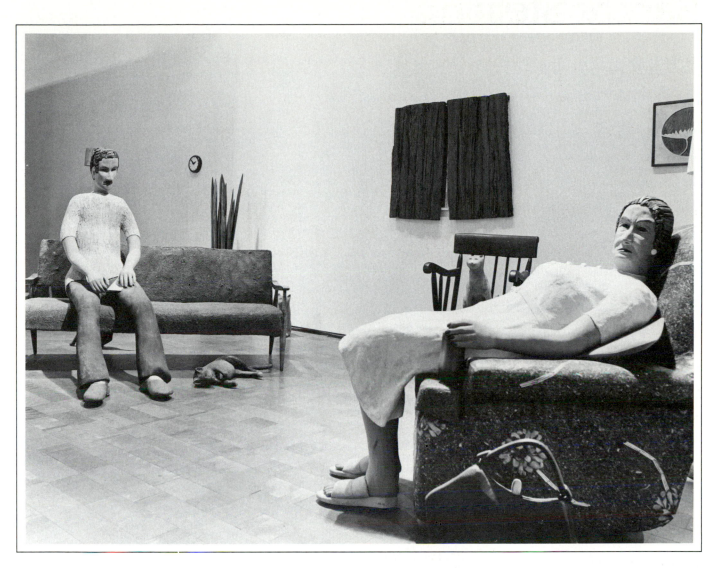

Willie Visits His Mother. 1977-1981. Wood, 12'h x 20'w x 15'd. Installation view 1981. Newport Harbor Art Museum, Newport Beach, California. Photograph by Mark P. Chamberlain.

Artist's Statement

"I had never worked in wood until I came to this country. I had what might be called an old-fashioned art training in England. We started out with modeling and worked mainly with the human form, doing our carving in stone. When I found an old railroad tie and did my first wood sculpture, it had an entirely different feel.

"I have not finished what I want to say with wood; it is an inexhaustible medium as far as I am concerned. When I find a different kind of wood or a different source of supply, it opens up all sorts of ideas. I also like to explore many variations of the same theme in my work and one piece will often lead to more of a similar type.

"If I were asked what I was trying to say with my sculpture, what meaning it has, I could not always tell you. I work because I have this tremendous push and desire to do sculpture. When I am alone and working, that is the most joyful thing of all."

Barbara Spring

Sandy Stein

née Sandra Jean
Born March 27, 1946 Dallas, Texas

Education and Training
1964- University of Texas at Austin,
65 Austin, Texas; premedical training
1965- Washington University, St. Louis,
66 Missouri; premedical training
1979 B.F.A., Sculpture, University of Texas at Dallas, Dallas, Texas
1981 Bethany College, Lindsborg, Kansas; study in sculpture
1982 American Academy of Paros, Paros, Greece; study in sculpture
1984 Independent study and research in France and Spain

Selected Individual Exhibitions
1981 University of Texas at Dallas, Richardson, Texas
1984, Foster Goldstrom Fine Arts, Dallas,
85 Texas
1984 Exposure Gallery, Dallas, Texas
1984 San Jacinto Tower Plaza, Dallas, Texas
1985 Rizzoli Gallery, Dallas, Texas
1985 Dallas Public Library, Dallas, Texas
1986 National Gallery and Alexander Soutzos Museum, Athens, Greece

Selected Group Exhibitions
1978 "Texas Fine Arts Association State Citation Show," Laguna Gloria Art Museum, Austin, Texas
1979 "Fifth Biennial Art Exhibition," Hayes Gallery, Port Arthur, Texas
1979 "Annual Delta Art Exhibition," Arkansas Arts Center, Little Rock, Arkansas, catalog
1979 "500 Exhibition Invitational," 500 Exposition Gallery, Dallas, Texas
1980 "Visual Arts/Performing Arts Benefit," Dallas Theater Center, Dallas, Texas
1983 "Third Annual Connemara Sculpture Exhibition," Connemara Conservancy, Allen, Texas
1983 "Fourth Texas Sculpture Symposium," Area Galleries and Institutions, Austin, Texas (Sponsored by College of Fine Arts and Humanities, University of Texas at Austin, Austin, Texas)
1983 "Icons of Contemporary Art," Foster Goldstrom Fine Arts, Dallas, Texas, catalog
1984 "Sandy Stein and Carl Andre," Richland College, Dallas, Texas
1984 "Outdoor Sculpture II," San Antonio Art Institute, San Antonio, Texas
1984 "Stein/Pepper: New Works," Manor House Gallery, Dallas, Texas
1985 "Fifth Texas Sculpture Symposium," Sited throughout Central Business District, Dallas, Texas and Connemara Conservancy, Allen, Texas (Sponsored by Texas Sculpture Symposium, Dallas, Texas), catalog
1985 "Art In The Metroplex," Texas Christian University, Fort Worth, Texas

Selected Public Collections
City of Dallas, Texas
Dallas Museum of Art, Dallas, Texas
Graphic Design Architects, Dallas, Texas
Hubbard, Thurman, Turner, Tucker and Glaser, Dallas, Texas
Lindemann Properties, Dallas, Texas
Mercantile National Bank, Dallas, Texas
Michael F. Puzzulli Law Office, Dallas, Texas
Randall L. Freedman Law Office, Dallas, Texas
San Antonio Art Institute, San Antonio, Texas
Southland Corporation, Dallas, Texas
Southmark Corporation, Dallas, Texas
Trammell Crow Company, Dallas, Texas

Selected Private Collections
William Armstrong, Dallas, Texas
Mr. and Mrs. James Clark III, Dallas, Texas
Mr. and Mrs. Foster Goldstrom, Dallas, Texas
Judith Kovisars, Dallas, Texas
Mr. and Mrs. David Orman, Dallas, Texas

Selected Awards
1983 Grant for Site Specific Work, Connemara Conservancy Foundation, Allen, Texas
1983 Recognition Award, "Fourth Texas Sculpture Symposium," Women & Their Work, Austin, Texas

Preferred Sculpture Media
Stone and Varied Media

Selected Bibliography
Albritton, Jane. "Reviews: The Third Annual Sculpture Exhibition at Connemara Conservancy Near Dallas, Texas." *Artspace* vol. 7 no. 3 (Summer 1983) pp. 68-69, illus.
Ennis, Michael. "Public Gestures." *Texas Monthly* (May 1985) pp. 172, 174–175.
Papers included in the Archives of American Art, Smithsonian Institution, New York, New York.

Gallery Affiliation
Foster Goldstrom Fine Arts
2722 Fairmount
Dallas, Texas 75201

Mailing Address
1200 Biscayne
Plano, Texas 75075

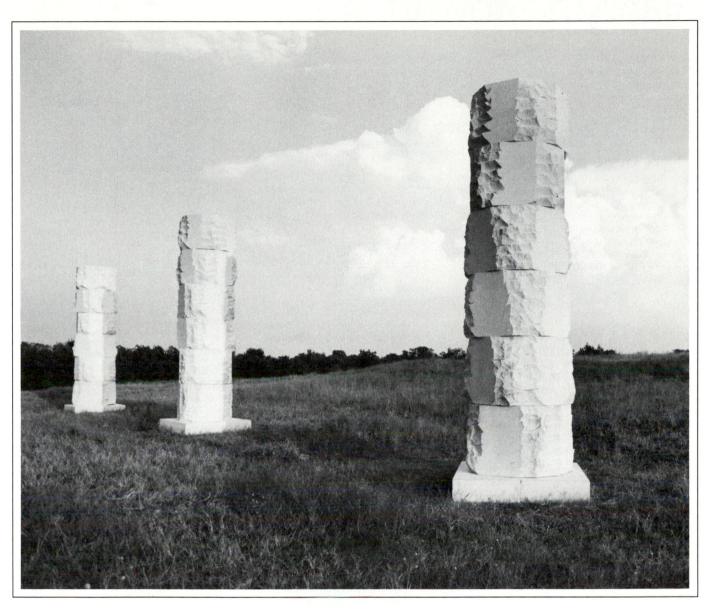

Gates of Hercules. 1983. Texas limestone, 12'h x
3'w x 3'd. Photograph by Raoul Schlepmann.

Artist's Statement

"I am a builder; my sculpture is architectonic
in nature. I am attempting to bridge that
area where sculpture and architectural
structure come together. My work is a direct
result of my major in classical studies and
my sojourns in Greece. The sculpture is
simple yet intellectual in nature. I utilize a
minimum number of tools to produce the
greatest spontaneity in a minimum amount of
time. The simplest shaping of broken versus
smooth surfaces creates the most dramatic
shadows of dark and light.

"Only stone, a classical medium, will
respond to my touch the way that I want
and produce the rugged, dramatic effect
that I intend. The material allows me to build
in modular units, both horizontally and
vertically, in a variety of interchangeable
configurations. Stone is the basic material of
our planet and will endure through the ages."

Sandy Stein

Hannah Stewart

Born February 7, 1929 Birmingham, Alabama

Education and Training
1950 B.F.A., Painting and Ceramic Sculpture, University of Montevallo, Montevallo, Alabama
1955 M.F.A., Ceramics and Design/Metalsmithing, Cranbrook Academy of Art, Bloomfield Hills, Michigan; study in ceramics with Maija Grotell; study in design/metalsmithing with Richard Thomas
1959-60 St. Petersburg Industrial School, St. Petersburg, Florida; study in welding with Thomas James
1961 Fundición Gonzales, Guanajuato, México; study in bronze casting with Ricardo Gonzales
1968 Frank Colson Workshop, Sarasota, Florida; study in bronze shell casting
1978 Studio of L. C. Burns, Prescott, Arizona; study in woodcarving

Selected Individual Exhibitions
1956 Beaumont Art Museum, Beaumont, Texas
1966 David Gallery, Houston, Texas
1967 Dubose Gallery, Houston, Texas, catalog
1967, 68, 69 Circle Gallery, New Orleans, Louisiana
1970 River Oaks Bank, Houston, Texas, catalog
1970 Birmingham Museum of Art, Birmingham, Alabama

1971 Fairmont Gallery, Dallas, Texas, catalog
1974 Jamison Gallery, Santa Fe, New Mexico
1975 First City National Bank, Houston, Texas
1975 Contemporary Arts Museum, Houston, Texas, catalog
1979 University of St. Thomas, Houston, Texas
1982 Texas Eastern Corporation, One Houston Center, Houston, Texas
1984 Hooks-Epstein Gallery, Houston, Texas, catalog

Selected Group Exhibitions
1964 "Texas Painting and Sculpture Exhibition," Traveling Exhibition, Dallas Museum of Fine Arts, Dallas, Texas, catalog
1966 "Creative Collaboration," Rice University, Houston, Texas
1966 "Artists of the Southeast and Texas," Isaac Delgado Museum of Art, New Orleans, Louisiana, catalog
1968 "Versatile Shell," Museum of Fine Arts, Houston, Houston, Texas
1968 "For All Mankind," Hermann Park, Houston, Texas (Sponsored by Museum of Fine Arts, Houston, Houston, Texas)
1976 "Seventeen Houston Women," Contemporary Arts Museum, Houston, Texas
1977 "Content," Museum of Modern Art Gallery, Houston, Texas
1977, 78, 79 "Faculty Exhibition," University of St. Thomas, Houston, Texas
1977 "Women in Art, International Women's Year," Alley Theatre, Houston, Texas
1979 "Fire: One Hundred Texas Artists," Contemporary Arts Museum, Houston, Texas, catalog
1980 "Five Sculptors," Texas Bank of Commerce, Houston, Texas
1985 "The New Nude," Midtown Art Center, Houston, Texas, catalog

Selected Public Collections
Brice Construction Company, Birmingham, Alabama
City of Dallas, Samuels Park, Dallas, Texas
City of Houston, Miller Theatre, Hermann Park, Houston, Texas
Cranbrook Academy of Art Museum, Bloomfield Hills, Michigan
Cranbrook Foundation, Bloomfield Hills, Michigan
Eduardo Valesca Enterprises, México, D.F., México
First City National Bank, Dallas, Texas
Harte & Hanks Communications, Mercantile Bank Building, San Antonio, Texas
Lakeside Shopping Center, New Orleans, Louisiana
San Antonio Museum of Art, San Antonio, Texas
University of St. Thomas, Houston, Texas

World Trade Center, Houston, Texas
Collection Port of Houston, Texas

Selected Private Collections
Bill Blass, New York, New York
Mr. and Mrs. James Harithas, Houston, Texas and New York, New York
Mr. and Mrs. Charles Kohlmeyer, New Orleans, Louisiana
Mr. and Mrs. George Mitchell, Houston, Texas
Eduardo Valseca, México, D.F., México

Preferred Sculpture Media
Metal (cast), Metal (welded) and Varied Media

Selected Bibliography
Fuermann, George Melvin. *The Face of Houston.* Houston: Press of Premier, 1963.
A Marmac Guide to Houston and Galveston. Atlanta: Marmac Publishing, 1983.
Papers included in the Archives of American Art, Smithsonian Institution, New York, New York.

Mailing Address
3518 Garrott
Houston, Texas 77006

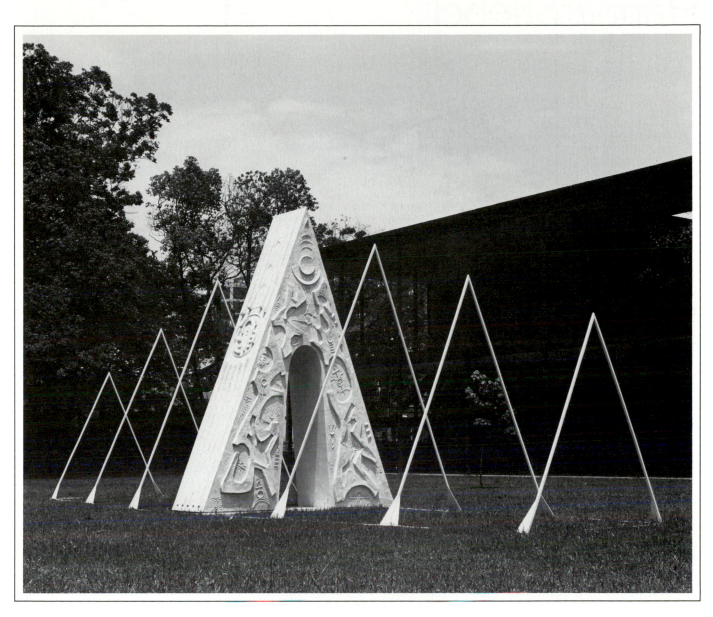

Passage. 1979. Concrete and steel, 13'h x 10'w x 34'd. Collection University of St. Thomas, Houston, Texas. Photograph by Hickey & Robertson.

Artist's Statement

"When I was eight years old, I asked my mother what the wind really looked like. I remember spending hours . . . days . . . sitting with my hands open wide or running with my lightning-bug jar, hoping to catch the wind. I wanted to SEE the wind, that magical force that could bend the huge oak tree in a summer storm, gently caress me on a hot summer day or sing to me as it played through a tree or around the house.

"This early interest in natural forces has sustained me throughout my life as a sculptor. My goal is to render visible the hidden realities of pent-up, contained energy. The direct fields of reference are astronomy, philosophy and astrophysics. Each sculpture is an energy form, a movement arrested in space, a form sustaining an energy. My work is a response to these patterns and delineations and communicates with viewers through the universality of symbolism and form."

Hannah Stewart

Hanna Stiebel

née Hanna Nosovsky
(Husband Ariel Stiebel)
Born April 21, 1923 Tel Aviv, Israel

Education and Training
1955- New School for Social Research,
56 New York, New York; study in
sculpture with Manolo Pasqual
1962 B.F.A., Sculpture, Cranbrook Academy
of Art, Bloomfield Hills, Michigan;
study with Berthold Schiwetz
1963 M.F.A., Sculpture, Cranbrook
Academy of Art, Bloomfield Hills,
Michigan; study with Julius Schmidt
1963- Università degli Studi di Firenze,
64 Florence, Italy; research in bronze
casting with Bruno Bearzi
1975- Wayne State University, Detroit,
76 Michigan; study in museology

Selected Individual Exhibitions
1966 University of Michigan Museum of Art,
Ann Arbor, Michigan, catalog
1971 Somerset Mall, Troy, Michigan
1971 London Arts Gallery, Birmingham,
Michigan
1972 London Arts Gallery, New York, New
York
1975 LeBel Fine Arts Gallery, University of
Windsor, Windsor, Ontario, Canada,
catalog
1976 Samuel Stein Fine Arts, Chicago,
Illinois, catalog
1976 London Arts Gallery, Atlanta, Georgia
1979 Gallery Renaissance, Detroit,
Michigan, catalog
1985 London Arts Gallery, Detroit, Michigan

Selected Group Exhibitions
1966 "Fifty-Sixth Exhibition for Michigan
Artists," Detroit Institute of Arts,
Detroit, Michigan, catalog
1972 "Cranbrook Academy of Art Gallery
Go," Traveling Exhibition, Area
Galleries, Birmingham, Michigan
1976 "Gallery Artists," London Arts Gallery,
Detroit, Michigan, catalog
1976 "Michigan Collects Michigan Art,"
Pontiac Art Center, Pontiac, Michigan,
catalog
1981 "Meadow Brook Invitational I: Outdoor
Sculpture," Meadow Brook Art Gallery,
Rochester, Michigan
1981 "National Sculpture Competition
Exhibition," Phoenix Center, Pontiac,
Michigan
1982 "Southfield Invitational Competition,"
City of Southfield, Michigan
1984 "Studio Artists of Pontiac Exhibit,"
Pontiac Art Center, Pontiac, Michigan

Selected Public Collections
Alsar Aluminum Company, Detroit, Michigan
Bank of the Commonwealth, Detroit,
Michigan
Blue Cross and Blue Shield Building, Detroit,
Michigan
City of Detroit, Harmony Park, Detroit,
Michigan
City of Pontiac, Phoenix Center Pedestrian
Plaza, Pontiac, Michigan
George Meany Center for Labor Studies,
Silver Spring, Maryland
Illinois-Central Building, Chicago, Illinois
Interlochen Music Academy, Interlochen,
Michigan
Lake Fairlee Art Camp, Lake Fairlee,
Vermont
Meadow Brook Art Gallery Sculpture Park,
Rochester, Michigan
Northland Geriatric Hospital, Detroit,
Michigan
Renaissance Center, Detroit, Michigan
Somerset Mall, Troy, Michigan
Temple Kol-Ami, West Bloomfield, Michigan

Selected Private Collections
Mr. and Mrs. Martin Bader, Bloomfield Hills,
Michigan
James Fitzpatrick, Orchard Link, Michigan
Henry Ford II, Dearborn, Michigan
George D. Rogers, New York, New York
F. Rossi, Florence, Italy

Selected Awards
1981 Finalist, "National Sculpture
Competition Exhibition," Phoenix
Center, Pontiac, Michigan
1981 Winner, "Meadow Brook Invitational I:
Outdoor Sculpture Competition,"
Meadow Brook Music Festival,
Oakland University, Rochester,
Michigan
1982 Winner, "Artists Equity Sculpture
Competition Exhibition," George
Meany Center for Labor Studies,
Silver Spring, Maryland, catalog

Preferred Sculpture Media
Metal (cast) and Metal (welded)

Additional Art Field
Painting

Selected Bibliography
Nawrocki, Dennis Alan with Thomas J.
Holleman. Art in Detroit Public Places.
Detroit: Wayne State University Press,
1980.
Redstone, Louis G. New Dimensions in
Shopping Centers and Stores. New York:
McGraw Hill, 1973.
Redstone, Louis G. and Ruth R. Redstone.
Public Art: New Directions. New York:
McGraw-Hill, 1981.

Gallery Affiliation
Meadow Brook Art Gallery
Oakland University
Rochester, Michigan 48063

Mailing Address
88 Marlborough
Bloomfield Hills, Michigan 48013

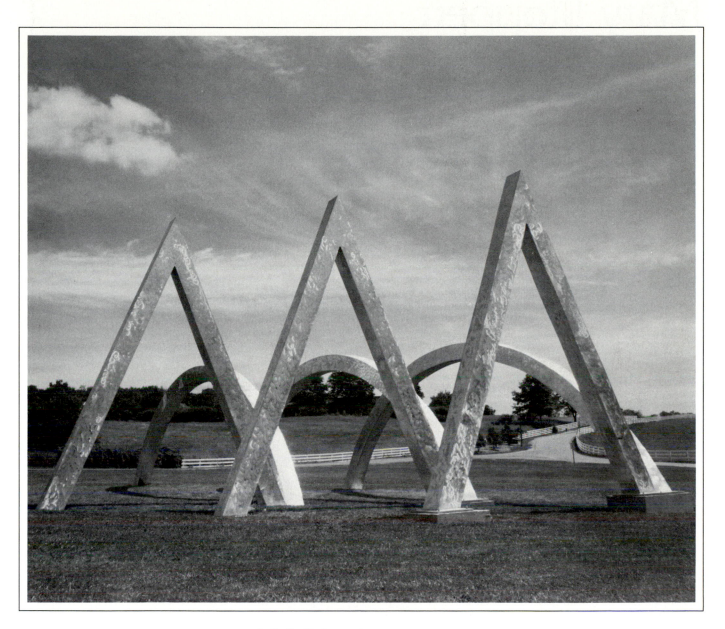

Rhythms and Vibrations. 1981. Aluminum, 24'h x 56'w x 36'd. Collection Meadow Brook Art Gallery Sculpture Park, Rochester, Michigan. Photograph by Benyas-Kaufman.

Artist's Statement

"As a sculptor, I would like to contribute to the formation of the human and emotional environment by aesthetic means. The main concept of my work, like life itself, must have vitality, rhythm, tension, strength and movement. While retaining a complete independence in the creation of my sculpture, it is imperative to find a rapport with the human, environmental and architectural surroundings."

Mary Stoppert

née Mary Kay
Born August 19, 1941 Flint, Michigan

Education and Training
1964　B.S., Art, Western Michigan University, Kalamazoo, Michigan
1964-　Wayne State University, Detroit,
65　Michigan
1968　M.F.A., Sculpture, School of the Art Institute of Chicago, Chicago, Illinois

Selected Individual Exhibitions
1977　Women's Interart Center, New York, New York
1978　Festival Gallery, Krannert Center for Performing Arts, University of Illinois at Urbana-Champaign, Urbana, Illinois
1979　Marianne Deson Gallery, Chicago, Illinois
1980　Museum of Nations, Illinois State University, Normal, Illinois
1980　Space Gallery, Western Michigan University, Kalamazoo, Michigan
1981　Northeastern Illinois University, Chicago, Illinois
1982,　Phyllis Kind Gallery, Chicago, Illinois
84
1982　New Museum, New York, New York, catalog

Selected Group Exhibitions
1975　"Six Contemporary Sculptors," Northern Illinois University, DeKalb, Illinois
1976　"Abstract Art in Chicago," Museum of Contemporary Art, Chicago, Illinois, catalog
1976　"Painting and Sculpture Today 1976," Indianapolis Museum of Art, Indianapolis, Indiana, catalog
1976　"Women Artists: Here and Now," O'Shaughnessy Gallery, University of Notre Dame, Notre Dame, Indiana, catalog
1977　"The Challenge of New Ideas: Contemporary Chicago Sculpture," Kalamazoo Institute of Arts, Kalamazoo, Michigan, catalog

1978　"Chicago: The City and Its Artists 1945-1978," University of Michigan, Ann Arbor, Michigan, catalog
1978　"Chicago Abstractionists: Romanticized Structures," Traveling Exhibition, University of Missouri-Kansas City Art Gallery, Kansas City, Missouri, catalog
1978　"Seven Sculptors," DePaul University, Chicago, Illinois, catalog
1979　"Abstractionists from Chicago," Ukrainian Institute of Modern Art, Chicago, Illinois, catalog
1979　"New Dimensions: Volume and Space," Museum of Contemporary Art, Chicago, Illinois, catalog
1979　"Chicago and Vicinity: Prizewinners Revisited," Art Institute of Chicago, Chicago, Illinois, catalog
1980　"American Women Artists 1980," Museu de Arte Contemporânea da Universidade de São Paulo, São Paulo, Brazil, catalog
1982　"Androgyny in Art," Emily Lowe Gallery, Hempstead, New York, catalog
1983-　"Chicago: Some Other Traditions,"
86　Traveling Exhibition, Madison Art Center, Madison, Wisconsin, catalog
1984　"Alternative Spaces: A History in Chicago," Museum of Contemporary Art, Chicago, Illinois, catalog
1985　"Sculpture-Overview 1985," Evanston Art Center, Evanston, Illinois, catalog

Selected Public Collections
Michael C. Rockefeller Arts Center Gallery, Fredonia, New York
Museum of Contemporary Art, Chicago, Illinois
Northern Illinois University, DeKalb, Illinois

Selected Private Collections
Robert Lewis, Chicago, Illinois
Albert A. List Family Collection, Greenwich, Connecticut
Jim Nutt, Wilmette, Illinois

Selected Awards
1974　Mr. and Mrs. Frank G. Logan Prize, "Seventy-Fifth Exhibition by Artists of Chicago and Vicinity," Art Institute of Chicago, Chicago, Illinois, catalog
1977　John G. Curtis, Jr. Prize, "Seventy-Sixth Exhibition by Artists of Chicago and Vicinity," Art Institute of Chicago, Chicago, Illinois, catalog
1979　Presidential Merit Award, Northeastern Illinois University, Chicago, Illinois

Preferred Sculpture Media
Varied Media and Wood

Additional Art Fields
Contemporary Art Issues and Drawing

Teaching Position
Professor of Art, Northeastern Illinois University, Chicago, Illinois

Selected Bibliography
Day, Holliday T. "Report from Chicago, Vital Signs: Drawing Invitational." Art in America vol. 66 no. 6 (November-December 1978) pp. 38-39, illus.
Glueck, Grace. "Art: Kiesler's 'Galaxy,' Surrealist Opera Set." The New York Times (Friday, June 18, 1982) p. C27.
Morrison, C. L. "Reviews Chicago: Richard Artschwager, Walter Kelly Gallery; Cletus Johnson, Chicago Arts Club; Mary Stoppert, Deson-Zaks Gallery." Artforum vol. 14 no. 8 (April 1976) pp. 78-79, illus.
Schjeldahl, Peter. "Letter from Chicago." Art in America vol. 64 no. 4 (July-August 1976) pp. 52-58, illus.
Stein, Judith E. "Contemporary Issues: Works on Paper by Women." Art Journal vol. 36 no. 4 (Summer 1977) pp. 328-329.

Gallery Affiliation
Phyllis Kind Gallery
313 West Superior Street
Chicago, Illinois 60610

Mailing Address
1949 West Wabansia Street
Chicago, Illinois 60622

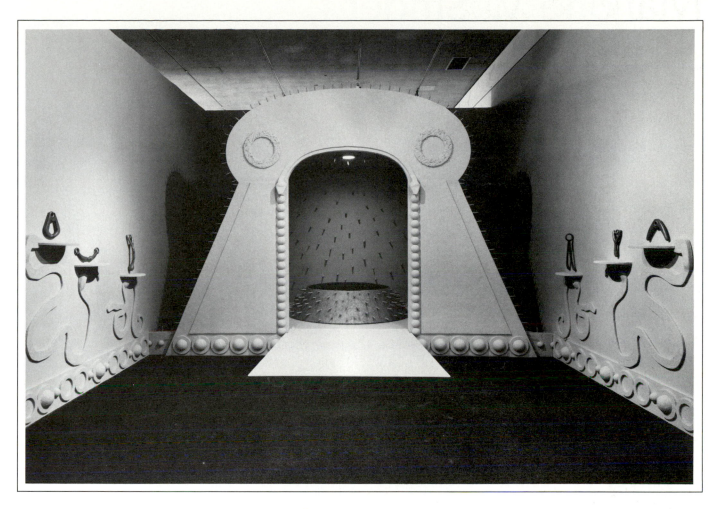

Queen's Ring within the Temple. 1982. Mixed media, 8'h x 8'w x 8'd. Installation view 1982. New Museum, New York, New York, catalog. Courtesy Phyllis Kind Gallery, Chicago, Illinois. Photograph by David Lubarsky.

Artist's Statement

"In 1980 I traveled to Latin America to study archaeological sites. As a composite of that experience, I created an outdoor sculpture called *Queen's Ring—Marcia's Piece* composed of earth molded into the form of a collar surrounding an earthen mound. The ring shape and the spikes protruding from it were incorporated into a sculptural series of devices or tools designed to hold or display the 'ring.' These objects may have been ceremonial artifacts retrieved from the original mound. The round earthen ring became the central theme of a narrative environment, the *Queen's Ring*, symbolizing the religion and culture of a mythical queen. My current pieces describe the queen herself and use her hand to define her many personalities."

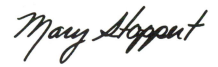

Marjorie V. Strider

née Marjorie Virginia
Born January 26, 1939 Guthrie, Oklahoma

Education and Training
1962 B.A., Fine Arts, Kansas City Art
Institute, Kansas City, Missouri

Selected Individual Exhibitions
1965, Pace Gallery, New York, New York
66
1973, Nancy Hoffman Gallery, New York,
74 New York
1974 Weatherspoon Art Gallery,
Greensboro, North Carolina
1976 Graduate Center Mall, City University
of New York, City College, New York,
New York
1976 The Clocktower, New York, New York
1978 Colby-Sawyer College, New London,
New Hampshire
1982- Myers Fine Arts Gallery, State
85 University of New York College at
Plattsburgh, Plattsburgh, New York,
Traveling Exhibition to galleries and
museums throughout the United
States, retrospective and catalog
1983 Sculpture Center, New York, New
York; P.M. and Stein Gallery, New
York, New York
1983, Bernice Steinbaum Gallery, New York,
84 New York

Selected Group Exhibitions
1963 "Images-New-Real," University of
Massachusetts at Amherst, Amherst,
Massachusetts
1964 "First International Girlie Exhibition,"
Pace Gallery, New York, New York
1965 "New American Realism," Worcester
Art Museum, Worcester,
Massachusetts
1969 "The Dominant Woman," Finch College
Museum of Art, New York, New York,
catalog
1970 "Light and Motion," Hudson River
Museum, Yonkers, New York, catalog
1970 "1970 Annual Exhibition:
Contemporary American Sculpture,"
Whitney Museum of American Art,
New York, New York, catalog
1971 "Andre, Strider, Castoro," 112 Greene
Street Gallery, New York, New York
1971 "Twenty-Six by Twenty-Six," Vassar
College Art Gallery, Poughkeepsie,
New York, catalog
1972 "Unmanly Art," Suffolk Museum, Stony
Brook, New York, catalog
1972 "Outdoor Sculpture," Hamburger
Kunsthalle, Hamburg, Germany,
Federal Republic, catalog
1972 "Changing Times," Museum of Fine
Arts, Boston, Massachusetts, catalog
1973 "The Emerging Real," Storm King Art
Center, Mountainville, New York
1974 "Woman's Work: American Art 1974,"
Museum of the Philadelphia Civic
Center, Philadelphia, Pennsylvania,
catalog

1975 "Bicentennial Exhibition," Indianapolis
Museum of Art, Indianapolis, Indiana,
catalog
1975 "Outdoor Sculpture," Storm King Art
Center, Mountainville, New York
1976 "Allusions: Gianakos, Schmidt, Strider,"
Fine Arts Gallery, University of
Colorado at Boulder, Boulder,
Colorado, catalog
1976 "American Artists '76: A Celebration,"
Marion Koogler McNay Art Institute,
San Antonio, Texas, catalog
1977 "Women's Art Symposium," Rutgers
University, University College-Camden,
Camden, New Jersey
1977 "Copper, Brass, Bronze," University of
Arizona, Tucson, Arizona
1977 "Ten Years of Ten Downtown," P.S. 1,
Institute for Art and Urban Resources,
Long Island City, New York
1978 "Art of the 70s," P.S. 1, Institute for
Art and Urban Resources, Long Island
City, New York, catalog
1978 "Out of the House," Whitney Museum
of American Art, Downtown Branch,
New York, New York
1978 "90 by 30: A Festival of Small
Sculpture," Martha Jackson Gallery,
New York, New York, catalog
1979 "A.R.E.A. Sculpture—Ward's Island,"
Manhattan Psychiatric Center, Ward's
Island, New York, catalog
1979 "Outdoor Sculpture Show," Foley
Square, New York, New York
1980 "Magical Realism," Aldrich Museum of
Contemporary Art, Ridgefield,
Connecticut, catalog
1980 "Outdoor Sculpture Competition,"
Scottsdale Center for the Arts,
Scottsdale, Arizona
1981 "Decorative Sculpture," Sculpture
Center, New York, New York
1981 "Alternative Spaces," New Museum,
New York, New York
1981, "Outdoor Sculpture Exhibition," C. W.
83 Post Center of Long Island University,
Greenvale, New York
1982 "Group Show," Gloria Luria Gallery,
Bay Harbor Islands, Florida
1982- "Art Materialized: Selections from the
83 Fabric Workshop," Traveling
Exhibition, Institute of Contemporary
Art of The University of Pennsylvania,
Philadelphia, Pennsylvania, catalog
1983 "Terminal New York," Brooklyn Army
Terminal, Brooklyn, New York
1984 "American Bronze Sculpture: 1850 to
the Present," Newark Museum,
Newark, New Jersey, catalog
1985 "A New Beginning 1968-1978," Hudson
River Museum, Yonkers, New York,
New York, catalog

Selected Public Collections
Albright-Knox Art Gallery, Buffalo, New York
Aldrich Museum of Contemporary Art,
Ridgefield, Connecticut
Des Moines Art Center, Des Moines, Iowa
Graduate Center, City University of New
York, City College, New York, New York

Hirshhorn Museum and Sculpture Garden,
Smithsonian Institution, Washington, D.C.
Marion Koogler McNay Art Institute, San
Antonio, Texas
New York University, New York, New York
Solomon R. Guggenheim Museum, New
York, New York
Storm King Art Center, Mountainville, New
York
Wadsworth Atheneum, Hartford, Connecticut

Selected Private Collections
Theodore Kheel, New York, New York
Sol LeWitt, New York, New York
Albert A. List Family Collection, Greenwich,
Connecticut
I. M. Pei, New York, New York
Mr. and Mrs. Burton Tremaine, Greenwich,
Connecticut

Selected Awards
1973 Longview Foundation Grant
1974, Individual Artist's Fellowship,
81 National Endowment for the Arts

Preferred Sculpture Media
Metal (cast), Metal (welded) and Varied
Media

Additional Art Field
Drawing

Teaching Position
Sculpture Instructor, School of Visual Arts,
New York, New York

Selected Bibliography
Henry, Gerrit. "Review of Exhibitions New
York: Marjorie Strider at P. M. & Stein and
The Sculpture Center." Art in America vol.
71 no. 4 (April 1983) pp. 177-178, illus.
Henry, Gerrit. "Marjorie Strider." Arts
Magazine vol. 59 no. 2 (October 1984) p.
4, illus.
Hunter, Sam. American Art of the 20th
Century. New York: Harry N. Abrams,
1972.
Kuspit, Donald B. "Strider's Projecting
Presences." Art in America vol. 64 no. 3
(May-June 1976) pp. 88-89, illus.
Lippard, Lucy R. From the Center: Feminist
Essays on Women's Art. New York: E. P.
Dutton, 1976.

Gallery Affiliation
Bernice Steinbaum Gallery
132 Greene Street
New York, New York 10012

Mailing Address
7 Worth Street
New York, New York 10013

Artist's Statement

"I have attempted in my twenty-year career as an artist to search for the new. In the early 1960s I became dissatisfied with the flat plane of the canvas and started building out from the surface; however, the three-dimensional work always had a painted surface. My refusal to deal with any subject matter which I cannot handle life-size has, in turn, led me back to painting and drawing.

"I have always used forms drawn from my home and household and everyday life situations and perceptions. My primary concerns have been movement and time . . . the action that has just occurred . . . whether it has been imposed upon fruit, flowers, vegetable imagery, windows, water, brooms, Greek vases, brand-name boxes, words, landscape elements or figures. Experimentation in medium and in meaning have been my sculptural guidelines. It is too soon to know if I have achieved my goals and contributed to the history of art."

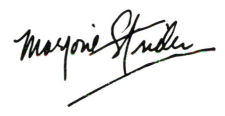

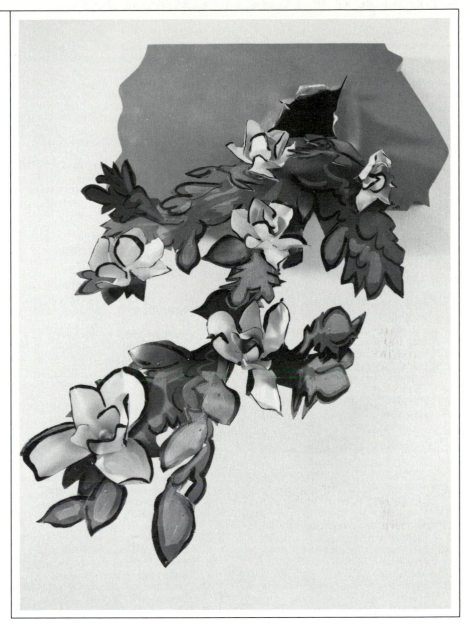

Deep South. 1984. Painted aluminum, 60"h x 40"w x 46"d. Photograph by Erik Landsberg.

Gisela-Heidi Strunck

née Gisela-Heidi Müller
(Husband Juergen Strunck)
Born September 17, 1945 Deggendorf,
Germany, Federal Republic

Education and Training
1962- Universidad Complutense de Madrid,
63 Madrid, Spain; study in literature and
 philosophy
1963- Università degli Studi di Firenze,
64 Florence, Italy; study in literature and
 philosophy
1964- Ethnikon Kai Kapodistriakon
65 Panepistimion Athinon, Athens,
 Greece; study in literature and
 philosophy
1965- Universitetet i Oslo, Oslo, Norway;
66 study in literature and philosophy
1970- University of Dallas, Irving, Texas;
72 study in ceramics
1972- University of Dallas, Irving, Texas;
74 study in sculpture with Heri Bert
 Bartscht

Selected Individual Exhibitions
1976 Braniff Graduate Building, University
 of Dallas, Irving, Texas
1976 Tyler Museum of Art, Tyler, Texas,
 catalog
1977 D. W. Co-Op, Dallas, Texas
1977 Art Gallery, University of Wisconsin-
 Stout, Menomonie, Wisconsin
1979 Art Department Gallery, Midwestern
 State University, Wichita Falls, Texas
1980 The Art Center, Waco, Texas, catalog
1984 Connecticut College, New London,
 Connecticut
1985 Conduit Gallery, Dallas, Texas

Selected Group Exhibitions
1973 "North Texas Painting and Sculpture
 Exhibition," Dallas Museum of Fine
 Arts, Dallas, Texas
1973 "Richardson Civic Art Society Annual,"
 Richardson Public Library, Richardson,
 Texas
1974 "Group Exhibition," Smither Gallery,
 Dallas, Texas
1974 "John Daniel, James Allumbaugh, Karl
 Umlauf and Gisela-Heidi Strunck,"
 University of Texas at Arlington
 Library, Arlington, Texas
1975 "Women Artists," University Gallery,
 Austin College, Sherman, Texas

1976, "Annual Invitational Exhibition,"
80, Longview Museum and Arts Center,
81 Longview, Texas
1976, "Group Show," D. W. Co-Op, Dallas,
77 Texas
1977 "Three Dimensions by Area Artists,"
 University Gallery, University of Dallas,
 Irving, Texas
1978, "Dallas Art," Dallas City Hall, Dallas,
79 Texas
1978 "1-2-3-4-5," Tyler Museum of Art, Tyler,
 Texas
1979- "Women-in-Sight: New Art in Texas,"
81 Traveling Exhibition, Dougherty
 Cultural Arts Center, Austin, Texas,
 catalog
1979 "Arlington Art Association Annual,"
 Arlington Civic Center, Arlington,
 Texas
1980 "Women Artists in Residence," Gallery
 Aquinas, South Bend, Indiana
1981, "Group Exhibition," Clifford Gallery,
82, Dallas, Texas
83
1981 "Sixth Biennial Five State Art
 Exhibition," Port Authur Public Library,
 Port Arthur, Texas
1981 "National Council on Education for the
 Ceramic Arts Invitational," Wichita Art
 Museum, Wichita, Kansas
1982 "Tri-State Art Exhibition," Beaumont
 Art Museum, Beaumont, Texas,
 catalog
1983 "Fourth Texas Sculpture Symposium,"
 Area Galleries and Institutions, Austin,
 Texas (Sponsored by College of Fine
 Arts and Humanities, University of
 Texas at Austin, Austin, Texas)
1984 "Line, Color, Form and Texture,"
 Gateway Gallery, Dallas Museum of
 Art, Dallas, Texas
1984 "Made in Texas: Gisela-Heidi Strunck,
 Geoff Winningham and Joseph
 Almeda," Nimbus Gallery, Dallas,
 Texas
1984 "Sculpture Invitational," Connecticut
 College, New London, Connecticut
1984 "The Critics' Choice," D-Art Visual Art
 Center, Dallas, Texas
1984 "Twenty-Seventh Annual Delta Art
 Exhibition," Arkansas Arts Center,
 Little Rock, Arkansas, catalog
1984 "Currents '84," Ana's Kitchen Art
 Services, Hot Springs, Arkansas
1985 "Fifth Texas Sculpture Symposium,"
 Sited throughout Central Business
 District, Dallas, Texas and Connemara
 Conservancy, Allen, Texas (Sponsored
 by Texas Sculpture Symposium,
 Dallas, Texas), catalog
1985 "Texas Sculpture Association
 Membership Exhibition," Bath House
 Cultural Center, Dallas, Texas
1985 "Gisela-Heidi Strunck and Juergen
 Strunck," Brazos Gallery, Richland
 College, Dallas, Texas
1985 "Gisela-Heidi Strunck and Juergen
 Strunck," Weil Gallery, Corpus Christi
 State University, Corpus Christi, Texas

Selected Public Collections
First National Bank of Chicago, Dallas, Texas
IS, Incorporated, Mill Valley, California
University of Dallas, Irving, Texas

Selected Private Collections
Mr. and Mrs. Duncan Boeckman, Dallas,
 Texas
Mr. and Mrs. Eugene Elam, Dallas, Texas
Mr. and Mrs. Ike Griffin, Dallas, Texas
Mr. and Mrs. Patrick Kelly, Dallas, Texas
Mr. and Mrs. Guenther Weihe, Dallas, Texas

Selected Awards
1983 Merit Award, "Annual Invitational
 Exhibition," Longview Museum and
 Arts Center, Longview, Texas
1983 First Prize, "Seventh Biennial Five
 State Art Exhibition," Port Authur
 Public Library, Port Authur, Texas
1984 Best of Show, "Visions '84, Texas
 Sculpture Association Awards
 Exhibition," D-Art Visual Art Center,
 Dallas, Texas

Preferred Sculpture Media
Varied Media and Wood

Selected Bibliography
Kutner, Janet. "The Nation Dallas: Five
 Artists, Four Shows, Three Dimensions."
 Art News vol. 76 no. 3 (March 1977) pp.
 95-98.

Gallery Affiliation
Conduit Gallery
2814 Elm Street
Dallas, Texas 75226

Mailing Address
Box 1055
Grapevine, Texas 76051

Artist's Statement
"My sculptures are my artist's statement."

Gisela- Heidi Strunck

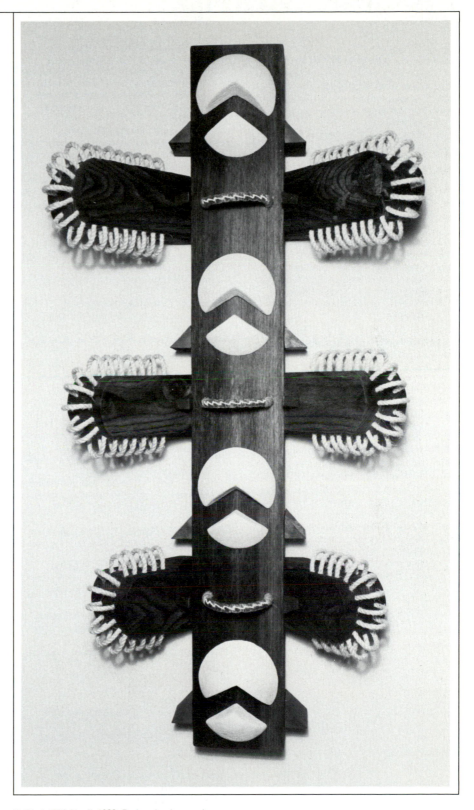

Untitled 1983 No. II. 1983. Red cedar, brass wire, clay, cast paper and sisal rope, 44"h x 22"w x 11"d. Photograph by Juergen Strunck.

Pamela Stump

née Mary Pamela
Born July 8, 1928 Detroit, Michigan

Education and Training
1946, Cranbrook Academy of Art, Bloomfield
47 Hills, Michigan; study in sculpture with Carl Milles
1948, Studio of Marshall Fredericks,
49 Birmingham, Michigan; study in sculpture
1951 B.D., Design, University of Michigan, Ann Arbor, Michigan; study in sculpture with Thomas McClure
1951 M.D., Design, University of Michigan, Ann Arbor, Michigan; additional study with Thomas McClure
1967- Oakland University, Rochester,
68 Michigan
1970 Kindergarten, Elementary and Secondary Education Certification, Art, English and Social Studies, University of Michigan, Ann Arbor, Michigan

Selected Individual Exhibitions
1949, Kingswood School Cranbrook,
50, Bloomfield Hills, Michigan
69
1952 Little Bohemia Gallery, St. Louis, Missouri
1963 United Presbyterian Assembly, Des Moines, Iowa
1963 Raven Gallery, Detroit, Michigan
1972 Sommerset Mall, Troy, Michigan
1978 Northwestern Michigan College, Traverse City, Michigan

Selected Group Exhibitions
1950, "Annual Exhibition for Michigan
56, Artists," Detroit Institute of Arts,
59 Detroit, Michigan, catalog
1951 "Sixteenth Annual Ceramic National Exhibition," Syracuse Museum of Fine Arts, Syracuse, New York, catalog

1951 "Eleventh Missouri Exhibition," City Art Museum, St. Louis, Missouri
1958 "One Hundred and Fifty-Third Annual Exhibition of Painting and Sculpture," Pennsylvania Academy of the Fine Arts, Philadelphia, Pennsylvania, catalog
1983 "Second Michigan Fine Arts Competition," Birmingham Bloomfield Art Association, Birmingham, Michigan
1984 "Ninety-Fifth National Association of Women Artists Annual Exhibition," Jacob K. Javits Federal Building, New York, New York, catalog

Selected Public Collections
Avon Township Library, Rochester, Michigan
Christ Church Dearborn, Dearborn, Michigan
City of Tokushima, Japan
Convent of the Transfiguration, Glendale, Ohio
Cranbrook Educational Community, Kingswood School, Bloomfield Hills, Michigan
Douglas MacArthur High School, Saginaw, Michigan
Grinnell Company, Saginaw, Michigan
Grosse Pointe Memorial Church, Grosse Pointe, Michigan
Lakeland High School, Milford, Michigan
Marian High School, Birmingham, Michigan
Michigan Bell Telephone Company, Data Processing Center, Saginaw, Michigan
Miles Machinery, Saginaw, Michigan
Norman A. Westland Child Guidance Clinic, Saginaw, Michigan
Office Building, 33150 Schoolcraft, Livonia, Michigan
Pattengill Elementary School, Ann Arbor, Michigan
Saginaw Civic Center, Saginaw, Michigan
St. Matthew's Episcopal Church, Saginaw, Michigan
St. Paul's Episcopal Church, Saginaw, Michigan
St. Stephen's Episcopal Church, Troy, Michigan
Samaritan Hospital, Bay City, Michigan
Santa María de los Angeles, Tegucigalpa, Honduras
Theodore Roosevelt High School, Wyandotte, Michigan
Trinity Church, Bay City, Michigan
University of Michigan, Alumni Center, Ann Arbor, Michigan
Village Woman's Club, Bloomfield Hills, Michigan
Western Michigan University, Kalamazoo, Michigan

Selected Private Collections
Deseree Caldwell Armitage, Detroit, Michigan
Henry Booth, Bloomfield Hills, Michigan
Walter Buell Ford II, Detroit, Michigan
Mr. and Mrs. Jean Mesritz, Grosse Pointe, Michigan
Mrs. George Trumbull, Bloomfield Hills, Michigan

Selected Awards
1959 Sculpture Prize, "First International Cultural and Artistic Exhibition," Cecile Gallery, New York, New York, catalog
1963 Work of Art Most Representative of Area, *Saginaw News* Award, Saginaw Art Museum, Saginaw, Michigan
1965 Craftsmanship and Allied Arts Award, American Institute of Architects, Saginaw Valley Chapter, Michigan

Preferred Sculpture Media
Metal (cast) and Metal (welded)

Related Profession
Poet

Teaching Position
Sculpture Instructor, Cranbrook Educational Community, Bloomfield Hills, Michigan

Gallery Affiliation
Dimensions in Art
300 South Washington Avenue
Lansing, Michigan 48933

Mailing Address
1415 West Tienken Road
Rochester, Michigan 48063

Artist's Statement

"I decided to be an artist when I was nine and my mother took me to a Van Gogh retrospective exhibition. Each week my fifteen-cent allowance went to Green Artist Supply for a tiny tube of oil paint. Later studies with Marshall Fredericks and Thomas McClure influenced my decision to be a sculptor.

"Sculpture requires activity of the mind, vision of the inner eye, knowledge of a variety of techniques and materials, physical strength and skill. It appeals through the sense of touch as well as sight. What have represented my concerns in the process of sculpture-making are the volume and surface tensions, the interior and external contours, the shape of the objects in space and the theme of fragmentation.

"Most of my visual images are composed of fragments of the human body and, recently, some from unassuming objects of domesticity assembled from my own environment—doors, chairs, tables and ladders—the furniture of a woman's life. In the form they are finally presented, the work expresses many emotions of life: ecstasy, despair and loneliness in the elements of birth, marriage, decision-making confrontation, old age, God, death and beyond."

Pamela Stump

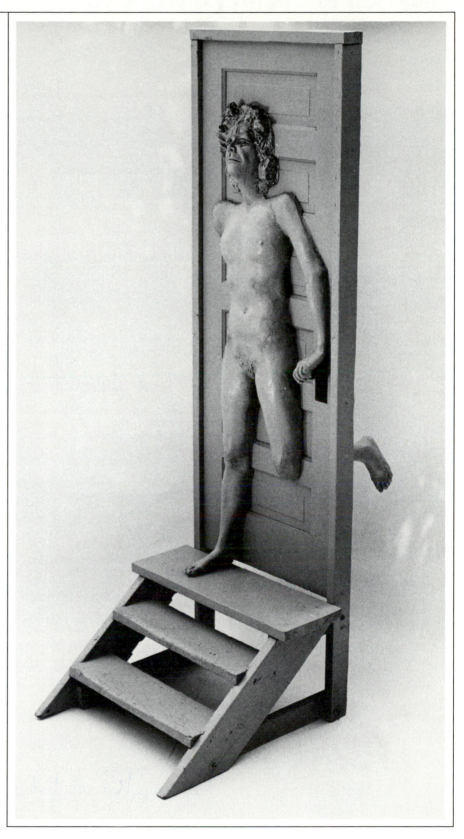

The Rape on the Stair. 1983. Mixed media, 97½"h x 35"w x 52"d. Photograph by Steven Rost.

Maxine Kim Stussy

née Maxine Kim Carlyle
(Husband Raymond Frankel)
Born November 11, 1924 Los Angeles,
California

Education and Training
1942 University of Southern California, Los
Angeles, California; study in sculpture
with Merle Gage
1947 B.A., Art, University of California, Los
Angeles, Los Angeles, California
1959 Independent study and research in
Belgium, France, Germany, Federal
Republic, Great Britain and Italy
1959- Studio of Amerigo Tot, Rome, Italy;
60 study in bronze casting
1959- Fonderia Bruni, Rome, Italy; study in
60 bronze casting
1963 Independent study and research in
France, Great Britain and Switzerland

Selected Individual Exhibitions
1957 Van Kepple Greene Gallery, Beverly
Hills, California
1958, Esther Robles Gallery, Los Angeles,
65 California
1958 Palos Verdes Gallery, Rancho Palos
Verdes, California
1959 Galleria Schnieder, Rome, Italy
1966 Western Michigan University,
Kalamazoo, Michigan
1967 Everett Community College, Everett,
Washington
1967 Lower Columbia College, Longview,
Washington
1967 Oregon State University, Corvallis,
Oregon
1967 University of Nevada Reno, Reno,
Nevada
1968 Galeria del Sol, Santa Barbara,
California
1968, Ceeje Gallery, San Francisco,
70 California

1974, Zara Gallery, San Francisco, California
75,
76,
77
1975, Adele Bednarz Galleries, Los Angeles,
76 California
1985 Lillian Heidenburg Gallery, New York,
New York
1985 Sindin Galleries, New York, New York

Selected Group Exhibitions
1954, "Regional Selected Art," Los Angeles
58, County Museum of Art, Los Angeles,
59, California, catalog
61
1958 "Art USA," Madison Square Garden,
New York, New York
1961 "Annual Exhibition," La Jolla Museum
of Contemporary Art, La Jolla,
California
1968 "25 California Women of Art," Lytton
Center of the Visual Arts, Los
Angeles, California
1969 "Micro-Cosmos '69," Traveling
Exhibition, Long Beach Museum of
Art, Long Beach, California
1971 "Four Women in Art," Mount St. Mary's
College, Los Angeles, California
1972 "Concepts," Costain Gallery, Taos,
New Mexico
1975, "Gallery Artists," Pavilion Gallery,
76 Scottsdale, Arizona
1977- "Annual Group Exhibition," Ianuzzi
86 Gallery, Phoenix, Arizona
1985 "Chicago International Art Exposition,"
Navy Pier, Chicago, Illinois
(Represented by Sindin Galleries, New
York, New York), catalog

Selected Public Collections
Children's Neuropsychiatric Hospital,
Children's Clinic and Doctors' Dining
Room, University of California Medical
Complex, Los Angeles, California
Ianuzzi Restaurant, Scottsdale, Arizona
St. Martin of Tours Catholic Church,
Brentwood, California
Scottsdale Center for the Arts, Scottsdale,
Arizona
Shulman Industrial Park, White Plains, New
York
University of California, Los Angeles, Los
Angeles, California

Selected Private Collections
Mr. and Mrs. Colin Cannon, London, Great
Britain
Mr. and Mrs. Truman Chaffin, Los Angeles,
California
Mr. and Mrs. Alvin Cooperman, New York,
New York
Mr. and Mrs. Tony Curtis, Bel Air, California
Mr. and Mrs. Eric Lidow, Bel Air, California

Preferred Sculpture Media
Concrete, Metal (cast) and Wood

Selected Bibliography
Johnson, Beverly Edna. "Fair but Not Faint
Hearted." *Los Angeles Times Home
Magazine* (September 14, 1969) pp. 20-21,
illus.
Johnson, Beverly Edna. "Sculptures Evolved
from Wood." *Los Angeles Times Home
Magazine* (February 23, 1975) p. 18, illus.
Miller, Bea. "The Anatomy of an Artist." *Los
Angeles Times Home Magazine*
(November 15, 1970) pp. 20-23, illus.
Papers included in the Archives of American
Art, Smithsonian Institution, New York,
New York.
Reinoehl, Kathleen. "The Many Faces of
Maxine Kim Stussy." *American Artist* vol.
39 no. 396 (July 1975) cover, pp. 46-51,
62-63, 68-69, illus.

Gallery Affiliations
Sindin Galleries
1035 Madison Avenue
New York, New York 10028

Mailing Address
211 Hommocks Road
Larchmont, New York 10538

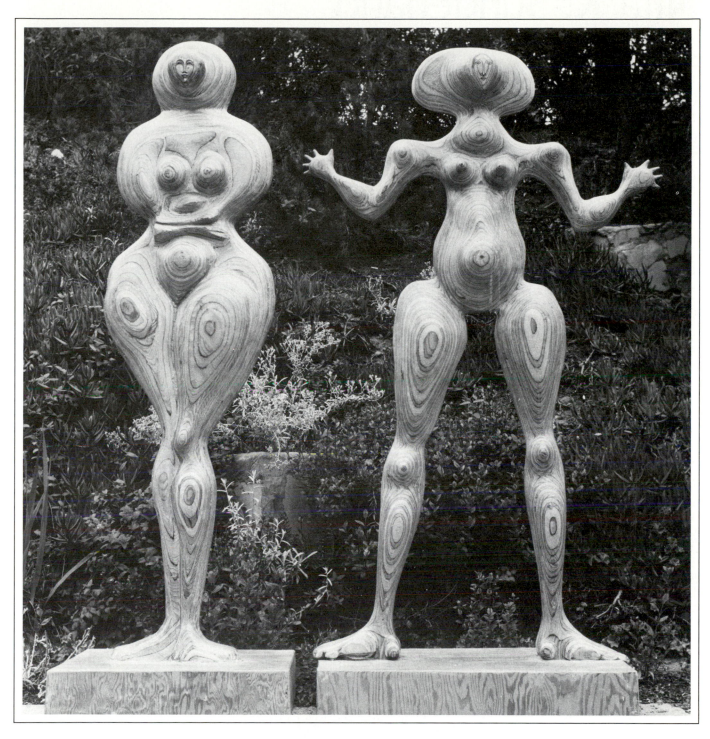

Spectre Mother Icon. 1984. Left: Laminated wood, 6'h. *Wind Dancer.* 1984. Right: Laminated wood, 6'h.

Artist's Statement

"There were times in my early life when the shadows on the walls became guardian watchers or myself looking back. As survival in reality became more intrusive, the inner life began to push through into spectre figures of these companions of the night and horses.

"At first it was the pure horse, the moving animal, balancing on incredible little feet. Then it became the spectral, the watching horse, horse and man, horse part man, spectre as horse. The spectres in human form and animals grew large into wood, cement and bronze.

"Then the shock of dark winters in the east, moist summers, the annual dying and rebirth of the spirit, a new sense of time, turning inward again I created the single form in space out of its own parts, fractured and fragmented, as in its creator's life. The isolated, silent observer stands alone, the watcher, the sentinel, indestructible."

563

Nita K. Sunderland

née Nita Kathleen
Born November 9, 1927 Olney, Illinois

Education and Training
1945- House-in-the-Pines,
47 Norton, Massachusetts
1950- Duke University,
51 Durham, North Carolina
1952 B.F.A., Sculpture, Bradley University, Peoria, Illinios
1955 M.A., Ceramics, Bradley University, Peoria, Illinois
1964 Independent study in bronze foundry and marble studios, Florence, Italy

Selected Individual Exhibitions
1962 Bradley University, Peoria, Illinois
1965 Lakeview Center for the Arts and Sciences, Peoria, Illinois
1965 Gilman Gallery, Chicago, Illinois
1966 Galesburg Civic Art Association, Galesburg, Illinois

Selected Group Exhibitions
1963 "Sculpture by Nine Illinois Artists," Peoria Art Center, Peoria, Illinois
1963 "Ninth Annual Drawing and Small Sculpture Show," Ball State Teachers College, Muncie, Indiana
1964 "Sculpture and Sculptor's Drawings," Eastern Michigan University, Ypsilanti, Michigan
1965 "Recent Drawings and Sculpture," Bradley University, Peoria, Illinois
1966 "Nineteenth North Mississippi Valley Artists Exhibition," Illinois State Museum, Springfield, Illinois
1967, 78, 84 "Faculty Exhibition," Bradley University, Peoria, Illinois
1968 "Art for Architecture," Gilman Gallery, Chicago, Illinois
1972 "Fun and Games," Traveling Exhibition, Xerox Square Exhibition Center, Rochester, New York
1976 "Signatures," Peoria Art Guild, Peoria, Illinois
1978 "Museum Without Walls," Chicago Federal Plaza, Chicago, Illinois
1979 "Thirty-First Illinois Invitational," Illinois State Museum, Springfield, Illinois, catalog
1980 "Selections from the Collection of George M. Irwin," Krannert Art Museum, Champaign, Illinois, catalog
1981 "Thirty Years of Illinois Public Sculpture," Lakeview Museum of Art and Sciences, Peoria, Illinois
1983 "Eighteen Illinois Sculptors," Traveling Exhibition, Western Illinois University, Macomb, Illinois

Selected Public Collections
Bradley University, Peoria, Illinois
Chicago Federal Center Museum, Chicago, Illinois
City of Peoria, Illinois
Lakeview Museum of Art and Sciences, Peoria, Illinois

Selected Private Collections
William S. Block, Peoria, Illinois
George M. Irwin, Quincy, Illinois
Dr. and Mrs. George J. Kottemann, Peoria, Illinois

Preferred Sculpture Media
Metal (cast) and Stone

Additional Art Field
Outdoor Sculpture Restoration

Teaching Position
Professor of Sculpture, Bradley University, Peoria, Illinois

Mailing Address
Grosenbach Hill Road
Rural Route 1
Washington, Illinois 61571

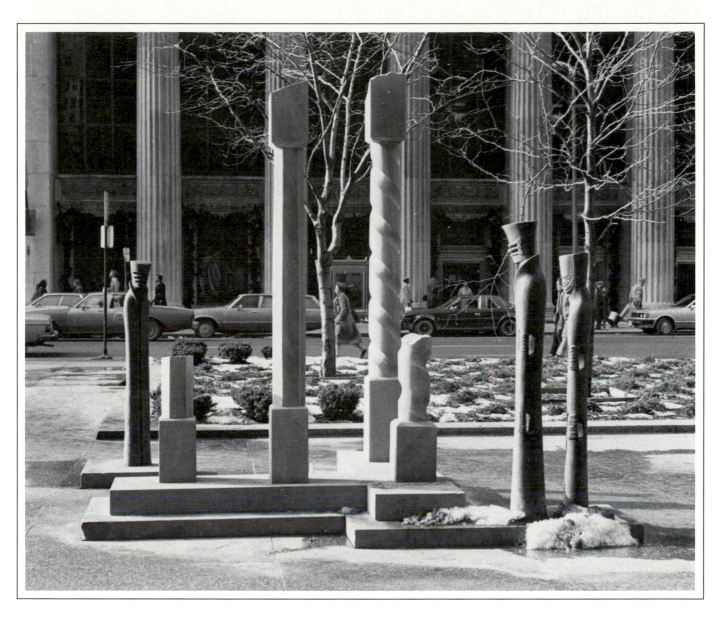

Ruins III. 1978. Bronze and Indiana limestone, 10'h x 12'w x 13'd. Collection Chicago Federal Center Museum, Chicago, Illinois. Photograph by Beth Linn.

Artist's Statement

"The 'Ruins' series, of which there were numerous maquettes and drawings, was derived from the assimilation of art historical experiences of many years ago in Italy and England. It reflects my continued interest in the parallels of medieval and contemporary society. The integration of this visual material in combination with adversity in my own life accounted for the symbolism—a leper's veil and medieval headdress of the woman—the visored helmets and masks of the knights—the isolation and integral relationships of the figures—the symbolism of broken columns. The sculpture may be symbolically prophetic."

Nita K. Sunderland

Jean Sutter

(Husband Samuel H. Lerner)
Born August 9, 1934 Chicago, Illinois

Education and Training
1965- Oglethorpe University, Atlanta,
66　 Georgia; study in sculpture with
　　 Duane Hanson
1974　B.V.A., Sculpture, Georgia State
　　 University, Atlanta, Georgia; study
　　 with George Mallett
1977　University of Georgia, Athens,
　　 Georgia, Studies Abroad Program,
　　 Palazzo Vagnotti, Cortona, Italy; study
　　 in sculpture with John D. Kehoe
1978　M.V.A., Sculpture, Georgia State
　　 University, Atlanta, Georgia; study
　　 with George Beasley
1982- Independent study and travel in
83　 Europe
1984　Independent study and travel in China

Selected Individual Exhibitions
1978　School of Architecture, Auburn
　　 University, Auburn, Alabama
1979　Georgia State University, Atlanta,
　　 Georgia
1981　Quinlan Art Center, Gainesville,
　　 Georgia
1984　Memorial Stadium Gallery, College of
　　 Environmental Design, University of
　　 Oklahoma, Norman, Oklahoma

Selected Group Exhibitions
1974　"Jean Sutter and Leonard Robertson,"
　　 Georgia State University, Atlanta,
　　 Georgia
1975, "Arts Festival of Atlanta," Piedmont
80, 　Park, Atlanta, Georgia
84
1976　"Eight Women Artists," Colony Square
　　 Gallery, Atlanta, Georgia
1978　"Group Exhibition," Peachtree Center
　　 Gallery, Atlanta, Georgia
1978- "Artists in Georgia," High Museum of
79　 Art, Atlanta, Georgia, catalog
1979　"Seven Artists in Georgia," High
　　 Museum of Art, Atlanta, Georgia,
　　 catalog
1980　"Thirteen Minus One: Atlanta
　　 Sculptors Guild Exhibition," Central
　　 City Park, Atlanta, Georgia and
　　 Richard B. Russell Federal Building,
　　 Atlanta, Georgia
1980　"Sculpture Outdoors '80," Temple
　　 University Music Festival, Ambler
　　 Campus, Ambler, Pennsylvania
　　 (Co-Sponsored by Cheltenham Art
　　 Centre, Cheltenham, Pennsylvania),
　　 catalog
1980- "Sculpture Outdoors 1980-1981,"
81　 Cedar Crest College, Allentown,
　　 Pennsylvania (Co-Sponsored by
　　 Cheltenham Art Centre, Cheltenham,
　　 Pennsylvania), catalog
1981　"American Art Artists," American Art,
　　 Incorporated, Atlanta, Georgia
1981　"Invitational Exhibition," Museum of
　　 Touch, Atlanta, Georgia
1982　"Arts Festival of Atlanta," Piedmont
　　 Park, Atlanta, Georgia, catalog
1982　"The Atlanta Arts Festival," Columbia
　　 Museums of Art & Science, Columbia,
　　 South Carolina, catalog
1982　"Great Garden Sculpture Show,"
　　 Sculptural Arts Museum, Atlanta,
　　 Georgia, catalog

Selected Public Collections
Daniel Griffing Collection, Orlando, Florida
Georgia State University, Atlanta, Georgia
Martin Rubin Law Office, Atlanta, Georgia
William Gignilliat Law Office, Atlanta, Georgia

Selected Private Collections
John Bacheller III, Dallas, Texas
Mignon Bruce, Cornelia, Georgia
Lewis and Jacqueline Holland, Atlanta,
　Georgia
Robert M. and Janice Hunt, Chicago, Illinois
Ricardo Viera, Bethlehem, Pennsylvania

Preferred Sculpture Media
Metal (cast), Metal (welded) and Wood

Additional Art Field
Three-Dimensional Drawing

Gallery Affiliation
Heath Gallery
416 East Paces Ferry Road NE
Atlanta, Georgia 30305

Mailing Address
4344 Conway Valley Road NW
Atlanta, Georgia 30327

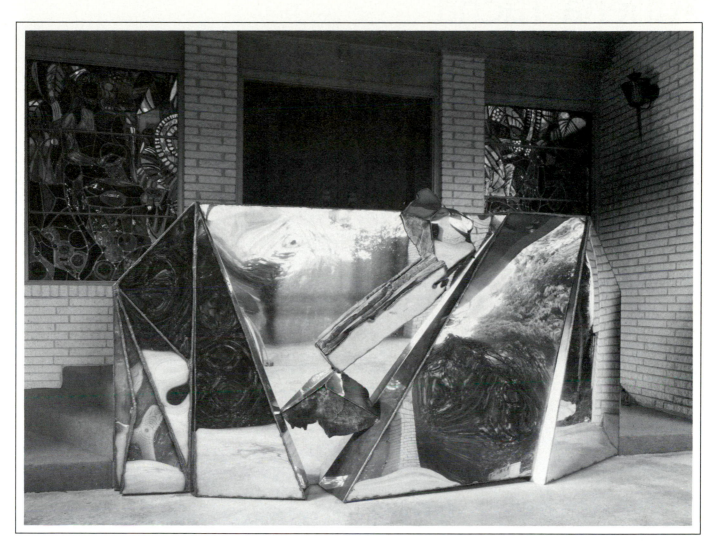

Lost Lane-End into Heaven Series: The Valley No.
15. 1983. Mirror finish stainless steel and
weathered oak, 72"h x 144"w x 24"d. Photograph
by Bruce W. Taylor.

Artist's Statement
"I have always built things—as a child, clay
figures of humans and animals. My father
and grandfather were both architects. I do all
my own studio work and have learned any
necessary skill in order to implement ideas.
 "My work explores my perception of
landscape, the emotional amd mental
landscape as well as the physical one in
which we all live. The use of wood and
stainless steel, a natural and an industrial
material, complement each other and
enhance my inclination toward geometric
forms. Travel enriches my awareness and
the actual forms of the earth trigger intuitive
thought and vision which then become real
in another form—that of sculpture."

Athena Tacha

(Husband Richard E. Spear)
Born April 23, 1936 Larissa, Greece

Education and Training
1959 M.A., Sculpture, National Academy of Fine Arts, Athens, Greece
1961 M.A., Art History, Oberlin College, Oberlin, Ohio
1963 Ph.D., Aesthetics, Université Paris-Sorbonne, Paris, France

Selected Individual Exhibitions
1969 Akron Art Institute, Akron, Ohio
1969 New Gallery of Contemporary Art, Cleveland, Ohio
1971 Cooper School of Art, Cleveland, Ohio
1973 Gallery of the Loretto-Hilton Center, St. Louis, Missouri
1975 93 Crosby Street, New York, New York
1977 Mabel Smith Douglass Library, Rutgers University, Douglass College, New Brunswick, New Jersey
1978 Wright State University, Dayton, Ohio, catalog
1979 Zabriskie Gallery, New York, New
81 York
1984 Max Hutchinson Gallery, New York, New York, catalog

Selected Group Exhibitions
1966- "Annual May Show," Cleveland
69, Museum of Art, Cleveland, Ohio,
71, catalog
74,
77,
79,
84
1969, "All Ohio Painting and Sculpture
70, Exhibition," Dayton Art Institute,
74 Dayton, Ohio
1971 "Outdoor Sculpture Exhibition," Blossom Music Center, Kent, Ohio
1972 "GEDOK American Woman Artist Show," Kunsthaus, Hamburg, Germany, Federal Republic, catalog
1972 "Six Artists: Breidel, Davidovich, Eubel, Lucas, Pearson, Tacha," Akron Art Institute, Akron, Ohio
1973, "Oberlin Artists," Allen Memorial Art
74, Museum, Oberlin, Ohio
77,
79,
82
1974 "Spring Invitational: Cynthia Carlson, Joyce Kozloff, Athena Tacha, Ann Wilson," A.I.R. Gallery, New York, New York
.1975 "Wooster Invitational," College of Wooster Art Museum, Wooster, Ohio
1975 "Site Sculpture: Hamrol, Healy, Tacha," Zabriskie Gallery, New York, New York; Graduate Center, City University of New York, City College, New York, New York
1975 "Small Sculpture," New Gallery of Contemporary Art, Cleveland, Ohio

1976 "Salute the Women," Butler Institute of American Art, Youngstown, Ohio
1976 "Sculpture '76," Hurlbutt Gallery, Greenwich Library, Greenwich, Connecticut
1976 "Washington Art '76," National Armory, Washington, D.C.
1976 "Sculpture '76: 15 Sculptors," Outdoor Sites, Greenwich, Connecticut
1976 "Site Sculpture II: Hamrol, Healy, Tacha," Zabriskie Gallery, New York, New York
1976 "Scott Burton, Athena Tacha, George Trakas," Parrish Art Museum, Southampton, New York
1977 "Telic: International Exhibition of Structure and Phenomena," Art Research Center, Kansas City, Missouri
1977 "Site Sculpture: Hamrol, Healy, Miss, Tacha," Zabriskie Gallery, New York, New York
1977 "Proposals for Sawyer Point," Contemporary Arts Center, Cincinnati, Ohio
1979 "Beginnings: Maquettes and Photographs of Contemporary Public Sculpture," Laumeier International Sculpture Park And Gallery, St. Louis, Missouri
1979 "Afterimages/Projects of the '70s," Philadelphia College of Art, Philadelphia, Pennsylvania
1980 "Urban Encounters: Art, Architecture, Audience," Institute of Contemporary Art of The University of Pennsylvania, Philadelphia, Pennsylvania
1980- "Scapes: Seven Ohio Landscape
81 Artists-Milhoan, Peak, Puhalla, Shirley, Spaid, Tacha, Tyrrell," Traveling Exhibition, Tangeman Fine Arts Gallery, University of Cincinnati, Cincinnati, Ohio, catalog
1980- "Across the Nation: Fine Art for
81 Federal Buildings 1972-1979," National Collection of Fine Arts, Smithsonian Institution, Washington, D.C.; Hunter Museum of Art, Chattanooga, Tennessee
1980 "Eleventh International Sculpture Conference," Area Galleries and Institutions, Washington, D.C. (Sponsored by International Sculpture Center, Washington, D.C.)
1981 "Paintings and Sculpture by Candidates for Art Awards," American Academy and Institute of Arts and Letters, New York, New York, catalog
1981 "Transitions II: Landscape/Sculpture," Amelie A. Wallace Gallery, State University of New York College at Old Westbury, Old Westbury, New York, catalog
1982 "Inside/Out: Robert Huff, Ed Mayer, Athena Tacha," Dairy Barn, Athens, Ohio, catalog
1983 "Akron Collaboration: Artists and Architects," Akron Art Museum, Akron, Ohio
1983 "Connections: Bridges/Ladders/Ramps/Staircases/Tunnels," Institute

of Contemporary Art of The University of Pennsylvania, Philadelphia, Pennsylvania
1983 "John and Mildred Putman Collection," Case Western Reserve University, Cleveland, Ohio
1984 "Land Marks," Edith C. Blum Art Institute, Bard College Center, Annandale-on-Hudson, New York, catalog

Selected Public Collections
Allen Memorial Art Museum, Oberlin, Ohio
Anchorage Historical and Fine Arts Museum, Anchorage, Alaska
Ashland Chemical Company, Columbus, Ohio
Case Western Reserve University, Cleveland, Ohio
City of Cleveland, Huron Road Mall, Cleveland, Ohio
City of Findlay, Municipal Plaza, Findlay, Ohio
City of Oberlin, Vine Street Park, Oberlin, Ohio
City of Toledo, Civic Center Mall, Toledo, Ohio
City of Tulsa, Riverfront Park, Tulsa, Oklahoma
Cleveland Museum of Art, Cleveland, Ohio
General Services Administration Building, Norfolk, Virginia
International Airport, Columbus, Ohio
Metrorail Station, Miami, Florida
National Museum of American Art, Smithsonian Institution, Washington, D.C.
Power Gallery of Contemporary Art, Sydney, Australia
Township of Smithtown, Tide Park, Smithtown, New York
University of Arizona, Tucson, Arizona
Utah Museum of Fine Arts, Salt Lake City, Utah
Vassar College Art Gallery, Poughkeepsie, New York
Veteran's Administration Hospital, Coatesville, Pennsylvania
Woodinville High School, Seattle, Washington

Selected Private Collections
Suzi Gablik, London, Great Britain
Graham Gund Collection, Cambridge, Massachusetts
Ellen H. Johnson, Oberlin, Ohio
Louise Nevelson, New York, New York
Yannis Xenakis, Paris, France

Selected Awards
1974 Fellow, Center for Advanced Visual Studies, Massachusetts Institute of Technology, Cambridge, Massachusetts
1975 Individual Artist's Fellowship, National Endowment for the Arts
1976 Visual Arts Award, Ohio Arts Council

Tide Park. 1977. Gunite, evergreens, water and mural, 25'h x 30'w x 70'd. Collection Township of Smithtown, Tide Park, Smithtown, New York.

Preferred Sculpture Media
Concrete, Metal (welded) and Varied Media

Additional Art Fields
Conceptual Art and Drawing

Teaching Position
Professor of Sculpture, Oberlin College, Oberlin, Ohio

Selected Bibliography
Johnson, Ellen H. "Nature as Source in Athena Tacha's Art." *Artforum* vol. 19 no. 5 (January 1981) pp. 58-62, illus.
Johnson, Ellen H., ed. *American Artists on Art from 1940-1980*. New York: Harper & Row, 1982.
Tacha, Athena. "Rhythm as Form." *Landscape Architecture* (May 1978) pp. 196-205, illus.
Tacha, Athena. "Blair Fountain, River Sculpture." *Landscape Architecture* vol. 74 no. 2 (March-April 1984) pp. 72-74, illus.
Wolff, Theodore F. "Artist Athena Tacha." *The Christian Science Monitor* (Thursday, April 9, 1981) p. 18, illus.

Gallery Affiliation
Max Hutchinson Gallery
138 Greene Street
New York, New York 10012

Mailing Address
291 Forest Street
Oberlin, Ohio 44074

Artist's Statement
"As an artist whose work matured during the social upheavals of the late sixties, I feel, that given the present state of the world, it is morally untenable to pursue an art career unless one makes art available to everybody (not only the financially or educationally privileged). One way of achieving this aim is to bring art into the urban environment (such as a public plaza, a recreation or picnic area). Another way is to make art approachable by avoiding deliberate offensiveness and by allowing the work to be attractive.

"I was led to make sculpture on a landscape scale by several needs: to create a kind of form which could be experienced not only visually, but through body-locomotion as well; to make art that would not be at odds with nature and its organizing methods; and to endow it with a social function such as it used to have in past cultures. My sculpture can, for instance, embellish and render 'natural' riverbanks destroyed by industry or junkyards. Condensing the beauty of nature and bringing it into our daily environment is one way for art to serve its humanizing purpose in today's society."

Athena Tacha

Elsa Johnson Tarantal

née Elsa Christine Johnson
(Husband Stephen M. Tarantal)
Born July 30, 1944 Brooklyn, New York

Education and Training
1966 B.F.A., Applied and Fine Arts, Cooper
Union for the Advancement of
Science and Art, New York, New York
1968- Maharaja Sayajirao University of
69 Baroda, Baroda, India; study in
sculpture with Shanko Chaudry
1978 M.F.A., Sculpture, University of
Pennsylvania, Philadelphia,
Pennsylvania; study with Robert
Engman and Maurice Lowe

Selected Individual Exhibitions
1969 Maharaja Sayajirao University of
Baroda, Baroda, India
1979, Marian Locks Gallery, Philadelphia,
82, Pennsylvania
86

Selected Group Exhibitions
1970, "Gallery Artists," Gallery 252,
71, Philadelphia, Pennsylvania
72,
73

1972, "Gallery Artists," Pisces Gallery,
73 Nantucket, Massachusetts
1973, "Gallery Artists," Secrest Gallery,
74 Wellfleet, Massachusetts
1975 "Small Sculpture Exhibition,"
Cheltenham Art Centre, Cheltenham,
Pennsylvania
1975 "Women Artists," Philadelphia Art
Alliance, Philadelphia, Pennsylvania
1976 "Small Works," Rosenfeld Gallery,
Philadelphia, Pennsylvania
1980 "Women Artists Salute Women in
Transition," Marian Locks Gallery,
Philadelphia, Pennsylvania
1981 "Broad Spectrum," Traveling
Exhibition, Philadelphia College of Art,
Philadelphia, Pennsylvania, catalog
1982 "Member Artists Annual Exhibition,"
Provincetown Art Association and
Museum, Provincetown,
Massachusetts
1982 "Neo-Objective Sculpture," Dart
Gallery, Chicago, Illinois
1983 "Affects-Effects," Philadelphia College
of Art, Philadelphia, Pennsylvania,
catalog
1984 "Gallery Artists," Kendall Gallery,
Wellfeet, Massachusetts
1984 "Gallery Artists, Small Works," Marian
Locks Gallery, Philadelphia,
Pennsylvania

Selected Public Collection
City of Philadelphia, University City
Townhouses, Philadelphia, Pennsylvania

Selected Private Collections
Mr. and Mrs. William Blades, Philadelphia,
Pennsylvania
Mr. and Mrs. John Egan, Philadelphia,
Pennsylvania
Mr. and Mrs. Walter Erlebacher, Elkins Park,
Pennsylvania
Mr. and Mrs. David Noyes, Wyncote,
Pennsylvania
Mr. and Mrs. Richard Rosenfeld, Lafayette
Hills, Pennsylvania

Selected Awards
1976 Senatorial Scholarship, State of
Pennsylvania
1984 Venture Fund Grant, Philadelphia
College of Art, Philadelphia,
Pennsylvania

Preferred Sculpture Media
Metal (cast)

Teaching Position
Assistant Professor and Co-Chair,
Foundation Department, Philadelphia
College of Art, Philadelphia, Pennsylvania

Related Profession
Art Education

Gallery Affiliation
Marian Locks Gallery
1524 Walnut Street
Philadelphia, Pennsylvania 19102

Mailing Address
7923 Park Avenue
Elkins Park, Pennsylvania 19117

Artist's Statement

"Working in small-scale demands selectivity and a focus on the essential character of the form. It is not a matter of consistent reduction of size, but rather subtle alterations of proportional relationships made in response to the nature of perception.

"In my early training in art, I created abstract formal and geometric constructions. I have been engaged in making small bronze sculpture primarily of children since 1972. I began terra cotta studies of human figures while I lived in India and was inspired by the Indian people, their attitudes toward children and their small-scale bronzes. I continued this interest when my first child was born and began sculpting his attitudes and gestures. Later I did studies of my second child, rolling over, sitting up, crawling and standing."

Elsa Johnson Tarantal

Balancing. 1983. Plaster (cast in bronze 1983), 47"h. Collection City of Philadelphia, University City Townhouses, Philadelphia, Pennsylvania. Photograph by John Carlano.

Lenore Tawney

Born May 10, 1925 Lorain, Ohio

Education and Training
1945-46 University of Illinois at Urbana-Champaign, Urbana, Illinois
1946-47 Institute of Design, Chicago, Illinois; study in sculpture with Alexander Archipenko and Emerson Woelffer

Selected Individual Exhibitions
1962 Staten Island Institute of Arts and Sciences, Staten Island, New York, catalog
1962 Art Institute of Chicago, Chicago, Illinois
1967, 81 Elaine Benson Gallery, Bridgehampton, New York, catalog
1967, 70 Willard Gallery, New York, New York, catalog
1968 Adele Bednarz Gallery, Los Angeles, California
1969, 80 Fairweather Hardin Gallery, Chicago, Illinois
1974 Willard Gallery, New York, New York
1975 Art Gallery, California State University Fullerton, Fullerton, California, retrospective and catalog
1978 Brookfield Craft Center, Brookfield, Connecticut; Hadler/Rodriguez Galleries, New York, New York, retrospective and catalog
1978 Hunterdon Art Center, Clinton, New Jersey
1979 New Jersey State Museum, Trenton, New Jersey, retrospective and catalog
1979 Cleveland Museum of Art, Cleveland, Ohio, catalog
1981 Slippery Rock State College, Slippery Rock, Pennsylvania
1981 Tacoma Art Museum, Tacoma, Washington, catalog
1981 University of Wisconsin-Eau Claire, Eau Claire, Wisconsin
1981 Musée des Arts Décoratifs, Paris, France

Selected Group Exhibitions
1963 "Woven Forms," Museum of Contemporary Crafts, New York, New York, catalog
1964 "Gewebte Formen: Lenore Tawney, Claire Zeisler, Sheila Hicks," Kunstgewerbemuseum der Stadt, Zürich, Switzerland, catalog
1964 "Triennale di Milano," Milan, Italy, catalog
1967 "Intersection of Line," Art Gallery, California State University Fullerton, Fullerton, California
1969 "Wall Hangings," Museum of Modern Art, New York, New York, catalog

1973, 83 "Biennale Internationale de la Tapisserie," Musée Cantonal des Beaux-Arts, Lausanne, Switzerland, catalog
1974 "Nine Artists/Coenties Slip," Whitney Museum of American Art, Downtown Branch, New York, New York, catalog
1974 "In Praise of Hands," Ontario Science Centre, Toronto, Ontario, Canada, catalog
1977 "Fiberworks," Cleveland Museum of Art, Cleveland, Ohio, catalog
1979-80 "100 Artists: 100 Years," Art Institute of Chicago, Chicago, Illinois, catalog
1979 "Weich und Plastik, Soft and Plastic," Kunthaus, Zürich, Switzerland, catalog
1981 "Fiber Art: An Uncommon Thread," Modern Master Tapestries, New York, New York
1981-83 "The Art Fabric: Mainstream," Traveling Exhibition, San Francisco Museum of Modern Art, San Francisco, California, book
1982 "Fiber '82," Hunterdon Art Center, Clinton, New Jersey
1982 "3 x 5: Works in Fiber," Modern Masters Tapestries, New York, New York, catalog
1982 "Beyond Tradition: 25th Anniversary Exhibition," American Craft Museum, New York, New York
1982 "Twelfth International Sculpture Conference," Area Galleries and Institutions, Oakland, California and San Francisco, California (Sponsored by International Sculpture Center, Washington, D.C.)
1983 "Fifth Annual Exhibition Women's Caucus for Art," Port of History Museum, Penn's Landing, Philadelphia, Pennsylvania, catalog
1983 "American Living National Treasures," Fendrick Gallery, Washington, D.C.
1984 "Gallery Artists," Modern Master Tapestries, New York, New York

Selected Public Collections
American Craft Museum, New York, New York
Art Institute of Chicago, Chicago, Illinois
Brooklyn Museum, New York, New York
Chapel of the Inter-Church Center, New York, New York
Cleveland Museum of Art, Cleveland, Ohio
Cooper-Hewitt Museum, Smithsonian Institution, Washington, D.C.
First National Bank of Chicago, Chicago, Illinois and International Branch, New York, New York
Frank Lausche State Office Building, Cleveland, Ohio
General Services Administration Building, Santa Rosa, California
Kunstgewerbemuseum der Stadt, Zürich, Switzerland
Museum Bellerive, Zürich, Switzerland
Museum of Modern Art, New York, New York
North Shore Shopping Center, Marshall Field & Company, Chicago, Illinois
Philip Morris Collection, New York, New York

Southern Illinois University at Edwardsville, Edwardsville, Illinois
Synagogue Solel, Highland Park, Illinois

Selected Private Collections
Elaine Benson, Bridgehampton, New York
Jack Lenor Larsen, New York, New York
Dorothy Miller, New York, New York
Pierre Pauli Memorial Collection, Lausanne, Switzerland
Marian Willard, New York, New York

Selected Awards
1975 Fellow, American Craft Council, New York, New York
1979 Individual Artist's Fellowship, National Endowment for the Arts
1983 Honor Award for Outstanding Achievement in the Visual Arts, National Women's Caucus for Art Conference, Philadelphia, Pennsylvania

Preferred Sculpture Media
Fiber and Varied Media

Additional Art Fields
Collage, Drawing and Painting

Selected Bibliography
Constantine, Mildred and Jack Lenor Larsen. *Beyond Craft: The Art Fabric*. New York: Van Nostrand Reinhold, 1972.
Constantine, Mildred and Jack Lenor Larsen. *The Art Fabric: Mainstream*. New York: Van Nostrand Reinhold, 1981.
Howard, Richard. "Tawney." *Craft Horizons* vol. 35 no. 1 (February 1975) cover, pp. 46-47, 71-72, illus.
Kaufmann, Ruth. *The New American Tapestry*. New York: Reinhold, 1968.
Munro, Eleanor C. *Originals: American Women Artists*. New York: Simon and Schuster, 1979.

Gallery Affiliation
Modern Master Tapestries
11 East 57 Street
New York, New York 10022

Mailing Address
32 West 20 Street
New York, New York 10011

Artist's Statement

"After hanging the first cloud, *Cloud Series No. IV*, I wrote to a friend:
I think it is beautiful. It is not mine.
It is a gift. Now we celebrate.
We go to Yosemite.
We climb a high mountain.
We walk among waterfalls.
We are at the top, lying in a waterfall.
We are at the source."

Lenore Tawney

Cloud Series No. IV. 1978. Painted canvas and linen threads, 16'h x 32'w x 5'd. Collection General Services Administration Building, Santa Rosa, California. Photograph by Barbeau Engh.

Lois Teicher

née Lois Weinberger
Born September 22, 1938 Detroit, Michigan

Education and Training
1979 B.F.A., Ceramic Sculpture, Center for Creative Studies-College of Art and Design, Detroit, Michigan; study with Sue Linburg and Gordon Orear
1981 M.F.A., Sculpture, Eastern Michigan University, Ypsilanti, Michigan; study with Marvin Anderson

Selected Individual Exhibition
1984 Sales and Rental Gallery, Detroit Institute of Arts, Detroit, Michigan

Selected Group Exhibitions
1977- "National Cone Box Show," Traveling
79 Exhibition, University of Kansas, Lawrence, Kansas, catalog
1978 "Five Exhibitions," Detroit Focus Gallery, Detroit, Michigan
1978 "Marietta College Crafts National '78," Grover M. Hermann Fine Arts Center, Marietta College, Marietta, Ohio, catalog
1979 "Michigan Chapter of the Women's Caucus for Art Exhibition," Detroit Institute of Arts, Detroit, Michigan
1979 "Installations: The First Exhibit by The Contemporary Art Institute of Detroit," Contemporary Art Institute of Detroit, Detroit, Michigan, catalog
1979 "At Cranbrook: Twenty-One Downtown Detroit Artists," Cranbrook Academy of Art Museum, Bloomfield Hills, Michigan, catalog

1980 "Political Art," Contemporary Art Institute of Detroit, Detroit, Michigan
1980 "Bill Reid, Victoria Stoll and Lois Teicher," Detroit Artists Market, Detroit, Michigan
1982 "Individuals," Detroit Artists Market, Detroit, Michigan
1982 "Installations," Contemporary Art Institute of Detroit, Detroit, Michigan, catalog
1982 "Artists Equity Invitational Sculpture Exhibition," George Meany Center for Labor Studies, Silver Spring, Maryland
1982 "Artists Grant Recipients Exhibition, Michigan Council for the Arts," Pontiac Art Center, Pontiac, Michigan, catalog
1983 "Collectors Show—Fiftieth Anniversary," Detroit Artists Market, Detroit, Michigan
1983 "Lois Teicher and Allan Burke," Macomb Community College, Warren, Michigan
1984 "In Tandem: Made Possible by the Michigan Council for the Arts," Detroit Artists Market, Detroit, Michigan
1984 "Artists Against Apartheid, Visual and Literary Work," Michigan Gallery, Detroit, Michigan
1985 "Faculty Exhibition," Madonna College, Livonia, Michigan
1985 "Art and Jazz at the Fox Theatre, Benefit Exhibition for Detroit Focus Gallery," Fox Theatre, Detroit, Michigan

Selected Private Collections
Andrew and Gayle Camden, Grosse Pointe, Michigan
Mr. and Mrs. Joseph L. Hudson, Grosse Pointe Farms, Michigan
Mary Jane Jacob, Chicago, Illinois
Dennis Alan Nawrocki, Chicago, Illinois
Thomas and Diane Schoenith, Grosse Pointe, Michigan

Selected Awards
1981 Individual Artist's Fellowship, Michigan Council for the Arts
1982 Exhibition Grant, Michigan Foundation for the Arts, "Six Artists Installations," Detroit Focus Gallery, Detroit, Michigan

Preferred Sculpture Media
Varied Media

Additional Art Fields
Drawing and Printmaking

Teaching Position
Art Instructor, Madonna College, Livonia, Michigan

Selected Bibliography
Dorsey, Patricia. "Reviews Midwest Michigan: Lois Teicher, Detroit Institute of Arts." *New Art Examiner* vol. 12 no. 3 (December 1984) p. 69.

Shannon, Helen M. "Reviews Midwest Michigan: Installations, Detroit Focus Gallery." *New Art Examiner* vol. 9 no. 9 (June 1982) p. 21.
Slowinski, Dolores S. "Reviews Midwest Michigan: Winter Picnic, Detroit Artists Market." *New Art Examiner* vol. 10 no. 7 (April 1983) p. 20.
Wise, Julia Henshaw. "Reviews Midwest Michigan: At Cranbrook, Cranbrook Museum of Art." *New Art Examiner* vol. 7 no. 4 (January 1980) section two, p. 4, illus.
Wise, Julia Henshaw. "Reviews Midwest Michigan: Bill Reid, Victoria Stoll, Lois Teicher, Artists' Market of Detroit." *New Art Examiner* vol. 8 no. 5 (February 1981) p. 22.

Gallery Affiliation
Xochipilli Gallery
568 North Woodward Avenue
Birmingham, Michigan 48011

Mailing Address
Post Office Box 07097
Detroit, Michigan 48207

I Feel Like A Choreographer. 1981. Wood, hardware cloth and wheels, each unit, 40"h x 16"w x 9½"d, overall dimensions, 40"h x 8'w x 14'd. Photograph by Ralph Norris.

Artist's Statement

"Sculpture has been a life force. It is an avenue for energy and a personal challenge to see ideas and intuition in a tangible physical form. I grew up in the 1950s when women traditionally were excluded from the courses I liked, shop and drafting. As a result, I developed my own unconventional methods of working with every material I could find.

"Although the technical and formal problems are important, my ideas are involved not simply with materials. I draw when I need a quieter medium of expression. The drawings are often notes or a continuation and extension of sculpture. Obsessed with the idea of opposing forces in nature, the duality of opposites is an undercurrent in all my work. Sometimes this involves humor and pain, intuition and intellect, subjective or rational states of reality in direct or subtle spatial and architectural relationships. To search for truth and inspire the viewer are the objectives of my work."

Lois Teicher

Laura Telford

née Laura Katherine
(Husband Thomas Ray Vannatta)
Born March 3, 1952 Burnet, Texas

Education and Training
1975 B.F.A., Painting and Sculpture,
University of Texas at Austin, Austin,
Texas
1978 M.F.A., Sculpture, University of Texas
at Austin, Austin, Texas

Selected Individual Exhibition
1980 Artworks Gallery, Galveston Art
Center on the Strand, Galveston,
Texas

Selected Group Exhibitions
1978 "Ceramics as Sculpture," Kauffman
Fine Art, Houston, Texas
1978 "1978 Louisiana Festival of Arts,"
Masur Museum of Art, Monroe,
Louisiana
1979 "Telford, Teague-Cooper, Sturgill,
Lauhakaikul and Campbell," Studio
505, Austin, Texas
1979 "Texas Artists," Left Bank Gallery,
Houston, Texas
1979 "Miniature Exhibition," University of
Houston Lawndale Annex, Houston,
Texas
1979- "Women-in-Sight: New Art in Texas,"
81 Traveling Exhibition, Dougherty
Cultural Arts Center, Austin, Texas,
catalog
1979 "Works in Clay," Wichita Falls Art
Association, Wichita Falls, Texas
1980 "A February Sampler: Nine Austin
Artists," Moody Hall Atrium Gallery, St.
Edward's University, Austin, Texas
1980 "New Works Series: Laura Telford and
Vicki Teague-Cooper," Laguna Gloria
at First Federal Bank, Austin, Texas
1980 "Laura Telford and Susan Francis,"
Bank of the Hills Gallery, Austin,
Texas
1980 "'80 Texas Invitational," Galveston Art
Center on the Strand, Galveston,
Texas
1980- "Annual Faculty Exhibition," Austin
85 Community College, Austin, Texas
1980 "Faculty Exhibition," Dougherty
Cultural Arts Center, Austin, Texas

1981 "Austin—Houston Art Exchange
Exhibition," Moody Hall Atrium Gallery,
St. Edward's University, Austin,
Texas; Art Department Gallery,
University of St. Thomas, Houston,
Texas
1982 "Here & Now: Fourth Annual Exhibition
of Texas Art," Dougherty Cultural Arts
Center, Austin, Texas, catalog
1982 "California Hotel Group Show,"
California Hotel, Austin, Texas
1982 "Women & Their Work: Radiation Risk
Reception Area Exhibition," Dougherty
Cultural Arts Center, Austin, Texas;
University of Houston Lawndale
Annex, Houston, Texas
1982 "Artists for Peace Exhibition,"
Dougherty Cultural Arts Center,
Austin, Texas
1983 "Fourth Texas Sculpture Symposium,"
Area Galleries and Institutions, Austin,
Texas (Sponsored by College of Fine
Arts and Humanities, University of
Texas at Austin, Austin, Texas)
1983 "Outdoor Sculpture," Laguna Gloria Art
Museum, Austin, Texas
1983 "Face It: 10 Austin Artists," Data
Gallery, Austin, Texas
1983 "First Annual Indoor—Outdoor
Exhibition," San Antonio Art Institute,
San Antonio, Texas
1983- "Mixed Media Installation,"
84 Scarbroughs Congress Avenue
Window, Austin, Texas (Sponsored by
Laguna Gloria Art Museum, Austin,
Texas)
1984 "Outdoor Sculpture II," San Antonio Art
Institute, San Antonio, Texas
1984 "Five Austin Artists Invitational
Exhibition," Texas Commerce Bank
Building, Austin, Texas
1985 "Fifth Texas Sculpture Symposium,"
Sited throughout Central Business
District, Dallas, Texas and Connemara
Conservancy, Allen, Texas (Sponsored
by Texas Sculpture Symposium,
Dallas, Texas), catalog

Selected Public Collections
Design Center, Houston, Texas
Houston General Insurance, Fort Worth,
Texas
Targa Petroleum, Houston, Texas

Selected Private Collections
Ron Boling, San Antonio, Texas
Joyce Lieberman, Venice, California
Shannon McCarroll, New York, New York
Karen Winterkamp, Houston, Texas

Selected Awards
1978 First Prize in Sculpture, "Fiftieth
Anniversary National Exhibition,"
Cooperstown Art Association,
Cooperstown, New York
1979 First Place in Sculpture, "Sixty-Eighth
Annual Exhibition," Texas Fine Arts
Association, Austin, Texas

1982 Juror's Choice Award, "Citation
Exhibition," Moody Hall Atrium Gallery,
St. Edward's University, Austin, Texas
(Sponsored by Austin Contemporary
Visual Arts Association, Austin, Texas
and Texas Fine Arts Association,
Austin, Texas)

Preferred Sculpture Media
Wood

Additional Art Field
Painting

Teaching Positions
Art Instructor, Austin Community College,
Austin, Texas
Art Instructor, Laguna Gloria Art School,
Austin, Texas

Selected Bibliography
"News & Retrospect: Ceramics as Sculpture."
Ceramics Monthly vol. 27 no. 1 (January
1979) pp. 85, 87, illus.
Platt, Susan. "Reviews: Barbara Sturgill,
Vickie Teague-Cooper and Laura Telford at
Laguna Gloria, Austin." Artspace vol. 5 no.
1 (December-Fall 1980) pp. 49-50, illus.

Gallery Affiliation
Clayworks Gallery
1209 East Sixth Street
Austin, Texas 78702

Mailing Address
3105 Whitis Avenue
Austin, Texas 78705

No Particular Day in Childhood. 1983. Wood, 8'h x 6'6"w x 15"d. Installation view 1983. Town Lake, Austin, Texas. "Fourth Texas Sculpture Symposium," Area Galleries and Institutions, Austin, Texas (Sponsored by College of Fine Arts and Humanities, University of Texas at Austin, Austin, Texas). Photograph by T. R. Vannatta.

Artist's Statement

"My sculpture will always be my age. Each piece is a culmination, combination and screening of my experience. Rather than specific subject matter, I attempt to give the observer a pool of associations and memories from daily life enhanced by imagination. These multiple viewpoints might evoke images of geometry, architecture, animal forms, modern appliances, exaggeration and the humor of unlikely juxtapositions."

Laura Telford

Jane Teller

née Jane Simon
(Husband Walter Magnes Teller)
Born July 5, 1911 Rochester, New York

Education and Training
1920- Rochester Mechanics Institute,
22 Rochester, New York
1929- Skidmore College, Saratoga Springs,
30 New York
1933 B.A., Fine Arts, Barnard College, New
 York, New York
1935 Works Progress Administration, New
 York, New York; study in sculpture
 with Aaron J. Goodelman and wood
 carving with Karl Nielson
1951 Studio of Ibram Lassaw, New York,
 New York; study in welding

Selected Individual Exhibitions
1961, Parma Gallery, New York, New York
62
1974, Princeton Gallery of Fine Art,
76 Princeton, New Jersey
1976 New Jersey State Museum, Trenton,
 New Jersey
1978 Chauncey Conference Center Gallery,
 Educational Testing Services,
 Princeton, New Jersey
1981 City University of New York Queens
 College, Flushing, New York
1985 Montclair Art Museum, Montclair, New
 Jersey, retrospective

Selected Group Exhibitions
1955, "First Philadelphia Art Festival
62, Regional Exhibition," Philadelphia
65 Mueseum of Art, Philadelphia,
 Pennsylvania
1959 "Recent Sculpture U.S.A.," Traveling
 Exhibition, Museum of Modern Art,
 New York, New York, catalog
1959, "New Sculpture Group," Stable
60 Gallery, New York, New York
1960 "Selections from the New Sculpture
 Group," Galerie Claude Bernard, Paris,
 France
1960 "New York Selection," Lyman Allyn
 Museum, New London, Connecticut
1962 "1962 Biennial Exhibition:
 Contemporary American Art," Whitney
 Museum of American Art, New York,
 New York, catalog
1962- "Sculptors Guild Annual Exhibition,"
82 Lever House, New York, New York,
 catalog
1963 "Gerald Samuels and Jane Teller,"
 Osgood Gallery, New York, New York

1965 "New Jersey and the Artist," New
 Jersey State Museum, Trenton, New
 Jersey
1966, "Annual Juried Exhibition of Paintings,
71, Sculpture and Graphics by New
72, Jersey Artists," New Jersey State
79 Museum, Trenton, New Jersey
83
1966 "Regional Exhibition of Paintings,
 Sculpture, Prints and Drawings by
 Artists of Philadelphia and Vicinity,"
 Pennsylvania Academy of the Fine
 Arts, Philadelphia, Pennsylvania
1971 "Sculpture and Graphics,"
 Albright-Knox Art Gallery, Buffalo,
 New York
1972, "The Magic Muse," New Jersey State
74 Museum, Trenton, New Jersey
1977, "Biennial Exhibition New Jersey
79 Artists," Newark Museum, Newark,
 New Jersey and New Jersey State
 Museum, Trenton, New Jersey,
 catalog
1982 "Modern Masters: Women of the First
 Generation," Rutgers University,
 Douglass College, New Brunswick,
 New Jersey
1982 "Joy Saville and Jane Teller," Squibb
 Gallery, Princeton, New Jersey,
 catalog
1983 "Celebration of New Jersey Artists
 from the Capital to the Cape," Noyes
 Museum, Oceanville, New Jersey,
 catalog
1984 "Structure," Montclair Art Museum,
 Montclair, New Jersey

Selected Public Collections
First National Bank of Princeton, Princeton,
 New Jersey
George School, Newtown, Pennsylvania
Jewish Center, Princeton, New Jersey
Mergentime Corporation, Flemington, New
 Jersey
Newark Museum, Newark, New Jersey
New Jersey Department of Education and
 Association for the Arts, Trenton, New
 Jersey
New Jersey State Museum, Trenton, New
 Jersey
Princeton Unitarian Church, Princeton, New
 Jersey
Regional School for the Multiple
 Handicapped, Cassville, New Jersey
Skidmore College, Saratoga Springs, New
 York
Temple Judea, Doylestown, Pennsylvania

Selected Private Collections
Gillett Griffin, Princeton, New Jersey
Heineman-Pieper Collection, Chicago, Illinois
Herbert Kendall, Santa Ana, California
Albert A. List Family Collection, Greenwich,
 Connecticut
Olsen Foundation, Stamford, Connecticut

Selected Awards
1960 Mary and Gustave Kellner Prize,
 "National Association of Women
 Artists Annual Exhibition," National
 Academy of Design, New York, New
 York, catalog
1966 Sculpture Prize, "Fiftieth Anniversary
 Exhibition," Philadelphia Art Alliance,
 Philadelphia, Pennsylvania

Preferred Sculpture Media
Wood

Additional Art Fields
Drawing and Lithography

Selected Bibliography
Day, Worden. "Reviews and Previews: Jane
 Teller." *Art News* vol. 61 no. 1 (March
 1962) p. 50.
Meilach, Dona Z. *Woodcraft: Basic Concepts
 and Skills*. New York: Golden Press, 1976.
"The Wall and the Portal." *Craft Horizons* vol.
 22 no. 3 (May-June 1962) pp. 42-45, illus.
Van Dommelen, David. *Walls: Enrichment
 and Ornamentation*. New York: Funk &
 Wagnalls, 1965.
Wilcox, Donald. *Wood Design*. New York:
 Watson-Guptill, 1968.

Gallery Affiliation
Princeton Gallery of Fine Art
8 Chambers Street
Princeton, New Jersey 08540

Mailing Address
200 Prospect Avenue
Princeton, New Jersey 08540

Link. 1983. Paulownia wood and pine, 53″h x 55½″w x 22½″d.

Artist's Statement

"The statement of my work is in its stance. While working I think of my sculpture in a symbolic and ritualistic way, but at the same time I consider the formal relationships and balances of form, line and space. Recurrent symbols—linked forms, circles and posts, arcs and cubes—give my impression of the internal energy and power in the natural world. Structures appear as walls, arches and totems, and when installed together, tend to create a presence strongly related to prehistoric monuments. These ancient images have been a strong influence as well as the work of Brancusi and Giacometti. The photographer, Aaron Siskind, has been a lifelong mentor.

"It has been natural for me to use wood as a preferred medium. As a child I played with it and watched artisans at work in my father's woodworking factory. Because wood is organic, strong and sensuous, it emphasizes the expression of my work."

Jane Teller

Thea Tewi

née Thea Wittner
(Husband Charles Kalman Schlachet)
Born June 24, 1915 Berlin, Germany, Federal
Republic

Education and Training
1935 Staatliche Kunstakademie, Berlin,
Germany, Federal Republic; study in
sculpture with Bruno Paul
1953- Sculpture Center, New York, New
56 York; study in ceramic sculpture with
Dorothea Denslow and Lu Duble
1954- Art Students League, New York, New
55 York; study in anatomical drawing
1955 New School for Social Research, New
York, New York; study in sculpture
with Seymour Lipton and Manolo
Pascual
1970- Fonderia Tomási, Pietrasanta, Italy;
72 study in lost wax and bronze casting

Selected Individual Exhibitions
1961 Village Art Center, New York, New
York
1966, La Boetie Gallery, New York, New
68, York
70
1968 Maurice Villency Gallery, Roslyn
Heights, New York
1969 Sala Michelangelo, Carrara, Italy
1970 Lehigh University, Bethlehem,
Pennsylvania
1970 Snite Museum of Art, University of
Notre Dame, Notre Dame, Indiana,
catalog
1970 Main Place Gallery, Dallas, Texas
1974 Village Gallery, Croton, New York
1976, Hallway Gallery, Washington, D.C.
80
1977 Fink-Winfield Galleria, New York, New
York
1977, Randall Galleries, New York, New
79, York
83
1979 Kiva Gallery, Scarsdale, New York
1981 Randall Galleries, New York, New
York, catalog
1985 Vorpal Gallery, New York, New York,
catalog

Selected Group Exhibitions
1962, "Annual Juried Exhibition," Silvermine
68 Guild of Artists, New Canaan,
Connecticut
1964, "Painting and Sculptors Society of
66, New Jersey," Jersey City Museum,
67, Jersey City, New Jersey
68,
75
1965- "National Association of Women
78 Artists Annual Exhibition," National
Academy of Design, New York, New
York, catalog

1965- "Knickerbocker Artists Annual
79 Exhibition," National Arts Club, New
York, New York
1967 "Proto V: Source and Sorcery," Iona
College, New Rochelle, New York
1966- "American Society of Contemporary
85 Artists Annual Exhibition," Lever
House, New York, New York
1968 "Invited Artists Show," Book Gallery,
White Plains, New York
1969 "VI Internationale Biennale Carrara,"
Accademia di Belle Arti, Carrara, Italy
1969 "International Sculpture," La Boetie
Gallery, New York, New York, catalog
1972 "Critics' Choice," Sculpture Center,
New York, New York
1973 "American Artists in Paris," Société de
L'École Française, Paris, France
1973 "Selected Queens Artists," Queens
Museum, Flushing, New York
1974 "Living with Sculpture," Citicorp
Center, New York, New York
1977, "Sculptors League Members
79, Exhibition," Lever House, New York,
81, New York
83
1977, "Mostra Artegiana del Marmo,"
78 Camera di Commercio, Carrara, Italy
1979 "New York International Sculpture
Fair," Sheraton Hotel, New York, New
York
1982, "Sculpture on 42nd Street," Grace
83 Building, New York, New York
1982 "Sixty-Seventh Annual Juried
Exhibition," Hudson River Museum,
Yonkers, New York
1982 "Paintings, Tapestries, Drawings,
Graphics; Marble Sculptures by Thea
Tewi," Devernay-Vidal Contemporary
Art, New York, New York
1983 "Art Expo," Dallas Trade Mart, Dallas,
Texas
1985 "American Society of Contemporary
Artists Current Visions '85," National
Arts Club, New York, New York
1985 "Sculptors League Sculpture Scene
1985," Grace Building, New York, New
York
1985 "Sculptors League Benefit Exhibition,"
Middlesex General-University Hospital,
New Brunswick, New Jersey

Selected Public Collections
Ambassador Insurance Company, Bergen,
New Jersey
American Insurance Company, Galveston,
Texas
Bank of Tokyo, Tokyo, Japan
Chrysler Museum, Norfolk, Virginia
Chubb Insurance Group, New York, New
York
Cincinnati Art Museum, Cincinnati, Ohio
Citicorp Center, New York, New York
First Manhattan Company, New York, New
York
Fort Worth National Bank, Fort Worth, Texas
Genesis Hebrew Center, Tuckahoe, New
York
Grand Hyatt Hotel, New York, New York

Jewish Community Center, Richmond,
Virginia
National Museum of American Art,
Smithsonian Institution, Washington, D.C.
Norton Simon Collection, New York, New
York
Pfizer Corporation, New York, New York
Snite Museum of Art, University of Notre
Dame, Notre Dame, Indiana
Western Pacific Industries, New York, New
York

Selected Private Collections
Mr. and Mrs. Samuel Greenbaum,
Washington, D.C.
Dr. Murray List, New York, New York
Dr. and Mrs. George Murphy, New York,
New York
Mr. and Mrs. Stanley Sanger, Beverly Hills,
California
Dr. Thomas Schulten, Bilthoven, Netherlands

Selected Awards
1969 First Prize and Medal of Honor,
"National Association of Women
Artists Annual Exhibition," National
Academy of Design, New York, New
York, catalog
1975 First Prize and Medal of Merit,
"Knickerbocker Artists Annual
Exhibition," National Arts Club, New
York, New York
1979 First Prize, "American Society of
Contemporary Artists Annual
Exhibition," National Arts Club, New
York, New York

Preferred Sculpture Media
Stone

Related Profession
President, Sculptors League, New York, New
York

Selected Bibliography
Alexis, Karin. "Profiles: Thea Tewi (Silver
Spring, Maryland)." *Art Voices/South* vol. 3
no. 6 (November-December 1980) p. 51,
illus.
Fundaburk, Emma Lila and Thomas G.
Davenport, comps. *Art in Public Places in
the United States.* Bowling Green, Ohio:
Bowling Green University Popular Press,
1975.
Meilach, Dona Z. *Contemporary Stone
Sculpture; Aesthetics, Methods,
Appreciation.* New York: Crown, 1970.
Meilach, Dona Z. and Dennis Kowal.
*Sculpture Casting; Mold Techniques and
Materials, Metals, Plastics, Concrete.* New
York: Crown, 1972.

Gallery Affiliations

Vorpal Gallery
465 West Broadway
New York, New York 10012

Vorpal Gallery
393 Grove Street
San Francisco, California 94102

Mailing Address

100-30 67 Drive
Forest Hills, New York 11375

Artist's Statement

"It is an exciting adventure to discover that
the ordinary things in our everyday lives are
endowed with a soul of their own, the impact
of a human presence, as much in evidence
as it remains invisible. I began to notice the
potential of infusing life into the trivial and
apparently banal, the mirrored soul of
personal experiences, the imprint of our own
moods and failures. The style and approach
in my present work constitutes the essence
of a reality which transcends the limitations
of literal representation. Having worked and
experimented with many sculptural materials,
terra cotta, bronze, hammered and welded
metal, my choice remains stone in all its
varieties—the most demanding, the most
challenging of them all."

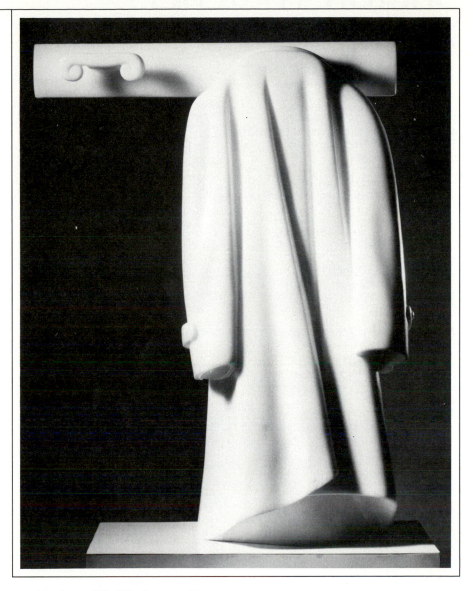

Last of the Guests. 1980. White Carrara marble,
25½"h x 18"w x 8"d. Photograph by Otto E.
Nelson.

Sharon Thatcher

née Sharon Ann Gillespie
(Husband Daniel Gregg Thatcher)
Born November 22, 1942 St. Louis, Missouri

Education and Training
1962 A.A., Liberal Arts, Diablo Valley College, Pleasant Hill, California
1981 B.A., Sculpture, University of Nevada Reno, Reno, Nevada; study with Robert Morrison

Selected Individual Exhibitions
1980, 82 Getchell Library Gallery, University of Nevada Reno, Reno, Nevada
1984 Art Space Gallery, Western Nevada Community College, Carson City, Nevada

Selected Group Exhibitions
1979 "Sharon Thatcher and Patricia Andrew," Sheppard Fine Art Gallery, University of Nevada Reno, Reno, Nevada
1980 "Voices and Silences: Nevada Women in Art," Getchell Library Gallery, University of Nevada Reno, Reno, Nevada
1981 "Walter McNamara Takes Shots At Other Artists," Sheppard Fine Art Gallery, University of Nevada Reno, Reno, Nevada; University of Nevada Las Vegas, Las Vegas, Nevada
1981 "The World's Greatest Artist Show," Sheppard Fine Art Gallery, University of Nevada Reno, Reno, Nevada
1982 "Faculty Exhibition," Sierra Nevada Museum of Art, Reno, Nevada
1982 "House Works, Environmental Sculpture: Trish Andrew, Sharon Thatcher and Charle Varble," Word O'Mouth Gallery, Reno, Nevada
1982 "Twenty-Eighth Annual Open Competition," Northern California Arts, Sacramento, California
1983 "Sound Divide, University of Nevada Reno Arts Festival," Sheppard Fine Art Gallery, University of Nevada Reno, Reno, Nevada
1984 "Trish Andrew and Sharon Thatcher," Winnemucca Fine Art Gallery, Carson City, Nevada
1985 "Nevada Artists Series," State Capitol, Carson City, Nevada
1985 "Kathy Kauffman, Oil Paintings; Sharon Thatcher, Sculpture," Allied Arts Gallery, Las Vegas, Nevada
1985 "Construction Site: A Collaboration by Sharon Thatcher and Jon Winet," Manville Gallery, Manville Medical Building, University of Nevada Reno, Reno, Nevada

Selected Public Collections
Nevada State Council on the Arts, Reno, Nevada
University of Nevada Reno, Reno, Nevada

Selected Private Collections
Patricia L. Andrew, Reno, Nevada
Robert Morrison, Reno, Nevada
Mr. and Mrs. Michael Sheldon, Sacramento, California
Dr. and Mrs. Glen Weber, Piedmont, California
Jon Winet, Carson City, Nevada

Selected Awards
1981 Best of Show, "Eighth Nevada Annual Exhibition: Contemporary Works of Paper," Sierra Nevada Museum of Art, Reno, Nevada
1983-85 Artist in Residence, Nevada State Council on the Arts

Preferred Sculpture Media
Varied Media

Related Professions
Art Instructor, Gallery Director and Juror

Mailing Address
4050 Lakeview Road
Carson City, Nevada 89701

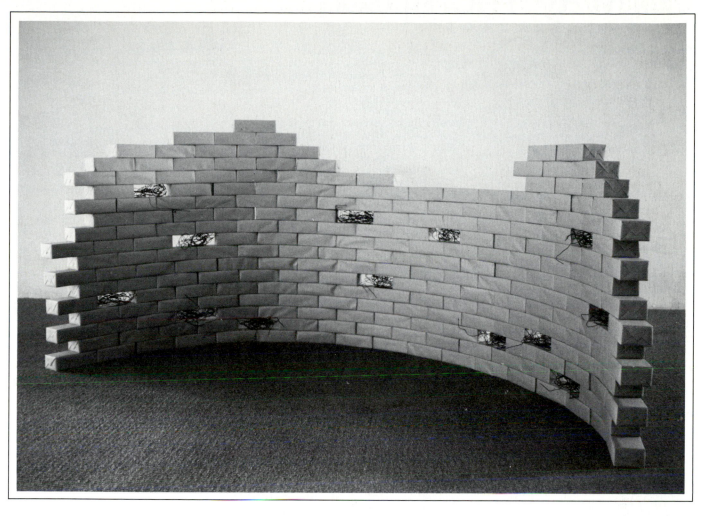

Barricade 3. 1984. Bricks, paper, glue and wire,
40"h x 181"w x 3½"d. Photograph by Jon Winet.

Artist's Statement

"I became involved in art after I was married
and a mother of two daughters. Perhaps the
fact that there is no illusion in mothering
influenced me toward a three-dimensional
object orientation rather than a two-
dimensional illusion orientation. My teacher,
the sculptor, Robert Morrison, encouraged
and guided me to discover and begin to
develop my own work. It was an obvious
choice to explore the sculpture qualities of
the industrial packaging products which my
husband sells. Another strong influence has
been the intense Nevada landscape. The
strongest colors of the Nevada-scape are the
soft warm browns and beiges of the earth
against the blue sky. My brown wrapped
bricks offer the same unending color of the
Great Basin.

"Through folding, wrapping, layering and
stacking, I manipulate cardboard, heavy
plastic wrap, brown paper and twine into a
sculptural structure. A brick or length of
twine wrapped in transparent or brown
paper becomes a metaphor for the external
social structure of our lives. The uniform
containment created by the wrapping is
destroyed with punctures, tears, slashes or
protrusions in an attempt to release
unexplored or untried talents and intuitions.
In *Barricade 3* tangled lengths of wire reach
out, providing a tenative and accidental
contact with the viewer."

Sharon Thatcher

Conway Thompson

née Conway Betty
Born May 13, 1926 Richmond, Virginia

Education and Training
1942- Randolph-Macon College, Ashland,
43 Virginia
1946 B.A., English, Mary Washington
 College, Fredericksburg, Virginia
1952- Apprenticeship to David Slivka,
54 New York, New York
1955 Professional Certificate, Sculpture,
 Cooper Union for the Advancement of
 Science and Art, New York, New
 York; study with Leo Amino
1959 Virginia Museum of Fine Arts,
 Richmond, Virginia; teaching
 fellowship in ceramic sculpture
1961 M.F.A., Sculpture, Instituto Allende de
 Universidad de Guanajuato, San
 Miguel de Allende, Guanajuato,
 México
1968 Fonderia Mariani Bellefiori, Pietrasanta,
 Italy; independent study in bronze
 casting and stone carving

Selected Individual Exhibitions
1958, Jewish Community Center, Richmond,
60 Virginia
1971 Janus Gallery, Greensboro, North
 Carolina
1972 College of Performing Arts, Winston-
 Salem, North Carolina
1978 Randolph Macon College, Ashland,
 Virginia
1979- Bedford Gallery, Longwood College,
80 Farmville, Virginia; Marsh Gallery,
 Modlin Fine Arts Center, University of
 Richmond, Richmond, Virginia

Selected Group Exhibitions
1959 "Virginia Artists Juried Exhibition,"
 Virginia Museum of Fine Arts,
 Richmond, Virginia
1959 "Group Exhibition," Artists Gallery,
 Washington, D.C.
1960 "Group Exhibition," 20th Century
62 Gallery, Williamsburg, Virginia
1963 "Gallery Exhibition," Gallery of Modern
78 Art, Fredericksburg, Virginia
1968 "Gallery Exhibition," Arno Gallery,
 Florence, Italy
1970 "Annual Juried Exhibition," Gallery of
 Contemporary Art, Winston-Salem,
 North Carolina
1972 "A Painter, A Potter and a Sculptor—
 Faculty Exhibition," University of
 Richmond, Richmond, Virginia
1974, "Southeastern Juried Exhibition,"
76 Mint Museum of Art, Charlotte, North
 Carolina
1974, "Juried Artists Exhibition,"
75, Roanoke Fine Arts Center, Roanoke,
76 Virginia; Virginia Museum of Fine Arts,
 Richmond, Virginia, catalog
1982 "20 Sculptors," Institute of
 Contemporary Art of the Virginia
 Museum of Fine Arts, Richmond,
 Virginia

Selected Public Collections
Barksdale Theater, Hanover, Virginia
Federal Reserve Bank of Richmond,
 Richmond, Virginia
First and Merchants National Bank,
 Richmond, Virginia
Randolph-Macon College, Ashland, Virginia
Virginia Museum of Fine Arts, Richmond,
 Virginia

Selected Private Collections
Jackson L. Blanton, Richmond, Virginia
Professor Marilyn Malina Hoban, Newport,
 Rhode Island
Dr. and Mrs. Steven Morse, Princeton, New
 Jersey
Professor and Mrs. Ritchie Watson, Ashland,
 Virginia
Jack and Nancy Witt, Ashland, Virginia

Selected Awards
1959, Fellowship for Professional Artists,
82 Virginia Museum of Fine Arts,
 Richmond, Virginia

Preferred Sculpture Media
Stone and Varied Media

Related Profession
Writer

Selected Bibliography
Witt, Jack. "Reviews of the Exhibitions,
 Virginia: Conway Betty Thompson at
 Longwood College, Farmville." *Art
 Voices/South* vol. 3 no. 1
 (January-February 1980) pp. 97-98, illus.

Mailing Address
Route 2 Box 556
Farmville, Virginia 23901

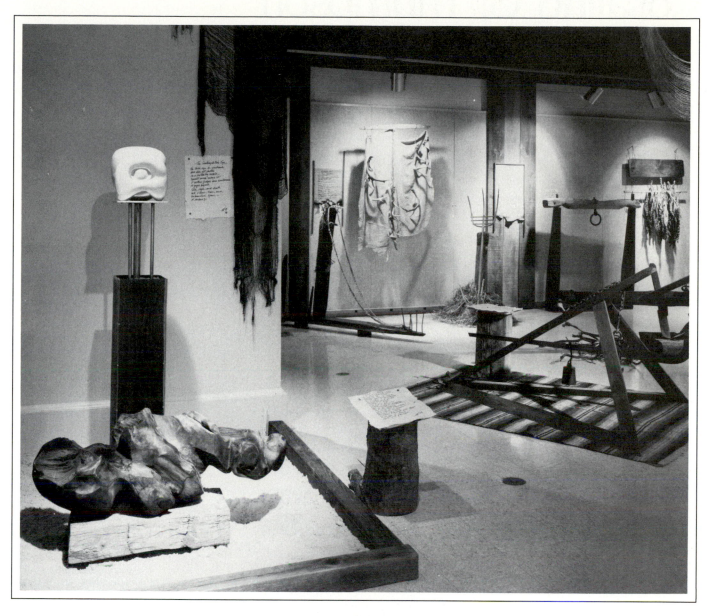

The Agrarian Series: With Other Forms & Words.
1973-1980. Mixed media, gallery size. Installation
view (detail) 1980. Marsh Gallery, Modlin Fine Arts
Center, University of Richmond, Richmond, Virginia.
Photograph by Katherine Wetzel.

Artist's Statement

"I view the veneer of civilization with
skepticism although I feel a great debt to
other generations. My best ideas come from
watching reflections in a pond or shapes of
tree limbs.

"*The Agrarian Series* is an assemblage of
sculptural tableaux and poetry in which I
strove to transform a gallery into a barn
environment with old farm implements,
natural materials of wood and stone and my
handwritten poems, often describing the
persons who once used the objects. An altar
of hay bales recalls the pain and hope of
hard rural lives. A pile of 'slave stones'
removed from the plowed fields of
Buckingham County becomes a memorial
cairn for the toil of black men. A horse skull,
powder horns and gray blanket are
combined in a eulogy for a young cousin
killed at Antietam. Other pieces pay tribute

to a fox hunting maiden aunt, to memories of
a family farm near Bear Island, to the barn
and the bull and the hunted deer. This work
is my legacy of my southern agrarian
heritage translated into art."

Conway Thompson

585

Rosalind G. Thompson

née Rosalind Gallops
(Husband Dewey Milford Thompson)
Born July 31, 1943 Tampa, Florida

Education and Training
1972 A.A., Painting and Drawing, Lenoir
Community College, Kinston, North
Carolina
1975 B.F.A., Interior Design and Sculpture,
East Carolina University, Greenville,
North Carolina; study in sculpture with
Paul Hartley
1975 Pitt Technical Institute, Greenville,
North Carolina; study in welding
1978 M.F.A., Sculpture, East Carolina
University, Greenville, North Carolina;
study with Norman Keller

Selected Individual Exhibitions
1979, Center/Gallery, Carrboro, North
83, Carolina
84
1980, Gallery B, Durham Arts Center,
83 Durham, North Carolina
1981 Newcomb College Art Department,
New Orleans, Louisiana
1983 Chowan College, Murfreesboro, North
Carolina
1983, Gaston College, Dallas, North Carolina
84
1983 Sculpture Court, Southeastern Center
for Contemporary Art, Winston-Salem,
North Carolina
1984 Gallery 10, Washington, D.C.
1985 Western Carolina University,
Cullowhee, North Carolina, catalog

Selected Group Exhibitions
1979 "Forty-First Annual North Carolina
State Competition," North Carolina
Museum of Art, Raleigh, North
Carolina, catalog
1979 "Outdoor Installation Sculpture
Invitational," Sertoma Art Center,
Raleigh, North Carolina
1979 "North Carolina Sculpture '79,"
Weatherspoon Art Gallery,
Greensboro, North Carolina, catalog
1980 "Southern Exposure," Hanson Gallery,
New Orleans, Louisiana, catalog
1980 "Twenty-Two Women Artists," Queens
College Gallery, Charlotte, North
Carolina
1980 "Feminist Art: Process & Product,"
Washington Women's Arts Center,
Washington, D.C.; Center/Gallery,
Carrboro, North Carolina, catalog
1980 "The Touchables—Soft Art," Durham
Art Council Galleries, Durham, North
Carolina
1980 "20 North Carolina Sculptors," Green
Hill Art Gallery, Greensboro, North
Carolina

1981 "13 from North Carolina," Foundry
Gallery, Washington, D.C., catalog
1981 "The Art of North Carolina," Squibb
Gallery, Princeton, New Jersey; Duke
University Museum of Art, East
Campus, Durham, North Carolina
1981 "Sculpture Invitational," Atlantic
Christian College, Wilson, North
Carolina
1981 "Tri-State Sculpture Conference
Exhibition," University of South
Carolina, Columbia, South Carolina,
catalog
1982 "Tri-State Sculptors Invitational,"
Horace Williams House, Chapel Hill,
North Carolina
1982 "Tri-State Sculpture Conference
Exhibition," East Carolina University
Museum of Art/Gray Art Gallery,
Greenville, North Carolina, catalog
1983 "Artsplosure '83: Regional Sculpture
Exhibition, Raleigh Arts Commission,"
Fayetteville Mall, Raleigh, North
Carolina
1983, "Annual Exhibit of North Carolina
84 Sculpture," Northern Telecom,
Research Triangle Park, North
Carolina, catalog
1983 "Tri-State Sculpture 1983," Green Hill
Center for North Carolina Art,
Greensboro, North Carolina, catalog
1983 "First Regional Juried Art Exhibition,"
Spartanburg Arts Center,
Spartanburg, South Carolina
(Sponsored by Friends of the Arts,
Spartanburg, South Carolina), catalog
1983 "Rituals and Celebrations,"
Center/Gallery, Carrboro, North
Carolina
1983 "Alternative Devotional Objects,"
Somerhill Gallery, Durham, North
Carolina
1984 "1984 Tri-State Sculptors," Queens
College, Charlotte, North Carolina
(Sponsored by Mint Museum of Art,
Charlotte, North Carolina; Queens
College, Charlotte, North Carolina and
Tri-State Sculptors), catalog
1984- "Tri-State Sculptors," Traveling
86 Exhibition, Louisiana State University,
Ruston, Louisiana
1984 "Southern Exposure IV," Ponder Fine
Arts Center, Benedict College,
Columbia, South Carolina
1984 "Texas Fine Arts Association Annual
Exhibition," Laguna Gloria Art
Museum, Austin, Texas, catalog
1984 "Twenty-Seventh Irene Leache
Memorial Biennial Exhibition," Chrysler
Museum, Norfolk, Virginia, catalog
1984 "4 x 4 by Floor," Center/Gallery,
Carrboro, North Carolina
1984 "Ninth Annual Art Affair," Fayetteville
Museum of Art, Fayetteville, North
Carolina and Fayetteville Parks and
Recreation Department, Fayetteville,
North Carolina
1985 "A Salute to Robert F. Kennedy,"
North Carolina Central University,
Durham, North Carolina

Selected Public Collections
East Carolina University, Greenville, North
Carolina
General Telephone Electric Network
Systems, Durham, North Carolina
Rauch Industries, Gastonia, North Carolina

Selected Private Collections
Beverly Ayscue, Raleigh, North Carolina
Robin Crozier, Sunderland, Great Britain
Shirley Koller, Washington, D.C.
Dr. Earnest Marshall, Greenville, North
Carolina
Vernessa Riley-Foelix, Graffet, Switzerland

Selected Awards
1977 First Place, "Illumina Competition,"
East Carolina University, Greenville,
North Carolina
1979 Bronze Medal, "Forty-First North
Carolina Artists Exhibition," North
Carolina Museum of Art, Raleigh,
North Carolina, catalog

Preferred Sculpture Media
Varied Media

Additional Art Fields
Artists Books, Collage/Drawing and
Correspondence Art

Related Professions
Consultant, Lecturer and Visting Artist

Selected Bibliography
Greenberg, Blue. "North Carolina's Center
Gallery: A Progressive Woman's Co-Op."
Art Voices/South vol. 3 no. 2 (March-April
1980) pp. 52-54.
McCoy, Mary. "Art Reviews: Rosie
Thompson, Gallery 10." Washington Review
vol. 10 no. 5 (February-March 1985) p. 29.
Powell, M. C. and Annie Cheatham. This Way
Daybreak Comes: Women's Values and the
Future. Philadelphia: New Society
Publishers, 1985.
"Rosie Thompson Celebrates Life." The Arts
Journal vol. 9 no. 2 (November 1983) p. 9,
illus.

Gallery Affiliation
Southeastern Center for Contemporary Art
750 Marguerite Drive
Winston-Salem, North Carolina 27106

Mailing Address
Route 4 Box 1274
Hillsborough, North Carolina 27278

Artist's Statement

"My work is about the celebration of life and/or death of the spirit. My creative method exists in the tension between these two modes. In my work and through self-dialogue, I am investigating the inner and outer limits of art, life and death.

"A main focus in my work is the intrinsic energy tension between static and kinetic forms. This is a threefold exploration of expression: poems, collage/drawings and sculpture. My poems are used for gaining additional conceptual clarity. The direct and spontaneous process of my collage/drawings is similar to the juxtaposition of materials in the investigation of sculptural forms. The sculptures of soft materials, pastel colors and sewn method of construction, contain juxtaposing hard chrome materials, electronic workings and an absence of inner support structures for the forms. They are akin to the pastel, hand-shaped paper cutouts, containing juxtaposing rivets, wire tension and analytic pencil marks."

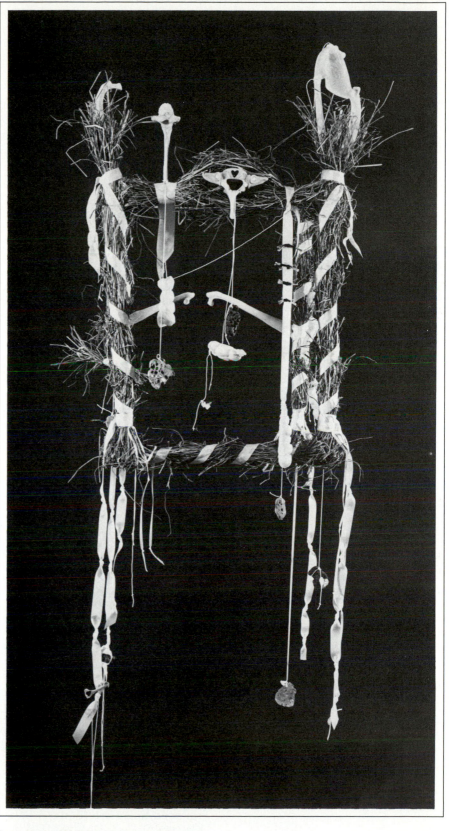

Oracle No. 2. 1983. Painted bones, straw, rocks, ribbon, string and nylon fabric, suspended at 7' with monofilament, 46"h x 14"w x 12"d. Photograph by Richard Faughn.

Hilda Thorpe

née Hilda Gottlieb
(Husband James Joseph Thorpe)
Born December 1, 1919 Baltimore, Maryland

Education and Training
1955- American University, Washington,
59 D.C.; study in drawing, painting and
sculpture

Selected Individual Exhibitions
1961, Jefferson Place Gallery, Washington,
63, D.C.
64,
66,
68,
72
1966 Instituto de Arte Contemporâneo,
Lima, Peru, catalog
1973 Northern Virginia Community College,
Annandale, Virginia, retrospective
1975 Phillips Collection, Washington, D.C.,
catalog
1979 Gallery 4, Alexandria, Virginia
1981 Barbara Fiedler Gallery, Washington,
D.C.
1983 Addison-Ripley Gallery, Washington,
D.C.
1984 Georgetown Court Artists' Space,
Washington, D.C.

Selected Group Exhibitions
1956 "Eleventh Annual Area Exhibition of
Work by Artists of Washington &
Vicinity," Corcoran Gallery of Art,
Washington, D.C., catalog
1959 "Maryland Artists," Baltimore Museum
of Art, Baltimore, Maryland
1970- "Small Sculpture from the United
72 States," Traveling Exhibition, National
Collection of Fine Arts, Smithsonian
Institution, International Art
Programme, Washington, D.C.,
catalog
1970 "New Sculpture: Baltimore,
Washington, Richmond," Corcoran
Gallery of Art, Washington, D.C.,
catalog
1973 "Washington Sculptors," Philadelphia
Art Alliance, Philadelphia,
Pennsylvania
1977 "New Ways with Paper," National
Collection of Fine Arts, Smithsonian
Institution, Washington, D.C., catalog
1978 "Outdoor Sculpture 1978," Northern
Virginia Community College,
Annandale, Virginia, catalog
1978 "Twenty-First Area Exhibition:
Sculpture," Corcoran Gallery of Art,
Washington, D.C., catalog

1981 "New Wave, East Meets West,"
International Monetary Fund,
Washington, D.C.
1981 "Works of Art from the Private
Collections of the Friends of the
Corcoran 1961-1981," Corcoran Gallery
of Art, Washington, D.C., catalog
1983 "Of, On or About Paper, USA Today,"
USA Today Building, Arlington,
Virginia, catalog
1983 "Alexandria Sculpture Festival," The
Athenaeum, Northern Virginia Fine
Arts Association, Alexandria, Virginia,
catalog
1984 "Washington Sculpture: Prospects &
Perspective," Georgetown Court
Artists' Space, Washington, D.C.
1985 "The Washington Show," Corcoran
Gallery of Art, Washington, D.C.,
catalog
1985 "Dimensional Paper," College Art
Gallery, State University of New York
College at New Paltz, New Paltz, New
York

Selected Public Collections
Brownstein & Zeidman & Schomer,
Washington, D.C.
Carley Capitol Group, Washington, D.C.
City of Rockville, Maryland
Corcoran Gallery of Art, Washington, D.C.
Crockett National Bank, San Francisco,
California
Hotel Investors Corporation, Washington,
D.C.
Hyatt Regency Hotel, Arlington, Virginia
International Business Machines, McLean,
Virginia and Rockville, Maryland
International Monetary Fund, Washington,
D.C.
Latham, Watkins & Hill, Washington, D.C.
National Museum of American Art,
Smithsonian Institution, Washington, D.C.
Pharmaceutical Manufacturers Association,
Washington, D.C.
Prudential Life Insurance Company of
America, Washington, D.C.
Riggs National Bank, Washington, D.C.
Security State Bank, New Hampton, Iowa
Sohio Petroleum, San Francisco, California
U.S. News & World Report, Washington, D.C.
Wilner & Scheiner, Washington, D.C.
Woodburn Center for Community Mental
Health, Falls Church, Virginia

Selected Private Collections
Alan L. Freed, McLean, Virginia
Dr. and Mrs. Michael Lapadulas, Washington,
D.C.
Mr. and Mrs. Mortimer Lebowitz, McLean,
Virginia
Ira Lowe, Washington, D.C.
Dr. Melinda Wolf, Pittsburgh, Pennsylvania

Preferred Sculpture Media
Metal (welded), Paper (handmade) and
Varied Media

Additional Art Fields
Drawing and Painting

Teaching Position
Adjunct Faculty in Sculpture, American
University, Washington, D.C.

Selected Bibliography
Lewis, Jo Ann. "Galleries." The Washington
Post (September 29, 1979) p. B3, illus.
Lewis, Jo Ann. "The Nation: Washington,
D.C." Art News vol. 78 no. 10 (December
1979) pp. 127, 129.
Richard, Paul. "The Art of Hilda Thorpe." The
Washington Post (Thursday, May 31, 1973)
p. C6, illus.
Swift, Mary. "Art Reviews: Hilda Thorpe,
'Recent Works On Paper', Barbara Fiedler
Gallery." Washington Review vol. 7 no. 3
(October-November 1981) p. 27, illus.

Gallery Affiliation
Addison-Ripley Gallery
9 Hillyer Court
Washington, D.C. 20008

Mailing Address
200 King Street
Alexandria, Virginia 22314

Artist's Statement

"Woods, trees, light, sun, clouds, mountains, rivers and shorelines are the landscapes of my mind. Nature is a strong part of my life and work.

"Over the years I have been concerned with three-dimensionality and the interplay of light, color and movement on complex forms. My sculpture now is merging into environmental statements which transform a given atmosphere into an illusive space with infinite possibilities. With cotton pulp as a working medium applied spontaneously to a gauzy cotton net, the resulting forms hung in various ways flow around, about and through space.

"The spectator can walk among them and become part of the piece. This involvement for myself and the viewer is a culmination of a great deal of my experiences in art and living. The imagery is born of inner necessity, a private journey."

Hilda Thorpe

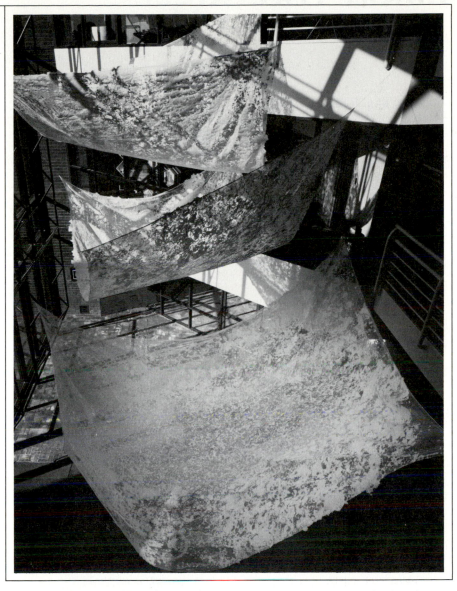

Sky Shift. 1984. Handmade paper and cotton net, 96"h x 210"w x 120"d. Installation view 1984. VVKR Building, Alexandria, Virginia. "Cityspaces: Alexandria Sculpture Festival," Area Locations, City of Alexandria, Virginia, catalog. Photograph by Charles Rumph.

Linda Threadgill

née Linda Holzworth
(Husband James Ernest Threadgill)
Born December 31, 1947 Corpus Christi,
Texas

Education and Training
1970 B.F.A., Ceramics and Metalsmithing,
University of Georgia, Athens,
Georgia; study in metal sculpture with
Robert Ebendorf
1978 M.F.A., Metal Sculpture, Tyler School
of Art, Temple University, Philadelphia,
Pennsylvania; study with Stanley
Lechtzin

Selected Individual Exhibitions
1976 Pensacola Art Center, Pensacola,
Florida
1976 Franconia College, Franconia, New
Hampshire
1982 Fine Arts Gallery, Ohio State
University-Newark Campus, Newark,
Ohio
1984 Charles A. Wustum Museum of Fine
Arts, Racine, Wisconsin
1985 Southwest Craft Center, San Antonio,
Texas
1986 St. Norbert College, De Pere,
Wisconsin

Selected Group Exhibitions
1978 "Juried 2, National Crafts Exhibition,"
Summit Art Center, Summit, New
Jersey, catalog
1978 "Craft Invitational," Salisbury State
College, Salisbury, Maryland
1978 "Saenger National Jewelry & Small
Sculpture Exhibit," University of
Southern Mississippi, Hattiesburg,
Mississippi, catalog
1978 "Fine Arts Invitational," Florida State
University, Tallahassee, Florida
1978 "National Metalsmiths Invitational,"
Creative Arts Workshop, New Haven,
Connecticut, catalog
1979, "Faculty Exhibition," Crossman Gallery,
80, University of Wisconsin-Whitewater,
81, Whitewater, Wisconsin
83
1980 "Arts Council of Florida Grant
Recipients Invitational Show,"
Lemoyne Art Foundation, Tallahassee,
Florida, catalog
1980 "Crafts Invitational," Carnegie-Mellon
University, Pittsburgh, Pennsylvania
1981 "Metalsmith '81," University of Kansas
Art and Design Gallery, Lawrence,
Kansas, catalog
1982 "Craft Summer Faculty Exhibition,"
Private Collection Gallery, Cincinnati,
Ohio

1982, "Wisconsin Impressions," Cudahy
84 Gallery of Wisconsin Art, Milwaukee
Art Museum, Milwaukee, Wisconsin
1983 "Invitational Exhibition of Metalwork,"
Arizona Western College, Yuma,
Arizona
1983 "Invitational Metalsmithing Exhibition,"
Montana State University, Bozeman,
Montana
1983 "Recent Works: Linda Threadgill and
Karl Borgeson," Memorial Union Main
Gallery, University of
Wisconsin-Madison, Madison
Wisconsin
1983 "Invitational Metals Exhibition," Murray
State University, Murray, Kentucky
1983 "Artstreet Sculpture Exhibition," Neville
Public Museum, Green Bay, Wisconsin
1983 "Alternative Image II," John Michael
Kohler Arts Center, Sheboygan,
Wisconsin, catalog
1984 "Metals," Southwest Texas State
University, San Marcos, Texas,
catalog
1984 "Invitational Metalsmithing Exhibition,"
Fine Arts Gallery, University of
Alabama in Birmingham, Birmingham,
Alabama
1984 "Distinguished Members of the Society
of North American Goldsmiths,"
Mitchell Museum, Mount Vernon,
Illinois, catalog
1984 "A Mano National Metals Invitational,"
New Mexico State University, Las
Cruces, New Mexico, catalog
1984 "Precious Objects, Invitational
Exhibition," Worcester Craft Center,
Worcester, Massachusetts
1984 "Jewelry and Unique Objects
Invitational," Fine Arts Center of
Tempe, Tempe, Arizona
1984 "Golden Years, Crafts Alumni
Invitational," Tyler School of Art,
Temple University, Philadelphia,
Pennsylvania, catalog
1984 "McFall Gallery Metalsmithing
Invitational," McFall Gallery, Bowling
Green State University, Bowling
Green, Ohio
1984 "Working Together, Invitational Faculty
Exhibition," Edna Carlsten Gallery,
University of Wisconsin-Stevens Point,
Stevens Point, Wisconsin
1984 "Jewelry and Small Objects," Sarah
Squeri Gallery, Cincinnati, Ohio
1985 "Invitational Metals Exhibition,"
University Art Gallery, University of
Wisconsin-La Crosse, La Crosse,
Wisconsin
1985- "Wisconsin Survey-3-D Art Today,"
86 Traveling Exhibition, Memorial Union,
University of Wisconsin-Madison,
Madison, Wisconsin (Sponsored by
Wisconsin Academy Review, Madison,
Wisconsin), catalog

Selected Public Collections
American Craft Council, New York, New York
The Lannan Foundation, West Palm Beach,
Florida

Northeast Wisconsin Fine Arts Council,
Green Bay, Wisconsin
Tyler School of Art, Temple University,
Philadelphia, Pennsylvania

Selected Awards
1979 Individual Artist's Fellowship, Arts
Council of Florida
1982 Faculty Research Grant, State of
Wisconsin
1984 Individual Artist's Fellowship, National
Endowment for the Arts

Preferred Sculpture Media
Metal (soldered) and Varied Media

Related Professions
Lecturer and Visiting Artist

Teaching Position
Assistant Professor, College of the Arts,
University of Wisconsin-Whitewater,
Whitewater, Wisconsin

Selected Bibliography
Peterson, Allan. "Exhibitions: Metal, Linda
Threadgill." Craft Horizons vol. 36 no. 5
(October 1976) p. 59.
Threadgill, Linda H. "Spray Etching and Its
Application to Metalwork and Jewelry."
Goldsmiths Journal vol. 4 no. 5 (October
1978) pp. 16-17, illus.
Williams, Marylou. "New Boundaries of Mixed
Media in Wisconsin Art." Wisconsin
Academy Review vol. 31 no. 2 (March
1985) pp. 52-59, illus.

Mailing Address
1913 Beulah Lane Road
East Troy, Wisconsin 53120

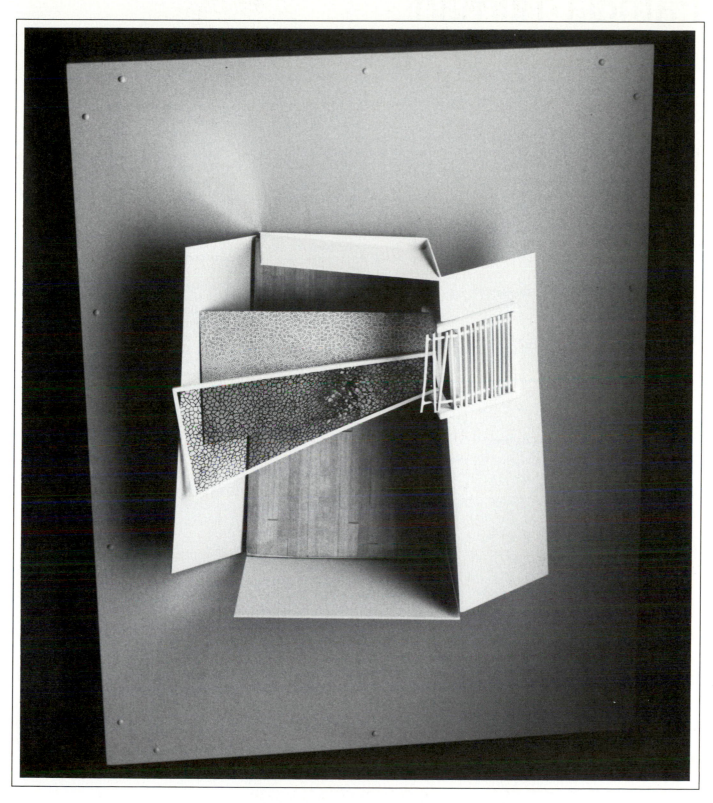

Pink Room. 1984. Sterling silver, brass, aluminum, glass and wooden frame, 18"h x 14"w x 5"d. Photograph by James E. Threadgill.

Artist's Statement

"I am concerned with the depiction of a particular time and space, a first impression, a memory or a feeling. This imagery is usually of an environment affected by the lives of those who have touched or altered it in some way. I am also interested in the way light fills and changes these spaces and shapes. The technical steps in constructing these objects are the result of the joy of working with the materials, becoming part of the structures. They are about technique, discovery and invention."

Linda Threadgill

591

Patricia Tillman

née Patricia Ann
(Husband John Thomas Chatmas)
Born February 15, 1954 Limestone, Maine

Education and Training
1976 B.F.A., Drawing and Painting, University of Texas at Austin, Austin, Texas
1978 M.F.A., Painting and Mixed Media Constructions, University of Oklahoma, Norman, Oklahoma

Selected Individual Exhibitions
1977 College Art Gallery, Fine Arts Building, McLennan Community College, Waco, Texas
1979 Art Museum of South Texas, Corpus, Christi, Texas
1980 DW Gallery, Dallas, Texas
1980 Koehler Cultural Center, San Antonio College, San Antonio, Texas
1984 Brown-Lupton Gallery, Texas Christian University, Fort Worth, Texas
1984 The Art Center, Waco, Texas, catalog
1985 Fort Worth Gallery, Fort Worth, Texas

Selected Group Exhibitions
1978 "Group Exhibition," Fred Jones Memorial Art Museum, University of Oklahoma, Norman, Oklahoma
1978 "Shreveport Art Guild National," Meadows Museum of Art of Centenary College, Shreveport, Louisiana
1979 "Made-in-Texas," University Art Museum, University of Texas at Austin, Austin, Texas, catalog

1979 "Constructions by Patricia Tillman; Paintings by John Chatmas," University Art Gallery, North Texas State University, Denton, Texas
1979-81 "Woman-in-Sight: New Art in Texas," Traveling Exhibition, Dougherty Cultural Arts Center, Austin, Texas, catalog
1980 "Invitational '80," Longview Museum and Arts Center, Longview, Texas
1981 "The Image of the House in Contemporary Art," University of Houston Lawndale Annex, Houston, Texas, catalog
1981 "Off the Wall: Installations & Environments," San Antonio Museum of Art, San Antonio, Texas, catalog
1982 "1982 Annual Visual Arts Faculty Exhibition," University Art Gallery, Baylor University, Waco, Texas
1983 "Sculpture on the Wall," San Antonio Art Institute, San Antonio, Texas
1984 "Line, Color, Form and Texture," Gateway Gallery, Dallas Museum of Art, Dallas, Texas
1985 "Crescent Exhibition II," Crescent Marketing Center, Dallas, Texas

Selected Private Collections
Mr. and Mrs. Jay Followell, Fort Worth, Texas
R. L. Spangler, Fort Worth, Texas
Mariana Thomas, Forth Worth, Texas

Selected Awards
1978 First Place, "Corpus Christi Art Foundation Exhibition," Art Museum of South Texas, Corpus Christi, Texas
1980 Samuel Weiner Award for Sculpture, "Shreveport Art Guild National," Meadows Museum of Art of Centenary College, Shreveport, Louisiana, catalog
1983 First Place, "The Art Center 1983 Competition," The Art Center, Waco, Texas, catalog

Preferred Sculpture Media
Varied Media and Wood

Additional Art Fields
Drawing and Painting

Teaching Position
Art Instructor, McLennan Community College, Waco, Texas

Selected Bibliography
Freudenheim, Susan. "Review of Exhibitions Fort Worth: Patricia Tillman at Texas Christian University." *Art in America* vol. 72 no. 10 (November 1984) pp. 171, 173, illus.
Hickey, Dave. "Linnea Glatt and Patricia Tillman: Post-Modern Options." *Artspace* vol. 9 no. 3 (Summer 1985) pp. 28-31, illus.

Gallery Affiliation
Fort Worth Gallery
901 Boland Street
Fort Worth, Texas 76107

Mailing Address
1315 North 34 Street
Waco, Texas 76710

Artist's Statement

"To be an artist means making a commitment to being in contact with one's inner self. To me, art-making has to do with self-actualization; I do not believe I could be an artist if it had nothing to do with my development as a human being. My personal values, commitments and thoughts are all a part of my work.

"I do not really think of my works as 'sculpture'; they are more like landmarks to personal experiences or simply 'constructed responses.' My environment, specific personal situations and attitudes provide the basis for my work. Certain architectural images are personally meaningful. My use of these images grew out of a realization of my sources (environment) and also the desire to make objects. This personal meaning and also the possibilty for universal meaning makes the image of the house the best means I can, at this time, work with as an artist."

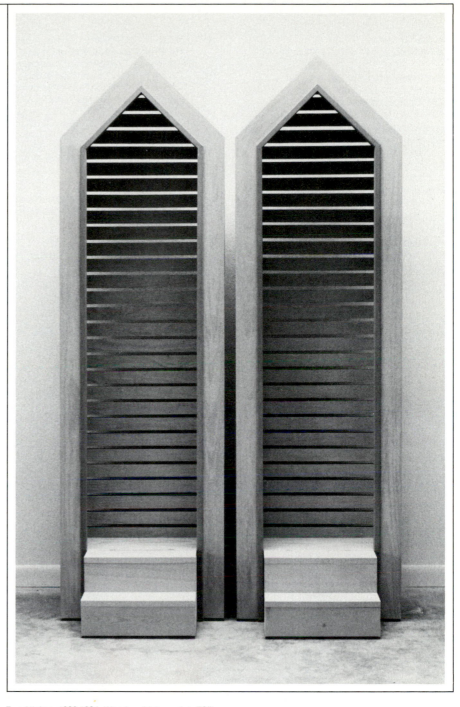

Two Niches. 1983-1984. Wood and latex paint, 72"h x 44"w x 19⅝"d. Installation view 1984. The Art Center, Waco, Texas, catalog.

Jean Tock

née Jean Brotman
Born July 22, 1904 Boston, Massachusetts

Education and Training
1922- Normal Art School, Boston,
26 Massachusetts

Selected Individual Exhibitions
1941 Boris Mirski Art Gallery, Boston,
 Massachusetts
1950 Botolph Gallery, Boston,
 Massachusetts
1982 Joseph P. Healey Library, University
 of Massachusetts at Boston, Boston,
 Massachusetts, retrospective

Selected Group Exhibitions
1942, "New England Sculptors," Addison
51 Gallery of American Art, Andover,
 Massachusetts
1947- "Fifty-Eighth Annual Exhibition of
48 American Paintings and Sculpture:
 Abstract and Surrealist American Art,"
 Art Institute of Chicago, Chicago,
 Illinois, catalog

1952 "Sculpture by Painters," Museum of
 Art, Rhode Island School of Design,
 Providence, Rhode Island, catalog
1958 "Critics Choice, First Annual Boston
 Art Festival," Boston Public Garden,
 Boston, Massachusetts, catalog
1977 "Jean and Frank P. Tock," Art
 Complex Museum, Duxbury,
 Massachusetts
1986 "Figurative Sculpture," Boston
 University Art Gallery, Boston,
 Massachusetts, catalog

Selected Public Collections
Addison Gallery of American Art, Andover,
 Massachusetts
Art Complex Museum, Duxbury,
 Massachusetts
Hebrew Rehabilitation Center, West Rosbury,
 Massachusetts
Highland Heights Apartments for Physically
 Impaired, Fall River, Massachusetts
Michael Reese Hospital and Medical Center,
 Chicago, Illinois
University Lutheran Church, Cambridge,
 Massachusetts
University of Massachusetts at Boston,
 Joseph P. Healey Library, Boston,
 Massachusetts

Preferred Sculpture Media
Stone and Varied Media

Additional Art Field
Drawing

Selected Bibliography
Hayes, Bartlett H., Jr. "Three New England
 Artists: Gardner Cox, George Lloyd and
 Jean Tock." *Art in America* vol. 42 no. 1
 (Winter 1954) pp. 28-31, illus.
Hayes, Bartlett H., Jr. *The Naked Truth and
 Personal Vision.* Andover, Massachusetts:
 Addison Gallery of American Art, 1955.
Tock, Jean. *Acts of Form.* Duxbury,
 Massachusetts: Jean Tock, 1978.

Mailing Address
Post Office Box 1298
Duxbury, Massachusetts 02331

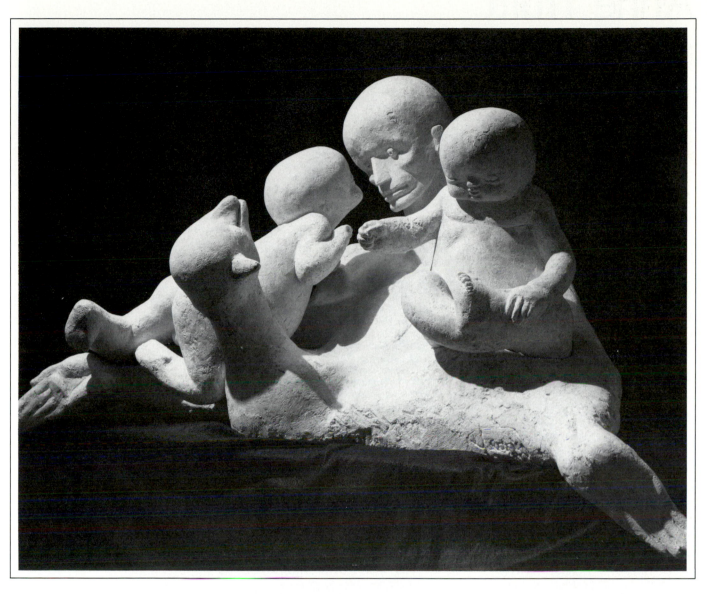

Healer. 1979. Plaster, vermiculite and polymer shell on hardware cloth, 3½′w. Collection Michael Reese Hospital and Medical Center, Chicago, Illinois. Photograph by David Clifton.

Artist's Statement

"I was a professional artist then because of circumstances, I withdrew into a more contemplative pace. I searched and sometimes found—looked deep, long and far—and sometimes saw. My hands shaped, destroyed, beat and caressed and came to know a little. I created in various media figures of women and men, horses and babies, to clarify structure, methods, concepts and principles in a number of collages, drawings and sculptures. Only the past seven years have been a time of great productivity and exultant joy, teaching, lecturing and guiding young apprentices. The goal of all my work has been that it be for people and publicly placed.

"The force that effects creative work can occur independently of our physical resources. This power is available to those who never betray themselves and are searching and audacious. Near blindness and octogenarian, my efforts came to life. Katherine Kuh wrote to me about my work: 'It is special. It has vigor and originality.' Now I stand among my inadequacies—like myself, unique and universal and alive."

Anne Truitt

née Anne Dean
Born March 16, 1921 Baltimore, Maryland

Education and Training
1943 B.A., Psychology, Bryn Mawr College, Bryn Mawr, Pennsylvania
1948- Institute of Contemporary Art,
49 Washington, D.C.; study in sculpture with Alexander Giampietro
1950 School of the Dallas Museum of Fine Arts, Dallas, Texas; study in sculpture with Octavio Medellin

Selected Individual Exhibitions
1963, André Emmerich Gallery, New York,
65, New York
69,
75,
80
1964 Minami Gallery, Tokyo, Japan
1969 Baltimore Museum of Art, Baltimore, Maryland
1971, Pyramid Gallery, Washington, D.C.
75,
77
1973 Whitney Museum of American Art, New York, New York, retrospective
1974 Corcoran Gallery of Art, Washington, D.C., retrospective and catalog
1975, University of Virginia Art Museum,
76 Charlottsville, Virginia, catalog
1981 Osuna Gallery, Washington, D.C.
1983 Sawhill Gallery, James Madison University, Harrisonburg, Virginia
1983 Artemisia Gallery, Chicago, Illinois

Selected Group Exhibitions
1949 "Second Annual Exhibition," Institute of Contemporary Art, Washington, D.C.
1953, "Annual Area Exhibition of Work by
54 Artists of Washington & Vicinity," Corcoran Gallery of Art, Washington, D.C., catalog
1954 "Sixty-Second Society of Washington Artists Annual Exhibition," National Collection of Fine Arts, Smithsonian Institution, Washington, D.C.
1963 "Art has Many Facets: The Artistic Fascination with the Cube," University of St. Thomas, Houston, Texas
1964 "Black, White and Grey," Wadsworth Atheneum, Hartford, Connecticut
1965 "Seven Sculptors," Institute of Contemporary Art of The University of Pennsylvania, Philadelphia, Pennsylvania, catalog
1966 "Primary Structures: Younger American and British Sculptors," Jewish Museum, New York, New York, catalog
1967 "American Sculpture of the Sixties," Los Angeles County Museum of Art, Los Angeles, California; Philadelphia Museum of Art, Philadelphia, Pennsylvania, catalog
1968, "Annual Exhibition: Contemporary
70 American Sculpture," Whitney Museum of American Art, New York, New York, catalog

1968 "The Pure and Clear: American Innovations," Philadelphia Museum of Art, Philadelphia, Pennsylvania, catalog
1969 "International Selection 1968-1969," Dayton Art Institute, Dayton, Ohio
1970 "Washington: Twenty Years," Baltimore Museum of Art, Baltimore, Maryland, catalog
1971 "A Small Loan Exhibition of Washington Artists at the Phillips Collection," Phillips Collection, Washington, D.C., catalog
1972 "The Collection of Philip and Leni Stern," Baltimore Museum of Art, Baltimore, Maryland
1973 "1973 Biennial Exhibition: Contemporary American Art," Whitney Museum of American Art, New York, New York, catalog
1974 "Five Artists: A Logic of Vision," Museum of Contemporary Art, Chicago, Illinois
1974 "Recent Acquisitions and Promised Gifts: Sculpture, Drawings, Prints," National Gallery of Art, Washington, D.C.
1975 "Sculpture: American Directions 1945-1975," National Collection of Fine Arts, Smithsonian Institution, Washington, D.C.
1976 "200 Years of American Sculpture," Whitney Museum of American Art, New York, New York, book
1976 "Washington in Philadelphia," Marian Locks Gallery, Philadelphia, Pennsylvania
1979 "The Decade in Review: Selections from the 1970s," Whitney Museum of American Art, New York, New York, catalog
1979 "Women Artists in Washington Collections," Women's Caucus for Art and University of Maryland Art Gallery, College Park, Maryland, catalog
1980 "Eleventh International Sculpture Conference," Area Galleries and Institutions, Washington, D.C. (Sponsored by International Sculpture Center, Washington, D.C.)
1981 "20th Century American Art: Highlights of the Permanent Collection," Whitney Museum of American Art, New York, New York
1982 "Museum 1982," Baltimore Museum of Art, Baltimore, Maryland, catalog
1982 "20/20," Terry Dintenfass Gallery, New York, New York and Grace Borgenicht Gallery, New York, New York, catalog
1984 "50 Artists/50 States," Fuller Golden Gallery, San Francisco, California
1984 "Seven Sculptors," André Emmerich Gallery, New York, New York
1984 "350 Years of Art and Architecture in Maryland," University of Maryland Art Gallery, College Park, Maryland, catalog
1984 "Profiles: 1984 Faculty Exhibition," University of Maryland Art Gallery, College Park, Maryland

Selected Public Collections
Albright-Knox Art Gallery, Buffalo, New York
Baltimore Museum of Art, Baltimore, Maryland
Corcoran Gallery of Art, Washington, D.C.
Hirshhorn Museum and Sculpture Garden, Smithsonian Institution, Washington, D.C.
Metropolitan Museum of Art, New York, New York
Michael C. Rockefeller Arts Center Gallery, Fredonia, New York
Mint Museum of Art, Charlotte, North Carolina
Museum of Fine Arts, Houston, Houston, Texas
Museum of Modern Art, New York, New York
National Gallery of Art, Washington, D.C.
National Museum of American Art, Smithsonian Institution, Washington, D.C.
National Museum of Women in the Arts, Washington, D.C.
New Orleans Museum of Art, New Orleans, Louisiana
Saint Louis Art Museum, St. Louis, Missouri
University of Arizona Museum of Art, Tucson, Arizona
Vassar College Art Gallery, Poughkeepsie, New York
Walker Art Center, Minneapolis, Minnesota
Whitney Museum of American Art, New York, New York

Selected Awards
1970 John Simon Guggenheim Memorial Foundation Fellowship
1971 Artist's Fellowship Grant, Corcoran Gallery of Art, Washington, D.C.
1977 Individual Artist's Fellowship, National Endowment for the Arts

Preferred Sculpture Media
Wood

Additional Art Fields
Drawing and Painting

Teaching Position
Professor, University of Maryland at College Park, College Park, Maryland

Selected Bibliography
Baro, Gene. "Review of Exhibitions: Washington, Anne Truitt at the Corcoran." *Art in America* vol. 62 no. 4 (July-August 1974) pp. 92-93, illus.
Munro, Eleanor C. *Originals: American Women Artists.* New York: Simon and Schuster, 1979.
Russell, John. "New Sculpture by Anne Truitt." *The New York Times* (Friday, March 7, 1980) p. C19.
Truitt, Anne. *Daybook, The Journal of An Artist/Anne Truitt.* New York: Pantheon Books, 1982.
200 Years of American Sculpture. New York: Whitney Museum of American Art, 1976.

Carson. 1963. Acrylic on wood, 72¾"h x 72"w x 13"d. Installation view 1973. Whitney Museum of American Art, New York, New York, retrospective. Photograph by John Gossage.

Gallery Affiliation
André Emmerich Gallery
41 East 57 Street
New York, New York 10022

Mailing Address
3506 Thirty-Fifth Street NW
Washington, D.C. 20016

Agnese Udinotti

Born January 9, 1940 Athens, Greece

Education and Training
1962 B.A., Painting, Arizona State University, Tempe, Arizona
1963 M.A., Art History, Arizona State University, Tempe, Arizona

Selected Individual Exhibitions
1965 Tucson Art Center, Tucson, Arizona
1969, New Forms Gallery, Athens, Greece
73,
74,
77,
81
1969, Vorpal Gallery, San Francisco,
71, California
73,
80
1971 Yuma Art Center, Traveling Exhibition, Yuma, Arizona
1971 Arthur White Gallery, Toronto, Ontario, Canada
1972 Bishop Gallery, Estes Park, Colorado
1973, Galerie Balans, Amsterdam,
74, Netherlands
75,
78
1974 Elaine Horwitch Gallery, Scottsdale, Arizona
1975 Arizona State University, Tempe, Arizona
1975, Vorpal Gallery, Chicago, Illinois
78
1975, Discovery Gallery, Santa Fe, New
76 Mexico
1976, Vorpal Gallery, New York, New York
78,
79,
81
1976 Yuma Art Center, Yuma, Arizona
1978 Museo National de Oaxaca, Oaxaca, México
1978 Galerie 1-2-3, San Salvador, El Salvador
1980 Panselinos Gallery, Salonica, Greece
1980 Galerie Modern Art International, Munich, Germany, Federal Republic
1981 Udinotti Gallery, Scottsdale, Arizona, retrospective
1983 Valley Verde Art Association, Valley Verde, Arizona
1984 Udinotti Gallery, Traveling Exhibition, Scottsdale, Arizona, catalog
1984 Pasquale Iannetti Art Gallery, San Francisco, California

Selected Group Exhibitions
1966- "Annual Invitational Exhibition," Yuma
80 Art Center, Yuma, Arizona
1969, "Panhellenic Exhibition," Zappeion Hall,
73 Athens, Greece
1970 "Eight Sculptors," Vorpal Gallery, San Francisco, California
1971 "Biennial Exhibition," Phoenix Art Museum, Phoenix, Arizona
1972 "Annual Exhibition," Tucson Art Center, Tucson, Arizona
1972 "Annual Invitational Exhibition," Phoenix Art Museum, Phoenix, Arizona
1975 "Scottsdale 100," Scottsdale Center for the Arts, Scottsdale, California
1979 "Greek Artists," Traveling Exhibition, Maison de l'UNESCO, Paris, France
1982 "Sculptors Guild Open Air Exhibition," Athens, Greece
1983 "Sculptors Guild Open Air Exhibition," Vólos, Greece
1983 "Group Exhibition," Kouros Gallery, New York, New York
1983 "Sculptors Guild Open Air Exhibition," Tríkala, Greece
1984 "Group Exhibition," Pasquale Iannetti Art Gallery, San Francisco, California
1984 "Annual San Francisco Arts Festival," Civic Center Plaza, San Francisco, California
1985 "Sculpture Invitational," Fine Arts Center of Tempe, Tempe, Arizona

Selected Public Collections
Arizona State University, Tempe, Arizona
Chicago Medical School, Chicago, Illinois
Environmental Protection Agency, San Francisco, California
Glendale Community College, Glendale, Arizona
Ministry of Education, Athens, Greece
National Gallery and Alexander Soutzos Museum, Athens, Greece
Orme School, Mayer, Arizona
Phoenix Art Museum, Phoenix, Arizona
Phoenix County Hospital, Phoenix, Arizona
San Francisco Ballet Association, San Francisco, California
Scottsdale Civic Center, Scottsdale, Arizona
Stanford University School of Medicine, Stanford, California
Vorres Museum, Paiania, Greece
Yuma Art Center, Yuma, Arizona

Selected Private Collections
Jeffrey Bohm, Tucson, Arizona
Mr. and Mrs. Richard Litschgi, Phoenix, Arizona
Mr. and Mrs. Marshall Robinson, New York, New York
Mr. and Mrs. John Rubenstein, Los Angeles, California
Mr. and Mrs. Elton Rule, Scarsdale, New York

Selected Awards
1964 First Prize, "Annual Invitational Exhibition," Phoenix Art Museum, Phoenix, Arizona
1971 First Prize, "Solomos Competition," New Forms Gallery, Athens, Greece
1974 Sculpture Prize, "Scottsdale Fine Arts Festival," Scottsdale Center for the Arts, Scottsdale, Arizona

Preferred Sculpture Media
Metal (welded)

Additional Art Fields
Drawing and Painting

Related Profession
Poet

Selected Bibliography
Meilach, Dona Z. Direct Metal Sculpture: Creative Techniques and Appreciation. New York: Crown, 1966.
Perry, Paul. "An Independent Unoppressible Artist." Southwest Art vol. 6 no. 10 (April 1977) pp. 60-63, illus.
Udinotti, Agnese. Udinotti. Flagstaff, Arizona: Northland Press, 1973.
Udinotti, Agnese. My Udinotti: A Dialogue with Zeus. (Vol. 1) San Francisco: Amaranth Press, 1977.

Mailing Address
Udinotti Gallery
4215 North Marshall Way
Scottsdale, Arizona 85251

Relief A/19 (detail). 1974. Welded steel, 4½′h x 2′w x 4″d.

Artist's Statement

"On a philosophical level, the general theme of my work is that of the spiritual and emotional death of man. 'Death,' in this sense, can also be described as inner numbness. On another level, it is the exploration of the sensitivity and limitation of the medium, the use of a seemingly hard surface as a backdrop to miniaturized human forms, as though their existence becomes a mirror of haunting and/or haunted images.

"Again, on a different level, beneath the unsettling and unsettled facade there is fragility, a sensitivity, a vulnerability of an almost alarming presence. Is this, then, a continuous self-portrait?

"The bodies at times expand into multitudes or masses of depersonalized matter. The theme is solitude or, better, human alienation."

599

Andrea V. Uravitch

née Andrea Vaiksnoras
(Husband Joseph Anthony Uravitch)
Born May 12, 1949 Cleveland, Ohio

Education and Training
1972 B.F.A., Weaving, Cleveland Institute of Art, Cleveland, Ohio
1979- Arlington County Adult Education
83 Program. Arlington, Virginia; study in welding with professional commercial welders

Selected Individual Exhibitions
1978, Fendrick Gallery, Washington, D.C.
83
1984 Textile Museum, Washington, D.C.

Selected Group Exhibitions
1973, "Annual May Show," Cleveland
76 Museum of Art, Cleveland, Ohio, catalog
1974 "Nineteenth Area Exhibition," Corcoran Gallery of Art, Washington, D.C., catalog
1975 "Andrea Uravitch and Deborah Vaiksnoras," International Monetary Fund, Washington, D.C.
1976 "Friends of the National Zoo," Fendrick Gallery, Washington, D.C.
1976 "Convergence '76," Heinz Gallery of the Museum of Art, Carnegie Institute, Pittsburgh, Pennsylvania, catalog
1977 "Fiber 200," Textural Arts Gallery, London, Great Britain
1977 "Beauty of the Beast," John Michael Kohler Arts Center, Sheboygan, Wisconsin
1977 "Craft Art," Textile Museum, Washington, D.C., catalog
1979 "Curious Creatures and Bizarre Beasts," Monmouth Museum, Lincroft, New Jersey, catalog
1979 "The Unpainted Portrait: Contemporary Portraiture in a Non-Traditional Media," John Michael Kohler Arts Center, Sheboygan, Wisconsin, catalog
1979 "5 Years of Exhibitions: 1974-1979," Gallery 10, Washington, D.C., catalog
1979 "The Peaceable Kingdom," Fendrick Gallery, Washington, D.C.
1980 "Eleventh International Sculpture Conference," Area Galleries and Institutions, Washington, D.C. (Sponsored by International Sculpture Center, Washington, D.C.)

1980 "National Invitational Fibre Arts Exhibition," Montgomery College-Rockville Campus, Rockville, Maryland, catalog
1980 "Animal Fantasy," Taft Museum, Cincinnati, Ohio
1980- "The Fascinating Cat," Traveling
81 Exhibition, Mulvane Art Center, Topeka, Kansas, catalog
1981 "Old Traditions—New Directions," Textile Museum, Washington, D.C., catalog
1981 "The Animal Image: Contemporary Objects and the Beast," Renwick Gallery of the National Museum of American Art, Smithsonian Institution, Washington, D.C., catalog
1982 "Surface Structure/Fiber Innovations," Arlington Arts Center, Arlington, Virginia
1982 "Tenth Birthday Souvenirs," Renwick Gallery of the National Museum of American Art, Smithsonian Institution, Washington, D.C.
1983 "1983 Crafts Invitational," Southeastern Center for Contemporary Art, Winston-Salem, North Carolina
1983- "Spotlight '83," Traveling Exhibition,
84 Sawtooth Center for Visual Design, Winston-Salem, North Carolina, catalog
1984 "Fish: An Exhibit," Hockaday Center for the Arts, Kalispell, Montana, catalog
1984 "Fiber/Fabric," Holtzman Art Gallery, Towson State University, Baltimore, Maryland, catalog
1984 "American Politics and the Presidency," Renwick Gallery of the National Museum of American Art, Smithsonian Institution, Washington, D.C.
1984 "Animals!: Tradition and Fantasy in Sculpture," Washington Square Partnership and Public Art Trust, Washington, D.C., catalog
1985 "Art Materialized," Southeastern Center for Contemporary Art, Winston-Salem, North Carolina
1985 "Fiber Images: Thirtieth Annual Contemporary Art Exhibition," Lehigh University Art Galleries, Bethlehem, Pennsylvania, catalog
1985 "Female Animals," Delaware Art Museum, Wilmington, Delaware

Selected Private Collections
Christine Carter, New York, New York
James Henson, New York, New York
JoAnn Nicholson, Washington, D.C.
William Nicholson, Houston, Texas
Henry and Lillian Steinberg, Cleveland, Ohio

Selected Awards
1974 Honorable Mentions, "Annual May Show," Cleveland Museum of Art, Cleveland, Ohio, catalog
1976 Individual Craftman's Fellowship, National Endowment for the Arts

Preferred Sculpture Media
Fiber, Metal (welded) and Varied Media

Additional Art Field
Photography

Related Professions
Lecturer and Visiting Artist

Selected Bibliography
Fiber Structures. New York: Van Nostrand Reinhold, 1976.
Phillips, Samuel. "Andrea Uravitch: Red River Hogbench and Other Delights." *Fiberarts* vol. 3 no. 6 (November-December 1976) pp. 2, 14-16, illus.
Portfolio: Andrea Uravitch." *American Craft* vol. 44 no. 4 (August-September 1984) p. 24, illus.
Stevens, Rebecca A. T. "Reviews: Andrea V. Uravitch, Wild and Domestic." *Fiberarts* vol. 10 no. 2 (March-April 1983) p. 71, illus.
Timmons, Chris. "Cows in Fiber." *Fiberarts* vol. 11 no. 4 (July-August 1984) pp. 55-59, illus.

Gallery Affiliation
Fendrick Gallery
3059 M Street NW
Washington, D.C. 20007

Mailing Address
1701 North Roosevelt Street
Arlington, Virginia 22205

Moo Cow: A Dedication to Motherhood. 1980.
Wooden base, carved structure and crochet
covering, 37½"h x 53"w x 16"d.

Artist's Statement

"The central themes of my work are from
nature: animals, landscapes and vegetation.
My interest in animals focuses on the
challenge of capturing life through surface
texture, patterning, motion and facial
expressions. The interplay of light and
shadow, the fluidity and relationship of color
and motion are endless.

"The ephemeral nature of landscapes and
vegetation pose a quieter, slower solution.
For example, the colors of ripening bananas
change hourly and, over days, even the
shape is transformed.

"My tools, materials and methods vary
from crocheted or woven fiber surfaces
covering an inner structure which is either a
soft core or welded, shaped metal or
wooden framework. Fine details can be hair,
glass, wood or plastic. My purpose is to
express an aspect of the life in each subject
so that this can be appreciated by others."

Andrea V. Uravitch

Maureen O'Hara Ure

née Maureen O'Hara
(Husband Lincoln Richard Ure III)
Born November 28, 1949 Detroit, Michigan

Education and Training
1970 B.F.A., Art History, University of Utah, Salt Lake City, Utah
1971- New York University, New York, New
72 York; study in sculpture with Vincent Glinsky
1979 M.F.A., Painting and Drawing, University of Utah, Salt Lake City, Utah; study in sculpture with Frank Anthony Smith

Selected Individual Exhibitions
1980 Meadows Museum of Art of Centenary College, Shreveport, Louisiana
1981 Arts Place, Portland, Oregon
1981 Memorial Union Gallery, Arizona State University, Tempe, Arizona
1982 Anna Gardner Gallery, Stinson Beach, California
1983 Space Gallery, Los Angeles, California

Selected Group Exhibitions
1979, "Large-Scale Outdoor Installations,
80 Utah Festival of the Arts," Downtown Locations, Salt Lake City, Utah
1980 "In a Major and Minor Scale," Los Angeles Municipal Art Gallery, Los Angeles, California

1980 "Four Corners States' Biennial," Phoenix Art Museum, Phoenix, Arizona, catalog
1981 "The Grand Beehive Exhibition," Traveling Exhibition, Renwick Gallery of the National Museum of American Art, Smithsonian Institution, Washington, D.C., catalog
1981 "Invitational Exhibition," Sonoma State University, Rohnert Park, California
1981 "Invitational Artists," Memorial Union Gallery, Arizona State University, Tempe, Arizona
1982 "Collage," Gallery North, Setauket, New York
1982 "Twelfth International Sculpture Conference," Area Galleries and Institutions, Oakland, California and San Francisco, California (Sponsored by International Sculpture Center, Washington, D.C.)
1982 "Still Life," Anna Gardner Gallery, Stinson Beach, California
1983 "Construction," San Francisco International Airport, San Francisco, California
1984 "Interiors," Sun Valley Center, Sun Valley, Idaho
1984 "Utah Landscape," Salt Lake City Art Center, Salt Lake City, Utah

Selected Public Collection
Frederick Mayer Investments, Denver, Colorado

Selected Private Collections
Mrs. Robert Applewhite, Phoenix, Arizona
Vinnie Fish, Stony Brook, New York
Daniel Melnick, Los Angeles, California
Betye Saar, Hollywood, California
Beth Sellars, Spokane, Washington

Preferred Sculpture Media
Varied Media

Additional Art Field
Painting

Teaching Position
Instructor, University of Utah, Salt Lake City, Utah

Selected Bibliography
Bush, Donald. "The Southwest Biennial at Phoenix Art Museum: Nary A Cowpoke To Be Seen." *Art Voices* vol. 4 no. 5 (September-October 1981) pp. 65-67, illus.
Harrison, Helen A. "Collage Defined and Redefined." *The New York Times* (Sunday, April 4, 1982) p. L.I. 24, illus.

Gallery Affiliations
Space Gallery
6015 Santa Monica Boulevard
Los Angeles, California 90038

Anna Gardner Gallery
3445 Shoreline Highway
Post Office Box 582
Stinson Beach, California 94970

Mailing Address
158 East 200 South-203
Salt Lake City, Utah 84111

Artist's Statement

"A painter, I came to sculpture through found objects, initially painting on and cutting up my friends' discarded masonite paintings. Then I began scavenging three-dimensional objects from junk stores and materials and wooden forms from scout projects.

"My media include acrylics, inks, colored pencils and gesso on wood constructions. I let surfaces weather over time by repetitive painting, then sanding and painting, building up a patterned, layered and smooth finish. Other sculptures and paintings of my own serve as found objects in themselves when I jigsaw them apart and reassemble them into new configurations. The symbolic images have come to stand in for events, persons, ideas—parts of myself."

Maureen O'Hara Ure

False Front. 1981. Mixed media and found objects, 12¾"h x 7¾"w x 5⅛"d. Photograph by Fred Wright.

603

Jean Van Harlingen

Born February 12, 1947 Dayton, Ohio

Education and Training
1970 B.S., Art, Ohio State University, Columbus, Ohio
1970- Columbus College of Art and Design, 71 Columbus, Ohio
1975 M.F.A., Sculpture, Tyler School of Art, Temple University, Philadelphia, Pennsylvania; study with Douglas Holmes

Selected Individual Exhibitions
1975 Alfred O. Deshong Museum, Widener University, Chester, Pennsylvania
1978 Drexel University, Philadelphia, Pennsylvania
1981 Lawrence Art Center, Lawrence, Kansas
1982 Independence Arts Center, Independence, Kansas
1982 Lawrence Gallery, Kansas City, Missouri
1983 Pittsburg State University, Pittsburg, Kansas
1983 Independence Community College, Independence, Kansas
1983 Kellas Gallery, Lawrence, Kansas
1985 Central Exchange, Kansas City, Missouri
1985 Arthur Vincent Gallery, Columbia, Missouri

Selected Group Exhibitions
1975 "Bicentennial Azalea Garden Sculpture Exhibition," Philadelphia Museum of Art, Philadelphia, Pennsylvania
1976 "Sculpture/Dance," Temple University, Philadelphia, Pennsylvania
1977 "Benchmark 5," Widener University, Chester, Pennsylvania
1979 "Sculpture Outdoors '79," Temple University Music Festival, Ambler Campus, Ambler, Pennsylvania (Co-Sponsored by Cheltenham Art Centre, Cheltenham, Pennsylvania), catalog
1980 "Tyler Alumni Show," Tyler School of Art, Temple University, Philadelphia, Pennsylvania, catalog
1980 "Women in the Arts, Celebration '80," William Penn Memorial Museum, Harrisburg, Pennsylvania

1981 "Yesterday, Today, Tomorrow," William Penn Memorial Museum, Harrisburg, Pennsylvania
1981 "Big Art for Big Spaces," Woodmere Art Gallery, Philadelphia, Pennsylvania
1981 "Nineteenth Regional Art Exhibition," University of Delaware, Newark, Delaware, catalog
1981 "Fortieth Annual Exhibition," Museum of the Philadelphia Civic Center, Philadelphia, Pennsylvania
1981 "Opens Friday," Moore College of Art, Philadelphia, Pennsylvania
1982 "First National Landscape in Art Exhibition," Springfield Art Association, Springfield, Illinois
1982 "Kansas Women Artists," Marymount College of Kansas, Salina, Kansas
1982 "Fiber Sculpture National," Nazareth College of Rochester, Rochester, New York
1982 "Works: Paper," Ohio University, Athens, Ohio, catalog
1982 "Twelfth International Sculpture Conference," Area Galleries and Institutions, Oakland, California and San Francisco, California (Sponsored by International Sculpture Center, Washington, D.C.)
1983 "Kansas Sculptors Association Exhibition," Johnson County Community College, Overland Park, Kansas
1983 "Kansas Sculpture," Saint Mary College, Leavenworth, Kansas
1983 "Dancing on Air," Crafton-Preyer Theatre, Murphy Hall, University of Kansas, Lawrence, Kansas
1984 "Summer Landscape Exhibition," Strecker Gallery, Manhattan, Kansas
1984 "Mid-Summer Magic II," Batz/Lawrence Gallery, Kansas City, Missouri
1984 "Eighteenth Joslyn Biennial," Joslyn Art Museum, Omaha, Nebraska, catalog
1984 "Paper: A National Invitational," Cheney Cowles Memorial Museum, Spokane, Washington, catalog
1984 "Kansas City Renaissance Festival," Fairgrounds, Bonner Springs, Missouri
1984 "Landscape: 3 Views, Colette Bangert, Joan Foth and Jean Van Harlingen," Batz/Lawrence Gallery, Kansas City, Missouri
1984 "Kansas Fiber Direction '84," Wichita Art Museum, Wichita, Kansas
1985 "Fibre/Espace: XII Biennale Internationale de la Tapisserie," Musée Cantonal des Beaux Arts, Lausanne, Switzerland, catalog

Selected Public Collections
Bethel Park School District, Bethel Park, Pennsylvania
Brandywine Art Park, Philadelphia, Pennsylvania
Mills College, Oakland, California
Tulsa Humanities and Arts Council, Tulsa, Oklahoma

Selected Private Collection
Gene Riggs, Spring City, Pennsylvania

Selected Award
1978 Individual Artist's Fellowship, Pennsylvania Council on the Arts and National Endowment on the Arts

Preferred Sculpture Media
Fiber and Varied Media

Additional Art Fields
Painting and Sculptural Environments for Modern Dance

Selected Bibliography
Grilikhess, Alexandra. *On Women Artists: Poems, 1975-1980.* Minneapolis: Cleis Press, 1981.
Kisselgoff, Anna. "Dance: Zero Movers." *The New York Times* (Sunday, April 20, 1975) section one, p. 50.

Gallery Affiliation
Batz/Lawrence Gallery
4116 Pennsylvania
Kansas City, Missouri 64111

Mailing Address
2143 Summit Street
Kansas City, Missouri 64108

Sculpture/Dance. 1974. Inflated vinyl, 12'h x 36'w x 24'd. Installation view 1975. "Bicentennial Azalea Garden Sculpture Exhibition," Philadelphia Museum of Art, Philadelphia, Pennsylvania.

Artist's Statement

"The sources of my artistic ideas come from nature and the landscape. My images arise from the rearrangement of the structural elements of nature and from nature's process of accumulation, assemblage and compression. In the dialogue between the everchanging and the enduring structures in nature, the natural materials (fibers) are reclaimed and allowed to bring forth their own expression. They become a reflection of the viewer's own sightings and privately held metaphors.

"In the early 1970s the process of the work reinforced my connection with nature yet changed to explore the relationship of landscape to movement. I designed an inflated vinyl sculpture for modern dance. Thus I created a new environment combining two distinct art forms, sculpture and dance. The movement or dance for the sculpture will be rechoreographed by different choreographers many times during my lifetime."

jean Van Harlingen

Marian J. Vieux

née Marian JoAnn
Born November 11, 1950 Dodge City,
Kansas

Education and Training
1972 B.S.E., Art Education, Emporia State
University, Emporia, Kansas
1975 M.A., Metalsmithing, Emporia State
University, Emporia, Kansas
1976 M.F.A., Design, University of Kansas,
Lawrence, Kansas

Selected Individual Exhibitions
1978 Union Gallery, University of Wisconsin-
Madison, Madison, Wisconsin
1983 Concordia College, Mequon,
Wisconsin

Selected Group Exhibitions
1981 "Wisconsin Directions 3: The Third
Dimension," Milwaukee Art Museum,
Milwaukee, Wisconsin, catalog
1981- "Collage & Assemblage," Traveling
84 Exhibition, Mississippi Museum of Art,
Jackson, Mississippi, catalog

1982 "Airspace," Milwaukee Public Airport,
Milwaukee, Wisconsin
1983 "Landscape in Wisconsin," Wisconsin
Arts Board and Governor's Office,
State Capitol, Madison, Wisconsin
1984 "Sticks," Addison Gallery of American
Art, Andover, Massachusetts, catalog
1984 "Arts Festival of Atlanta," Peidmont
Park, Atlanta, Georgia
1984 "Fiber Crosscurrents," John Michael
Kohler Arts Center, Sheboygan,
Wisconsin, catalog
1985 "Sculpture-Overview 1985," Evanston
Art Center, Evanston, Illinois, catalog

Selected Awards
1980 Special Project Grant, Wisconsin Arts
Board
1982 Juror's Award, "Small Works National
'82," Zaner Gallery, Rochester, New
York, catalog
1985 Individual Artist's Fellowship,
Wisconsin Arts Board

Preferred Sculpture Media
Varied Media

Additional Art Field
Photographic Documentation

Related Profession
Visiting Artist

Selected Bibliography
"Fiber Crosscurrents." *American Craft* vol. 44
no. 4 (August-September 1984) pp. 48-49,
illus.
Manger, Barbara. "Reviews Midwest
Wisconsin: Karon Hagemeister Winzenz,
Woodland Pattern Gallery; Marian Vieux,
Concordia College." *New Art Examiner* vol.
11 no. 5 (February 1984) p. 22, illus.

Mailing Address
2963 North Summit Avenue
Milwaukee, Wisconsin 53211

Forest Panorama. 1983. 9'h x 15'w x 20'd.
Installation view 1983. MacDowell Colony,
Peterborough, New Hampshire.

Artist's Statement

"The site sculpture *Forest Panorama* is
intended to evoke our memory of ages past.
It is a monument to primordial life and a
reminder of our presence in that history. The
sculpture calls attention to its boundaries as
if the viewer were walking within a defined
forest. The tree wrappings of colors and
patterns define a composition of visual
rhythms, negative and positive spaces, solid
and ephemeral illusions. It is this illusion of
space which allows our imagination to flow
backwards in time to the landscape of our
subconscious memory, an illusion of uncanny
familiarity."

Marian J. Vieux

Linda E. A. Wachtmeister

née Linda Elisabeth Anne
(Husband Robert Louis Strini)
Born March 9, 1950 Washington, D.C.

Education and Training
1970 A.A., Fine Art, Bennett College, Millbrook, New York
1972 B.F.A., Ceramic Sculpture, Maryland Institute College of Art, Baltimore, Maryland; study with Doug Baldwin
1977, Independent research in ceramic art
78 history in Italy
1978 M.F.A., Ceramic Sculpture, University of Montana, Missoula, Montana; study with Ken Little

Selected Individual Exhibitions
1975 Turner Hall Gallery of the Visual Arts, University of Montana, Missoula, Montana
1978 Missoula Museum of the Arts, Missoula, Montana
1984 Western Washington University, Bellingham, Washington
1985 Lawrence Dillon Gallery, Seattle, Washington
1985 Percival Gallery, Des Moines, Iowa

Selected Group Exhibitions
1973 "Invitational Exhibition," Phoenix Chase Gallery, Baltimore, Maryland
1974 "Group Exhibition," Decker Gallery, Maryland Institute College of Art, Baltimore, Maryland

1976 "Bicentennial Ten State Exhibition," C. M. Russell Museum, Great Falls, Montana
1976 "Annual Juried Exhibition," Missoula Museum of the Arts, Missoula, Montana
1977 "Art in Public Places," Cheney Cowles Memorial Museum, Spokane, Washington
1977 "Missoula Women Artists," Women's Resource Center, Missoula, Montana; Turner Hall Gallery of the Visual Arts, University of Montana, Missoula, Montana
1977 "Three Women Artists: Amanda Jaffe, Pat Thomas and Linda Wachtmeister," Turner Hall Gallery of the Visual Arts, University of Montana, Missoula, Montana
1978 "Invitational Birthday Exhibition," Missoula Museum of the Arts, Missoula, Montana
1978 "Invitational Sculpture Show," Turner Hall Gallery of the Visual Arts, University of Montana, Missoula, Montana
1979 "Another Side to Art: Ceramic Sculpture of the Northwest 1959-1979," Modern Art Pavilion, Seattle Art Museum, Seattle, Washington, catalog
1982 "Montana Women's Show," Missoula Museum of the Arts, Missoula, Montana
1985 "Northwest Juried Art '85," Cheney Cowles Memorial Museum, Spokane, Washington

Selected Award
1984 Merit Award, "Centennial Great Falls Missouri River Meeting," Paris Gibson Square Gallery, Great Falls, Montana, catalog

Selected Private Collections
Robert Adair, London, Great Britain
David Burnham, Philipsburg, Montana
Anne Marie Lawrence, Warrenton, Virginia
Leslie Van Stavern Millar II, Missoula, Montana
Suzanne Ott, Zürich, Switzerland

Preferred Sculpture Media
Clay and Varied Media

Additional Art Field
Drawing

Selected Bibliography
Harrington, LaMar. *Ceramics in the Pacific Northwest: A History.* Seattle: University of Washington Press, 1979.
"News & Retrospect: Ceramics in the Northwest." *Ceramics Monthly* vol. 28 no. 1 (January 1980) pp. 83, 85, illus.

Gallery Affiliation
Lawrence Dillon Gallery
2010 Third Avenue
Seattle, Washington 98121

Mailing Address
5555 South Holly Street
Seattle, Washington 98118

Home Sweet Home. 1984. Mixed media, 13'h x
13'w x 4½'d. Installation view 1984. Western
Washington University, Bellingham, Washington.

Artist's Statement

"I realize that I am not alone in my creative
efforts. This sounds presumptuous but after
some years of isolation in Montana I viewed
the world differently. The seclusion forced
me to face the fears and anguish of my
personal life. They were no different than
another's, but in living there is very little time
to consider what Louise Bogan has called
one's 'lost heart.' The animals in Montana,
who enriched my understanding of what it
means to be human, reflect in my work
aspects of that lost heart, a reminder of my
own and, hopefully, yours."

Lin S. Walker

née Lin Dickenson Swensson
(Husband William Croft Walker)
Born February 20, 1958 Harvey, Illinois

Education and Training
1976 Middle Tennessee State University, Murfreesboro, Tennessee; study in aluminum and bronze casting techniques with Jim Gibson
1977- The Marble Shop, Knoxville,
79 Tennessee; independent study in marble carving
1979 B.F.A., Sculpture, University of Tennessee, Knoxville, Knoxville, Tennessee; study in welded steel sculpture with Dennis Peacock
1979- Carnegie-Mellon University, Pittsburgh,
80 Pennsylvania; study in marble carving and welded steel sculpture with Ron Bennett
1982 M.F.A., Sculpture, University of Utah, Salt Lake City, Utah; study in welded steel sculpture with Richard Johnston

Selected Individual Exhibition
1982 Salt Lake Art Center, Salt Lake City, Utah
1985 Nashville Artists Guild Gallery, Nashville, Tennessee

Selected Group Exhibitions
1979 "Not in New York," Frank H. McClung Museum, Knoxville, Tennessee
1980 "Century III Celebration of the Arts," The Parthenon, Nashville, Tennessee
1983 "Opening Exhibition," Canyon Gallery, Salt Lake City, Utah

Selected Public Collections
Earl Swensson Associates, Nashville, Tennessee
First American Bank Center, Nashville, Tennessee
Opryland Hotel, Nashville, Tennessee
Salt Lake Art Center, Salt Lake City, Utah

Selected Private Collections
Mr. and Mrs. Daniel Mattis, Salt Lake City, Utah
Constance Elizabeth Merendino, Salt Lake City, Utah
Mr. and Mrs. Earl Swensson, Nashville, Tennessee

Selected Award
1981 Best of Show, "Utah '82," Utah Museum of Fine Arts, Salt Lake City, Utah

Preferred Sculpture Media
Metal (welded) and Stone

Gallery Affiliations
Canyon Gallery
324 South State Street, Suite 260
Salt Lake City, Utah 84111

Norman Worrell Associates
Art Consultants
2328 Golf Club Lane
Nashville, Tennessee 37215

Mailing Address
3903 Sunset Drive
Valparaiso, Indiana 46383

Artist's Statement

"A fascination with the landscape of southern Utah has nourished the development of my imagery. The first images influenced by this interest dealt with properties such as the monumentality, inherent surface qualities, weight and balance of the sandstone formations. As I spent more time in the red rock country, more intimate impressions of the back country began to evolve in my work through the use of symbols. Color and surface treatments were refined to complete the impressions.

"Trips to the desert became less frequent and detached reflections of the area brought a shift in my work. The scale of the pieces reduced and an awareness of forms as an abstract vocabulary increased. These developments led to later explorations with forms more specifically used as formal elements. Through the changing meanings of this visual vocabulary, my personal style has unfolded."

Jim S. Walker

Fins. 1982. Brass and wired glass, 32"h x 18"w x 12"d. Collection Earl Swensson Associates, Nashville, Tennessee. Photograph by Chip Schofield.

Patti Warashina

née M. Patricia
(Husband Robert H. Sperry)
Born March 16, 1940 Spokane, Washington

Education and Training
1962 B.F.A., Ceramics, University of Washington, Seattle, Washington
1964 M.F.A., Ceramics and Jewelry, University of Washington, Seattle, Washington

Selected Individual Exhibitions
1968 Lantern Gallery, Ann Arbor, Michigan
1970 Cone 10 Gallery, Seattle, Washington
1976 Grossmont College Gallery, El Cajon, California, catalog
1977 Polly Friedlander Gallery, Seattle, Washington
1977 Following Sea Gallery, Honolulu, Hawaii
1980, Foster/White Gallery, Seattle,
84 Washington
1980 Theo Portnoy Gallery, New York, New York
1982 Tucson Museum of Art, Tucson, Arizona, catalog
1984 Morgan Gallery, Kansas City, Missouri
1985 Napa College, Napa, California

Selected Group Exhibitions
1969- "Objects: USA," Traveling Exhibition,
71 National Collection of Fine Arts, Smithsonian Institution, Washington, D.C.
1971 "Contemporary Ceramic Art: Canada, USA, México and Japan," National Museum of Modern Art, Kyoto, Japan; Museum of Modern Art, Tokyo, Japan, catalog
1972 "International Ceramics 1972," Victoria and Albert Museum, London, Great Britain, catalog
1972 "A Decade of Ceramic Art 1962-1972: From the Collection of Professor and Mrs. R. Joseph Monsen," San Francisco Museum of Art, San Francisco, California, catalog
1973 "Creative America: Forty-Five Sculptors," American Art Center, Tokyo, Japan, catalog
1974 "The Fred and Mary Marer Collection: Thirtieth Annual Ceramics Exhibition," Lang Art Gallery, Scripps College, Claremont, California, catalog
1974 "Clay," Whitney Museum of American Art, Downtown Branch, New York, New York, catalog
1975 "The Plastic Earth and Extraordinary Vehicles," John Michael Kohler Arts Center, Sheboygan, Wisconsin
1976 "One Hundred Artists Commemorate Two-Hundred Years," Xerox Square Exhibition Center, Rochester, New York, catalog
1976 "Contemporary Clay: Ten Approaches," Dartmouth College, Hanover, New Hampshire, catalog

1977 "Soup Tureens: 1976," Traveling Exhibition, Campbell Museum, Camden, New Jersey, catalog
1978 "Clay from Molds: Multiples, Altered Castings, Combinations," John Michael Kohler Arts Center, Sheboygan, Wisconsin, catalog
1979 "Another Side to Art: Ceramic Sculpture of the Northwest 1959-1979," Modern Art Pavilion, Seattle Art Museum, Seattle, Washington, catalog
1979- "A Century of Ceramics in the United
80 States 1878-1978," Everson Museum of Art, Syracuse, New York; Renwick Gallery of the National Collection of Fine Arts, Smithsonian Institution, Washington, D.C., book
1980 "Robert L. Pfannebecker Collection: A Selection of Contemporary American Crafts," Moore College of Art, Philadelphia, Pennsylvania, catalog
1980 "Contemporary Washington State Artists," Cranberry World Gallery, Plymouth, Massachusetts, catalog
1980 "Contemporary Ceramics: A Response to Wedgwood," Traveling Exhibition, Museum of the Philadelphia Civic Center, Philadelphia, Pennsylvania
1981 "The Animal Image: Contemporary Objects and the Beast," Renwick Gallery of the National Museum of American Art, Smithsonian Institution, Washington, D.C., catalog
1981 "Centering on Contemporary Clay: American Ceramics from the Joan Mannheimer Collection," University of Iowa Museum of Art, Iowa City, Iowa, catalog
1981 "Master Craftsmen," Jacksonville Art Museum, Jacksonville, Florida
1982 "Washington Craft Forms: An Historical Perspective 1950-1980," Washington State Capitol Museum, Olympia, Washington, catalog
1982 "Imbued Clay Figures," Antonio Prieto Memorial Gallery, Mills College, California
1982 "Pacific Currents/Ceramics 1982," San Jose Museum of Art, San Jose, California
1982 "Art and/or Craft; USA & Japan," Traveling Exhibition, MRO Hall, Hokuriku Broadcasting Company, Kanazawa, Japan, catalog
1983 "The Pacific Northwest Today," Brentwood Gallery, St. Louis, Missouri
1983 "Contemporary Clay Sculpture: Selections from the Daniel Jacobs Collection," Heckscher Museum, Huntington, New York
1984 "Return of the Narrative," Palm Springs Desert Museum, Palm Springs, California, catalog
1984 "Clay: 1984, A National Survey Exhibition," Traver Sutton Gallery, Seattle, Washington
1984 "A Passionate Vision: Contemporary Ceramics from the Daniel Jacobs Collection," DeCordova and Dana

Museum and Park, Lincoln, Massachusetts
1985 "Paintings and Sculpture by Candidates for Art Awards," American Academy and Institute of Arts and Letters, New York, New York, catalog
1985 "Clay," Dayton Art Institute, Dayton, Ohio, catalog

Selected Public Collections
Brooks Memorial Art Gallery, Memphis, Tennessee
Cheney Cowles Memorial Museum, Spokane, Washington
City of Seattle, Portable Works Collection, Seattle, Washington
Detroit Institute of Arts, Detroit, Michigan
Evergreen State College, Olympia, Washington
Everson Museum of Art, Syracuse, New York
Harborview Medical Center, Seattle, Washington
Henry Art Gallery, Seattle, Washington
John Michael Kohler Arts Center, Sheboygan, Wisconsin
Johnson Wax Collection, Racine, Wisconsin
Kalamazoo Institute of Arts, Kalamazoo, Michigan
Lowe Art Museum, Coral Gables, Florida
National Museum of Modern Art, Kyoto, Japan
Nelson-Atkins Museum of Art, Kansas City, Missouri
Seattle Art Museum, Seattle, Washington
University of Montana Art Museum, Missoula, Montana

Selected Private Collection
Allan Chasanoff, Jericho, New York
Daniel Jacobs Collection, New York, New York
Joan Mannheimer Collection, Des Moines, Iowa
Professor and Mrs. R. Joseph Monsen Collection, Seattle, Washington
Robert L. Pfannebecker Collection, Lancaster, Pennsylvania

Selected Awards
1975 Individual Craftsman's Fellowship, National Endowment for the Arts
1980 Governor's Award of Special Commendation for Art, State of Washington

Preferred Sculpture Media
Clay and Varied Media

Additional Art Field
Painting

Teaching Position
Professor of Art, University of Washington, Seattle, Washington

Selected Bibliography

Glowen, Ron. "Ceramic Metamorphosis."
Artweek vol. 11 no. 33 (October 11, 1980)
p. 16, illus.

Guenther, Bruce. *50 Northwest Artists: A
Critical Selection of Painters and Sculptors
Working in the Pacific Northwest.* San
Francisco: Chronicle Books, 1983.

Harrington, LaMar. *Ceramics in the Pacific
Northwest: A History.* Seattle: University of
Washington Press, 1979.

Kangas, Matthew. "Patti Warashina: The
Ceramic Self." *American Craft* vol. 39 no. 2
(April-May 1980) pp. 2-8, illus.

Weschsler, Susan. *Low-Fire Ceramics: A New
Direction in American Clay.* New York:
Watson-Guptill, 1982.

Gallery Affiliations

Foster/White Gallery
311½ Occidental South
Seattle, Washington 98104

Morgan Gallery
1616 Westport Road
Kansas City, Missouri 64111

Mailing Address

120 East Edgar
Seattle, Washington 98102

Artist's Statement

"For many years my interest has been in
surrealism (Magritte, Miró and Gorky) which
has exerted the strongest influence on my
work. I have always been interested in the
small world or cosmos in which life is
unpredictable and moving. My sculpture is
developed through flashes of images or
perhaps a stream of consciousness. These
images are described through identifiable
objects such as cars, flames, flowers and
religious symbols. I prefer the neutral color
so that the action appears immediately
without the distraction of color. Because of
the emotional quality of clay, it is as though
in creating my work the sculpture could
happen in reality."

Glass Cage. 1982. Low fire clay and mixed media,
47"h x 15"w x 15"d. Photograph by Roger C.
Schreiber.

Jean Ward

née Jean Virginia Qualtire
Born Mingo Junction, Ohio

Education and Training
1972 Honors Program, University of Miami, Coral Gables, Florida; study and travel in Africa, India and Spain
1973 B.F.A., Sculpture, University of Miami, Coral Gables, Florida
1976 M.F.A., Sculpture, University of Miami, Coral Gables, Florida

Selected Individual Exhibitions
1979 Art and Culture Center of Hollywood, Hollywood, Florida
1980 Store Front Gallery, Tampa, Florida
1981 Frances Wolfson Art Gallery, Miami-Dade Community College, New World Center Campus, Miami, Florida, catalog
1984 Barbara Gillman Gallery, Miami, Florida and The Library, Miama-Dade Community College, New World Center Campus, Miami, Florida, catalog

Selected Group Exhibitions
1975 "Sculptors of Florida," Norton Gallery and School of Art, West Palm Beach, Florida
1976 "Sculptors of Florida," Metropolitan Museum and Art Center, Coral Gables, Florida
1977 "Nine Emerging Artists," Lowe Art Museum, Coral Gables, Florida
1978 "Sculpture Invitational," Metropolitan Museum and Art Center, Coral Gables, Florida
1978, "Annual Hortt Memorial Exhibition,"
79, Museum of Art, Fort Lauderdale,
80 Florida, catalog
1979 "Sculpture Park Miami '79," Miami Bicentennial Park, Miami, Florida, catalog
1979 "Florida Sculptors Invitational," Florida International University Art Gallery, Miami, Florida
1979 "Sculpture Invitational," Meeting Point Gallery, Coral Gables, Florida
1979 "Sculpture Invitational," Market Gallery, Omaha, Nebraska
1979 "Sculpture Invitational," Gallery Contemporania, Jacksonville, Florida

1979 "Metal Works," Barry College, Miami, Florida
1982 "Self Portraits: Florida Artists See Themselves," Frances Wolfson Art Gallery, Miami-Dade Community College, New World Center Campus, Miami, Florida
1982 "New World Festival of the Arts," University of Miami, Coral Gables, Florida
1982 "Twelfth International Sculpture Conference," Area Galleries and Institutions, Oakland, California and San Francisco, California (Sponsored by International Sculpture Center, Washington, D.C.)
1982 "Monumental Sculpture," Oakland Museum, Oakland, California
1983 "Florida Artists," Greene Gallery, Coconut Grove, Florida
1983 "Group Exhibition," Gallery G, Pittsburgh, Pennsylvania
1983 "Group Exhibition," Hodges Taylor Gallery, Charlotte, North Carolina
1983 "Urban Sculpture Bacardi Plaza," Bacardi Art Gallery, Miami, Florida, catalog
1985 "Three Women Artists: Athens, Levy and Ward," New Gallery, University of Miami, Coral Gables, Florida
1985 "Miami Three/Figurative Works: Ward, Levy and Lurie," Rowe Art Center, University of North Carolina at Charlotte, Charlotte, North Carolina
1985 "Florida Figures," Frances Wolfson Art Gallery, Miami-Dade Community College, New World Center Campus, Miami, Florida

Selected Public Collections
City of Charlotte, Central Piedmont Community College Campus, Charlotte, North Carolina
City of Miami, Miami-Dade Community College, New World Center Campus, Miami, Florida
King's Bay Yacht and Country Club, Miami, Florida
Museum of Art, Fort Lauderdale, Florida
Oakland Museum, Oakland, California
Ohio Nut and Washer Corporation, Mingo Junction, Ohio
Tracor Marine, Port Everglades, Florida

Selected Private Collections
Mr. and Mrs. Sidney Feldman, Bay Harbor Islands, Florida
Martin and Pat Fine, Miami, Florida
Juergen and Ingrid Koch, Cologne, Germany, West Germany
Dick and Ruth Shack, Miami, Florida
Penny Stallings, New York, New York

Selected Awards
1983 Individual Artist's Fellowship, Arts Council of Florida
1985 Artist in Residence, Kennesaw College, Marietta, Georgia and Georgia Council for the Arts and Humanities

Preferred Sculpture Media
Clay and Metal (welded)

Additional Studio Field
Drawing

Teaching Position
Assistant Professor, Miami-Dade Community College, New World Center Campus, Miami, Florida

Selected Bibliography
Kohen, Helen L. "The South: Art Looks for a Place in the Sun." *Art News* vol. 82 no. 2 (February 1983) pp. 62-65.

Gallery Affiliation
Barbara Gillman Gallery
270 NE 39 Street
Miami, Florida 33137

Mailing Address
9355 SW 94 Street
Miami, Florida 33176

For Miami, A Good Heart—Para Miami un Buen Corazon. 1983. Steel 1″ plate, 12′h x 20′w x 18′d. Collection City of Miami, Miami-Dade Community College, New World Center Campus, Miami, Florida. Photograph by Michael R. Bleichfeld.

Artist's Statement

"My upbringing in the Ohio Valley created an interest in steel and its methods. I work without preconceived images or ideals. My work is a process of self-discovery, recognizing my personal identity, yet with concern for the human condition."

Jean Ward

Patricia Wasserboehr

Born January 1, 1954 Winchester,
Massachusetts

Education and Training
1976 B.F.A., Sculpture, Boston University,
Boston, Massachusetts
1979 M.F.A., Sculpture, Boston University,
Boston, Massachusetts; study with
Natalie Charkow, Marianna Pineda
and Harold Tovish

Selected Individual Exhibitions
1984 Art Annex Gallery, Hollins College,
Roanoke, Virginia
1984 Weatherspoon Art Gallery,
Greensboro, North Carolina

Selected Group Exhibitions
1980 "Boston University Faculty Exhibition,"
Sculpture Center, New York, New
York
1981 "American Association of University
Women Exhibition," Boston University
Art Gallery, Boston, Massachusetts
1982 "Faculty Exhibition," Sculpture Center,
New York, New York
1982 "Exhibition for Disabled Persons,"
George Sherman Union Gallery,
Boston University, Boston,
Massachusetts
1982 "Seven Sculptors," George Sherman
Union Gallery, Boston University,
Boston, Massachusetts
1982- "Art on Paper," Weatherspoon Art
84 Gallery, Greensboro, North Carolina,
catalog

1982 "Tri-State Sculpture Conference
Exhibition," East Carolina University
Museum of Art/Gray Art Gallery,
Greenville, North Carolina, catalog
1982 "Eleventh Annual Competition for
North Carolina Artists," Fayetteville
Museum of Art, Fayetteville, North
Carolina
1983 "Second Annual Exhibit of North
Carolina Sculpture," Northern Telecom,
Research Triangle Park, North
Carolina, catalog
1983 "Tri-State Sculpture 1983," Green Hill
Center for North Carolina Art,
Greensboro, North Carolina, catalog
1984 "Tri-State Sculptors: Small Drawings
and Sculpture," Case Art Gallery,
Atlantic Christian College, Wilson,
North Carolina; Gallery 105, Warren
Wilson College, Swannanoa, North
Carolina; Sawhill Gallery, James
Madison University, Harrisonburg,
Virginia, catalog
1984 "1984 Tri-State Sculptors," Queens
College, Charlotte, North Carolina
(Sponsored by Mint Museum of Art,
Charlotte, North Carolina; Queens
College, Charlotte, North Carolina and
Tri-State Sculptors), catalog
1984 "Paris Salon Invitational," St. John's
Museum of Art, Wilmington, North
Carolina
1984 "Tri-State Sculpture," Gaston County
Art and History Museum, Dallas, North
Carolina, catalog
1985 "Wasserboehr and Fetterols," Tate
Center Gallery, University of Georgia,
Athens, Georgia
1985 "Tri-State Sculptors: Small Works and
Drawings," East Carolina University
Museum of Art/Gray Art Gallery,
Greenville, North Carolina

Selected Awards
1983 New Faculty Grant, University of North
Carolina at Greensboro, Greensboro,
North Carolina
1984 Summer Excellence Grant, University
of North Carolina at Greensboro,
Greensboro, North Carolina
1985 Artist in Residence, University of
Georgia, Athens, Georgia; Studies
Abroad Program, Palazzo Vagnotti,
Cortona, Italy

Preferred Sculpture Media
Clay and Stone

Additional Art Field
Drawing

Teaching Position
Assistant Professor of Art, University of
North Carolina at Greensboro, Greensboro,
North Carolina

Mailing Address
339 South Davie Street
Greensboro, North Carolina 27401

Pomona II. 1983. Plaster, 25½"h x 11½"w x 9"d.
Photograph by Jan G. Hensley.

Sara Waters

née Sara Marie
(Husband James Curley Watkins)
Born August 20, 1948 New Albany, Indiana

Education and Training
1974 B.F.A., Painting, Spalding College, Louisville, Kentucky
1977 M.F.A., Ceramic Sculpture, Indiana University Bloomington, Bloomington, Indiana

Selected Individual Exhibition
1981 Fine Arts Gallery, University of Texas at Permian Basin, Odessa, Texas

Selected Group Exhibitions
1979 "Small Images Exhibition," Santa Barbara City College, Santa Barbara, California
1980 "1980 Mid-America National Art Exhibition," Owensboro Museum of Fine Art, Owensboro, Kentucky, catalog
1980 "Second Texas Sculpture Symposium," University of Houston Lawndale Annex, Houston, Texas
1980 "Fourteenth Annual National Drawing and Small Sculpture Show," Del Mar College, Corpus Christi, Texas
1980 "Paper, Clay, Metal, Glass," Summit Art Center, Summit, New Jersey
1980 "Seven Texas Artists," Carlsbad Municipal Fine Arts & Museum, Carlsbad, New Mexico
1980 "Fifteenth November Annual of Non-Functional Art," Coos Art Museum, Coos Bay, Oregon, catalog
1981 "Third Texas Sculpture Symposium," Southwest Texas State University, San Marcos, Texas
1981 "Clay, Metal, Fiber, Wood," Architecture Gallery, Texas Tech University, Lubbock, Texas
1981 "Small Works National '81," Zaner Gallery, Rochester, New York, catalog
1981 "Twenty-Fourth Annual Delta Art Exhibition," Arkansas Arts Center, Little Rock, Arkansas, catalog
1982 "OSO Bay Biennial: Regional Clay Exhibition," Corpus Christi State University, Corpus Christi, Texas
1982 "AMST 1/1982," Art Museum of South Texas, Corpus Christi, Texas
1982 "Texas Sculpture Invitational," Visual Arts Gallery, Pensacola Junior College, Pensacola, Florida, catalog
1982 "National Sculpture Exhibition," Art Department Gallery, University of Georgia, Athens, Georgia, catalog
1983 "Spalding College Art Alumni," Spalding College Gallery, Louisville, Kentucky
1983 "SPAR National Art Exhibition," Barnwell Garden and Art Center, Shreveport, Louisiana
1983 "Object as Metaphor," Patrick Gallery, Austin, Texas
1983 "The Figure: New Form and New Function," Arrowmont School of Arts and Crafts, Gatlinburg, Tennessee, catalog
1983 "Selected Faculty Invitational," Amarillo Art Center, Amarillo, Texas
1983 "Fourth Texas Sculpture Symposium," Area Galleries and Institutions, Austin, Texas (Sponsored by College of Fine Arts and Humanities, University of Texas at Austin, Austin, Texas)
1984 "New Talent in Texas," Brown-Lupton Student Center Gallery and Moudy Exhibition Space, Texas Christian University, Fort Worth, Texas, catalog
1984 "3-Dimensions," University of Texas at El Paso, El Paso, Texas, catalog
1984 "Nine Sighted," Midtown Art Center, Houston, Texas, catalog
1985 "Fifth Texas Sculpture Symposium," Sited throughout Central Business District, Dallas, Texas and Connemara Conservancy, Allen, Texas (Sponsored by Texas Sculpture Symposium, Dallas, Texas), catalog
1985 "O.K.—U.S.A. National Sculpture Exhibition," University Gallery, Cameron University, Lawton, Oklahoma, catalog

Selected Awards
1980 Merit Award, "1980 Fall Regional Art Exhibition, Midland Arts Association," Fine Arts Building, Midland College, Midland, Texas
1983 Merit Award, "Works in Clay III," Wichita Falls Art Association, North Texas Federal Savings and Loan Gallery, Wichita Falls, Texas

Preferred Sculpture Media
Varied Media

Additional Art Fields
Drawing and Painting

Teaching Position
Associate Professor of Art, Texas Tech University, Lubbock, Texas

Selected Bibliography
Lavatelli, Mark. "Reviews: 'New Talent in Texas at Texas Christian University, Fort Worth'." *Artspace* vol. 8 no. 3 (Summer 1984) pp. 56-57, illus.
"Louisville Alumni Invitational." *Ceramics Monthly* vol. 31 no. 4 (April 1983) p. 46.
"Sara Waters." *New America* vol. 4 no. 3 (1982) p. 29, illus.

Mailing Address
3017 Twenty-Eighth Street
Lubbock, Texas 79410

With Teeth Tight, They Said, "She was a Fine Example." 1984. Wood, clay, wire and paint, 89½"h x 138"w x 113"d. Installation view 1984. "New Talent in Texas," Brown-Lupton Student Center Gallery and Moudy Exhibition Space, Texas Christian University, Fort Worth, Texas, catalog. Photograph by Ron Milke.

Artist's Statement

"The content of my work comes from an intense interest in dialogue—the dialogue within one's mind—the dialogue provoked by relentless contradiction. The work expresses the psychological dynamics of duality: calmness within chaos, anger within serenity, revealing passion within constraint. I structure space with forms which indicate the three-dimensionality of time fragments. Each work suggests an episode in behavorial interaction. I am in a constant search of visual equivalents through which the intergration of recognizable figurative imagery and abstracted territorial space is realized."

sary waters

Genna Watson

née Virginia
(Husband John George Dickson)
Born March 10, 1948 Baltimore, Maryland

Education and Training
1970 B.F.A., Sculpture, Maryland Institute College of Art, Baltimore, Maryland; study with Roger Majorowicz
1971- Washington University, St. Louis, 73 Missouri; study in sculpture
1976 M.F.A., Sculpture, University of Wisconsin-Madison, Madison, Wisconsin; study with Art Shade

Selected Individual Exhibitions
1978 Washington Project for the Arts, Washington, D.C.
1982 Fendrick Gallery, Washington, D.C.
1983 Southeastern Center for Contemporary Art, Winston-Salem, North Carolina
1984 The Athenaeum, Northern Virginia Fine Arts Association, Alexandria, Virginia

Selected Group Exhibitions
1970, "Maryland Annual Exhibition," 71 Baltimore Museum of Art, Baltimore, Maryland
1973 "Midwestern Regional," Springfield Art Museum, Springfield, Missouri
1976 "A Room of One's Own," Johnson Street Gallery, Madison, Wisconsin
1978 "Twenty-First Area Exhibition: Sculpture," Corcoran Gallery of Art, Washington, D.C., catalog
1979 "Second Annual Invitational Exhibit: Sculpture," Art Barn, Washington, D.C.
1979 "Contemporary Washington Artists," Washington Project for the Arts, Washington, D.C.
1979 "Uncommon Visions," Memorial Art Gallery of the University of Rochester, Rochester, New York, catalog
1979 "Contradictions," Fendrick Gallery, Washington, D.C.
1979 "Reunions," Second Street Gallery, Charlottesville, Virginia
1979 "The Figure in Sculpture," Institute of Contemporary Art of the Virginia Museum of Fine Arts, Richmond, Virginia

1980 "Images of the 70s: 9 Washington Artists," Corcoran Gallery of Art, Washington, D.C., catalog
1981 "The Animal Image: Contemporary Objects and the Beast," Renwick Gallery of the National Museum of American Art, Smithsonian Institution, Washington, D.C., catalog
1982 "20 from D.C.," University of Houston Lawndale Annex, Houston, Texas
1982 "Ten Variations on a Theme," Siegal Contemporary Art, New York, New York
1982 "Seventy-Fifth Anniversary Sculpture Exhibition," Artists Gallery, California College of Arts and Crafts, Oakland, California, catalog
1983- "Dogs," Museum of Contemporary Art, 84 Chicago, Illinois; Aspen Center for the Visual Arts, Aspen, Colorado; Floor Museum of Art, Dartmouth College, Hanover, New Hampshire; Lowe Art Museum, Coral Gables, Florida, catalog
1984- "Awards in the Visual Arts 3, An 85 Exhibition of Works by Recipients of Third Annual Awards in the Visual Arts," San Antonio Museum of Art, San Antonio, Texas; Loch Haven Art Center, Orlando, Florida; Cranbrook Academy of Art Museum, Bloomfield Hills, Michigan, catalog
1985 "The Washington Show," Corcoran Gallery of Art, Washington, D.C., catalog
1985 "Body and Soul: Recent Figurative Sculpture," Traveling Exhibition, Contemporary Arts Center, Cincinnati, Ohio, catalog

Selected Public Collection
Loch Haven Art Center, Orlando, Florido

Selected Private Collections
Dr. and Mrs. Alan Entin, Richmond, Virginia
Mr. and Mrs. Marvin Gerstin, Bethesda, Maryland
Caroline Huber, Washington, D.C.
Michael Rea, Washington, D.C.
Holly B. Rosenfeld, Alexandria, Virginia

Selected Awards
1983 First Prize, "Alexandria Sculpture Festival," The Athenaeum, Northern Virginia Fine Arts Association, Alexandria, Virginia, catalog
1984 Recipient of Third Annual AVA Award, Program administered by Southeastern Center for Contemporary Art, Winston-Salem, North Carolina and funded through Equitable Life Assurance Society of the United States, New York, New York; Rockefeller Foundation, New York, New York and National Endowment for the Arts

Preferred Sculpture Media
Varied Media

Selected Bibliography
Forgey, Benjamin. "Galleries: Beneath the Violence, Genna Watson's Poignant & Beautiful Sculptures." *The Washington Post* (Saturday, March 10, 1984) p. G9, illus.
Rubenfeld, Florence. "Reviews East Coast: Genna Watson, The Athenaeum." *New Art Examiner* vol. 11 no. 8 (May 1984) section II, p. 4.

Gallery Affiliation
Fendrick Gallery
3059 M Street NW
Washington, D.C. 20007

Mailing Address
604 Bashford Lane-201
Alexandria, Virginia 22314

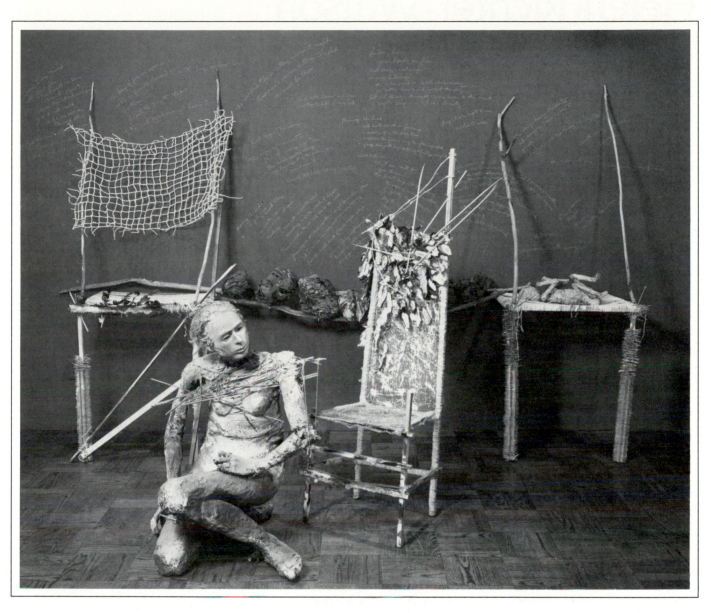

Springtime Resurrection Concerto. 1981. Mixed media, 79"h x 118"w x 75"d. Installation view 1982. Fendrick Gallery, Washington, D.C. Photograph by John Tennant.

Artist's Statement

"My work is multilayered. It is a reflection of what I feel about who I am, of who everyone is. Infinity exists within us in a myriad of memories, half-realized experiences, emotions and thoughts. I grew up in the country near a river and saw what makes up the life fources of nature: a complexity and layering in the physical world.

"I have been a collector of objects since childhood—little treasure troves of materials, small animal figurines and bits of costume jewely hidden away in boxes. My teen years were an interim which did not replace the fantasy worlds of childhood. Art school was the beginning of freedom from an old shell. I developed a figurative approach in my work using papier-mâché over chicken wire. Then I began combining figurative and non-figurative pieces with whatever materials were at hand including gesso, tape, wood, self-hardening clay, found objects and paint.

None of the figures, or any part of them, are life castings but are hand-modeled. I attempt to draw upon a subconscious flow on both psychic and physical levels, arranging what I have gathered in throughout my life into complex structures."

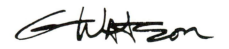

Helen Richter Watson

Born May 10, 1926 Laredo, Texas

Education and Training
1947 B.A., Functional Ceramics, Scripps College, Claremont, California
1949 M.F.A., Functional and Sculptural Ceramics, Claremont Graduate School and University Center, Claremont, California
1950 Wichita Art Association, Wichita, Kansas; study in functional ceramics
1966 Alfred University, Alfred, New York; study in functional ceramics

Selected Individual Exhibitions
1964 Long Beach City College, Long Beach, California
1972 Oklahoma Art Center, Oklahoma City, Oklahoma; Marion Koogler McNay Art Institute, San Antonio, Texas; Wichita Art Association, Wichita, Kansas, catalog
1975 Woman's Building, Los Angeles, California
1978 Humanities Gallery, Scripps College, Claremont, California
1979 Nuevo Santander Museum Complex, Laredo, Texas, retrospective and catalog

Selected Group Exhibitions
1950 "Annual Decorative Arts and Ceramics Exhibition," Wichita Art Association, Wichita, Kansas, catalog
1951, "Annual Art Exhibition, Los Angeles
52, County Fair," Los Angeles County
53 Fairgrounds, Pomona, California
1954 "A Selection of Modern Pottery," Renaissance Society, University of Chicago, Chicago, Illinois
1954 "Midwest Designer Craftsmen," Art Institute of Chicago, Chicago, Illinois
1955 "Susan Lautmann, Marjorie Burgeson, Helen Richter Watson and Betty Davenport Ford," Lang Art Gallery, Scripps College, Claremont, California, catalog
1956 "Faculty Exhibition," Mount San Antonio College, Walnut, California
1958 "Five Artists," Los Angeles County Art Institute, Los Angeles, California
1958 "Twenty-Five Years of Ceramic Art," Lang Art Gallery, Scripps College, Claremont, California
1961 "Ceramic Art Exhibition," Mount San Antonio College, Walnut, California
1962, "California Design," Pasadena Art
71 Museum, Pasadena, California, catalog

1962- "Twenty-Second Annual Ceramic
64 National Exhibition," Traveling Exhibition, Everson Museum of Art, Syracuse, New York, catalog
1964 "Invitational Ceramics," Downey Museum of Art, Downey, California
1964 "Exhibition of Work by Scripps College Distinguished Art Alumnae," Lang Art Gallery, Scripps College, Claremont, California, catalog
1964 "Artist as Craftsman—Craftsman as Artist," Long Beach Museum of Art, Long Beach, California, catalog
1965 "Second National Ceramic Invitational," San Jose State College, San Jose, California
1967 "Media Explored," Laguna Beach Museum of Art, Laguna Beach, California
1968 "Faculty Exhibition," Otis Art Institute, Los Angeles, California
1971 "Allied Craftsmen of San Diego," Fine Arts Gallery, Balboa Park, California
1971 "Keith Finch, Manuel Fuentes, Joe Mugnaini and Helen Richter Watson," Otis Art Institute, Los Angeles, California, catalog
1975 "First National Juried Ceramics Exhibition," Woman's Building, Los Angeles, California
1978 "Chapman College Exhibition: Voulkos, Soldner, Kaganoff, Groneberg, Rosenus, Soldate and Watson," Guggenheim Gallery, Chapman College, Orange, California
1978 "First Annual Distinguished Alumna Exhibition," Humanities Gallery, Scripps College, Claremont, California
1978 "Ames, Symington and Watson," Gallery 8, Claremont, California
1984 "Scripps Clay Connection: Fortieth Annual Ceramics Exhibition," Lang Art Gallery, Scripps College, Claremont, California

Selected Public Collections
Christ Church Episcopal, Laredo, Texas
City National Bank, Laredo, Texas
Home Savings and Loan, La Mirada, California
Laredo National Bank, Laredo, Texas
Lubbock National Bank, Lubbock, Texas
Mall del Norte, Laredo, Texas
Nueces County Courthouse, Corpus Christi, Texas
San Antonio Community Hospital, Ontario, California
San Jacinto Savings Association, Houston, Texas
Scripps College, Claremont, California
Stafford Building, Claremont, California
Tyler Bank and Trust Company Building, Tyler, Texas

Selected Private Collections
Howard Ahmanson, Los Angeles, California
Herbert Hafif, Claremont, California
David Scott, Washington, D.C.

Mr. and Mrs. Millard Sheets, Gualala, California
Marti Suneson, Neuvo Laredo, México

Selected Awards
1952 Swedish Government Grant for the Study of Arts and Crafts, Konstfackskolan, Stockholm, Sweden
1976 Bicentennial Sculpture Award, Nueces County Courthouse, Corpus Christi, Texas
1978 Distinguished Alumna Award, Alumnae Association, Scripps College, Claremont, California

Preferred Sculpture Media
Clay

Related Professions
Lecturer and Visiting Artist

Teaching Position
Instructor, Otis Art Institute of Parsons School of Design, Los Angeles, California

Selected Bibliography
Conrad, John W. Contemporary Ceramic Techniques. Englewood Cliffs, New Jersey: Prentice-Hall, 1979.
"Helen Richter Watson: Monumental Sculpture." Ceramics Monthly vol. 28 no. 4 (April 1980) pp. 56-57, illus.
Nelson, Glenn C. Ceramics. New York: Holt, Rinehart and Winston, 1960.
Nigrosh, Leon I. Claywork: Form and Idea in Ceramic Design. Worcester, Massachusetts: Davis, 1975.
Petterson, Richard B., ed. Ceramic Art in America; A Portfolio. Columbus, Ohio: Professional Publications, 1969.

Gallery Affiliation
Helen Richter Watson Architectural and Studio Ceramics
1918 Houston Street
Laredo, Texas 78040

Mailing Address
1918 Houston Street
Laredo, Texas 78040

Artist's Statement

"Working with clay has always been a natural tendency. As a child in Laredo, I spent hours on the banks of the Rio Grande making mud pies which I would cook in a little campfire. My first elective choice of study in college in the art field was clay. I did not know that I was destined to be associated with many historically important people, such as Bernard Leach, Marguerite Wildenhain, Millard Sheets and many others. I have watched ceramics advance beyond functional ware and gain a fine arts status in its expressive qualities. Through the different periods of my development, I have progressed from clay dishes to abstract architectural forms and enjoyed teaching for many years.

"The imagery in my work is derived from plant rather than human forms. In this sculpture, I wanted to capture the essence of the coastal bend area. The gulls represent the seafaring industry; the cattle skull and horns the ranches and history of the area. The symbolism suggests the conflict of energy and restlessness of life and the stillness and serenity of death; however, the form of the sculpture is what ultimately matters. My greatest satisfaction is when I am totally involved and creating from some subconscious need."

Helen Richter Watson

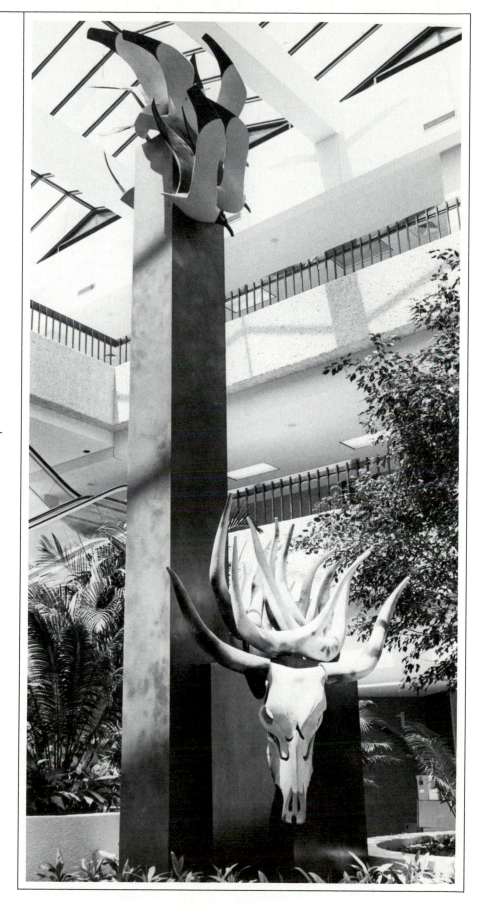

Great Southwest Series II: Cycle of Life. 1976. Stoneware, white mat glaze, black and grey gloss glaze, roseate bills and lacquered wooden base, 24'h. Collection Nueces County Courthouse, Corpus Christi, Texas. Photograph by Robert Kipp.

Nancy Webb

née Nancy McIvor
(Husband Dwight Willson Webb)
Born December 27, 1926 Concord, New
Hampshire

Education and Training
1944- Smith College, Northampton,
47 Massachusetts
1947 Harry Engel School of Painting,
 Provincetown, Massachusetts
1953- School of General Education,
54 Columbia University, New York, New
 York
1971- Tallix Art Foundry, Peekskill, New
73 York; study in sculpture techniques
 with Richard Polich and Toni Putnam
1979 Studio of Marianna Pineda, Boston,
 Massachusetts; assistant in the
 technical creation of ceramic
 sculpture

Selected Individual Exhibitions
1974, Cherrystone Gallery, Wellfleet,
77 Massachusetts
1980, Swansborough Gallery, Wellfleet,
81 Massachusetts
1981 Hunt Institute for Botanical
 Documentation, Carnegie-Mellon
 University, Pittsburgh, Pennsylvania

Selected Group Exhibitions
1947, "Annual Juried Exhibition,
66, Provincetown Art Association and
69, Museum, Provincetown,
76, Massachusetts
79,
80
1973, "Boston Visual Artists Union Juried
75 Exhibition," Hayden Gallery,
 Massachusetts Institute of
 Technology, Cambridge,
 Massachusetts
1973 "The Show: Boston Visual Artists
 Union," Arts and Science Center,
 Nashua, New Hampshire
1973- "Annual Exhibition," Cherrystone
78 Gallery, Wellfleet, Massachusetts
1973- "Annual Group Exhibition," FAR
79 Gallery, New York, New York
1973, "Arts On The Line," Hayden Gallery,
80 Massachusetts Institute of
 Technology, Cambridge,
 Massachusetts

1974 "The Artist and the Animal," FAR
 Gallery, New York, New York, catalog
1974 "Boston Visual Artists Union Spring
 Exhibition," Boston Visual Artists
 Union, Boston, Massachusetts,
 catalog
1974 "Invitational Exhibition," Hillyer Hall,
 Smith College, Northampton,
 Massachusetts
1975 "Group Show," Attleboro Museum,
 Attleboro, Massachusetts
1975 "New England Women," DeCordova
 and Dana Museum and Park, Lincoln,
 Massachusetts, catalog
1976 "A Sculptor and a Photographer,"
 Shore Gallery, Boston, Massachusetts
1977 "Gallery Exhibition," Shore Gallery,
 Boston, Massachusetts
1978 "New Directions, New Dimensions,"
 Impressions Gallery, Boston,
 Massachusetts
1979, "Group Exhibition," New Provinceton
80 Group Gallery, Provinceton,
 Massachusetts
1979, "Gallery Artists," Michael Walek
80, Gallery, Kennebunkport, Maine
81
1980, "Gallery Exhibition," Swansborough
81 Gallery, Wellfleet, Maine
1983 "October Exhibition," Art Association
 of Newport, Newport, Rhode Island
1983, "Gallery Exhibition," Capricorn Gallery,
84 Bethesda, Maryland
1984 "Gallery Exhibition," Kendall Gallery,
 Wellfleet, Massachusetts
1984 "Aspects of the Human Form,"
 Fitchburg Art Museum, Fitchburg,
 Massachusetts

Selected Public Collection
Massachusetts Bay Transportation Authority,
 Alewife Station, Cambridge,
 Massachusetts

Selected Private Collections
Mr. and Mrs. Serge Chermayeff, Wellfleet,
 Massachusetts
Cherrystone Gallery Permanent Collection,
 Wellfleet, Massachusetts
Graham Gund Collection, Cambridge,
 Massachusetts
Eleanor C. Munro, New York, New York
Mrs. Theodore White, New York, New York

Selected Awards
1966 Best of Show, "Annual Juried
 Exhibition," Cambridge Art
 Association, Cambridge,
 Massachusetts
1967 Sculpture Prize, "Annual Juried
 Exhibition," Cambridge Art
 Association, Cambridge,
 Massachusetts
1971 Gertrude Vanderbilt Whitney Prize,
 "Member Artists Exhibition," Art
 Association of Newport, Newport,
 Rhode Island

Preferred Sculpture Media
Metal (cast) and Varied Media

Additional Art Fields
Drawing and Printmaking

Related Professions
Art Instructor, Author and Illustrator

Selected Bibliography
Broderick, Mosette Glaser. "Arts Reviews:
 The Artist & The Animal." *Arts Magazine*
 vol. 49 no. 3 (November 1974) p. 19.
Munro, Eleanor C. *Originals: American
 Women Artists*. New York: Simon and
 Schuster, 1979.

Gallery Affiliation
Kendall Gallery
Main Street
Wellfleet, Massachusetts 02667

Mailing Address
Box 664
Wellfleet, Massachusetts 02667

Feles Dentata. 1980. Bronze unique, 7"h x 15"w x
8"d. Photograph by Joseph Szaszfai.

Artist's Statement

"My work is derived from natural forms,
animal (including the human), insect, fish
(including the crustaceans) and vegetable. In
the process of transforming these creatures
into bronze (to me a marvelously living
material) they are changed and modified as
though to present a new additional order of
life. Quite often I use dead forms, skulls,
skeletons, dried flowers or the bodies of
insects. But my interest is not simply in the
fact that they are dead, leftover, but also in
the mysterious power that is retained within
these intricate structures. A friend once said
of my work that it was "a dream of nature." I
would agree as long as the dream included
the nightmare."

Margaret Wharton

née Margaret Agnes
(Husband William Harold Bengtson)
Born August 4, 1943 Portsmouth, Virginia

Education and Training
1965 B.S., Advertising, University of Maryland at College Park, College Park, Maryland
1975 M.F.A., Sculpture, School of the Art Institute of Chicago, Chicago, Illinois

Selected Individual Exhibitions
1975, Phyllis Kind Gallery, Chicago, Illinois
80,
85
1977, Phyllis Kind Gallery, New York, New
79, York
81,
83,
86
1981- Museum of Contemporary Art,
82 Chicago, Illinois; Laguna Gloria Art Museum, Austin, Texas; University of South Florida Art Galleries, Tampa, Florida; Gibbes Art Gallery, Charleston, South Carolina, catalog

Selected Group Exhibitions
1976 "Artpark: The Program in Visual Arts," Artpark, Lewiston, New York, catalog
1976, "Painting and Sculpture Today,"
80 Indianapolis Museum of Art, Indianapolis, Indiana, catalog
1976 "Paintings and Sculpture by Midwest Faculty-Artists," Krannert Art Museum, Champaign, Illinois; Indiana University Art Museum, Bloomington, Indiana, catalog
1976 "Visions/Painting and Sculpture: Distinguished Alumni 1945 to Present," School of the Art Institute of Chicago, Chicago, Illinois, catalog
1976 "Improbable Furniture," Institute of Contemporary Art of The University of Pennsylvania, Philadelphia, Pennsylvania; La Jolla Museum of Contemporary Art, La Jolla, California; Museum of Contemporary Art, Chicago, Illinois, catalog
1977 "Seventy-Sixth Exhibition by Artists of Chicago and Vicinity," Art Institute of Chicago, Chicago, Illinois, catalog
1978 "American Chairs: Form, Function and Fantasy," John Michael Kohler Arts Center, Sheboygan, Wisconsin, catalog
1978 "Chicago: Self-Portraits," Nancy Lurie Gallery, Chicago, Illinois, catalog
1979 "American Portraits of the Sixties and Seventies," Aspen Center for the Visual Arts, Aspen, Colorado, catalog

1979 "Chicago and Vicinity: Prize Winners Revisited," Art Institute of Chicago, Chicago, Illinois, catalog
1979 "100 Artists: 100 Years," Art Institute of Chicago, Chicago, Illinois, catalog
1979 "New Dimensions: Volume and Space," Museum of Contemporary Art, Chicago, Illinois, catalog
1980 "Chicago, Chicago," Contemporary Arts Center, Cincinnati, Ohio, catalog
1980 "Six Artists from Chicago," James Mayor Gallery, London, Great Britain
1982 "Dead or Alive," Traveling Exhibition, Lerner Heller Gallery, New York, New York
1982 "Wood Into the 80s," Turman Gallery, Indiana State University, Terre Haute, Indiana, catalog
1982 "Works in Wood," Margo Leavin Gallery, Los Angeles, California
1982- "Dialect/Dialectic: A Group Show of
83 Artists with Complex Individual Vocabularies," Phyllis Kind Gallery, Chicago, Illinois and Phyllis Kind Gallery, New York, New York
1983 "Poetic Objects," Washington Project for the Arts, Washington, D.C.
1983 "Day In/Day Out: Ordinary Life as a Source of Art," Freedman Gallery, Albright College, Reading, Pennsylvania, catalog
1983 "Personification," Massachusetts College of Art, Boston, Massachusetts
1983 "Sculpture Then and Now," James Mayor Gallery, London, Great Britain
1984 "Artemisia: Ten Years 1973-1983," Artemisia Gallery, Chicago, Illinois, catalog
1984- "Awards in the Visual Arts 3, An
85 Exhibition of Works by Recipients of Third Annual Awards in the Visual Arts," San Antonio Museum of Art, San Antonio, Texas; Loch Haven Art Center, Orlando, Florida; Cranbrook Academy of Art Museum, Bloomfield Hills, Michigan, catalog

Selected Public Collections
Madison Art Center, Madison, Wisconsin
Museum of Contemporary Art, Chicago, Illinois
Seattle Art Museum, Seattle, Washington
Whitney Museum of American Art, New York, New York

Selected Private Collections
Mr. and Mrs. Edwin A. Bergman, Chicago, Illinois
William Copley, New York, New York
Mr. and Mrs. Arnold B. Glimcher, New York, New York
Mr. and Mrs. Sydney Lewis, Richmond, Virginia
Lewis and Susan Manilow, Chicago, Illinois

Selected Awards
1974 Mr. and Mrs. Frank G. Logan Prize, "Seventy-Fifth Exhibition by Artists of Chicago and Vicinity," Art Institute of Chicago, Chicago, Illinois, catalog

1980 Individual Artist's Fellowship, National Endowment for the Arts
1984 Recipient of Third Annual AVA Award, Program administered by Southeastern Center for Contemporary Art, Winston-Salem, North Carolina and funded through Equitable Life Assurance Society of the United States, New York, New York; Rockefeller Foundation, New York, New York and National Endowment for the Arts

Preferred Sculpture Media
Varied Media and Wood

Additional Art Field
Photography

Selected Bibliography
Glauber, Robert. "Chairs as Metaphor: The Sculpture of Margaret Wharton." *Arts Magazine* vol. 56 no. 1 (September 1981) pp. 84-87, illus.
Hoffeld, Jeffrey. "Chairperson Margaret Wharton." *Arts Magazine* vol. 53 no. 3 (November 1978) p. 160, illus.
Kirshner, Judith Russi. "Reviews Chicago: Margaret Wharton, Museum of Contemporary Art." *Artforum* vol. 20 no. 5 (January 1982) pp. 85-86, illus.
Lubell, Ellen. "Arts Reviews: Margaret Wharton." *Arts Magazine* vol. 51 no. 10 (June 1977) p. 45, illus.
Tully, Judd. "Vita Breva, Chaise Lounge: The Art of Margaret Wharton." *Arts Magazine* vol. 57 no. 10 (June 1983) pp. 114-115, illus.

Gallery Affiliations
Phyllis Kind Gallery
313 West Superior Street
Chicago, Illinois 60610

Phyllis Kind Gallery
136 Greene Street
New York, New York 10012

Mailing Address
Phyllis Kind Gallery
313 West Superior Street
Chicago, Illinois 60610

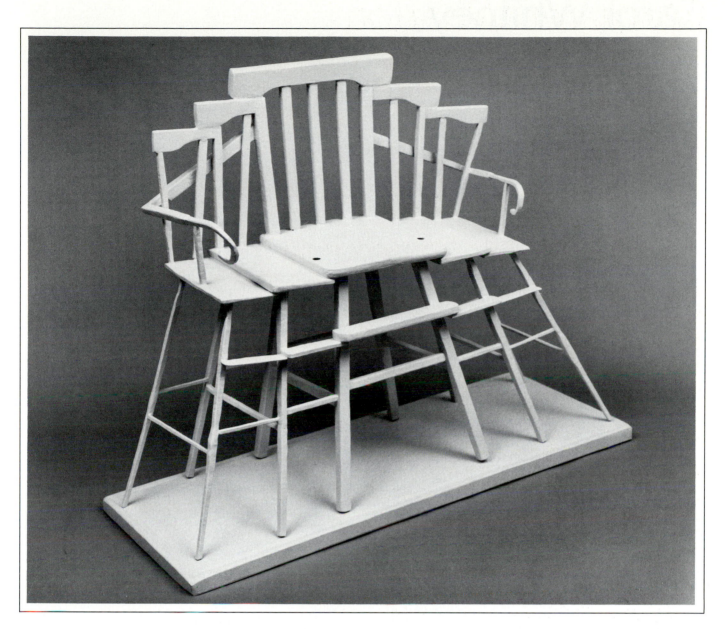

Harmony. 1983. Baby's wooden highchair, epoxy and enamel paint, 27¼"h x 35"w x 12⅞"d. Courtesy Phyllis Kind Gallery, Chicago, Illinois. Photograph by William H. Bengtson.

Artist's Statement

"The use of the chair as media began for me on an impulse in graduate school. It now has become a study on infinite variation. The resulting work describes the nature of what I know about humanness. It incorporates both construction and destruction. It begins with a mental notion and evolves through physical discovery; the consequence is a form that I could never have envisioned."

Margaret Wharton

Carol Whitney

née Carol Hall
(Husband David Alan Whitney)
Born December 24, 1936 Denver, Colorado

Education and Training
1955- Rosary College, River Forest, Illinois;
56 study in illustration and painting
1956- University of Kansas, Lawrence,
57, Kansas; study in ceramics
68-
69

Selected Individual Exhibitions
1972 Creative Handcrafts, Oklahoma City,
 Oklahoma
1976 Craft Alliance, Shreveport, Louisiana
1976 Paseo Design Center, Oklahoma City,
 Oklahoma
1977 Clay and Fiber Gallery, Taos, New
 Mexico
1978 Firehouse Art Center, Norman,
 Oklahoma
1978 Arts Place II, Oklahoma City,
 Oklahoma
1980 Governor's Gallery, State Capitol,
 Oklahoma City, Oklahoma
1980 Southwest Craft Center, San Antonio,
 Texas
1981, Wadle Gallery, Santa Fe, New Mexico
82,
83
1982 Upstairs Gallery, Conway, Arkansas
1982 In the Spirit Gallery, Kansas City,
 Kansas

Selected Group Exhibitions
1971 "Oklahoma Designer Craftsmen
 Invitational," Ponca City Art Center,
 Ponca City, Oklahoma
1972 "Oklahoma Designer Craftsmen
 Invitational," Museum of Art, University
 of Oklahoma, Norman, Oklahoma
1973 "Oklahoma Designer Craftsmen
 Invitational," Philbrook Art Center,
 Tulsa, Oklahoma
1973 "Toys Designed by Artists," Arkansas
 Arts Center, Little Rock, Arkansas
1975 "Oklahoma Designer Craftsmen
 Invitational," Charles B. Goddard
 Center, Ardmore, Oklahoma
1978 "Tri-State Exhibition," Oklahoma Art
 Center, Oklahoma City, Oklahoma
1978 "National Cowboy Rodeo Final
 Invitational and Western Art
 Exhibition," Exhibition Hall, State
 Fairgrounds, Oklahoma City,
 Oklahoma
1979 "Clay Workshop," Phillips University,
 Enid, Oklahoma
1982 "Oklahoma Diamond Jubilee
 Exhibition," State Capitol, Oklahoma
 City, Oklahoma
1984 "Landscape Variations on a Timeless
 Theme," Firehouse Art Center,
 Norman, Oklahoma
1984 "Annual Spring Group Exhibition,"
 Moulton Gallery, Fort Smith, Arkansas
1985 "Gallery Artists," Wadle Gallery, Santa
 Fe, New Mexico

Selected Public Collections
Alfred P. Murrah Federal Building, Oklahoma
 City, Oklahoma
Drover's Bank of Chicago, Chicago, Illinois
First National Bank, Oklahoma City,
 Oklahoma
Kirkpatrick Oil Company, Oklahoma City,
 Oklahoma
Oklahoma City Arts Council, Oklahoma City,
 Oklahoma
Oklahoma Indian Education Association,
 Norman, Oklahoma
Saks Fifth Avenue, Dallas, Texas
Southwestern Bell Telephone, Oklahoma
 City, Oklahoma

Selected Private Collections
Mr. and Mrs. William Bein, Los Angeles,
 California
Mr. and Mrs. Joseph M. Dealey, Jr., Dallas,
 Texas
Mr. and Mrs. Eugene Gottlieb, Boulder,
 Colorado
Mr. and Mrs. Roger Speidel, Columbia,
 Maryland
Sidney J. Taylor, Chicago, Illinois

Selected Awards
1979 First Place in Figurative Ceramics,
 "Oklahoma Designer Craftsmen
 Invitational," Phillips University, Enid,
 Oklahoma
1981 First Place, "Member Artists
 Exhibition," Oklahoma Museum of Art,
 Oklahoma City, Oklahoma
1982 First Place, "Art Annual III," Oklahoma
 Art Center, Oklahoma City, Oklahoma,
 catalog

Preferred Sculpture Media
Clay and Fiber

Additional Art Field
Painting

Selected Bibliography
Thalacker, Donald W. *The Place of Art in the
 World of Architecture*. New York: Chelsea
 House, 1980.

Gallery Affiliations
Moulton Gallery
115 North Tenth Street
Fort Smith, Arkansas 72901

Wadle Gallery
123 West Palace Avenue
Santa Fe, New Mexico 87501

Mailing Address
429 South Flood Avenue
Norman, Oklahoma 73069

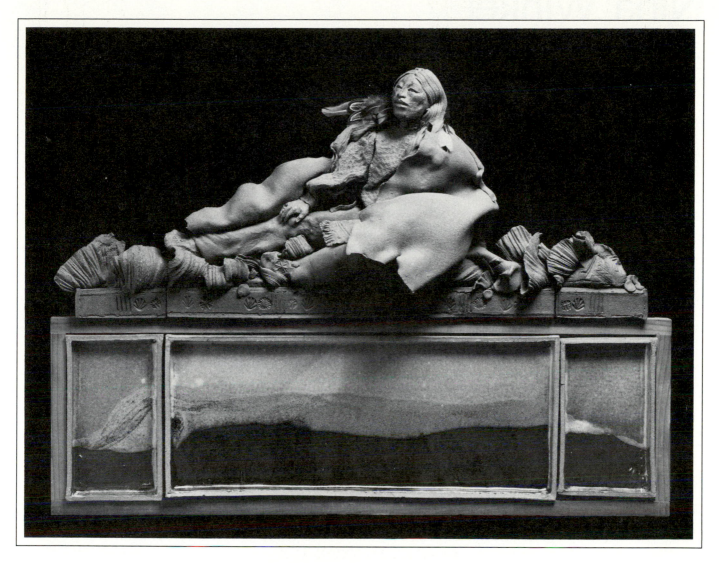

Earthbound. 1982. Bas relief stoneware, wood and feathers, 26"h x 34"w x 7"d. Photograph by Sandford Mauldin.

Artist's Statement

"My grandfather traveled the Oklahoma and Indian Territories at the turn of the century. His photographs of Indian braves on horseback, blanket-swathed chiefs and tribal occasions have been valuable resources. In the last years more of my work has turned to these images of the Plains Indians. My hope to honor their dignity and beauty is particularly expressed in the ways they adorned themselves with ribbons, feathers, silverwork and fringes. The flexibility and warmth of clay make it the perfect medium to convey the humanity and presence of their lives on the prairie. The rich earth colors with the texture of leather or hide reflect the light over the forms as the sun over the earth. Clay can flow like a blanket caught in the endless wind or accept the pattern of calico shirts and stamped silver. I use color primarily to contrast and emphasize the vast and latent power of this rawboned land."

Carol E Whitney

629

Nina Winkel

née Katharina Maria Johanna Koch
(Husband George J. Winkel)
Born May 21, 1905 Borken-Westfalen,
Germany, Federal Republic

Education and Training
1921 Kunstgewerbe Schule, Essen,
Germany, Federal Republic
1922- Staatliche Kunstakademie Düsseldorf,
23 Düsseldorf, Germany, Federal
Republic
1929- Kunstgewerbe Schule Abteilung
31 Staedel-Museum, Frankfurt am Main,
Germany, Federal Republic; study in
sculpture with Joseph Hartwig and
Richard Scheibe

Selected Individual Exhibitions
1944, Sculpture Center, New York, New
47, York, catalog
48,
58,
77
1954 O'Shaughnessy Gallery, University of
Notre Dame, Notre Dame, Indiana
1966 Salem Fine Arts Center,
Winston-Salem, North Carolina
1972 Sculpture Center, New York, New
York, retrospective and catalog
1975 Keene Valley Library, Keene Valley,
New York
1976 Adirondack Center Museum,
Elizabethtown, New York, catalog
1977 Center for Music, Drama and Art,
Lake Placid, New York
1979 National Savings Bank, Plattsburgh,
New York
1982 Carpenter & Painter Gallery,
Elizabethtown, New York, catalog
1982 Allentown Art Museum, Allentown,
Pennsylvania, catalog
1984 Sculpture Center, New York, New
York
1984 Kent Gallery, State University of New
York at Plattsburgh, Plattsburgh, New
York; Kreisverhaltung,
Borken-Westfalen, Germany, Federal
Republic

Selected Group Exhibitions
1942- "Annual Exhibition," Sculpture Center,
85 New York, New York
1943 "Clay Club Exhibition," Newark
Museum, Newark, New Jersey
1945- "Annual Exhibition," National Academy
85 of Design, New York, New York,
catalog
1946- "Annual Exhibition of Painting and
55 Sculpture," Pennsylvania Academy of
the Fine Arts, Philadelphia,
Pennsylvania, catalog
1946, "Women Sculptors," Philadelphia Art
50 Alliance, Philadelphia, Pennsylvania
1946- "Sculptors Guild Annual Exhibition,"
83 Lever House, New York, New York
1946- "National Sculpture Society Annual
83 Exhibition," National Sculpture Society,
New York, New York, catalog

1948 "George Cerny, Cleo Hartwig and Nina
Winkel," Clay Club Sculpture Center,
New York, New York
1949 "Fifty-Ninth Annual Exhibition of
Contemporary Art, Nebraska Art
Association," University of
Nebraska-Lincoln, Lincoln, Nebraska
1949 "International Fairmount Park
Exhibition," Fairmount Park Art
Association, Philadelphia,
Pennsylvania
1950, "Annual Exhibition: Contemporary
54 American Sculpture," Whitney
Museum of Art, New York, New York,
catalog
1951 "Exhibition of Works by Contemporary
American Artists," American Academy
of Arts and Letters, New York, New
York, catalog
1951- "American Sculpture," Metropolitan
52 Museum of Art, New York, New York,
catalog
1951 "Ten Women Artists," Riverside
Museum, New York, New York
1951 "Owned by Members," Newark
Museum, Newark, New Jersey
1952 "Nina Winkel, Leon Pledger and Elsa
Hutzler," Sculpture Center, New York,
New York
1972 "Critics' Choice," Sculpture Center,
New York, New York
1981 "Sculpture in the Garden 1981,"
Sculptors Guild at the Enid A. Haupt
Conservatory, New York Botanical
Garden, Bronx, New York, catalog
1982 "Ann Pember, Watercolor and Nina
Winkel, Sculpture," Carpenter &
Painter Gallery, Elizabethtown, New
York, catalog
1983 "Edgar G. Barton and Nina Winkel,
Sculpture," Myers Fine Arts Gallery,
Center for Art, Music and Theatre,
State University of New York College
at Plattsburgh, Plattsburgh, New York,
catalog
1984 "Edgar Barton and Nina Winkel,
Sculpture," Plaza Gallery, State
University of New York at Albany,
Albany, New York
1985 "The Educated Eye, Art Collections
from the State University of New York
Campuses," New York State Museum,
Albany, New York

Selected Public Collections
Adirondack Center Museum, Elizabethtown,
New York
Albert Schweitzer School, Wiesbaden,
Germany, Federal Republic
Allentown Art Museum, Allentown,
Pennsylvania
City of Borken-Westfalen, Kreisverhaltung,
Borken-Westfalen, Germany, Federal
Republic
City of Borken-Westfalen, Rathaus,
Borken-Westfalen, Germany, Federal
Republic
Clinton-Essex-Franklin Library, Plattsburgh,
New York
Keene Valley Library, Keene Valley, New
York

Lassiter Memorial, Charlotte, North Carolina
Moravian Bank, Charlotte, North Carolina and
Winston-Salem, North Carolina
Myers Fine Arts and Rockwell Kent Galleries,
Winkel Collection, Plattsburgh, New York
Nabu Manufacturing Corporation, Ottawa,
Ontario, Canada
Salem College, Winston-Salem, North
Carolina
Seward Park High School, New York, New
York
State Surrogate Court, New York, New York
University of Notre Dame, Notre Dame,
Indiana

Selected Private Collections
Mrs. Lawrence B. Dunham, Sr., St. Huberts,
New York
Ronald Freemond, Beverly Hills, California
Consul Werner Less, Zürich, Switzerland
Dr. and Mrs. Herbert Savel, Westport, New
York
Mr. and Mrs. Burns Weston, Keene, New
York

Selected Awards
1945 Elizabeth Watrous Gold Medal,
"Annual Exhibition," National Academy
of Design, New York, New York,
catalog
1964 Samuel F. B. Morse Gold Medal,
"Annual Exhibition," National Academy
of Design, New York, New York,
catalog
1985 Honorary Doctorate of Fine Arts, State
University of New York College at
Plattsburgh, Plattsburgh, New York

Preferred Sculpture Media
Clay and Metal (welded)

Related Profession
Lecturer on Antique and Byzantine Mosaics

Teaching Position
Honorary Adjunct Faculty, State University of
New York College at Plattsburgh,
Plattsburgh, New York

Selected Bibliography
Brummé, C. Ludwig. Contemporary American
Sculpture. New York: Crown, 1948.
Hale, Nathan Cabot. Welded Sculpture. New
York: Watson-Guptill, 1968.
Papers included in the Archives of American
Art, Smithsonian Institution, New York,
New York.
Proske, Beatrice Gilman. "American Women
Sculptors, Part II." National Sculpture
Review vol. 24 no. 4 (Winter 1975-1976)
pp. 8-17, 28, illus.
Schnier, Jacques Preston. Sculpture in
Modern America. Berkeley: University of
California Press, 1948.

Gallery Affiliation
Sculpture Center
167 East 69 Street
New York, New York 10021

Mailing Address
Dunham Road
Keene Valley, New York 12943

Artist's Statement
"The creation of a work of public art is, in my opinion, the most demanding and difficult task for any artist, perhaps even more for a sculptor because of the added difficulty of the third dimension. The secret of success lies, I think, in a philosophy of life. Not to seek oneself, not to create for immediate success in fame or money but to consider oneself as a servant to a high ideal and to humanity. This is the root of creation which will survive time and give meaning for generations to come.

"I think mostly of future work—despite my eighty years—and not about theories of what I do or why. I work because nature seems to have destined me to be a sculptor. When I have an inner vision, I attempt to give it an outer reality so that others may share my feelings. It is a task which, despite the struggle of a lifetime, I have not been able to carry to its ideal limits; however, I have achieved a measure of success satisfactory to my conscience as an artist and human being."

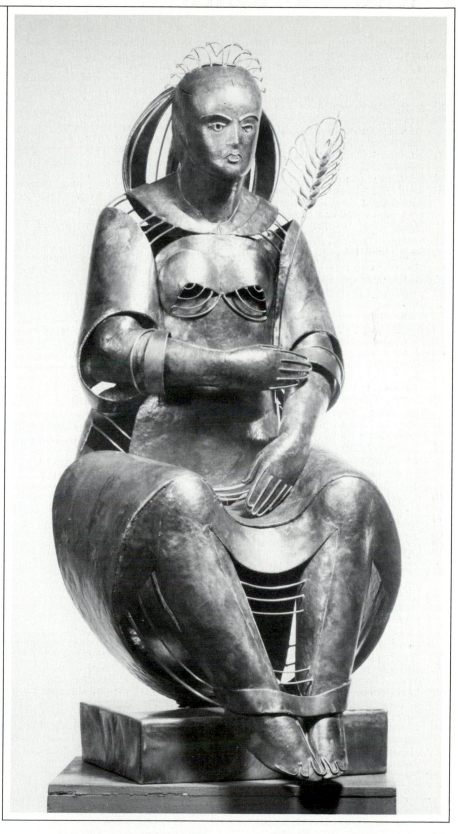

Constellation Virgo. 1968. Copper and brass, 40"h x 18"w x 18"d. Myers Fine Arts and Rockwell Kent Galleries, Winkel Collection, Plattsburgh, New York. Photograph by Otto E. Nelson.

631

Paula Winokur

née Paula Colton
(Husband Robert Mark Winokur)
Born May 13, 1935 Philadelphia,
Pennsylvania

Education and Training
1958 B.F.A., Ceramics and Painting, Tyler
School of Art, Temple University,
Philadelphia, Pennsylvania; study in
sculpture with Raphael Sabatini and
Rudolf Staffel
1958 B.S.Ed., Art Education, Tyler School of
Art, Temple University, Philadelphia,
Pennsylvania; additional study in
sculpture with Raphael Sabatini and
Rudolf Staffel
1958 College of Ceramics, Alfred University,
Alfred, New York

Selected Individual Exhibitions
1968 Philadelphia Art Alliance, Philadelphia,
Pennsylvania
1976 Contemporary Crafts Gallery, Portland,
Oregon
1978, Helen Drutt Gallery, Philadelphia,
82 Pennsylvania
1979 Jackie Chalkley Gallery, Washington,
D.C.
1979 University of Akron, Akron, Ohio
1980 College of William and Mary,
Williamsburg, Virginia
1980 Chatham College, Pittsburgh,
Pennsylvania
1981 Dickinson College, Carlisle,
Pennsylvania

Selected Group Exhibitions
1958, "Young Americans," Museum of
62 Contemporary Crafts, New York, New
York
1962, "Annual Ceramic National Exhibition,"
64 Everson Museum of Art, Syracuse,
New York
1966 "Annual Ceramics Exhibition," Lang Art
Gallery, Scripps College, Claremont,
California
1972 "Profile '72, Tyler School of Art
Alumni," Museum of the Philadelphia
Civic Center, Philadelphia,
Pennsylvania
1973 "Ceramic Art of the World 1973,"
University of Calgary, Calgary,
Alberta, Canada
1973 "Contemporary Porcelain," Philadelphia
Art Alliance, Philadelphia,
Pennsylvania
1973 "American Crafts Council: 20 Potters,"
Traveling Exhibition (Far Eastern
Embassies), United States Information
Agency, Washington, D.C.
1974 "Baroque '74," Museum of
Contemporary Crafts, New York, New
York
1975 "National Porcelain Exhibition," Loch
Haven Art Center, Orlando, Florida
1976 "Soup Tureens: 1976," Traveling
Exhibition, Campbell Museum,
Camden, New Jersey, catalog
1976 "One Hundred Artists Commemorate
Two Hundred Years," Xerox Square

Exhibition Center, Rochester, New
York, catalog
1976 "Philadelphia: Three Centuries of
American Art," Philadelphia Museum
of Art, Philadelphia, Pennsylvania,
catalog
1976 "Works in Clay," Emily H. Davis Art
Gallery, University of Akron, Akron,
Ohio, catalog
1977 "Invitational Box Show," John Michael
Kohler Arts Center, Sheboygan,
Wisconsin
1978- "Women Artists: Clay, Fiber, Metal,"
79 Traveling Exhibition, Bronx Museum of
The Arts, Bronx, New York
1979 "The Box," Philadelphia Art Alliance,
Philadelphia, Pennsylvania
1980 "Winter Olympic Art Festival," Olympic
Village, Lake Placid, New York
1980- "American Porcelain: New Expressions
85 In An Ancient Art," Traveling
Exhibition, Renwick Gallery of the
National Museum of American Art,
Smithsonian Institution, Washington,
D.C., catalog
1980- "Contemporary Ceramics: A Response
83 to Wedgwood," Traveling Exhibition,
Museum of the Philadelphia Civic
Center, Philadelphia, Pennsylvania,
catalog
1981 "Centering on Contemporary Clay:
American Ceramics from the Joan
Mannheimer Collection," University of
Iowa Museum of Art, Iowa City, Iowa,
catalog
1981 "Dionyse International," Centrum Voor
Kunsten Kultur, Gent, Belgium
1982 "Continuity and Change: Three
Generations of American Potters,"
Southern Alleghenies Museum of Art,
Loretto, Pennsylvania, catalog
1982 "Intimate Spaces," Traveling Exhibition,
San Jose State University, San Jose,
California, catalog
1983 "American Clay Artists: Philadelphia
'83," Helen Drutt Gallery, Philadelphia,
Pennsylvania, catalog
1983 "Six Artists," Philadelphia Art Alliance,
Philadelphia, Pennsylvania
1983 "Sculpture '83," Beaver College,
Glenside, Pennsylvania (Co-Sponsored
by Cheltenham Art Centre,
Cheltenham, Pennsylvania)
1983 "SOUP SOUP Beautiful SOUP!,"
Traveling Exhibition, Campbell
Museum, Camden, New Jersey,
catalog
1983 "Contemporary Artifacts 1983,"
National Museum of American Jewish
History, Philadelphia, Pennsylvania,
catalog
1984 "Tyler Alumni Craft Exhibition," Tyler
School of Art, Temple University,
Philadelphia, Pennsylvania, catalog
1984 "Porcelain '84," Liberty Gallery,
Louisville, Kentucky, catalog
1985 "Members Juried Exhibition," Craft
Alliance Gallery, St. Louis, Missouri,
catalog
1985 "Botanical Inspired Ceramics," Missouri
Botanical Garden, St. Louis, Missouri,
catalog

Selected Public Collections
Alberta Potters Association, Calgary, Alberta,
Canada
Arizona State University, Tempe, Arizona
Connecticut College, New London,
Connecticut
Delaware Art Museum, Wilmington, Delaware
Philadelphia Museum of Art, Philadelphia,
Pennsylvania
Utah Museum of Fine Arts, Salt Lake City,
Utah

Selected Private Collections
Helen Williams Drutt, Philadelphia,
Pennsylvania
Daniel Jacobs Collection, New York, New
York
Jack Lenor Larsen, New York, New York
Joan Mannheimer Collection, Des Moines,
Iowa
Potamkin Collection, Philadelphia,
Pennsylvania

Selected Awards
1976 Individual Craftsman's Fellowship,
National Endowment for the Arts
1983 Honorary Fellowship, National Council
on Education in the Ceramic Arts

Preferred Sculpture Media
Clay

Related Professions
Lecturer and Visiting Artist

Teaching Position
Assistant Professor, Beaver College,
Glenside, Pennsylvania

Selected Bibliography
Axel, Jan and Karen McCready. Porcelain:
Traditions And New Visions. New York:
Watson-Guptill, 1981.
Donhauser, Paul S. History of American
Ceramics: The Studio Potter. Dubuque,
Iowa: Kendall/Hunt, 1978.
Gundaker, Grey. "Paula Winokur." Ceramics
Monthly vol. 30 no. 3 (March 1982) pp.
56-59, illus.
Speight, Charlotte F. Images in Clay
Sculpture: Historical and Contemporary
Techniques. New York: Harper & Row,
1983.
Woody, Elsbeth S. Handbuilding Ceramic
Forms. New York: Farrar, Straus and
Giroux, 1978.

Gallery Affiliation
Helen Drutt Gallery
1721 Walnut Street
Philadelphia, Pennsylvania 19103

Mailing Address
435 Norristown Road
Horsham, Pennsylvania 19044

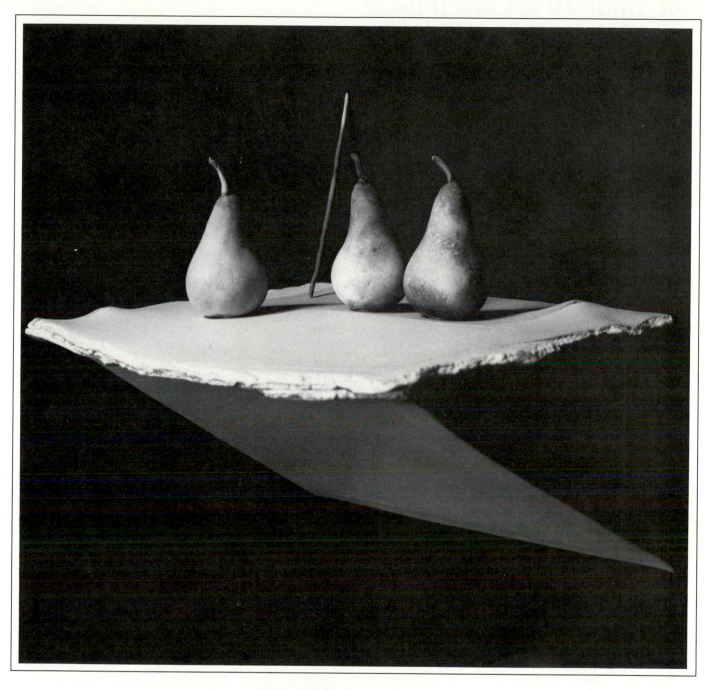

Site XVII: Precipice with Pears. 1984. Porcelain and metallic sulfates, 8″h x 14″w x 10″d. Photograph by Steve Fiorella.

Artist's Statement

"I use porcelain as an art media because it has a sensuality unlike other clay and allows for marking and coloring as if it were a white canvas. My work has evolved in the past ten years or so from essentially decorative objects, boxes, vessels and plates with a rather romantic context, to objects dealing with a broader aesthetic. In the last three or four years the work has shifted from the female image and intricate embossed designs to a concern for landscape. As I became more involved with content, the idea of the container and sometimes functional orientation became less important.

"The 'site' drawings, or the earth as a container of magic places, were the biggest jump for me. In these pieces I gave up the pottery identity altogether and made what I consider to be small sculpture or really painting and sculpture combined. The work has moved towards a totally sculptural base, but still in porcelain and with some reference to the ceramic tradition."

Paula Winokur

Jacqueline Winsor

née Vera Jacqueline
Born October 20, 1941 St. John's,
Newfoundland, Canada

Education and Training
1964 Summer School of Art and Music,
Yale University, New Haven,
Connecticut
1965 B.F.A., Painting, Massachusetts
College of Art, Boston, Massachusetts
1967 M.F.A., Painting, Rutgers University,
Douglass College, New Brunswick,
New Jersey

Selected Individual Exhibitions
1968 Rutgers University, Douglass College,
New Brunswick, New Jersey
1971 Nova Scotia College of Art and
Design, Halifax, Nova Scotia, Canada
1973, Paula Cooper Gallery, New York, New
76, York
82,
83
1976- Contemporary Arts Center, Cincinnati,
77 Ohio; Portland Center for the Visual
Arts, Portland, Oregon; San Francisco
Museum of Modern Art, San
Francisco, California, catalog
1978 Wadsworth Atheneum, Hartford,
Connecticut, catalog
1979 Museum of Modern Art, New York,
New York; Art Gallery of Ontario,
Toronto, Ontario, Canada; Fort Worth
Art Museum, Fort Worth, Texas,
catalog
1981 Virginia Museum of Fine Arts,
Richmond, Virginia
1982 Akron Art Museum, Akron, Ohio
1983 Hayden Gallery, Massachusetts
Institute of Technology, Cambridge,
Massachusetts

Selected Group Exhibitions
1969, "Group Exhibition," Galerie Riche,
70 Cologne, Germany, Federal Republic
1971 "Twenty-Six Contemporary Women
Artists," Aldrich Museum of
Contemporary Art, Ridgefield,
Connecticut, catalog
1972 "GEDOK American Woman Artist
Show," Kunsthaus, Hamburg,
Germany, Federal Republic, catalog
1972 "Twelve Statements Beyond the 60s,"
Detroit Institute of Arts, Detroit,
Michigan, catalog
1973, "Biennial Exhibition: Contemporary
77, American Art," Whitney Museum of
79, American Art, New York, New
83 York, catalog
1973 "Art in Evolution," Xerox Square
Exhibition Center, Rochester, New
York, catalog
1973 "Four Young Americans," Allen
Memorial Art Museum, Oberlin, Ohio
1973 "The Emerging Real," Storm King Art
Center, Mountainville, New York
1973 "Biennale de Paris," Musée de Art
Moderne de la Ville de Paris, Paris,
France, catalog

1974 "Painting and Sculpture Today 1974,"
Indianapolis Museum of Art,
Indianapolis, Indiana, catalog
1974 "Seventy-First Annual Exhibition of
American Paintings and Sculpture,"
Art Institute of Chicago, Chicago,
Illinois, catalog
1975 "A Response to the Environment,"
Rutgers University, Douglass College,
New Brunswick, New Jersey, catalog
1975 "The Condition of Sculpture," Hayward
Gallery, London, Great Britain, catalog
1976 "The Liberation: 14 American Artists,"
Traveling Exhibition, Aarhus
Kunstmuseum, Copenhagen,
Denmark, catalog
1977 "For the Mind and the Eye: Artwork by
Nine Americans," New Jersey State
Museum, Trenton, New Jersey
1977 "Ideas in Sculpture 1965-1977,"
Renaissance Society, University of
Chicago, Chicago, Illinois, catalog
1977 "Ten Years: A View of A Decade,"
Museum of Contemporary Art,
Chicago, Illinois, catalog
1977 "Strata: Nancy Graves, Eva Hesse,
Michelle Stuart, Jackie Winsor,"
Vancouver Art Gallery, Vancouver,
British Columbia, Canada, catalog
1977 "Twelve from Rutgers," Rutgers
University, Douglass College, New
Brunswick, New Jersey, catalog
1978 "Fading Bounds in Sculpture,"
Stedelijk Museum, Amsterdam,
Netherlands, catalog
1979 "Born in Boston," DeCordova and
Dana Museum and Park, Lincoln,
Massachusetts, catalog
1979 "The Decade in Review: Selections
from the 1970s," Whitney Museum of
American Art, New York, New York,
catalog
1979 "Contemporary Sculpture: Selections
from the Collection of the Museum of
Modern Art," Museum of Modern Art,
New York, New York, catalog
1979 "The Minimal Tradition," Aldrich
Museum of Contemporary Art,
Ridgefield, Connecticut, catalog
1979 "Weich und Plastik, Soft and Plastic,"
Kunsthaus, Zürich, Switzerland,
catalog
1980 "The Norman Fisher Collection,"
Jacksonville Art Museum, Jacksonville,
Florida, catalog
1981 "Contemporary Artists," Cleveland
Museum of Art, Cleveland, Ohio,
catalog
1982 "Post-Minimalism," Aldrich Museum of
Contemporary Art, Ridgefield,
Connecticut, catalog
1982 "Sculptors at UC Davis: Past and
Present," Richard L. Nelson Gallery,
University of California, Davis, Davis,
California, catalog
1983 "Objects, Structures, Artifice:
American Sculpture 1970-1982,"
University of South Florida, Tampa,
Florida; Bucknell University,
Lewisburg, Pennsylvania

1983 "Minimalism to Expressionism: Painting
and Sculpture Since 1965 From the
Permanent Collection," Whitney
Museum of American Art, New York,
New York
1983 "Twentieth Century Sculpture: Process
and Presence," Whitney Museum of
American Art at Philip Morris, New
York, New York, catalog
1984 "A Celebration of American Women
Artists Part II: The Recent Generation,"
Sidney Janis Gallery, New York, New
York, catalog

Selected Public Collections
Akron Art Museum, Akron, Ohio
Albright-Knox Art Gallery, Buffalo, New York
Allen Memorial Art Museum, Oberlin, Ohio
Detroit Institute of Arts, Detroit, Michigan
Fonds National d'Art Contemporain, Paris,
France
Museum of Fine Arts, Boston, Massachusetts
Museum of Modern Art, New York, New York
National Gallery of Australia, Canberra,
Australia
San Francisco Museum of Modern Art, San
Francisco, California
University of Colorado at Boulder, Boulder,
Colorado
Whitney Museum of American Art, New York,
New York

Selected Private Collections
Mr. and Mrs. Charles H. Carpenter, Jr., New
Canaan, Connecticut
Paula Cooper, New York, New York
Keith Sonnier, New York, New York
Paul Walter, Princeton, New Jersey

Selected Awards
1977 Louis Comfort Tiffany Foundation
Grant
1978 John Simon Guggenheim Memorial
Foundation Fellowship
1984 Individual Artist's Fellowship, National
Endowment for the Arts

Preferred Sculpture Media
Concrete and Wood

Selected Bibliography
Gruen, John. "Jackie Winsor: Eloquence of a
'Yankee Pioneer'." Art News vol. 78 no. 3
(March 1979) pp. 57-60, illus.
Lippard, Lucy R. "Jackie Winsor." Artforum
vol. 12 no. 6 (February 1974) pp. 56-58,
illus.
Lippard, Lucy R. From the Center: Feminist
Essays on Women's Art. New York: E. P.
Dutton, 1976.
Munro, Eleanor C. Originals: American
Women Artists. New York: Simon and
Schuster, 1979.
Pincus-Witten, Robert A. "Winsor Knots: The
Sculpture of Jackie Winsor." Arts Magazine
vol. 51 no. 10 (June 1977) cover, pp.
127-133, illus.

Gallery Affiliation
Paula Cooper Gallery
155 Wooster Street
New York, New York 10012

Mailing Address
112 Mercer Street
New York, New York 10012

Artist's Statement
"The cube form is derived from the specific character of the materials I use including plywood, plaster and concrete. The color and texture in the pieces result directly from the material and processes. The focus is intended to be within the form and/or the internal space. The activity of the surface implies a contained energy and this containment creates an interest in what cannot be seen. The enclosed space is a private core within the sculpture but it is accessible in that the viewer can project visually into it. All the formal elements direct the viewer to this center (the interior), yet the initial experience of the piece (the exterior) is about density, weight and solidity.

"What seems clearest to me in my work is the interest in meshing the metaphor of the physical and the tangible—the presence of the mass of the piece—with the less tangible, the mind or psyche. For me making art is making discoveries."

Jacqueline Winsor

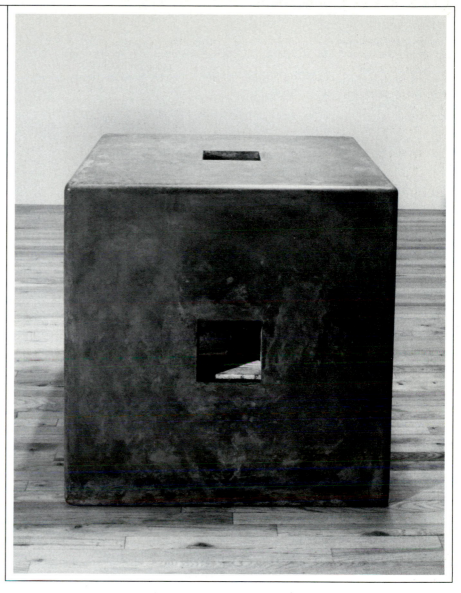

Exploded Piece. 1980-1982. Wood, reinforced concrete, plaster, gold leaf and explosives residue, 34½"h x 34½"w x 34½"d. Collection Museum of Fine Arts, Boston, Massachusetts. Courtesy Paula Cooper Gallery, New York, New York. Photograph by Geoffrey Clements.

Ann Wolfe

(Husband Mark Graubard)
Born November 14, 1905 Mlawa, Poland

Education and Training
1926 B.A., French, Hunter College, New York, New York
1931-32 Academy of Fine Arts, Manchester, Great Britain
1932-33 Académie de la Grande Chaumière, Paris, France; study in sculpture with Charles Despiau

Selected Individual Exhibitions
1939 Worcester Art Museum, Worcester, Massachusetts
1941 Grace Horne Galleries, Boston, Massachusetts
1945 Whyte Gallery, Washington, D.C.
1951 Drew Fine Arts Center, Hamline University, St. Paul, Minnesota
1954 World Theater Gallery, St. Paul, Minnesota
1955 Walker Art Center, Minneapolis, Minnesota
1964 Minneapolis Institute of Arts, Minneapolis, Minnesota
1966 Adele Bednarz Galleries, Los Angeles, California
1966 Stewart-Verde Galleries, San Francisco, California
1970 Westlake Gallery, Minneapolis, Minnesota
1970 Jewish Community Center, Minneapolis, Minnesota

Selected Group Exhibitions
1939 "Golden Gate International Exposition," San Francisco Museum of Art, San Francisco, California, catalog
1942 "New England Sculptors," Addison Gallery of American Art, Andover, Massachusetts, catalog
1944 "Artists' Guild of Washington," Corcoran Gallery of Art, Washington, D.C.
1945 "Society of Washington Artists Annual Exhibition," Corcoran Gallery of Art, Washington, D.C.
1945 "Artists' Guild of Washington," Baltimore Museum of Art, Baltimore, Maryland
1949 "Third International Exhibition of Sculpture," Philadelphia Museum of Art, Philadelphia, Pennsylvania, catalog
1950 "Group Exhibition," Kraushaar Gallery, New York, New York
1951 "One Hundred and Forty-Sixth Annual Exhibition of Painting and Sculpture," Pennsylvania Academy of the Fine Arts, Philadelphia, Pennsylvania, catalog
1951 "Biennial of Paintings, Prints, Sculpture-Upper Midwest," Walker Art Center, Minneapolis, Minnesota, catalog
1951 "Fortieth Annual Exhibition of Fine Arts," Fine Art Galleries, Minnesota State Fair, St. Paul, Minnesota, catalog
1952 "Annual Local Artists' Exhibition," Minneapolis Institute of Arts, Minneapolis, Minnesota, catalog
1954 "Sculpture '54," Sculpture Center, New York, New York
1956-63 "Society of Minnesota Sculptors Annual Exhibition," Minnesota Museum of Art, St. Paul, Minnesota
1957 "Society of Minnesota Sculptors Spring Salon," Woman's Club of Minneapolis, Minneapolis, Minnesota

Selected Public Collections
Children's Hospital, St. Paul, Minnesota
City University of New York, City College, New York, New York
Colgate University, Hamilton, New York
Duksoo Palace, Seoul, Korea, Republic
Hamline University Galleries, St. Paul, Minnesota
Jerusalem Museum, Jerusalem, Israel
Mount Zion Temple, St. Paul, Minnesota
University Art Museum, Berkeley, California
University Gallery, University of Minnesota Twin Cities Campus, Minneapolis, Minnesota
University of Hartford, Hartt College, West Hartford, Connecticut

Selected Private Collections
Mr. and Mrs. Francis Butler, St. Paul, Minnesota
Evelyn Donaldson, Minnetonka, Minnesota
Mr. and Mrs. Walter W. Walker, Minneapolis, Minnesota
Dr. and Mrs. Edmond Yunis, Concord, Massachusetts
Dr. and Mrs. Louis Zelle, St. Paul, Minnesota

Selected Awards
1936 First Honorable Mention, "Twenty-Third Allied Artists of America Annual Exhibition," American Fine Arts Building, New York, New York, catalog
1944 Sculpture Prize, "Society of Washington Artists Annual Exhibition," Corcoran Gallery of Art, Washington, D.C.
1951 Sculpture Prize, "Annual Local Artists' Exhibition," Minneapolis Institute of Arts, Minneapolis, Minnesota, catalog

Preferred Sculpture Media
Metal (cast), Stone and Wood

Additional Art Field
Painting

Related Professions
Lecturer and Sculpture Instructor

Selected Bibliography
Cohen, Morris Raphael. *A Dreamer's Journey; The Autobiography of Morris Raphael Cohen*. Boston: Beacon Press, 1949.
Leuchovius, Deborah. "Anne Wolfe." *WARM Journal* (Autumn 1982) pp. 8-11, illus.
Rood, John. *Sculpture in Wood*. Minneapolis: University of Minnesota Press, 1950.

Mailing Address
2928 Dean Parkway
Minneapolis, Minnesota 55416

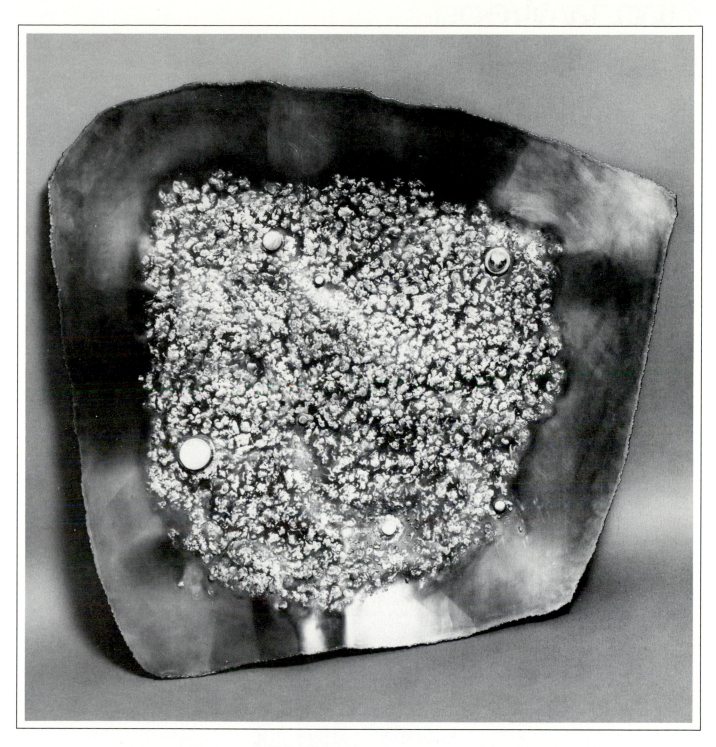

Milky Way I. 1966. Welded steel, bronze and silver relief, 31″h x 33½″w.

Artist's Statement

"Contemporary sculpture is rich in a multiplicity of ideas, the search for new forms of expression and a variety of media. My objectives are to capture the unique qualities of the medium and to use a material that will best express the idea. Nature is invariably my point of departure whether in sculptured groups of figures, portraits or steel with bronze and silver reliefs. I have always felt that expressiveness is achieved through abstract forms and conciseness. To this extent I have been influenced by such greats as Brancusi and Moore whose works reveal simplicity and depth."

Ann Wolfe

Marcia Wood

née Marcia Joan
Born March 22, 1933 Paw Paw, Michigan

Education and Training
1955 B.A., Painting, Kalamazoo College, Kalamazoo, Michigan
1956 M.F.A., Painting, Cranbrook Academy of Art, Bloomfield Hills, Michigan
1957 Huntington Hartford Foundation, Los Angeles, California; independent study in painting
1960- Courtauld Institute of Art,
61 University of London, London, Great Britain; research in art history
1962 Harvard University, Cambridge, Massachusetts; study in art history
1967 MacDowell Colony, Peterborough, New Hampshire; independent study in painting

Selected Individual Exhibitions
1980, Kalamazoo Institute of Arts,
85 Kalamazoo, Michigan
1983 Numazu City Hall, Numazu, Japan
1985 Art Center of Battle Creek, Battle Creek, Michigan
1985 Central Michigan University, Mount Pleasant, Michigan

Selected Group Exhibitions
1973 "West Michigan Annual," Kalamazoo Institute of Arts, Kalamazoo, Michigan
1974 "Invitational Exhibition," Colgate University, Hamilton, New York
1974, "Mid-Michigan Annual," Midland Art
75 Council, Midland, Michigan
1976 "Women Works," University of Michigan Museum of Art, Ann Arbor, Michigan
1980 "Twenty-Sixth Ball State Annual Drawing and Small Sculpture Show," Ball State University, Muncie, Indiana
1981 "Meadow Brook Invitational 1: Outdoor Sculpture," Meadow Brook Art Gallery, Rochester, Michigan
1981 "Invitational Exhibition," Texas Tech University, Lubbock, Texas
1981 "State of Michigan," Art Center of Battle Creek, Battle Creek, Michigan
1981 "Outdoor Sculpture Invitational Exhibition," Ferris State College, Big Rapids, Michigan
1982 "Art League Regional," Indianapolis Art League, Indianapolis, Indiana
1983 "Sculpture Exhibition," Episcopal Cathedral, Kalamazoo, Michigan

Selected Public Collections
City of Detroit, Washington Boulevard Plaza, Detroit, Michigan
City of La Porte Hospital, La Porte, Indiana
City of Numazu, Japan
Hope College Art Gallery Permanent Collection, Holland, Michigan
Kalamazoo College, Kalamazoo, Michigan
Lakeland Library Association, South Haven, Michigan

Selected Private Collections
Dorothy Dalton, Kalamazoo, Michigan
Mr. and Mrs. David Handleman, Bloomfield Hills, Michigan
Robert Helman, Chicago, Illinois
David Hermelin, Birmingham, Michigan
Elizabeth Ujohn, Kalamazoo, Michigan

Selected Awards
1978 Winner, State of Michigan Outdoor Sculpture Competition, Detroit Council of the Arts and National Endowment for the Arts
1980 Sculpture Prize, "Western Michigan Annual," Kalamazoo Institute of Arts, Kalamazoo, Michigan
1981 Lucasse Fellowship Award for Creative Work, Kalamazoo College, Kalamazoo, Michigan

Preferred Sculpture Media
Metal (cast) and Metal (welded)

Additional Art Field
Painting

Teaching Position
Professor of Art, Kalamazoo College, Kalamazoo, Michigan

Gallery Affiliation
Prajna Gallery of American Art
134 Butler Street
Saugatuck, Michigan 49085

Mailing Address
2125 Ridge Road
Kalamazoo, Michigan 49008

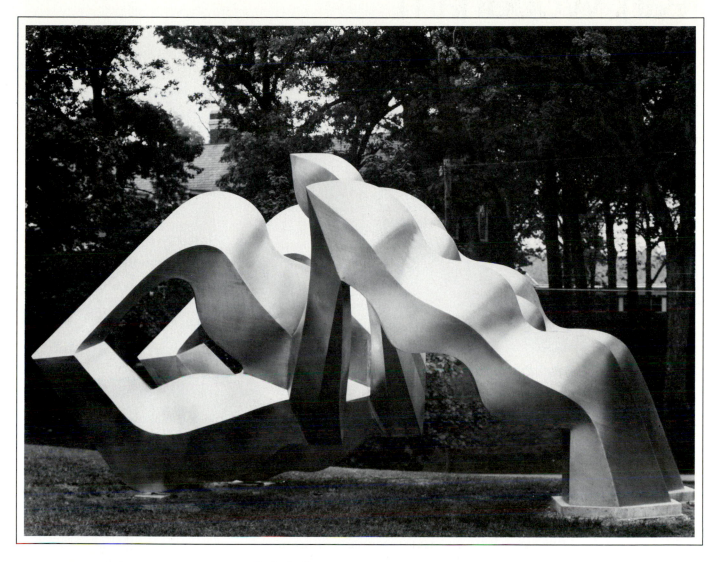

Prospect. 1982. Stainless steel, 12′h x 17′w x 8′d.
Collection Kalamazoo College, Kalamazoo,
Michigan. Photograph by David H. Curl.

Artist's Statement

"The starting point for my work is often in
natural forms—landscape and the human
figure—or in architectural conceptions. The
three-dimensional, physical presence of
sculpture is so compelling I made a shift
from painting to sculpture twelve years ago.

"I am particularly interested in working on
a monumental scale. In contrast to a great
deal of contemporary public sculpture, which
I have found to be severe and
unapproachable, my sculpture invites a more
direct participation between viewer and
object—bringing together the humanistic and
the structural in a sculptural metaphor."

Marcia J. Wood

Jean Woodham

Born August 16, 1925 Midland City, Alabama

Education and Training
1946 B.A., Advertising and Fine Arts, Auburn University, Auburn, Alabama
1946- Sculpture Center, New York, New
49 York; study with Dorothea Denslow
1950 Sculpture Center, New York, New York; independent study, Kate Neal Kinley Memorial Fellowship, University of Illinois at Urbana-Champaign, Urbana, Illinois

Selected Individual Exhibitions
1950 Auburn University, Auburn, Alabama, catalog
1952 University of Illinois at Urbana-Champaign, Urbana, Illinois
1955, Silvermine Guild Center For The Arts,
84 New Canaan, Connecticut
1956 Davison Art Center, Wesleyan University, Middleton, Connecticut
1959 Stuttman Gallery, New York, New York
1962, Rive Gauche Gallery, Darien,
66 Connecticut
1968 Mattatuck Museum, Waterbury, Connecticut
1970 Fairfield University, Fairfield, Connecticut, retrospective
1980 Town Hall Gallery, Westport, Connecticut

Selected Group Exhibitions
1950, "Annual Exhibition of Painting and
54 Sculpture," Pennsylvania Academy of the Fine Arts, Philadelphia, Pennsylvania, catalog
1951 "Inaugural Exhibition," Sculpture Center, New York, New York, catalog
1951- "National Association of Women
74 Artists Annual Exhibition," National Academy of Design, New York, New York, catalog
1954 "Nine Young Americans," Heller Gallery, New York, New York, catalog
1955 "Women's International Art Club," New Burlington Galleries, London, Great Britain, catalog
1955- "Annual New England Exhibition,"
60 Silvermine Guild of Artists, New Canaan, Connecticut, catalog
1956- "Audubon Artists Annual Exhibition,"
66 National Arts Club, New York, New York, catalog
1957 "Opening Exhibition," Barone Gallery, New York, New York, catalog
1959- "Sculptors Guild Annual Exhibition,"
83 Lever House, New York, New York, catalog
1959 "Seven Sculptors and Five Printmakers," Silvermine Guild of Artists, New Canaan, Connecticut, catalog

1963 "National Association of Women Artists Exhibition," Museo Nacional de Bellas Artes, Buenos Aires, Argentina, catalog
1963 "National Association of Women Artists Exhibition," Museo Nacional de Bellas Artes, Santiago, Chile, catalog
1963 "National Association of Women Artists Exhibition," Museu de Arte Moderna, Rio de Janeiro, Brazil, catalog
1964 "National Association of Women Artists Exhibition," Museo de Arte Moderno, México, D.F., México, catalog
1965 "National Association of Women Artists Exhibition," Museo del Estado de Jalisco, Guadalajara, México, catalog
1969 "Eight Connecticut Sculptors," Mattatuck Museum, Waterbury, Connecticut, catalog
1970 "Sculpture in the Spring, Twenty-Nine Contemporary Sculptors," William Benton Museum of Art, Storrs, Connecticut, catalog
1972 "Sculpture Exhibition," Fairfield University, Fairfield, Connecticut (Sponsored by Connecticut Society of Architects and Connecticut Commission on the Arts), catalog
1981 "Sculpture in the Garden 1981," Sculptors Guild at the Enid A. Haupt Conservatory, New York Botanical Garden, Bronx, New York, catalog
1982 "Art of the USA," Silvermine Guild Center For The Arts," New Canaan, Connecticut, catalog
1984- "Sculptors Guild Member Artists
85 Outdoor Exhibition, Schulman Sculpture in the Park," White Plains Office Park, White Plains, New York

Selected Public Collections
Alabama State University, Montgomery, Alabama
Auburn University Architecture and Fine Arts Center, Goodwin Music Building, Auburn, Alabama
Flintkote Company Corporate Headquarters, White Plains, New York
General Electric Credit Corporation, Stamford, Connecticut
General Telephone and Electronics Corporation, Stamford, Connecticut
Harrison Jewish Community Center, Harrison, New York
Harry S. Truman High School, Bronx, New York
International Bank for Reconstruction and Redevelopment, Washington, D.C.
Lewis Cooper Memorial Library and Art Center, Opelika, Alabama
Massillon Museum, Massillon, Ohio
Norwalk Public Library, Norwalk, Connecticut
Telfair Academy of Arts and Science, Savannah, Georgia
Temple Beth-Or, Montgomery, Alabama
Temple Israel, Westport, Connecticut
Texas Eastern Transmission, Houston, Texas

Selected Private Collections
Mr. and Mrs. James Cannon, Washington, D.C.
Mr. and Mrs. Charles Carpenter, New Canaan, Connecticut
Mr. and Mrs. Eli Golberg, Harrison, New York
Harry Kisiliski, Norwood, New Jersey
Mr. and Mrs. Gerald Levy, New York, New York and Wilton, Connecticut

Selected Awards
1970 Retrospective Exhibition Award, Fairfield University, Fairfield, Connecticut and Carlson Foundation Grant
1974 Medal of Honor, "National Association of Women Artists Annual Exhibition," National Academy of Design, New York, New York, catalog
1983 Creative Sculpture Grant, Djerassi Foundation, Woodside, California

Preferred Sculpture Media
Metal (welded)

Related Profession
Board of Trustees, Westport-Weston Arts Council, Westport, Connecticut

Selected Bibliography
Benton, Suzanne. The Art of Welded Sculpture. New York: Van Nostrand Reinhold, 1975.
Charles, Eleanor. "Sculpture Moves Outdoors." The New York Times (Sunday, July 25, 1982) pp. CN1, CN21, illus.
Fundaburk, Emma Lila and Thomas G. Davenport, comps. Art in Public Places in the United States. Bowling Green, Ohio: Bowling Green University Popular Press, 1975.
Padovano, Anthony. The Process of Sculpture. New York: Doubleday, 1981.
Schnier, Jacques Preston. Sculpture in Modern America. Berkeley: University of California Press, 1948.

Gallery Affiliation
River Gallery
9 Riverside Avenue
Westport, Connecticut 06880

Mailing Address
26 Pin Oak Lane
Westport, Connecticut 06880

Artist's Statement

"My sculpture is derived from nature and my rural Alabama background. The most unique aspect of my technique is that I fabricate large sculpture on a scale that is very unusual. I started welding because I could realize the forms I visualized through that medium.

"I have two studios, one 17' high and the other 40' high. The front of the large studio can be removed and a 30' flatbed truck can be driven in to be loaded by the overhead hoist. Sometimes I bring in a full-sized crane and a cherrypicker for loading. I use industrial techniques and TIG welders, arc welders and gas welding equipment, grinders and contour band-saws.

"For the past twenty years I have worked only by commission. I usually work in bronze, brass and steel but I have also worked in nickel silver, aluminum and stainless steel. Currently, my sculpture is on a smaller scale which may represent a new direction or a return to the first phase of my career."

Jean Woodham

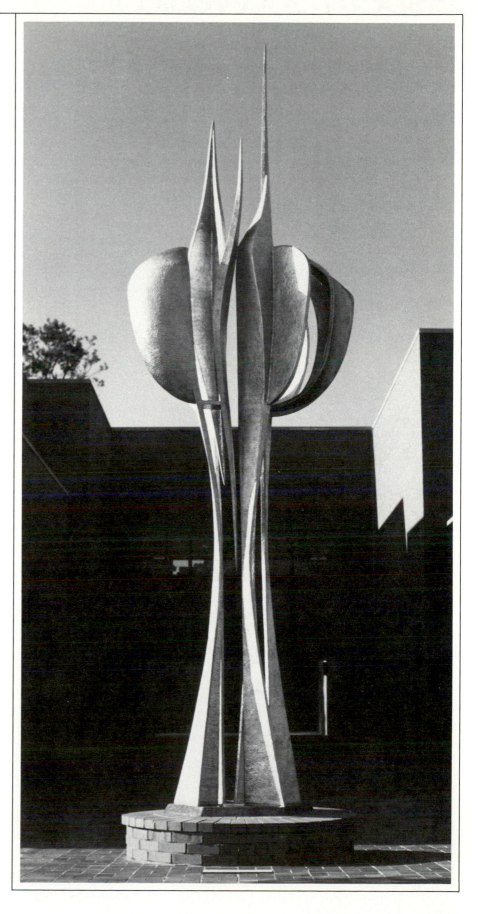

Monody. 1979. Welded bronze, 18'3"h. Collection Auburn University Architecture and Fine Arts Center, Goodwin Music Building, Auburn, Alabama. Photograph by Richard Millman.

Elsbeth S. Woody

née Elsbeth Siglinde Wetzel
(Husband Viennerly Merritt Woody)
Born January 8, 1940 Waldsee, Germany,
 Federal Republic

Education and Training
1967 B.A., Art, California State University
 Long Beach, Long Beach, California
1970 M.A., Fine Art and Fine Art Education,
 Teachers College, Columbia
 University, New York, New York

Selected Individual Exhibitions
1975 Mercer County Community College,
 Trenton, New Jersey
1976 Gloucester County College, Sewell,
 New Jersey
1978 Sign of the Swan Gallery,
 Philadelphia, Pennsylvania

Selected Group Exhibitions
1965 "Ceramics '65," Long Beach Museum
 of Art, Long Beach, California
1966 "Craftsmen USA," Los Angeles County
 Museum of Art, Los Angeles,
 California
1966 "Twenty-Fourth Annual Ceramic
 National Exhibition," Everson Museum
 of Art, Syracuse, New York, catalog
1969 "Twentieth Anniversary Annual New
 England Exhibition," Silvermine Guild
 of Artists, New Canaan, Connecticut,
 catalog
1969 "Young Americans 1969," Museum of
 Contemporary Crafts, New York, New
 York
1970 "Crafts '70," Boston City Hall, Boston,
 Massachusetts
1971 "Invitational Exhibition," Lillian
 Kornbluth Gallery, Fairlawn, New
 Jersey

1972 "Northeast Regional Exhibition,"
 American Craft Council, New York,
 New York
1972 "New Jersey Designer Craftsmen,"
 Morris Museum of Arts and Sciences,
 Morristown, New York
1972 "Art in Other Media," Westby Gallery,
 Glassboro State College, Glassboro,
 New Jersey
1973 "Four Artists," Hunterdon Art Center,
 Clinton, New Jersey
1973 "Multiples and Interlocking Forms,"
 Westby Gallery, Glassboro State
 College, Glassboro, New Jersey
1973 "New Jersey Designer Craftsmen,"
 Newark Museum, Newark, New Jersey
1974 "Energy in Clay," Pratt Institute, New
 York, New York
1974 "New Jersey Designer Craftsmen
 Jurors Invitational," Bergen Community
 Museum, Paramus, New Jersey
1975 "Clay," Women's Interart Center, New
 York, New York
1977 "Artistry: Clay and Fiber," Sarah
 Lawrence College, Bronxville, New
 York
1977 "Group Exhibition," Sign of the Swan
 Gallery, Philadelphia, Pennsylvania
1978- "Women Artists: Clay, Fiber, Metal,"
79 Traveling Exhibition, Bronx Museum of
 The Arts, Bronx, New York
1978 "Faculty Exhibition," Peters Valley
 Center, Layton, New Jersey
1980 "Invitational Exhibition," Millersville
 State College, Millersville,
 Pennsylvania
1981 "A.I.R. Holiday Exhibition," A.I.R.
 Gallery, New York, New York
1981 "Craft-In-Process: A Living Workshop,"
 American Craft Museum, New York,
 New York
1982 "Architectural Ceramics: A
 Documentation," Women's Interart
 Center, New York, New York
1982 "TC Clay," Castle Gallery, College of
 New Rochelle, New Rochelle, New
 York
1982 "A Quarter Century: Reunion
 Exhibition," Clay Art Center, Port
 Chester, New York
1983 "Terminal New York: An Art
 Exhibition," Brooklyn Terminal Building,
 Brooklyn, New York

Selected Public Collections
City of Victoria, Riverside Park, Victoria,
 Texas
Pretoria Art Museum, Pretoria, South Africa

Preferred Sculpture Media
Clay

Related Professions
Lecturer and Visiting Artist

Teaching Position
Associate Professor, City University of New
 York Bernard M. Baruch College, New
 York, New York

Selected Bibliography
Blandino, Betty. *Coiled Pottery: Traditional
 and Contemporary Ways*. London: A & C
 Black, 1984.
Burstein, Joanne. "Ceramics and Art,
 Ceramic Art, Art Ceramics?" *Art New
 England* vol. 5 no. 5 (April 1984) pp. 3, 17,
 illus.
Woody, Elsbeth S. *Pottery on the Wheel*.
 New York: Farrar, Straus and Giroux, 1975.
Woody, Elsbeth S. *Handbuilding Ceramic
 Forms*. New York: Farrar, Straus and
 Giroux, 1978.
Woody, Elsbeth S. "Alternatives: The
 Concept of the Itinerant Artist." *Pottery in
 Australia* vol. 20 no. 2 (May-June 1982) pp.
 12-13, illus.

Mailing Address
116-118 West 29 Street
New York, New York 10001

Artist's Statement

"My concerns over the past few years have increasingly centered around two issues: form, space and their effect upon each other. I react to form on a very emotional level, never to the literal meaning but to its dynamics. I prefer simple strong forms, both man-made and natural. A cone can assume as much meaning as the trunk of a tree or the shape of a mountain. I use these forms in repetition: repetition, not in terms of mere duplication but to create a new whole which is different than the sum of its parts; repetition where the individual form is changed and effected, as well as is affected by its partners. At the same time, the space acts upon the forms and is transformed by it. There is constant shifting of emphasis between form and space, neither considered separately. I am as much a sculptor of space as of forms."

Elsbeth S. Woody

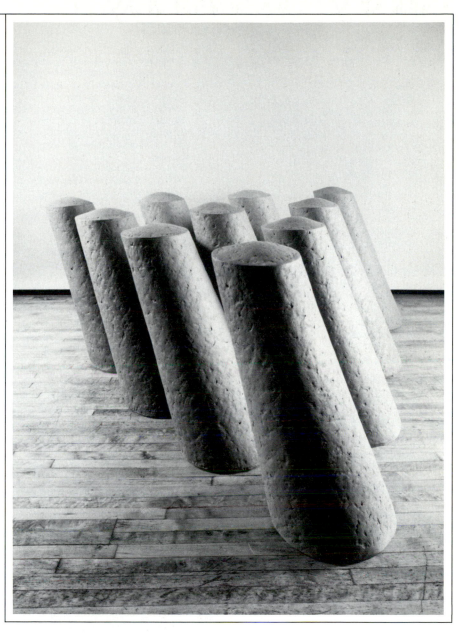

Floating Cones. 1983. Unglazed stoneware, each unit, 40"h x 18"w x 24"d.

Nancy Worthington

née Nancy Anne Gilliam
Born July 20, 1947 Norfolk, Virginia

Education and Training
1969 B.A., Fine Arts, Madison College, Harrisonburg, Virginia
1972 Department of Industrial Engineering, Pennsylvania State University-University Park Campus, University Park, Pennsylvania; study in metal foundry techniques
1972 M.F.A., Sculpture, Pennsylvania State University-University Park Campus, University Park, Pennsylvania; study with John Cook
1972 Good Samaritan Hospital, Zanesville, Ohio; training in art psychotherapy

Selected Individual Exhibitions
1974 East Gallery, Pennsylvania State University-University Park Campus, University Park, Pennsylvania
1977 Union Gallery, San Jose State University, San Jose, California, catalog
1977 Montalvo Center for the Arts, Saratoga, California
1977 Los Robles Galleries, Palo Alto, California
1978 Twin Pines Gallery, Belmont, California
1979 Zara Gallery, San Francisco, California
1979 North Gallery, Memorial Union, University of California, Davis, Davis, California
1979 California College of Arts and Crafts, Oakland, California
1981 Joseph Chowning Gallery, San Francisco, California
1984 San Jose Museum of Art, San Jose, California, catalog

Selected Group Exhibitions
1973 "Invitational Art Exhibition," William Zoller Gallery, Pennsylvania State University-University Park Campus, University Park, Pennsylvania
1975 "West Valley College Faculty Exhibition," Triton Museum of Art, Santa Clara, California
1975 "All Media Exhibit," Crown-Zellerbach Gallery, San Francisco, California
1976- "Annual San Francisco Art Festival,"
79 Civic Center Plaza, San Francisco, California
1977, "Gallery Invitational," Capricorn
78 Asunder Gallery, San Francisco, California
1977 "Variations on the Sculptural Idea," Center for the Visual Arts, Oakland, California

1978- "In Touch with Art," Traveling
79 Exhibition, Octagon Gallery, Daly City, California; San Mateo County Arts Council, San Mateo, California; Corridor Gallery, Redwood City, California; Office of the Mayor, Los Angeles, California
1979 "Humanform," Walnut Creek Civic Arts Gallery, Walnut Creek, California, catalog
1980 "First International Festival of Women Artists," Ny Carlsberg Glyptotek, Copenhagen, Denmark, catalog
1980 "Addressing the Nuclear Issue," Environmental Arts Gallery, Ecology Center of San Francisco, San Francisco, California
1981 "The Western Edge," Capricorn Asunder Gallery, San Francisco, California
1981 "The Exchange Show: San Francisco/Bay Area—Berlin," Galerie Franz Mehring, Berlin, Germany, Federal Republic, catalog
1982- "Forgotten Dimension . . . A Survey of
84 Small Sculpture in California Now," Fresno Arts Center, Fresno, California; San Francisco International Airport, San Francisco, California; Center for the Visual Arts Gallery, Illinois State University, Normal, Illinois; Aspen Center for the Visual Arts, Aspen, Colorado; Mary and Leigh Block Gallery, Northwestern University, Evanston, Illinois; Colorado Gallery of the Arts, Arapahoe Community College, Littleton, Colorado; Palo Alto Cultural Center, Palo Alto, California; Visual Arts Gallery, Florida International University, Miami, Florida, catalog
1982 "International Arts Festival," Southern Exposure Gallery, San Francisco, California
1982 "Painted Sculptures," Los Angeles Municipal Art Gallery, Los Angeles, California
1982 "Twelfth International Sculpture Conference," Area Galleries and Institutions, Oakland, California and San Francisco, California (Sponsored by International Sculpture Center, Washington, D.C.)
1983 "Social Statements—Our Time in Painting and Sculpture," Walnut Creek Civic Arts Gallery, Walnut Creek, California
1984 "Cadre '84: Computers in Art and Design, Research and Education," San Jose State University, San Jose, California, catalog
1984 "Indoor Satellite Exhibition," San Francisco Art Institute, San Francisco, California
1985 "Women's Caucus for Art Invitational," Sun Gallery, Hayward, California
1985 "100 Vows of the Sun," Southern Exposure Gallery, San Francisco, California

1985 "XVIII Bienal Internacional de São Paulo," Museu de Arte Moderna de São Paulo, São Paulo, Brazil, catalog

Selected Public Collections
James Madison University, Harrisonburg, Virginia
Management Systems Design, Arlington, Virginia
Pennsylvania State University-University Park Campus, University Park, Pennsylvania
Theatre of Man, San Francisco, California

Selected Private Collections
Greta Berman, New York, New York
Patricia D'Alessandro, New York, New York
John J. Davis, Jr., Oakland, California
Arabella Decker, Montara, California
Dr. Judith T. Fein, San Francisco, California

Selected Awards
1977 Artist in Residence, California Arts Council
1978 Nomination, Artist of the Year, Oakland Museum, Oakland, California
1982 Honorable Mention, "West '82/Art and The Law National Competition," Minnesota Museum of Art, St. Paul, Minnesota

Preferred Sculpture Media
Varied Media

Additional Art Fields
Drawing and Graphics

Selected Bibliography
Dryer, Dianne. "Nancy Worthington's Social Commentaries." Artweek vol. 8 no. 12 (March 19, 1977) p. 4, illus.
Jan, Alfred. "Exhibitions: Polemics Through Art." Artweek vol. 15 no. 15 (April 14, 1984) p. 3, illus.
MacDonald, Robert. "Forms of Figuration." Artweek vol. 10 no. 11 (March 17, 1979) p. 7, illus.
Malone, Mollie. "Exhibitions: Judging Our Society." Artweek vol. 14 no. 7 (February 19, 1983) p. 16, illus.
Weeks, H. J. "Reviews of the Exhibitions California: Nancy Worthington at Zara, San Francisco." Art Voices/South vol. 2 no. 3 (May-June 1979) pp. 65-66, illus.

Gallery Affiliation
WF & Associates
58 Wawona Street
San Francisco, California 94127

Mailing Address
Post Office Box 27352
San Francisco, California 94127

The Age of Anxiety. 1982. Mixed media, kinetic construction/assemblage, 6'3"h x 7'6"w x 4'6"d. Installation view 1984. San Jose Museum of Art, San Jose, California, catalog. Photograph by Judith T. Fein.

Artist's Statement

"My visual images are on a tightrope between comedy and tragedy. I attempt a balance between thought carried to its ultimate extreme in comic absurdity and feeling at its most intense level in tragic consequence. A vital part of my work exists in the social and psychological entrapment of ambiguities, inconsistencies, polarities and dualities of the human condition. Also prominent are the symbolic projections of inner subconscious images of my own ontological insecurities. The images integrate lights, sound and motion and become catalysts to levels of awareness in which the comic absurdities and the tragic consequences of being coexist. Hopefully my optimism for the future will facilitate change through awareness for a better, more humane world."

Shirley Wyrick

née Shirley Brown
(Husband Darrell D. Wyrick)
Born August 11, 1936 Des Moines, Iowa

Education and Training
1959 B.A., University of Iowa, Iowa City, Iowa
1960 Minneapolis Institute of Art, Minneapolis, Minnesota
1976 M.A., Sculpture and Drawing, University of Iowa, Iowa City, Iowa
1983 M.F.A., Sculpture and Drawing, University of Iowa, Iowa City, Iowa

Selected Individual Exhibitions
1979 Percival Gallery, Des Moines, Iowa
1979- Armstrong Gallery, Cornell College,
81 Mount Vernon, Iowa; Artspace/5, Department of Physiology, University of Iowa, Iowa City, Iowa; Art Center of Minnesota, Crystal Bay, Minnesota; Campus Center Gallery, North Hennepin Community College, Minneapolis, Minnesota; Charles H. MacNider Museum, Mason City, Iowa; Employers Mutual Companies, Employers Mutual Building, Des Moines, Iowa; Blanden Memorial Art Gallery, Fort Dodge, Iowa, catalog

Selected Group Exhibitions
1979 "319-79," Cedar Rapids Art Center, Cedar Rapids, Iowa
1979 "Thirty-First Annual Iowa Artists' Exhibit," Des Moines Art Center, Des Moines, Iowa
1980 "Fourteenth Annual Muscatine Juried Art Exhibition," Muscatine Art Center, Muscatine, Iowa
1985 "First Biennial Invitational," Muscatine Art Center, Muscatine, Iowa

Selected Public Collections
Blanden Memorial Art Gallery, Fort Dodge, Iowa
Regency West Office Park, West Des Moines, Iowa
University of Iowa Foundation, Iowa City, Iowa

Selected Private Collections
Mr. and Mrs. Sigurd Anderson, Des Moines, Iowa
Mr. and Mrs. E. T. Meredith II, Des Moines, Iowa
Mr. and Mrs. James Wockenfuss, Iowa City, Iowa

Selected Award
1980, Exhibition Grant, Iowa State Arts
81 Council and National Endowment for the Arts

Preferred Sculpture Media
Metal (cast) and Metal (welded)

Additional Art Fields
Drawing and Painting

Related Profession
Co-Founder/Co-Owner, Artworks, Cedar Rapids, Iowa

Gallery Affiliation
Artworks
2403 Indian Hill Road SE
Cedar Rapids, Iowa 52403

Mailing Address
132 Potomac Drive
Iowa City, Iowa 52240

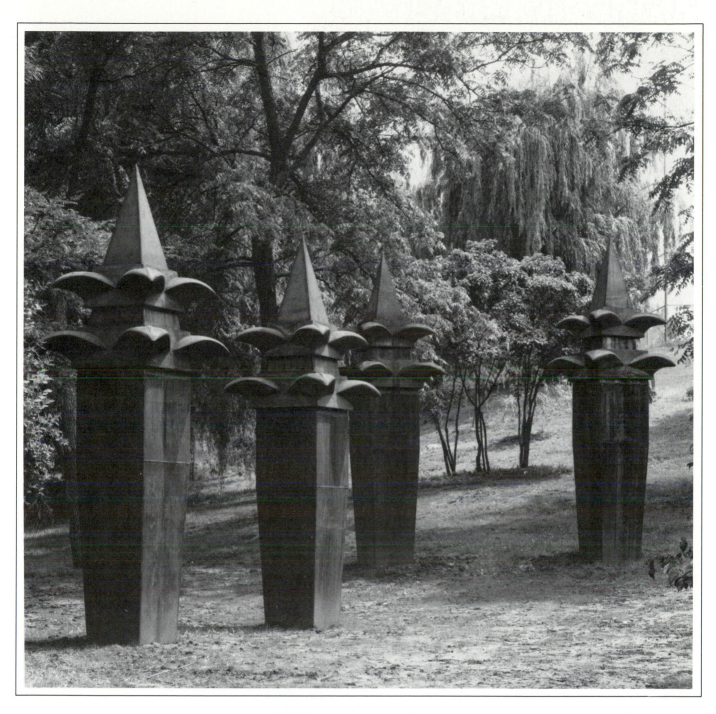

Eighth Continent. 1978. Cast iron and CorTen steel, each unit, 13'h x 4'w x 4'd above ground. Photograph by Jerry Schmidt.

Artist's Statement

"I like to bond sculpture to its supporting earth so that the piece emerges from it or is submerged within it; to use more than one form which allows one to move within the piece as well as view it from outside; to superimpose the abstractions of language and time on the visual work. Site or environment—its scale, mood and appearance—often trigger my associations and begin my search.

"My expression becomes an amalgam of what I see, have seen; of what I feel, have felt; of what I discover as I work.... movement—change—passage of time—the partly remembered—the selections of forms and materials to strengthen the expression—are all participants in my work. My hope is, above all, that my work will remain challenging because it stays just on the verge of revealing itself."

Shirley Wyrick

647

Elizabeth Yanish

née Elizabeth Yaffe
Born July 26, 1922 St. Louis, Missouri

Education and Training
1940- Washington University, St. Louis,
41 Missouri
1960 University of Colorado at Denver,
Denver, Colorado; study in sculpture
with Angelo di Benidetto, Edgar
Britton and Wilbert Verhelst

Selected Individual Exhibitions
1962 Beaux Arts Gallery, Denver, Colorado
1963 International House, Denver, Colorado
1963 Contemporaries Gallery, Santa Fe,
New Mexico
1964 7th Red Door, Pueblo, Colorado
1965 Rubenstein-Serkez Gallery, Denver,
Colorado
1966 Southern Colorado State College,
Pueblo, Colorado
1968 Neusteters Gallery, Denver, Colorado
1972 Littledale Gallery, Littleton, Colorado
1973 Colorado Women's College, Denver,
Colorado
1973 Woodstock Gallery, London, Great
Britain
1979 Edgar Britton Gallery, Denver,
Colorado
1982 L. B. Baumerder Gallery, Denver,
Colorado, retrospective

Selected Group Exhibitions
1961, "Denver Metropolitan Annual
62, Exhibition," Denver Art Museum,
63, Denver, Colorado
64,
66,
70,
72
1961- "Own Your Own Annual Exhibition,"
71 Denver Art Museum, Denver, Colorado
1962 "Artists Equity Association Exhibition,"
International House, Denver, Colorado
1963, "Blossom Festival," Fine Arts Center,
67, Canon City, Colorado
70
1963 "Juried Arts National Exhibition," Tyler
Museum of Art, Tyler, Texas
1963 "Seventy-Fifth Anniversary Invitational
Exhibition," Colorado Women's
College, Denver, Colorado
1964, "Midwest Biennial Exhibition," Joslyn
68 Art Museum, Omaha, Nebraska

1964, "Annual Invitational Exhibition,"
65, Southern Colorado State College,
66, Pueblo, Colorado
67
1964, "American Association of University
67, Women Annual Exhibition," Southern
69, Colorado State College, Pueblo,
70, Colorado
71
1964 "Invitational Exhibition," Salt Lake Art
Center, Salt Lake City, Utah
1964 "Materials and Techniques," Denver
Art Museum, Denver, Colorado
1964, "Annual Exhibition of Colorado Artists,"
65, Neusteters Gallery, Denver, Colorado
66,
67,
68,
69
1964 "Fifty-Third Annual Art Association
Exhibition," Art Association of
Newport, Newport, Rhode Island
1964, "Annual Exhibition of Southwest
65, American Art," Oklahoma Museum of
68 Art, Oklahoma City, Oklahoma
1965 "Collectors Choice V," Denver Art
Museum, Denver, Colorado
1965 "Seventy-First Western Annual
Exhibition," Denver Art Museum,
Denver, Colorado
1966 "Southwestern Fiesta Biennial,"
Museum of Fine Arts, Museum of New
Mexico, Santa Fe, New Mexico
1968 "Art in Metal Invitational Exhibition,"
Revere Copper Company," May
Company, Denver, Colorado
1971 "Biennial Exhibition," Utah Museum of
Fine Arts, Salt Lake City, Utah
1971 "Allied Sculptors of Colorado,"
Colorado State Bank, Denver,
Colorado; Loretto Heights College,
Denver, Colorado; Littledale Gallery,
Littleton, Colorado
1971 "Rocky Mountain Liturgical Arts,"
University Park Methodist Church,
Denver, Colorado
1971 "Internazionale 'Ai Frati'," Lucca, Italy,
catalog
1975 "Special Group Exhibition," Randi's Art
Gallery, Denver, Colorado
1977 "Sculpture Exhibition," Beaumont Art
Gallery, Loretto Heights College,
Denver, Colorado
1979 "North American Sculpture Exhibition,"
Foothills Art Center, Golden, Colorado,
catalog
1983 "Tenth Anniversary Artists of the
Rockies Exhibition," Sangre de Cristo
Arts and Conference Center, Pueblo,
Colorado

Selected Public Collections
Beth Israel Hospital, Denver, Colorado
BMH Synagogue, Denver, Colorado
Colorado State Bank, Denver, Colorado
Colorado Women's College, Denver,
Colorado
Congregation Har Ha-Shem, Boulder,
Colorado
Denver General Hospital, Denver, Colorado

Denver Public School District 1, Hamilton
Southwest Community School, Denver,
Colorado
Faith Bible Chapel, Arvada, Colorado
Martin Marietta Corporation, Denver,
Colorado

Selected Private Collections
Red Buttons, Bel Air, California
Mr. and Mrs. Lloyd Joshel, Denver, Colorado
Robert Maytag, Colorado Springs, Colorado
Mr. and Mrs. Jack McGee, Denver, Colorado
Dr. Irwin Vinnik, Denver, Colorado

Selected Awards
1962 First Place, "First Annual National
Space Art Exhibition," United States
Air Force Academy, Colorado Springs,
Colorado
1964 McCormick Award, "Juried National
Exhibition," Ball State Teachers
College, Muncie, Indiana
1968 First Place, "American Association of
University Women Annual Exhibition,"
Southern Colorado State College,
Pueblo, Colorado

Preferred Sculpture Media
Metal (welded)

Selected Bibliography
Manson, John. "Elizabeth Yanish, Sculptor."
Artists of the Rockies vol. 1 no. 1 (Winter
1974) pp. 10-11, illus.

Gallery Affiliation
L. B. Baumerder Gallery
300 Fillmore Street
Denver, Colorado 80206

Mailing Address
131 Fairfax Street
Denver, Colorado 80220

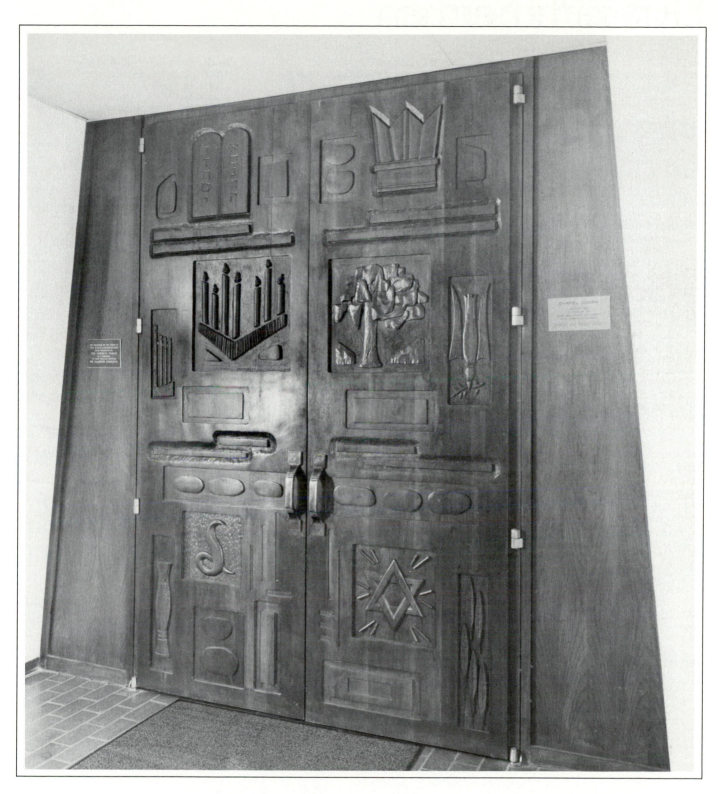

Chapel Doors. 1968. Carved walnut, 9'h x 6'w.
Collection BMH Synagogue, Denver, Colorado.

Artist's Statement

"Art, whether realistic or abstract, is an expression of the artist, a personal creative effort in bringing forth the most intimate thoughts and feelings. In an everchanging contemporary world, only in the field of art does the creator have this discretion to choose a direction. Art offers the possibility of contributing an important record of the human spirit and greater personal freedom than is available in many other occupations.

"I attempt to create fresh ideas, challenging myself with the medium in which I am working but with the hope of its being aesthetically pleasant to the viewer. I am grateful for having been given a talent and for the ability to do the best I know how with that talent."

Elizabeth Yanish

649

Elyn Zimmerman

née Elyn Beth
(Husband Kirk Varnedoe)
Born December 16, 1945 Philadelphia,
 Pennsylvania

Education and Training
1968 B.A., Psychology, University of
 California, Los Angeles, Los Angeles,
 California
1972 M.F.A., Painting, University of
 California, Los Angeles, Los Angeles,
 California

Selected Individual Exhibitions
1974 University Art Museum, Berkeley,
 California
1975 Baxter Art Gallery, California Institute
 of Technology, Pasadena, California
1976 SITE, San Francisco, California
1976, Broxton Gallery, Los Angeles,
77 California
1977 P.S. 1, Institute for Art and Urban
 Resources, Long Island City, New
 York
1979 80 Langton Street, San Francisco,
 California, catalog
1979 Museum of Contemporary Art,
 Chicago, Illinois, catalog
1981 Galleria del Cavallino, Venice, Italy
1982 Hudson River Museum, Yonkers, New
 York, catalog
1982 Sakaimach Gallery, Kyoto, Japan
1984 Koplin Gallery, Los Angeles, California
1985 Joslyn Art Museum, Omaha, Nebraska

Selected Group Exhibitions
1974 "Five Women Artists," Art Gallery,
 University of Nevada Las Vegas, Las
 Vegas, Nevada
1976 "Sequence," SITE, San Francisco,
 California
1977 "Three Artists: Zimmerman, Kasten,
 Callis," Fisher Gallery, University of
 Southern California, Los Angeles,
 California
1978 "Artpark: The Program in Visual Arts,"
 Artpark, Lewiston, New York, catalog
1979 "Custom and Culture Part II," U. S.
 Custom House, New York, New York
1979 "Eight Artists: The Elusive Image,"
 Walker Art Center, Minneapolis,
 Minnesota, catalog

1979 "Four Artists/Sixteen Projects," Wright
 State University, Dayton, Ohio,
 catalog
1980 "California Sculpture 1975-1980," San
 Diego Museum of Art, San Diego,
 California, catalog
1980 "Environmental Sculpture Program,"
 Olympic Village, Lake Placid, New
 York
1980 "Architectural Sculpture," Los Angeles
 Institute of Contemporary Art, Los
 Angeles, California, catalog
1981 "New York Artists," Palazzo Ducale,
 Genoa, Italy
1981 "Artists' Gardens and Parks," Hayden
 Gallery, Massachusetts Institute of
 Technology, Cambridge,
 Massachusetts; Museum of
 Contemporary Art, Chicago, Illinois
1981 "Quintessence: Alternative Spaces
 Residency Program," City Beautiful
 Council, Dayton, Ohio and Wright
 State University, Department of Art,
 Dayton, Ohio, catalog
1982 "Los Angeles/New York," Koplin
 Gallery, Los Angeles, California
1983 "Directions 1983," Hirshhorn Museum
 and Sculpture Garden, Smithsonian
 Institution, Washington, D.C.,
 book-catalog
1985 "The Artist as Social Designer," Los
 Angeles County Museum of Art, Los
 Angeles, California, catalog
1985 "Art and Architecture and Landscape,"
 San Francisco Museum of Modern Art,
 San Francisco, California, catalog

Selected Public Collections
Hudson River Museum, Yonkers, New York
Los Angeles County Museum of Art, Los
 Angeles, California
National Geographic Society, Washington,
 D.C.
Neuberger Museum, Purchase, New York
University of Hartford, West Hartford,
 Connecticut
Whitney Museum of American Art, New York,
 New York

Selected Awards
1976 New Talent Award, Los Angeles
 County Museum of Art, Los Angeles,
 California
1980 Creative Artists Public Service Grant,
 New York State Council on the Arts
1983 Individual Artist's Fellowship, National
 Endowment for the Arts

Preferred Sculpture Media
Stone and Varied Media

Additional Art Fields
Drawing and Photography

Selected Bibliography
Frueh, Joanna. "Reviews Chicago: Elyn
 Zimmerman, Museum of Contemporary
 Art." Artforum vol. 18 no. 6 (February 1980)
 pp. 103-104, illus.

Gopnik, Adam. "Elyn Zimmerman's
 'Marabar'." Arts Magazine vol. 59 no. 2
 (October 1984) pp. 78-79, illus.
Lubell, Ellen. "Review of Exhibitions: Yonkers,
 Elyn Zimmerman at Hudson River
 Museum." Art in America vol. 70 no. 5
 (May 1982) pp. 139-140, illus.
Silverthorne, Jeanne. "Reviews Washington,
 D.C.: 'Directions 1983,' Hirshhorn
 Museum." Artforum vol. 22 no. 2 (October
 1983) pp. 79-80, illus.
Tsai, Eugenie. "Elyn Zimmerman: Palisades
 Project." Arts Magazine vol. 56 no. 8 (April
 1982) pp. 138-139, illus.

Gallery Affiliation
Koplin Gallery
8225½ Santa Monica Boulevard
Los Angeles, California 90069

Mailing Address
39 Worth Street
New York, New York 10013

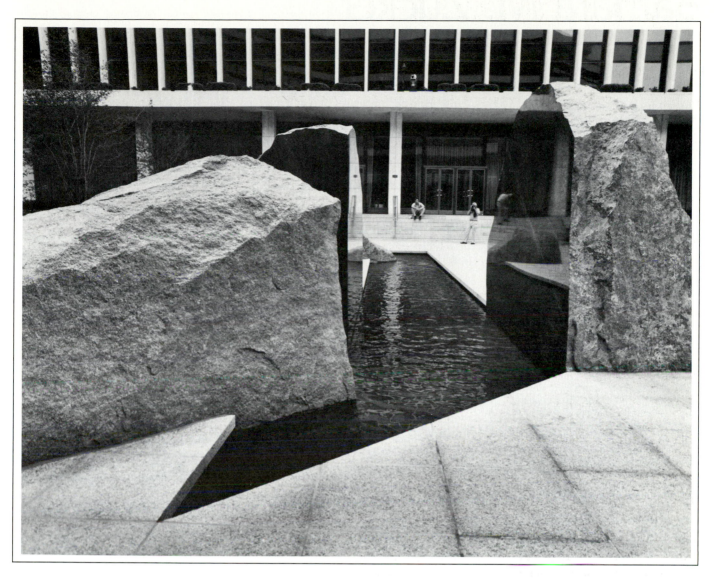

Marabar. 1984. Granite boulders, natural cleft and polished, dimensions variable; pool, 60'l x 6'w x 18"d. Collection National Geographic Society, Washington, D.C. Photograph by S. Varnedoe.

Artist's Statement

"The work that I do as an artist, the installations and constructions that I make, create spatial situations in which the viewer becomes a participant in the work. The projects are constructed to be experienced with the whole body, through movement and time. All aspects of the work are not seen at once; the work reveals itself sequentially, through inspection.

"Each project is conceived for its particular site and built for that site alone. Materials and formal considerations change to accommodate the unique qualities of each site, but the intention of the work is constant: to create an active, participatory situation that allows for discovery and the growth of awareness."

Barbara M. Zucker

née Barbara M. Cohen
Born August 2, 1940 Philadelphia,
Pennsylvania

Education and Training
1962 B.S., Design, University of Michigan,
Ann Arbor, Michigan
1975 M.F.A. Equivalency, Awarded by
College Art Association of America,
New York, New York
1977 M.A., Sculpture, City University of
New York Hunter College, New York,
New York

Selected Individual Exhibitions
1971, Elaine Benson Gallery,
75 Bridgehampton, New York
1972, A.I.R. Gallery, New York, New York
74
1973 Rutgers University, Douglass College,
New Brunswick, New Jersey
1976 112 Greene Street Gallery, New York,
New York, catalog
1978, Robert Miller Gallery, New York, New
80 York
1979 Marianne Deson Gallery, Chicago,
Illinois
1980 Pennsylvania Academy of the Fine
Arts, Philadelphia, Pennsylvania
1981 Robert Hull Fleming Museum,
Burlington, Vermont
1981 Joslyn Art Museum, Omaha,
Nebraska, catalog
1982 University Gallery, Fine Arts Center,
University of Massachusetts at
Amherst, Amherst, Massachusetts
1983 Swarthmore College, Swarthmore,
Pennsylvania
1983 University of Connecticut, West
Hartford, Connecticut
1983, Pam Adler Gallery, New York, New
85 York
1984 Hurlbutt Gallery, Greenwich Library,
Greenwich, Connecticut, catalog

Selected Group Exhibitions
1971 "Twenty-Six Contemporary Women
Artists," Aldrich Museum of
Contemporary Art, Ridgefield,
Connecticut, catalog
1974 "Woman's Work: American Art 1974,"
Museum of the Philadelphia Civic
Center, Philadelphia, Pennsylvania,
catalog
1974 "Seven Sculptors," Institute of
Contemporary Art, Boston,
Massachusetts, catalog
1977 "Small Objects," Whitney Museum of
American Art, New York, New York
1977 "A Collection in Progress: Milton
Brutten and Helen Herrick," Moore
College of Art, Philadelphia,
Pennsylvania

1977 "Improbable Furniture," Traveling
Exhibition, Institute of Contemporary
Art of The University of Pennsylvania,
Philadelphia, Pennsylvania, catalog
1978 "Artpark: The Program in Visual Arts,"
Artpark, Lewiston, New York, catalog
1979 "The Decorative Impulse," Traveling
Exhibition, Institute of Contemporary
Art of The University of Pennsylvania,
Philadelphia, Pennsylvania, catalog
1979 "Fabric Workshop," Marian Locks
Gallery, Philadelphia, Pennsylvania
1979 "Art as Furniture, Furniture as Art,"
Ingber Gallery, New York, New York
1979- "Supershow!," Traveling Exhibition,
80 Hudson River Museum, Yonkers, New
York, catalog
1980 "Painting and Sculpture Today 1980,"
Indianapolis Museum of Art,
Indianapolis, Indiana, catalog
1981 "Decorative Sculpture," Sculpture
Center, New York, New York
1981 "O.I.A. Sculpture Exhibition," Ward's
Island, New York
1981 "The Great American Fan Show,"
Lerner Heller Gallery, New York, New
York; Reynolds/Minor Gallery,
Richmond, Virginia
1982 "Art Materialized: Selections from the
Fabric Workshop," Traveling
Exhibition, Contemporary Arts Center,
Cincinnati, Ohio, catalog
1982 "Dynamix," Traveling Exhibition,
Contemporary Arts Center, Cincinnati,
Ohio, catalog
1982 "Women's Art—Women's Lives: An
Invitational Exhibition of Vermont
Women Artists," Brattleboro Museum
and Art Center, Brattleboro, Vermont
1983 "Affects-Effects," Philadelphia College
of Art, Philadelphia, Pennsylvania,
catalog
1983 "Sculpture: The Tradition in Steel,"
Nassau County Museum of Fine Arts,
Roslyn, New York, catalog
1984 "Anne Sperry/Barbara Zucker: A
Decade of Work," Hillwood Art Gallery,
C. W. Post Center of Long Island
University, Greenvale, New York,
retrospective and catalog
1984 "A Celebration of American Women
Artists Part II: The Recent Generation,"
Sidney Janis Gallery, New York, New
York, catalog

Selected Public Collections
American Can Company, Greenwich,
Connecticut
Chase Manhattan Corporation, New York,
New York
Greenwich Library, Greenwich, Connecticut
Hartwick College, Oneonta, New York
Indianapolis Museum of Art, Indianapolis,
Indiana
University of Colorado at Boulder, Boulder,
Colorado
University of Massachusetts at Amherst,
Amherst, Massachusetts
Whitney Museum of American Art, New York,
New York

Selected Private Collections
Marlies Black, New York, New York
Mr. and Mrs. Sydney Lewis, Richmond,
Virginia
Vera List, New York, New York
Hans Strelow, Düsseldorf, Germany, Federal
Republic

Selected Award
1975 Individual Artist's Fellowship, National
Endowment for the Arts

Preferred Sculpture Media
Varied Media

Additional Art Field
Drawing

Related Professions
Lecturer and Writer

Teaching Position
Professor and Chair, Department of Art,
University of Vermont, Burlington, Vermont

Selected Bibliography
Gorney, Jay. "Barbara Zucker." *Arts
Magazine* vol. 51 no. 5 (January 1977) p.
16, illus.
Martin, Richard. "Barbara Zucker." *Arts
Magazine* vol. 58 no. 1 (September 1983)
p. 15, illus.
Rickey, Carrie. "Conduits of a Feather
Flocked Together: Barbara Zucker's New
Sculptures." *Arts Magazine* vol. 52 no. 10
(June 1978) pp. 106-107, illus.
Russell, John. "Art: Barbara Zucker and Her
Sculptures." *The New York Times* (Friday,
June 10, 1983) p. C24, illus.
Silverthorne, Jeanne. "Reviews New York:
Barbara Zucker, Pam Adler Gallery."
Artforum vol. 22 no. 3 (November 1983) p.
83, illus.

Gallery Affiliation
Pam Adler Gallery
37 West 57 Street
New York, New York 10019

Mailing Address
16 Orchard Terrace
Burlington, Vermont 05401

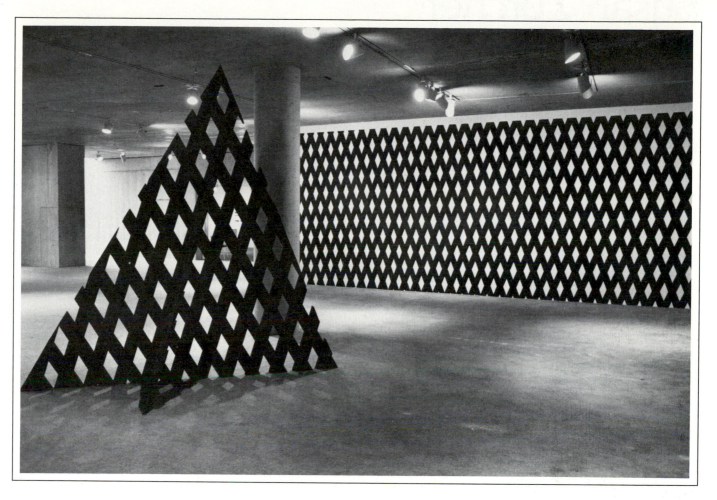

Lattice Series: Triangle, Elipse and the Monster (detail). 1982. Painted wood, overall dimensions variable to insallation. Installation view 1982. University Gallery, Fine Arts Center, University of Massachusetts at Amherst, Amherst, Massachusetts.

Artist's Statement

"I begin with an idea and try to make it look like the picture in my head. The material is chosen to suit the idea which is why I have no specific interest in one medium. I work on a theme until it is exhausted. Then I wait for the next theme to surface. When it does, I begin again.

"The older I get the harder it is to talk about my work. The cliché that the work should speak for itself is true. Or someone other than I can talk about it if they wish. I just want to make things."

Susan Zurcher

née Susan Jane
Born December 15, 1944 Youngstown, Ohio

Education and Training
1966 B.S., Health and Physical Education, University of Dayton, Dayton, Ohio

Selected Individual Exhibitions
1979, Wright State University Experimental
83 Gallery, Wright State University, Dayton, Ohio
1980 Great Miami River Festival, Dayton, Ohio
1980 Seigfred Gallery, Seigfred Hall, Ohio University, Athens, Ohio
1983 Artemisia Gallery, Chicago, Illinois
1984 Gund Gallery, Ohio Arts Council, Columbus, Ohio
1985 University of Akron, Akron, Ohio

Selected Group Exhibitions
1970 "Annual Ohio Ceramic and Sculpture Show," Butler Institute of American Art, Youngstown, Ohio
1981 "Natur-Skulptur, Nature-Sculpture," Württembergischer Kunstverein, Stuttgart, Germany, Federal Republic, catalog
1983 "Susan Zurcher and John Moore," Spaces Gallery, Cleveland, Ohio
1983 "Ring in the New," Columbus Cultural Center, Columbus, Ohio
1983 "Ohio Selection," Dayton Art Institute, Dayton, Ohio, catalog
1984 "Annual Three Rivers Arts Festival," Gateway Center, Pittsburgh, Pennsylvania, catalog
1985 "National & International Studio Program Exhibition: Artists Currently in Residence," The Clocktower, New York, New York

Selected Public Collection
Thwing Center, Case Western Reserve University, Cleveland, Ohio

Selected Awards
1981, Individual Artist's Fellowship,
84 Ohio Arts Council
1985 Artist in Residence, P.S. 1, Institute for Art and Urban Resources, Long Island City, New York

Preferred Sculpture Media
Varied Media and Wood

Additional Art Field
Photography

Related Professions
Editor and Poet

Selected Bibliography
Hudson. "Reviews Chicago: Susan Zurcher." *New Art Examiner* vol. 11 no. 5 (January 1984) p. 17, illus.
Jordan, Jim. "Commentary, Zurcher at Wright State University Experimental Gallery." *Dialogue* (November-December 1979) p. 36, illus.
Kalister, Fred. "Commentary, Susan Zurcher: Pelts." *Dialogue* (January-February 1981) p. 14, illus.
Kiefer, Geraldine Wojno. "Reviews: Susan Zurcher's Sculpture." *Dialogue* vol. 6 no. 2 (November-December 1983) pp. 12-13, illus.
Kohles-Fryer, Jeanne. "Reviews Midwest, Ohio: Susan Zurcher, Mel Durand, Julia Suits, Columbus Cultural Arts Center." *New Art Examiner* vol. 10 no. 5 (February 1983) p. 22.

Mailing Address
1231 Cumberland Avenue
Dayton, Ohio 45406

Artist's Statement

"When I started to work as a sculptor at age thirty-five, I began a visual dialogue about the conflicts between individuals and how we live together on and with the earth. The underlying intent of my work is to harmonize these tensions through the combination of a natural material—wood—with a man-made substance—wire—into works that ask as many questions as they answer.

"The tree limbs are meant to suggest or evoke memories of things long forgotten but intuitively understood. The repeated use of layering, a premise that begins in nature, forms a continuous theme throughout the sculpture prompting thoughts of processes, time and inevitabilities. The use of shadow conveys the reality of the mysterious."

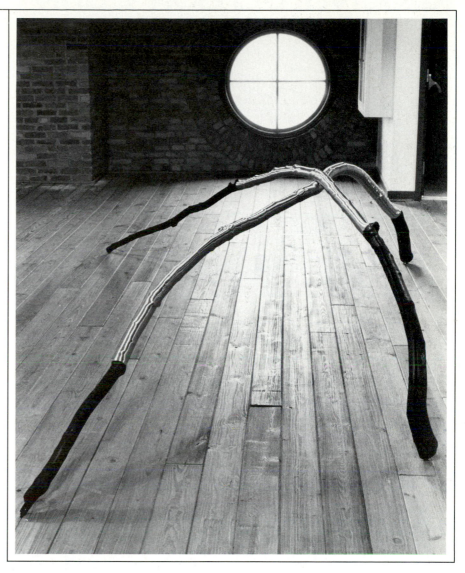

Quills. 1982. Tree limbs and aluminum wire, 31"h x 6'5"w x 12'10"d.

Jesselyn Benson Zurik

née Jesselyn Benson
(Husband Samuel Zurik)
Born December 26, 1916 New Orleans,
 Louisiana

Education and Training
1926- Arts and Crafts Club, New Orleans,
28 Louisiana
1938 B.D., Painting and Art History,
 Newcomb College, New Orleans,
 Louisiana
1958- Newcomb College, New Orleans,
61 Louisiana; study in art

Selected Individual Exhibitions
1963, Uptown Gallery, New Orleans,
64 Louisiana
1964 School of Art, Sam Houston State
 Teachers College, Huntsville, Texas,
 catalog
1965, Glade Gallery, New Orleans, Louisiana
66,
67,
68,
70
1965 Lauren Rogers Library and Museum of
 Art, Laurel, Mississipppi
1969 DuBose Gallery, Houston, Texas,
 catalog
1972 Tyler Museum of Art, Tyler, Texas
1972 Michael A. Ledet Gallery, New
 Orleans, Louisiana
1974, Circle Gallery, New Orleans, Louisiana
76,
79
1976 Longview Museum and Arts Center,
 Longview, Texas
1981 Beall/Lambremont Gallery, New
 Orleans, Louisiana
1985 Mario Villa Gallery, New Orleans,
 Lousisiana

Selected Group Exhibitions
1959 "Southeast Regional and Texas
 Exhibition," Isaac Delgado Museum of
 Art, New Orleans, Louisiana
1963, "Brandeis University Invitational
69, Evening of Art, New Orleans Chapter,"
73, Major Hotels, New Orleans,
77, Louisiana
80,
81,
84
1964 "Artists of the Gulf States Juried
 Exhibition," Isaac Delgado Museum of
 Art, New Orleans, Louisiana
1964 "Annual Delta Art Exhibition," Arkansas
 Arts Center, Little Rock, Arkansas,
 catalog
1965 "Southeastern Annual Exhibition," High
 Museum of Art, Atlanta, Georgia
1965 "New Art, New Orleans," John and
 Mabel Ringling Museum of Art,
 Sarasota, Florida

1966- "Southern Sculpture 1966," Traveling
67 Exhibition, Arkansas Arts Center, Little
 Rock, Arkansas, catalog
1970 "Selected Artists of Glade Gallery,
 New Orleans, Louisiana," Lauren
 Rogers Library and Museum of Art,
 Laurel, Mississippi
1973 "Fifteenth Annual Painting and
 Sculpture Invitational," Longview
 Museum and Arts Center, Longview,
 Texas
1973 "Louisiana Artists Invitational," New
 Orleans Museum of Art, New Orleans,
 Louisiana
1976 "Ninth International Sculpture
 Conference," Area Galleries and
 Institutions, New Orleans, Louisiana
 (Sponsored by International Sculpture
 Center, Washington, D.C.)
1976 "Materials Indigenous to Louisiana,"
 Louisiana Crafts Council, New
 Orleans, Louisiana
1978 "Art Works and Book Works," Los
 Angeles Institute of Contemporary Art,
 Los Angeles, California
1978 "The Artist's Burial Ground: Personal
 Monuments," Contemporary Arts
 Center, New Orleans, Louisiana
1978 "Animal Fantasies," Contemporary Arts
 Center, New Orleans, Louisiana
1980 "Louisiana Premiere: Women Artists,"
 Hanson Gallery, New Orleans,
 Louisiana, catalog
1980 "Southern Exposure," Hanson Gallery,
 New Orleans, Louisiana, catalog
1980, "Louisiana Sculpture Biennial,"
81 Contemporary Arts Center, New
 Orleans, Louisiana, catalog
1981 "Art Cars Preview," Newcomb College,
 New Orleans, Louisiana
1981, "Art for Art's Sake," Contemporary
82 Arts Center, New Orleans, Louisiana
1982 "Art Cars for Krewe of Clones,"
 Contemporary Arts Center, New
 Orleans, Louisiana, catalog
1982 "Art Cars," P.S. 1, Institute for Art and
 Urban Resources, Long Island City,
 New York
1982 "Art Cars Exhibition," Tweed Gallery,
 Plainfield, New Jersey
1983 "Art Cars National Juried Exhibition,"
 Contemporary Arts Center, New
 Orleans, Louisiana, catalog
1983 "Art Cars National Juried Exhibition,"
 Barbara Gillman Gallery, Miami,
 Florida, catalog
1984 "Eat Your 'Art' Out: Wearable Art and
 Eatable Art," Contemporary Arts
 Center, New Orleans, Louisiana
1984 "Women's Caucus for Art National
 Juried Exhibition," Ralph L. Wilson
 Gallery, Alumni Memorial Building,
 Lehigh University, Bethlehem,
 Pennsylvania
1984 "Mardi Gras Invitational,"
 Contemporary Arts Center, New
 Orleans, Louisiana

Selected Public Collections
Arts Council of Greater New Orleans
 Collection, New Orleans, Louisiana
Isidore Newman School, New Orleans,
 Louisiana
Kilgore Junior College, Kilgore, Texas
New Orleans Museum of Art, New Orleans,
 Louisiana
New Orleans Public Library, Algiers,
 Louisiana and New Orleans, Louisiana
Rose Art Museum, Brandeis University,
 Waltham, Massachusetts
Touro Infirmary, New Orleans, Lousiana
Tulane University, Howard-Tilton Memorial
 Library, New Orleans, Louisiana
Willow Wood, Home for Jewish Aged, New
 Orleans, Louisiana

Selected Private Collections
Arthur Brodie, Laguna Beach, California
Mr. and Mrs. Thomas B. Lemann, New
 Orleans, Louisiana
Dr. and Mrs. Richard Levy, Santa Fe, New
 Mexico
Allan Spirtas, New Orleans, Louisiana
Mr. and Mrs. Francis Witherspoon, Dallas,
 Texas

Selected Awards
1966 Honorable Mention and Prize,
 "Southern Association of Sculptors
 Regional Juried Exhibition," Arkansas
 Arts Center, Little Rock, Arkansas
1979 Merit Award and Prize, "National
 Triennial," Contemporary Arts Center,
 New Orleans, Louisiana
1982 Honorable Mention, "Third Annual
 Louisiana Women's Art Exhibition,
 Women's Caucus for Art," New
 Century Gallery, New Orleans,
 Louisiana

Preferred Sculpture Media
Varied Media and Wood

Additional Art Fields
Drawing and Painting

Selected Bibliography
American Artists of Renown. Gilmer, Texas:
 Wilson, 1981.

Gallery Affiliation
Mario Villa Gallery
3908 Magazine Street
New Orleans, Louisiana 70115

Mailing Address
7740 Belfast Street
New Orleans, Louisiana 70125

Artist's Statement

"My work is an effort to fuse both painting and sculpture. After long years of training with color and the two-dimensional, I gravitated to old wood artifacts, some of them fifty to one hundered years old, the throw aways of our highly mobile society. Giving these shapes and forms a new life with paints and various types of oils, I feel the two disciplines are being brought together, creating my own unique form of assemblage and sculpture."

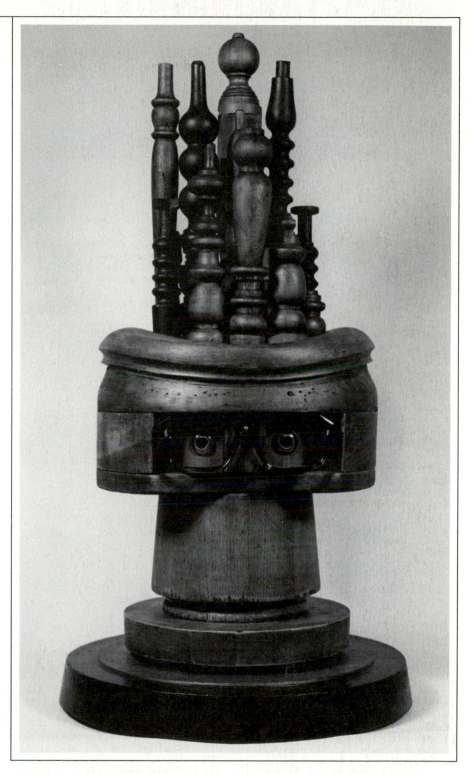

Mind Boggling. 1977. Wood, glass and oil, 32"h x 10"w. Photograph by Bill van Calsem.

Geographic Index

Alabama
Johnson, Sally W. (Birmingham)
Rieger, Sonja O. (Birmingham)

Alaska
Bevins, Sue (Anchorage)
Olanna, Karen Jenkins (Shishmaref)

Arizona
Graves, Kā (Phoenix)
Grygutis, Barbara (Tucson)
Klotz-Reilly, Suzanne (Tempe)
Magenta, Muriel (Scottsdale)
McKenna, Sally (Cave Creek)
Sherwood, Carol A. (Tempe)
Udinotti, Agnese (Scottsdale)

Arkansas
Huffington, Anita (Winslow)
Phillips, Helen Evans (Little Rock)
Roper, Jo (Rogers)

California
Abeles, Kim (Los Angeles)
Albuquerque, Lita (Los Angeles)
Alexander, Marsia R. (Pasadena)
Bates, Mary P. (Rohnert Park)
Bruria (Santa Monica)
Carhartt, Elaine (Pasadena)
Carman, Nancy (San Francisco)
Falkenstein, Claire (Venice)
Feldman, Bella Tabak (Berkeley)
Ford, Betty Davenport (Claremont)
Frey, Viola (Oakland)
Fuller, Mary (Petaluma)
Gold, Betty (Venice)
Hanson, Jo (San Francisco)
Hassinger, Maren (Los Angeles)
Healy, Anne (San Francisco)
Jordan, Johanna (Santa Monica)
Keelan, Margaret (San Pablo)
Levine, Marilyn (Oakland)
Malloff, Georganna Pearce (Caspar)
Murrill, Gwyn (Agoura)
Shannonhouse, Sandra L. (Benicia)
Spring, Barbara (Big Sur)
Worthington, Nancy (San Francisco)

Colorado
Baer, Barbara (Denver)
Calzolari, Elaine (Denver)
Dixon, T. J. (Boulder)
Sebastian, Jill (Lakewood)
Yanish, Elizabeth (Denver)

Connecticut
Caparn, Rhys (Newtown)
Davidson, Carol Kreeger (West Hartford)
Kaplan, Penny (Greenwich)
Petersen, Karen A. (West Hartford)
Schupack, Vera (South Norwalk)
Woodham, Jean (Westport)

Delaware
Reynolds, Nancy du Pont (Greenville)

District of Columbia
Brennan, Nizette (Washington)
Danziger, Joan (Washington)
Falk, Elizabeth C. (Washington)
Gambaro, Retha Walden (Washington)
Rankine, V. V. (Washington)
Shaffer, Mary (Washington)
Truitt, Anne (Washington)

Florida
Armstrong, Jane B. (Highland Beach)
Brito-Avellana, María (Miami)
Brown, Carol K. (Miami Beach)
Federighi, Christine (Miami)
Hanna, Gay Powell (Tallahassee)
Leeper, Doris (New Smyrna Beach)
Neijna, Barbara (Coral Gables)
Satin, Claire Jeanine (Dania)
Ward, Jean (Miami)

Georgia
Artemis, Maria (Atlanta)
Berge, Dorothy (Atlanta)
Montague, Caroline (Atlanta)
Sutter, Jean (Atlanta)

Hawaii
Gilbert, Helen (Honolulu)
Ruby, Laura (Honolulu)

Idaho
Larson, Gail Farris (Pocatello)

Illinois
Altman, Edith (Chicago)
Block, Mary (Highland Park)
Carroll, Maryrose (Chicago)
Duckworth, Ruth (Chicago)
Florsheim, Lillian H. (Chicago)
Greene-Mercier, Marie Zoe (Chicago)
Hart, Kathleen (Glencoe)
Kramer, Linda (Winnetka)
McCullough, Geraldine (Oak Park)
Simpson, Diane (Wilmette)
Stoppert, Mary (Chicago)
Sunderland, Nita K. (Washington)
Wharton, Margaret (Chicago)

Indiana
Calman, W. (Bloomington)
Geoffrion, Moira Marti (South Bend)
Walker, Lin S. (Valparaiso)

Iowa
Sage, Priscilla K. (Ames)
Wyrick, Shirley (Iowa City)

Kansas
Blitt, Rita (Leawood)
Frazier, Beverly (Lawrence)

Kentucky
Dueber, Jeanne (Nerinx)
Ferguson, Kathleen (Lexington)

Louisiana
Connell, Clyde (Elm Grove)
Emery, Lin (New Orleans)
Gregory, Angela (New Orleans)
Kohlmeyer, Ida (Metairie)
Lief, Dona Lee (New Orleans)
Savoy, Chyrl L. (Youngsville)
Zurik, Jesselyn Benson (New Orleans)

Maine
de Moulpied, Deborah (Hancock)
Hall, Chenoweth (Prospect Harbor)
Matthews, Harriett (Clinton)

Maryland
Frank, Jane (Towson)
Mears, Mary Ann E. (Baltimore)
Rosen-Queralt, Jann (Baltimore)
Rothschild, Amalie (Baltimore)

Massachusetts
D'Amore, Bernadette (Winthrop)
Gunter, Virginia (Somerville)
Harries, Mags (Cambridge)
Hutchinson, Jaqueth (Cambridge)
Jencks, Penelope (Newton)
McDaniel, Joyce (Newton)
McIlvain, Isabel (Boston)
Pineda, Marianna (Boston)
Tock, Jean (Duxbury)
Webb, Nancy (Wellfleet)

Michigan
McCagg, Louise (East Lansing)
Stiebel, Hanna (Bloomfield Hills)
Stump, Pamela (Rochester)
Teicher, Lois (Detroit)
Wood, Marcia (Kalamazoo)

Minnesota
Fiene, Susan (Minneapolis)
Follett, Jean F. (St. Paul)
Lofquist, Janet (Minneapolis)
Raymond, Evelyn (Minneapolis)
Sosin, Georgette (Chanhassen)
Wolfe, Ann (Minneapolis)

Mississippi
Allen, Joe Ann Marshall (Oxford)
Jones, Marilyn (Wiggins)

Missouri
Field, Kathryn E. (St. Louis)
Jones, Wiz (St. Louis)
Van Harlingen, Jean (Kansas City)

Montana
Butterfield, Deborah (Bozeman)
Dreyer, Clarice A. (Bozeman)
Mathiesen, Pat (West Yellowstone)

Nebraska
Ferguson, Catherine (Omaha)
Fogarty, Mary Beth (Omaha)

Nevada
Andrew, Trish (Reno)
Thatcher, Sharon (Carson City)

New Hampshire
Barnett, Loretta S. Wonacott (New London)
Bradley, Mary E. (Grantham)
Cenci, Silvana (Northwood Narrows)
Dombek, Blanche (Hancock)

New Jersey
Banks, Rela (Short Hills)
Fine, Joan (Leonia)
Held, Marion E. (West Orange)
Margoulies, Berta (R. D. Flanders)
Price, Joan Webster (Maplewood)
Rizo-Patron, B. P. (Trenton)
Teller, Jane (Princeton)

New Mexico
Graham, Gloria (Albuquerque)
Lacy, Ann (Pecos)
Lowney, Beverley Magennis (Albuquerque)

New York
Abish, Cecile (New York)
Adams, Alice (New York)
Arms, Anneli (New York)
Arnold, Anne (New York)
Aycock, Alice (New York)
Benglis, Lynda (New York)
Bermann, Lenora (Forest Hills)
Borgatta, Isabel Case (New York)
Bourgeois, Louise (New York)
Bowles, Marianne von Recklinghausen (White Plains)
Brandt, Helene (New York)
Castanis, Muriel B. (New York)
D'Alessandro, Sara (Riverhead)
Dehner, Dorothy (New York)
Dennis, Donna (New York)
Ente, Lily (New York)
Ferrara, Jackie (New York)
Feuerman, Carole Jeane (Mineola)
Finke, Leonda F. (Roslyn)
Frank, Mary (New York)
Fuller, Sue (Southampton)
Gillespie, Dorothy (New York)
Goulet, Lorrie (New York)
Graves, Nancy (New York)
Grossen, Françoise (New York)
Grossman, Nancy (New York)
Hammond, Harmony (New York)
Hampton, Lucille Charlotte (New York)
Harrison, Carole (Southampton)
Hartwig, Cleo (New York)
Helman, Phoebe (New York)
Holt, Nancy (New York)

Kaish, Luise (New York)
Katzen, Lila (New York)
Klavun, Betty (New York)
Kruger, Louise (New York)
Lekberg, Barbara (Mamaroneck)
Marisol (New York)
Mason, Molly (Stony Brook)
Miss, Mary (New York)
Model, Elisabeth (New York)
Nevelson, Louise (New York)
Newmark, Marilyn (East Hills)
Norvell, Patsy (New York)
Perry, Beatrice (Germantown)
Pfaff, Judy (New York)
Pinto, Jody (New York)
Schwebel, Renata M. (New Rochelle)
Sperry, Ann (New York)
Strider, Marjorie (New York)
Stussy, Maxine Kim (Larchmont)
Tawney, Lenore (New York)
Thea, Tewi (Forest Hills)
Winkel, Nina (Keene Valley)
Winsor, Jacqueline (New York)
Woody, Elsbeth S. (New York)
Zimmerman, Elyn (New York)

North Carolina
Fanelli, Deborah (Winston-Salem)
Irwin, Kim (Chapel Hill)
Mintich, Mary R. (Belmont)
Oliver, Jeanette M. (Greensboro)
Puls, Lucy (Cullowhee)
Rhoades, Barbara (Chapel Hill)
Shaw, Mary Todd (Charlotte)
Thompson, Rosalind G. (Hillsborough)
Wasserboehr, Patricia (Greensboro)

North Dakota
McCleery, Kathryn L. (Grand Forks)
Mulligan, Catherine (Fargo)

Ohio
Chavous, Barbara (Columbus)
Collings, Betty (Columbus)
Cooper, Stephanie (Cincinnati)
Eckhardt, Edris (Cleveland Heights)
Horrell, Deborah (Columbus)
Pereyma, Aka (Troy)
Renick, Patricia A. (Cincinnati)
Robinson, Aminah Brenda Lynn (Columbus)
Rosenberg, Yetta (Cleveland)
Shirley, Karen (Yellow Springs)
Tacha, Athena (Oberlin)
Zurcher, Susan (Dayton)

Oklahoma
Alaupović, Alexandra V. (Oklahoma City)
Frazier, Lena Beth (Norman)
Whitney, Carol (Norman)

Oregon
Bell, Lilian A. (McMinnville)
Feves, Betty W. (Pendleton)
Lewis, Mary (Rainier)
Neuenschwander, Ronna (Portland)

Pennsylvania
Bontecou, Lee (Huntingdon Valley)
deCoux, Janet (Gibsonia)
de Guatemala, Joyce (Glenmoore)
de Wit, Margot (Philadelphia)
Filkosky, Josefa (Greensburg)
Gruber, Aaronel deRoy (Pittsburgh)
Kerrigan, Maurie (Philadelphia)
Kumata, Carol (Pittsburgh)
Levick, Ellen (Pittsburgh)
Love, Arlene (Philadelphia)
Mulcahy, Kathleen (Oakdale)
Nicholas, Donna Lee (Edinboro)
Samuels, Diane (Pittsburgh)
Tarantal, Elsa Johnson (Elkins Park)
Winokur, Paula (Horsham)

Rhode Island
Helfant, Nancy (Providence)
Malik, Marlene (Kingston)
Rice, Jacquelyn (Barrington)
Rozhon, Ann (Pascoag)

South Carolina
Jarrard-Dimond, Terry (Clemson)
McCune, Linda Williams (Allendale)

South Dakota
Hepper, Carol (McLaughlin)

Tennessee
Bullard, Helen (Sparta)
Havens, Jan (Nashville)
Horner, Lou (Knoxville)
McMahon, Maggie (Signal Mountain)

Texas
Bagley, Frances Stevens (Dallas)
Biggs, Electra Waggoner (Vernon)
Elkin, Rowena C. (Dallas)
Glatt, Linnea (Dallas)
Knapp, Candace (Houston)
Reese, Claudia (Dallas)
Shaffer, Diana (Fort Worth)
Smith, Mara (Denton)
Stein, Sandy (Plano)
Stewart, Hannah (Houston)
Strunck, Gisela-Heidi (Grapevine)
Telford, Laura (Austin)
Tillman, Patricia (Waco)
Waters, Sara (Lubbock)
Watson, Helen Richter (Laredo)

Utah
Hansen, Florence P. (Sandy)
Ure, Maureen O'Hara (Salt Lake City)

Vermont
de Gogorza, Patricia (East Calais)
Eldredge, Mary Agnes (Springfield)
Solbert, R.G. (Randolph)
Zucker, Barbara M. (Burlington)

Virginia

Kamen, Rebecca (Arlington)
King, Elizabeth C. (Williamsburg)
Mason, Jimilu (Alexandria)
Quarberg, Laurel J. (Norfolk)
Smith, Linda Thern (Fairfax Station)
Thompson, Conway (Farmville)
Thorpe, Hilda (Alexandria)
Watson, Genna (Alexandria)
Uravitch, Andrea V. (Arlington)

Washington

Barzel, Dina (Bellevue)
Ford, Margaret (Seattle)
Glowen, Kathryn A. (Arlington)
Katsiaficas, Diane (Seattle)
Lysohir, Marilyn (Pullman)
Mandeberg, Jean (Olympia)
Perrigo, Anne (Sequim)
Rockwood, Lynda K. (Medina)
Wachmeister, Linda E. A. (Seattle)
Warashina, Patti (Seattle)

West Virginia

Helm, Alison (Morgantown)

Wisconsin

Falkman, Susan (Glendale)
Glowacki, Martha (Madison)
Gunderman, Karen (Milwaukee)
King, Katherine (Milwaukee)
Michie, Mary (Madison)
Rice, Paula Jean (Marshall)
Threadgill, Linda (East Troy)
Vieux, Marian J. (Milwaukee)

Wyoming

Connell, Bunny (Sheridan)

RESIDENTS OUTSIDE UNITED STATES

Canada

Hecht, Mary (Toronto)

Denmark

Shanklin, Barbara K. (Copenhagen)

France

Chase-Riboud, Barbara (Paris)
Diska (Vaucluse)
Holt, Sara (Paris)
Lee, Caroline (Paris)

Italy

FitzGerald, Joan (Venice)
Pepper, Beverly (Perugia)

Mexico

Catlett, Elizabeth (Cuernavaca)

Media Index

Brick
Malik, Marlene

Clay
Alaupović, Alexandra V.
Allen, Joe Ann Marshall
Arnold, Anne
Block Mary
Brito-Avellana, María
Bruria
Carhartt, Elaine
Carman, Nancy
Collings, Betty
D'Alessandro, Sara
Dixon, T. J.
Dombek, Blanche
Duckworth, Ruth
Eckhardt, Edris
Federighi, Christine
Feves, Betty W.
Finke, Leonda F.
Ford, Betty Davenport
Ford, Margaret
Frank, Mary
Frazier, Lena Beth
Frey, Viola
Graham, Gloria
Gregory, Angela
Grygutis, Barbara
Gunderman, Karen
Hansen, Florence P.
Havens, Jan
Hecht, Mary
Held, Marion E.
Horrell, Deborah
Jarrard-Dimond, Terry
Jencks, Penelope
Keelan, Margaret
Klavun, Betty
Klotz-Reilly, Suzanne
Kramer, Linda
Lacy, Ann
Levick, Ellen
Levine, Marilyn
Lief, Dona Lee
Lowney, Beverley Magennis
Lysohir, Marilyn
Mathiesen, Pat
McCagg, Louise
McCleery, Kathryn L.
McIlvain, Isabel
Murrill, Gwynn
Neuenschwander, Ronna
Nicholas, Donna Lee
Pereyma, Aka
Perrigo, Anne
Petersen, Karen A.
Phillips, Helen Evans
Pineda, Marianna
Reese, Claudia
Rice, Jacquelyn
Rice, Paula Jean
Robinson, Aminah Brenda Lynn
Rosenberg, Yetta
Ruby, Laura
Schwebel, Renata M.
Shannonhouse, Sandra L.

Sherwood, Carol A.
Smith, Linda Thern
Smith, Mara
Wachtmeister, Linda E. A.
Warashina, Patti
Ward, Jean
Wasserboehr, Patricia
Watson, Helen Richter
Whitney, Carol
Winkel, Nina
Winokur, Paula
Woody, Elsbeth S.

Concrete
Fuller, Mary
Mason, Molly
Pepper, Beverly
Roper, Jo
Stussy, Maxine Kim
Tacha, Athena
Winsor, Jacqueline

Fiber
Baer, Barbara
Barzel, Dina
Castanis, Muriel B.
Chase-Riboud, Barbara
Fuller, Sue
Grossen, Françoise
Hammond, Harmony
Irwin, Kim
Jarrard-Dimond, Terry
McKenna, Sally
Sage, Priscilla K.
Samuels, Diane
Tawney, Lenore
Uravitch, Andrea V.
Van Harlingen, Jean
Whitney, Carol

Glass
Eckhardt, Edris
Falkenstein, Claire
Mulcahy, Kathleen
Rhoades, Barbara
Rieger, Sonja O.
Shaffer, Mary

Horn
Olanna, Karen Jenkins

Leather
Love, Arlene

Metal (brazed)
Eldredge, Mary Agnes
Kumata, Carol

Metal (cast)
Alaupović, Alexandra V.
Andrew, Trish
Bates, Mary P.
Berge, Dorothy
Biggs, Electra Waggoner
Block, Mary
Bruria
Caparn, Rhys
Chase-Riboud, Barbara

Collings, Betty
Connell, Bunny
D'Alessandro, Sara
D'Amore, Bernadette
de Gogorza, Patricia
de Moulpied, Deborah
Dehner, Dorothy
Diska
Dreyer, Clarice A.
Eckhardt, Edris
Elkin, Rowena C.
Falk, Elizabeth C.
Ferguson, Kathleen
Field, Kathryn E.
Finke, Leonda F.
FitzGerald, Joan
Follett, Jean F.
Ford, Betty Davenport
Frank, Mary
Frazier, Beverly
Frazier, Lena Beth
Frey, Viola
Gambaro, Retha Walden
Geoffrion, Moira Marti
Gold, Betty
Graves, Nancy
Greene-Mercier, Marie Zoe
Hampton, Lucille Charlotte
Hansen, Florence P.
Harrison, Carole
Hecht, Mary
Helfant, Nancy
Jencks, Penelope
Jones, Marilyn
Jordan, Johanna
Kaish, Luise
Knapp, Candace
Kohlmeyer, Ida
Lacy, Ann
Lee, Caroline
Lekberg, Barbara
Love, Arlene
Margoulies, Berta
Mason, Jimilu
Mathiesen, Pat
McCagg, Louise
McCleary, Kathryn L.
McCullough, Geraldine
McIlvain, Isabel
Mitchie, Mary
Murrill, Gwynn
Newmark, Marilyn
Olanna, Karen Jenkins
Pepper, Beverly
Petersen, Karen A.
Pineda, Marianna
Puls, Lucy
Raymond, Evelyn
Reynolds, Nancy du Pont
Roper, Jo.
Schupack, Vera
Shanklin, Barbara K.
Shannonhouse, Sandra L.
Sosin, Georgette
Stewart, Hannah
Stiebel, Hannah
Strider, Marjorie

Stump, Pamela
Stussy, Maxine Kim
Sunderland, Nita K.
Sutter, Jean
Tarantal, Elsa Johnson
Webb, Nancy
Wolfe, Ann
Wood, Marcia
Wyrick, Shirley

Metal (exploded)
Cenci, Silvana

Metal (forged)
Perry, Beatrice

Metal (joined)
Davidson, Carol Kreeger

Metal (raised)
Roper, Jo

Metal (rolled)
Fogarty, Mary Beth
Gillespie, Dorothy
Katzen, Lila

Metal (soldered)
Banks, Rela
Glowacki, Martha
Larson, Gail Farris
Threadgill, Linda

Metal (welded)
Aycock, Alice
Barnett, Loretta S. Wonacott
Bates, Mary P.
Berge, Dorothy
Blitt, Rita
Bontecou, Lee
Bradley, Mary E.
Brandt, Helene
Brown, Carol K.
Butterfield, Deborah
Carroll, Maryrose
Catlett, Elizabeth
D'Amore, Bernadette
de Guatemala, Joyce
Emery, Lin
Falkenstein, Claire
Fanelli, Deborah
Filkosky, Josefa
Ford, Betty Davenport
Frank, Jane
Gold, Betty
Greene-Mercier, Marie Zoe
Gruber, Aaronel deRoy
Harrison, Carole
Holt, Nancy
Holt, Sara
Hutchinson, Jaqueth
Johnson, Sally W.
Jordan, Johanna

Kaish, Luise
Kaplan, Penny
Katzen, Lila
Larson, Gail Farris
Lee, Caroline
Leeper, Doris
Lekberg, Barbara
Mandeberg, Jean
Mason, Jimilu
Mason, Molly
Matthews, Harriett
McCullough, Geraldine
McDaniel, Joyce
McKenna, Sally
Mears, Mary Ann E.
Montague, Caroline
Neijna, Barbara
Nevelson, Louise
Oliver, Jeanette M.
Pepper, Beverly
Pereyma, Aka
Perry, Beatrice
Petersen, Karen A.
Raymond, Evelyn
Rockwood, Lynda K.
Schwebel, Renata M.
Sosin, Georgette
Sperry, Ann
Stewart, Hannah
Stiebel, Hannah
Strider, Marjorie
Stump, Pamela
Sutter, Jean
Tacha, Athena
Thorpe, Hilda
Udinotti, Agnese
Uravitch, Andrea V.
Walker, Lin S.
Ward, Jean
Winkel, Nina
Wood, Marcia
Woodham, Jean
Wyrick, Shirley
Yanish, Elizabeth

Neon
Rhoades, Barbara

Paper
Alexander, Marsia R.
Fogarty, Mary Beth
Gillespie, Dorothy
Helman, Phoebe
Johnson, Sally W.
Satin, Claire Jeanine

Paper (cast)
Borgatta, Isabel Case

Paper (handmade)
Bell, Lilian A.
Bruria
Geoffrion, Moira Marti
Thorpe, Hilda

Plaster
Malik, Marlene

Plastic
Arms, Anneli
Blitt, Rita
Florsheim, Lillian H.
Frank, Jane
Frazier, Beverly
Fuller, Sue
Gruber, Aaronel deRoy
Love, Arlene
Mulligan, Catherine
Rankine, V. V.
Reynolds, Nancy du Pont

Plastic (fiberglass)
Renick, Patricia A.
Rozhon, Ann

Plastic (Plexiglas)
Rothschild, Amalie

Plastic (polyester resin)
Feuerman, Carole Jeane
Holt, Sara
Love, Arlene
McCullough, Geraldine

Plastic (thermal formed)
de Moulpied, Deborah

Plastic (vinyl)
Collings, Betty

Stone
Adams, Alice
Albuquerque, Lita
Armstrong, Jane B.
Banks, Rela
Bevins, Sue
Biggs, Electra Waggoner
Borgatta, Isabel Case
Bourgeois, Louise
Brennan, Nizette
Calzolari, Elaine
Caparn, Rhys
Catlett, Elizabeth
Chase-Riboud, Barbara
D'Amore, Bernadette
deCoux, Janet
Diska
Ente, Lily
Falkman, Susan
Fine, Joan
Gambaro, Retha Walden
Goulet, Lorrie
Gregory, Angela
Hall, Chenoweth
Hanna, Gay Powell
Hartwig, Cleo
Holt, Nancy

Huffington, Anita
Lewis, Mary
Malloff, Georganna Pearce
Margoulies, Berta
Model, Elisabeth
Olanna, Karen Jenkins
Raymond, Evelyn
Rosenberg, Yetta
Shanklin, Barbara K.
Shaw, Mary Todd
Solbert, R. G.
Stein, Sandy
Sunderland, Nita K.
Tewi, Thea
Thompson, Conway
Tock, Jean
Walker, Lin S.
Wasserboehr, Patricia
Wolfe, Ann
Zimmerman, Elyn

Varied Media

Abeles, Kim
Abish, Cecile
Adams, Alice
Albuquerque, Lita
Allen, Joe Ann Marshall
Altman, Edith
Andrew, Trish
Arms, Anneli
Artemis, Maria
Aycock, Alice
Baer, Barbara
Bagley, Frances Stevens
Benglis, Lynda
Bermann, Lenora
Bevins, Sue
Bontecou, Lee
Bourgeois, Louise
Bowles, Marianne von Recklinghausen
Brito-Avellana, María
Butterfield, Deborah
Calman, W.
Calzolari, Elaine
Carhartt, Elaine
Carroll, Maryrose
Chavous, Barbara
Connell, Clyde
Cooper, Stephanie
Danziger, Joan
Davidson, Carol Kreeger
de Moulpied, Deborah
Dennis, Donna
de Wit, Margot
Dueber, Jeanne
Elkin, Rowena C.
Emery, Lin
Feldman, Bella Tabak
Ferguson, Catherine
Ferguson, Kathleen
Field, Kathryn E.
Fiene, Susan
Fine, Joan
Follett, Jean F.
Ford, Margaret
Frank, Jane
Frazier, Beverly

Gilbert, Helen
Glatt, Linnea
Glowacki, Martha
Glowen, Kathryn A.
Graves, Kā
Grossen, Françoise
Grossman, Nancy
Gunter, Virginia
Hammond, Harmony
Hanson, Jo
Harries, Mags
Hart, Kathleen
Hassinger, Maren
Havens, Jan
Healy, Anne
Helm, Alison
Hepper, Carol
Holt, Nancy
Horner, Lou
Horrell, Deborah
Hutchinson, Jaqueth
Irwin, Kim
Jarrard-Dimond, Terry
Jones, Marilyn
Jones, Wiz
Kaish, Luise
Kamen, Rebecca
Kaplan, Penny
Katsiaficas, Diane
King, Elizabeth C.
King, Katherine
Klavun, Betty
Klotz-Reilly, Suzanne
Kumata, Carol
Levick, Ellen
Lief, Dona Lee
Lofquist, Janet
Lysohir, Marilyn
Magenta, Muriel
Mandeberg, Jean
Margoulies, Berta
Marisol
McCleery, Kathryn L.
McCune, Linda Williams
McKenna, Sally
McMahon, Maggie
Mintich, Mary R.
Miss, Mary
Montague, Caroline
Mulcahy, Kathleen
Mulligan, Catherine
Neijna, Barbara
Norvell, Patsy
Perrigo, Anne
Perry, Beatrice
Pfaff, Judy
Phillips, Helen Evans
Pinto, Jody
Price, Joan Webster
Quarberg, Laurel J.
Renick, Patricia A.
Rhoades, Barbara
Rice, Paula Jean
Rieger, Sonja O.
Rizo-Patron, B. P.
Robinson, Aminah Brenda Lynn
Rosen-Queralt, Jann
Ruby, Laura
Satin, Claire Jeanine
Savoy, Chyrl L.
Schupack, Vera

Sebastian, Jill
Shaffer, Diana
Shaffer, Mary
Shaw, Mary Todd
Shirley, Karen
Simpson, Diane
Smith, Linda Thern
Smith, Mara
Sosin, Georgette
Stein, Sandy
Stewart, Hannah
Stoppert, Mary
Strider, Marjorie
Strunck, Gisela-Heidi
Tacha, Athena
Tawney, Lenore
Teicher, Lois
Thatcher, Sharon
Thompson, Conway
Thomspon, Rosalind G.
Thorpe, Hilda
Threadgill, Linda
Tillman, Patricia
Tock, Jean
Uravitch, Andrea V.
Ure, Maureen O'Hara
Van Harlingen, Jean
Vieux, Marian J.
Wachtmeister, Linda E. A.
Warashina, Patti
Waters, Sara
Watson, Genna
Webb, Nancy
Wharton, Margaret
Worthington, Nancy
Zimmerman, Elyn
Zurcher, Susan
Zurik, Jesselyn Benson

Wood

Adams, Alice
Alexander, Marsia R.
Arnold, Anne
Aycock, Alice
Bagley, Frances Stevens
Banks, Rela
Barnett, Loretta S. Wonacott
Bell, Lilian A.
Bermann, Lenora
Blitt, Rita
Bourgeois, Louise
Bullard, Helen
Catlett, Elizabeth
Chavous, Barbara
Connell, Clyde
Cooper, Stephanie
deCoux, Janet
de Gogorza, Patricia
Dehner, Dorothy
de Wit, Margot
Diska
Dombek, Blanche
Dueber, Jeanne
Eldredge, Mary Agnes
Elkin, Rowena C.
Ente, Lily

Falkenstein, Claire
Fanelli, Deborah
Ferrara, Jackie
Field, Kathryn E.
Follett, Jean F.
Geoffrion, Moira Marti
Glowen, Kathryn A.
Goulet, Lorrie
Hall, Chenoweth
Hartwig, Cleo
Hecht, Mary
Helfant, Nancy
Helm, Alison
Helman, Phoebe
Jones, Marilyn
Jones, Wiz
Kamen, Rebecca
Kerrigan, Maurie
King, Katherine
Klavun, Betty
Knapp, Candace

Kohlmeyer, Ida
Kruger, Louise
Lewis, Mary
Malik, Marlene
Malloff, Georganna Pearce
Marisol
Mason, Molly
McDaniel, Joyce
Miss, Mary
Model, Elisabeth
Murrill, Gwynn
Nevelson, Louise
Pereyma, Aka
Pineda, Marianna
Pinto, Jody
Puls, Lucy
Rankine, V. V.
Renick, Patricia A.
Rice, Jacquelyn
Robinson, Aminah Brenda Lynn
Rothschild, Amalie
Samuels, Diane
Savoy, Chyrl L.
Schwebel, Renata M.
Sebastian, Jill
Shaw, Mary Todd
Simpson, Diane
Solbert, R. G.

Spring, Barbara
Stoppert, Mary
Strunck, Gisela-Heidi
Stussy, Maxine Kim
Sutter, Jean
Telford, Laura
Teller, Jane
Tillman, Patricia
Truitt, Anne
Wharton, Margaret
Winsor, Jacqueline
Wolfe, Ann
Zurcher, Susan
Zurik, Jesselyn Benson

About the Author

Virginia Watson-Jones was born in San Antonio, Texas. Ceramics and painting were her first interests in the arts. She studied art at Incarnate Word College, San Antonio, the San Antonio Art Institute, The School of the Art Institute of Chicago, and privately with Robin Bond and Toby Joysmith in Mexico City. She obtained undergraduate degrees from Loyola University, New Orleans, and The University of Texas at San Antonio. She received an M.A. in Art History and Photography from the Texas Woman's University. She earned an M.F.A. in Ceramic Sculpture also from the Texas Woman's University, studying with J. Brough Miller. Her own experience as a sculptor served as an invaluable aid in preparing this study. Ms. Watson-Jones intends to continue to lecture on women sculptors and write.

The woodcut illustration is by
Mary Azarian, Plainfield, Vermont.
The book was designed by
Linda M. Archer, The Oryx Press, Phoenix,
Arizona.
The text was set in Geneva Light.
The book was printed by offset lithography
at Malloy Lithographing, Inc.,
Ann Arbor, Michigan
and bound at John H. Dekker and Sons,
Grand Rapids, Michigan.